GARDNER'S ART THROUGH THE AGES

A CONCISE HISTORY OF WESTERN ART

GARDNER'S ART

THROUGH THE AGES

A CONCISE HISTORY OF WESTERN ART

Fred S. Kleiner

Christin J. Mamiya

ABOUT THE AUTHORS

Fred S. Kleiner received his Ph.D. in art history and archaeology from Columbia University. Author of more than a hundred publications on classical art and architecture, including *A History of Roman Art*, also published by Thomson Wadsworth, he served as editor-in-chief of the *American Journal of Archaeology* from 1985–1998. He has taught the art history survey course for three decades, first at the University of Virginia and, since 1978, at Boston University, where he is currently professor of art history and archaeology and chairman of the art history department. Long recognized for his inspiring lectures and devotion to students, Professor Kleiner won Boston University's prestigious Metcalf Award for Excellence in Teaching as well as the College Prize for Undergraduate Advising in the Humanities in 2002.

Christin J. Mamiya received her Ph.D. in art history from the University of California, Los Angeles, and is professor of art history at the University of Nebraska–Lincoln. A recipient of numerous teaching awards, including the Annis Chaikin Sorensen Award for Distinguished Teaching in the Humanities from the University of Nebraska in 2001, Professor Mamiya specializes in the areas of modern, postmodern, and Oceanic art. She has published a book on Pop art, as well as many articles, catalog essays, and book reviews. She is an active participant in the wider community as both a curator and lecturer.

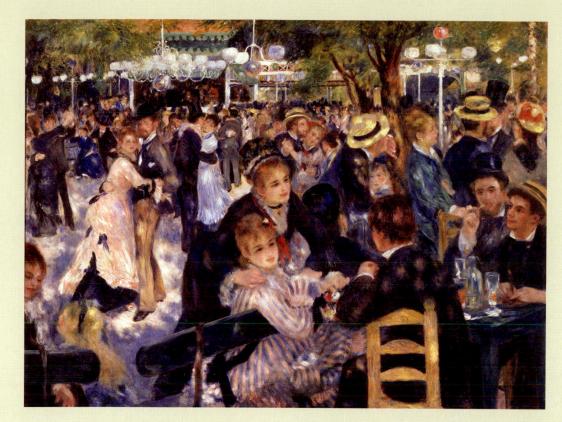

PIERRE-AUGUSTE RENOIR, *Le* Moulin de la Galette, 1876. Oil on canvas, approx. 4' 3" × 5' 8". Musée d'Orsay, Paris.

ABOUT THE COVER ART

Le Moulin de la Galette by French painter Pierre-Auguste Renoir (1841-1919) is one of the most important artworks produced during a revolutionary period in the history of art. A hostile critic dubbed Renoir and a group of likeminded painters the "Impressionists" because their paintings shared many qualities with sketches—speed and spontaneity and especially an "unfinished" look. The Impressionists made no attempt to disguise the brush strokes they applied to the canvas in their effort to catch the fleeting effects of sunlight. They also addressed subjects that more traditional painters considered frivolous, for example, modern urban leisure activities. In addition, the Impressionists composed their paintings in radically new ways. In Le Moulin de la Galette (the name of a popular Parisian dance hall), Renoir placed the figures in a seemingly causal manner that suggests the continuity of space, spreading in all directions and only accidentally limited by the frame. Whereas most 19thcentury artists still working in the classical Renaissance tradition sought to express universal and timeless qualities in their paintings, the Impressionists attempted to depict just the opposite—the incidental and the momentary. Unappreciated in their own day, the Impressionists are now among the most revered artists in the world and their paintings constitute a significant chapter in this Concise History of Western Art.

Gardner's Art through the Ages: A Concise History of Western Art Fred S. Kleiner Christin J. Mamiya

Publisher: Clark Baxter

Senior Development Editor: Sharon Adams Poore

Assistant Editor: Emily Perkins Editorial Assistant: Nell Pepper

Development Project Manager: Julie Yardley Executive Marketing Manager: Diane Wenckebach

Marketing Assistant: Kassie Tosiello

Marketing Communications Manager: Patrick Rooney

Senior Project Manager, Editorial Production: Kimberly Adams

Creative Director: Rob Hugel Executive Art Director: Maria Epes

© 2008 Thomson Wadsworth, a part of The Thomson Corporation. Thomson, the Star logo, and Wadsworth are trademarks used herein under license.

ALL RIGHTS RESERVED. No part of this work covered by the copyright hereon may be reproduced or used in any form or by any means—graphic, electronic, or mechanical, including photocopying, recording, taping, Web distribution, information storage and retrieval systems, or in any other manner—without the written permission of the publisher.

Printed in the United States of America
1 2 3 4 5 6 7 11 10 09 08 07

For more information about our products, contact us at: Thomson Learning Academic Resource Center 1-800-423-0563

For permission to use material from this text or product, submit a request online at http://www.thomsonrights.com.

Any additional questions about permissions can be submitted by email to thomsonrights@thomson.com.

Thomson Higher Education 10 Davis Drive Belmont, CA 94002-3098 USA

Library of Congress Control Number: 2006907655

Student Edition: ISBN-13 978-0-534-60511-9 ISBN-10 0-534-60511-7 Print Buyer: Judy Inouye Permissions Editor: Bob Kauser

Production Service: Joan Keyes, Dovetail Publishing Services

Photo Researcher: Stephen Forsling

Cover Designer: Lisa Henry

Cover Image: Renoir, Auguste (1841–1919), Dance at the Moulin de la Galette. 1876. Oil on canvas, 4'3" × 5'8". Musée d'Orsay, Paris, France.

© Erich Lessing/Art Resource, NY. Cover Printer: Phoenix Color Corp. Compositor: Thompson Type Printer: R.R. Donnelley/Willard

CONTENTS IN BRIEF

Preface xi

INTRODUCTION | The Subjects and Vocabulary of Art History 1

- 1 | Prehistory and the First Civilizations 15
- 2 | Greece 47
- 3 | The Roman Empire 89
- 4 | Early Christianity and Byzantium 123
- 5 | The Islamic World 147
- 6 | Early Medieval and Romanesque Europe 157
- 7 | Gothic Europe 185
- 8 | 15th-Century Europe 215
- 9 | 16th-Century Europe 249
- 10 | Baroque Europe 285
- 11 | Europe and America, 1750–1850 317
- 12 | Europe and America, 1850–1900 345
- **13** | Europe and America, 1900–1945 371
- 14 | Europe and America after World War II 405

Historical Atlas 434 | Notes 447 | Glossary 450 | Bibliography 461 | Credits 468 | Index 470

CONTENTS

Preface xi

INTRODUCTION

The Subjects and Vocabulary of Art History 1

Art History in the 21st Century 2

CHAPTER 1

Prehistory and the First Civilizations 15

Paleolithic Art 15

Neolithic Art 19

Sumerian Art 22

Akkadian Art 26

Babylonian Art 27

Assyrian Art 28

Neo-Babylonian Art 29

Achaemenid Persian Art 30

Egyptian Art 31

Art and Society: Art in the Old Stone Age 17

Art and Society: Mummification and the Afterlife 33

Architectural Basics: Building the Great Pyramids 35

Chronological Overview 30,000 BCE to 330 BCE 45

CHAPTER 2

Greece 47

Prehistoric Aegean Art 48

Greek Art 55

Religion and Mythology: The Gods and Goddesses of Mount

Olympus 48

Architectural Basics: Doric and Ionic Temples 59

Materials and Techniques: Hollow-Casting Life-Size Bronze

Statues 67

Chronological Overview 3000 BCE to 31 BCE 87

CHAPTER 3

The Roman Empire 89

Etruscan Art 89

Roman Art 93

Art and Society: An Outline of Roman History 94

Architectural Basics: The Roman Architectural Revolution:

Concrete Construction 97

Architectural Basics: The Roman House 99

Chronological Overview 753 BCE to 337 CE 121

CHAPTER 4

Early Christianity and Byzantium 123

Early Christian Art 123

Byzantine Art 132

Religion and Mythology: The Life of Jesus in Art 126

Materials and Techniques: Mosaics 130

Architectural Basics: Pendentives 134

Art and Society: Icons and Iconoclasm 139

Chronological Overview 29 to 1453 145

CHAPTER 5

The Islamic World 147

Architecture 147

Luxury Arts 153

Religion and Mythology: Muhammad and Islam 148

Architectural Basics: The Mosque 150

Chronological Overview 570 to 1600 155

CHAPTER 6

Early Medieval and Romanesque Europe 157

The Art of the Warrior Lords 157

Hiberno-Saxon Art 158

Carolingian Art 160

Ottonian Art 165

Romanesque Art 167

Religion and Mythology: Medieval Monasteries and Benedictine Rule 164

Art and Society: Pilgrimages and the Cult of Relics 168
Architectural Basics: The Romanesque Portal 175
Chronological Overview 500 to 1200 183

CHAPTER 7

Gothic Europe 185

France 185 England 199 Germany 201 Italy 203

Architectural Basics: The Gothic Rib Vault 187
Architectural Basics: The Gothic Cathedral 191
Materials and Techniques: Stained-Glass Windows 192

Materials and Techniques: Fresco Painting 206
Chronological Overview 1140 to 1400 213

CHAPTER 8

15th-Century Europe 215

Flanders 216 France 223 Germany 225 Italy 227

Materials and Techniques: Painters, Pigments, and Panels 219
Materials and Techniques: Graphic Changes: The Development

of Printmaking 226

Materials and Techniques: Depicting Objects in Space: Perspectival Systems in the Early Renaissance 230 Chronological Overview 1400 to 1500 247

CHAPTER 9

16th-Century Europe 249

Italy 250 Holy Roman Empire 272 France 277 The Netherlands 278 Spain 280

Art and Society: The Role of Religious Art in Counter-Reformation

Italy 251

Materials and Techniques: Disegno 254
Chronological Overview 1500 to 1600 283

CHAPTER 10

Baroque Europe 285

Italy 286
Spain 295
Flanders 298
The Dutch Republic 300
France 308
England 313
Germany 314

Art and Society: Dutch Patronage and Art Collecting 301
Chronological Overview 1600 to 1750 315

CHAPTER 11

Europe and America, 1750 - 1850 317

Rococo 317
The Enlightenment 319
The Taste for the "Natural" 321
Neoclassicism 325
Romanticism 329
Mid-19th-Century Architecture 339
The Beginnings of Photography 340
Art and Society: The Romantic Spirit in Music and Literature 335
Chronological Overview 1750 to 1850 343

CHAPTER 12

Europe and America, 1850 - 1900 345

Painting 346 Sculpture 366 Architecture 367

Art and Society: The Academies: Defining the Range of

Acceptable Art 351

Materials and Techniques: 19th-Century Color Theory 363

Chronological Overview 1850 to 1900 369

CHAPTER 13

Europe and America, 1900 – 1945 371

Fauvism 373
German Expressionism 374
Cubism 376
Futurism 380
Dada 381
The Armory Show and Its Legacy 383
Neue Sachlichkeit 386
Surrealism 387

Suprematism and De Stijl 391

Architecture 393

Sculpture 396

Political and Social Commentary 397

Art and Society: Art "Matronage" in America 383

Chronological Overview 1900 to 1945 403

CHAPTER 14

Europe and America after World War II 405

Postwar Expressionism in Europe 406 Abstract Expressionism 407 Post-Painterly Abstraction 411 Minimalism 411

Performance Art 413

Conceptual Art 414

Pop Art 415

Superrealism 418

Environmental Art 418

Modernist Architecture 420

Postmodern Architecture 421

Deconstructivist Architecture 423

Postmodern Painting, Sculpture, and Photography 424

New Media 430

Art and Society: The Power of Minimalism: Maya Lin's Vietnam

Veterans Memorial 413

Art and Society: Contesting Culture: Controversies in Art 426

Chronological Overview 1945 to PRESENT 433

Historical Atlas 434 | Notes 447 | Glossary 450 | Bibliography 461 | Credits 468 | Index 470

PREFACE

In 2005, Thomson Wadsworth published the first concise edition of *Gardner's Art through the Ages*, which in its unabridged form first appeared in 1926. The original edition by Helen Gardner became an instant classic and the current 12th edition by Fred S. Kleiner and Christin J. Mamiya remains the number one choice for yearlong introductory art history courses. Kleiner and Mamiya were the coauthors also of the 11th edition, which won both the 2001 Texty and McGuffey Book Prizes of the Text and Academic Authors Association as the best college textbook in the humanities and social sciences. *Gardner's Art through the Ages* is the only art history book to win either award and the first title ever to win both prizes in the same year.

It is extremely gratifying to note that the concise edition of *Art through the Ages* has already become the best-selling text for one-semester introductions to the history of art. Readers familiar with the Gardner books will know that Thomson Wadsworth also publishes a version of the 12th edition for yearlong courses that cover only Western art. In response to many requests, we now offer this *Concise History of Western Art*, which contains only the Western and Islamic art chapters in the 2005 concise version of *Art through the Ages*.

Planning for *Gardner's Art through the Ages: A Concise History* began by consulting professors at universities where a one-semester art history survey course has been offered for many years. The invaluable advice these colleagues provided helped us decide on not only the general format and bold new look (see below) of the concise Gardner but also which artworks discussed in the 12th edition were most important to retain in the new book. We are therefore confident that our selection of works is especially well suited for the "real world" of the one-semester survey course.

Readers who compare the concise and the 12th editions of *Gardner's Art through the Ages* will immediately notice that the changes we have made go far beyond the reduction of words and illustrations and the reorganization of the text into about half the number of chapters as in the unabridged edition. The concise edition features a new design with a larger typeface and more color typography, making it easy to distinguish the various sections of each chapter and to locate in the text where each illustration is discussed. We also introduced what immediately became a very popular new feature of the concise Gardner: Quick-Review Captions, short synopses of

the most significant aspects of each artwork illustrated. These brief commentaries accompany the caption to every image in the volume. Professors who have used the concise Gardner in their classes report that these extended captions have greatly assisted students in reviewing material and preparing for examinations. Another important new feature is the Historical Atlas that appears at the end of the text, containing one to three maps for each of the chapters (numbered MAP 1-1, 1-2, 2-1, 2-2, and so on). References to the maps appear throughout the text, highlighted by a map icon in the margin, so that readers can conveniently consult the maps while reading about each historical era. At the same time, having all the maps gathered together in one place will facilitate cross-cultural comparisons.

Readers of the 12th edition of Gardner's Art through the Ages will nonetheless find much that is familiar in the two concise editions. Above all, as already noted, the authorship is identical and so too is the approach to the study of art history, which has won such a wide and devoted audience for the Gardner books. We think, as Helen Gardner did, that the most effective way to tell the story of art through the ages, especially for those who are studying art history for the first time, is to organize the vast array of artistic monuments according to the civilizations that produced them and to consider each work in roughly chronological order. This approach has not only stood the test of time but is the most appropriate for narrating the history of art. We believe that the enormous variation in the form and meaning of paintings, sculptures, buildings, and other artworks is largely the result of the constantly changing historical, social, economic, religious, and cultural contexts in which artists and architects worked. A historically based narrative is best suited for introducing the history of art. Therefore, consistent with the latest art historical research emphases, we pay greater attention than ever before to function and context, while sustaining attention to style, chronology, iconography, and technique. We consider artworks with a view toward their purpose and meaning in the society that produced them at the time at which they were made. We also address the important role of patronage in the production of art and examine the individuals or groups who paid the artists and influenced the shape the artworks took. We devote more space to the role of women and women artists in societies over time. Throughout, we

have aimed to integrate the historical, political, and social contexts of art and architecture with the artistic and intellectual aspects. Consequently, we often treat painting, sculpture, architecture, and the so-called minor arts together, highlighting how they all reflect the conventions and aspirations of a common culture, rather than treating them as separate and distinct media. And we feature many works that until recently art historians would not have considered "art" at all. In every chapter, we have tried to reflect in our choice of artworks and buildings the increasingly wide range of interests of scholars today, while not rejecting the traditional list of "great" works or the very notion of a "canon." The works discussed encompass every artistic medium and almost every era and culture from prehistory to the present.

As in the unabridged 12th edition, the concise editions of *Gardner's Art through the Ages* feature the highest percentage of color photographs of any introductory art history textbook. Indeed, nearly every photograph in this book is in color. The only exceptions are works that were created in black and white, such as prints or photographs, and a small number of other objects or buildings of which we were unable to obtain a color view that met our very high standards for reproduction.

The rich illustration program is not, however, confined to the printed page. Every copy of this book comes with a complimentary copy of *ArtStudy CD-ROM version 2.1*, *Art Through the Ages: A Concise History of Western Art*, a CD-ROM that contains hundreds of high-quality digital images of the works discussed in the text. To facilitate the coordinated use of the CD-ROM and the book itself, every monument illustrated on the CD-ROM has an identifying icon () appended to the caption of the corresponding figure in the text. Every map in the historical atlas is also included on the CD-ROM.

Another popular feature of the 12th edition that is retained in the concise editions is the inclusion at the end of each chapter of a short conclusion summarizing the major themes discussed. These summaries face a full-page Chronological Overview of the material presented in the chapter, organized as a vertical timeline, with four "thumbnail" illustrations of characteristic works in a variety of media, generally including at least one painting, sculpture, and building. Each thumbnail is numbered. The corresponding number appears on the time rule to the left so that the chronological sequence of production is clear.

The two concise versions of *Gardner's Art through the Ages* also feature the boxed essays that we introduced in the 11th edition and that were enthusiastically received by students and instructors alike. In this edition, these essays are presented in four broad categories:

Architectural Basics provide students with a sound foundation for the understanding of architecture. These discussions are concise primers, with drawings and diagrams of the major aspects of design and construction. The information included is essential to an understanding of architectural technology and terminology. Topics discussed include the orders of classical architecture, Roman concrete construction, and the design and terminology of mosques and Gothic cathedrals.

Materials and Techniques essays explain the various media artists employed from prehistoric to modern times. Because materials and techniques often influence the character of works of art, these discussions also contain essential information on why many artworks look the way they do. Hollow-casting bronze statues, fresco painting, printing and engraving, and perspective are among the many subjects treated.

Religion and Mythology boxes introduce students to the principal elements of the world's great religions, past and present, and to the representation of religious and mythological themes in painting and sculpture of all periods and places. These discussions of belief systems and iconography give readers a richer understanding of some of the greatest artworks ever created. The topics include the gods and goddesses of the Egyptians and Greeks, the life of Jesus in art, and Muhammad and Islam.

Art and Society essays treat the historical, social, political, cultural, and religious contexts of art and architecture. Subjects include Egyptian mummification, medieval pilgrimages, the role of women in founding art museums, and the Vietnam Veterans Memorial in Washington, D.C.

In order to aid our readers in mastering the vocabulary of art history, we have italicized and defined all art historical terms and other unfamiliar words at their first occurrence in the text—and at later occurrences too, whenever the term has not been used again for several chapters. Definitions of all terms introduced in the text appear once more in the Glossary at the back of the book, which also includes pronunciations. A Concise History of Western Art also has a select bibliography of books in English, including both general works and a chapter-by-chapter list of more focused studies.

The captions to our 522 illustrations contain a wealth of information, including the name of the artist or architect, if known; the formal title (printed in italics), if assigned, description of the work, or name of the building; the provenance or place of production of the object or location of the building; the date; the material or materials used; the size; and the present location if the work is in a museum or private collection. We urge readers to pay attention to the scales provided on the plans and to all dimensions given in the captions. The objects we illustrate vary enormously in size, from colossal sculptures carved into mountain cliffs and paintings that cover entire walls or ceilings to tiny figurines that one can hold in the hand. Note, too, the location of the works discussed. Although many buildings and museums are in cities or countries that a reader may never visit, others are likely to be close to home. Nothing can substitute for walking through a building, standing in the presence of a statue, or inspecting the brushwork of a painting close up. Consequently, we have made a special effort to illustrate artworks in geographically wide-ranging public collections.

An extensive ancillary package is available for both students and instructors.

For students:

ArtStudy CD-ROM version 2.1, Art Through the Ages: A Concise History of Western Art, free with each new copy of this text, which includes access to a host of study resources. Activities and exercises correlate with each of the book's 14 chapters, including hundreds of digital images of the works discussed in the text, flashcards, interactive maps and timelines, and links to chapter quizzes and the study guide. Additional resources on the CD-ROM include drag-and-drop exercises in Architectural Basics, a Museum Guide, Tips on Becoming a Successful Student, the Guide to Researching Art History Online, and Art Links

Companion Web Site at

http://www.thomsonedu.com/art/kleiner provides chapter outlines, brief chapter overviews, audio glossary flashcards, Internet exercises, InfoTrac College EditionTM exercises, and a pronunciation guide.

Study Guide, SlideGuide, ArtBasics: An Illustrated Glossary and Timeline, and The Museum Experience

For instructors:

Presentation Tools: MultiMedia Manager, A Microsoft® PowerPoint® Link Tool includes digital images from the text, Slide Sets, WebTutorTM Advantage onWebCT and Blackboard.

Class Preparation Tools: Instructor's Manual and Test Bank; and ExamView a computerized Test Bank and classroom management tool.

A work as extensive as Gardner's Art through the Ages could not be undertaken or completed without the counsel of experts in all fields of art history. For contributions to the preparation of the unabridged 12th edition, we wish to thank again Stanley K. Abe, Duke University; C. Edson Armi, University of California, Santa Barbara; Frederick M. Asher, University of Minnesota; Cynthia Atherton, Middlebury College; Paul G. Bahn, Hull, England; Janis Bergman-Carton, Southern Methodist University; Janet Berlo, University of Rochester; Anne Bertrand, Bard College; Jonathan M. Bloom, Boston College; Kendall H. Brown, California State University, Long Beach; Andrew L. Cohen, University of Central Arkansas; Harry A. Cooper, Fogg Art Museum, Harvard University; Roger J. Crum, University of Dayton; LouAnn Faris Culley, Kansas State University; Thomas E. A. Dale, University of Wisconsin, Madison; Anne D'Alleva, University of Connecticut; Eve D'Ambra, Vassar College; Cindy Bailey Damschroder, University of Cincinnati; Abraham A. Davidson, Temple University; Carolyn Dean, University of California, Santa Cruz; William Diebold, Reed College; Erika Doss, Uni-

versity of Colorado; Daniel Ehnbom, University of Virginia; David Ehrenpreis, James Madison University; Jerome Feldman, Hawaii Pacific University; Peter Fergusson, Wellesley College; Barbara Frank, State University of New York, Stony Brook; Rita E. Freed, Museum of Fine Arts, Boston; Eric G. Garbersen, Virginia Commonwealth University; Clive F. Getty, Miami University; Paula Girshick, Indiana University; Carma R. Gorman, Southern Illinois University, Carbondale; Elizabeth ten Grotenhuis, Boston University; Melinda K. Hartwig, Georgia State University; Marsha Haufler, University of Kansas; Mary Beth Heston, College of Charleston; Hannah Higgins, University of Illinois, Chicago; Charlotte Houghton, the Pennsylvania State University; Aldona Jonaitis, University of Alaska Museum; Adrienne Kaeppler, Smithsonian Institution; Padma Kaimal, Colgate University; Stacy L. Kamehiro, University of California, Santa Cruz; Thomas DaCosta Kaufmann, Princeton University; Dale Kinney, Bryn Mawr College; Sandy Kita, University of Maryland, College Park; Cecelia F. Klein, University of California, Los Angeles; James Kornwolf, College of William and Mary; Andrew Ladis, University of Georgia, Athens; Ellen Johnston Laing, University of Michigan; Joseph Lamb, Ohio University; Dana Leibsohn, Smith College; Janice Leoshko, University of Texas at Austin; Henry Maguire, Johns Hopkins University; Joan Marter, Rutgers University; Michael Meister, University of Pennsylvania; Samuel C. Morse, Amherst College; Susan E. Nelson, Indiana University; Irene Nero, Southeastern Louisiana University; Esther Pasztory, Columbia University; Jeanette F. Peterson, University of California, Santa Barbara; Elizabeth Piliod, Oregon State University; Martin Powers, University of Michigan; Ingrida Raudzens, Salem State College; Paul Rehak, University of Kansas; Margaret Cool Root, University of Michigan; Lisa Rosenthal, University of Illinois, Urbana-Champaign; Jonathan M. Reynolds, University of Southern California; Conrad Rudolph, University of California, Riverside; Denise Schmandt-Besserat, University of Texas at Austin; Ellen C. Schwartz, Eastern Michigan University; Michael Schwartz, Augusta State University; Raymond A. Silverman, Michigan State University; Jeffrey Chipps Smith, University of Texas at Austin; Anne Rudloff Stanton, University of Missouri, Columbia; Rebecca Stone-Miller, Emory University; Mary C. Sturgeon, University of North Carolina at Chapel Hill; Peter C. Sturman, University of California, Santa Barbara; Melinda Takeuchi, Stanford University; Woodman Taylor, University of Illinois at Chicago; Jehanne Teilhet-Fisk, Florida State University; Dorothy Verkerk, University of North Carolina at Chapel Hill; Monica Blackmun Visonà, Metro State College; Deborah B. Waite, University of Hawaii; Gerald Walker, Clemson University; Martha Ward, University of Chicago; Gregory Warden, Southern Methodist University; Kent R. Weeks, American University in Cairo; Victoria Weston, University of Massachusetts, Boston; and Catherine Wilkinson Zerner, Brown University.

For their indispensable comments when we were formulating our plans for the first edition of *Gardner's Art through the*

Ages: A Concise History, we are especially grateful to Alexandra Carpino, Northern Arizona University; Paul Crenshaw, Washington University of St. Louis; Alyson A. Gill, Arkansas State University; Stephen B. Henderson, Quinnipiac University; A. Lawrence Jenkens, University of New Orleans; Scott Karakas, University of North Carolina-Greensboro; Christopher R. Lawton, University of Georgia; Virginia Hagelstein Marquardt, Marist College; Andrew Marvick, Southwestern Oklahoma State University; Claire Black McCoy, Longwood College; Carolyn West Pace, Mohawk Valley Community College; Carole Paul, University of California, Santa Barbara; Andrea Pearson, Bloomsburg University; Elizabeth A. Peterson, University of Utah; Lauren Hackworth Petersen, University of Delaware; Mark B. Pohlad, DePaul University; Robert Vincent Prestiano, Angelo State University; Ronald D. Rarick, Ball State University; Rhonda L. Reymond, University of Georgia; Gwen Robertson, Humboldt State University; Basic Rozmeri, University of Oklahoma; K. Andrea Rusnock, Glendale Community College; Michael Schwartz, Augusta State University; Tiffanie P. Townsend, University of Georgia; Patricia Vettel-Becker, Montana State University-Billings; Carolynne Whitefeather, Utica College of Syracuse University; and Kristi A. Wormhoudt, Pennsylvania State University.

It is also a pleasure to acknowledge those at Thomson Wadsworth who worked with us to make *Gardner's Art through the Ages: A Concise History* a success. The commitment to this project at all levels of the company was extraordinary. We thank Clark Baxter, publisher; Sharon Adams Poore, senior development editor; Emily Perkins, assistant edi-

tor; Kim Adams, senior project manager; Maria Epes, executive art director; and Julie Yardley, development project manager; as well as Sean Wakely, president Thomson Arts & Sciences and Susan Badger, CEO of Thomson Higher Education.

In addition, we are deeply indebted to Joan Keyes of Dovetail Publishing Services for her expert work in so many areas; Michele Jones, our eagle-eyed copy editor; and Carrie Ward and Lili Weiner, our tireless photo researchers. Linda Beaupre has designed still another beautiful book for us and Lisa Henry who designed the cover of this Western version of the concise Gardner. We are happy to recognize the important contributions of Pete Shanks, our proofreader, and Nancy Ball, our indexer. We also owe thanks to the peerless Thomson Wadsworth marketing and sales professionals for their dedication to making this newest member of the Gardner family of publications a success: Elana Dolberg, vice president of marketing communications; Diane Wenckebach, executive marketing manager; Kassie Tosiello, marketing assistant; Patrick Rooney, associate marketing communications manager; and Scott Stewart, vice president and managing director of sales.

We also owe a deep debt of gratitude to our colleagues at Boston University and the University of Nebraska, Lincoln, and to the thousands of students and the scores of teaching fellows in our art history courses over many years. They too have contributed to the success of *Gardner's Art through the Ages*.

Fred S. Kleiner Christin J. Mamiya

GARDNER'S ART THROUGH THE AGES

A CONCISE HISTORY OF WESTERN ART

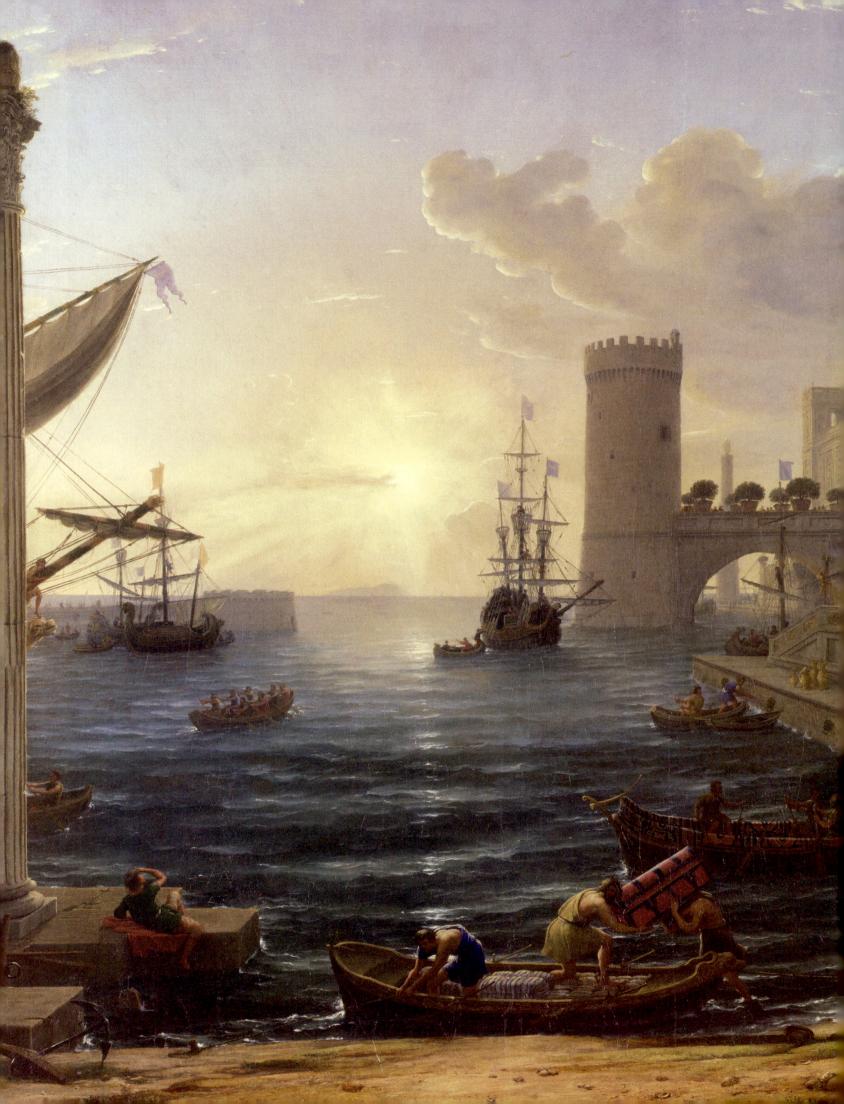

INTRODUCTION

THE SUBJECTS AND VOCABULARY OF ART HISTORY

People do not often juxtapose the terms *art* and *history*. They tend to think of history as the record and interpretation of past human actions, particularly social and political actions. Most think of art, quite correctly, as part of the present—as something people can see and touch. People cannot, of course, see or touch history's vanished human events. But a visible and tangible artwork is a kind of persisting event. One or more artists made it at a certain time and in a specific place, even if no one now knows just who, when, where, or why. Although created in the past, an artwork continues to exist in the present, long surviving its times. The first painters and sculptors died 30,000 years ago, but their works remain, some of them exhibited in glass cases in museums built only a few years ago.

Modern museum visitors can admire these relics of the remote past and the countless other objects humankind has produced over the millennia without any knowledge of the circumstances that led to the creation of those works. An object's beauty or sheer size can impress people, the artist's virtuosity in the handling of ordinary or costly materials can dazzle them, or the subject depicted can move them. Viewers can react to what they see, interpret the work in the light of their own experience, and judge it a success or a failure. These are all valid responses to a work of art. But the enjoyment and appreciation of artworks in museum settings are relatively recent phenomena, as is the creation of artworks solely for museum-going audiences to view.

Today, it is common for artists to work in private studios and to create paintings, sculptures, and other objects that commercial art galleries will offer for sale. Usually, someone the artist has never met will purchase the artwork and display it in a setting the artist has never seen. But although this is not a new phenomenon in the history of art—an ancient potter decorating a vase for sale at a village market stall also probably did not know who would buy the pot or where it would be housed—it is not at all typical. In fact, it is exceptional. Throughout history, most artists created the paintings, sculptures, and other objects exhibited in museums today for specific patrons and settings and to fulfill a specific purpose. Often, no one knows the original contexts of those artworks. Although people may appreciate the visual and tactile qualities of these objects, they cannot understand why they were made or why they look the way they do without knowing the circumstances of their creation. Art appreciation does not require knowledge of the historical context of an artwork (or a building). Art history does.

Thus, a central aim of art history is to determine the original context of artworks. Art historians seek to achieve a full understanding not only of why these "persisting events" of human history look the way they do but also of why the artistic events happened at all. What unique set of circumstances gave rise to the erection of a particular building or led a specific patron to commission an individual artist to fashion a singular artwork for a certain place? The study of history is therefore vital to art history. And art history is often very important to the

CLAUDE LORRAIN, Embarkation of the Queen of Sheba (detail), 1648. Oil on canvas, approx. 4′ 10″ × 6′ 4″. National Gallery, London.

study of history. Art objects and buildings are historical documents that can shed light on the peoples who made them and on the times of their creation in a way other historical documents cannot. Furthermore, artists and architects can affect history by reinforcing or challenging cultural values and practices through the objects they create and the structures they build. Thus, the history of art and architecture is inseparable from the study of history, although the two disciplines are not the same. In the following pages, we outline some of the distinctive subjects art historians address and the kinds of questions they ask, and explain some of the basic terminology art historians use when answering their questions. Armed with this arsenal of questions and terms, you will be ready to explore the multifaceted world of art through the ages.

ART HISTORY IN THE 21ST CENTURY

Art historians study the visual and tangible objects humans make and the structures humans build. From the earliest Greco-Roman art critics on, scholars have studied works that their makers consciously manufactured as "art" and to which the artists assigned formal titles. But today's art historians also study a vast number of objects that their creators and owners almost certainly did not consider to be "works of art." Few ancient Romans, for example, would have regarded a coin bearing their emperor's portrait as anything but money. Today, an art museum may exhibit that coin in a locked case in a climate-controlled room, and scholars may subject it to the same kind of art historical analysis as a portrait by an acclaimed Renaissance or modern sculptor or painter.

The range of objects art historians study is constantly expanding and now includes, for example, computer-generated images, whereas in the past almost anything produced using a machine would not have been regarded as art. Most people still consider the performing arts—music, drama, and dance—as outside art history's realm because these arts are fleeting, impermanent media. But recently even this distinction between "fine art" and performance art has become blurred. Art historians, however, generally ask the same kinds of questions about what they study, whether they employ a restrictive or an expansive definition of art.

The Questions Art Historians Ask

How Old Is It? Before art historians can construct a history of art, they must be sure they know the date of each work they study. Thus, an indispensable subject of art historical inquiry is *chronology*, the dating of art objects and buildings. If researchers cannot determine a monument's age, they cannot place the work in its historical context. Art historians have developed many ways to establish, or at least approximate, the date of an artwork.

Physical evidence often reliably indicates an object's age. The material used for a statue or painting—bronze, plastic, or oil-based pigment, to name only a few—may not have

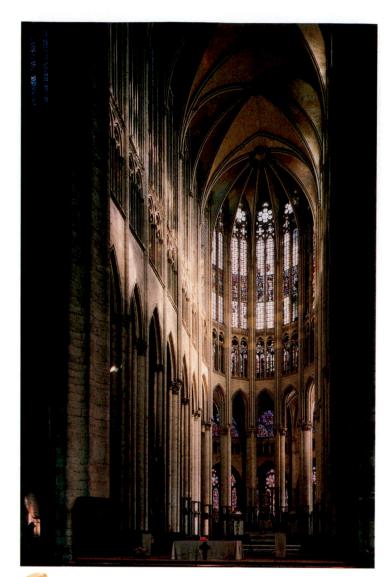

France, rebuilt after 1284.

Defining the style of an object or building is a key element of art historical inquiry. Style often varies from region to region. This church has high stone vaults and large stained-glass windows typical of French Gothic architecture.

been invented before a certain time, indicating the earliest possible date someone could have fashioned the work. Or artists may have ceased using certain materials—such as specific kinds of inks and papers for drawings and prints—at a known time, providing the latest possible dates for objects made of such materials. Sometimes the material (or the manufacturing technique) of an object or a building can establish a very precise date of production or construction. Studying tree rings, for instance, usually can determine within a narrow range the date of a wood statue or a timber roof beam.

Documentary evidence also can help pinpoint the date of an object or building when a dated written document mentions the work. For example, official records may note when church officials commissioned a new altarpiece—and how much they paid to which artist.

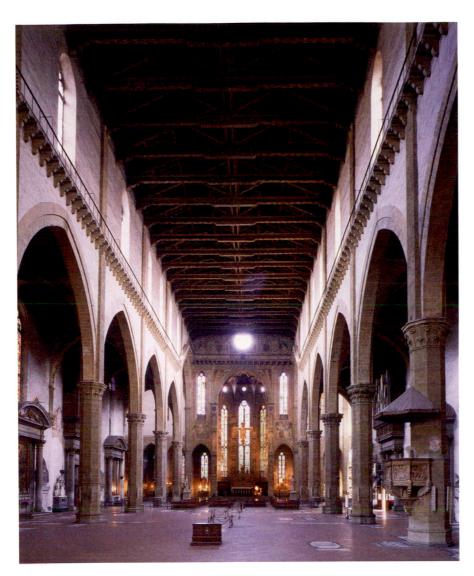

Florence, Italy, begun 1294.

Built around the same time as Beauvais Cathedral, Santa Croce exhibits the very different regional features of Italian Gothic architecture, including a low timber roof and small, widely separated windows.

Visual evidence, too, can play a significant role in dating an artwork. A painter might have depicted an identifiable person or a kind of hairstyle, clothing, or furniture fashionable only at a certain time. If so, the art historian can assign a more accurate date to that painting.

Stylistic evidence is also very important. The analysis of style—an artist's distinctive manner of producing an object, the way a work looks—is the art historian's special sphere. Unfortunately, because it is a subjective assessment, stylistic evidence is by far the most unreliable chronological criterion. Still, art historians sometimes find style a very useful tool for establishing chronology.

What Is Its Style? Defining artistic style is one of the key elements of art historical inquiry, although the analysis of artworks solely in terms of style no longer dominates the field the way it once did. Art historians speak of several different kinds of artistic styles.

Period style refers to the characteristic artistic manner of a specific time, usually within a distinct culture, such as "Archaic Greek." But many periods do not display any stylistic unity at all. How would someone define the artistic style of the opening

decade of the new millennium in North America? Far too many crosscurrents exist in contemporary art for anyone to describe a period style of the early 21st century—even in a single city such as New York.

Regional style is the term art historians use to describe variations in style tied to geography. Like an object's date, its provenance, or place of origin, can significantly determine its character. Very often two artworks from the same place made centuries apart are more similar than contemporaneous works from two different regions. To cite one example, usually only an expert can distinguish between an Egyptian statue carved in 2500 BCE and one made in 500 BCE. But no one would mistake an Egyptian statue of 500 BCE for one of the same date made in Greece or Mexico.

Considerable variations in a given area's style are possible, however, even during a single historical period. In late medieval Europe during the so-called Gothic age, French architecture differed significantly from Italian architecture. The interiors of Beauvais Cathedral (Fig. Intro-1) and Santa Croce in Florence (Fig. Intro-2) typify the architectural styles of France and Italy, respectively, at the end of the 13th century. The rebuilding of the choir of Beauvais Cathedral began in

Intro-3 | GEORGIA O'KEEFFE, *Jack-in-the-Pulpit No. 4*, 1930. Oil on canvas, 3' 4" × 2' 6". National Gallery of Art, Washington, D.C. (Alfred Stieglitz Collection, bequest of Georgia O'Keeffe).

O'Keeffe's paintings feature close-up views of petals and leaves in which the organic forms are transformed into powerful abstract compositions. This approach to painting typifies the artist's distinctive personal style.

1284. Construction commenced on Santa Croce only 10 years later. Both structures employ the characteristic Gothic pointed arch, yet they contrast strikingly. The French church has towering stone vaults and large expanses of stained-glass windows, whereas the Italian building has a low timber roof and small, widely separated windows. Because the two contemporaneous churches served similar purposes, regional style mainly explains their differing appearance.

Personal style, the distinctive manner of individual artists or architects, often decisively explains stylistic discrepancies among monuments of the same time and place. In 1930 the American painter GEORGIA O'KEEFFE produced a series of paintings of flowering plants. One of them was Jack-in-the-Pulpit No. 4 (Fig. Intro-3), a sharply focused close-up view of petals and leaves. O'Keeffe captured the growing plant's slow, controlled motion while converting the organic form into a powerful abstract composition of lines, shapes, and colors (see the discussion of art historical vocabulary in the

Vanzetti, 1931–1932. Tempera on canvas, $7'\frac{1}{2}'' \times 4'$. Whitney Museum of American Art, New York (gift of Edith and Milton Lowenthal in memory of Juliana Force).

A contemporary of O'Keeffe, Shahn had a style of painting markedly different from hers. His paintings are often social commentaries on contemporary events and incorporate readily identifiable human figures.

next section). Only a year later, another American artist, BEN SHAHN, painted *The Passion of Sacco and Vanzetti* (Fig. Intro-4), a stinging commentary on social injustice inspired by the trial and execution of two Italian anarchists, Nicola Sacco and Bartolomeo Vanzetti. Many people believed Sacco and Vanzetti had been unjustly convicted of killing two men in a holdup in 1920. Shahn's painting compresses time in a symbolic representation of the trial and its aftermath. The two executed men lie in their coffins. Presiding over them are

the three members of the commission (headed by a college president wearing academic cap and gown) who declared the original trial fair and cleared the way for the executions. Behind, on the wall of a columned government building, hangs the framed portrait of the judge who pronounced the initial sentence. Personal style, not period or regional style, sets Shahn's canvas apart from O'Keeffe's. The contrast is extreme here because of the very different subjects the artists chose. But even when two artists depict the same subject, the results can vary widely. The *way* O'Keeffe painted flowers and the way Shahn painted faces are distinctive and unlike the styles of their contemporaries. (See the "Who Made It?" discussion, below.)

The different kinds of artistic styles are not mutually exclusive. For example, an artist's personal style may change dramatically during a long career. Art historians then must distinguish among the different period styles of a particular artist, such as the "Blue Period" and the "Cubist Period" of the prolific 20th-century artist Pablo Picasso.

What Is Its Subject? Another major concern of art historians is, of course, subject matter. Some artworks, such as modern abstract paintings, have no subject, not even a setting. But when artists represent people, places, or actions, viewers must identify these aspects to achieve complete understanding of the works. Art historians traditionally separate pictorial subjects into various categories, such as religious, historical, mythological, *genre* (daily life), portraiture, *landscape* (a depiction of a place), *still life* (an arrangement of inanimate objects), and their numerous subdivisions and combinations.

Iconography—literally, the "writing of images"—refers both to the content, or subject of an artwork, and to the study of content in art. By extension, it also includes the study of symbols, images that stand for other images or encapsulate ideas. In Christian art, two intersecting lines of unequal length or a simple geometric cross can serve as an emblem of the religion as a whole, symbolizing the cross of Jesus Christ's crucifixion. A symbol also can be a familiar object the artist imbued with greater meaning. A balance or scale, for example, may symbolize justice or the weighing of souls on Judgment Day.

Artists also may depict figures with unique *attributes* identifying them. In Christian art, for example, each of the authors of the New Testament Gospels, the Four Evangelists, has a distinctive attribute. Saint John is known by his eagle, Luke by an ox, Mark by a lion, and Matthew by a winged man.

Throughout the history of art, artists have also used *personifications*—abstract ideas codified in bodily form. Worldwide, people visualize Liberty as a robed woman with a torch because of the fame of the colossal statue set up in New York City's harbor in the 19th century. *The Four Horsemen of the Apocalypse* (Fig. INTRO-5) is a terrifying late-15th-century depiction of the fateful day at the end of time when, according to the Bible's last book, Death, Famine, War, and Pestilence will cut down the human race. The artist, Albrecht Dürer, portrayed Death as an emaciated old man with a pitchfork.

Intro-5 | Albrecht Dürer, The Four Horsemen of the Apocalypse, ca. 1498. Woodcut, approx. 1' $3\frac{1}{4}$ " × 11". Metropolitan Museum of Art, New York (gift of Junius S. Morgan, 1919).

Artists often depict abstract ideas in human form. Dürer portrayed Death, Famine, War, and Pestilence as horsemen carrying distinctive attributes—a pitchfork, scale, sword, and bow, respectively.

Dürer's Famine swings the scales that will weigh human souls, War wields a sword, and Pestilence draws a bow.

Even without considering style and without knowing a work's maker, informed viewers can determine much about the work's period and provenance by iconographical and subject analysis alone. In *The Passion of Sacco and Vanzetti* (FIG. INTRO-4), for example, the two coffins, the trio headed by an academic, and the robed judge in the background are all pictorial clues revealing the painting's subject. The work's date must be after the trial and execution, probably while the event was still newsworthy. And because the deaths of the two men caused the greatest outrage in the United States, the painter-social critic was probably American.

Who Made It? If Ben Shahn had not signed his painting of Sacco and Vanzetti, an art historian could still assign, or *attribute*, the work to him based on knowledge of the artist's personal style. Although signing (and dating) works is quite

common (but by no means universal) today, in the history of art countless works exist whose artists remain unknown. Because personal style can play a large role in determining the character of an artwork, art historians often try to attribute anonymous works to known artists. Sometimes they attempt to assemble a group of works all thought to be by the same person, even though none of the objects in the group is the known work of an artist with a recorded name. Art historians thus reconstruct the careers of artists such as "the Achilles Painter," the anonymous ancient Greek vase painter whose masterwork is a depiction of the hero Achilles. Scholars base their attributions on internal evidence, such as the distinctive way an artist draws or carves drapery folds, earlobes, or flowers. It requires a keen, highly trained eye and long experience to become a connoisseur, an expert in assigning artworks to "the hand" of one artist rather than another.

Sometimes a group of artists works in the same style at the same time and place. Art historians designate such a group as a *school*. "School" does not mean an educational institution. The term connotes only chronological, stylistic, and geographic similarity. Art historians speak, for example, of the Dutch school of the 17th century and, within it, of subschools such as those of the cities of Haarlem, Utrecht, and Leyden.

Who Paid For It? The interest many art historians show in attribution reflects their conviction that the identity of an artwork's maker is the major reason the object looks the way it does. For them, personal style is of paramount importance. But in many times and places, artists had little to say about what form their work would take. They toiled in obscurity, doing the bidding of their *patrons*, those who paid them to make individual works or employed them on a continuing basis. The role of patrons in dictating the content and shaping the form of artworks is also an important subject of art historical inquiry.

In the art of portraiture, for example, the patron has often played a dominant role in deciding how the artist represented the subject, whether the patron or another person, such as a spouse, son, or mother. Many Egyptian pharaohs and some Roman emperors insisted that artists depict them with unlined faces and perfect youthful bodies no matter how old they were when portrayed. In these cases, the state employed the sculptors and painters, and the artists had no choice but to depict their patrons in the officially approved manner.

All modes of artistic production reveal the impact of patronage. Learned monks provided the themes for the sculptural decoration of medieval church portals. Renaissance princes and popes dictated the subjects, sizes, and materials of artworks destined, sometimes, for buildings constructed according to their specifications. An art historian could make a very long list along these lines, and it would indicate that throughout the history of art, patrons have had diverse tastes and needs and demanded different kinds of art. Whenever a patron contracts an artist or architect to paint, sculpt, or build in a prescribed manner, personal style often becomes a very minor factor in how the painting, statue, or building looks. In

such cases, the identity of the patron reveals more to art historians than does the identity of the artist or school.

The Words Art Historians Use

Like all specialists, art historians have their own specialized vocabulary. That vocabulary consists of hundreds of words, but certain basic terms are indispensable for describing artworks and buildings of any time and place, and we use those terms throughout this book. They make up the essential vocabulary of *formal analysis*, the visual analysis of artistic form. We define the most important of these art historical terms here.

Form and Composition Form refers to an object's shape and structure, either in two dimensions (for example, a figure painted on a canvas) or in three dimensions (such as a statue carved from a marble block). Two forms may take the same shape but differ in their color, texture, and other qualities. Composition refers to how an artist organizes (composes) forms in an artwork, either by placing shapes on a flat surface or by arranging forms in space.

Material and Technique To create art forms, artists shape materials (pigment, clay, marble, gold, and many more) with tools (pens, brushes, chisels, and so forth). Each of the materials and tools available has its own potentialities and limitations. Part of all artists' creative activity is to select the *medium* and instrument most suitable to the artists' purpose—or to pioneer the use of new media and tools, such as bronze and concrete in antiquity and cameras and computers in modern times. The processes artists employ, such as applying paint to canvas with a brush, and the distinctive, personal ways they handle materials constitute their *technique*. Form, material, and technique interrelate and are central to analyzing any work of art.

Line Line is one of the most important elements defining an artwork's shape or form. A line can be understood as the path of a point moving in space, an invisible line of sight or a visual axis. But, more commonly, artists and architects make a line concrete by drawing (or chiseling) it on a plane, a flat and two-dimensional surface. A line may be very thin, wirelike, and delicate; it may be thick and heavy; or it may alternate quickly from broad to narrow, the strokes jagged or the outline broken. When a continuous line defines an object's outer shape, art historians call it a contour line.

One can observe all of these line qualities in Dürer's *Four Horsemen of the Apocalypse* (Fig. Intro-5). Contour lines define the basic shapes of clouds, human and animal limbs, and weapons. Within the forms, series of short broken lines create shadows and textures. An overall pattern of long parallel strokes suggests the dark sky on the frightening day when the world is about to end.

Color *Light* reveals all colors. Light in the world of the painter and other artists differs from natural light. Natural

light, or sunlight, is whole or *additive light*. As the sum of all the wavelengths composing the visible *spectrum*, it may be disassembled or fragmented into the individual colors of the spectral band. The painter's light in art—the light reflected from pigments and objects—is *subtractive light*. Paint pigments produce their individual colors by reflecting a segment of the spectrum while absorbing all the rest. Red pigment, for example, subtracts or absorbs all the light in the spectrum except that seen as red, which it reflects to the eyes.

Red, yellow, and blue are the *primary colors*. Orange, green, and purple, the *secondary colors*, result from mixing pairs of primaries. *Complementary colors*—red and green, purple and yellow, and orange and blue—"complement," or complete, each other, one absorbing colors the other reflects.

Texture Is the quality of a surface (such as rough or shiny) that light reveals. Art historians distinguish between *actual* texture, or the tactile quality of the surface, and *represented* texture, as when painters depict an object as having a certain texture, even though the pigment is the actual texture. Sometimes artists combine different materials of different textures on a single surface, juxtaposing paint with pieces of wood, newspaper, fabric, and so forth. Art historians refer to

this mixed-media technique as *collage*. Texture is, of course, a key determinant of any sculpture's character. People's first impulse is usually to handle a piece of sculpture—even though museum signs often warn "Do not touch!" Sculptors plan for this natural human response, using surfaces varying in texture from rugged coarseness to polished smoothness. Textures are often intrinsic to a material, influencing the type of stone, wood, plastic, clay, or metal that sculptors select.

Space *Space* is the bounded or boundless "container" of objects. For art historians, space can be *actual*, the three-dimensional space occupied by a statue or a vase or contained within a room or courtyard. Or it can be *illusionistic*, as when painters depict an image (or illusion) of the three-dimensional spatial world on a two-dimensional surface.

Perspective Perspective is one of the most important pictorial devices for organizing forms in space. Throughout history, artists have used various types of perspective to create an illusion of depth or space on a two-dimensional surface. The French painter CLAUDE LORRAIN employed several perspectival devices in Embarkation of the Queen of Sheba (Fig. INTRO-6), a painting of a biblical episode set in a

Intro-6 | CLAUDE LORRAIN, *Embarkation of the Queen of Sheba*, 1648. Oil on canvas, approx. 4′ 10″ × 6′ 4″. National Gallery, London.

To create the illusion of a deep landscape, this French painter employed perspective, reducing the size of and blurring the most distant forms and making all diagonal lines converge on a single point.

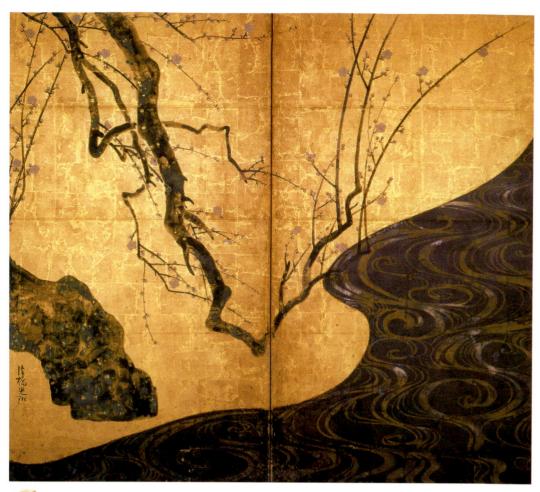

Intro-7 | OGATA KORIN, White and Red Plum Blossoms, ca. 1710–1716. Pair of twofold screens. Ink, color, and gold leaf on paper, each screen 5' $1\frac{5}{8}" \times 5'$ $7\frac{7}{8}"$. MOA Art Museum, Shizuoka-ken.

17th-century European harbor with a Roman ruin in the left foreground. For example, the figures and boats on the shoreline are much larger than those in the distance. Decreasing an object's size makes it appear farther away from the viewer. Also, the top and bottom of the port building at the painting's right side are not parallel horizontal lines, as they are in an actual building. Instead, the lines converge beyond the structure, leading the viewer's eye toward the hazy, indistinct sun on the horizon. These perspectival devices—the reduction of figure size, the convergence of diagonal lines, and the blurring of distant forms—have been familiar features of Western art since the ancient Greeks. But it is important to note at the outset that all kinds of perspective are only pictorial conventions, even when one or more types of perspective may be so common in a given culture that they are accepted as "natural" or as "true" means of representing the natural world.

In White and Red Plum Blossoms (Fig. Intro-7), a Japanese landscape painting on two folding screens, OGATA KORIN used none of these Western perspective conventions. He showed the two plum trees as seen from a position on the ground, while the viewer looks down on the stream between them from above. Less concerned with locating the trees and stream in space than

with composing shapes on a surface, the painter played the water's gently swelling curves against the jagged contours of the branches and trunks. Neither the French nor the Japanese painting can be said to project "correctly" what viewers "in fact" see. One painting is not a "better" picture of the world than the other. The European and Asian artists simply approached the problem of picture-making differently. Claude Lorrain's approach is, however, one of the distinctive features of the Western tradition in art that we examine exclusively in this book.

Foreshortening Artists also represent single figures in space in varying ways. When PETER PAUL RUBENS painted Lion Hunt (Fig. Intro-8) in the early 17th century, he used foreshortening for all the hunters and animals—that is, he represented their bodies at angles to the picture plane. When in life one views a figure at an angle, the body appears to contract as it extends back in space. Foreshortening is a kind of perspective. It produces the illusion that one part of the body is farther away than another, even though all the forms are on the same surface. Especially noteworthy in Lion Hunt are the gray horse at the left, seen from behind with the bottom of its left rear hoof facing the viewer and most of its head hidden by

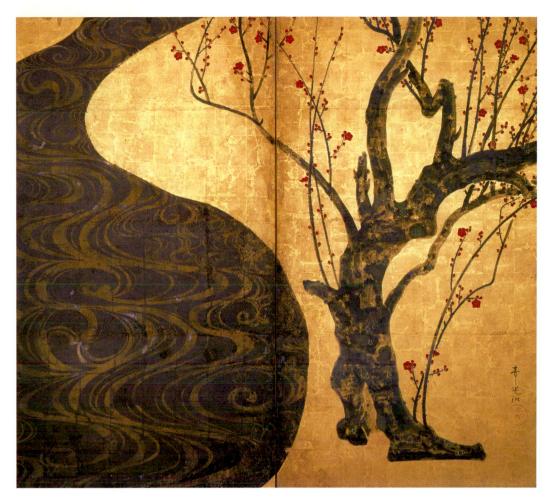

Ogata Korin was more concerned with creating an interesting composition of shapes on a surface than with locating objects in space. Asian artists rarely employed Western perspective in their pictures of the world.

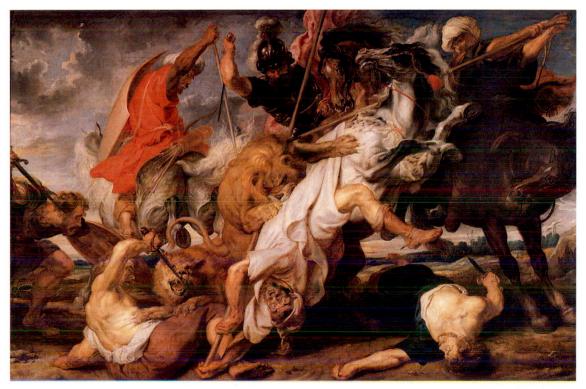

Intro-8

PETER PAUL RUBENS, *Lion Hunt*, 1617–1618. Oil on canvas, approx. 8′ 2″ × 12′ 5″. Alte Pinakothek, Munich.

Foreshortening—the representation of a figure or object at an angle to the picture plane—is another Western device for depicting space. Foreshortening is a kind of perspective.

its rider's shield, and the fallen hunter at the painting's lower right corner, whose barely visible legs and feet recede into the distance.

The artist who carved the portrait of the ancient Egyptian official Hesire (Fig. Intro-9) did not employ foreshortening. That artist's purpose was to present the various human body parts as clearly as possible, without overlapping. The lower part of Hesire's body is in profile to give the most complete view of the legs, with both the heels and toes of the foot visible. The frontal torso, however, allows the viewer to see

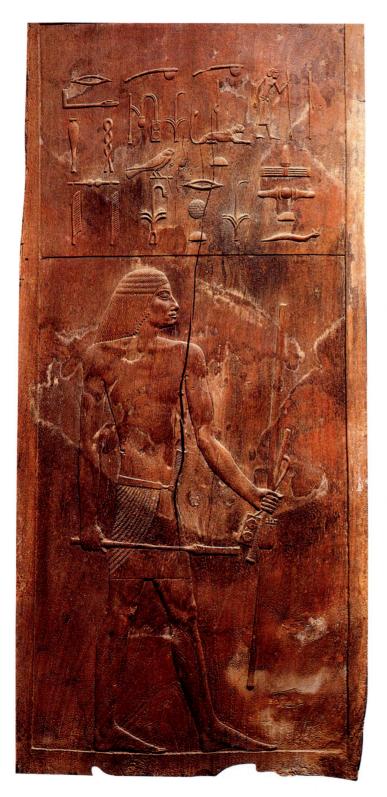

its full shape, including both shoulders, equal in size, as in nature. (Compare the shoulders of the hunter on the gray horse or those of the fallen hunter in *Lion Hunt*'s left foreground.) The result, an "unnatural" 90-degree twist at the waist, provides a precise picture of human body parts. Rubens and the Egyptian sculptor used very different means of depicting forms in space. Once again, neither is the "correct" manner, although foreshortening, like perspective, is one of the characteristic features of the Western artistic tradition.

Proportion and Scale *Proportion* concerns the relationships (in terms of size) of the parts of persons, buildings, or objects. "Correct proportions" may be judged intuitively ("that statue's head seems the right size for the body"). Or proportion may be formalized as a mathematical relationship between the size of one part of an artwork or building and the other parts within the work. Proportion in art implies using a *module*, or basic unit of measure. When an artist or architect uses a formal system of proportions, all parts of a building, body, or other entity will be fractions or multiples of the module. A module might be a column's diameter, the height of a human head, or any other component whose dimensions can be multiplied or divided to determine the size of the work's other parts.

In certain times and places, artists have formulated *canons*, or systems, of "correct" or "ideal" proportions for representing human figures, constituent parts of buildings, and so forth. In ancient Greece, many sculptors formulated canons of proportions so strict and all-encompassing that they calculated the size of every body part in advance, even the fingers and toes, according to mathematical ratios. Proportional systems can differ sharply from period to period, culture to culture, and artist to artist. Part of the task art history students face is to perceive and adjust to these differences.

In fact, many artists have used *disproportion* and distortion deliberately for expressive effect. Dürer's Death (Fig. INTRO-5) hardly has any flesh on his bones, and his limbs are distorted and stretched. Disproportion and distortion distinguish him from all the other figures in the work, precisely as the artist intended.

In other cases, artists have used disproportion to focus attention on one body part (often the head) or to single out a group member (usually the leader). These intentional "unnatural" discrepancies in proportion constitute what art historians call *hierarchy of scale*, the enlarging of elements considered the most important. On a bronze plaque (Fig. INTRO-10) from Benin, Nigeria, the sculptor enlarged all the heads for emphasis and also varied the size of each figure according to

Dynasty III, ca. 2650 BC. Wood, approx. 3' 9" high. Egyptian Museum, Cairo.

Egyptian and other early artists combined frontal and profile views to give a complete picture of what a human body is, as opposed to what it looks like from a specific viewpoint.

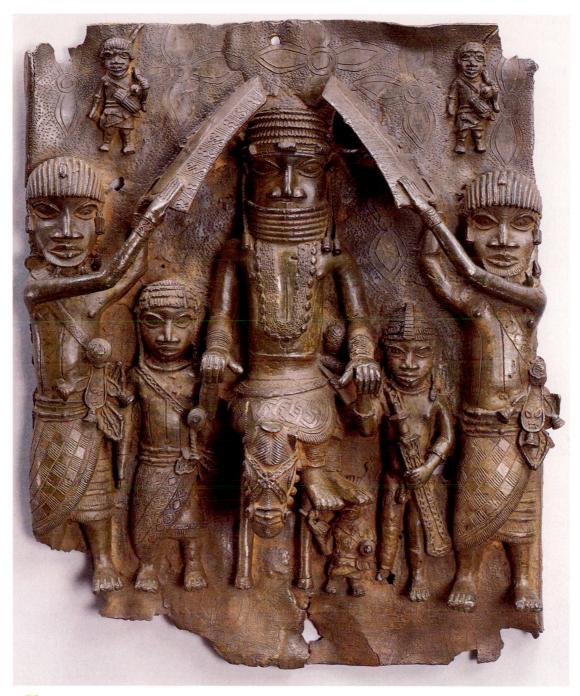

Intro-10 | King on horseback with attendants, from Benin, Nigeria, ca. 1550–1680. Bronze, 1' $7\frac{1}{2}$ " high. Metropolitan Museum of Art, New York (Michael C. Rockefeller Memorial Collection, gift of Nelson A. Rockefeller).

This African artist used hierarchy of scale to distinguish the relative rank of the figures, making the king the largest. The relief was created by the casting process, in which bronze is poured into a mold.

its social status. Central, largest, and therefore most important is the Benin king, mounted on horseback. The horse has been a symbol of power and wealth in many societies from prehistory to the present. That the Benin king is disproportionately larger than his horse, contrary to nature, further aggrandizes him. Two large attendants fan the king. Other figures of smaller size and lower status at the Benin court stand on the king's left and right and in the plaque's upper corners. One tiny figure next to the horse is almost hidden from view

beneath the king's feet. Hierarchy of scale is not unique to Africa or even to the non-Western world. European and American artists have also employed this device to great effect. For example, medieval artists often used hierarchy of scale to focus attention on the most important figures in a group. The sculptor of the church portal (Fig. 6-25) at Vézelay, France, depicted Christ as the central figure and much larger than his apostles, who are in turn of far greater size than all the other figures.

Carving and Casting Sculptural technique falls into two basic categories, *subtractive* and *additive*. *Carving* is a subtractive technique. The final form is a reduction of the original mass of a block of stone, a piece of wood, or another material. Wooden statues were once tree trunks, and stone statues began as blocks pried from mountains. In an unfinished 16th-century marble statue of a bound slave (Fig. Intro-11) by MICHELANGELO, the original shape of the stone block is still visible. Michelangelo thought of sculpture as a process of "liberating" the statue within the block. All sculptors of stone or wood cut away (subtract) "excess material." When they finish, they "leave behind" the statue—in our example, a twisting nude male form whose head Michelangelo never freed from the stone block.

In additive sculpture, the artist builds up the forms, usually in clay around a framework, or *armature*. Or a sculptor may fashion a *mold*, a hollow form for shaping, or *casting*, a fluid substance such as bronze. That is how the Benin artist made the bronze sculpture of the king and his attendants (Fig. INTRO-10).

Relief Sculpture Statues or busts that exist independent of any architectural frame or setting and that the viewer can walk around are *freestanding sculptures*, or *sculptures in the round* (Fig. Intro-11). In *relief sculptures*, the subjects project from the background but remain part of it. In *high relief* sculpture, the images project boldly. In some cases (Fig. Intro-10), the relief is so high that not only do the forms cast shadows on the background, but some parts are actually in the round. In *low relief*, or *bas-relief* (Fig. Intro-9), the projection is slight. Relief sculpture, like sculpture in the round, can be produced either by carving (Fig. Intro-9) or casting (Fig. Intro-11).

Architectural Drawings Buildings are groupings of enclosed spaces and enclosing masses, such as walls, piers, and roofs. People experience architecture both visually and by moving through and around it, so they perceive architectural space and mass together. These spaces and masses can be represented graphically in several ways, including as plans, sections, elevations, and cutaway drawings.

A plan, essentially a map of a floor, shows the placement of a structure's masses and, therefore, the spaces they bound and enclose. A section, like a vertical plan, depicts the placement of the masses as if the building were cut through along a plane. Drawings showing a theoretical slice across a structure's width are lateral sections. Those cutting through a building's length are longitudinal sections. An elevation drawing is a head-on view of an external or internal wall. A cutaway combines an exterior view with an interior view of part of a building in a single drawing. Illustrated here are the plan and lateral section (Fig. Intro-12) of Beauvais Cathedral, which may be compared to the photograph of the church's choir (Fig. Intro-1). The plan shows not only the choir's shape and the location of the piers dividing the aisles and

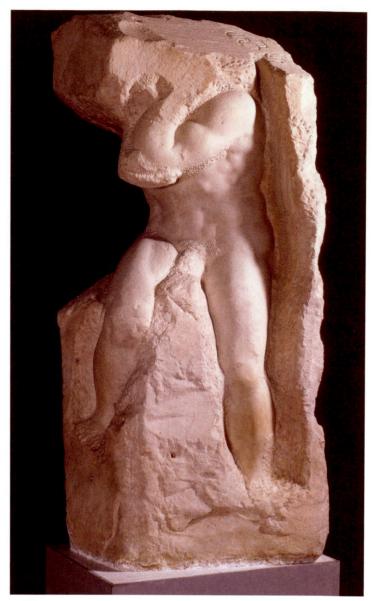

Intro-11 | MICHELANGELO, unfinished captive, 1527-1528. Marble, $8' 7\frac{1}{2}''$ high. Accademia, Florence.

Freestanding sculpture can also be cast in molds, but artists more frequently carve statues from stone or wood, cutting away excess material to leave behind the shape of a human figure or other subject.

supporting the *vaults* above but also the pattern of the criss-crossing vault *ribs*. The lateral section reveals the interior of the choir with its towering central vault and flanking aisle vault, and also the structure of the roof and the form of the exterior *buttresses* that hold the vaults in place.

This overview of the art historian's vocabulary is not exhaustive, nor have artists used only painting, drawing, sculpture, and architecture as media over the millennia. Ceramics, jewelry, textiles, photography, and computer art are just some of the numerous other arts. All of them involve highly specialized techniques described in distinct vocabularies. These are considered and defined where they arise in the text.

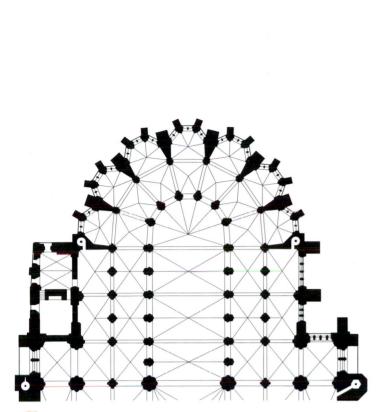

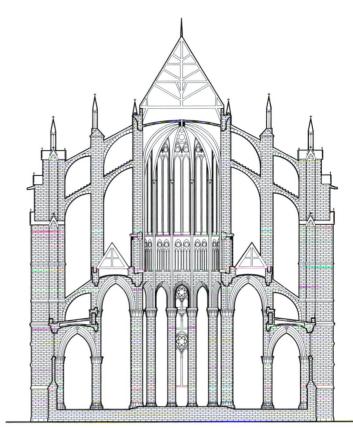

Plan (left) and lateral section (right) of Beauvais Cathedral, Beauvais, France, rebuilt after 1284.

Architectural drawings are indispensable aids for the analysis of buildings. Plans are maps of floors, "footprints" of the structure's masses. Sections are vertical "slices," across either the width or length of a building.

Art History and Other Disciplines

By its very nature, the work of art historians intersects with that of others in many fields of knowledge, not only in the humanities but also in the social and natural sciences. To "do their job" well today, art historians regularly must go beyond the boundaries of what the public and even professional art historians of previous generations traditionally have considered the specialized discipline of art history. Art historical research in the 21st century is frequently interdisciplinary in nature. To cite one example, in an effort to unlock the secrets of a particular statue, an art historian might conduct archival research hoping to uncover new documents shedding light on who paid for the work and why, who made it and when, where it originally stood, how its contemporaries viewed it, and a host of other questions. Realizing, however, that the authors of the written documents often were not objective recorders of fact but observers with their own biases and agendas, the art historian may also use methodologies developed in such fields as literary criticism, philosophy, sociology, and gender studies to weigh the evidence the documents provide.

At other times, rather than attempting to master many disciplines at once, art historians band together with other specialists in *multidisciplinary* inquiries. Art historians might call

in chemists to date an artwork based on the composition of the materials used or might ask geologists to determine which quarry furnished the stone for a particular statue. X-ray technicians might be enlisted in an attempt to establish whether or not a painting is a forgery. Of course, art historians often contribute their expertise to the solution of problems in other disciplines. A historian, for example, might ask an art historian to determine—based on style, material, iconography, and other criteria—if any of the portraits of a certain king were made after his death. That would help establish the ruler's continuing prestige during the reigns of his successors.

A Multifaceted Approach The history of art can be a history of artists and their works, of styles and stylistic change, of materials and techniques, of images and themes and their meanings, and of contexts and cultures and patrons. The best art historians analyze artworks from many viewpoints. Our purpose in writing *A Concise History of Western Art* is to present a history of art and architecture that will help you understand not only the subjects, styles, and techniques of paintings, sculptures, buildings, and other art forms created in the Western world during 30 millennia but also their cultural and historical contexts. That story now begins.

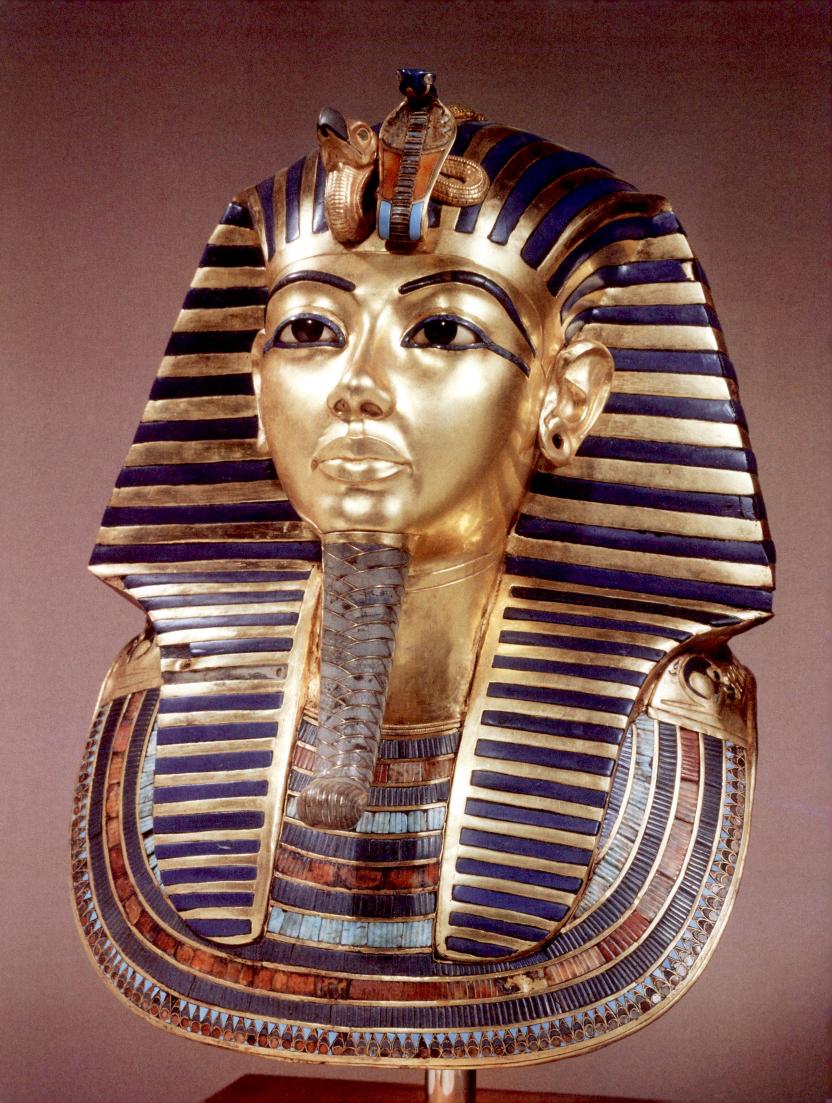

1

PREHISTORY AND THE FIRST CIVILIZATIONS

Humankind seems to have originated in Africa in the very remote past. Yet it was not until millions of years later that ancient hunters began to represent (literally, "to present again"—in different and substitute form) the world around them and to fashion the first examples of what people generally call "art." The immensity of this intellectual achievement cannot be exaggerated. It occurred around 30,000 BCE, during the Old Stone Age or *Paleolithic* period (from the Greek *paleo*, old, and *lithos*, stone).

PALEOLITHIC ART

The objects produced during the Paleolithic period are of an astonishing variety. They range from simple shell necklaces to human and animal forms in ivory, clay, and stone to monumental paintings, engravings, and relief sculptures covering the huge wall surfaces of caves.

The First Sculptures One of the oldest sculptures discovered to date, carved using simple stone tools, is the tiny (only slightly more than four inches tall) limestone figurine of a woman (Fig. 1-1) found at Willendorf, Austria. In the absence of any Stone Age written explanations—this is a time before writing, before (or pre-) history—one can only speculate on the function and meaning of an object like the Willendorf sculpture. Yet the preponderance of female over male figures in the Old Stone Age seems to indicate a preoccupation with women, whose childbearing capabilities ensured the survival of the species. The anatomical exaggeration of the Willendorf figurine has suggested to many scholars that this and similar works served as fertility images. The breasts of the Willendorf woman are enormous, far larger than the tiny forearms and hands that rest on them. The sculptor also took pains to scratch into the stone the outline of the pubic triangle. In other Paleolithic female figurines, however, this detail is omitted. Many of the women also have far more slender proportions than the Willendorf woman, leading some scholars to question the nature of these figures as fertility images. Whatever the purpose of such statuettes, the makers' intent seems to have been to represent not a specific woman but the female form.

Paleolithic Animals Far more common than Paleolithic representations of humans are sculptures and paintings of animals (see "Art in the Old Stone Age," page 17). Nearly every animal was depicted in the same manner—in strict

Death mask of Tutankhamen, from the innermost coffin in his tomb at Thebes, Egypt, Dynasty XVIII, ca. 1323 BCE. Gold with inlay of semi-precious stones, $1' 9\frac{1}{4}''$ high. Egyptian Museum, Cairo.

profile. The profile is the only view of an animal wherein the head, body, tail, and all four legs can be seen. A frontal view would conceal most of the body, and a three-quarter view would not show either the front or side fully. Only the profile view is completely informative about the animal's shape, and this is why it was the almost universal choice during the Stone Age. A very long time passed before artists placed any premium on "variety" or "originality," either in subject choice or in representational manner. These are quite modern notions in the history of art. The aim of the earliest sculptors and painters was to create a convincing image of the subject, a kind of pictorial definition of the animal capturing its very essence, and only the profile view met their needs.

Clay Bison An early example of animal sculpture is the pair of clay bison (Fig. 1-2) in the cave at Le Tuc d'Audoubert, France. The bison, each about two feet long and depicted in profile, are *relief sculptures*, in contrast to the Willendorf figurine, which was *sculpted in the round* (that is, it is a *freestanding* object). Some Paleolithic reliefs were created by carving stone blocks or walls with stone chisels. These bison were built up out of clay. The sculptor modeled the forms by pressing the clay against the surface of a large rock and using both hands to form the overall shape of the animals. Then the artist smoothed the surfaces with a spatula-like tool and used fingers to shape the eyes, nostrils, mouths, and manes.

Cave Painting The bison of Le Tuc d'Audoubert are among the largest sculptures of the Paleolithic period, but they are dwarfed by the "herds" of painted animals that roam the cave walls of southern France and northern Spain (MAP 1-1, page 523). Examples of Paleolithic painting now have been found at more than 200 European sites. Nonetheless, archaeologists still regard painted caves as rare occurrences, because the images in them, even if they number in the hundreds, were created over a period of some 10,000 to 20,000 years.

1-2 | Two bison, reliefs in the cave at Le Tuc d'Audoubert, Ariège, France, ca. 15,000–10,000 BCE. Clay, each approx. 2' long.

Animals are far more common than humans in Old Stone Age art. In both relief sculpture and painting, they are always represented in profile, the only view completely informative about the animals' shape.

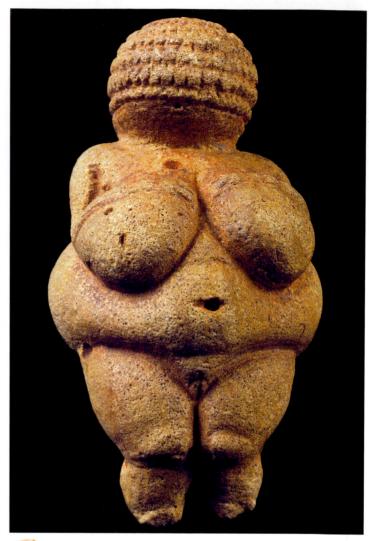

1-1 | Nude woman (Venus of Willendorf), from Willendorf, Austria, ca. 28,000-25,000 BCE. Limestone, approx. $4\frac{1}{4}$ high. Naturhistorisches Museum, Vienna.

One of the oldest sculptures known, this tiny figurine, with its anatomical exaggeration, typifies Paleolithic representations of women, whose child-bearing capabilities ensured the survival of the species.

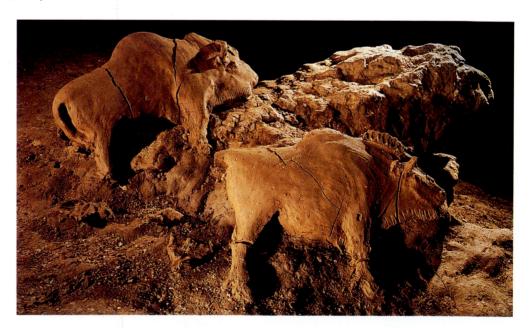

Art in the Old Stone Age

Since the first cave paintings were discovered in the late 19th century, scholars have wondered why the hunters of the Old Stone Age decided to cover the walls of dark caverns with animal images (Figs. 1-2 to 1-4). Various theories have been proposed, including that the animals were mere decoration, but this explanation cannot account for the narrow range of subjects or the inaccessibility of many of the representations. In fact, the remoteness and difficulty of access of many of the images, and indications that the caves were used for centuries, are precisely why many scholars have suggested that the prehistoric hunters attributed magical properties to the images they painted and sculpted. According to this argument, by confining animals to the surfaces of their cave walls, the Paleolithic hunters believed they were bringing the beasts under their control. Some have even hypothesized that rituals or dances were performed in front of the images and that these rites served to improve the hunters' luck. Still others have stated that the animal representations may have served as teaching tools to instruct new hunters about the character of the various species they would encounter or even to serve as targets for spears!

In contrast, some prehistorians have argued that the magical purpose of the paintings and reliefs was not to facilitate the *destruction* of animal

species. Instead, they believe that the first painters and sculptors created animal images to ensure the *survival* of the herds on which Paleolithic peoples depended for their food supply and for their clothing. A central problem for both the hunting-magic and food-creation theories is that the animals that seem to have been diet staples of Old Stone Age peoples are not those most frequently portrayed.

Other researchers have sought to reconstruct an elaborate mythology based on the cave paintings and sculptures, suggesting that Paleolithic humans believed they had animal ancestors. Still others have equated certain species with men and others with women and postulated various meanings for the abstract signs that sometimes accompany the images. Almost all of these theories have been discredited over time, and most prehistorians admit that no one knows the intent of the representations. In fact, a single explanation for all Paleolithic animal images, even ones similar in subject, style, and composition (how the motifs are arranged on the surface), is unlikely to apply universally. The works remain an enigma—and always will, because before the invention of writing, no contemporary explanations could be recorded.

Paleolithic painters drew their images using chunks of red and yellow ocher. For painting, they ground these same ochers into powders they mixed with water before applying. Large flat stones served as *palettes*. The painters made brushes from reeds, bristles, or twigs, and may have used a blowpipe of reeds or hollow bones to spray pigments on out-of-reach surfaces. Some caves have natural ledges on the rock walls upon which the painters could have stood in order to reach the upper surfaces of the naturally formed "rooms" and corridors.

To illuminate their work, the painters used stone lamps filled with marrow or fat, perhaps with a wick of moss. Despite the difficulty of making the tools and pigments, modern attempts at replicating the techniques of Paleolithic painting have demonstrated that skilled workers could cover large surfaces with images in less than a day.

Horses and Hands A *mural* (wall) painting (Fig. 1-3) at Pech-Merle, France, provides some insight into the reason

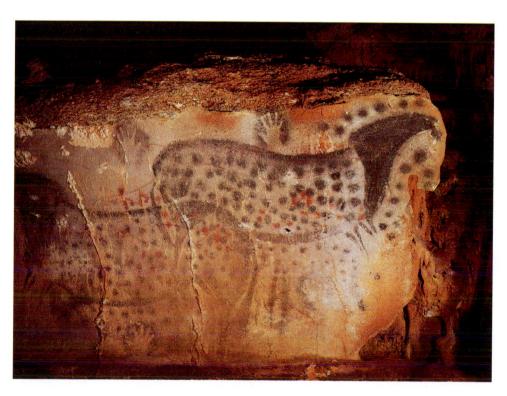

1-3 | Spotted horses and negative hand imprints, wall painting in the cave at Pech-Merle, Lot, France, ca. 22,000 BCE. Approx. 11' 2" long.

The purpose and meaning of Paleolithic paintings are unknown. Some scholars think the painted hands near the Pech-Merle horses are "signatures" of cult or community members or, less likely, of individual painters.

certain subjects may have been chosen for a specific location. One of the horses (at the right in our illustration) may have been inspired by the rock formation in the wall surface resembling a horse's head and neck. Like the clay bison at Le Tuc d'Audoubert, the Pech-Merle horses are in strict profile. Here, however, they are accompanied by painted hands. These and the majority of painted hands at other sites are "negative"—that is, the painter placed one hand against the wall and then brushed or blew or spat pigment around it. Occasionally, the painter dipped a hand in the pigment and then pressed it against the wall, leaving a "positive" imprint. These handprints must have had a purpose. Some scholars have considered them "signatures" of cult or community members or, less likely, of individual painters. Checks, dots, squares, and other abstract signs appear near the painted animals in other Paleolithic caves. Several observers think these signs are a primitive form of writing, but like the hands—and everything else in Paleolithic art—their meaning is unknown.

The Bulls of Lascaux Perhaps the best-known Paleolithic cave is that at Lascaux, near Montignac, France, which features a large circular gallery called the Hall of the Bulls (Fig. 1-4). Not all of the painted animals are bulls, despite the modern nickname, and the several species depicted vary in size. Many of the animals, such as the great bull at the right in our illustration, were created by outline alone, as were the Pech-Merle horses, but others are represented using colored silhouettes. On the walls of the Lascaux cave one sees, side by side, the two basic approaches to drawing and painting found repeatedly in the history of art. These differences in style and technique alone suggest that the animals were painted at different times. The modern impression of a rapidly moving herd of beasts was probably not the original intent. In any case, the "herd" consists of several different kinds of animals of various sizes moving in different directions. Although most share a common ground line (the horizontal base of the composition), some, like those in the upper right corner of Fig. 1-4, seem to float above the viewer's head, like clouds in the sky. The painting has no setting, no background, no indication of place. The Paleolithic painter was concerned solely with representing the animals, not with locating them in a specific place.

Another feature of the Lascaux paintings deserves attention. The bulls there show a convention of representing horns that has been called *twisted perspective*, because the viewer sees the heads in profile but the horns from the front. Thus, the painter's approach is not strictly or consistently *optical*

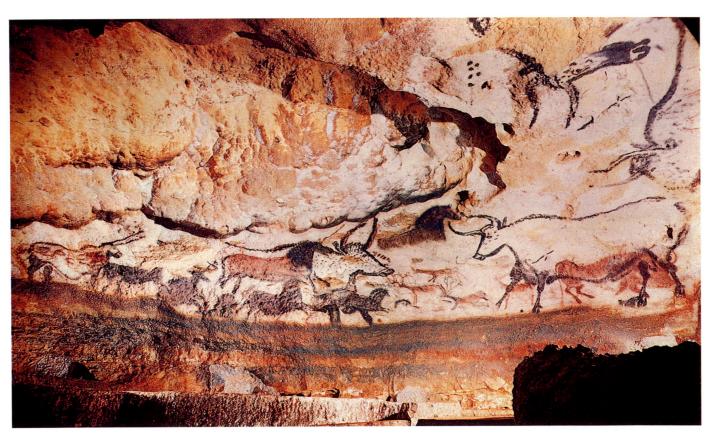

1-4 | Hall of the Bulls (left wall), Lascaux, Dordogne, France, ca. 15,000–13,000 BCE. Largest bull approx. 11' 6" long.

Like all of the earliest known paintings, the Lascaux murals have no ground line or indication of place. The Paleolithic painter was concerned solely with representing the animals, not with locating them in a specific place.

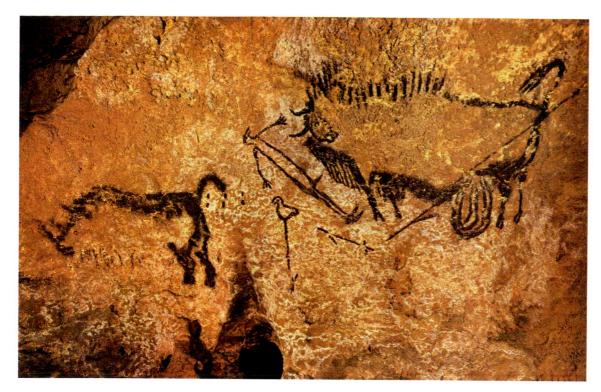

1-5 | Rhinoceros, wounded man, and disemboweled bison, painting in the well, Lascaux, Dordogne, France, ca. 15,000 – 13,000 BCE. Bison approx. 3' 8" long.

If these paintings of two animals and a bird-faced (masked?) man, deep in a well shaft in the Lascaux cave, represent a hunting scene, they constitute the earliest example of narrative art ever discovered.

(seen from a fixed viewpoint). Rather, the approach is *descriptive* of the fact that cattle have two horns. Two horns are part of the concept "bull." In strict optical-perspective profile, only one horn would be visible, but to paint the animal in that way would, as it were, amount to an incomplete definition of it.

Paleolithic Narrative Art? Perhaps the most perplexing painting in any Paleolithic cave is the one deep in the well shaft (Fig. 1-5) at Lascaux, where man (as opposed to woman) makes one of his earliest appearances in prehistoric art. At the left is a rhinoceros, rendered with all the skilled attention to animal detail customarily seen in cave art. Beneath its tail are two rows of three dots of uncertain significance. At the right is a bison, more schematically painted, probably by someone else. The second painter nonetheless successfully suggested the bristling rage of the animal, whose bowels are hanging from it in a heavy coil. Between the two beasts is a bird-faced (masked?) man with outstretched arms and hands with only four fingers. The man is depicted with far less care and detail than either animal, but the painter made the hunter's gender explicit by the prominent penis. The position of the man is ambiguous. Is he wounded or dead or merely tilted back and unharmed? Do the staff(?) with the bird on top and the spear belong to him? Is it he or the rhinoceros who has gravely wounded the bison—or neither? Which animal, if either, has knocked the man down, if indeed he is on the ground? Are these three images related at all? Researchers can be sure of nothing, but if the figures were placed beside

each other to tell a story, then this is evidence for the creation of narrative compositions involving humans and animals at a much earlier date than anyone had imagined only a few generations ago. Yet it is important to remember that even if a story was intended, very few people would have been able to "read" it. The painting, in a deep shaft, is very difficult to reach and could have been viewed only in flickering lamplight. Like all Paleolithic art, the scene in the Lascaux well shaft remains enigmatic.

NEOLITHIC ART

Around 9000 BCE, the ice that covered much of northern Europe during the Paleolithic period melted as the climate grew warmer. The reindeer migrated north, and the woolly mammoth and rhinoceros disappeared. The Paleolithic gave way to a transitional period, the Mesolithic, or Middle Stone Age, when Europe became climatically, geographically, and biologically much as it is today. Then, for several thousand years at different times in different parts of the globe, a great new age, the Neolithic (New Stone Age), dawned. Human beings began to settle in fixed abodes and to domesticate plants and animals. Their food supply assured, many groups changed from hunters to herders, to farmers, and finally to townspeople. Wandering hunters settled down to organized community living in villages surrounded by cultivated fields. The new sedentary societies of the Neolithic age originated systematic agriculture, weaving, metalworking, pottery, and counting and recording with tokens.

Neolithic Urbanism One of the most extensively excavated Neolithic sites is Catal Höyük on the central Anatolian plateau, a settlement that flourished between 7000 and 5000 BCE. Çatal Höyük was one of the world's first experiments in urban living. The regularity of the town's plan suggests that it was built according to some predetermined scheme. The houses, constructed of mud brick strengthened by sturdy timber frames, varied in size but repeated the same basic plan. Walls and floors were plastered and painted, and platforms along walls served as sites for sleeping, working, and eating. The dead were buried beneath the floors. Many decorated rooms have been found at Çatal Höyük. The excavators called these rooms "shrines," but their function is uncertain. Their number suggests that these rooms played an important role in the life of Çatal Höyük's inhabitants.

Painting at Catal Höyük The "shrines" are distinguished from the house structures by the greater richness of their interior decoration, which included wall paintings and plaster reliefs. One of the walls is covered with a painted representation of a deer hunt (Fig. 1-6). The mural is worlds apart from the cave paintings produced by the hunters of the Paleolithic period. Perhaps what is most strikingly new about the Çatal Höyük painting and others like it is the regular appearance of the human figure—not only singly but also in large, coherent groups with a wide variety of poses, subjects, and settings. As noted earlier, humans were unusual in Paleolithic painting, and pictorial narratives have almost never been found. Even the "hunting scene" in the well at Lascaux (Fig. 1-5) is doubtful as a narrative. In Neolithic paintings, human themes and concerns and action scenes with humans dominating animals are central.

In the Catal Höyük hunt, the group of hunters—and no one doubts it is, indeed, an organized hunting party, not a series of individual figures—shows a tense exaggeration of movement and a rhythmic repetition of basic shapes customary for the period. The painter took care to distinguish important descriptive details—for example, bows, arrows, and garments—and the heads have clearly defined noses, mouths, chins, and hair. The Neolithic painter placed all the heads in profile for the same reason Paleolithic painters universally chose the profile view for representations of animals. Only the side view of the human head shows all its shapes clearly. At Catal Höyük, however, the torsos are presented from the front—again, the most informative viewpoint—while the profile view was chosen for the legs and arms. This composite view of the human body is quite artificial because the human body cannot make an abrupt 90-degree shift at the hips. But it is very descriptive of what a human body is—as opposed to what it looks like from a particular viewpoint. The composite view is another manifestation of the twisted perspective of Paleolithic paintings that combined a frontal view of an animal's two horns with a profile view of the head (Fig. 1-4). The technique of painting also changed dramatically since Paleolithic times. The pigments were applied with a brush to a white background of dry plaster. The careful preparation of the wall surface is in striking contrast to the direct application of pigment to the rock surfaces of Old Stone Age caves.

1-6 | Deer hunt, detail of a wall painting from level III. Çatal Höyük, Turkey, ca. 5750 BCE. Museum of Anatolian Civilization, Ankara.

This Neolithic painter depicted human figures as a composite of frontal and profile views, the most descriptive picture of the shape of the human body. This format would become the rule for millennia.

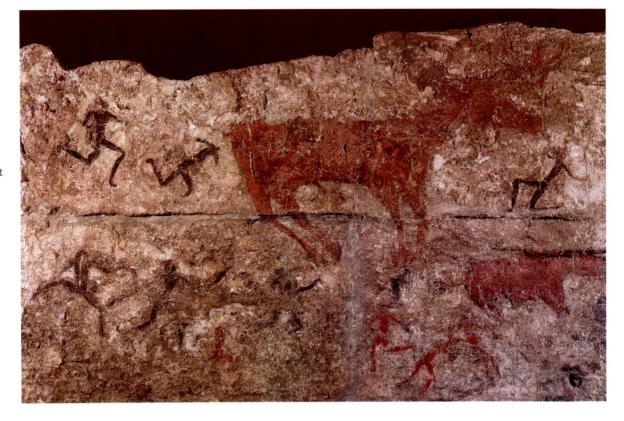

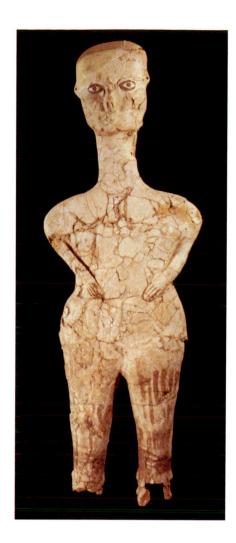

P 1-7

Human figure, from Ain Ghazal, Jordan, ca. 6750-6250 BCE. Plaster, painted and inlaid with cowrie shell and bitumen, 3' $5\frac{3''}{8}$ high. Louvre, Paris.

At Ain Ghazal, archaeologists have uncovered dozens of large white plaster Neolithic statuettes with details added in paint and shell. They mark the beginning of monumental sculpture in the history of art.

Sculpture at Ain Ghazal At Ain Ghazal, near Amman, Jordan, archaeologists have uncovered another important Neolithic settlement. The Jordanian site was occupied from the late eighth through the late sixth millennium BCE. The most striking finds at Ain Ghazal are two caches containing three dozen plaster statuettes (Fig. 1-7) and busts datable to the mid-seventh millennium BCE. The sculptures appear to have been ritually buried. The figures were fashioned of white plaster, which was built up over a core of reeds and twine. Black bitumen, a tarlike substance, was used to delineate the pupils of the eyes, which are inset cowrie shells. Painters added orange and black hair, clothing, and, in some instances, body paint or tattooing. Only rarely did the sculptors indicate the gender of the figures. Whatever their purpose, by their size (a few exceed three feet in height) and sophisticated technique, the Ain Ghazal statuettes and busts differ fundamentally from Paleolithic figurines such as the tiny Willendorf woman (Fig. 1-1). They mark the beginning of monumental sculpture in the ancient world.

Megaliths and Henges In western Europe, where Paleolithic paintings and sculptures abound, no comparably developed towns of the time of Çatal Höyük or Ain Ghazal have been found. However, in succeeding millennia, perhaps as early as 4000 BCE, the local Neolithic populations in several

areas developed a monumental architecture employing massive rough-cut stones. The very dimensions of the stones, some as tall as 17 feet and weighing as much as 50 tons, have prompted historians to call them *megaliths* (great stones) and to designate the culture that produced them *megalithic*.

Although megalithic monuments are plentiful throughout Europe, the arrangement of huge stones in a circle (called a cromlech or henge), often surrounded by a ditch, is almost entirely limited to Britain. The most imposing today is Stonehenge (Fig. 1-8) on Salisbury Plain in southern England. Stonehenge is a complex of rough-cut sarsen (a form of sandstone) stones and smaller "bluestones" (various volcanic rocks). Outermost is a ring, almost 100 feet in diameter, of large monoliths of sarsen stones capped by lintels (a stone "beam" used to span an opening). Next is a ring of bluestones, which, in turn, encircles a horseshoe (open end facing east) of trilithons (three-stone constructions)—five lintel-topped pairs of the largest sarsens, each weighing 45 to 50 tons. Standing apart and to the east (outside our photograph at the lower right corner) is the "heel-stone," which, for a person looking outward from the center of the complex, would have marked the point where the sun rose at the summer solstice.

Stonehenge probably was built in several phases in the centuries before and after 2000 BCE. It seems to have been a kind of astronomical observatory. The mysterious structures were believed in the Middle Ages to have been the work of the magician Merlin of the King Arthur legend, who spirited them from

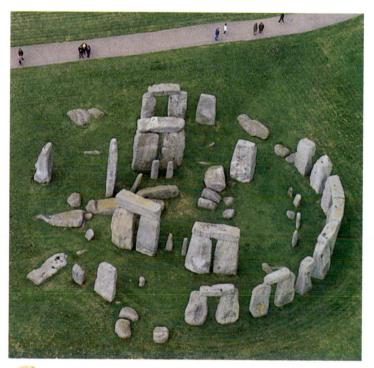

1-8 | Aerial view of Stonehenge, Salisbury Plain, Wiltshire, England, ca. 2550–1600 BCE. Circle is 97' in diameter; trilithons approx. 24' high.

One of the earliest examples of monumental architecture in Neolithic Europe, the circle of trilithons at Stonehenge probably functioned as an astronomical observatory and solar calendar.

Ireland. Most archaeologists now consider Stonehenge a remarkably accurate solar calendar. This achievement is testimony to the rapidly developing intellectual powers of Neolithic humans as well as to their capacity for heroic physical effort.

SUMERIAN ART

The fundamental change in human society from the dangerous and uncertain life of the hunter and gatherer to the more predictable and stable life of the farmer and herder first occurred in Mesopotamia. Mesopotamia—a Greek word that means "the land between the [Tigris and Euphrates] rivers"—is at the core of the region often called the Fertile Crescent, a land mass that forms a huge arc from the mountainous border between Turkey and Syria through Iraq to Iran's Zagros Mountain range (MAP 1-2, page 523). There, humans first used the wheel and the plow, learned how to control floods and construct irrigation canals, and established the first great urban communities.

The people who transformed the vast, flat, sparsely inhabited lower valley between the Tigris and Euphrates into the giant oasis of the Fertile Crescent were the Sumerians. They also developed the earliest known writing system, using wedge-shaped (cuneiform) signs. Ancient Sumer was not a unified nation; rather, it was made up of a dozen or so independent city-states. Each was thought to be under the protection of a different Mesopotamian deity.

The Sumerian rulers were the gods' representatives on earth and the stewards of their earthly treasure. The rulers and priests directed all communal activities, including canal construction, crop collection, and food distribution. The development of agriculture to the point where only a portion of the population had to produce food made it possible for some members of the community to specialize in other activities, including manufacturing, trade, and administration. Such labor specialization is the hallmark of the first complex urban societies. In the Sumerian citystates of the fourth millennium BCE, activities that once had been individually initiated became institutionalized for the first time. The community, rather than the family, assumed such functions as defense against enemies and against the caprices of nature. Whether ruled by a single person or a council chosen from among the leading families, these communities gained permanent identities as discrete cities. The city-state was one of the great Sumerian inventions.

Temples and Ziggurats The Sumerian city plan reflected the central role of the local god in the daily life of the city-state's occupants. The god's temple formed the monumental nucleus of the city. It was not only the focus of local religious practice but also an administrative and economic center. It was indeed the domain of the god, whom the Sumerians regarded as a great and rich holder of lands and herds, as well as the protector of the city-state. The vast temple complex was a kind of city within a city, where priests and scribes carried on official business. Sumerian temple precincts had both religious and secular functions.

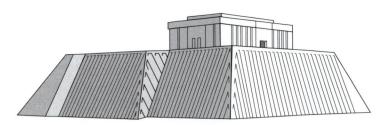

1-9 | Reconstruction drawing of the White Temple and ziggurat, Uruk (modern Warka), Iraq, ca. 3200–3000 BCE (after S. E. Piggott).

Using only mud bricks, the Sumerians erected temples on high platforms called ziggurats several centuries before the Egyptians built stone pyramids. The most famous ziggurat was the biblical Tower of Babel.

The outstanding preserved example of early Sumerian temple architecture is the 5,000-year-old White Temple at Uruk, the home of the legendary Gilgamesh. Archaeologists have been able to produce a fairly reliable reconstruction drawing of the monument (Fig. 1-9). Sumerian builders did not have access to stone quarries and instead formed mud bricks for the superstructures of their temples and other buildings. The fragile nature of the building materials did not, however, prevent the Sumerians from erecting towering works, such as the Uruk temple, several centuries before the Egyptians built their stone pyramids (Figs. 1-23 and 1-24). This says a great deal about the Sumerians' desire to provide monumental settings for the worship of their deities.

The Uruk temple (whose whitewashed walls lend it its modern nickname) stands on top of a high platform, or ziggurat, 40 feet above street level in the city center. A stairway (not shown in the drawing) leads to the top. Like those of other Sumerian temples, the corners of the White Temple are oriented to the cardinal points of the compass. The building, probably dedicated to Anu, the sky god, is of modest proportions (61 \times 16 feet). By design, it did not accommodate large throngs of worshipers but only a select few, the priests and perhaps the leading community members. The temple has several chambers. The central hall, or cella, was set aside for the divinity and housed a stepped altar. The Sumerians referred to their temples as "waiting rooms," a reflection of their belief that the deity would descend from the heavens to appear before the priests in the cella. How or if the Uruk temple was roofed is uncertain.

Eroded ziggurats still dominate most of the ruined cities of Sumer. The best preserved is the ziggurat at Ur (Fig. 1-10). It was built about a millennium later than the Uruk ziggurat and is much grander. The base is a solid mass of mud brick 50 feet high. The builders used baked bricks laid in bitumen for the facing of the entire monument. Three ramplike stairways of a hundred steps each converge on a tower-flanked gateway. From there another flight of steps probably led to the temple proper, which does not survive. The loftiness of the great ziggurats of Mesopotamia made a profound impression on the peoples of the ancient Near East. The tallest ziggurat of all—at Babylon—was about 270 feet high. Known to the Hebrews

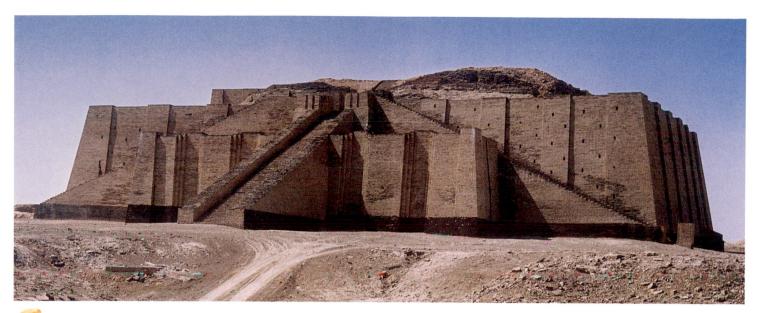

1-10 | Ziggurat (northeastern facade with restored stairs), Ur (modern Tell Muqayyar), Iraq, ca. 2100 BCE.

The Ur ziggurat is the best preserved in Mesopotamia. It has three ramplike stairways of a hundred steps each that originally ended at a gateway to a brick temple, which does not survive.

as the Tower of Babel, it became the centerpiece of a biblical tale about insolent pride. Humankind's desire to build a tower to Heaven angered God. Therefore, the Lord caused the workers to speak different languages, preventing them from communicating with one another and bringing construction of the ziggurat to a halt.

Gifts for a Goddess The Sumerians, pioneers in so many areas, also may have been the first to use pictures to tell complex stories. Sumerian narrative art goes far beyond Stone Age artists' tentative efforts at storytelling. The so-called *Warka Vase* (Fig. 1-11) from Uruk (modern Warka) is the first great work of narrative relief sculpture known. Found within the temple complex dedicated to Inanna, the goddess of love and war, it depicts a religious festival in her honor.

The sculptor divided the vase's reliefs into three bands (called *registers* or *friezes*). This new kind of composition marks a significant break with the haphazard figure placement in earlier art. The register format for telling a story was to have a very long future. In fact, artists still employ registers today in modified form in comic books.

The lowest band on the Warka Vase shows ewes and rams—in strict profile, as in the Old Stone Age—above crops and a wavy line representing water. The animals and plants

1-11 | Presentation of offerings to Inanna (*Warka Vase*), from Uruk (modern Warka), Iraq, ca. 3200–3000 BCE. Alabaster, 3' $\frac{1}{4}$ " high. Iraq Museum, Baghdad.

In this oldest known example of Sumerian narrative art, the sculptor divided the vase's reliefs into three bands, a significant break with the haphazard figure placement found in earlier art.

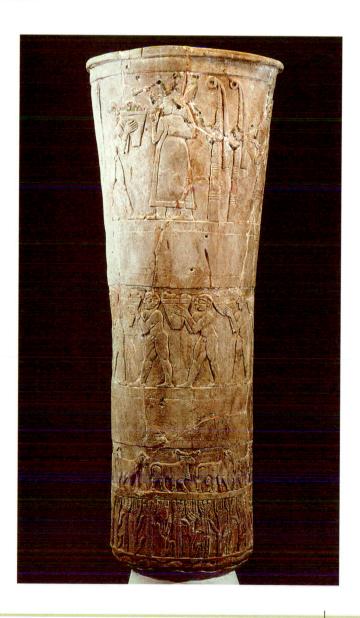

underscore that Inanna has blessed Uruk's inhabitants with good crops and increased herds. Above, naked men carry baskets and jars overflowing with earth's abundance. They will present their bounty to the goddess as a *votive offering* (gift of gratitude to a deity usually made in fulfillment of a vow) and will deposit it in her temple. The spacing of each figure involves no overlapping. The Uruk men, like the Neolithic deer hunters at Çatal Höyük (Fig. 1-6), are a composite of frontal and profile views, with large staring frontal eyes in profile heads. (If the eyes were in profile, they would not "read" as eyes at all, because they would not have their distinctive flat oval shape.)

In the uppermost (and tallest) band is a female figure with a tall horned headdress. Whether she is Inanna or her priestess is not known. A nude male figure brings a large vessel brimming with offerings to be deposited in the goddess's shrine. Not visible in our illustration is an only partially preserved clothed man who is usually, if ambiguously, referred to as a "priest-king" because similar figures appear in other Sumerian artworks as leaders in both religious and secular contexts. The greater height of the "priest-king" and Inanna compared to the offering bearers indicates their greater importance. Some scholars interpret the scene as a symbolic marriage between the "priest-king" and the goddess, ensuring her continued goodwill—and reaffirming the leader's exalted position in society.

Perpetual Worshipers Further insight into Sumerian religion comes from a cache of soft gypsum statuettes inlaid with shell and black limestone found in a temple at Eshnunna (modern Tell Asmar). We illustrate the two largest figures (Fig. 1-12). All of the statuettes represent mortals, rather than deities, with their hands folded in front of their chests in a gesture of prayer, usually holding the small beakers the Sumerians used in religious rites. The men wear belts and fringed skirts. Most have beards and shoulder-length hair. The women wear long robes, with the right shoulder bare. Similar figurines from other sites bear inscriptions giving such information as the name of the donor and the god or even specific prayers to the deity on the owner's behalf. With their heads tilted upward, they wait in the Sumerian "waiting room" for the divinity to appear. Most striking is the disproportionate relationship between the inlaid oversized eyes and the tiny hands. Scholars have explained the exaggeration of the eye size in various ways. But because the purpose of these votive figures was to offer constant prayers to the gods on their donors' behalf, the open-eyed stares most likely symbolize the eternal wakefulness necessary to fulfill their duty.

War and Peace The spoils of war, as well as success in farming and trade, brought considerable wealth to some of the city-states of ancient Sumer. Nowhere is this clearer than in the so-called Royal Cemetery at Ur, the city that was home to the biblical Abraham. Researchers still debate whether those buried in Ur's cemetery were true kings and queens or simply aristocrats and priests, but they were laid to rest in regal fashion. Their tombs contained gold helmets and daggers with handles

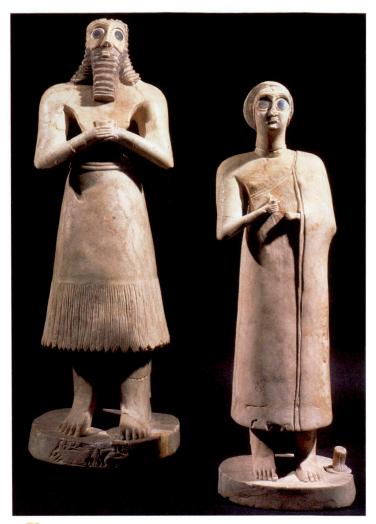

1-12 | Statuettes of two worshipers, from the Square Temple at Eshnunna (modern Tell Asmar), Iraq, ca. 2700 BCE. Gypsum inlaid with shell and black limestone, male figure approx. 2' 6" high. Iraq Museum, Baghdad.

The oversized eyes probably symbolized the perpetual wakefulness of these substitute worshipers offering prayers to the deity. The beakers the figures hold were used to pour libations in honor of the gods.

of lapis lazuli (a rich azure-blue stone imported from Afghanistan), golden beakers and bowls, jewelry of gold and lapis, musical instruments, chariots, and other luxurious items.

Not the costliest object found in the "royal" graves, but probably the most significant from the viewpoint of the history of art, is the so-called *Standard of Ur* (Fig. 1-13), a rectangular box of uncertain function. It has sloping sides inlaid with shell, lapis lazuli, and red limestone, and was originally thought to have been mounted on a pole as a kind of military standard, hence its nickname. Art historians usually refer to the two long sides of the box as the "war side" and "peace side," but the two sides may represent the first and second parts of a single narrative. The artist divided each into three horizontal bands. The narrative reads from left to right and bottom to top.

On the war side, four ass-drawn four-wheeled war chariots mow down enemies, whose bodies appear on the ground in front of and beneath the animals. Above, foot soldiers gather

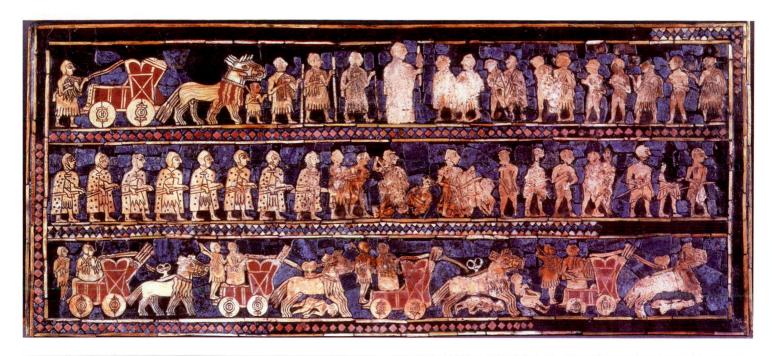

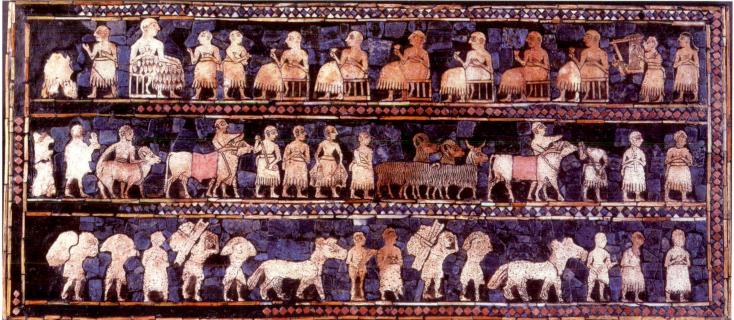

1-13 | War side (top) and peace side (bottom) of the Standard of Ur, from tomb 779, Royal Cemetery, Ur (modern Tell Muqayyar), Iraq, ca. 2600 BCE. Wood inlaid with shell, lapis lazuli, and red limestone, approx. 8" × 1' 7". British Museum, London.

This Sumerian artist employed a mosaic-like technique to tell the story of victory in battle in three registers. The size of the figures on both sides of the box varies with their relative importance.

up and lead away captured foes. In the uppermost register, soldiers present bound captives (who have been stripped naked to degrade them) to a kinglike figure, who has stepped out of his chariot. His central place in the composition and his greater stature (his head breaks through the border at the top) set him apart from all the other figures.

In the lowest band on the peace side, men carry provisions, possibly war booty, on their backs. Above, attendants bring animals, perhaps also spoils of war, and fish for the great banquet

depicted in the uppermost register. There, seated dignitaries and a larger-than-life "king" (third from the left) feast, while a lyre player and singer (at the far right) entertain the group. Scholars have interpreted the scene both as a victory celebration and as a banquet in connection with cult ritual. The two are not necessarily incompatible. The absence of an inscription prevents connecting the scenes with a specific event or person, but the *Standard of Ur* undoubtedly is an early example of historical narrative.

AKKADIAN ART

In 2334 BCE, the loosely linked group of cities known as Sumer came under the domination of a great ruler, Sargon of Akkad. Archaeologists have yet to locate the specific site of the city of Akkad, but it was in the vicinity of Babylon. Under Sargon (whose name means "true king") and his followers, the Akkadians introduced a new concept of royal power based on unswerving loyalty to the king rather than to the city-state. During the rule of Sargon's grandson, Naram-Sin (r. 2254–2218 BCE), governors of cities were considered mere servants of the king, who, in turn, called himself "King of the Four Quarters"—in effect, ruler of the earth, akin to a god.

Imperial Majesty Vandalized A magnificent copper head of an Akkadian king (Fig. 1-14) found at Nineveh

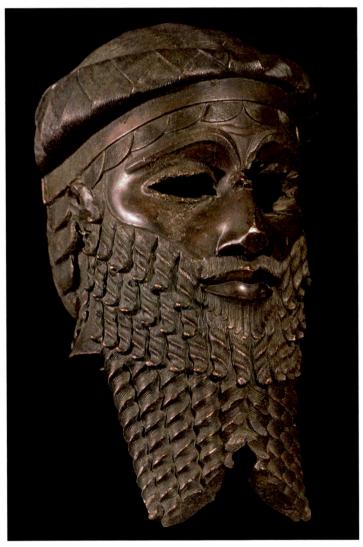

1-14 | Head of an Akkadian ruler, from Nineveh (modern Kuyunjik), Iraq, ca. 2250–2200 BCE Copper, 1' $2\frac{2}{8}$ " high. Iraq Museum, Baghdad.

The sculptor of this first known life-size hollow-cast head captured the distinctive portrait features of the ruler while also displaying a keen sense of abstract pattern. The head was later vandalized, probably by an enemy.

embodies this new concept of absolute monarchy. The head is all that survives of a statue that was knocked over in antiquity, perhaps during the sack of Nineveh in 612 BCE. To make a political statement, the enemy not only toppled the Akkadian royal portrait but gouged out the eyes (once inlaid with precious or semiprecious stones), broke off the lower part of the beard, and slashed the ears. Nonetheless, the king's majestic serenity, dignity, and authority are evident. So, too, is the masterful way the sculptor balanced naturalism and abstract patterning. The artist carefully observed and recorded the distinctive profile of the ruler's nose and his long, curly beard. The sculptor also brilliantly communicated the differing textures of flesh and hair—even the contrasting textures of the mustache, beard, and the braided hair on the top of the head. The coiffure's triangles, lozenges, and overlapping disks of hair and the great arching eyebrows that give such character to the portrait reveal that the artist was also sensitive to formal pattern. No less remarkable is the fact that this is a life-size, hollow-cast metal sculpture (see "Hollow-Casting Life-Size Bronze Statues," Chapter 2, page 67), one of the earliest known. The head demonstrates its maker's sophisticated skill in casting and polishing copper and in engraving the details.

A God-King Crushes Foes The godlike sovereignty the kings of Akkad claimed is also evident in the victory stele (Fig. 1-15) Naram-Sin set up at Sippar. A *stele* is a carved stone slab erected to commemorate a historical event or, in some other cultures, to mark a grave (Fig. 2-42). Naram-Sin's stele commemorates his defeat of the Lullubi, a people of the Iranian mountains to the east. On the stele, the grandson of Sargon leads his victorious army up the slopes of a wooded mountain. His routed enemies fall, flee, die, or beg for mercy. The king stands alone, far taller than his men, treading on the bodies of two of the fallen Lullubi. He wears the horned helmet—the first time a king appears as a god in Mesopotamian art. At least three favorable stars (the stele is damaged at the top and broken at the bottom) shine on his triumph.

By storming the mountain, Naram-Sin seems also to be scaling the ladder to the heavens, the same conceit that lies behind the great ziggurat towers of the ancient Near East. His troops march up the slope behind him in orderly files, suggesting the discipline and organization of the king's forces. The enemy, in contrast, is in disarray, depicted in a great variety of postures—one falls headlong down the mountainside. The sculptor adhered to older conventions in many details, especially by portraying the king and his soldiers in composite views and by placing a frontal two-horned helmet on Naram-Sin's profile head. But in other respects this work shows daring innovation. Here, the sculptor created one of the first landscapes in the history of art and set the figures on successive tiers within that landscape. This was a bold rejection of the standard compositional formula of telling a story in a series of horizontal registers.

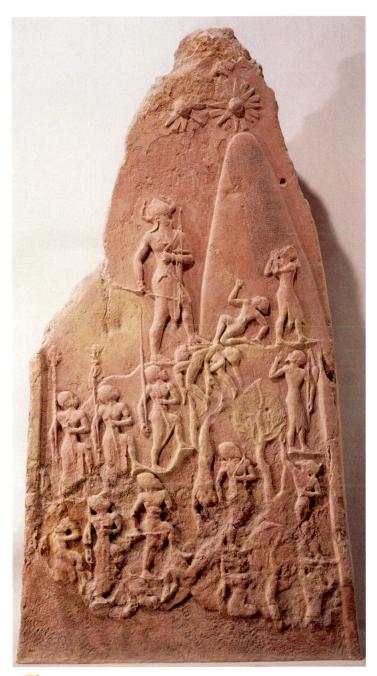

1-15 | Victory stele of Naram-Sin, from Susa, Iran, ca. 2254–2218 BCE. Pink sandstone, approx. 6' 7" high. Louvre, Paris.

To commemorate his conquest of the Lullubi, Naram Sin set up this stele showing him leading his army against the enemy. The sculptor staggered the figures on the mountain, boldly rejecting the traditional register format.

BABYLONIAN ART

Around 2150 BCE, a mountain people, the Gutians, brought Akkadian power to an end. The cities of Sumer, however, soon united in response to the alien presence, drove the Gutians out of Mesopotamia, and established a Neo-Sumerian state ruled by the kings of Ur. This age, which historians call the Third Dynasty of Ur, saw the construction of the ziggurat at Ur (Fig. 1-10). Sumer's resurgence was short lived, however. The last of the kings of the Third Dynasty of Ur fell

at the hands of the Elamites, who ruled the territory east of the Tigris River. The following two centuries witnessed the reemergence of the traditional Mesopotamian political pattern of several independent city-states existing side by side, until one of those cities, Babylon, succeeded in establishing a centralized government that ruled southern Mesopotamia in the 18th and 17th centuries BCE. Babylon's most powerful king was Hammurabi (r. 1792–1750 BCE). Famous in his own time for his conquests, he is best known today for his law code, which prescribed penalties for everything from adultery and murder to the cutting down of a neighbor's trees.

The code is inscribed in 3,500 lines of cuneiform characters on a tall black-basalt stele (Fig. 1-16). At the top is a relief depicting Hammurabi in the presence of the flame-shouldered sun god, Shamash. The king raises his hand in respect. The god extends to Hammurabi the rod and ring that symbolize authority. The symbols derive from builders' tools—measuring rods and coiled rope—and connote Hammurabi's capacity to build the social order and to measure people's lives, that is, to render judgements. The sculptor depicted Shamash in the familiar convention of combined front and side views, but

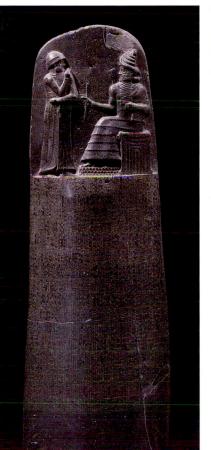

1-16 | Stele with law code of Hammurabi, from Susa, Iran, ca. 1780 BCE. Basalt, approx. 7' 4" high. Louvre, Paris.

The stele that records
Hammurabi's remarkably
early comprehensive law code
also is one of the first examples of an artist's employing
foreshortening — the representation of a figure or
object at an angle.

with two important exceptions. The god's great headdress with its four pairs of horns is in true profile so that only four, not all eight, of the horns are visible. And the artist seems to have tentatively explored the notion of *foreshortening*—a device for suggesting depth by representing a figure or object at an angle, rather than frontally or in profile. Shamash's beard is a series of diagonal rather than horizontal lines, suggesting its recession from the picture plane. Like the bold abandonment of the register format in favor of a tiered landscape on the Naram-Sin stele, such innovations in representational modes were exceptional in early eras of the history of art. These occasional departures from the norm testify to the creativity of ancient Near Eastern artists.

ASSYRIAN ART

The Babylonian Empire toppled in the face of an onslaught by the Hittites, an Anatolian people who conquered and sacked Babylon around 1595 BCE. They then retired to their homeland, leaving Babylon in the hands of the Kassites. By around 900 BCE, however, Mesopotamia was overtaken by the Assyrians. The new conquerors took their name from Assur, the city of the god Ashur on the Tigris River. At the height of their power, the Assyrians ruled an empire that extended from the Tigris to the Nile Rivers and from the Persian Gulf to Asia Minor (MAP 1-2, page 523).

Sargon's Citadel The royal citadel of Sargon II (r. 721– 705 BCE) at Dur Sharrukin is the most completely excavated of the many Assyrian palaces. Its ambitious layout reveals the confidence of the Assyrian kings in their all-conquering might, but its strong defensive walls also reflect a society ever fearful of attack during a period of almost constant warfare. The city measured about a square mile in area and included a great ziggurat and six sanctuaries for six different gods. The palace, elevated on a mound 50 feet high, covered some 25 acres and had more than 200 courtyards and timberroofed rooms. Sargon II regarded his city and palace as an expression of his grandeur. In one inscription, he boasted, "I built a city with [the labors of] the peoples subdued by my hand, whom [the gods] Ashur, Nabu, and Marduk had caused to lay themselves at my feet and bear my yoke." And in another text, he proclaimed, "Sargon, King of the World, has built a city. Dur Sharrukin he has named it. A peerless palace he has built within it."

Monstrous Guardians Guarding the gate to Sargon's palace were colossal limestone monsters (Fig. 1-17), which the Assyrians probably called *lamassu*. These winged, manheaded bulls served to ward off the king's enemies. The task of moving and installing such immense stone sculptures was so daunting that several reliefs in the palace of Sargon's successor celebrate the feat, showing scores of men dragging lamassu figures with the aid of ropes and sledges.

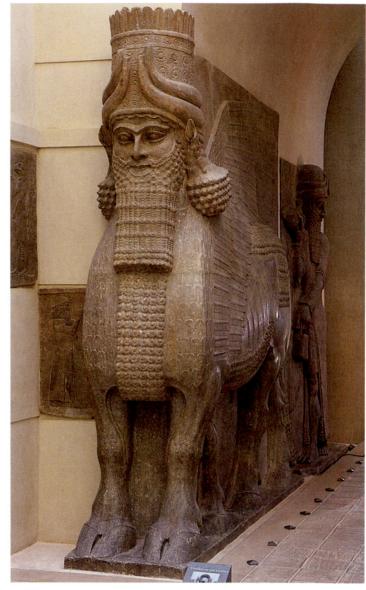

1-17 | Lamassu (winged, human-headed bull), from the citadel of Sargon II, Dur Sharrukin (modern Khorsabad), Iraq, ca. 720–705 BCE. Limestone, approx. 13′ 10″ high. Louvre, Paris.

The monsters guarding Assyrian palaces reveal ancient sculptors' insistence on showing complete views of animals. This four-legged lamassu has five legs—two when seen from the front and four in profile view.

The Assyrian lamassu sculptures are partly in the round, but the sculptor nonetheless conceived them as high reliefs on adjacent sides of a corner. They combine the front view of the animal at rest with the side view of it in motion. Seeking to present a complete picture of the lamassu from both the front and the side, the sculptor gave the monster five legs (two seen from the front, four seen from the side). The three-quarter view the modern photographer chose would not have been favored in antiquity. This sculpture, then, is yet another case of early artists' providing a *conceptual picture* of an animal or person and all its important parts, as opposed to an *optical view* of the lamassu as it would actually stand in space.

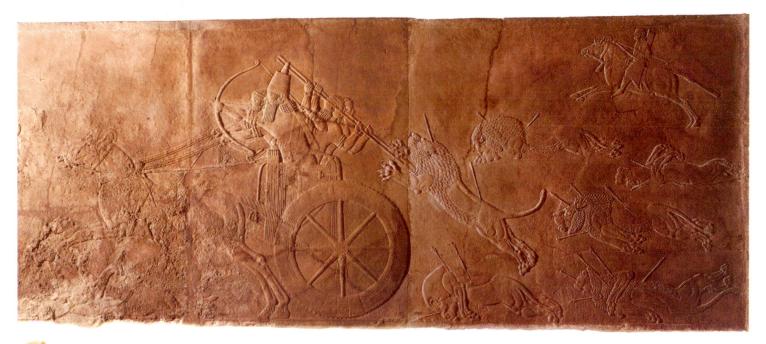

1-18 | Ashurbanipal hunting lions, relief from the North Palace of Ashurbanipal, Nineveh (modern Kuyunjik), Iraq, ca. 645–640 BCE. Gypsum, 5' 4" high. British Museum, London.

The walls of Assyrian palaces were adorned with extensive series of narrative stone reliefs exalting royal power. The hunting of lions was regarded as a manly virtue on a par with victory in warfare.

Chronicles in Stone For their palace walls the Assyrian kings commissioned extensive series of narrative reliefs exalting royal power and piety. The sculptures record not only battlefield victories but also the slaying of wild animals. (The Assyrians, like many other societies before and after, regarded prowess in hunting as a manly virtue on a par with success in warfare.) One of the most extensive cycles of Assyrian narrative reliefs comes from the palace of Ashurbanipal (r. 668–627 BCE) at Nineveh. Throughout the palace, painted gypsum reliefs sheathed the lower parts of the mudbrick walls below brightly colored plaster. Rich textiles on the floors contributed to the luxurious ambience. The reliefs celebrated the king and bore inscriptions describing his accomplishments.

We illustrate one of the palace's hunting scenes (Fig. 1-18) in which lions released from cages in a large enclosed arena charge the king. (The hunt did not take place in the wild but in a controlled environment, ensuring the king's safety and success.) In our detail, the king is in his chariot with his attendants. He thrusts a spear into a savage lion, which leaps at the king even though it already has two arrows in its body. All around the royal chariot is a pathetic trail of dead and dying animals, pierced by far more arrows than needed to kill them. Blood streams from some of the lions, but they refuse to die. The artist brilliantly depicted the straining muscles, the swelling veins, the muzzles' wrinkled skin, and the flattened ears of the powerful and defiant beasts. Modern sympathies make this scene of carnage a kind of heroic tragedy, with the lions as protagonists. It

is unlikely, however, that the king's artists had any intention other than to glorify their ruler by showing the king of men pitting himself against and repeatedly conquering the king of beasts. Portraying Ashurbanipal's beastly foes as possessing courage and nobility as well as strength served to make the king's accomplishments that much grander.

NEO-BABYLONIAN ART

The Assyrian Empire was never very secure, and most of its kings had to fight revolts in large sections of the Near East. During the last years of Ashurbanipal's reign, the empire began to disintegrate. Under his successors, it collapsed from the simultaneous onslaught of the Medes from the east and the resurgent Babylonians from the south. For almost a century beginning in 612 BCE, Neo-Babylonian kings held sway over the former Assyrian Empire.

Wondrous Babylon The most renowned of the Neo-Babylonian kings was Nebuchadnezzar II (r. 604–562 BCE), who restored Babylon to its rank as one of the great cities of antiquity. The city's famous hanging gardens were counted among the Seven Wonders of the ancient world, and, as noted previously, its enormous ziggurat dedicated to Marduk, the chief god of the Babylonians, was immortalized in the Bible as the Tower of Babel. Nebuchadnezzar's Babylon was a mudbrick city, but dazzling blue *glazed bricks* faced the most important monuments. Some of the buildings, such as the Ishtar

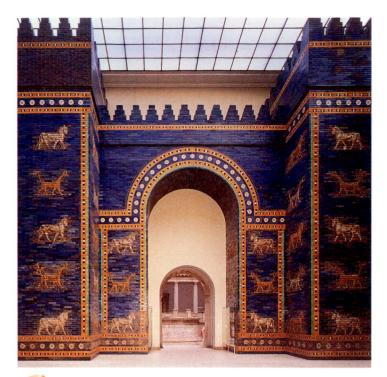

1-19 | Ishtar Gate (restored), Babylon, Iraq, ca. 575 BCE. Glazed brick. Staatliche Museen, Berlin.

Babylon under King Nebuchadnezzar II was one of the greatest cities of the ancient world. The monumental Ishtar Gate is sheathed in glazed bricks depicting Marduk's dragon and Adad's bull.

Gate (Fig. 1-19), with its imposing arched opening flanked by towers, featured glazed bricks with molded reliefs of animals, real and imaginary. Each Babylonian brick was molded and glazed separately, then set in proper sequence on the wall. On Ishtar's Gate, profile figures of Marduk's dragon and Adad's bull alternate. (Ishtar was the Babylonian equivalent of

Inanna; Adad was the Babylonian god of storms.) Lining the processional way leading up to the gate were reliefs of Ishtar's sacred lion, glazed in yellow, brown, and red against a blue ground.

ACHAEMENID PERSIAN ART

Although Nebuchadnezzar, "King of Kings" of the biblical Daniel, had boasted that he "caused a mighty wall to circumscribe Babylon...so that the enemy who would do evil would not threaten," Cyrus of Persia (r. 559-529 BCE) captured the city in the sixth century BCE. Cyrus was the founder of the Achaemenid dynasty and traced his ancestry back to a mythical King Achaemenes. Babylon was but one of the Persians' conquests. Egypt fell to them in 525 BCE, and by 480 BCE the Persian Empire was the largest the world had vet known, extending from the Indus River in South Asia to the Danube River in northeastern Europe. Only the successful Greek resistance in the fifth century BCE prevented Persia from embracing southeastern Europe as well (see Chapter 2). The Achaemenid line ended with the death of Darius III in 330 BCE, after his defeat at the hands of Alexander the Great (Fig. 2-47).

Imperial Persepolis The most important source of knowledge about Persian art and architecture is the ceremonial and administrative complex on the citadel at Persepolis (Fig. 1-20), which the successors of Cyrus, Darius I (r. 522–486 BCE) and Xerxes (r. 486–465 BCE), built between 521 and 465 BCE. Situated on a high plateau, the heavily fortified complex of royal buildings stood on a wide platform overlooking the plain. Alexander the Great razed the site in a gesture symbolizing the destruction of Persian imperial power. Even in ruins, the Persepolis citadel is impressive.

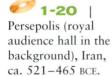

The imperial Persian capital at Persepolis contained a grandiose royal audience hall with 36 colossal columns. The terraces leading up to it were decorated with reliefs of subject nations bringing tribute to the king.

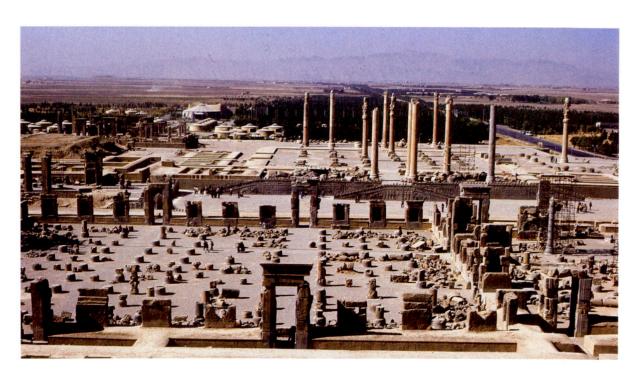

The approach to the citadel led through a monumental gate-way called the Gate of All Lands, a reference to the harmony among the peoples of the vast Persian empire. Assyrian-inspired colossal man-headed winged bulls flanked the great entrance. Broad ceremonial stairways provided access to the platform and the huge royal audience hall, or *apadana*, 60 feet high and 217 feet square, containing 36 colossal *columns*. An audience of thousands could have stood within the hall.

The reliefs decorating the walls of the terrace and staircases leading to the apadana represent processions of royal guards, Persian nobles and dignitaries, and representatives from 23 subject nations bringing the king tribute. Every one of the emissaries wears his national costume and carries a typical regional gift for the conqueror. Traces of color prove that the reliefs were painted, and the original effect must have been very striking. Although the Persepolis sculptures may have been inspired by those in Assyrian palaces, they are different in style. The forms are more rounded, and they project more from the background. Some of the details, notably the treatment of drapery folds, echo forms characteristic of Archaic Greek sculpture, and Greek influence seems to be one of the many ingredients of Achaemenid style. Persian art testifies to the active exchange of ideas and artists among Mediterranean and Near Eastern civilizations at this date. A building inscription at Susa, for example, names Ionian Greeks, Medes (who occupied the land north of Persia), Egyptians, and Babylonians among those who built and decorated the palace.

The New Persian Empire Alexander the Great's conquest of Persia in 330 BCE marked the beginning of a long period of first Greek and then Roman rule of large parts of the ancient Near East. In the third century CE, however, a new power rose up in Persia that challenged the Romans and sought to force them out of Asia. The new rulers called themselves Sasanians. They traced their lineage to a legendary figure named Sasan, said to be a direct descendant of the Achaemenid kings. Their New Persian Empire was founded in 224 CE, when the first Sasanian king, Artaxerxes I (r. 211-241), defeated the Parthians (another of Rome's eastern enemies). The son and successor of Artaxerxes, Shapur I (r. 241-272), succeeded in further extending Sasanian territory. So powerful was the Sasanian army that in 260 CE Shapur I even succeeded in capturing the Roman emperor Valerian near Edessa (in modern Turkey). The New Persian Empire endured more than 400 years, until the Arabs drove the Sasanians out of Mesopotamia in 636, just four years after the death of Muhammad. Thereafter, the greatest artists and architects of Mesopotamia worked in the service of Islam (see Chapter 5).

EGYPTIAN ART

Nearly 2,500 years ago, the Greek historian Herodotus wrote, "Concerning Egypt itself I shall extend my remarks to a great length, because there is no country that possesses so many wonders, nor any that has such a number of works that

defy description." Even today, many would agree with this assessment. The ancient Egyptians left to the world countless monuments of architecture, sculpture, and painting dating across three millennia. The solemn and ageless art of the Egyptians expresses the unchanging order that, for them, was divinely established.

The backbone of Egypt was, and still is, the Nile River, whose annual floods supported all life in that ancient land (MAP 1-3, page 524). Even more than the Tigris and the Euphrates rivers of Mesopotamia, the Nile defined the cultures that developed along its banks. Originating deep in Africa, the world's longest river flows through regions that may not have a single drop of rainfall in a decade. Yet crops thrive from the rich soil that the Nile brings thousands of miles from the African hills. In the time of the *pharaohs*, the ancient Egyptian kings, the land bordering the Nile consisted of marshes dotted with island ridges. Amphibious animals swarmed in the marshes and were hunted through tall forests of papyrus and rushes (Fig. 1-28). Egypt's fertility was famous. When Egypt became a province of the Roman Empire after the death of Queen Cleopatra (r. 51-30 BCE), it served as the granary of the Mediterranean world.

The Predynastic and Early Dynastic Periods

The Predynastic, or prehistoric, beginnings of Egyptian civilization are chronologically vague. But tantalizing remains of tombs, paintings, pottery, and other artifacts from around 3500 BCE attest to the existence of a sophisticated culture on the banks of the Nile. In Predynastic times, Egypt was divided geographically and politically into Upper Egypt (the southern, upstream part of the Nile Valley) and Lower (northern) Egypt. The ancient Egyptians began the history of their kingdom with the unification of the two lands. Until recently, this was thought to have occurred during the rule of the First Dynasty pharaoh Menes.

Narmer and Historical Art Many scholars identify Menes with King Narmer, whose image and name appear on both sides of a ceremonial palette (stone slab with a circular depression) found at Hierakonpolis. The palette (Fig. 1-21) is an elaborate, formalized version of a utilitarian object commonly used in the Predynastic period to prepare eye makeup. (Egyptians used makeup to protect their eyes against irritation and the glare of the sun.) Narmer's palette is the earliest existing labeled work of historical art. Although it is no longer regarded as commemorating the foundation of the first of Egypt's 31 dynasties around 2920 BCE (the last ended in 332 BCE),² it does record the unification of Upper and Lower Egypt at the very end of the Predynastic period. Although scholars now believe this unification occurred over several centuries, the palette reflects the ancient Egyptian belief that the creation of the "Kingdom of the Two Lands" was a single great event.

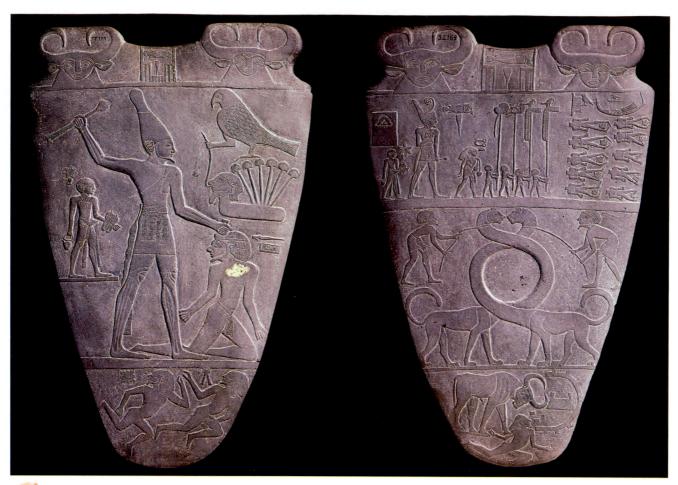

1-21 | Palette of King Narmer (left, back; right, front), from Hierakonpolis, Egypt, Predynastic, ca. 3000–2920 BCE. Slate, approx. 2' 1" high. Egyptian Museum, Cairo.

These oldest preserved labeled historical reliefs commemorate the unification of Upper and Lower Egypt. Narmer, the largest figure, effortlessly defeats a foe on one side, and on the other surveys the beheaded enemy.

King Narmer's palette is important not only as a document marking the transition from the prehistorical to the historical period in ancient Egypt but also as a kind of early blueprint of the formula for figure representation that characterized most Egyptian art for 3,000 years. At the top of each side of the palette are two heads of the goddess Hathor, the divine mother of the pharaoh, who nourishes him with her milk and is here represented as a cow with a woman's face. Between the Hathor heads is a hieroglyph giving Narmer's name within a frame representing the royal palace. Below, the story of the unification of Egypt is told in registers.

On the back of the palette, the king, wearing the high, white, bowling-pin-shaped crown of Upper Egypt and accompanied by an official who carries his sandals, is shown slaying an enemy. Above and to the right, the falcon with human arms is Horus, the Egyptian god who was the special protector of the pharaohs. The falcon-god takes captive a manheaded hieroglyph with a papyrus plant growing from it that stands for the land of Lower Egypt. Below the king are two fallen enemies. On the front of the palette, the elongated necks of two felines form the circular depression that would have held eye makeup in an ordinary palette not made for

display. The intertwined necks of the animals may be another pictorial reference to Egypt's unification. In the uppermost register, Narmer, wearing the red crown of Lower Egypt, reviews the beheaded bodies of the enemy. The artist depicted each body with its severed head neatly placed between its legs. By virtue of his superior rank, the king, on both sides of the palette, performs his ritual task alone and towers over his own men and the enemy. The king's superhuman strength is symbolized in the lowest band by a great bull knocking down a rebellious city whose fortress walls are seen from above.

Specific historical narrative was not the artist's goal in this work. What was important was the characterization of the king as supreme, isolated from and larger than all ordinary men and solely responsible for the triumph over the enemy. Here, at the very beginning of Egyptian history, is evidence of the Egyptian convention of thought, of art, and of state policy that established the pharaoh as a divine ruler.

Tombs and the Afterlife Narmer's palette is exceptional among surviving Egyptian artworks because it is commemorative rather than funerary in nature. In fact, Egyptian tombs provide the principal, if not the exclusive, evidence for the

Mummification and the Afterlife

The Egyptians did not make the sharp distinction between body and soul that is basic to many religions. Rather, they believed that from birth a person was accompanied by a kind of other self, the ka or life force, which, on the death of the body, could inhabit the corpse and live on. For the ka to live securely, however, the body had to remain as nearly intact as possible. To ensure that it did, the Egyptians developed the technique of embalming (mummification) to a high art.

Embalming generally lasted 70 days. The first step was the surgical removal of the lungs, liver, stomach, and intestines through an incision in the left flank. The Egyptians thought these organs were most subject to decay. The organs were individually wrapped and placed in four jars for eventual deposit in the burial chamber with the corpse. The brain was extracted through the nostrils and discarded. The Egyptians did not attach any special significance to the brain. But they left in place the heart, necessary for life and regarded as the seat of intelligence.

Next, the body was treated for 40 days with natron, a naturally occurring salt compound that dehydrated the body. Then the corpse was filled with resin-soaked linens, and the embalming incision was closed and covered with a representation of Horus's eye, a powerful *amulet* (a device

to ward off evil and promote rebirth). Finally, the body was treated with lotions and resins and then wrapped tightly with hundreds of yards of linen bandages to maintain its shape. The Egyptians often placed other amulets within the bandages or on the corpse. The mummies of the wealthy had their faces covered with funerary masks (Fig. 1-36).

Preserving the deceased's body by mummification was only the first requirement for immortality. Food and drink also had to be provided, as did clothing, utensils, and furniture. Nothing that had been enjoyed on earth was to be lacking. Statuettes called *ushabtis* (answerers) also were placed in the tomb. These figurines performed any labor the deceased required in the afterlife, answering whenever his or her name was called.

Images of the deceased, sculpted in the round and placed in shallow recesses, also were set up in the tomb. They were meant to guarantee the permanence of the person's identity by providing substitute dwelling places for the ka in case the mummy disintegrated. Wall paintings and reliefs recorded the recurring round of human activities. The Egyptians hoped and expected that the images and inventory of life, collected and set up within the tomb's protective stone walls, would ensure immortality.

historical reconstruction of Egyptian civilization. The overriding concern in this life was to insure safety and happiness in the next life. The majority of monuments the Egyptians left behind were dedicated to this preoccupation (see "Mummification and the Afterlife," above).

The standard tomb type in early Egypt was the *mastaba* (Fig. 1-22). The mastaba (Arabic, "bench") was a rectangular brick or stone structure with sloping sides erected over an underground burial chamber. A shaft connected this chamber with the outside, providing the ka with access to the tomb. The form probably was developed from earth or stone mounds that had covered even earlier tombs. Although mastabas originally housed single burials, as in our example, during the latter part of the Old Kingdom they were used for multiple family burials and became increasingly complex. The central underground

chamber was surrounded by storage rooms and compartments whose number and size increased with time until the area covered far surpassed that of the tomb chamber. Built into the superstructure, or sometimes attached to the outside, was a chapel housing a statue of the deceased in a small concealed chamber called the *serdab*. The chapel's interior walls and the ancillary rooms were decorated with colored relief carvings and paintings of scenes from daily life intended magically to provide the deceased with food and entertainment.

The First Pyramid One of the most renowned figures in Egyptian history was IMHOTEP, the royal builder for King Djoser (r. 2630–2611 BCE) of the Third Dynasty. Imhotep was a man of legendary talent who served also as the pharaoh's chancellor and high priest of the sun god Re. After his death,

1. Chapel 2. False door 3. Shaft into burial chamber 4. Serdab (chamber for statue of deceased) 5. Burial chamber

1-22 | Section (*left*), plan (*center*), and restored view (*right*) of typical Egyptian mastaba tombs.

The standard early form of Egyptian tomb had an underground burial chamber and rooms to house a portrait statue and offerings to the deceased. The interior walls were often decorated with scenes of daily life.

I-23 | IMHOTEP, Stepped Pyramid and mortuary precinct of Djoser, Saqqara, Egypt, Dynasty III, ca. 2630–2611 BCE.

The first pyramid took the form of a series of stacked mastabas. Djoser's stepped pyramid was the centerpiece of an immense funerary complex glorifying the god-king and his eternal existence in the hereafter.

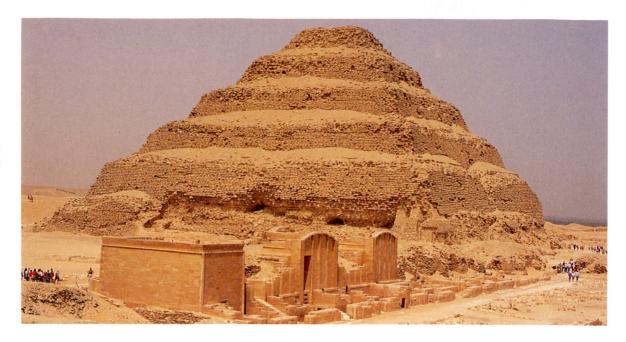

the Egyptians revered Imhotep as a god and in time may have inflated the list of his achievements. Nonetheless, his is the first known name of an artist in recorded history. Imhotep designed the Stepped Pyramid (Fig. 1-23) of Djoser at Saqqara, near Memphis, Egypt's capital at the time. Djoser's pyramid was the centerpiece of an immense (37-acre) rectangular enclosure surrounded by a monumental (34-foot-high and 5,400-foot-long) wall of white limestone. The huge precinct also contained a funerary temple, where priests performed daily rituals in celebration of the divine pharaoh, and several structures connected with the Jubilee Festival, the event that perpetually reaffirmed the royal existence in the hereafter.

Built before 2600 BCE, Djoser's pyramid is one of the oldest stone structures in Egypt and, in its final form, the first truly grandiose royal tomb. Begun as a large mastaba with each of its faces oriented toward one of the cardinal points of the compass, the tomb was enlarged at least twice before taking on its ultimate shape. About 200 feet high, the Stepped Pyramid seems to be composed of a series of mastabas of diminishing size, stacked one on top of another. The tomb's dual function was to protect the mummified king and his possessions and to symbolize, by its gigantic presence, his absolute and godlike power. Beneath the pyramid was a network of underground galleries resembling a palace. It was to be Djoser's new home in the afterlife.

The Old Kingdom

The Old Kingdom is the first of the three great periods of Egyptian history, called the Old, Middle, and New Kingdoms, respectively. Many Egyptologists now begin the Old Kingdom with the first pharaoh of the Fourth Dynasty, Sneferu (r. 2575–2551 BCE), although the traditional division of kingdoms places Djoser and the Third Dynasty in the Old Kingdom. It ended with the demise of the Eighth Dynasty around 2134 BCE.

Pyramids and the Sun God At Gizeh stand the three Great Pyramids (Fig. 1-24), the oldest of the Seven Wonders of the ancient world. The prerequisites for membership in this elite club were colossal size and enormous cost. The Gizeh pyramids testify to the wealth and pretensions of the Fourth Dynasty pharaohs Khufu (r. 2551–2528 BCE), Khafre (r. 2520–2494 BCE), and Menkaure (r. 2490–2472 BCE).

The three pyramids, built in the course of about 75 years, represent the culmination of an architectural evolution that began with the mastaba. The pyramid form did not evolve out of necessity. Kings could have gone on indefinitely stacking mastabas to make their weighty tombs. The new tomb shape probably reflects the influence of Heliopolis, the seat of the powerful cult of Re, whose emblem was a pyramidal stone, the *ben-ben*. The Great Pyramids are symbols of the sun. The Pyramid Texts, inscribed on the burial chamber walls of many royal tombs, refer to the sun's rays as the ramp the pharaoh uses to ascend to the heavens. Djoser's Stepped Pyramid (Fig. 1-23) may also have been conceived as a giant stairway. The pyramids were where Egyptian kings were reborn in the afterlife, just as the sun is reborn each day at dawn.

Of the three Fourth Dynasty pyramids at Gizeh, the tomb of Khufu is the oldest and largest. Except for its internal galleries and burial chamber, it is an almost solid mass of limestone masonry (see "Building the Great Pyramids," page 35)—a stone mountain built on the same principle as the earlier Stepped Pyramid at Saqqara. When its original stone facing was intact, the sunlight it reflected would have been dazzling, underscoring the pyramid's role as a solar symbol. The immensity of the Gizeh pyramids and that of Khufu in particular is indicated by some dimensions. At the base, the length of one side of Khufu's tomb is approximately 775 feet, and its area is some 13 acres. Its present height is about 450 feet (originally 480 feet). The structure contains roughly 2.3 million blocks of stone, each weighing an average of 2.5 tons. Napoleon's scholars calculated

ARCHITECTURAL BASICS

Building the Great Pyramids

The three Great Pyramids of Khufu, Khafre, and Menkaure at Gizeh (Fig. 1-24) attest to Egyptian builders' mastery of stone masonry and to their ability to mobilize, direct, house, and feed a huge workforce engaged in one of the most labor-intensive enterprises ever undertaken. Like all building projects of this type, the process of erecting the pyramids began with the quarrying of stone, in this case primarily the limestone of the Gizeh plateau itself. Teams of skilled workers had to cut into the rock and remove large blocks of roughly equal size using stone or copper chisels and wooden mallets and wedges. Often, the artisans had to cut deep tunnels to find high-quality stone free of cracks and other flaws. To remove a block, the workers cut channels on all sides and partly underneath. Then they pried the stones free from the bedrock with wooden levers.

After workers liberated the stones, the rough blocks had to be transported to the building site and *dressed* (shaped to the exact dimensions required, with smooth faces for a perfect fit). The massive blocks used to construct the Great Pyramids were moved using wooden rollers and sleds. The artisans dressed the blocks by chiseling and pounding the surfaces and, in the last stage, by rubbing and grinding the surfaces with fine polishing stones. This kind of construction, in which carefully cut and regu-

larly shaped blocks of stone are piled in successive rows, or *courses*, is called *ashlar masonry*.

To set the ashlar blocks in place, workers erected great rubble ramps against the core of the pyramid. Their size and slope were adjusted as work progressed and the tomb grew in height. Scholars still debate whether the Egyptians used simple linear ramps inclined at a right angle to one face of the pyramid or zigzag or spiral ramps akin to staircases. Linear ramps would have had the advantage of simplicity and would have left three sides of the pyramid unobstructed. But zigzag ramps placed against one side of the structure or spiral ramps winding around the pyramid would have greatly reduced the slope of the incline and would have made the dragging of the blocks easier. Some scholars also have suggested a combination of straight and spiral ramps.

Ropes, pulleys, and levers were used both to lift and to lower the stones, guiding each block into its designated place. Finally, the pyramid was surfaced with a casing of white limestone, cut so precisely that the eye could scarcely detect the joints. A few casing stones still can be seen in the cap that covers the Pyramid of Khafre (Figs. 1-24, center, and 1-25, left).

that the blocks in the three Great Pyramids were sufficient to build a wall 1 foot wide and 10 feet high around France.

As with Djoser's Stepped Pyramid, the four sides of each of the Great Pyramids are oriented to the cardinal points of the compass. But the funerary temples associated with the three Gizeh pyramids are not placed on the north side, facing the stars of the northern sky, as was Djoser's temple. The temples sit on the east side, facing the rising sun and underscoring their connection with Re.

Khafre and the Sphinx From the remains surrounding the Pyramid of Khafre, archaeologists have been able to reconstruct an entire funerary complex. The complex included the pyramid itself with the pharaoh's burial chamber; the

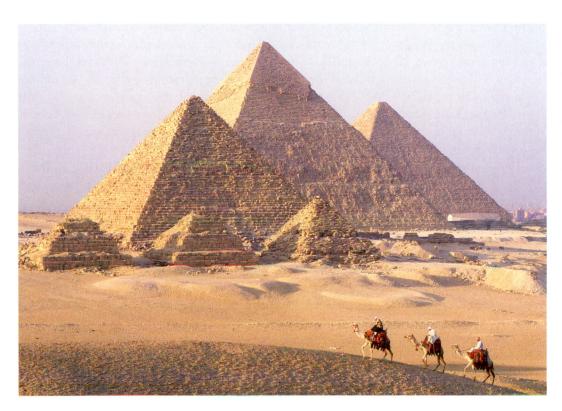

1-24 | Great Pyramids, Gizeh, Egypt, Dynasty IV. From left: Pyramids of Menkaure, ca. 2490–2472 BCE; Khafre, ca. 2520–2494 BCE; and Khufu, ca. 2551–2528 BCE.

The Great Pyramids of the Fourth Dynasty pharaohs took the shape of the ben-ben, emblem of the sun, Re. The sun's rays were the ramp the pharaohs used to ascend to the heavens after their death and rebirth. Sphinx (with Pyramid of Khafre in the background at left), Gizeh, Egypt, Dynasty IV, ca. 2520–2494 BCE. Sandstone, approx. 65' high, 240' long.

Carved from the rock of the Gizeh plateau, the Great Sphinx is the largest statue in the Near East. The sphinx is associated with the sun god, and joins a lion's body with the head of the pharaoh.

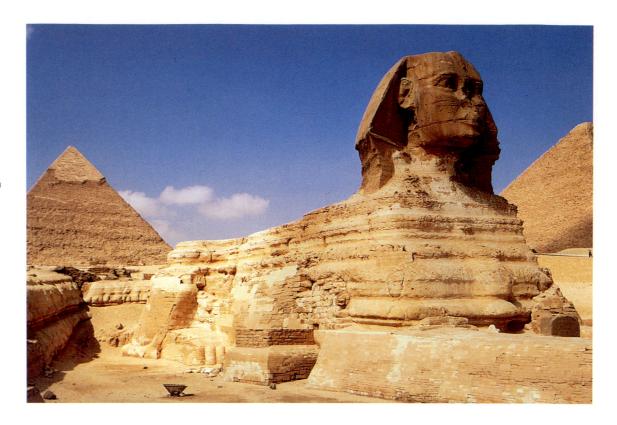

mortuary temple adjoining the pyramid on the east side, where offerings were made to the dead king, ceremonies performed, and cloth, food, and ceremonial vessels stored; the covered *causeway*, or raised corridor, whose walls were decorated with painted reliefs; and the *valley temple* at the edge of the floodplain. According to one theory, the complex served not only as the king's tomb and temple but also as his palace in the afterlife.

Beside the causeway and dominating the valley temple of Khafre rises the Great Sphinx (Fig. 1-25). Carved from a spur of rock in an ancient quarry, the colossal statue—the largest in the ancient Near East—is probably an image of Khafre, although some scholars believe it portrays Khufu and was carved before construction of Khafre's complex began. Whoever it portrays, the *sphinx*—a lion with a human head—was associated with the sun god and therefore was an appropriate image for a pharaoh. The composite form suggests that the pharaoh combines human intelligence with the awesome strength and authority of the king of beasts.

Statues for Eternity As already noted, statues fulfilled an important function in Egyptian tombs. Sculptors created images of the deceased to serve as abodes for the ka should the mummies be destroyed. Although wood, clay, and other materials were used, mostly for images of those not of the royal or noble classes, the primary material for funerary statuary was stone.

The seated statue of Khafre (Fig. 1-26) is one of a series of similar statues carved for the pharaoh's valley temple near the Great Sphinx. The stone is diorite, an exceptionally hard dark stone brought some 400 miles down the Nile from royal

quarries in the south. Khafre wears a simple kilt and sits rigidly upright on a throne formed of two stylized lions' bodies. Intertwined lotus and papyrus plants-symbol of the united Egypt—are carved between the legs of the throne. The falcongod Horus extends his protective wings to shelter the pharaoh's head. Khafre has the royal false beard fastened to his chin and wears the royal linen nemes headdress with the uraeus cobra of kingship on the front. The headdress covers his forehead and falls in pleated folds over his shoulders. (The head of the Great Sphinx is similarly attired.) As befitting a divine ruler, Khafre is shown with a well-developed, flawless body and a perfect face, regardless of his actual age and appearance. The Egyptians considered ideal proportions appropriate for representing imposing majesty, and artists used them quite independently of reality. This and all other generalized representations of the pharaohs are not true portraits and were not intended to be. Their purpose was not to record individual features or the distinctive shapes of bodies, but rather to proclaim the godlike nature of Egyptian kingship.

The seated king radiates serenity. The sculptor created this effect, common to Egyptian royal statues, in part by giving the figure great compactness and solidity, with few projecting, breakable parts. The form manifests the purpose: to last for eternity. Khafre's body is attached to the unarticulated slab that forms the back of the king's throne. His arms are held close to the torso and thighs, and his legs are close together and connected to the chair by the stone the artist chose not to remove. The pose is frontal, rigid, and *bilaterally symmetrical* (the same on either side of an axis, in this case the vertical axis). The sculptor suppressed all movement and with it the notion of time, creating an eternal stillness.

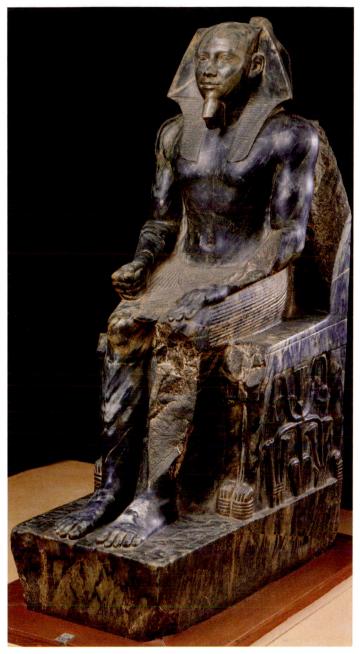

1-26 | Khafre, from Gizeh, Egypt, Dynasty IV, ca. 2520–2494 BCE. Diorite, approx. 5' 6" high. Egyptian Museum, Cairo.

This enthroned portrait from his pyramid complex depicts Khafre as a divine ruler with a perfect body. The rigidity of the pose creates the effect of eternal stillness, appropriate for the timelessness of the afterlife.

To produce the statue, the artist first drew the front, back, and two profile views of the pharaoh on the four vertical faces of the stone block. Next, apprentices chiseled away the excess stone on each side, working inward until the planes met at right angles. Finally, the master sculpted the parts of Khafre's body, the falcon, and so forth. The finishing was done by *abrasion* (rubbing or grinding the surface). This subtractive method accounts in large part for the blocklike look of the standard Egyptian statue. Nevertheless, other sculptors, both ancient and modern, with different aims, have transformed

stone blocks into dynamic, twisting human forms (for example, Fig. INTRO-11).

An Emotionless Embrace The seated statue is one of only a small number of basic formulaic types the Egyptians employed to represent the human figure. Another is the image of a person or deity standing, either alone or in a group, as in the double portrait (Fig. 1-27) of Menkaure and one of his wives, probably the queen Khamerernebty. The portraits once stood in the valley temple of Menkaure at Gizeh. Here, too, the figures remain wedded to the stone block from which they were carved, and the sculptor used conventional postures to suggest the timeless nature of these eternal substitute homes for the ka. Menkaure's pose, which is duplicated in countless other

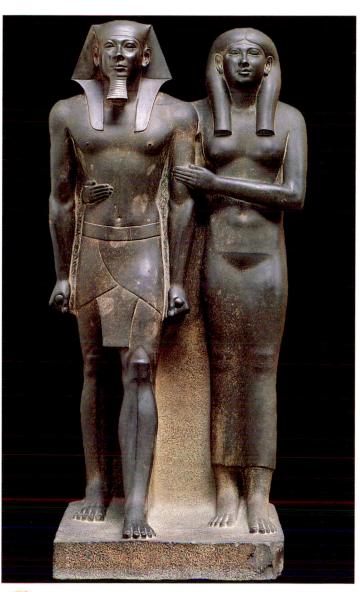

1-27 | Menkaure and Khamerernebty(?), from Gizeh, Egypt, Dynasty IV, ca. 2490–2472 BCE. Graywacke, approx. 4' $6\frac{1}{2}$ " high. Museum of Fine Arts, Boston.

The joined portraits of the pharaoh and his wife display the conventional postures used for statues designed as substitute homes for the ka. The frozen gestures signify that the man and woman are married.

Egyptian statues, is rigidly frontal with the arms hanging straight down and close to his well-built body. His hands are clenched into fists with the thumbs forward. His left leg is slightly advanced, but no shift occurs in the angle of the hips to correspond to the uneven distribution of weight. Khamerernebty stands in a similar position. Her right arm, however, circles around the king's waist, and her left hand gently rests on his left arm. This frozen stereotypical gesture indicates their marital status. The husband and wife show no other sign of affection or emotion and look not at each other but out into space.

Hunting in the Afterlife In Egyptian tombs, the deceased were not represented exclusively in freestanding statuary. Artists also depicted many individuals in relief sculpture and in mural painting, sometimes alone—as on the wooden panel of Hesire discussed in the Introduction (Fig. Intro-9)—and sometimes in a narrative context. The scenes in painted limestone relief (Fig. 1-28) that decorate the walls of the mastaba of Ti at Saqqara typify the subjects Old Kingdom patrons favored for the adornment of their final resting places. Ti was an official of the Fifth Dynasty. Depictions of agriculture and hunting fill his tomb. These activities were associated

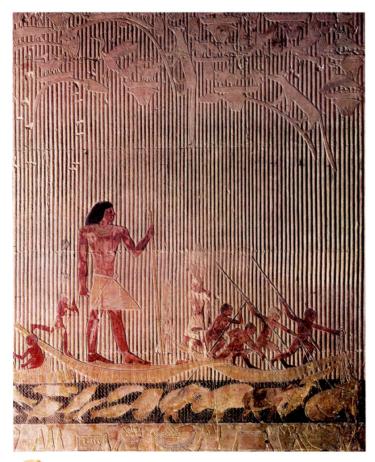

1-28 | Ti watching a hippopotamus hunt, relief in the mastaba of Ti, Saqqara, Egypt, Dynasty V, ca. 2450–2350 BCE. Painted limestone, approx. 4' high.

In Egypt, a successful hunt was a metaphor for triumph over evil. In this painted tomb relief, the deceased stands aloof from the hunters busily attempting to spear hippopotami. Ti's size reflects his high rank.

with the provisioning of the ka in the hereafter, but they also had powerful symbolic overtones. In ancient Egypt, success in the hunt, for example, was a metaphor for triumph over the forces of evil.

In our detail, Ti, his men, and his boats move slowly through the marshes, hunting hippopotami and birds in a dense growth of towering papyrus. The reedy stems of the plants are delineated with repeated fine grooves that fan out gracefully at the top into a commotion of frightened birds and stalking foxes. The water beneath the boats, signified by a pattern of wavy lines, is crowded with hippopotami and fish. Ti's men seem frantically busy with their spears, while Ti, depicted twice their size, stands aloof. The basic conventions of Egyptian figure representation used half a millennium earlier in King Narmer's palette (Fig. 1-21) are seen again here. As on the Predynastic palette and the portrait relief of Hesire (Fig. Intro-9), the artist used the conceptual rather than the optical approach, representing what was known to be true of the subject, instead of a random view of it, and showing its most characteristic parts at right angles to the line of vision. The composite view expressed a feeling for the constant and changeless aspect of things and was well suited for Egyptian funerary art. Ti's outsize proportions bespeak his rank. His conventional pose contrasts with the realistically rendered activities of his tiny servants and with the naturalistically carved and painted birds and animals among the papyrus buds. Ti's immobility suggests that he is not an actor in the hunt. He does not do anything. He simply is, a figure apart from time and an impassive observer of life, like his ka. Scenes such as this demonstrate that Egyptian artists could be close observers of daily life. The absence of the anecdotal (that is, of the time bound) from their representations of the deceased both in relief and in the round was a deliberate choice. Their primary purpose was to suggest the deceased's eternal existence in the afterlife, not to portray nature.

The Egyptian Canon The idealized image of Ti is typical of Egyptian relief sculpture. Egyptian artists regularly ignored the endless variations in body types of real human beings. Painters and sculptors did not sketch their subjects from life but applied a strict *canon*, or system of proportions, to the human figure. They first drew a grid on the wall. Then they placed various human body parts at specific points on the network of squares. The height of a figure, for example, was a fixed number of squares, and the head, shoulders, waist, knees, and other parts of the body also had a predetermined size and place within the scheme. This approach to design lasted for thousands of years. Specific proportions might vary from workshop to workshop and change over time, but the principle of the canon persisted.

The New Kingdom

About 2150 BCE, the Egyptians challenged the pharaohs' power, and for more than a century the land was in a state of civil unrest and near anarchy. But in 2040 BCE the pharaoh of

Upper Egypt, Mentuhotep II (r. 2050–1998 BCE), managed to unite Egypt again under the rule of a single king and established the so-called Middle Kingdom (Dynasties XI-XIV). The Middle Kingdom brought stability to Egypt for four centuries, but in the 17th century, it too disintegrated. Power passed to the Hyksos, or shepherd kings, who descended on Egypt from the Syrian and Mesopotamian uplands. They were in turn overthrown by native Egyptian kings of the 17th Dynasty around 1600–1550 BCE. Ahmose I (r. 1550–1525 BCE), final conqueror of the Hyksos and first king of the 18th Dynasty, ushered in the New Kingdom, the most brilliant period in Egypt's long history. At this time, Egypt extended its borders by conquest from the Euphrates River in the east deep into Nubia (the Sudan) to the south. A new capital—Thebes, in Upper Egypt—became a great and luxurious metropolis with magnificent palaces, tombs, and temples along both banks of the Nile.

Hatshepsut, Female Pharaoh One of the most intriguing figures in the ancient world was the New Kingdom pharaoh Hatshepsut (r. 1473–1458 BCE). In 1479 BCE, Thutmose II (r. 1492–1479 BCE), the fourth pharaoh of the 18th Dynasty, died. Hatshepsut, his principal wife (and half sister), had not given birth to any sons who survived, so the title of king went to the 12-year-old Thutmose III, son of Thutmose II by a minor wife. Hatshepsut was named regent for the boy king. Within a few years, however, the queen proclaimed herself pharaoh and insisted that her father Thutmose I had actually chosen her as his successor during his lifetime. Hatshepsut is the first great female monarch whose name has been recorded. For two decades she ruled what was then the most powerful and prosperous

empire in the world. As always, Egyptian sculptors produced statues of their pharaoh in great numbers for display throughout the kingdom. Hatshepsut uniformly wears the costume of the male pharaohs, with royal headdress and kilt, and in some cases even a false ceremonial beard. Many inscriptions refer to Hatshepsut as "His Majesty"!

One of the most impressive of the many grandiose monuments erected by the New Kingdom pharaohs is Hatshepsut's mortuary temple (Fig. 1-29) on the Nile at Deir el-Bahri. The temple rises in three colonnaded terraces connected by ramps. It is remarkable how visually well suited the structure is to its natural setting. The long horizontals and verticals of the colonnades and their rhythm of light and dark repeat the pattern of the limestone cliffs above. In Hatshepsut's day, the terraces were not the barren places they are now but gardens with frankincense trees and rare plants the pharaoh brought from the faraway "land of Punt" on the Red Sea. Her expedition to Punt figures prominently in the once brightly painted low reliefs that cover many walls of the complex. In addition to representing great deeds, the reliefs also show Hatshepsut's coronation and divine birth. She was said to be the daughter of the sun god, whose sanctuary was situated on the temple's uppermost level. The reliefs of Hatshepsut's mortuary temple, unfortunately defaced after her death, constitute the first great tribute to a woman's achievements in the history of art.

The Colossi of Ramses Perhaps the greatest pharaoh of the New Kingdom was Ramses II (r. 1290–1224 BCE), who ruled Egypt for two-thirds of a century, an extraordinary accomplishment in an era when life expectancy was far less than it is today. Four colossal images of Ramses never fail to

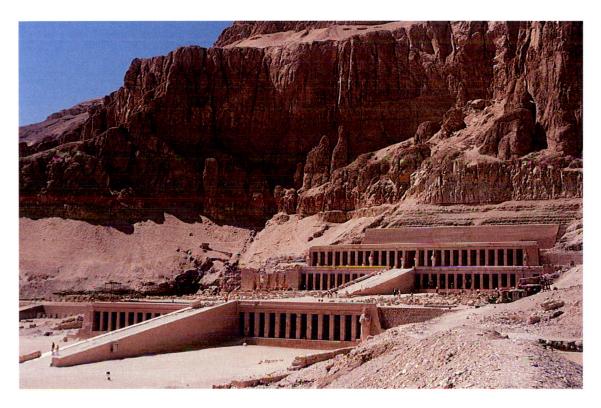

Mortuary temple of Hatshepsut, Deir el-Bahri, Egypt, Dynasty XVIII,

са. 1473-1458 все.

Hatshepsut was the first great female monarch in history, and her immense funerary temple was once adorned with painted reliefs recounting her divine birth and great deeds. Her resentful successor defaced them. **9** 1-30 |

Temple of Ramses II, Abu Simbel, Egypt, Dynasty XIX, ca. 1290–1224 BCE. Sandstone, colossi approx. 65' high.

Four rock-cut colossal images of Ramses II seated dominate the facade of his mortuary temple. Inside, more gigantic figures of the long-reigning king depict him as Osiris, god of the dead and giver of eternal life.

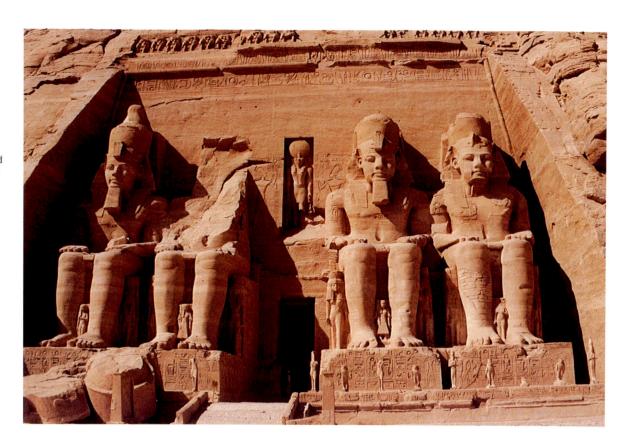

impress visitors to the pharaoh's mortuary temple (Fig. 1-30) at Abu Simbel. The portraits, carved directly into the cliff face, are almost a dozen times an ancient Egyptian's height, even though the pharaoh is seated. The grand scale extends inside the temple also, where giant (32-foot-tall) figures of the king, carved as one with the *pillars*, face each other across the narrow corridor. Ramses appears in his pillar-statues in the guise of Osiris, god of the dead and king of the underworld, as well as giver of eternal life.

Immense Pylon Temples Colossal scale also characterizes the temples the New Kingdom pharaohs built to honor one or more of the gods. Successive kings often extended the building campaigns for centuries. The temple of Amen-Re at Karnak (Fig. 1-31), for example, was largely the work of the 18th-Dynasty pharaohs, including Hatshepsut, but Ramses II (19th Dynasty) and others also contributed sections. Chapels were added to the complex as late as the 26th Dynasty.

1-31 | Restored view of the temple of Amen-Re, Karnak, Egypt, begun 15th century BCE (Jean-Claude Golvin).

The vast Karnak temple complex took centuries to complete. It contains an artificial lake associated with the Egyptian creation myth and a pylon temple whose axial plan conforms to Egyptian religious rituals.

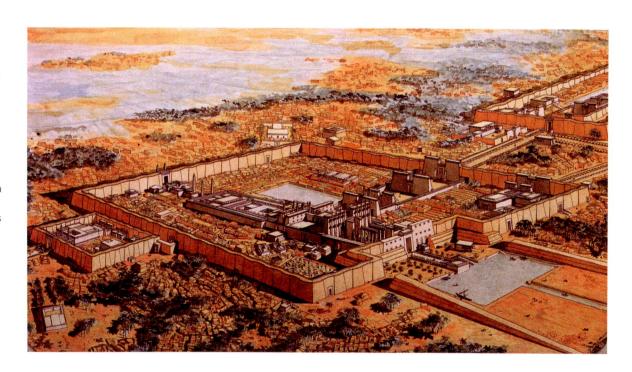

The Karnak temple has an artificial sacred lake within its precinct, a reference to the primeval waters before creation. The temple rises from the earth as the original sacred mound rose from the waters at the beginning of time. In other respects, however, the temple is a typical, if especially large, New Kingdom pylon temple. The name derives from the simple and massive pylons (gateways with sloping walls) that are characteristic features of New Kingdom temple design. A typical pylon temple is bilaterally symmetrical along a single axis that runs from an approaching avenue through a colonnaded court and hall into a dimly lit sanctuary. This Egyptian temple plan evolved from ritualistic requirements. Only the pharaohs and the priests could enter the sanctuary. A chosen few were admitted to the great columnar hall. The majority of the people were allowed only as far as the open court, and a high wall shut off the site from the outside world. The central feature of the New Kingdom pylon temple plan—a narrow axial passageway through the complex—is characteristic of much of Egyptian architecture. Axial corridors are also the approaches to the Old Kingdom pyramids of Gizeh and to the multilevel mortuary temple of Hatshepsut at Deir el-Bahri (Fig. 1-29).

Hypostyle Halls In the Karnak plan, the hall (Fig. 1-32) between the court and sanctuary has its long axis placed at right angles to the corridor of the entire building complex. This *hypostyle hall* (one where columns support the roof) is crowded with massive columns and roofed by stone slabs carried on lintels. The lintels rest on cubical blocks that in turn rest on giant *capitals* ("heads"). The central columns are 66 feet high, and the capitals are 22 feet in diameter at the top, large enough to hold a hundred people. The Egyptians, who used no cement,

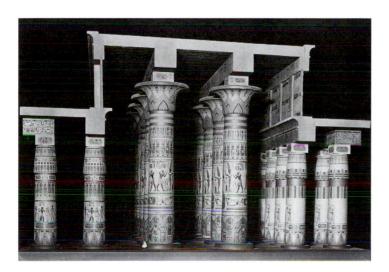

1-32 | Model of the hypostyle hall, temple of Amen-Re, Karnak, Egypt, Dynasty XIX, ca. 1290–1224 BCE. Metropolitan Museum of Art, New York.

The two central rows of columns of the hypostyle hall at Karnak are 66 feet high, with capitals 22 feet in diameter. The columns support a clerestory that permitted sunlight to illuminate the hall's interior.

depended on precise cutting of the joints and the weight of the huge stone blocks to hold the columns in place.

Egyptian columns appear to have originated from an early building technique that used firmly bound sheaves of reeds and swamp plants as roof supports in adobe structures. Egyptian masons first translated such early and relatively impermanent building methods into stone in Djoser's funerary precinct at Saqqara. Evidence of the columns' swamp-plant origin is still seen at Karnak, where the columns have budcluster or bell-shaped capitals resembling lotus or papyrus (the plants of Upper and Lower Egypt).

In the Amen-Re temple at Karnak and in many other Egyptian hypostyle halls, the builders made the central rows of columns higher than those at the sides. Raising the roof's central section created a *clerestory*. Openings in the clerestory permitted sunlight to filter into the interior, although the stone grilles meant that much of the light would have been blocked. This method of construction appeared in primitive form as early as the Old Kingdom in the valley temple of the Pyramid of Khafre. The clerestory is evidently an Egyptian innovation, and its significance hardly can be overstated. Before the invention of the electric light bulb, illuminating a building's interior was always a challenge for architects. The clerestory played a key role, for example, in Roman *basilica* and medieval church design and has remained an important architectural feature up to the present.

Upheaval under Akhenaton The Karnak sanctuary also provides evidence for a period of religious upheaval during the New Kingdom and for a corresponding revolution in Egyptian art. In the mid-14th century BCE, the pharaoh Amenhotep IV, later known as Akhenaton (r. 1353–1335 BCE), abandoned the worship of most of the Egyptian gods in favor of Aton, whom he declared to be the universal and only god, identified with the sun disk. He blotted out the name of Amen from all inscriptions and even from his own name and that of his father, Amenhotep III. He emptied the great temples, enraged the priests, and moved his capital downriver from Thebes to a site he named Akhetaton (after his new god), where he built his own city and shrines. It is now called Tell el-Amarna. The pharaoh claimed to be both the son and sole prophet of Aton. Moreover, in stark contrast to earlier practice, Akhenaton's god was represented neither in animal nor in human form but simply as the sun disk emitting life-giving rays. The pharaohs who followed Akhenaton reestablished the cult and priesthood of Amen and restored the temples and the inscriptions. Akhenaton's religious revolution was soon undone, and his new city was largely abandoned.

During the brief heretical episode of Akhenaton, however, profound changes occurred in Egyptian art. A colossal statue of Akhenaton (Fig. 1-33) from Karnak, toppled and buried after his death, retains the standard frontal pose of canonical pharaonic portraits. But the effeminate body, with its curving contours, and the long face with full lips and heavy-lidded eyes are a far cry indeed from the heroically proportioned

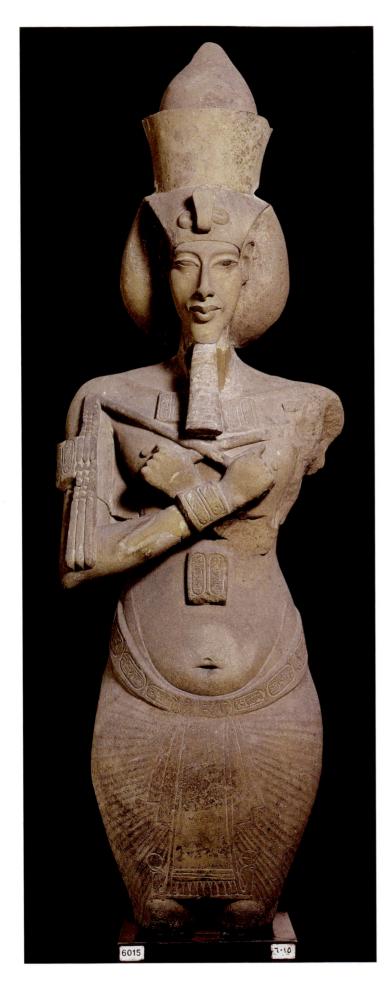

figures of Akhenaton's predecessors (compare Fig. 1-27). Akhenaton's body is curiously misshapen, with weak arms, a narrow waist, protruding belly, wide hips, and fatty thighs. Modern doctors have tried to explain his physique by attributing a variety of illnesses to the pharaoh. They cannot agree on a diagnosis, and their premise—that the statue is an accurate depiction of a physical deformity—is probably faulty. Some art historians think that Akhenaton's portrait is a deliberate artistic reaction against the established style, paralleling the suppression of traditional religion. They argue that Akhenaton's artists tried to formulate a new androgynous image of the pharaoh as the manifestation of Aton, the sexless sun disk. But no consensus exists other than that the style was revolutionary and short lived.

Nefertiti A painted limestone bust (Fig. 1-34) of Akhenaton's queen, Nefertiti (her name means "The Beautiful One Is Here"), exhibits a similar expression of entranced musing and an almost mannered sensitivity and delicacy of curving contour. Nefertiti was an influential woman during her husband's kingship. She frequently appears in the decoration of the Aton temple at Karnak, and not only is she equal in size to her husband, but she sometimes wears pharaonic headgear. The portrait illustrated here was found in the workshop of the sculptor Thutmose and is a deliberately unfinished model very likely by the master's own hand. The left eye socket still lacks the inlaid eyeball, making the portrait a kind of beforeand-after demonstration piece. With this elegant bust, Thutmose may have been alluding to a heavy flower on its slender stalk by exaggerating the weight of the crowned head and the length of the almost serpentine neck. The Tell el-Amarna sculptor seems to have adjusted the actual likeness of his subject to meet the era's standard of spiritual beauty.

Treasures of a Boy King Tutankhamen (r. 1333–1323 BCE), who was probably Akhenaton's son by a minor wife, ruled for a decade and died at age 18. Although he was a very minor figure in Egyptian history, he is famous today because of the fabulously rich art and artifacts found in his largely unplundered tomb at Thebes, uncovered in 1922.

The principal monument in the collection is the enshrined body of the pharaoh himself. The royal mummy reposed in the innermost of three coffins, nested one within the other.

1-33 Akhenaton, from the temple of Aton, Karnak, Egypt, Dynasty XVIII, ca. 1353-1335 BCE. Sandstone, approx. 13' high. Egyptian Museum, Cairo.

Akhenaton initiated a religious revolution, and his art is also a deliberate artistic reaction against tradition. This curious androgynous image may be an attempt to portray the pharaoh as Aton, the sexless sun disk.

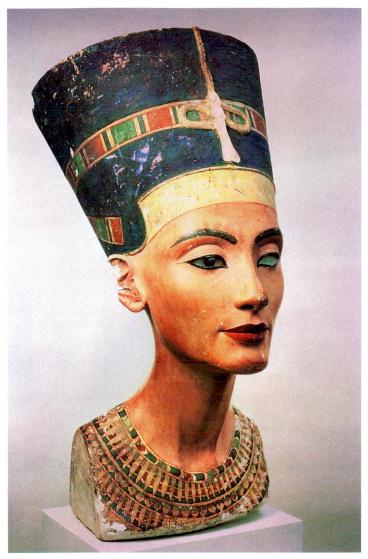

1-34 | THUTMOSE, Nefertiti, from Tell el-Amarna, Egypt, Dynasty XVIII, ca. 1353–1335 BCE. Painted limestone, approx. 1' 8" high. Ägyptisches Museum, Berlin.

Nefertiti, Akhenaton's influential wife, is portrayed here as an elegant beauty, with an expression of entranced musing and a long, delicately curved neck. The unfinished portrait was found in Thutmose's workshop.

The innermost coffin (Fig. 1-35) was the most luxurious of the three. It shows Tutankhamen in the guise of Osiris. Made of beaten gold (about a quarter ton of it) and inlaid with such semiprecious stones as lapis lazuli, turquoise, and carnelian, it is a supreme monument to the sculptor's and goldsmith's

1-35 | Innermost coffin of Tutankhamen, from his tomb at Thebes, Egypt, Dynasty XVIII, ca. 1323 BCE. Gold with inlay of enamel and semiprecious stones, approx. 6' 1" long. Egyptian Museum, Cairo.

Tutankhamen was a boy king whose fame today is due to the discovery of his unplundered tomb. His mummy was encased in three nested coffins. The most costly, innermost one portrays the pharaoh as Osiris.

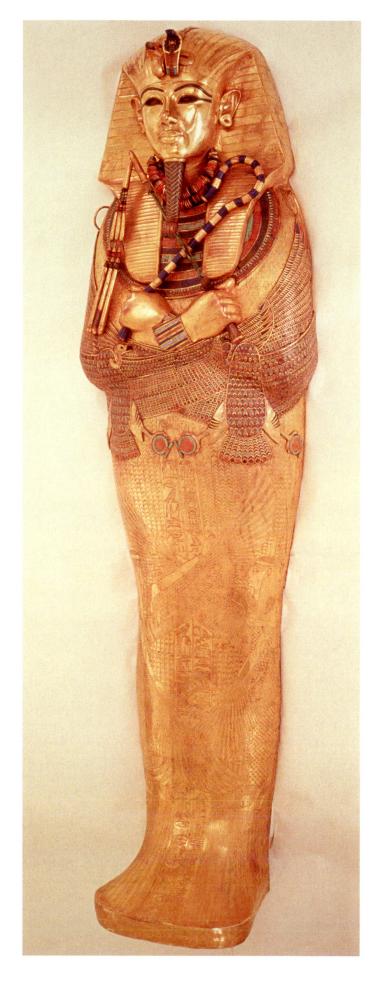

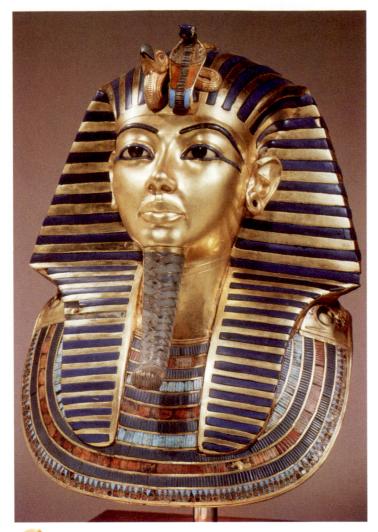

1-36 | Death mask of Tutankhamen, from the innermost coffin in his tomb at Thebes, Egypt, Dynasty XVIII, ca. 1323 BCE. Gold with inlay of semiprecious stones, 1' 9\frac{1}{4}" high. Egyptian Museum, Cairo.

The gold mask that covered Tutankhamen's mummy radiates grandeur and richness. It is a sensitive portrayal of the adolescent king dressed in his official regalia, including nemes headdress and false beard.

crafts. The portrait mask (Fig. 1-36), which covered the king's face, is also made of gold with inlaid semiprecious stones. It is a sensitive portrayal of the serene adolescent king dressed in his official regalia, including the nemes headdress and false beard. The general effect of the mask and of the tomb treasures as a whole is of grandeur and richness expressive of Egyptian power, pride, and affluence.

Egypt in Decline During the last millennium BCE, Egypt lost the commanding role it once had played in the ancient Near East. The empire dwindled away, and foreign powers

invaded, occupied, and ruled the land, until it was taken over by Alexander the Great of Macedon and his Greek successors and, eventually, by Rome. But even after Egypt became a province of the Roman Empire, its prestige remained high. Visitors to Rome today who enter the city from the airport road are greeted by the tomb of a Roman nobleman who died around 12 BCE. His memorial takes the form of a pyramid, 2,500 years after the Old Kingdom pharaohs erected the great pyramids of Gizeh.

CONCLUSION

The first sculptures and paintings antedate the invention of writing by tens of thousands of years. No one knows why the first "artists" began to paint and carve images of animals and humans or what role those images played in the lives of Paleolithic hunters. All that is certain is that the statuettes, reliefs, and mural paintings were not created as "art" in the modern sense of the word. But the Paleolithic "artists" were the first to represent the world around them in stone and paint, initiating an intellectual revolution of enormous consequences. They and their Neolithic successors also invented many of the techniques and established many of the conventions that would characterize sculpture and painting for millennia.

Many Neolithic sites are located in Mesopotamia, and it is there, in the fourth millennium BCE, that urban life began and writing was invented. The Sumerians built the first monumental temples and filled their religious precincts and tombs with statues, reliefs, and objects of gold, lapis lazuli, and other costly materials. Their successors—the Akkadians, Babylonians, Assyrians, Persians, and others—continued the tradition of monumental art and architecture, erecting ruler portraits, stelae recording victories and law codes, and great palaces decorated with painted narrative reliefs. At times challenging both the Greeks and the Romans for supremacy in the Mediterranean, the empires of the ancient Near East finally succumbed to the Arabs in the seventh century CE.

The story of art in Egypt also began in the fourth millennium BCE, when Predynastic sculptors and painters formulated the patterns for representing figures and narrating stories that endured for thousands of years. The exceptional longevity of formal traditions in Egypt is one of the marvels of the history of art. It is perhaps the most eloquent testimony of all to the greatness of Egyptian figural art. In architecture too, the Egyptian achievement was extraordinary. From the time of Imhotep, the first master of building in stone, to the architects of the Late Period, the tombs and temples of the Egyptians have expressed the grandeur and permanence of the Kingdom of the Nile.

EUROPE	NEAR	EGYPT			
PALEOLITHIC EL	N E/	3	30,000 BCE		
			9000 BCE		
MESOLITHIC	NEOLITHIC	NEOLITHIC	9000 pcs	■ Final recession of ice, ca. 9000 BCE	Hall of the Bulls, Lascaux, ca. 15,000–13,000 BCE
ESOL			8000 BCE	■ Neolithic period begins in the Near East, ca. 8000 BCE	
NEOLITHIC			4000 BCE	•	
			3500 pcs	■ Neolithic period begins in Europe, ca. 4000 BCE	
	URUK	PREDYNASTIC	3500 все		
			3100 BCE		
			2	■ Union of Upper and Lower Egypt, ca. 3000–2920 BCE ■ First Sumerian cuneiform inscriptions, ca. 3000–2900 BCE	
	SUMERIAN	M EARLY DYNASTIC	2920 BCE		2 Palette of King
				■ Djoser, r. 2630–2611 BCE ■ Imhotep, first recorded name of an artist, ca. 2625 BCE	Narmer, Hierakonpolis, ca. 3000-2920 BCE
			2575 BCE	I Innotes, hist recorded hame of an artist, ca. 2023 act	
				■ Khufu, Khafre, and Menkaure, r. 2551–2472 BCE	
	AKKADIAN	NGDO	2300 все	■ Naram-Sin, r. ca. 2254–2218 BCE	
		OLD KINGDOM	2150 BCE	1 Marain 311, 1. ca. 2234 2210 Bec	
	BABYLONIAN NEO-SUMARIAN				3 Head of an Akkadian
		OM MIDDLE KINGDOM	2040 BCE		king, Nineveh, ca. 2250–2200 BCE
			1800 все	■ Hammurabi, r. ca. 1792–1750 BCE	
			1640 все		to training our
			1550 BCE		
			1990 RCE	■ Hatshepsut, r. 1473–1458 BCE	
		INGD	4	■ Akhenaton, r. 1353–1335 BCE	
		NEW KINGDOM		■ Tutankhamen, r. 1333–1323 BCE ■ Ramses II, r. 1290–1224 BCE	
			1070 все		
	PERSIAN NEO- ASSYRIAN BABYLONIAN	LATE PERIOD	900 BCE		4 Temple of Ramses II, Abu Simbel, ca. 1290–1224 BCE
			710 202	■ Sargon II, r. 721–705 BCE	Cui 1230 1224 st.
			712 BCE	Ashurbanipal, r. 668-627 BCE	
			612 BCE		
			5	Nebuchadnezzar II, r. 604–562 BCE	
			538 BCE		
		LAJ	220 RCF	■ Persia conquers Egypt, 525 BCE	
				Darius I, r. 522-486 BCE	
			330 BCE	■ Xerxes, r. 486–465 BCE	Ishtar Gate, Babylon,
				Alexander the Great conquers Persia, 330 BCE	ca. 575 BCE

GREECE

Greek art occupies a special place in the history of art through the ages. Many of the cultural values of the Greeks, especially their honoring of the individual and exaltation of humanity as "the measure of all things," remain fundamental tenets of Western civilization. In fact, these ideas are so completely part of modern Western habits of mind that most people are scarcely aware that the concepts originated in Greece more than 2,500 years ago.

The Greeks, or *Hellenes*, as they called themselves, never formed a single nation but instead established independent city-states on the Greek mainland, on the islands of the Aegean Sea, and on the western coast of Asia Minor (MAP 2-1, page 524). In 776 BCE, the separate Greek states held their first ceremonial games in common at Olympia. From then on, despite their differences and rivalries, the Greeks regarded themselves as citizens of *Hellas*, distinct from the surrounding "barbarians" who did not speak Greek.

Even the gods of the Greeks ("The Gods and Goddesses of Mount Olympus," page 48) differed in kind from those of neighboring cultures. Unlike the Egyptian and Mesopotamian gods (see Chapter 1), the Greek deities differed from human beings only in that they were immortal. It has been said the Greeks made their gods into humans and their humans into gods. This humanistic world view led the Greeks to create the concept of democracy (rule by the *demos*, the people) and to make seminal contributions in the fields of art, literature, and science.

The distinctiveness and originality of Greek civilization should not, however, obscure the enormous debt the Greeks owed to the cultures of Egypt and the Near East. Scholars today increasingly recognize this debt, and the Greeks themselves readily acknowledged borrowing ideas, motifs, conventions, and skills from these older civilizations. Nor should a high estimation of Greek art and culture blind historians to the realities of Hellenic life and society. Even "democracy" was a political reality for only one segment of the Greek demos. Slavery was regarded as natural, even beneficial, and was a universal institution among the Greeks. And Greek women were in no way the equals of Greek men. Women normally remained secluded in their homes, emerging usually only for weddings, funerals, and religious festivals. They played little part in public or political life. Nonetheless, the importance of the Greek contribution to the later development of Western civilization and Western art can hardly be overstated.

The story of art in Greece does not begin with the Greeks, however, but with their prehistoric predecessors in the Aegean world—the people who would later become the heroes of Greek mythology.

EUTHYMIDES, Three revelers (red-figure amphora), from Vulci, Italy, ca. 510 BCE. Approx. 2' high. Staatliche Antikensammlungen, Munich.

The Gods and Goddesses of Mount Olympus

The Greek deities most often represented in art—not only in antiquity but also in the Middle Ages, the Renaissance, and up to the present—are the 12 gods and goddesses of Mount Olympus, the Olympian gods:

Zeus (the Roman Jupiter) was king of the gods and ruled the sky. His weapon was the thunderbolt, and with it he led the other gods to victory over the giants, who had challenged the Olympians for control of the world.

Hera (Juno), the wife and sister of Zeus, was the goddess of marriage. Poseidon (Neptune), Zeus's brother, was lord of the sea. He controlled waves, storms, and earthquakes with his three-pronged pitchfork (trident).

Hestia (Vesta), sister of Zeus, Poseidon, and Hera, was goddess of the hearth.

Demeter (Ceres), Zeus's third sister, was the goddess of grain and agriculture.

Ares (Mars), the god of war, was the son of Zeus and Hera and the lover of Aphrodite. As father of the twin founders of Rome, Romulus and Remus, Mars looms much larger in Roman mythology and religion than Ares does in Greek.

Athena (Minerva) was the goddess of wisdom and warfare. She was a virgin (parthenos in Greek), born not from a woman's womb but from the head of her father, Zeus.

Hephaistos (Vulcan), the son of Zeus and Hera, was the god of fire and of metalworking. He provided Zeus his scepter and Poseidon his trident, and fashioned the armor Achilles wore in battle against Troy. He was also the "surgeon" who split open Zeus's head when Athena was born. Hephaistos

was born lame and, uncharacteristically for a god, ugly. His wife, Aphrodite, was unfaithful to him.

Apollo (Apollo) was the god of light and music, and a great archer. He was the son of Zeus with Leto (Latona), daughter of one of the Titans who preceded the Olympians. His epithet *Phoibos* means "radiant," and the young, beautiful Apollo is sometimes identified with the sun (Helios/Sol).

Artemis (Diana), the sister of Apollo, was the goddess of the hunt and of wild animals. As Apollo's twin, she was occasionally regarded as the moon (Selene/Luna).

Aphrodite (Venus), the daughter of Zeus and Dione (one of the nymphs—the goddesses of springs, caves, and woods), was the goddess of love and beauty. She was the mother of the Trojan hero Aeneas by Anchises.

Hermes (Mercury), the son of Zeus and another nymph, was the fleet-footed messenger of the gods and possessed winged sandals. He was also the guide of travelers and carried the caduceus, a magical herald's rod.

Three other important Greco-Roman gods and goddesses were:

Hades (Pluto), Zeus's other brother, was equal in stature to the Olympian deities, but he never resided on Mount Olympus. Zeus allotted him lordship over the Underworld when he gave the realm of the sea to Poseidon. Hades was the god of the dead.

Dionysos (Bacchus) was the god of wine and the son of Zeus and a mortal woman.

Eros (Amor or *Cupid)* was the winged child god of love and the son of Aphrodite and Ares.

PREHISTORIC AEGEAN ART

Historians, art historians, and archaeologists alike divide the prehistoric Aegean into three geographic areas. Each has a distinctive artistic identity. Cycladic art is the art of the Cycladic Islands (so named because they *circle* around Delos), as well as of the adjacent islands in the Aegean, excluding Crete. Minoan art, named for the legendary King Minos, encompasses the art of Crete. Mycenaean art, which takes its name from the great citadel of Mycenae celebrated in Homer's *Iliad*, the epic tale of the Trojan War, is the art of the Greek mainland.

Cycladic Art

Although the heyday of the ancient Aegean was not until the second millennium BCE, humans inhabited Greece as far back as the Paleolithic period. Village life was firmly established in Greece in Neolithic times. However, the earliest distinctive Aegean artworks date to the third millennium BCE and come from the Cyclades.

Marble Women Marble was abundantly available in the Aegean Islands, and many Cycladic marble sculptures have

been found. Most of these, like their Stone Age predecessors (Fig. 1-1), represent nude women with their arms folded across their abdomens. Our example (Fig. 2-1), about a foot and a half tall, comes from a grave on Syros. It is almost flat, and the human body is rendered in a highly schematized manner. Large, simple triangles dominate the form—the head, the body itself (which tapers from exceptionally broad shoulders to tiny feet), and the incised triangular pubis. The feet are too fragile to support the figurine. If these sculptures were primarily funerary offerings, as archaeologists believe they were, they must have been placed on their backs in the graves—lying down, like the deceased themselves. Whether they represent those buried with the statuettes or fertility figures or goddesses is still debated. As is true of all such images, the sculptor took pains to emphasize the breasts as well as the pubic area. Traces of paint found on some of the Cycladic figurines indicate that at least parts of these sculptures were colored. The now almost featureless faces would have had painted eyes and mouths in addition to the sculpted noses. Red and blue necklaces and bracelets, as well as painted dots on the cheeks, characterize a number of the surviving figurines.

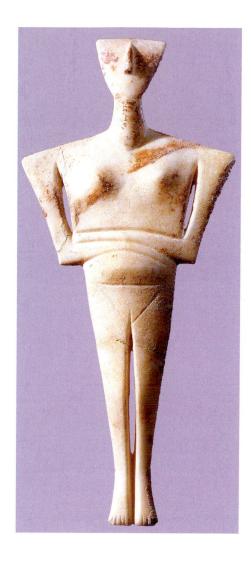

2-1

Figurine of a woman, from Syros (Cyclades), Greece, ca. 2500–2300 BCE. Marble, approx. 1'6" high. National Archaeological Museum, Athens.

Most Cycladic statuettes depict nude women. This one comes from a grave, but whether it represents the deceased is uncertain. The sculptor rendered the female body schematically as a series of large triangles.

Minoan Art

During the third millennium BCE, both on the Aegean Islands and the Greek mainland, most settlements were small and consisted of simple buildings. Only rarely were the dead buried with costly offerings such as the Syros statuette. The second millennium BCE, in contrast, saw the construction of large palaces on Crete. This was the golden age of the prehistoric Aegean, the era when the first great Western civilization emerged. The Cretan palaces were large, comfortable, and handsome, with ample staircases and courtyards for pageants, ceremonies, and games. They also had storerooms, offices, and shrines that permitted these huge complexes to serve as the key administrative, commercial, and religious centers of the island. All of the Cretan palaces were laid out along similar lines. Their size and number, as well as the rich finds they have yielded, attest to the power and prosperity of the people archaeologists have dubbed the Minoans, after the legendary King Minos.

The Minotaur's Maze Minos's palace, at Knossos (Fig. 2-2), was the largest on Crete, and was also said to have been home to the Minotaur, a creature half bull and half man. According to the myth, the Minotaur inhabited a vast labyrinth, and when the Athenian king Theseus defeated the monster, he was able to find his way out of the maze only with the aid of Minos's daughter Ariadne. She had given Theseus a spindle of thread to mark his path through the labyrinth and then safely out again.

Our aerial view reveals that the Knossos palace was indeed mazelike in plan. Its central feature was a large rectangular

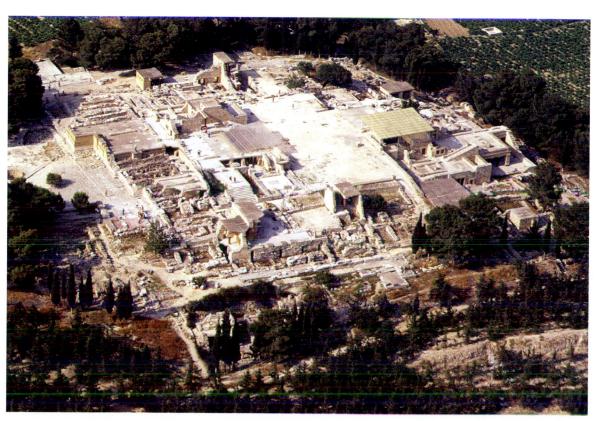

2-2 | Aerial view (looking northeast) of the palace at Knossos (Crete), Greece, ca. 1700–1400 BCE.

The largest palace on Crete, this was the legendary home of King Minos. Scores of rooms surround a large rectangular court. The palace's mazelike plan gave rise to the myth of the Minotaur in the labyrinth.

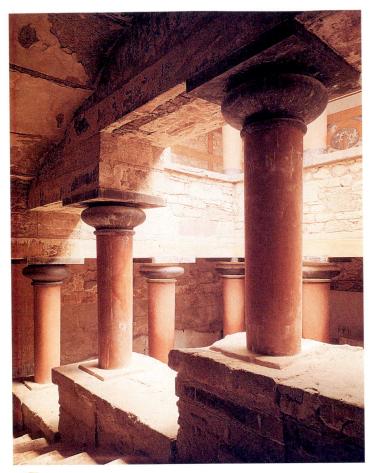

2-3 | Stairwell in the residential quarter of the palace at Knossos (Crete), Greece, ca. 1700–1400 BCE.

The Knossos palace was complex in elevation as well as plan. It had three or more stories on all sides of the central court. Minoan columns taper from top to bottom, the opposite of Egyptian and Greek columns.

court. The other palace units—living quarters, ceremonial rooms, and storerooms—were grouped around it. The palace was also complex in elevation. It had as many as three stories around the central court and even more on the south and east sides where the terrain sloped off sharply. Interior staircases built around light and air wells (Fig. 2-3) provided necessary illumination and ventilation. Minoan columns were fashioned of wood and usually painted red, with black, bulbous, cushionlike capitals resembling those of the later Greek Doric order (see "Doric and Ionic Temples," page 59). Minoan column shafts, however, taper from a wide top to a narrower base—the opposite of both Egyptian and later Greek columns.

Palace Frescoes Mural paintings liberally adorn the Knossos palace, constituting one of its most striking features. The paintings depict many aspects of Minoan life (bull-leaping, processions, and ceremonies) and of nature (birds, animals, flowers, and marine life). Unlike the Egyptians, who painted in *fresco secco (dry fresco)*, the Minoans coated the rough fabric of their rubble walls with a fine white lime plaster and used a *true (wet) fresco* method (see "Fresco Painting," Chapter 7, page 206). The Minoan frescoes required rapid execution and great skill.

Bull-Leaping The most famous fresco (**Fig. 2-4**) from the palace at Knossos depicts the Minoan ceremony of bull-leaping. Only fragments of the full composition have been recovered. The dark patches are original; the rest is a modern restoration. The Minoan artist painted the young women (with fair skin) and the youth (with dark skin) according to a convention for distinguishing male and female that was also observed in the ancient Near East and Egypt. The young man is shown in

2-4

Bull-leaping, from the palace at Knossos (Crete), Greece, ca. 1450– 1400 BCE. Fresco, approx. 2' 8" high, including border. Archaeological Museum, Herakleion.

Frescoes decorated the Knossos palace walls. The human figures have stylized shapes with pinched waists. The skin color varies with gender, a common convention in ancient paintings.

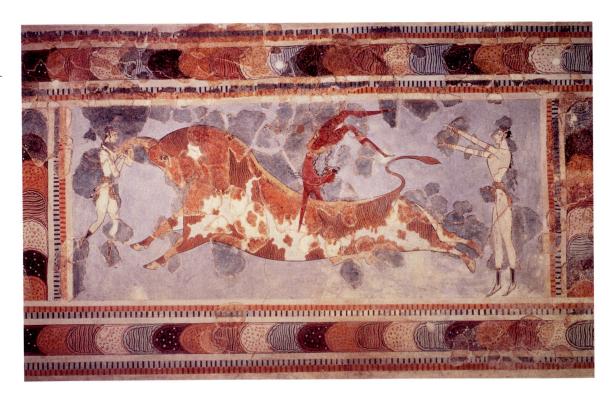

the air, having, it seems, grasped the bull's horns and vaulted over its back in a perilous and extremely difficult acrobatic maneuver. The painter brilliantly suggested the powerful charge of the bull by elongating the animal's shape and using sweeping lines to form a funnel of energy, beginning at the very narrow hindquarters of the bull and culminating in its large, sharp horns and galloping forelegs. The human figures also have stylized shapes, with typically Minoan pinched waists, and are highly animated. The elegant, elastic Cretan figures, with their long curly hair and proud and self-confident bearing, are easily distinguished from Mesopotamian and Egyptian figures.

Buried by a Volcano Much better preserved than the Knossos frescoes are those uncovered in the excavations of Akrotiri on the volcanic island of Santorini (ancient Thera), some 60 miles north of Crete. The excellent condition of the Theran paintings is due to an enormous seismic explosion on Santorini that buried Akrotiri in volcanic pumice and ash, probably in 1628 BCE.

One almost perfectly preserved Theran mural painting, the *Spring Fresco* (Fig. 2-5), has nature itself as its sole subject. The artist's aim, however, was not to render the rocky island terrain realistically but, rather, to capture the landscape's essence and to express joy in the splendid surroundings. The irrationally undulating and vividly colored rocks, the graceful lilies swaying in the

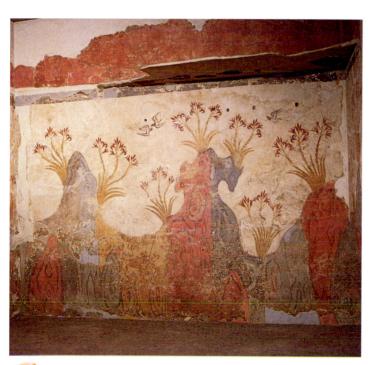

2-5 | Landscape with swallows (*Spring Fresco*), from room Delta 2, Akrotiri, Thera (Cyclades), Greece, ca. 1650 BCE. Fresco, approx. 7' 6" high. National Archaeological Museum, Athens.

Aegean muralists painted in wet fresco, which required rapid execution. In this first known pure landscape, the painter used vivid colors and undulating lines to capture the essence of springtime in the islands.

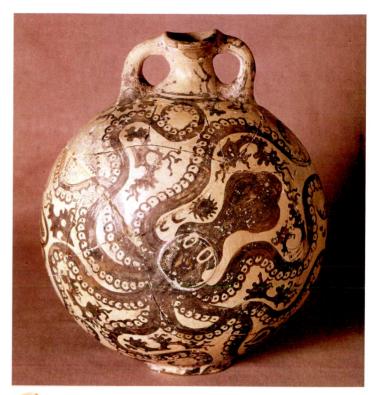

2-6 | Octopus jar, from Palaikastro (Crete), Greece, ca. 1500 BCE. Approx. 11" high. Archaeological Museum, Herakleion.

The sea figures prominently in Minoan art. The octopus motif is perfectly united to the shape of this vase. The sea creature's tentacles reach out to fill the curving surfaces of the vessel.

cool island breezes, and the darting swallows express the vigor of growth, the delicacy of flowering, and the lightness of birdsong and flight. In the lyrical language of curving line, the artist celebrated the rhythms of spring. This is the first known example of a pure landscape painting, a picture of a place without humans or animals present. The *Spring Fresco* represents the polar opposite of the first efforts at mural painting in the caves of Paleolithic Europe, where animals (and occasionally humans) appeared as isolated figures without any indication of setting.

Sea Life on Pottery Minoan painters also decorated small objects, especially ceramic pots, usually employing dark silhouettes against a cream-colored background. On the octopus jar we illustrate (Fig. 2-6), from Palaikastro on Crete, the tentacles of the sea creature reach out over the curving surfaces of the vessel, embracing the piece and emphasizing its volume. This is a masterful realization of the relationship between the vessel's decoration and its shape, always a problem for the ceramist.

Goddess or Priestess? In contrast to Mesopotamia and Egypt, no temples nor any monumental statues of gods, kings, or monsters have been found in Minoan Crete, although large wooden images may once have existed. What remains of

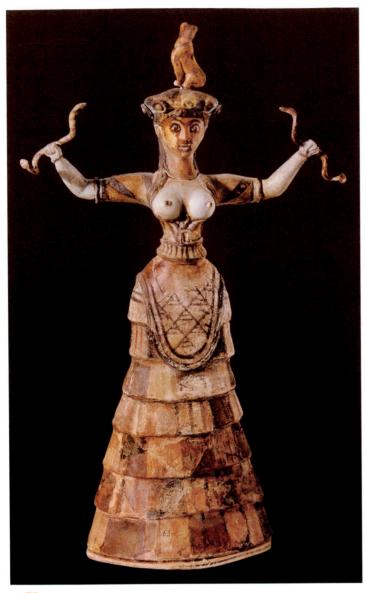

2-7 | *Snake Goddess*, from the palace at Knossos (Crete), Greece, ca. 1600 BCE. Faience, approx. 1' $1\frac{1}{2}$ " high. Archaeological Museum, Herakleion.

This Minoan figurine may represent a priestess, but it is more likely a bare-breasted goddess. The snakes in her hands and the leopardlike feline on her head imply that she has power over the animal world.

Minoan sculpture in the round is small in scale, such as the faience (glazed earthenware) statuette known as the *Snake Goddess* (Fig. 2-7), found in the palace at Knossos. It is one of several similar figurines that some scholars believe may represent mortal attendants rather than deities, although the prominently exposed breasts suggest that these figurines stand in the long line of prehistoric fertility images usually considered divinities. (The Knossos woman holds snakes in her hands and supports a leopardlike feline peacefully on her head. This implied power over the animal world also seems appropriate for a deity.) The frontality of the figure is reminiscent of Egyptian and Near Eastern statuary, but the costume, with its open bodice and flounced skirt, is distinctly Minoan.

Minoan Decline Scholars dispute the circumstances ending the Minoan civilization, although they now widely believe that Mycenaeans had already moved onto Crete and established themselves at Knossos in the 15th century BCE. Parts of the palace continued to be occupied until its final destruction around 1200 BCE, but its importance as a cultural center faded soon after 1400 BCE, as the focus of Aegean civilization shifted to the Greek mainland.

Mycenaean Art

The origins of the Mycenaean culture are still debated. The only certainty is the presence of these forerunners of the Greeks on the mainland at the beginning of the second millennium BCE. Some researchers believe that the mainland was a Minoan economic dependency for a long time, but by 1500 BCE a distinctive Mycenaean culture was flourishing in Greece.

Citadels Giants Built The destruction of the Cretan palaces left the mainland culture supreme. Although this civilization has come to be called Mycenaean, Mycenae was but one of several large citadels. The best-preserved and most impressive Mycenaean remains are those of the fortified palaces at Tiryns and Mycenae. Both were built beginning about 1400 BCE.

Homer, writing in the mid-eighth century BCE, called the citadel of Tirvns (Fig. 2-8), located about 10 miles from Mycenae, Tiryns of the Great Walls. In the second century CE, when Pausanias, author of an invaluable guidebook to Greece, visited the site, he marveled at the towering fortifications and considered the walls of Tiryns as spectacular as the pyramids of Egypt. Indeed, the Greeks of the historical age believed mere humans could not have erected such edifices and instead attributed the construction of the great Mycenaean citadels to the mythical Cyclopes, a race of one-eyed giants. Archaeologists still refer to the huge, roughly cut stone blocks forming the massive fortification walls of Tiryns and other Mycenaean sites as Cyclopean masonry. The walls of Tiryns average about 20 feet in thickness and incorporate blocks often weighing several tons each. The heavily fortified Mycenaean palaces contrast sharply with the open Cretan palaces (Fig. 2-2) and clearly reveal their defensive character.

Mycenae's Lion Gate The severity of these fortresses was relieved by frescoes, as in the Cretan palaces, and, at Mycenae at least, by monumental architectural sculpture. The Lion Gate (Fig. 2-9) is protected on the left by a wall built on a natural rock outcropping and on the right by a projecting bastion of large blocks. Any approaching enemies would have had to enter this 20-foot-wide channel and face Mycenaean defenders above them on both sides. The gate itself is formed of two great monoliths capped with a huge lintel. Above the lintel, the masonry courses form a *corbeled arch*, constructed by placing the blocks in horizontal courses and then cantilevering them inward until they meet, leaving an opening that lightens the weight carried by the lintel. This *relieving triangle* is filled with

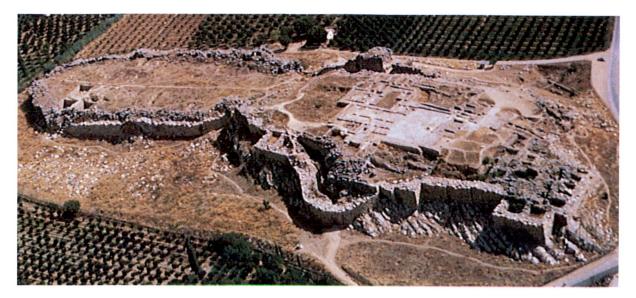

Aerial view of the citadel at Tiryns, Greece, ca. 1400–1200 BCE.

In the Iliad, Homer called the fortified citadel of Tiryns the City of the Great Walls. Its huge roughly cut stone blocks are examples of Cyclopean masonry, named after the mythical one-eyed giants.

a great limestone slab where two lions carved in high relief stand on the sides of a Minoan-type column. The whole design admirably fills its triangular space, harmonizing in dignity, strength, and scale with the massive stones that form the walls and gate. Similar groups appear in miniature on Cretan seals, but the idea of placing monstrous guardian figures at the entrances to palaces, tombs, and sacred places has its origin in the Near East (FIGS. 1-17 and 1-25). At Mycenae the animals' heads were fashioned separately and are lost. Some scholars

have suggested that the "lions" were actually composite beasts in the Near Eastern tradition, possibly sphinxes.

Beehive Tombs The Lion Gate at Mycenae and the towering fortification wall circuit of which it formed a part were constructed a few generations before the presumed date of the Trojan War. At that time, wealthy Mycenaeans were laid to rest outside the citadel walls in tombs covered by enormous earthen mounds. The best preserved of these is the so-called Treasury of

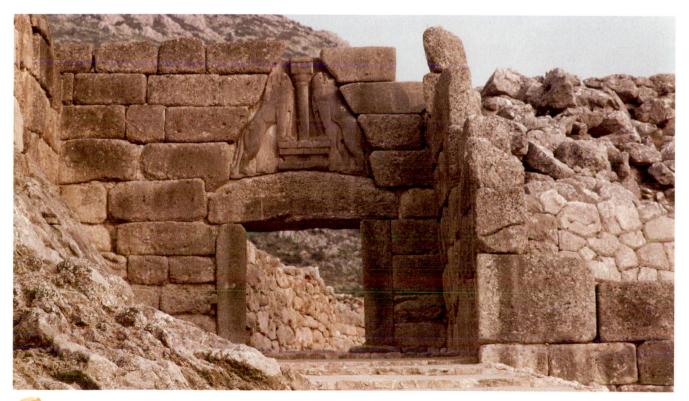

2-9 | Lion Gate, Mycenae, Greece, ca. 1300–1250 BCE. Limestone, relief panel approx. 9' 6" high.

The largest sculpture in the prehistoric Aegean is the relief panel with confronting lions that fills the relieving triangle of Mycenae's main gate. The gate itself is formed of two great monoliths and a huge lintel.

Z-10 | Treasury of Atreus, Mycenae, Greece, ca. 1300–1250 BCE.

The best-preserved tholos tomb outside the walls of Mycenae is named for Homer's King Atreus. The burial chamber is covered by an earthen mound and was entered through a doorway at the end of a long passageway.

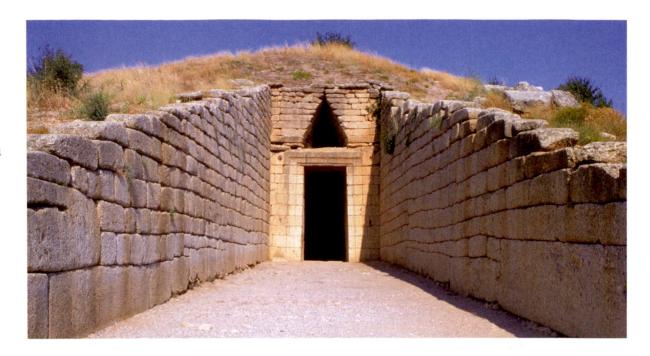

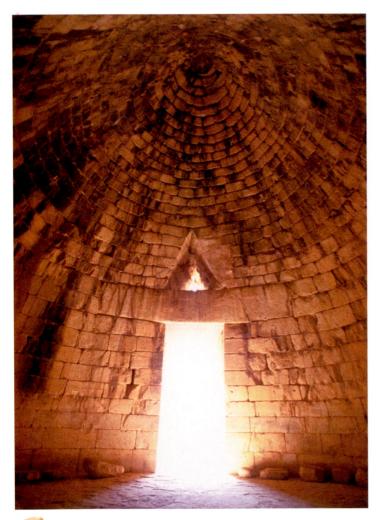

2-11 | Interior of the tholos of the Treasury of Atreus, Mycenae, Greece, ca. 1300–1250 BCE.

The beehive-shaped tholos of the Treasury of Atreus is composed of corbeled courses of stone blocks laid on a circular base. The 43-foot-high dome was the largest in the ancient world for almost 1,500 years.

Atreus (Fig. 2-10), which already in antiquity was mistakenly believed to be the repository of the treasure of Atreus, father of King Agamemnon, who waged war against Troy. Approached by a long passageway, the beehive-shaped tomb chamber (tholos) was entered through a doorway surmounted by a relieving triangle similar to that employed in the roughly contemporary Lion Gate. The tholos (Fig. 2-11) is composed of a series of stone corbeled courses laid on a circular base and ending in a lofty dome-shaped vault. The builders probably constructed the vault using rough-hewn blocks. After they set the stones in place, the masons had to finish the surfaces with great precision to make them conform to both the horizontal and vertical curves of the wall. The principle involved is no different from a corbeled arch, but the problem of constructing a complete dome is much more complicated. About 43 feet high, the tholos of the Treasury of Atreus is the largest known vaulted space without interior supports that had ever been built.

Rich in Gold The Treasury of Atreus had been thoroughly looted long before its modern rediscovery, but excavators have found spectacular grave goods elsewhere at Mycenae. Just inside the Lion Gate, but predating it by some three centuries, is the burial area archaeologists refer to as Grave Circle A. Here, at a site protected within the circuit of the later walls, six deep shafts served as tombs for kings and their families.

Among the most spectacular finds from Mycenae is the beaten (repoussé) gold mask (Fig. 2-12) we illustrate, one of many gold artifacts from the royal shaft graves. Homer described the Mycenaeans as "rich in gold." The Mycenaean mask often has been compared to the gold mummy mask of Tutankhamen (Fig. 1-36). The treatment of the human face is, of course, more primitive in the Mycenaean mask. But this was one of the first known attempts in Greece to render the human face at life-size, whereas Tutankhamen's mask stands

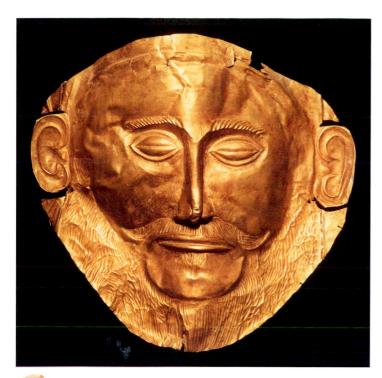

2-12 | Funerary mask, from Grave Circle A, Mycenae, Greece, ca. 1600–1500 BCE. Beaten gold, approx. 1' high. National Archaeological Museum, Athens.

Homer described the Mycenaeans as "rich in gold." This repoussé gold mask of a bearded man comes from a royal shaft grave and has often been compared to Tutankhamen's gold mummy mask (Fig. 1-36).

in a long line of monumental Egyptian sculptures going back more than a millennium. It is not known whether the Mycenaean masks were intended as portraits, but the goldsmiths recorded different physical types with care. Our example, with its full beard, must depict a mature man, perhaps a king—although not Agamemnon, as its 19th-century discoverer wished. If Agamemnon was a real king, he lived some 300 years after this mask was fashioned.

The End of Mycenae Despite their mighty walls, the citadels of Mycenae and Tiryns were burned between 1250 and 1200 BCE, when the Mycenaeans seem to have been overrun by northern invaders or to have fallen victim to internal warfare. By Homer's time, the heyday of Aegean civilization was but a distant memory, and the men and women of Crete and Mycenae had assumed the stature of heroes from a lost golden age.

GREEK ART

Disintegration of the Bronze Age social order accompanied the destruction of the Mycenaean palaces. The disappearance of powerful kings and their retinues led to the loss of the knowledge of how to cut masonry, to construct citadels and tombs, to paint frescoes, and to sculpt in stone. Even the arts of reading and writing were forgotten. Depopulation, poverty, and an almost total loss of contact with the outside world characterized the succeeding centuries, sometimes called the Dark Age of Greece.

Geometric and Archaic Art

Only in the eighth century BCE did economic conditions improve and the population begin to grow again. This era was in its own way a heroic age, a time when the city-states of Greece took shape; when the Greeks broke out of their isolation and once again began to trade with their neighbors both in the east and the west; when Homer's epic poems, formerly memorized and passed down from bard to bard, were recorded in written form; and when the Olympic Games were established. Art historians call the art of this formative period *Geometric*, because Greek vase painting of the time consisted almost exclusively of abstract motifs.

Figure Painting Revived The eighth century also saw the return of the human figure to Greek art. One of the earliest examples of Geometric figure painting is found on a huge *krater* (Fig. 2-13), or bowl for mixing wine and water, that

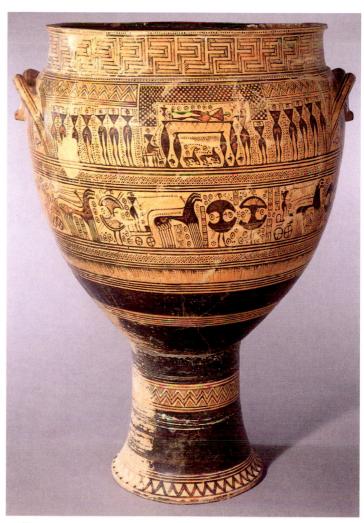

2-13 | Geometric krater, from the Dipylon cemetery, Athens, Greece, ca. 740 BCE. Approx. 3' $4\frac{1}{2}$ " high. Metropolitan Museum of Art, New York.

Figure painting reappeared in Greece in the Geometric period, named for the abstract ornament on vessels like this funerary krater. Here, a mourning scene and a procession in honor of the deceased are featured.

marked the grave of an Athenian man buried around 740 BCE. At well over a yard tall, this remarkable vase is a considerable technical achievement. Characteristically for this date, the artist covered much of the krater's surface with precisely painted abstract angular motifs in horizontal bands. Especially prominent is the *meander*, or *key*, pattern around the rim. But the Geometric painter reserved the widest part of the krater for two bands of human figures and horse-drawn chariots. Befitting the vase's function as a grave marker, the scenes depict the mourning for a man laid out on his bier and the grand chariot procession in his honor. In the upper band, the shroud, raised to reveal the corpse, is an abstract checkerboard-like backdrop, and the funerary couch has only two legs because the artist had no interest in suggesting depth or representing space. The human figures and the furniture are as two-dimensional as the geometric shapes elsewhere on the vessel. Every empty space has circles and M-shaped ornament, further negating any sense that the mourners inhabit a three-dimensional world. The figures are silhouettes constructed of triangular (frontal) torsos with attached profile arms, legs, and heads (with a single large frontal eye in the center!), following the age-old convention. To distinguish male from female, the painter added a penis growing out of one of the deceased's thighs. The mourning women, who tear their hair out in grief, have breasts emerging beneath their armpits. In both cases the artist was concerned with specifying gender, not with anatomical accuracy. Below are warriors, drawn as though they were walking shields, and several chariots. The horses have the correct number of heads and legs but seem to share a common body, negating any sense of depth. Despite the highly stylized and conventional manner of representation, this vessel marks a significant turning point in the history of Greek art. Not only was the human figure reintroduced into the painter's repertoire, but the art of storytelling also was revived.

Daidalos and Archaic Art In the seventh century BCE, the first Greek stone sculptures since the Lion Gate of Mycenae (Fig. 2-9) began to appear. One of the earliest, probably originally from Crete, is a limestone statuette of a goddess or maiden (kore; plural, korai) popularly known as the Lady of Auxerre (Fig. 2-14) after the French town that is her oldest recorded location. Because she does not wear a headdress, as early Greek goddesses frequently do, and the gesture of her right hand probably signifies prayer, the Lady of Auxerre is most likely a kore. The style is characteristic of the early Archaic period of Greek art, when monumental sculpture was revived. The flattopped head takes the form of a triangle framed by complementary triangles of four long strands of hair each. Also typical are the small belted waist and a fondness for pattern, seen, for example, in the almost Geometric treatment of the long skirt with its incised concentric squares, once brightly painted.

This early Greek style is usually referred to as *Daedalic*, after the legendary artist Daedalus, whose name means "the skillful one." In addition to having been a great sculptor, Daedalus was said to have built the labyrinth of Knossos

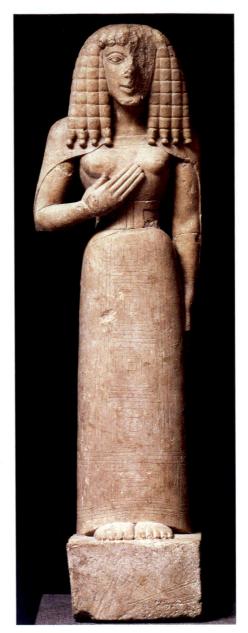

2-14 | Lady of Auxerre, statue of a goddess or kore, ca. 650 – 625 BCE. Limestone, approx. 2' $1\frac{1}{2}$ " high. Louvre, Paris.

Probably from Crete, this kore (maiden) typifies the so-called Daedalic style of the seventh century BCE with its triangular face and hair and lingering Geometric fondness for abstract pattern.

(Fig. 2-2) and also to have designed a temple at Memphis in Egypt. The historical Greeks attributed to him almost all the great achievements in early sculpture and architecture before the names of artists and architects were recorded. The story that Daedalus worked in Egypt reflects the enormous impact of Egyptian art and architecture on the Greeks.

Greek Kouroi and Egypt The first life-size Greek statues follow very closely the canonical Egyptian format. A marble *kouros* (youth; plural, *kouroi*) now in New York (Fig. 2-15) emulates the stance of Egyptian statues (Fig. 1-27). In both cases the male figure is rigidly frontal with the left foot advanced slightly. The arms are held beside the body, and the fists are clenched with the thumbs forward. Greek kouros statues differ, however, from their Egyptian models in

56

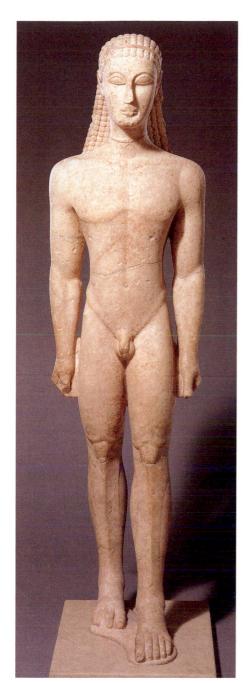

Museum of Art, New York.

The earliest life-size statues of kouroi (young men) adopt the Egyptian pose for standing figures (Fig. 1-27), but they are nude and carved in the round, liberated from their original stone block.

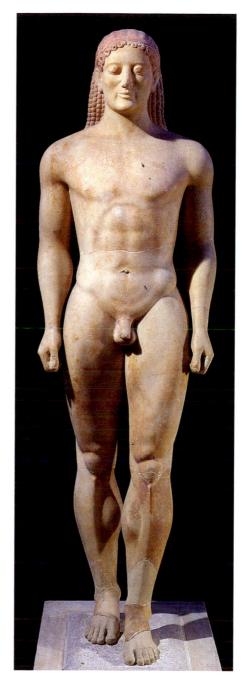

2-16

Kroisos, from Anavysos, Greece, ca. 530 BCE. Marble, approx. 6' 4" high. National Archaeological Museum, Athens.

This later kouros displays increased naturalism in its proportions and more rounded modeling of face, torso, and limbs. Kroisos also smiles the Archaic Greek sculptor's way of indicating life.

two important ways. First, they were liberated from their original stone block. The Egyptian obsession with permanence was alien to the Greeks, who were preoccupied with finding ways to represent motion rather than stability in their sculpted figures. Second, the kouroi are nude, and, in the absence of attributes, Greek youths as well as maidens are formally indistinguishable from Greek statues of deities.

The New York kouros shares many traits with the Lady of Auxerre (Fig. 2-14), especially the triangular shape of head and hair and the flatness of the face—the hallmarks of the Daedalic style. Eyes, nose, and mouth all sit on the front of the head, ears were placed on the sides, and the long hair forms a flat backdrop behind the head. In every instance one sees the result of the sculptor's having drawn these features on four independent sides of the marble block, following the

same workshop procedure used in Egypt for millennia. The New York kouros also has the slim waist of earlier Greek statues, and exhibits the same love of pattern. The pointed arch of the rib cage, for example, echoes the V-shaped ridge of the hips, which suggests but does not accurately reproduce the rounded flesh and muscle of the human body.

The Grave of Kroisos Sometime around 530 BCE, a young man named Kroisos died a hero's death in battle, and his grave at Anavysos, not far from Athens, was marked by a kouros (Fig. 2-16). The statue is two generations later than the New York kouros, and although the stance is the same, the rendition of human anatomy is more naturalistic. The head is no longer too large for the body, and the face is more rounded, with swelling cheeks replacing the flat planes of the earlier work. The long hair does not form a stiff backdrop to the head but falls naturally over the back. Rounded hips replace the V-shaped ridges of the New York kouros.

Also new is that Kroisos smiles—or seems to. From this time on, Archaic Greek statues always smile—even with an arrow in their chest (Fig. 2-26)! This so-called *Archaic smile* has been variously interpreted, but it is not to be taken literally. Rather, the smile is the Archaic sculptor's way of indicating that the person portrayed is alive. By adopting such a convention, the Greek artist signaled a very different intention from any Egyptian counterpart.

Some of the original paint survives on the Kroisos statue, enhancing the sense of life. All Greek stone statues were painted. The modern notion that classical statuary was pure white is mistaken. The Greeks did not, however, color their statues garishly. The flesh was left in the natural color of the stone, which was waxed and polished; eyes, lips, hair, and drapery were painted in *encaustic*, a technique in which the painter mixed the pigment with hot wax and applied it to the statue.

The Peplos Kore A stylistic "sister" to the Anavysos kouros, also with paint preserved, is the smiling Peplos Kore (Fig. 2-17), so called because she wears a peplos, a simple, long, woolen belted garment that gives the female figure a columnar appearance. The kore's missing left arm was extended, a break from the frontal compression of the arms at the sides in Egyptian statues. She once held in her hand an attribute that would identify the figure as a maiden or, as some have suggested, a goddess, perhaps Athena herself, because the statue was a votive offering in that goddess's sanctuary in Athens. Whatever the Peplos Kore's identity, the contrast with the Lady of Auxerre (Fig. 2-14) is striking. Although in both cases the drapery conceals the entire body save for head, arms, and feet, the sixth-century sculptor rendered the soft female form much more naturally. This softer treatment of the flesh also sharply differentiates later korai from contemporaneous kouroi, which have hard, muscular bodies.

Greek Temples Egypt also had a profound impact on Greek architecture. Shortly after the foundation of a Greek trading colony at Naukratis (MAP 1-3, page 524) around 650–630 BCE, the first stone buildings since the fall of the Mycenaean kingdoms began to be constructed in Greece. Although Greek temples cannot be confused with Egyptian buildings, Greek architects were clearly inspired by Egyptian columnar halls such as that at Karnak (Fig. 1-32).

The basic plan of all Greek temples (see "Doric and Ionic Temples," page 59) reveals an order, compactness, and symmetry that reflect the Greeks' sense of proportion and their effort to achieve ideal forms in terms of regular numerical relationships and geometric rules. The earliest temples tended to be long and narrow, with the proportion of the ends to the sides roughly expressible as 1:3. From the sixth century on, plans approached but rarely had a proportion of exactly 1:2. Classical temples tended to be a little longer than twice their

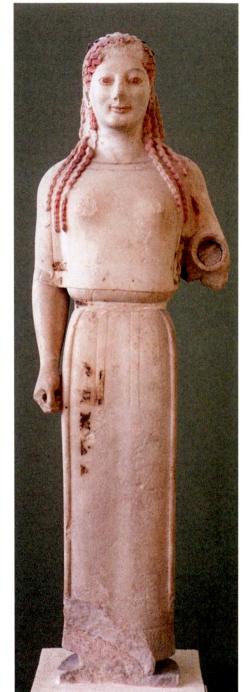

Peplos Kore, from the Acropolis, Athens, Greece, ca. 530 BCE. Marble, approx. 4' high. Acropolis Museum, Athens.

Unlike men, women are always clothed in Archaic art. This smiling statue was a votive offering in Athena's Acropolis sanctuary. The woman once held an attribute in her left hand, perhaps identifying her as Athena herself.

width. To the Greek mind, proportion in architecture and sculpture was much the same as harmony in music, reflecting and embodying the cosmic order. The history of Greek temple architecture is the history of Greek architects' unflagging efforts to find the most satisfactory (that is, what they believed were perfect) proportions for each part of the building and for the structure as a whole.

The Greeks gathered outside, not inside, their temples to worship. The altar always lay outside the temple—at the east end, facing the rising sun. The temple proper housed the *cult statue* of the deity, the grandest of all votive offerings. Both in its early and mature manifestations, the Greek temple was the house of the god or goddess, not of his or her followers.

ARCHITECTURAL BASICS

Doric and Ionic Temples

The plan and elevation of Greek temples varied with date, geography, and the requirements of individual projects, but Greek temples have common defining elements that set them apart from both the religious edifices of other civilizations and other kinds of Greek buildings.

Plan The temple core was the *naos*, or *cella*, which housed the cult statue of the deity. It was preceded by a *pronaos*, or porch, often with two columns between the *antae*, or extended walls (columns *in antis*, that is, between the antae). A smaller second room might be placed behind the cella, but in its classical form, the Greek temple had a porch at the rear *(opisthodomos)* set against the blank back wall of the cella. The purpose was not functional but decorative, satisfying the Greek passion for balance and symmetry. A colonnade could be placed across the front of the temple *(prostyle; Fig. 2-39)*, across both front and back *(amphiprostyle; Fig. 2-40)*, or, more commonly, all around the cella and its porch(es) to form a *peristyle*, as in our diagram and Figs. 2-18 and 2-33).

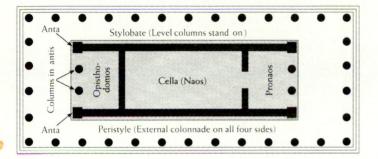

Elevation The elevation of a Greek temple is described in terms of the platform, the colonnade, and the superstructure *(entablature)*. In the Archaic period, two basic systems evolved for articulating the three units. These are the so-called *orders* of Greek architecture. The orders are differen-

tiated both in the nature of the details and in the relative proportions of the parts. The names of the orders are derived from the Greek regions where they were most commonly employed. The *Doric* was formulated on the mainland and remained the preferred manner there and in the western colonies of the Greeks. The *Ionic* was the order of choice in the Aegean Islands and on the western coast of Asia Minor. The geographical distinctions are by no means absolute. The Ionic order was, for example, often used in Athens.

In both orders, the columns rest on the *stylobate*, the uppermost course of the platform. The columns have two or three parts, depending on the order: the *shaft*, which is marked with vertical channels *(flutes)*; the *capital*; and, in the Ionic order, the *base*. Greek column shafts, in contrast to their Minoan and Mycenaean forebears, taper gradually from bottom to top. The capital has two elements. The lower part (the *echinus*) varies with the order. In the Doric, it is convex and cushionlike, similar to the echinus of Minoan (Fig. 2-3) and Mycenaean (Fig. 2-9) capitals. In the Ionic, it is small and supports a bolster ending in spirals (the *volutes*). The upper element, present in both orders, is a flat block (the *abacus*) that provides the immediate support for the entablature.

The entablature has three parts: the *architrave* or *epistyle*, the main weight-bearing and weight-distributing element; the *frieze*; and the *cornice*, a molded horizontal projection that together with two sloping (*raking*) cornices forms a triangle that enframes the *pediment*. In the Ionic order, the architrave is usually subdivided into three horizontal bands (*fasciae*). In the Doric order, the frieze is subdivided into *triglyphs* and *metopes*, whereas in the Ionic the frieze is left open to provide a continuous field for relief sculpture.

The Doric order is massive in appearance, its sturdy columns firmly planted on the stylobate. Compared with the weighty and severe Doric, the Ionic order seems light, airy, and much more decorative. Its columns are more slender and rise from molded bases. The most obvious differences between the two orders are, of course, in the capitals—the Doric, severely plain, and the Ionic, highly ornamental.

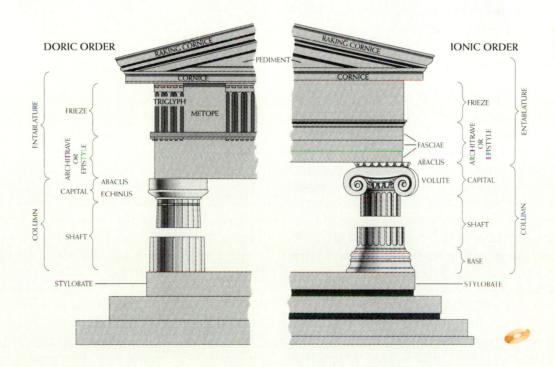

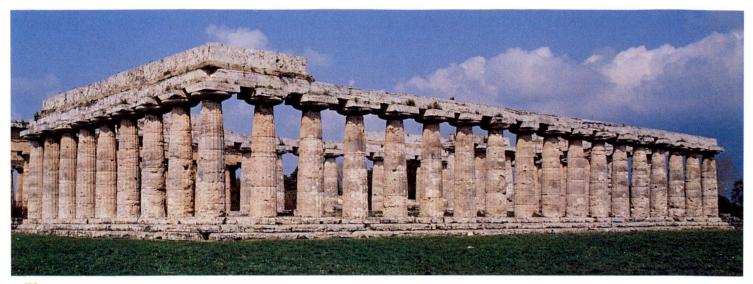

2-18 | Temple of Hera ("Basilica"), Paestum, Italy, ca. 550 BCE.

The peristyle of this huge early Doric temple is composed of heavy, closely spaced cigar-shaped columns with bulky, pancakelike capitals, characteristic features of Archaic Greek architecture. The gabled roof is missing.

Figural sculpture played a major role in the exterior program of the Greek temple from early times. Sculptural ornament was concentrated in the frieze and pediments. Architectural sculpture, like freestanding statuary, was painted and usually was placed only in the building parts that had no structural function. This is true particularly of the Doric order, where decorative sculpture appears only in the metope and pediment "voids." Ionic builders, less severe in this respect as well, were willing to decorate the entire frieze. Occasionally, they replaced their columns with female figures (*caryatids*; Fig. 2-39). Capitals, decorative *moldings*, and other architectural elements were also painted. By painting parts of the building, the designer could bring out more clearly the relationships of the structural parts and soften the stone's glitter at specific points, as well as provide a background to set off the figures.

Early Doric The prime example of early Greek efforts at Doric temple design is not in Greece but in Italy, at Paestum. The huge $(80 \times 170 \text{ feet})$ Archaic temple (Fig. 2-18) erected there around 550 BCE retains its entire *peripteral* colonnade, but most of the entablature, including the frieze, pediment, and all of the roof, has vanished. Called the Basilica after the Roman columnar hall building type that early investigators felt it resembled, the structure was actually a temple of Hera.

The misnomer is partly due to the building's plan (Fig. 2-19), which differs from that of most other Greek temples. The unusual feature, found only in early Archaic temples, is the central row of columns that divides the cella into two aisles. Placing columns underneath the *ridgepole* (the timber beam running the length of the building below the peak of the gabled roof) might seem the logical way to provide interior support for the roof structure. But it resulted in several disadvantages. Among these was that this interior arrangement allowed no place for a central

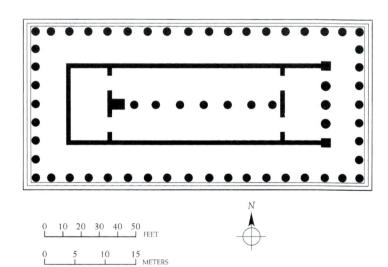

2-19 | Plan of the Temple of Hera, Paestum, Italy, ca. 550 BCE.

The plan of the Archaic Hera temple also reveals its early date. The temple has an odd number of columns on the facade and a single row of columns in the cella, allowing no place for a central statue of the goddess.

statue of the deity to whom the temple was dedicated. Also, the peripteral colonnade, in order to correspond with the interior, had to have an odd number of columns (nine in this case) across the building's *facade*. At Paestum, three columns were also set in antis instead of the standard two, which in turn ruled out a central doorway for viewing the statue. However, a simple 1:2 ratio of facade and flank columns was achieved by erecting 18 columns on each side of the temple.

The temple's elevation is characterized by heavy, closely spaced columns with a pronounced swelling (entasis) at the

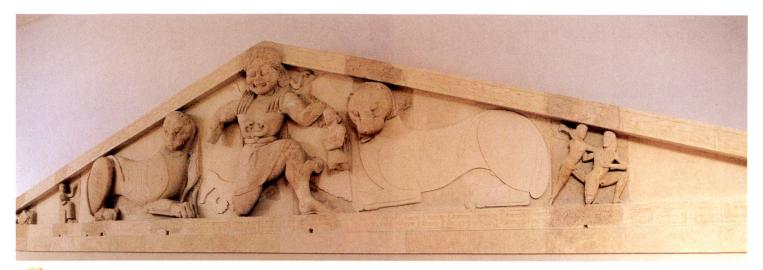

2-20 | West pediment of the Temple of Artemis, Corfu, Greece, ca. 600–580 BCE. Limestone, greatest height approx. 9' 4". Archaeological Museum, Corfu.

The hideous Medusa and two panthers at the center of this very early pediment serve as temple guardians. To either side, and at much smaller scale, are scenes from the Trojan War and the battle of gods and giants.

middle of the shafts, giving the columns a profile akin to that of a cigar. The shafts are topped by large, bulky, pancakelike Doric capitals, which seem compressed by the overbearing weight of the entablature. The columns and capitals thus express in a vivid manner their weight-bearing function. The heaviness of the design and the narrowness of the spans between the columns probably reflects the Archaic builders' fear that thinner and more widely spaced columns would result in the superstructure's collapse. In later Doric temples, the columns were placed farther apart, and the shafts became more slender, the entasis subtler, the capitals smaller, and the entablature lighter.

The Pediment Problem Even older than the Paestum temple is the Doric temple of Artemis at Corfu, which was constructed early in the sixth century BCE. The building is unfortunately in ruins, but most of the sculpture that embellished its pediments (Fig. 2-20) is preserved. Designing figural decoration for a pediment was never an easy task for the Greek sculptor because of the pediment's awkward triangular shape. The central figures had to be of great size (more than nine feet tall at Corfu). As the pediment tapered toward the corners, the available area became increasingly cramped.

At the center of the Corfu pediment is the *gorgon* Medusa, a demon with a woman's body and bird wings. Medusa also had a hideous face and snake hair, and anyone who gazed at her was turned to stone. She is shown in the conventional Archaic bentleg, bent-arm, pinwheel-like posture that signifies running or, for a winged creature, flying. To her left and right are two great felines. Together they serve as temple guardians, repulsing all enemies from the sanctuary of the goddess. Between Medusa and the great beasts are two small figures—the human Chrysaor at her left and the winged horse Pegasus at her right (only the rear legs are visible today). Chrysaor and Pegasus were

Medusa's children. They sprang from her head when the Greek hero Perseus severed it with his sword. Their presence here with the living Medusa is therefore a chronological impossibility. The Archaic artist was not interested in telling a coherent story but in identifying the central figure by depicting her offspring.

Narration was, however, the purpose of the much smaller groups situated in the pediment corners. To the viewer's right is Zeus, brandishing his thunderbolt and slaying a kneeling giant. In the extreme corner was a dead giant. The *gigantomachy* (battle of gods and giants) was a popular Greek theme that was a metaphor for the triumph of reason and order over chaos. In the pediment's left corner is one of the climactic events of the Trojan War: Achilles' son Neoptolemos kills the enthroned King Priam. The fallen figure to the left of this group may be a dead Trojan.

The master responsible for the Corfu pediments was a pioneer, and the composition shows all the signs of experimentation. The lack of narrative unity in the Corfu pediment and the extraordinary scale diversity of the figures eventually gave way to pedimental designs with figures all acting out a single event and appearing the same size. But the Corfu designer already had shown the way, realizing, for example, that the area beneath the raking cornice could be filled with gods and heroes of similar size if a combination of standing, leaning, kneeling, seated, and prostrate figures were employed in the composition. And the Corfu master discovered that animals could be very useful space fillers because, unlike humans, they have one end taller than the other.

Black-Figure Painting Greek artists also pioneered a new ceramic painting technique during the Archaic period. Invented in Corinth, *black-figure painting* quickly replaced the simpler silhouette painting favored in the Geometric period.

2-21 | EXEKIAS, Achilles and Ajax playing a dice game (detail of a black-figure

amphora), from Vulci, Italy, ca. 540-530 BCE. Whole vessel approx. 2' high. Musei Vaticani, Rome.

The dramatic tension, adjustment of the figures' poses to the shape of the vase, and extraordinary intricacy of the engraved patterns of the cloaks are hallmarks of Exekias, the greatest master of black-figure painting.

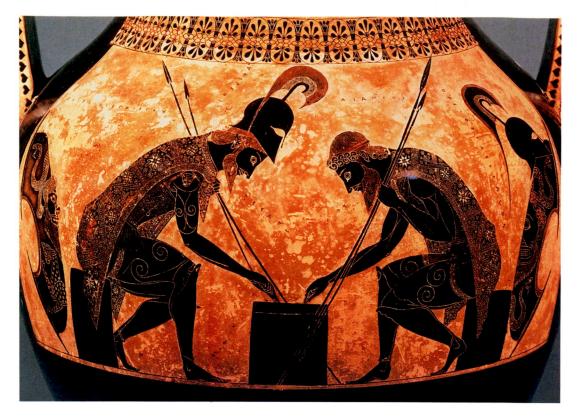

The black-figure painter also put down black silhouettes on the clay surface, but then used a sharp, pointed instrument (graver) to incise linear details within the forms, usually adding highlights in purplish red or white over the black figures before firing the vessel. The combination of the weighty black silhouettes with the delicate detailing and the bright polychrome overlay proved to be irresistible, and painters in other Greek cities soon copied the technique from the Corinthians.

Exekias The acknowledged master of the black-figure technique was an Athenian named EXEKIAS. The amphora, or two-handled storage jar, that we illustrate (Fig. 2-21) bears his signature as both painter and potter. Such signatures, common on Greek vases, reveal both pride and a sense of selfidentity as an "artist." They also served as "brand names" because the vases of Athens and Corinth were widely exported, especially to Etruscan Italy. This amphora was found at Vulci.

Unlike his Geometric predecessors (Fig. 2-13), Exekias used figures of monumental stature and placed them in a single large framed panel. At the left is Achilles, fully armed. He plays a dice game with his comrade Ajax. Ajax has taken off his helmet, but both men hold their spears. Their shields are nearby. Each man is ready for action at a moment's notice. The gravity and tension that characterize this composition are rarely seen in Archaic art.

Exekias had no equal as a black-figure painter. That may be seen in such details as the extraordinarily intricate engraving of the patterns on the heroes' cloaks (highlighted with delicate touches of white) and in the brilliant composition. The arch formed by the backs of the two warriors echoes the shape of the rounded shoulders of the amphora. The shape of the vessel is echoed again in the void between the heads and spears of Achilles and Ajax. Exekias also used the spears to lead the viewer's eye toward the thrown dice, where the heroes' eyes are fixed. Of course, those eyes do not really look down at the table but stare out from the profile heads in the old manner. For all his brilliance, Exekias was still wedded to many of the old conventions. Real innovation in figure drawing would have to await the invention of a new ceramic painting technique of greater versatility than black-figure.

Red-Figure Painting The birth of this new technique, called red-figure painting, came around 530 BCE. Red-figure is the opposite of black-figure. What was previously black became red, and vice versa. The artist still employed the same black glaze. But instead of using the glaze to create the silhouettes of figures, the painter outlined the figures and then colored the background black. The red clay was reserved for the figures themselves. Interior details were then drawn with a soft brush in place of a metal graver. And the artist could vary the glaze thickness, building it up to give relief to hair curls or diluting it to create brown shades, thereby expanding the chromatic range of the Greek vase painter's craft.

Euphronios One of the most admired red-figure painters was EUPHRONIOS, whose krater depicting the struggle between Herakles, the greatest Greek hero, and the giant Antaios (Fig. 2-22) reveals the exciting possibilities of the new technique. Antaios was a son of Earth, and he derived his power from

2-22 | EUPHRONIOS, Herakles wrestling Antaios (detail of a red-figure calyx krater), from Cerveteri, Italy, ca. 510 BCE. Whole vessel approx. 1' 7" high. Louvre, Paris.

The early red-figure master Euphronios rejected the age-old composite view for painted figures and instead attempted to reproduce how the human body is seen from a particular viewpoint.

contact with the ground. To defeat him, Herakles had to lift him up into the air and strangle him while no part of the giant's body touched the earth. Here, the two wrestle on the ground, and Antaios still possesses enormous strength. Nonetheless, Herakles has the upper hand. The giant's face is a mask of pain. His eyes roll and his teeth are bared. His right arm is paralyzed, with the fingers limp.

Euphronios used diluted glaze to show Antaios's unkempt golden brown hair—intentionally contrasted with Herakles' neat coiffure and carefully trimmed beard—and to delineate the muscles of both figures. But rendering human anatomy convincingly was not his only interest. Euphronios also wished to show that his figures occupy space. He deliberately rejected the conventional composite posture for the human figure and attempted to reproduce how a particular human body is seen. He presented, for example, not only Antaios' torso but also his right thigh from the front. The lower leg disappears behind the giant, and one glimpses only part of the right foot. The viewer must mentally make the connection between the upper leg and the foot. Euphronios's panel is a window onto a mythological world with protagonists occupying three-dimensional space—a revolutionary new conception of what a picture was supposed to be.

Euthymides A preoccupation with the art of drawing per se may be seen in a remarkable amphora (Fig. 2-23) painted by EUTHYMIDES, a rival of Euphronios. The subject is appropriate for a wine storage jar—three tipsy revelers. But the theme was little more than an excuse for the artist to experiment with the representation of unusual positions of the human form. It is no coincidence that the bodies do not overlap, for each is an independent figure study. Euthymides cast aside the conventional frontal and profile composite views. Instead, he painted torsos that are not two-dimensional surface patterns but are foreshortened, that is, drawn in a three-quarter view. Most

2-23 | EUTHYMIDES, Three revelers (red-figure amphora), from Vulci, Italy, ca. 510 BCE. Approx. 2' high. Staatliche Antikensammlungen, Munich.

Euthymides chose this theme as an excuse for representing the human form in unusual positions, including a foreshortened three-quarter view from the rear. He claimed to have surpassed Euphronios as a draftsman. noteworthy is the central figure, who is shown from the rear with a twisting spinal column and buttocks in three-quarter view. Earlier artists had no interest in attempting such postures because they not only are incomplete but also do not show the "main" side of the human body. But for Euthymides the challenge of drawing the figure from such an unusual viewpoint was a reward in itself. With understandable pride he proclaimed his achievement by adding to the formulaic signature "Euthymides painted me" the phrase "as never Euphronios [could do]!"

Refining Doric Design The years just before and after 500 BCE were a time of dynamic transition in architecture and architectural sculpture. The key monument is the temple at Aegina (Fig. 2-24) dedicated to Aphaia, a local goddess. Its colonnade is 45×95 feet and consists of 6 Doric columns on the facade and 12 on the flanks. This is a much more compact structure than the impressive but ungainly Archaic Temple of Hera at Paestum (Fig. 2-18), even though the ratio of width to length is similar. Doric architects had learned a great deal in the half century that elapsed between construction of the two temples. The columns of the Aegina temple are more widely spaced and more slender. The capitals create a smooth transition from the vertical shafts below to the horizontal architrave

above. Gone are the Archaic flattened echinuses and bulging shafts of the Paestum columns. The Aegina architect also refined the temple plan and internal elevation. In place of a single row of columns down the cella's center is a double colonnade—and each row has two stories. This arrangement allowed the placement of a statue on the central axis and also gave those gathered in front of the building an unobstructed view through the pair of columns in the pronaos.

The pediments were filled with life-size statuary (Fig. 2-25). Both pediments depicted the same subject and used a similar composition. The theme was the battle of Greeks and Trojans, with Athena at the center. She is larger than all the other figures because she is superhuman, but all the mortal heroes are the same size, regardless of their position in the pediment. Unlike the experimental design at Corfu (Fig. 2-20), the Aegina pediments feature a unified theme and consistent scale. The latter was achieved by using the whole range of body postures from upright (Athena) to leaning, falling, kneeling, and lying (Greeks and Trojans).

Archaism to Classicism The sculptures of the west pediment were set in place when the temple was completed around 490 BCE. The eastern statues are a decade or two later. It is very instructive to compare the earlier and later figures.

2-24 | Plan (*left*) and restored cutaway view (*right*) of the Temple of Aphaia, Aegina, Greece, ca. 500–490 BCE.

In this refined Doric design, the columns are more slender and widely spaced, there are only six columns on the facade, and the cella has two colonnades of two stories each (originally with a statue between them).

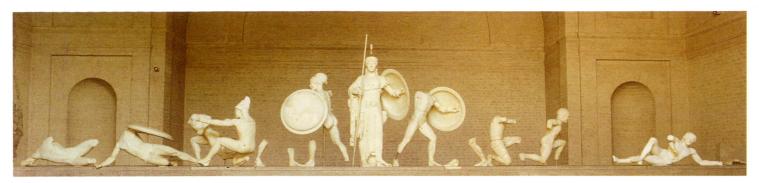

2-25 | Statues from the west pediment of the Temple of Aphaia, Aegina, Greece, ca. 500–490 BCE. Marble, approx. 5' 8" high at center. Glyptothek, Munich.

The problem of placing figures in a triangular pediment is here solved by using the whole range of body postures from upright to leaning, falling, kneeling, and lying. Only Athena is larger than the rest.

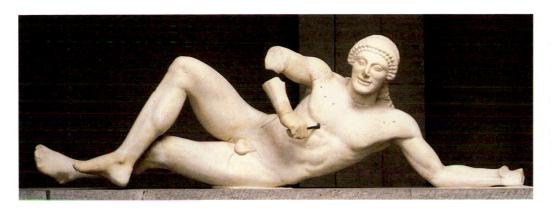

2-26 | Dying warrior, from the west pediment of the Temple of Aphaia, Aegina, Greece, ca. 500-490 BCE. Marble, approx. 5' $2\frac{1}{2}''$ long. Glyptothek, Munich.

The two sets of Aegina pediment statues were installed 10 to 20 years apart. The earlier statues exhibit Archaic features. This fallen warrior still has a rigidly frontal torso and an Archaic smile.

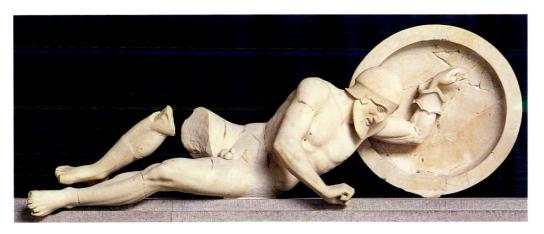

2-27 | Dying warrior, from the east pediment of the Temple of Aphaia, Aegina, Greece, ca. 490–480 BCE. Marble, approx. 6' 1" long. Glyptothek, Munich.

This later dying warrior already belongs to the Classical era. His posture is more natural, and he exhibits a new selfconsciousness. Concerned with his own pain, he does not face the viewer.

The west pediment's dying warrior (Fig. 2-26) was still conceived in the Archaic mode. His torso is rigidly frontal, and he looks out directly at the spectator. In fact, he smiles at us, in spite of the bronze arrow that punctures his chest. He is like a mannequin in a store window whose arms and legs have been arranged by someone else for effective display.

The comparable figure (Fig. 2-27) in the later east pediment is radically different. Not only is his posture more natural and more complex, with the torso placed at an angle to the viewer—he is on a par with the painted figures of Euphronios (Fig. 2-22)—but he also reacts to his wound. He

knows that death is inevitable, but he still struggles to rise once again, using his shield for support. And he does not look out at the viewer. He is concerned with his pain, not with us. The two statues belong to different eras. The later warrior is not a creation of the Archaic world, when sculptors imposed anatomical patterns (and smiles) on statues from without. It belongs to the Classical world, where statues move as humans move and possess the self-consciousness of real men and women. This was a radical change in the conception of what a statue was meant to be. In sculpture, as in painting, the Classical revolution had occurred.

Early and High Classical Art

Art historians reckon the beginning of the Classical* age from a historical event, the defeat of the Persian invaders of Greece by the allied Hellenic city-states. Shortly after Athens was occupied and sacked in 480 BCE, the Greeks won a decisive naval victory over the Persians at Salamis. It had been a difficult war, and at times it had seemed as though Asia would swallow up Greece, and the Persian king Xerxes would rule over all. The close escape of the Greeks from domination by Asian "barbarians" nurtured a sense of Hellenic identity so strong that, from then on, the history of European civilization would be distinct from that of Asia. The decades following the removal of the Persian threat are universally considered the high point of Greek civilization. This is the era of the dramatists Aeschylus, Sophocles, and Euripides, the historian Herodotus, the statesman Pericles, the philosopher Socrates, and many of the most famous Greek architects, sculptors, and painters.

A New Way to Stand The sculptures of the Early Classical period (ca. 480-450 BCE) display a seriousness that contrasts sharply with the smiling figures of the Archaic period. But a more fundamental and significant break from the Archaic style was the rejection of the rigid and unnatural Egyptian-inspired pose of Archaic statuary. This change may be seen in a marble statue known as the Kritios Boy (Fig. 2-28), so named because it was once thought to have been carved by the sculptor Kritios. Never before had a sculptor been concerned with portraying how a human being, as opposed to a stone image, actually stands. Real people do not stand in the stiff-legged pose of the kouroi and korai or their Egyptian predecessors. Humans shift their weight and the position of the main body parts around the vertical, but flexible, axis of the spine. The sculptor of the Kritios Boy was among the first to grasp this fact and to represent it in statuary. The youth has a slight dip to the right hip, indicating the shifting of weight onto his left leg. His right leg is bent, at ease. The head also turns slightly to the right and tilts, breaking the unwritten rule of frontality dictating the form of virtually all earlier statues. This weight shift, which art historians describe as contrapposto (counterbalance), separates Classical from Archaic Greek statuary.

Rescued from the Sea The innovations of the *Kritios Boy* were carried even further in the bronze statue of a warrior (Fig. 2-29) found in the sea near Riace, Italy. It is one of a pair of nearly perfectly preserved statues discovered in a ship that sank in antiquity on its way from Greece probably to Rome. The statue lacks only its shield, spear, and helmet. It is a masterpiece of hollow-casting (see "Hollow-Casting

*Note: In this book, the adjective "Classical," with uppercase *C*, refers specifically to the Classical period of ancient Greece, 480–323 BCE. Lowercase "classical" refers to Greco-Roman antiquity in general, that is, the period treated in Chapters 2 and 3.

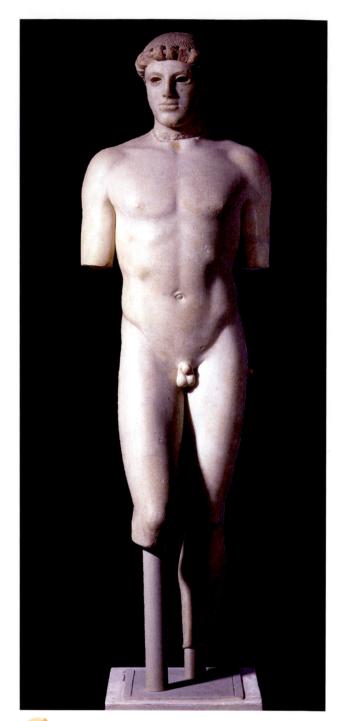

2-28 | *Kritios Boy*, from the Acropolis, Athens, Greece, ca. 480 BCE. Marble, approx. 2' 10" high. Acropolis Museum, Athens.

This is the first statue to show how a person really stands. The sculptor represented the figure shifting weight from one leg to the other (contrapposto). The youth's head also turns slightly, and the Archaic smile is gone.

Life-Size Bronze Statues," page 67), with inlaid eyes, silver teeth and eyelashes, and copper lips and nipples. The weight shift is more pronounced than in the *Kritios Boy*. The warrior's head turns more forcefully to the right, his shoulders tilt, his hips swing more markedly, and his arms have been freed from the body. Natural motion in space has replaced Archaic frontality and rigidity.

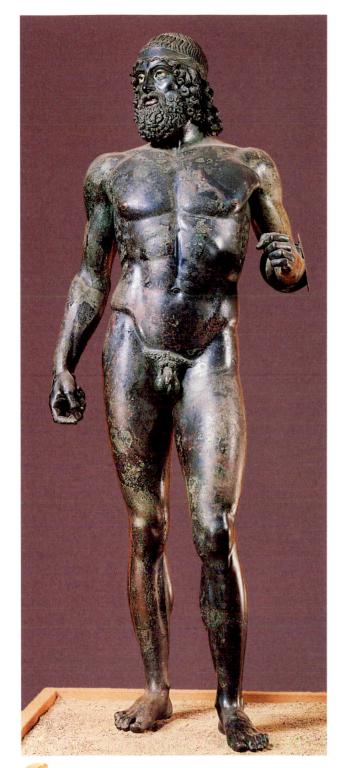

2-29 | Warrior, from the sea off Riace, Italy, ca. 460–450 BCE. Bronze, approx. 6' 6" high. Archaeological Museum, Reggio Calabria.

One of the few surviving life-size hollow-cast Classical bronze statues, the Riace warrior has inlaid eyes, silver teeth and eyelashes, and copper lips and nipples. The contrapposto is more pronounced than in the *Kritios Boy* (Fig. 2-28).

MATERIALS + TECHNIQUES

Hollow-Casting Life-Size Bronze Statues

Monumental bronze statues could not be manufactured using a single simple mold, as could small-scale figures. Weight, cost, and the tendency of large masses of bronze to distort when cooling made life-size castings in solid bronze impractical, if not impossible. Instead, large statues were hollow-cast by the *cire perdue* (lost-wax) method. The *lost-wax process* entailed several steps and had to be repeated many times, because monumental statues were typically cast in parts—head, arms, hands, torso, and so forth.

First, the sculptor fashioned a full-size clay model of the intended statue. Then a clay master mold was made around the model and removed in sections. When dry, the various pieces of the master mold were put back together for each separate body part. Next, a layer of beeswax was applied to the inside of each mold. When the wax cooled, the mold was removed, and the sculptor was left with a hollow wax model in the shape of the original clay model. The artist could then correct or refine details — for example, engrave fingernails on the hands, or individual locks of hair on the head.

In the next stage, a final clay mold (investment) was applied to the exterior of the wax model, and a liquid clay core was poured inside the hollow wax. Metal pins (chaplets) then were driven through the new mold to connect the investment with the clay core (a). Now the wax was melted out ("lost") and molten bronze poured into the mold in its place (b). When the bronze hardened and assumed the shape of the wax model, the investment and as much of the core as possible were removed, and the casting process was complete. Finally, the individually cast pieces were fitted together and soldered, surface imperfections and joins smoothed, eyes inlaid, teeth and eyelashes added, attributes such as spears and wreaths provided, and so forth.

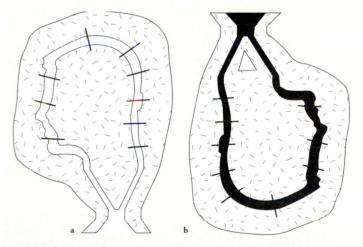

Two stages of the lost-wax method of bronze casting (after S. A. Hemingway¹): (a) clay mold (investment), wax model, and clay core connected by chaplets; (b) wax melted out and molten bronze poured into the mold.

¹Sean A. Hemingway, *How Bronze Statues Were Made in Classical Antiquity* (Cambridge: Harvard University Art Museums, 1996), 4.

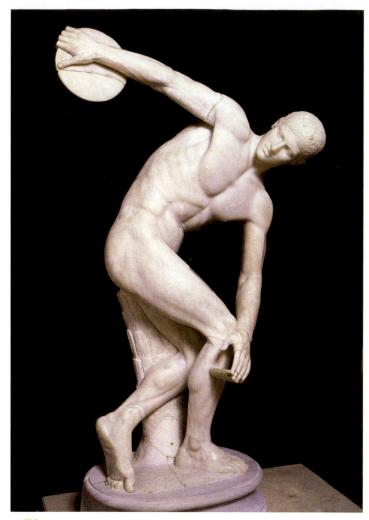

2-30 | MYRON, *Diskobolos (Discus Thrower)*. Roman copy after a bronze original of ca. 450 BCE. Marble, 5' 1" high. Museo Nazionale Romano—Palazzo Massimo alle Terme, Rome.

Although a marble copy of a bronze original, the replica captures the way Myron froze the action of discus throwing and arranged the nude athlete's body and limbs so that they formed two intersecting arcs.

Myron's Discus Thrower The Kritios Boy and the Riace warrior are at rest, but Early Classical Greek sculptors also explored the problem of representing figures engaged in vigorous action. The renowned Diskobolos (Discus Thrower) by Myron (Fig. 2-30), with its arms boldly extended, body twisted, and right heel raised off the ground, is such a statue. Nothing comparable survives from the Archaic period. The pose suggests the motion of a pendulum clock. The athlete's right arm has reached the apex of its arc but has not yet begun to swing down again. Myron froze the action and arranged the body and limbs to form two intersecting arcs, creating the impression of a tightly stretched bow a moment before the string is released.

The statue we illustrate, however, is not Myron's, which was cast in bronze. It is a marble copy made in Roman times. Roman demand for famous Greek statues so far exceeded the supply that a veritable industry was born to meet the Roman call for copies to be displayed in both public and private venues. The copies usually were made in less costly marble.

The change in medium resulted in a different surface appearance. In most cases, the copyist also had to add an intrusive tree trunk to support the great weight of the stone statue and insert struts between arms and body to strengthen weak points. The copies rarely approach the quality of the originals, but they are indispensable today. Without them it would be impossible to reconstruct the history of Greek sculpture after the Archaic period.

The Perfect Statue One of the most frequently copied Greek statues was the *Doryphoros (Spear Bearer)* by POLY-KLEITOS (FIG. 2-31), a work that epitomizes the intellectual rigor of High Classical (ca. 450–400 BCE) statuary design. The *Doryphoros* is the culmination of the evolution in Greek statuary from the Archaic kouros to the *Kritios Boy* to the Riace warrior. The contrapposto is more pronounced than ever before in a standing statue, but Polykleitos was not content with simply rendering a figure that stands naturally. His aim was to impose order on human movement, to make it

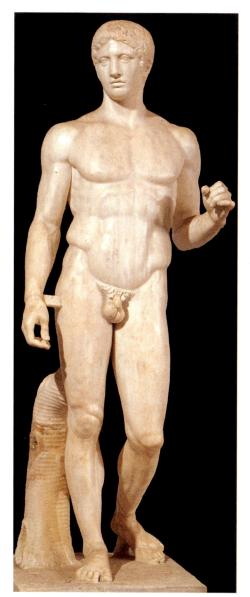

POLYKLEITOS,
Doryphoros (Spear
Bearer). Roman
copy from Pompeii,
Italy, after a bronze
original of ca. 450–
440 BCE. Marble,
6' 11" high. Museo
Archeologico
Nazionale, Naples.

Polykleitos sought to portray the perfect man and to impose order on human movement. He achieved his goals by employing harmonic proportions and a system of cross balance for all parts of the body. "beautiful," to "perfect" it. He achieved this through a system of *chiastic*, or cross, balance of the figure's various parts. Note, for instance, how the rigid supporting leg is echoed by the straight-hanging arm, providing the figure's right side with the columnar stability needed to anchor the left side's dynamically flexed limbs. The tensed and relaxed limbs oppose each other diagonally. The right arm and the left leg are relaxed, and the tensed supporting leg opposes the flexed arm, which held a spear. In like manner, the head turns to the right while the hips twist slightly to the left. And although the *Doryphoros* seems to take a step forward, he does not move. This dynamic asymmetrical balance, this motion while at rest, and the resulting harmony of opposites are the essence of the Polykleitan style.

Polykleitos made the *Doryphoros* as a demonstration piece to accompany his treatise on the ideal statue of a nude man. *Spear Bearer* is but a modern descriptive epithet for the work. The name the artist assigned to the statue was *Canon*. Polykleitos was greatly influenced by the philosopher Pythagoras of Samos, who lived during the latter part of the sixth century BCE. A famous geometric theorem still bears his name. Pythagoras also is said to have discovered that harmonic chords in music are produced on the strings of a lyre at regular intervals that may be expressed as ratios of whole numbers—2:1, 3:2, 4:3. He and his followers, the Pythagoreans, believed more generally that underlying harmonic proportions could be found in all of nature, determining the form of the cosmos as well as of things on earth, and that beauty resided in harmonious numerical ratios.

By this reasoning, a perfect statue would be one constructed according to an all-encompassing mathematical formula—and that is what Polykleitos achieved in his *Doryphoros*. Galen, a physician who lived during the second century CE, summarized Polykleitos's philosophy as follows:

"[Beauty arises from] the commensurability [symmetria] of the parts, such as that of finger to finger, and of all the fingers to the palm and the wrist, and of these to the forearm, and of the forearm to the upper arm, and, in fact, of everything to everything else, just as it is written in the *Canon* of Polykleitos.... Polykleitos supported his treatise [by making] a statue according to the tenets of his treatise, and called the statue, like the work, the *Canon*."

This is why Pliny the Elder, writing in the first century CE, maintained that Polykleitos "alone of men is deemed to have rendered art itself [that is, the theoretical basis of art] in a work of art."²

Alliance and Tyranny While Polykleitos was working out his prescription for the perfect statue, the Athenians, under the leadership of Pericles, were initiating one of history's most ambitious building projects, the reconstruction of the Acropolis (*acropolis* means "high city") after the Persian sack. In 478 BCE, in the aftermath of the Persian defeat, the Greeks formed an alliance for mutual protection against any renewed threat from the east. The new confederacy came to

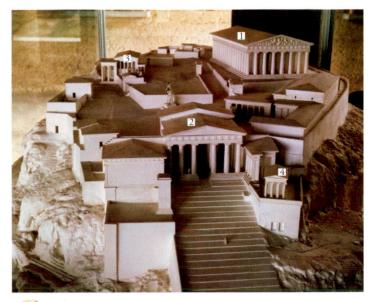

2-32 | Model of the Acropolis, Athens, Greece. Acropolis Museum, Athens. 1) Parthenon, 2) Propylaia, 3) Erechtheion, 4) Temple of Athena Nike.

Under the leadership of Pericles, the Athenians undertook one of history's most ambitious building projects, the reconstruction of the Acropolis after the Persian sack. The funds came from the Delian League treasury.

be known as the Delian League, because its headquarters were on the Cycladic island of Delos. Although at the outset each league member had an equal vote, Athens was "first among equals," providing the allied fleet commander and determining which cities were to furnish ships and which were instead to pay an annual tribute to the treasury at Delos. Continued fighting against the Persians kept the alliance intact, but Athens gradually assumed a dominant role. In 454 BCE the Delian treasury was transferred to Athens, ostensibly for security reasons. Tribute continued to be paid, but the surplus reserves were not expended for the common good of the allied Greek states. Instead, Pericles expropriated the funds to resurrect the Acropolis (Fig. 2-32). Thus, the Periclean building program was not the glorious fruit of Athenian democracy, as commonly thought, but the by-product of tyranny and the abuse of power. Too often art and architectural historians do not ask how a monument was financed. The answer can be very revealing.

The centerpiece of the Periclean Acropolis was the Parthenon (Fig. 2-32, no. 1), or the Temple of Athena Parthenos, erected in the remarkably short period between 447 and 438 BCE. (Work on the great temple's ambitious sculptural ornamentation continued until 432 BCE.) As soon as the Parthenon was completed, construction commenced on a grand new gateway to the Acropolis, the Propylaia (Fig. 2-32, no. 2). Two later temples, the Erechtheion (Fig. 2-32, no. 3) and the Temple of Athena Nike (Fig. 2-32, no. 4), built after Pericles' death, were probably also part of the original design.

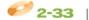

IKTINOS and KALLIKRATES, Parthenon, the Temple of Athena Parthenos (view from the northwest), Acropolis, Athens, Greece, 447–438 BGE.

The architects of the Parthenon believed that perfect beauty could be achieved by using harmonic proportions. The controlling ratio for larger and smaller parts was x = 2y + 1 (for example, a plan of 8×17 columns).

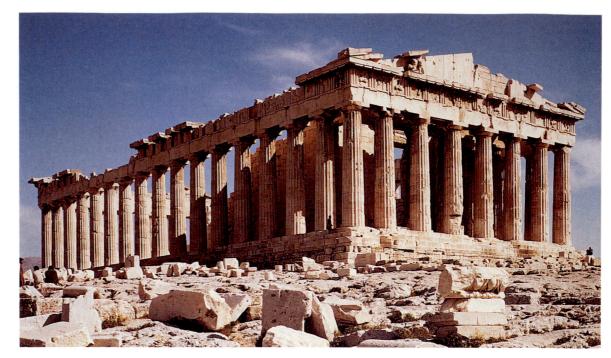

Parthenon: Ideal Temple Most of the Parthenon's peripteral colonnade (Fig. 2-33) is still standing (or has been reerected), and art historians know a great deal about the building and its sculptural program. The architects were IKTINOS and KALLIKRATES. The statue of Athena was the work of PHIDIAS, who was also the overseer of the temple's sculptural decoration. In fact, Plutarch claims that Phidias was in charge of the entire Periclean building program.

Just as the contemporaneous *Doryphoros* may be seen as the culmination of nearly two centuries of searching for the ideal proportions of the human body, so, too, the Parthenon may be viewed as the ideal solution to the Greek architect's quest for perfect proportions in Doric temple design. The Parthenon architects and Polykleitos were kindred spirits in their belief that strict adherence to harmonious numerical ratios produced ideal forms. For the Parthenon, the controlling ratio for the *symmetria* of the parts may be expressed algebraically as x = 2y + 1. Thus, for example, the temple's short ends have 8 columns and the long sides have 17 (17 = $[2 \times 8] + 1$). The stylobate's ratio of length to width is 9:4 (9 = $[2 \times 4] + 1$), as is the cella's, and so forth.

Optics The Parthenon's harmonious design and the mathematical precision of the sizes of its constituent elements obscure the fact that throughout the building are pronounced deviations from the strictly horizontal and vertical lines assumed to be the basis of all Greek *post-and-lintel* structures. The stylobate, for example, curves upward at the center on both the sides and the facade, forming a kind of shallow dome, and this curvature is carried up into the entablature. Moreover, the peristyle columns lean inward slightly. Those at the corners have a diagonal inclination and are also about two inches thicker than the rest. If their lines were continued, they

would meet about 1.5 miles above the temple. These deviations from the norm meant that virtually every Parthenon block had to be carved according to the special set of specifications dictated by its unique place in the structure. Vitruvius, a Roman architect of the late first century BCE, explained these adjustments as compensations for optical illusions. According to Vitruvius, if a stylobate is laid out on a level surface, it will appear to sag at the center. He also said that the corner columns of a building should be thicker because they are surrounded by light and would otherwise appear thinner than their neighbors.

Mixing Doric and Ionic One of the ironies of the Parthenon, the world's most famous Doric temple, is that it is "contaminated" by Ionic elements. Although the cella had a two-story Doric colonnade around Phidias's Athena, the back room (Fig. 2-34)—which housed the goddess's treasury and the tribute collected from the Delian League—had four tall and slender Ionic columns as sole supports for the superstructure. And whereas the temple's exterior had a canonical Doric frieze, the inner frieze that ran around the top of the cella wall was Ionic. Perhaps this fusion of Doric and Ionic elements reflects the Athenians' belief that the Ionians of the Cycladic Islands and Asia Minor were descended from Athenian settlers and were therefore their kin. Or it may be Pericles and Iktinos's way of suggesting that Athens was the leader of all the Greeks. In any case, a mix of Doric and Ionic features characterizes the fifth-century buildings of the Acropolis as a whole.

Phidias and the Parthenon The Parthenon was more lavishly decorated than any Greek temple before it, Doric or Ionic (Fig. 2-34). Every one of the 92 Doric metopes was decorated with relief sculpture. So, too, was every inch of the

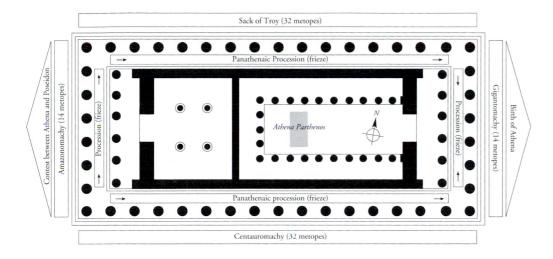

2-34 | Plan of the Parthenon, Acropolis, Athens, Greece, with diagram of sculptural program, 447–432 BCE (after A. Stewart).

The Parthenon was lavishly decorated. Statues filled both pediments, and reliefs adorned all 92 Doric metopes as well as the 524-foot Ionic frieze. In the cella was Phidias's colossal gold-and-ivory Athena.

524-foot-long Ionic frieze. The pediments were filled with dozens of larger-than-life-size statues. The director of this vast sculptural program was Phidias, but the only part that he executed himself was the Athena Parthenos, the statue of Athena the Virgin, which stood in the Parthenon's cella. It was a chryselephantine statue, that is, fashioned of gold and ivory, and stood 38 feet tall. Athena was fully armed with shield, spear, and helmet, and she held Nike (the winged female personification of victory) in her extended right hand. No one doubts that this Nike referred to the victory of 479 BCE. The memory of the Persian sack of the Acropolis was still vivid, and the Athenians were intensely conscious that by driving back the Persians, they were saving their civilization from the eastern "barbarians" who had committed atrocities against the Greeks of Asia Minor. In fact, the Athena Parthenos had multiple allusions to the Persian defeat. On the thick soles of Athena's sandals was a representation of a centauromachy, a battle between Greeks and centaurs (mythological beasts that were part man, part horse). The exterior of her shield was emblazoned with high reliefs depicting the battle of Greeks and Amazons (Amazonomachy), in which Theseus drove the Amazons (female warriors) out of Athens. And Phidias painted a gigantomachy on the shield's interior. Each of these mythological contests was a metaphor for the triumph of order over chaos, of civilization over barbarism, and of Athens over Persia.

Centaurs and Persians These same themes were taken up again in the Parthenon's Doric metopes (Fig. 2-34). The south metopes are the best preserved. They depict the battle of Lapiths and centaurs, a combat in which Theseus of Athens played a major role. On one extraordinary slab (Fig. 2-35), a triumphant centaur rises up on its hind legs, exulting over the crumpled body of the Greek it has defeated. The relief is so high that parts are fully in the round; some have broken off. The sculptor knew how to distinguish the vibrant, powerful form of the living beast from the lifeless corpse on the ground. In other metopes the Greeks have the upper hand, but the full set suggests that the battle was a difficult one against a dangerous

enemy and that losses as well as victories occurred. The same was true of the war against the Persians.

The Birth of Athena The subjects of the two pediments were especially appropriate for a temple that celebrated the Athenians as well as the goddess Athena. The east pediment depicted the birth of Athena. At the west was the contest between Athena and Poseidon to determine which one would become the city's patron deity. Athena won, giving her name to the city and its people. It is significant that in the story and in the pediment the Athenians are the judges of the relative merits of the two gods. Here one sees the same arrogance that led to the use of Delian League funds to adorn the Acropolis.

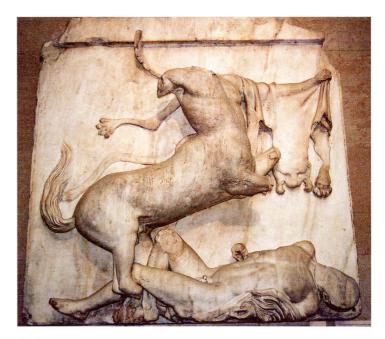

2-35 | Lapith versus centaur, metope from the south side of the Parthenon, Acropolis, Athens, Greece, ca. 447–438 BCE. Marble, approx. 4' 8" high. British Museum, London.

The Parthenon's centauromachy metopes alluded to the Greek defeat of the Persians. The sculptor of this metope knew how to distinguish the vibrant living centaur from the lifeless Greek corpse.

2-36 | Helios and his horses, and Dionysos (Herakles?), from the east pediment of the Parthenon, Acropolis, Athens, Greece, ca. 438–432 BCE. Marble, greatest height approx. 4′ 3″. British Museum, London.

The east pediment of the Parthenon depicts the birth of Athena. At the left, the horses of Helios (the Sun) emerge from the pediment's floor, suggesting the sun rising above the horizon at dawn.

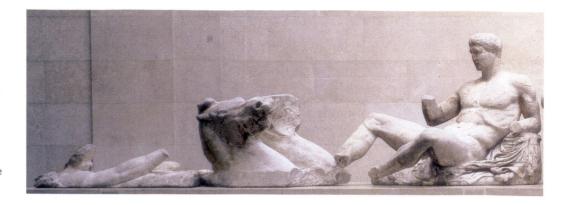

2-37 | Three goddesses (Hestia, Dione, and Aphrodite?), from the east pediment of the Parthenon, Acropolis, Athens, Greece, ca. 438–432 BCE. Marble, greatest height approx. 4' 5". British Museum, London.

The statues of Hestia, Dione, and Aphrodite conform perfectly to the sloping right side of the Parthenon's east pediment. The thin and heavy folds of the garments alternately reveal and conceal the body forms.

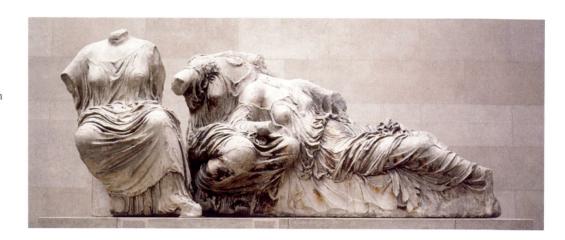

All that remains of the pediment's statues are the spectators to the left and the right who witnessed Athena's birth on Mount Olympus. At the far left are the head and arms of Helios (the sun) and his chariot horses rising from the pediment floor (Fig. 2-36). Next to them is a powerful male figure usually identified as Dionysos or possibly Herakles, who entered the realm of the gods after he completed 12 impossible labors. At the right are three goddesses, probably Hestia, Dione, and Aphrodite (Fig. 2-37), and either Selene (the moon) or Nyx (night) and more horses, this time sinking below the pediment's floor. Here, Phidias discovered an entirely new way to deal with the awkward triangular frame of the pediment. Its bottom line is the horizon line, and charioteers and their horses move through it effortlessly.

Phidias and his assistants were master sculptors. They fully understood not only the surface appearance of human anatomy, both male and female, but also the mechanics of how muscles and bones make the body move. They mastered the rendition of clothed forms too. In the Dione-Aphrodite group, the thin and heavy folds of the garments alternately reveal and conceal the main and lesser body masses while swirling in a compositional tide that subtly unifies the two figures. The articulation and integration of the bodies produce a wonderful variation of surface and play of light and shade. Moreover, all the figures, even the animals, are brilliantly characterized. The horses of the sun, at the beginning of the day, are energetic. Those of the moon or night, having labored until dawn, are weary.

Athenians on the Parthenon In many ways the most remarkable part of the Parthenon's sculptural program is the inner Ionic frieze (Fig. 2-38). Scholars still debate the subject of the frieze, but most agree that what is represented is the Panathenaic Festival procession that took place every four years in Athens. The procession began at the Dipylon Gate to the city and ended on the Acropolis, where a new peplos was placed on an ancient wooden statue of Athena. That statue (probably similar in general appearance to the Lady of Auxerre, Fig. 2-14) was housed in the Archaic temple razed by the Persians. (The statue survived because it had been removed from the Acropolis on the eve of the Persian attack.) On the Parthenon frieze the procession begins on the west, that is, at the temple's rear, the side facing the gateway to the Acropolis. It then proceeds in parallel lines down the long north and south sides of the building and ends at the center of the east frieze, over the doorway to the cella housing Phidias's statue. The upper part of the relief is higher than the lower part so that the more distant and more shaded upper zone is as legible from the ground as the lower part of the frieze. This is another instance of the architects' taking optical effects into consideration in the Parthenon's design.

The frieze vividly communicates the procession's acceleration and deceleration. At the outset, on the west side, marshals gather and youths mount their horses. On the north (Fig. 2-38, *top*) and south, the momentum of the cavalcade picks up. On the east, the procession slows to a halt (Fig.

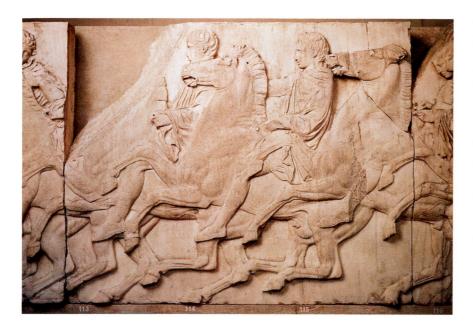

2-38 | Details of the Panathenaic Festival procession frieze, from the Parthenon, Acropolis, Athens, Greece, ca. 447–438 BCE. Marble, approx. 3' 6" high. Horsemen of north frieze (top), British Museum, London; elders and maidens of east frieze (bottom), Louvre, Paris.

The Ionic frieze of the Parthenon represents the festival procession of citizens on horseback and on foot that took place every four years. The temple celebrated the mortal Athenians as much as the goddess Athena.

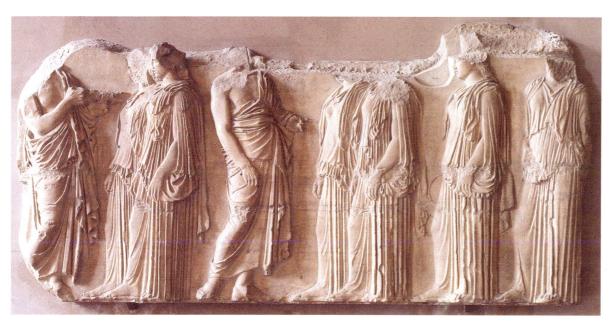

2-38, bottom) in the presence of seated gods and goddesses, the invited guests. The role assigned to the Olympian deities is extraordinary. They do not take part in the festival or determine its outcome but are merely spectators. They watch the Athenian people, the new masters of a new Aegean empire who consider themselves worthy of depiction on a temple. The Parthenon celebrated the greatness of Athens and the Athenians as much as it honored Athena.

Erechtheion: Multiple Shrine In 421 BCE work finally began on the temple that was to replace the Archaic Athena temple the Persians had razed. The new structure, the Erechtheion (Fig. 2-39), built to the north of the old temple's remains, was, however, to be a multiple shrine. It honored Athena and housed the ancient wooden image of the goddess that was the goal of the Panathenaic Festival procession. But it also incorporated shrines to a host of other gods and

demigods who loomed large in the city's legendary past. Among these were Erechtheus, an early king of Athens, during whose reign the ancient wooden idol of Athena was said to have fallen from the heavens, and Kekrops, another king of Athens, who served as judge of the contest between Athena and Poseidon. In fact, the site chosen for the new temple was the very spot where that contest occurred. Poseidon had staked his claim to Athens by striking the Acropolis rock with his trident and producing a salt-water spring. Nearby, Athena had miraculously caused an olive tree to grow.

The asymmetrical plan of the Ionic Erechtheion is unique for a Greek temple and the antithesis of the simple and harmoniously balanced plan of the Doric Parthenon across the way. Its irregular form reflected the need to incorporate the tomb of Kekrops and other preexisting shrines, Poseidon's trident mark, and Athena's olive tree into a single complex. The unknown architect responsible for the building also had to

2-39 | Erechtheion (view from the southeast), Acropolis, Athens, Greece, ca. 421–405 BCE.

The asymmetrical form of the Erechtheion is unique for a Greek temple. It reflects the need to incorporate preexisting shrines into the plan. The decorative details are perhaps the finest in Greek architecture.

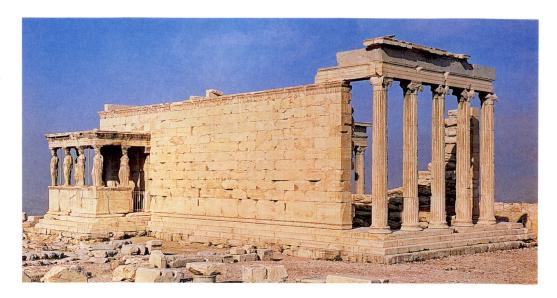

struggle with the problem of uneven terrain. The area could not be made level by terracing because that would disturb the ancient sacred sites. As a result, the Erechtheion has four sides of very different character, and each side also rests on a different ground level.

Perhaps to compensate for the awkward character of the building as a whole, the architect took great care with the Erechtheion's decorative details. The frieze, for example, was given special treatment. The stone chosen was the dark-blue limestone of Eleusis to contrast with the white Pentelic marble of the walls and columns. Marble relief figures were attached to this dark ground. The temple's most striking and famous feature, however, is its south porch, where caryatids replaced Ionic columns. Although the caryatids exhibit the weight shift that was standard for Phidian-era statues, their role as architectural supports is underscored by the vertical flutelike drapery folds concealing their stiff, weight-bearing legs. The Classical architect-sculptor successfully balanced the dual and contradictory functions of these female statue-columns. The figures have enough rigidity to suggest the structural column and just the degree of flexibility needed to suggest the living body.

Athena, Bringer of Victory Another Ionic building on the Athenian Acropolis is the little Temple of Athena Nike (Fig. 2-40), designed by Kallikrates, who worked with Iktinos on the Parthenon. It stands on what used to be a Mycenaean bastion and greets all visitors entering Athena's great sanctuary. As on the Parthenon, here the Athenians also recalled the victory over the Persians—and not just in the temple's name. Part of its frieze was devoted to a representation of the decisive battle at Marathon that turned the tide against the Persians—a human event, as in the Parthenon's Panathenaic Festival procession frieze. But now the sculptors chronicled a specific occasion, not a recurring event acted out by anonymous citizens.

Around the building, at the bastion's edge, a *parapet* was built about 410 BCE and decorated with reliefs. The theme of the *balustrade* matched that of the temple proper—Nike (victory).

Her image was repeated dozens of times, always in different attitudes, sometimes erecting trophies bedecked with Persian spoils and sometimes bringing forward sacrificial bulls to Athena. One of the reliefs (Fig. 2-41) shows Nike adjusting her sandal—an awkward posture rendered elegant and graceful. The sculptor carried the style of the Parthenon pediments (Fig. 2-37) even further and created a figure whose garments cling so tightly to the body that they seem almost transparent, as if drenched with water. But the drapery folds form intricate linear patterns unrelated to the body's anatomical structure and have a life of their own as abstract designs. Deep carving produced

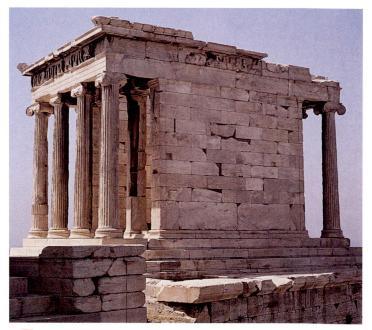

2-40 | Kallikrates, Temple of Athena Nike (view from the northeast), Acropolis, Athens, Greece, ca. 427–424 BCE.

The little temple at the entrance to the Acropolis is a splendid example of Ionic architecture. It celebrated Athena as bringer of victory, and one of its friezes depicts the Persian defeat at Marathon.

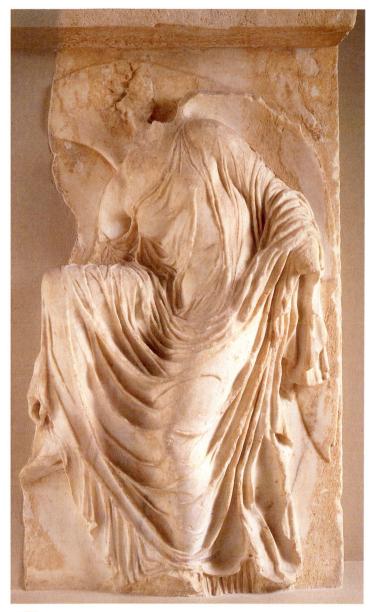

2-41 Nike adjusting her sandal, from the south side of the parapet of the Temple of Athena Nike, Acropolis, Athens, Greece, ca. 410 BCE. Marble, approx. 3′ 6″ high. Acropolis Museum, Athens.

The image of winged Victory was repeated dozens of times on the parapet around the Athena Nike temple. Here, the sculptor carved a figure whose garments appear almost transparent.

pockets of shade to contrast with the polished marble surface and enhance the ornamental beauty of the design.

Remembering a Woman Decorating temples was not the only job available to sculptors in fifth-century BCE Athens. Around 400 BCE, a grave stele (Fig. 2-42) was set up in the Dipylon cemetery in memory of a woman named Hegeso, daughter of Proxenos. Both names are inscribed on the monument. Hegeso is the well-dressed woman seated on an elegant chair (with footstool). She examines a piece of jewelry (once rendered in paint, not now visible) she has selected from a box a servant girl brings to her. The maid's simple ungirt

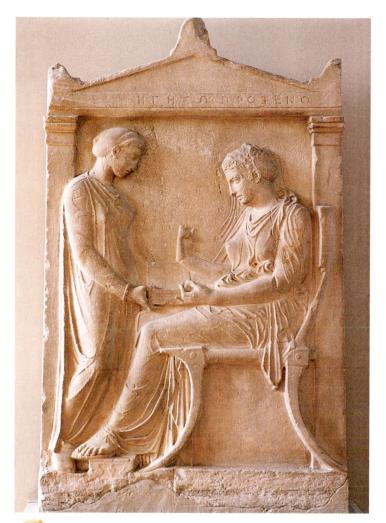

2-42 | Grave stele of Hegeso, from the Dipylon cemetery, Athens, Greece, ca. 400 BCE. Marble, 5' 2" high. National Archaeological Museum, Athens.

On her tombstone, Hegeso examines a piece of jewelry from a box her servant girl holds. Mistress and maid share a serene moment out of daily life. Only the epitaph reveals that Hegeso is the one who has died.

chiton contrasts sharply with the more elaborate attire of her mistress. The garments of both women reveal the body forms beneath them, as on the parapet reliefs of the Athena Nike temple. The faces are serene, without a trace of sadness. Indeed, both mistress and maid are shown in a characteristic shared moment out of daily life. Only the epitaph reveals that Hegeso is the one who has departed.

The simplicity of the scene on the Hegeso stele is deceptive, however. This is not merely a bittersweet scene of tranquil domestic life before an untimely death. The setting itself is significant—the secluded women's quarters of a Greek house, from which Hegeso rarely would have emerged. Contemporaneous grave stelae of men regularly show them in the public domain, as warriors. And the servant girl is not so much the faithful companion of the deceased in life as she is Hegeso's possession, like the jewelry box. The slave girl may look solicitously at her mistress, but Hegeso has eyes only for her ornaments. Both slave and jewelry attest to the wealth of

Hegeso's father, unseen but prominently cited in the epitaph. (It is noteworthy that the mother's name is not mentioned.) Indeed, even the jewelry box carries a deeper significance, for it probably represents the dowry Proxenos would have provided to his daughter's husband when she left her father's home to enter that of her husband. In the patriarchal society of ancient Greece, the dominant position of men is manifest even when only women are depicted.

Polychromy in Vase Painting Because they were painted on wooden panels, all the masterpieces of Classical painting celebrated in ancient literature are lost, but researchers know that they were polychrome. The so-called ACHILLES PAINTER was able to emulate the polychromy of monumental panels by using the *white-ground painting* technique for a *lekythos* (flask containing perfumed oil; Fig. 2-43) he painted about 440 BCE. White-ground painting takes its name from the chalky-white *slip* (liquefied clay) used to provide a background for the figures. Experiments with white-ground painting date back to the late sixth century, but the method became popular only toward the middle of the fifth century.

White-ground is essentially a variation of the red-figure technique. First the painter covered the pot with a slip of very fine white clay, then applied black glaze to outline the figures, and diluted brown, purple, red, and white to color them. Other colors—for example, the yellow chosen for the garments of both figures on our lekythos-also could be employed, but these had to be applied after firing because the Greeks did not know how to make them withstand the intense heat of the kiln. Despite the obvious attractions of the white-ground technique, the impermanence of the expanded range of colors discouraged its use for everyday vessels, such as amphoras and kraters. In fact, the full polychrome possibilities of white-ground painting were explored almost exclusively on lekythoi, which were commonly placed in Greek graves as offerings to the deceased. For such vessels designed for short-term use, the fragile nature of the white-ground technique was of little concern.

The Achilles Painter's lekythos (Fig. 2-43) is decorated with a scene appropriate for its funerary purpose. A youthful warrior takes leave of his wife. The red scarf, mirror, and jug hanging on the wall behind the woman indicate that the setting is the interior of their home. The motif of the seated woman is strikingly similar to that of Hegeso on her grave stele (FIG. 2-42), but here the woman is the survivor. It is her husband, preparing to go to war, who will depart, never to return. On his shield is a large painted eye, roughly life-size. Greek shields often were decorated with devices such as the horrific face of Medusa, intended to ward off evil spirits and frighten the enemy. This eye undoubtedly was meant to recall this tradition, but it was little more than an excuse for the Achilles Painter to display superior drawing skills. Since the late sixth century BCE, Greek painters had abandoned the Archaic habit of placing frontal eyes on profile faces and attempted to render the eyes in profile. The Achilles Painter's mastery of this difficult problem in foreshortening is on exhibit here.

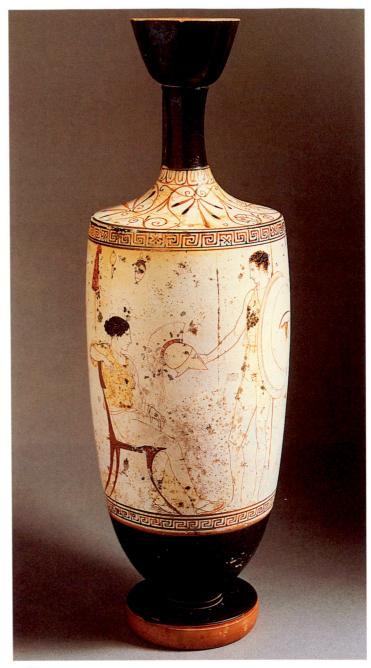

2-43 | ACHILLES PAINTER, Warrior taking leave of his wife (white-ground lekythos), from Eretria, Greece, ca. 440 BCE. Approx. 1' 5" high. National Archaeological Museum, Athens.

White-ground painters applied the colors after firing because most colored glazes could not withstand the kiln's heat. The Achilles Painter here displays his mastery at drawing an eye in profile.

Late Classical Art

The Peloponnesian War, which began in 431 BCE, ended in 404 BCE with the complete defeat of a plague-weakened Athens, and left Greece drained of its strength. The victor, Sparta, and then Thebes undertook the leadership of Greece, both unsuccessfully. In the middle of the fourth century BCE, a threat from without caused the rival Greek states to put aside

their animosities and unite for their common defense, as they had earlier against the Persians. But at the battle of Chaeronea in 338 BCE, the Greek cities suffered a devastating loss and had to relinquish their independence to Philip II, king of Macedon. Philip was assassinated in 336, and his son, Alexander III ("the Great") succeeded him. In the decade before his death in 323, Alexander led a powerful army on an extraordinary campaign that overthrew the Persian Empire (the ultimate revenge for the Persian invasion of Greece), wrested control of Egypt, and even reached India.

New Directions in Art The fourth century BCE was thus a time of political upheaval in Greece, and the chaos had a profound impact on the psyche of the Greeks and on the art they produced. In the fifth century, Greeks had generally believed that rational human beings could impose order on their environment, create "perfect" statues such as the Canon (Fig. 2-31), and discover the "correct" mathematical formulas for constructing temples such as the Parthenon (Fig. 2-33). The Parthenon frieze (Fig. 2-38) celebrated the Athenians as a community of citizens with shared values. The Peloponnesian War and the unceasing strife of the fourth century brought an end to the serene idealism of the fifth century. Disillusionment and alienation followed. Greek thought and Greek art began to focus more on the individual and on the real world of appearances rather than on the community and the ideal world of perfect beings and perfect buildings.

Humanizing the Gods The new approach to art is immediately apparent in the work of PRAXITELES, one of the great masters of the Late Classical period (ca. 400–323 BCE). Praxiteles did not reject the themes favored by High Classical sculptors. His Olympian gods and goddesses retained their superhuman beauty, but in his hands they lost some of their solemn grandeur and took on a worldly sensuousness.

Nowhere is this new humanizing spirit plainer than in the statue of Aphrodite (Fig. 2-44) that Praxiteles sold to the Knidians after another city had rejected it. The lost marble original is known only through copies of Roman date, but Pliny considered it "superior to all the works, not only of Praxiteles, but indeed in the whole world." The statue made Knidos famous, and Pliny reported that many people sailed there just to see it. The Aphrodite of Knidos caused such a sensation in its time because Praxiteles took the unprecedented step of representing the goddess of love completely nude. Female nudity was rare in earlier Greek art and had been confined almost exclusively to paintings on vases designed for household use. The women so depicted also tended to be courtesans or slave girls, not noblewomen or goddesses, and no one had dared fashion a life-size statue of a goddess without her clothes. Moreover, Praxiteles' Aphrodite is not a cold and remote image. In fact, the goddess engages in a trivial act out of everyday life. She has removed her garment, draped it over a large hydria (water pitcher), and is about to step into the bath.

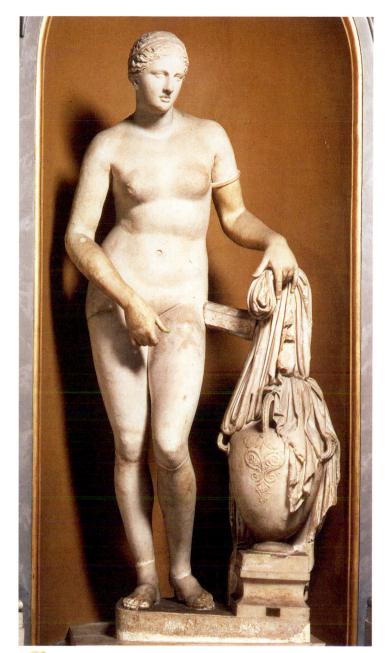

2-44 | PRAXITELES, *Aphrodite of Knidos*. Roman copy after an original of ca. 350–340 BCE. Marble, approx. 6' 8" high. Musei Vaticani, Rome.

The first nude statue of a goddess caused a sensation in the fourth century BCE. But Praxiteles was also famous for his ability to transform marble into soft and radiant flesh. His Aphrodite had "dewy eyes."

Praxitelean Sensuality Although shocking in its day, the *Aphrodite of Knidos* is not openly erotic (the goddess modestly shields her pelvis with her right hand), but she is quite sensuous. Lucian, writing in the second century CE, noted that she had a "welcoming look" and a "slight smile" and that Praxiteles was renowned for his ability to transform marble into soft and radiant flesh. Lucian mentions, for example, the "dewy quality of Aphrodite's eyes." Unfortunately, the rather mechanical Roman copies do not capture the quality of Praxiteles' modeling of the stone, but one can

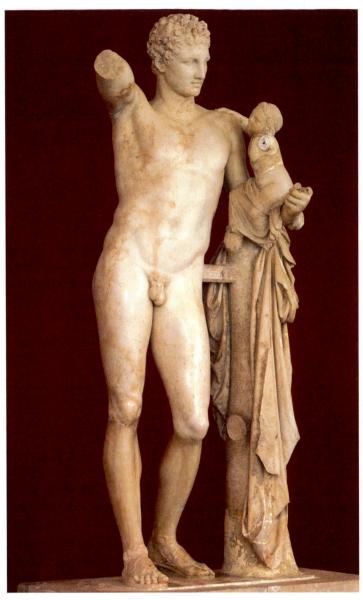

2-45 | PRAXITELES, Hermes and the infant Dionysos, from the Temple of Hera, Olympia, Greece. Copy after an original of ca. 340 BCE. Marble, approx. 7' 1" high. Archaeological Museum, Olympia.

Praxiteles' Hermes is as sensuous as his Aphrodite. The god looks off dreamily into space while he dangles a bunch of grapes as temptation for the infant wine god. Praxiteles humanized the deities of Mount Olympus.

imagine the "look" of the *Aphrodite of Knidos* from a statue once thought to be by the hand of the master himself but now generally considered a copy of the highest quality. In the statue of Hermes and the infant Dionysos (Fig. 2-45) found in the Temple of Hera at Olympia, Praxiteles depicted Hermes resting in a forest during his journey to deliver Dionysos to the *satyr* Papposilenos and the nymphs, who were entrusted with raising the child. Hermes leans on a tree trunk (here it is an integral part of the composition and not the copyist's addition), and his slender body forms a sinuous, shallow S-curve that is the hallmark of many of Praxiteles' statues. He looks off dreamily into space while he dangles a bunch of grapes (now missing) as a temptation for the infant who is to become

the Greek god of the vine. This is the kind of tender and very human interaction between an adult and a child that one encounters frequently in real life but that had been absent from Greek statuary before the fourth century BCE.

The superb quality of the carving appears to be faithful to the Praxitelean original. The modeling is deliberately smooth and subtle, producing soft shadows that follow the planes as they flow almost imperceptibly one into another. The delicacy of the marble facial features stands in sharp contrast to the metallic precision of Polykleitos's bronze *Doryphoros* (Fig. 2-31). Even the spear bearer's locks of hair were subjected to the High Classical sculptor's laws of symmetry and do not violate the skull's perfect curve. One need only compare these two statues to see how broad a change in artistic attitude and intent took place from the mid-fifth to the mid-fourth century BCE. Sensuous languor and an order of beauty that appeals more to the eye than to the mind replaced majestic strength and rationalizing design. In the statues of Praxiteles, the deities of Mount Olympus still possess a beauty mortals can aspire to, although

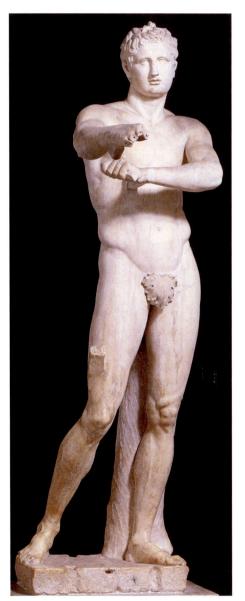

2-46 | Lysippos, Apoxyomenos (Scraper). Roman copy after a bronze original of ca. 330 BCE. Marble, approx. 6' 9" high. Musei Vaticani, Rome.

Lysippos introduced a new canon of proportions and a nervous energy to his statues. He also began to break down the dominance of the frontal view and encouraged looking at his statues from multiple angles.

not achieve, but they are no longer awesome and remote. Praxiteles' gods have stepped off their High Classical pedestals and entered the Late Classical world of human experience.

Lysippos and a New Canon As renowned in his day as Praxiteles was Lysippos, whom Alexander the Great selected to create his official portrait. (Alexander could afford to employ the best. His father, Philip II, hired the leading thinker of his age, Aristotle, as the young Alexander's tutor!) Lysippos introduced a new canon of proportions in which the bodies were more slender than those of Polykleitos—whose own canon continued to exert enormous influence—and the heads roughly one-eighth the height of the body rather than oneseventh, as in the previous century. The new proportions may be seen in one of Lysippos's most famous works, a bronze statue of an apoxyomenos (an athlete scraping oil from his body after exercising), known, as usual, only from Roman copies in marble (Fig. 2-46). A comparison with Polykleitos's Doryphoros (Fig. 2-31) reveals more than a change in physique. A nervous energy runs through the Apoxyomenos that one seeks in vain in the balanced form of the Doryphoros. The strigil (scraper) is about to reach the end of the right arm, and at any moment the athlete will switch it to the other hand so that he can scrape his left arm. At the same time, he will shift his weight and reverse the positions of his legs. Lysippos rejected stability and balance as worthy goals for statuary. He also began to break down the dominance of the frontal view in freestanding sculpture and encouraged the observer to look at his statues from multiple angles. Because Lysippos represented the apoxyomenos with his right arm boldly thrust forward, the figure breaks out of the shallow rectangular box that defined the boundaries of earlier statues. To comprehend the action, the observer must move to the side and view the work at a three-quarter angle or in full profile.

Alexander at Issus The life of Alexander the Great was very much like an epic saga, full of heroic battles, exotic places, and unceasing drama. Alexander was a man of singular character, an inspired leader with boundless energy and an almost foolhardy courage, who always personally led his army into battle. A Roman mosaic captures the extraordinary character of the Macedonian king. It also provides a welcome glimpse of Greek monumental painting during Alexander's time. In the Alexander Mosaic (Fig. 2-47), as it is usually called, the mosaicist employed tesserae (tiny stones or pieces of glass cut to the desired size and shape) to "paint" what art historians believe is a reasonably faithful copy of a famous panel painting of around 310 BCE by PHILOXENOS OF ERETRIA. The subject is a great battle between Alexander the Great and the Persian king Darius III, probably the battle of Issus in southeastern Turkey, which Darius fled in humiliating defeat.

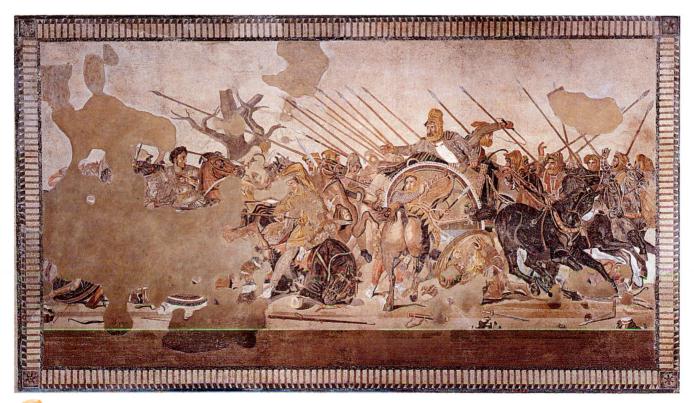

2-47 | PHILOXENOS OF ERETRIA, *Battle of Issus*, ca. 310 BCE. Roman copy (*Alexander Mosaic*) from the House of the Faun, Pompeii, Italy, late second or early first century BCE. Tessera mosaic, approx. 8′ 10″ × 16′ 9″. Museo Archeologico Nazionale, Naples.

Philoxenos here reveals his mastery of foreshortening, modeling in color, and depicting reflections and shadows. Most impressive, however, is the psychological intensity of the confrontation between Alexander and Darius.

POLYKLEITOS THE YOUNGER, Theater, Epidauros, Greece, ca. 350 BCE.

Greek theaters were always situated on hillsides, which supported the cavea of stone seats overlooking the circular orchestra. The Epidauros theater is the finest in Greece. It accommodated 12.000 spectators.

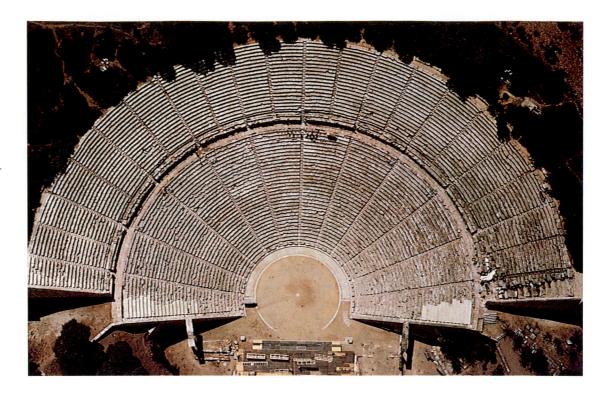

Philoxenos's painting is notable for its technical mastery of problems that had long fascinated Greek painters. Even Euthymides (Fig. 2-23) would have marveled at the rearing horse seen in a three-quarter rear view below Darius. And the subtle modulation of the horse's rump through shading in browns and yellows goes far beyond anything even a whiteground vase painter ever attempted. Other details are even more impressive. The Persian to the right of the rearing horse has fallen to the ground and raises, backwards, a dropped Macedonian shield to protect himself from being trampled. Philoxenos recorded the reflection of the man's terrified face on the polished surface of the shield. Everywhere men, animals, and weapons cast shadows on the ground. Philoxenos and other Classical painters' interest in the reflection of insubstantial light on a shiny surface, and in the absence of light (shadows), was far removed from earlier painters' preoccupation with the clear presentation of weighty figures seen against a blank background. The Greek painter here truly opened a window into a world filled not only with figures, trees, and sky but also with light.

Most impressive about *Battle of Issus*, however, is the psychological intensity of the drama unfolding before the viewer's eyes. Alexander leads his army into battle without even a helmet to protect him. He drives his spear through one of Darius's bodyguards while the Persian's horse collapses beneath him. Alexander is only a few yards away from Darius, and he directs his gaze at the king, not at the man impaled on his now-useless spear. Darius has called for retreat. In fact, his charioteer is already whipping the horses and speeding the king to safety. Before he escapes, Darius looks back at Alexander and in a pathetic gesture reaches out toward his

brash foe. But the victory has slipped out of his hands. Pliny says Philoxenos's painting of the battle between Alexander and Darius was "inferior to none." 5

Greek Theaters In ancient Greece, plays were not performed repeatedly over months or years as they are today, but only once, during sacred festivals. Greek drama was closely associated with religious rites and was not pure entertainment. At Athens, for example, the great tragedies of Aeschylus, Sophocles, and Euripides were performed in the fifth century BCE at the Dionysos festival in the theater dedicated to the god on the southern slope of the Acropolis. The finest theater in Greece, however, is at Epidauros (FIG. 2-48). The architect was POLYKLEITOS THE YOUNGER, possibly a nephew of the great fifth-century sculptor.

The precursor of the formal Greek theater was a place where ancient rites, songs, and dances were performed. This circular piece of earth with a hard and level surface later became the orchestra of the theater. Orchestra literally means "dancing place." The actors and the chorus performed there, and at Epidauros an altar to Dionysos stood at the center of the circle. The spectators sat on a slope overlooking the orchestra—the theatron, or "place for seeing." When the Greek theater took architectural shape, the auditorium (cavea, Latin for "hollow place, cavity") was always situated on a hillside. The cavea at Epidauros, composed of wedge-shaped sections of stone benches separated by stairs, is somewhat greater than a semicircle in plan. The auditorium is 387 feet in diameter, and its 55 rows of seats accommodated about 12,000 spectators. They entered the theater via a passageway between the seating area and the scene building (skene), which housed dressing rooms for the actors and also formed a backdrop for the plays. The design is simple but perfectly suited to its function. Even in antiquity the Epidauros theater was renowned for the harmony of its proportions. Although spectators sitting in some of the seats would have had a poor view of the skene, all had unobstructed views of the orchestra. Because of the excellent acoustics of the open-air cavea, everyone could hear the actors and chorus.

Hellenistic Art

Alexander the Great's conquest of the Near East, Egypt, and India ushered in a new cultural age. The *Hellenistic* period is traditionally reckoned from the death of Alexander in 323 BCE and lasted nearly three centuries, until 31 BCE, when Queen Cleopatra of Egypt and her Roman consort Mark Antony were decisively defeated at the battle of Actium by Antony's rival Augustus. A year later, Augustus made Egypt a province of the Roman Empire.

After Alexander's death, his generals divided his far-flung empire among themselves and established their own regional kingdoms. The cultural centers of the Hellenistic period were the court cities of these Greek kings—Antioch in Syria, Alexandria in Egypt, Pergamon in Asia Minor, and others. An international culture united the Hellenistic world, and its language was Greek. Hellenistic kings became enormously rich on the spoils of the East, priding themselves on their libraries, art collections, and scientific enterprises, as well as on the learned men they could assemble at their courts. The world of the small, austere, and heroic city-state passed away, as did the power and prestige of its center, Athens. A cosmopolitan (Greek, "citizen of the world") civilization, much like today's, replaced it.

Giants at Pergamon The kingdom of Pergamon, founded in the early third century BCE after the breakup of

Alexander's empire, embraced almost all of western and southern Asia Minor. The Pergamene kings enjoyed immense wealth, and much of it was expended on embellishing their capital city, especially its acropolis. The Altar of Zeus, erected about 175 BCE, is the most famous of all Hellenistic sculptural ensembles. The monument's west front (FIG. 2-49) has been reconstructed in Berlin. The altar proper was on an elevated platform and framed by an Ionic colonnade with projecting wings on either side of a broad central staircase.

All around the altar platform is a sculpted frieze almost 400 feet long, populated by about a hundred larger-than-life-size figures. The subject is the battle of Zeus and the gods against the giants. It is the most extensive representation Greek artists ever attempted of that epic conflict for control of the world. A similar subject appeared on the shield of Phidias's *Athena Parthenos* and on some of the Parthenon metopes, where the Athenians wished to draw a parallel between the defeat of the giants and the defeat of the Persians. The Pergamene king Attalos I (r. 241–197 BCE) had successfully turned back an invasion by the Gauls in Asia Minor. The gigantomachy of the Altar of Zeus alluded to his victory over those barbarians.

A deliberate connection was also made with Athens, whose earlier defeat of the Persians was by then legendary, and with the Parthenon, which already was recognized as a Classical monument—in both senses of the word. The figure of Athena (Fig. 2-50), for example, who grabs the hair of the giant Alkyoneos as Nike flies in to crown her, is a quotation of the Athena from the Parthenon's east pediment. But the Pergamene frieze is not a dry series of borrowed motifs. On the contrary, its tumultuous narrative has an emotional intensity that has no parallel in earlier monuments. The battle rages everywhere, even up and down the very steps one must ascend to reach Zeus's altar (Fig. 2-49). Violent movement, swirling draperies, and

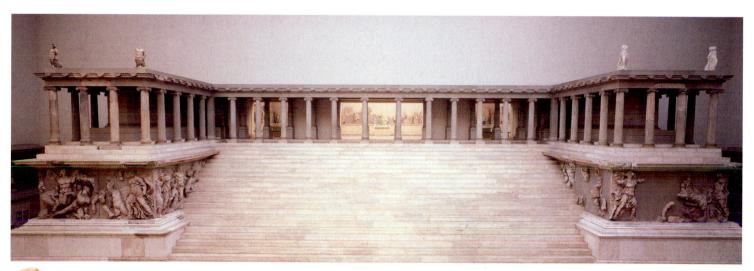

2-49 | Reconstructed west front of the Altar of Zeus, from Pergamon, Turkey, ca. 175 BCE. Staatliche Museen, Berlin.

The gigantomachy frieze of Pergamon's monumental altar to Zeus is almost 400 feet long. The battle of gods and giants here alluded to the victory of King Attalos I over the Gauls of Asia Minor.

2-50 | Athena battling Alkyoneos, detail of the gigantomachy frieze of the Altar of Zeus, Pergamon, Turkey, ca. 175 BCE. Marble, approx. 7' 6" high. Staatliche Museen, Berlin.

The tumultuous gigantomachy of the Pergamon altar has an emotional intensity unparalleled in earlier Greek art. Violent movement, swirling draperies, and vivid depictions of suffering fill the frieze.

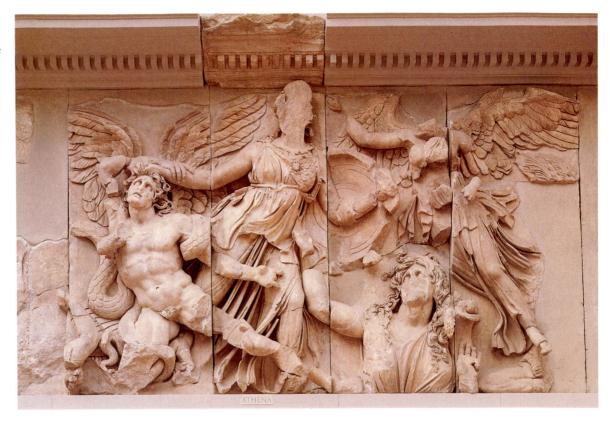

vivid depictions of death and suffering are the norm. Wounded figures writhe in pain, and their faces reveal their anguish. Deep carving creates dark shadows. The figures project from the background like bursts of light.

Nobility in Defeat The Altar of Zeus was not the only Pergamene monument to celebrate the victory of Attalos I over the Gauls. An earlier Pergamene statuary group had

explicitly represented the defeat of the barbarians, instead of cloaking it in mythological disguise. The Greek victors, however, were apparently not included in the group. The viewer saw only their Gallic foes and their noble and moving response to defeat. Roman copies of some of these figures survive, including a trumpeter who collapses on his large oval shield as blood pours out of the gash in his chest (Fig. 2-51). If this figure is the *tubicen* (trumpeter) Pliny mentions in

🥯 2-51 |

EPIGONOS(?), Dying Gaul. Roman copy after a bronze original from Pergamon, Turkey, ca. 230–220 BCE. Marble, approx. 3' ½" high. Museo Capitolino, Rome.

The defeat of the Gauls was also the subject of Pergamene statuary groups. The Gauls were shown as barbarians with bushy hair, mustaches, and neck bands, but they were also portrayed as noble foes.

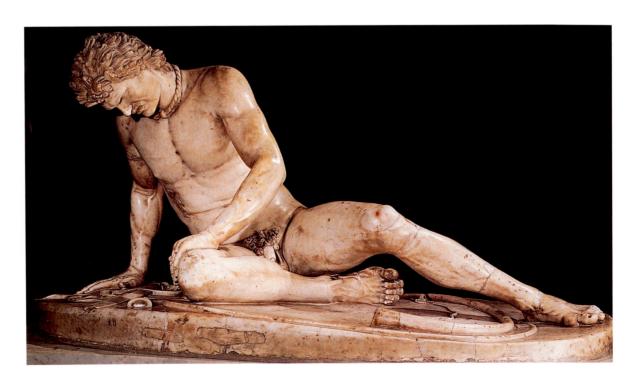

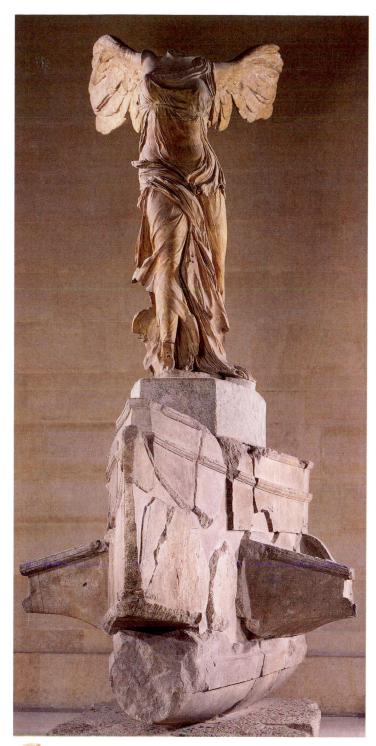

2-52 | Nike alighting on a warship (*Nike of Samothrace*), from Samothrace, Greece, ca. 190 BCE. Marble, figure approx. 8' 1" high. Louvre, Paris.

Victory has just landed on a prow to crown a victor at sea. Her wings still beat, and the wind sweeps her drapery. The dramatic visual effect was heightened by the statue's placement in a fountain of splashing water.

his *Natural History*, then the sculptor's name was EPIGONOS. In any case, the sculptor carefully studied and reproduced the distinctive features of the foreign Gauls, most notably their long, bushy hair and mustaches and the *torques* (neck bands) they frequently wore. Male anatomy was also closely

observed. Note the tautness of the fallen Gaul's chest and the bulging veins of his left leg. The trumpeter is reminiscent of the dying warrior from the east pediment of the Temple of Aphaia at Aegina (Fig. 2-27), but the suffering Gaul's pathos and drama are far more pronounced. Nonetheless, the sculptor depicted the fallen Gaul with sympathy. The enemy's powerful body implies that the unseen Greek hero who struck down this noble and savage foe must have been an extraordinary man.

Victory in a Fountain Another masterpiece of Hellenistic sculpture is the statue of Nike originally set up in the Sanctuary of the Great Gods on the island of Samothrace. The Nike of Samothrace (Fig. 2-52) has just alighted on the prow of a Greek warship. Her missing right arm was once raised high to crown the naval victor, just as Nike placed a wreath on Athena on the Altar of Zeus (Fig. 2-50). But the Pergamene relief figure seems calm by comparison. The Samothracian Nike's wings still beat, and the wind sweeps her drapery. Her himation bunches in thick folds around her right leg, and her chiton is pulled tightly across her abdomen and left leg. The statue's setting amplified its theatrical effect. The war galley was displayed in the upper basin of a two-tiered fountain. In the lower basin were large boulders. The fountain's flowing water created the illusion of rushing waves dashing up against the prow of the ship. The statue's reflection in the shimmering water below accentuated the sense of lightness and movement. The sound of splashing water added an aural dimension to the visual drama. In the Nike of Samothrace, art and nature were combined. The Hellenistic sculptor resoundingly rejected the Polykleitan conception of a statue as an ideally proportioned, self-contained entity on a bare pedestal. The Hellenistic statue interacts with its environment and appears as a living, breathing, and intensely emotive presence.

Hellenistic Eroticism In the fourth century BCE, Praxiteles had already taken bold steps in redefining the nature of Greek statuary. His influence on later sculptors was enormous. The undressing of Aphrodite, for example, became the norm, but Hellenistic sculptors went beyond Praxiteles and openly explored the eroticism of the nude female form. The Venus de Milo (Fig. 2-53) is a larger-than-life-size marble statue of Aphrodite found on Melos together with its inscribed base (now lost) signed by the sculptor, ALEXANDROS OF ANTIOCH-ON-THE-MEANDER. In this statue, the goddess of love is more modestly draped than the Aphrodite of Knidos (Fig. 2-44) but more overtly sexual. Her left hand (separately preserved) holds the apple the Trojan hero Paris awarded her when he judged her the most beautiful goddess. Her right hand may have lightly grasped the edge of her drapery near the left hip in a halfhearted attempt to keep it from slipping farther down her body. The sculptor intentionally designed the work to tease the spectator. By so doing he imbued his partially draped Aphrodite with a sexuality that is not present in Praxiteles' entirely nude image of the goddess.

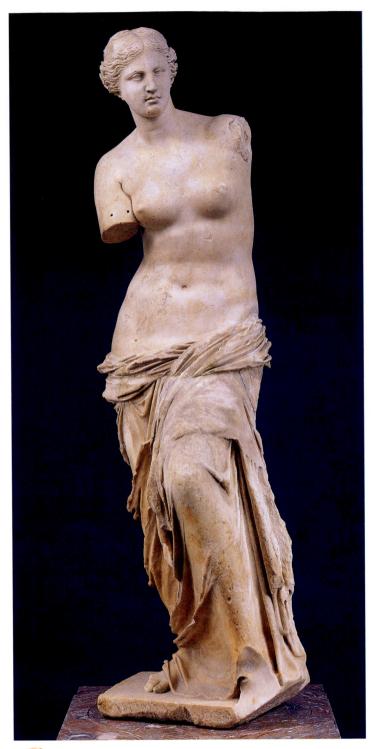

2-53 | ALEXANDROS OF ANTIOCH-ON-THE-MEANDER, Aphrodite (*Venus de Milo*), from Melos, Greece, ca. 150–125 BCE. Marble, approx. 6' 7" high. Louvre, Paris.

Displaying the eroticism of many Hellenistic statues, this Aphrodite is more overtly sexual than the Knidian Aphrodite (Fig. 2-44). To tease the spectator, the sculptor represented the goddess with a slipping garment.

The Aged and the Ugly Hellenistic sculpture stands in contrast to Classical sculpture in other ways too. Many Hellenistic sculptors were interested in exploring realism—the very opposite of the Classical period's idealism. This realistic mode is evident above all in Hellenistic statues of old men and

2-54 | Old market woman, ca. 150–100 BCE. Marble, approx. 4' $\frac{1}{2}$ " high. Metropolitan Museum of Art, New York (Rogers Fund, 1909).

Hellenistic art is sometimes brutally realistic. Many statues portray old men and women from the lowest rungs of society. They were never considered suitable subjects in the Archaic or Classical period.

women from the lowest rungs of the social order. Shepherds, fishermen, and drunken beggars are common—the kinds of people who were sometimes pictured on Archaic and Classical vases but were never before thought worthy of monumental statuary. One statue of this type (Fig. 2-54) depicts a

haggard old woman bringing chickens and a basket of fruits and vegetables to sell in the market. Her face is wrinkled, her body bent with age, and her spirit broken by a lifetime of poverty. She carries on because she must, not because she derives any pleasure from life. No one knows the purpose of such statues, but they attest to an interest in social realism absent in earlier Greek statuary. The Hellenistic world was a cosmopolitan place, and the highborn could not help but encounter the poor and a growing number of foreigners (non-Greek "barbarians") on a daily basis. Hellenistic art reflects this different social climate in the depiction of a much wider variety of physical types, including different ethnic types—for example, Gallic warriors with their shaggy hair, strange mustaches, and golden torques (Fig. 2-51).

Rome in Greece In the opening years of the second century BCE, the Roman general Flamininus defeated the Macedonian army and declared the old city-states of Classical Greece as free once again. They never regained their former glory, however. Greece became a Roman province in 146 BCE. When, 60 years later, Athens sided with King Mithridates VI

of Pontus (r. 120–63 BCE) in his war against Rome, the general Sulla crushed the Athenians. Thereafter, Athens retained some of its earlier prestige as a center of culture and learning, but politically it was just another city in the ever-expanding Roman Empire. Nonetheless, Greek artists continued to be in great demand, both to furnish the Romans with an endless stream of copies of Classical and Hellenistic masterpieces and to create new statues à *la grecque* for Roman patrons.

Laocoön's Agony The marble group of the Trojan priest Laocoön and his sons (Fig. 2-55) is such a work. Long believed to be an original of the second century BCE, it was found in the remains of the palace of the emperor Titus (r. 79–81 CE), exactly where Pliny had seen it in the late first century CE. Pliny attributed the statue to three sculptors—ATHANADOROS, HAGESANDROS, and POLYDOROS OF RHODES—who are now generally thought to have worked in the early first century CE. They probably based their group on a Hellenistic masterpiece depicting Laocoön and only one son. Their variation on the original added the son at Laocoön's left (note the greater compositional integration of the two other figures) to conform

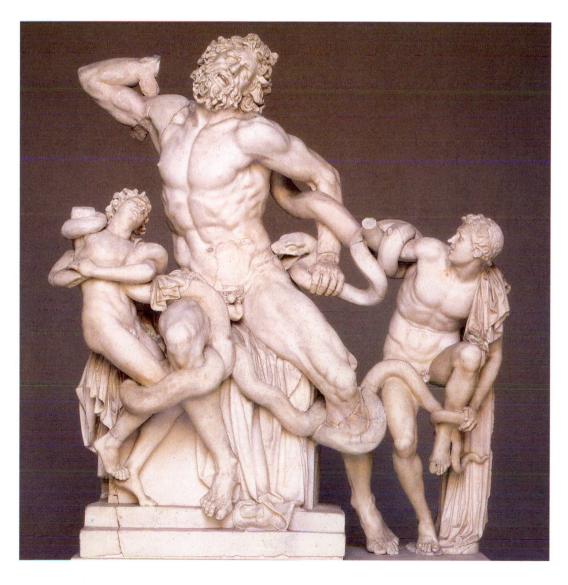

2-55 | ATHANADOROS, HAGESANDROS, and POLYDOROS OF RHODES, Laocoön and his sons, from Rome, Italy, early first century CE. Marble, approx. $7' 10\frac{1}{2}''$ high. Musei Vaticani, Rome.

Hellenistic style lived on in Rome. Although stylistically akin to Pergamene sculpture (Fig. 2-50), this statue of sea serpents attacking Laocoön and his two sons matches the account given only in the *Aeneid*. with the Roman poet Vergil's account in the *Aeneid*. Vergil vividly described the strangling of Laocoön and his *two* sons by sea serpents while sacrificing at an altar. The gods who favored the Greeks in the war against Troy had sent the serpents to punish Laocoön, who had tried to warn his compatriots about the danger of bringing the Greeks' wooden horse within the walls of their city.

In Vergil's graphic account, Laocoön suffered in terrible agony, and the torment of the priest and his sons is communicated in a spectacular fashion in the marble group. The three Trojans writhe in pain as they struggle to free themselves from the death grip of the serpents. One bites into Laocoön's left hip as the priest lets out a ferocious cry. The serpent-entwined figures recall the suffering giants of the great frieze of the Altar of Zeus at Pergamon, and Laocoön himself is strikingly similar to Alkyoneos (Fig. 2-50), Athena's opponent. In fact, many scholars believe that a Pergamene statuary group of the second century BCE was the inspiration for the three Rhodian sculptors.

That the work seen by Pliny and displayed in the Vatican today was made for Romans rather than Greeks was confirmed in 1957 by the discovery of fragments of several Hellenisticstyle groups illustrating scenes from Homer's *Odyssey*. These sculptures were found in a grotto that served as the picturesque summer banquet hall of the seaside villa of the Roman emperor Tiberius (r. 14–37 CE) at Sperlonga, some 60 miles south of Rome. One of these groups is signed by the same three sculptors Pliny cited as the creators of the Laocoön group. At Tiberius's villa in Sperlonga and in Titus's palace in Rome, Hellenistic sculpture lived on long after Greece ceased to be a political force.

CONCLUSION

In Homer's time (eighth century BCE), the heyday of Aegean civilization was but a distant memory. The Minoans and Mycenaeans had assumed the stature of heroes from a lost golden age. Since the late 19th century, however, archaeologists have

been uncovering the remains of that heroic era. The ruins of Cretan palaces, with their open access and mural paintings of palace life and nature itself, attest to the prosperity—and security—of the Minoans. The citadels of Mycenae and Tiryns, with their fortified "Cyclopean" walls, paint a very different picture of Mycenaean society—constantly at war, whether against Troy, northern invaders, or each other. With the destruction of the Mycenaean palaces around 1200 BCE, Greece was plunged into a "Dark Age," when the arts of painting, carving, building, and even writing almost disappeared.

Monumental art and architecture reappeared in Greece shortly after the founding of a Greek trading post in the Nile delta in the seventh century BCE, and Egypt provided models for the historical Greeks' earliest stone sculptures and columnar temples. But in time the Greeks rejected the Egyptianinspired Archaic style and revolutionized the history of art. Greek painters formulated a new way of depicting human figures in space, and Greek sculptors introduced contrapposto into their statues. In the mid-fifth century BCE, Polykleitos developed a formula for the perfect statue in the belief that harmonious proportions produced beauty. Similarly, Iktinos and Kallikrates applied numerical ratios to the parts of buildings and constructed the ideal temple, the Parthenon.

In the aftermath of the Peloponnesian War, however, although still adhering to the philosophy that humanity was the "measure of all things," Greek artists began to focus more on the real world of appearances than on the ideal world of perfect beings. Late Classical and Hellenistic sculptors humanized the gods of Mount Olympus and expanded the range of subjects for monumental art to encompass the old, ugly, and foreign, as well as the young, beautiful, and Greek.

By the second century BCE, Greece had come under the sway of the Romans, and when Rome inherited the Pergamene kingdom in 133 BCE, it also became heir to the Greek artistic legacy. What Rome adopted from Greece it passed on to the medieval and modern worlds. If Greece was peculiarly the inventor of the European spirit, Rome was its propagator and amplifier.

		SOURCE SERVICE OF RESIDENCE SERVICES AND ADDRESS OF THE SE	
i.Y DIC	3000 BCE		
EARLY			Ž.
5	2000 BCE		
_		Palaces constructed on Crete, beginning ca. 2000 BCE	
MINOAN		■ Theran eruption, ca. 1628 BCE	
MIM	1	Mycenaeans at Knossos, ca. 1450–1400 BCE	
	1400 pcs		
Z	1400 BCE		
NAE			
MYCENAEAN			Snake Goddess,
Σ	1200 BCE		Knossos, ca. 1600 BCE
		Destruction of Mycenaean palaces, ca. 1200 BCE	
	900 BCE		
TRI		First Olympic Games, 776 BCE	
GEOMETRIC		■ Homer, active ca. 750–700 BCE	POPULATION OF THE WARREST PARTIES
GE	700 BCE		The same of the sa
	700 BCE	Crock trading post established at Neutratia Frunt as 650, 620 ass	
		I Greek trading post established at Naukratis, Egypt, ca. 650–630 BCE	
		Pythagoras of Samos, active ca. 530–500 BCE	
ARCHAIC		Aeschylus, 525–456 BCE	
		Democratic reforms of Kleisthenes, 507 BCE	Exekias, Achilles and Ajax,
		Persian Wars, 499–479 BCE	са. 540-530 все
	2	Sophocles, 496–406 BCE	
		Pericles, 490–429 BCE	
		Herodotus, ca. 485–425 BCE	
		■ Euripides, 485–406 BCE	
	480 BCE		
LY		■ Persians sack Athenian Acropolis, 480 BCE	
ARL		Socrates, 469–399 BCE	A STATE OF THE STA
EAR		■ Delian League treasury transferred to Athens, 454 BCE	THE PROPERTY OF THE PARTY OF TH
	450 BCE		
H	3	Peloponnesian War, 431–404 BCE	3 Iktinos and Kallikrates, Parthenon,
HIGASSI		■ Plato, 429-347 BCE	Athens, 447–438 BCE
ี่	400 BCE		
CAL		Aristotle, 384–322 BCE	
IC LATE HIGH CLASSICAL CLASSICAL		Alexander the Great, r. 336–323 BCE	
	323 BCE	* Meximiler the dieut, it. 550 SES SEE	
	JZJ BLE	L Grance becomes a Roman province 1/6 per	
HELLENISTIC		Greece becomes a Roman province, 146 BCE	
LEN	4	Attalos III wills Pergamene kingdom to Rome, 133 BCE	
HEL		■ Sulla sacks Athens, 86 BCE	
	31 BCE		
		■ Battle of Actium, 31 BCE	Line Andrew

Altar of Zeus, Pergamon, ca. 175 BCE

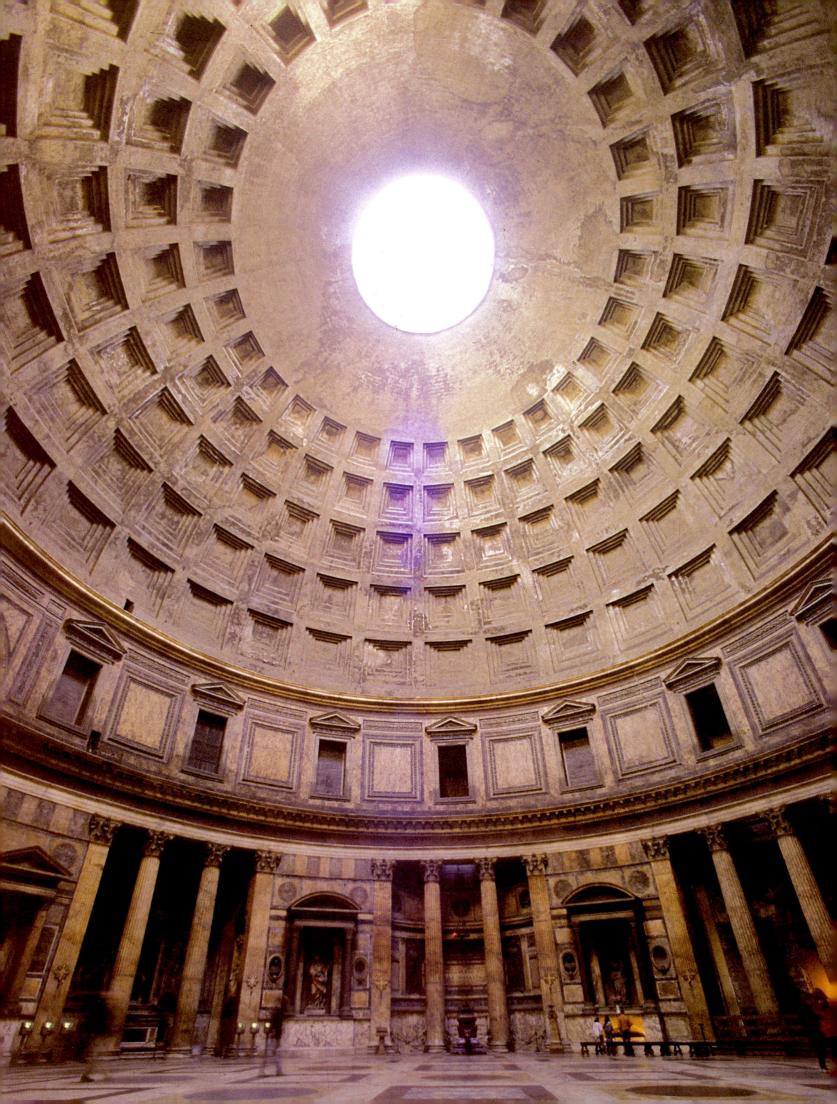

THE ROMAN EMPIRE

With the rise and triumph of Rome, a single government ruled, for the first (and last) time in human history, from the Tigris and Euphrates to the Thames and beyond, from the Nile to the Rhine and Danube (MAP 3-1, page 525). Roman monuments of art and architecture are the most conspicuous and numerous of all the remains of ancient civilization. But early in its history, the city that Romulus founded in 753 BCE was not the most powerful or the most sophisticated even in central Italy. In fact, in the sixth century BCE, the rulers of Rome were Etruscan kings.

ETRUSCAN ART

The heartland of the Etruscans was the territory between the Arno and Tiber rivers of central Italy. During the eighth and seventh centuries BCE, the Etruscans, as highly skilled seafarers, enriched themselves through trade abroad. By the sixth century BCE, they controlled most of northern and central Italy from such strongholds as Tarquinia, Cerveteri, Vulci, and Veii. But these cities never united to form a state. They coexisted, flourishing or fading independently. Any semblance of unity among them was based primarily on common linguistic ties and religious beliefs and practices. This lack of political cohesion eventually made the Etruscans relatively easy prey for the Romans.

Etruscan Temples In the sixth century BCE, the most innovative artists and architects in the Mediterranean were the Greeks (see Chapter 2). But however eager the Etruscans may have been to emulate Greek works, the vast majority of Archaic Etruscan artworks depart markedly from their Greek prototypes. This is especially true of religious architecture, where the design of Etruscan temples superficially owes much to Greece but where the differences far outweigh the similarities. Because of the materials Etruscan architects employed, usually only the foundations of Etruscan temples have survived. Supplementing the archaeological record, however, is the Roman architect Vitruvius's treatise on architecture written near the end of the first century BCE. In it, Vitruvius provided an invaluable chapter on Etruscan temple design.

The typical Archaic Etruscan temple (Fig. 3-1) resembled the Greek stone gable-roofed temple (Fig. 2-33), but it had wooden columns and a wooden roof, and its walls were of sun-dried brick. Entrance was via a narrow staircase at the center of the front of the temple, which sat on a high podium, the only part of the building made of stone. Columns also were restricted to the front of the building,

Interior of the Pantheon, Rome, Italy, 118–125 cc.

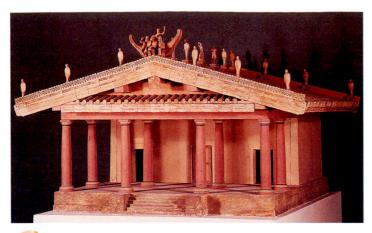

3-1 | Model of a typical Etruscan temple of the sixth century BCE, as described by Vitruvius. Istituto di Etruscologia e di Antichità Italiche, Università di Roma, Rome.

Etruscan temples resembled Greek temples, but they had widely spaced unfluted wooden columns only at the front, walls of sun-dried brick, and a narrow staircase at the center of the facade.

creating a deep porch that occupied roughly half the podium, setting off one side of the structure as the main side. In contrast, the front and rear of a Greek temple were indistinguishable, and steps and columns were placed on all sides. The Etruscan temple was not meant to be seen as a sculptural mass from the outside and from all directions, as the Greek temple was.

Etruscan temples differed in other ways from those of Greece. Etruscan columns (also called *Tuscan columns*) resembled Greek Doric columns, but they were made of wood, were unfluted, and had bases. Because of the lightness of the superstructure they had to support, Etruscan columns were, as a rule, much more widely spaced than Greek columns. Unlike their Greek counterparts, Etruscan temples frequently had three cellas—one for each of their chief gods, Tinia (Roman Jupiter/Greek Zeus), Uni (Juno/Hera), and Menrva (Minerva/Athena). And pedimental statuary was exceedingly rare in Etruria. The Etruscans normally placed narrative statuary—in *terracotta* instead of stone—on the peaks of their temple roofs.

An Epic Rooftop Contest The finest of these rooftop statues to survive today is the life-size image of Apulu (the Greco-Roman Apollo; Fig. 3-2), a brilliant example of the energy and excitement that characterizes Archaic Etruscan art in general. The statue is but one of a group of at least four painted terracotta figures that adorned the rooftop of a temple at Veii. The god confronts Hercle (Hercules/Herakles) for possession of the Ceryneian hind, a wondrous beast with golden horns that was sacred to Apulu's sister Artumes (Diana/Artemis). The bright paint and the rippling folds of Apulu's garment immediately distinguish the statue from the nude images of the Greek gods. Apulu's extraordinary force, huge swelling contours, plunging motion, gesticulating arms, fanlike calf muscles, and animated face are also distinctly Etruscan.

Dining in the Afterlife Also made of terracotta, the favored medium for life-size statuary in Etruria, is a *sarcophagus*

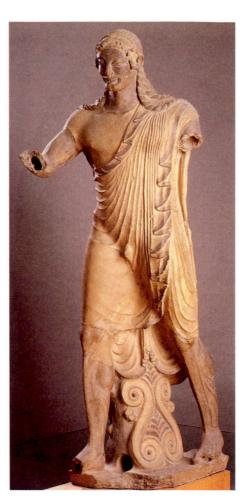

Apulu (Apollo), from the roof of the Portonaccio Temple, Veii, Italy, ca. 510–500 BCE. Painted terracotta, approx. 5' 11" high. Museo Nazionale di Villa Giulia, Rome.

This Apollo was part of a group depicting the Greek myth of the Ceryneian hind. Distinctly Etruscan, however, are the plunging motion and gesticulating arms and the placement of the statue on a temple roof.

(FIG. 3-3) in the form of a husband and wife reclining on a banqueting couch, from a tomb at Cerveteri. *Sarcophagus* literally means "flesh-eater," and most ancient sarcophagi contained the bodies of the deceased, but this one contained only ashes. Cremation was the most common means of disposing of the dead in Etruscan Italy. This kind of funerary monument had no parallel in Greece, which, at this date, had no monumental tombs to house such sarcophagi. The Greeks buried their dead in simple graves marked by a vase (Fig. 2-13), statue (Fig. 2-16), or stele (Fig. 2-42). Moreover, only men dined at Greek banquets. Their wives remained at home, excluded from most aspects of public life. The image of a husband and wife sharing the same banqueting couch is uniquely Etruscan.

The man and woman on the Cerveteri sarcophagus are as animated as the Veii Apulu (Fig. 3-2), even though they are at rest. They are the antithesis of the stiff and formal figures encountered in Egyptian tomb sculptures (Fig. 1-27). Also typically Etruscan, and in striking contrast to contemporaneous Greek statues with their emphasis on proportion and balance, is the manner in which the Etruscan sculptor rendered the upper and lower parts of each body. The legs were only summarily modeled, and the transition to the torso at the waist is unnatural. The artist's interest focused on the upper half of the figures, especially on the vibrant faces and gesticulating arms. The Cerveteri banqueters and the Veii Apulu speak to the viewer in a way that Greek statues of similar date never do.

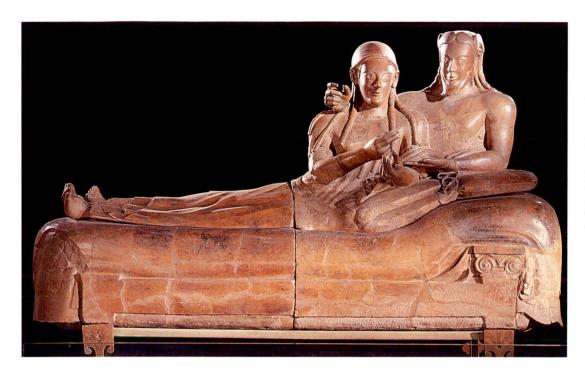

3-3 | Sarcophagus with reclining couple, from Cerveteri, Italy, ca. 520 BCE. Painted terracotta, approx. $3' 9\frac{1}{2}" \times 6' 7"$. Museo Nazionale di Villa Giulia, Rome.

Sarcophagi in the form of a husband and wife on a dining couch have no parallel in Greece. In this example, the artist's interest focused on the upper half of the figures and on their vibrant faces and emphatic gestures.

Houses for the Dead The exact findspot of the Cerveteri sarcophagus is not known, but the kind of tomb that housed such sarcophagi is well documented. The typical Cerveteri tomb took the form of a mound, or *tumulus*, not unlike the Mycenaean Treasury of Atreus (Fig. 2-10). But whereas the Mycenaean tholos tomb was constructed of masonry blocks and then covered by an earthen mound, each Etruscan tumulus covered one or more subterranean multichambered tombs cut out of the dark local limestone called tufa. These burial mounds sometimes reached colossal size, with diameters in excess of 130 feet. They were arranged in cemeteries in an orderly manner along a network of streets, producing the effect of veritable cities of the dead (which is

the literal meaning of the Greek word *necropolis*), always located some distance from the cities of the living. The very different values of the Etruscans and the Greeks are highlighted here. The Etruscans' temples no longer stand because they were constructed of wood and mud brick, but their grand underground tombs are as permanent as the bedrock itself. The Greeks employed stone for the shrines of their gods but only rarely built monumental tombs for their dead.

The most elaborately decorated of the Cerveteri tombs is the so-called Tomb of the Reliefs (Fig. 3-4), which housed the remains of several generations of a single family. The walls, ceiling beams, piers, and funerary couches of this tomb were, as in other Cerveteri tombs, gouged out of the tufa bedrock,

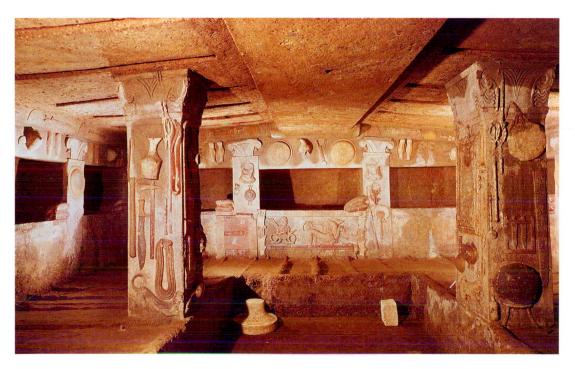

3-4 | Interior of the Tomb of the Reliefs, Cerveteri, Italy, third century BCE.

The Cerveteri necropolis had scores of tumuli with underground burial chambers. These Etruscan houses of the dead resembled the houses of the living. This interior has painted stucco reliefs evoking a domestic context.

but in this instance brightly painted stucco reliefs cover the stone. The stools, mirrors, drinking cups, pitchers, and knives effectively suggest a domestic context, underscoring the visual and conceptual connection between Etruscan houses of the dead and those of the living.

Tarquinia's Painted Tombs The Etruscans also decorated their underground burial chambers with mural paintings. Painted tombs are statistically rare, the privilege of only the wealthiest Etruscan families. Most have been found at Tarquinia. A well-preserved example, dating to the early fifth century BCE, is the Tomb of the Leopards (Fig. 3-5), named for the beasts that guard the tomb from their perch within the rear wall pediment. They are reminiscent of the panthers on each side of Medusa in the pediment of the Archaic Greek Temple of Artemis at Corfu (Fig. 2-20). But mythological figures, whether Greek or Etruscan, are uncommon in Tarquinian murals, and the Tomb of the Leopards has none. Instead, banqueting couples (the men with dark skin, the women with light skin, in conformity with the age-old convention) adorn the

walls—painted versions of the terracotta sarcophagus from Cerveteri (Fig. 3-3). Pitcher- and cupbearers serve them, and musicians entertain them. The banquet takes place in the open air or perhaps in a tent set up for the occasion. In characteristic Etruscan fashion, the banqueters, servants, and entertainers all make exaggerated gestures with unnaturally enlarged hands. The man on the couch at the far right on the rear wall holds up an egg, the symbol of regeneration. The painting is a joyful celebration of life, food, wine, music, and dance, rather than a somber contemplation of death.

Etruscan Decline The fifth century BCE was a golden age in Greece but not in Etruria. In 509 BCE, the Romans expelled the last of their Etruscan kings, replacing the monarchy with a republican form of government. In 474 BCE, an alliance of Cumaean Greeks and Hieron I of Syracuse defeated the Etruscan fleet off Cumae, effectively ending Etruscan dominance of the seas and with it Etruscan prosperity. These events had important consequences in the world of art and architecture. The number of Etruscan tombs, for example, decreased

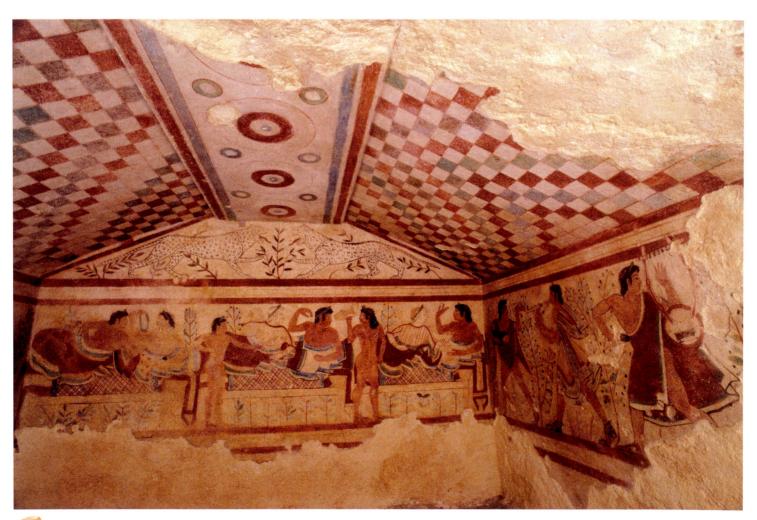

3-5 | Leopards, banqueters, and musicians, mural paintings in the Tomb of the Leopards, Tarquinia, Italy, ca. 480–470 BCE.

Mural paintings appear in many Tarquinian tombs. Here, banqueting couples, servants, and musicians celebrate the joys of the good life. The men have dark skin, the women fair skin.

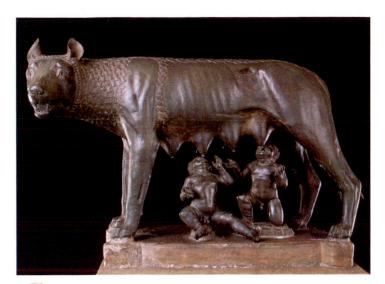

3-6 | *Capitoline Wolf*, from Rome, Italy, ca. 500-480 BCE. Bronze, approx. 2' $7\frac{1}{2}$ " high. Palazzo dei Conservatori, Rome.

An Etruscan sculptor created this statue of the she-wolf that nursed the infants Romulus and Remus, founders of Rome. The animal has a tense, gaunt body and an unforgettable psychic intensity.

sharply, and the quality of the furnishings declined markedly. No longer were tombs filled with golden jewelry and imported Greek vases or mural paintings and terracotta sarcophagi of the first rank. But Etruscan art did not cease.

Rome's Etruscan Wolf The best-known of these later Etruscan works—one of the most memorable portrayals of an animal in the history of world art—is the Capitoline Wolf (Fig. 3-6). The statue is a somewhat larger than life-size hollow-cast bronze portrayal of the she-wolf that, according to ancient legend, nursed Romulus and Remus after they were abandoned as infants. When the twins grew to adulthood, they quarreled, and Romulus killed his brother at the time he founded Rome and became the city's first king. The Capitoline Wolf is not, however, a work of Roman art, which had not yet developed a distinct identity, but the product of an Etruscan workshop. (The suckling infants are 16th-century additions.) The vitality noted in the human figure in Etruscan art is here concentrated in the tense, watchful animal body of the she-wolf, with her spare flanks, gaunt ribs, and taut, powerful legs. The lowered neck and head, alert ears, glaring eyes, and ferocious muzzle capture the psychic intensity of the fierce and protective beast as danger approaches.

Rome Overwhelms Etruria Veii fell to the Romans in 396 BCE, after a terrible 10-year siege. Peace was concluded with Tarquinia in 351, but by the beginning of the next century, Tarquinia, too, was annexed by Rome, and Cerveteri was conquered in 273. By the first century BCE, Roman hegemony over the Etruscans became total. The life-size bronze statue of Aule Metele (Fig. 3-7) is an eloquent document of

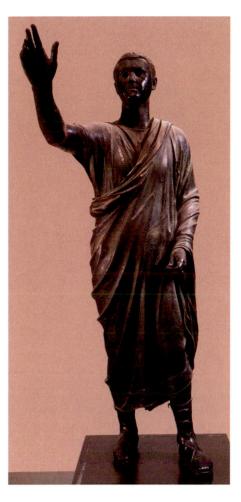

3-7 | Aule Metele (Arringatore), from Cortona, near Lake Trasimeno, Italy, early first century BCE. Bronze, approx. 5' 7" high. Museo Archeologico Nazionale, Florence.

Inscribed in Etruscan, this bronze statue of an orator is Etruscan in name only. Aule Metele wears the short toga and high boots of a Roman magistrate, and the style of the portrait is Republican.

the Roman absorption of the Etruscans. The sculptor portrayed him raising his arm to address an assembly—hence the statue's modern nickname, *Arringatore (Orator)*. Although Aule Metele's Etruscan name and the names of both of his Etruscan parents are inscribed on the statue, he wears the short toga and high laced boots of a Roman magistrate. This orator is Etruscan in name only. Scholars still debate the origin of the Etruscan people, but the question of their demise has a ready answer. Aule Metele and his compatriots became Romans, and Etruscan art became Roman art.

ROMAN ART

The Rome of Romulus in the eighth century BCE comprised only small huts of wood, wattle, and daub, clustered together on the Palatine Hill overlooking what was then uninhabited marshland. In the Archaic period, Rome was essentially an Etruscan city, both politically and culturally. Its greatest shrine, the late-sixth-century BCE Temple of Jupiter on the Capitoline Hill, was built by an Etruscan king, designed by an Etruscan architect, made of wood and mud brick in the Etruscan manner, and decorated with an Etruscan sculptor's terracotta statuary. When the Romans expelled the last of Rome's Etruscan kings in 509 BCE, they established a constitutional government, or republic (see "An Outline of Roman History," page 94)—and the she-wolf (FIG. 3-6) became its emblem.

An Outline of Roman History

MONARCHY (753-509 BCE)

Latin and Etruscan kings ruled Rome from the city's foundation by Romulus in 753 BCE until the revolt against Rome's last king, Tarquinius Superbus, in 509 BCE (exact dates of rule unreliable).

REPUBLIC (509-27 BCE)

The Republic lasted almost 500 years, until the bestowing of the title of Augustus on Octavian, the grandnephew of Julius Caesar and victor over Mark Antony in the civil war of 41–31 BCE that ended republican government. Some major figures were:

- Marcellus, b. 268(?), d. 208 BCE, consul
- Sulla, b. 138, d. 79 BCE, consul and dictator
- Julius Caesar, b. 100, d. 44 BCE, consul and dictator
- Mark Antony, b. 83, d. 30 BCE, consul

EARLY EMPIRE (27 BCE-96 CE)

The Early Empire began with the rule of Augustus and his Julio-Claudian successors and continued until the end of the Flavian dynasty. The emperors discussed in this chapter are:

- Augustus, r. 27 BCE 14 CE
- Nero, r. 54-68

- Vespasian, r. 69-79
- Titus, r. 79-81
- Domitian, r. 81-96

HIGH EMPIRE (96-192 CE)

The High Empire began with the death of Domitian and the rule of the Spanish emperors, Trajan and Hadrian, and ended with the last emperor of the Antonine dynasty. The major rulers of this period were:

- Trajan, r. 98-117
- Hadrian, r. 117 138
- Marcus Aurelius, r. 161-180

LATE EMPIRE (192-337 CE)

The Late Empire began with the Severan dynasty and included the socalled soldier emperors of the third century, the tetrarchs, and Constantine, the first Christian emperor. Some of these emperors were:

- Septimius Severus, r. 193-211
- Caracalla, r. 211-217
- Trajan Decius, r. 249-251
- Diocletian, r. 284 305
- Constantine I, r. 306-337

The Republic

The new Roman Republic vested power mainly in a *senate* (literally, "a council of elders, *senior* citizens") and in two elected *consuls*. Under extraordinary circumstances a *dictator* could be appointed for a specified time and a specific purpose, such as commanding the army during a crisis. Before long, the descendants of Romulus conquered Rome's neighbors one by one: the Etruscans to the north, the Samnites and the Greek colonists to the south. Even the Carthaginians of North Africa, who under Hannibal's dynamic leadership had annihilated some of Rome's legions and almost brought down the Republic, fell before the might of Roman armies.

The Craze for Greek Art The year 211 BCE was a turning point both for Rome and for Roman art. Breaking with precedent, Marcellus, conqueror of the fabulously wealthy Sicilian Greek city of Syracuse, brought back to Rome not only the usual spoils of war—captured arms and armor, gold and silver coins, and the like—but also the city's artistic patrimony. Thus began, in the words of the historian Livy, "the craze for works of Greek art." Ships filled with plundered Greek statues and paintings became a frequent sight in Rome's harbor of Ostia.

Exposure to Greek sculpture and painting and to the splendid marble temples of the Greek gods increased as the Romans expanded their conquests beyond Italy. Greece became a Roman province in 146 BCE, and in 133 the last king of Pergamon willed his kingdom to Rome (see Chapter 2). Nevertheless, although the Romans developed a virtually insatiable taste for

Greek "antiques," their own monuments were not slavish imitations of Greek masterpieces. The Etruscan basis of Roman art and architecture was never forgotten. The statues and buildings of the Roman Republic are highly eclectic, drawing on both Greek and Etruscan traditions.

Eclecticism on the Tiber This Roman eclecticism characterizes the temple on the Tiber known as the Temple of "Fortuna Virilis" (FIGS. 3-8, no. 1, and 3-9), actually the Temple of Portunus, the Roman god of harbors. In plan it follows the Etruscan pattern. The high podium is accessible only at the front via a wide flight of steps. Freestanding columns are confined to the deep porch. But the structure is built of stone (local tufa and travertine), overlaid originally with stucco in imitation of the gleaming white marble temples of the Greeks. The columns are not Tuscan but Ionic, complete with flutes and bases and a matching Ionic frieze. Moreover, in an effort to approximate a peripteral Greek temple while maintaining the basic Etruscan plan, the architect added a series of Ionic engaged columns (attached half-columns) around the cella's sides and back. The result was a pseudoperipteral temple. Although the design combines Etruscan and Greek elements, it is uniquely Roman.

Republican Verism The patrons of Republican religious and civic buildings were in almost all cases members of the *patrician* class of old and distinguished families, often victorious generals who used the spoils of war to finance public works. These aristocrats were fiercely proud of their lineage.

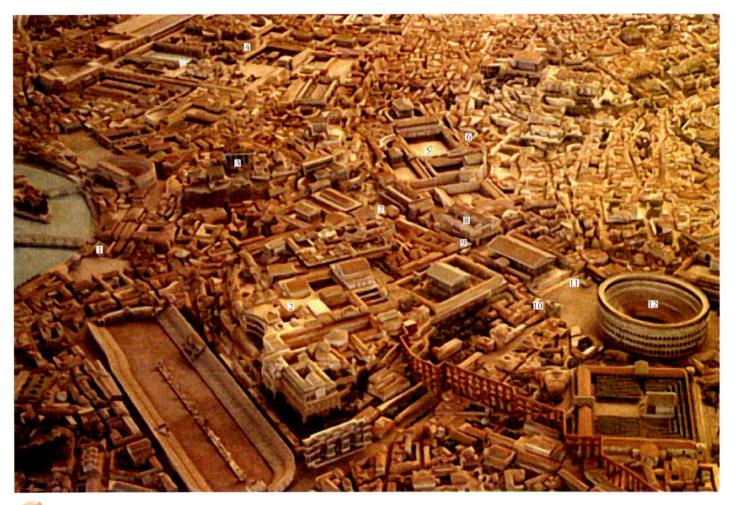

3-8 | Model of the city of Rome during the early fourth century CE. Museo della Civiltà Romana, Rome. 1) Temple of Fortuna Virilis, 2) Palatine Hill, 3) Capitoline Hill, 4) Pantheon, 5) Forum of Trajan, 6) Markets of Trajan, 7) Forum Romanum, 8) Basilica Nova, 9) Arch of Titus, 10) Arch of Constantine, 11) Colossus of Nero, 12) Colosseum.

At the height of its power, Rome was the capital of the greatest empire in human history. The Romans ruled from the Tigris and Euphrates to the Thames and beyond, from the Nile to the Rhine and Danube.

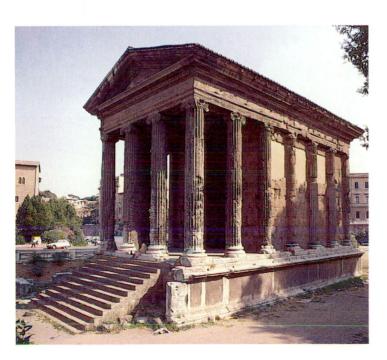

They kept likenesses (*imagines*) of their ancestors in wooden cupboards in their homes and paraded them at the funerals of prominent relatives. The surviving portraits of patricians, which appear to be literal reproductions of individual faces, must be seen in this context. Portraits were one way the patrician class celebrated its elevated position in society. The subjects of these portraits were almost exclusively men of advanced age, for generally only elders held power in the Republic. These patricians did not ask sculptors to idealize them. Instead, they requested brutally realistic images of distinctive features, in the tradition of the treasured household imagines.

3-9 | Temple of "Fortuna Virilis" (Temple of Portunus), Rome, Italy, ca. 75 BCE.

Republican temples eclectically combine Etruscan plan and Greek elevation. This pseudoperipteral temple employs the Ionic order and is built of stone, but it has a staircase and freestanding columns only at the front.

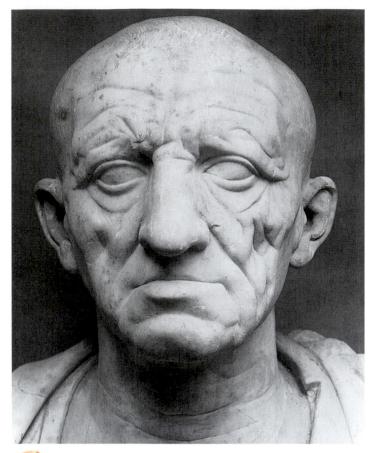

3-10 | Head of a Roman patrician, from Otricoli, Italy, ca. 75-50 BCE. Marble, approx. 1' 2" high. Museo Torlonia, Rome.

Veristic (superrealistic) portraits of old men from distinguished families were the norm during the Republic. The sculptor of this head painstakingly recorded every detail of the elderly patrician's face.

One of the most striking of these so-called *veristic* (superrealistic) portraits is the head of a man (Fig. 3-10) found near Otricoli. The sculptor painstakingly recorded each rise and fall, each bulge and fold, of the facial surface, like a mapmaker who did not want to miss the slightest detail of surface change. Scholars debate whether such portraits were truly blunt records of actual features or exaggerated types designed to make a statement about personality: serious, experienced, determined, loyal to family and state-virtues that were much admired during the Republic.

Pompeii and the Cities of Vesuvius

On August 24, 79 CE, Mount Vesuvius, a long-dormant volcano, suddenly erupted. Many prosperous towns around the Bay of Naples, among them Pompeii, were buried in a single day. This catastrophe has been a boon for archaeologists, who have been able to reconstruct the art and life of the Vesuvian towns with a completeness far beyond that possible anywhere else.

Oscans, Samnites, and Romans The Oscans, one of the many Italic tribes that occupied Italy during the heyday of the Etruscans, were the first to settle at Pompeii. Toward the

end of the fifth century BCE, the Samnites, another Italic people, took over the town. Under the influence of their Greek neighbors, the Samnites greatly expanded the original settlement and gave monumental shape to the city center. Pompeji fought with other Italian cities on the losing side against Rome in the so-called Social War of the early first century BCE. In 80 BCE, Sulla founded a new Roman colony on the site. with Latin as its official language. The colony's population had grown to between 10,000 to 20,000 when Mount Vesuvius buried Pompeii in volcanic ash.

The Heart of Pompeii The center of civic life in any Roman town was its forum, or public square. Pompeii's forum (Fig. 3-11, no. 1) lies in the southwest corner of the expanded Roman city but at the heart of the original town. The forum took on monumental form in the second century BCE when the Samnites, inspired by Hellenistic architecture, erected two-story porticos (colonnades) on three sides of the long and narrow plaza. At the north end they constructed a Temple of Jupiter (Fig. 3-11, no. 2). When Pompeii became a Roman colony, the Romans converted the temple into a Capitolium—a triple shrine to Jupiter, Juno, and Minerva. The temple is of standard Republican type, constructed of tufa covered with fine white stucco and combining an Etruscan plan with Greek columns. It faces into the civic square, dominating the area. This is very different from the siting of Greek temples (Fig. 2-32), which stood

Aerial view of the forum (1), with Temple of Jupiter (Capitolium, 2) and Basilica (3), Pompeii, Italy, second century BCE and later.

The center of Roman civic life was the forum. At Pompeii, colonnades frame a rectangular plaza with a Capitolium at the northern end. At the southwestern corner is the basilica, Pompeii's law court.

ARCHITECTURAL BASICS

The Roman Architectural Revolution

The history of Roman architecture would be very different if the Romans had been content to use the same building materials as the Greeks, Etruscans, and other ancient peoples. Instead, the Romans developed concrete construction, which revolutionized architectural design. Roman concrete was made from a changing recipe of lime mortar, volcanic sand, water, and small stones (caementa, from which the English word cement is derived). Builders placed the mixture in wooden frames and left it to dry and to bond with a brick or stone facing. When the concrete dried completely, the wooden molds were removed, leaving behind a solid mass of great strength, though rough in appearance. The Romans often covered the rough concrete with stucco or with marble revetment (facing). Despite this lengthy procedure, concrete walls were much less costly to construct than walls of imported Greek marble or even local tufa and travertine.

The advantages of concrete go well beyond cost, however. It is possible to fashion concrete shapes that masonry construction cannot achieve, especially huge vaulted and domed rooms without internal supports. The Romans came to prefer these over the Greek and Etruscan postand-lintel structures. Concrete enabled Roman builders to think of architecture in a radical new way: as the shaping of spaces rather than of solids. To cover these new "spatial envelopes," the Romans employed a variety of vaulting systems. The following were the most common types:

Barrel Vaults Also called the *tunnel vault*, the *barrel vault* is an extension of a simple *arch*, creating a semicylindrical ceiling over parallel walls. Such vaults were constructed both before and after the Romans using traditional ashlar masonry (for example, FIGS. 1-19 and 6-16), but those vaults are less stable than concrete barrel vaults. If any of the blocks of a cut-stone vault come loose, the whole may collapse. Also, masonry barrel vaults can be illuminated only by light entering at either end of the tunnel. In contrast, windows can be placed at any point in

Concrete Construction

concrete barrel vaults, because once the concrete hardens, it forms a seamless sheet of "artificial stone" that may be punctured almost at will. Whether made of stone or concrete, barrel vaults require *buttressing* (lateral support) of the walls below the vaults to counteract their downward and outward thrust.

Groin Vaults *Groin* or *cross vaults* are formed by the intersection at right angles of two barrel vaults of equal size. Besides appearing lighter than the barrel vault, the groin vault needs less buttressing. The barrel vault's thrust is concentrated along the entire length of the supporting wall. The groin vault's thrust, however, is concentrated along the *groins*, and buttressing is needed only at the points where the groins meet the vault's vertical supports, usually *piers*. The system leaves the covered area open, permitting light to enter. Groin vaults, like barrel vaults, can be built using stone blocks — but with the same structural limitations when compared to concrete vaulting.

When a series of groin vaults covers an interior hall, as in our diagram and in FIGS. 3-32, 3-38, and 3-44, the open lateral arches of the vaults form the equivalent of a clerestory of a traditional timber-roofed structure (FIG. 4-3c). Such a *fenestrated* (with openings or windows) sequence of groin vaults has a major advantage over wooden clerestories: concrete vaults are relatively fireproof.

Hemispherical Domes If a barrel vault is described as a round arch extended in a line, then a hemispherical *dome* may be described as a round arch rotated around the full circumference of a circle. Masonry domes (Fig. 2-11), like masonry vaults, cannot accommodate windows without threatening their stability. Concrete domes can be opened up even at their apex with a circular "eye" (oculus), as in our diagram and Fig. 3-35, allowing much-needed light to reach the often vast spaces beneath. Hemispherical domes usually rest on concrete cylindrical drums.

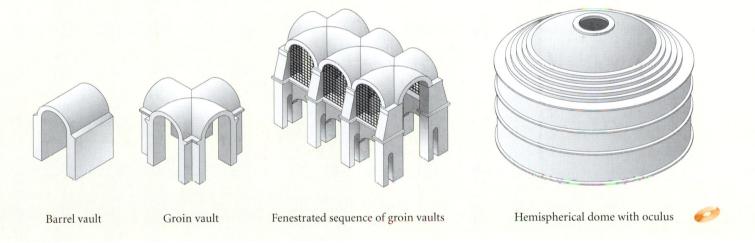

in isolation and could be approached and viewed from all sides, like colossal statues on giant stepped pedestals. The Roman forum, like the Etrusco-Roman temple, has a chief side, a focus of attention.

All around the square, behind the colonnades, were secular and religious structures, including the town's administrative offices. Most noteworthy is the *basilica* at the southwest corner

(Fig. 3-11, no. 3), the earliest well-preserved example of a building type that would have a long history in both Roman and Christian architecture. Constructed during the late second century BCE, the basilica was the town's administrative center and housed the law court. In plan it resembles the forum itself: long and narrow, with two stories of internal columns dividing the space into a central *nave* and flanking *aisles*.

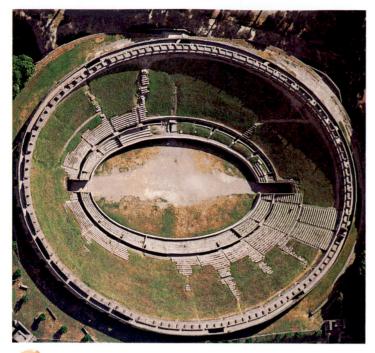

3-12 | Aerial view of the amphitheater, Pompeii, Italy, ca. 70 BCE.

Pompeii boasts the earliest known amphitheater. Its elliptical cavea was made possible by Roman concrete technology. In the arena, bloody gladiatorial combats and wild animal hunts were staged.

Gladiators and Wild Animals At the southeastern end of town, shortly after the Romans took control of Pompeii. two of the town's wealthiest officials used their own funds to erect a large amphitheater (Fig. 3-12) or "double theater." Roman amphitheaters do resemble two Greek theaters put together, but the Greeks never built amphitheaters. Greek theaters were situated on natural hillsides (Fig. 2-48), but supporting an amphitheater's continuous elliptical cavea (seating area) required building an artificial mountain. Only concrete, unknown to the Greeks, was capable of such a job (see "The Roman Architectural Revolution: Concrete Construction," page 97). In the Pompeii amphitheater, the earliest known, a series of radially disposed concrete barrel vaults forms a giant retaining wall that holds up the earthen mound and stone seats. Barrel vaults also form the tunnels leading to the arena, the central area where bloody gladiatorial combats and wild animal hunts occurred. (Arena is Latin for "sand," which soaked up the blood of the wounded and killed.) The Roman amphitheater stands in sharp contrast, both architecturally and functionally, to the Greek theater, home of refined performances of comedies and tragedies.

Townhouses for the Wealthy The evidence from Pompeii regarding Roman domestic architecture (see "The Roman House," page 99) is unparalleled anywhere else. One of the best-preserved houses at Pompeii is the House of the Vettii. Our photograph (Fig. 3-13) was taken in the fauces. It shows

the impluvium in the center of the atrium, the opening in the roof above, and, in the background, the peristyle garden. Of course, only the wealthy—whether patricians or former slaves like the Vettius brothers, who made their fortune as merchants—could own such houses. The masses, especially in expensive cities like Rome, lived in multistory apartment houses.

The First Style and Greece The houses and villas around Mount Vesuvius have also yielded the most complete record of the changing fashions in fresco painting anywhere in the ancient world. Art historians divide the various Roman mural types into four so-called Pompeian Styles. In the *First Style*, the decorator's aim was to imitate costly marble panels (for example, those seen in Fig. 3-35) using painted stucco relief. In the fauces (Fig. 3-14) of the Samnite House at Herculaneum, the visitor is greeted at the doorway by a stunning illusion of walls constructed, or at least faced, with marbles imported from quarries all over the Mediterranean. This approach to wall decoration is comparable to the modern practice of using cheaper manufactured materials to approximate the look and shape of genuine wood paneling. This style is not,

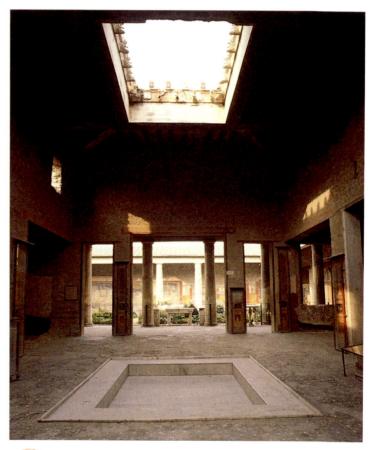

3-13 | Atrium of the House of the Vettii, Pompeii, Italy, second century BCE, rebuilt 62–79 CE.

Roman townhouses had a central atrium with an impluvium to collect rainwater. Cubicula opened onto the atrium, and in Hellenized houses like this one, a peristyle garden was added at the rear.

ARCHITECTURAL BASICS

The Roman House

The typical Roman domus (private house) was entered through a narrow fover (fauces), which led to a large central reception area, the atrium. The rooms flanking the fauces could open inward, as in our diagram, or outward, in which case they were rented out as shops. The roof over the atrium was partially open to the sky, not only to admit light but also to channel rainwater into a basin (impluvium) below. The water could be stored in cisterns for household use. Opening onto the sides of the atrium were small bedrooms called cubicula (cubicles). At the back was the owner's tablinum or "home office." Early Roman houses also had a dining room (triclinium) and kitchen at the back or side of the atrium, and sometimes a small garden at the rear of the house. Endless variations of the same basic plan exist, dictated by the owners' personal tastes and means, the nature of the land plot, and so forth, but all Roman houses of this type were inward-looking in nature. The design shut off the street's noise and dust, and all internal activity focused on the brightly illuminated atrium at the center of the residence.

During the second century BCE, the Roman house took on Greek airs. Builders added a *peristyle* (colonnaded) garden at the rear, as in our illustration, providing a second internal illumination source as well as a pleasant setting for meals served in a summer triclinium. The axial symmetry of the plan meant that on entering the fauces of the house, a visitor had a view through the atrium directly into the peristyle garden (as in FIG. 3-13), which often boasted a fountain or pool, marble statuary, mural paintings, and mosaic floors.

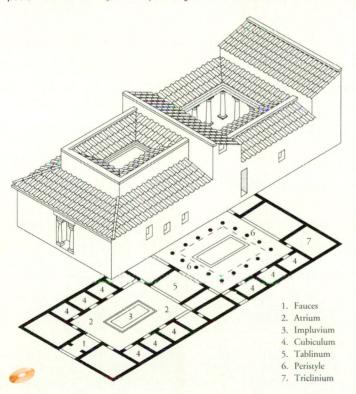

however, uniquely Roman. First Style walls are well documented in the Greek world from the late fourth century BCE on. The use of the First Style in Republican houses is yet another example of the Hellenization of Roman architecture.

3-14 | First Style wall painting in the fauces of the Samnite House, Herculaneum, Italy, late second century BCE.

In First Style murals, the decorator's aim was to imitate costly marble panels using painted stucco relief. The style is Greek in origin and another example of the Hellenization of Republican architecture.

Second Style Illusionism The *Second Style*, introduced around 80 BCE, seems to be a Roman innovation and is in most respects the antithesis of the First Style. Second Style painters aimed to dissolve a room's confining walls and replace them with the illusion of an imaginary three-dimensional world. They did this purely pictorially. The First Style's modeled stucco panels gave way to the Second Style's flat wall surfaces.

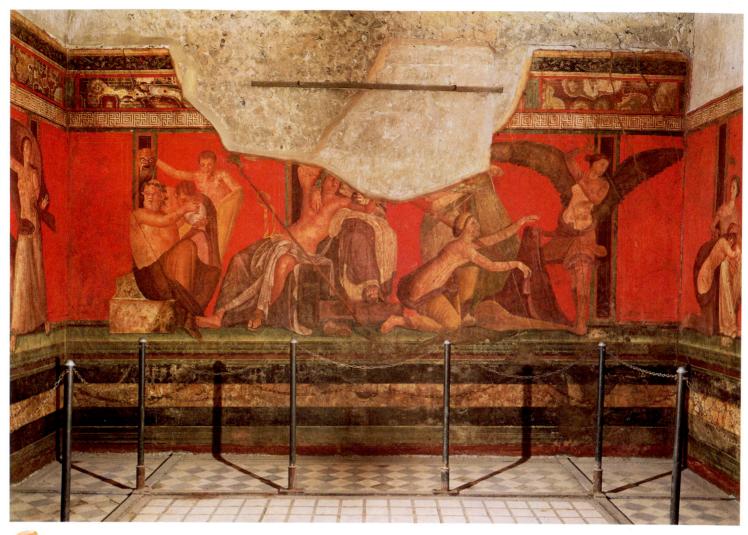

3-15 | Dionysiac mystery frieze, Second Style wall paintings in room 5 of the Villa of the Mysteries, Pompeii, Italy, ca. 60–50 BCE. Frieze approx. 5' 4" high.

Second Style painters created the illusion of an imaginary three-dimensional world on the walls of Roman houses. The figures in this room are acting out the initiation rites of the mystery religion of Dionysos.

An early example of the new style is the room (Fig. 3-15) that gives its name to the Villa of the Mysteries at Pompeii. Many scholars believe that this chamber was used to celebrate, in private, the rites of the Greek god Dionysos (Roman Bacchus). Dionysos was the focus of an unofficial mystery religion popular among Italian women at this time. The precise nature of the Dionysiac rites is unknown, but the figural cycle in the Villa of the Mysteries, illustrating mortals (all female save for one boy) interacting with mythological figures, probably provides some evidence for the cult's initiation rites. In these rites, young women were united in marriage with Dionysos. The Second Style painter created the illusion of a shallow ledge on which human and divine actors move around the room. Especially striking is the way some of the figures interact across the corners of the room. For example, a seminude winged woman at the far right of the rear wall lashes out with her whip across the space of the room at a kneeling woman with a bare back (the initiate and bride-to-be of Dionysos) on the left end of the right wall.

Perspective Painting In later Second Style designs, painters created a three-dimensional setting that also extends beyond the wall. An example is a cubiculum (Fig. 3-16) from the Villa of Publius Fannius Synistor at Boscoreale, decorated between 50 and 40 BCE. All around the room the painter opened up the walls with vistas of Italian towns, marble temples, and colonnaded courtyards. Painted doors and gates invite the viewer to walk through the wall into the magnificent world the painter created. Knowledge of single-point linear perspective (see "Depicting Objects in Space," Chapter 8, page 230) explains in large part the Boscoreale painter's success in suggesting depth. In this kind of perspective, all the receding lines in a composition converge on a single point along the painting's central axis. Ancient writers state that Greek painters of the fifth century BCE first used linear perspective for the design of Athenian stage sets (hence its Greek name, skenographia, "scene painting"). In the Boscoreale cubiculum, the device is most successfully employed in the far corners, where a low gate leads to a peristyle framing a round temple (Fig. 3-16, right).

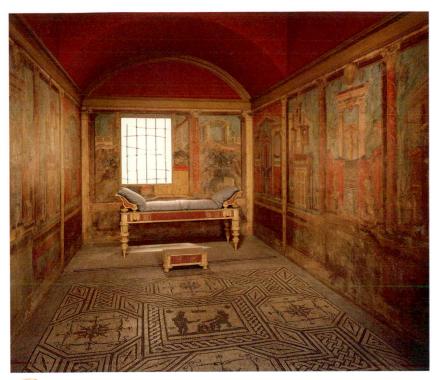

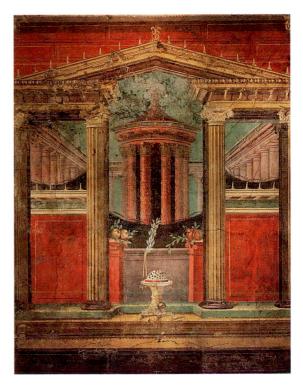

3-16 | Second Style wall paintings (general view, *left*, and detail of tholos, *right*) from cubiculum M of the Villa of Publius Fannius Synistor, Boscoreale, Italy, ca. 50–40 BCE. Approx. 8' 9" high. Metropolitan Museum of Art, New York.

In this Second Style bedroom, the painter opened up the walls with vistas of towns, temples, and colonnaded courtyards. The convincing illusionism is due in part to the Romans' use of linear perspective.

Livia's Painted Garden The ultimate example of a Second Style "picture window" wall is the gardenscape (Fig. 3-17) in the Villa of Livia, wife of the emperor Augustus, at Primaporta, just north of Rome. To suggest recession, the painter mastered another kind of perspective, *atmospheric*

perspective, indicating depth by the increasingly blurred appearance of objects in the distance. At Livia's villa, the fence, trees, and birds in the foreground are precisely painted, whereas the details of the dense foliage in the background are indistinct.

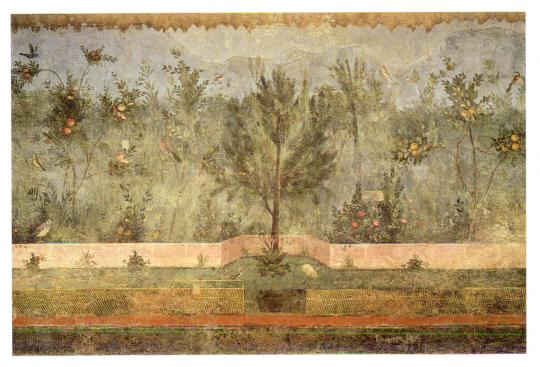

3-17 | Gardenscape, Second Style wall painting, from the Villa of Livia, Primaporta, Italy, ca. 30–20 BCE. Approx. 6' 7" high. Museo Nazionale Romano-Palazzo Massimo alle Terme, Rome.

The ultimate example of a Second Style "picture window" wall is this gardenscape in Livia's villa. To suggest recession, the painter used atmospheric perspective, intentionally blurring the most distant forms.

Third Style Elegance The Primaporta gardenscape is the polar opposite of First Style designs, which reinforce, rather than deny, the heavy presence of confining walls. But tastes changed rapidly in the Roman world, as in society today. Not long after Livia had her villa painted, Roman patrons began to favor mural designs that reasserted the primacy of the wall surface. In the *Third Style* of Pompeian painting, popular from about 15 BCE to 60 CE, artists no longer attempted to replace the walls with three-dimensional worlds of their own creation. Nor did they seek to imitate the appearance of the marble walls of Hellenistic kings. Instead they decorated walls with delicate linear fantasies sketched on predominantly monochromatic (one-color) backgrounds.

One of the earliest examples of the new style is a room (Fig. 3-18) in the Villa of Agrippa Postumus at Boscotrecase. Nowhere does the artist use illusionistic painting to penetrate the wall. In place of the stately columns of the Second Style are insubstantial and impossibly thin *colonnettes* supporting featherweight canopies barely reminiscent of pediments. In the center of this delicate and elegant architectural frame is a tiny floating landscape painted directly on the jet-black ground. It is hard to imagine a sharper contrast to the panoramic gardenscape at Livia's villa.

The Fourth Style In the Fourth Style, a taste for illusionism returned once again. This style was fashionable in the two decades before the Vesuvian eruption of 79 and is characterized by crowded and confused compositions with a mixture of fragmentary architectural vistas, framed panel paintings, and motifs favored in the First and Third Styles. The Ixion Room (Fig. 3-19) of the House of the Vettii was probably painted shortly before the eruption. Its Fourth Style design is a kind of résumé of all the previous styles, another instance of the eclecticism noted earlier as characteristic of Roman art in general. The lowest zone, for example, is one of the most successful imitations anywhere of costly multicolored imported marbles. The large white panels in the corners of the room, with their delicate floral frames and floating central motifs, would fit naturally into the most elegant Third Style design. Unmistakably Fourth Style, however, are the fragmentary architectural vistas of the central and upper zones. They are unrelated to one another, do not constitute a unified cityscape beyond the wall, and are peopled with figures that would tumble into the room if they took a single step forward.

Greek Myths on Roman Walls The Ixion Room takes its nickname from the mythological painting at the center of the rear wall. Ixion had attempted to seduce Hera, and Zeus punished him by binding him to a perpetually spinning wheel. The paintings on the two side walls (not visible in Fig. 3-19) also have Greek myths as subjects. The Ixion Room may be likened to a small private art gallery with framed paintings decorating the walls, as in many modern homes. Scholars long have believed that these and the many other mythological paintings on Third and Fourth Style walls were based on lost Greek panels.

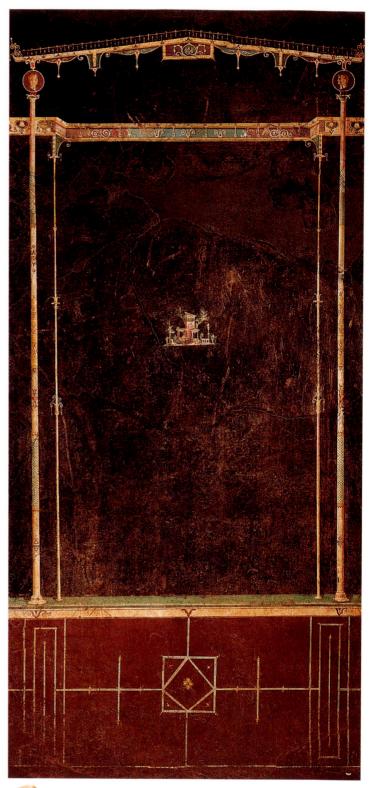

3-18 | Detail of a Third Style wall painting, from cubiculum 15 of the Villa of Agrippa Postumus, Boscotrecase, Italy, ca. 10 BCE. Approx. 7' 8" high. Metropolitan Museum of Art, New York.

In the Third Style, Roman painters decorated walls with delicate linear fantasies sketched on predominantly monochromatic backgrounds. A tiny floating landscape is the central motif on the solid black wall.

Although few, if any, of the mythological paintings at Pompeii can be described as true copies of "Old Masters," they attest to the Romans' continuing admiration for Greek art.

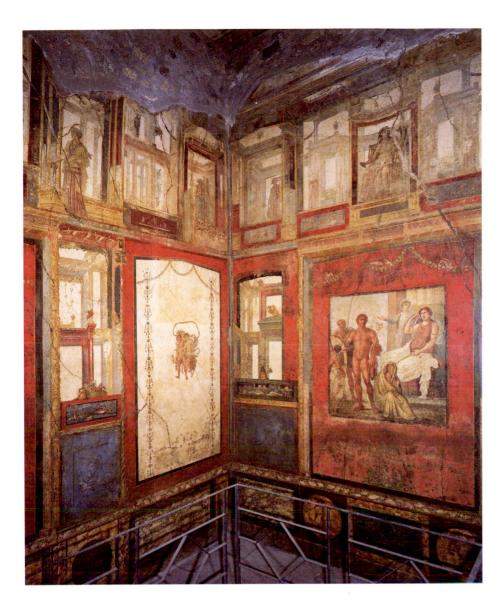

3-19 | Fourth Style wall paintings in the Ixion Room (triclinium P) of the House of the Vettii, Pompeii, Italy, ca. 70–79 CE.

Fourth Style murals are often crowded and confused compositions with a mixture of fragmentary architectural vistas, framed panel paintings, and motifs favored in the First and Third Styles.

Painting the Inanimate One of the most frequent motifs on Roman painted walls is the *still life*, or painting of inanimate objects. In our example (Fig. 3-20), a detail of a painted wall from Herculaneum, the fruit, the stem and leaves, and the glass jar were set out on shelves to give the illusion of the casual, almost accidental, relationship of objects in a cupboard. The artist paid scrupulous attention to shadows and highlights. Note especially the glistening light on the carafe and the water it contains. The goal was to paint light as one would strive to paint the touchable object that reflects and absorbs it.

3-20 | Still life with peaches, detail of a Fourth Style wall painting, from Herculaneum, Italy, ca. 62-79 CE. Approx. $1' 2'' \times 1' 1\frac{1}{2}''$. Museo Archeologico Nazionale, Naples.

The Roman interest in illusionism explains the popularity of still-life paintings. This painter paid scrupulous attention to the play of light and shadow on different shapes and textures.

The Early Empire

The murder of Julius Caesar on the Ides of March, 44 BCE, plunged the Roman world into a bloody civil war. The fighting lasted 13 years and ended only when Octavian, Caesar's grandnephew and adopted son, crushed the naval forces of Mark Antony and Queen Cleopatra of Egypt at Actium in northwestern Greece. Antony and Cleopatra committed suicide, and in 30 BCE, Egypt, once the wealthiest and most powerful kingdom of the ancient world, became another province in the ever-expanding Roman Empire.

Historians reckon the passage from the old Roman Republic to the new Roman Empire from the day in 27 BCE when the Senate conferred the majestic title of Augustus (r. 27 BCE—14 CE) on Octavian. The Empire was ostensibly a continuation of the Republic, with the same constitutional offices, but in fact Augustus, who was recognized as *princeps* (first citizen), occupied all the key positions. He was consul and *imperator* (commander in chief; root of the word *emperor*) and even, after 12 BCE, *pontifex maximus* (chief priest of the state religion). These offices gave Augustus control of all aspects of Roman public life.

The Pax Romana With powerful armies keeping order on the Empire's frontiers and no opposition at home, Augustus brought peace and prosperity to a war-weary Mediterranean world. Known in his own day as the *Pax Augusta* (Augustan Peace), the peace Augustus established prevailed for two centuries. It came to be called simply the *Pax Romana*. During this time Roman emperors commissioned a huge number of public works throughout their territories, all on an unprecedented scale. The erection of imperial portraits and monuments covered with reliefs recounting the emperors' great deeds reminded people everywhere of the source of this beneficence. These portraits and reliefs often presented a picture of the emperors and their achievements that bore little resemblance to historical fact. Their purpose, however, was not to provide an objective record but to mold public opinion.

Augustus, Son of a God When Augustus vanquished Antony and Cleopatra in 31 BCE and became undisputed master of the Mediterranean world, he had not reached his 32nd birthday. The rule by elders that had characterized the Roman Republic for nearly half a millennium came to an abrupt end. Suddenly Roman portraitists were called on to produce images of a *youthful* head of state. But Augustus was not just young. Caesar had been made a god after his death, and Augustus, while never claiming to be a god himself, widely advertised himself as the son of a god. His portraits were designed to present the image of a godlike leader, a superior being who, miraculously, never aged.

Augustus's idealized portraits were modeled on Classical Greek art. The statue of Augustus from Primaporta (Fig. 3-21) depicting him as general is based closely on Polykleitos's *Doryphoros* (Fig. 2-31). Here, however, the emperor addresses

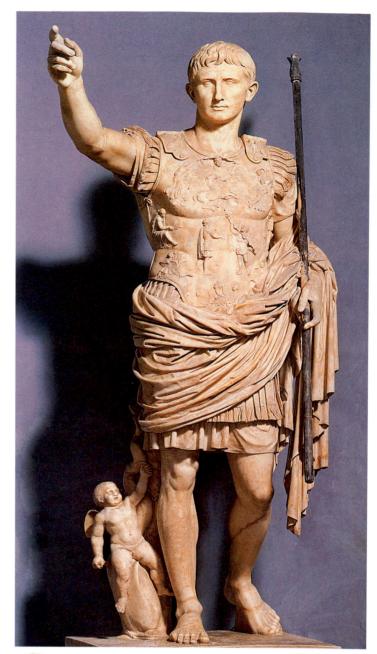

3-21 | Portrait of Augustus as general, from Primaporta, Italy, early first century CE copy of a bronze original of ca. 20 BCE. Marble, 6' 8" high. Musei Vaticani, Rome.

Augustus's idealized portraits were modeled on Classical Greek statues (for example, Fig. 2-31) and depict him as a never-aging son of a god. This portrait presents the emperor in armor in his role as general.

his troops with his right arm extended in the manner of the orator Aule Metele (Fig. 3-7). Although the head is that of an individual and not a nameless athlete, its overall shape, the sharp ridges of the brows, and the tight cap of layered hair emulate the Polykleitan style. The reliefs on the emperor's breastplate celebrate a victory over the Parthians. The Cupid at Augustus's feet refers to his divine descent from Venus. Every facet of the portrait carried a political message.

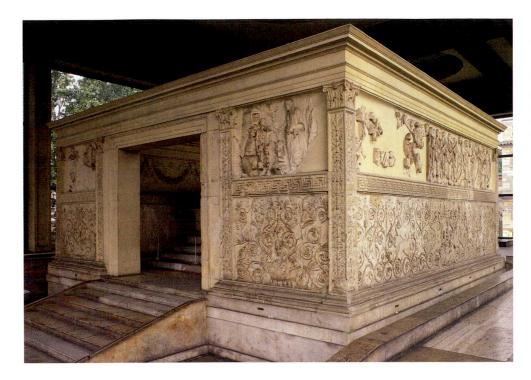

3-22 | Ara Pacis Augustae (Altar of Augustan Peace), Rome, Italy, 13–9 BCE.

Augustus sought to present his new order as a Golden Age equaling that of Athens under Pericles. The Ara Pacis celebrates the emperor's most important achievement, the establishment of peace.

A Shrine to Peace In 9 BCE, Augustus dedicated the Ara Pacis Augustae (Altar of Augustan Peace; Fig. 3-22), the monument celebrating his most important achievement, the establishment of peace. Acanthus tendrils adorn the altar's marble precinct walls, which have Corinthian *pilasters* at the corners. The *Corinthian capital* was a Greek innovation of the fifth century BCE, but it did not become popular until Hellenistic and especially Roman times. More ornate then either the Doric or Ionic capital, the Corinthian capital consists of a double row of acanthus leaves, from which tendrils and flowers emerge, wrapped around a bell-shaped echinus. The rich floral and vegetal ornament of the altar's exterior alludes to the prosperity that peace brings.

Four panels on the east and west ends of the Ara Pacis depict carefully selected mythological subjects, including (at the

right in Fig. 3-22) a relief of Aeneas making a sacrifice. Aeneas was the son of Venus and one of Augustus's forefathers. The connection between the emperor and Aeneas was a key element of Augustus's political ideology for his new Golden Age. It is no coincidence that the *Aeneid* was written during the rule of Augustus. Vergil's epic poem glorified the young emperor by celebrating the founder of the Julian line.

Processions of the imperial family and other important dignitaries appear on the long north and south (Fig. 3-23) sides of the Ara Pacis. These parallel friezes were clearly inspired to some degree by the Panathenaic procession frieze of the Parthenon (Fig. 2-38, bottom). Augustus sought to present his new order as a Golden Age equaling that of Athens under Pericles. The emulation of Classical models thus made a political statement, as well as an artistic one. Even so, the Roman

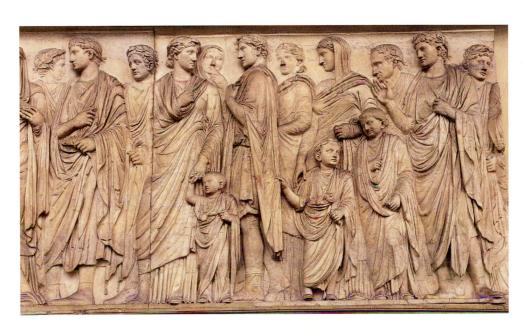

3-23 | Procession of the imperial family, detail of the south frieze of the Ara Pacis Augustae, Rome, Italy, 13–9 BCE. Marble, approx. 5′ 3″ high.

Although inspired by the Panathenaic procession frieze of the Parthenon (Fig. 2-38), the Ara Pacis friezes depict recognizable individuals, including children. Augustus promoted marriage and childbearing.

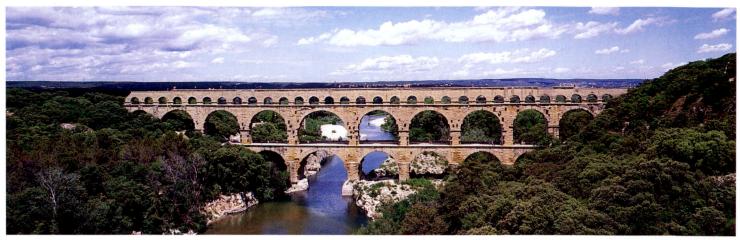

3-24 | Pont-du-Gard, Nîmes, France, ca. 16 BCE.

Roman engineers constructed roads, bridges, and aqueducts throughout the empire. This aqueduct bridge brought water from a distant mountain spring to Nîmes—about 100 gallons a day for each of the city's inhabitants.

procession is very different in character from the Greek. On the Parthenon, anonymous figures act out an event that recurred every four years. The frieze stands for *all* Panathenaic Festival processions. The Ara Pacis depicts a specific event (the inaugural ceremony of 13 BCE) and recognizable contemporary figures. Among those portrayed are children, who restlessly tug on their elders' garments and talk to one another when they should be quiet on a solemn occasion. Augustus was concerned about a decline in the birthrate among the Roman nobility, and he enacted a series of laws designed to promote marriage, marital fidelity, and raising children. The portrayal of men with their families on the Altar of Peace was intended as a moral exemplar.

Rome in France During the Pax Romana, Rome sent engineers to construct aqueducts, roads, and bridges throughout its far-flung empire. In southern France, outside Nîmes, still stands the aqueduct-bridge known as the Pont-du-Gard (Fig. 3-24). The aqueduct provided about 100 gallons of water a day for each inhabitant of Nîmes from a mountain spring some 30 miles away. The water was carried over the considerable distance by gravity flow, which required channels built with a continuous gradual decline over the entire route from source to city. The three-story bridge at Nîmes was erected to maintain the height of the water channel where the water crossed the Gard River. Each large arch spans some 82 feet and is constructed of blocks weighing up to two tons each. The bridge's uppermost level consists of a row of smaller arches, three above each of the large openings below. They carry the water channel itself. Their quickened rhythm and the harmonious proportional relationship between the larger and smaller arches reveal that the Roman engineer had a keen aesthetic, as well as practical, sense.

Nero and Civil War For half a century after Augustus's death, Rome's emperors all came from his family, the Julians, or his wife Livia's, the Claudians. But the outrageous behavior

of Nero (r. 54–68 CE) produced a powerful backlash. Nero was forced to commit suicide in 68 CE, bringing the Julio-Claudian dynasty to an end. A year of renewed civil strife followed. The man who emerged triumphant in this brief but bloody conflict was Vespasian (r. 69–79 CE), a general who had served under Nero. Vespasian, whose family name was Flavius, had two sons, Titus (r. 79–81 CE) and Domitian (r. 81–96 CE). The Flavian dynasty ruled Rome for more than a quarter century.

Colossus and Colosseum The Flavian Amphitheater, or Colosseum (Fig. 3-25 and 3-8, no. 12), was one of Vespasian's first undertakings after becoming emperor. The decision to build the Colosseum was very shrewd politically. The site chosen was on the property Nero had confiscated from the Roman people after a great fire in 64 CE in order to build a private villa for himself. By constructing the new amphitheater there, Vespasian reclaimed the land for the public and also provided Romans with the largest arena for gladiatorial combats and other lavish spectacles that had ever been constructed. The Colosseum could hold more than 50,000 spectators, but it takes its name from its location beside the Colossus of Nero (Fig. 3-8, no. 11). The huge statue, which stood at the entrance to his villa, portrayed the emperor as the sun god. To mark the opening of the Colosseum, the Flavians staged games for 100 days. The highlight was the flooding of the arena to stage a complete naval battle with more than 3,000 participants.

The Colosseum, like the much earlier amphitheater at Pompeii (Fig. 3-12), could not have been built without concrete. A complex system of barrel-vaulted corridors holds up the enormous oval seating area. This concrete "skeleton" was revealed when the amphitheater's marble seats were hauled away during the Middle Ages and Renaissance. Also exposed are the arena substructures, which housed waiting rooms for the gladiators, animal cages, and machinery for raising and lowering stage sets as well as animals and humans. Ingenious lifting devices brought beasts from their dark dens into the arena's bright light.

The exterior travertine shell is approximately 160 feet high, the height of a modern 16-story building. The facade is divided into four bands, with large arched openings piercing the lower three. Ornamental Greek *superimposed orders* frame the arches in the standard Roman sequence for multistoried buildings: from the ground up, Tuscan Doric, Ionic, and then Corinthian. The use of engaged columns and a lintel to frame the openings in the Colosseum's facade is a common motif on

Roman buildings. Like the pseudoperipteral temple (FIG. 3-8), which is an eclectic mix of Greek orders and Etruscan plan, this way of decorating a building's facade combined Greek orders with an architectural form foreign to Greek post-and-lintel architecture, namely the arch. The engaged columns and even the arches had no structural purpose, but they added variety to the surface and unified the multistoried facade by casting a net of verticals and horizontals over it.

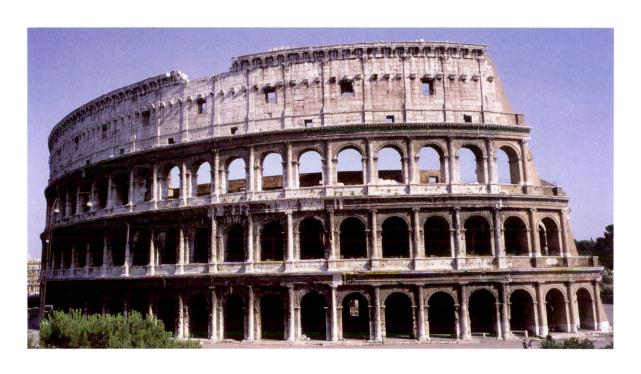

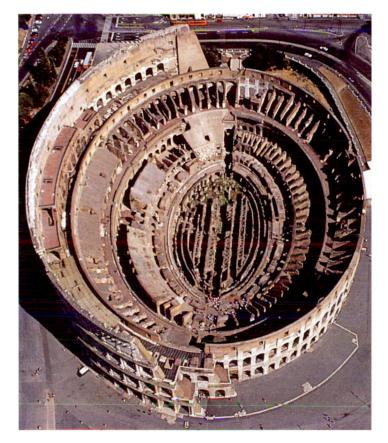

3-25 | Facade (top) and aerial view (bottom) of the Colosseum (Flavian Amphitheater), Rome, Italy, ca. 70–80 CE.

A complex system of concrete barrel vaults once held up the seats for 50,000 spectators in the world's largest amphitheater. On the exterior, engaged Doric, Ionic, and Corinthian columns frame the arcuated openings.

Flavian Portraiture Flavian portraits survive in large numbers. One that is of special interest as an early example of the use of the drill in Roman sculpture is the marble bust of a young woman (Fig. 3-26), probably a Flavian princess. The portrait is notable for its elegance and delicacy and for the virtuoso way the sculptor rendered the differing textures of hair and flesh. The artist reproduced the corkscrew curls of the elaborate Flavian coiffure by drilling deep into the stone in addition to carving with the traditional hammer and chisel. The drillwork created a dense mass of light and shadow set off boldly from the softly modeled and highly polished skin of the face and swanlike neck.

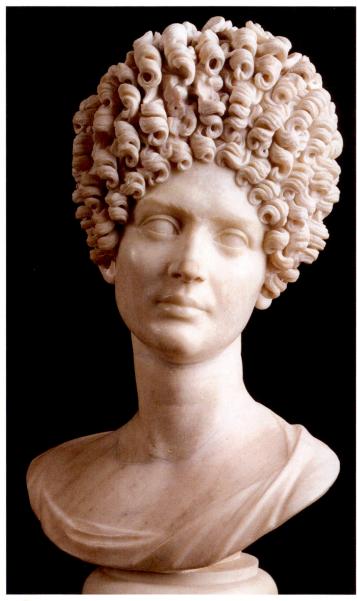

3-26 | Portrait bust of a Flavian woman, from Rome, Italy, ca. 90 CE. Marble, approx. 2' 1" high. Museo Capitolino, Rome.

The Flavian sculptor reproduced the elaborate coiffure of this elegant woman by drilling deep holes for the corkscrew curls, and carved the rest of the hair and the face with hammer and chisel.

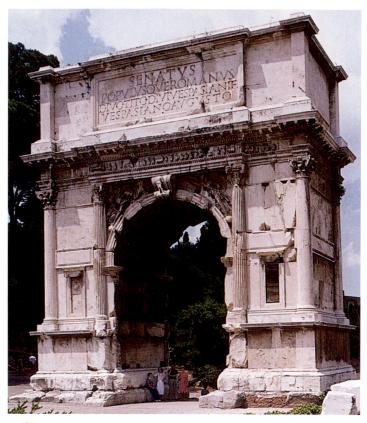

3-27 | Arch of Titus, Rome, Italy, after 81 CE.

Domitian erected this triumphal arch on the road leading into the Roman Forum to honor his brother, the emperor Titus, who became a god after his death. Victories fill the spandrels of the arcuated passageway.

The God Titus When Titus died in 81 CE, his younger brother, Domitian, who succeeded him as emperor, erected a triumphal arch (Figs. 3-27 and 3-8, no. 9) in Titus's honor on the road leading into the Roman Forum (Fig. 3-8, no. 7). The Arch of Titus is typical of early triumphal arches and has only one passageway. As on the Colosseum, engaged columns frame the arcuated (arch-shaped) opening. Reliefs depicting personified Victories fill the spandrels (the area between the arch's curve and the framing columns and entablature). A dedicatory inscription stating that the arch was set up to honor the god Titus, son of the god Vespasian, dominates the attic. (Roman emperors normally were proclaimed gods after they died, as Augustus was, but if they ran afoul of the Senate, they were damned. The statues of those who suffered damnatio memoriae were torn down, and their names were erased from public inscriptions. This was Nero's fate.)

The Spoils of Jerusalem Inside the passageway of the Arch of Titus are two great relief panels. They represent the triumphal parade of Titus after his return from the conquest of Judaea at the end of the Jewish Wars in 70 CE. One of the reliefs (Fig. 3-28) depicts Roman soldiers carrying the spoils from the Temple in Jerusalem. Despite considerable damage to the relief, the illusion of movement is convincing. The parade moves forward from the left background into the center

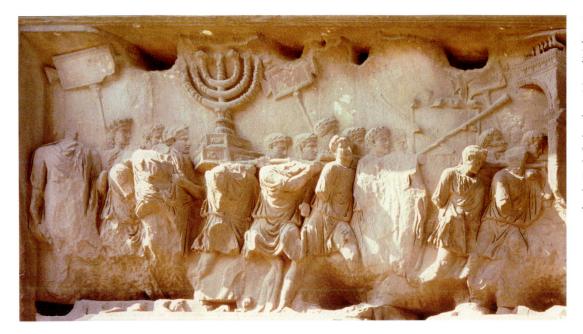

3-28 | Spoils of Jerusalem, relief panel in passageway of the Arch of Titus, Rome, Italy, after 81 CE. Marble, approx. 7' 10" high.

The reliefs inside the bay of the Arch of Titus commemorate the emperor's greatest achievement—the conquest of Judaea. Here, Roman soldiers carry the spoils taken from the Jewish temple in Jerusalem.

foreground and disappears through the obliquely placed arch in the right background. The energy and swing of the column of soldiers suggest a rapid march. The sculptor rejected the low relief of the Ara Pacis (Fig. 3-23) in favor of extremely deep carving, which produces strong shadows. The heads of the forward figures have broken off because they stood free from the block. Their high relief emphasized their different placement in space from the heads in low relief, which are intact. The play of light and shade across the protruding foreground and receding background figures enhances the sense of movement.

Titus in Triumph The panel on the other side of the passageway shows Titus in his triumphal chariot (Fig. 3-29). Victory rides with the emperor and places a wreath on his head. Below her is a bare-chested youth who is probably a

personification of Honor (Honos). A female personification of Valor (Virtus) leads the horses. These allegorical figures transform the relief from a record of Titus's battlefield success into a celebration of imperial virtues. Such an intermingling of divine and human figures occurs in the Mysteries frieze (FIG. 3-15) at Pompeii, but the Titus panel is the first known instance of divine beings interacting with humans on an official Roman historical relief. (On the Ara Pacis, Fig. 3-22, the gods, heroes, and personifications appear in separate framed panels and were carefully segregated from the procession of living Romans.) The Arch of Titus was erected after the emperor's death, and its reliefs were carved when Titus was already a god. Soon afterward, however, this kind of interaction between mortals and immortals became a staple of Roman narrative relief sculpture, even on monuments honoring a living emperor.

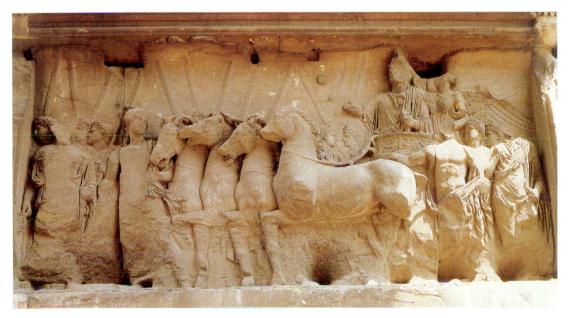

3-29 | Triumph of Titus, relief panel in passageway of the Arch of Titus, Rome, Italy, after 81 CE. Marble, approx. 7' 10" high.

Victory accompanies Titus in his triumphal chariot. Also present are personifications of Honor and Valor. This is the first known instance of the intermingling of human and divine figures in a Roman historical relief.

The High Empire

Domitian's extravagant lifestyle and ego resembled Nero's. He so angered the senators that he was assassinated in 96 CE. The first emperor of the second century, chosen with the consent of the Senate, was Trajan (r. 98–117 CE), a capable and popular general. Born in Spain, Trajan was the first non-Italian to rule Rome. During his reign, the Roman Empire reached its greatest extent, and the imperial government took on ever greater responsibility for its people's welfare by instituting a number of farsighted social programs.

Rome's Greatest Forum Trajan's major building project in Rome was a huge new forum (Figs. 3-30 and 3-8, no. 5), which glorified his victories in two wars against the Dacians (who occupied what is now Romania). The architect was APOL-LODORUS OF DAMASCUS, Trajan's chief military engineer, who had constructed a world-famous bridge across the Danube River. Apollodorus's plan incorporated the main features of most early forums (Fig. 3-11), except that a huge basilica, not a temple, dominated the colonnaded open square. The temple (completed after the emperor's death and dedicated to the newest god in the Roman pantheon, Trajan himself) was set instead behind the basilica. One entered Trajan's forum through an impressive gateway resembling a triumphal arch, complete with an attic statuary group of Trajan driving a six-horse chariot while Victory crowns him. Inside the forum were other reminders of Trajan's military prowess. A larger-than-life-size gilded-bronze equestrian statue of the emperor stood at the center of the great court in front of the basilica. Statues of captive Dacians stood above the columns of the forum porticos.

The Basilica Ulpia (Trajan's family name was Ulpius) was a much larger and far more ornate version of the basilica in the forum of Pompeii (Fig. 3-11, no. 3). As shown in Fig. 3-30, no. 4, it had *apses*, or semicircular recesses, on each short end. Two aisles flanked the nave on each side. The building was vast:

about 400 feet long (without the apses) and 200 feet wide. Light entered through clerestory windows, made possible by elevating the timber-roofed nave above the colonnaded aisles. In the Republican basilica at Pompeii, light reached the nave only indirectly through aisle windows. The clerestory (used millennia before at Karnak in Egypt; Fig. 1-32) was a much better solution.

Trajan's Column The Column of Trajan (Fig. 3-31), erected between the Basilica Ulpia and the Temple of Trajan, still stands. It is 128 feet high and has a monumental base decorated with captured Dacian arms and armor. A heroically nude statue of the emperor once topped the column. The 625-foot band that winds around the shaft is the first instance of a spiral narrative frieze. The reliefs depict Trajan's two Dacian campaigns. The story is told in more than 150 episodes in which some 2,500 figures appear. The relief is very low so as not to distort the contours of the column. Legibility was enhanced in antiquity by paint, but it still would have been very difficult for anyone to follow the narrative from beginning to end. That is why much of the frieze is given over to easily recognizable compositions: Trajan addressing his troops, sacrificing to the gods, and so on. The narrative is not a reliable chronological account of the Dacian Wars, as was once thought. The sculptors nonetheless accurately recorded the general character of the campaigns. Notably, battle scenes take up only about a quarter of the frieze. The Romans spent more time constructing forts, transporting men and equipment, and preparing for battle than they did fighting. The focus is always on the emperor, who appears again and again in the frieze, but the enemy is not belittled. The Romans won because of their superior organization and more powerful army, not because they were inherently superior beings.

Shopping in Imperial Rome On the Quirinal Hill overlooking the forum, Apollodorus built the Markets of Trajan (Fig. 3-8, no. 6) to house both shops and administrative

3-30 | APOLLODORUS OF DAMASCUS, Forum of Trajan, Rome, Italy, dedicated 112 CE. Reconstruction by James E. Packer and John Burge. 1) Temple of Trajan, 2) Column of Trajan, 3) Libraries, 4) Basilica Ulpia, 5) Forum, 6) Equestrian statue of Trajan.

Trajan built Rome's largest forum with the spoils from two wars in Dacia. It featured a triumphal gateway, statues of Dacian captives, an equestrian statue of the emperor, and a basilica with clerestory lighting.

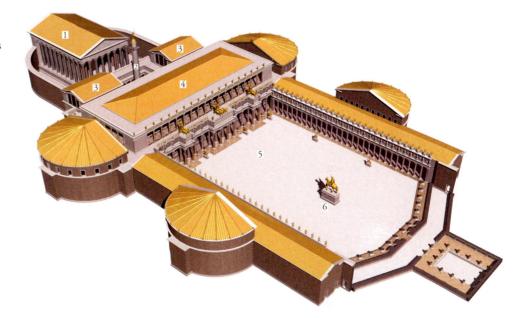

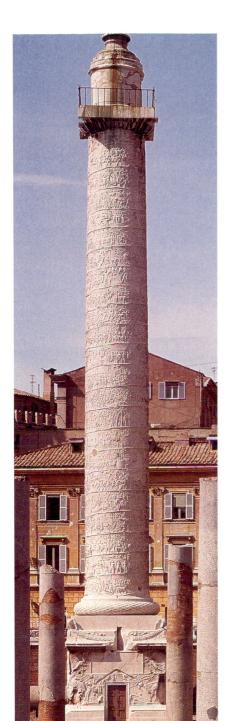

Golumn of Trajan, Forum of Trajan, Rome, Italy, dedicated 112 CE.

The spiral frieze of Trajan's Column tells the story of the Dacian wars in 150 episodes. All aspects of the campaigns are included, from fierce battles to solemn sacrifices and road and fort construction.

3-32 | APOLLODORUS OF DAMASCUS, interior of the great hall, Markets of Trajan, Rome, Italy, ca. 100–112 CE.

The great hall of Trajan's Markets resembles a modern shopping mall. It housed two floors of shops, with the upper shops set back and lit by skylights. Concrete groin vaults covered the central space.

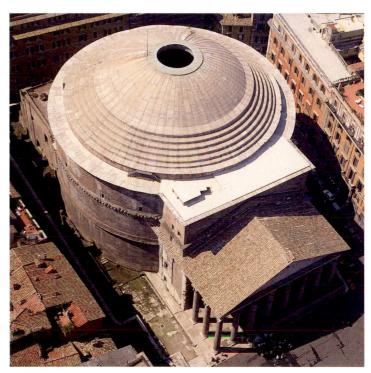

3-33 | Aerial view of the Pantheon, Rome, Italy, 118–125 CE.

Hadrian's "temple of all gods" originally was approached from a columnar courtyard and, like a temple in a Roman forum (Fig. 3-11), stood at one narrow end of the enclosure.

Hadrian and the Pantheon Upon Trajan's death, Hadrian (r. 117–138 CE), also a Spaniard, succeeded him as emperor. Almost immediately, he began work on the Pantheon (Figs. 3-33 and 3-8, no. 4), the temple of all the gods,

offices. The transformation of the hill into a multilevel complex was made possible by the use of concrete. The basic unit was the *taberna*, a single-room shop covered by a barrel vault. The shops were on several levels. They opened either onto a hemispherical facade winding around one of the great *exedras* (semicircular recessed areas) of Trajan's forum, onto a paved street farther up the hill, or onto a great indoor market hall (Fig. 3-32) resembling a modern shopping mall. The hall housed two floors of shops, with the upper shops set back on each side and lit by skylights. Light from the same sources reached the ground-floor shops through arches beneath the great umbrella-like groin vaults covering the hall (see "The Roman Architectural Revolution," page 97).

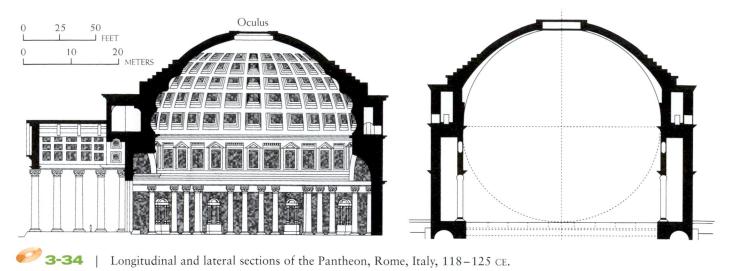

The Pantheon's traditional facade masked its revolutionary cylindrical drum and its huge hemispherical dome. The interior symbolized both the orb of the earth and the vault of the heavens.

one of the best-preserved buildings of antiquity. The Pantheon reveals the full potential of concrete, both as a building material and as a means for shaping architectural space. The temple originally was approached from a columnar courtyard, and, like temples in Roman forums, stood at one narrow end of the enclosure. Its facade of eight Corinthian columns—almost all that could be seen from ground level in antiquity—was a bow to tradition. Everything else about the Pantheon was revolutionary. Behind the columnar porch is an immense concrete cylinder covered by a huge hemispherical dome 142 feet in diameter. The dome's top is also 142 feet from the floor (Fig. 3-34). The design is thus based on the intersection of two circles (one horizontal, the other vertical) so that the interior space could be imagined as the orb of the earth and the dome as the vault of the heavens.

If the Pantheon's design is simplicity itself, executing that design took all the ingenuity of Hadrian's engineers. The cylindrical drum was built up level by level using concrete of varied composition. Extremely hard and durable basalt was employed in the mix for the foundations, and the "recipe" was gradually modified until, at the top, featherweight pumice replaced stones to lighten the load. The dome's thickness also decreases as it nears the oculus, the circular opening 30 feet in diameter that is the only light source for the interior (Fig. 3-35). The dome's weight was lessened, without weakening its structure, through the use of *coffers* (sunken decorative panels). These further reduced the dome's mass and also

3-35 | Interior of the Pantheon, Rome, Italy, 118–125 CE.

The coffered dome of the Pantheon is 142 feet in diameter and 142 feet high. The light entering through its oculus forms a circular beam that moves across the dome as the sun moves across the sky.

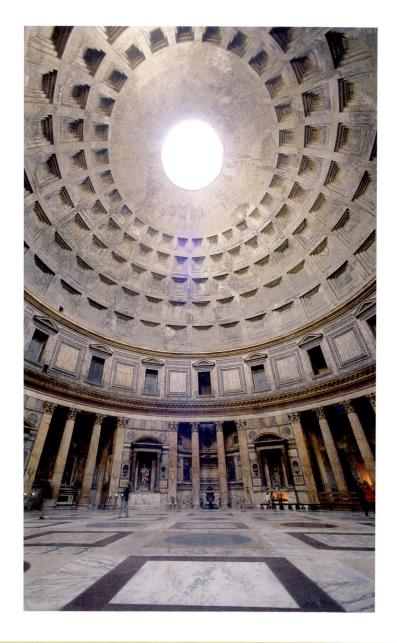

provided a handsome pattern of squares within the vast circle. Renaissance drawings suggest that each coffer once had a glistening gilded-bronze rosette at its center, enhancing the symbolism of the dome as the starry heavens.

Below the dome, much of the original marble veneer of the walls, niches, and floor has survived (Fig. 3-35). In the Pantheon, visitors can get a sense, as almost nowhere else, of how magnificent the interiors of Roman concrete buildings could be. But despite the luxurious skin of the Pantheon's interior, on first entering the structure one senses not the weight of the enclosing walls but the space they enclose. In pre-Roman architecture, the form of the enclosed space was determined by the placement of the solids, which did not so much shape space as interrupt it. Roman architects were the first to conceive of architecture in terms of units of space that could be shaped by the enclosures. The Pantheon's interior is a single unified, self-sufficient whole, uninterrupted by supporting solids. Through the oculus, the space opens to the drifting clouds, the blue sky, the sun, and the gods. In the Pantheon, the architect used light not just to illuminate the darkness but to create drama and underscore the symbolism of the interior shape. On a sunny day, the light that passes through the oculus forms a circular beam, a disk of light that moves across the coffered dome in the course of the day as the sun moves across the sky itself. Escaping from the noise and torrid heat of a Roman summer day into the Pantheon's cool, calm, and mystical immensity is an experience almost impossible to describe and one that should not be missed.

Imperial Majesty on Horseback Perhaps the most majestic surviving portrait of a Roman emperor is the larger-than-life-size gilded-bronze equestrian statue (Fig. 3-36) of Marcus Aurelius (r. 161–180 CE), one of the Antonine emperors who followed Hadrian. Marcus possesses a superhuman grandeur and is much larger than any normal human would be in relation to his horse. He stretches out his right arm in a gesture that is both a greeting and an offer of clemency. Some evidence suggests that beneath the horse's raised right foreleg an enemy once cowered, begging Marcus for mercy. The statue conveys the awesome power of the god-like Roman emperor as ruler of the whole world.

This message of supreme confidence is not, however, conveyed by the emperor's head, with its long, curly hair and full beard, consistent with the latest fashion. Marcus's forehead is lined, and his eyes appear saddened. He seems weary, even worried. For the first time, the strain of constant warfare on the frontiers and the burden of ruling a worldwide empire show in the emperor's face. The Antonine sculptor ventured beyond Republican verism. The ruler's character, his thoughts, and his soul were exposed for all to see, as Marcus revealed them himself in his *Meditations*, a deeply moving philosophical treatise setting forth the emperor's personal worldview. This kind of introspective verism was a profound change from classical idealism. It marks a major turning point in the history of ancient art.

3-36 | Equestrian statue of Marcus Aurelius, from Rome, Italy, ca. 175 CE. Bronze, approx. 11' 6" high. Musei Capitolini, Rome.

In this portrait on horseback, Marcus Aurelius stretches out his arm in a gesture of clemency. An enemy once cowered beneath the horse's raised foreleg. The statue conveys the awesome power of the conquering emperor.

Roman Mummy Portraits Painted portraits were common in the Roman Empire, but most have perished. In Roman Egypt, however, large numbers have been found because the Egyptians continued to bury their dead in mummy cases (see "Mummification," Chapter 1, page 33), with painted portraits on wood replacing the traditional stylized portrait masks. Our example (Fig. 3-37), from the Faiyum district, depicts a bearded man. The portrait was probably painted while the man was still alive. The technique is *encaustic*, in which colors were mixed with hot wax and then applied with a spatula to a wooden panel. The portrait we illustrate exhibits the painter's refined use of the brush and spatula, mastery of the depiction of varied textures and of the play of light over the soft and delicately modeled face, and sensitive portrayal of the deceased's calm demeanor. Artists also applied encaustic to stone, and the mummy portraits give some idea of what Roman marble portraits once looked like. According to Pliny, in the fourth

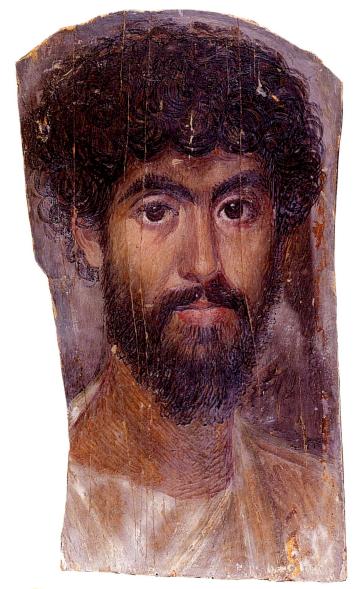

3-37 | Mummy portrait of a man, from Faiyum, Egypt, ca. 160–170 CE. Encaustic on wood, approx. 1' 2" high. Albright-Knox Art Gallery, Buffalo.

In Roman times, the Egyptians continued to bury their dead in mummy cases, but painted portraits replaced the traditional masks. This portrait was painted in encaustic, in which colors were mixed with hot wax.

century BCE, when Praxiteles, perhaps the greatest marble sculptor of the ancient world, was asked which one of his statues he preferred, the Greek artist replied, "Those that Nikias painted." This anecdote underscores the importance of coloration in ancient statuary.

The Late Empire

By the time of Marcus Aurelius, two centuries after Augustus established the Pax Romana, Roman power was beginning to erode. It was more and more difficult to keep order on the frontiers, and even within the Empire the authority of Rome was being challenged. Marcus's son Commodus (r. 180–192 CE)

was assassinated, bringing the Antonine dynasty to an end. The economy was in decline, and the efficient imperial bureaucracy was disintegrating. Even the official state religion was losing ground to Eastern cults, Christianity among them, which were beginning to gain large numbers of converts. The Late Empire, which is reckoned from Commodus's death, was a pivotal era in world history, during which the pagan civilization of classical antiquity was gradually transformed into the Christian civilization of the Middle Ages.

Severan Rome Civil conflict followed Commodus's death. When it ended, an African-born general named Septimius Severus (r. 193–211 CE) was master of the Roman world. The Severans were active builders in the capital. Septimius's son and successor, Caracalla (r. 211–217 CE), built the greatest in a long line of bathing and recreational complexes erected with imperial funds to win the public's favor. Made of brick-faced concrete and covered by enormous vaults springing from thick walls up to 140 feet high (Fig. 3-38), the Baths of Caracalla covered an area of almost 50 acres. The design was symmetrical along a central axis, facilitating the Roman custom of taking sequential plunges in cold-, warm-, and hot-water baths in the *frigidarium*, *tepidarium*, and *caldarium*, respectively.

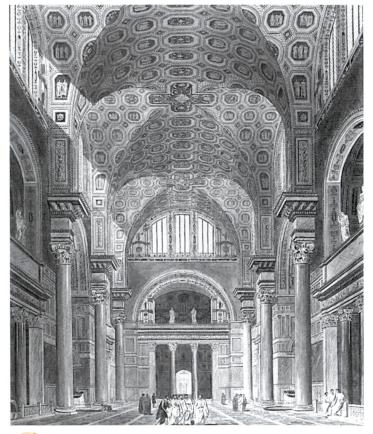

3-38 | Reconstruction drawing of the central hall (*frigidarium*) of the Baths of Caracalla, Rome, Italy, 212–216 CE.

Caracalla's Baths covered an area of almost 50 acres, and included landscaped gardens. The lavishly decorated central hall had stuccoed concrete groin vaults, mosaic floors, marble-faced walls, and colossal statuary.

Our reconstruction of the frigidarium (Fig. 3-38), which was also the central hall of the baths, shows not only the scale of the architecture and the way light entered through fenestrated groin vaults but also how lavishly the rooms were decorated. Stuccoed vaults, mosaic floors, marble-faced walls, and colossal statuary were found throughout the complex. The complex also had landscaped gardens, lecture halls, libraries, colonnaded exercise courts, and a giant swimming pool. Archaeologists estimate that up to 1,600 bathers at a time could enjoy this Roman equivalent of a modern health spa. A branch of one of the city's major aqueducts supplied water, and furnaces circulated hot air through hollow floors and walls throughout the complex.

A Suspicious Portrait Caracalla is also remembered for his cruelty. He ruthlessly had his brother (a contender for emperor) murdered, as well as his wife and father-in-law. Caracalla's personality is brilliantly captured in a marble portrait (Fig. 3-39) in which the sculptor depicted the emperor's short hair and close-cropped beard by etching into the surface. Caracalla's brow is knotted, and he abruptly turns his head

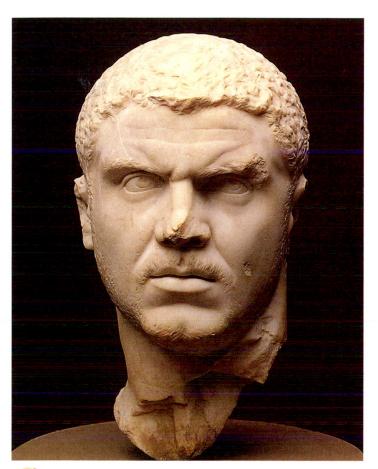

3-39 | Portrait of Caracalla, ca. 211–217 CE. Marble, approx. 1' 2" high. Metropolitan Museum of Art, New York.

The emperor's suspicious personality is brilliantly captured in this portrait. Caracalla's brow is knotted, and he abruptly turns his head over his left shoulder, as if he suspects danger from behind.

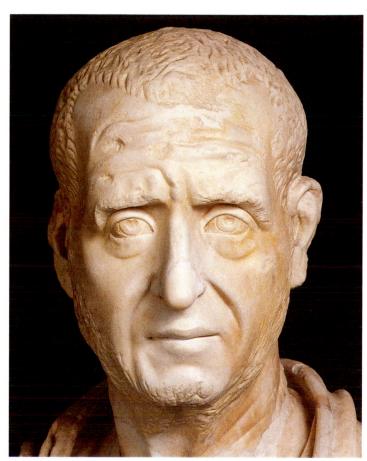

3-40 | Portrait bust of Trajan Decius, 249–251 CE. Marble, full bust approx. 2' 7" high. Museo Capitolino, Rome.

This portrait of a short-lived "soldier emperor" depicts an older man with bags under his eyes and a sad expression. The eyes glance away nervously, reflecting the anxiety of an insecure ruler.

over his left shoulder, as if he suspects danger from behind. The emperor had reason to be fearful. He was felled by an assassin's dagger in the sixth year of his rule.

The Soldier Emperors The next half century was one of almost continuous civil war. One general after another was declared emperor by his troops, only to be murdered by another general a few years or even a few months later. The unstable times of the so-called soldier emperors nonetheless produced some of the most moving portraits in the history of art. Following the lead of the sculptors of the Marcus Aurelius and Caracalla portraits, artists fashioned likenesses of the soldier emperors that are as notable for their emotional content as they are for their technical virtuosity. Trajan Decius (r. 249-251), for example, whose brief reign is best known for persecution of Christians, was portrayed in marble (Fig. 3-40) as an old man with bags under his eyes and a sad expression. In his eyes, which glance away nervously rather than engage the viewer directly, is the anxiety of a man who knows he can do little to restore order to an out-of-control world. The sculptor modeled the marble as if it were pliant clay, compressing the

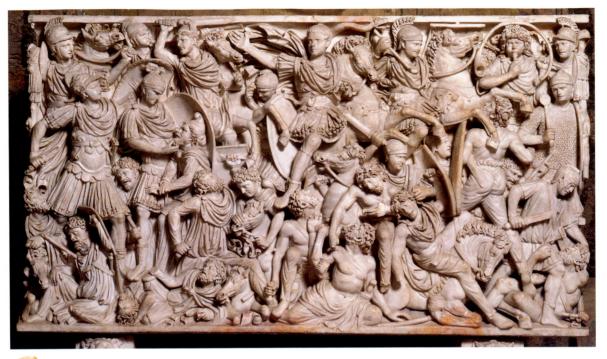

3-41 | Sarcophagus with battle of Romans and barbarians, from Rome, Italy, ca. 250–260 CE. Marble, approx. 5' high. Museo Nazionale Romano—Palazzo Altemps, Rome.

A chaotic scene of battle between Romans and barbarians decorates the front of this unusually large sarcophagus. The sculptor piled up the writhing, emotive figures in an emphatic rejection of classical perspective.

sides of the head at the level of the eyes, incising the hair and beard into the stone, and chiseling deep lines in the forehead and around the mouth. The portrait reveals the anguished soul of the man—and of the times.

From Cremation to Burial Beginning under Trajan and Hadrian and especially during the rule of the Antonines, the Romans began to favor burial over cremation. This reversal of funerary practices may reflect the influence of Christianity and other Eastern religions, whose adherents believed in an afterlife for the human body. Whatever the explanation, the shift to burial led to a sudden demand for sarcophagi. By the third century CE, burial had become so widespread that even the imperial family was practicing it in place of cremation. An unusually large sarcophagus (Fig. 3-41) of the mid-third century is decorated on the front with a chaotic scene of battle between Romans and one of their northern foes, probably the Goths. The sculptor spread the writhing and highly emotive figures evenly across the entire relief, with no illusion of space behind them. This piling of figures is an emphatic rejection of classical perspective. Like the contemporaneous "soul portraits" of the soldier emperors, it underscores the increasing dissatisfaction Late Roman artists felt with the classical style.

Within this dense mass of intertwined bodies, the central horseman stands out vividly. He is bareheaded and thrusts out his open right hand to demonstrate that he holds no weapon. Several scholars have identified him as one of the sons of Trajan Decius. In an age when the Roman army was far from invincible and Roman emperors were constantly felled by other Romans, the young general is boasting that he is a fearless commander assured of victory. His self-assurance may stem from his having embraced one of the increasingly popular Eastern mystery religions. On the youth's forehead is carved the emblem of Mithras, the Persian god of light, truth, and victory over death. Many shrines to Mithras dating to this period have been found in Rome.

Power Shared, Order Restored In 293 CE, in an attempt to restore order to the Roman Empire, Diocletian (r. 284– 305 CE), whose troops had proclaimed him emperor a decade earlier, decided to share power with his potential rivals. He established the tetrarchy (rule by four) and adopted the title of Augustus of the East. The other three tetrarchs were a corresponding Augustus of the West, and Eastern and Western Caesars (whose allegiance to the two Augusti was cemented by marriage to their daughters). The four tetrarchs often were portrayed together. Artists did not try to capture their individual appearances and personalities but sought instead to represent the nature of the tetrarchy itself—that is, to portray four equal partners in power. In the two pairs of porphyry (purple marble) tetrarchic portraits we illustrate (Fig. 3-42), it is impossible to name the rulers. Each of the four emperors has lost his identity as an individual and been subsumed into the larger entity of the tetrarchy. All are identically clad in breastplate and cloak, and

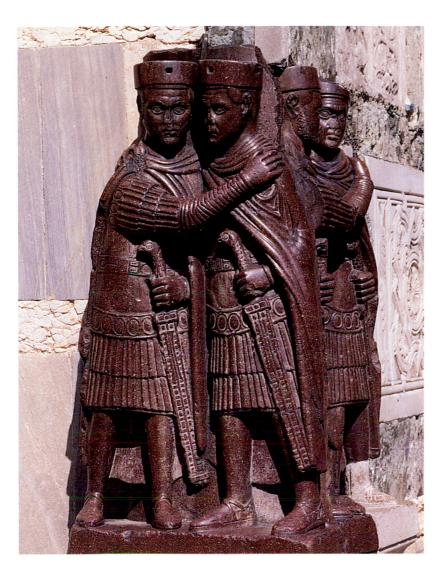

3-42 | Portraits of the four tetrarchs, from Constantinople, ca. 305 CE. Porphyry, approx. 4′ 3″ high. Saint Mark's, Venice.

Diocletian established the tetrarchy to bring order to the Roman world. Whenever the four co-rulers appeared together, artists did not portray them as individuals but as nearly identical partners in power.

each grasps a sheathed sword in the left hand. With their right arms they embrace one another in an overt display of concord. The figures have large cubical heads on squat bodies. The drapery is schematic. The faces are emotionless masks, distinguished only by the beard on two of the figures (probably to identify them as the older Augusti, as opposed to the younger Caesars). Nonetheless, each pair is as alike as freehand carving can achieve. In this group portrait, carved eight centuries after Greek sculptors first freed the human form from the formal rigidity of the Egyptian-inspired kouros stance, the human figure was once again conceived in iconic terms. Idealism, naturalism, individuality, and personality now belonged to the past.

Constantine and Christianity The short-lived concord among the tetrarchs ended with Diocletian's abdication in 305 CE. An all-too-familiar period of conflict among rival Roman armies followed. The eventual victor was Constantine (r. 306–337 CE), son of Constantius Chlorus, Diocletian's Caesar of the West. After the death of his father, Constantine invaded Italy in 312 and took control of Rome. Constantine attributed his decisive victory at the Milvian Bridge, the gateway to the capital, to the aid of the Christian god. In 313, he

and Licinius, Constantine's co-emperor in the East, issued the Edict of Milan, ending the persecution of Christians.

In time, Constantine and Licinius became foes, and in 324 Constantine defeated and executed Licinius near Byzantium (modern Istanbul, Turkey). Constantine was now unchallenged ruler of the whole Roman Empire. Shortly after the death of Licinius, he founded a "New Rome" on the site of Byzantium and named it Constantinople (City of Constantine). A year later, in 325, at the Council of Nicaea, Christianity became the de facto official religion of the Roman Empire. From this point on, paganism declined rapidly. Constantinople was dedicated on May 11, 330, "by the commandment of God." Constantine himself was baptized on his deathbed in 337. For many scholars, the transfer of the seat of power from Rome to Constantinople and the recognition of Christianity mark the beginning of the Middle Ages. Constantinian art is a mirror of this transition from the classical to the medieval world. In Rome, for example, Constantine was a builder in the grand tradition of the emperors of the first, second, and early third centuries, erecting public baths, a basilica near the Roman Forum, and a triumphal arch. But he was also the patron of the city's first churches, including Saint Peter's (FIG. 4-3).

Constantine's Colossus The most impressive by far of Constantine's preserved portraits is an eight-and-one-halffoot-tall head (Fig. 3-43), one of several marble fragments of a colossal enthroned statue of the emperor that was composed of a brick core, a wooden torso covered with bronze, and a head and limbs of marble. Constantine's artist modeled the seminude seated portrait on Roman images of Jupiter, but also resuscitated the Augustan image of an eternally youthful head of state. The emperor held an orb (possibly surmounted by the cross of Christ), the symbol of global power, in his extended left hand. Constantine's personality is lost in this immense image of eternal authority. The colossal size, the likening of the emperor to Jupiter, the eyes directed at no person or thing of this world—all combine to produce a formula of overwhelming power appropriate to Constantine's exalted position as absolute ruler.

Rome's New Basilica Constantine's gigantic portrait sat in the western apse of the Basilica Nova (Figs. 3-44 and 3-8, no. 8) he constructed near the Arch of Titus. From its position in the apse, the emperor's image dominated the interior of the "New Basilica" in much the same way enthroned statues of Greco-Roman divinities loomed over awestruck mortals who entered the cellas of pagan temples.

The ruins of the Basilica Nova never fail to impress tourists with their size and mass. The original structure was 300 feet long and 215 feet wide. Brick-faced concrete walls 20 feet thick supported coffered barrel vaults in the aisles. These vaults also buttressed the groin vaults of the nave, which was 115 feet high. The walls and floors were richly marbled and stuccoed and could be readily admired by those who came to the basilica to conduct business, because the groin vaults permitted ample light to enter the nave directly. Our reconstruction (Fig. 3-44) effectively suggests the immensity of the interior, where the

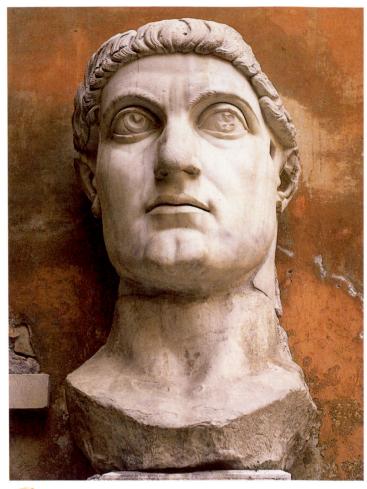

3-43 | Portrait of Constantine, from the Basilica Nova, Rome, Italy, ca. 315–330 CE. Marble, approx. 8' 6" high. Palazzo dei Conservatori, Rome.

Constantine's portraits revive the Augustan image of an eternally youthful ruler. This colossal head is one of several fragments of an enthroned Jupiter-like statue of the emperor holding the orb of world power.

3-44 | Reconstruction drawing of the Basilica Nova (Basilica of Constantine), Rome, Italy, ca. 306–312 CE.

The lessons learned in the construction of baths and market halls were applied to the Basilica Nova, where fenestrated concrete groin vaults replaced the clerestory of a traditional stone-and-timber basilica.

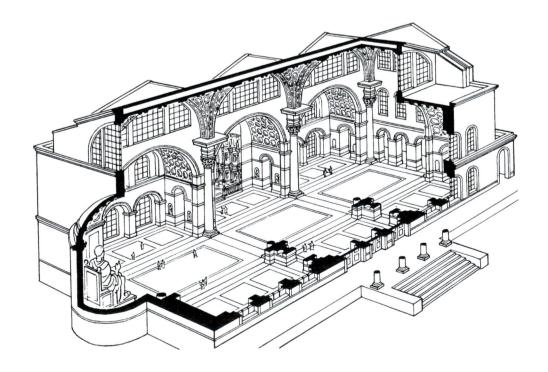

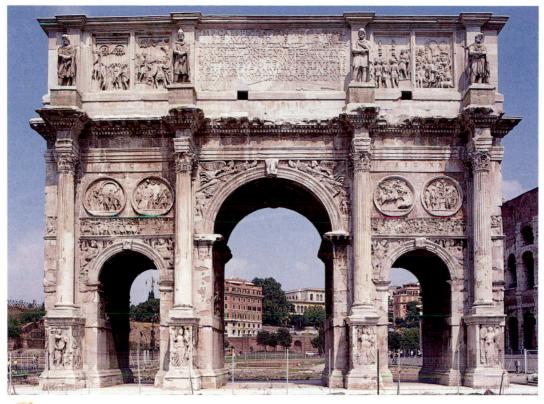

3-45 | Arch of Constantine (south side), Rome, Italy, 312-315 CE.

Much of the sculptural decoration of Constantine's arch was taken from monuments of Trajan, Hadrian, and Marcus Aurelius. Sculptors recut the heads of the earlier emperors with Constantine's features.

great vaults dwarf not only humans but also even the emperor's colossal portrait. The drawing also clearly reveals the fenestration of the groin vaults, a lighting system akin to the clerestory of a traditional stone-and-timber basilica (Fig. 3-30, no. 4). The lessons learned in the design and construction of buildings such as Trajan's great market hall (Fig. 3-32) and the Baths of Caracalla (Fig. 3-38) were applied here to the Roman basilica.

New Arch, Old Reliefs Also grandiose is Constantine's nearby triple-passageway arch (Fig. 3-45 and 3-8, no. 10), the largest erected in Rome since the end of the Severan dynasty nearly a century before. Much of the sculptural decoration, however, was taken from earlier monuments of Trajan, Hadrian, and Marcus Aurelius. Sculptors refashioned the second-century reliefs to honor Constantine by recutting the heads of the earlier emperors with the features of the new ruler. The Arch of Constantine has often been cited as evidence of a decline in creativity and technical skill in the waning years of the pagan Roman Empire. Although such a judgment is in large part deserved, it ignores the fact that the reused sculptures were carefully selected to associate Constantine with famous emperors of the second century. That message is underscored in one of the new Constantinian reliefs above the arch's lateral passageways. It shows Constantine on the speaker's platform in the Roman Forum, flanked by statues of Hadrian and Marcus Aurelius.

In another Constantinian relief (Fig. 3-46), the emperor is shown with attendants, distributing largess to grateful citizens who approach him from right and left. Constantine is a frontal and majestic presence, elevated on a throne above the

3-46 | Distribution of largess, detail of the north frieze of the Arch of Constantine, Rome, Italy, 312–315 CE. Marble, approx. 3' 4" high.

This Constantinian frieze is less a narrative of action than a picture of actors frozen in time. The composition's rigid formality reflects the new values that would come to dominate medieval art.

recipients of his munificence. (Constantine's head, which was carved separately and set into the relief, has been lost.) The figures are squat in proportion, like the tetrarchs (FIG. 3-42). They do not move according to any classical principle of naturalistic movement but, rather, with the mechanical and repeated stances and gestures of puppets. The relief is very shallow, the forms were not fully modeled, and the details were incised. The heads were not distinguished from one another. The sculptor depicted a crowd, not a group of individuals. The frieze is less a narrative of action than a picture of actors frozen in time so that the viewer can distinguish instantly the all-important imperial donor (at the center on a throne) from his attendants (to the left and right above) and the recipients of the largess (below and of smaller stature).

This approach to pictorial narrative was once characterized as a "decline of form," and when judged by classical art standards, it was. But the rigid formality of the composition, determined by the rank of those portrayed, was consistent with a new set of values. It soon became the preferred mode, supplanting the classical notion that a picture is a window onto a world of anecdotal action. Comparing this Constantinian relief with a Byzantine icon (Fig. 4-18) reveals that the new compositional principles are those of the Middle Ages. They were very different from, but not necessarily "better" or "worse" than, those of classical antiquity. The Arch of Constantine is the quintessential monument of its era, exhibiting a respect for the classical past in its reuse of second-century sculptures while at the same time rejecting the norms

of classical design in its frieze, paving the way for the iconic art of the Middle Ages.

CONCLUSION

In Europe, the Middle East, and North Africa today, the remains of Roman civilization are everywhere. Roman temples and basilicas have an afterlife as churches. The powerful concrete vaults of ancient Roman buildings form the cores of modern houses, stores, restaurants, factories, and museums. Bullfights, sports events, operas, and rock concerts are staged in Roman amphitheaters. Roman aqueducts continue to supply water to some modern towns. Ships dock in what were once Roman ports, and western Europe's highway system still closely follows the routes of Roman roads.

Roman civilization also lives on in law and government, in language, in the calendar—even in the coins used daily. Indeed, Roman art speaks in a language almost everyone can readily understand. Its diversity and eclecticism foreshadowed the modern world. The Roman use of art, especially portraits and historical relief sculptures, to manipulate public opinion is similar to the carefully crafted imagery of contemporary political campaigns. And the Roman mastery of concrete construction began an architectural revolution still felt today. Indeed, the Roman Empire is the bridge—in politics, the arts, and religion—between the ancient and the medieval and modern Western worlds.

753 BCE

- Romulus founds Rome, 753 BCE
- Expulsion of the last Etruscan king of Rome, 509 BCE
 - Greeks defeat the Etruscan navy at Cumae, 474 BCE
 - Romans destroy Veii, 396 BCE
 - Peace between Rome and Tarquinia, 351 BCE
 - I Roman conquest of Cerveteri, 273 BCE
 - I Marcellus brings spoils of Syracuse to Rome, 211 BCE
 - Roman conquest of Greece, 146 BCE
 - I Rome inherits kingdom of Pergamon, 133 BCE
 - Social War and completion of Romanization of Italy, 89 BCE
 - Foundation of Roman colony at Pompeii, 80 BCE
 - Assassination of Julius Caesar, 44 BCE
 - Battle of Actium, 31 BCE

- ☑ I Augustus, r. 27 BCE-14 CE
 - Vitruvius, The Ten Books of Architecture, ca. 25 BCE
 - Vergil, 70−19 BCE
 - I Julio-Claudians, r. 14-68 CE
 - I Flavians, r. 69-96
 - Eruption of Mount Vesuvius, 79

96 CE

EARLY EMPIRE

HIGH EMPIRE

LATE EMPIRE

- I Trajan, r. 98-117
 - I Hadrian, r. 117-138
 - Antonines, r. 138-192

192

- Severans, r. 193-235
- Soldier emperors, r. 235-284
- I Diocletian, r. 284-305
- Constantine, r. 306-337
- Edict of Milan, 313
- Dedication of Constantinople, 330

4

337

Tomb of the Leopards, Tarquinia, ca. 480–470 BCE

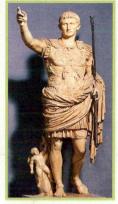

Portrait of Augustus, from Primaporta, ca. 20 BCE

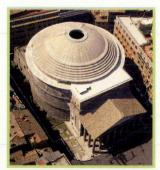

3 Pantheon, Rome, 118-125 CE

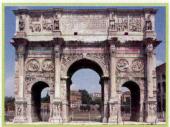

Arch of Constantine, Rome, 312-315 CE

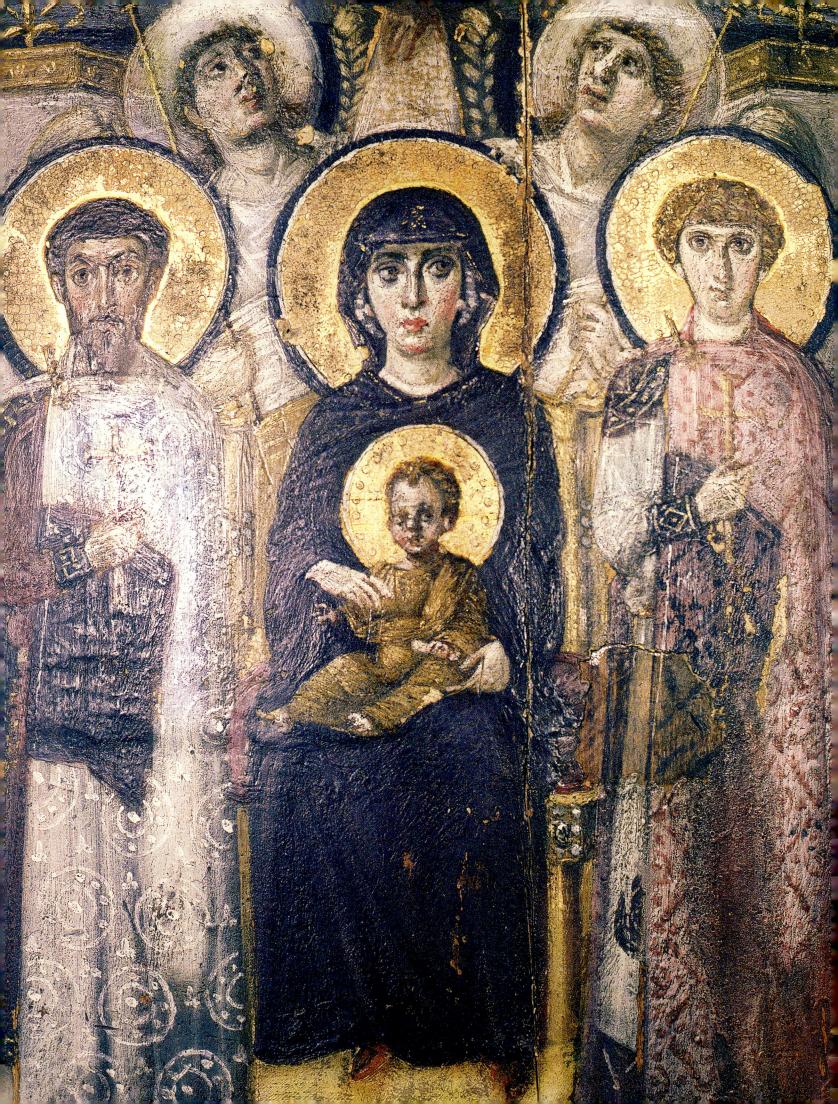

EARLY CHRISTIANITY AND BYZANTIUM

By the third and fourth centuries,* a rapidly growing number of people throughout the vast Roman Empire had rejected the emperors' polytheism (belief in multiple gods) in favor of monotheism (the worship of a single all-powerful god). The most prominent of these religions was Christianity. The emperor Diocletian (r. 284–305) was so concerned by the growing popularity of Christianity in the Roman army ranks that he ordered a fresh round of persecutions in 303 to 305, a half century after the last great persecutions under Trajan Decius (r. 249–251). The Romans hated the Christians because of their alien beliefs—that their god had been incarnated in the body of a man and that the death and resurrection of the god-man Christ made possible the salvation and redemption of all. But they also hated them because they refused to pay even token homage to the official gods of the Roman state. As Christianity's appeal grew, so too did the Roman state's fear of weakening imperial authority. Persecution ended only when Constantine came to believe that the Christian god was the source of his power rather than a threat to it (Chapter 3). In 313, his Edict of Milan brought an end to the official mistreatment of Christians.

EARLY CHRISTIAN ART

Very little is known about the art of the first Christians. When we speak of "Early Christian art," we mean the earliest preserved works with Christian subjects, not the art of Christians at the time of Jesus.

Funerary Art

Most Early Christian art in Rome dates to the third and fourth centuries and is found in the *catacombs*—vast subterranean networks of passageways and chambers designed as cemeteries for burying the Christian dead. The name derives from the Latin *ad catacumbas*, which means "in the hollows." The builders tunneled the catacombs out of the tufa bedrock, much as the Etruscans created the underground tomb chambers at Cerveteri (Fig. 3-4). The catacombs are less elaborate than the Etruscan tombs, but much more extensive. Researchers have estimated that they run for 60 to 90 miles, housing as many as four million bodies.

Virgin (Theotokos) and Child between Saints Theodore and George, icon, sixth or early seventh century. Encaustic on wood, 2' 3" \times 1' $7\frac{3}{8}$ ". Monastery of Saint Catherine, Mount Sinai, Egypt.

^{*} From this point on, all dates are CE unless otherwise indicated.

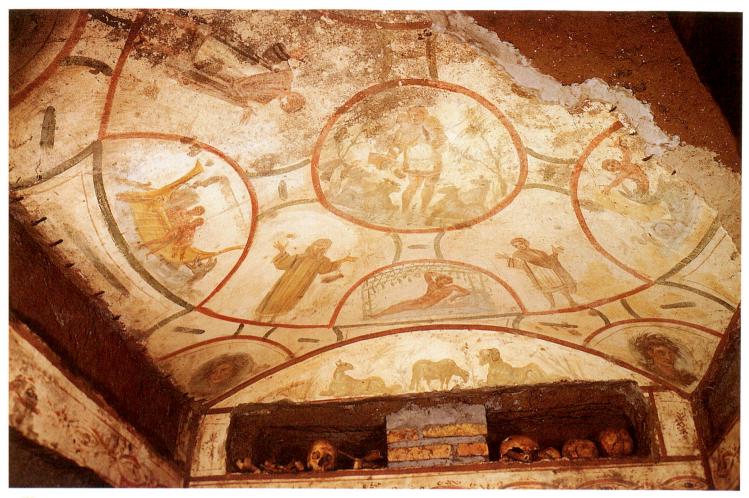

4-1 | The Good Shepherd, the story of Jonah, and orants, painted ceiling of a cubiculum in the Catacomb of Saints Peter and Marcellinus, Rome, Italy, early fourth century.

Early Christian paintings regularly mixed Old and New Testament themes. Jonah was a popular subject because he was swallowed by a sea monster and emerged safely after three days, prefiguring Christ's Resurrection.

Jonah and Jesus Often, the Christians carved out small rooms, called *cubicula* (as in Roman houses), to serve as mortuary chapels within the catacombs. The painted ceiling (Fig. 4-1) of a cubiculum in the Catacomb of Saints Peter and Marcellinus in Rome features a large circle with the symbol of the Christian faith, the cross, at its center. The arms of the cross terminate in four *lunettes* (semicircular frames) containing the key episodes from the Old Testament story of Jonah. On the left, the sailors throw him from his ship. He emerges on the right from the "whale" (actually a sea dragon) that swallowed him. At the bottom, safe on land, Jonah contemplates the miracle of his salvation and the mercy of God.

From the beginning, the Old Testament played an important role in Christian life and Christian art, in part because Jesus was a Jew and so many of the first Christians were converted Jews, but also because Christians came to view many of the persons and events of the Old Testament as *prefigurations* (prophetic forerunners) of New Testament persons and events. Christ himself established the pattern for this kind of biblical interpretation when he compared Jonah's spending

three days in the belly of the sea monster to the comparable time he would be entombed in the earth before his Resurrection (Matt. 12:40). In the fourth century Saint Augustine (354–430) confirmed the validity of this approach to the Old Testament when he stated that "the New Testament is hidden in the Old; the Old is clarified by the New."

A man, a woman, and at least one child occupy the compartments between the Jonah lunettes. They are *orants* (praying figures), raising their arms in the ancient attitude of prayer. Together they make up a cross-section of the Christian family seeking a heavenly afterlife. The cross's central medallion shows Christ as the Good Shepherd, whose powers of salvation are underscored by his juxtaposition with Jonah's story. In Early Christian art, Christ is often portrayed as the youthful and loyal protector of the Christian flock, who said to his disciples, "I am the good shepherd; the good shepherd gives his life for the sheep" (John 10:11). Only after Christianity became the Roman Empire's official religion did Christ take on in art such imperial attributes as the halo, the purple robe, and the throne, which denoted rulership.

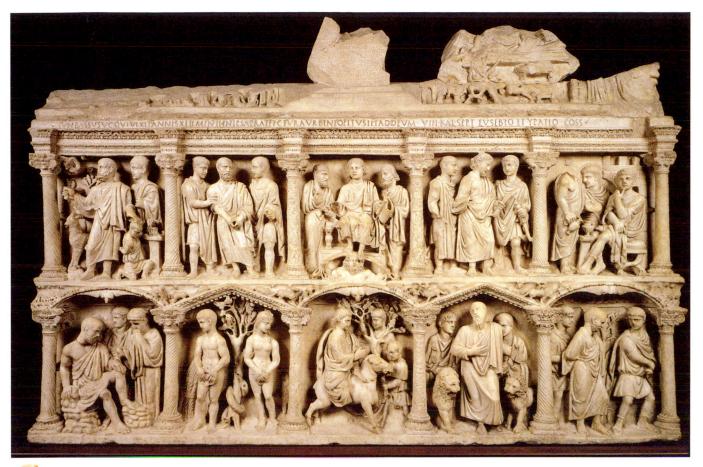

4-2 | Sarcophagus of Junius Bassus, from Rome, Italy, ca. 359. Marble, $3' 10\frac{1}{2}'' \times 8'$. Museo Storico del Tesoro della Basilica di San Pietro, Rome.

The wealthiest Christians, like the city prefect Junius Bassus, favored elaborately decorated sarcophagi. Here, biblical episodes from Adam and Eve to Christ before Pilate appear in ten niches in two rows.

A Convert's Coffin All Christians rejected cremation, and the wealthiest Christian faithful, like their pagan contemporaries, favored impressive marble sarcophagi. The finest surviving Early Christian sarcophagus (Fig. 4-2) is that of Junius Bassus, city prefect of Rome and a pagan convert to Christianity, who died in 359. His sarcophagus is divided into two registers of five compartments, each framed by columns. Stories from the Old and New Testaments fill the 10 niches. Christ has pride of place and appears in the central compartment of each register: as a teacher enthroned between his chief apostles, Saints Peter and Paul (above), and triumphantly entering Jerusalem on a donkey (below). Appropriately, the scene of Christ's heavenly triumph is situated above that of his earthly triumph (see "The Life of Jesus in Art," pages 126–127). Both compositions owe a great deal to pagan Roman art. In the upper zone, Christ, like an enthroned Roman emperor, sits above a personification of the sky god holding a billowing mantle over his head, indicating that Christ is ruler of the universe. The scene below derives in part from portrayals of Roman emperors entering cities on horseback, but Christ's steed and the absence of imperial attributes contrast sharply with the imperial models the sculptor used as compositional sources.

The Old Testament scenes on the Junius Bassus sarcophagus were chosen for their significance in the early Christian Church. Adam and Eve, for example, are in the second niche from the left on the lower level. Their Original Sin of eating the apple in the Garden of Eden ultimately necessitated Christ's sacrifice for the salvation of humankind. To the right of the entry into Jerusalem is Daniel, unscathed by flanking lions, saved by his faith. At the upper left, Abraham is about to sacrifice Isaac. Christians believe that this Old Testament story was a prefiguration of God's sacrifice of his own son, Jesus.

The Crucifixion itself, however, does not appear on the Junius Bassus sarcophagus. Indeed, the subject was very rare in Early Christian art, and unknown prior to the fifth century. Artists emphasized Christ's divinity and exemplary life as teacher and miracle worker, not his suffering and death at the hands of the Romans. This sculptor, however, alluded to the Crucifixion in the scenes in the two compartments at the upper right depicting Jesus being led before Pontius Pilate for judgment. The Romans condemned Jesus to death, but he triumphantly overcame it. Junius Bassus hoped for a similar salvation.

The Life of Jesus in Art

Christians believe that Jesus of Nazareth is the son of God, the *Messiah* (Savior, *Christ*) of the Jews prophesied in the Old Testament. His life — from his miraculous birth from the womb of a virgin mother through his preaching and miracle working to his execution by the Romans and subsequent ascent to Heaven — has been the subject of countless artworks from Roman times through the present day. Although many of the events of Jesus' life were rarely or never depicted during certain periods, it is useful to summarize the entire cycle here in one place, giving selected references to illustrations of the various episodes.

INCARNATION AND CHILDHOOD

The first "cycle" of the life of Jesus consists of the events of his conception, birth, infancy, and childhood.

Annunciation to Mary (Figs. 7-31 and 8-27) The archangel Gabriel announces to the Virgin Mary that she will miraculously conceive and give birth to God's son, Jesus. God's presence at the *Incarnation* is sometimes indicated by a dove, the symbol of the Holy Spirit, the third "person" of the Trinity with God the Father and Jesus.

Visitation (Fig. 7-12) The pregnant Mary visits Elizabeth, her older cousin, who is pregnant with the future Saint John the Baptist. Elizabeth is the first to recognize that the baby Mary is bearing is the Son of God.

Nativity (Fig. 7-25), **Annunciation to the Shepherds**, and **Adoration of the Shepherds** Jesus is born at night in Bethlehem and placed in a basket. Mary and her husband, Joseph, marvel at the newborn, while an angel announces the birth of the Savior to shepherds in the field.

Adoration of the Magi A bright star alerts three wise men (*magi*) in the East that the King of the Jews has been born. They travel 12 days to find the Holy Family and present precious gifts to the infant Jesus.

Presentation in the Temple Mary and Joseph bring their son to the temple in Jerusalem, where the aged Simeon, who God said would not die until he had seen the Messiah, recognizes Jesus as the prophesied Savior of humankind.

Massacre of the Innocents and Flight into Egypt King Herod, fearful that a rival king has been born, orders the massacre of all infants

in Bethlehem, but an angel warns the Holy Family, and they escape to Egypt.

Dispute in the Temple Joseph and Mary travel to Jerusalem for the feast of Passover (the celebration of the release of the Jews from bondage to the pharaohs of Egypt). Jesus, only 12 years old at the time, engages in learned debate with astonished Jewish scholars in the temple, foretelling his ministry.

PUBLIC MINISTRY

The public ministry cycle comprises the teachings of Jesus and the miracles he performed.

Baptism The beginning of Jesus' public ministry is marked by his baptism at age 30 by John the Baptist in the Jordan River. God's voice proclaims Jesus as his son.

Calling of Matthew (Fig. 10-10) Jesus summons Matthew, a tax collector, to follow him, and Matthew becomes one of his 12 disciples, or *apostles* (from the Greek for "messenger").

Miracles In the course of his teaching and travels, Jesus performs many miracles, revealing his divine nature. In the miracle of loaves and fishes (Fig. 4-8), for example, Jesus transforms a few loaves of bread and a handful of fishes into enough food to feed several thousand people. Other miracles include acts of healing and the raising of the dead, the turning of water into wine, and walking on water.

Delivery of the Keys to Peter (Fig. 8-31) The fisherman Peter was one of the first Jesus summoned as a disciple. Jesus chooses Peter (whose name means "rock") as his successor, the rock on which his church will be built, and symbolically delivers to Peter the keys to the Kingdom of Heaven.

Transfiguration Jesus scales a high mountain and, in the presence of Peter and two other disciples, James and John the Evangelist, is transformed into radiant light. God, speaking from a cloud, discloses that Jesus is his son.

Cleansing of the Temple Jesus returns to Jerusalem, where he finds money changers and merchants conducting business in the temple. He rebukes them and drives them out of the sacred precinct.

Architecture and Mosaics

The earliest Christian places of worship were usually remodeled private houses that could accommodate only a small community. Once Christianity achieved imperial sanction under Constantine, an urgent need suddenly arose to construct churches. The new buildings had to meet the requirements of Christian liturgy, provide a suitably monumental setting for the celebration of the Christian faith, and accommodate the rapidly growing numbers of worshipers.

Constantinian Patronage Constantine was convinced that the Christian god had guided him to victory, and in lifelong gratitude he protected and advanced Christianity

throughout the empire, as well as in the obstinately pagan capital city of Rome. As emperor, he was, of course, obliged to safeguard the ancient Roman religion, traditions, and monuments, and, as noted in Chapter 3, he was (for his time) a builder on a grand scale in the heart of the city. But eager to provide buildings to house the Christian rituals and venerated burial places, especially the memorials of founding saints, Constantine also was the first major patron of Christian architecture. He constructed elaborate basilicas, memorials, and *mausoleums* not only in Rome but also in Constantinople, his "New Rome" in the East, and at sites sacred to Christianity, most notably Bethlehem, the birthplace of Jesus, and Jerusalem, the site of his Crucifixion (MAP 4-1, decent).

The Life of Jesus in Art (continued)

PASSIO

The Passion (from Latin *passio*, "suffering") cycle includes the episodes leading to Jesus' death, Resurrection, and ascent to Heaven.

Entry into Jerusalem (Fig. 4-2) On the Sunday before his Crucifixion (Palm Sunday), Jesus rides triumphantly into Jerusalem on a donkey, accompanied by disciples.

Last Supper (Figs. 8-28, 9-2, and 9-24) and **Washing of the Disciples' Feet** In Jerusalem, Jesus celebrates Passover with his disciples. During this Last Supper, Jesus foretells his imminent betrayal, arrest, and death and invites the disciples to remember him when they eat bread (symbol of his body) and drink wine (his blood). This ritual became the celebration of *Mass (Eucharist)* in the Christian Church. At the same meal, Jesus sets an example of humility for his apostles by washing their feet.

Agony in the Garden Jesus goes to the Mount of Olives in the Garden of Gethsemane, where he struggles to overcome his human fear of death by praying for divine strength.

Betrayal and Arrest One of the disciples, Judas Iscariot, agrees to betray Jesus to the Jewish authorities in return for 30 pieces of silver. Judas identifies Jesus to the soldiers by kissing him, and Jesus is arrested.

Trials of Jesus (Fig. 4-2) and **Denial of Peter** Jesus is brought before Caiaphas, the Jewish high priest, and is interrogated about his claim to be the Messiah. Meanwhile, the disciple Peter thrice denies knowing Jesus, as Jesus predicted he would. Jesus is then brought before the Roman governor of Judea, Pontius Pilate, on the charge of treason because he had proclaimed himself as King of the Jews. Pilate asks the crowd to choose between freeing Jesus or Barabbas, a murderer. The people choose Barabbas, and the judge condemns Jesus to death. Pilate washes his hands, symbolically relieving himself of responsibility for the mob's decision.

Flagellation and **Mocking** The Roman soldiers who hold Jesus captive whip (flagellate) him and mock him by dressing him as King of the Jews and placing a crown of thorns on his head.

Carrying of the Cross, Raising of the Cross (Fig. 10-17), and **Crucifixion** (Figs. 4-20, 6-6, and 6-13) The Romans force Jesus to carry the cross on which he will be crucified from Jerusalem to Mount Calvary (Gol-

Old Saint Peter's The greatest of Constantine's churches in Rome was Old Saint Peter's, probably begun as early as 319. The present-day church (FIGS. 10-1 and 10-2) is a replacement for the fourth-century structure. Old Saint Peter's stood on the spot where Constantine and Pope Sylvester believed that Peter, the first apostle and founder of the Christian community in Rome, had been buried. Excavations in the Roman cemetery beneath the church have in fact revealed a second-century memorial erected in honor of the Christian martyr at his reputed grave. The great Constantinian church, capable of housing 3,000 to 4,000 worshipers at one time, therefore fulfilled the words of Christ himself, when he said, "Thou art Peter, and upon this rock [in Greek, *petra*] I will build my church" (Matt. 16:18).

gotha, the "place of the skull," where Adam was buried). He falls three times and gets stripped along the way. Soldiers erect the cross and nail his hands and feet to it. The Virgin Mary, John the Evangelist, and Mary Magdalene mourn at the foot of the cross, while soldiers torment Jesus. One of them (the centurion Longinus) stabs his side with a spear. After suffering great pain, Jesus dies. The Crucifixion occurred on a Friday, and Christians celebrate the day each year as Good Friday.

Deposition (Figs. 8-4 and 9-20), **Lamentation** (Figs. 4-22 and 7-29), and **Entombment** Two disciples, Joseph of Arimathea and Nicodemus, remove Jesus' body from the cross (the Deposition) and take him to the tomb Joseph had purchased for himself. Joseph, Nicodemus, the Virgin Mary, Saint John the Evangelist, and Mary Magdalene mourn over the dead Jesus (the Lamentation). (When in art the isolated figure of the Virgin Mary cradles her dead son in her lap, it is called a *Pietà* [Italian for "pity"; Fig. 7-24]). In portrayals of the Entombment, his followers lower Jesus into a sarcophagus in the tomb.

Descent into Limbo During the three days he spends in the tomb, Jesus (after death, Christ) descends into Hell, or Limbo, and triumphantly frees the souls of the righteous, including Adam, Eve, Moses, David, Solomon, and John the Baptist.

Resurrection and **Three Marys at the Tomb** On the third day (Easter Sunday), Christ rises from the dead and leaves the tomb while the guards outside are sleeping. The Virgin Mary, Mary Magdalene, and Mary, the mother of James, visit the tomb, find it empty, and learn from an angel that Christ has been resurrected.

Noli Me Tangere, Supper at Emmaus, and Doubting of Thomas During the 40 days between Christ's Resurrection and his ascent to Heaven, he appears on several occasions to his followers. Christ warns Mary Magdalene, weeping at his tomb, with the words "Don't touch me" (Noli me tangere in Latin), but he tells her to inform the apostles of his return. At Emmaus he eats supper with two of his astonished disciples. Later, Thomas, who cannot believe that Christ has risen, is invited to touch the wound in his side that he received at his Crucifixion.

Ascension (Fig. 6-25) On the 40th day, with his mother and apostles as witnesses, Christ gloriously ascends from the Mount of Olives to Heaven in a cloud.

Basilica to Church The plan and elevation of Old Saint Peter's (Fig. 4-3) resemble those of Roman basilicas, such as Trajan's Basilica Ulpia (Fig. 3-30, no. 4), rather than the design of any Greco-Roman temple. The Christians, understandably, did not want their houses of worship to mimic the form of pagan shrines, but practical considerations also contributed to their shunning the pagan temple type. The Greco-Roman temple housed only the cult statue of the deity. All rituals took place outside at open-air altars. The classical temple, therefore, could have been adapted only with great difficulty as a building that could accommodate large numbers of people within it. The Roman basilica, in contrast, was ideally suited as a place for congregation, and Early Christian architects eagerly embraced it.

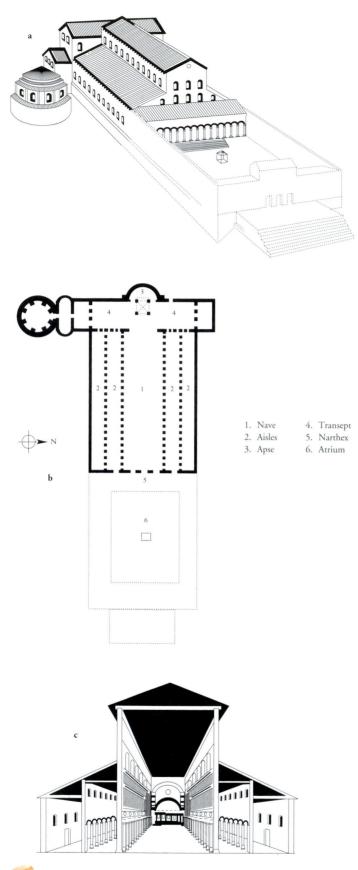

4-3 | Restored view (a), plan (b), and lateral section (c) of Old Saint Peter's, Rome, Italy, begun ca. 320. (The restoration of the forecourt is conjectural.)

Erected by Constantine, the first imperial patron of Christianity, this huge church stood on the spot of Saint Peter's grave. The building's plan and elevation are based on those of Roman basilicas, not pagan temples.

Like Roman basilicas, Old Saint Peter's (FIG. 4-3) had a wide central nave (300 feet long) with flanking aisles and an apse at the end. Preceding it was an open colonnaded courtvard, very much like the forum proper in the Forum of Trajan but called an *atrium*, like the central room in a private house. Worshipers entered the basilica through a narthex, or vestibule. When they emerged in the nave, they had an unobstructed view of the altar in the apse. A special feature of the Constantinian church was the transept, or transverse aisle, an area perpendicular to the nave between the nave and apse. It housed the relics of Saint Peter that hordes of pilgrims came to see. (Relics are the body parts, clothing, or any object associated with a saint or Christ himself; see "Pilgrimages and the Cult of Relics," Chapter 6, page 168.) The transept became a standard element of church design in the West only much later, when it also took on, with the nave and apse, the symbolism of the Christian cross.

Unlike pagan temples, Old Saint Peter's was not adorned with lavish exterior sculptures, and it had austere brick walls. Inside, however, were frescoes and mosaics, marble columns, grandiose chandeliers, and gold and silver vessels on jeweled altar cloths for use in the Mass. A huge marble baldacchino (domical canopy over an altar), supported by four spiral columns, marked the spot of Saint Peter's tomb. One can get some idea of the character of the timber-roofed interior of Old Saint Peter's by comparing our section drawing (Fig. 4-3c) with our photograph (Fig. 4-4) of the interior of the later Church of Sant'Apollinare Nuovo in Ravenna. The columns of both naves produce a steady rhythm that focuses all attention on the apse, which frames the altar. In Ravenna, as in Rome, the nave is drenched with light from the *clerestory* windows piercing the thin upper wall beneath the timber roof. That light illuminates the mosaics in Sant'Apollinare Nuovo's nave. Mosaics and frescoes commonly adorned the nave and apse of Early Christian churches.

The Central Plan The rectangular basilican church design was long the favorite of the Western Christian world, but Early Christian architects also adopted another classical architectural type: the *central-plan* building. The type is so named because the building's parts are of equal or almost equal dimensions around the center. Roman central-plan buildings were usually round or polygonal domed structures. Byzantine architects developed this form to monumental proportions and amplified its theme in numerous ingenious variations (Figs. 4-12, 4-13, and 4-21). In the West, the central plan was used generally for structures adjacent to the main basilicas, such as mausoleums, *baptisteries*, and private chapels, rather than for actual churches, as in the East.

A highly refined example of the central-plan design is Santa Costanza in Rome (Figs. 4-5 and 4-6), built in the mid-fourth century, possibly as the mausoleum for Constantina, the emperor Constantine's daughter. Recent excavations have called the traditional identification into question, but Constantina's monumental porphyry sarcophagus was placed in the building, even if the structure was not built as her tomb. The mausoleum,

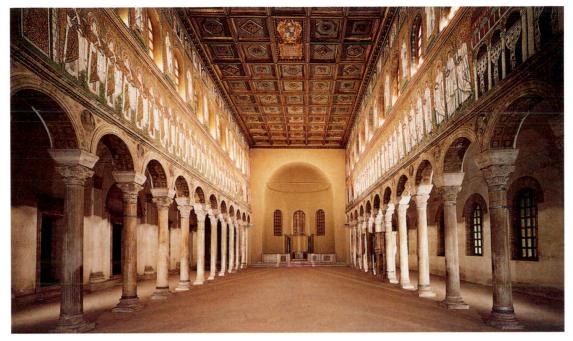

4-4 | Interior of Sant'Apollinare Nuovo, Ravenna, Italy, dedicated 504.

Early Christian basilican churches were timber roofed and illuminated by clerestory windows. The columns of the nave produced a steady rhythm that focused all attention on the apse, which framed the altar.

later converted into a church, stood next to the basilican Church of Saint Agnes, whose tomb was in a nearby catacomb. Santa Costanza has antecedents in the domed structures of the Romans, such as the Pantheon (Fig. 3-35), but the interior was modified to accommodate an *ambulatory*, a ringlike barrel-vaulted corridor separated from the central domed

cylinder by 12 pairs of columns. It is as if the nave of the Early Christian basilica with its clerestory wall were bent around a circle, the ambulatory corresponding to the basilican aisles. Like Early Christian basilicas, Santa Costanza has a severe brick exterior. Its interior was also once richly adorned with mosaics, although most are lost.

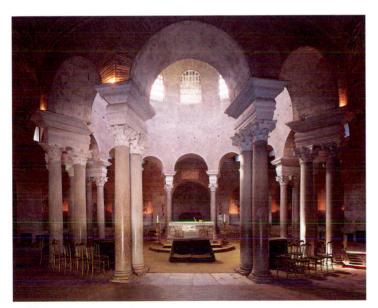

4-5 | Interior of Santa Costanza, Rome, Italy, ca. 337–351.

Santa Costanza has antecedents in the domed structures of the Romans, but it has an ambulatory framed by 12 pairs of columns. The building was once richly adorned with mosaics.

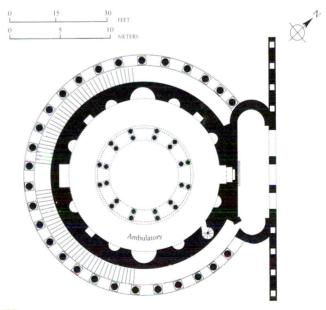

4-6 | Plan of Santa Costanza, Rome, Italy, ca. 337–351.

Possibly built as the mausoleum of Constantine's daughter, Santa Costanza was later converted into a church. Its central plan, featuring a domed interior, would become the preferred form for churches in Byzantium.

MATERIALS + TECHNIQUES

Mosaics

As an art form, mosaic had a rather simple and utilitarian beginning, seemingly invented primarily to provide an inexpensive and durable flooring. Originally, small beach pebbles were set, unaltered from their natural form and color, into a thick coat of cement. Mosaicists soon discovered, however, that the stones could be arranged in decorative patterns. At first, these *pebble mosaics* were uncomplicated and were confined to geometric shapes. Generally, the artists used only black and white stones. The earliest examples of this type were made in the eighth century BCE. Eventually, mosaicists arranged the stones to form more complex pictorial designs, and by the fourth century BCE, artists were able to depict elaborate figural scenes using a broad range of colors—yellow, brown, and red in addition to black, white, and gray—and to shade the figures, clothing, and setting to suggest volume.

By the middle of the third century BCE, the Greeks had invented a new kind of mosaic employing *tesserae* (Latin, "cubes" or "dice"). These tiny cut stones gave the artist much greater flexibility because their size and shape could be adjusted at will. Much more gradual gradations of color also became possible, and mosaicists finally could aspire to rival the achievements of panel painters (Fig. 2-47).

Mosaics for a Martyr Mosaic decoration played an important role in the interiors of Early Christian buildings (see "Mosaics," above). When, under Constantine, Christianity suddenly became a public and official religion in Rome, not only were new buildings required to house the faithful, but wholesale decoration programs for the churches also became necessary. To advertise the new faith in all its diverse aspects and to instruct believers, acres of walls in dozens of new churches had to be filled in the style and medium that would carry the message most effectively.

4-7 | Christ as the Good Shepherd, mosaic from the entrance wall of the Mausoleum of Galla Placidia, Ravenna, Italy, ca. 425.

Jesus sits among his flock, haloed and robed in gold and purple. The landscape and the figures, with their cast shadows, are the work of a mosaicist still deeply rooted in the naturalistic classical tradition.

In Early Christian mosaics, the tesserae are usually made of glass, which reflects light and makes the surfaces sparkle. Glass tesserae were occasionally used in ancient mosaics, but the Romans preferred opaque marble pieces.

Mosaics quickly became the standard means of decorating walls and vaults in Early Christian buildings, although mural paintings were also used. The mosaics caught the light flooding through the windows in vibrant reflection, producing sharp contrasts and concentrations of color that could focus attention on a composition's central, most relevant features. Mosaics made in the Early Christian manner were not intended for the subtle tonal changes a naturalistic painter's approach would require. Color was placed, not blended. Bright, hard, glittering texture, set within a rigorously simplified pattern, became the rule. For mosaics situated high in an apse or ambulatory vault or over the nave colonnade, far above the observer's head, the painstaking use of tiny tesserae seen in Roman floor mosaics became meaningless. Early Christian mosaics, designed to be seen from a distance, employed larger tesserae. The pieces were also set unevenly so that their surfaces could catch and reflect the light.

The so-called Mausoleum of Galla Placidia (Fig. 4-7) in Ravenna is a rare example of a virtually intact Early Christian mosaic program. Galla Placidia was the half sister of the emperor Honorius (r. 395–423), who had moved the capital of his crumbling Western Roman Empire from Milan to Ravenna in 404. Galla Placidia's "mausoleum," built shortly after 425, almost a quarter century before her death in 450, is actually a chapel to the martyred Saint Lawrence. The building has a characteristically unadorned brick exterior. Inside, however, mosaics cover every square inch above the marble-faced walls.

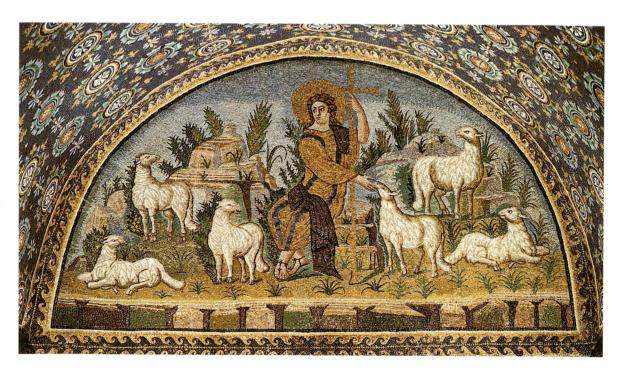

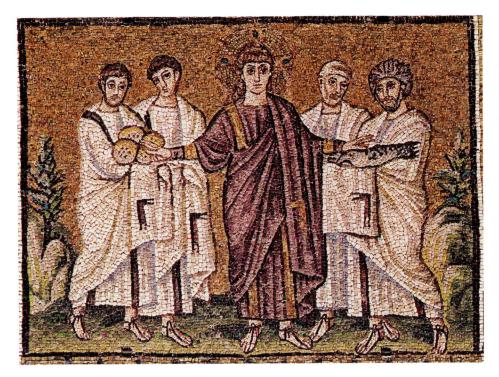

4-8 | Miracle of the loaves and fishes, mosaic from the top register of the nave wall (above the clerestory windows) of Sant'Apollinare Nuovo, Ravenna, Italy, ca. 504.

In contrast to Fig. 4-7, Jesus here faces directly toward the viewer. Blue sky has given way to the otherworldly splendor of heavenly gold, the standard background color for medieval mosaics.

Christ as Good Shepherd is the subject of the lunette (Fig. 4-7) above the entrance. No earlier version of the Good Shepherd is as regal as this one. Instead of carrying a lamb on his shoulders, Jesus sits among his flock, haloed and robed in gold and purple. To his left and right, the sheep are distributed evenly in groups of three. But their arrangement is rather loose and informal, and they occupy a carefully described landscape that extends from foreground to background beneath a blue sky. All the forms have three-dimensional bulk and cast shadows. In short, the panel is full of Greco-Roman illusionistic devices. It is the work of a mosaicist still deeply rooted in the classical tradition.

Theodoric's Palace-Church In 476, Ravenna fell to Odoacer, the first Germanic king of Italy, who was overthrown in turn by Theodoric, king of the Ostrogoths, who established his capital at Ravenna in 493. The mosaics in his palace church, Sant'Apollinare Nuovo (Fig. 4-4), date from different periods, but those Theodoric installed already reveal a new, much more abstract and formal, style. The mosaics above the clerestory windows depict scenes from Christ's life. In the panel showing the miracle of the loaves and fishes (Fig. 4-8), Jesus, beardless, in the imperial dress of gold and purple, and now distinguished by the cross-inscribed nimbus (halo) that signifies his divinity, faces directly toward the viewer. With extended arms he directs his disciples to distribute to the great crowd the miraculously increased supply of bread and fish he has produced. The artist made no attempt to supply details of the event. The emphasis is instead on the holy character of it, the spiritual fact that Jesus is performing a miracle by the power of his divinity. The fact of the miracle takes it out of the world of time and of incident. The presence of almighty power, not anecdotal narrative, is the important aspect of this scene. The mosaicist told the story with the least number of figures necessary to make its meaning explicit. The artist aligned the figures laterally, moved them close to the foreground, and placed them in a shallow picture box cut off by a golden screen close behind their backs. The landscape setting, which the artist who worked for Galla Placidia so explicitly described, is here merely a few rocks and bushes that enclose the figure group like parentheses. The blue sky of the physical world has given way to the otherworldly splendor of heavenly gold, the standard background color for mosaics from this point on. Remnants of Roman illusionism appear only in the handling of the individual figures, which still cast shadows and retain some of their former volume. But the shadows of the drapery folds already are only narrow bars.

Manuscript Illumination

The long tradition of placing pictures in manuscripts began in Egypt. Ancient books, however, are very rare. The dissemination of manuscripts, as well as their preservation, was aided greatly by an important invention of the Early Empire period, the *codex*. The codex is much like a modern book, composed of separate leaves (folios) enclosed within a cover and bound together at one side. The new format superseded the long manuscript scroll (rotulus) used by the Egyptians, Greeks, Etruscans, and Romans. (Christ holds a rotulus in his left hand in Fig. 4-2.) Much more durable vellum (calfskin) and parchment (lambskin), which provided better surfaces for painting, also replaced the comparatively brittle papyrus (an Egyptian plant) used for ancient scrolls. As a result, luxuriousness of ornament became more and more typical. Art historians refer to the painted books produced before the invention of the printing press as illuminated manuscripts, from the Latin illuminare, meaning "to adorn, ornament, or brighten," and manu scriptus ("handwritten").

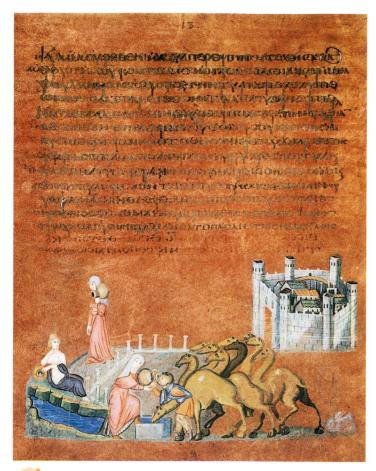

4-9 | Rebecca and Eliezer at the well, folio 7 recto of the *Vienna Genesis*, early sixth century. Tempera, gold, and silver on purple vellum, approx. $1'\frac{1}{4}'' \times 9\frac{1}{4}''$. Österreichische Nationalbibliothek, Vienna.

Classical motifs and stylistic modes persist in this sumptuously painted book—the oldest well-preserved manuscript containing biblical scenes. The artist represented two episodes of the story in a single setting.

The First Illustrated Bibles The oldest well-preserved painted manuscript containing biblical scenes is the early-sixth-century *Vienna Genesis*, so called because of its present location. The book is sumptuous. The pages are fine calfskin dyed with rich purple, the same dye used to give imperial cloth its distinctive color, and the Greek text is written in silver ink. The page we reproduce (Fig. 4-9) illustrates the story of Rebecca and Eliezer in the Book of Genesis (24:15–61). When Isaac, Abraham's son, was 40 years old, his parents sent their servant Eliezer to find a wife for him. Eliezer chose Rebecca because when he stopped at a well, she was the first woman to draw water for him and his camels.

The Vienna Genesis illustration presents two episodes of the story within a single frame. In the first episode, at the left, Rebecca leaves the city of Nahor to fetch water from the well. In the second episode, she gives water to Eliezer and his 10 camels, while one of them already laps water from the well. The artist painted Nahor as a walled city seen from above, a familiar convention in Roman art. Rebecca walks to the well along the colonnaded avenue of a Roman city. A seminude female per-

sonification of a spring is the source of the well water. These are further reminders of the persistence of classical motifs and stylistic modes in Early Christian art even while other artists (Fig. 4-8) were rejecting classical norms in favor of a style better suited for a focus on the spiritual instead of the natural world.

BYZANTINE ART

In the decades following the foundation in 324 of Constantinople—the New Rome in the East, on the site of the Greek city of Byzantium—the pace of Christianization of the Roman Empire quickened. In 380, Theodosius I (r. 379–395) issued an edict finally establishing Christianity as the state religion. In 391, he enacted a ban against pagan worship. In 394, the Olympic Games, the enduring symbol of the classical world and its values, were abolished. Theodosius died in 395. and imperial power passed to his two sons, Arcadius, who became Emperor of the East, and Honorius, Emperor of the West. Though not formally codified, the division of the Roman Empire became permanent. In the western half, the Visigoths, under their king Alaric, sacked Rome in 410. The Western Empire soon collapsed and was replaced by warring kingdoms that, during the Middle Ages, formed the foundations of the modern nations of Europe (see Chapter 6). The eastern half of the Roman Empire, only loosely connected by religion to the west, and with only minor territorial holdings there, had a long and complex history of its own. Centered at New Rome, the Eastern Christian Empire remained a cultural and political entity for a millennium, until the last of a long line of Eastern Roman emperors, ironically named Constantine XI, died at Constantinople in 1453, defending it in vain against the Muslim armies of the Ottoman Turks.

Historians call that Eastern Christian Roman Empire "Byzantium," employing Constantinople's original name, and use the term *Byzantine* to identify whatever pertains to Byzantium—its territory, its history, and its culture. The Byzantine emperors, however, did not use these terms to define themselves. They called their empire "Rome" (Romania) and themselves "Romans" (Romaioi). Though they spoke Greek and not Latin, the Eastern Roman emperors never relinquished their claim as the legitimate successors to the ancient Roman emperors. Nevertheless, *Byzantium* and *Byzantine*, though inexact terms, have become in modern times the accepted designations for the Eastern Roman Empire.

The Byzantine emperors considered themselves the earthly vicars of Jesus Christ. Their will was God's will. They exercised the ultimate spiritual as well as temporal authority. As sole executives for church and state, the emperors shared power with neither senate nor church council. They reigned supreme, combining the functions of both pope and caesar, which the Western Christian world would keep strictly separate. The Byzantine emperors' exalted position made them quasi-divine. The imperial court was an image of the Kingdom of Heaven.

Art historians divide the history of Byzantine art into three periods. The first, *Early Byzantine*, extends from the age of the

emperor Justinian (r. 527–565) to the onset of *Iconoclasm* (the destruction of images used in religious worship) under Leo III in 726. The *Middle Byzantine* period begins with the renunciation of Iconoclasm in 843 and ends with the western Crusaders' occupation of Constantinople in 1204. *Late Byzantine* corresponds to the period after the Byzantines recaptured Constantinople in 1261 until its final loss in 1453 to the Ottoman Turks.

Early Byzantine Art

The reign of Justinian marks the end of the Late Roman Empire and the beginning of the Byzantine Empire. At this time Byzantine art emerged as a recognizably novel and distinctive style, leaving behind the uncertainties and hesitations of Early Christian artistic experiment. Justinianic art and architecture definitively expressed, with a new independence and power of invention, the unique character of the Eastern Christian culture centered at Constantinople. In the capital alone, Justinian built or restored more than 30 churches, and his activities as builder extended throughout the Byzantine Empire. The historian of his reign, Procopius, declared that the emperor's ambitious building program was an obsession that cost his subjects dearly in taxation. But his grand monuments defined the Byzantine style in architecture forever after.

Holy Wisdom The most important monument of early Byzantine art is Hagia Sophia (Fig. 4-10), the Church of Holy Wisdom, in Constantinople. Anthemius of Tralles and

4-10 | Anthemius of Tralles and Isidorus of Miletus, Hagia Sophia (view facing north), Constantinople (Istanbul), Turkey, 532–537.

The reign of Justinian marks the beginning of the first golden age of Byzantine art and architecture. Justinian built or restored more than 30 churches in Constantinople alone. Hagia Sophia was the greatest.

ISIDORUS OF MILETUS designed and built the church for Justinian between 532 and 537. It is Byzantium's grandest building and one of the supreme accomplishments of world architecture. Its dimensions are formidable: about 270 feet long and 240 feet wide, with a dome 108 feet in diameter whose crown rises some 180 feet above the pavement. In exterior view, the great dome dominates the structure, but the building's present external aspects are much changed from their original appearance. Huge buttresses were added to the Justinianic design, and four towering Turkish minarets were constructed after the Ottoman conquest of 1453, when Hagia Sophia became a mosque.

The characteristic Byzantine plainness and unpretentiousness of the exterior scarcely prepare visitors for the building's interior (Fig. 4-11), which was once richly appointed. The walls and floors were clad with colored stones from all over the known world. But what distinguishes Hagia Sophia from the equally lavishly revetted and paved interiors of Roman buildings such as the Pantheon (Fig. 3-35) is the special mystical quality of the light that floods the building. The soaring canopy-like dome that dominates the inside as well as the outside of the church rides on a halo of light from 40 windows in the dome's base. The windows create the illusion that the dome is resting on the light that pours through them. Procopius observed that the dome looked as if it were suspended

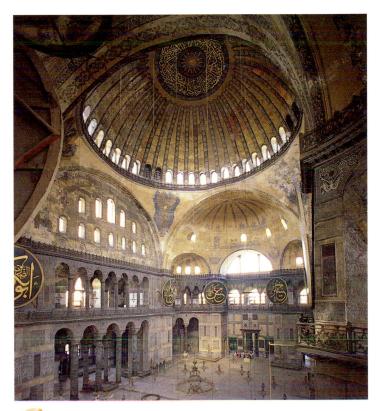

4-11 | Anthemius of Tralles and Isidorus of Miletus, interior of Hagia Sophia (view facing southwest), Constantinople (Istanbul), Turkey, 532–537.

Pendentive construction made possible Hagia Sophia's lofty dome, which seems to ride on a halo of light. A contemporary said the dome seemed to be suspended by "a golden chain from Heaven."

ARCHITECTURAL BASICS

Pendentives

Perhaps the most characteristic feature of Byzantine architecture is the placement of a dome, which is circular at its base, over a square, as at Hagia Sophia in Constantinople (Figs. 4-10 to 4-12) and Saint Mark's in Venice (Fig. 4-21). The structural device that made this feat possible was the *pendentive*.

In pendentive construction (from the Latin *pendere*, "to hang") a dome rests on what is, in effect, a second, larger dome. The top portion and four segments around the rim of the larger dome are omitted so that four curved triangles, or pendentives, are formed. The pendentives join to form a ring and four arches whose planes bound a square. The weight of the dome is thus transferred through the pendentives and arches to the four piers from which the arches spring, instead of to the walls. The first use of pendentives on a monumental scale was in Hagia Sophia in the mid-sixth century. In Roman and Early Christian central-plan buildings, such as the Pantheon (Figs. 3-34 and 3-35) and Santa Costanza (Figs. 4-5 and 4-6), the domes spring directly from the circular top of a cylinder.

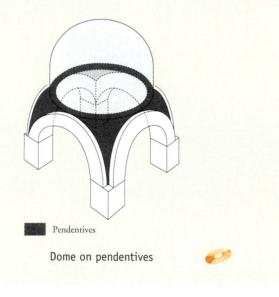

by "a golden chain from Heaven." Said he: "You might say that the space is not illuminated by the sun from the outside, but that the radiance is generated within, so great an abundance of light bathes this shrine all around."²

Paul the Silentiary, a poet and member of Justinian's court, compared the dome to "the firmament which rests on air" and described the vaulting as covered with "gilded tesserae from which a glittering stream of golden rays pours abundantly and strikes men's eyes with irresistible force. It is as if one were gazing at the midday sun in spring." Thus, Hagia Sophia has a vastness of space shot through with light and a central dome that appears to be supported by the light it admits. Light is the mystic element—light that glitters in the mosaics, shines forth from the marbles, and pervades and defines spaces that, in themselves, seem to escape definition. Light seems to dissolve material substance and transform it into an abstract spiritual vision.

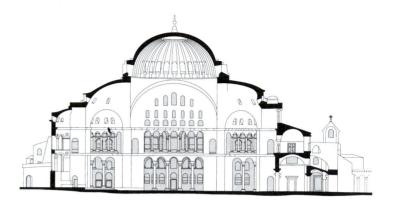

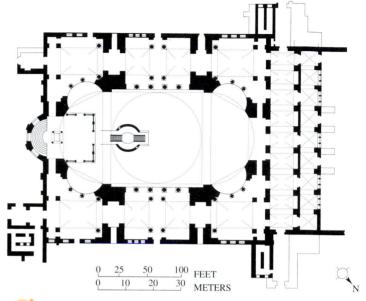

4-12 | Anthemius of Tralles and Isidorus of Miletus, longitudinal section (*top*) and plan (*bottom*) of Hagia Sophia, Constantinople (Istanbul), Turkey, 532–537 (after drawings by Van Nice and Antoniades).

In Hagia Sophia, Justinian's architects succeeded in fusing two previously independent architectural traditions: the vertically oriented central-plan building and the longitudinally oriented basilica.

Pendentives How was this illusion of a floating "dome of Heaven" achieved? Justinian's architects used *pendentives* (see "Pendentives," page 135) to transfer the weight from the great dome to the piers beneath, rather than to the walls. With pendentives, not only could the space beneath the dome be unobstructed but scores of windows could puncture the walls themselves. This created the impression of a dome suspended above, not held up by, walls. Experts today can explain the technical virtuosity of Anthemius and Isidorus, but it remained a mystery to their contemporaries. Procopius communicated the sense of wonderment experienced by those who entered Justinian's great church: "No matter how much they concentrate . . . they are unable to understand the craftsmanship and always depart from there amazed by the perplexing spectacle."

The Domed Basilica By placing a hemispherical dome on a square base instead of on a circular base, as in the

Pantheon, Anthemius and Isidorus succeeded in fusing two previously independent and seemingly mutually exclusive architectural traditions: the vertically oriented central-plan building and the longitudinally oriented basilica. Hagia Sophia is, in essence, a domed basilica (Fig. 4-12)—a uniquely successful conclusion to centuries of experimentation in Christian church architecture. However, the thrusts of the pendentive construction at Hagia Sophia made external buttresses necessary, as well as huge internal northern and southern wall piers and eastern and western half-domes. The semidomes' thrusts descend, in turn, into still smaller half-domes surmounting columned exedrae that give a curving flow to the design.

The diverse vistas and screenlike ornamented surfaces mask the structural lines. The columnar arcades of the nave and galleries have no real structural function. Like the walls they pierce, they are only part of a fragile "fill" between the huge piers. Structurally, although Hagia Sophia may seem Roman in its great scale and majesty, it does not have Roman organization of its masses. The very fact that the "walls" in Hagia Sophia are actually concealed (and barely adequate) piers indicates that the architects sought Roman monumentality as an effect and did not design the building according to Roman principles. Using brick in place of concrete marked a further departure from Roman practice and characterizes Byzantine architecture as a distinctive structural style. Hagia Sophia's eight great supporting piers are ashlar masonry, but the screen walls are brick, as are the vaults of the aisles and galleries and the dome and semicircular half-domes known as conches.

Byzantine Liturgy The ingenious design of Hagia Sophia provided the illumination and the setting for the solemn liturgy of the Greek Orthodox faith. The large windows along the rim of the great dome poured light down upon the interior's jeweled splendor, where priests staged the sacred spectacle. Sung by clerical choirs, the Orthodox equivalent of the Latin Mass celebrated the sacrament of the Eucharist at the altar in the apsidal sanctuary, in spiritual reenactment of Jesus' Crucifixion. Processions of chanting priests, accompanying the patriarch (archbishop) of Constantinople, moved slowly to and from the sanctuary and the vast nave. The gorgeous array of their vestments rivaled the interior's polychrome marbles, metals, and mosaics, all glowing in shafts of light from the dome.

The nave of Hagia Sophia was reserved for the clergy, not the congregation. The laity, segregated by sex, were confined to the shadows of the aisles and galleries, restrained in most places by marble parapets. The complex spatial arrangement allowed only partial views of the brilliant ceremony. The emperor was the only lay person privileged to enter the sanctuary. When he participated with the patriarch in the liturgical drama, standing at the pulpit beneath the great dome, his rule was sanctified and his person exalted. Church and state were symbolically made one, as in fact they were. The church building was then the earthly image of the court of Heaven, its light the image of God and God's holy wisdom. At Hagia

Sophia, the ambitious scale of Rome and the mysticism of Eastern Christianity combined to create a monument that is at once a summation of antiquity and a positive assertion of the triumph of Christian faith.

San Vitale In 539, Justinian's general Belisarius captured Ravenna from the Ostrogoths. As the seat of Byzantine dominion in Italy, Ravenna enjoyed unparalleled prosperity, and its culture became an extension of Constantinople. Its art, even more than that of the Byzantine capital (where relatively little outside of architecture has survived), clearly reveals the transition from the Early Christian to the Byzantine style.

San Vitale (Fig. 4-13), dedicated by Bishop Maximianus in 547 in honor of Saint Vitalis, who was martyred at Ravenna in the second century, is the most spectacular building in Ravenna. Construction began under Bishop Ecclesius shortly after Theodoric's death in 526. Julianus Argentarius (Julian the Banker) provided the enormous sum of 26,000 gold *solidi* (weighing in excess of 350 pounds) required to proceed with the work. The church is unlike any of Ravenna's other sixth-century churches (Fig. 4-4). Indeed, it is unlike any other church in Italy. Although it has a traditional plain exterior and a polygonal apse, San Vitale is not a basilica. It is

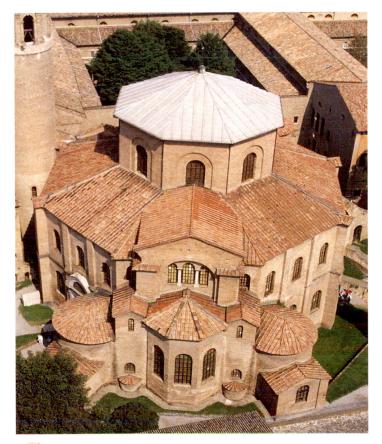

4-13 | Aerial view of San Vitale (view facing northwest), Ravenna, Italy, 526–547.

Justinian's general Belisarius captured Ravenna from the Ostrogoths. The city became the seat of Byzantine dominion in Italy. San Vitale honored Saint Vitalis, who was martyred at Ravenna in the second century.

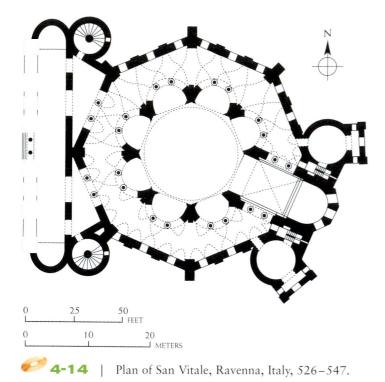

Centrally planned like Justinian's churches in Constantinople, San Vitale is unlike any other church in Italy. The design features two concentric octagons. A dome crowns the taller, inner octagon.

centrally planned (Fig. 4-14), like Justinian's churches in Constantinople.

The design features two concentric octagons. The dome-covered inner octagon rises above the surrounding octagon to provide the interior with clerestory lighting. The central space is defined by eight large piers that alternate with curved, columned exedrae, pushing outward into the surrounding two-story ambulatory (Fig. 4-15) and creating, on the plan, an intricate eight-leafed design. The exedrae closely integrate the inner and outer spaces that otherwise would have existed simply side by side as independent units. A cross-vaulted *choir* preceding the apse interrupts the ambulatory and gives the plan some axial stability. This effect is weakened, however, by the off-axis placement of the narthex, whose odd angle never has been explained fully. (The atrium, which no longer exists, may have paralleled a street that ran in the same direction as the angle of the narthex.)

San Vitale's intricate plan and elevation combine to produce an effect of great complexity. The exterior's octagonal regularity is not readily apparent inside. A rich diversity of ever-changing perspectives greets visitors walking through the building. Arches looping over arches, curving and flattened spaces, and wall and vault shapes seem to change constantly with the viewer's position. Light filtered through alabaster-paned windows plays over the glittering mosaics and glowing marbles that cover the building's complex surfaces, producing a sumptuous effect.

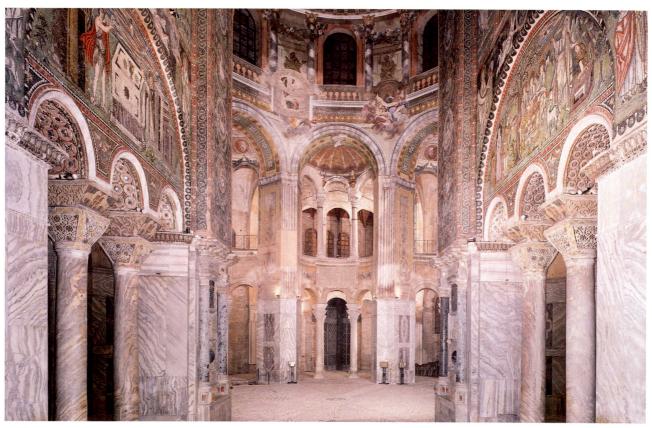

4-15 | Interior of San Vitale (view from the apse into the choir), Ravenna, Italy, 526-547.

Light filtered through alabaster-paned windows plays over the glittering mosaics and glowing marbles that cover San Vitale's complex wall and vault shapes, producing a sumptuous effect.

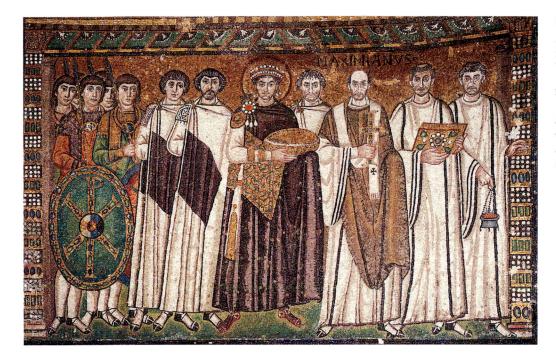

4-16 | Justinian, Bishop Maximianus, and attendants, mosaic from the north wall of the apse, San Vitale, Ravenna, Italy, ca. 547.

San Vitale's mosaics reveal the new Byzantine aesthetic. Justinian is foremost among the dematerialized frontal figures who hover before the viewer, weightless and speechless, their positions in space uncertain.

Justinian and Christ The mosaics that decorate San Vitale's choir and apse, like the building itself, must be regarded as one of the climactic achievements of Byzantine art. Completed less than a decade after the Ostrogoths surrendered Ravenna, the apse and choir decorations form a unified composition, whose theme is the holy ratification of Justinian's right to rule. In the apse vault are Christ, who extends the golden martyr's wreath to Saint Vitalis, the patron saint of the church, and Bishop Ecclesius, who began the construction of San Vitale and offers a model of the new church to Christ. On the choir wall to the left of the apse mosaic appears Justinian (Fig. 4-16). He stands on the Savior's right side. The two are united visually and symbolically by the imperial purple they wear and by their haloes. Justinian is also accompanied by a dozen attendants, paralleling Christ's Twelve Apostles. Thus, the mosaic program underscores the dual political and religious role of the Byzantine emperor.

The positions of the figures are all-important. They express the formulas of precedence and rank. Justinian is at the center, distinguished from the other dignitaries by his purple robe and halo. At his left is Bishop Maximianus, the man responsible for San Vitale's completion. The mosaicist stressed the bishop's importance by labeling his figure with the only identifying inscription in the composition. Some have identified the figure behind and between Justinian and Maximianus as Julius Argentarius, the church's benefactor.

The artist divided the figures into three groups: the emperor and his staff; the clergy; and the imperial guard, bearing a shield with the *Christogram*, the monogram made up of *chi* and *rho*, the initial letters of Christ's name in Greek. Each group has a leader whose feet precede (by one foot overlapping) the feet of those who follow. The positions of Justinian and Maximianus are curiously ambiguous. Although the emperor appears to be slightly behind the bishop, the golden

paten (large bowl holding the Eucharist bread) he carries overlaps the bishop's arm. Thus, symbolized by place and gesture, the imperial and churchly powers are in balance. Justinian's paten, Maximianus's cross, and the attendant clerics' book and censer produce a slow forward movement that strikingly modifies the scene's rigid formality. No background is indicated. The artist wished the observer to understand the procession as taking place in this very sanctuary. Thus, the emperor appears forever as a participant in the sacred rites and as the proprietor of this royal church, the very symbol of his rule in Italy.

The procession at San Vitale recalls but contrasts with that of Augustus and his entourage on the Ara Pacis (FIG. 3-23), erected more than half a millennium earlier in Rome. There the fully modeled marble figures have their feet planted firmly on the ground. The Romans talk among themselves, unaware of the viewer's presence. All is anecdote, all very human and of this world, even if the figures themselves conform to a classical ideal of beauty that cannot be achieved. The frontal figures of the Byzantine mosaic, however, hover before the viewer, weightless and speechless, their positions in space uncertain. Tall, spare, angular, and elegant, the figures have lost the rather squat proportions characteristic of much Early Christian work. The garments fall straight, stiff, and thin from the narrow shoulders. The organic body has dematerialized, and, except for the heads, some of which seem to be true portraits, the viewer sees a procession of solemn spirits gliding silently in the presence of the sacrament. This mosaic reveals the Byzantine world's new aesthetic, one very different from that of the classical world but equally compelling. Blue sky has given way to heavenly gold, and matter and material values are disparaged. Byzantine art is an art without solid bodies or cast shadows, with blank golden spaces, and with the perspective of Paradise, which is nowhere and everywhere.

4-17 | Theodora and attendants, mosaic from the south wall of the apse, San Vitale, Ravenna, Italy, ca. 547.

Justinian's counterpart on the opposite wall is the empress Theodora, a powerful figure at the Byzantine court. Neither she nor Justinian ever visited Ravenna. San Vitale's mosaics are proxies for the absent sovereigns.

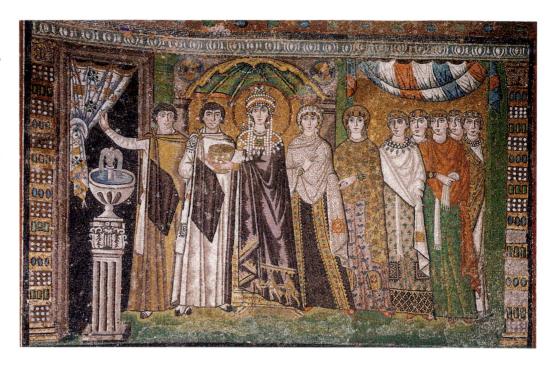

Theodora at San Vitale Justinian's counterpart on the opposite wall of the apse is his empress, Theodora (Fig. 4-17), who was Justinian's most trusted adviser as well as his spouse. She too is accompanied by her retinue. Both processions move into the apse, Justinian proceeding from left to right and Theodora from right to left, in order to take part in the Eucharist. Justinian carries the paten containing the bread, Theodora the golden cup with the wine. The portraits in the Theodora mosaic exhibit the same stylistic traits as those in the Justinian mosaic, but the women are represented within a definite architecture, perhaps the atrium of San Vitale. The empress stands in state beneath an imperial canopy, waiting to follow the emperor's procession. An attendant beckons her to pass through the curtained doorway. The fact that she is outside the sanctuary in a courtyard with a fountain and only about to enter attests that, in the ceremonial protocol, her rank was not quite equal to her consort's. But the very presence of Theodora at San Vitale is significant. Neither she nor Justinian ever visited Ravenna. Their participation in the liturgy at San Vitale is pictorial fiction. The mosaics are proxies for the absent sovereigns. Justinian was represented because he was the head of the Byzantine state, and by his presence he exerted his authority over his territories in the West. But Theodora's portrayal is more surprising and testifies to her unique position in Justinian's court. Theodora's prominent role in the mosaic program of San Vitale is proof of the power she wielded at Constantinople and, by extension, at Ravenna. In fact, the representation of the Three Magi on the border of her robe suggests that she belongs in the elevated company of the three monarchs who approached the newborn Jesus bearing gifts.

Monasticism in Egypt During Justinian's reign, almost continuous building took place, not only in Constantinople and Ravenna but all over the Byzantine Empire. Between 548 and

565, Justinian rebuilt an important early monastery at Mount Sinai in Egypt where Moses received the Ten Commandments from God. Now called Saint Catherine's, the monastery marked the spot at the foot of the mountain where the Bible says God first spoke to the Hebrew prophet from a burning bush.

The monastic movement began in Egypt in the third century and spread rapidly to Palestine and Syria in the east and as far as Ireland in the west. It began as a migration to the wilderness by those who sought a more spiritual way of life, far from the burdens, distractions, and temptations of town and city. In desert places these refuge seekers lived austerely as hermits, in contemplative isolation, cultivating the soul's perfection. So many thousands fled the cities that the authorities became alarmed—noting the effect on the tax base, military recruitment, and business in general.

The origins of organized monasticism are associated with Saint Anthony and Saint Pachomius in Egypt in the fourth century. By the fifth century, regulations governing monastic life began to be codified. Individual monks were brought together to live according to a rule within a common enclosure, a community under the direction of an abbot (see "Medieval Monasteries and Benedictine Rule," Chapter 6, page 164). The monks typically lived in a walled monastery, an architectural complex that included the monks' residence (an alignment of single cells), a refectory (dining hall), a kitchen, storage and service quarters, a guest house for pilgrims, and, of course, an oratory or monastery church (Fig. 6-9). The monastery at Mount Sinai had been an important pilgrimage destination since the fourth century, and Justinian enclosed it within new walls to protect not only the hermit-monks but also the lay pilgrims during their visits. The Mount Sinai church was dedicated to the Virgin Mary, whom the Council of Ephesus had officially recognized in 431 as the Mother of God (Theotokos, "bearer of God" in Greek).

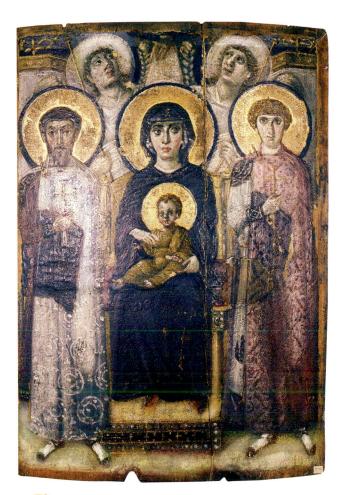

4-18 | Virgin (Theotokos) and Child between Saints Theodore and George, icon, sixth or early seventh century. Encaustic on wood, 2' $3'' \times 1' 7\frac{3}{8}''$. Monastery of Saint Catherine, Mount Sinai, Egypt.

Byzantine icons continued the Roman tradition of panel painting in encaustic on wood panels (Fig. 3-37), but the hieratic style as well as the Christian subjects broke sharply from classical models.

Monks and Icons Icons ("Icons and Iconoclasm," above right) played an important role in monastic life. Unfortunately, few early icons survive because of the wholesale destruction of images (iconoclasm) that occurred in the eighth century. Some of the finest early examples come from Mount Sinai. The one we illustrate (Fig. 4-18) was painted in encaustic on wood, continuing a tradition of panel painting in Egypt that, like so much else in the Byzantine world, goes back to the Roman Empire (Fig. 3-37). The icon depicts the enthroned Theotokos and Child with Saints Theodore and George. The two guardian saints intercede with the Virgin on the viewer's behalf. Behind them, two angels look upward to a shaft of light where the hand of God appears. The foreground figures are strictly frontal and have a solemn demeanor. Background details are few and suppressed. The forward plane of the picture dominates; space is squeezed out. It is a perfect example of Byzantine hieratic style. Traces of Greco-Roman illusionism remain in the Virgin's rather

ART + SOCIETY

Icons and Iconoclasm

Icons (Greek, "images") are small portable paintings depicting Christ, the Virgin, or saints (or a combination of all three, as in FIG. 4-18). Icons survive from as early as the fourth century. From the sixth century on, they became enormously popular in Byzantine worship, both public and private. Eastern Christians considered icons a personal, intimate, and indispensable medium for spiritual transaction with holy figures. Some icons (FIG. 4-24) came to be regarded as wonderworking, and believers ascribed miracles and healing powers to them.

Icons were by no means universally accepted, however. From the beginning, many Christians were deeply suspicious of the practice of imaging the divine, whether on portable panels, on the walls of churches, or especially as statues that reminded them of pagan idols. The opponents of Christian figural art had in mind the Old Testament prohibition of images the Lord dictated to Moses in the Second Commandment: "Thou shalt not make unto thee any graven image or any likeness of anything that is in heaven above, or that is in the earth beneath, or that is in the water under the earth. Thou shalt not bow down thyself to them, nor serve them" (Exod. 20:4, 5).

Opposition to icons became especially strong in the eighth century, when the faithful often burned incense and knelt before them in prayer to seek protection or a cure for illness. Although icons were intended only to evoke the presence of the holy figures addressed in prayer, in the minds of many, icons became identified with the personages represented. Icon worship became confused with idol worship, and this brought about an imperial ban on all sacred images. The term for this destruction of holy pictures is *iconoclasm*.

The consequences of iconoclasm for the history of Byzantine art are difficult to overstate. For more than a century not only did the portrayal of Christ, the Virgin, and the saints cease, but the *iconoclasts* (breakers of images) also systematically destroyed countless works from the early centuries of Christendom.

personalized features, in her sideways glance, and in the posing of the angels' heads. But the painter rendered the saints in the new Byzantine manner.

Iconoclasm (726-843)

The preservation of Early Byzantine icons at the Mount Sinai monastery is fortuitous but ironic, for opposition to icon worship was especially prominent in Syria and Egypt. And there, in the seventh century, a series of calamities erupted, indirectly causing the imperial ban on images. The Sasanians, chronically at war with Rome, swept into the eastern provinces early in the seventh century. Between 611 and 617 they captured the great cities of Antioch, Jerusalem, and Alexandria. Hardly had the Byzantine emperor Heraclius (r. 610–641) pressed them back and defeated them in 627 when a new and overwhelming power appeared unexpectedly on the stage of history. The Arabs, under the banner of the new Islamic religion, conquered not only Byzantium's eastern provinces but also Persia itself, replacing the Sasanians in the age-old balance of power with the Christian West (see Chapter 5). In a few years the

Arabs were launching attacks on Constantinople, and Byzantium was fighting for its life.

These were catastrophic years for the Eastern Roman Empire. They terminated once and for all the long story of imperial Rome, closed the Early Byzantine period, and inaugurated the medieval era of Byzantine history. Almost two-thirds of the Byzantine Empire's territory was lost—many cities and much of its population, wealth, and material resources. The shock of these events persuaded the emperor Leo III (r. 717–741) that God had punished the Christian Roman Empire for its idolatrous worship of icons by setting upon it the merciless armies of the infidel. In 726, he formally prohibited the use of images, and for more than a century Byzantine artists produced little new religious figurative art.

Middle Byzantine Art

In the ninth century, a powerful reaction against iconoclasm set in. The destruction of images was condemned as a heresy, and restoration of the images began in 843. Shortly thereafter, under the Macedonian dynasty, art, literature, and learning sprang to life once again. Basil I (r. 867–886), head of the new line of emperors, thought of himself as the restorer of the Roman Empire. He denounced as usurpers the Frankish Carolingian monarchs of the West (see Chapter 6) who, since 800, had claimed the title "Roman Empire" for their realm. Basil bluntly reminded their emissary that the only true emperor of Rome reigned in Constantinople. They were not Roman emperors but merely "kings of the Germans."

New Churches, New Mosaics Basil I and his immediate successors undertook the laborious and costly task of refurbishing the churches that the iconoclasts had defaced and neglected, but they initiated little new church construction. In the 10th century and through the 12th, however, a number of monastic churches arose that are the flowers of Middle Byzantine architecture. They feature a brilliant series of variations on the domed central plan. From the exterior, the typical later Byzantine church building is a domed cube, with the dome rising above the square on a kind of cylinder or drum. The churches are small, vertical, and high shouldered, and, unlike earlier Byzantine buildings, they have exterior wall surfaces with vivid decorative patterns, probably reflecting the impact of Islamic architecture.

The interiors of the new churches were covered with mosaics. Some of the best-preserved examples are in the monastery Church of the Dormition (from the Latin for "sleep," referring to the ascension of the Virgin Mary to Heaven at the moment of her death), at Daphni, near Athens, Greece. The main elements of the late-11th-century pictorial program are intact, although the mosaics were restored in the 19th century. Gazing down from on high in the central dome (Fig. 4-19) is the fearsome image of Christ as *Pantokrator* (literally "ruler of all" in Greek but usually applied to Christ in his role as Last Judge of humankind). The dome mosaic is the climax of an elaborate

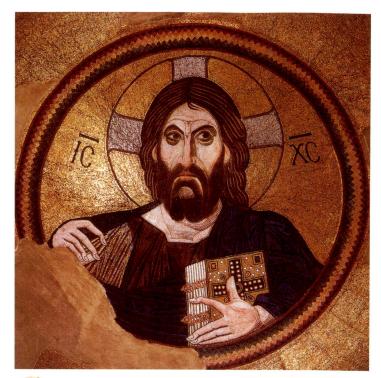

4-19 | Christ as Pantokrator, dome mosaic in the Church of the Dormition, Daphni, Greece, ca. 1090–1100.

The fearsome image of Christ as "ruler of all" is like a gigantic icon hovering dramatically in space. The mosaic serves to connect the awestruck worshiper below the dome with Heaven through Christ.

hierarchical pictorial program including several New Testament episodes below. The Daphni Pantokrator is like a gigantic icon hovering dramatically in space. The mosaic serves to connect the awestruck worshiper in the church below with Heaven through Christ.

On one of the walls below the Daphni dome, an unknown artist depicted Christ's Crucifixion (Fig. 4-20). Like the Pantokrator mosaic in the dome, the Daphni Crucifixion is a subtle blend of the painterly, Hellenistic style and the later more abstract and formalistic Byzantine style. The Byzantine artist fully assimilated classicism's simplicity, dignity, and grace into a perfect synthesis with Byzantine piety and pathos. The figures have regained the classical organic structure to a surprising degree, particularly compared to figures from the Justinianic period (compare Figs. 4-16 and 4-17). The style is a masterful adaptation of classical statuesque qualities to the linear Byzantine manner.

In quiet sorrow and resignation, the Virgin and Saint John flank the crucified Christ. A skull at the foot of the cross indicates Golgotha, the "place of the skull." Nothing else was needed to set the scene. Symmetry and closed space combine to produce an effect of the motionless and unchanging aspect of the deepest mystery of the Christian religion. The timeless presence is, as it were, beheld in unbroken silence. The picture is not a narrative of the historical event of the Crucifixion, although it contains anecdotal details. Christ has a tilted head and sagging body, and blood spurts from the wound Longinus inflicted on

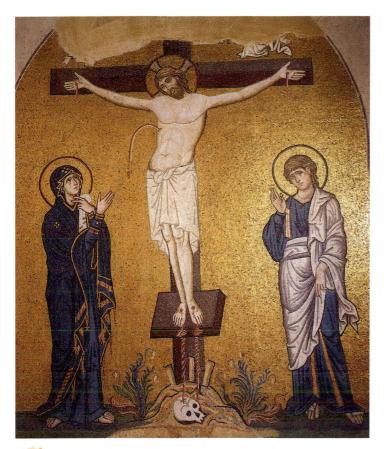

4-20 | Crucifixion, mosaic in the Church of the Dormition, Daphni, Greece, ca. 1090–1100.

The Daphni Crucifixion is a subtle blend of Hellenistic style and the more abstract Byzantine manner. The Virgin Mary and Saint John point to Christ on the cross as if to a devotional object.

him, but he is not overtly in pain. The Virgin and John point to the figure on the cross as if to a devotional object. They act as intercessors between the viewer below and Christ, who, in the dome, appears as the Last Judge of all humans.

Venice and Byzantium The revival on a grand scale of church building, featuring vast stretches of mosaic-covered walls, was not confined to the Greek-speaking Byzantine East in the 10th to 12th centuries. A resurgence of religious architecture and of the mosaicist's art also occurred in areas of the former Western Roman Empire where the ties with Constantinople were the strongest. In the Early Byzantine period, Venice, about 80 miles north of Ravenna on the eastern coast of Italy, was a dependency of that Byzantine stronghold. In 751, Ravenna fell to the Lombards, who wrested control of most of northern Italy from Constantinople. Venice, however, became an independent power. Its doges (dukes) enriched themselves and the city through seaborn commerce, serving as the crucial link between Byzantium and the West.

Venice had obtained the relics of Saint Mark from Alexandria in Egypt in 829, and the doges constructed the first Venetian shrine dedicated to the apostle shortly thereafter. In 1063, Doge Domenico Contarini began the construction of

the present Saint Mark's. The grandiose new building was modeled on the Church of the Holy Apostles at Constantinople, built in Justinian's time. That church no longer exists, but its key elements were a *cruciform* (cross-shaped) plan with a central dome over the crossing and four other domes over the four equal arms of the *Greek cross*, as at Saint Mark's.

The interior of Saint Mark's (Fig. 4-21) is, like its plan, Byzantine in effect. Light enters through a row of windows at the bases of all five domes, vividly illuminating a rich cycle of mosaics. Both Byzantine and local artists worked on the project over the course of several centuries. Most of the mosaics date to the 12th and 13th centuries. Cleaning and restoration on a grand scale have enabled visitors to experience the full radiance of mosaic (some 40,000 square feet of it) as it covers, like a gold-brocaded and figured fabric, all the walls, arches, vaults, and domes.

In the vast central dome, 80 feet above the floor and 42 feet in diameter, Christ ascends to Heaven in the presence of the Virgin Mary and the Twelve Apostles. The great arch framing the church crossing bears a narrative of the Crucifixion and

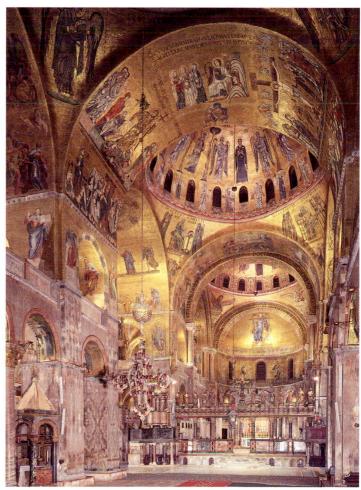

4-21 | Interior of Saint Mark's (view facing east), Venice, Italy, begun 1063.

Saint Mark's has a central dome over the crossing and four other domes over the four equal arms of the Greek cross. The walls and vaults are covered with 40,000 square feet of dazzling gold-ground mosaics.

Resurrection of Christ and of his descent into Limbo to liberate from death Adam and Eve, Saint John the Baptist, and other biblical figures. The mosaics have explanatory labels in both Latin and Greek, reflecting Venice's position as the key link between eastern and western Christendom in the later Middle Ages. The insubstantial figures on the walls, vaults, and domes appear weightless and project from their flat field no more than the elegant Latin and Greek letters above them. Nothing here reflects on the world of matter, of solids, of light and shade, of perspective space. Rather, the mosaics reveal the mysteries of the Christian faith.

Byzantium in the Balkans When the emperors lifted the ban against religious images and again encouraged religious painting at Constantinople, the impact was felt far and wide. The style varied from region to region, but a renewed enthusiasm for picturing the key New Testament figures and events was universal.

In 1164, at Nerezi in Macedonia, Byzantine painters embellished the Church of Saint Pantaleimon with murals of great emotional power. One of these represents the Lamentation over the dead Christ (Fig. 4-22). It is an image of passionate grief. The artist captured Christ's followers in attitudes, expressions, and gestures of quite human bereavement. Joseph of Arimathea and the disciple Nicodemus kneel at his feet, while Mary presses her cheek against her dead son's face

and Saint John clings to Christ's left hand. In the Gospels, neither Mary nor John was present at the entombment of Christ. Their presence here, as elsewhere in Middle Byzantine art, was designed to intensify for the viewer the emotional impact of Christ's death. Such representations parallel the development of liturgical hymns recounting the Virgin's lamenting her son's death on the Cross.

At Nerezi, the scene is set in a hilly landscape below a blue sky—a striking contrast to the abstract golden world of the mosaics favored for church walls elsewhere in the Byzantine Empire. The artist strove to make utterly convincing an emotionally charged realization of the theme by staging the Lamentation in a more natural setting and peopling it with fully modeled actors. This alternate representational mode is no less Byzantine than the hieratic style of Ravenna or the poignant melancholy of Daphni.

David as Greek Harpist Another example of this classicizing style is a page from a book of the Psalms of David. The so-called *Paris Psalter* (Fig. 4-23) reasserts the artistic values of the Greco-Roman past with astonishing authority. Art historians believe the manuscript dates from the mid-10th century—the so-called Macedonian Renaissance, a time of enthusiastic and careful study of the language and literature of ancient Greece, and of humanistic reverence for the classical past.

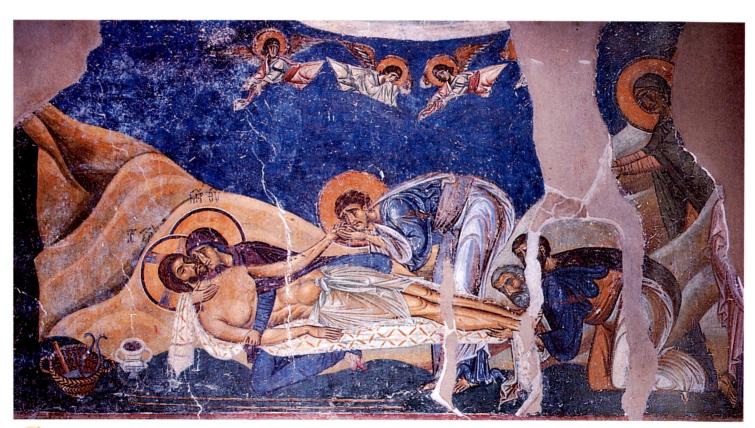

💞 4-22 | Lamentation, wall painting, Saint Pantaleimon, Nerezi, Macedonia, 1164.

Working in the Balkans in an alternate Byzantine mode, this painter staged the emotional scene of the Lamentation in a hilly landscape below a blue sky and peopled it with fully modeled actors.

4-23 | David composing the Psalms, folio 1 verso of the *Paris Psalter*, ca. 950–970. Tempera on vellum, 1' $2\frac{1}{8}'' \times 10\frac{1}{4}''$. Bibliothèque Nationale, Paris.

During the so-called Macedonian Renaissance, Byzantine painters revived the classical style. David is here portrayed like a Greek hero and is accompanied by Melody, Echo, and Bethlehem.

David, the psalmist, surrounded by sheep, goats, and his faithful dog, plays his harp in a rocky landscape with a town in the background. Similar settings appeared frequently in Pompeian murals. Befitting an ancient depiction of Orpheus, the Greek hero who could charm even inanimate objects with his music, allegorical figures accompany the Old Testament harpist. Melody looks over his shoulder, while Echo peers from behind a column. A reclining male figure points to a Greek inscription that identifies him as representing the mountain of Bethlehem. These allegorical figures do not appear in the Bible. They are the stock population of Greco-Roman painting. Apparently, the artist had seen a work from the Late Roman Empire or perhaps earlier and partly translated it into a Byzantine pictorial idiom. In works such as this, Byzantine artists kept the classical style alive in the Middle Ages.

A Miracle-Working Icon Nothing in Middle Byzantine art better demonstrates the rejection of the iconoclastic viewpoint than the painted icon's return to prominence. After the restoration of images, such icons multiplied by the thousands to meet public and private demand. In the 11th century, the clergy began to display icons in hieratic order (Christ, the Theotokos, John the Baptist, and then other saints) in tiers on

the *templon*, the columnar screen separating the sanctuary from the main body of a Byzantine church.

One example is the renowned *Vladimir Virgin* (Fig. 4-24). Descended from works such as the Mount Sinai icon (Fig. 4-18), the *Vladimir Virgin* clearly reveals the stylized abstraction resulting from centuries of working and reworking the conventional image. Probably painted by a Constantinopolitan artist, the characteristic traits of Byzantine Virgin and Child icons are all present: the Virgin's long, straight nose and small mouth; the golden rays in the infant's drapery; the sweep of the unbroken contour that encloses the two figures; and the flat silhouette against the golden ground. But this is a much more tender and personalized image of the Virgin than that in

4-24 | Virgin (Theotokos) and Child, icon (*Vladimir Virgin*), late 11th to early 12th century. Tempera on wood, original panel approx. $2' 6\frac{1}{2}'' \times 1' 9''$. Tretyakov Gallery, Moscow.

In this Middle Byzantine icon, Mary is depicted as the Virgin of Compassion, who presses her cheek against her son's as she contemplates his future. The reverse side shows the instruments of Christ's Passion. the Mount Sinai icon. Here Mary is depicted as the Virgin of Compassion, who presses her cheek against her son's in an intimate portrayal of Mother and Child. The image is also infused with a deep pathos as Mary contemplates the future sacrifice of her son. (The back of the icon bears images of the instruments of Christ's Passion.)

The icon of Vladimir, like most icons, has seen hard service. Placed before or above altars in churches or private chapels, the icon was blackened by the incense and the smoke from candles that burned before or below it. It was frequently repainted, often by inferior artists, and only the faces show the original surface. First painted in the late 11th or early 12th century, it was taken to Kiev (Ukraine) in 1131, then to Vladimir (Russia) in 1155 (hence its name), and in 1395, as a wonder-working image, to Moscow to protect that city from the Mongols. The Russians believed that the sacred picture saved the city of Kazan from later Tartar invasions and all of Russia from the Poles in the 17th century. The *Vladimir Virgin* is a historical symbol of Byzantium's religious and cultural mission to the Slavic world.

Byzantium after 1204

When rule passed from the Macedonian to the Comnenian dynasty in the later 11th and the 12th centuries, three events of fateful significance changed Byzantium's fortunes for the worse. The Seljuk Turks conquered most of Anatolia. The Byzantine Orthodox Church broke finally with the Church of Rome. And the Crusades brought the Latins (a generic term for the peoples of the West) into Byzantine lands on their way to fight for the Cross against the Saracens (Muslims) in the Holy Land (see "The Crusades," Chapter 6, page 177).

Crusaders had passed through Constantinople many times en route to "smite the infidel" and had marveled at its wealth and magnificence. Envy, greed, religious fanaticism (the Latins called the Greeks "heretics"), and even ethnic enmity motivated the Crusaders when, during the Fourth Crusade in 1203 and 1204, the Venetians persuaded them to divert their expedition against the Muslims in Palestine and to attack Constantinople instead. They took the city and sacked it.

The Latins set up kingdoms within Byzantium, notably in Constantinople itself. What remained of Byzantium was split into three small states. The Palaeologans ruled one of these, the kingdom of Nicaea. In 1261, Michael VIII Palaeologus (r. 1259–1282) succeeded in recapturing Constantinople. But his empire was no more than a fragment, and even that disintegrated during the next two centuries. Isolated from the Christian West by Muslim conquests in the Balkans and besieged by Muslim Turks to the east, Byzantium sought help from the West. It was not forthcoming. In 1453, the Ottoman Turks, then a formidable power, took Constantinople and brought to an end the long history of Byzantium.

CONCLUSION

Under Constantine, Christianity became an imperially sponsored religion, and Christian themes have ever since been the subjects of many of the greatest works of Western art. Although Old Testament themes were popular because they were frequently interpreted as prefigurations of events in the New Testament, during the Early Christian period much of the iconography of the life of Jesus in art was established. In architecture, too, Early Christian basilican churches stand at the head of a long line of shrines of similar plan extending to the present day.

Reflecting the division of the Roman Empire into eastern and western realms that began at the end of the third century, the Christian world also became divided into the Latin West centered on Rome and the Greek Orthodox East with its capital at Constantinople (Byzantium). Under Justinian, Byzantine art quickly developed a distinctive hieratic style with frontally posed, wafer-thin figures seen against a gold background, in sharp contrast to the classically inspired art of the Early Christian West. Byzantine architecture also mirrors the schism in the Church, favoring centrally planned domecovered churches over longitudinal basilicas. The New Rome of the East lasted for more than a millennium, until its final defeat at the hands of the Muslims in 1453. By then, however, Byzantine artists had already made a major impact on the art of the medieval West (see Chapter 7).

29

- I Crucifixion of Christ, 29
- Persecution of Christians under Trajan Decius, 249–251
- I Persecution of Christians under Diocletian, 303-305
- Constantine, r. 306-337
- I Edict of Milan, 313
- Pope Sylvester, r. 314-335
- I Foundation of Constantinople, 324
- Theodosius I, r. 379-395
- I Christianity proclaimed state religion of Roman Empire, 380
- I Theodosius prohibits pagan worship, 391
- I Honorius, r. 395-423
- Honorius moves capital to Ravenna, 404
 - I Fall of Rome to Alaric, 410
 - I Mary declared Theotokos at Council of Ephesus, 431
- Romulus Augustus, last Roman emperor, r. 475-476
 - I Fall of Ravenna to Odoacer; end of Western Roman Empire, 476
 - I Theodoric at Ravenna, 493-526

Sarcophagus of Junius Bassus, Rome, ca. 359

Mausoleum of Galla Placidia, Ravenna, ca. 425

527

EARLY CHRISTIAN

EARLY BYZANTINE

ICONOCLASM

MIDDLE BYZANTINE

LATE BYZANTINE

- 3 | Justinian, r. 527-565
 - | Belisarius captures Ravenna, 539
 - I Heraclius defeats Persians, 627
 - Arabs besiege Constantinople, 717-718

726

- Leo III prohibits image making, 726
- Ravenna falls to the Lombards, 751

843

- Restoration of images, 843
- Basil I, r. 867-886
- I Schism between Byzantine and Roman Churches, 1054
- Seljuk Turks capture Byzantine Asia Minor, 1073

First Crusade, 1095-1099

■ Fourth Crusade and the Frankish conquest, 1202–1204

1204

Michael VIII Palaeologus recaptures Constantinople from the Franks, 1261

1453

Ottoman Turks capture Constantinople; end of Byzantine Empire, 1453

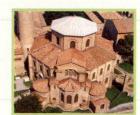

San Vitale, Ravenna, 526-547

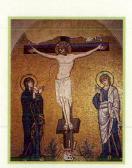

Church of the Dormition, Daphni, ca. 1090-1100

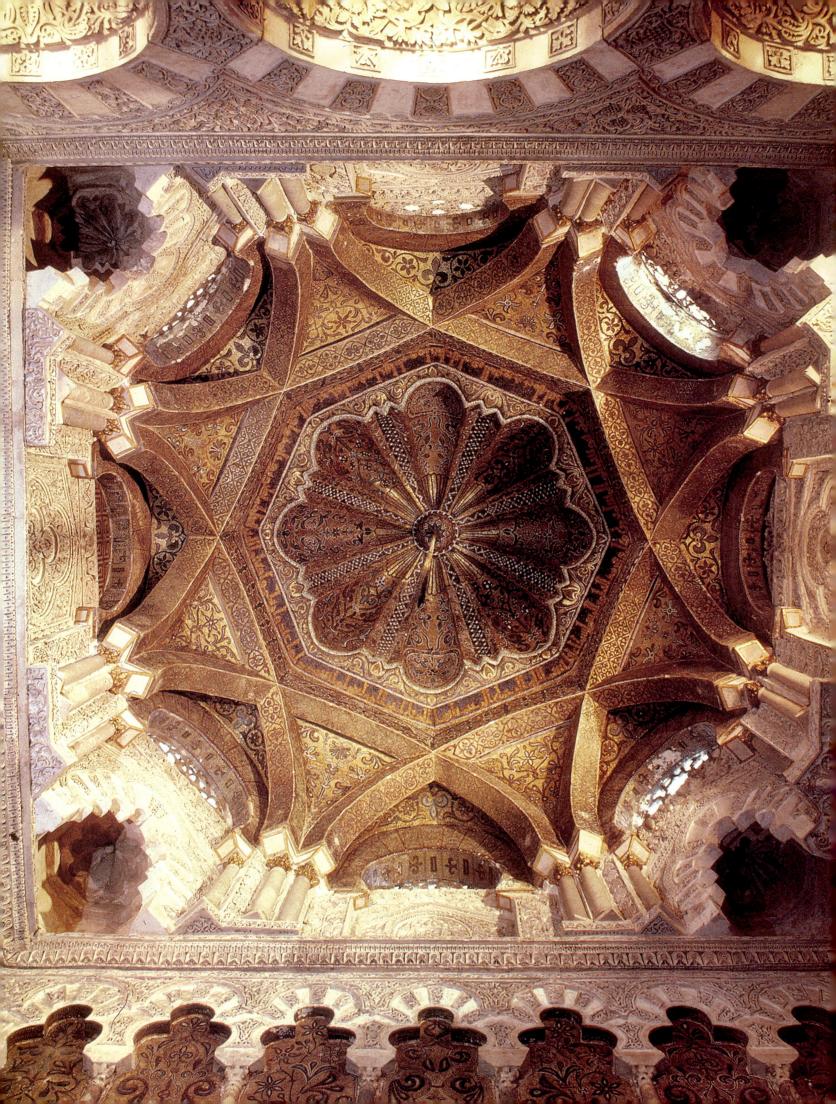

THE ISLAMIC WORLD

The religion of Islam arose in the Arabian peninsula early in the seventh century (see "Muhammad and Islam," page 148). At the time, the Arabs were peripheral to the Byzantine and Persian Empires. Yet within little more than a century, Muslim armies had subdued the Middle East and the followers of Muhammad controlled much of the Mediterranean (MAP 5-1, page 526). The swiftness of the Islamic advance is among the wonders of world history. By 640, Muslims ruled Syria, Palestine, and Iraq. In 642, the Byzantine army abandoned Alexandria, marking the Muslim conquest of northern Egypt. In 651, the successors of Muhammad brought more than 400 years of Sasanian rule in Iran to an end. By 710, all of North Africa was under Muslim control. A victory in southern Spain in 711 seemed to open all of Western Europe to the Muslims. By 732, they had advanced north to Poitiers in France. There, however, the Franks turned them back. But in Spain, the Muslim rulers of Córdoba flourished until 1031, and not until 1492 did Islamic influence and power in Iberia end. In the East, the Muslims reached the Indus River in South Asia by 751. In Anatolia, relentless Muslim pressure against the shrinking Byzantine Empire eventually caused its collapse in 1453.

ARCHITECTURE

During the early centuries of Islamic history, the Muslim world's political and cultural center was the Fertile Crescent of ancient Mesopotamia (see Chapter 1). The caliphs of Damascus (capital of modern Syria) and Baghdad (capital of Iraq) appointed provincial governors to rule the vast territories they controlled. These governors eventually gained relative independence by setting up dynasties in various territories and provinces: the Umayyads in Syria and in Spain (756–1031), the Abbasids in Iraq, and so on. Like other potentates before and after, the Islamic rulers were builders on a grand scale.

Triumph in Jerusalem The first great achievement of Islamic architecture is the Dome of the Rock (Fig. 5-1) in Jerusalem. The Muslims had taken the city from the Byzantines in 638, and the Umayyad caliph Abd al-Malik (r. 685–705) erected the monumental sanctuary between 687 and 692 as an architectural tribute to the triumph of Islam. The Dome of the Rock marked the coming of the new religion to the city that had been, and still is, sacred to both Jews and Christians. The sanctuary was erected on the traditional site of Adam's burial, of Abraham's preparation for the sacrifice of Isaac, and of the Temple of Solomon the Romans

Dome in front of the mihrab of the Great Mosque, Córdoba, Spain, 961–965.

Muhammad and Islam

Muhammad, founder of Islam (an Arabic word meaning "submission to God") and revered as its Final Prophet, was a native of Mecca on the west coast of Arabia. Born around 570 into a family of merchants, Muhammad was inspired to prophecy. Critical of the polytheistic religion of his fellow Arabs, he preached a religion of the one and only God (Allah in Arabic), whose revelations Muhammad received beginning in 610 and for the rest of his life. Opposition to Muhammad's message among the Arabs was strong enough to prompt the Prophet to flee from Mecca to a desert oasis eventually called Medina (City of the Prophet). Islam dates its beginnings from this flight in 622, known as the Hijra, or emigration. (Muslims date events beginning with the Hijra in the same way Christians reckon events from Christ's birth.) Barely eight years later, in 630, Muhammad returned to Mecca with 10,000 soldiers. He took control of the city, converted the population to Islam, and destroyed all the idols. But he preserved as the Islamic world's symbolic center the small cubical building that had housed the idols. The Arabs associated the Kaaba (from the Arabic for "cube") with the era of Abraham and Ishmael, the common ancestors of Jews and Arabs. Muhammad died in Medina in 632.

The essence of Islam is acceptance of and submission to Allah's will. Believers in Islam are called *Muslims* (Those Who Submit). Islam broadly includes living according to the rules laid down in the collected revelations communicated through Muhammad during his lifetime. These are recorded in the *Koran*, Islam's sacred book. "Koran" means "recitations"—a reference to the archangel Gabriel's instructions to Muhammad in 610 to "recite in the name of Allah."

The profession of faith in Allah is the first of five obligations binding all Muslims. In addition, the faithful must worship five times daily, facing

in Mecca's direction; give alms to the poor; fast during the month of Ramadan; and once in a lifetime—if possible—make a pilgrimage to Mecca. Muslims are guided not only by the revelations in the Koran but also by Muhammad's life. The Prophet's exemplary ways and customs, collected in the *Sunnah*, are supplemental to the Koran, offering guidance to the faithful on ethical problems of everyday life. The reward for the Muslim faithful is Paradise.

Islam has much in common with Judaism and Christianity. Its adherents think of it as a continuation, completion, and in some sense a reformation of those other great monotheisms. In addition to the belief in one God, Islam incorporates many of the Old Testament teachings, with their sober ethical standards and hatred of idol worship, and those of the New Testament Gospels. Adam, Abraham, Moses, and Jesus are acknowledged as the prophetic predecessors of Muhammad. The Final Prophet did not claim to be divine, as did Jesus, and he did not perform miracles. Rather, Muhammad was God's messenger, the purifier and perfecter of the common faith of Jews, Christians, and Muslims in one God. Islam also differs from Judaism and Christianity in its simpler organization. Muslims worship God directly, without a hierarchy of rabbis, priests, or saints acting as intermediaries.

In Islam, as Muhammad defined it, religious and secular authority were united even more completely than in Byzantium. Muhammad established a new social order, taking complete charge of his community's temporal, as well as spiritual, affairs. After Muhammad's death, the caliphs (from the Arabic for "successor") continued this practice of uniting religious and political leadership in one ruler.

destroyed in 70. It houses the rock (Fig. 5-2) from which Muslims later came to believe Muhammad ascended to Heaven.

As Islam took much of its teaching from Judaism and Christianity, so its architects and artists borrowed and transformed design, construction, and ornamentation principles that had been long applied in, and were still current in, Byzantium and the Middle East. The Dome of the Rock is a domed octagon resembling San Vitale in Ravenna (Fig. 4-13) in its basic design. In all likelihood, a neighboring Christian monument, Constantine's Rotunda of the Holy Sepulchre, inspired

5-1 | Dome of the Rock, Jerusalem, 687–692.

Abd al-Malik erected the Dome of the Rock to commemorate the triumph of Islam in Jerusalem, which the Muslims had captured from the Byzantines. The shrine takes the form of an octagon with a towering dome.

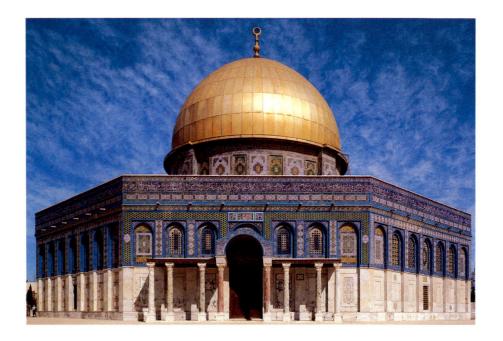

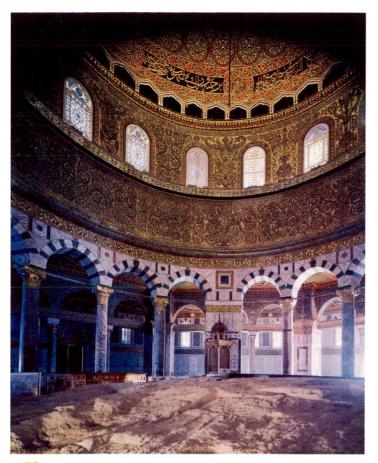

Interior of the Dome of the Rock, Jerusalem, 687-692.

The exterior of the Dome of the Rock is sheathed with 16th-century tiles, but the interior's original mosaic ornament has been preserved. The mosaics conjure up the places of Paradise awaiting the Muslim faithful.

the Dome of the Rock's designers. That fourth-century rotunda bore a family resemblance to the roughly contemporary Santa Costanza in Rome (Figs. 4-5 and 4-6). The Dome of the Rock is a member of the same extended family. Its double-shelled wooden dome, however, some 60 feet across and 75 feet high, so dominates the elevation as to reduce the octagon to serving merely as its base. This soaring, majestic unit creates a decidedly more commanding effect than that of Late Roman and Byzantine domical structures (for example, Figs. 4-6 and 4-10). The silhouettes of those domes are comparatively insignificant when seen from the outside.

The building's exterior has been much restored. Tiling from the 16th century and later has replaced the original mosaic. Yet the vivid, colorful patterning that wraps the walls like a textile is typical of Islamic ornamentation. It contrasts markedly with Byzantine brickwork and Greco-Roman sculptured profiling and carved decoration. The interior's mosaic ornament (Fig. 5-2) has been preserved. Consisting of rich floral and vegetal motifs against a field of gold, it conjures up the gorgeous places of Paradise awaiting the faithful. From the interior mosaics one can imagine how the exterior walls of the Dome of the Rock originally appeared.

The Hypostyle Mosque The Dome of the Rock is a unique monument. Throughout the Islamic world, the most important buildings were usually mosques (see "The Mosque," page 150). Of all the variations, the hypostyle mosque most closely reflects the mosque's supposed origin, Muhammad's house in Medina. One of the oldest well-preserved hypostyle mosques is the mid-eighth-century Great Mosque (Fig. 5-3) at Kairouan in Tunisia. Like the Dome of the Rock, the Kairouan

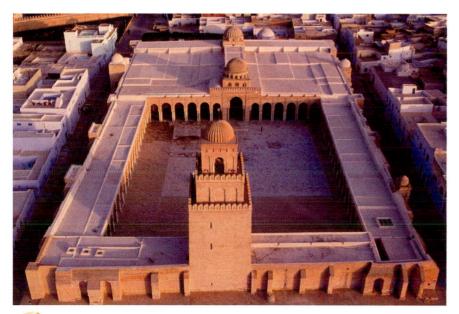

5-3 | Aerial view (*left*) and plan (*right*) of the Great Mosque, Kairouan, Tunisia, ca. 836-875.

The hypostyle type of mosque most closely resembles Muhammad's house in Medina. Kairouan's Great Mosque is one of the oldest. An arcaded forecourt resembling a Roman forum leads to the columnar prayer hall.

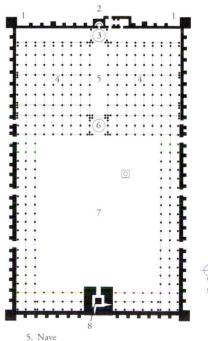

- 1. Qibla wall
- 2. Mihrab
- 3. Mihrab dome
- 4. Hypostyle prayer hall 8. Minaret
- 6. Entrance dome 7. Forecourt
- 20 30 METERS

149

ARCHITECTURAL BASICS

The Mosque

Islamic religious architecture is closely related to Muslim prayer. In Islam, worshiping can be a private act. It requires neither prescribed ceremony nor a special locale. Only the *qibla*—the direction (toward Mecca) Muslims face while praying—is important. But worship also became a communal act when the first Muslim community established a simple ritual for it. To celebrate the Muslim sabbath, which occurs on Friday, the community convened each Friday at noon, probably in the Prophet's house in Medina. The main feature of Muhammad's house was a large, square court with rows of palm trunks supporting thatched roofs along the north and south sides. The southern side was wider and had a double row of trunks. It faced Mecca. During these communal gatherings, the *imam*, or leader of collective worship, stood on a stepped pulpit, or *minbar*, set up in front of the southern (qibla) wall.

These features became standard in the Islamic house of worship, the *mosque* (from Arabic *masjid*, "a place of prostration"), where the faithful gathered for the five daily prayers. The *congregational mosque* (also called the *Friday mosque* or *great mosque*), was ideally large enough to accommodate a community's entire population for the Friday noonday prayer. Both ordinary and congregational mosques usually have a *mihrab*

(Fig. 5-8), a semicircular niche set into the qibla wall. Often a dome over the bay in front of the mihrab marked its position (Figs. 5-3 and 5-5). The niche may recall the place where the Prophet stood in his house at Medina when he led communal worship.

In some mosques, a *maqsura* precedes the mihrab. The maqsura is the area reserved for the ruler or his representative. Mosques may also have one or more *minarets* (Fig. 5-3), towers from which the faithful are called to worship. Early mosques are generally *hypostyle halls*, communal worship halls with roofs held up by a multitude of columns (Figs. 5-3 and 5-4). An important later variation is the mosque with four *iwans* (vaulted rectangular recesses), one on each side of a courtyard (Fig. 5-7). Other plans were also used.

The mosque's origin is still in dispute, although one prototype may well have been the Prophet's house in Medina. Today, mosques continue to be erected throughout the world. Despite many variations in design and detail, and the employment of modern building techniques and materials unknown in Muhammad's day, all mosques, wherever they are built and whatever their plan, are oriented toward Mecca, and the faithful worship facing the qibla wall.

mosque owes much to Greco-Roman and Early Christian architecture. The precinct takes the form of a slightly askew parallelogram of huge scale, some 450×260 feet. A series of lateral entrances on the east and west lead to an arcaded forecourt (no. 7 on the plan), reminiscent of Roman forums (FIG. 3-30) and the atriums of Early Christian basilicas (Fig. 4-3). The courtyard is oriented north-south on axis with the mosque's minaret (no. 8) and the two domes (nos. 3 and 6) of the hypostyle prayer hall (no. 4). The first dome (no. 6) is over the entrance bay, the second (no. 3) over the bay that fronts the mihrab (no. 2) set into the qibla wall (no. 1). A raised nave connects the domed spaces and prolongs the north-south axis of the minaret and courtyard. Eight columned aisles flank the nave on either side, providing space for a large congregation. The hypostyle mosque synthesizes elements received from other cultures into a novel architectural unity.

Umayyad Córdoba At the time the Kairouan mosque was built, much of North Africa was ruled by the Abbasids. In 750, they had overthrown the Umayyad caliphs and moved the capital from Damascus to Baghdad. The only Umayyad notable to escape the Abbasid massacre of his clan in Syria fled to Spain. There, the Arabs, who had defeated the Christian kingdom of the Visigoths in 711, accepted the fugitive as their overlord, and he founded the Spanish Umayyad dynasty. Their capital was Córdoba, which became the center of a brilliant culture rivaling that of the Abbasids at Baghdad and exerting major influence on the civilization of the Christian West.

The jewel of Córdoba was its Great Mosque, begun in 784 and enlarged several times during the 9th and 10th centuries. The hypostyle prayer hall (Fig. 5-4) has 36 piers and 514

columns topped by a unique system of double-tiered arches that carried a wooden roof (now replaced by vaults). The two-story system was the builders' response to the need to

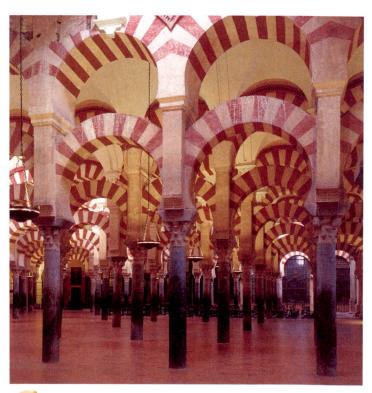

5-4 | Prayer hall of the Great Mosque, Córdoba, Spain, 8th to 10th centuries.

Córdoba was the capital of the Umayyad dynasty in Spain. The Great Mosque's prayer hall has 36 piers and 514 columns topped by a unique system of double-tiered horseshoe-shaped arches.

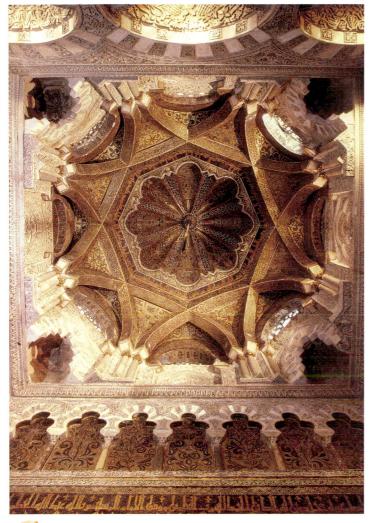

5-5 | Dome in front of the mihrab of the Great Mosque, Córdoba, Spain, 961–965.

This dome is a prime example of Islamic experimentation with highly decorative multilobed arches. The rich and varied abstract patterns create a magnificent effect, which is further heightened by mosaics.

raise the roof to an acceptable height using short columns that had been employed earlier in other structures. The lower arches are horseshoe shaped, a form perhaps adapted from earlier Near Eastern architecture or of Visigothic origin. In the West, the horseshoe arch quickly became closely associated with Muslim architecture. Visually, these arches seem to billow out like windblown sails, and they contribute greatly to the light and airy effect of the Córdoba mosque's interior.

The 10th-century renovations to the mosque included the addition of a series of domes to emphasize the axis leading to the mihrab. The dome that covers the area immediately in front of the mihrab (Fig. 5-5) rests on an octagonal base of arcuated *squinches* and is crisscrossed by ribs that form an intricate pattern centered on two squares set at 45-degree angles to each other. It is a prime example of Islamic experimentation with highly decorative multilobed arches. The builders created rich and varied abstract patterns and further enhanced the magnificent effect of the complex arches by

sheathing the surfaces with mosaics. The mosaicists and even the tesserae were brought to Spain from Constantinople.

The Red Fortress In the early years of the 11th century, the Umayyad caliphs' power in Spain unraveled, and their palaces fell prey to Berber soldiers from North Africa. The Berbers ruled southern Spain for several generations but could not resist the pressure of Christian forces from the north. Córdoba fell to the Christians in 1236. From then until the final Christian triumph in 1492, the Nasrids, an Arab dynasty that had established its capital at Granada in 1230, ruled the remaining Muslim territories in Spain. On a rocky spur at Granada, the Nasrids constructed a huge palace-fortress called the Alhambra ("the Red" in Arabic) because of the rose color of the stone used for its walls and 23 towers. By the end of the 14th century, the complex, a veritable city with a population of 40,000, included at least a half dozen royal residences.

One of those palaces is the so-called Palace of the Lions, the residence of Muhammad V (r. 1354–1391). Its court-yards, lush gardens, stucco walls and ceilings, and luxurious carpets and other furnishings were designed to conjure the image of Paradise. We reproduce a view of the ceiling (Fig. 5-6) of the so-called Hall of the Two Sisters. The dome of the square room rests on an octagonal drum supported by squinches and pierced by eight pairs of windows, but its structure is difficult to discern because of the intricately carved stucco decoration. The ceiling is covered with some 5,000

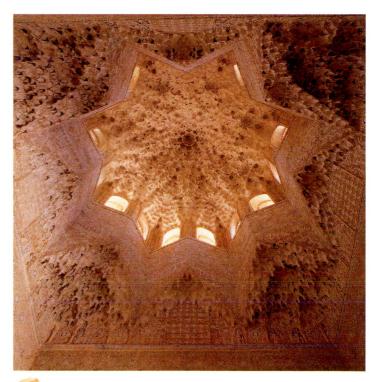

5-6 | Muqarnas dome, Hall of the Two Sisters, Alhambra palace, Granada, Spain, 1354–1391.

The structure of this dome on an octagonal drum is difficult to discern because of the intricately carved stucco mugarnas decoration. The prismatic forms catch and reflect sunlight, creating the effect of a starry sky.

muqarnas (Arabic, "stalactites")—tier after tier of nichelike prismatic forms that seem aimed at denying the structure's solidity. The muqarnas ceiling was intended to catch and reflect sunlight as well as form beautiful abstract patterns. The lofty vault was meant to symbolize the dome of Heaven. The flickering light and shadows create the effect of a starry sky as the sun's rays move from window to window during the day. To underscore the symbolism, the palace walls were inscribed with verses by the court poet Ibn Zamrak, who compared the Alhambra's lacelike muqarnas ceilings to "the heavenly spheres whose orbits revolve."

Isfahan's Great Mosque At the opposite end of the Islamic world, in Iran, successive dynasties erected a series of mosques at Isfahan. The largest is the Great Mosque (Fig. 5-7), which was remodeled several times over nearly a millennium. The earliest mosque on the site, of the hypostyle type, was constructed in the eighth century during the caliphate of the Abbasids. Seljuk sultans (rulers) transformed the structure in the 11th century, and later alterations further changed the mosque's appearance. The present mosque, which retains its basic 11th-century plan, consists of a large courtyard bordered by a two-story arcade on each side. Four iwans open onto the courtyard, one at the center of each side (see "The Mosque," page 150). The southwestern iwan leads into a dome-covered room in front of the mihrab. It functioned as a maqsura reserved for the sultan and his attendants. It is uncertain whether this plan, with four iwans and a dome before the mihrab, was employed for the first time in the Great Mosque at Isfahan, but it became standard in Iranian mosque design. In four-iwan mosques, the qibla iwan is always the largest. Its size (and the dome that often accompanied it) immediately indicated to worshipers the proper direction for prayer.

Iranian Tilework The iwans of the Isfahan mosque feature soaring pointed arches framing tile-sheathed muqarnas vaults. The muqarnas ceilings probably were installed in the 14th century, and the ceramic-tile revetment on the walls and vaults is the work of the 17th-century Safavid rulers of Iran. The use of glazed tiles has a long history in the Middle East. Even in ancient Mesopotamia, gates and walls were sometimes covered with colorful baked bricks (Fig. 1-19). In the Islamic world, the art of ceramic tilework reached its peak in the 16th and 17th centuries in Iran and Turkey. Employed as a veneer over a brick core, tiles could sheathe entire buildings (Fig. 5-1), including domes and minarets.

Ceramic Calligraphy One of the masterworks of Iranian tilework is the 14th-century mihrab (Fig. 5-8) from the Madrasa Imami in Isfahan. It is also a splendid example of Arabic calligraphy, or ornamental writing. In the Islamic world, the art of calligraphy was revered, and the sacred words of the Koran were often displayed on the walls of buildings. Quotations from the Koran appear, for example, in a mosaic band above the outer ring of columns inside the Dome of the Rock (Fig. 5-2). The Isfahan mihrab exemplifies the perfect aesthetic union between the calligrapher's art and abstract ornament. The pointed arch that immediately enframes the mihrab niche bears an inscription from the Koran in an early stately rectilinear script called Kufic, after the city of Kufah, one of the renowned centers of Arabic calligraphy. A cursive style, Muhaggag, fills the mihrab's outer rectangular frame. The tile ornament on the curving surface of the niche and the area above the pointed arch are composed of tighter and looser networks of geometric and abstract floral motifs. The technique used here is the most difficult of all the varieties Islamic artisans practiced: mosaic tilework. Every piece had to be chiseled and cut to fit its specific

9 5-7

Aerial view of the Great Mosque (looking southwest), Isfahan, Iran, 11th to 17th centuries.

Mosques take a variety of forms. In Iran, the standard type of mosque has four iwans opening onto a courtyard. The largest iwan leads into a dome-covered maqsura in front of the mihrab.

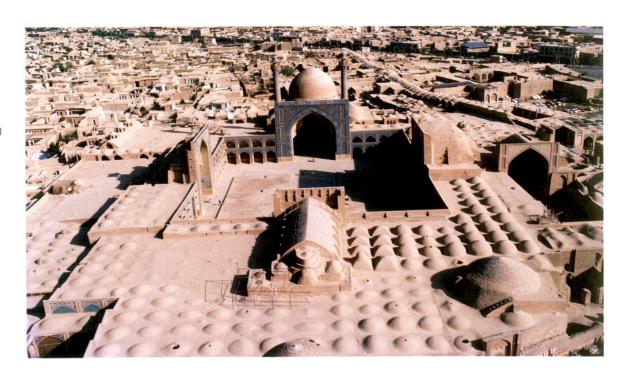

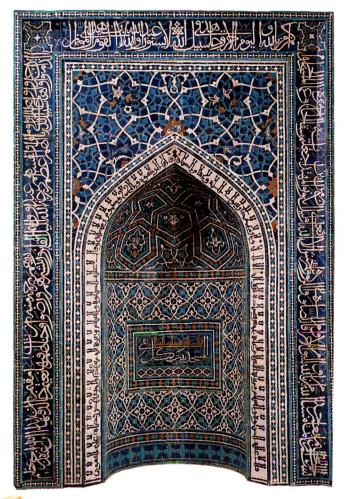

5-8 | Mihrab from the Madrasa Imami, Isfahan, Iran, ca. 1354. Glazed mosaic tilework, 11′ 3″ × 7′ 6″. Metropolitan Museum of Art, New York.

This mihrab is one of the masterworks of Iranian tilework, but it is also a splendid example of Arabic calligraphy. In the Islamic world, the sacred words of the Koran were often displayed on the walls of buildings.

place in the mihrab, even the inscriptions. The framed inscription in the center of the niche—proclaiming that the mosque is the domicile of the pious believer—is smoothly integrated with the subtly varied patterns. The mihrab's outermost inscription—detailing the five pillars of Islamic faith—serves as a fringelike extension, as well as a boundary, for the entire design. The calligraphic and geometric elements are so completely unified that only the practiced eye can distinguish them.

LUXURY ARTS

In the smaller-scale, and often private, realm of the luxury arts, Muslim artists also excelled. Indeed, in the Islamic world, the term "minor arts" is especially inappropriate. Although of modest size, the books, textiles, ceramics, and metalwork Islamic artists produced in great quantities are among the finest works of any age. From the vast array of Islamic luxury arts, we select two representative examples.

The Art of the Koran Although the chief Islamic book, the sacred Koran, was codified in the mid-seventh century, the earliest preserved Korans are datable to the ninth century. Koran pages were either bound into books or stored as loose sheets in boxes. Most of the early examples are written in the angular Kufic script used in the central panel of the mihrab in Fig. 5-8. Arabic is written from right to left, with certain characters connected by a baseline. In Kufic script, the uprights almost form right angles with the baseline. As with Hebrew and other Semitic languages, the usual practice was to write in consonants only. But to facilitate recitation of the Koran, scribes often indicated vowels by red or yellow symbols above or below the line.

On a 9th- or early 10th-century Koran page (Fig. 5-9), five text lines in black ink with red vowels appear below a decorative band incorporating the chapter title in gold and ending

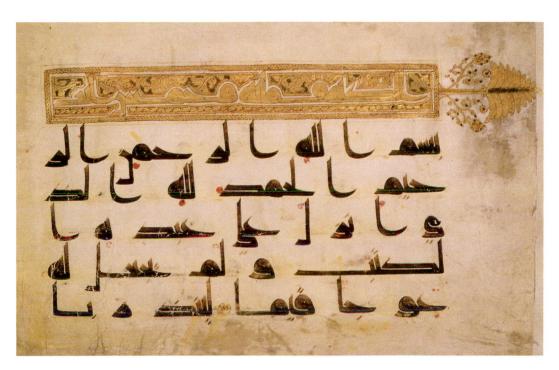

5-9 | Koran page, 9th or early 10th century. Ink and gold on vellum, $7\frac{1}{4}'' \times 10\frac{1}{4}''$. Chester Beatty Library and Oriental Art Gallery, Dublin.

The stately rectilinear Kufic script was used for the text of the oldest known Korans. This page has five text lines and a palm-tree finial. Islamic tradition shuns the representation of fauna in sacred books as well as in mosques.

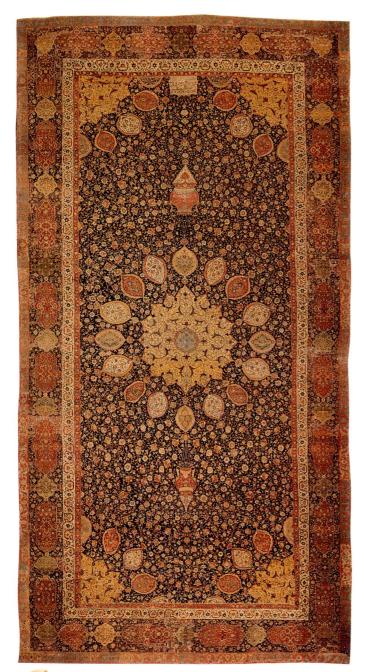

5-10 | Maqsud of Kashan, carpet from the funerary mosque of Shaykh Safi al-Din, Ardabil, Iran, 1540. Knotted pile of wool and silk, 34′ 6″ × 17′ 7″. Victoria & Albert Museum, London.

Textiles are among the glories of Islamic art. This carpet consists of roughly 25 million knots. The decoration presents the illusion of a heavenly dome with lamps reflected in a pool of water with floating lotus blossoms.

in a palm-tree *finial* (a crowning ornament). This approach to page design has parallels at the extreme northwestern corner of the then-known world—in the early medieval manuscripts of the British Isles, where text and ornament are similarly united (Fig. 6-3). But the stylized human and animal forms that populate those Christian books never appear in Korans. Islamic tradition shuns the representation of fauna of any kind in sacred contexts. This also explains the total absence of

figural ornament in mosques, setting the Islamic world sharply apart from both the classical world and Christian Europe and Byzantium.

Islamic Textiles Wood is scarce in most of the Islamic world, and the kind of furniture used in the West-beds, tables, and chairs—is rarely found in Muslim structures. Architectural spaces, therefore, are not defined by the type of furniture placed in them. A room's function (eating or sleeping, for example) can change simply by rearranging the carpets and cushions. Textiles are among the glories of Islamic art. Unfortunately, because of their fragile nature and the heavy wear carpets endure, early Islamic textiles are rare today and often fragmentary. One of the best—and largest—later examples comes from Ardabil in Iran. The carpet (Fig. 5-10), one of a pair, adorned the funerary mosque of Shaykh Safi al-Din (1252–1334), but it was made in 1540, two centuries after the erection of the mosque, during the reign of Shah Tahmasp (r. 1524-1576). Tahmasp elevated carpet weaving to a national industry and set up royal factories at Isfahan, Kashan, Kirman, and Tabriz. The name of MAQSUD OF KASHAN is woven into the fabric. He must be the designer who supplied the master pattern to two teams of royal weavers (one for each of the two carpets). The carpet, almost 35×18 feet, consists of roughly 25 million knots (some 340 to the square inch; its twin has even more knots).

The design consists of a central sunburst medallion, representing the inside of a dome, surrounded by 16 pendants. Mosque lamps (appropriate motifs for the Ardabil funerary mosque) are suspended from two pendants on the long axis of the carpet. The lamps are of different sizes, and some scholars have suggested that this is an optical device to make the two appear equal in size when viewed from the end of the carpet at the room's threshold (the bottom end in our illustration). The rich blue background is covered with leaves and flowers attached to a framework of delicate stems that spreads over the whole field. The entire composition presents the illusion of a heavenly dome with lamps reflected in a pool of water full of floating lotus blossoms.

CONCLUSION

The irresistible and far-ranging sweep of Islam from Arabia to India to North Africa and Spain brought a new and compelling tradition to the history of world art and architecture. Like Islam itself, Islamic art spread quickly. In the Middle East and North Africa, Islamic art largely replaced Roman and Early Christian art. And from a foothold in the Iberian peninsula, it made an impact on Western medieval art, although Islamic art stands in sharp contrast both to the figural art of Europe and the Mediterranean and to the Western architectural vocabulary. Islamic artists and architects also brought their distinctive style to South Asia, where a Muslim sultanate was established at Delhi in India in the early 13th century (see Chapter 15).

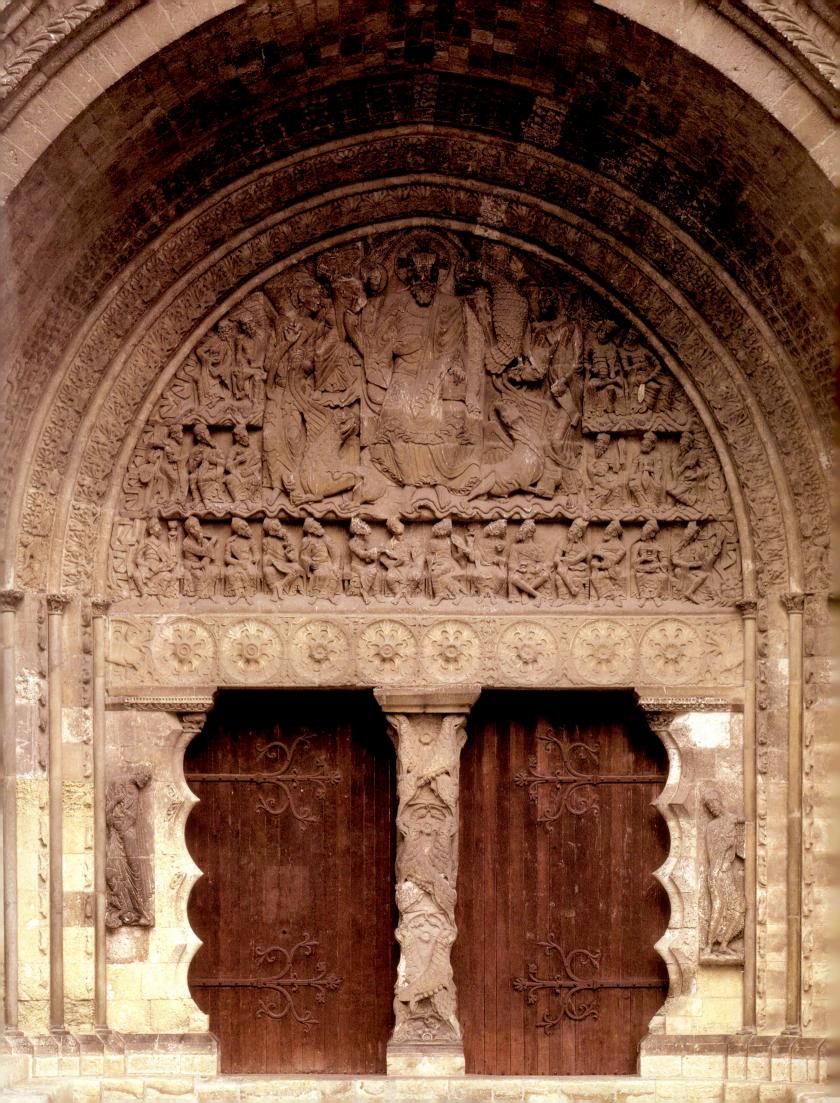

EARLY MEDIEVAL AND ROMANESQUE EUROPE

Historians once referred to the thousand years (roughly 400 to 1400) between the dying Roman Empire's official adoption of Christianity and the rebirth (Renaissance) of interest in classical art as the Dark Ages. They viewed this period as a blank between classical antiquity and the beginning of modern Europe. This negative assessment, a legacy of the humanist scholars of Renaissance Italy, persists today in the retention of the noun *Middle Ages* and the adjective *medieval* to describe this "era in between" and its art. Modern scholars, however, long ago ceased to see the art of medieval Europe as unsophisticated or inferior.

Early medieval (ca. 500–1000) civilization in western Europe (MAP 6-1, page 527) represents a fusion of Christianity, the Greco-Roman heritage, and the cultures of the non-Roman peoples north of the Alps. Over the centuries a new political and social order gradually replaced what had been the Roman Empire, resulting eventually in the foundation of today's European nations.

THE ART OF THE WARRIOR LORDS

Art historians do not know the full range of art and architecture the early medieval transalpine peoples produced. What has survived is not truly representative and consists almost exclusively of small "status symbols"—weapons and items of personal adornment such as bracelets, pendants, and belt buckles discovered in lavish burials. Earlier scholars, who viewed medieval art through a Renaissance lens, ignored these "minor arts" because of their small scale, seeming utilitarian nature, and abstract ornament, and because the people who made them rejected the classical idea that the representation of organic nature should be the focus of artistic endeavor. In their own time, however, these objects were regarded as treasures. They enhanced the prestige of those who owned them and testified to the stature of those who were buried with them. In the great Anglo-Saxon epic *Beowulf*, for example, the hero is cremated and his ashes placed in a huge tumulus overlooking the sea. As an everlasting tribute, his people "buried rings and brooches in the barrow, all those adornments that brave men had brought out from the hoard after Beowulf died. They bequeathed the gleaming gold, treasure of men, to the earth." I

A King's Final Voyage The *Beowulf* saga also recounts the funeral of the warrior lord Scyld, who was laid to rest in a ship set adrift in the North Sea overflowing with arms and armor and costly adornments. In 1939, a treasure-laden ship was discovered in a burial mound at Sutton Hoo in Suffolk, England.

South portal of Saint-Pierre, Moissac, France, ca. 1115 – 1135. **6-1** | Purse cover, from the Sutton Hoo ship burial in Suffolk, England, ca. 625. Gold, glass, and enamel cloisonné with garnets and emeralds, $7\frac{1}{2}$ " long. British Museum, London.

This purse cover is but one of many treasures found in a ship beneath a royal burial mound. The combination of abstract interlace ornament with animal figures is the hallmark of early medieval art in the West.

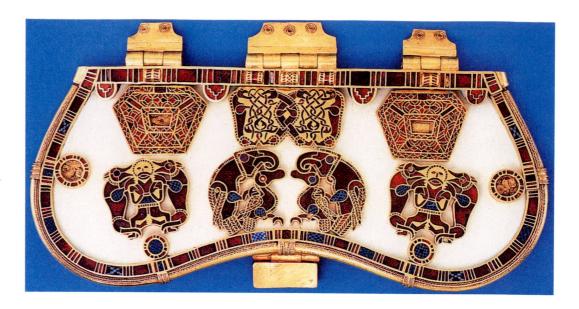

Although unique, it epitomizes the early medieval tradition of burying great lords with rich furnishings. Among the many precious finds were a gold belt buckle, 10 silver bowls, 40 gold coins, and 2 silver spoons inscribed "Saulos" and "Paulos" (Saint Paul's names in Greek before and after his baptism). The spoons may allude to a conversion to Christianity. Some historians have associated the site with the East Anglian king Raedwald, who was baptized a Christian before his death in 625.

Cloisonné The most extraordinary Sutton Hoo find was a purse cover (Fig. 6-1) decorated with cloisonné-enamel plaques. (In enamel work, artists fuse colored glass in powder or paste form to metal plaques by firing.) Early medieval metalworkers produced *cloisonné* jewelry by soldering small metal strips, or cloisons (French, "partitions"), edge-up, to a metal background and then filling the compartments with semiprecious stones, pieces of colored glass, or glass paste fired to resemble sparkling jewels. On the Sutton Hoo purse cover, four symmetrically arranged groups of cloisonné figures make up the lower row. The end groups consist of a facing man standing between two profile beasts. The *heraldic* trio is a pictorial parallel to the epic sagas of the era in which heroes like Beowulf battle and conquer horrific monsters. The two center groups represent eagles attacking ducks. The convex beaks of the eagles fit against the concave beaks of the ducks. The two figures fit together so snugly that they seem at first to be a single dense abstract design. This is true also of the man-animals motif.

Above these figures are three geometric designs. The outer ones are clear and linear in style. In the central design, an interlace pattern, the lines turn into writhing animal figures. Elaborate interlace patterns are characteristic of many times and places, but the combination of interlace with animal figures was uncommon outside the realm of the early medieval warlords. In fact, metalcraft with a vocabulary of interlace patterns and other motifs beautifully integrated with the animal form was, without doubt, *the* art of the early Middle Ages in the West.

HIBERNO-SAXON ART

In 432, Saint Patrick established a church in Ireland and began the Christianization of the Celts. The new converts quickly founded monasteries throughout Ireland and also in Britain and Scotland. In 563, for example, Saint Columba established an important monastery on the Scottish island of Iona, where he successfully converted the native Picts to Christianity. Iona monks built a monastery at Lindisfarne off the northern coast of Britain in 635. These and other later foundations became great centers of learning. Art historians call the art that flourished within the monasteries of the British Isles *Hiberno-Saxon* (Irish-English).

Hiberno-Saxon Books The most important extant Hiberno-Saxon artworks are the illuminated manuscripts of the Christian Church. Liturgical books were the primary vehicles in the effort to Christianize the British Isles. They literally brought the Word of God to a predominantly illiterate population who regarded the monks' sumptuous volumes with awe. Books were scarce, jealously guarded treasures. Most of them were housed in the libraries and *scriptoria* (writing studios) of monasteries or major churches.

One of the most characteristic features of Hiberno-Saxon book illumination is the inclusion of full pages devoted neither to text nor to illustration but to pure embellishment. Interspersed between the text pages are so-called *carpet pages*, resembling textiles, made up of decorative panels of abstract and zoomorphic forms. Many books also contain pages on which the initial letters of an important passage of sacred text are enormously enlarged and transformed into elaborate decorative patterns. This type of manuscript decoration merged the abstraction of early medieval personal adornment with the pictorial tradition of Early Christian art.

Carpets and Crosses The marriage between Christian imagery and the animal-interlace style of the North is seen in the *Lindisfarne Gospels*. The *Gospels* ("good news"), the

6-2 | Cross and carpet page, folio 26 verso of the *Lindisfarne Gospels*, from Northumbria, England, ca. 698–721. Tempera on vellum, 1' $1\frac{1}{2}$ " × $9\frac{1}{4}$ ". British Library, London.

The marriage between Christian imagery and the animal-interlace style of the early medieval warrior lords can be seen in this full-page painting in one of the oldest known Hiberno-Saxon Gospel books.

opening four books of the New Testament, tell the story of the life of Christ, but the painter of the Lindisfarne Gospels had little interest in narrative. Rather, the cross-inscribed carpet page that we illustrate (Fig. 6-2) is typical of this lavish book. Serpentine interlacements of fantastic animals devour each other, curling over and returning on their writhing, elastic shapes. The rhythm of expanding and contracting forms produces a most vivid effect of motion and change. But it is held in check by the regularity of the design and by the dominating motif of the inscribed cross. The cross—the all-important symbol of the imported religion—stabilizes the rhythms of the serpentines and, perhaps by contrast with its heavy immobility, seems to heighten the effect of motion. The illuminator placed the motifs in detailed symmetries, with inversions, reversals, and repetitions that must be studied closely to appreciate not so much their variety as their mazelike complexity. The zoomorphic forms intermingle with clusters and knots of line, and the whole design vibrates with energy. The color is rich yet cool. The painter adroitly adjusted shape and color to achieve a smooth and perfectly even surface.

Illuminating the Word The greatest achievement of Hiberno-Saxon art in the eyes of almost all modern observers is the *Book of Kells*. Medieval commentators shared this high opinion, and one wrote in the *Annals of Ulster* for the year 1003 that this "great Gospel [is] the chief relic of the western world." The *Book of Kells* was created for display on a church altar. From an early date it was housed in an elaborate metalwork box, befitting a greatly revered "relic." It boasts an unprecedented number of full-page illuminations, including carpet pages, New Testament figures and narrative scenes, and monumentalized and embellished words from the Bible.

The page we reproduce (FIG. 6-3) opens the account of the nativity of Jesus in the Gospel of Saint Matthew. The initial letters of Christ in Greek (XPI, chi-rho-iota) occupy nearly the entire page, although two words—autem (abbreviated simply as h) and generatio—appear at the lower right. Together they read, "Now this is how the birth of Christ came about." The page corresponds to the opening of Matthew's Gospel, the passage read in church on Christmas Day. The illuminator transformed the holy words into abstract pattern, literally making

6-3 | Chi-rho-iota page, folio 34 recto of the *Book of Kells*, from Iona, Scotland, late eighth or early ninth century. Tempera on vellum, $1' 1'' \times 9\frac{1}{2}''$. Trinity College Library, Dublin.

In this opening page to the Gospel of Saint Matthew, the illuminator transformed the biblical text into abstract pattern, literally making God's words beautiful. The intricate design recalls early medieval metalwork.

God's words beautiful. The intricate design recalls early medieval metalwork, but the cloisonné-like interlace is not pure abstraction. The letter *rho*, for example, ends in a male head, and animals are at its base to the left of *h generatio*. Half-figures of winged angels appear to the left of *chi*, accompanying the monogram as if accompanying Christ himself. Close observation reveals many other figures, human and animal.

CAROLINGIAN ART

In Saint Peter's (FIG. 4-3) on Christmas Day of the year 800, Pope Leo III crowned Charles the Great (Charlemagne), king of the Franks since 768, as emperor of Rome (r. 800–814). In time, Charlemagne came to be seen as the first Holy (that is, Christian) Roman Emperor, a title his successors in the West did not formally adopt until the 12th century. Born in 742, when northern Europe was still in chaos, Charlemagne consolidated the Frankish kingdom his father and grandfather bequeathed him and defeated the Lombards in Italy. He thus united Europe and laid claim to reviving the glory of the ancient Roman Empire. His official seal bore the words *renovatio imperii Romani* (renewal of the Roman Empire). Charlemagne gave his name (Carolus Magnus in Latin) to an entire era, the *Carolingian* period.

The Revival of Learning Charlemagne was a sincere admirer of learning, the arts, and classical culture. He invited to his court the best minds of his age, among them Alcuin, master of the cathedral school at York, the center of Northumbrian learning. One of Charlemagne's dearest projects was the recovery of the true text of the Bible, which, through centuries of errors in copying, had become quite corrupt. Alcuin of York's revision of the Bible became the most widely used. Charlemagne himself could read and speak Latin fluently, in addition to Frankish, his native tongue. He also could understand Greek, and held books, both sacred and secular, in especially high esteem, importing many and producing far more.

Saint Matthew at Work The most famous of Charlemagne's books is the Coronation Gospels. The text is written in handsome gold letters on purple vellum. The major fullpage illuminations show the four Gospel authors at work— Saints Matthew, Mark, Luke, and John, the Four Evangelists (from the Greek word for "one who announces good news"). The page we reproduce (Fig. 6-4) depicts Saint Matthew. Author portraits were familiar features of Greek and Latin books, and similar representations of seated philosophers or poets writing or reading abound in ancient art. The Matthew of the Coronation Gospels follows a long tradition of Mediterranean manuscript illumination, and the legacy of classical art is evident. Deft, illusionistic brushwork defines the massive drapery folds wrapped around the body beneath. The Carolingian painter used color and modulation of light and shade to create the illusion of three-dimensional form. The cross-legged chair, the lectern, and the saint's toga

6-4 | Saint Matthew, folio 15 recto of the Coronation Gospels (Gospel Book of Charlemagne), from Aachen, Germany, ca. 800–810. Ink and tempera on vellum, $1'\frac{3}{4}'' \times 10''$. Schatzkammer, Kunsthistorisches Museum, Vienna.

The painted manuscripts produced for Charlemagne's court clearly reveal the legacy of classical art. The Carolingian painter used light and shade and perspective to create the illusion of three-dimensional form.

are familiar Roman accessories, and the placement of the book and lectern top at an angle suggests a Mediterranean model employing classical perspective. The landscape background is also a classical feature, and the frame is filled with the kind of acanthus leaf frieze commonly found in Roman art. Almost nothing is known in the Hiberno-Saxon or Frankish West that could have prepared the way for such a classicizing portrayal of Saint Matthew. If a Frank, rather than an Italian or a Byzantine, painted the Saint Matthew and the other Evangelist portraits of the Coronation Gospels, the northern artist had fully absorbed the classical manner. Classical painting style was one of the many components of Charlemagne's program to establish himself as the head of a renewed Christian Roman Empire.

An Impassioned Evangelist Another Saint Matthew (Fig. 6-5), in a gospel book made for Archbishop Ebbo of Reims, France, may be an interpretation of an author portrait very similar to the one the *Coronation Gospels* master used as a model. It resembles it in pose and in brushwork technique, but there the resemblance stops. The illuminator of the *Ebbo*

6-5 | Saint Matthew, folio 18 verso of the *Ebbo Gospels* (Gospel Book of Archbishop Ebbo of Reims), from Hautvillers (near Reims), France, ca. 816–835. Ink and tempera on vellum, $10\frac{1}{4}" \times 8\frac{3}{4}"$. Bibliothèque Municipale, Épernay.

Saint Matthew writes in frantic haste, and the folds of his drapery writhe and vibrate. Even the landscape behind him rears up alive. This Carolingian painter merged classical illusionism with the linear tradition of the North.

Gospels replaced the classical calm and solidity of the Coronation Gospels with an energy that amounts to frenzy, and the frail saint almost leaps under its impulse. Matthew writes in frantic haste. His hair stands on end, his eyes open wide, the folds of his drapery writhe and vibrate, the landscape behind him rears up alive. The painter even set the page's leaf border in motion. This Evangelist portrait contrasts strongly with the Coronation Gospels Matthew. The Ebbo Gospels painter translated a classical prototype into a new Carolingian vernacular, merging classical illusionism and the linear tradition of the North.

Bejeweled Golden Books The taste for luxurious portable objects, shown previously in the art of the early medieval warrior lords, persisted under Charlemagne and his successors. They commissioned numerous works employing costly materials, including book covers made of gold and jewels, and sometimes also ivory or pearls. Gold and gems not only glorified the Word of God but also evoked the heavenly Jerusalem.

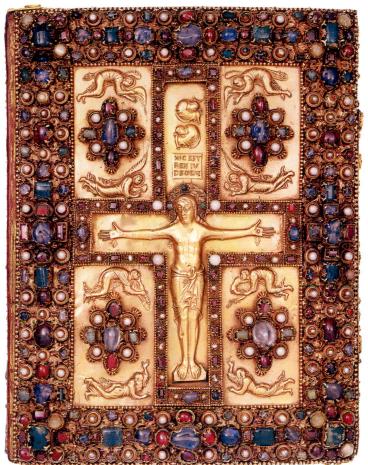

6-6 | Crucifixion, front cover of the *Lindau Gospels*, from Saint Gall, Switzerland, ca. 870. Gold, precious stones, and pearls, $1' \frac{13}{8}'' \times 10\frac{3}{8}''$. Pierpont Morgan Library, New York.

This sumptuous Carolingian book cover revives the Early Christian imagery of the youthful Christ. The statuesque figure of the crucified Savior, oblivious to pain, is classical in both conception and execution.

One of the most sumptuous Carolingian book covers (Fig. 6-6) is the one later added to the Lindau Gospels. The gold cover was fashioned in one of the royal workshops of Charlemagne's grandson, Charles the Bald (r. 840-875). A youthful Christ in the Early Christian tradition is shown nailed to the cross but oblivious to pain. He is surrounded by pearls and jewels (raised on golden claw feet so that they can catch and reflect the light even more brilliantly and protect the delicate metal relief from denting). The statuesque figure, rendered in hammered relief, is classical both in conception and in execution. In contrast, the four angels and the personifications of the moon and the sun above and the crouching figures of the Virgin Mary and Saint John (and two other figures of uncertain identity) in the quadrants below display the vivacity and nervous energy of the Ebbo Gospels Matthew (Fig. 6-5). This eclectic work highlights the stylistic diversity of early medieval art in Europe. Here, however, the translated figural style of the south prevails, in keeping with the classical tastes and imperial aspirations of the Frankish "emperors of Rome."

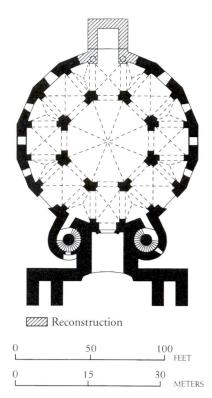

6-7 | Restored plan of the Palatine Chapel of Charlemagne, Aachen, Germany, 792–805.

Charlemagne often visited Ravenna and sought to emulate Byzantine splendor in the North. The plan of his German palace chapel is based on that of San Vitale (Fig. 4-14), but the Carolingian plan is simpler.

Aachen and Ravenna In his eagerness to reestablish the imperial past, Charlemagne looked to Rome and Ravenna for models for his buildings. One was the former heart of the Roman Empire, which he wanted to "renew." The other was the western outpost of Byzantine might and splendor (see Chapter 4), which he wanted to emulate in his own capital at Aachen, Germany. Charlemagne often visited Ravenna, and once brought from there porphyry columns to adorn his Palatine (palace) Chapel. The plan (Fig. 6-7) of the Aachen chapel resembles that of Ravenna's San Vitale (Fig. 4-14), and a direct relationship very likely exists between the two.

A comparison between the northern building, the first vaulted structure of the Middle Ages in the West, and its southern counterpart is instructive. The Aachen plan is simpler. Omitted were San Vitale's apselike extensions reaching from the central octagon into the ambulatory. At Aachen, the two main units stand in greater independence of each other. This solution may lack the subtle sophistication of the Byzantine building, but the Palatine Chapel gains geometric clarity. A view of the interior of the Palatine Chapel (Fig. 6-8) shows that the "floating" quality of San Vitale (Fig. 4-15) was converted into massive geometric form, expressing robust strength.

The treatment of the Palatine Chapel's exterior is of special interest. Above the portal, Charlemagne could appear in a large framing arch and be seen by those gathered in the atrium in front of the chapel (only part of the atrium is included in our plan, Fig. 6-7). Directly behind that second-story arch was

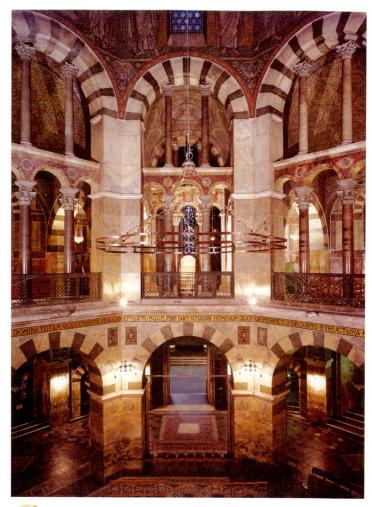

6-8 | Interior of the Palatine Chapel of Charlemagne, Aachen, Germany, 792–805.

Charlemagne's Aachen chapel is the first vaulted structure of the Middle Ages in the West. The architect transformed the complex, glittering interior of San Vitale (Fig. 4-15) into simple and massive geometric form.

Charlemagne's marble throne. From there he could peer down at the altar in the apse. Charlemagne's imperial gallery followed the model of the western imperial gallery at Hagia Sophia in Constantinople (Figs. 4-11 and 4-12). But the design of the facade broke sharply from Byzantine tradition. Two cylindrical towers with spiral staircases flank the entrance portal—a first step toward the great dual-tower facades of churches in the West from the 10th century to the present.

The Ideal Monastery The Carolingian period was also a great era for the construction of monasteries. About 819, a schematic plan (Fig. 6-9) for a Benedictine community (see "Medieval Monasteries and Benedictine Rule," page 164) was drawn for Haito, the abbot of Reichenau and bishop of Basel, and sent to the abbot of Saint Gall in Switzerland. The plan provided a coherent arrangement of all the buildings of a monastic community and was intended as a guide in the rebuilding of the Saint Gall monastery. It constitutes a treasure

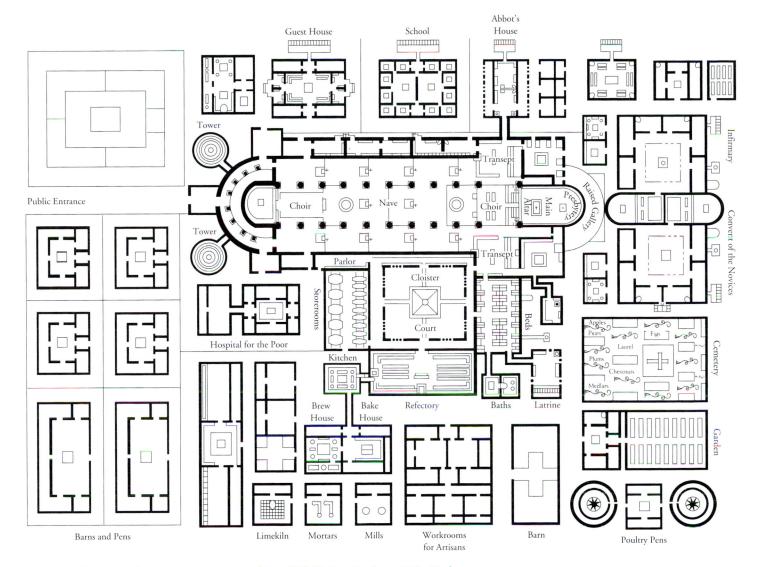

6-9 | Schematic plan for a monastery at Saint Gall, Switzerland, ca. 819. (Redrawn after a ninth-century manuscript; original in red ink on parchment, $2' 4'' \times 3' 8^{1''}_{8}$. Stiftsbibliothek, Saint Gall.)

The fundamental purpose of this plan for an ideal, self-sufficient monastery was to separate the monks from the laity. Near the center is the church with its cloister, an earthly Paradise reserved for the monks alone.

trove of information about Carolingian monastic life. The design's fundamental purpose was to separate the monks from the *laity*, or nonclergy, who also inhabited the community. Variations of the scheme may be seen in later monasteries all across Western Europe.

Near the center, dominating everything, was the church with its *cloister*, a colonnaded courtyard (compare Fig. 6-22) not unlike the Early Christian atrium (Fig. 4-3) but situated to the side of the church rather than in front of its main portal. "Cloister" (from the Latin word *claustrum*, an enclosed place) connotes being shut away from the world. Architecturally, the medieval church cloister expressed the seclusion of the spiritual life. Reserved for the monks alone, the cloister provided the peace and quiet necessary for contemplation and was regarded as a kind of earthly paradise removed from the

world at large. Around the cloister were grouped the most essential buildings: dormitory, refectory, kitchen, and storage rooms. Other structures, including an infirmary, school, guest house, bakery, brewery, and workshops, were grouped around this central core of church and cloister.

Haito invited the abbot of Saint Gall to adapt the plan as he saw fit, and the Saint Gall builders did not, in fact, follow the Reichenau model exactly. Nonetheless, if the abbot had wished, Haito's plan could have served as a practical guide for the Saint Gall masons because it was laid out on a module (standard unit) of two and a half feet. Parts or multiples of this module were used consistently throughout the plan. For example, the nave's width, indicated on the plan as 40 feet, was equal to 16 modules; the length of each monk's bed to two and a half modules.

Medieval Monasteries and Benedictine Rule

Monastic foundations appeared in the West beginning in Early Christian times. The monks who established monasteries also made the rules that governed them. The most significant of these monks was Benedict of Nursia (Saint Benedict), who founded the Benedictine Order in 529. By the ninth century, the "Rule" Benedict wrote (Regula Sancti Benedicti) had become standard for all Western monastic establishments, in part because Charlemagne had encouraged its adoption throughout the Frankish territories.

Saint Benedict believed that the corruption of the clergy that accompanied the increasing worldliness of the Christian Church was rooted in the lack of firm organization and regulation. Neglect of the commandments of God and of the Church was due, as he saw it, to idleness and selfishness. The cure for this was communal association in an abbey under the absolute rule of an abbot the monks elected (or an abbess the nuns chose), who would see to it that each hour of the day was spent in useful work and in sacred reading. The emphasis was on work and study and not on meditation and austerity. This is of great historical significance. Since antiquity, manual labor had been considered disgraceful, the business of the lowborn or of slaves. Benedict raised it to the dignity of religion. By thus exalting the virtue of manual labor, Benedict not only rescued it from its age-old association with slavery but also recognized it as the way to self-sufficiency for the entire religious community.

Whereas some of Saint Benedict's followers emphasized spiritual "work" over manual labor, others, most notably the Cistercians, put his teachings about the value of physical work into practice. These monks reached into their surroundings and helped reduce the vast areas of daunting wilderness of early medieval Europe. They cleared dense forest teeming with wolves, bear, and wild boar; drained swamps; cultivated wastelands; and built roads, bridges, and dams, as well as monastic churches and their associated living and service quarters. An ideal monastery (Fig. 6-9) provided all the facilities necessary for the conduct of daily life—a mill, bakery, infirmary, vegetable garden, and even a brewery—so that the monks felt no need to wander outside its protective walls.

Such religious communities were centrally important to the revival of learning. The clergy, who were also often scribes and scholars, had a monopoly on the skills of reading and writing in an age of almost universal illiteracy. The monastic libraries and scriptoria, where books were read, copied, illuminated, and bound with ornamented covers, became centers of study. These were almost the sole repositories of what remained of the literary culture of the Greco-Roman world and early Christianity. Saint Benedict's requirements of manual labor and sacred reading were expanded to include writing and copying books, studying music for chanting the day's offices, and — of great significance — teaching. The monasteries were also the schools of the early Middle Ages.

Carolingian Basilicas The models that carried the greatest authority for Charlemagne and his builders were those from the Christian phase of the Roman Empire. The widespread adoption of the Early Christian basilica, at Saint Gall and elsewhere, rather than the domed central plan of Byzantine churches, was crucial to the subsequent development of Western church architecture. Unfortunately, no Carolingian basilica has survived in anything approaching its original form. Nevertheless, it is possible to reconstruct the appearance of some of them with fair accuracy. The monastery church at Saint Gall (Fig. 6-9), for example, was essentially a traditional basilica, but it had features not found in any Early Christian church. Most obvious is the addition of a second apse on the west end of the building.

Not quite as evident but much more important to the subsequent development of church architecture in the North was the presence of a transept at Saint Gall, a very rare feature, but one that characterized the two greatest Early Christian basilicas in Rome, Saint Peter's (Fig. 4-3) and Saint Paul's. The Saint Gall transept is as wide as the nave on the plan and was probably the same height. Early Christian builders had not been concerned with proportional relationships. They assembled the various portions of their buildings only in accordance with the dictates of liturgical needs. On the Saint Gall plan, however, the various parts of the building are related to one another by a geometric scheme that ties them

together into a tight and cohesive unit. Equalizing the widths of nave and transept automatically makes the area where they cross (the *crossing*) a square. Most Carolingian churches shared this feature. But Haito's planner also used the *crossing square* as the unit of measurement for the remainder of the church plan. The transept arms are equal to one crossing square, the distance between transept and apse is one crossing square, and the nave is four and a half crossing squares long. The fact that the two aisles are half as wide as the nave integrates all parts of the church in a rational, lucid, and orderly plan.

The Saint Gall plan also reveals another important feature of many Carolingian basilicas: towers framing the end(s) of the church. Haito's plan shows only two towers, both cylindrical and on the west side of the church, as at the Palatine Chapel at Aachen (Fig. 6-7), but they stand apart from the church facade. If a tower existed above the crossing, the silhouette of Saint Gall would have shown three towers altering the horizontal profile of the traditional basilica and identifying the church even from afar. Other Carolingian basilicas had towers that were incorporated in the fabric of the west end of the building, as in Charlemagne's Palatine Chapel, thereby creating a unified monumental facade that greeted all those who entered the church. Architectural historians call this feature of Carolingian and some later churches the *westwork* (German *Westwerck*, western entrance structure).

OTTONIAN ART

Charlemagne's empire survived him by fewer than 30 years. When his son Louis the Pious (r. 814–840) died, the Carolingian Empire was divided among Louis's sons, Charles the Bald, Lothair, and Louis the German. After bloody conflicts among the brothers, a treaty was signed in 843 partitioning the Frankish lands into western, central, and eastern areas, very roughly foreshadowing the later nations of France and Germany and a third realm corresponding to a long strip of land stretching from the Netherlands and Belgium to Rome.

In the mid-10th century, the eastern part of the former empire was consolidated under the rule of a new Saxon line of German emperors called, after the names of the three most illustrious family members, the *Ottonians*. The first Otto (r. 936–973) was crowned emperor in Rome by Pope John XII in 962. The three Ottos not only preserved but enriched the culture and tradition of the Carolingian period.

Bishop Bernward One of the great patrons of Ottonian art and architecture was Bishop Bernward of Hildesheim, Germany. He was the tutor of Otto III (r. 983–1002) and builder of the abbey church of Saint Michael at Hildesheim (Figs. 6-10 and 6-11). Bernward, who made Hildesheim a center of learning, was an expert craftsman and bronze caster as well as a scholar. In 1001, he traveled to Rome as the guest of Otto III. During this stay, Bernward studied at first hand the ancient monuments the Carolingian and Ottonian emperors so revered.

Constructed between 1001 and 1031 (and rebuilt after World War II), Bernward's Saint Michael's is an elaborate version of a Carolingian basilica. It has two apses, two transepts,

6-10 | Saint Michael's, Hildesheim, Germany, 1001–1031.

Built by Bishop Bernward, a great patron of Ottonian art and architecture, Saint Michael's is a masterpiece of Ottonian basilica design. It has a distinctive profile, with two apses, two transepts, and multiple towers.

and multiple towers. The transepts create eastern and western centers of gravity. The nave merely seems to be a hall that connects them. Lateral entrances leading into the aisles from the north and south (Fig. 6-11) additionally make for an almost complete loss of the traditional basilican orientation toward the east. Some ancient Roman basilicas, such as the Basilica Ulpia in Trajan's Forum (Fig. 3-30, no. 4), also had two apses and were entered from the side, and Bernward probably was familiar with this variant basilican plan.

At Hildesheim, as in the plan of the monastery at Saint Gall (Fig. 6-9), the builders adopted a modular approach. The crossing squares, for example, were used as the basis for the nave's dimensions—three crossing squares long and one square wide. This fact was emphasized visually by the placement of heavy piers at the corners of each square. These piers alternate with pairs of columns to form what architectural historians call the *alternate-support system*. The alternating piers and columns divide the nave into vertical units, mitigating the tunnel-like horizontality of the Early Christian basilica.

Colossal Bronze Doors In 1001, when Bishop Bernward was in Rome, he resided in Otto III's palace on the Aventine hill in the neighborhood of Santa Sabina, an Early Christian church renowned for its carved wooden doors. Those doors, decorated with episodes from both the Old and New Testaments, may have inspired the remarkable bronze

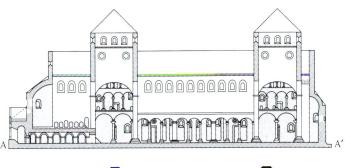

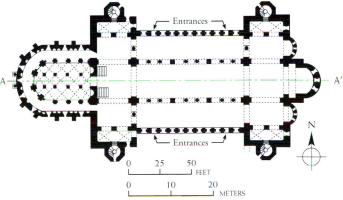

6-11 | Longitudinal section (top) and plan (bottom) of the abbey church of Saint Michael's, Hildesheim, Germany, 1001–1031.

Saint Michael's was entered from the side, and its nave has alternating piers and columns, dividing the space into vertical units. These features transformed the tunnel-like horizontality of Early Christian basilicas.

6-12 | Doors with relief panels (Genesis, left door; life of Christ, right door), commissioned by Bishop Bernward for Saint Michael's, Hildesheim, Germany, 1015. Bronze, 16' 6" high. Dom-Museum, Hildesheim.

Bernward's doors tell the story of Original Sin and ultimate redemption, showing the expulsion from the Garden of Eden and the infancy and suffering of Christ. The Ottonian sculptor had a genius for anecdotal detail.

doors the bishop had cast for Saint Michael's. The Hildesheim doors (Fig. 6-12) are more than 16 feet tall. Each was cast in a single piece with the figural sculpture, a technological tour de force. Carolingian sculpture, like most sculpture since the

fall of Rome, consisted primarily of small-scale art executed in ivory and precious metals. Although the 16 individual panels of the Hildesheim doors may be compared to the covers of Carolingian (Fig. 6-6) and Ottonian books, the colossal scale of the ensemble is unprecedented.

The panels of the left door illustrate highlights from the biblical Book of Genesis, beginning with the Creation of Adam (at the top) and ending with the murder of Adam and Eve's son Abel by his brother Cain (at the bottom). The right door recounts the life of Christ (reading from the bottom up), starting with the Annunciation and terminating with the appearance to Mary Magdalene of Christ after the Resurrection. Together, the doors tell the story of Original Sin and ultimate redemption. showing the expulsion from the Garden of Eden and the path back to Paradise through the Christian Church. As in Early Christian times, the Old Testament was interpreted as prefiguring the New Testament. The panel depicting the Fall of Adam and Eve, for example, is juxtaposed with the Crucifixion on the other door. Eve nursing the infant Cain is opposite Mary with the Christ Child in her lap. The figures show a vivid animation that recalls the Saint Matthew of the Ebbo Gospels, but the narrative compositions also reveal the Hildesheim artist's genius for anecdotal detail. For example, in the fourth panel from the top on the left door, God, portrayed as a man, accuses Adam and Eve after their fall from grace. He jabs his finger at them with the force of his whole body. The frightened pair crouch, both to hide their shame and to escape the lightning bolt of divine wrath. Each passes the blame—Adam pointing backward to Eve and Eve pointing downward to the deceitful serpent. Both figures struggle to point with one arm while attempting to shield their bodies from sight with the other. With an instinct for expressive pose and gesture, the artist brilliantly communicated their newfound embarrassment at their nakedness and their unconvincing denials of wrongdoing.

Monumental Suffering Nowhere is the Ottonian revival of interest in monumental sculpture more evident than in the crucifix (Fig. 6-13) Archbishop Gero commissioned and presented to Cologne Cathedral in 970. Carved in oak and then painted and gilded, the six-foot-tall image of Christ nailed to the cross presents a dramatically different conception of the Savior than that seen on the cover of the Lindau Gospels (Fig. 6-6), with its Early Christian imagery of the youthful Christ triumphant over death. The bearded Christ of the Cologne crucifix is more akin to Byzantine representations of the suffering Jesus (Fig. 4-20), but the emotional power of the Ottonian work is greater still. The sculptor depicted Christ as an all-toohuman martyr. Blood streaks down his forehead from the (missing) crown of thorns. His eyelids are closed, and his face is contorted in pain. Christ's body sags under its own weight. The muscles are stretched to the limit—those of his right shoulder and chest seem almost to rip apart. The halo behind Christ's head may foretell his subsequent Resurrection, but all the worshiper senses is his pain. Gero's crucifix is the most powerful characterization of intense agony of the early Middle Ages.

6-13 | Crucifix commissioned by Archbishop Gero for Cologne Cathedral, Germany, ca. 970. Painted wood, height of figure 6' 2". Cathedral, Cologne.

In this early example of the revival of monumental sculpture in the Middle Ages, an Ottonian sculptor depicted with unprecedented emotional power the intense agony of Christ's ordeal on the cross.

ROMANESQUE ART

The Romanesque era is the first since Archaic and Classical Greece to take its name from an artistic style rather than from politics or geography. Unlike Carolingian and Ottonian art, named for emperors, or Hiberno-Saxon art, a regional term, Romanesque is a title art historians invented to describe an artistic phenomenon. Romanesque means "Romanlike" and first was applied in the early 19th century to describe European architecture of the 11th and 12th centuries. Scholars noted that certain architectural elements of this period, principally barrel and groin vaults based on the round arch, resembled those of ancient Roman architecture. Thus, the word distinguished most Romanesque buildings from earlier medieval timber-roofed structures, as well as from later Gothic churches with vaults resting on pointed arches. Scholars in

other fields quickly borrowed the term. Today "Romanesque" broadly designates the history and culture of western Europe between about 1050 and 1200.

Architecture

During the 11th and 12th centuries, thousands of ecclesiastical buildings were remodeled or newly constructed. This immense building enterprise reflected in part the rise of independent and increasingly prosperous towns during the Romanesque period. But it also was an expression of the widely felt relief and thanksgiving that the conclusion of the first Christian millennium in the year 1000 had not brought an end to the world, as many had feared. In the Romanesque age, the construction of churches became almost an obsession.

Pilgrimages and the Cult of Relics

The cult of *relics* was not new in the Romanesque era. For centuries, Christians had traveled to sacred shrines housing the body parts of, or objects associated with, the holy family or the saints. The faithful had long believed that such relics — bones, clothing, instruments of martyrdom, and the like — had the power to heal body and soul. Nevertheless, the veneration of relics reached a high point in the 11th and 12th centuries.

In Romanesque times, pilgrimage was the most conspicuous feature of public devotion, proclaiming the pilgrim's faith in the power of saints and hope for their special favor. The major shrines—Saint Peter's and Saint Paul's in Rome and the Church of the Holy Sepulcher in Jerusalem—drew pilgrims from all over Europe. The visitors braved, for salvation's sake, bad roads and hostile wildernesses infested with robbers who preyed on innocent travelers. The journeys could take more than a year to complete—when they were successful. People often undertook pilgrimage as an act of repentance or as a last resort in their search for a cure for some physical disability. Hardship and austerity were means of

increasing pilgrims' chances for the remission of sin or of disease. The distance and peril of the pilgrimage were measures of pilgrims' sincerity of repentance or of the reward they sought.

For those with less time or money than required for a pilgrimage to Rome or Jerusalem, holy destinations could be found closer to home. In France, for example, the church at Vézelay housed the bones of Mary Magdalene. Saint Lazarus's remains were enshrined at Autun and Saint Saturninus's at Toulouse. These and other great churches were also important way stations en route to the most venerated shrine in the West, the tomb of Saint James at Santiago de Compostela in northwestern Spain.

Hordes of pilgrims paying homage to saints placed a great burden on the churches that stored their relics, but they also provided significant revenues, making possible the erection of ever grander and more luxuriously appointed structures. The popularity of pilgrimages led to changes in church design, necessitating longer and wider naves and aisles, transepts and ambulatories with additional chapels (FIG. 6-15), and second-story galleries (FIG. 6-16).

Pilgrimages The enormous investment in ecclesiastical buildings and furnishings also reflected a significant increase in pilgrimage traffic in Romanesque Europe (see "Pilgrimages and the Cult of Relics," above, and MAP 6-1, page 527). Pilgrims were important sources of funding for those monasteries that possessed the relics of venerated saints. The clergy of the various monasteries vied with one another to provide magnificent settings for the display of relics. Justification for such heavy investment to attract donations was found in the Bible itself, for example in Psalm 26:8: "Lord, I have loved the beauty of your house, and the place where your glory dwells." Traveling pilgrims fostered the growth of towns as well as monasteries.

Pilgrimages were, in fact, the primary economic and conceptual catalyst for the art and architecture of the Romanesque period.

Saint-Sernin at Toulouse Around 1070, construction of a great new church began in honor of Toulouse's first bishop, Saint Saturninus (Saint Sernin in French). Large congregations were common at the southwestern French shrines along the pilgrimage routes to Santiago de Compostela, and Saint-Sernin was designed to accommodate thousands of people. The grand scale of the building is highlighted in our aerial view (**Fig. 6-14**), which includes automobiles, trucks, and nearly invisible pedestrians. The church's 12th-century exterior is still largely intact,

6-14 | Aerial view of Saint-Sernin (from the southeast), Toulouse, France, ca. 1070–1120.

Pilgrimages were the primary economic catalyst for the art and architecture of the Romanesque period. The clergy vied with one another to provide magnificent settings for the display of holy relics.

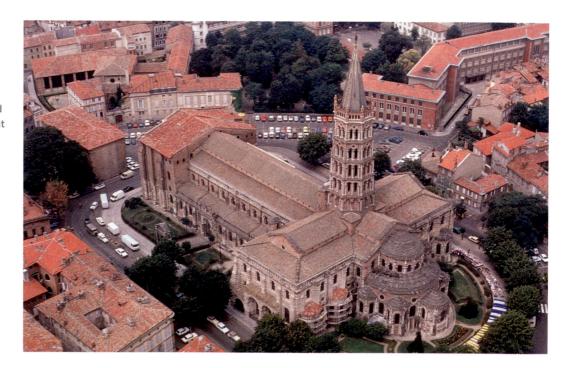

although the two towers of the western facade (at the left in Fig. 6-14) were never completed, and the prominent *crossing tower* is largely Gothic and later.

Saint-Sernin's plan (Fig. 6-15) is extremely regular and geometrically precise. The crossing square, flanked by massive piers and marked off by heavy arches, served as the module for the entire church. Each nave bay, for example, measures exactly one-half of the crossing square, and each aisle bay measures exactly one-quarter. The Toulouse design was a crisply rational and highly refined realization of an idea first seen three centuries earlier at Saint Gall (Fig. 6-9). But the Toulouse plan differs in significant ways from those of earlier monastic churches. It exemplifies what has come to be called the "pilgrimage church" type. At Toulouse one clearly can see how the builders provided additional space for curious pilgrims, worshipers, and liturgical processions alike. They increased the length of the nave, doubled the side aisles, and added a transept and ambulatory with radiating chapels housing the church's relics so that the faithful could view them without having to enter the choir where the main altar was situated.

Tribunes and Vaults Saint-Sernin also has upper galleries, or *tribunes*, over the inner aisle and opening onto the nave (Fig. 6-16), which housed overflow crowds on special occasions. The tribunes played an important role in buttressing the continuous semicircular cut-stone barrel vault that covers Saint-Sernin's nave. Groin vaults (indicated by Xs on the plan, Fig. 6-15) in the tribune galleries as well as in the ground-floor aisles absorbed the pressure (*thrust*) exerted by the barrel vault along the entire length of the nave. The groin vaults served as buttresses for the barrel vault and transferred the main thrust to the thick outer walls.

The builders of Saint-Sernin were not content with just buttressing the massive nave vault. They also carefully coordinated the vault's design with that of the nave arcade below and with the modular plan of the building as a whole. Our

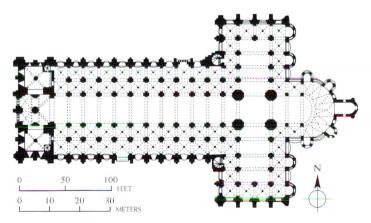

6-15 | Plan of Saint-Sernin, Toulouse, France, ca. 1070–1120 (after Kenneth John Conant).

The popularity of pilgrimages led to changes in church design, necessitating longer and wider naves and aisles, as well as transepts and ambulatories with additional chapels for viewing relics.

view of the interior (Fig. 6-16) shows that the geometric floor plan (Fig. 6-15) is fully reflected in the nave walls, where the piers marking the corners of the bays are embellished with engaged half-columns. Architectural historians refer to piers with columns or pilasters attached to their rectangular cores as *compound piers*. At Saint-Sernin, the engaged columns rise from the bottom of the compound piers to the vault's *springing* (the lowest stone of an arch) and continue across the nave as *transverse arches*.

As a result, the Saint-Sernin nave seems to be composed of numerous identical vertical volumes of space placed one behind the other, marching down the building's length in orderly procession. The segmentation of the nave corresponds to and renders visually the plan's geometric organization. This rationally integrated scheme, with repeated units decorated and separated by moldings, had a long future in later church architecture in the West.

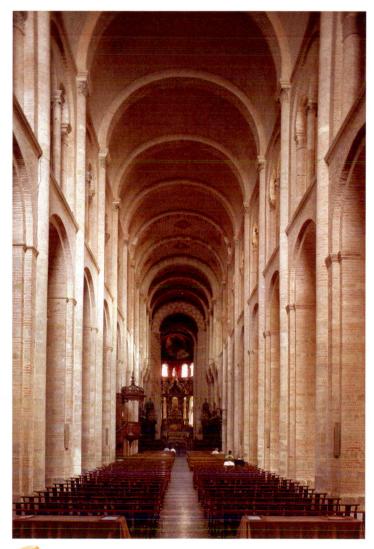

6-16 | Interior of Saint-Sernin, Toulouse, France, ca. 1070–1120.

Saint-Sernin has groin-vaulted tribune galleries over the aisles to house overflow crowds and to buttress the stone barrel vault over the nave. The transverse arches continue the lines of the compound piers.

Saint-Sernin's stone vaults provided protection from the devastating conflagrations that regularly destroyed traditional timber-roofed basilicas. But although fireproofing was no doubt one of the attractions of vaulted naves and aisles in an age when candles provided interior illumination, other factors probably played a greater role in the decision to make the enormous investment that stone masonry required. A desire to provide a suitably majestic setting for the display of relics—and the competition for pilgrimage traffic and the donations pilgrims brought with them—as well as enhanced acoustics for the Christian liturgy and the music that accompanied it, probably better explain the rapid spread of stone vaulting throughout Romanesque Europe. Some texts of the time, in fact, comment on the "wondrous" visual impact of costly stone vaults.

Groin Vaults in Naves The nave vaults of Saint-Sernin at Toulouse and similar early Romanesque churches nonetheless had a significant drawback. Due to the great outward thrust the barrel vaults exerted along their full length, a clerestory was difficult to construct. Another type of vaulting was needed to provide adequate lighting. Structurally, the central problem facing Romanesque builders was the need to develop a masonry vault system that admitted light and was also aesthetically pleasing.

Covering the nave with groin vaults instead of barrel vaults became the solution. Ancient Roman builders had used the groin vault widely, because they realized that its concentration of thrusts at four supporting points permitted clerestory windows (see "The Roman Architectural Revolution," Chapter 3, page 97, and Figs. 3-32 and 3-44). The great Roman vaults were made possible by the use of concrete, which could be

poured into forms, where it solidified into a homogeneous mass. But the technique of mixing concrete had not survived into the Middle Ages. The technical problems of building groin vaults of cut stone and heavy rubble, which had very little cohesive quality, at first limited their use to the covering of small areas, such as the individual bays of the aisles of Saint-Sernin (Fig. 6-15). But during the 11th century, masons used ashlar blocks joined by mortar to develop a groin vault of monumental dimensions.

Lombard Innovation An early example of groin vaults used to cover a nave is Sant'Ambrogio (Fig. 6-17) in Milan, in the Lombardy region of northern Italy. The church was erected in honor of Saint Ambrose, Milan's first bishop (d. 397), in the late 11th or early 12th century. Sant'Ambrogio has a nave and two aisles, but no transept. Above each inner aisle is a tribune gallery. Each nave bay consists of a full square flanked by two small squares in each aisle, all covered with groin vaults. The main vaults are slightly domical, rising higher than the transverse arches. An octagonal dome covers the last bay, its windows providing the major light source (the building lacks a clerestory) for the otherwise rather dark interior. The emphatic alternate-support system perfectly reflects the plan's geometric regularity. The lightest pier moldings are interrupted at the gallery level, and the heavier ones rise to support the main vaults. At Sant'Ambrogio, the compound piers even continue into the ponderous vaults, which have supporting arches, or ribs, along their groins. This is one of the first instances of rib vaulting, a salient characteristic of mature Romanesque and of later Gothic architecture (see "The Gothic Rib Vault," Chapter 7, page 187).

6-17 | Interior of Sant'Ambrogio, Milan, Italy, late 11th to early 12th century.

This Milanese church was one of the first to use groin vaults in the nave as well as the aisles. Each nave bay corresponds to two aisle bays. The alternate-support system is the perfect complement to this modular plan.

The Conqueror's Church The combination of groin vaults with a clerestory can be seen in the abbey church of Saint-Étienne (Figs. 6-18 and 6-19) at Caen in northern France. After their conversion to Christianity in the early 10th century, the Vikings settled the northern French coast. Their territory came to be called Normandy—home of the Norsemen, or *Normans*. The Normans quickly developed a distinctive Romanesque architectural style that became the major source of French Gothic architecture.

Saint-Étienne was begun by William of Normandy (William the Conqueror; see page 181) in 1067 and must have advanced

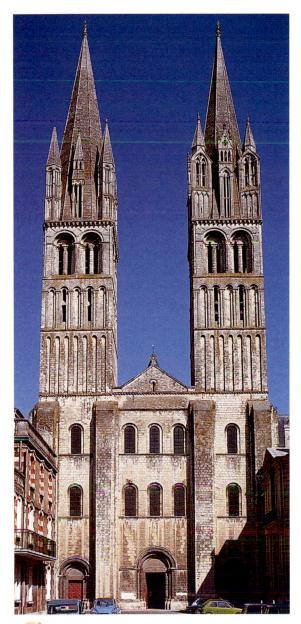

6-18 | West facade of Saint-Étienne, Caen, France, begun 1067.

Displaying the increased rationalism of Romanesque architecture, the facade of this Norman church is divided into three parts corresponding to the nave and aisles. The towers also have a tripartite design.

rapidly, as he was buried there in 1087. The church's west facade (Fig. 6-18) is a striking design rooted in the tradition of Carolingian and Ottonian westworks, but it displays the increased rationalism of Romanesque architecture. Four large buttresses divide the facade into three bays that correspond to the nave and aisles. Above the buttresses, the towers also display a triple division and a progressively greater piercing of their walls from lower to upper stages. (The culminating spires are a Gothic addition.) The tripartite division is employed throughout the facade, both vertically and horizontally, organizing it into a close-knit, well-integrated design that reflects the careful and methodical planning of the entire structure.

From the beginning, even though Saint-Étienne had a wooden roof, its nave walls (Fig. 6-19) were built with an alternating rhythm of compound piers with simple engaged half-columns and piers with half-columns attached to pilasters. The decision to employ an alternate-support system must have been motivated by aesthetic rather than structural concerns. When groin vaults were introduced around 1115, the varied nave piers proved an ideal match. The alternating

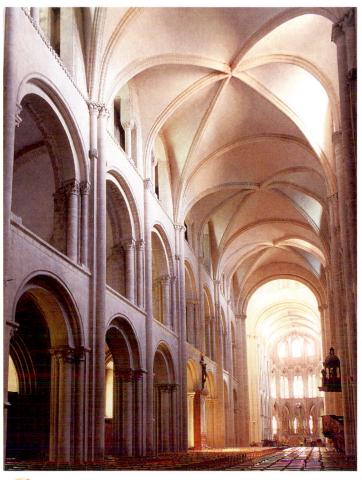

6-19 | Interior of Saint-Étienne, Caen, France, vaulted ca. 1115–1120.

The six-part groin vaults of Saint-Étienne rise high enough to provide room for an efficient clerestory. The resulting three-story elevation, with its large arched openings, provided ample light to the interior. compound piers soar all the way to the vaults' springing. Their branching ribs divide the large square-vault compartments into six sections, making a *sexpartite vault*. These vaults rise high enough to provide room for an efficient clerestory. The resulting three-story elevation, with its large arched openings, provides more light to the interior. It also makes the nave appear even taller than it actually is. As in the Milanese Church of Sant'Ambrogio (Fig. 6-17), the Norman building has rib vaults. The diagonal and transverse ribs compose a structural skeleton that partially supports the still fairly massive paneling between them. But despite the heavy masonry, the large windows and reduced interior wall surface give Saint-Étienne's nave a light and airy quality.

English Romanesque William of Normandy's conquest of Anglo-Saxon England in 1066 began a new epoch in English history. In architecture, it signaled the importation of French Romanesque building and design methods. The *cathedral* (Fig. 6-20) of Durham, on the Scottish frontier of northern England, was begun around 1093, in the generation following the Norman conquest. It predates the remodeled Caen church, but was conceived from the very beginning as a vaulted structure. Consequently, the pattern of the ribs of the

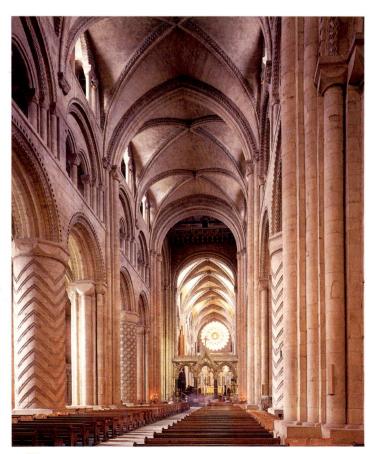

6-20 | Interior of Durham Cathedral, England, begun ca. 1093.

Durham Cathedral is the earliest example known of a ribbed groin vault placed over a three-story nave. Large simple pillars ornamented with abstract designs alternate with compound piers below the seven-part vaults.

nave's groin vaults is reflected in the design of the arcade below. Each seven-part nave vault covers two bays. Large, simple pillars ornamented with abstract designs (diamond, chevron, and cable patterns, all originally painted) alternate with compound piers that carry the transverse arches of the vaults. The pier-vault relationship scarcely could be more visible or the building's structural rationale better expressed.

The bold surface patterning of the Durham nave is a reminder that the raising of imposing stone edifices such as the Romanesque churches of England and Normandy required more than just the talents of master designers. A corps of expert masons had to transform rough stone blocks into the precise shapes necessary for their specific place in the church's fabric. Although thousands of simple quadrangular ashlar blocks make up the great walls of these buildings, much more complex shapes also needed to be produced in large numbers. To cover the nave and aisles, the stonecutters had to carve blocks with concave faces to conform to the curve of the vault. Also required were blocks with projecting moldings for the ribs, blocks with convex surfaces for the pillars or with multiple profiles for the compound piers, and so forth. It was an immense undertaking, and it is no wonder that medieval building campaigns often lasted for decades.

Durham Cathedral is the earliest example known of a ribbed groin vault placed over a three-story nave. And in the nave's western parts, completed before 1130, rib vaults were combined with slightly pointed arches, bringing together for the first time two of the key elements that determined the structural evolution of Gothic architecture. Also of great significance is the way the nave vaults were buttressed. In the tribune, simple *quadrant arches* (arches whose curve extends for one quarter of a circle's circumference) were used in place of groin vaults. The structural descendants of the Durham quadrant arches are the flying buttresses that epitomize the mature Gothic solution to church construction (see "The Gothic Cathedral," Chapter 7, page 191).

Regional Diversity Although the widespread use of stone vaults in 11th- and 12th-century churches inspired the term "Romanesque," Romanesque architecture was, in fact, highly varied and not always vaulted. Some Romanesque churches, especially in Italy, retained the wooden roofs of their Early Christian predecessors long after stone vaulting had become commonplace elsewhere. Nonetheless, despite pronounced regional differences, almost all Romanesque buildings manifest a new, widely shared method of architectural thinking, a new logic of design and construction. To a certain extent, Romanesque architecture can be compared to the Romance languages of Europe, which vary regionally but have a common core in Latin, the language of the Romans.

Romanesque Pisa In the Romanesque era, the buildings of Tuscany, along with those of Rome itself, were structurally less experimental than those of the North and adhered closely to the traditions of the Early Christian basilica. The cathedral

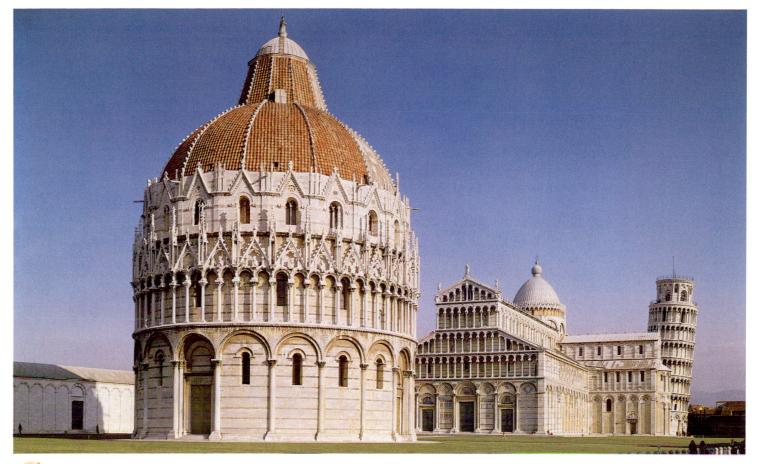

6-21 | Cathedral complex, Pisa, Italy; cathedral begun 1063; baptistery begun 1153; campanile begun 1174.

Pisa's cathedral continues the tradition of the Early Christian basilica and is structurally less experimental than contemporaneous northern buildings, highlighting the regional diversity of Romanesque architecture.

complex at Pisa (Fig. 6-21) dramatically testifies to this regional diversity in Romanesque Europe. The cathedral, its freestanding bell tower, and the *baptistery*, where infants and converts were initiated into the Christian community, present a rare opportunity to study a coherent group of three Romanesque buildings. Save for the upper portion of the baptistery, with its remodeled Gothic exterior, the three structures are stylistically homogeneous.

Construction of Pisa Cathedral began first—in 1063, the same year work began on Saint Mark's (Fig. 4-21) in Venice, another prosperous maritime city. The spoils of a naval victory over the Muslims off Palermo in Sicily in 1062 funded the Pisan project. The cathedral is large, with a nave and four aisles, and is one of the most impressive and majestic of all Romanesque churches. Although at first glance Pisa Cathedral resembles an Early Christian basilica, its broadly projecting transept, its crossing dome, and the facade's multiple arcade galleries distinguish the church as Romanesque. So too does the rich marble *incrustation* (wall decoration consisting of bright panels of different colors, as in the Pantheon's interior; see Fig. 3-35).

The cathedral's *campanile*, detached in the standard Italian fashion, is the famous Leaning Tower of Pisa (Fig. 6-21, *right*).

The tilted vertical axis is the result of a settling foundation. It began to "lean" even while under construction and now inclines some 21 perilous feet out of plumb at the top. Graceful arcaded galleries mark the tower's stages and repeat the cathedral's facade motif, effectively relating the round campanile to its mother building.

Sculpture

Stone sculpture had almost disappeared from the art of western Europe during the early Middle Ages. The revival of stonecarving is one of the hallmarks of the Romanesque age—and one of the reasons the period is aptly named. As one would expect, individual Romanesque sculptural motifs and compositions often originated in Carolingian and Ottonian ivory carving, metalwork, and manuscript illumination. But the inspiration for stone sculpture no doubt came, at least in part, from the abundant remains of ancient statues and reliefs throughout Rome's northwestern provinces.

Cloister Sculpture The revived tradition of stonecarving seems to have begun with decorating column and pier capitals

6-22 | Cloister of Saint-Pierre, Moissac, France, ca. 1100–1115. Limestone with marble relief panels, piers approx. 6' high.

The revived tradition of stonecarving seems to have begun with decorating capitals with reliefs. The most extensive preserved ensemble of sculptured early Romanesque capitals is in the Moissac cloister.

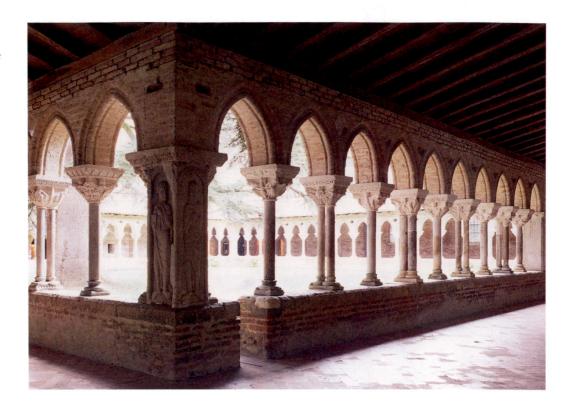

with reliefs. The most extensive preserved ensemble of sculptured early Romanesque capitals is found in the cloister (Fig. 6-22) of Saint-Pierre at Moissac in southwestern France. The Moissac abbey had joined the Cluniac order in 1047 and was an important stop along the pilgrimage route to Santiago de Compostela. The monks, enriched by the gifts of pilgrims and noble benefactors, adorned their church with an elaborate series of relief sculptures.

At Moissac, as elsewhere, the cloister and its garden provided the monks (and nuns) with a foretaste of Paradise. There, they could read their devotions, pray, and meditate in an atmosphere of calm serenity, each monk withdrawn into the private world where the soul communes only with God. Moissac's cloister sculpture program consists of large figural reliefs on the piers as well as historiated (ornamented with figures) capitals on the columns. The pier reliefs portray the Twelve Apostles and the first Cluniac abbot of Moissac, Durandus (1047–1072), who was buried in the cloister. The 76 capitals alternately crown single and paired column shafts. They are variously decorated, some with abstract patterns, many with biblical scenes or the lives of saints, others with fantastic monsters of all sorts. Such bestiaries became very popular in the Romanesque age. The monstrous forms were reminders of the chaos and deformity of a world without God's order. Medieval artists delighted in inventing composite beasts with multiple heads and other fantastic creations.

Bernard of Clairvaux Historiated capitals were common in Cluniac monasteries. In the minds of many medieval monks, especially those of the Cluniac order, the construction of beautiful churches with elegant carvings was equated with piety. But

one of the founding principles of monasticism was the rejection of worldly pleasures in favor of a life of contemplation. Some monks were appalled by the costly churches being erected all around them. One group founded a new order at Cîteaux in eastern France in 1098. The Cistercians (so called from the Latin name for Cîteaux) were Benedictine monks who split from the Cluniac order to return to the strict observance of the Rule of Saint Benedict. The Cistercian movement expanded with astonishing rapidity. Within a half century, more than 500 Cistercian monasteries had been established.

The Cistercians, not surprisingly, rejected historiated capitals as distractions from their devotions. The most outspoken Cisterican critic of the new Romanesque sculptures was Abbot Bernard of Clairvaux (1090–1153). In a letter Bernard wrote in 1127 to William, abbot of Saint-Thierry, he complained about the sculptural adornment of non-Cistercian churches: "In the cloisters . . . so plentiful and astonishing a variety of [monstrous] forms is seen that one would rather read in the marble than in books, and spend the whole day wondering at every single one of them than in meditating on the law of God."²

Art and the Laity The Romanesque period also witnessed the spread of stone sculpture to other areas of the church, both inside and out. The proliferation of sculpture reflects the changing role of many churches in Western Christendom. In the early Middle Ages, most churches served small monastic communities, and the worshipers were primarily or exclusively clergy. With the rise of towns in the Romanesque period, churches, especially those on the major pilgrimage routes, increasingly served the lay public. To reach this new, largely illiterate audience and to draw a wider population into their places of

A STARCHITECTURAL BASICS

The Romanesque Portal

Although sculpture in a variety of materials adorned different areas of Romanesque churches, it was most often found in the grand stone portals through which the faithful had to pass. Sculpture had been employed in church doorways before. For example, Ottonian bronze doors decorated with Old and New Testament scenes marked one entrance to Saint Michael's at Hildesheim (Fig. 6-12). In the Romanesque era (and during the Gothic period that followed), sculpture usually appeared in the area around, rather than on, the doors.

Our drawing shows the parts of church portals that Romanesque sculptors regularly decorated with figural reliefs:

- Tympanum (Figs. 6-23 to 6-25), the prominent semicircular lunette above the doorway proper, comparable in importance to the triangular pediment of a Greco-Roman temple
- Voussoirs (Fig. 6-25), the wedge-shaped blocks that together form the archivolts of the arch framing the tympanum
- Lintel (Figs. 6-24 and 6-25), the horizontal beam above the doorway
- Trumeau (Fig. 6-23), the center post supporting the lintel in the middle of the doorway
- Jambs (Fig. 6-23), the side posts of the doorway

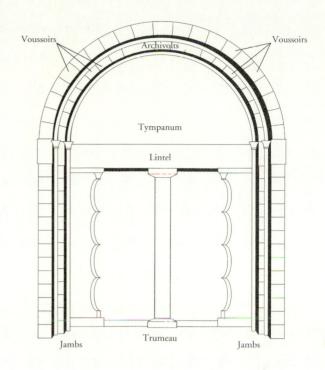

worship, church officials decided to display Christian symbols and stories throughout their churches, especially in the portals (see "The Romanesque Portal," above) opening onto the town squares. Stone, rather than painting or mosaic, was the most suitable durable medium for such exterior decorative programs.

The Second Coming The tympanum of the south portal (Fig. 6-23) of Saint-Pierre at Moissac, facing the town square, depicts the Second Coming of Christ as King and Judge of the world in its last days. As befits his majesty, the enthroned Christ is at the center. The signs of the Four Evangelists—Matthew's winged man, Mark's lion, John's eagle, and Luke's ox—flank him. To one side of each pair of signs is an attendant angel holding scrolls to record human deeds for judgment. The figures of crowned musicians, which complete the design, are the Twenty-Four Elders who accompany Christ as the kings of this world and make music in his praise. Two courses of wavy lines symbolizing the clouds of Heaven divide the Elders into three tiers.

As many variations exist within the general style of Romanesque sculpture as within Romanesque architecture. The extremely elongated bodies of the recording angels; the

Romanesque churches increasingly served a largely illiterate lay public. To attract worshipers, the clergy commissioned sculptors to carve Christian symbols and stories on the portals opening onto the town squares.

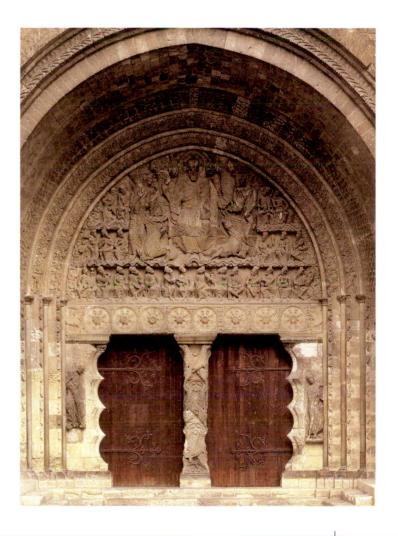

cross-legged dancing pose of Saint Matthew's angel; the jerky, hinged movement of the Elders' heads; the zigzag and dovetail lines of the draperies; the bandlike folds of the torsos; and the bending back of the hands against the body are all characteristic of the anonymous Moissac sculptor's distinctive style. The animation of the individual figures contrasts with the stately monumentality of the composition as a whole, producing a dynamic tension in the tympanum.

Below the tympanum are a richly decorated trumeau and elaborate door jambs with scalloped contours, the latter a borrowing from Islamic Spain (Fig. 5-5). On the trumeau's right face is a prophet displaying the scroll where his prophetic vision is written. Six roaring interlaced lions fill the trumeau's outer face. Lions were the church's ideal protectors. In the Middle Ages, people believed lions slept with their eyes open.

Judgment Day at Autun In 1132, the Cluniac bishop Étienne de Bage consecrated the Burgundian cathedral of Saint-Lazare (Saint Lazarus) at Autun. For its tympanum (Fig. 6-24) he commissioned a dramatic vision of the Last Judgment, announced by four trumpet-blowing angels. In the tympanum's center, far larger than any other figure, is Christ, enthroned in a mandorla. He dispassionately presides over the separation of the blessed from the damned. At the left, an obliging angel boosts one of the blessed into the heavenly city. Below, the souls

of the dead line up to await their fate. Two of the men at the left end of the lintel carry bags emblazoned with a cross and a shell. These are the symbols of pilgrims to Jerusalem and Santiago de Compostela. Those who had made the difficult journey would be judged favorably. To their right, three small figures beg an angel to intercede on their behalf. The angel responds by pointing to the Judge above. On the right side are those who will be condemned to Hell. One poor soul is plucked from the earth by giant hands. Directly above, in the tympanum, is an unforgettable vision of the weighing of souls. Angels and devils contest at the scales, each trying to manipulate the balance for or against a soul. Hideous demons guffaw and roar. Their gaunt, lined bodies, with legs ending in sharp claws, writhe and bend like long, loathsome insects. A devil, leaning from the dragon mouth of Hell, drags souls in, while above him a howling demon crams souls headfirst into a furnace.

One can appreciate the terror the Autun tympanum must have inspired in the believers who passed beneath it as they entered the cathedral. Even those who could not read could, in the words of Bernard of Clairvaux, "read in the marble." For the literate, the Autun clergy composed explicit written warnings to reinforce the pictorial message, and had the words engraved in Latin on the tympanum. For example, beneath the weighing of souls, the inscription reads, "May this terror terrify those whom earthly error binds, for the horror of these images

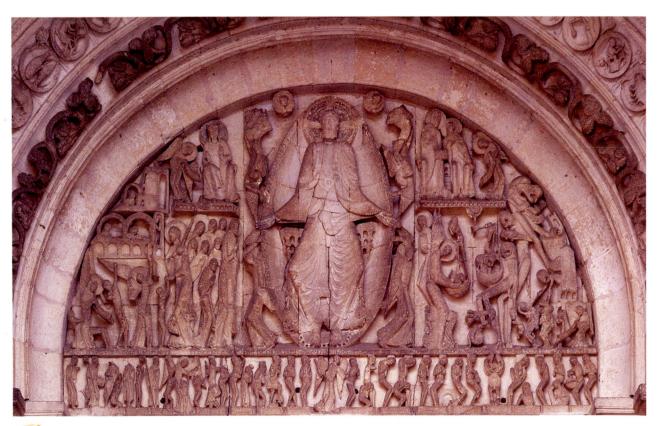

6-24 | GISLEBERTUS, Last Judgment, west tympanum of Saint-Lazare, Autun, France, ca. 1120–1135. Marble, approx. 21' wide at base.

Christ, enthroned in a mandorla, presides over the separation of the Blessed from the Damned in this dramatic vision of the Last Judgment, designed to terrify those guilty of sin and beckon them into the church.

here in this manner truly depicts what will be." A second prominent inscription on the Autun portal, directly beneath the feet of Christ, names GISLEBERTUS as the sculptor.

Vézelay and the Crusades Another large tympanum (Fig. 6-25), this one at the Church of La Madeleine (Mary Magdalene) at Vézelay, not far from Autun, depicts the Ascension of Christ and the Mission of the Apostles. As related in Acts 1:4-9, Christ foretold that the Twelve Apostles would receive the power of the Holy Spirit and become the witnesses of the truth of the Gospels throughout the world. The light rays emanating from Christ's hands represent the instilling of the Holy Spirit in the apostles (Acts 2:1-42) at the Pentecost (the seventh Sunday after Easter). The apostles, holding the Gospel books, receive their spiritual assignment, to preach the Gospel to all nations. The Christ figure is a splendid essay in calligraphic theme and variation. The drapery lines shoot out in rays, break into quick zigzag rhythms, and spin into whorls, wonderfully conveying the spiritual light and energy that flow from Christ over and into the equally animated apostles. The overall composition, as well as the detailed treatment of the figures, contrasts with the much more sedate representation of the Second Coming at Moissac (Fig. 6-23), where almost all the figures are contained within a grid of horizontal and vertical lines. The sharp differences between

the two tympana highlight the regional diversity of Romanesque art.

The world's heathen, the objects of the apostles' mission, appear on the lintel below and in eight compartments around the tympanum. The portrayals of the yet-to-be-converted constitute a medieval anthropological encyclopedia. Present are the legendary giant-eared Panotii of India, Pygmies (who require ladders to mount horses), and a host of other races, some characterized by a dog's head, others by a pig's snout, and still others by flaming hair. The assembly of agitated figures also includes hunchbacks, mutes, blind men, and lame men. Humanity, still suffering, awaits the salvation to come. The whole world is electrified by the promise of the ascended Christ, who looms above human misery and deformity. Again, as at Autun, as worshipers entered the church, the tympanum established God's omnipotence.

The Mission of the Apostles theme was an ideal choice for the Vézelay tympanum. Vézelay is more closely associated with the Crusades than any other church in Europe. The *Crusades* ("taking of the Cross") were mass armed pilgrimages, whose stated purpose was to wrest the Christian shrines of the Holy Land from Muslim control. Crusaders and pilgrims were bound by similar vows. They hoped not only to atone for sins and win salvation but also to glorify God and extend the power of the Christian Church. Pope Urban II had intended to preach

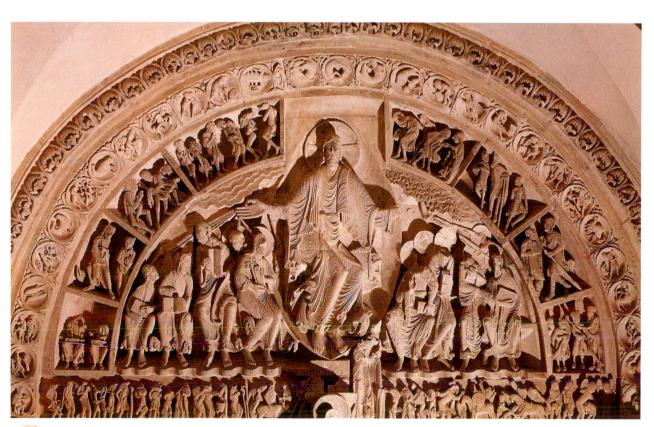

6-25 | Ascension of Christ and Mission of the Apostles, tympanum of the center portal of the narthex of La Madeleine, Vézelay, France, 1120–1132.

The light rays emanating from Christ's hands represent the instilling of the Holy Spirit in the apostles. Vézelay was closely associated with the Crusades, which were viewed as a second mission of the apostles. the launching of the First Crusade at Vézelay in 1095. In 1147, Bernard of Clairvaux called for the Second Crusade at Vézelay, and King Louis VII of France took up the cross there. In 1190, it was from Vézelay that King Richard the Lionheart of England and King Philip Augustus of France set out on the Third Crusade. The spirit of the Crusades determined in part the iconography of the Vézelay tympanum. The Crusades were a kind of "second mission of the apostles" to convert the infidel.

Wibald's Silver Reliquary The monumental stone portals of Moissac, Autun, Vézelay, and other 12th-century churches are the most conspicuous examples of Romanesque sculpture, but far more costly materials were employed for sculptures of small scale. The *reliquary* of Saint Alexander (Fig. 6-26), made in 1145 for Abbot Wibald of Stavelot in

6-26 | Head reliquary of Saint Alexander, from Stavelot Abbey, Belgium, 1145. Silver repoussé (partly gilt), gilt bronze, gems, pearls, and enamel, approx. 1' $5\frac{1}{2}$ " high. Musées Royaux d'Art et d'Histoire, Brussels.

This reliquary is typical in the use of costly materials for containers of saints' relics. The combination of an idealized classical head with Byzantine-style enamels underscores the stylistic diversity of Romanesque art.

Belgium to house the relics of Pope Alexander II (r. 1061-1073), is especially sumptuous. The idealized head, which resembles portraits of youthful Roman emperors such as Augustus (Fig. 3-21) and Constantine (Fig. 3-43), is almost life-size and was fashioned in beaten (repoussé) silver with bronze gilding for the hair. The saint wears a collar of jewels and enamel plaques around his neck. Enamels and gems also adorn the box on which the head is mounted. The three plaques on the front depict Saints Eventius, Alexander, and Theodolus. The nine plaques on the other three sides represent female allegorical figures—Wisdom, Piety, and Humility among them. Although a local artist produced these enamels in the Meuse River region, the models were surely Byzantine. Saint Alexander's reliquary underscores the multiple sources of Romanesque art, as well as its stylistic diversity. Not since antiquity had people journeyed as extensively as they did in the Romanesque period, and artists regularly saw works of wide geographic origin. Abbot Wibald himself epitomizes the welltraveled 12th-century clergyman. He was abbot of Montecassino in southern Italy, took part in the Second Crusade, and was sent by Frederick Barbarossa (Holy Roman Emperor, r. 1152-1190) to Constantinople to arrange Frederick's wedding to the niece of the Byzantine emperor Manuel Comnenus.

Painting

The number and variety of illuminated manuscripts dating to the Romanesque era attest to the great demand for illustrated religious tomes in the abbeys of western Europe and to the extraordinary productivity of the scribes and painters, almost exclusively monks and nuns, working in the scriptoria of these isolated religious communities.

Knight versus Dragons One of the major Romanesque scriptoria was at the abbey of Cîteaux, France, mother church of the Cistercian order. Just before Bernard joined the monastery in 1112, the monks completed work on an illuminated copy of Saint Gregory's *Moralia in Job*. It is an example of Cistercian illumination before Bernard's passionate opposition to figural art in monasteries led in 1134 to a Cistercian ban on elaborate paintings in manuscripts. After 1134, full-page illustrations were prohibited, and even initial letters had to be nonfigurative and of a single color.

The historiated initial we reproduce (FIG. 6-27) clearly would have been in violation of Bernard's ban if it had not been painted before his prohibitions took effect. A knight, his squire, and two roaring dragons form an intricate letter R, the initial letter of the salutation *Reverentissimo*. This page is the opening of Gregory's letter to "the very reverent" Leandro, Bishop of Seville. The knight is a slender regal figure who raises his shield and sword against the dragons while the squire, crouching beneath him, runs a lance through one of the monsters.

Ornamented initials go back to the Hiberno-Saxon period (Fig. 6-3), but here the artist translated the theme into Romanesque terms. This page may be a reliable picture of a

6-27 | Initial *R* with knight fighting a dragon, folio 4 verso of the *Moralia in Job*, from Cîteaux, France, ca. 1115–1125. Ink and tempera on vellum, $1' 1\frac{3}{4}'' \times 9\frac{1}{4}''$. Bibliothéque Municipale, Dijon.

Ornamented initials go back to the Hiberno-Saxon period (Fig. 6-3), but this artist translated the theme into Romanesque terms. The duel between knight and dragons may symbolize the spiritual struggle of monks.

medieval baron's costume. The typically Romanesque banding of the torso and partitioning of the folds (especially the servant's skirts) are evident, but the master painter deftly avoided stiffness and angularity. The partitioning actually accentuates the knight's verticality and elegance and the thrusting action of his squire. The flowing sleeves add a spirited flourish to the swordsman's gesture. The knight, handsomely garbed, cavalierly wears no armor and aims a single stroke with proud disdain, unmoved by the ferocious dragons lunging at him. The duel between knight and dragons may be an allegory of the spiritual struggle of monks.

Master Hugo The frontispiece (Fig. 6-28) to the Book of Deuteronomy from the *Bury Bible*, produced at the Bury Saint Edmunds abbey in England around 1135, exemplifies the lavish illustration common to the large Bibles produced in wealthy Romanesque abbeys not subject to the Cistercian ban. The page shows two scenes from Deuteronomy framed

by symmetrical leaf motifs in softly glowing harmonized colors. The upper register depicts Moses and Aaron proclaiming the law to the Israelites. Moses has horns, consistent with Saint Jerome's translation of the Hebrew word that also means "rays." The lower panel portrays Moses pointing out the clean and unclean beasts. The gestures are slow and gentle and have quiet dignity. The figures of Moses and Aaron seem to glide. This presentation is quite different from the abrupt emphasis and spastic movement of contemporaneous Romanesque relief sculptures. Yet the patterning remains in the multiple divisions of the draped limbs, the lightly shaded volumes connected with sinuous lines and ladderlike folds.

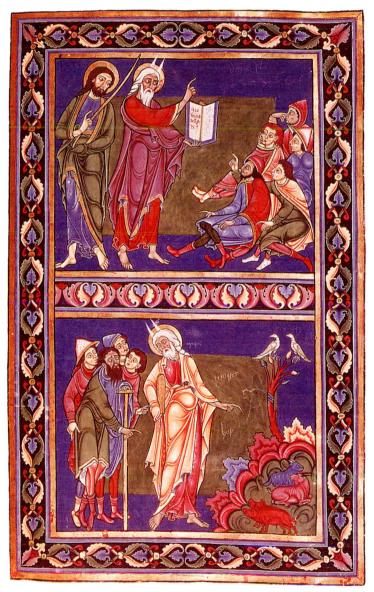

6-28 | MASTER HUGO, Moses expounding the Law, folio 94 recto of the *Bury Bible*, from Bury Saint Edmunds, England, ca. 1135. Ink and tempera on vellum, approx. 1' 8" × 1' 2". Corpus Christi College, Cambridge.

Master Hugo seems to have been a rare Romanesque lay artist, one of the emerging class of professional artists and artisans who depended for their livelihood on commissions from well-endowed monasteries.

The artist responsible for the Bury Bible is known: MASTER Hugo, who was also a sculptor and metalworker. He joins Gislebertus (Fig. 6-24) in the small but growing company of Romanesque artists who signed their works or whose names were recorded. In the 12th century, artists—illuminators as well as sculptors—increasingly began to identify themselves. Although most medieval artists remained anonymous, the contrast of the Romanesque period with the early Middle Ages is striking. Hugo seems to have been a secular artist, one of the emerging class of professional artists and artisans who depended for their livelihood on commissions from wellendowed monasteries. These artists resided in towns rather than within secluded abbey walls, and they traveled frequently to find work. They were the exception, however, and the typical Romanesque scribes and illuminators continued to be monks and nuns working anonymously in the service of God.

The "Prince of Scribes" The Eadwine Psalter (psalters are separate books containing the 150 psalms of King David) is the masterpiece of an English monk known as EADWINE THE SCRIBE. It contains 166 illustrations. The last page (Fig. 6-29), however, presents a rare picture of a Romanesque artist at work. The "portrait" of Eadwine—it is probably a generic type and not a specific likeness—is in the long tradition of author portraits in ancient and medieval manuscripts, although the true author of the Eadwine Psalter is King David. Eadwine exaggerated his importance by likening his image to that of an Evangelist writing his gospel (compare Figs. 6-4 and 6-5) and by including an inscription within the inner frame that identifies him and proclaims that he is a "prince among scribes." He declares that, due to the excellence of his work, his fame will endure forever and that he can offer his book as an acceptable gift to God.

The style of the Eadwine portrait is related to that of the *Bury Bible*, but, although the patterning is still firm (notably in the cowl and the thigh), the drapery falls more softly and follows the movements of the body beneath it. Here, the arbitrariness of many Romanesque painted and sculpted garments yielded slightly, but clearly, to the requirements of more naturalistic representation. The Romanesque artist's instinct for decorating the surface remained, as is apparent in the gown's whorls and spirals. But, significantly, these were painted in very lightly so that they would not conflict with the functional lines that contain them.

Hildegard's Visions One Romanesque manuscript that stands apart from all the rest is the *Scivias* (*Know the Ways* [*Scite vias*] of *God*) of Hildegard of Bingen (1098–1179), the most prominent nun of the 12th century and one of the greatest religious figures of the Middle Ages. Hildegard was born into an aristocratic family that owned large estates in the German Rhineland. At a very early age she began to have visions, and her parents had her study to become a nun. In 1141, God instructed Hildegard to disclose her visions to the world.

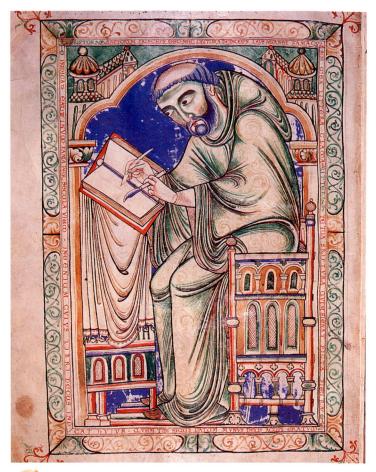

6-29 | EADWINE THE SCRIBE(?), Eadwine the scribe at work, folio 283 verso of the *Eadwine Psalter*, ca. 1160–1170. Ink and tempera on vellum. Trinity College, Cambridge.

Although he humbly offered his book as a gift to God, Eadwine added an inscription to his seated portrait declaring that he is a "prince among scribes" and that his fame will endure forever.

Bernard of Clairvaux certified in 1147 that those visions were authentic. Archbishop Heinrich of Mainz joined him in endorsing Hildegard. In 1148, the Cistercian pope Eugenius III formally authorized Hildegard "in the name of Christ and Saint Peter to publish all that she had learned from the Holy Spirit." At this time Hildegard became the abbess of a new convent built for her near Bingen. As reports of Hildegard's visions spread, kings, popes, barons, and prelates sought her counsel.

On the opening page (Fig. 6-30) of the *Scivias*, Hildegard sits within a monastery experiencing her divine vision. Five long tongues of fire emanating from above enter her brain, just as she describes the experience in the accompanying text. She immediately sets down what has been revealed to her on a wax tablet resting on her left knee. Nearby, the monk Volmar, Hildegard's confessor, copies into a book all she has written. Here, in a singularly dramatic context, is a picture of the essential nature of ancient and medieval book manufacture—individual scribes copying and recopying texts by hand.

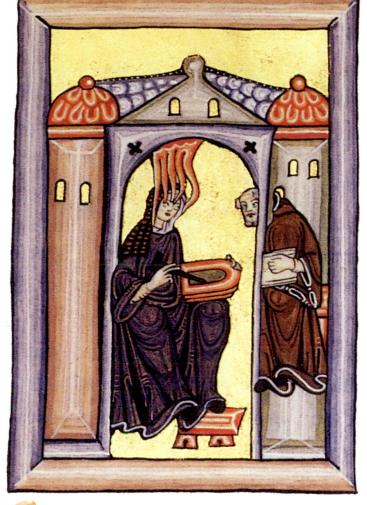

6-30 | The vision of Hildegard of Bingen, detail of a facsimile of a lost folio in the *Scivias* by Hildegard of Bingen, from Trier or Bingen, Germany, ca. 1150–1179. Formerly in Hessische Landesbibliothek, Wiesbaden.

Hildegard of Bingen was one of the great religious figures of the Middle Ages. Here, she experiences a divine vision, shown as five tongues of fire emanating from above and entering her brain.

The Conquest of England This account of Romanesque painting concludes with a work that is *not* a painting. Nor is the so-called *Bayeux Tapestry* (FIG. 6-31) a woven *tapestry*. It is, instead, an *embroidered* fabric made of wool sewn on linen. But the *Bayeux Tapestry* is closely related to Romanesque manuscript illumination. Its borders are populated by the kinds of real and imaginary animals found in contemporaneous books, and an explanatory Latin text sewn in thread accompanies many of the pictures.

Some 20 inches high and about 230 feet long, the *Bayeux Tapestry* is a continuous, friezelike, pictorial narrative of a crucial moment in England's history and of the events that led up to it. The Norman defeat of the Anglo-Saxons at Hastings in 1066 brought England under the control of the Normans, uniting all of England and much of France under one rule. The

dukes of Normandy became the kings of England. Commissioned by Bishop Odo, the half brother of the conquering Duke William, the embroidery may have been sewn by women at the Norman court. Many art historians, however, believe it was the work of English needleworkers in Kent, where Odo was earl after the Norman conquest. Odo donated the work to Bayeux Cathedral (hence its nickname), but it is uncertain whether it was originally intended for display in the church's nave, where the theme would have been a curious choice.

The circumstances leading to the Norman invasion of England are well documented. In 1066, Edward the Confessor, the Anglo-Saxon king of England, died. The Normans believed Edward had recognized William of Normandy as his rightful heir. But the crown went to Harold, earl of Wessex, the king's Anglo-Saxon brother-in-law, who had sworn an oath of allegiance to William. The betrayed Normans, descendants of the seafaring Vikings, boarded their ships, crossed the English Channel, and crushed Harold's forces.

We illustrate two episodes of the epic tale as represented in the *Bayeux Tapestry*. The first detail (Fig. 6-31, *top*) depicts King Edward's funeral procession. The hand of God points the way to the church where he was buried—Westminster Abbey, consecrated on December 28, 1065, just a few days before Edward's death. The church was one of the first Romanesque buildings erected in England, and the embroiderers took pains to record its main features, including the imposing crossing tower and the long nave with tribune gallery. Here William was crowned king of England on Christmas Day, 1066.

The second detail (Fig. 6-31, bottom) shows the Battle of Hastings in progress. The Norman cavalry cuts down the English defenders. The lower border is filled with the dead and wounded, although the upper register continues the animal motifs of the rest of the embroidery. The Romanesque artist co-opted some of the characteristic motifs of Greco-Roman battle scenes. Note, for example, the horses with twisted necks and contorted bodies (compare Fig. 2-47). But the artists translated the figures into the Romanesque manner. Linear patterning and flat color replaced classical three-dimensional volume and modeling in light and dark hues.

The *Bayeux Tapestry* is unique in Romanesque art in that it depicts an event in full detail at a time shortly after it occurred, recalling the historical narratives of ancient Roman art. The Norman embroidery often has been likened to the scroll-like frieze of the Column of Trajan (Fig. 3-31). Like the Roman account, the story told on the *Bayeux Tapestry* is the conqueror's version of history, a proclamation of national pride. And as on Trajan's Column, the narrative is not confined to battlefield successes. It is a complete chronicle of events. Included are the preparations for war, with scenes depicting the felling and splitting of trees for ship construction, the loading of equipment onto the vessels, the cooking and serving of meals, and so forth. In this respect, the *Bayeux Tapestry* is the most *Roman*-esque of all Romanesque artworks.

6-31 Funeral procession to Westminster Abbey (top) and Battle of Hastings (bottom), details of the Bayeux Tapestry, from Bayeux Cathedral, Bayeux, France, ca. 1070-1080. Embroidered wool on linen, 1' 8" high (entire length of fabric 229' 8"). Centre Guillaume

The Bayeux Tapestry is unique in Romanesque art. Like the historical narratives of ancient Roman art, it depicts a contemporaneous event in full detail, as in the scroll-like frieze of Trajan's Column (Fig. 3-31).

le Conquérant, Bayeux.

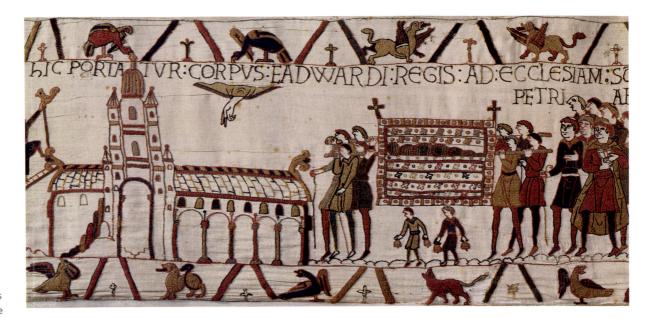

CONCLUSION

The last emperor of the Western Roman Empire died in 476. For centuries, western Europe, save for the Byzantine Empire's stronghold at Ravenna, was home to competing groups of non-Romans—Franks, Goths, Celts, Anglo-Saxons, and Vikings, among others. Constantly on the move, these peoples left behind monuments that are all of small scale, but often of costly materials, expert workmanship, and sophisticated design. The permanent centers of artistic culture in the early Middle Ages were the monasteries that Christian missionaries established beyond the Alps and across the English Channel. There, master painters illuminated liturgical books in a distinctive style that fused the abstract and animal interlace forms of the native peoples with Christian iconography.

When the Frankish Charlemagne was crowned Emperor of Rome in 800, imperial rule was reestablished in the former

Roman provinces. With it came a revival of interest in the classical style and monumental architecture, a tradition carried on by Charlemagne's Carolingian and Ottonian successors. With the death of the last Ottonian emperor in 1024, the greatest patrons of art and architecture in Europe became the monasteries, especially those along the pilgrimage routes leading to the tomb of Saint James at Santiago de Compostela in Spain. In the Romanesque age, immense churches with stone vaults rose throughout Europe, didactic relief sculptures adorned church portals, and the relics of saints were housed in gold and silver and enamel reliquaries. Each region had a characteristic style, like the various Romance languages rooted in Latin, but the revival of monumental architecture and sculpture was Europe-wide. As the monk Raoul Glaber observed in 1003, "it was as if the whole earth . . . were clothing itself everywhere in the white robe of the church."4

- I Saint Benedict establishes Benedictine rule for monasteries, 529
- I Charles Martel defeats Muslims at Poitiers, 732

751

CAROLINGIAN

OTTONIAN

- I Charlemagne, r. 768-814, crowned emperor in Rome, 800
- Louis the Pious, r. 814-840
- I Charles the Bald, r. 840-875
- Cluniac order founded, 910

Coronation Gospels, Aachen, ca. 800–810

Bronze doors, Saint Michael's, Hildesheim, 1015

936

- I Otto I, r. 936-973, crowned emperor in Rome, 962
- 1 Otto II, r. 973-983; marries Byzantine princess Theophanu, 972
- Otto III, r. 983-1002
- Bernward, Bishop of Hildesheim, 993-1022
- Henry II, r. 1002-1024, last Ottonian emperor

2

1024

Edward the Confessor, Anglo-Saxon king of England, r. 1042–1066

1050

- Final separation of the Latin (Roman) Church from the Byzantine (Greek Orthodox) Church, 1054
 - William of Normandy conquers England (Battle of Hastings), 1066
 - Bernard of Clairvaux, ca. 1090-1153
 - I Pope Urban II preaches the First Crusade, 1095
 - I Cistercian order founded, 1098
 - I Hildegard of Bingen, 1098-1179
 - Second Crusade, 1147
 - I Frederick Barbarossa, Holy Roman Emperor, r. 1152-1190
- King Philip Augustus of France, r. 1180–1223
 - I King Richard the Lionheart of England, r. 1189-1199
 - I Third Crusade, 1190

Saint-Étienne, Caen, begun 1067

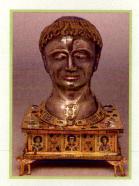

4 Reliquary of Saint Alexander, Stavelot, 1145

ROMANESQUE

1200

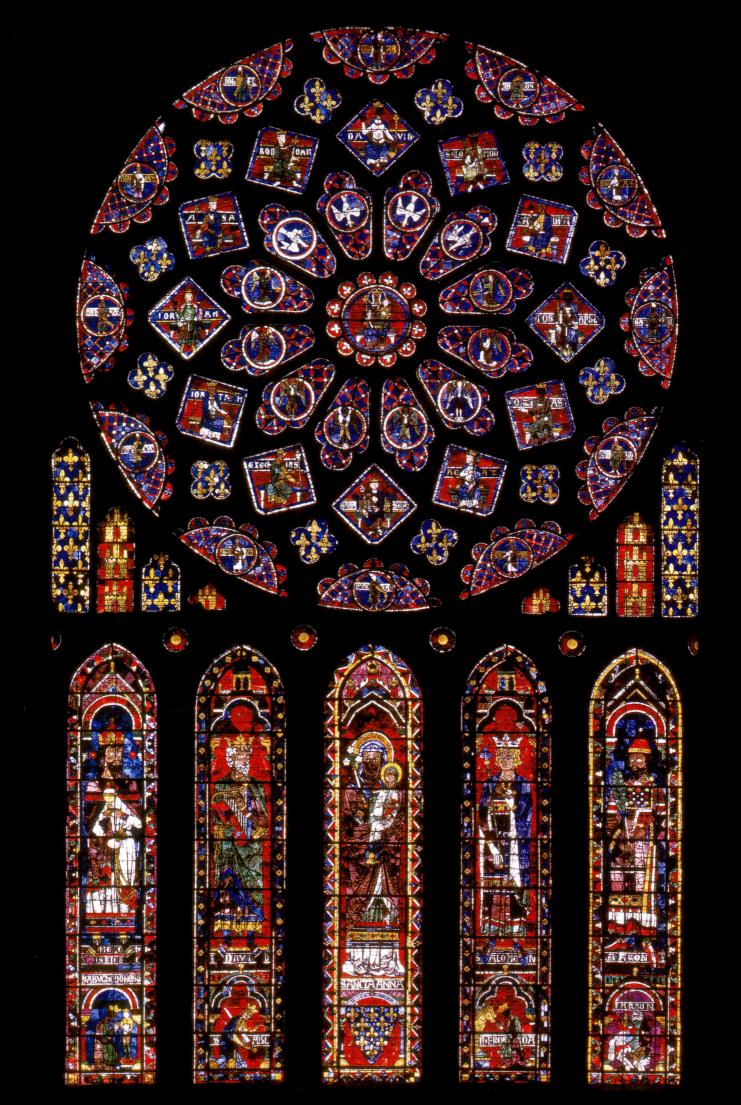

GOTHIC EUROPE

The 12th through 14th centuries were a time of profound change in European society. The focus of both intellectual and religious life shifted definitively from monasteries in the countryside and pilgrimage churches to rapidly expanding secular cities with enormous cathedrals reaching to the sky. In these new urban centers, prosperous merchants made their homes, and universities run by professional guilds of scholars formed. Modern Europe's independent secular nations were beginning to take shape (MAP 7-1, page 528).

Giorgio Vasari (1511–1574), the Italian "father of art history," used *Gothic* as a term of ridicule to describe the art and architecture of this period. For him, Gothic art was "monstrous and barbarous," invented by the uncouth Goths whom he believed were responsible not only for Rome's downfall but also for the destruction of the classical style in art and architecture. Vasari and other Renaissance artists and scholars regarded Gothic art with contempt and considered it ugly and crude. In the 13th and 14th centuries, however, when the Gothic style was the rage in most of Europe, especially north of the Alps, contemporary commentators considered Gothic buildings *opus modernum* (modern work) or *opus francigenum* (French work). They recognized that the cathedrals then being erected all over Europe displayed an exciting and new building and decoration style—and that the style originated in France. For them, Gothic cathedrals were not distortions of the classical style but glorious images of the City of God, the Heavenly Jerusalem.

Although Gothic art and architecture became an international style, it was a European phenomenon. To the east and south of Europe, the Islamic and Byzantine styles still held sway. Moreover, many regional variants existed within European Gothic, just as distinct regional styles characterized the Romanesque period. Gothic began and ended at different dates in different places, but it first appeared in northern France in the mid-12th century.

FRANCE

About 1130, King Louis VI (r. 1108–1137) moved his official residence to Paris, spurring much commercial activity and a great building boom. Paris soon became the leading city of France, indeed of northern Europe. Although Rome remained the religious center of western Christendom, Paris became its intellectual capital. The University of Paris attracted the best minds from all over the continent. Virtually every thinker of note in the Gothic world at some point studied or taught at Paris. Even in the Romanesque period, Paris was a learning center.

Rose window and lancets, north transept, Chartres Cathedral, Chartres, France, ca. 1220. Stained glass, rose window approx. 43' in diameter.

Its Cathedral School professors were known as Schoolmen and the philosophy they developed as Scholasticism. Until the 12th century, truth had been considered the exclusive property of divine revelation as given in the Holy Scriptures. But the Schoolmen sought to demonstrate that reason alone could lead to certain truths. Their goal was to prove the central articles of Christian faith by argument (disputatio). By the 13th century, the Schoolmen of Paris already had organized as a professional guild of master scholars, separate from the numerous Church schools overseen by the bishop of Paris. The structure of the Parisian guild served as the model for many other European universities.

Architecture and Architectural Decoration

The earliest manifestations of the Gothic spirit in art and architecture are contemporary with the first stages of Scholastic philosophy. Both also originated in Paris and its environs. Many art historians have noted the parallels between them, how the logical thrust and counterthrust of Gothic construction, the geometric relationships of building parts, and the systematic organization of the iconographical programs of Gothic church portals coincide with Scholastic principles and methods. Although no documents exist linking the scholars, builders, and sculptors, Gothic art and architecture shared

with Scholasticism an insistence on systematic design and procedure. They both sought stable, coherent, consistent, and structurally intelligible solutions.

Suger and Early Gothic On June 11, 1144, King Louis VII of France (r. 1137–1180), Queen Eleanor of Aquitaine, royal court members, five archbishops, and other distinguished clergy converged on the Benedictine abbey church of Saint-Denis for the dedication of its new east end. The church, just a few miles north of Paris, had been erected centuries before in honor of Saint Dionysius, the apostle who brought Christianity to Gaul. It housed the saint's tomb and those of the French kings. The basilica was France's royal church, the very symbol of the monarchy. By the early 12th century, however, the old building was in disrepair and had become too small to accommodate the growing number of pilgrims. Its abbot, Suger, also believed it was of insufficient grandeur to serve as the official church of the French kings. He began to rebuild Saint-Denis in 1135 by erecting a new west facade with sculptured portals. In 1140, work began on the east end. Suger died before he could remodel the nave, but he attended the 1144 dedication of the new choir, ambulatory, and radiating chapels.

The mid-12th-century portion of Saint-Denis represented a sharp break from past practice. Innovative rib vaults resting on *pointed arches* (see "The Gothic Rib Vault," page 187) cover the ambulatory and chapels (Figs. 7-1 and 7-2). These pioneering,

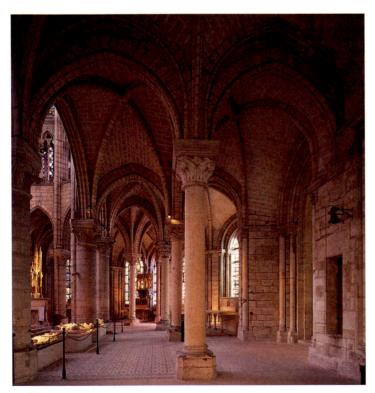

7-1 | Ambulatory and radiating chapels, abbey church, Saint-Denis, France, 1140–1144.

Abbot Suger's remodeling of the east end of Saint-Denis marked the beginning of Gothic architecture. Rib vaults resting on pointed arches spring from slender columns. Lux nova enters through the windows.

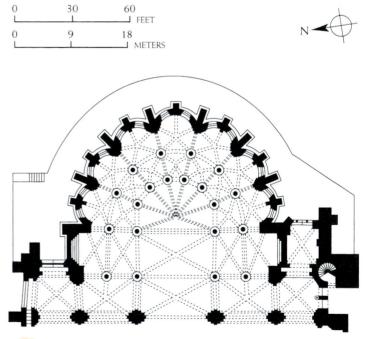

7-2 | Plan of the east end, abbey church, Saint-Denis, France, 1140–1144 (after Sumner Crosby).

By using very light rib vaults, the builders of Saint-Denis were able to eliminate the walls between the radiating chapels. They also opened up the outer walls with large stained-glass windows.

ARCHITECTURAL BASICS

The Gothic Rib Vault

The ancestors of the Gothic *rib vault* are the Romanesque vaults found at Caen (Fig. 6-19), Durham (Fig. 6-20), and elsewhere. The rib vault's distinguishing feature is the crossed, or diagonal, arches under its groins, as seen in the Saint-Denis ambulatory and chapels (Fig. 7-1). These arches form the *armature*, or skeletal framework, for constructing the vault. Gothic vaults generally have more thinly vaulted *webs* between the arches than Romanesque vaults have. But the chief difference between Romanesque and Gothic rib vaults is the *pointed arch*, an integral part of the Gothic skeletal armature. French Romanesque architects (Fig. 6-23) borrowed the form from Muslim Spain and passed it to their Gothic successors. Pointed arches allowed Gothic builders to make the crowns of all the vault's arches approximately the same level, regardless of the space to be vaulted. The Romanesque architects could not achieve this with their semicircular arches.

Our diagrams illustrate this key difference. In diagram a, the rectangle ABCD is an oblong nave bay to be vaulted. AC and DB are the diagonal ribs; AB and DC, the transverse arches; and AD and BC, the nave arcade's arches. If the architect uses semicircular arches (AFB, BJC, and DHC), their radii and, therefore, their heights (EF, IJ, and GH) will be different, because the

height of a semicircular arch is determined by its width. The result will be a vault (diagram b) with higher transverse arches (DHC) than the arcade's arches (CJB). The vault's crown (F) will be still higher. If the builder uses pointed arches, the transverse (DLC) and arcade (BKC) arches can have the same heights (GL and IK in diagram a). The result will be a Gothic rib vault (diagram c), where the points of the arches (L and K) are at the same level as the vault's crown (F).

A major advantage of the Gothic vault is its flexibility, which permits the vaulting of compartments of varying shapes, as may be seen in the Saint-Denis plan (Fig. 7-2). Pointed arches also channel the weight of the vaults more directly downward than do semicircular arches. The vaults, therefore, require less buttressing to hold them in place, in turn permitting the opening up of the walls with large windows beneath the arches. Because pointed arches also lead the eye upward, they make the vaults appear taller than they actually are. In our diagrams, the crown (F) of both the Romanesque (diagram b) and Gothic (diagram c) vaults is the same height from the pavement, but the Gothic vault seems taller. Both the physical and visual properties of rib vaults with pointed arches aided Gothic builders in their quest for soaring height in church interiors.

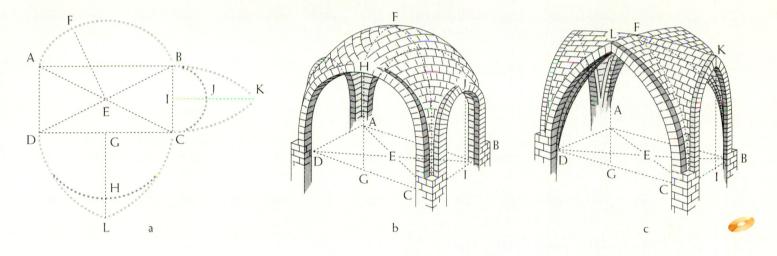

exceptionally light vaults spring from slender columns in the ambulatory and from the thin masonry walls framing the chapels. The lightness of the vault enabled the builders to eliminate the walls between the chapels and open up the outer walls and fill them with stained-glass windows (see "Stained-Glass Windows," page 192). Suger and his contemporaries marveled at the "wonderful and uninterrupted light" that poured in through these "most sacred windows." The abbot called the colored light lux nova, "new light." The polychrome rays coming through the windows shone on the walls and columns, almost dissolving them. The light-filled space made Suger feel as if he were "dwelling . . . in some strange region of the universe which neither exists entirely in the slime of the earth nor entirely in the purity of Heaven." In Suger's eyes, his splendid new church was a way station on the road to Paradise, which "transported [him] from this inferior to that higher world."³

The Royal Portal Suger's stained-glass windows and the new type of vaulting employed at Saint-Denis quickly became hallmarks of French Gothic architecture. Saint-Denis is also the key monument of Early Gothic sculpture. Little of the sculpture that Suger commissioned for the west facade of the abbey church survived the French Revolution, but in the mid-12th century, statues of Old Testament kings, queens, and prophets attached to columns screened the jambs of all three doorways.

This innovative design appeared immediately afterward at the Cathedral of Notre-Dame ("Our Lady," that is, the Virgin Mary) at Chartres (Fig. 7-3), also in the Île-de-France, the region centered on Paris. Work on the west facade began around 1145. Called the "Royal Portal" because of the statue-columns of kings and queens flanking its three doorways, it is almost all that remains of a cathedral begun in 1134 and destroyed by fire in 1194 before it had been completed.

7-3 | Aerial view of Chartres Cathedral (from the northwest), Chartres, France, begun 1134; rebuilt after 1194.

The Early Gothic west facade was all that remained of Chartres Cathedral after the fire of 1194. Architectural historians consider the rebuilt church the first great monument of High Gothic architecture.

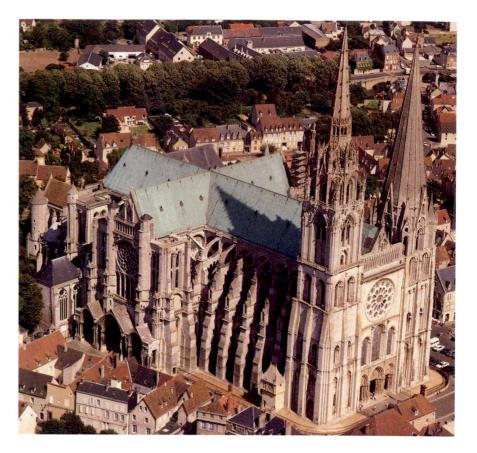

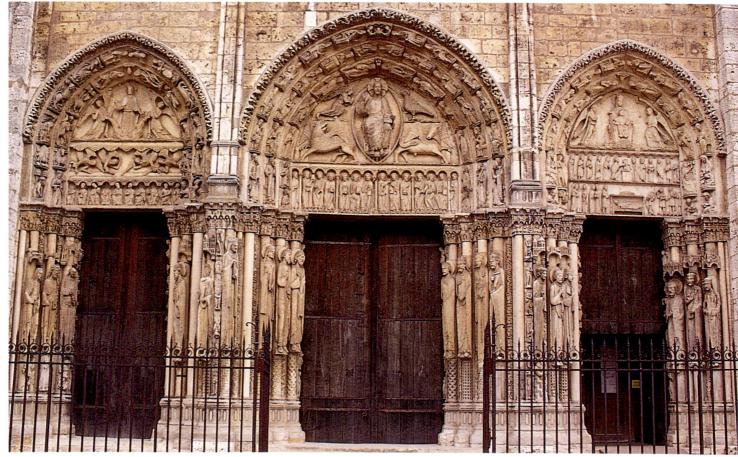

7-4 | Royal Portal, west facade, Chartres Cathedral, Chartres, France, ca. 1145–1155.

The sculptures of the Royal Portal proclaim the majesty and power of Christ. The tympana depict, from left to right, Christ's Ascension, the Second Coming, and Jesus in the lap of the Virgin Mary.

The sculptures of the Royal Portal (Fig. 7-4) proclaim the majesty and power of Christ. Christ's Ascension into Heaven appears in the tympanum of the left doorway. The Second Coming is the subject of the center tympanum. The theme—in essence, the Last Judgment—was still of central importance, as it was in Romanesque portals, but at Chartres the emphasis is on salvation rather than damnation. In the tympanum of the right portal, Christ appears in the lap of the Virgin Mary. Mary's prominence on the Chartres facade has no parallel in the decoration of Romanesque church portals. At Chartres the designers gave her a central role in the sculptural program, a position she maintained throughout the Gothic period. As the Mother of Christ, Mary stood compassionately between the Last Judge and the horrors of Hell, interceding for all her faithful. Worshipers in the later 12th and 13th centuries sang hymns to Notre Dame, put her image everywhere, and dedicated great cathedrals to her. Soldiers carried the Virgin's image into battle on banners, and her name joined Saint Denis's as part of the French king's battle cry. She became the spiritual lady of chivalry, and the Christian knight dedicated his life to her. The severity of Romanesque themes stressing the Last Judgment yielded to the gentleness of Gothic art, in which Mary is the kindly Queen of Heaven.

Statue-Columns Statues of Old Testament kings and queens (Fig. 7-5) decorate the jambs flanking each doorway

of the Royal Portal. They are the royal ancestors of Christ and, both figuratively and literally, support the New Testament figures above the doorways. They wear 12th-century clothes, and medieval observers also regarded them as images of the kings and queens of France, symbols of secular as well as of biblical authority.

Seen from a distance, the statue-columns appear to be little more than vertical decorative accents within the larger designs of the portals (Fig. 7-4). The figures stand rigidly upright with their elbows held close against their hips. The linear folds of their garments—inherited from the Romanesque style, along with the elongated proportions—generally echo the vertical lines of the columns behind them. (In this respect, Gothic jamb statues differ significantly from classical carvatids [Fig. 2-39]. The Gothic figures are attached to columns. The classical statues replaced the columns.) And yet, within and despite this architectural straitjacket, the statues display the first signs of a new naturalism. They stand out from the plane of the wall. The sculptors conceived and treated the statues as threedimensional volumes, so the figures "move" into the space of observers. The new naturalism is noticeable particularly in the statues' heads, where kindly human faces replaced the masklike features of most Romanesque figures. The sculptors of the Royal Portal statues initiated an era of artistic concern with personality and individuality.

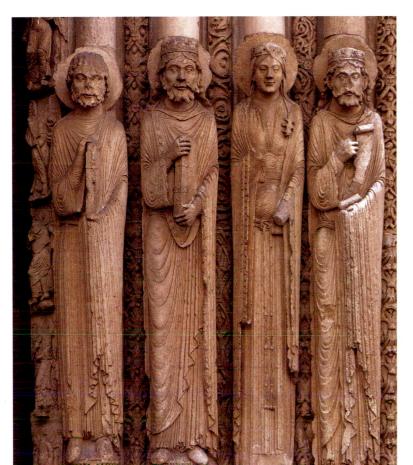

7-5 | Old Testament kings and queen, jamb statues, central doorway of Royal Portal, Chartres Cathedral, Chartres, France, ca. 1145–1155.

The biblical kings and queens of the Royal Portal are the royal ancestors of Christ. These Early Gothic statue-columns display the first signs of a new naturalism in European sculpture.

7-6 | Notre-Dame (view from the south), Paris, France, begun 1163; nave and flying buttresses, ca. 1180–1200; remodeled after 1225.

Flying buttresses were first used on a grand scale at the Cathedral of Notre-Dame in Paris. They countered the outward thrust of the nave vaults and held up the towering nave walls.

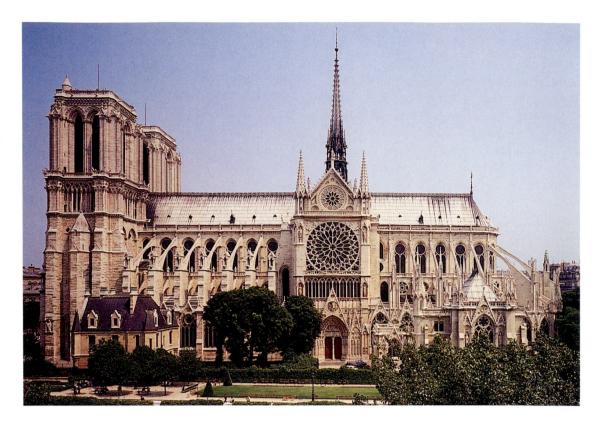

Notre-Dame of Paris The rapid urbanization of Paris under Louis VI and his successors and the accompanying increase in population made a new cathedral a necessity. Notre-Dame of Paris (Fig. 7-6) occupies a picturesque site on an island in the Seine River called the Île-de-la-Cité. The Gothic church replaced an earlier basilica and has a complicated building history. The choir and transept were completed by 1182; the nave, by around 1225; and the facade not until about 1250-1260. The original nave elevation had four stories, with stained-glass oculi (singular oculus, a small round window) inserted between the vaulted tribune and clerestory typical of Norman Romanesque churches like Saint-Étienne at Caen (Fig. 6-19). As a result, two of the four stories were now filled by windows, significantly reducing the masonry area. (This four-story nave elevation can be seen in only one bay in Fig. 7-6, immediately to the right of the south transept and partially hidden by it.)

Flying Buttresses To hold the much thinner—and taller—walls of Notre-Dame in place, the unknown architect introduced *flying buttresses*, exterior arches that spring from the lower roofs over the aisles and ambulatory (FIG. 7-6) and counter the outward thrust of the nave vaults. Flying buttresses seem to have been employed as early as 1150 in a few smaller churches, but at Notre-Dame in Paris they circle a great urban cathedral. The internal quadrant arches beneath the aisle roofs at Durham Cathedral (FIG. 6-20) perform a similar function and may be regarded as precedents for exposed Gothic flying buttresses. The combination of precisely positioned flying buttresses and rib vaults with pointed arches was the ideal solution to the problem of constructing towering naves with huge

windows filled with stained glass. The flying buttresses, like slender extended fingers holding up the walls, also are important elements contributing to the distinctive "look" of Gothic cathedrals (see "The Gothic Cathedral," page 191).

High Gothic Chartres Churches burned frequently in the Middle Ages, and church officials often had to raise money suddenly for new building campaigns. In contrast to monastic churches, which usually were small and completed fairly quickly, the building histories of urban cathedrals often extended over decades and sometimes over centuries. The rebuilding of Chartres Cathedral after the devastating fire of 1194 took a relatively short 27 years. Architectural historians usually consider the post-1194 Chartres Cathedral the first High Gothic building. At Chartres (Fig. 7-7), rectangular nave bays with four-part vaults replaced the square bays with six-part vaults and the alternate-support system seen at Saint-Étienne at Caen (Fig. 6-19) and in Early Gothic churches. The new system, in which a rectangular unit in the nave, defined by its own vault, was flanked by a single square in each aisle rather than two, as before, became the High Gothic norm. The High Gothic vault covered a relatively smaller area and therefore was braced more easily than its Early Gothic predecessor, making taller naves more practical to build.

The 1194 Chartres Cathedral was also the first church to have been planned from the beginning with flying buttresses, another key High Gothic feature. The flying buttresses made it possible to eliminate the tribune gallery above the aisle, which had partially braced Romanesque and Early Gothic naves. Taking its place was the *triforium*, the band of arcades between

ARCHITECTURAL BASICS

The Gothic Cathedral

Most of the architectural components of Gothic cathedrals appeared in earlier structures, but the way Gothic architects combined these elements made these buildings unique expressions of medieval faith. The key ingredients of the Gothic "recipe" were rib vaults with pointed arches,

flying buttresses, and huge windows of colored glass (see "Stained-Glass Windows," page 192). Our "exploded" view of a typical Gothic cathedral illustrates how these and other important Gothic architectural devices worked together.

The Vocabulary of Gothic Architecture

- Pinnacle: A sharply pointed ornament capping the piers or flying buttresses; also used on cathedral facades.
- 2. Flying buttresses: Masonry struts that transfer the thrust of the nave vaults across the roofs of the side aisles and ambulatory to a tall pier rising above the church's exterior wall. (Compare the cross-section of Beauvais Cathedral, Fig. INTRO-12.)
- **3.** Vaulting web: The masonry blocks that fill the area between the ribs of a groin vault.
- **4.** Diagonal rib: In plan, one of the ribs that form the X of a groin vault. In the diagrams of rib vaults on page 187, the diagonal ribs are the lines AC and DB.
- **5.** *Transverse rib:* A rib that crosses the nave or aisle at a 90-degree angle (lines *AB* and *DC* in the diagrams on page 187).
- **6.** *Springing:* The lowest stone of an arch; in Gothic vaulting, the lowest stone of a diagonal or transverse rib.
- 7. Clerestory: The windows below the vaults that form the uppermost level of the nave elevation. By using flying buttresses and rib vaults on pointed arches, Gothic architects could build huge clerestory windows and fill them with stained glass held in place by ornamental stonework called tracery.
- 8. Oculus: A small round window.
- **9.** Lancet: A tall, narrow window crowned by a pointed arch.
- 10. Triforium: The story in the nave elevation consisting of arcades, usually blind (Fig. 7-7), but occasionally filled with stained glass (Figs. INTRO-1 and 7-21).
- **11.** Nave arcade: The series of arches supported by piers separating the nave from the side aisles.
- **12.** Compound pier with shafts (responds):
 Also called the cluster pier, a pier with a group, or cluster, of attached shafts, or responds, extending to the springing of the vaults.

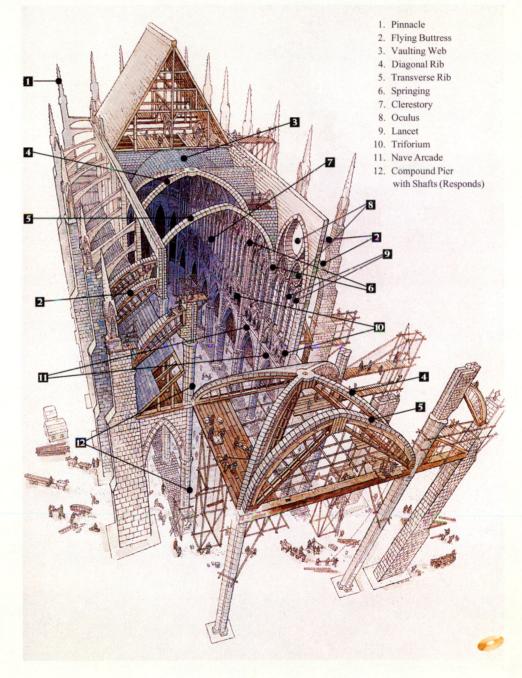

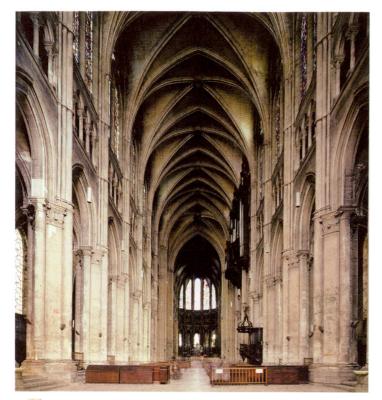

7-7 | Interior of Chartres Cathedral (view facing east), Chartres, France, begun 1194.

The post-1194 Chartres Cathedral was the first church to have been planned from the beginning with flying buttresses, which made possible the substitution of the triforium for the tribune gallery in the nave.

the clerestory and the nave arcade. The triforium occupies the space corresponding to the exterior strip of wall covered by the sloping timber roof above the galleries. The new High Gothic tripartite nave elevation consisted of arcade, triforium, and clerestory with greatly enlarged windows. The Chartres windows are almost as high as the main arcade and consist of double lancets crowned by a single oculus. The strategic placement of flying buttresses permitted the construction of nave walls with so many voids that heavy masonry played a minor role.

Stained Glass Despite the vastly increased size of the clerestory windows, the Chartres nave is relatively dark. The explanation for this seeming contradiction is that light-muffling colored glass fills the windows. These windows were not meant to illuminate the interior with bright sunlight but to transform natural light into Suger's mystical lux nova (see "Stained-Glass Windows," right). Chartres retains almost the full complement of its original stained glass, which, although it has a dimming effect, transforms the character of the interior in dramatic fashion. The immense (approximately 43 feet in diameter) *rose window* (circular stained-glass window) and tall lancets of Chartres Cathedral's north transept (Fig. 7-8) were the gift of the Queen of France, Blanche of Castile, around 1220. The royal motifs of yellow castles on a red

MATERIALS + TECHNIQUES

Stained-Glass Windows

Stained-glass windows are almost synonymous with Gothic architecture. They differ from the mural paintings and mosaics that adorned earlier churches in one all-important respect. They do not conceal walls; they replace them. And they transmit rather than reflect light, filtering and transforming the natural sunlight as it enters the building. Abbot Suger called this colored light "lux nova." According to Hugh of Saint-Victor, a prominent Parisian theologian who died while Suger's Saint-Denis was under construction, "stained-glass windows are the Holy Scriptures . . . and since their brilliance lets the splendor of the True Light pass into the church, they enlighten those inside." William Durandus, Bishop of Mende, expressed a similar sentiment at the end of the 13th century: "The glass windows in a church are Holy Scriptures, which expel the wind and the rain, that is, all things hurtful, but transmit the light of the True sun, that is, God, into the hearts of the faithful."

The manufacture of stained-glass windows was labor-intensive and costly. The full process was recorded around 1100 in a treatise on the arts written by a Benedictine monk named Theophilus. First, the master designer drew the exact composition of the planned window on a wooden panel, indicating all the linear details and noting the colors for each section. Glassblowers provided flat sheets of glass of different colors to glaziers (glassworkers), who cut the windowpanes to the required size and shape with special iron shears. Glaziers produced an even greater range of colors by flashing (fusing one layer of colored glass to another). Purple, for example, resulted from the fusing of red and blue. Next, painters added details such as faces, hands, hair, and clothing in enamel by tracing the master design on the wood panel through the colored glass. Then they heated the painted glass to fuse the enamel to the surface. The glaziers then leaded the various fragments of glass; that is, they joined them by strips of lead called cames. The leading not only held the (usually guite small) pieces together but also separated the colors to heighten the design's effect as a whole. The distinctive character of Gothic stained-glass windows is largely the result of this combination of fine linear details with broad flat expanses of color framed by black lead. Finally, the glassworkers strengthened the completed window with an armature of iron bands (Fig. 7-8).

The form of the stone window frames into which the glass was set evolved throughout the Gothic era. Early rose windows, such as the one on Chartres Cathedral's west facade (Fig. 7-3), have stained glass held in place by *plate tracery*. The glass fills only the "punched holes" in the heavy ornamental stonework. *Bar tracery* (Fig. 7-8), a later development, is much more slender. The stained-glass windows fill almost the entire opening, and the stonework is unobtrusive, more like delicate leading than masonry wall.

¹ Attributed to Hugh of Saint-Victor, Speculum de mysteriis ecclesiae, Sermon 2.

² William Durandus, *Rationale divinorum officiorum*, 1.1.24. Translated by John Mason Neale and Benjamin Webb, *The Symbolism of Churches and Church Ornaments* (Leeds: Green, 1843), 28.

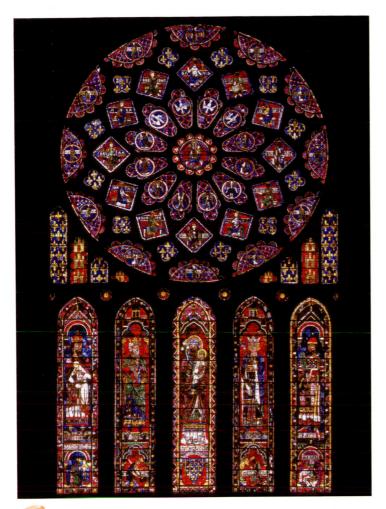

7-8 | Rose window and lancets, north transept, Chartres Cathedral, Chartres, France, ca. 1220. Stained glass, rose window approx. 43' in diameter.

Stained-glass windows transformed natural light into Suger's lux nova. This immense rose window and tall lancets were the gift of Blanche of Castile. Queen of France, to Chartres Cathedral.

ground and yellow fleurs-de-lis-three-petaled iris flowerson a blue ground fill the eight narrow windows in the rose's lower spandrels. The iconography is also fitting for a queen. The enthroned Virgin and Child appear in the roundel at the center of the rose, which resembles a gem-studded book cover. Around her are four doves of the Holy Spirit and eight angels. Twelve square panels contain images of Old Testament kings, including David and Solomon (at the 12 and 1 o'clock positions respectively). These are the royal ancestors of Christ. Isaiah (11:1-3) had prophesized that the Messiah would come from the family of the patriarch Jesse, father of David. The genealogical "tree of Jesse" is a familiar motif in medieval art. Below, in the lancets, are Saint Anne and the baby Virgin flanked by four of Christ's Old Testament ancestors, Melchizedek, David, Solomon, and Aaron, echoing the royal genealogy of the rose, but at a larger scale.

The rose and lancets change in hue and intensity with the hours, turning solid architecture into a floating vision of the celestial heavens. Almost the entire mass of wall opens up into stained glass, which is held in place by an intricate stone armature of bar tracery. Here, the Gothic passion for light led to a most daring and successful attempt to subtract all superfluous material bulk just short of destabilizing the structure in order to transform hard substance into insubstantial, luminous color. That this vast, complex fabric of stone-set glass has maintained its structural integrity for almost 800 years attests to the Gothic builders' engineering genius.

Porch of the Martyrs The sculptures adorning the portals of the two new Chartres transepts erected after the 1194 fire are also prime examples of the new High Gothic spirit. The Chartres transept portals project more forcefully from the church than do the Early Gothic portals of its west facade (Figs. 7-3 and 7-4). Similarly, the statues of saints on the portal jambs are more independent from the architectural framework. Saint Theodore (Fig. 7-9) from the Porch of the Martyrs in the south transept reveals the great changes Gothic sculpture underwent since the Royal Portal statues (Fig. 7-5)

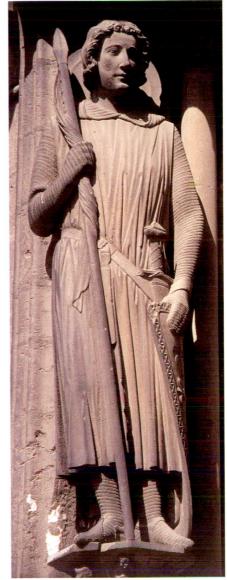

7-9 | Saint Theodore, jamb statue, Porch of the Martyrs (left doorway), south transept, Chartres Cathedral, Chartres, France, ca. 1230.

Although the statue of Theodore is still attached to a column, the setting no longer determines its pose. The High Gothic sculptor portrayed the saint swinging out one hip, as in Greek statuary (Fig. 2-31).

of the mid-12th century. These changes recall in many ways the revolutionary developments in ancient Greek sculpture during the transition from the Archaic to the Classical style (see Chapter 2). The High Gothic sculptor portrayed Theodore as the ideal Christian knight and clothed him in the cloak and chain-mail armor of Gothic Crusaders. The handsome, longhaired youth holds his spear firmly in his right hand and rests his left hand on his shield. Although the statue is still attached to a column, the architectural setting no longer determines its pose. The saint turns his head to the left and swings out his hip to the right, breaking the rigid vertical line that, on the Royal Portal, fixes the figures immovably. The body's resulting torsion and pronounced sway call to mind Classical Greek statuary, especially the contrapposto stance of Polykleitos's Spear Bearer (Fig. 2-31). It is not inappropriate to speak of the changes that occurred in 13th-century Gothic sculpture as a second "Classical revolution."

The Quest for Height Chartres Cathedral set a pattern that many other Gothic architects followed, even if they refined the details. Construction of Amiens Cathedral began in 1220, while work was still in progress at Chartres. The architects were ROBERT DE LUZARCHES, THOMAS DE CORMONT, and RENAUD DE CORMONT. The builders finished the nave (Fig. 7-10) by 1236 and the radiating chapels by 1247, but work on the choir continued until almost 1270. The Amiens elevation derived from the High Gothic formula established at Chartres (Fig. 7-7). But Amiens Cathedral's proportions are even more elegant, and the number and complexity of the lancet windows in both its clerestory and triforium are even greater. The whole design reflects the builders' confident use of the complete High Gothic structural vocabulary: the rectangular-bay system, the four-part rib vault, and a buttressing system that permitted almost complete dissolution of heavy masses and thick weightbearing walls. At Amiens, the concept of a self-sustaining skeletal architecture reached full maturity.

The nave vaults of Chartres Cathedral rise to a height of 118 feet. Those at Amiens are 144 feet above the floor, reflecting the French Gothic obsession with constructing ever taller cathedrals. The tense, strong lines of the Amiens vault ribs converge to the colonnettes and speed down the walls to the compound piers. Almost every part of the superstructure has its corresponding element below. The overall effect is of effortless strength, of a buoyant lightness one normally does not associate with stone architecture. The light flooding in from the clerestory—and, in the choir, also from the triforium—makes the vaults seem even more insubstantial. The effect recalls another great building, one utterly different from Amiens but where light also plays a defining role: Hagia Sophia in Constantinople (Fig. 4-12). Once again, the designers reduced the building's physical mass by structural ingenuity and daring, and light dematerializes further what remains. If Hagia Sophia is the perfect expression of Byzantine spirituality in architecture, Amiens, with its soaring vaults and giant windows admitting divine colored light, is its Gothic counterpart.

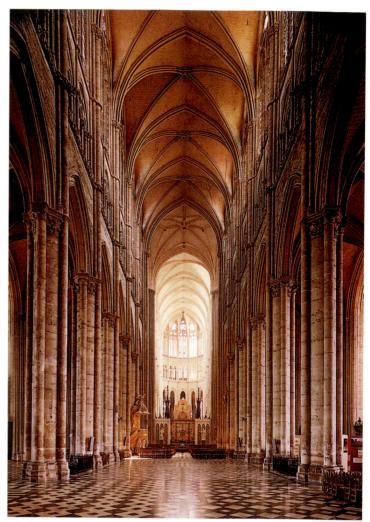

7-10 | ROBERT DE LUZARCHES, THOMAS DE CORMONT, and RENAUD DE CORMONT, interior of Amiens Cathedral (view facing east), Amiens, France, begun 1220.

The concept of a self-sustaining skeletal architecture reached full maturity at Amiens Cathedral. The four-part High Gothic vaults rise an astounding 144 feet above the nave floor.

The High Gothic Facade Construction of Reims Cathedral (Fig. 7-11) began only a few years after work commenced at Amiens. Its west facade displays the Gothic desire to reduce sheer mass and replace it with intricately framed voids. The builders punctured almost the entire stone skin of the building. The deep piercing of walls and towers left few continuous surfaces for decoration, but the ones that remained were covered with a network of colonnettes, arches, pinnacles, rosettes, and other decorative stonework that visually screens and nearly dissolves the structure's solid core. Sculpture also extends to the areas above the portals, especially the band of statues (the so-called kings' gallery) running the full width of the facade directly above the rose window. Below, sculpture-lined funnel-like portals project boldly from the rest of the facade. The treatment of the tympana over the doorways is telling. There, stained-glass windows replaced

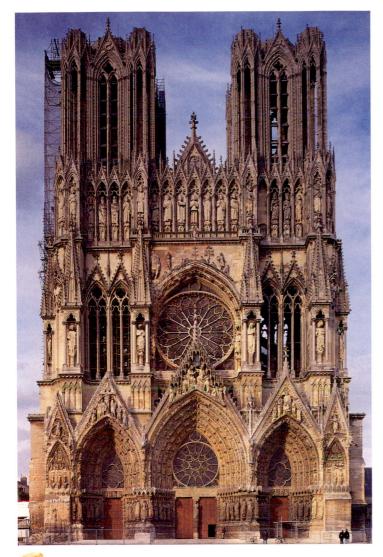

7-11 West facade of Reims Cathedral, Reims, France, ca. 1225–1290.

The facade of Reims Cathedral displays the High Gothic architect's desire to reduce sheer mass and replace it with intricately framed voids. Stained-glass windows, not stone sculpture, fill the tympana.

the stone relief sculpture of earlier facades. The contrast with Romanesque heavy masonry construction (Fig. 6-18) is extreme. But the rapid transformation of the Gothic facade since Saint-Denis and Chartres (Fig. 7-3) is no less noteworthy.

Statues Begin to Converse At Reims the fully ripened Gothic style also can be seen in sculpture. At first glance, the jamb statues (Fig. 7-12) of the west portals of Reims Cathedral appear to be completely detached from their architectural background. The sculptors shrank the supporting columns into insignificance so that they in no way restrict the free and easy movements of the full-bodied figures. (Compare the Reims statue-columns with those of the Royal Portal of Chartres, Fig. 7-5, where the background columns occupy a volume equal to that of the figures.) The two Reims jamb statues we illustrate portray Saint Elizabeth visiting the Virgin

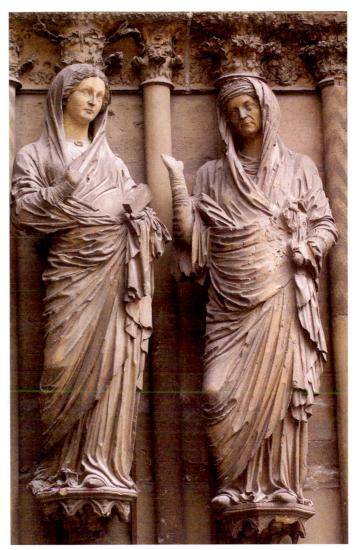

7-12 | Visitation, jamb statues of central doorway, west facade, Reims Cathedral, Reims, France, ca. 1230.

Saint Elizabeth and the Virgin Mary appear to be completely detached from their columns. The High Gothic sculptor set both their bodies and their arms in motion, and they converse through gestures.

Mary before the birth of Jesus. They are two of a series of statues celebrating Mary's life and are further testimony to the Virgin's central role in Gothic iconography.

The sculptor of the Visitation group reveals a classicizing bent startlingly unlike anything seen since Roman times. The artist probably studied actual classical statuary in France. Although art historians have been unable to pinpoint specific models, the heads of both women look like ancient Roman portraits. Whatever the sculptor's source, the statues are astonishing approximations of the classical naturalistic style. The Reims master even incorporated the Greek contrapposto posture, going far beyond the stance of the Chartres Saint Theodore (Fig. 7-9). At Reims, the swaying of the hips is much more pronounced. The right legs bend, and the knees press through the rippling folds of the garments. The sculptor also set the figures' arms in motion. Mary and Elizabeth not only turn

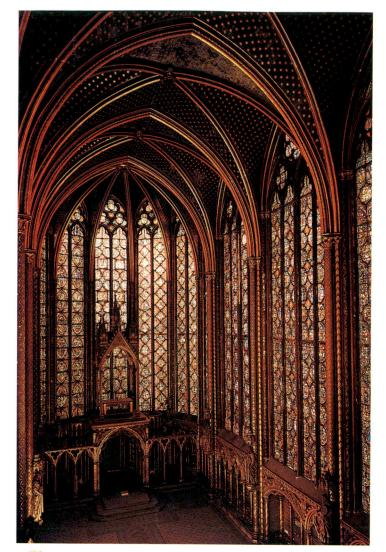

7-13 | Interior of the upper chapel, Sainte-Chapelle, Paris, France, 1243–1248.

At Louis IX's Sainte-Chapelle, the architect succeeded in dissolving the walls to the point that 6,450 square feet of stained glass make up more than three-quarters of the High Gothic structure.

their faces toward each other but also converse through gestures. In the Reims Visitation group, the formerly isolated Gothic jamb statues became actors in a biblical narrative.

A Radiant Royal Chapel If the stained-glass windows inserted into the portal tympana of Reims Cathedral exemplify the wall-dissolving High Gothic architectural style, Sainte-Chapelle (Fig. 7-13) in Paris shows this principle applied to a whole building. Louis IX (Saint Louis, r. 1226–1270) built Sainte-Chapelle, joined to the royal palace, as a repository for the crown of thorns and other relics of Christ's Passion he had purchased in 1239. The chapel is a prime example of the so-called *Rayonnant* (radiant) style of the High Gothic age, which was closely associated with the royal Parisian court of Saint Louis. In Sainte-Chapelle, the dissolution of walls and the reduction of the bulk of the supports were carried to the point that some 6,450 square feet of stained glass make up more than

three-quarters of the structure. The supporting elements were reduced so much that they are hardly more than large *mullions*, or vertical stone bars. The emphasis is on the extreme slenderness of the architectural forms and on linearity in general. Sainte-Chapelle's enormous stained-glass windows filter the light and fill the interior with an unearthly rose-violet atmosphere. Approximately 49 feet high and 15 feet wide, they were the largest designed up to their time.

The Virgin as Queen The "court style" of Saint Louis was not confined to architecture. Indeed, the elegance and delicacy displayed in Sainte-Chapelle's design permeated the pictorial arts as well. By the early 14th century, a mannered style that marks Late Gothic art in general had replaced the monumental and solemn sculptural style of the High Gothic portals. Perhaps the best example of French Late Gothic sculpture is the statue nicknamed the *Virgin of Paris* (Fig. 7-14) because of

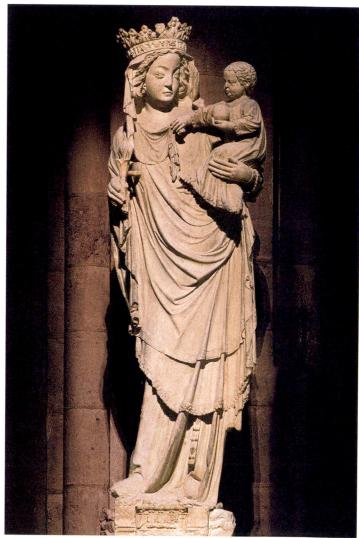

7-14 | Virgin and Child (*Virgin of Paris*), Notre-Dame, Paris, France, early 14th century.

Late Gothic sculpture is elegant and mannered. Here, the solemnity of Early and High Gothic religious figures gave way to a tender and anecdotal portrayal of Mary and Jesus as royal mother and son.

its location in the Parisian Cathedral of Notre-Dame. The sculptor portrayed Mary as a very worldly queen, decked out in royal garments and wearing a heavy gem-encrusted crown. The Christ Child is equally richly attired and is very much the infant prince in the arms of his young mother. The tender, anecdotal characterization of mother and son represents a further humanization of the portrayal of religious figures in Gothic sculpture.

The playful interaction of an adult and an infant in the *Virgin of Paris* may be compared with the similarly composed statuary group of Hermes and the infant Dionysos (Fig. 2-45) by the Greek sculptor Praxiteles. Indeed, the exaggerated swaying S curve of the Virgin's body superficially resembles the shallow S curve Praxiteles introduced in the fourth century BCE. But unlike its Late Classical predecessor, the Late Gothic S curve was not organic (derived from within the figure), nor was it a rational, if pleasing, organization of human anatomical parts. Rather, the Gothic curve was an artificial form imposed on the figures, a decorative device that produced the desired effect of elegance but that had nothing to do with body structure. In fact, in our example, the body is quite lost behind the heavy drapery, which, deeply cut and hollowed, almost denies the figure a solid existence.

Book Illumination and Luxury Arts

Paris's claim as the intellectual center of Gothic Europe did not rest solely on the stature of its university faculty and on the reputation of its architects, masons, sculptors, and stained-glass makers. The city was also a renowned center for the production of fine books. The Florentine poet Dante Alighieri (1265–1321), in fact, referred to Paris in his *Divine Comedy* of about 1310–1320 as the city famed for the art of illumination.⁴ Indeed, the Gothic period is when book manufacture shifted from monastic scriptoria shut off from the world to urban workshops. Owned and staffed by laypersons who sold their products to the royal family, scholars, and prosperous merchants, these for-profit secular businesses, concentrated in Paris, were the forerunners of modern publishing houses.

God as Architect One of the finest examples of French Gothic book illustration is the frontispiece (Fig. 7-15) of a moralized Bible produced in Paris during the 1220s. Moralized Bibles are heavily illustrated, each page pairing Old and New Testament episodes with illustrations explaining their moral significance. The page we show does not conform to this formula because it is the introduction to all that follows. Above the illustration, the scribe wrote (in French rather than Latin): "Here God creates heaven and earth, the sun and moon, and all the elements." God appears as the architect of the world, shaping the universe with the aid of a compass. Within the perfect circle already created are the spherical sun and moon and the unformed matter that will become the

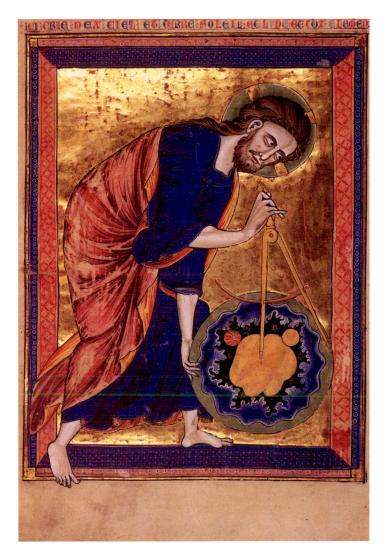

7-15 | God as architect of the world, folio 1 verso of a moralized Bible, from Paris, ca. 1220–1230. Ink, tempera, and gold leaf on vellum, 1' $1\frac{1}{2}$ " \times $8\frac{1}{4}$ ". Österreichische Nationalbibliothek, Vienna.

Paris was the intellectual capital of Europe and the center of production for fine books. This artist portrayed God as an industrious architect creating the universe using the same tools as Gothic builders.

earth once God applies the same geometric principles to it. In contrast to the biblical account of Creation, where God created the sun, moon, and stars after the earth had been formed, and where God made the world by sheer force of will and a simple "Let there be . . ." command, the Gothic artist portrayed God as an industrious architect, creating the universe with some of the same tools used by mortal builders.

A Bible Fit for a Queen Not surprisingly, most of the finest Gothic books known today belonged to the French monarchy. One of these is a moralized Bible now in the Pierpont Morgan Library. Saint Louis inherited the throne when he was only 12 years old, so until he reached adulthood, his mother, Blanche of Castile, served as France's regent

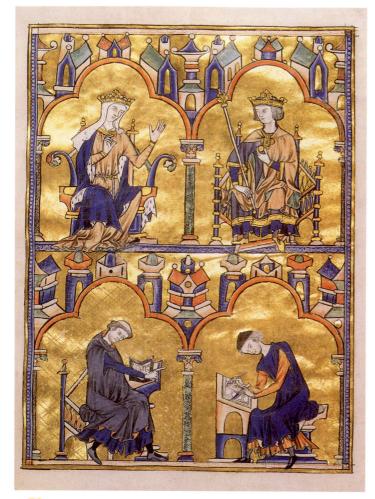

7-16 | Blanche of Castile, Louis IX, and two monks, dedication page (folio 8 recto) of a moralized Bible, from Paris, France, 1226-1234. Ink, tempera, and gold leaf on vellum, $1' 3'' \times 10\frac{1}{2}''$. Pierpont Morgan Library, New York.

The costly gold-leaf dedication page of this royal book depicts Saint Louis, his mother, and two monks. The younger monk is at work on the paired illustrations of a moralized Bible.

(1226–1234). Blanche ordered this Bible for her teenage son during that time. The dedication page (Fig. 7-16) has a costly gold background and depicts Blanche and Louis enthroned beneath triple-lobed arches and miniature cityscapes. Below, in similar architectural frames, are a monk and a scribe. The older clergyman dictates a sacred text to his young apprentice. The scribe already has divided his page into two columns of four roundels each, a format often used for the paired illustrations of moralized Bibles. The inspirations for such designs were probably the roundels of Gothic stained-glass windows (compare the windows of Louis's own, later, Sainte-Chapelle, Fig. 7-13).

The picture of Gothic book production on the dedication page of Blanche of Castile's moralized Bible is a very abbreviated one. The manufacturing process used in the workshops of 13th-century Paris involved many steps and numerous specialized artists, scribes, and assistants of varying skill levels.

The Benedictine abbot Johannes Trithemius (1462–1516) described the way books were still made in his day in his treatise *In Praise of Scribes*:

If you do not know how to write, you still can assist the scribes in various ways. One of you can correct what another has written. Another can add the rubrics [headings] to the corrected text. A third can add initials and signs of division. Still another can arrange the leaves and attach the binding. Another of you can prepare the covers, the leather, the buckles and clasps. All sorts of assistance can be offered the scribe to help him pursue his work without interruption. He needs many things which can be prepared by others: parchment cut, flattened and ruled for script, ready ink and pens. You will always find something with which to help the scribe.⁵

The preparation of the illuminated pages also involved several hands. Some artists, for example, specialized in painting borders or initials. Only the workshop head or one of the most advanced assistants would paint the main figural scenes. Given this division of labor and the assembly-line nature of Gothic book production, it is astonishing how uniform the style is on a single page, as well as from page to page, in most illuminated manuscripts. Inscriptions in some Gothic illuminated books state the production costs—the prices paid for materials, especially gold, and for the execution of initials, figures, flowery script, and other embellishments. By this time, illuminators were professional guild members, and their personal reputation, like modern "brand names," guaranteed the quality of their work. Though the cost of materials was still the major factor determining a book's price, individual skill and reputation increasingly decided the value of the illuminator's services. The centuries-old monopoly of the Christian Church in book production had ended.

A Virgin for Saint-Denis The royal family also patronized goldsmiths, silversmiths, and other artists specializing in the production of luxury works in metal and enamel for churches, palaces, and private homes. Especially popular among the wealthy were statuettes of sacred figures purchased either for their private devotion or as gifts to the churches they frequented. The Virgin Mary was a favored subject.

Perhaps the finest of these costly statuettes is the large (more than two-foot-tall) silver-gilt figurine known as the Virgin of Jeanne d'Evreux (Fig. 7-17). The queen, wife of Charles IV (r. 1322–1328), donated the image of the Virgin and Child to the royal abbey church of Saint-Denis in 1339. Mary stands on a rectangular base decorated with enamel scenes of Christ's Passion. But no hint of grief appears in the beautiful young Mary's face. The Christ Child, also without a care in the world, playfully reaches for his mother. The elegant proportions of the two figures, Mary's swaying posture, the heavy drapery folds, and the intimate human characterization of the holy figures are also features of the roughly contemporary Virgin of Paris (Fig. 7-14). In the Virgin of Jeanne d'Evreux, as in the Virgin of Paris, Mary appears not only as the Mother of Christ but as the Queen of Heaven. The

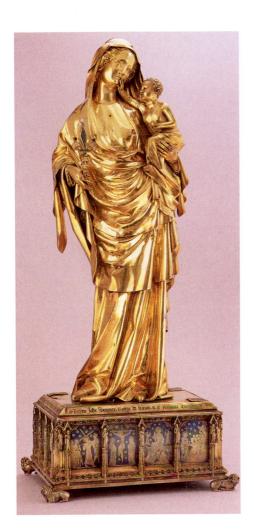

P 7-17 |

Virgin of Jeanne d'Evreux, from the abbey church of Saint-Denis, France, 1339. Silver gilt and enamel, $2' 3\frac{1}{2}''$ high. Louvre, Paris.

Queen Jeanne d'Evreux donated this luxurious reliquary-statuette to the royal abbey church of Saint-Denis. The intimate human characterization of the holy figures recalls that of the Virgin of Paris (Fig. 7-14).

Saint-Denis Mary also originally had a crown on her head, and the scepter she holds is in the form of the fleur-de-lis, the French monarchy's floral emblem. The statuette also served as a reliquary. The Virgin's scepter contained hairs believed to come from Mary's head.

ENGLAND

In 1269, the prior (deputy abbot) of the Church of Saint Peter at Wimpfen-im-Tal in the German Rhineland hired "a very experienced architect who had recently come from the city of Paris" to rebuild his monastery church. The architect reconstructed the church *opere francigeno* (in the French manner)—that is, in the Gothic style of the Île-de-France. The spread of the Parisian Gothic style had begun even earlier, but in the second half of the 13th century the new style became dominant throughout western Europe. European architecture did not, however, turn Gothic all at once nor in a uniform way. Almost everywhere, patrons and builders modified the "court style" of the Île-de-France according to local preferences.

French Translated into English Salisbury Cathedral (Fig. 7-18) embodies the essential characteristics of English Gothic architecture. Begun in 1220, work was mostly completed in about 40 years. Salisbury is, therefore, almost exactly contemporary to Amiens and Reims Cathedrals, and the differences between the French and English buildings are very instructive. Although Salisbury's facade has lancet windows and blind arcades with pointed arches and statuary, it presents a striking contrast to the Reims design (Fig. 7-11). The English facade is a squat screen in front of the nave, wider than the building behind it. The soaring height of the French facade is absent. Its design does not correspond to the threepart division of the interior (nave and two aisles). Also different is the emphasis on the great crossing tower (added ca. 1320-1330), which dominates the silhouette. Salisbury's height is modest compared with that of Amiens and Reims. And because height is not a decisive factor in the English building, the architect used the flying buttress sparingly and as a rigid prop, rather than as an integral part of the vaulting system within the church. In short, the English builders adopted some of the superficial motifs of French Gothic architecture but did not embrace its structural logic or emphasis on height.

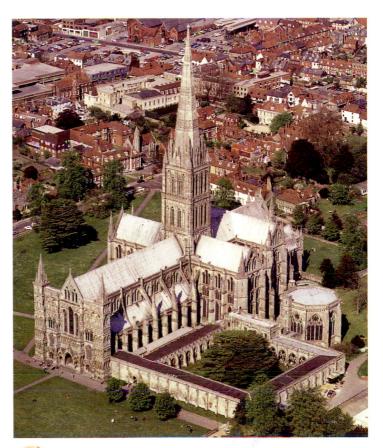

7-18 | Aerial view of Salisbury Cathedral, Salisbury, England, 1220–1258; west facade completed 1265; spire ca. 1320–1330.

Exhibiting the distinctive regional features of English Gothic architecture, Salisbury Cathedral has a squat facade that is wider than the building behind it. Flying buttresses were used sparingly.

Salisbury's interior (Fig. 7-19), although Gothic in its three-story elevation, pointed arches, four-part rib vaults, and compound piers, conspicuously departs from the French Gothic style seen at Amiens (Fig. 7-10). The pier colonnettes stop at the springing of the nave arches and do not connect with the vault ribs. Instead, the vault ribs rise from *corbels* in the triforium, producing a strong horizontal emphasis. Underscoring this horizontality is the rich color contrast between the light stone of the walls and vaults and the dark Purbeck marble used for the triforium moldings and corbels, compound pier responds, and other details. Once again, however, the impact of the French Gothic style is clearly visible in the decorative details, especially the tracery of the triforium. Nonetheless, visitors to Salisbury could not mistake the English cathedral for a French one.

Fan Vaults English Gothic architecture found its native language in the elaboration of architectural pattern for its own sake. Structural logic, expressed in the building fabric, was

secondary. The pier, wall, and vault elements, still relatively simple at Salisbury, became increasingly complex and decorative in the 14th century and later. In the early-16th-century chapel of Henry VII (Fig. 7-20) adjoining Westminster Abbey in London, the so-called Perpendicular Style of late English Gothic is on display. The style takes its name from the pronounced verticality of its decorative details, in contrast to the horizontal emphasis of Salisbury and early English Gothic. In Henry's chapel, the vault ribs have been multiplied many times over and then pulled into uniquely English fan vault shapes with large hanging pendants resembling stalactites. The vault looks like something organic that hardened in the process of melting. Intricate tracery recalling lace overwhelms the cones hanging from the ceiling. The chapel represents the dissolution of structural Gothic into decorative fancy. The architect released the original lines of the French Gothic style from their function and multiplied them into the uninhibited architectural virtuosity and theatrics of the English Perpendicular Style.

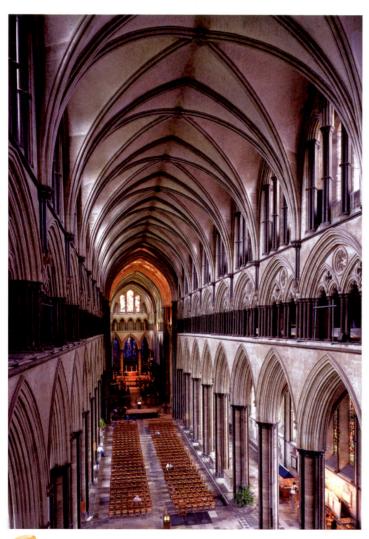

7-19 | Interior of Salisbury Cathedral (view facing east), Salisbury, England, 1220–1258.

Salisbury Cathedral's interior also differs from contemporaneous French Gothic designs in the strong horizontal emphasis of its three-story elevation and the use of dark Purbeck marble for moldings.

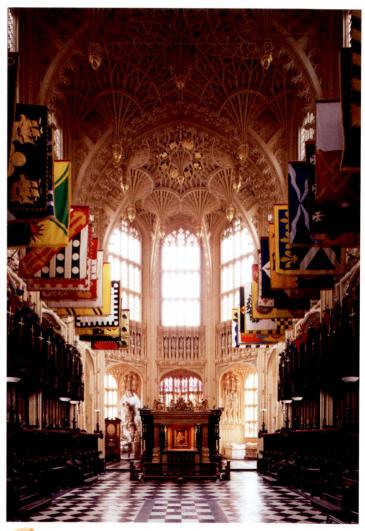

7-20 | ROBERT and WILLIAM VERTUE, chapel of Henry VII, Westminster Abbey, London, England, 1503–1519.

Two hallmarks of the Perpendicular Style of late English Gothic architecture are the multiplication of ribs and the use of fan vaults with lacelike tracery and large hanging pendants resembling stalactites.

GERMANY

The architecture of Germany remained conservatively Romanesque well into the 13th century. In many German churches, the only Gothic feature was the rib vault, buttressed solely by the heavy masonry of the walls. By mid-century, though, the French Gothic style began to make a profound impact.

Cologne's Soaring Vaults Begun in 1248 under the direction of GERHARD OF COLOGNE, Cologne Cathedral was not completed until more than 600 years later. It is the largest cathedral in northern Europe and boasts a giant (422-footlong) nave with two aisles on each side. The 150-foot-high 14th-century choir (Fig. 7-21) is a skillful variation of the Amiens Cathedral choir (Fig. 7-10) design, with double lancets in the triforium and tall, slender single windows in the clerestory above and choir arcade below. The Cologne choir expresses the Gothic quest for height even more emphatically than many French Gothic buildings.

High Drama at Strasbourg Like French Gothic architects, French sculptors also often set the standard for their counterparts in other countries. In the German Rhineland, work began in 1176 on a new cathedral for Strasbourg, today a French city. The apse, choir, and transepts were in place by around 1240. Stylistically, these sections of the new church are Romanesque. But the reliefs of the two south-transept portals are fully Gothic and reveal the impact of contemporaneous French sculpture, especially that of Reims.

We illustrate the left tympanum, where the theme is the death of the Virgin Mary (Fig. 7-22). A comparison of the Strasbourg Mary on her deathbed with the Mary of the Reims

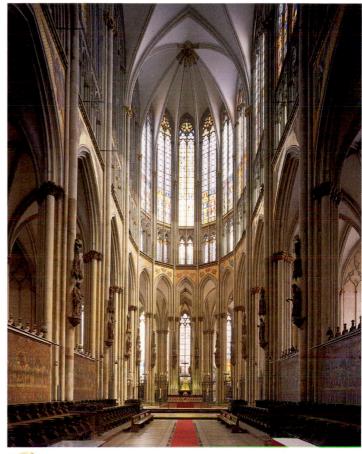

7-21 | GERHARD OF COLOGNE, choir of Cologne Cathedral (view facing east), Cologne, Germany, completed 1322.

Cologne Cathedral is the largest church in northern Europe. Its 150-foothigh choir, a variation of the Amiens Cathedral choir (Fig. 7-10), is a prime example of the Gothic quest for height.

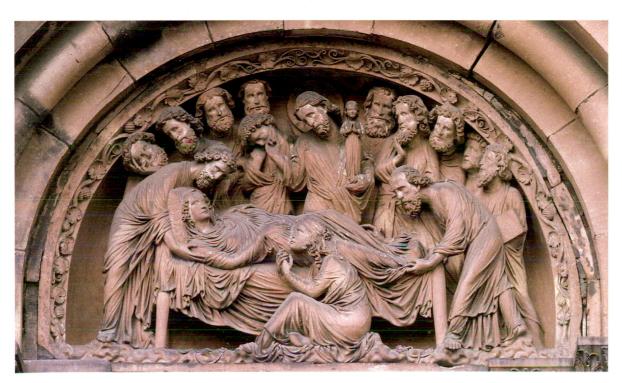

7-22

Death of the Virgin, tympanum of left doorway, south transept, Strasbourg Cathedral, Strasbourg, France, ca. 1230.

Stylistically akin to the sculptures of Reims Cathedral (Fig. 7-12), Strasbourg's tympanum figures express profound sorrow through dramatic poses and gestures, and stir an emotional response in the viewer.

Visitation group (Fig. 7-12) suggests that the German master had studied the recently installed French jamb statues. The Twelve Apostles gather around the Virgin, forming an arc of mourners well suited to the semicircular frame. At the center, Christ receives his mother's soul (the doll-like figure he holds in his left hand). Mary Magdalene, wringing her hands in grief, crouches beside the deathbed. The sorrowing figures express emotion in varying degrees of intensity, from serene resignation to gesturing agitation. The sculptor organized the group by dramatic pose and gesture but also by the rippling flow of deeply incised drapery that passes among them like a rhythmic electric pulse. The sculptor's objective was to imbue the sacred figures with human emotions and to stir emotional responses in observers. In Gothic France, as already noted, art became increasingly humanized and natural. In Gothic Germany, artists carried this humanizing trend even further by emphasizing passionate drama.

Donor "Portraits" The Strasbourg style, with its feverish emotionalism, was particularly appropriate for narrating dramatic events in relief. The sculptor entrusted with the decoration of the west choir of Naumburg Cathedral faced a very different challenge. The task was to carve statues of the 12 benefactors of the original 11th-century church. The vivid gestures and agitated faces of the Strasbourg portal contrast with the quiet solemnity of the Naumburg statues. Two of the figures stand out from the group because of their exceptional quality. They represent the margrave (German military governor) Ekkehard II of Meissen and his wife Uta (Fig. 7-23). The statues are/attached to columns and stand beneath architectural canopies, a common framing device on French Gothic portal statuary. Their location indoors accounts for the preservation of much of the original paint. Ekkehard and Uta give an idea of how the facade and transept sculptures of Gothic cathedrals once looked.

The period costumes and the individualized features and personalities of the margrave and his wife give the impression that they sat for their own portraits, although the subjects lived well before the sculptor's time. Ekkehard, the intense and somewhat stout knight, contrasts with the beautiful and aloof Uta. With a wonderfully graceful gesture, she draws the collar of her gown partly across her face while she gathers up a soft fold of drapery with a jeweled, delicate hand. The sculptor understood that the drapery and the body it enfolds are distinct. The artist subtly revealed the shape of Uta's right arm beneath her cloak and rendered the fall of drapery folds with an accuracy that indicates the use of a model. The two statues are arresting images of real people, even if they bear the names of aristocrats the artist never met. By the mid-13th century, life-size images of secular personages had found their way into churches.

Mary Grieves for Christ The confident Naumburg donors stand in marked contrast to a haunting German image of the Virgin Mary holding the dead Christ in her lap

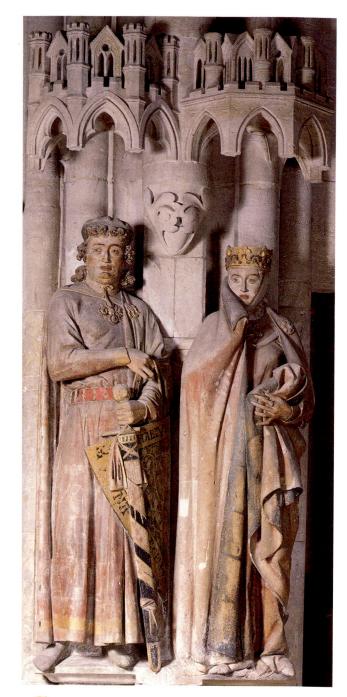

7-23 | Ekkehard and Uta, statues in the west choir, Naumburg Cathedral, Naumburg, Germany, ca. 1249–1255. Painted limestone, approx. 6' 2" high.

The period costumes and individualized features of these donor portraits give the impression that Ekkehard and Uta posed for their statues, but they lived long before the sculbtor's time.

(FIG. 7-24). The widespread troubles of the 14th century—war, plague, famine, and social strife—brought on an ever more acute awareness of suffering. This found its way readily into religious art. A fevered and fearful piety sought comfort and reassurance in the reflection that Christ and the Virgin Mother shared humanity's woes. To represent this, artists emphasized the traits of human suffering in powerful, expressive exaggeration. In the illustrated carved and painted wood

7-24 | Virgin with the Dead Christ (*Röttgen Pietà*), from the Rhineland, Germany, ca. 1300–1325. Painted wood, 2' $10\frac{1}{2}$ " high. Rheinisches Landemuseum, Bonn.

The widespread troubles of the 14th century and the German interest in emotional imagery are reflected in this statuette of the Virgin grieving over the distorted dead body of Christ in her lap.

group (called a *Pietà*, "pity" or "compassion" in Italian), the sculptor portrayed Christ as a stunted, distorted human wreck, stiffened in death and covered with streams of blood gushing from a huge wound. Mary, who cradles him like a child in her lap, is the very image of maternal anguish, her oversized face twisted in an expression of unbearable grief.

This statue expresses nothing of the serenity of earlier Gothic depictions of the Virgin (Fig. 7-4, right tympanum). Nor does the *Röttgen Pietà* (named after a collector) have anything in common with the aloof, iconic images of the Theotokos with the infant Jesus in her lap common in Byzantine art (Fig. 4-18). Here the artist forcibly confronts the devout with an appalling icon of agony, death, and sorrow that

humanizes, to the point of heresy, the sacred personages. The work calls out to the horrified believer, "What is your suffering compared to this?"

The humanizing of religious themes and religious images accelerated steadily from the 12th century. By the 14th century, art addressed the private person (often in a private place) in a direct appeal to the emotions. The expression of feeling accompanied the representation of the human body in motion. As the figures of the church portals began to twist on their columns, then move within their niches, and then stand independently, their details became more outwardly related to the human audience as expressions of recognizable human emotions.

ITALY

Nowhere is the regional diversity of Gothic art and architecture more evident than in Italy. In fact, scholars debate whether late-13th- and 14th-century Italian art should be considered Late Gothic, the last phase of medieval art, or Early Renaissance, the dawn of a new artistic age when artists broke away from medieval conventions and consciously revived the classical style. Both of these characterizations have merit.

Sculpture and Painting

Although the Visitation group statues of Reims Cathedral (Fig. 7-12) show the French sculptor's interest in Roman statuary, the reawakening of interest in the art of classical antiquity was most pronounced in Italy, where the Holy Roman Emperor Frederick II was the king of Sicily. Known in his own time as "the wonder of the world" for his many intellectual gifts and other talents, Frederick had a nostalgia for Rome's past grandeur. He fostered a revival of Roman sculpture and decoration in Sicily and southern Italy before the mid-13th century.

Nicola Pisano and Classical Art Nicola Pisano (Nicola of Pisa, active ca. 1258-1278) may have received his early training in this environment. After Frederick's death in 1250, Nicola traveled northward and eventually settled in Pisa. Then at the height of its political and economic power, Pisa was a locale for lucrative commissions. Nicola Pisano's sculpture, unlike the French sculpture of the period, was not part of the extensive decoration of great portals. He carved marble reliefs and ornament for large pulpits, completing the first in 1260 for the baptistery of Pisa Cathedral. Some elements of the pulpit's design carried on medieval traditions, but Nicola incorporated classical elements into this medieval type of structure. The large, bushy capitals are a Gothic variation of the Corinthian capital; the arches are round rather than pointed; and the large rectangular relief panels, if their proportions were altered slightly, could have come from the sides of Roman sarcophagi.

7-25 | NICOLA PISANO, *The Annunciation* and the Nativity, detail of pulpit of Pisa Cathedral baptistery, Pisa, Italy, 1259–1260. Marble relief, approx. 2' 10" × 3' 9".

The face types, beards, coiffures, and draperies as well as the bulk and weight of Pisano's figures were inspired by ancient reliefs the sculptor had studied in Italy. Specific motifs also derive from classical sources.

In one of these panels, *The Annunciation and the Nativity* (Fig. 7-25), the Virgin reclines like a lid figure on an Etruscan (Fig. 3-3) or Roman sarcophagus, and the face types, beards, coiffures, and draperies, as well as the bulk and weight of the figures, were clearly inspired by classical relief sculpture. Scholars have even been able to pinpoint the models for some of Nicola's figures on Roman sarcophagi the sculptor would have known.

Cimabue and Byzantium Late-13th-century Italian painting also differs sharply from the elegant court style popular north of the Alps. Byzantine style dominated Italian painting throughout the Middle Ages. The Italo-Byzantine style, or maniera greca (Greek style), still characterizes the art of Cenni di Pepo (ca. 1240-1302), better known by his nickname, CIMABUE (Bull's Head). In Cimabue's Madonna Enthroned with Angels and Prophets (Fig. 7-26), the heritage of Byzantine icon painting (Figs. 4-18 and 4-24) is apparent in the careful structure and symmetry, the poses of the figures, the gold lines of Mary's garments, and the gold background. However, Cimabue constructed a deeper space for the Madonna and the surrounding figures to inhabit than one finds in Byzantine painting, and he enhanced the folds and three-dimensionality of the drapery of the angels and prophets. Despite these and other progressive touches, such as the throne's solid appearance, this vast altarpiece is a final summary of Italo-Byzantine art before its utter transformation.

Giotto and Nature A naturalistic approach based on observation was the major contribution of GIOTTO DI BONDONE (ca. 1266–1337), who made a much more radical break with the past. Scholars still debate the sources of Giotto's style, although one source must have been the work of the man presumed to be his teacher, Cimabue. Late medieval mural

painting in Rome, French Gothic sculpture (emulated in Italy by Nicola Pisano's son, Giovanni Pisano, who had spent time in Paris), and ancient Roman sculpture and painting must also have contributed to Giotto's artistic education. Some believe that he was further influenced by new developments in contemporaneous Byzantine art. Yet no synthesis of these varied sources could have produced the significant shift in artistic approach that has led some scholars to describe Giotto as the father of Western pictorial art. Renowned in his own day, his reputation has never faltered. Regardless of the other influences on his artistic style, his true teacher was nature—the world of visible things.

Giotto's revolution in painting did not consist only of displacing the Byzantine style, establishing painting as a major art form for the next seven centuries, and restoring the naturalistic approach invented by the ancient Greeks and largely abandoned in the Middle Ages. He also inaugurated a method of pictorial expression based on observation and initiated an age that might be called "early scientific." By stressing the preeminence of sight for gaining knowledge of the world, Giotto and his successors contributed to the foundation of empirical science. They recognized that the visual world must be observed before it can be analyzed and understood. Praised in his own and later times for his fidelity to nature, Giotto was more than a mere imitator of it. He revealed nature while observing it and divining its visible order. In fact, he showed his generation a new way of seeing. With Giotto, Western artists turned resolutely toward the visible world as their source of knowledge of nature.

Giotto's Madonna On nearly the same great scale as the Madonna painted by Cimabue (Fig. 7-26), Giotto depicted her in a work that offers an opportunity to appreciate his perhaps most telling contribution to representational art—sculptural solidity and weight. In Giotto's *Madonna Enthroned*

7-26 | CIMABUE, *Madonna Enthroned with Angels and Prophets*, ca. 1280–1290. Tempera on wood, 12′ 7″ × 7′ 4″. Galleria degli Uffizi, Florence.

Cimabue was a master of the Italo-Byzantine style, which dominated Italian painting throughout the Middle Ages. Here, the heritage of Byzantine icon painting (Figs. 4-18 and 4-24) is apparent.

(Fig. 7-27), the Virgin rests within her Gothic throne with the unshakable stability of an ancient marble goddess. Giotto replaced Cimabue's slender Virgin, fragile beneath the thin gold ripplings of her drapery, with a sturdy, queenly mother, bodily of this world, even to the swelling of her bosom. The new art aimed, before all else, to construct a figure that has substance, dimensionality, and bulk. Works painted in the new style portray figures that project into the light and give the illusion that they could throw shadows. In Giotto's *Madonna Enthroned*, the throne is deep enough to contain the monumental figure and breaks away from the flat ground to project and enclose her.

The Arena Chapel Projecting on a flat surface the illusion of solid bodies moving through space presents a double

7-27 | GIOTTO DI BONDONE, *Madonna Enthroned*, ca. 1310. Tempera on wood, 10' 8" \times 6' 8". Galleria degli Uffizi, Florence.

Giotto displaced the Byzantine style in Italian painting and revived the naturalism of classical art. His figures have substance, dimensionality, and bulk, and give the illusion that they could throw shadows.

challenge. Constructing the illusion of a body also requires constructing the illusion of a space sufficiently ample to contain that body. In Giotto's fresco cycles (he was primarily a muralist), he constantly strove to reconcile these two aspects of illusionistic painting. His frescoes (see "Fresco Painting," page 206) in the Arena Chapel (Cappella Scrovegni) at Padua show his art at its finest. The Arena Chapel, which takes its name from an ancient Roman amphitheater nearby, was built for Enrico Scrovegni, a wealthy Paduan merchant, on a site adjacent to his now razed palace. This building, intended for the Scrovegni family's private use, was consecrated in 1305, and its design is so perfectly suited to its interior decoration that some scholars have suggested that Giotto himself may have been its architect.

MATERIALS + TECHNIQUES

Fresco Painting

Fresco has a long history, particularly in the Mediterranean region, where the Minoans used it as early as 1650 BCE (FIGS. 2-4 and 2-5). Fresco (Italian, "fresh") is a mural-painting technique that involves applying permanent limeproof pigments, diluted in water, on freshly laid lime plaster. Because the pigments are absorbed into the surface of the wall as the plaster dries, fresco is one of the most permanent painting techniques. The stable condition of frescoes such as those in the Arena Chapel (Fig. 7-28) and the Sistine Chapel (Fig. 9-8), now hundreds of years old, testify to the longevity of this painting method. The colors have remained vivid (although dirt and soot have necessitated cleaning) because of the chemically inert pigments the artists used. In addition to this buon fresco ("true" fresco) technique, artists used fresco secco (dry fresco). Fresco secco involves painting on dried lime plaster. Although the finished product visually approximates buon fresco, the pigments are not absorbed into the wall and simply adhere to the surface, so fresco secco does not have buon fresco's longevity. Compare, for example, the current condition of Michelangelo's buon fresco Sistine Ceiling (Fig. 9-9) with Leonardo da

Vinci's Last Supper (Fig. 9-2), executed largely in fresco secco (with experimental techniques and pigments).

The buon fresco process is time consuming and demanding and requires several layers of plaster. Although buon fresco methods vary, generally the artist prepares the wall with a rough layer of lime plaster called the *arriccio* (brown coat). The artist then transfers the composition to the wall, usually by drawing directly on the arriccio with a burnt-orange pigment called *sinopia* (most popular during the 14th century) or by transferring a *cartoon* (a full-sized preparatory drawing). Cartoons increased in usage in the 15th and 16th centuries, largely replacing sinopia underdrawings. Finally, the *intonaco* (painting coat) is laid smoothly over the drawing in sections (called *giornate*, Italian for "days") only as large as the artist expects to complete in that session. The artist must paint fairly quickly because once the plaster is dry, it will no longer absorb the pigment. Any areas of the intonaco that remain unpainted after a session must be cut away so that fresh plaster can be applied for the next qiornata.

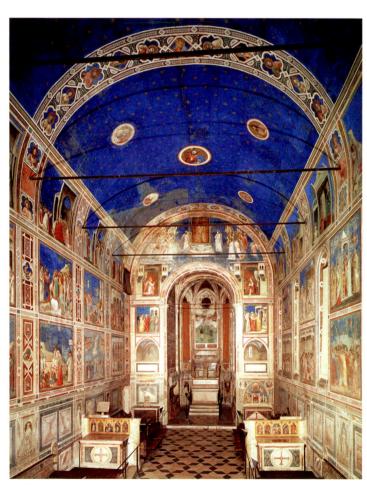

7-28 | Interior of the Arena Chapel (Cappella Scrovegni; view facing east), Padua, Italy, 1305–1306.

The frescoes Giotto painted for the Arena Chapel show his art at its finest. In 38 framed panels, he presented the complete cycle of the life of Christ, culminating in the Last Judgment covering the entrance wall.

The rectangular barrel-vaulted hall (Fig. 7-28) has six narrow windows in its south wall only, which leaves the entire north wall an unbroken and well-illuminated surface for painting. The entire building seems to have been designed to provide Giotto with as much flat surface as possible for presenting one of the most impressive and complete pictorial cycles of Christian Redemption ever rendered (see "The Life of Jesus in Art," Chapter 4, pages 126-127). With 38 framed pictures, arranged on three levels, the artist related the most poignant incidents from the lives of the Virgin and her parents Joachim and Anna (top level), the life and mission of Christ (middle level), and his Passion, Crucifixion, and Resurrection (bottom level). These three pictorial levels rest on a coloristically neutral base. Imitation marble veneer, reminiscent of ancient Roman wall decoration (Fig. 3-35), alternates with the Virtues and Vices painted in grisaille (monochrome grays, often used for modeling in paintings) to resemble sculpture. The climactic event of the cycle of human salvation, the Last Judgment, covers most of the west wall above the chapel's entrance.

Subtly scaled to the chapel's space (only about one-half life-size), Giotto's stately and slow-moving actors present their dramas convincingly and with great restraint. *Lamentation* (Fig. 7-29) reveals the essentials of his style. In the presence of angels darting about in hysterical grief, a congregation mourns over the dead body of the Savior just before its entombment. Mary cradles her son's body, while Mary Magdalene looks solemnly at the wounds in Christ's feet and Saint John the Evangelist throws his arms back dramatically. Giotto arranged a shallow stage for the figures, bounded by a thick diagonal rock incline that defines a horizontal ledge in the foreground. Though rather narrow, the ledge provides firm visual support for the figures, and the steep slope indicates the

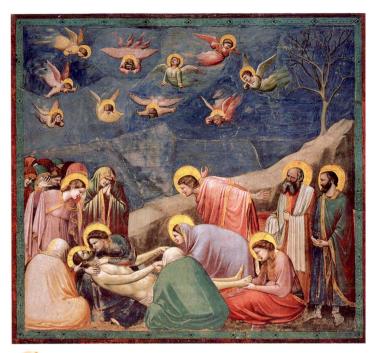

7-29 | GIOTTO DI BONDONE, *Lamentation*, Arena Chapel (Cappella Scrovegni), Padua, Italy, ca. 1305. Fresco, $6' \frac{6^{3}}{4}'' \times 6' \frac{3}{4}''$.

In this dramatic scene of grief, Giotto arranged his sculpturesque figures on a shallow stage and used the rocky landscape to direct the viewer's attention toward the head of the dead Christ.

picture's dramatic focal point at the lower left. The figures are sculpturesque, simple, and weighty, but this mass did not preclude motion and emotion. Postures and gestures that might have been only rhetorical and mechanical convey, in Lamentation, a broad spectrum of grief. They range from Mary's almost fierce despair to the passionate outbursts of Mary Magdalene and John to the philosophical resignation of the two disciples at the right and the mute sorrow of the two hooded mourners in the foreground. Giotto constructed a kind of stage that served as a model for artists who depicted human dramas in many subsequent paintings. His style was far removed from the isolated episodes and figures seen in art until the late 13th century. In Lamentation, a single event provokes an intense response. This integration of formality with emotional composition was rarely attempted, let alone achieved, in art before Giotto.

The formal design of the *Lamentation* fresco, the way the figures are grouped within the constructed space, is worth close study. Each group has its own definition, and each contributes to the rhythmic order of the composition. The strong diagonal of the rocky ledge, with its single dead tree (the tree of knowledge of good and evil, which withered at the Fall of Adam), concentrates the viewer's attention on the group around the head of Christ, whose positioning is dynamically off center. All movement beyond this group is contained, or arrested, by the massive bulk of the seated mourner in the painting's left corner. The seated mourner to the right

establishes a relation with the central figures, who, by their gazes and gestures, draw the viewer's attention back to Christ's head. Figures seen from the back, which are frequent in Giotto's compositions, represent an innovation in the development away from the formal Italo-Byzantine style. These figures emphasize the foreground, aiding the visual placement of the intermediate figures farther back in space. This device, the very contradiction of the old frontality, in effect puts the viewer behind the "observer" figures, who, facing the action as spectators, reinforce the sense of stagecraft as a model for painting.

Giotto's new devices for depicting spatial depth and bodily mass could not, of course, have been possible without his management of light and shade. He shaded his figures to indicate both the direction of the light that illuminates them and the shadows (the diminished light), giving the figures volume. In *Lamentation*, light falls upon the upper surfaces of the figures (especially the two central bending figures) and passes down to dark in their draperies, separating the volumes one from the other and pushing one to the fore, the other to the rear. The graded continuum of light and shade, directed by an even, neutral light from a single steady source—not shown in the picture—was the first step toward the development of *chiaroscuro* (the use of dramatic contrasts of dark and light to produce *modeling*).

Giotto's stagelike settings are pictorial counterparts to contemporaneous "mystery plays," in which the drama of the Mass was performed in one- and two-act narratives at church portals and in city squares. The great increase in popular sermons to huge city audiences prompted a public taste for narrative, recited as dramatically as possible. The arts of illusionistic painting, of drama, and of sermon rhetoric with all their theatrical flourishes were developing simultaneously and were mutually influential. Giotto's art masterfully—perhaps uniquely—synthesized dramatic narrative, holy lesson, and truth to human experience in a visual idiom of his own invention, accessible to all.

Duccio's Maestà The Republics of Siena and Florence were two of the leading city-states of 14th-century Italy. The Sienese were particularly proud of their victory over the Florentines at the battle of Monteperti in 1260, and believed the Virgin Mary had sponsored their triumph. This belief reinforced Sienese devotion to the Virgin, which was paramount in the religious life of the city. Sienese citizens could boast of Siena's dedication to the Queen of Heaven as more ancient and venerable than that of all others. To honor the Virgin, the Sienese commissioned Duccio di Buoninsegna (active ca. 1278-1318) to paint an immense altarpiece, the Maestà (Virgin Enthroned in Majesty), for the Cathedral of Siena in 1308. Duccio's inscription of his name at the base of the Virgin's throne in the Maestà is part of a prayer for himself and for the city of Siena and its churches. The work, painted in tempera front and back and composed of many panels, was completed by Duccio and his assistants in 1311. As originally

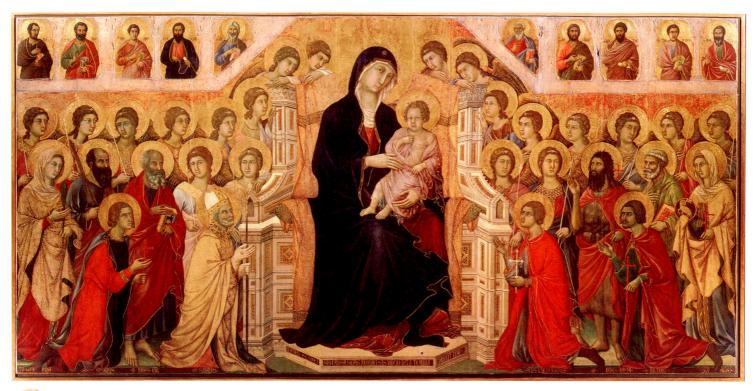

7-30 | DUCCIO DI BUONINSEGNA, *Virgin and Child Enthroned with Saints*, principal panel of the *Maestà* altarpiece, from Siena Cathedral, Siena, Italy, 1308–1311. Tempera on wood, panel 7' × 13'. Museo dell'Opera del Duomo, Siena.

Duccio derived the formality and symmetry of his composition from Byzantine tradition, but relaxed the rigidity and frontality of the figures, softened the drapery, and individualized the faces.

executed, it consisted of a 7-foot-high center panel (Fig. 7-30), surmounted by 7 pinnacles above, and a predella, or raised shelf, of panels at the base, altogether some 13 feet high.

The main panel of the front side represents the Virgin as the enthroned Queen of Heaven amid choruses of angels and saints. Duccio derived the composition's formality and symmetry, along with the figures and facial types of the principal angels and saints, from Byzantine tradition. But the artist relaxed the strict frontality and rigidity of the Byzantine compositions. The figures turn to each other in quiet conversation. Further, Duccio individualized the faces of the four saints kneeling in the foreground, who perform their ceremonial gestures without stiffness. Similarly, he softened the usual Byzantine hard body outlines and drapery patterning. The drapery, particularly that of the female saints at both ends of the panel, falls and curves loosely. This is a feature familiar in French Gothic works (FIG. 7-17) and is a mark of the artistic dialogue that occurred between Italy and the north in the 14th century.

Despite these changes that reveal Duccio's interest in the new naturalism, he respected the age-old requirement that as an altarpiece, the *Maestà* would occupy the very center of the sanctuary as the focus of worship. As such, it should be an object holy in itself—a work of splendor to the eyes, precious in its message and its materials. Duccio thus recognized that the function of this work naturally limited experimentation with depicting narrative action and producing illusionistic effects

(such as Giotto's) by modeling forms and adjusting their placement in pictorial space. Instead, the Queen of Heaven panel is a miracle of color composition and texture manipulation, unfortunately not apparent in a photo. Close inspection of the original reveals what the Sienese artists learned from other sources. In the 13th and 14th centuries, Italy was the distribution center for the great silk trade from China and the Middle East. After processing in city-states such as Lucca and Florence, the silk was exported throughout Europe to satisfy an immense market for sumptuous dress. People throughout Europe prized fabrics from China, Byzantium, and the Islamic realms. In the *Maestà* panel, Duccio created the glistening and shimmering effects of textiles, adapting the motifs and design patterns of exotic materials.

The International Style SIMONE MARTINI (ca. 1285–1344) was a pupil of Duccio and a close friend of the poet and scholar Francesco Petrarch (1304–1374), who praised him highly for his portrait of "Laura" (the woman to whom Petrarch dedicated his sonnets). Martini worked for the French kings in Naples and Sicily and, in his last years, produced paintings for the papal court, which in the 14th century was located at Avignon, France, where he came in contact with northern painters. By adapting the insubstantial but luxuriant patterns of the French Gothic manner to Sienese art and, in turn, by acquainting northern painters with the

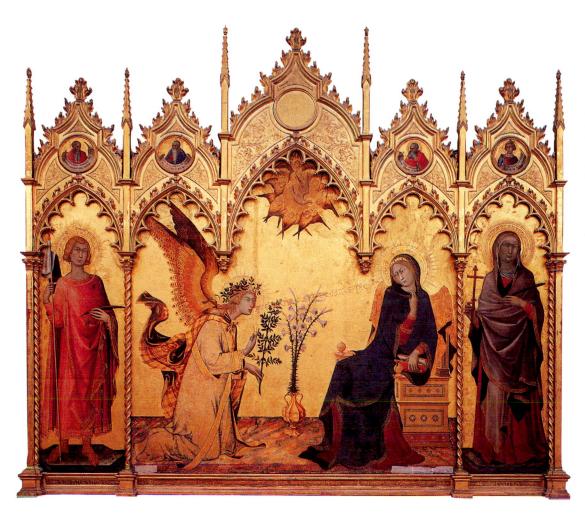

7-31 | SIMONE MARTINI and LIPPO MEMMI(?), Annunciation, 1333 (frame reconstructed in the 19th century). Tempera and gold leaf on wood; center panel, approx. 10′ 1″ × 8′ 8³/₄″. Galleria degli Uffizi, Florence.

A pupil of Duccio, Martini was instrumental in the formation of the International Style, which featured elegant shapes, radiant color, flowing line, and weightless figures in spaceless settings.

Sienese style, Martini was instrumental in forming the socalled *International Style*. This new style swept Europe during the late 14th and early 15th centuries. It appealed to the aristocratic taste for brilliant colors, lavish costumes, intricate ornamentation, and themes involving splendid processions.

Martini's own style did not quite reach the full exuberance of the developed International Style, but his famous Annunciation altarpiece (Fig. 7-31) provides a counterpoint to Giotto's style. Elegant shapes and radiant color; flowing, fluttering line; and weightless figures in a spaceless setting characterize the Annunciation. The complex etiquette of the European chivalric courts dictated the presentation. The angel Gabriel has just alighted, the breeze of his passage lifting his mantle, his iridescent wings still beating. The gold of his sumptuous gown heraldically represents the celestial realm from which he has descended. The Virgin, putting down her book of devotions, shrinks demurely from Gabriel's reverent genuflection, an appropriate gesture in the presence of royalty. She draws about her the deep blue, golden-hemmed mantle, the heraldic colors she wears as Queen of Heaven. Despite the Virgin's modesty and diffidence and the tremendous import of the angel's message, the scene subordinates drama to court ritual and structural experimentation to surface splendor. The intricate tracery of the richly tooled Late Gothic frame enhances the painted magnificence. Of French inspiration, it replaced the more sober, clean-cut shapes traditional in Italy, and its appearance

here is eloquent testimony to the two-way flow of transalpine influences that fashioned the International Style.

Simone Martini and his student and assistant, LIPPO MEMMI, signed the altarpiece and dated it (1333). Lippo's contribution to the *Annunciation* is still a matter of debate, but historians now generally agree he painted the two lateral saints. Lippo depicted these figures, which are reminiscent of the jamb statues of Gothic church portals, with greater solidity and without the linear elegance of Martini's central pair. Given medieval and Renaissance workshop practices, it is often next to impossible to distinguish the master's hand from those of assistants, especially if the master corrected or redid part of the assistants' work. This uncertainty is exacerbated by the fact that Annunciation's current architectural frame is much later than the center panel.

Good Government Another of Duccio's students was AMBROGIO LORENZETTI (active 1319–1348), who shared in the general experiments in pictorial realism that characterized 14th-century Italy. In a vast fresco program he executed in Siena's Palazzo Pubblico (city hall), Lorenzetti both elaborated in spectacular fashion the advances in illusionistic representation and gave visual form to Sienese civic concerns. He painted three frescoes in the Palazzo Pubblico: *Allegory of Good Government, Bad Government and the Effects of Bad Government in the City*, and *Effects of Good Government in*

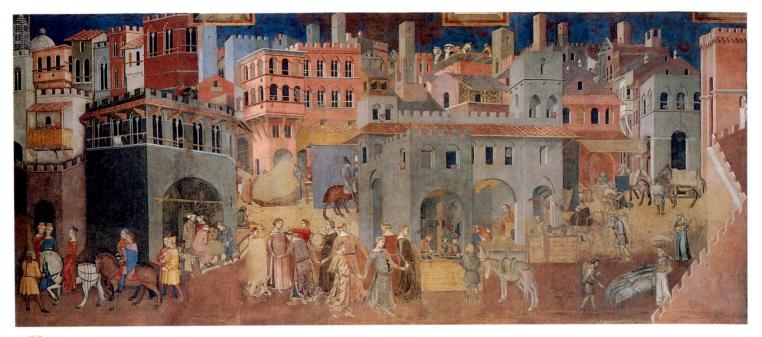

7-32 | Ambrogio Lorenzetti, *Peaceful City*, detail from *Effects of Good Government in the City and in the Country*, Sala della Pace, Palazzo Pubblico, Siena, Italy, 1338–1339. Fresco.

Also a student of Duccio, Lorenzetti pursued his interest in illusionistic representation in this panorama of the bustling city of Siena. The fresco was intended as an allegory of good government.

the City and in the Country. The turbulent politics of the Italian cities—the violent party struggles, the overthrow and reinstatement of governments—certainly would have called for solemn reminders of fair and just administration. And the city hall was just the place for paintings such as Ambrogio Lorenzetti's. Indeed, the leaders of the Sienese government who commissioned this fresco series had undertaken the "ordering and reformation of the whole city and countryside of Siena."

In *Peaceful City* (Fig. 7-32), a detail of *Effects of Good Government in the City and in the Country*, the artist depicted the urban effects of good government. The fresco is a panoramic view of Siena, with its palaces, markets, towers, churches, streets, and walls. The city's traffic moves peacefully, guild members ply their trades and crafts, and a cluster of radiant maidens, hand in hand, performs a graceful circling dance. Such dancers were part of festive springtime rituals. Here, their presence also serves as a metaphor for a peaceful commonwealth. The artist fondly observed the life of his city, and its architecture gave him an opportunity to apply Sienese artists' rapidly growing knowledge of perspective.

In the *Peaceful Country* section of the fresco (not illustrated), Lorenzetti presented a bird's-eye view of the undulating Tuscan countryside, with its villas, castles, plowed farmlands, and peasants going about their seasonal occupations. An allegorical figure of Security hovers above the landscape, unfurling a scroll that promises safety to all who live under the rule of law. Lorenzetti's "portrait" of the Sienese countryside is one of the first appearances of landscape in Western art since antiquity.

Architecture

The picture of Siena in Ambrogio Lorenzetti's *Peaceful City* (Fig. 7-32) could not be confused with a view of a French, German, or English city of the 14th century. Italian architects stood apart from developments north of the Alps, and some architectural historians even have questioned whether it is proper to speak of late medieval Italian buildings as Gothic structures.

Orvieto Cathedral The west facade of Orvieto Cathedral (Fig. 7-33) is typical of "Gothic" architecture in Italy. Designed in the early 14th century by the Sienese architect LORENZO MAITANI, the Orvieto facade imitates some elements of the French Gothic architectural vocabulary. French influence is especially noticeable in the pointed gables over the three doorways, in the rose window in the upper zone framed by statues in niches, and in the four large pinnacles that divide the facade into three bays. The outer pinnacles serve as miniature substitutes for the big northern European west-front towers. Maitani's facade is, however, merely a Gothic overlay masking a marble-revetted structure in the Tuscan Romanesque tradition, as our threequarter view of the cathedral reveals. The Orvieto facade resembles a great altar screen, its single plane covered with carefully placed carved and painted ornament. In principle, Orvieto belongs with Pisa Cathedral (Fig. 6-21) and other Italian buildings, rather than with Reims Cathedral (Fig. 7-11). Inside, Orvieto Cathedral has a timber-roofed nave with a two-story elevation (columnar arcade and clerestory). Both the arch framing the apse and the nave arcade's arches are round as opposed to pointed.

7-33 | LORENZO MAITANI, west facade of Orvieto Cathedral, Orvieto, Italy, begun 1310.

The pointed gables over the doorways, the rose window, and the large pinnacles derive from French architecture, but the facade of Orvieto Cathedral is merely a Gothic overlay masking a timber-roofed basilica.

The Republic of Florence Like Siena, the Republic of Florence was a dominant city-state during the 14th century. One early historian, Giovanni Villani (ca. 1270–1348), wrote that Florence was "the daughter and the creature of Rome," suggesting a preeminence inherited from the Roman Empire. Florentines prided themselves on what they perceived as economic and cultural superiority. Florence assured its centrality to banking operations by making its gold florin the standard coin of exchange everywhere. Florence's economic prosperity was further enhanced by its control of the textile industry.

Tuscany's Most Beautiful Church The city's citizens translated their pride in their predominance into landmark buildings such as Florence Cathedral (Fig. 7-34), begun in 1296 by Arnolfo Di Cambio. Intended as the "most beautiful and honorable church in Tuscany," this structure reveals the competitiveness Florentines felt with such cities as Siena and Pisa. Cathedral authorities planned for the church to hold the city's entire population, and although it holds only about 30,000 (Florence's population at the time was slightly less than 100,000), it seemed so large that the architect Leon Battista Alberti (1404–1472) commented that it seemed to cover "all of Tuscany with its shade." The vast gulf that separates this low, longitudinal basilican church with its Tuscan-style marble-encrusted walls from its towering transalpine counterparts is strikingly evident when the former is compared with Reims Cathedral (Fig. 7-11), completed several years before work began in Florence.

The giant dome of Florence Cathedral (Fig. 8-18) dates to the 15th century, but the painter Giotto di Bondone designed its tower in 1334. The campanile stands apart from the cathedral in the Italian tradition (Fig. 6-21). In fact, it could stand

7-34

ARNOLFO DI CAMBIO and others, Florence Cathedral (view from the south), Florence, Italy, begun 1296.

This longitudinal basilican church with its Tuscan-style marble-encrusted walls forms a striking contrast to Reims Cathedral (Fig. 7-11) and underscores the regional diversity of Gothic architecture. **7-35** | Aerial view of Milan Cathedral (from the southwest), Milan, Italy, begun 1386.

Milan Cathedral's elaborate facade is a confused mixture of Late Gothic pinnacles and tracery and Renaissance pediment-capped rectilinear portals. It marks the waning of the Gothic style.

anywhere else in Florence without looking out of place; it is essentially self-sufficient. The same can hardly be said of northern Gothic towers. They are essential elements of the building behind them, and it would be unthinkable to detach one of them and place it somewhere else. Giotto's tower is neatly subdivided into cubic sections. Not only could this tower be removed from the building without adverse effects, but also each of the component parts—cleanly separated from each other by continuous moldings—seems capable of existing independently as an object of considerable aesthetic appeal. This compartmentalization is reminiscent of the Romanesque style, but it also forecasts the ideals of Renaissance architecture. Artists hoped to express structure in the clear, logical relationships of the component parts and to produce self-sufficient works that could exist in complete independence.

Milanese Eclecticism Not all of Italy was as fiercely resistant to the French Gothic manner as was Tuscany. Since Romanesque times, northern European influences had been felt strongly in Lombardy. When Milan's citizens decided to build their own cathedral (Fig. 7-35) in 1386, they invited experts not only from Italy but also from France, Germany, and England. These masters argued among themselves and with the city council, and no single architect ever played a dominant role. The result of this attempt at "architecture by committee" was, not surprisingly, a compromise. The building's proportions, particularly the nave's, became Italian (that is, wide in relation to height), and the surface decorations and details remained Gothic. Clearly derived from France are the cathedral's multitude of pinnacles and the elaborate tracery on the facade, flank, and transept. But even before the building was half

finished, the new classical style of the Italian Renaissance had been well launched (see Chapter 8), and the Gothic design had become outdated. Thus, Milan Cathedral's elaborate facade represents a confused mixture of Late Gothic and classicizing Renaissance elements. With its classicizing pediment-capped rectilinear portals amid Gothic pinnacles, the cathedral stands as a symbol of the waning of the Gothic style.

CONCLUSION

The story of Gothic art and architecture is a tale of two regions. North of the Alps, the creative center was the Île-de-France. At Saint-Denis, Paris, Chartres, and elsewhere, French architects pioneered a new building style. Using rib vaults with pointed arches, flying buttresses, and stained-glass windows, French builders constructed towering cathedrals with statue-lined portals that contemporaries regarded as images of the City of God on earth. The French architectural style spread quickly throughout Europe, as did the Parisian court style of book illumination and freestanding sculpture.

In contrast, Italian "Gothic" churches carried on the basilican tradition of Early Christian and Romanesque times. But the Italians were pioneers in the field of painting. Artists such as Giotto and Duccio began to abandon some of the conventions of medieval art and increasingly based their artworks on their worldly observations, resulting in a greater naturalism in art. Greater illusionism, more emphatic pictorial solidity and spatial depth, and stronger emotional demonstrations from depicted figures were among the developments. This changing worldview, rooted in a revived veneration of classical cultures, came to be known as the Renaissance.

HIGH GOTHIC

1140

- Suger, Abbot of Saint-Denis, 1122-1151
- I King Louis VII of France, r. 1137-1180
 - Frederick Barbarossa, Holy Roman Emperor, r. 1152-1190

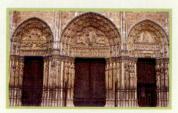

Royal Portal, Chartres Cathedral, ca. 1145-1155

1194

- I University of Paris founded, ca. 1200
- I Latins capture Constantinople, 1204
- I Frederick II, Holy Roman Emperor, r. 1220-1250
- Saint Thomas Aquinas, 1225-1274
- I King Louis IX (Saint Louis) of France, r. 1226-1270
- I Blanche of Castile, regent of France, 1226-1234

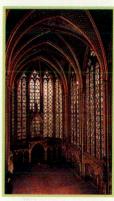

Sainte-Chapelle, Paris, 1243-1248

2

- 1250
- | Byzantines retake Constantinople, 1261
- Dante Alighieri, 1265-1321
- Marco Polo in China, 1275-1292
- Francesco Petrarch, 1304-1374

3 Giotto, Lamentation, Arena Chapel, Padua, 1305

1305

- Papacy moved to Avignon, 1305
 - I Hundred Years' War between France and England, 1337–1453
 - Black Death, 1348-mid 1350s
 - I Great Schism in the Christian Church, 1378-1417

4

LATE GOTHIC

1400

4 Milan Cathedral, begun 1386

15TH-CENTURY EUROPE

In the Late Gothic period, Europe experienced the calamities of war, plague, and social upheaval. The Black Death that ravaged Italy in 1348, killing 50 to 60 percent of the population in the largest cities, also decimated much of the rest of Europe. The Hundred Years' War (1337–1453) further contributed to instability across the continent. Primarily a protracted series of conflicts between France and England, the war also involved Flanders. Technically, Flanders was a principality or county in the Netherlands, a country that consisted of what today is Belgium, Holland, Luxembourg, and part of northern France (MAP 8-1, page 528). However, during the 15th century, "Flanders" also referred more generally to a broader territory. During the Hundred Years' War, urban revolts erupted in this larger Flanders, England's chief market for raw wool. France's intervention in the Flemish problem threatened England's revenues, thereby intensifying the antagonism between France and England that underlay the long-simmering war.

Crisis in the religious realm exacerbated the period's political instability. In 1305, a French pope, Clement V, was elected. He and the French popes who succeeded him chose to reside in Avignon, France, despite their announced intentions to return to Rome. Understandably, this did not sit well with Italians, who saw Rome as the rightful capital of the universal church. The conflict between the French and Italians resulted in the election in 1378 of two popes—Clement VII, who remained in Avignon, and Urban VI, who resided in Rome. Thus began what became known as the Great Schism, which lasted four decades, until a new Roman pope acceptable to all, Martin V, was elected in 1417.

Despite the troubles of the age, a new economic system evolved—the early stage of European capitalism. Responding to the financial requirements of trade, new credit and exchange systems created an economic network of enterprising European cities. The trade in money accompanied the trade in commodities, and the former financed industry. Both were in the hands of trading companies with central offices and international branches. In Italy, the most prominent financiers were the Medici of Florence, who were also great art patrons. North of the Alps, the first international commercial stock exchange was established in Flanders at Antwerp in 1460. It became pivotal for Europe's integrated economic activity. The thriving commerce, industry, and finance contributed to the evolution of cities, as did the migration of a significant portion of the rural population to urban centers.

A Cultural Rebirth The 15th century also witnessed the flourishing of a significantly new and expanded artistic culture that had already taken root in 14th-century Italy—the Renaissance (French, "rebirth"). Although religion continued

LORENZO GHIBERTI, east doors ("Gates of Paradise"), baptistery of Florence Cathedral, Florence, Italy, 1425–1452. Gilded bronze relief, approx. 17' high. Modern copy, ca. 1980. Original panels in Museo dell'Opera del Duomo, Florence.

to occupy a primary position in the lives of Europeans, a growing concern with the natural world, the individual, and humanity's worldly existence characterized the Renaissance period. A revived interest in classical cultures—indeed, the veneration of classical antiquity as a model—was central to this rebirth, hence the notion of the Middle Ages, or medieval period, as the age in between antiquity and the Renaissance. The transition from the medieval to the Renaissance, though dramatic, did not come about abruptly. The Renaissance had its roots in epochs that even preceded the Middle Ages, and much that is medieval persisted in the Renaissance and in later periods. The Renaissance eventually gave way to the modern era. The continuous nature of this development is revealed in the use of the term "early modern" by many scholars to describe the Renaissance.

Fundamental to the development of the Italian Renaissance was humanism. Humanism was more a code of civil conduct, a theory of education, and a scholarly discipline than a philosophical system. As the word suggests, the chief concerns of the humanists were human values and interests as distinct from—but not opposed to—religion's otherworldly values. Humanists held up classical cultures as particularly laudatory. This enthusiasm for antiquity engendered study of Latin classics and a conscious emulation of what proponents thought were the Roman civic virtues. These included self-sacrificing service to the state, participation in government, defense of state institutions (especially the administration of justice), and stoic indifference to personal misfortune in the performance of duty. With the help of a new interest in and knowledge of Greek, the humanists of the late 14th and 15th centuries recovered a large part of the Greek as well as the Roman literature and philosophy that had been lost, left unnoticed, or cast aside in the Middle Ages. What classical cultures provided to humanists was a model for living in this world, a model primarily of human focus that derived not from an authoritative and traditional religious dogma but from reason.

Ideally, humanists sought no material reward for services rendered. The sole reward for heroes of civic virtue was fame, just as the reward for leaders of the holy life was sainthood. For the educated, the lives of heroes and heroines of the past became as edifying as the lives of the saints. Francesco Petrarch (1304–1374) wrote a book on illustrious men, and his colleague Giovanni Boccaccio (1313-1375) complemented it with biographies of famous women—from Eve to his contemporary, Joanna, queen of Naples. Both Petrarch and Boccaccio were famous in their own day as poets, scholars, and men of letters, and their achievements were considered equivalent in honor to those of the heroes of civic virtue. In 1341, Petrarch was crowned in Rome with the laurel wreath, the ancient symbol of victory and merit. The humanist cult of fame emphasized the importance of creative individuals and their role in contributing to the renown of their own city-state and of all Italy.

The humanism disseminated by Petrarch and Boccaccio during the 14th century had greater impact as the 15th century progressed. The development of a literature based on a

vernacular (commonly spoken) Tuscan dialect expanded the audience for humanist writings. Further, the invention of movable metal type by the German Johann Gutenberg around 1445 facilitated the printing and wide distribution of books. Italians enthusiastically embraced this new printing process. By 1464 Subiaco (near Rome) boasted a press, and by 1469 Venice had established one as well. Among the first books printed in Italy using this new press was *Divine Comedy*, a vernacular epic poem by Dante Alighieri (1265–1321) about Heaven, Purgatory, and Hell.

The humanists avidly acquired information in a wide range of fields other than classical antiquity, including science (such as botany, geology, geography, and optics), medicine, and engineering. Leonardo da Vinci's phenomenal expertise in many fields—from art and architecture to geology, aerodynamics, hydraulics, botany, and military science, among many others—served to define the modern notion of a "Renaissance man."

FLANDERS

At the opening of the 15th century, Philip the Good (r. 1419–1467) ruled a region known as the Duchy of Burgundy (MAP 8-1, page 528), the fertile east-central region of France still known for its wines. In the late 14th century, one of Philip the Good's predecessors, Philip the Bold (r. 1364–1404), had married the daughter of the count of Flanders, thereby acquiring counties in the Netherlands. The dukes of Burgundy wielded power over not just the county of Flanders proper but the broader Flanders as well.

The source of Burgundian wealth and power was at Bruges, the city that made Burgundy a dangerous rival of royal France. Bruges initially derived its wealth from the wool trade and soon expanded into banking, becoming the financial clearing-house for all of northern Europe. Indeed, Bruges so dominated Flanders that the duke of Burgundy eventually chose to make the city his capital and moved his court there from Dijon in the early 15th century.

Due to the expanded territory and the prosperity of the "Burgundian Netherlands," the dukes of Burgundy were probably the most powerful rulers in northern Europe during the first three quarters of the 15th century. Although cousins of the French kings, they usually supported England (on which they relied for the raw materials used in their wool industry) during the Hundred Years' War and, at times, controlled much of northern France, including Paris. The death of Charles the Bold (r. 1467–1477) brought to an end the Burgundian dream of forming a strong middle kingdom between France and the Holy Roman Empire. After Charles's death, France reabsorbed the southern Burgundian lands, and the Netherlands passed to the Holy Roman Empire by virtue of the dynastic marriage of Charles's daughter, Mary of Burgundy, to Maximilian of Habsburg.

Chartreuse de Champmol Philip the Bold was among the greatest art patrons in northern Europe. His largest artistic enterprise was the building of the Chartreuse (Carthusian

monastery) de Champmol, near Dijon. Founded in the late 11th century by Saint Bruno, the Carthusian order consisted of monks who devoted their lives to solitary living and prayer. Saint Bruno established the order at Chartreuse, near Grenoble in southeastern France; hence, the term *chartreuse* ("charter house" in English) refers to a Carthusian monastery. Because Carthusian monasteries did not generate revenues, Philip the Bold's generous endowment at Champmol was significant and attracted artists from all parts of northern Europe. Intended as a tomb repository for the duchy of Burgundy, the Chartreuse de Champmol also served as a dynastic symbol meant to ensure Burgundian power and salvation in perpetuity.

The Fountain of Life For the cloister of the Chartreuse de Champmol, Philip the Bold's head sculptor, CLAUS SLUTER (active ca. 1380–1406), designed a large fountain located in a well that provided water for the monastery. It seems probable, however, that the fountain did not actually spout water, because the Carthusian commitment to silence and prayer would have precluded anything that produced sound. Although Sluter died before completing the entire fountain, he did finish Well of Moses (Fig. 8-1) in 1406. Moses, David, and four other prophets (Daniel, Isaiah, Jeremiah, and Zachariah) surround a base that once supported a Crucifixion group. Despite the nonfunctioning nature of this fountain, it had immense symbolic significance as a fountain of life, with the blood of Christ (on the cross above) flowing down over the Old Testament prophets, washing away their sins and spilling into the well below. The Well of Moses thus represented the promise of everlasting life.

Although the six figures recall the jamb statues (Figs. 7-9 and 7-12) of Gothic portals, they are much more realistically rendered. Sluter's intense observation of natural appearance enabled him to sculpt the figures in minute detail. Heavy draperies with voluminous folds swath the life-size figures. The artist succeeded in making their difficult, complex surfaces seem remarkably naturalistic. He enhanced this effect by skill-fully differentiating textures, from coarse drapery to smooth flesh and silky hair. The paint (much of which has flaked off) applied to the sculptural surfaces by Jean Malouel further augments the naturalism of the figures. This fascination with the specific and tangible in the visible world became one of the chief characteristics of 15th-century Flemish painting.

Flemish Altarpieces One of the most characteristic art forms in 15th-century Flanders was the monumental freestanding altarpiece. Placed behind the altar, these imposing works served as backdrops for the Mass. Given their function, it is not surprising that many altarpieces depict scenes directly related to Christ's sacrifice. Flemish altarpieces most often took the form of *polyptychs* (hinged multipaneled paintings or relief panels). The hinges allowed the clergy to close the polyptych's side wings over the center panel(s). Artists decorated both the exterior and interior of the altarpieces. This multi-image format allowed artists to construct narratives through a sequence of images, somewhat like manuscript

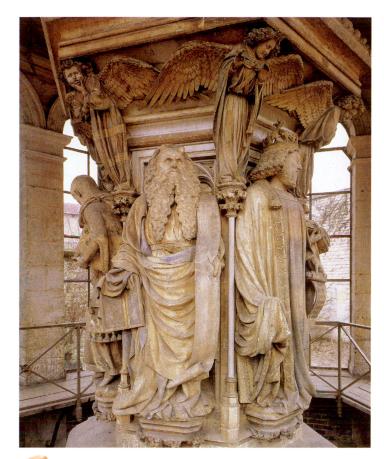

8-1 | CLAUS SLUTER, Well of Moses, Chartreuse de Champmol, Dijon, France, 1395–1406. Limestone with traces of paint, figures approx. 6' high.

Once supporting a Crucifixion group, Sluter's Well of Moses was a symbolic fountain of life. His figures recall the jamb statues (Figs. 7-9 and 7-12) of French Gothic portals but are far more realistic.

illustration. Although it is not known precisely when these altarpieces were opened or closed, evidence suggests that they remained closed on regular days and were opened on Sundays and feast days. This schedule would have allowed viewers to see both the interior and exterior—diverse imagery at various times according to the liturgical calendar.

Redemption and Salvation The *Ghent Altarpiece* (Figs. 8-2 and 8-3) in the Cathedral of Saint Bavo in Ghent is one of the largest and most admired Flemish altarpieces of the 15th century. Jodocus Vyd and his wife Isabel Borluut commissioned this polyptych from Jan van Eyck (ca. 1390–1441), who was Philip the Good's court painter. Vyd's largess and the political and social connections that this work revealed to its audience contributed to Vyd's appointment as *burgomeister* (chief magistrate) of Ghent shortly after the work was unveiled in 1432. Two of the exterior panels (Fig. 8-2) of the *Ghent Altarpiece* include *donor portraits* (likenesses of the individuals who commissioned—donated—a religious work as evidence of devotion) at the bottom. The husband and wife, painted in illusionistically rendered niches, kneel with their hands clasped in prayer. They gaze piously at illusionistic stone sculptures of

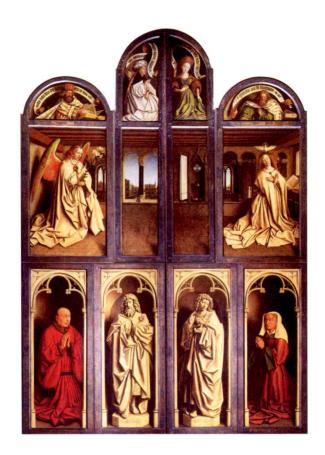

8-2 | JAN VAN EYCK, Ghent Altarpiece (closed), Saint Bavo Cathedral, Ghent, Belgium, completed 1432. Oil on wood, approx. 11' 6" × 7' 6".

Monumental altarpieces were popular backdrops for the Mass in 15th-century Flanders. Artists decorated both the interiors and exteriors of these hinged polyptychs, often incorporating donor portraits.

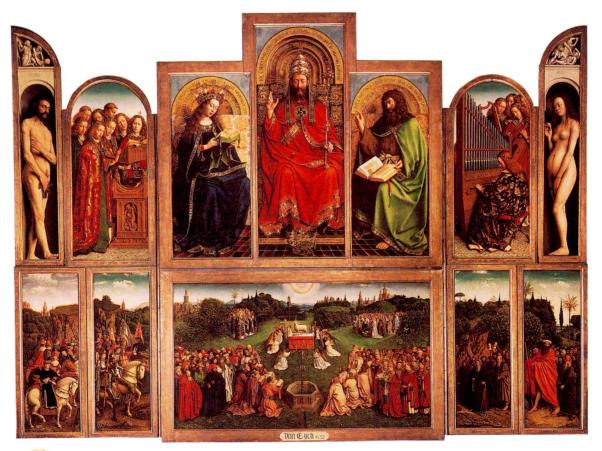

8-3 | JAN VAN EYCK, *Ghent Altarpiece* (open), Saint Bavo Cathedral, Ghent, Belgium, completed 1432. Oil on wood, approx. 11' 6" × 15'.

In this sumptuous painting of salvation from the Original Sin of Adam and Eve, God the Father presides in majesty. Van Eyck rendered every figure, garment, and object with loving fidelity to appearance.

Painters, Pigments, and Panels

The generic word *paint* or *pigment* encompasses a wide range of substances artists have used over the years. Fresco aside (see "Fresco Painting," Chapter 7, page 206), egg tempera was the material of choice for most painters during the 14th century, both in Italy and northern Europe. *Tempera* consists of egg combined with a wet paste of ground pigment. In his influential treatise *Il libro dell'arte (The Craftsman's Handbook)*, Cennino Cennini, an Italian painter, mentioned that artists mixed only the egg yolk with the ground pigment, but analysis of paintings from this period has revealed that some artists chose to use the whole egg. Images painted with tempera have a velvety sheen to them and exhibit a lightness of artistic touch because thick application of the pigment mixture results in premature cracking and flaking.

Scholars have discovered that artists used oil paints as far back as the 8th century, but not until the early 15th century did painting with this material become widespread. Flemish artists were among the first to employ oils extensively (often mixing them with tempera), and Italian painters quickly followed suit. The discovery of better drying components in the early 15th century enhanced the setting capabilities of oils. Rather than apply these oils in the light, flecked brush strokes that tempera encouraged, artists laid the oils down in transparent glazes over opaque or

semiopaque underlayers. In this manner, painters could build up deep tones through repeated glazing. Unlike tempera, whose surface dries quickly due to water evaporation, oils dry more uniformly and slowly, providing the artist time to rework areas. This flexibility must have been particularly appealing to artists who worked very deliberately, such as Leonardo da Vinci (see Chapter 9). Leonardo also preferred oil paint because its gradual drying process and consistency permitted him to blend the pigments, thereby creating the impressive *sfumato* (smoky effect) that contributed to his fame.

Both tempera and oils can be applied to various surfaces. Through the early 16th century, wooden panels served as the foundation for most paintings. Italians painted on poplar; northern artists used oak, lime, beech, chestnut, cherry, pine, and silver fir. Availability of these timbers determined the choice of wood. Linen canvas became increasingly popular in the late 16th century. Although evidence suggests that artists did not intend permanency for their early images on canvas, the material proved particularly useful in areas such as Venice where high humidity warped wood panels and made fresco unfeasible. Further, until canvas paintings are stretched on wooden stretcher bars before framing or affixed to a surface, they are more portable than wood panels.

Ghent's patron saints, Saint John the Baptist and Saint John the Evangelist. The Annunciation appears on the upper register, with a careful representation of a Flemish town outside the painted window of the center panel. In the uppermost arched panels, van Eyck depicted images of the Old Testament prophets Zachariah and Micah, along with sibyls, classical mythological prophetesses whose writings the Christian Church interpreted as prophesies of Christ.

When opened (Fig. 8-3), the altarpiece reveals a sumptuous, superbly colored painting of the medieval conception of humanity's Redemption. In the upper register, God the Father wearing the pope's triple tiara, with a worldly crown at his feet, and resplendent in a deep-scarlet mantle—presides in majesty. To God's right is the Virgin, represented as the Queen of Heaven, with a crown of 12 stars upon her head. Saint John the Baptist sits to God's left. To either side is a choir of angels and on the right an angel playing an organ. Adam and Eve appear in the far panels. The inscriptions in the arches above Mary and Saint John extol the Virgin's virtue and purity and Saint John's greatness as the forerunner of Christ. The inscription above the Lord's head translates as "This is God, all-powerful in his divine majesty; of all the best, by the gentleness of his goodness; the most liberal giver, because of his infinite generosity." The step behind the crown at the Lord's feet bears the inscription, "On his head, life without death. On his brow, youth without age. On his right, joy without sadness. On his left, security without fear." The entire altarpiece amplifies the central theme of salvation—even though humans, symbolized by Adam and Eve, are sinful, they will be saved because God, in his infinite love, will sacrifice his own son for this purpose.

The panels of the lower register extend the symbolism of the upper. In the center panel, the community of saints comes from the four corners of the earth through an opulent, flowerspangled landscape. They proceed toward the altar of the Lamb and toward the octagonal fountain of life. The Lamb symbolizes the sacrificed Son of God, whose heart bleeds into a chalice, while into the fountain spills the "pure river of water of life, clear as crystal, proceeding out of the throne of God and of the Lamb" (Rev. 22:1). On the right, the Twelve Apostles and a group of martyrs in red robes advance; on the left appear prophets. In the right background come the Virgin martyrs, and in the left background the holy confessors approach. On the lower wings, other approaching groups symbolize the four cardinal virtues: the hermits, Temperance; the pilgrims, Prudence; the knights, Fortitude; and the judges, Justice. The altarpiece celebrates the whole Christian cycle from the Fall to the Redemption (see "The Life of Jesus in Art," Chapter 4, pages 126–127), presenting the Church triumphant in heavenly Jerusalem.

Van Eyck rendered the entire altarpiece in a shimmering splendor of color that defies reproduction. No small detail escaped the artist's eye. With pristine specificity, he revealed the beauty of the most insignificant object as if it were a work of piety as much as a work of art. He depicted the soft texture of hair, the glitter of gold in the heavy brocades, the luster of pearls, and the flashing of gems, all with loving fidelity to appearance.

Oil Paints and Glazes *Oil paints* (see "Painters, Pigments, and Panels," above) facilitated the exactitude found in the work of Jan van Eyck and his contemporaries. Although

8-4

ROGIER VAN DER WEYDEN, Deposition, center panel of a triptych, from Notre-Dame hors-lesmurs, Louvain, Belgium, ca. 1435. Oil on wood, approx. 7' $3'' \times 8'$ 7". Museo del Prado, Madrid.

Rogier's Deposition resembles a relief carving in which crisply drawn and precisely modeled figures painted in oil act out a drama of passionate sorrow as if on a shallow stage.

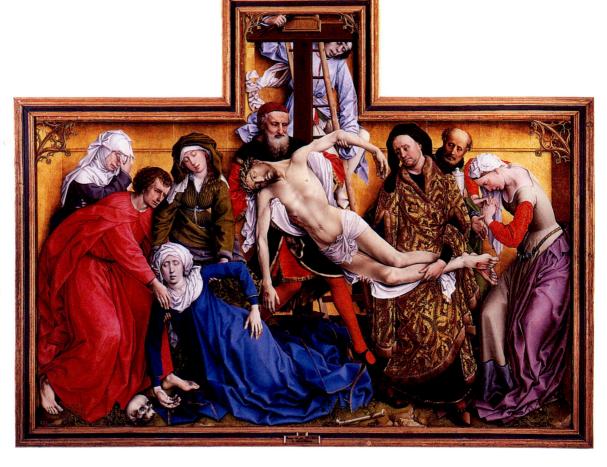

traditional scholarship credited van Eyck with the invention of oil painting, recent evidence has revealed that oil paints had been known for some time and that another Flemish painter, Melchior Broederlam, was using oils in the 1390s. Flemish painters built up their pictures by superimposing translucent paint layers, called glazes, on a layer of underpainting, which in turn had been built up from a carefully planned drawing made on a panel prepared with a white ground. With the oil medium, painters created richer colors than previously had been possible. Thus, a deep, intense tonality; the illusion of glowing light; and hard, enamel-like surfaces characterize 15th-century Flemish painting. These traits differed significantly from the high-keyed color, sharp light, and rather matte surfaces of tempera. The brilliant and versatile oil medium suited perfectly the formal intentions of the Flemish painters, who aimed for sharply focused, hard-edged, and sparkling clarity of detail in their representation of thousands of objects ranging in scale from large to almost invisible.

The Drama of Christ's Death Like the art of van Eyck, that of ROGIER VAN DER WEYDEN (ca. 1400-1464) had a great impact on northern painting during the 15th century. In particular, Rogier (as scholars refer to him) created fluid and dynamic compositions stressing human action and drama. He concentrated on such themes as the Crucifixion and the Pietà, moving observers emotionally by relating the sufferings of Christ.

Deposition (Fig. 8-4) is the center panel of a triptych (three-paneled painting) commissioned by the Archers' Guild of Louvain. Rogier acknowledged the patrons of this altarpiece by incorporating the crossbow (the guild's symbol) into the decorative spandrels in the corners. The painting nicely sums up Rogier's early style and content. Instead of creating a deep landscape setting, as Jan van Eyck might have, he compressed the figures and action onto a shallow stage to concentrate the observer's attention. The painting, with the artist's crisp drawing and precise modeling of forms, resembles a stratified relief carving. A series of lateral undulating movements gives the group a unity, a formal cohesion that Rogier strengthened by imbuing the figures with desolating anguish. The similar poses of Christ and the Virgin Mary further unify the composition. Few painters have equaled Rogier in the rendering of passionate sorrow as it vibrates through a figure or distorts a tear-stained face. His depiction of the agony of loss is among the most authentic in religious art. The emotional impact on the viewer is immediate and direct.

Private Devotional Imagery Large altarpieces in churches were public manifestations of piety in 15th-century Flanders, but individuals also commissioned artworks for devotional use in the home. So strong was the impetus for private devotional imagery that it seems, based on an accounting of extant Flemish religious paintings, that lay patrons outnumbered clerical patrons by a ratio of two to one. Dissatisfaction

with the clergy explains, in part, this commitment to private prayer. In addition, popular reform movements advocated personal devotion, and in the years leading up to the Protestant Reformation in the early 16th century, private devotional exercises and prayer grew in popularity.

One of the more prominent features of these images commissioned for private use is the integration of religious and secular concerns. For example, biblical scenes were often presented as transpiring in a Flemish house. Although this may seem inappropriate or even sacrilegious, religion was such an integral part of Flemish life that separating the sacred from the secular became virtually impossible. Further, the presentation in religious art of familiar settings and objects no doubt strengthened the direct bond the patron or viewer felt with biblical figures.

The Symbolic and the Secular The *Mérode Altarpiece* (Fig. 8-5) is probably the most famous triptych commissioned for private use. Scholars generally agree that the artist, referred to as the Master of Flémalle, is ROBERT CAMPIN (ca. 1378–1444), the leading painter of the city of Tournai. Similar in format to large-scale Flemish public altarpieces, the *Mérode Altarpiece* is considerably smaller (the center panel is roughly two feet square), which allowed the owners to close the wings and move the painting when necessary. The popular Annunciation theme (as prophesied in Isaiah 7:14) occupies the triptych's center panel. The archangel Gabriel approaches

Mary, who sits reading. The artist depicted a well-kept middleclass Flemish home as the site of the event. The carefully rendered architectural scene in the background of the right wing confirms this identification of the locale.

The depicted accessories, furniture, and utensils help identify the setting as Flemish. However, the objects represented are not merely decorative. They also function as religious symbols, thereby reminding the viewer of the event's miraculous nature. The book, extinguished candle, lilies, copper basin (in the corner niche), towels, fire screen, and bench symbolize, in different ways, the Virgin's purity and her divine mission. In the right panel, Joseph has made a mousetrap, symbolic of the theological tradition that Christ is bait set in the trap of the world to catch the Devil. The ax, saw, and rod in the foreground not only are tools of the carpenter's trade but also are mentioned in Isaiah 10:15.

In the left panel, the altarpiece's donor, Peter Inghelbrecht, and his wife kneel and seem to be permitted to witness this momentous event through an open door. The Inghelbrechts, a devout, middle-class couple, appear in a closed garden, symbolic of the Virgin's purity, and the flowers depicted (such as strawberries and violets) all relate to Mary's virtues, especially humility. The careful personalization of this entire altarpiece is further suggested by the fact that the Annunciation theme refers to the patron's name, Inghelbrecht (Angelbringer), and the workshop scene in the right panel also refers to his wife's name, Schrinmechers (Shrinemaker).

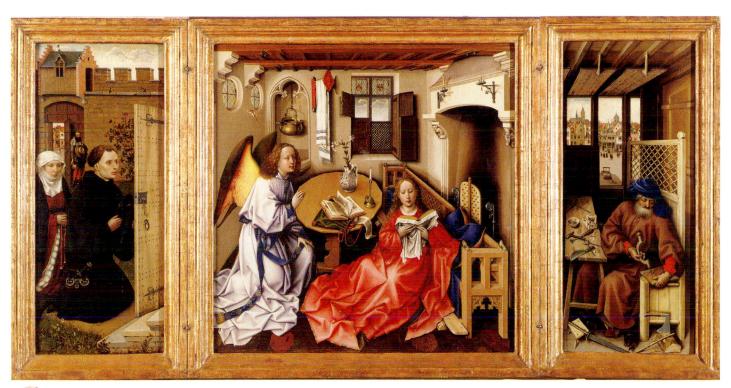

8-5 | ROBERT CAMPIN (Master of Flémalle), *Mérode Altarpiece* (open), *The Annunciation*, ca. 1425–1428. Oil on wood; center panel, approx. 2' 1" × 2' 1". Metropolitan Museum of Art, New York (The Cloisters Collection, 1956).

This Annunciation takes place in a middle-class Flemish home in which the objects represented have symbolic significance. The mousetrap, for example, refers to Christ as bait to catch the Devil.

Marriage Portraits References to both the secular and the religious in Flemish painting also surface in Jan van Eyck's double portrait Giovanni Arnolfini and His Bride (Fig. 8-6). Van Eyck depicted the Lucca financier (who had established himself in Bruges as an agent of the Medici family) and his betrothed in a Flemish bedchamber that is simultaneously mundane and charged with the spiritual. As in the Mérode Altarpiece, almost every object portrayed conveys the sanctity of the event—specifically, the holiness of matrimony. Arnolfini and his bride, Giovanna Cenami, hand in hand, take the marriage vows. The cast-aside clogs indicate that this event is taking place on holy ground. The little dog symbolizes fidelity. Behind the pair, the curtains of the marriage bed have been opened. The bedpost's finial is a tiny statue of Saint Margaret, patron saint of childbirth. From the finial hangs a whisk broom, symbolic of domestic care. The oranges on the chest below the window may refer to fertility, and the all-seeing eye of God seems to be referred to twice. It is symbolized once by

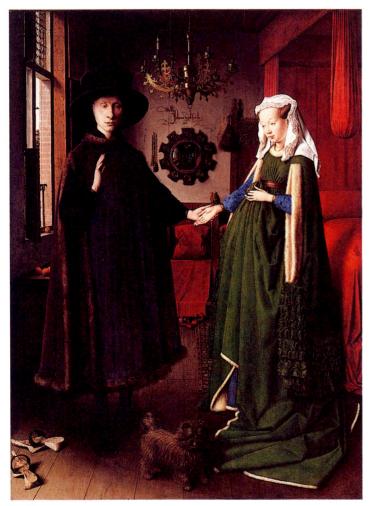

8-6 | JAN VAN EYCK, Giovanni Arnolfini and His Bride, 1434. Oil on wood, approx. 2' $8'' \times 1'$ $11\frac{1}{2}''$. National Gallery, London.

Van Eyck played a major role in establishing portraiture as an important art form. In this oil painting, he depicted an Italian financier and his wife, and also portrayed himself in the mirror on the back wall.

the single candle burning in the left rear holder of the ornate chandelier and again by the mirror, in which the viewer sees the entire room reflected. The small medallions set into the mirror frame show tiny scenes from the Passion of Christ and represent God's promise of salvation for the figures reflected on the mirror's convex surface.

Flemish viewers would have been familiar with many of the objects included in *Giovanni Arnolfini and His Bride* because of traditional Flemish customs. Husbands traditionally presented brides with clogs, and the solitary lit candle in the chandelier was also part of Flemish marriage practices. Van Eyck's placement of the two figures suggests conventional gender roles—the woman stands near the bed and well into the room, whereas the man stands near the open window, symbolic of the outside world.

Van Eyck enhanced the documentary nature of this scene by exquisitely painting each object. He carefully distinguished textures and depicted the light from the window on the left reflecting off various surfaces. The artist augmented the scene's credibility by including the convex mirror, because the viewer can see not only the principals, Arnolfini and his wife, but also two persons who look into the room through the door. One of these must be the artist himself, as the florid inscription above the mirror, "Johannes de Eyck fuit hic," announces that he was present. The picture's purpose, then, seems to have been to record and sanctify this marriage. Some scholars recently have taken issue with this reading, however, suggesting that Arnolfini is conferring legal privileges on his wife to conduct business in his absence.

Van Eyck and his contemporaries established portraiture as a major art form. Great patrons embraced the opportunity to have their likenesses painted. They wanted to memorialize themselves in their dynastic lines; to establish their identity, rank, and station with images far more concrete than heraldic coats of arms; or to represent themselves at state occasions when they could not attend. They even used such paintings when arranging marriages. Royalty, nobility, and the very rich would send painters to "take" the likeness of a prospective bride or groom. When young King Charles VI of France sought a bride, he dispatched a painter to three different royal courts to make portraits of the candidates for queen.

An Enigmatic Painter One of the most fascinating and puzzling painters in history, HIERONYMUS BOSCH (ca. 1450–1516), also worked in 15th-century Flanders. Interpretations of Bosch differ widely. Was he a satirist, an irreligious mocker, or a pornographer? Was he a heretic or an orthodox fanatic like Girolamo Savonarola, his Italian contemporary (page 243)? Was he obsessed by guilt and the universal reign of sin and death?

Bosch's most famous painting, the so-called *Garden of Earthly Delights* (Fig. 8-7), is also his most enigmatic, and no interpretation of it is universally accepted. This large-scale work takes the familiar form of a triptych. More than 7 feet high, the painting extends to more than 12 feet wide when opened. The

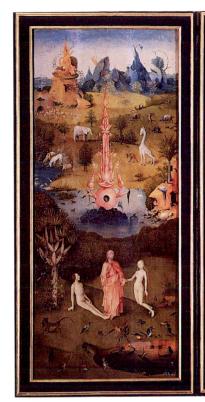

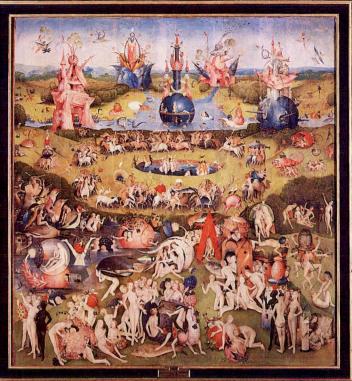

8-7 | HIERONYMUS BOSCH, Garden of Earthly Delights. Creation of Eve (left wing), Garden of Earthly Delights (center panel), Hell (right wing), 1505–1510. Oil on wood; center panel, $7' 2\frac{5}{8}'' \times 6' 4\frac{3}{4}''$. Museo del Prado, Madrid.

Bosch was the most imaginative and enigmatic painter of his era. In this triptych, he created a fantasy world filled with nude men and women and bizarre creatures and objects. It has defied interpretation.

triptych format seems to indicate a religious function for this work. But the painting is documented as being in the palace of Henry III of Nassau, regent of the Netherlands, seven years after its completion, suggesting a secular commission for private use. Scholars have proposed that such a commission, in conjunction with the central themes of marriage, sex, and procreation, points to a wedding commemoration, which, as seen in *Giovanni Arnolfini and His Bride* (Fig. 8-6), was not uncommon. Any similarities between the two paintings end there, however. Whereas van Eyck grounded his depiction of a betrothed couple in contemporary Flemish life and custom, Bosch portrays a visionary world of fantasy and intrigue.

In the left panel, God presents Eve to Adam in a landscape, presumably the Garden of Eden. Bosch complicated his straightforward presentation of this event by placing it in a wildly imaginative setting that includes an odd pink fountain-like structure in a body of water and an array of fanciful and unusual animals, which may hint at an interpretation involving alchemy—the medieval study of seemingly magical changes, especially chemical changes. The right panel, in contrast, bombards the viewer with the horrors of Hell. Beastly creatures devour people, while others are impaled or strung on musical instruments, as if on a medieval rack. A gambler is nailed to his own table. A spidery monster embraces a girl while toads bite her. A sea of inky darkness envelops all of

these horrific scenes. Observers must search through the hideous enclosure of Bosch's Hell to take in its fascinating though repulsive details.

Sandwiched between Paradise and Hell is the huge center panel, with nude people blithely cavorting in a landscape dotted with bizarre creatures and unidentifiable objects. The prevalence of fruit and birds (fertility symbols) throughout the scene suggests procreation, and, indeed, many of the figures are paired off as couples. The orginatic overtones of *Garden of Earthly Delights*, in conjunction with the terrifying image of Hell, have led some scholars to interpret this triptych, like other Last Judgment images, as a warning to the viewer of the fate awaiting the sinful, decadent, and immoral.

FRANCE

In France, the anarchy of the Hundred Years' War and the weakness of the French kings gave rise to a group of powerful duchies. The strongest of these, the Duchy of Burgundy, has already been discussed. The dukes of Berry, Bourbon, and Nemours were also significant art patrons.

Very Sumptuous Hours Among the most noteworthy 15th-century French artists were the Limbourg Brothers—Pol, Hennequin, and Herman—three nephews of Jean

Malouel, painter of the Well of Moses (Fig. 8-1). They were renowned for expanding the illusionistic capabilities of manuscript illumination. The Limbourgs produced a gorgeously illustrated Book of Hours for Jean, the duke of Berry (1340-1416) and brother of King Charles V of France. The duke was an avid art patron and focused much of his collecting energy on manuscripts, jewels, and rare artifacts. An inventory of the duke's libraries revealed that he owned more than 300 manuscripts. The three brothers worked on Les Très Riches Heures du Duc de Berry (The Very Sumptuous Hours of the Duke of Berry) until their deaths in 1416. A Book of Hours, like a breviary, was a book used for reciting prayers. As prayer books, they replaced the traditional psalters, which had been the only liturgical books in private hands until the mid-13th century. The centerpiece of a Book of Hours was the "Office [prayer] of the Blessed Virgin," which contained liturgical passages to be read privately at set times during the day, from matins (dawn prayers) to compline (the last of the prayers recited daily). An illustrated calendar containing local religious feast days usually preceded the "Office of the Blessed Virgin." Penitential psalms, devotional prayers, litanies to the saints, and other prayers, including those of the dead and of the Holy Cross, followed the centerpiece. Such books became favorite possessions of the northern aristocracy during the 14th and 15th centuries. They eventually became available to affluent burghers and contributed to the decentralization of religious practice that was one factor in the Protestant Reformation in the early 16th century.

The calendar pictures of *Les Très Riches Heures* are perhaps the most famous in the history of manuscript illumination. They represent the 12 months in terms of the associated seasonal tasks, alternating scenes of nobility and peasantry. Above each picture is a lunette depicting the chariot of the sun as it makes its yearly cycle through the 12 months and zodiac signs. Beyond its function as a religious book, *Les Très Riches Heures* also visually captures the social relationships in effect at that time—the power of the duke and his relationship to the peasants.

The illustration for October (Fig. 8-8) focuses on the peasantry. The Limbourgs depicted a sower, a harrower on horseback, and washerwomen, along with city dwellers, who promenade in front of the Louvre (the king's residence at the time). The peasants do not appear particularly disgruntled as they go about their tasks. Surely such an image flattered the duke's sense of himself as a compassionate master. The growing artistic interest in naturalism—the close observation of the natural world and the depiction of a perceptual reality—is revealed here in the careful architectural detail with which the Louvre is rendered, as well as in the convincing shadows cast by the objects (such as the archer scarecrow and the horse) and people in the scene.

As a whole, *Les Très Riches Heures* reinforced the image of the duke of Berry as a devout man, cultured bibliophile, sophisticated art patron, and powerful and magnanimous leader. Further, the expanded range of subject matter, especially the prominence of *genre* subjects in a religious book, reflected the increasing integration of religious and secular concerns in both

8-8 | LIMBOURG BROTHERS (POL, HENNEQUIN, HERMAN), October, from Les Très Riches Heures du Duc de Berry, 1413–1416. Tempera and ink on vellum, approx. $8\frac{1}{2}" \times 5\frac{1}{2}"$. Musée Condé, Chantilly.

The 12 calendar pictures in this luxurious prayer book give unusual prominence to genre subjects, reflecting the increasing integration of religious and secular concerns in 15th-century France.

art and life at the time. Although all three Limbourg brothers worked on *Les Très Riches Heures*, art historians have never been able to ascertain definitively which brother painted which images. Given the common practice of collaboration on artistic projects at this time, this determination of specific authorship is not very important.

Portraying the Pious Images for private devotional use were popular in France, as in Flanders. Among the French artists whose paintings were in demand was JEAN FOUQUET (ca. 1420–1481), who worked for King Charles VII and for the duke of Nemours. Fouquet painted a *diptych* (two-paneled

8-9 | JEAN FOUQUET, Melun Diptych. Étienne Chevalier and Saint Stephen (left wing), ca. 1450. Oil on wood, $3'\frac{1}{2}''\times2'9\frac{1}{2}''$. Gemäldegalerie, Staatliche Museen, Berlin. Virgin and Child (right wing), ca. 1451. Oil on wood, $3'1\frac{1}{4}''\times2'9\frac{1}{2}''$. Koninklijk Museum voor Schone Kunsten, Antwerp.

Fouquet's meticulous representation of a pious kneeling donor with a standing patron saint recalls Flemish painting (Fig. 8-2), as do the three-quarter stances and the sharp focus of the portraits.

painting; Fig. 8-9) for Étienne Chevalier, who, despite lowly origins, elevated himself in French society. In 1452, King Charles VII named Chevalier treasurer of France. In the left panel, Chevalier appears with his patron saint, Saint Stephen (Étienne in French). Appropriately, Fouquet depicted Chevalier as devout—kneeling, with hands clasped in prayer. The representation of the pious donor with his standing saint recalls Flemish art (Fig. 8-2), as do the three-quarter stances and the sharp, clear focus of the portraits. The artist depicted the saint holding the stone of his martyrdom (death by stoning) atop a volume of the Scriptures, thereby ensuring that the viewer could properly identify the saint. Fouquet rendered the entire image in meticulous detail and included a highly ornamented architectural setting.

In its original diptych form (the two panels were separated some time ago), the viewer would follow the gaze of Chevalier and Saint Stephen over to the right panel, which depicts the Virgin Mary and Christ Child. The juxtaposition of these two images allowed the patron to bear witness to the sacred. However, other interpretations present themselves. The integration of sacred and secular (especially the political or personal) common in other northern European artworks also emerges here, complicating the reading of this diptych. The depiction of the Virgin Mary was modeled after Agnès Sorel,

the mistress of King Charles VII. Sorel was respected as a pious individual, and, according to an inscription, Chevalier commissioned this painting to fulfill a vow he made after Sorel's death in 1450. Thus, in addition to the religious interpretation of this diptych, there is surely a personal narrative here as well.

GERMANY

Whereas the monarchies in France, England, and Spain fostered cohesive and widespread developments in the arts of those countries, the lack of a strong centralized power in the Holy Roman Empire (whose core was Germany) led to provincial artistic styles that the strict guild structure perpetuated. Because the Holy Roman Empire did not participate in the long, drawn-out saga of the Hundred Years' War, its economy was stable and prosperous. In the absence of a dominant court culture, German 15th-century art was quite varied.

Ornate Wooden Retables TILMAN RIEMENSCHNEIDER (ca. 1460–1531) specialized in carving large wooden *retables* (altarpieces). He created the *Creglingen Altarpiece* for a parish church in Creglingen, incorporating intricate Gothic forms, especially in the altarpiece's elaborate canopy. The

MATERIALS + TECHNIQUES

Graphic Changes

The popularity of prints over the centuries attests to the medium's enduring appeal. Generally speaking, a *print* is an artwork on paper, usually produced in multiple impressions. The set of prints an artist creates from a single print surface is often referred to as an *edition*. The printmaking process involves the transfer of ink from a printing surface to paper, which can be accomplished in several ways. During the 15th and 16th centuries, artists

most commonly used the relief and intaglio methods of printmaking.

Artists produce relief prints by carving into a surface, usually wood. The oldest and simplest of the printing methods, relief printing requires artists to conceptualize their images negatively; that is, they remove the surface areas around the images, as in relief sculpture. Thus, when the printmaker inks the surface, the carved-out areas remain clean, and a positive image results when the artist presses the printing block against paper. Because artists produce *woodcuts* through a subtractive process (removing parts of the material), it is difficult to create very thin, fluid, and closely spaced lines. As a result, woodcut prints tend to exhibit stark contrasts and sharp edges (for example, Fig. INTRO-5).

In contrast to the production of relief prints, the intaglio method involves a positive process. The artist *incises* or scratches an image on a metal plate, often copper. The image can be created on the plate manually (engraving or drypoint) using a tool (burin or stylus; for example,

The Development of Printmaking

FIGS. 8-11 and 8-24) or chemically (etching). In the latter process, an acid bath eats into the exposed parts of the plate where the artist has drawn through an acid-resistant coating. When the artist inks the surface of the intaglio plate and wipes it clean, the ink is forced into the incisions. Then the printmaker runs the plate and paper through a roller press, and the paper absorbs the remaining ink, creating the print. Because the engraver "draws" the image onto the plate, intaglio prints possess a character different from that of relief prints. Engravings, drypoints, and etchings generally present a wider variety of linear effects. They also often reveal to a greater extent evidence of the artist's touch, the result of the hand's changing pressure and shifting directions.

The paper and inks artists use also affect the finished look of the printed image. During the 15th and 16th centuries, European printmakers had papers produced from cotton and linen rags that papermakers mashed with water into a pulp. The papermakers then applied a thin layer of this pulp to a wire screen and allowed it to dry to create the paper. As contact with Asia increased, printmakers made greater use of what was called Japan paper (of mulberry fibers) and China paper. Artists, then as now, could select from a wide variety of inks. The type and proportion of the ink ingredients affect the consistency, color, and oiliness of inks, which various papers absorb differently.

center panel (Fig. 8-10) depicts the Assumption of the Virgin. By employing a restless line that runs through the draperies of the figures, Riemenschneider succeeded in setting the whole design into fluid motion, and no individual element functions without the rest. The draperies float and flow around bodies lost within them, serving not as descriptions but as design elements that tie the figures to one another and to the framework. A look of psychic strain, a facial expression common to Riemenschneider's figures and consonant with the emerging age of disruption, heightens the spirituality of the figures, immaterial and weightless as they appear.

Woodblock Printing A new age blossomed in the 15th century with the German invention of the *letterpress*, printing with movable type. Printing had been known in China centuries before but had never developed, as it did in 15th-century Europe, into a revolution in written communication and in the generation and management of information. Printing provided new and challenging media for artists, and the earliest form was the *woodcut* (see "Graphic Changes: The Development of Printmaking," above). Using a gouging instrument, artists

8-10 | TILMAN RIEMENSCHNEIDER, *The Assumption of the Virgin*, center panel of the *Creglingen Altarpiece*, parish church, Creglingen, Germany, ca. 1495–1499. Carved lindenwood, 6′ 1″ wide.

Riemenschneider specialized in carving large wooden retables featuring intricate Gothic tracery and religious figures whose bodies are almost lost within their swirling garments.

remove sections of wood blocks, sawing along the grain. Print-makers then ink the ridges that carry the designs, and the hollows remain dry of ink and do not print. Artists produced woodblock prints well before the development of movable-type printing. But when a rise in literacy and the improved economy necessitated production of illustrated books on a grand scale, artists met the challenge of bringing the woodcut picture onto the same page as the letterpress.

Drawing on Metal The woodcut medium hardly had matured when the technique of *engraving* (inscribing on a hard surface), begun in the 1430s and well developed by 1450, proved much more flexible (see "Graphic Changes," page 226). Predictably, in the second half of the century, engraving began to replace the woodcut process, for making both book illustrations and widely popular single prints. Metal engraving produces an *intaglio* (incised) surface for printing; the incised lines (hollows) of the design, rather than the ridges, take the ink. It is the reverse of the woodcut technique, which produces *rilievo* (relief).

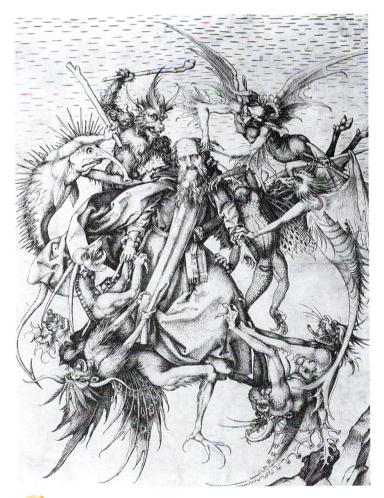

8-11 | Martin Schongauer, *Saint Anthony Tormented by Demons*, ca. 1480–1490. Engraving, approx. 1' 1" × 11". Metropolitan Museum of Art, New York (Rogers Fund, 1920).

Schongauer was the most skilled of the early masters of metal engraving. By using a burin to incise lines in a copper plate, he was able to create a marvelous variety of tonal values and textures.

MARTIN SCHONGAUER (ca. 1430–1491) was the most skilled and subtle early master of metal engraving in northern Europe. His Saint Anthony Tormented by Demons (Fig. 8-11) shows both the versatility of the medium and the artist's mastery of it. The stoic saint is caught in a revolving thornbush of spiky demons, who claw and tear at him furiously. With unsurpassed skill and subtlety, Schongauer created marvelous distinctions of tonal values and textures—from smooth skin to rough cloth, from the furry and feathery to the hairy and scaly. The method of describing forms with hatching that follows them, probably developed by Schongauer, became standard among German graphic artists. The Italians preferred parallel hatching (compare Antonio Pollaiuolo's engraving, Fig. 8-24) and rarely adopted the other method, which, in keeping with the general northern approach to art, tends to describe the surfaces of things rather than their underlying structures.

ITALY

During the 15th century, Italy witnessed constant fluctuations in its political and economic spheres, including shifting power relations among the numerous city-states and republics and the rise of princely courts (MAP 8-2, page 528). Condottieri (military leaders) with large numbers of mercenary troops at their disposal played a major role in the ongoing struggle for power. Papal Rome and the courts of Urbino, Mantua, and other cities emerged as cultural and artistic centers. The association of humanism with education and culture appealed to accomplished individuals of high status, and humanism had its greatest impact among the elite and powerful, such as those associated with these courts. It was these individuals who were in the best position to commission art. As a result, much of Italian Renaissance art was infused with humanist ideas. The intersection of art with humanist doctrines during the Renaissance can be seen in the popularity of subjects selected from classical history or mythology, in the increased concern with developing perspectival systems and depicting anatomy accurately, in the revival of portraiture and other self-aggrandizing forms of patronage, and in citizens' extensive participation in civic and religious art commissions.

Florence

Because high-level patronage required significant accumulated wealth, the individuals and families who had managed to prosper economically came to the fore in artistic circles. Among the best known was the Medici family of Florence, which acquired its vast fortune from banking. Although they were not a court family, the Medici used their tremendous wealth to wield great power and to commission art and architecture on a scale rarely seen, then or since. The Medici were such lavish patrons of art and learning that, to this day, the term "Medici" is widely used to refer to a generous patron of the fine arts.

Sculpture and Civic Pride The history of 15th-century Florentine art, however, does not begin with the Medici but

with a competition in 1401 sponsored by the Arte di Calimala (wool merchant's guild). Artists were invited to submit designs for the new east doors of the Florence baptistery. The commission was prestigious because the doors faced the entrance to Florence Cathedral. The judges required each entrant to prepare a relief panel depicting the sacrifice of Isaac, an important Old Testament subject (see Chapter 4). The selection of this theme may also have been influenced by historical developments. In the late 1390s, Giangaleazzo Visconti of Milan began a military campaign to take over the Italian peninsula. By 1401, Visconti's troops had virtually surrounded Florence, and its independence was in serious jeopardy. Despite dwindling water and food supplies, Florentine officials exhorted the public to defend the city's freedom. For example, the humanist chancellor, Coluccio Salutati, whose Latin style of writing was widely influential, urged his fellow citizens to adopt the republican ideal of civil and political liberty associated with ancient Rome and to identify themselves with its spirit. To be Florentine was to be Roman. Freedom was the distinguishing virtue of both. (Florentine faith and sacrifice were rewarded in 1402, when Visconti died suddenly, ending the invasion threat.) The story of Abraham and Isaac, with its theme of sacrifice, paralleled the message city officials had conveyed to inhabitants.

8-12 | FILIPPO BRUNELLESCHI, *Sacrifice of Isaac*, competition panel for east doors, baptistery of Florence Cathedral, Florence, Italy, 1401–1402. Gilded bronze relief, 1' 9" × 1' 5". Museo Nazionale del Bargello, Florence.

Brunelleschi's entry in the competition to make new bronze doors for the Florentine baptistery shows a frantic angel about to halt an emotional, lunging Abraham clothed in swirling Gothic draperies.

Ghiberti and Brunelleschi Only the panels of the two finalists, Lorenzo Ghiberti (1378–1455) and Filippo Brunelleschi (1377–1446), have survived. In 1402, the selection committee awarded the commission to Ghiberti. Both artists chose the same French Gothic *quatrefoil* frames used for the panels on the baptistery's south doors, and depicted the same moment of the narrative—the angel's intervening to stop Abraham from plunging his knife into Isaac's throat.

Brunelleschi's panel (Fig. 8-12) shows a sturdy and vigorous interpretation of the theme, with something of the emotional agitation characteristic of Italian Gothic sculpture. Abraham seems suddenly to have summoned the dreadful courage needed to kill his son at God's command. He lunges forward, draperies flying, exposing Isaac's throat to the knife. Matching Abraham's energy, the saving angel darts in from the left, grabbing Abraham's arm to halt the killing. Brunelleschi's figures demonstrate his ability to observe carefully and represent faithfully all the elements in the biblical narrative.

Whereas Brunelleschi imbued his image with dramatic emotion, Ghiberti emphasized grace and smoothness. In Ghiberti's panel (Fig. 8-13), Abraham appears in the familiar Gothic S-curve pose and seems to contemplate the act he is about to perform, even as he draws his arm back to strike.

8-13 | LORENZO GHIBERTI, Sacrifice of Isaac, competition panel for east doors, baptistery of Florence Cathedral, Florence, Italy, 1401–1402. Gilded bronze relief, 1' 9" × 1' 5". Museo Nazionale del Bargello, Florence.

In contrast to Brunelleschi's (Fig. 8-12), Ghiberti's entry in the baptistery competition features gracefully posed figures that recall classical statuary. Even Isaac's altar is decorated with a Roman acanthus frieze.

The figure of Isaac, beautifully posed and rendered, recalls Greco-Roman statuary. Unlike his medieval predecessors, Ghiberti revealed a genuine appreciation of the nude male form and a deep interest in how the muscular system and skeletal structure move the human body. Even the altar on which Isaac kneels displays Ghiberti's emulation of antique models. It is decorated with acanthus scrolls of a type that commonly adorned Roman buildings. These classical references reflect the increasing influence of humanism.

Ghiberti's training included both painting and goldsmithery. His careful treatment of the gilded bronze surfaces, with their sharply and accurately incised detail, proves his skill as a goldsmith. As a painter, he was interested in spatial illusion. The rocky landscape seems to emerge from the blank panel toward the viewer, as does the strongly foreshortened angel. Brunelleschi's image, in contrast, emphasizes the planar orientation of the surface. Although Ghiberti's image was perhaps less overtly emotional than Brunelleschi's, it was more cohesive and presented a more convincing spatial illusion.

That Ghiberti cast his panel in only two pieces (thereby reducing the amount of bronze needed) no doubt impressed the selection committee. Ghiberti's construction method differed from that of Brunelleschi, who built his from several cast pieces. Thus, Ghiberti's doors, as proposed, not only would be lighter and more impervious to the elements but also would represent a significant cost savings. Ghiberti's submission clearly had much to recommend it, both stylistically and technically, and the jury awarded the commission to him.

The "Gates of Paradise" Ghiberti completed the competition commission in 1424, but his doors were moved to the north side of the building so that he could execute another pair of doors for the eastern entrance. This second project (1425–1452) produced the famous east doors (Fig. 8-14) that Michelangelo later declared were "so beautiful that they would do well for the gates of Paradise." In these "Gates of Paradise," Ghiberti abandoned the quatrefoil frames used on the south and north doors and reduced the number of panels from 28 to 10, possibly at the behest of his patrons. Each of the panels contains a relief set in plain moldings and depicts a scene from the Old Testament. The complete gilding of the reliefs creates an effect of great splendor and elegance.

Renaissance Perspective and Science The east doors display Ghiberti's enthusiasm for the new Renaissance system for representing space. Earlier Italian artists, such as Duccio (Fig. 7-30) and Lorenzetti (Fig. 7-32), had used several devices to indicate distance, but with the invention of "true" linear perspective (a discovery generally attributed to Brunelleschi), 15th-century artists acquired a way to make the illusion of distance mathematical and certain (see "Depicting Objects in Space: Perspectival Systems in the Early Renaissance," page 230). In effect, they thought of the picture plane as a transparent window through which one sees the constructed pictorial world. This discovery was enormously

8-14 | LORENZO GHIBERTI, east doors ("Gates of Paradise"), baptistery of Florence Cathedral, Florence, Italy, 1425–1452. Gilded bronze relief, approx. 17' high. Modern copy, ca. 1980. Original panels in Museo dell'Opera del Duomo, Florence.

In Ghiberti's later doors for the Florentine baptistery, the sculptor abandoned the Gothic quatrefoil frame and employed the new science of perspective to create the illusion of distance in his relief panels.

important, for it made possible what has been called the "rationalization of sight." It brought all our random and infinitely various visual sensations under a simple rule that could be expressed mathematically.

Indeed, the Renaissance artists' interest in perspective (based on principles already known to the ancient Greeks and Romans) reflects the emergence of science itself, which is, put simply, the mathematical ordering of our observations of the physical world. Of course, Early Renaissance artists were not primarily scientists. They simply found perspective an

Depicting Objects in Space

Scholars long have noted the Renaissance fascination with perspective. In essence, portraying perspective involves constructing a convincing illusion of space in two-dimensional imagery while unifying all objects within a single spatial system. Renaissance artists were not the first to focus on depicting illusionistic space. Both the Greeks and the Romans were well versed in perspectival rendering. However, the perspectival systems developed during the Renaissance contrasted sharply with the portrayal of space during the preceding medieval period, when spiritual concerns superseded interest in the illusionistic presentation of objects.

Renaissance perspectival systems included both linear perspective and atmospheric perspective. Developed by Brunelleschi, *linear perspective* allows artists to determine mathematically the relative size of rendered objects to correlate them with the visual recession into space. Linear perspective can be either one-point or two-point. In *one-point linear perspective* (diagram a) the artist first must identify a horizontal line that

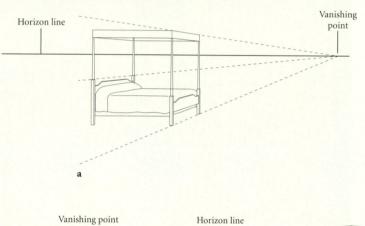

Perspectival Systems in the Early Renaissance

marks, in the image, the horizon in the distance (hence the term horizon line). The artist then selects a vanishing point on that horizon line (often located at the exact center of the line). By drawing orthogonals (diagonal lines) from the edges of the picture to the vanishing point, the artist creates a structural grid that organizes the image and determines the size of objects within the image's illusionistic space. Under this system of linear perspective, artists often foreshorten a figure as the body recedes back into an illusionistic space, as seen in Andrea Mantegna's Dead Christ (Fig. 8-34). Among the works that provide clear examples of one-point linear perspective are Masaccio's Holy Trinity (Fig. 8-17), Leonardo da Vinci's Last Supper (Fig. 9-2), and Raphael's School of Athens (Fig. 9-6).

Two-point linear perspective (diagram b) also involves the establishment of a horizon line. Rather than utilizing a single vanishing point along this horizon line, the artist identifies two of them. The orthogonals that result from drawing lines from an object to each of the vanishing points creates, as in one-point perspective, a grid that indicates the relative size of objects receding into space.

Rather than rely on a structured mathematical system (as does linear perspective), atmospheric perspective involves optical phenomena. Artists using atmospheric (sometimes called aerial) perspective exploit the principle that the farther back the object is in space, the blurrier, less detailed, and bluer it appears. Further, color saturation and value contrast diminish as the image recedes into the distance. Leonardo da Vinci used atmospheric perspective to great effect, as seen in such works as Virgin of the Rocks (Fig. 9-1) and Mona Lisa (Fig. 9-3).

These two methods of creating the illusion of space in pictures are not exclusive, and Renaissance artists often used both to heighten the sensation of three-dimensional space.

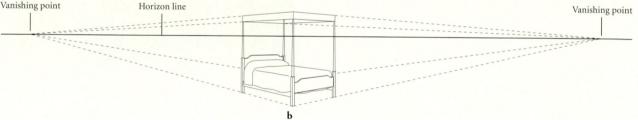

Mathematical truth and formal beauty conjoined in the minds of Renaissance artists.

Alberti and Ghiberti The individual panels of Ghiberti's east doors clearly recall painting techniques in their depiction of space as well as in their treatment of the narrative. Some exemplify more fully than painting many of the principles formulated by the influential architect and theorist Leon Battista Alberti in his 1435 treatise, *On Painting*. In his relief, Ghiberti created the illusion of space partly through the use of pictorial perspective and partly by sculptural means. He represented buildings according to a painter's one-point perspective construction, but the figures (in the bottom section of the relief,

which actually projects slightly) appear almost in the full round, some of their heads standing completely free. As the eye progresses upward, the relief increasingly flattens, concluding with the architecture in the background, which Ghiberti depicted in barely raised lines. In this manner, the artist created a sort of sculptor's aerial perspective, with forms appearing less distinct the deeper they are in space.

In these panels, Ghiberti achieved a greater sense of depth than had seemed possible in a relief. His principal figures, however, do not occupy the architectural space he created for them. Rather, the artist arranged them along a parallel plane in front of the grandiose architecture. Ghiberti's figure style mixes a Gothic patterning of rhythmic line; classical poses and motifs; and a new realism in characterization, movement, and surface detail. The figures, in varying degrees of projection, gracefully twist and turn, appearing to occupy and move through a convincing stage space, which Ghiberti deepened by showing some figures from behind. The classicism derives from the artist's close study of ancient art. Ghiberti admired and collected classical sculpture, bronzes, and coins. Their influence is seen in many of the figures on Ghiberti's doors. The emerging practice of collecting classical art in the 15th century had much to do with the appearance of classicism in Renaissance humanistic art.

Donatello and Or San Michele A younger contemporary of Ghiberti was Donatello (ca. 1386-1466). He participated along with other esteemed sculptors, including Ghiberti, in another major Florentine art program of the early 1400s, the decoration of Or San Michele. The building was the headquarters of Florence's guilds. City officials assigned each of the niches on the building's exterior to a specific guild for decoration with a statue of its patron saint. Donatello's Saint Mark (Fig. 8-15) was carved for the guild of linen drapers and completed in 1413. In this sculpture, Donatello introduced the classical principle of weight shift, or contrapposto (see Chapter 2), into Early Renaissance sculpture. As the saint's body moves, its drapery moves with it, hanging and folding naturally from and around bodily points of support so that the viewer senses the figure as a draped nude, not simply as an integrated column with arbitrarily incised drapery. This separates Donatello's Saint Mark from all medieval portal statuary. It was the first Renaissance figure whose voluminous drapery (the pride of the Florentine guild that paid for the statue) did not conceal but accentuated the movement of the arms, legs, shoulders, and hips. This development further contributed to the sculpted figure's independence from its architectural setting. Saint Mark's stirring limbs, shifting weight, and mobile drapery suggest impending movement out of the niche.

Masaccio's Revolution Tommaso Guidi, known as Masaccio (1401–1428), was the leading Florentine painter of the early 15th century. Although his presumed teacher, Masolino da Panicale, had worked in the International Style

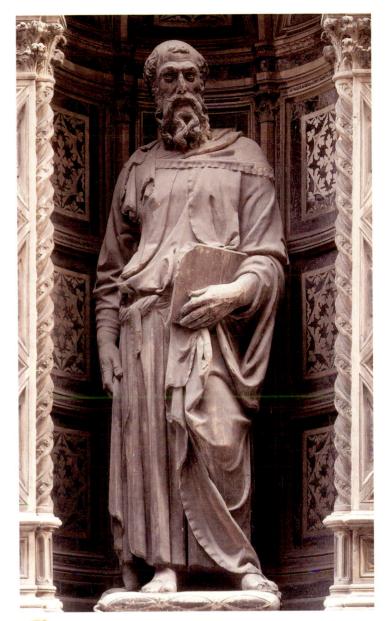

8-15 | DONATELLO, *Saint Mark*, Or San Michele, Florence, Italy, 1411–1413. Marble, approx. 7' 9" high. Modern copy in exterior niche. Original sculpture in museum on second floor of Or San Michele.

In this statue carved for the guild of linen drapers, Donatello introduced the classical principle of contrapposto into Early Renaissance sculpture. The drapery falls naturally and moves with the body.

(see Chapter 7), Masaccio moved suddenly, within the short span of six years, into unexplored territory. Most art historians recognize no other painter in history to have contributed so much to the development of a new style in so short a time as Masaccio, whose creative career was cut short by his death at age 27. Masaccio was the artistic descendant of Giotto, whose calm monumental style he revolutionized with a whole new repertoire of representational devices that generations of Renaissance painters later studied and developed.

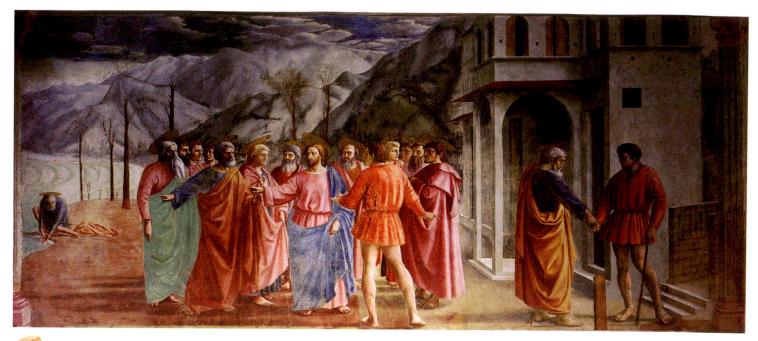

8-16 | MASACCIO, *Tribute Money*, Brancacci Chapel, Santa Maria del Carmine, Florence, Italy, ca. 1427. Fresco, 8' 1" × 19' 7".

Masaccio's figures recall Giotto's in their simple grandeur, but they convey a greater psychological and physical credibility and are illuminated by light coming from a single source outside the picture.

Tribute Money (Fig. 8-16), in the Brancacci Chapel of Santa Maria del Carmine in Florence, displays Masaccio's innovations. The fresco depicts an episode from the Gospel of Matthew (17:24–27). As the tax collector confronts Christ at the entrance to the Roman town of Capernaum, Christ directs Saint Peter to the shore of Lake Galilee. There, as foreseen by Christ, Peter finds the tribute money in the mouth of a fish and returns to pay the tax. Masaccio presented this narrative in three episodes within the fresco. In the center, Christ, surrounded by his disciples, tells Saint Peter to retrieve the coin from the fish, while the tax collector stands in the foreground, his back to spectators and hand extended, awaiting payment. At the left, in the middle distance, Saint Peter extracts the coin from the fish's mouth, and, at the right, he thrusts the coin into the tax collector's hand.

Masaccio's figures recall Giotto's in their simple grandeur, but they convey a greater psychological and physical credibility. Masaccio realized the bulk of the figures through modeling not with a flat, neutral light lacking an identifiable source but with a light coming from a specific source outside the picture. The light strikes the figures at an angle, illuminating the parts of the solids that obstruct its path and leaving the rest in deep shadow. This chiaroscuro gives the illusion of deep sculptural relief. Between the extremes of light and dark, the light appears as a constantly active but fluctuating force highlighting the scene in varying degrees, almost a tangible substance independent of the figures. In Giotto's frescoes, light is revealed only by the modeling of masses. In Masaccio's, light has its own nature, and the masses are visible only because of

its direction and intensity. The viewer can imagine the light as playing over forms—revealing some and concealing others, as the artist directs it.

The individual figures in *Tribute Money* are solemn and weighty, but they also express bodily structure and movement, as do Donatello's statues. Masaccio's representations adeptly suggest bones, muscles, and the pressures and tensions of joints. Each figure conveys a maximum of contained energy. The figure of Christ and the two appearances of the tax collector illustrate what the Renaissance biographer Giorgio Vasari meant when he said, "the works made before his [Masaccio's] day can be said to be painted, while his are living, real, and natural."

Masaccio's arrangement of the figures is equally inventive. They do not appear as a stiff screen in the front planes. Instead, the artist grouped them in circular depth around Christ, and he placed the whole group in a spacious landscape, rather than in the confined stage space of earlier frescoes. The group itself generates the foreground space that the architecture on the right amplifies. Masaccio depicted this architecture in one-point perspective, locating the vanishing point, where all the orthogonals converge, to coincide with Christ's head. Aerial perspective, the diminishing of light and the blurring of outlines as the distance increases, unites the foreground with the background. Although ancient Roman painters used aerial perspective, medieval artists had abandoned it. Thus it virtually disappeared from art until Masaccio and his contemporaries rediscovered it, apparently independently. They came to realize that light and air interposed

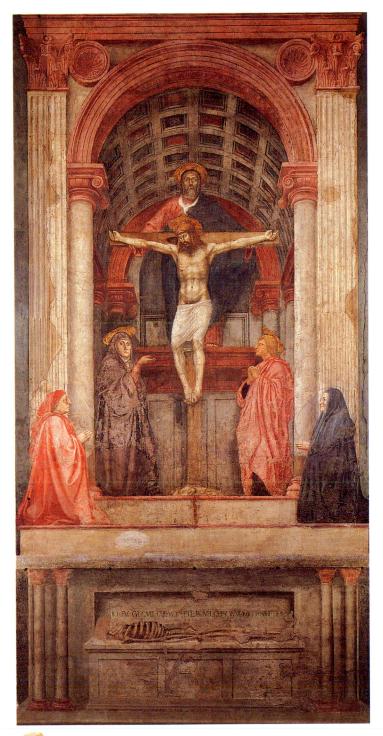

8-17 | MASACCIO, *Holy Trinity*, Santa Maria Novella, Florence, Italy, ca. 1428. Fresco, 21' × 10' 5".

Masaccio's *Holy Trinity* fresco embodies two principal interests of the Italian Renaissance: realism based on observation and the application of mathematics to pictorial organization (perspective).

between viewers and what they see are parts of the visual experience called "distance."

Father, Son, and Holy Spirit Masaccio's *Holy Trinity* fresco (Fig. 8-17) in Santa Maria Novella embodies two principal Renaissance interests. One is realism based on observation,

and the other is the application of mathematics to pictorial organization in the new science of perspective. The artist painted the composition on two levels of unequal height. Above, in a coffered barrel-vaulted chapel reminiscent of a Roman triumphal arch (Fig. 3-27), the Virgin Mary and Saint John appear on either side of the crucified Christ. God the Father emerges from behind Christ, supporting the arms of the cross. The dove of the Holy Spirit hovers between God's head and Christ's head. Masaccio also included portraits of the donors of the painting, Lorenzo Lenzi and his wife, who kneel just in front of the pilasters that enframe the chapel. Below, the artist painted a tomb containing a skeleton. An inscription in Italian painted above the skeleton reminds spectators that "I was once what you are, and what I am you will become."

The illusionism of Masaccio's depiction is breathtaking and a brilliant demonstration of the principles of Brunelleschi's perspective. Indeed, this work is so much in the Brunelleschian manner that some historians have suggested that Brunelleschi may have collaborated with Masaccio. Masaccio placed the vanishing point at the foot of the cross. With this point at eye level, spectators look up at the Trinity and down at the tomb. About five feet above the floor level, the vanishing point pulls the two views together, creating the illusion of an actual structure that transects the wall's vertical plane. Whereas the tomb appears to project, the chapel recedes visually behind the wall and appears as an extension of the spectators' space. This adjustment of the pictured space to the position of the viewer was a first step in the development of illusionistic painting, which fascinated many artists of the Renaissance and the later Baroque period. Masaccio was so exact in his metrical proportions that it is actually possible to calculate the dimensions of the chapel (for example, the span of the painted vault is seven feet; the depth of the chapel, nine feet). Thus, he achieved not only a successful illusion but also a rational measured coherence that, by maintaining the mathematical proportions of the surface design, is responsible for the unity and harmony of this monumental composition.

Masaccio's commitment to pictorial illusionism resulted in a powerful fresco that still instructs the faithful through its images. The ascending pyramid of figures leads the viewer from the despair of death to the hope of resurrection and eternal life.

Brunelleschi, Architect Filippo Brunelleschi's ability to codify a system of linear perspective derived in part from his skill as an architect. Although his biographer, the Florentine humanist Giannozzo Manetti, reported that Brunelleschi turned to architecture out of disappointment over the loss of the baptistery commission, he continued to work as a sculptor for several years and received commissions for sculpture as late as 1416. It is true, however, that as the 15th century progressed, Brunelleschi's interest turned increasingly toward architecture. Several trips to Rome (the first in 1402, probably with his friend Donatello), where he was captivated by the Roman ruins, heightened his fascination with architecture. It may well be in connection with his close study of Roman monuments and his

effort to make an accurate record of what he saw that Brunelleschi developed his revolutionary system of geometric linear perspective that 15th-century artists so eagerly adopted. It made him the first acknowledged Renaissance architect.

A Crowning Achievement Brunelleschi's broad knowledge of Roman construction principles, combined with an analytical and inventive mind, permitted him to solve an engineering problem that no other 15th-century architect could solve. The challenge was the design and construction of a dome (Fig. 8-18) for the huge crossing of the unfinished Florence Cathedral. The problem was staggering; the space to be spanned (140 feet) was much too wide to permit construction with the aid of traditional wooden centering. Nor was it possible (because of the crossing plan) to support the dome with buttressed walls. Brunelleschi seems to have begun work on the problem about 1417.

With exceptional ingenuity, Brunelleschi not only discarded traditional building methods and devised new ones but also invented much of the machinery necessary for the job. Although he might have preferred the hemispheric shape of Roman domes, Brunelleschi raised the center of his dome and designed it around an *ogival* (pointed arch) section, which is inherently more stable because it reduces the outward thrust around the dome's base. To minimize the structure's weight, he designed a relatively thin double shell (the first in history) around a skeleton of 24 ribs. The 8 most important are visible on the exterior. Finally, in almost paradoxical fashion, Brunelleschi anchored the structure at the top with a heavy lantern.

Despite Brunelleschi's knowledge of and admiration for Roman building techniques and even though the Florence Cathedral dome was his most outstanding engineering achievement, he arrived at the solution to this most critical structural problem through what were essentially Gothic building principles. Thus, the dome, which also had to harmonize in formal terms with the century-old building (FIG. 7-34), does not really express Brunelleschi's architectural style.

Santo Spirito and Modular Design Santo Spirito (Fig. 8-19), begun around 1436, shows the clarity and classically inspired rationality that characterize Brunelleschi's mature style. Brunelleschi established the dimensions of every

8-18 | FILIPPO BRUNELLESCHI, dome of Florence Cathedral (view from the south), Florence, Italy, 1420–1436.

Brunelleschi solved the problem of placing a dome over the 140-foot crossing of Florence Cathedral by designing a thin double shell that was ogival instead of round in section. A heavy lantern anchors the dome at the top.

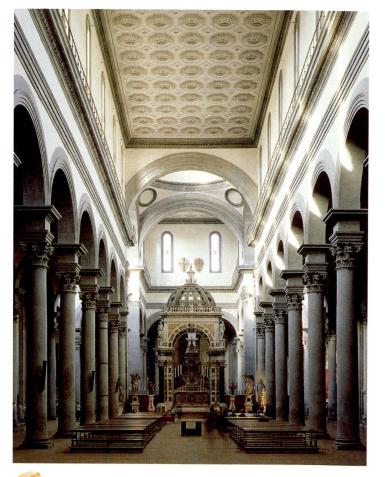

8-19 | FILIPPO BRUNELLESCHI, interior of Santo Spirito (view facing northeast), Florence, Italy, begun ca. 1436.

Santo Spirito displays the classically inspired rationality of Brunelleschi's mature architectural style in its all-encompassing modular scheme based on the dimensions of the dome-covered crossing square.

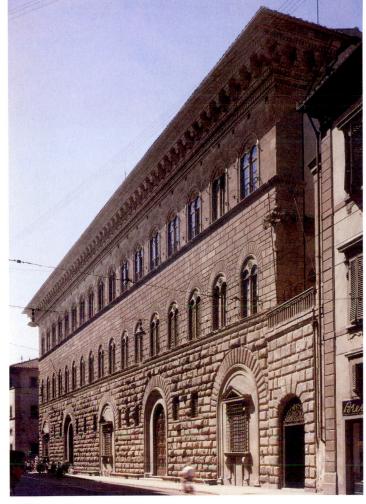

8-20 | MICHELOZZO DI BARTOLOMMEO, facade of the Palazzo Medici-Riccardi, Florence, Italy, begun 1445.

Michelozzo's design for the Medici palace, with its combination of dressed and rusticated masonry and classical moldings, drew heavily on ancient Roman architecture, but the architect creatively reinterpreted his models.

part of this cruciform basilica as either multiples or segments of the dome-covered crossing square, creating a rhythmic harmony throughout the interior. For example, the nave is twice as high as it is wide; the arcade and clerestory are of equal height, which means that the height of the arcade equals the nave's width; and so on. The austerity of the decor enhances the restful and tranquil atmosphere. The calculated logic of the design echoes that of classical buildings. The rationality of Santo Spirito contrasts sharply with the soaring drama and spirituality of the vaults and nave arcades of Gothic churches (Figs. 7-10 and 7-21). Santo Spirito fully expressed the new Renaissance spirit that placed its faith in reason rather than in the emotions.

A Palace Fit for a Medici Early in the 15th century, Giovanni de' Medici (ca. 1360-1429) had established the family fortune. Cosimo (1389-1464) expanded his family's financial control, which led to considerable political power as well. This consolidation of power in a city that prided itself on its republicanism did not go unchallenged. In the early 1430s, a power struggle with other wealthy families led to the Medici's expulsion from Florence. In 1434, the Medici returned, but Cosimo, aware of the importance of public perception, attempted to maintain a lower profile and to wield his power from behind the scenes. He rejected an ostentatious design that Brunelleschi had proposed for a new Medici residence and awarded the commission instead to MICHELOZZO DI BARTOLOMMEO (1396-1472), a young architect who had been Donatello's collaborator in several sculptural enterprises. Although Cosimo chose Michelozzo instead of Brunelleschi, Brunelleschi's architectural style in fact deeply influenced the young architect. To a limited extent, the Palazzo Medici-Riccardi (Fig. 8-20) reflects Brunelleschian principles.

Later bought by the Riccardi family (hence the name Palazzo Medici-Riccardi), who almost doubled the facade's length in the 18th century, the palace, both in its original and extended form, is a simple, massive structure. Heavy rustication (rough, unfinished masonry) on the ground floor accentuates its strength. Michelozzo divided the building block into stories of decreasing height by using long, unbroken stringcourses (horizontal bands), which give the facade coherence. Dressed stone on the upper levels produces a smoother surface with each successive story and modifies the severity of the ground floor. The building thus appears progressively lighter as the eye moves upward. The extremely heavy cornice, which Michelozzo related not to the top story but to the building as a whole, dramatically reverses this effect. Like the ancient Roman cornices that served as Michelozzo's models (compare, for example, Fig. 3-27), the Palazzo Medici-Riccardi cornice is a very effective lid for the structure, clearly and emphatically defining its proportions. Michelozzo also may have been inspired by the many extant examples of Roman rusticated masonry. However, nothing in the ancient world precisely compares with Michelozzo's design. The Palazzo Medici-Riccardi is an excellent example of the simultaneous respect for and independence from the antique that characterize the Early Renaissance in Italy.

The Palazzo Medici-Riccardi is built around an open colonnaded court (Fig. 8-21) that clearly shows Michelozzo's debt to Brunelleschi. The round-arched colonnade, although more massive in its proportions, closely resembles the nave of Santo Spirito (Fig. 8-19). This interior court surrounded by an arcade was, however, the first of its kind, and it influenced a long line of descendants in Renaissance domestic architecture.

Of Ratios and Rationality Leon Battista Alberti (1404-1472) entered the profession of architecture rather late in life, but nevertheless made a remarkable contribution to architectural design. He was the first to study seriously the treatise of Vitruvius (De architectura), and his knowledge of it, combined with his own archaeological investigations, made him the first Renaissance architect to understand

8-21

MICHELOZZO DI BARTOLOMMEO, interior court of the Palazzo Medici-Riccardi, Florence, Italy, begun 1445.

The Medici palace's interior court surrounded by a roundarched colonnade was the first of its kind, but the austere design clearly reveals Michelozzo's debt to Brunelleschi (Fig. 8-19).

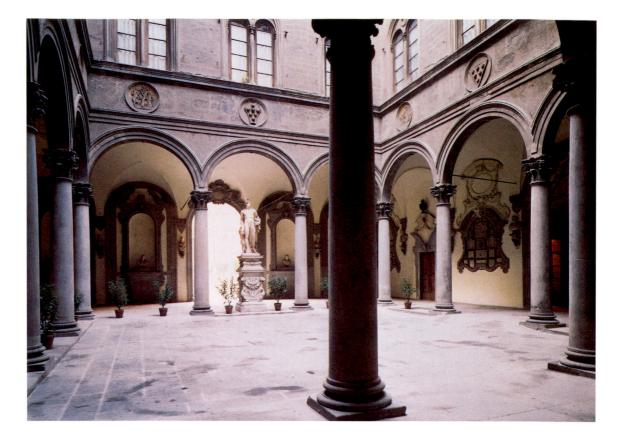

Roman architecture in depth. Alberti's most important and influential theoretical work, *De re aedificatoria* (*On the Art of Building*, written about 1450, published 1486), although inspired by Vitruvius, contains much original material. Alberti advocated a system of ideal proportions and argued that the central plan was the ideal form for a Christian church. He also considered incongruous the combination of column and arch, which had persisted from Roman times to the 15th century (Figs. 8-19 and 8-21). By arguing that the arch is a wall opening that should be supported only by a section of wall (a pier), not by an independent sculptural element (a column), Alberti (with a few exceptions) disposed of the medieval arcade used for centuries.

Alberti's own architectural style represents a scholarly application of classical elements to contemporary buildings. For the new facade (Fig. 8-22) he designed for the 13th-century Gothic Church of Santa Maria Novella in Florence, Alberti chose a small, pseudoclassical, pediment-capped temple front supported by a broad base of pilaster-enframed arcades. Throughout the facade, Alberti defined areas and related them to one another in terms of proportions that can be expressed in simple numerical ratios (1:1, 1:2, 1:3, 2:3, and so on). For example, the height of Santa Maria Novella (to the pediment tip) equals its width, such that the entire facade can be inscribed in a square. The upper structure can be encased in a square one-fourth the size of the main square. The cornice of the entablature that separates the two levels halves the major square. The result is that the lower portion of the building is a rectangle twice as wide as it is high. Further, the

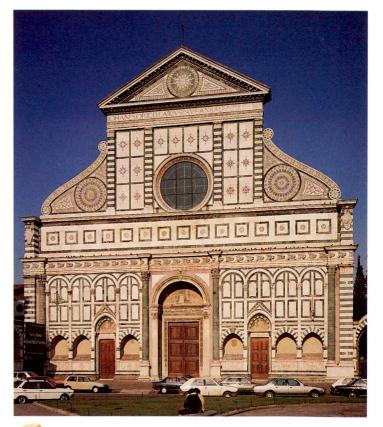

8-22 | LEON BATTISTA ALBERTI, west facade of Santa Maria Novella, Florence, Italy, ca. 1458–1470.

Alberti's design for the facade of this Gothic church features a classicizing pediment-capped temple front and pilaster-enframed arcades. The proportions of all parts of the facade were based on numerical ratios.

areas outlined by the columns on the lower level are squares with sides about one-third the width of the main unit. In his treatise, Alberti wrote at length about how such harmonic relationships were necessary for designing beautiful buildings.

Alberti shared this conviction with Brunelleschi and other Early Renaissance architects, and this fundamental dependence on classically derived mathematics distinguished their architectural work from that of their medieval predecessors. They believed in the eternal and universal validity of numerical ratios as the source of beauty. In this respect, Alberti and Brunelleschi revived the true spirit of the High Classical age of ancient Greece, as epitomized by the sculptor Polykleitos and the architect Iktinos, who produced canons of proportions for the perfect statue and the perfect temple (see Chapter 2). But it was not only a desire to emulate Vitruvius and the Greek masters that motivated Alberti to turn to mathematics in his quest for beauty. His contemporary, Giannozzo Manetti, had argued that Christianity itself possessed the order and logic of mathematics. In his 1452 treatise, On the Dignity and Excellence of Man, Manetti stated that Christian religious truths were as self-evident as mathematical axioms.

The Santa Maria Novella facade was an ingenious solution to a difficult design problem. Alberti succeeded in subjecting preexisting and quintessentially medieval features, such as the large round window on the second level, to a rigid geometrical order that instilled a quality of classical calm and reason. This facade also introduced a feature of great historical consequence—the scrolls that simultaneously unite the broad lower and narrow upper level and screen the sloping roofs over the aisles. With variations, such spirals appeared in literally hundreds of church facades throughout the Renaissance and Baroque periods.

The Medici as Patrons Santa Maria Novella's new facade was paid for by the Rucellai family, but the greatest Florentine art patrons were the Medici. Scarcely a major architect, painter, sculptor, philosopher, or humanist scholar escaped the family's notice. The Medici were Renaissance humanists in the broadest sense of the term. Cosimo, in fact, expended a fortune on manuscripts and books, and opened the first public library since antiquity. Cosimo's grandson Lorenzo (1449–1492), called "the Magnificent," was a talented poet himself and gathered about him a galaxy of artists and gifted men in all fields, extending the library Cosimo had begun and revitalizing his academy for instructing artists. He also participated in what some have called the Platonic Academy of Philosophy (most likely an informal reading group), and lavished funds (often the city's own) on splendid buildings, festivals, and pageants. In their art commissions, the Medici did not favor any specific style or artist, but they were careful to select the most esteemed sculptors and painters of the day for their coveted commissions.

A Classically Inspired David One of those artists was Donatello. The bronze statue *David* (Fig. 8-23), which Donatello created sometime between the late 1420s and the late

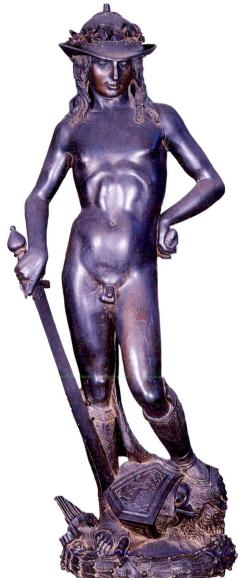

8-23 | DONATELLO, *David*, late 1420s-late 1450s. Bronze, 5' 2\frac{1}{4}" high. Museo Nazionale del Bargello, Florence.

Donatello's David possesses both the relaxed nude contrapposto and the sensuous beauty of nude Greek gods (Fig. 2-45). The revival of classical statuary style appealed to the sculptor's patrons, the Medici.

1450s for the Palazzo Medici courtyard, was the first free-standing nude statue since ancient times. The nude, as such, proscribed in the Christian Middle Ages as both indecent and idolatrous, had been shown only rarely—and then only in biblical or moralizing contexts, such as the story of Adam and Eve or descriptions of sinners in Hell. Donatello reinvented the classical nude, even though his subject was not a pagan god, hero, or athlete but the biblical David, the young slayer of Goliath and the symbol of the independent Florentine republic. David possesses both the relaxed classical contrapposto stance and the proportions and sensuous beauty of Greek Praxitelean gods (Fig. 2-45), qualities absent from medieval figures. The invoking of classical poses and formats appealed to the humanist Medici.

The Medici were aware of Donatello's earlier *David*, a sculpture located in the Palazzo della Signoria, the center of political activity in Florence. The artist had produced it during the threat of invasion by King Ladislaus (r. 1399–1414) of Naples, and it had become a symbol of Florentine strength

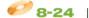

Antonio Pollaiuolo, *Battle of the Ten Nudes*, ca. 1465. Engraving, approx. 1' 3" × 1' 11". Metropolitan Museum of Art, New York (bequest of Joseph Pulitzer, 1917).

Pollaiuolo was fascinated by how muscles and sinews activate the human skeleton. He delighted in showing nude figures in violent action and from numerous foreshortened viewpoints.

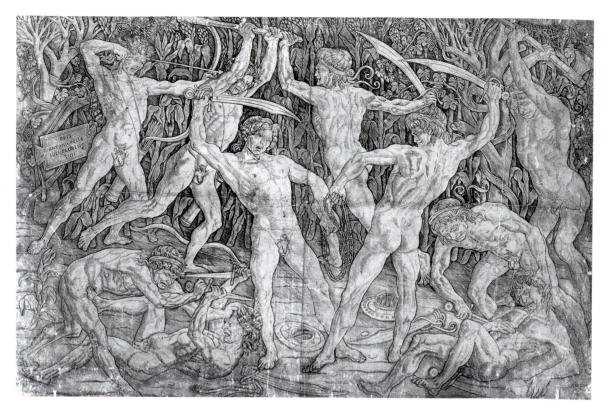

and independence. Their selection of the same subject suggests that the Medici identified themselves with Florence or, at the very least, saw themselves as responsible for Florence's prosperity and freedom.

Battling Nudes Another of the many artists who produced sculptures and paintings for the Medici was ANTONIO POLLAIUOLO (ca. 1431–1498), who took delight in showing human figures in violent action. Masaccio and his contemporaries had dealt effectively with the problem of rendering human anatomy, but they usually depicted their figures at rest or in restrained motion. Pollaiuolo favored subjects dealing with combat. He conceived the body as a powerful machine and liked to display its mechanisms, such as knotted muscles and taut sinews that activate the skeleton as ropes pull levers. To this end, Pollaiuolo developed a figure so lean and muscular that it appears écorché (as if without skin), with strongly accentuated delineations at the wrists, elbows, shoulders, and knees. His engraving Battle of the Ten Nudes (Fig. 8-24) shows this figure type in a variety of poses and from numerous viewpoints, allowing the artist to demonstrate his prowess in rendering the nude male figure. In this, Pollaiuolo was a kindred spirit of late-sixth-century Greek vase painters, such as Euthymides (Fig. 2-23), who had experimented with foreshortening for the first time in history. If Pollaiuolo's figures, even though they hack and slash at each other without mercy, seem somewhat stiff and frozen, it is because the artist showed all the muscle groups at maximum tension. Not until several decades later did an even greater anatomist, Leonardo, observe that only part of the body's muscle groups are involved in any one action, while the others are relaxed.

Pollaiuolo's engraving is an early Italian example of the new medium that northern European artists probably developed around the middle of the 15th century. But whereas German graphic artists, such as Martin Schongauer (Fig. 8-11), described their forms with hatching that follows the forms, Italian engravers, such as Pollaiuolo, preferred parallel hatching.

Visual Poetry Among the best-known artists who produced works for the Medici was Pollaiuolo's younger contemporary SANDRO BOTTICELLI (1444-1510). One of the works Botticelli painted in tempera on canvas for the Medici is Birth of Venus (Fig. 8-25). A poem on that theme by Angelo Poliziano, one of the leading humanists of the day, inspired Botticelli to create this lyrical image around 1482. Zephyrus (the west wind) blows Venus, born of the sea foam and carried on a cockle shell, to her sacred island, Cyprus. There, the nymph Pomona runs to meet her with a brocaded mantle. The lightness and bodilessness of the winds move all the figures without effort. Draperies undulate easily in the gentle gusts, perfumed by rose petals that fall on the whitecaps. The nudity of Botticelli's Venus figure was in itself an innovation. As mentioned earlier, the nude, especially the female nude, had been proscribed during the Middle Ages. The artist's use (especially on such a large scale) of an ancient statue of the Venus pudica (modest Venus) type—a Hellenistic variant of Praxiteles' famous Aphrodite of Knidos (Fig. 2-44)—as a model could have drawn the charge of paganism and infidelity. But in the more

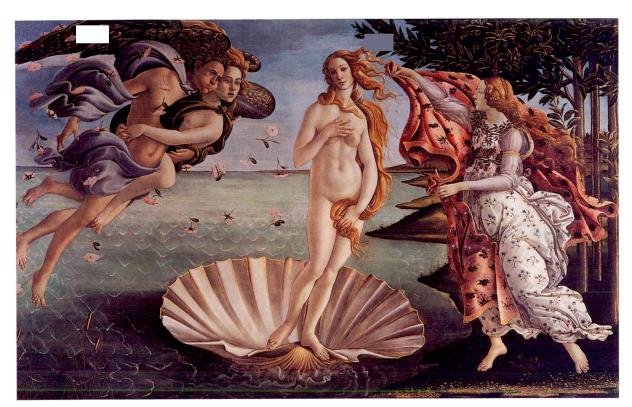

8-25 | SANDRO BOTTICELLI, Birth of Venus, ca. 1482. Tempera on canvas, approx. 5' 8" × 9' 1". Galleria degli Uffizi, Florence.

Inspired by a Poliziano poem and classical statues of Aphrodite (Fig. 2-44), Botticelli revived the theme of the female nude in this elegant and romantic representation of Venus born of the sea foam.

accommodating Renaissance culture and under the protection of the powerful Medici, the depiction went unchallenged.

Botticelli's style is clearly distinct from the earnest search many other artists pursued to comprehend humanity and the natural world through a rational and empirical order. Indeed, Botticelli's elegant and beautiful style seems to have ignored all of the scientific knowledge experimental art had gained (for example, in the areas of perspective and anatomy). His style paralleled the allegorical pageants that were staged in Florence as chivalric tournaments but were structured around allusions to classical mythology. The same trend is evident in the poetry of the 1470s and 1480s. Artists and poets at this time did not directly imitate classical antiquity but used the myths, with delicate perception of their charm, in a way still tinged with medieval romance. Ultimately, Botticelli created a style of visual poetry, parallel to the Petrarchan love poetry written by Lorenzo de' Medici. His paintings possess a lyricism and courtliness that appealed to cultured patrons such as the Medici.

A Cat on a Horse Consistent with humanism's increased emphasis on individual achievement and recognition, portraiture enjoyed a revival in the 15th century. Commemorative portraits of the deceased were common, and patrons also commissioned portraits of themselves. In painting, the profile pose was customary in Florence until about 1470, when three-quarter and full-face portraits began to replace it. Bustlength portraits based on Roman precedents also became prominent. The grandest portrait of the era, however, was an 11-foot-tall bronze statue (Fig. 8-26) that Donatello produced for the Republic of Venice. His assignment was to create a

8-26 | DONATELLO, *Gattamelata* (equestrian statue of Erasmo da Narni), Piazza del Santo, Padua, Italy, ca. 1445–1450. Bronze, approx. 11' × 13'.

Donatello's giant equestrian portrait of a Venetian general is based on statues of ancient Roman emperors mounted on horseback (Fig. 3-36). The orb beneath the horse's hoof symbolizes world rule.

commemorative monument in honor of the recently deceased Venetian condottiere Erasmo da Narni. City officials asked Donatello to portray the condottiere (whose nickname was Gattamelata, or "honeyed cat," a wordplay on his mother's name, Melania Gattelli) on horseback. The giant statue was to be erected in the square of Sant'Antonio in Padua. Although equestrian statues occasionally had been set up in Italy in the late Middle Ages, Donatello's Gattamelata is the first to rival the grandeur of the mounted portraits of antiquity, such as that of Marcus Aurelius (Fig. 3-36), which the artist must have seen in Rome. Donatello's contemporaries, one of whom described Gattamelata as sitting "there with great magnificence like a triumphant Caesar,"3 recognized this reference to antiquity. The figure stands high on a lofty elliptical base, set apart from its surroundings, and seems to celebrate sculpture's liberation from architecture. Massive and majestic, the great horse bears the armored general easily, for, unlike the sculptor of Marcus Aurelius, Donatello did not represent the Venetian commander as superhuman and more than life-size. The officer dominates his mighty steed by force of character rather than sheer size. Together, man and horse convey an overwhelming image of irresistible strength and unlimited power—an impression Donatello reinforced visually by placing the left forehoof of the horse on an orb, reviving a venerable ancient symbol for hegemony over the earth. The Italian rider, his face set in a mask of dauntless resolution and unshakable will, is the very portrait of the male Renaissance individualist. Such a man-intelligent, courageous, ambitious, and frequently of humble origin—could, by his own

resourcefulness and on his own merits, rise to a commanding position in the world.

A Visual Call to Prayer As is evident by the abundant religious imagery produced during the 15th century, humanism and religion were not mutually exclusive. For many artists, humanist concerns were not a primary consideration. Guido di Pietro (ca. 1400-1455), better known today as FRA ANGELICO (the Angelic Friar), was among those. His art focused on serving the Roman Catholic Church. In the late 1430s, the abbot of the Dominican monastery of San Marco in Florence asked Fra Angelico to produce a series of frescoes for the monastery. The Dominicans of San Marco had dedicated themselves to lives of prayer and work, and the religious compound was mostly spare and austere to encourage the monks to immerse themselves in their devotional lives. Fra Angelico's frescoes illustrated a 13th-century text, De modo orandi (The Way of Prayer), which describes the nine ways of prayer used by Saint Dominic, the order's founder.

Among the works he completed was Annunciation (Fig. 8-27), which appears at the top of the stairs leading to the friars' cells. Appropriately, Fra Angelico presented the scene of the Virgin Mary and the Archangel Gabriel with simplicity and serenity. The two figures appear in a plain loggia, and the artist painted all the fresco elements with a pristine clarity. As an admonition to heed the devotional function of the images, Fra Angelico included a small inscription at the base of the image that reads, "As you venerate, while passing before it, this figure of the intact Virgin, beware lest you omit to say a Hail

8-27 | Fra ANGELICO, Annunciation, San Marco, Florence, Italy, ca. 1440-1445. Fresco, $7' \ 1'' \times 10' \ 6''$.

Painted for the Dominican monks of San Marco, Fra Angelico's fresco is characteristically simple and direct. The figures and architecture have a pristine clarity that befits their function as devotional images.

8-28 | Andrea del Castagno, *Last Supper*, the refectory, monastery of Sant'Apollonia, Florence, Italy, 1447. Fresco, approx. 15' × 32'.

Judas sits isolated in this fresco of the Last Supper based on the Gospel of Saint John. The figures are small compared to the setting, reflecting Castagno's preoccupation with the new science of perspective.

Mary." Like most of Fra Angelico's paintings, *Annunciation*'s simplicity and directness still has an almost universal appeal and fully reflects the artist's simple and humble character.

The Last Supper in Perspective Another painter who accepted a commission to produce a series of frescoes for a religious establishment was Andrea del Castagno (ca. 1421–1457). His Last Supper (Fig. 8-28), painted in the refectory (dining hall) of Sant'Apollonia in Florence, a convent for Benedictine nuns, manifests both a commitment to the biblical narrative and an interest in perspective. The lavishly painted space that Christ and his 12 disciples occupy suggests Castagno's absorption with creating the illusion of three-dimensional space. However, closer scrutiny reveals inconsistencies, such as the fact that Renaissance perspectival systems make it impossible to see both the ceiling and the roof, as Castagno depicted. Further, the two side walls do not appear parallel.

The artist chose a conventional compositional format, with the figures seated at a horizontally placed table. Castagno derived the apparent self-absorption of most of the disciples and the malevolent features of Judas (who sits alone on the outside of the table) from the Gospel of Saint John, rather than the more familiar version of the Last Supper recounted in the Gospel of Saint Luke. The exploration of per-

spective so prevalent in 15th-century Italian art clearly influenced Castagno's depiction of the Last Supper, which no doubt was a powerful presence for the nuns during their daily meals.

A Facility with Line A younger contemporary of Fra Angelico, Fra Filippo Lippi (ca. 1406–1469), was also a friar but there all resemblance ends. From reports, Fra Filippo seems to have been an amiable man unsuited for monastic life. He indulged in misdemeanors ranging from forgery and embezzlement to the abduction of a pretty nun, Lucretia, who became his mistress and the mother of his son, the painter Filippino Lippi (1457-1504). Only the Medici's intervention on his behalf at the papal court preserved Fra Filippo from severe punishment and total disgrace. An orphan, Fra Filippo spent his youth in a monastery adjacent to the Church of Santa Maria del Carmine and must have met Masaccio there and witnessed the decoration of the Brancacci Chapel. Fra Filippo's early work survives only in fragments, but these show that he tried to work with Masaccio's massive forms. Later, probably under the influence of Ghiberti's and Donatello's relief sculptures, he developed a linear style that emphasized the contours of his figures and permitted him to suggest movement through flying and swirling draperies.

8-29 | Fra Filippo Lippi, *Madonna and Child with Angels*, ca. 1455. Tempera on wood, approx. 3' × 2' 1". Galleria degli Uffizi, Florence.

Fra Filippo, a monk guilty of many misdemeanors, here represented the Virgin and Christ Child in a distinctly worldly manner, carrying the humanization of the holy family further than ever before.

A painting from Fra Filippo's later years, Madonna and Child with Angels (Fig. 8-29), shows his skill in manipulating line. A wonderfully fluid line unifies the composition and contributes to the precise and smooth delineation of forms. Few artists have surpassed Fra Filippo's skill in using line. He interpreted his subject here in a surprisingly worldly manner. The Madonna, a beautiful young mother, is not at all spiritual or fragile, and neither is the Christ Child, whom two angels hold up. One of the angels turns with the mischievous, puckish grin of a boy refusing to behave for the pious occasion. Significantly, all figures reflect the use of live models (that for the Madonna even may have been Lucretia). Fra Filippo plainly relished the charm of youth and beauty as he found it in this world. He preferred the real in landscape also. The background, seen through the window, incorporates with some exaggerations recognizable features of the Arno River valley. Compared with the earlier Madonnas by Giotto (Fig. 7-27) and Duccio (Fig. 7-30), this work shows how far artists had carried the humanization of the theme. Whatever the ideals of spiritual perfection may have meant to artists in past centuries, Renaissance artists realized such ideals in terms of the sensuous beauty of this world.

Piero della Francesca Born in Borgo San Sepolcro, south of Florence, PIERO DELLA FRANCESCA (ca. 1420–1492) worked in several Tuscan cities as well as at the Urbino court of the condottiere Federico da Montefeltro. (The humanist writer Paolo Cortese described Federico as one of the two greatest artistic patrons of the 15th century. The other was Cosimo de' Medici.) Piero's art reveals a mind cultivated by mathematics. He believed that the highest beauty resided in forms that have the clarity and purity of geometric figures. Toward the end of his long career, Piero, a skilled geometrician, wrote the first theoretical treatise on systematic perspective, after having practiced the art with supreme mastery for almost a lifetime. His association with the architect Alberti at Ferrara and at Rimini around 1450-1451 probably turned his attention fully to perspective and helped determine his later, characteristically architectonic, compositions. Piero established his compositions almost entirely by his sense of the exact and lucid structures defined by mathematics.

The True Cross One of Piero's most important works is the fresco cycle in the apse of the Church of San Francesco in Arezzo, southeast of Florence on the Arno. Painted between 1452 and 1456, the cycle represents 10 episodes from the legend of the True Cross (the cross on which Christ died) and is based on a 13th-century popularization of the Scriptures, the Golden Legend, by Jacobus de Voragine. In the climactic scene of Piero's Arezzo cycle, the Finding of the True Cross and Proving of the True Cross (Fig. 8-30), Saint Helena, mother of Constantine, accompanied by her retinue, oversees the unearthing of the buried crosses (at left), and witnesses (at right) how the True Cross miraculously restores a dead man (the nude figure) to life. The architectural background organizes and controls the grouping of the figures. Its medallions, arches, and rectangular panels are the two-dimensional counterparts of the ovoid, cylindrical, and cubic forms placed in front of it. The careful delineation of architecture suggests an architect's vision, certainly that of a man entirely familiar with compass and straightedge. As the architectonic nature of the abstract shapes controls the grouping, so too does it impart a mood of solemn stillness to the figures.

Piero's work shows, in addition, an unflagging interest in the properties of light and color. In his effort to make the clearest possible distinction between forms, he flooded his pictures with light, imparting a silver-blue tonality. To avoid heavy shadows, he illuminated the dark sides of his forms with reflected light. By moving the darkest tones of his modeling toward the centers of his volumes, he separated them from their backgrounds. Because of this technique, Piero's paintings lack some of Masaccio's relief-like qualities but gain

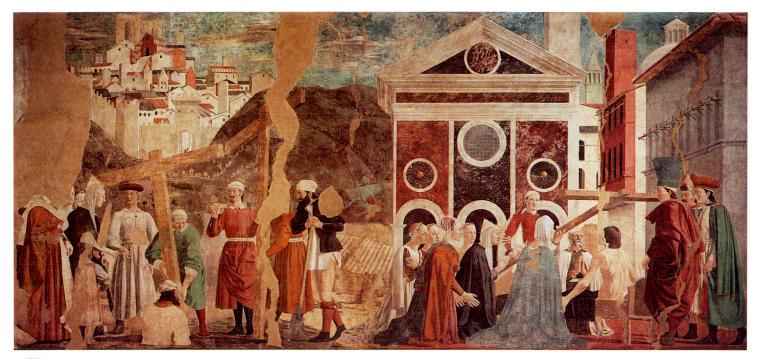

8-30 | PIERO DELLA FRANCESCA, Finding of the True Cross and Proving of the True Cross, San Francesco, Arezzo, Italy, ca. 1455. Fresco, 6' $4'' \times 11' 8\frac{3}{8}''$.

Piero was a skilled geometrician and the author of a treatise on perspective. The almost abstract shapes of his architectural settings impart a mood of solemn stillness to his figures.

in spatial clarity, as each shape forms an independent unit surrounded by an atmospheric envelope and movable to any desired position, like a figure on a chessboard.

Turmoil at Century's End In the 1490s, Florence underwent a political, cultural, and religious upheaval. Florentine artists and their fellow citizens responded then not only to humanist ideas but also to the incursion of French armies and especially to the preaching of the Dominican monk Girolamo Savonarola, the reforming priest-dictator who denounced the paganism of the Medici and their artists, philosophers, and poets. Savonarola exhorted the people of Florence to repent their sins, and, when Lorenzo de' Medici died in 1492 and the Medici fled, he prophesied the downfall of the city and of Italy and assumed absolute control of the state. Together with a large number of citizens, Savonarola believed that the Medici's political, social, and religious power had corrupted Florence and had invited the scourge of foreign invasion. Savonarola denounced humanism and encouraged "bonfires of the vanities" for citizens to burn their classical texts, scientific treatises, and philosophical publications. Modern scholars still debate the significance of Savonarola's brief span of power. Apologists for the undoubtedly sincere monk deny that his actions played a role in the decline of Florentine culture at the end of the 15th century. But he did condemn humanism as heretical nonsense, and his banishing of the Medici and other wealthy families from Florence deprived local artists of some of their major patrons. Certainly, the

puritanical spirit that moved Savonarola must have dampened considerably the neopagan enthusiasm of the Florentine Early Renaissance.

The Princely Courts

Although Florence gave birth to the Renaissance, the papacy in Rome and the princely courts established in cities such as Naples, Urbino, Milan, Ferrara, and Mantua deserve much credit for nurturing the arts in the 15th century.

Establishing Papal Authority Between 1481 and 1483, Pope Sixtus IV summoned a group of artists, including Botticelli, Domenico Ghirlandaio, and Luca Signorelli, from Florence to Rome to decorate with frescoes the walls of the newly completed Sistine Chapel. Pietro Vannucci (ca. 1450-1523), known as PERUGINO (the Perugian), was among this group and painted Christ Delivering the Keys of the Kingdom to Saint Peter (Fig. 8-31). The papacy had, from the beginning, based its claim to infallible and total authority over the Roman Catholic Church on this biblical event. In Perugino's version, Christ hands the keys to Saint Peter, who stands amid an imaginary gathering of the Twelve Apostles and Renaissance contemporaries. These figures occupy the apron of a great stage space that extends into the distance to a point of convergence in the doorway of a central-plan temple. (Perugino used parallel and converging lines in the pavement to mark off the intervening space.) Figures in the middle distance complement the near group,

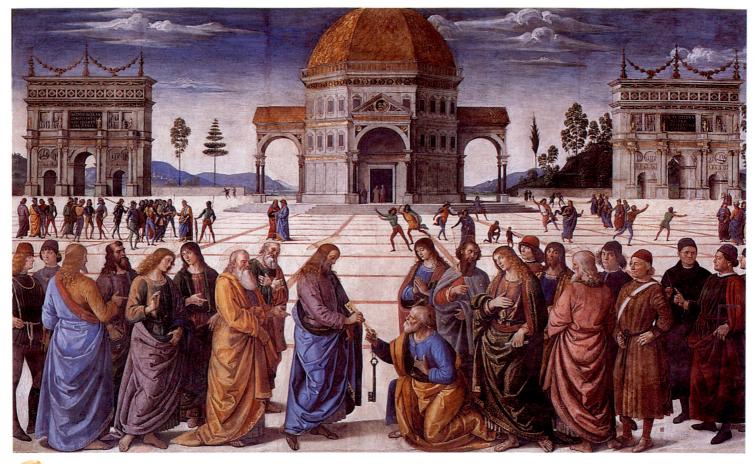

8-31 | PERUGINO, Christ Delivering the Keys of the Kingdom to Saint Peter, Sistine Chapel, Vatican, Rome, Italy, 1481–1483. Fresco, 11' $5\frac{1}{2}$ " × 18' $8\frac{1}{2}$ ".

Painted for the Vatican, this fresco depicts the event on which the papacy based its authority. The action takes place in the foreground but is connected to the background by the converging lines of the pavement.

emphasizing its density and order by their scattered arrangement. At the corners of the great piazza, duplicate triumphal arches serve as the base angles of a distant compositional triangle whose apex is in the central building. Perugino modeled the arches very closely on the Arch of Constantine (Fig. 3-45) in Rome. Although an anachronism in a painting depicting a scene from Christ's life, the arches remind viewers of the close ties between Constantine and Saint Peter and of the great basilica (Fig. 4-3) the first Christian emperor built over Saint Peter's tomb in Rome. Christ and Peter flank the triangle's central axis, which runs through the temple's doorway, the perspective's vanishing point. Thus, the composition interlocks both two-dimensional and three-dimensional space, and the placement of central actors emphasizes the axial center. This spatial science allowed the artist to organize the action systematically. Perugino, in this single picture, incorporated the learning of generations.

Alberti in Mantua Marquis Ludovico Gonzaga (1412–1478) ruled one of the wealthiest princely courts of the 15th century, the marquisate of Mantua in northern Italy. A famed condottiere, Gonzaga established his reputation as a fierce military leader while general of the Milanese armies. A visit to

Mantua by Pope Pius II in 1459 stimulated the marquis's determination to transform Mantua into a spectacular city. After the pope's departure, Gonzaga set about building a city that would be the envy of all of Italy.

One of the major projects Gonzaga instituted was the redesigning of the Church of Sant'Andrea (Fig. 8-32) to replace an 11th-century church. Gonzaga turned to Alberti for this important commission. In the ingeniously planned facade, which illustrates the culmination of Alberti's experiments, the architect locked together two complete Roman architectural motifs—the temple front and the triumphal arch. The combination was already a feature of classical architecture. Many Roman triumphal arches incorporated a pediment over the arcuated passageway and engaged columns. Alberti's concern for proportion led him to equalize the facade's vertical and horizontal dimensions, which left it considerably lower than the church behind it. Because of the primary importance of visual appeal, many Renaissance architects made this concession not only to the demands of a purely visual proportionality in the facade but also to the facade's relation to the small square in front of it, even at the expense of continuity with the body of the building. Yet structural correspondences to the building do exist in the Sant'Andrea

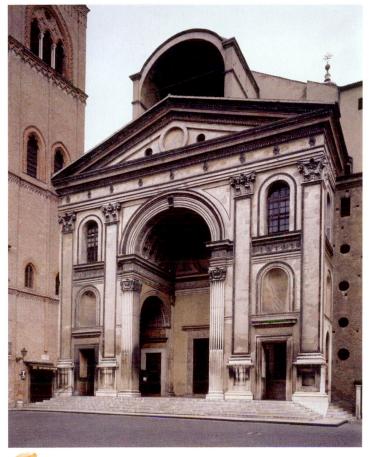

8-32 | LEON BATTISTA ALBERTI, west facade of Sant'Andrea, Mantua, Italy, designed ca. 1470.

Alberti's design for the facade of Sant'Andrea reflects his study of geometry and ancient Roman architecture. The renowned architect locked together a triumphal arch and a Roman temple front with pediment.

facade. The facade pilasters are the same height as those on the nave's interior walls, and the central barrel vault over the main exterior entrance, with smaller barrel vaults branching off at right angles, introduces (in proportional arrangement but on a smaller scale) the interior system. The facade pilasters, as part of the wall, run uninterrupted through three stories in an early application of the "colossal" or "giant" order that became a favorite motif of Michelangelo (see Chapter 9).

Inside, Alberti abandoned the medieval columned arcade Brunelleschi used in Santo Spirito (FIG. 8-19). Thick walls alternating with vaulted chapels and interrupted by a massive dome over the crossing support the huge barrel vault. The vaulted interior calls to mind the vast spaces and dense enclosing masses of Roman architecture. In his architectural treatise, Alberti criticized the traditional basilican plan (with continuous aisles flanking the central nave) as impractical because the colonnades conceal the ceremonies from the faithful in the aisles. For this reason, he designed a single huge hall with independent chapels branching off at right angles. This break with a Christian building tradition that had endured for a thousand years was extremely influential in later Renaissance and Baroque church planning.

Painting Away the Walls Like other princes, Ludovico Gonzaga believed that an impressive palace was an important visual expression of his authority. One of the most spectacular rooms in the Palazzo Ducale (Duke's Palace) in Mantua was the so-called Camera degli Sposi (Room of the Newlyweds; FIG. 8-33), originally the Camera Picta (Painted Room), decorated by Andrea Mantegna (ca. 1431–1506) of Padua. Taking almost nine years to complete the extensive fresco

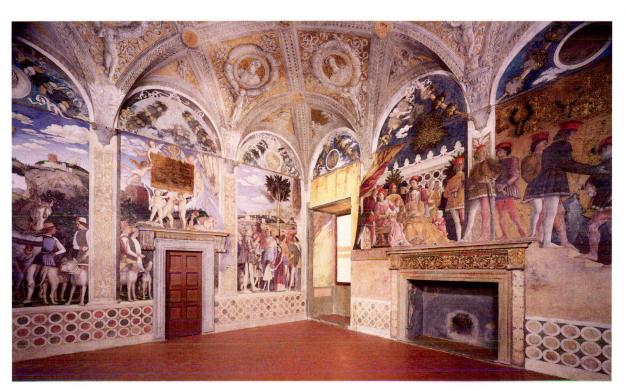

8-33

Andrea Mantegna, interior of the Camera degli Sposi (Room of the Newlyweds), Palazzo Ducale, Mantua, Italy, 1474. Fresco.

Working for Ludovico Gonzaga, who established Mantua as a great art city, Mantegna produced for the duke's palace the first completely consistent illusionistic fresco decoration of an entire room.

8-34 | ANDREA MANTEGNA, Dead Christ, ca. 1501. Tempera on canvas, 2' $2\frac{3}{4}$ " \times 2' $7\frac{7}{8}$ ". Pinacoteca di Brera, Milan.

In this work of overwhelming emotional power, Mantegna presented both a harrowing study of a strongly foreshortened cadaver and an intensely poignant depiction of a biblical tragedy.

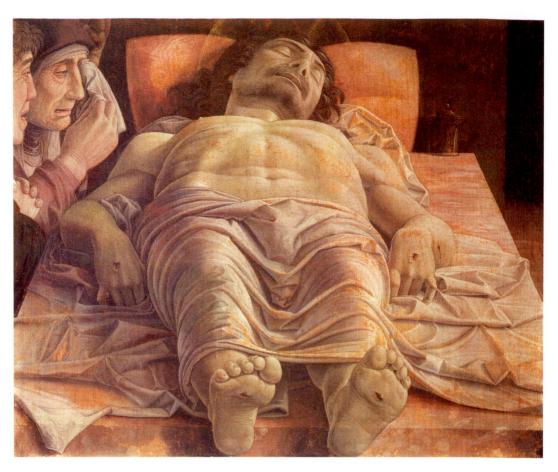

program, Mantegna produced a series of images that aggrandize Ludovico Gonzaga and his family, and reveal the activities and rhythm of courtly life. The scenes depict vignettes that include Ludovico, his wife, his children, courtiers, and attendants, among others. Standing in the Camera degli Sposi, surrounded by the spectacle and majesty of these scenes, the viewer cannot help but be thoroughly impressed by both the commanding presence and elevated status of the patron and the dazzling artistic skills of Mantegna.

In the Camera degli Sposi, Mantegna performed a triumphant feat of pictorial illusionism, producing the first completely consistent illusionistic decoration of an entire room. Using actual architectural elements, Mantegna painted away the room's walls in a manner that foretold later Baroque decoration. It recalls the efforts of Italian painters more than 15 centuries earlier at Pompeii and elsewhere to integrate mural painting and actual architecture in frescoes of the so-called Second Style of Roman painting (Figs. 3-15 and 3-16).

Examining Christ's Wounds One of Mantegna's later paintings, Dead Christ (Fig. 8-34), is a work of overwhelming power. At first glance, this painting seems to be a strikingly realistic study in foreshortening. Careful scrutiny, however, reveals that the artist reduced the size of the figure's feet, which, as he must have known, would cover much of the body if properly represented. Thus, tempering naturalism with artistic license, Mantegna presented both a harrowing study of a strongly foreshortened cadaver and an intensely poignant

depiction of a biblical tragedy. The painter's harsh, sharp line seems to cut the surface as if it were metal and conveys, by its grinding edge, the theme's corrosive emotion. Remarkably, all the science of the 15th century here serves the purpose of devotion.

CONCLUSION

The 15th century witnessed momentous changes in art on both sides of the Alps. Among the notable transformations in the north were the increased use of oil paints in Flanders, a greater illusionism in French manuscript illumination, and the invention of movable-type printing in Germany. Flanders, in particular, was at the forefront of artistic developments, in part because of the power and patronage of the Burgundian dukes.

In Italy, political instability resulted in the rising influence of princely courts, such as that at Mantua, and dominant families, such as the Medici of Florence. These wealthy princes and families saw themselves not just as political and economic leaders but as cultural ones as well. For this reason, art patronage was a priority for many of them, and their commissions—in terms of quantity, scale, subjects, selected artists, and, often, visibility—affected the direction of Early Renaissance art. The expanding interest in humanism led to a fascination with perspectival systems, the popularity of subjects derived from classical history or mythology, and a revival of classical design principles in architecture.

Cosimo de' Medici, 1389-1464

1400

- Giangaleazzo Visconti dies; Milanese armies withdraw from Tuscany, 1402
 - I King Ladislaus of Naples dies, 1414
 - I End of Great Schism in Catholic Church, 1417
 - I Philip the Good, Duke of Burgundy, r. 1419-1467

Lorenzo Ghiberti, Sacrifice of Isaac, 1401–1402

1425

- I Leon Battista Alberti, On Painting, 1435
- Invention of movable metal type by Johann Gutenberg, ca. 1445
 - Lorenzo de' Medici, 1449-1492

2 Jan van Eyck, Ghent Altarpiece, 1432

1450

- Leon Battista Alberti, On the Art of Building, ca. 1450, published 1486
- I Hundred Years' War ends, 1453
- I First international stock exchange, Antwerp, 1460
- I Charles the Bold, last Duke of Burgundy, r. 1467–1477

Sant'Andrea, Mantua, ca. 1470

1475

3

4

- Medici expelled from Florence, 1494
- I Girolamo Savonarola assumes power in Florence, 1496; burned at stake, 1498

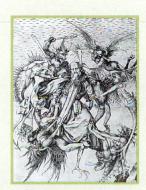

4 Martin Schongauer, Saint Anthony Tormented by Demons, ca. 1480–1490

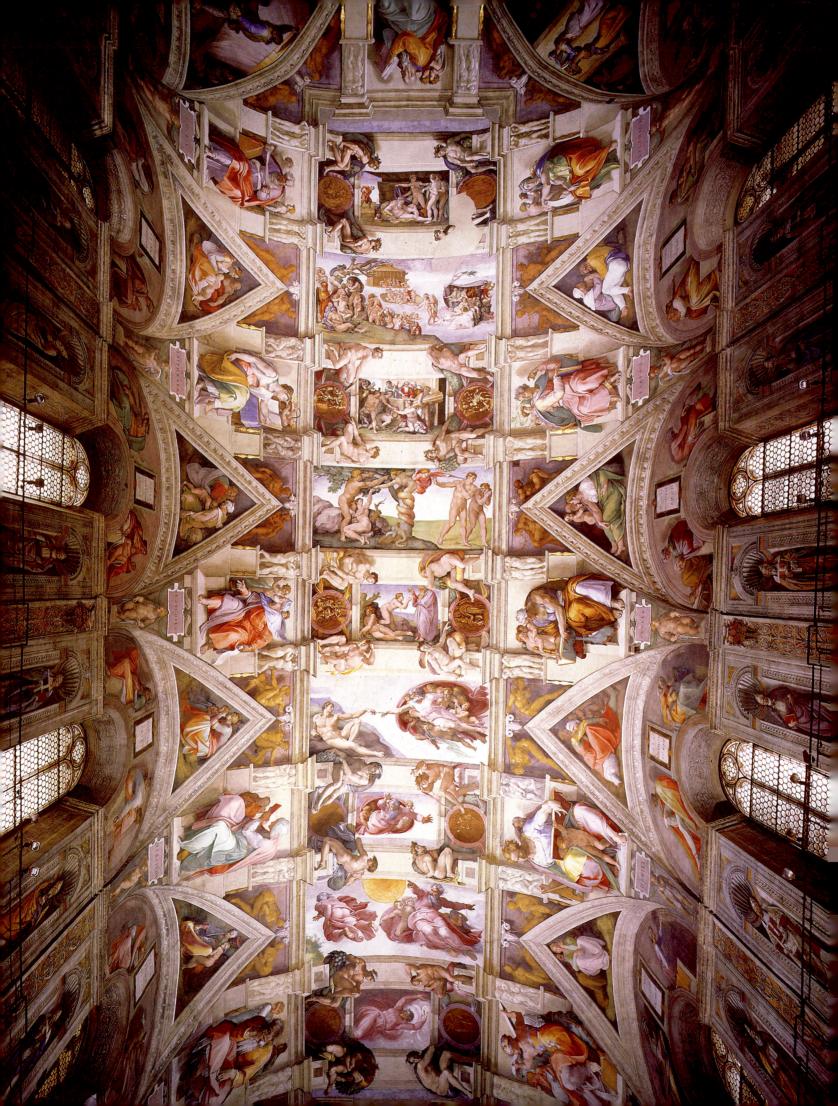

16TH-CENTURY EUROPE

The 16th century witnessed major upheaval and change in Europe (MAP 9-1, page 529), particularly in the realm of religion. Widespread dissatisfaction with the leadership and policies of the Roman Catholic Church instigated the Protestant Reformation. Led by theologians such as Martin Luther (1483–1546) and John Calvin (1509–1564) in the Holy Roman Empire, early 16th-century reformers directly challenged papal authority. Disgruntled Catholics voiced concerns about the sale of indulgences (pardons for sins, reducing the time a soul spent in Purgatory—equated with buying one's way into Heaven), nepotism (the appointment of relatives to important positions), and high Church officials pursuing personal wealth. Particularly damaging was the perception that popes concerned themselves more with temporal power and worldly goods than with the salvation of Church members. The fact that many 15th-century popes and cardinals came from wealthy families, such as the Medici—Clement VII (Giulio de' Medici) and Leo X (Giovanni de' Medici) are two examples—intensified this perception.

Protestantism The northern reform movement resulted in the establishment of Protestantism, with sects such as Lutheranism and Calvinism. Central to Protestantism was a belief in personal faith rather than adherence to decreed Church practices and doctrines. Because the Protestants believed that the only true religious relationship was the personal relationship between individuals and God, they were, in essence, eliminating the need for Church intercession central to Catholicism.

In 1517, in Wittenberg, Luther posted for discussion his *Ninety-Five Theses*, which enumerated his objections to Church practices. Luther's goal was significant reform and clarification of major spiritual issues, but his ideas ultimately led to the splitting of Christendom. According to Luther, the Catholic Church's extensive ecclesiastical structure needed casting out, for it had no basis in Scripture. The Bible and nothing else could serve as the foundation for Christianity. Luther declared the pope the Antichrist (for which the pope excommunicated him), called the Church the "whore of Babylon," and denounced ordained priests. He also rejected most of Catholicism's sacraments, decrying them as pagan obstacles to salvation. He did, however, accept two sacraments, baptism and the Eucharist. According to Luther, for Christianity to be restored to its original purity, the Church needed cleansing of all the impurities of doctrine that had collected through the ages.

MICHELANGELO BUONARROTI, ceiling of the Sistine Chapel, Vatican City, Rome, Italy, 1508-1512. Fresco, approx. $128'\times45'$.

Central to the reformers' creed was the question of how to achieve salvation. Rather than perceive salvation as something for which weak and sinful humans must constantly strive through good deeds performed under a punitive God's watchful eye, Luther proposed that faithful individuals attain redemption by God's bestowal of grace. Therefore, people cannot earn salvation. Further, no ecclesiastical machinery with all its miraculous rites and indulgences could save sinners from God's judgment. Only absolute faith in Christ could justify sinners and ensure salvation. Justification by faith alone, with the guidance of Scripture, was the fundamental doctrine of Protestantism. Luther advocated the Bible as the source of all religious truth. The Bible—the sole scriptural authority—was the word of God, not the Church's councils, laws, and rituals. Luther facilitated the lay public's access to biblical truths by producing the first translation of the Bible in a vernacular language (German).

Art and Religion The seismic shifts occurring in all aspects of European life due to the Reformation affected the arts, particularly its patronage and the types of art commissioned. In addition to doctrinal differences, Catholics and Protestants took divergent stances on the role of visual imagery in religion. Protestants believed that such imagery could lead to idolatry and distracted viewers from focusing on the real reason for their presence in church—to communicate directly with God. Because of this, Protestant churches were relatively bare.

Protestant proscriptions against religious imagery also often led to eruptions of iconoclasm. Particularly violent waves of iconoclastic fervor swept Basel, Zurich, Strasbourg and Wittenberg in the 1520s. In an episode known as the Great Iconoclasm, bands of Calvinists visited Catholic churches in the Netherlands in 1566, shattering stained-glass windows, smashing statues and destroying paintings and other artworks that they perceived as idolatrous. These strong reactions to art reflect not just the religious fervor of the time. They also serve as dramatic demonstrations of the power of art—and how much art mattered.

In striking contrast, Catholics embraced church decoration as an aid to communicating with God. Under Pope Paul III (Alessandro Farnese, r. 1534–1549), the Catholic Church mounted a full-fledged campaign to counteract the defection of its members to Protestantism. This response, the Counter-Reformation, consisted of numerous initiatives. The Council of Trent, which met intermittently from 1545 through 1563, was a major component of this effort. Composed of cardinals, archbishops, bishops, abbots, and theologians, the Council of Trent dealt with issues of Church doctrine, including many the Protestants contested. Many papal commissions during this period can be viewed as an integral part of the Counter-Reformation effort. Popes long had been aware of the power of visual imagery to construct and reinforce ideological claims, and 16thcentury popes exploited this capability (see "The Role of Religious Art in Counter-Reformation Italy," page 251).

Due in large part to the Counter-Reformation, papal commissions accounted for a much higher percentage of the most important artistic projects in 16th-century Italy. This period, known as the High Renaissance, witnessed the maturation of the key developments of Early Renaissance art—for example, the interest in perspectival systems, in depicting anatomy, and in classical cultures. Although no singular style characterizes the High Renaissance, the art of those most closely associated with this period—Leonardo da Vinci, Raphael, Michelangelo, and Titian—exhibits an astounding mastery, both technical and aesthetic. High Renaissance artists created works of such authority that generations of later artists relied on these artworks for instruction.

These exemplary artistic creations further elevated the prestige of artists. Artists could claim divine inspiration, thereby raising visual art to a status formerly given only to poetry. Thus, painters, sculptors, and architects came into their own, successfully claiming for their work a high position among the fine arts. In a sense, 16th-century masters created a new profession with its own rights of expression and its own venerable character.

Leonardo da Vinci

LEONARDO DA VINCI (1452–1519) was born in the small town of Vinci, near Florence. Art was but one of the innumerable interests of this quintessential "Renaissance man." Leonardo's immense intellect, talent, and foresight allowed him to map the routes art and science were to take in Renaissance Italy.

Although we focus on Leonardo as an artist, exploring his art in conjunction with his other interests considerably enhances an understanding of his artistic production. Leonardo revealed his unquenchable curiosity in his voluminous notes, liberally interspersed with sketches dealing with botany, geology, geography, cartography, zoology, military engineering, animal lore, anatomy, and aspects of physical science, including hydraulics and mechanics. These studies informed his art. For example, Leonardo's in-depth exploration of optics gave him an understanding of perspective, light, and color that he used in his painting. His scientific drawings are themselves artworks.

Leonardo's great ambition in his painting, as well as in his scientific endeavors, was to discover the laws underlying the processes and flux of nature. With this end in mind, he also studied the human body and contributed immeasurably to knowledge of physiology and psychology. Leonardo believed that reality in an absolute sense is inaccessible and that humans can know it only through its changing images. He considered the eyes the most vital organs and sight the most essential function, as, using the eyes, individuals could grasp the images of reality most directly and profoundly. In his notes, he stated repeatedly that all his scientific investigations made him a better painter.

Leonardo in Milan Around 1481, Leonardo left Florence, offering his services to Ludovico Sforza, duke of Milan,

The Role of Religious Art in Counter-Reformation Italy

Both Catholics and Protestants took seriously the role of devotional imagery in religious life. However, their views differed dramatically. Whereas Catholics deemed art as valuable for cultivating piety, Protestants believed that such visual imagery could produce idolatry and could distract the faithful from their goal—developing a personal relationship with God. As part of the Counter-Reformation effort, Pope Paul III convened the Council of Trent in 1545 and ordered a review of controversial Church doctrines. At its conclusion in 1563, the Council issued the following edict on the veneration of saints' relics and the role of sacred images, published in *Canons and Decrees of the Council of Trent*:

The images of Christ, of the Virgin Mother of God, and of the other saints are to be placed and retained especially in the churches, and that due honor and veneration is to be given them; ... because the honor which is shown them is referred to the prototypes which they represent, so that by means of the

images which we kiss and before which we uncover the head and prostrate ourselves, we adore Christ and venerate the saints whose likeness they bear. . . .

Moreover, let the bishops diligently teach that by means of the stories of the mysteries of our redemption portrayed in paintings and other representations the people are instructed and confirmed in the articles of faith, which ought to be borne in mind and constantly reflected upon; also that great profit is derived from all holy images, not only because the people are thereby reminded of the benefits and gifts bestowed on them by Christ, but also because through the saints the miracles of God and salutary examples are set before the eyes of the faithful, so that they may give God thanks for those things, may fashion their own life and conduct in imitation of the saints and be moved to adore and love God and cultivate piety.¹

¹ Robert Klein and Henri Zerner, *Italian Art 1500–1600: Sources and Documents* (Evanston, Ill.: Northwestern University Press, 1966), 120–21.

who accepted them. The political situation in Florence was uncertain, and Leonardo may have felt that his particular skills would be in greater demand in Milan, providing him with the opportunity for increased financial security. He devoted most of a letter to the duke of Milan to advertising his competence and his qualifications as a military engineer, mentioning only at the end his abilities as a painter and sculptor: "And in short, according to the variety of cases, I can contrive various and endless means of offence and defence. . . . In time of peace I believe I can give perfect satisfaction and to the equal of any other in architecture and the composition of buildings, public and private; and in guiding water from one place to another. . . . I can carry out sculpture in marble, bronze, or clay, and also I can do in painting whatever may be done, as well as any other, be he whom he may."

This letter illustrates the 15th-century artist's relation to patrons, as well as Leonardo's breadth of competence. That he should select military engineering and design to interest a patron is an index of the period's instability.

Painting the Soul's Intention During his first sojourn in Milan, Leonardo painted *Virgin of the Rocks* (Fig. 9-1) as the center panel of an altarpiece for a chapel in the Church of San Francesco Grande. The painting builds on Masaccio's

9-1 | LEONARDO DA VINCI, *Virgin of the Rocks*, ca. 1485. Oil on wood (transferred to canvas), approx. 6' 3" × 3' 7". Louvre, Paris.

Leonardo's *Virgin of the Rocks* is a groundbreaking achievement. The holy figures are united by gestures in a pyramidal composition and share the same light-infused environment.

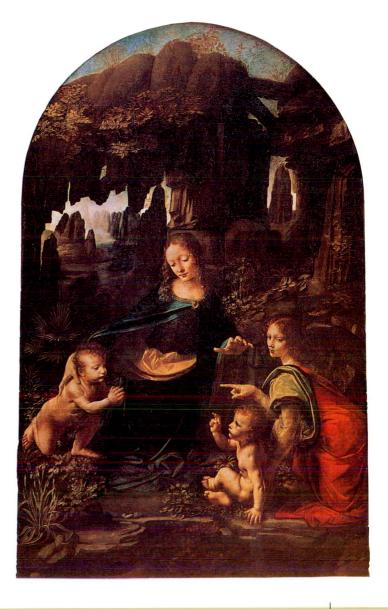

understanding and usage of chiaroscuro, the subtle play of light and dark. Modeling with light and shadow and expressing emotional states were, for Leonardo, the heart of painting: "A good painter has two chief objects to paint—man and the intention of his soul. The former is easy, the latter hard, for it must be expressed by gestures and the movement of the limbs. . . . A painting will only be wonderful for the beholder by making that which is not so appear raised and detached from the wall." 2

Leonardo presented the figures in *Virgin of the Rocks* in a pyramidal grouping. They pray, point, and bless, and these acts and gestures, although their meanings are not certain, visually unite the individuals portrayed. The angel points to the infant John and, through his outward glance, involves spectators in the tableau. John prays to the Christ Child and is blessed in return. The Virgin herself completes the series of interlocking gestures, her left hand reaching toward the Christ Child and her right hand resting protectively on John's shoulder. A melting mood of tenderness suffuses the entire composition. What the eye sees is fugitive, as are the states of the soul, or, in Leonardo's term, its "intentions."

In *Virgin of the Rocks*, the holy figures share the same light-infused environment. This groundbreaking achievement—the unified representation of objects in an atmospheric setting—was a manifestation of Leonardo's scientific curiosity about the invisible substance surrounding things. The Madonna, Christ Child, infant John the Baptist, and an-

gel emerge through nuances of light and shade from the halflight of the cavernous visionary landscape. Light simultaneously veils and reveals the forms, immersing them in a layer of atmosphere between them and the observer.

Leonardo wrote about the importance of atmospheric perspective in his *Treatise on Painting*, where he set forth the reasons he believed painting was a greater art than sculpture:

The painter will show you things at different distances with variation of color due to the air lying between the objects and the eye; he shows you mists through which visual images penetrate with difficulty; he shows you rain which discloses within it clouds with mountains and valleys; he shows the dust which discloses within it and beyond it the combatants who stirred it up; he shows streams of greater or lesser density; he shows fish playing between the surface of the water and its bottom; he shows the polished pebbles of various colors lying on the washed sand at the bottom of rivers, surrounded by green plants; he shows the stars at various heights above us, and thus he achieves innumerable effects which sculpture cannot attain.³

A Dramatic Betrayal For the refectory of the Church of Santa Maria delle Grazie in Milan, Leonardo painted *Last Supper* (Fig. 9-2). His technique was experimental—and unfortunately contributed to the poor condition of the painting today, even in its restored state. Leonardo had mixed oil and tempera, applying much of it *a secco* (to dried, rather than wet, plaster). Thus, the wall did not absorb the pigment as in the *buon fresco* technique (see "Fresco Painting, Chapter 7,

LEONARDO DA VINCI, Last Supper (after cleaning), ca. 1495–1498. Fresco (oil and tempera on plaster), 13′ 9″ × 29′ 10″. Refectory, Santa Maria delle Grazie, Milan.

Christ has just announced that one of his disciples will betray him, and each one reacts. Christ is both the psychological focus of the fresco and the focal point of all the converging perspective lines.

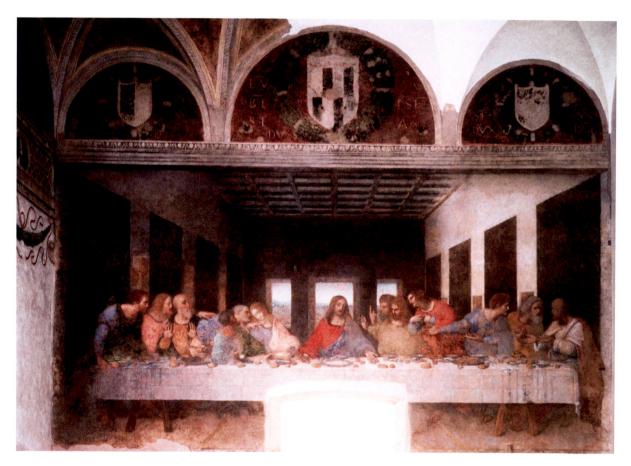

page 206), and the paint quickly began to flake. The humidity of Milan further accelerated the deterioration. Over the centuries, the fresco also has been cleaned and restored ineptly. Nonetheless, the painting is both formally and emotionally Leonardo's most impressive work.

Christ and his 12 disciples are seated at a long table set parallel to the picture plane in a simple, spacious room. Leonardo amplified the painting's highly dramatic action by placing the group in an austere setting. Christ, with outstretched hands, has just said, "One of you is about to betray me" (Matt. 26:21). A wave of intense excitement passes through the group as each disciple asks himself and, in some cases, his neighbor, "Is it I?" (Matt. 26:22). Leonardo joined the dramatic "One of you is about to betray me" with the initiation of the ancient liturgical ceremony of the Eucharist, when Christ, blessing bread and wine, said, "This is my body, which is given for you. Do this for a commemoration of me. . . . This is the chalice, the new testament in my blood, which shall be shed for you" (Luke 22:19-20). The artist's careful conceptualization of the composition imbued this dramatic moment with force and lucidity.

In the center, Christ appears isolated from the disciples and in perfect repose, the still eye of the swirling emotion around him. The central window at the back, whose curved pediment arches above his head, frames his figure. The pediment is the only curve in the architectural framework, and it serves here, along with the diffused light, as a halo. Christ's head is the focal point of all converging perspective lines in the composition (see "Depicting Objects in Space," Chapter 8, page 230). Thus, the still, psychological focus and cause of the action is also the perspectival focus, as well as the center of the two-dimensional surface. One could say that the two-dimensional, the threedimensional, and the psychodimensional focuses are the same. Leonardo presented the agitated disciples in four groups of three, united among and within themselves by the figures' gestures and postures. The artist sacrificed traditional iconography to pictorial and dramatic consistency by placing Judas on the same side of the table as Jesus and the other disciples. His face in shadow, Judas clutches a money bag in his right hand and reaches his left forward to fulfill the Master's declaration: "But yet behold, the hand of him that betrayeth me is with me on the table" (Luke 22:21). The two disciples at the table ends are more quiet than the others, as if to bracket the energy of the composition, which is more intense closer to Christ, whose calm both halts and intensifies it.

The disciples register a broad range of emotional responses, including fear, doubt, protestation, rage, and love. Leonardo's numerous preparatory studies suggest he thought of each figure as carrying a particular charge and type of emotion. Like a skilled stage director (perhaps the first, in the modern sense), he read the gospel story carefully, and scrupulously cast his actors as the New Testament described their roles. In this work, as in his other religious paintings, Leonardo revealed his extraordinary ability to apply his voluminous knowledge about the observable world to the pictorial representation of a

religious scene, resulting in a psychologically complex and compelling painting.

A Smile for the Ages Leonardo's Mona Lisa (Fig. 9-3) is probably the world's most famous portrait. The sitter's identity is still the subject of scholarly debate, but Renaissance biographer Giorgio Vasari⁴ asserted that she is Lisa di Antonio Maria Gherardini, the wife of Francesco del Giocondo, a wealthy Florentine—hence, "Mona (an Italian contraction of ma donna, "my lady") Lisa." Despite the uncertainty of this identification, this portrait is notable because it stands as a convincing representation of an individual, rather than serving as an icon of status. Mona Lisa appears in half-length view, her hands quietly folded and her gaze directed at observers, engaging them psychologically. The ambiguity of the famous "smile" is really the consequence of Leonardo's fascination and skill with chiaroscuro and atmospheric perspective. Here,

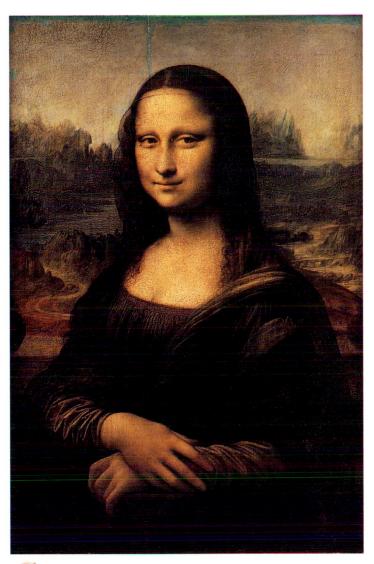

9-3 | LEONARDO DA VINCI, *Mona Lisa*, ca. 1503–1505. Oil on wood, approx. 2' $6'' \times 1'$ 9". Louvre, Paris.

Leonardo's skill with chiaroscuro and atmospheric perspective is evident in this portrait of a Florentine woman whom the artist depicted as an individual personality who engages the viewer psychologically.

MATERIALS + TECHNIQUES

Disegno

In 16th-century Italy, drawing (or disegno) assumed a position of greater prominence than ever before in artistic production. Until the late 15th century, the expense of drawing surfaces and their lack of availability limited the production of preparatory sketches. Most artists drew on parchment (prepared from the skins of calves, sheep, and goats) or on vellum (made from the skins of young animals). Because of the high cost of these materials, especially vellum, drawings in the 14th and 15th centuries tended to be extremely detailed and meticulously executed. Artists often drew using silverpoint (a stylus made of silver) because of the fine line it produced and the sharp point it maintained. The introduction in the late 15th century of less expensive paper made of fibrous pulp, from the developing printing industry, allowed artists to experiment more and to draw with greater freedom. As a result, sketches abounded. Artists executed these drawings in pen and ink, chalk, charcoal, brush, and graphite or lead.

The importance of drawing extended beyond the mechanical or technical possibilities that drawing afforded artists, however. The term disegno also referred to design, an integral component of good art. Design was the foundation of art, and drawing was the fundamental element of design. A statement by the artist Federico Zuccaro that drawing is the external physical manifestation (disegno esterno) of an internal intellectual idea or design (disegno interno) confirms this connection.

The design dimension of art production became increasingly important as artists cultivated their own styles. The early stages of an apprentice's training largely focused on the study and copying of exemplary artworks. But to achieve widespread recognition, artists were expected to move beyond this dependence on prestigious models and develop their own styles. Although the artistic community and public at large acknowledged technical skill, the conceptualization of the artwork—its theoretical and formal development—was paramount. Disegno, or design in this case, represented an artist's conceptualization and intention. In the period's literature, the terms writers and critics often invoked to praise esteemed artists included *invenzione* (invention), *ingegno* (ingenuity), *fantasia* (imagination), and *capriccio* (originality).

they serve to disguise rather than reveal a human psyche. The artist subtly adjusted the light and blurred the precise planes—Leonardo's famous smoky *sfumato* (misty haziness)—rendering the facial expression hard to determine.

The lingering appeal of *Mona Lisa* derives in large part from Leonardo's decision to set his subject against the backdrop of a mysterious uninhabited landscape. This landscape, with roads and bridges that seem to lead nowhere, is reminiscent of his *Virgin of the Rocks* (Fig. 9-1). It also recalls Fra Filippo Lippi's *Madonna and Child with Angels* (Fig. 8-29). Originally, Leonardo represented Mona Lisa in a loggia with columns. When the painting was trimmed (not by the artist), these columns were eliminated. The remains of the column bases may still be seen to the left and right of Mona Lisa's shoulders.

Anatomical Drawing Leonardo completed very few paintings. His perfectionism, relentless experimentation, and far-ranging curiosity diffused his efforts. However, the drawings in his notebooks preserve an extensive record of his ideas (see "Disegno," above). His interests focused increasingly on science in his later years, and he embraced knowledge of all facets of the natural world. His investigations in anatomy yielded drawings of great precision and beauty of execution. The Fetus and Lining of the Uterus (FIG. 9-4), although it does not meet 21st-century standards for accuracy (for example, Leonardo regularized the uterus's shape to a sphere, and his characterization of the lining is incorrect), was an astounding achievement in its day. Analytical anatomical studies such as this epitomized the scientific spirit of the Renaissance, establishing that era as a prelude to the modern world and setting it in sharp contrast to the preceding Middle Ages. Although Leonardo may not have been the first scientist of the modern world (at least not in the modern sense of "scientist"), he

9-4 | LEONARDO DA VINCI, The Fetus and Lining of the Uterus, ca. 1510. Pen and ink on paper. Royal Library, Windsor Castle.

Analytical anatomical studies such as this epitomize the scientific spirit of the Renaissance, establishing that era as a prelude to the modern world and setting it in sharp contrast to the preceding Middle Ages.

certainly originated a method of scientific illustration, especially cutaway and exploded views. Scholars have long recognized the importance of these drawings for the development of anatomy as a science, especially in an age predating photographic methods such as X rays.

Leonardo was well known in his time as both architect and sculptor, although no actual buildings or surviving sculptures can be definitively attributed to him. From his many drawings of central-plan buildings, it appears he shared the interest of other Renaissance architects in this building type. As for sculpture, Leonardo left numerous drawings of monumental equestrian statues, and one resulted in a full-scale model for a monument to Francesco Sforza (Ludovico's father). The French used it as a target and shot it to pieces when they occupied Milan in 1499. Due to the French presence, Leonardo left Milan and served for a while as a military engineer for Cesare Borgia, who, with the support of his father, Pope Alexander VI, tried to conquer the cities of the Romagna region in north-central Italy and create a Borgia duchy. At a later date, Leonardo returned to Milan in the service of the French. At the invitation of King Francis I, he then went to France, where he died at the château of Cloux in 1519.

Raphael

Raffaello Santi (or Sanzio), known as RAPHAEL (1483–1520), was born in a small town in Umbria near Urbino. He probably learned the rudiments of his art from his father, Giovanni Santi, a painter connected with the ducal court of Federico da Montefeltro. Raphael spent the four years from 1504 to 1508 in Florence, where he encountered—and was strongly influenced by—Leonardo and Michelangelo. But Raphael's powerful originality soon prevailed, and he developed an individual style that epitomizes the ideals of High Renaissance art.

Unifying Devotion and Beauty Under Leonardo's influence, Raphael painted *Madonna in the Meadow* (Fig. 9-5) in 1506. He used the pyramidal composition of Leonardo's Virgin of the Rocks (Fig. 9-1) and based his modeling of faces and figures in subtle chiaroscuro on Leonardo's drawings and paintings. But Raphael retained the lighter tonalities of his Umbrian masters, preferring clarity to obscurity. He was not fascinated, as Leonardo was, with dusky modeling and mystery. Raphael's great series of Madonnas, of which this is an early example, unifies Christian devotion and pagan beauty. No artist ever has rivaled Raphael in his definitive rendering of this sublime theme of grace and dignity, of sweetness and lofty idealism.

Raphael and Julius II In 1508, Pope Julius II (Giuliano della Rovere, r. 1503–1513) called Raphael to Rome. Beyond his responsibility as the spiritual leader of Christendom, Julius II extended his quest for authority to the temporal realm, as other medieval and Renaissance popes had done. An immensely ambitious man, Julius II indulged his enthusiasm for

9-5 | RAPHAEL, *Madonna in the Meadow*, 1505–1506. Oil on panel, $3' 8\frac{1}{2}'' \times 2' 10\frac{1}{4}''$. Kunsthistorisches Museum, Vienna.

Emulating Leonardo's pyramidal composition (Fig. 9-1) but rejecting his dusky modeling and mystery, Raphael set his Madonna in a well-lit landscape and imbued her with grace, dignity, and beauty.

engaging in battle, which earned him a designation as the "warrior-pope." In addition, his selection of the name Julius, after Julius Caesar, reinforces the perception that the Roman Empire served as his governmental model.

Julius II's papacy is notable for his contributions to the arts. He was an avid art patron and understood well the propagandistic value of visual imagery. After his election as pope, he immediately commissioned artworks that would present an authoritative image of his rule and reinforce the primacy of the Catholic Church. Among the many projects he commissioned were a new design for Saint Peter's basilica, the painting of the Sistine Chapel ceiling, and the decoration of the papal apartments. These large-scale projects clearly required considerable financial resources. Many Church members perceived the increasing sale of indulgences as a revenuegenerating mechanism to fund papal art, architecture, and lavish lifestyles. This perception, accurate or not, prompted disgruntlement among the faithful. Thus, Julius II's patronage, despite its exceptional artistic legacy, also contributed to the rise of the Reformation.

Although the commissions for Saint Peter's and the Sistine Chapel went to others, Raphael was awarded the responsibility of decorating the papal apartments. Of the suite's several rooms (stanze), Raphael painted the Stanza della Segnatura (Room of the Signature—the papal library) and the Stanza d'Eliodoro (Room of Heliodorus). His pupils completed the others, following his sketches. On the four walls of the Stanza della Segnatura, under the headings of Theology, Law, Poetry, and Philosophy, Raphael presented images that symbolize and sum up Western learning as Renaissance society understood it. The frescoes refer to the four branches of human knowledge and wisdom while pointing out the virtues and the learning appropriate to a pope. Given Julius II's desire for recognition as both a spiritual and temporal leader, it is appropriate that the Theology and the Philosophy frescoes face each other. The two images present a balanced picture of the pope—as a cultured, knowledgeable individual, on the one hand, and as a wise, divinely ordained religious authority, on the other hand.

A Congregation of Great Thinkers Raphael's Philosophy mural is generally known as School of Athens (Fig. 9-6). The setting, however, is not a "school" but a congregation of the great philosophers and scientists of ancient Greece. Raphael depicted these luminaries—rediscovered by Renaissance thinkers—conversing and explaining their various theories and ideas. In a vast hall covered by massive vaults that recall Roman architecture (and approximate the appearance of the new Saint Peter's in 1509, when the painting was executed; Fig. 10-3), colossal statues of Apollo and Athena, patron gods of the arts and of wisdom, oversee the interactions. Plato and Aristotle serve as the central figures around whom Raphael carefully arranged the others. Plato holds his book Timaeus and points to heaven, the source of his inspiration, while Aristotle carries his book Nichomachean Ethics and gestures toward the earth, from which his observations of reality sprang. Appropriately, ancient philosophers, men concerned with the ultimate mysteries that transcend this world, stand on Plato's side. On Aristotle's side are the philosophers

9-6 | RAPHAEL, Philosophy (School of Athens), Stanza della Segnatura, Vatican Palace, Rome, Italy, 1509–1511. Fresco, approx. 19' × 27'.

Raphael included himself in this gathering of great philosophers and scientists whose self-assurance conveys calm reason. The setting resembles the interior of the new Saint Peter's (Fig. 10-3).

and scientists concerned with nature and human affairs. At the lower left, Pythagoras writes as a servant holds up the harmonic scale. In the foreground, Heraclitus (probably a portrait of Michelangelo) broods alone. Diogenes sprawls on the steps. At the right, students surround Euclid, who demonstrates a theorem. This group is especially interesting; Euclid may be a portrait of the aged architect Bramante (discussed later). At the extreme right, just to the right of the astronomers Zoroaster and Ptolemy, both holding globes, Raphael included his own portrait.

The groups appear to move easily and clearly, with eloquent poses and gestures that symbolize their doctrines and present an engaging variety of figural positions. Their self-assurance and natural dignity convey the very nature of calm reason, that balance and measure the great Renaissance minds so admired as the heart of philosophy. Significantly, in this work, Raphael placed himself among the mathematicians and scientists, and certainly the evolution of pictorial science came to its perfection in *School of Athens*. Raphael's convincing depiction of a vast perspectival space on a two-dimensional surface was the consequence of the union of mathematics with pictorial science, here mastered completely.

The artist's psychological insight matured along with his mastery of the problems of physical representation. All the characters in Raphael's School of Athens, like those in Leonardo's Last Supper (Fig. 9-2), communicate moods that reflect their beliefs, and the artist's placement of each figure tied these moods together. Raphael carefully considered his design devices for relating individuals and groups to one another and to the whole. These compositional elements demand close study. From the center, where Plato and Aristotle stand, Raphael arranged the groups of figures in an elliptical movement. It seems to swing forward, looping around two foreground groups on both sides and then back again to the center. Moving through the wide opening in the foreground along the floor's perspectival pattern, the viewer's eye penetrates the assembly of philosophers and continues, by way of the reclining Diogenes, up to the here-reconciled leaders of the two great opposing camps of Renaissance philosophy. The perspectival vanishing point falls on Plato's left hand, drawing attention to Timaeus. In the Stanza della Segnatura, Raphael reconciled and harmonized not only the Platonists and Aristotelians but also paganism and Christianity, surely a major factor in his appeal to Julius II.

Michelangelo

The artist who received the most coveted commissions from Julius II was MICHELANGELO BUONARROTI (1475–1564), whom the pope deemed best able to convey his message. Although Michelangelo was an architect, sculptor, painter, poet, and engineer, he thought of himself first as a sculptor, regarding that calling as superior to that of a painter because the sculptor shares in something like the divine power to "make man." Drawing a conceptual parallel to Plato's ideas, Michelangelo believed that the image produced by the artist's

hand must come from the idea in the artist's mind. The idea, then, is the reality that the artist's genius has to bring forth. But artists are not the creators of the ideas they conceive. Rather, they find their ideas in the natural world, reflecting the absolute idea, which, for the artist, is beauty.

Novel and Lofty Things One of Michelangelo's best-known observations about sculpture is that the artist must proceed by finding the idea—the image locked in the stone, as it were. Thus, by removing the excess stone, the sculptor extricates the idea (Fig. Intro-11). The artist, Michelangelo felt, works through many years at this unceasing process of revelation and "arrives late at novel and lofty things." 5

Michelangelo did indeed arrive at "novel and lofty things," for he broke sharply from the lessons of his predecessors and contemporaries in one important respect. He mistrusted the application of mathematical methods as guarantees of beauty in proportion. Measure and proportion, he believed, should be "kept in the eyes." Vasari quotes Michelangelo as declaring that "it was necessary to have the compasses in the eyes and not in the hand, because the hands work and the eye judges."6 Thus, Michelangelo set aside the ancient Roman architect Vitruvius, Alberti, Leonardo, and others who tirelessly sought the perfect measure, and asserted that the artist's inspired judgment could identify other pleasing proportions. In addition, Michelangelo argued that the artist must not be bound, except by the demands made by realizing the idea. This insistence on the artist's own authority was typical of Michelangelo and anticipated the modern concept of the right to a self-expression of talent limited only by the artist's own judgment. The artistic license to aspire far beyond the "rules" was, in part, a manifestation of the pursuit of fame and success that humanism fostered. In this context, Michelangelo created works in architecture, sculpture, and painting that departed from High Renaissance regularity. He put in its stead a style of vast, expressive strength conveyed through complex, eccentric, and often titanic forms that loom before the viewer in tragic grandeur. Michelangelo's self-imposed isolation, creative furies, proud independence, and daring innovations led Italians to speak of the dominating quality of the man and his works in one word—terribilità, the sublime shadowed by the awesome and the fearful.

"The Giant" In 1501, the Florence Cathedral building committee asked Michelangelo to work a great block of marble left over from an earlier aborted commission. From this stone, Michelangelo crafted *David* (Fig. 9-7), which assured his reputation then and now as an extraordinary talent. This early work reveals Michelangelo's fascination with the human form, and *David*'s formal references to classical antiquity surely appealed to Julius II, who associated himself with the humanists and with Roman emperors. Thus, this sculpture and the fame that accrued to Michelangelo on its completion called the artist to the pope's attention, leading to major papal commissions.

9-7 | MICHELANGELO BUONARROTI, *David*, 1501–1504. Marble, 13' 5" high. Galleria dell'Accademia, Florence.

In this colossal statue, Michelangelo represented David in heroic classical nudity, capturing the tension of Lysippan athletes (Fig. 2-46) and the emotionalism of Hellenistic statuary (Fig. 2-51).

For *David* (Fig. 9-7), Michelangelo took up the theme Donatello had used successfully. Like Donatello's *David* (Fig. 8-23), Michelangelo's version had a political dimension. With the stability of the republic in some jeopardy, it seems certain that Florentines viewed David as the symbolic defiant hero of the Florentine republic, especially given the statue's placement near the west door of the Palazzo della Signoria. Michelangelo

was surely cognizant of the political symbolism associated with the figure of David and other public sculptures in Florentine history. However, the degree to which the artist intended a specific political message is unknown. Regardless, only 40 years after *David*'s completion, Vasari extolled the political value of the colossal statue, claiming that "without any doubt the figure has put in the shade every other statue, ancient or modern, Greek or Roman—this was intended as a symbol of liberty for the Palace, signifying that just as David had protected his people and governed them justly, so whoever ruled Florence should vigorously defend the city and govern it with justice."

Despite the traditional association of David with heroism, the artist chose to represent David not after the victory, with Goliath's head at his feet, but turning his head to his left, sternly watchful of the approaching foe. His whole muscular body, as well as his face, is tense with gathering power. *David* exhibits the characteristic representation of energy in reserve that imbues Michelangelo's later figures with the tension of a coiled spring. The young hero's anatomy plays an important part in this prelude to action. His rugged torso, sturdy limbs, and large hands and feet alert viewers to the strength to come. Each swelling vein and tightening sinew amplifies the psychological energy of the monumental David's pose.

Michelangelo doubtless had the classical nude in mind. He, like many of his colleagues, greatly admired Greco-Roman statues. In particular, classical sculptors' skillful and precise rendering of heroic physique impressed Michelangelo. In his David, without strictly imitating the antique style, Michelangelo captured the tension of Lysippan athletes (Fig. 2-46) and the psychological insight and emotionalism of Hellenistic statuary (Fig. 2-51). His David differs from Donatello's in much the same way that later Hellenistic statues departed from their Classical predecessors. Michelangelo abandoned the self-contained composition of the 15th-century statue by giving David's head the abrupt turn toward his gigantic adversary. Unlike Donatello's David, Michelangelo's is compositionally and emotionally connected to an unseen presence beyond the statue. This, too, is evident in Hellenistic sculpture. As early as 1504 then, Michelangelo invested his efforts in presenting towering pent-up emotion rather than calm ideal beauty. He transferred his own doubts, frustrations, and passions into the great figures he created or planned. And this resulted in works like David—a truly titanic sculpture (referred to as "The Giant" by Florentines) with immense physical and symbolic presence.

A Grand Biblical Drama In 1508, the same year Julius II asked Raphael to decorate the papal stanze, the pope convinced a reluctant Michelangelo to paint the ceiling of the Sistine Chapel (Figs. 9-8 and 9-9). Michelangelo insisted that painting was not his profession (a protest that rings hollow after the fact, although his major works until then had been in sculpture), but he accepted the commission. Michelangelo faced enormous difficulties in painting the Sistine ceiling. He had to address his relative inexperience in the fresco technique;

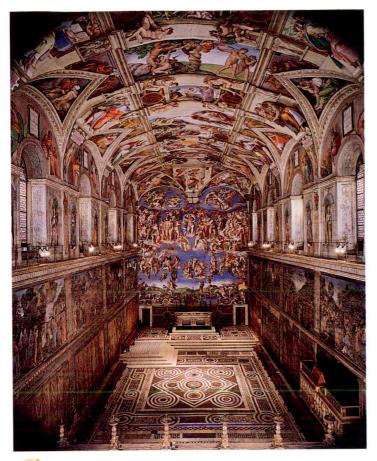

9-8 | Interior of the Sistine Chapel (view facing east), Vatican City, Rome, Italy, built 1473. Copyright © Nippon Television Network Corporation, Tokyo.

Julius II convinced a reluctant Michelangelo to paint the ceiling of the Sistine Chapel, even though the artist preferred sculpture. The subjects were taken from Genesis and depict the Creation and Fall of humankind.

the ceiling's dimensions (some 5,800 square feet); its height above the pavement (almost 70 feet); and the complicated perspective problems presented by the vault's height and curve. Yet, in less than four years, Michelangelo produced a monumental fresco incorporating the patron's agenda, Church doctrine, and the artist's interests. Depicting the most august and solemn themes of all, the Creation, Fall, and Redemption of humanity (most likely selected by Julius II with input from Michelangelo and a theological adviser), Michelangelo spread a colossal decorative scheme across the vast surface. He succeeded in weaving together more than 300 figures in a grand drama of the human race.

A long sequence of narrative panels describing the Creation, as recorded in Genesis, runs along the crown of the vault, from *God's Separation of Light and Darkness* (above the altar) to *Drunkenness of Noah* (nearest the entrance to the chapel). Thus, as visitors enter the chapel, look up, and walk toward the altar, they review, in reverse order, the history of the Fall of humankind. The Hebrew prophets and pagan sibyls who foretold the coming of Christ appear seated in large thrones on both sides of the central row of scenes from Genesis, where the vault

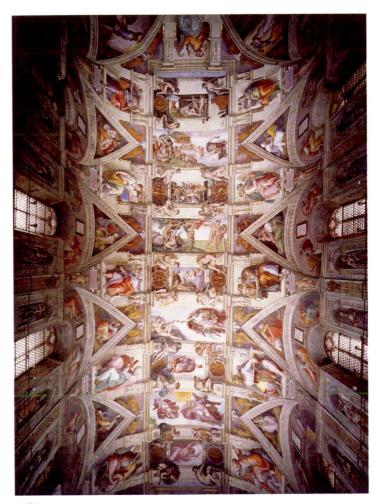

9-9 | MICHELANGELO BUONARROTI, ceiling of the Sistine Chapel, Vatican City, Rome, Italy, 1508–1512. Fresco, approx. 128' × 45'.

Michelangelo labored almost four years on the more than 300 figures on the Sistine ceiling. He had to overcome the complicated perspective problems presented by the height and curve of the vault.

curves down. In the four corner pendentives, Michelangelo placed four Old Testament scenes with David, Judith, Haman, and Moses and the Brazen Serpent. Scores of lesser figures also appear. The ancestors of Christ fill the triangular compartments above the windows, nude youths punctuate the corners of the central panels, and small pairs of *putti* (cherubic little boys) in grisaille support the painted cornice surrounding the entire central corridor. The overall conceptualization of the ceiling's design and narrative structure not only presents a sweeping chronology of Christianity but also is in keeping with Renaissance ideas about Christian history. Such ideas include interest in the conflict between good and evil and between the energy of youth and the wisdom of age. The conception of the entire ceiling was astounding in itself, and the articulation of it in its thousand details was a superhuman achievement.

Unlike Andrea Mantegna's decoration of the Camera degli Sposi in Mantua (Fig. 8-33), the strongly marked unifying architectural framework in the Sistine Chapel does not construct

"picture windows." Rather, the viewer focuses on figure after figure, each sharply outlined against the neutral tone of the architectural setting or the plain background of the panels. Here, as in his sculpture, Michelangelo relentlessly concentrated his expressive purpose on the human figure. To him, the body was beautiful not only in its natural form but also in its spiritual and philosophical significance. The body was simply the manifestation of the soul or of a state of mind and character. Michelangelo represented the body in its most simple, elemental aspect—in the nude or simply draped, with no background and no ornamental embellishment. He always painted with a sculptor's eye for how light and shadow communicate volume and surface. It is no coincidence that many of the figures seem to be tinted reliefs or full-rounded statues.

Depicting Man's Creation One of the ceiling's central panels is *Creation of Adam* (Fig. 9-10). Michelangelo did not paint the traditional representation but a bold, entirely humanistic interpretation of the momentous event. God and Adam confront each other in a primordial unformed landscape of which Adam is still a material part, heavy as earth. The Lord transcends the earth, wrapped in a billowing cloud of drapery and borne up by his powers. Life leaps to Adam like a spark from the mighty extended hand of God. The communication between gods and heroes, so familiar in classical myth, is here concrete. This blunt depiction of the Lord as

ruler of Heaven in the Olympian pagan sense indicates how easily High Renaissance thought joined classical and Christian traditions. Yet the classical trappings do not obscure the essential Christian message.

Beneath the Lord's sheltering left arm is a female figure, apprehensively curious but as yet uncreated. Scholars traditionally believed her to represent Eve but many now think she is the Virgin Mary (with the Christ Child at her knee). If this identification is correct, it suggests that Michelangelo incorporated into his fresco one of the essential tenets of Christian faith. This is the belief that Adam's Original Sin eventually led to the sacrifice of Christ, which in turn made possible the Redemption of all humankind. As God reaches out to Adam, the viewer's eye follows the motion from right to left, but Adam's extended left arm leads the eye back to the right, along the Lord's right arm, shoulders, and left arm to his left forefinger, which points to the Christ Child's face. The focal point of this right-to-left-to-right movementt—the fingertips of Adam and the Lord—is dramatically off-center. Michelangelo replaced the straight architectural axes found in Leonardo's compositions with curves and diagonals. For example, the bodies of the two great figures are complementary—the concave body of Adam fitting the convex body and billowing "cloak" of God. Thus, motion directs not only the figures but also the whole composition. The reclining positions of the figures, the heavy musculature, and the twisting poses are all intrinsic parts of Michelangelo's style.

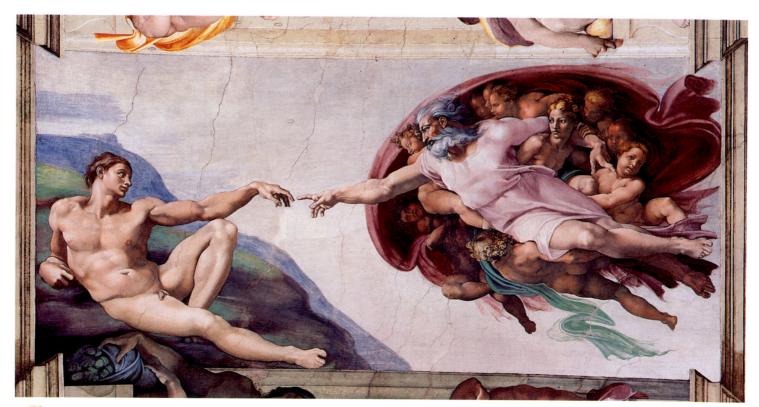

9-10 | MICHELANGELO BUONARROTI, *Creation of Adam*, detail of the ceiling of the Sistine Chapel, Vatican City, Rome, Italy, 1511–1512. Fresco, approx. 9' 2" × 18' 8".

Life leaps to Adam like a spark from the extended hand of God in this fresco, which recalls the communication between gods and heroes in the classical myths Renaissance humanists admired so much.

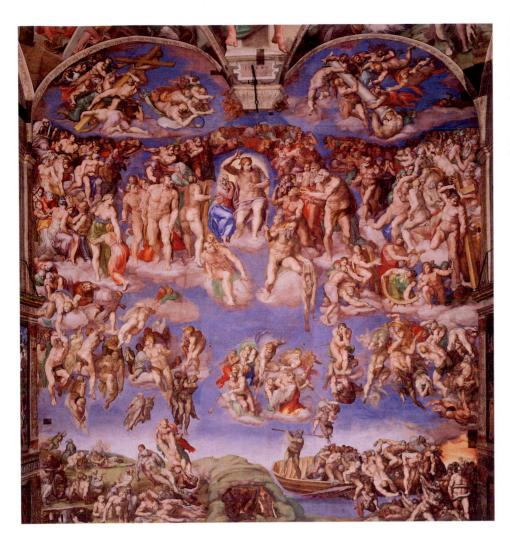

9-11 | MICHELANGELO
BUONARROTI, Last Judgment, fresco on the altar wall of the Sistine Chapel, Vatican City, Rome, Italy, 1534–1541. Copyright

© Nippon Television Network Corporation, Tokyo.

Michelangelo completed his fresco cycle in the Sistine Chapel with this terrifying vision of the fate that awaits sinners. Near the center, he placed his own portrait on the flayed skin Saint Bartholomew holds.

Christ on Judgment Day Following the death of Julius II, Michelangelo was employed by Leo X (r. 1513-1521), Clement VII (r. 1523-1534), and Paul III (r. 1534-1549). Among Paul III's first papal commissions was Last Judgment (Fig. 9-11), a large fresco for the Sistine Chapel's altar wall. Here, Michelangelo depicted Christ as the stern judge of the world—a giant whose mighty right arm is lifted in a gesture of damnation so broad and universal as to suggest he will destroy all creation, Heaven and Earth alike. The choirs of Heaven surrounding him pulse with anxiety and awe. Crowded into the spaces below are trumpeting angels, the ascending figures of the just, and the downward-hurtling figures of the damned. On the left, the dead awake and assume flesh. On the right, demons, whose gargoyle masks and burning eves revive the demons of Romanesque tympana (Fig. 6-24), torment the damned.

Michelangelo's terrifying vision of the fate that awaits sinners goes far beyond any previous rendition. Martyrs who suffered especially agonizing deaths crouch below the Judge. One of them, Saint Bartholomew, who was skinned alive, holds the flaying knife and the skin, its face a grotesque self-portrait of Michelangelo. The figures are huge and violently twisted, with small heads and contorted features. Yet although this immense fresco impresses on the viewer Christ's wrath on Judgment Day,

it also holds out hope. A group of saved souls—the elect—crowd around Christ, and on the far right appears a figure with a cross, most likely the Good Thief (crucified with Christ) or a saint martyred by crucifixion, such as Saint Andrew.

Architecture

During the High Renaissance, architects and patrons alike turned to classical antiquity to find a suitable architectural vocabulary to convey the new humanist worldview. In the buildings of ancient Rome, they discovered the perfect prototypes for the domed architecture that became the hallmark of the 16th century.

Bramante's Little Temple The leading architect of this classical-revival style at the opening of the century was DONATO D'ANGELO BRAMANTE (1444–1514). Born in Urbino and trained as a painter (perhaps by Piero della Francesca), Bramante went to Milan in 1481 and, like Leonardo, stayed there until the French arrived in 1499. In Milan, he abandoned painting for architecture. Under the influence of Brunelleschi, Alberti, and perhaps Leonardo, all of whom strongly favored the art and architecture of classical antiquity, Bramante developed the High Renaissance form of the central-plan church.

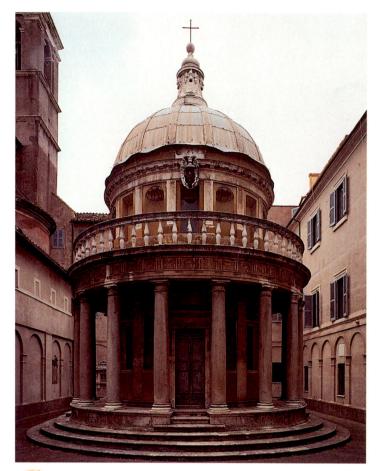

9-12 | DONATO D'ANGELO BRAMANTE, Tempietto, San Pietro in Montorio, Rome, Italy, 1502(?).

Bramante was celebrated as the first to revive the classical style in architecture. His "little temple" was inspired by the ruins of Roman round temples in Italy, but he combined the classical parts in new ways.

Bramante's ancient Rome-inspired style is on display in the small architectural gem known as the Tempietto (Fig. 9-12), so named because, to contemporaries, the building had the look of a small pagan temple from antiquity. "Little Temple" is, in fact, a perfectly appropriate nickname for the structure, because the ruined round temples of Roman Italy provided the direct models for its lower story. King Ferdinand and Queen Isabella of Spain commissioned the Tempietto to mark the conjectural location of Saint Peter's crucifixion. Available information suggests that the patrons asked Bramante to undertake the project in 1502, but some scholars have disputed that traditional dating of the building. In any case, Bramante began construction of the Tempietto during the first decade of the 16th century.

The architect relied on the composition of volumes and masses and on a sculptural handling of solids and voids to set apart this building, all but devoid of ornament, from structures built in the preceding century. Standing inside the cloister of the Church of San Pietro in Montorio, Rome, the Tempietto resembles a sculptured reliquary and would have

looked even more like one inside the circular colonnaded courtyard Bramante planned for it but never executed.

The structure is severely rational with its sober circular stylobate and the cool Tuscan style of the colonnade, neither giving any indication of the placement of an interior altar or of the entrance. Bramante achieved a truly wonderful balance and harmony in the relationship of the parts (dome, drum, and base) to one another and to the whole. Conceived as a tall domed cylinder projecting from the lower, wider cylinder of its colonnade, this small building incorporates all the qualities of a sculptured monument. Light and shade play around the columns and balustrade and across the deep-set rectangular windows, which alternate with shallow shell-capped niches in the cella walls and drum. Although the Tempietto, superficially at least, may resemble a Greco-Roman tholos (a circular shrine), and although antique models provided the inspiration for all its details, the combination of parts and details was new and original. (Classical tholoi, for instance, had neither drum nor balustrade.)

If one of the main differences between the Early and High Renaissance styles of architecture was the former's emphasis on detailing flat wall surfaces versus the latter's sculptural handling of architectural masses, then the Tempietto certainly broke new ground and stood at the beginning of a new High Renaissance era. Renaissance architects understood the significance of the Tempietto. The architect Andrea Palladio, an artistic descendant of Bramante, included it in his survey of ancient temples because Bramante was "the first to bring back to light the good and beautiful architecture that from antiquity to that time had been hidden." Round in plan and elevated on a base that isolates it from its surroundings, the Tempietto conforms to Alberti's and Palladio's strictest demands for an ideal church.

Re-Creating the Caesars' Rome One of the most important artistic projects Pope Julius II initiated was his plan to replace the Constantinian basilica, Old Saint Peter's (Fig. 4-3), with a new structure. The earlier building had fallen into considerable disrepair and, in any event, did not suit this ambitious pope's taste for the colossal. Julius wanted to gain control over the whole of Italy and to make the Rome of the popes reminiscent of (if not more splendid than) the Rome of the caesars. As the symbolic seat of the papacy, Saint Peter's represented the history of the Church. Given this importance, Julius II carefully chose the architect for the new church—and his choice was Bramante.

Bramante originally designed the new Saint Peter's to consist of a cross with arms of equal length, each terminated by an apse. Julius II intended the new building to serve as a martyrium to mark Saint Peter's grave and also hoped to have his own tomb in it. A large dome would have covered the crossing, and smaller domes over subsidiary chapels would have covered the diagonal axes of the roughly square plan. Bramante's ambitious plan called for a boldly sculptural treatment of the walls and piers under the dome. His design for the interior space was complex in the extreme, with the intricate symmetries of a crystal. It is possible to detect in the plan

some nine interlocking crosses, five of them supporting domes. The scale was titanic. According to sources, Bramante boasted he would place the dome of the Pantheon (Fig. 3-33) over the Basilica of Constantine (Fig. 3-44).

Michelangelo, Architect During Bramante's lifetime, the actual construction of the new Saint Peter's basilica did not advance beyond the building of the crossing piers and the lower choir walls. After his death, the work passed from one architect to another and finally to Michelangelo, whom Pope Paul III appointed in 1546 to complete the building. Michelangelo's work on Saint Peter's, after efforts by a succession of architects following Bramante's death, apparently became a long-term show of dedication, thankless and without pay. When Michelangelo died in 1564 at age 89, he was still hard at work on Saint Peter's.

Among Michelangelo's difficulties was his struggle to preserve Bramante's original design, whose central plan he praised. Michelangelo carried his obsession with human form over to architecture and reasoned that buildings should follow the form of the human body. This meant organizing their units symmetrically around a central and unique axis, as the

arms relate to the body or the eyes to the nose. "For it is an established fact," he once wrote, "that the members of architecture resemble the members of man. Whoever neither has been nor is a master at figures, and especially at anatomy, cannot really understand architecture."

Although Michelangelo admired Bramante's design for Saint Peter's, he modified it by reducing the central component from a number of interlocking crosses to a compact domed Greek cross inscribed in a square and fronted with a double-columned portico (Fig. 9-13). Without destroying the centralizing features of Bramante's plan, Michelangelo, with a few strokes of the pen, converted its snowflake complexity into massive, cohesive unity.

Michelangelo's treatment of the building's exterior further reveals his interest in creating a unified and cohesive design. Because of later changes to the front of the church, the west (apse) end (Fig. 9-14) offers the best view of his style and intention. Michelangelo employed the device of the colossal order, which Alberti had introduced in the 15th century (Fig. 8-32), to great effect. The giant pilasters seem to march around the undulating wall surfaces, confining the movement without interrupting it. The architectural sculpturing here extends up from the ground

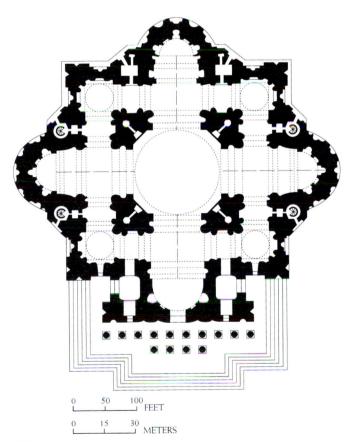

9-13 | MICHELANGELO BUONARROTI, plan for Saint Peter's, Vatican City, Rome, Italy, 1546.

Michelangelo's plan for the new Saint Peter's was radically different than that of the original basilica (Fig. 4-3). His central plan called for a domed Greek cross inscribed in a square and fronted by columns.

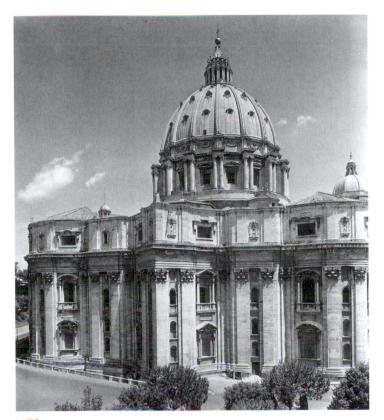

9-14 | MICHELANGELO BUONARROTI, Saint Peter's (view from the northwest), Vatican City, Rome, Italy, 1546–1564. Dome completed by GIACOMO DELLA PORTA, 1590.

Michelangelo intended to cap his design for Saint Peter's with a hemispherical dome like that of the ancient Roman Pantheon (Fig. 3-33), but after his death a more stable ogival dome was constructed.

9-15 | ANDREA PALLADIO, Villa Rotonda (formerly Villa Capra), near Vicenza, Italy, ca. 1566–1570.

Palladio's Villa Rotonda has four identical facades, each one resembling a Roman temple with a columnar porch. In the center is a great dome-covered rotunda modeled on the Pantheon (Fig. 3-33).

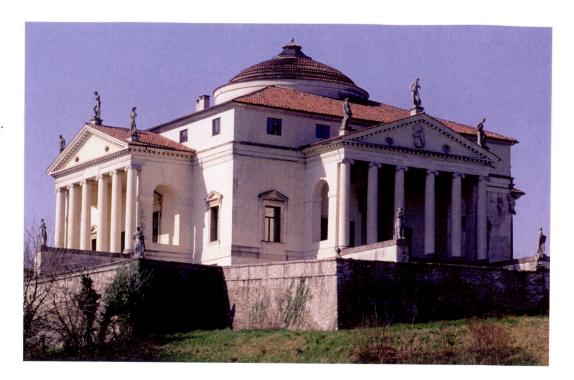

through the attic stories and into the drum and the dome, unifying the whole building from base to summit.

The domed west end—as majestic as it is today and as influential as it has been on architecture throughout the centuries—is not quite as Michelangelo intended it. Originally, Michelangelo had planned a dome with an ogival section (raised silhouette), like that of Florence Cathedral (Fig. 8-18). But in his final version, he decided on a hemispherical (semicircular silhouette) dome to temper the verticality of the design of the lower stories and to establish a balance between dynamic and static elements. However, when GIACOMO DELLA PORTA (ca. 1533-1602) executed the dome after Michelangelo's death, he restored the earlier high design, ignoring Michelangelo's later version. Giacomo's reasons were probably the same ones that had impelled Brunelleschi to use an ogival section for his Florentine dome—greater stability and ease of construction. The result is that the dome seems to rise from its base, rather than rest firmly on it—an effect Michelangelo might not have approved. Nevertheless, Saint Peter's dome is probably the most impressive in the world and has served as a model for generations of architects to this day.

Palladio and Venice The classicizing style of High Renaissance architecture in Rome spread far and wide. One of its most accomplished practitioners was ANDREA PALLADIO (1508–1580), the chief architect of the Venetian Republic. Having begun as a stonemason and decorative sculptor, at age 30 Palladio turned to architecture, engineering, topography, and military science. Unlike the universal scholar Alberti, Palladio became more of a specialist. He made several trips to Rome to study the ancient buildings firsthand. He illustrated Daniele Barbaro's edition of *De architectura* by Vitruvius (1556), and he wrote his own treatise on architecture, *I quattro*

libri dell'architettura (The Four Books of Architecture). Originally published in 1570, Palladio's treatise had a wide-ranging influence on succeeding generations of architects throughout Europe. Palladio's influence outside Italy, most significantly in England and in colonial America, was stronger and more lasting than that of any other architect.

Palladio accrued his significant reputation from his many designs for villas, built on the Venetian mainland. The same Arcadian spirit that prompted the ancient Romans to build villas in the countryside motivated a similar villa-building boom in the 16th century. One can imagine that Venice, with its very limited space, must have been more congested than any ancient city. But a longing for the countryside was not the only motive. Declining fortunes prompted the Venetians to develop their mainland possessions with new land investment and reclamation projects. Citizens who could afford it were encouraged to set themselves up as aristocratic farmers and to develop swamps into productive agricultural land. Wealthy families could look on their villas as providential investments. The villas were thus aristocratic farms (like the much later American plantations, which were influenced by Palladio's architecture) surrounded by service outbuildings that Palladio generally arranged in long, low wings branching out from the main building and enclosing a large rectangular court area.

Although it is the most famous, Villa Rotonda (Fig. 9-15), near Vicenza, is not really typical of Palladio's villa style. He did not construct it for an aspiring gentleman farmer but for a retired monsignor who wanted a villa for social events. Palladio planned and designed Villa Rotonda, located on a hill-top, as a kind of *belvedere* (literally, "beautiful view"; in architecture, a residence on a hill), without the usual wings of secondary buildings. Its central plan (Fig. 9-16), with four identical facades and projecting porches, is therefore both

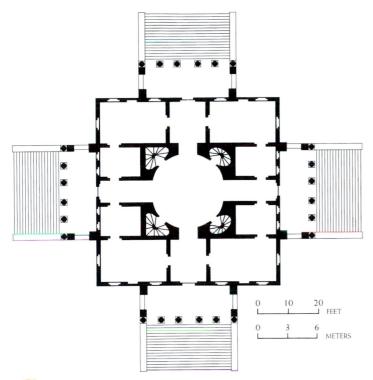

9-16 | Andrea Palladio, plan of the Villa Rotonda (formerly Villa Capra), near Vicenza, Italy, ca. 1566–1570.

Palladio was a theorist who wrote an influential treatise on architecture. In the Villa Rotonda, all the parts are related to one another in terms of calculated mathematical ratios.

sensible and functional. Each of the porches can be used as a platform for enjoying a different view of the surrounding landscape. In this design, the central dome-covered rotunda logically functions as a kind of circular platform from which visitors may turn in any direction for the preferred view. The result is a building with functional parts systematically related to one another in terms of calculated mathematical relationships. Villa Rotonda embodies all the qualities of self-sufficiency and formal completeness sought by most Renaissance architects, as well as a respect for classical architecture. Each facade of the Villa Rotonda resembles a Roman temple. In placing a traditional temple porch in front of a dome-covered interior, Palladio doubtless had the Pantheon (Fig. 3-33) in his mind as a model.

Giorgione and Titian

Venice long had been a major Mediterranean port and served as the gateway to the Orient. Having reached the height of its commercial and political power during the 15th century, Venice saw its fortunes decline in the 16th century. Even so, Venice and the Papal States were the only Italian sovereignties to retain their independence during the century of strife. While Michelangelo, Raphael, and others were working in Rome in the service of the popes, Venice developed a flourishing, independent, and influential school of artists.

The Primacy of Color The effect of Venice's soft-colored light was of particular interest to artists in the maritime republic, who favored the new medium of oil paint that had been developed in 15th-century Flanders (see "Painters, Pigments, and Panels," Chapter 8, page 219). This more flexible medium is wider in coloristic range than either tempera or fresco. Venetian oil painting became the great complement of the painting schools of Florence and Rome. The Venetians' instrument was color; that of the Florentines and Romans was sculpturesque form. Scholars often distill the contrast between these two approaches down to colorito (colored or painted) versus disegno (drawing and design—see "Disegno," page 254). Whereas most central Italian artists emphasized careful design preparation based on preliminary drawing, Venetian artists focused on color and the process of paint application. In addition, Venetian artists painted the poetry of the senses and delighted in nature's beauty and the pleasures of humanity. Artists in Florence and Rome gravitated toward more esoteric, intellectual themes—the epic of humanity, the masculine virtues, the grandeur of the ideal, and the lofty conceptions of religion involving the heroic and sublime.

Giorgione and Poesia Describing Venetian art as "poetic" is particularly appropriate, given the development of *poesia*, or painting meant to operate in a manner similar to poetry. Both classical and Renaissance poetry inspired Venetian artists, and their paintings focused on the lyrical and sensual. Thus, in many Venetian artworks, discerning concrete narratives or subjects (in the traditional sense) is virtually impossible.

The Venetian artist who deserves much of the credit for developing this poetic manner of painting was GIORGIONE DA CASTELFRANCO (ca. 1477–1510). Giorgione's so-called Pastoral Symphony (Fig. 9-17; some believe it an early work by his student Titian, discussed next) exemplifies poesia. Out of dense shadow emerge the soft forms of figures and landscape. The theme is as enigmatic as the lighting. Two nude women, accompanied by two clothed young men, occupy the rich, abundant landscape through which a shepherd passes. In the distance, a villa crowns a hill. The artist so eloquently evoked the pastoral mood that the viewer does not find the uncertainty about the picture's precise meaning distressing. The mood is enough. The shepherd symbolizes the poet. The pipes and the lute symbolize his poetry. The two women accompanying the young men may be thought of as their invisible inspiration, their muses. One turns to lift water from the sacred well of poetic inspiration. The voluptuous bodies of the women, softly modulated by the smoky shadow, became the standard in Venetian art. The fullness of their figures contributes to their effect as poetic personifications of nature's abundance.

As a pastoral poet in the pictorial medium and one of the greatest masters in the handling of light and color, Giorgione praised the beauty of nature, music, women, and pleasure.

9-17 | GIORGIONE DA CASTELFRANCO (and/or TITIAN?), *Pastoral Symphony*, ca. 1508. Oil on canvas, approx. 3' 7" × 4' 6". Louvre, Paris.

Venetian art is often described as poetic. In this painting, the artist so eloquently evoked the pastoral mood that the uncertainty about the picture's meaning is not distressing. The mood and rich color are enough.

Vasari reported that Giorgione was an accomplished lutenist and singer, and adjectives from poetry and music seem best suited for describing the pastoral air and muted chords of his painting. He cast a mood of tranquil reverie and dreaminess over the entire scene, evoking the landscape of a lost but never forgotten paradise.

Titian, Master of Color Giorgione's Arcadianism passed to Tiziano Vecelli, whose name has been anglicized into TITIAN (ca. 1490–1576). Titian, a supreme colorist, was the most extraordinary and prolific of the great Venetian painters. An important change occurring in Titian's time was the almost universal adoption of canvas, with its rough-textured surface, in place of wood panels for paintings. Titian's works established

oil color on canvas as the typical medium of pictorial tradition thereafter. According to a contemporary of Titian, Palma il Giovane:

Titian [employed] a great mass of colors, which served . . . as a base for the compositions. . . . I too have seen some of these, formed with bold strokes made with brushes laden with colors, sometimes of a pure red earth, which he used, so to speak, for a middle tone, and at other times of white lead; and with the same brush tinted with red, black and yellow he formed a highlight; and observing these principles he made the promise of an exceptional figure appear in four brushstrokes. . . . Having constructed these precious foundations he used to turn his pictures to the wall and leave them there without looking at them, sometimes for several months. When he wanted to apply his brush again he would examine them with the utmost rigor . . . to see if he could find

9-18 | TITIAN, Assumption of the Virgin, Santa Maria Gloriosa dei Frari, Venice, Italy, ca. 1516–1518. Oil on wood, 22' 6" × 11' 10".

Titian was renowned for his ability to convey light through color. In this dramatic depiction of the Virgin Mary's ascent to Heaven, the golden clouds seem to glow and radiate light into the church.

any faults.... In this way, working on the figures and revising them, he brought them to the most perfect symmetry that the beauty of art and nature can reveal.... [T]hus he gradually covered those quintessential forms with living flesh, bringing them by many stages to a state in which they lacked only the breath of life. He never painted a figure all at once and ... in the last stages he painted more with his fingers than his brushes.¹⁰

The Glorious Virgin Mary Titian's remarkable coloristic sense and his ability to convey light through color emerge in a major altarpiece, *Assumption of the Virgin* (Fig. 9-18), painted for the main altar of Santa Maria Gloriosa dei Frari in Venice. The monumental altarpiece (almost 23 feet high) appropriately depicts the glorious ascent of the Virgin's body to Heaven. Visually, the painting is a stunning tour de force. Golden clouds so luminous they seem to glow, radiating light into the church interior, envelop the Virgin. God the Father appears above, awaiting her with open arms. Below, apostles gesticulate wildly as they witness this momentous event. Using vibrant color, Titian infused the altarpiece with a drama and intensity that assured his lofty reputation, then and now.

A Venetian Venus In 1538, at the height of his powers, Titian painted the so-called *Venus of Urbino* (Fig. 9-19) for Guidobaldo II, duke of Urbino. The title (given to the

9-19 | TITIAN, *Venus of Urbino*, 1538. Oil on canvas, approx. 4' × 5' 6". Galleria degli Uffizi, Florence.

Titian established oil color on canvas as the preferred painting medium in Western art. Here, he also set the standard for representations of the reclining female nude, whether divine or mortal.

painting later) elevates to the status of classical mythology what probably merely represents a courtesan in her bedchamber. Indeed, no evidence suggests that the duke intended the commission as anything more than a female nude for his private enjoyment. Whether the subject is divine or mortal, Titian based his version on an earlier (and pioneering) painting of Venus (not illustrated) by Giorgione. Here, Titian established the compositional elements and the standard for paintings of the reclining female nude, regardless of the many variations that ensued. This "Venus" reclines on the gentle slope of her luxurious pillowed couch, the linear play of the draperies contrasting with her body's sleek continuous volume. At her feet is a slumbering lapdog. Behind her, a simple drape both places her figure emphatically in the foreground and indicates a vista into the background at the right half of the picture. Two servants bend over a chest, apparently searching for garments (Renaissance households stored clothing in carved wooden chests called *cassoni*) to clothe "Venus." Beyond them, a smaller vista opens into a landscape. Titian masterfully constructed the view back into space and the division of the space into progressively smaller units.

As in other Venetian paintings, color plays a prominent role in *Venus of Urbino*. The red tones of the matron's skirt and the muted reds of the tapestries against the neutral whites of the matron's sleeves and of the kneeling girl's gown echo the deep Venetian reds set off against the pale neutral whites of the linen and the warm ivory gold of the flesh. The viewer must study the picture carefully to realize the subtlety of color planning. For instance, the two deep reds (in the foreground cushions and in the background skirt) play a critical role in the composition as a gauge of distance and as indicators of an implied diagonal opposed to the real one of the reclining figure. Here, Titian used color not simply for tinting preexisting forms but also to organize his placement of forms.

Mannerism

Mannerism emerged as a distinctive artistic style in Italy during the 16th century. The term is derived from the Italian word maniera, meaning style or manner. Art historians usually define "style" as a characteristic or representative mode, especially of an artist or period (see Introduction). The term "style" can also refer to an absolute quality of fashion (someone has "style"). Mannerism's style (or representative mode) is characterized by style (being stylish, cultured, elegant). Over the years, scholars have refined their ideas about Mannerism, attempting to define its parameters. It is difficult to identify specific dates for Mannerism. Emerging in the 1520s, it overlapped considerably with High Renaissance art.

Among the features most closely associated with Mannerism is artifice. Actually, all art involves artifice, in the sense that art is not "natural." It is a representation of a scene or idea. But many artists, including High Renaissance artists such as Leonardo and Raphael, chose to conceal that artifice by using such devices as perspective and shading to make their art look natural. In contrast, Mannerist artists consciously revealed the constructed nature of their art. In other words, High Renaissance artists generally strove to create art that appeared natural, whereas Mannerist artists were less inclined to disguise the contrived nature of art production. This is why artifice is a central feature of discussions about Mannerism, and why Mannerist works can seem, appropriately, "mannered." The conscious display of artifice in Mannerism often reveals itself in imbalanced compositions and unusual complexities, both visual and conceptual. Ambiguous space, departures from expected conventions, and unique presentations of traditional themes also surface frequently in Mannerist art. And the stylishness of Mannerism often inspired artists to focus on themes of courtly grace and cultured sophistication.

Loss and Grief Descent from the Cross (Fig. 9-20) by JACOPO DA PONTORMO (1494-1557) exhibits almost all the stylistic features characteristic of Mannerism's early phase in painting. This subject had been frequently depicted in art, and Pontormo exploited the familiarity that viewers at the time would have had by playing off of their expectations. For example, rather than presenting the action as taking place across the perpendicular picture plan, as artists such as Rogier van der Weyden had done in their paintings of this scene (Fig. 8-4), Pontormo rotated the conventional figural groups along a vertical axis. As a result, the Virgin Mary falls back (away from the viewer) as she releases her dead Son's hand. In contrast with Early and High Renaissance artists, who had concentrated their masses in the center of the painting, Pontormo here leaves a void. This accentuates the grouping of hands that fill that hole, calling attention to the void—symbolic of loss and grief.

The artist enhanced the painting's ambiguity with the curiously anxious glances the figures cast in all directions. Athletic bending and distorted twisting characterize many of the figures, which have elastically elongated limbs and uniformly small and oval heads. The contrasting colors, primarily light blues and pinks, add to the dynamism and complexity of the work. The painting represents a departure from the balanced, harmoniously structured compositions of the earlier Renaissance.

Elegance and Grace Pontormo's younger contemporary, Girolamo Francesco Maria Mazzola, known as PARMIGIANINO (1503–1540), achieved in his best-known work, *Madonna with the Long Neck* (Fig. 9-21), the stylish elegance that was a principal aim of Mannerism. The oil painting (on wood) is a picture of exquisite grace and precious sweetness. The Madonna's small oval head; her long, slender neck; the unbelievable attenuation and delicacy of her hand; and the sinuous, swaying elongation of her frame are all marks of the aristocratic, sumptuously courtly taste of a later phase of Mannerism. Parmigianino amplified this elegance by expanding the Madonna's form as viewed from head to toe. On the left stands a bevy of angelic creatures, melting with emotions as soft and smooth as their limbs. On the right, the artist included a line of columns without

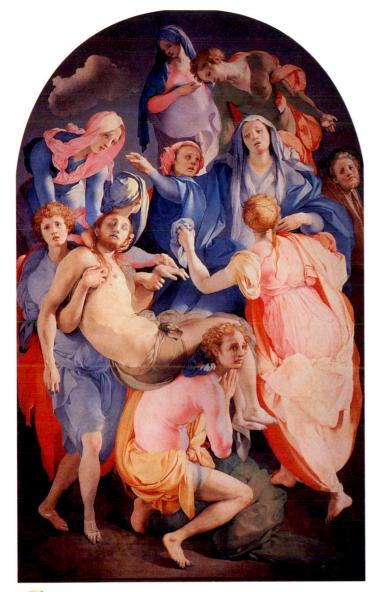

9-20 | JACOPO DA PONTORMO, Descent from the Cross, Capponi Chapel, Santa Felicità, Florence, Italy, 1525–1528. Oil on wood, approx. 10′ 3″ × 6′ 6″.

Mannerist paintings like this one represent a departure from the compositions of the earlier Renaissance. Instead of concentrating masses in the center of the painting, Pontormo left a void.

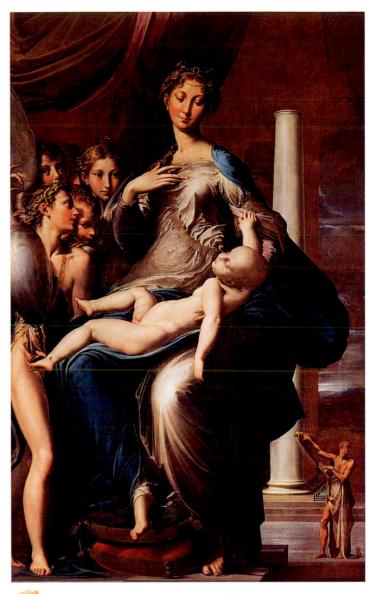

9-21 | PARMIGIANINO, *Madonna with the Long Neck*, ca. 1535. Oil on wood, approx. 7' 1" × 4' 4". Galleria degli Uffizi, Florence.

Parmigianino's Madonna displays the stylish elegance that was a principal aim of Mannerism. Mary has a small oval head, a long, slender neck, attenuated hands, and a sinuous body.

capitals and an enigmatic figure with a scroll, whose distance from the foreground is immeasurable and ambiguous.

Although the painting's elegance and sophisticated beauty are due in large part to the Madonna's attenuated limbs, that exaggeration is not solely decorative in purpose. *Madonna with the Long Neck* takes its subject from a simile in medieval hymns that compared the Virgin's neck to a great ivory tower or column. Thus, the work contains religious meaning in addition to the power derived from its beauty alone.

Women Painters Men far outnumbered women as artists during the Renaissance, as they had since ancient times. In the 16th century, the rarity of female artists reflects the

obstacles they faced. In particular, training practices mandating residence at a master's house precluded women from acquiring the necessary experience. In addition, social proscriptions, such as those preventing women from drawing from nude models, further hampered an aspiring female artist's advancement through the accepted avenues of artistic training. Still, there were determined women who surmounted these barriers and were able to develop not only considerable bodies of work but enviable reputations as well.

One such artist was SOFONISBA ANGUISSOLA (1527–1625) of Cremona, who was so accomplished that she can be considered the first Italian woman to have ascended to the level of international art celebrity. She knew and learned from the aged

269

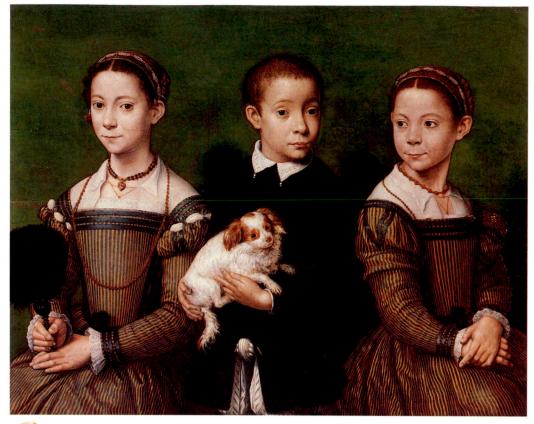

9-22 | SOFONISBA ANGUISSOLA, Portrait of the Artist's Sisters and Brother, ca. 1555. Methuen Collection, Corsham Court, Wiltshire.

Anguissola was the leading female artist of her time. Her use of relaxed poses and expressions in this intimate and informal group portrait was much admired by her contemporaries.

Michelangelo, became court painter to Phillip II of Spain, and, at the end of her life, gave advice on art to a young admirer of her work, Anthony Van Dyck, the great Flemish master (FIG. 10-19). Anguissola's Portrait of the Artist's Sisters and Brother (Fig. 9-22) is an informal and intimate group portrait of irresistible charm. Against a neutral ground, the artist placed her siblings in an affectionate pose meant not for official display but for private showing, much as they might be posed in a modern photo-studio portrait. The sisters, wearing matching striped gowns, flank their brother, who caresses a lapdog. The older sister (at the left) summons the dignity required for the occasion, while the boy looks quizzically at the portraitist with an expression of naive curiosity and the other girl diverts her attention toward something or someone to the painter's left. Anguissola's use of relaxed poses and expressions; her sympathetic, personal presentation; and her graceful treatment of the forms were much admired by her contemporaries.

Spiraling Figures Italian influence, working its way into Northern Europe, drew a brilliant young Netherlandish sculptor, Jean de Boulogne, to Italy, where he practiced his art under the equivalent Italian name of GIOVANNI DA BOLOGNA (1529–1608). Giovanni's *Abduction of the Sabine Women* (Fig. 9-23) exemplifies Mannerist principles of figure composition in sculpture.

Drawn from the legendary history of Rome, the title—relating how the early Romans abducted wives for themselves from their neighbors the Sabines—was given to the group only after it was raised. Giovanni probably intended to present only an interesting figural composition involving an old man, a young man, and a woman, all nude in the tradition of ancient statues portraying mythological figures. *Abduction of the Sabine Women* includes, for example, references to the Laocoön (Fig. 2-55)—once in the crouching old man and again in the woman's up-flung arm. The three bodies interlock on a vertical axis, creating an ascending spiral movement.

To appreciate the sculpture fully, one must walk around it, because the work changes radically according to the viewing point. One contributing factor to the shifting imagery is the prominence of open spaces that pass through the masses (for example, the space between an arm and a body), which have as great an effect as the solids. Giovanni's figures, however, do not break out of the spiral vortex of the composition but remain as if contained within a cylinder. Nonetheless, this sculpture was the first large-scale group since classical antiquity designed to be seen from multiple viewpoints.

Mannerism in Venice Venetian painting of the later 16th century built on established Venetian ideas, but also embraced the new Mannerist style. Jacopo Robusti, known as

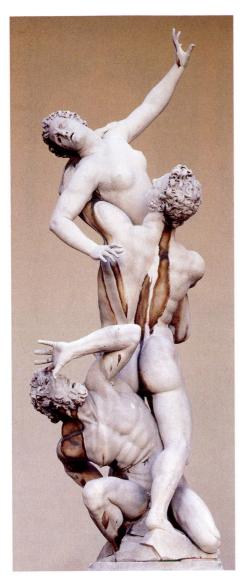

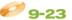

GIOVANNI DA
BOLOGNA, Abduction
of the Sabine
Women, Loggia dei
Lanzi, Piazza della
Signoria, Florence,
Italy, completed
1583. Marble,
approx. 13' 6" high.

This sculpture was the first large-scale group since classical antiquity designed to be seen from multiple viewpoints. The three bodies interlock to create a vertical spiral movement. TINTORETTO (1518–1594), claimed to be a student of Titian and aspired to combine Titian's color with Michelangelo's drawing. But he also adopted many Mannerist pictorial devices, which he employed to produce works imbued with dramatic power, depth of spiritual vision, and glowing Venetian color schemes.

Toward the end of Tintoretto's life, his art became spiritual, even visionary, as solid forms melted away into swirling clouds of dark shot through with fitful light. In *Last Supper* (Fig. 9-24), the figures appear in a dark interior illuminated by a single light in the upper left of the image. The shimmering halos reveal the biblical nature of the scene. The ability of this dramatic scene to engage viewers was well in keeping with Counter-Reformation ideals (see "The Role of Religious Art in Counter-Reformation Italy," page 251) and the Catholic Church's belief in the didactic nature of religious art.

Last Supper incorporates many Mannerist elements, including visual complexity and an imbalanced composition. In terms of design, the contrast with Leonardo's Last Supper (Fig. 9-2) is both extreme and instructive. Leonardo's composition, balanced and symmetrical, parallels the picture plane in a geometrically organized and closed space. The figure of Christ is the tranquil center of the drama and the perspectival focus. In Tintoretto's painting, Christ is above and beyond the converging perspective lines that race diagonally away from the picture surface, creating disturbing effects of limitless depth and motion. The viewer locates Tintoretto's Christ via the light flaring, beaconlike, out of darkness. The contrast between the two works reflects the direction Renaissance painting took in the 16th century, as it moved away from architectonic clarity of space and neutral lighting toward the dynamic perspectives and dramatic chiaroscuro of the coming Baroque (see Chapter 10).

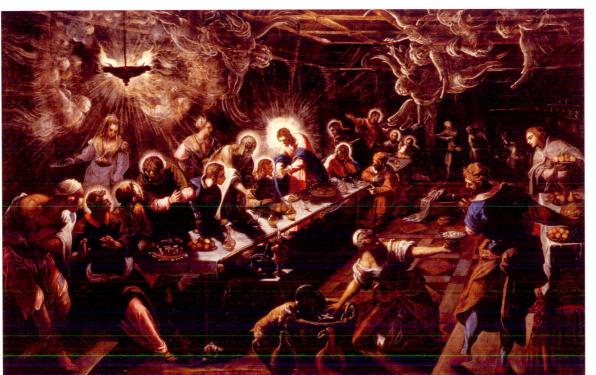

9-24

TINTORETTO, *Last*Supper, chancel, San
Giorgio Maggiore,
Venice, Italy, 1594. Oil
on canvas, 12' × 18' 8".

Tintoretto adopted many Mannerist pictorial devices to produce oil paintings imbued with emotional power, depth of spiritual vision, glowing Venetian color schemes, and dramatic lighting.

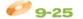

PAOLO VERONESE, Christ in the House of Levi, 1573. Oil on canvas, approx. 18' 6" × 42' 6". Galleria dell'Accademia, Venice.

Veronese was known for his superb color and majestic classical settings. The Catholic Church accused him of impiety for including clowns, dogs, and dwarfs near Christ in this painting originally titled Last Supper.

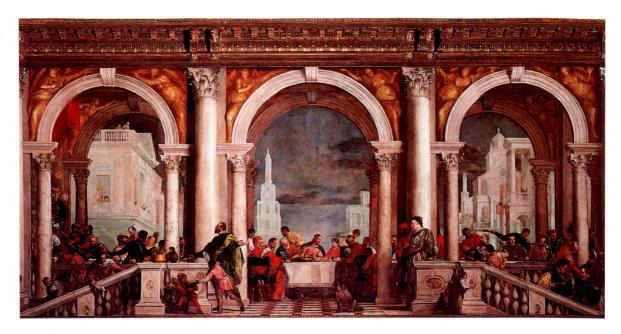

Mannerist Impiety Among the great Venetian masters was Paolo Cagliari of Verona, called PAOLO VERONESE (1528–1588). Whereas Tintoretto gloried in monumental drama and deep perspectives, Veronese specialized in splendid pageantry painted in superb color and set within majestic classical architecture. Like Tintoretto, Veronese painted on a huge scale, with canvases often as large as 20 × 30 feet or more. His usual subjects, painted for the refectories of wealthy monasteries, afforded him an opportunity to display magnificent companies at table.

Christ in the House of Levi (Fig. 9-25), originally called Last Supper, is an example. Here, in a great open loggia framed by three monumental arches, Christ sits at the center of the splendidly garbed elite of Venice. In the foreground, with a courtly gesture, the very image of gracious grandeur, the chief steward welcomes guests. Robed lords, their colorful retainers, clowns, dogs, and dwarfs crowd into the spacious loggia. Painted during the Counter-Reformation, this depiction prompted criticism from the Catholic Church. The Holy Office of the Inquisition accused Veronese of impiety for painting such creatures so close to the Lord, and it ordered him to make changes at his own expense. Reluctant to do so, he simply changed the painting's title, converting the subject to a less solemn one.

As Andrea Palladio looked to the example of classically inspired High Renaissance architecture, so Veronese returned to High Renaissance composition, its symmetrical balance, and its ordered architectonics. His shimmering color is drawn from the whole spectrum, although he avoided solid colors in favor of half shades (light blues, sea greens, lemon yellows, roses, and violets), creating veritable flower beds of tone.

HOLY ROMAN EMPIRE

The dissolution of the Burgundian Netherlands in 1477 led to a realignment in the European geopolitical landscape in the early 16th century. France and the Holy Roman Empire (at the time consisting primarily of today's Germany) expanded their territories after this breakup of Flanders.

Largely because of Martin Luther's presence, the Reformation initially had its greatest impact in Germany. The difference between Catholic and Protestant uses of art can be demonstrated by comparing two German artworks, one pre-Reformation and one produced in the years after the Reformation began.

Of Sickness and Salvation Matthias Neithardt, known conventionally as MATTHIAS GRÜNEWALD (ca. 1480–1528), worked for the archbishops of Mainz from 1511 on as court painter and decorator. He also served the archbishops as architect, hydraulic engineer, and superintendent of works. Grünewald eventually moved to northern Germany, where he settled at Halle in Saxony. Around 1510, he began work on the *Isenheim Altarpiece* (FIGS. 9-26 and 9-27), a complex and fascinating monument that reflects Catholic beliefs.

The altarpiece, created for the monastic hospital order Saint Anthony of Isenheim, consists of a wooden shrine (carved by sculptor NIKOLAUS HAGENAUER in 1490) that includes gilded and polychromed statues of Saints Anthony Abbot, Augustine, and Jerome (Fig. 9-27). Grünewald's contribution consists of two pairs of movable wings that open at the center. Hinged together at the sides, one pair stands directly behind the other. Painted between 1510 and 1515, the exterior panels of the first pair (visible when the altarpiece is closed; Fig. 9-26) present four scenes—Crucifixion in the center, Saint Sebastian on the left and Saint Anthony on the right, and Lamentation in the predella. Inside these exterior wings are four additional scenes (not illustrated)—Annunciation, Angelic Concert, Madonna and Child, and Resurrection. Opening this second pair of wings reveals the interior shrine, flanked by Meeting of Saints Anthony and Paul and Temptation of Saint Anthony (Fig. 9-27).

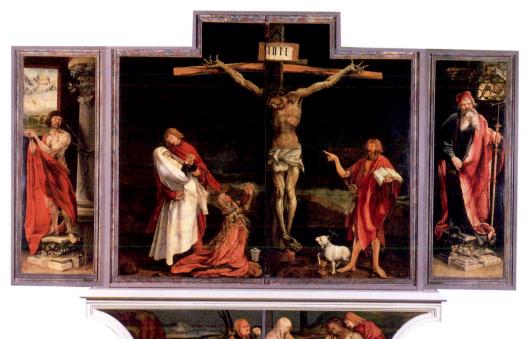

9-26

MATTHIAS GRÜNEWALD, Isenheim Altarpiece (closed), Crucifixion (center panel), from the chapel of the Hospital of Saint Anthony, Isenheim, Germany, ca. 1510-1515. Oil on panel; center panel, $9'\ 9\frac{1}{2}''\times 10'\ 9''$; each wing, $8'\ 2\frac{1}{2}''\times 3'\ \frac{1}{2}''$; predella, $2'\ 5\frac{1}{2}''\times 11'\ 2''$. Musée d'Unterlinden, Colmar.

Befitting its setting in a monastic hospital, Grünewald's *Isenheim Altarpiece* includes painted panels that deal specifically with dire illnesses but also with miraculous healing, hope, and salvation.

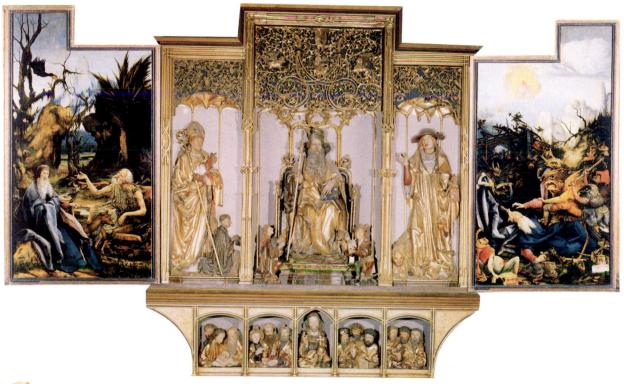

9-27 | MATTHIAS GRÜNEWALD, *Isenheim Altarpiece* (open), center shrine carved by NIKOLAUS HAGENAUER in 1490, from the chapel of the Hospital of Saint Anthony, Isenheim, Germany, ca. 1510–1515. Shrine, painted and gilt limewood, $9' \ 9\frac{1}{2}'' \times 10' \ 9''$ (center), $2' \ 5\frac{1}{2}'' \times 11' \ 2''$ (predella). Each wing, oil on panel, $8' \ 2\frac{1}{2}'' \times 3' \ \frac{1}{2}''$. Musée d'Unterlinden, Colmar.

The most memorable of Grünewald's terrifying images of suffering and disease is the right panel depicting the five temptations of Saint Anthony as ghoulish creatures in a dark landscape.

The placement of this altarpiece in the choir of a church adjacent to the monastery hospital dictated much of the imagery. Saints associated with diseases such as the plague and with miraculous cures, such as Saint Anthony and Saint Sebastian, occupy prominent positions in the iconographical program. Grünewald's panels deal specifically with the themes of dire illness and miraculous healing, and emphasize the suffering of the order's patron saint, Anthony. The images served as warnings, encouraging increased devotion from monks and hospital patients. They also functioned therapeutically by offering some hope to the afflicted. Indeed, Saint Anthony's legend encompassed his role as both vengeful dispenser of justice (by inflicting disease) and benevolent healer. Grünewald enhanced the impact of the altarpiece through his effective use of color. He intensified the contrast of horror and hope by playing subtle tones and soft harmonies against shocking dissonance of color.

One of the most memorable scenes is Temptation of Saint Anthony (Fig. 9-27), immediately to the right of the interior sculptured shrine. It is a terrifying image of the five temptations, depicted as an assortment of ghoulish and bestial creatures in a dark landscape, attacking the saint. In the foreground, Grünewald painted a grotesque image of a man, whose oozing boils, withered arm, and distended stomach all suggest a horrible disease. Medical experts have connected these symptoms with ergotism (a disease caused by ergot, a fungus that grows especially on rye). Although doctors did not discover the cause of this disease until about 1600, people lived in fear of its recognizable symptoms (convulsions and gangrene). The public referred to this illness as "Saint Anthony's Fire," and it was one of the major diseases treated at this hospital. The gangrene often compelled amputation, and scholars have noted that the two movable halves of the altarpiece's predella, if slid apart, make it appear as if Christ's legs have been amputated. The same observation can be made with regard to the two main exterior panels. Due to the offcenter placement of the cross, opening the left panel "severs" one arm from the crucified figure.

Thus, Grünewald carefully selected and presented his altarpiece's iconography to be particularly meaningful in its hospital setting. In the interior shrine, the artist balanced the horrors of the disease and the punishments that awaited those who did not repent with scenes such as the Meeting of Saints Anthony and Paul, depicting the two saints, healthy and aged, conversing peacefully. Even the exterior panels (the closed altarpiece) convey these same concerns. The Crucifixion emphasizes Christ's pain and suffering, but the knowledge that this act redeemed humanity tempers the misery. In addition, Saint Anthony appears in the right wing as a devout follower of Christ who, like Christ and for Christ, endured intense suffering for his faith. Saint Anthony's presence on the exterior thus reinforces the themes Grünewald intertwined throughout this entire altarpiece—themes of pain, illness, and death, as well as those of hope, comfort, and salvation.

The Protestant faith had not been formally established when Hagenauer and Grünewald produced the *Isenheim Altarpiece*,

and the complexity and monumentality of the altarpiece must be viewed as Catholic in orientation. Further, Grünewald incorporated several references to Catholic doctrines, such as the lamb (symbol of the Son of God), whose wound spurts blood into a chalice in the exterior Crucifixion scene.

Albrecht Dürer In contrast, the Lutheran sympathies of Grünewald's contemporary, Albrecht Dürer (1471–1528), are on display in many of his artworks. A native of Nuremberg, Germany, Dürer was the first artist outside Italy to become an international art celebrity. He traveled extensively, visiting and studying in Colmar, Basel, Strasbourg, Venice, Antwerp, and Brussels, among other locales, and became personally acquainted with many of the leading humanists and artists of his time. A man of exceptional talents and tremendous energy, Dürer achieved widespread fame in his own time and has enjoyed a lofty reputation ever since.

Dürer was apprenticed at the age of 15 to a painter, but he quickly mastered the arts of woodcut, engraving, and water-color as well. Dürer was fervently committed to advancing his career and employed an agent to help sell his prints. His wife, who served as his manager, and his mother also sold his prints at markets. His business acumen is revealed by the lawsuit he brought in 1506 against an Italian artist for copying his prints. Historians generally regard this lawsuit to be the first over artistic copyright and intellectual property.

Like Leonardo da Vinci, Dürer wrote theoretical treatises on a variety of subjects, such as perspective, fortification, and the ideal in human proportions. Unlike Leonardo, he both finished and published his writings. Through his prints, he exerted strong influence throughout Europe, especially in Flanders but also in Italy. Moreover, he was the first northern artist to leave a record of his life and career through several excellent self-portraits, through his correspondence, and through a carefully kept, quite detailed, and eminently readable diary.

Lutheranism in Nuremberg Born in one of the centers of the Reformation, Dürer immersed himself in the religious debates of the 16th century. His support for Lutheranism surfaces in Four Apostles (Fig. 9-28), which Dürer painted without commission and presented to the city fathers of Nuremberg in 1526 to be hung in the city hall. John and Peter appear on the left panel, Mark and Paul on the right. Dürer conveyed this painting's Lutheran orientation by his positioning of the figures. He relegated Saint Peter (as representative of the pope in Rome) to a secondary role by placing him behind John the Evangelist. John assumed particular prominence for Luther because of the evangelist's focus on Christ's person in his Gospel. In addition, Peter and John both read from the Bible, the single authoritative source of religious truth, according to Luther. Dürer emphasized the Bible's centrality by depicting it open to the passage "In the beginning was the Word, and the Word was with God, and the Word was God" (John 1:1). At the bottom of the panels, Dürer included quotations from each of the Four

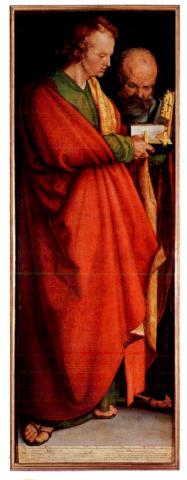

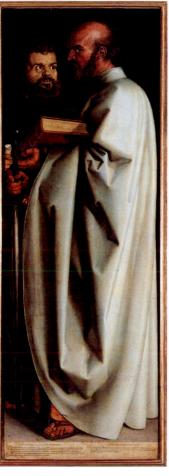

9-28 | ALBRECHT DÜRER, Four Apostles, 1526. Oil on panel, each panel 7' 1" × 2' 6". Alte Pinakothek, Munich.

Dürer's support for Lutheranism surfaces in these portraitlike depictions of the four apostles. Saint Peter, representative of the pope in Rome, plays a secondary role behind John the Evangelist.

Apostles' books, using Luther's German translation of the New Testament. The excerpts warn against the coming of perilous times and the preaching of false prophets who will distort God's word. The individuality of each of the four men's faces, along with the detailed depiction of their attire and attributes, communicate an integrity and spirituality.

Classical Ideas in the North Fascinated with classical ideas as passed along by Italian Renaissance artists, Dürer was among the first northern artists to travel to Italy expressly to study Italian art and its underlying theories at their source. After his first journey in 1494–1495 (the second was in 1505–1506), he incorporated many Italian Renaissance developments into his art. Art historians have acclaimed Dürer as the first northern artist to understand fully the basic aims of the Renaissance in Italy.

An engraving, *The Fall of Man* (Fig. 9-29), also known as *Adam and Eve*, represents the first distillation of his studies of the Vitruvian theory of human proportions, a theory based on arithmetic ratios. Clearly outlined against the dark background

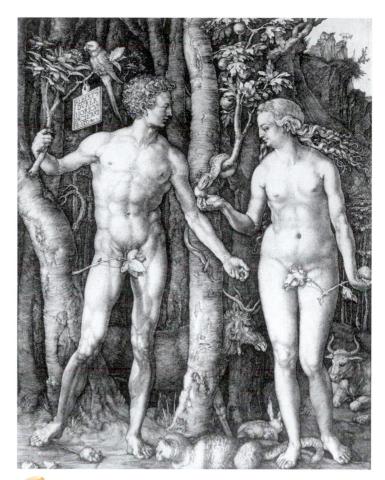

9-29 | ALBRECHT DÜRER, The Fall of Man (Adam and Eve), 1504. Engraving, approx. $9\frac{7}{8}$ " × $7\frac{5}{8}$ ". Museum of Fine Arts, Boston (centennial gift of Landon T. Clay).

This engraving reflects Dürer's studies of the Vitruvian theory of human proportions. The two nude figures were probably based on ancient idealized statues, here set in a landscape and tempered with naturalism.

of a northern forest, the two idealized figures of Adam and Eve stand in poses reminiscent of specific classical statues probably known to Dürer through graphic representations. Preceded by numerous geometric drawings in which the artist attempted to systematize sets of ideal human proportions in balanced contrapposto poses, the final print presents Dürer's concept of the "perfect" male and female figures. Yet Dürer tempered this idealization with naturalism—a commitment to observation.

Dürer demonstrated his well-honed observational skills in his rendering of the background foliage and animals. The gnarled bark of the trees and the feathery leaves authenticate the scene, as do the various creatures skulking underfoot. The animals populating the print are symbolic. The choleric cat, the melancholic elk, the sanguine rabbit, and the phlegmatic ox represent humanity's temperaments based on the "four humors," fluids that were the basis of theories of the body's function developed by the ancient Greek physician Hippocrates and practiced in medieval physiology. The tension between cat and mouse in the foreground symbolizes the relation between Adam and Eve at the crucial moment in *The Fall of Man*.

Holbein's Diplomatic Portrait The leading artist of the Holy Roman Empire in the generation after Dürer was Hans Holbein The Younger (ca. 1497–1543). Holbein produced portraits that reflected the northern tradition of close realism that had emerged in 15th-century Flemish art. Yet he also incorporated Italian ideas about monumental composition, body structure, and sculpturesque form. The color surfaces of his paintings are as lustrous as enamel, his detail is exact and exquisitely drawn, and his contrasts of light and dark are never heavy.

Holbein began his artistic career in Basel, but due to the immediate threat of a religious civil war, he left for England, where he became painter to the court of King Henry VIII. While there, Holbein produced a superb double portrait of the French ambassadors to England, Jean de Dinteville and Georges de Selve. The French Ambassadors (Fig. 9-30) exhibits Holbein's considerable talents—his strong sense of composition, his subtle linear patterning, his gift for portraiture, his marvelous sensitivity to color, and his faultlessly firm technique. This painting may have been Holbein's favorite, because it is the only one signed with his full name. The two men, both ardent humanists, stand at each end of a side table covered with an oriental rug and a collection of objects reflective of their worldliness and interest in learning and the arts. These include mathematical and astronomical models and implements, a lute with a broken string, compasses, a sundial, flutes, globes, and an open hymnbook with Luther's translation of *Veni*, *Creator Spiritus* and of the Ten Commandments.

Of particular interest is the long gray shape that slashes diagonally across the picture plane and interrupts the stable, balanced, and serene composition. This form is an *anamorphic image*, a distorted image recognizable when viewed with a special device, such as a cylindrical mirror, or by viewing the painting at an acute angle. Viewing this painting while standing off to the right reveals that this gray slash is a skull. Although scholars do not agree on this skull's meaning, at the very least it certainly refers to death. Artists commonly incorporated skulls into paintings as reminders of mortality. Indeed, Holbein depicted a skull on the metal medallion on Jean de Dinteville's hat. Holbein may have intended the skulls, in conjunction with the crucifix that appears half hidden behind the curtain in the upper left corner, to encourage the viewer to ponder death and resurrection.

This painting may allude to the growing tension between secular and religious authorities. Jean de Dinteville was a titled landowner, Georges de Selve a bishop. The inclusion of Luther's translations next to the lute with the broken string (a symbol of discord) may also subtly refer to the religious strife. Despite the uncertainty about the precise meaning of *The French Ambassadors*, it is a painting of supreme artistic achievement. Holbein rendered the still-life objects with the same meticulous care as the men themselves, as the woven

9-30 | Hans Holbein the Younger, The French Ambassadors, 1533. Oil and tempera on panel, approx. $6' 8'' \times 6' 9\frac{1}{2}''$. National Gallery, London.

In this double portrait, Holbein depicted two humanists with a collection of objects reflective of their worldliness and learning, but he also included an anamorphic skull, a reminder of death.

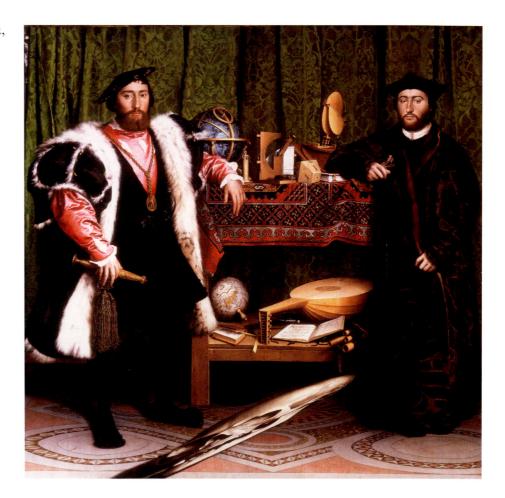

design of the deep emerald curtain behind them, and as the floor tiles, constructed in faultless perspective. He surely hoped that the elegance of this painting (produced shortly after Holbein arrived in England) and his virtuosity would impress Henry VIII.

FRANCE

As The French Ambassadors illustrates, France in the early 16th century continued its efforts to secure widespread recognition as a political power. Under the rule of Francis I (r. 1515–1547), the French established a firm foothold in Milan and its environs. Francis waged a campaign (known as the Habsburg-Valois Wars) against Charles V (the Spanish king and Holy Roman Emperor), which occupied him from 1521 to 1544. These wars involved disputed territories—southern France, the Netherlands, the Rhinelands, northern Spain, and Italy—and reflect France's central role in the shifting geopolitical landscape. Despite these military preoccupations, Francis I also endeavored to elevate his country's cultural profile. To that end, he invited esteemed Italian artists such as Leonardo da Vinci to his court. Francis's attempt to glorify the state and himself meant that the religious art

dominating the Middle Ages no longer prevailed, for the king and not the Christian Church held the power.

From Castles to Châteaux Francis I indulged his passion for building by commissioning several large-scale châteaux, among them the Château de Chambord (Fig. 9-31). These châteaux, developed from medieval fortified castles, served as country houses for royalty, who usually built them near forests for use as hunting lodges. Construction on Chambord began in 1519, but Francis I never saw its completion. Chambord's plan includes a central square block with four corridors, in the shape of a cross, and a broad, central staircase that gives access to groups of rooms—ancestors of the modern suite of rooms or apartments. At each of the four corners, a round tower punctuates the square plan, and a moat surrounds the whole. From the exterior, Chambord presents a carefully contrived horizontal accent on three levels, its floors separated by continuous moldings. Windows align precisely, one exactly over another. The Italian Renaissance palazzo (Fig. 8-20) served as the model for this matching of horizontal and vertical features, but above the third level the structure's lines break chaotically into a jumble of high dormers, chimneys, and lanterns that recall soaring ragged Gothic silhouettes on the skyline.

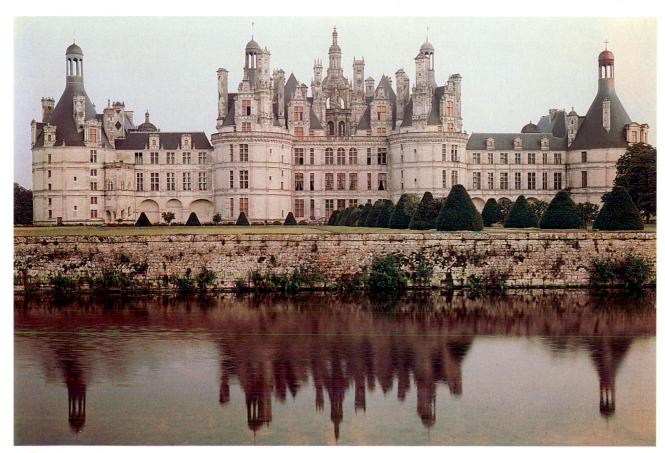

9-31 | Château de Chambord, Chambord, France, begun 1519.

French Renaissance châteaux served as country houses for royalty. Often built as hunting lodges, they developed from medieval fortified castles. The Château de Chambord is surrounded by a moat.

THE NETHERLANDS

With the demise of the Duchy of Burgundy in 1477 and the division of that territory between France and the Holy Roman Empire, the Netherlands at the beginning of the 16th century consisted of 17 provinces (corresponding to modern Holland, Belgium, and Luxembourg). The Netherlands was among the most commercially advanced and prosperous of European countries. Its extensive network of rivers and easy access to the Atlantic Ocean provided a setting conducive to overseas trade, and shipbuilding was one of the most profitable businesses. The geographic location of the region's commercial center changed toward the end of the 15th century. Partly from the silting of the Bruges estuary, traffic shifted to Antwerp, which became the hub of economic activity in the Netherlands after 1510. As many as 500 ships a day passed through Antwerp's harbor, and large trading colonies from England, the Holy Roman Empire, Italy, Portugal, and Spain established themselves in the city.

During the 16th century, the Netherlands was under the political control of Philip II of Spain (r. 1556–1598), who had inherited the region from his father, Charles V (r. 1519–1556). The economic prosperity of the Netherlands served as a potent incentive for Philip II to strengthen his control over those provinces. However, his heavy-handed tactics and repressive measures led in 1579 to revolt, resulting in the formation of two federations. The Union of Arras, a Catholic union of southern Netherlandish provinces, remained under Spanish dominion, and the Union of Utrecht, a Protestant union of northern provinces, became the Dutch Republic.

The increasing number of Netherlandish citizens converting to Protestantism affected the arts, as evidenced by a corresponding decrease in large-scale altarpieces and religious works (although such works continued to be commissioned for Catholic churches). Much of Netherlandish art of this period provides a wonderful glimpse into the lives of various strata of society, from nobility to peasantry, capturing their activities, environment, and values.

Both Secular and Spiritual Antwerp's growth and prosperity, along with its wealthy merchants' propensity for collecting and purchasing art, attracted artists to the city. Among them was QUINTEN MASSYS (ca. 1466–1530), who became Antwerp's leading painter after 1510. Son of a Louvain blacksmith, Massys demonstrated a willingness to explore the styles and modes of a variety of models, from van Eyck to Bosch and from van der Weyden to Dürer and Leonardo. Yet his eclecticism was subtle and discriminating, enriched by an inventiveness that gave a personal stamp to his paintings and made him a popular, as well as important, artist.

In Money-Changer and His Wife (Fig. 9-32), Massys presented a professional man transacting business. He holds scales, checking the weight of coins on the table. His wife interrupts her reading of a prayer book to watch him. The artist's detailed rendering of the figures, setting, and objects suggests a fidelity to observable fact. Money-Changer and His Wife also

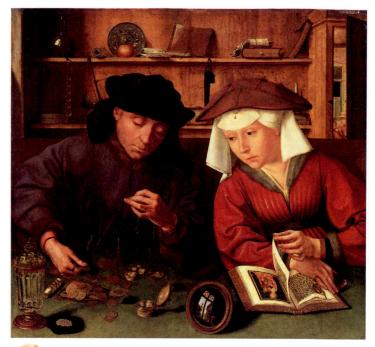

9-32 | QUINTEN MASSYS, Money-Changer and His Wife, 1514. Oil on panel, $2' 3\frac{3}{4}'' \times 2' 2\frac{3}{8}''$. Louvre, Paris.

Although this painting depicts a secular financial transaction, the artist tempered the focus on the material world with references to the importance of a moral, righteous, and spiritual life.

reveals Netherlandish values and mores. Although the painting highlights the financial transactions that were an increasingly prominent part of secular life in the 16th-century Netherlands, Massys tempered this focus on the material world with numerous references to the importance of a moral, righteous, and spiritual life. Not only does the wife hold a prayer book, but the artist also included other traditional religious symbols (for example, the carafe with water and candlestick). Massys inserted two small vignettes (not visible to the couple) that refer to the balance the merchant and his wife must establish between their worldly existence and their commitment to God's word. On the right, through a window, an old man talks with another man, suggesting idleness and gossip. The reflected image in the convex mirror on the counter offsets this image of sloth and foolish chatter. There, a man reads what is most likely a Bible or prayer book. Behind him is a church steeple.

An inscription on the original frame (now lost) seems to have reinforced this message. According to a 17th-century scholar, this inscription read, "Let the balance be just and the weights equal" (Lev. 19:36), which applies both to the money changer's professional conduct and the eventual Last Judgment.

Meeting Spiritual Obligations This tendency to inject reminders about spiritual well-being emerges in *Meat Still-Life* (Fig. 9-33) by Pieter Aertsen (ca. 1507–1575), who worked in Antwerp for more than three decades. At first glance, this painting appears to be a descriptive genre scene. On display is an array of meat products—a side of a hog, chickens, sausages,

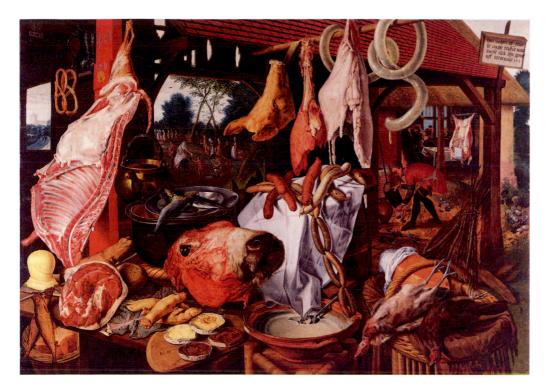

9-33 | PIETER AERTSEN, Meat Still-Life, 1551. Oil on panel, $4'\frac{3}{8}'' \times 6' 5\frac{3}{4}''$. Uppsala University Art Collection, Uppsala.

At first glance this appears to be a genre painting, but in the background, Joseph leads a donkey carrying Mary and the Christ Child. Aertsen balanced images of gluttony with allusions to salvation.

a stuffed intestine, pig's feet, meat pies, a cow's head, a hog's head, and hanging entrails. Also visible are fish, pretzels, cheese, and butter. Like Massys, Aertsen embedded strategically placed religious images as reminders to the viewer. In the background of Meat Still-Life, Joseph leads a donkey carrying Mary and the Christ Child. The Holy Family stops to offer alms to a beggar and his son, while the people behind the Holy Family wend their way toward a church. Furthermore, the crossed fishes on the platter and the pretzels and wine in the rafters on the upper left all refer to "spiritual food" (pretzels often served as bread during Lent). Aertsen accentuated these allusions to salvation through Christ by contrasting them to their opposite—a life of gluttony, lust, and sloth. He represented this degeneracy with the oyster and mussel shells (believed by Netherlanders to possess aphrodisiacal properties) scattered on the ground on the painting's right side, along with the people seen eating and carousing nearby under the roof.

A Woman's Self-Portrait With the accumulation of wealth in the Netherlands, portraits increased in popularity. The self-portrait (Fig. 9-34) by CATERINA VAN HEMESSEN (1528–1587) is the first known northern European self-portrait by a woman. She had learned her craft from her father, Jan Sanders van Hemessen, a well-known painter. Here, the daughter confidently presented herself as an artist, momentarily interrupting her painting to look out at the viewer. She holds brushes, a palette, and a *maulstick* (a stick used to steady the hand while painting) in her left hand, and delicately applies pigment to the canvas with her right hand. Caterina ensured proper identification (and credit) through the inscription in the painting: "Caterina van Hemessen painted me / 1548 / her age 20."

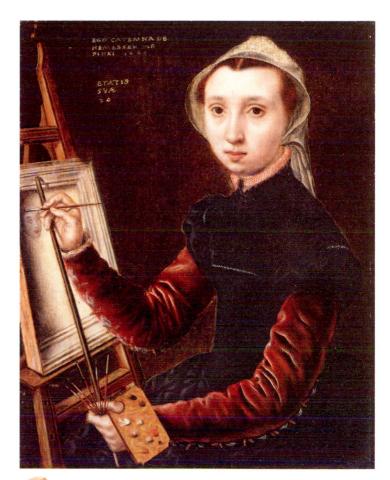

9-34 | CATERINA VAN HEMESSEN, Self-Portrait, 1548. Oil on panel, $1'\frac{3}{4}'' \times 9\frac{7}{8}''$. Kunstmuseum, Öffentliche Kunstsammlung Basel, Basel.

In this first known northern European self-portrait by a woman, van Hemessen represented herself as a confident artist momentarily interrupting her work to look out at the viewer.

PIETER BRUEGEL THE ELDER, Hunters in the Snow, 1565. Oil on panel, approx. 3' 10" × 5' 4". Kunsthistorisches Museum, Vienna.

In Hunters in the Snow, one of a series of six paintings illustrating seasonal changes in the year, Bruegel draws the viewer diagonally into its depth by his mastery of line, shape, and composition.

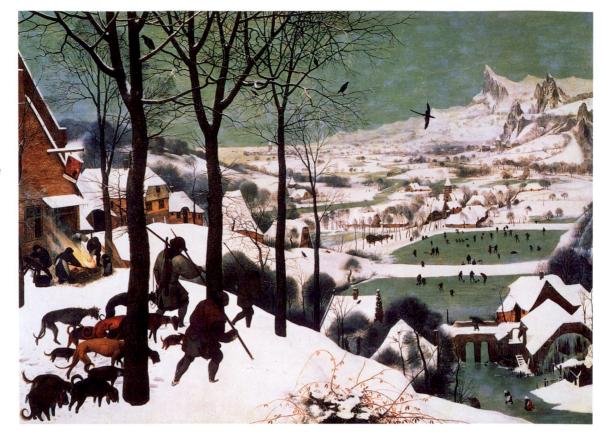

A Wintry Landscape Landscape painting also flourished in the 16th-century Netherlands. According to one scholar, the word landscape (Landschaft) first emerged in German literature as a characterization of an artistic genre when Dürer described the Netherlandish painter Joachim Patinir as a "good landscape painter." The landscapes of PIETER BRUEGEL THE ELDER (ca. 1528-1569) reveal Patinir's influence. But in Bruegel's paintings, no matter how huge a slice of the world he shows, human activities remain the dominant theme. Like many of his contemporaries, Bruegel traveled to Italy, where he seems to have spent almost two years, going as far south as Sicily. Unlike other artists, however, Bruegel chose not to incorporate classical elements into his paintings. The impact of his Italian experiences emerges in his work most frequently in the Italian or Alpine landscape features, which he recorded in numerous drawings during his journey.

Hunters in the Snow (FIG. 9-35) is one of a series of six paintings illustrating seasonal changes in the year. The series refers back to older Netherlandish traditions of depicting seasons and peasants in Books of Hours. Our example shows human figures and landscape locked in winter cold. (Bruegel's production of this painting in 1565 coincided with a particularly severe winter.) The weary hunters return with their hounds, women build fires, skaters skim the frozen pond, the town and its church huddle in their mantle of snow, and beyond this typically Netherlandic winter scene lies a bit of Alpine landscape. Aside from this trace of fantasy, however, the artist rendered the landscape in an optically accurate

manner. It develops smoothly from foreground to background and draws the viewer diagonally into its depths. Bruegel's consummate skill in using line and shape and his subtlety in tonal harmony make this one of the great landscape paintings in the history of European art.

SPAIN

Spain emerged as the dominant European power at the end of the 16th century. Under Charles V of Habsburg (r. 1516-1556) and his son, Philip II (r. 1556-1598), the Spanish Empire dominated a territory greater in extent than any ever known—a large part of Europe, the western Mediterranean, a strip of North Africa, and vast expanses in the New World. Spain acquired many of its New World colonies through aggressive overseas exploration. Among the most notable conquistadors sailing under the Spanish flag were Christopher Columbus (1451-1506), Vasco Nuñez de Balboa (ca. 1475-1517), Ferdinand Magellan (1480-1521), Hernán Cortés (1485-1547), and Francisco Pizarro (ca. 1470-1541). The Habsburg Empire, enriched by the New World plunder, supported the most powerful military force in Europe. Spain defended and then promoted the interests of the Catholic Church in its battle against the inroads of the Protestant Reformation. In fact, Philip II earned the title "Most Catholic King." Spain's crusading spirit, nourished by centuries of war with Islam, engaged body and soul in forming the most Catholic civilization of Europe and the Americas. In the 16th century, for good or

for ill, Spain left the mark of Spanish power, religion, language, and culture on two hemispheres (Chapter 18).

A Spanish Mannerist The most renowned painter in 16th-century Spain was not, however, a Spaniard. Doménikos Theotokópoulos (ca. 1547–1614), called EL GRECO (the Greek), was born on Crete but emigrated to Italy as a young man. In his youth, he absorbed the traditions of Late Byzantine frescoes and mosaics. While still young, El Greco went to Venice, where he was connected with Titian's workshop, although Tintoretto's painting seems to have made a stronger impression on him. A brief trip to Rome explains the influences of Roman and Florentine Mannerism on his work. By 1577, he had left for Spain to spend the rest of his life in Toledo.

El Greco's art is a strong personal blending of Late Byzantine and Italian Mannerist elements. The intense emotionalism of his paintings, which naturally appealed to the pious fervor of the Spanish; the dematerialization of form; and a great reliance on color bound him to 16th-century Venetian art and to Mannerism. His strong sense of movement and use of light, however, prefigured the Baroque style (see Chapter 10). El Greco's art was not strictly Spanish (although it appealed to certain sectors of that society), for it had no Spanish antecedents and little effect on later Spanish painters. Nevertheless, El Greco's hybrid style captured the fervor of Spanish Catholicism.

This fervor is vividly expressed in the artist's masterpiece, *The Burial of Count Orgaz* (Fig. 9-36), painted in 1586 for the Church of Santo Tomé in Toledo. El Greco based the artwork

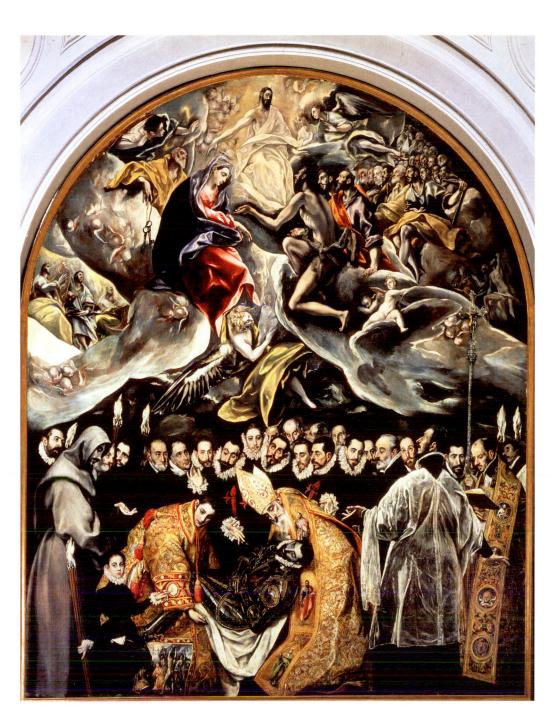

9-36 | EL GRECO, *The Burial of Count Orgaz*, Santo Tomé, Toledo, Spain, 1586. Oil on canvas, approx. 16' × 12'.

El Greco's art is a blend of Byzantine and Italian Mannerist elements. His intense emotional content captured the fervor of Spanish Catholicism, and his dramatic use of light foreshadowed the Baroque style.

on the legend that the count of Orgaz, who had died some three centuries before and who had been a great benefactor of Santo Tomé, was buried in the church by Saints Stephen and Augustine, who miraculously descended from heaven to lower the count's body into its sepulcher.

In the painting, the brilliant Heaven that opens above irradiates the earthly scene. El Greco carefully distinguished the terrestrial and celestial spheres. He represented the terrestrial with a firm realism, whereas he depicted the celestial, in his quite personal manner, with elongated undulating figures, fluttering draperies, and a visionary swirling cloud. Below, the two saints lovingly lower the count's armor-clad body, the armor and heavy draperies painted with all the rich sensuousness of the Venetian school. A solemn chorus of black-clad Spanish personages fills the background. In the carefully individualized features of these figures, El Greco demonstrated that he was also a great portraitist. These men call to mind both the conquistadors, who earlier in the century ventured to the New World, and the Spanish naval officers who, two years after the completion of this painting, led the Great Armada against both Protestant England and the Netherlands.

The upward glances of some figures below and the flight of an angel above link the painting's lower and upper spheres. The action of the angel, who carries the count's soul in his arms as Saint John and the Virgin intercede for it before the throne of Christ, reinforces this connection. El Greco's deliberate change in style to distinguish between the two levels of reality gives the viewer an opportunity to see the artist's early and late manners in the same work, one below the other. His relatively sumptuous and realistic presentation of the earthly sphere is still strongly rooted in Venetian art, but the abstractions and distortions El Greco used to show the immaterial nature of the heavenly realm characterized his later style. His elongated figures existing in undefined spaces, bathed in a cool light of uncertain origin, explain El Greco's usual classification

as a Mannerist, but it is difficult to apply that label to him without reservations. Although El Greco used Mannerist formal devices, his primary concerns were emotion and expressing his religious fervor or arousing that of the viewer. The forcefulness of his paintings is the result of his unique, highly developed expressive style.

CONCLUSION

The 16th century in Italy is often referred to as the High Renaissance because artists developed further many of the ideas that occupied earlier painters, sculptors, and architects. Interest in classical cultures, which was cultivated by the humanists of earlier centuries, became a mainstay of High Renaissance art. Religious art seemed to have a particular urgency. In the interest of promoting Counter-Reformation ideals, the Catholic Church emphasized the didactic value of art in reestablishing the prominence of the Church. The 16th century also saw the development of Mannerism, which contrasted with the rationality pervading much of High Renaissance art and architecture and paved the way for the complexity of the Baroque in 17th-century Italy.

In northern Europe and Spain, the 16th century was a time of upheaval, both religious and political. The Reformation and the creation of Protestantism brought about far-reaching change. Protestants promoted a spiritual model that differed from Catholicism in its emphasis on absolute faith and reliance on the Bible. These beliefs led to less ostentatious forms of art. In particular, Protestants discouraged the production of the expansive decoration programs regularly found in Catholic churches. The 16th century in the north was also characterized by extensive military hostilities. Yet despite the conflicts in Europe, extensive dialogue transpired among artists of various countries, and artistic influence and ideas traveled in many directions. In such a climate, the arts flourished.

1500

- Pope Julius II (della Rovere), r. 1503-1513
 - I John Calvin, 1509-1564
 - Pope Leo X (Medici), r. 1513-1521
 - Francis I of France, r. 1515-1547
 - Martin Luther, Ninety-Five Theses, 1517
 - I Charles V, Holy Roman Emperor, r. 1519-1556
 - | Habsburg-Valois Wars, 1521-1544
 - Pope Clement VII (Medici), r. 1523-1534

Bramante, Tempietto, San Pietro in Montorio, Rome, 1502

1525

- Spread of Calvinist Protestantism in France and Switzerland, 1530s
- I Henry VIII initiates Reformation in England, 1534
- Pope Paul III (Farnese), r. 1534-1549
 - I Council of Trent, 1545-1563

2 Hans Holbein the Younger, The French Ambassadors, 1533

1550

- I Giorgio Vasari, Lives of the Most Eminent Painters, Sculptors, and Architects, 1550
- I Spread of Calvinism in Scotland and the Netherlands, 1550s
- Philip II of Spain, r. 1556-1598
- I Great Iconoclasm in the Netherlands, 1566
- I Florence becomes Grand-Duchy of Tuscany, 1569

3 Pieter Bruegel the Elder, Hunters in the Snow, 1565

1575

- Andrea Palladio, The Four Books of Architecture, 1570
- I Formation of the Unions of Arras and Utrecht, 1579
- I Philip II sends the Great Armada against Holland and England, 1588

4 Giovanni da Bologna, Abduction of the Sabine Women, 1583

4

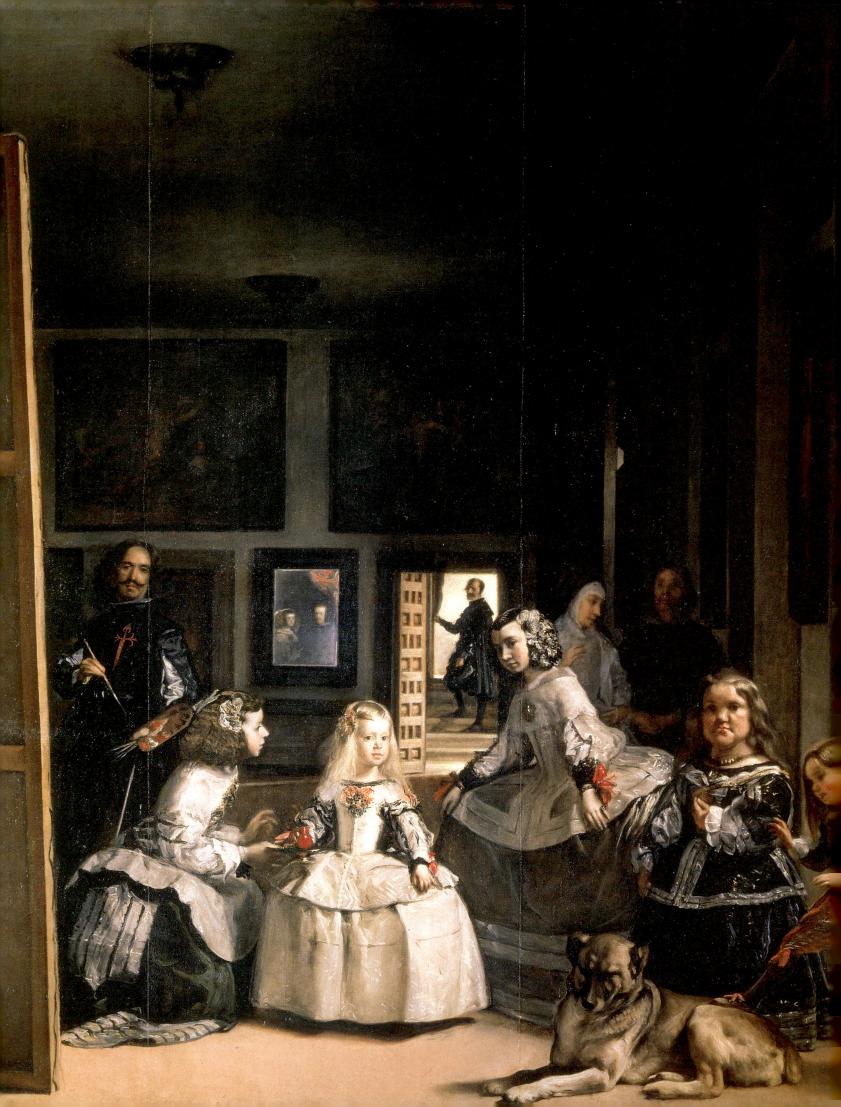

BAROQUE EUROPE

European art of the 17th and early 18th centuries is often described as "Baroque," a convenient blanket term. However, this term is problematic because the period encompasses a broad range of developments, both historical and artistic, across a wide geographic area. Although its origin is unclear, the term may have come from the Portuguese barroco, meaning an irregularly shaped pearl. Use of the term baroque emerged in the late 18th and early 19th centuries, when critics disparaged the art of that era, in large part because of perceived deficiencies in comparison to the art of the period preceding it, especially Italian Renaissance art. Over time, this negative connotation faded, and the term is now most often used as a general period designation. Some scholars employ "Baroque" to describe a particular style that emerged during the 17th century a style of complexity and drama that is usually associated with Italian art of this period. The dynamism and extravagance of this Baroque style contrast with the rational order of classicism. But not all artists adopted this style, and no commonalities can be ascribed to all of the art and cultures of the Baroque period. Therefore, we have limited use of the term in this book. Whenever "Baroque" is used, we have described characteristics that anchor the term in a particular culture—for example, Italian Baroque as compared to Dutch Baroque.

European Geopolitics During the 17th and early 18th centuries, numerous geopolitical shifts occurred in Europe (MAP 10-1, page 530) as the fortunes of the individual countries waxed and waned. Political and religious friction was prominent and resulted in widespread unrest and warfare. Indeed, one historian has claimed that between 1562 and 1721, all of Europe was at peace only four years. The major conflict of this period was the Thirty Years' War (1618–1648), which involved Spain, France, Sweden, Denmark, the Netherlands, Germany, Austria, Poland, the Ottoman Empire, and the Holy Roman Empire. Although the outbreak of this war was largely rooted in the conflict between militant Catholics and militant Protestants, the driving force quickly shifted to secular, dynastic, and nationalistic concerns. Among the major political entities vying for expanded power and authority in Europe were the Bourbon dynasty of France and the Habsburg dynasties of Spain and the Holy Roman Empire. The war, which concluded with the Treaty of Westphalia in 1648, was largely responsible for the political restructuring of Europe. As a result, the United Provinces of the Netherlands (the Dutch Republic), Sweden, and France expanded their authority. The relative power of Spain and Denmark diminished.

DIEGO VELÁZQUEZ, Las Meninas (The Maids of Honor), 1656. Oil on canvas, approx. $10'\ 5'' \times 9'$. Museo del Prado, Madrid.

The building of nation-states was emphatically under way. In addition to reconfiguring territorial boundaries, the Treaty of Westphalia in essence granted freedom of religious choice throughout Europe. This treaty thus marked the abandonment of the idea of a united Christian Europe, which was replaced by the practical realities of secular political systems.

Worldwide Mercantilism By the 17th century, European societies began to coordinate their long-distance trade more systematically. The allure of expanding markets, rising profits, and access to a wider range of goods all contributed to the relentless economic competition among countries. Much of the foundation for worldwide mercantilism—extensive geographic exploration, improved maps, and advances in shipbuilding—was laid in the previous century. In fact, by the end of the 16th century, all the major trade routes had been established.

In the 17th century, however, changes in financial systems, lifestyles, and trading patterns, along with growing colonialism, fueled the creation of a worldwide marketplace. The Dutch founded the Bank of Amsterdam in 1609, which eventually became the center of European transfer banking. By establishing a system in which merchant firms held money on account, the bank relieved traders of having to transport precious metals as payment. Trading practices became more complex. Unlike simple reciprocal trading, triangular trade (trade among three parties) allowed for a larger pool of desirable goods. Exposure to a wider array of goods affected European diets and lifestyles. Coffee (from island colonies) and tea (from China) became popular beverages during the early 17th century. Equally explosive was the growth of sugar use. Sugar, tobacco, and rice were slave crops, and the slave trade expanded to accommodate the demand for these goods.

The resulting worldwide mercantile system permanently changed the face of Europe. The prosperity such trading generated affected social and political relationships, necessitating new rules of etiquette and careful diplomacy. With increased disposable income, more of the newly wealthy spent money on art, expanding the number of possible sources of patronage.

ITALY

Although the Catholic Church launched the Counter-Reformation—its challenge to the Protestant Reformation—during the 16th century (see Chapter 9), the considerable appeal of Protestantism continued to preoccupy the popes throughout the succeeding century. The Treaty of Westphalia had formally recognized the principle of religious freedom, serving to validate Protestantism (predominantly in the German states). With the Church continuing to serve as a major artistic patron, as in earlier centuries, much of Italian Baroque art was aimed at propagandistically restoring Catholicism's predominance and centrality. Whereas Italian Renaissance artists often had reveled in the precise, orderly rationality of classical models, Italian Baroque artists embraced a more dynamic and complex aesthetic. During the 17th century, dramatic theatricality, grandiose scale, and

elaborate ornateness, all used to spectacular effect, characterized Italian Baroque art and architecture. Papal Rome's importance as the cradle of Italian Baroque art production further suggests the role art played in supporting the aims of the Church. The Council of Trent, one of the Counter-Reformation initiatives, firmly resisted Protestant objection to using images in religious worship (see "The Role of Religious Art in Counter-Reformation Italy," Chapter 9, page 251), insisting on their necessity for teaching the laity. Therefore, Italian Baroque art commissioned by the Church was not merely decorative but didactic as well.

Pope Sixtus V (r. 1585–1590) contributed significantly to reestablishing the preeminence of the Catholic Church. He augmented the papal treasury and intended to construct a new and more magnificent Rome. Several strong and ambitious popes — Paul V, Urban VIII, Innocent X, and Alexander VII—succeeded Sixtus V and were largely responsible for building the modern city of Rome, which bears the marks of their patronage everywhere. Italian 17th-century art and architecture embodied the renewed energy of the Catholic Counter-Reformation and communicated it to the populace.

Restoring Saint Peter's Grandeur In 1606, Pope Paul V (r. 1605-1621) commissioned CARLO MADERNO (1556-1629) to complete Saint Peter's in Rome. As the symbolic seat of the papacy, Saint Peter's radiated enormous symbolic presence. In light of lingering Counter-Reformation concerns, the desire of Baroque popes to conclude the extended rebuilding project and reestablish the force embodied in the mammoth structure is understandable. The preexisting core of an incomplete building restricted Maderno, so he did not have the luxury of formulating a totally new concept for Saint Peter's. But Maderno's new facade (Fig. 10-1) does embody the design principles of early Italian Baroque architecture. Vigorously projecting columns and pilasters mount dramatically toward the emphatically stressed pediment-capped central section. Strong shadows cast by the columns heighten the sculptural effect. Mitigating circumstances must be taken into consideration when assessing this design, however. Maderno's design for the facade was never fully executed. The two outside bell-tower bays were not part of his original plan. Hence, had the facade been constructed according to the architect's initial design, it would have exhibited greater verticality and visual coherence.

Maderno's plan for Saint Peter's also departed from the central plans designed for it during the Renaissance by Bramante and, later, by Michelangelo (Fig. 9-13). The clergy rejected a central plan for Saint Peter's because of its association with pagan buildings, such as the Pantheon (Fig. 3-35). Paul V had Maderno add three nave bays to the earlier nucleus. This longitudinal plan reinforced the symbolic distinction between clergy and laity and provided a space for the processions of ever-growing assemblies. Lengthening the nave, unfortunately, pushed the dome farther back from the facade, and the effect Michelangelo had planned—a structure pulled together and dominated by its dome (Fig. 9-14)—is not readily visible.

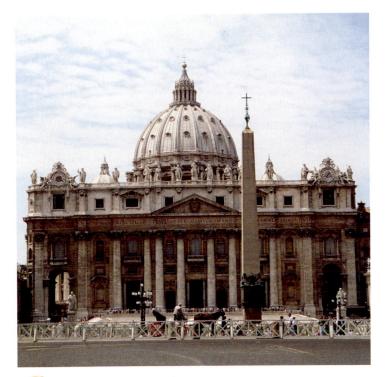

10-1 | CARLO MADERNO, facade of Saint Peter's, Vatican City, Rome, Italy, 1606–1612.

Maderno's facade embodies the design principles of early Baroque architecture. Vigorously projecting columns mount dramatically toward the emphatically stressed pediment-capped central section.

When viewed at close range, the dome hardly emerges above the facade's soaring frontal plane. Seen from farther back (Fig. 10-1), it appears to have no drum. Visitors must move back quite a distance from the front to see the dome and drum together and to experience the effect Michelangelo intended.

Welcoming the Pious The design of Saint Peter's finally was completed (except for details) by GIANLORENZO BERNINI (1598-1680). Bernini was an architect, painter, and sculptor—one of the most important and imaginative artists of the Italian Baroque era and its most characteristic and sustaining spirit. Bernini's largest and most impressive single project was the design for a monumental piazza (plaza) in front of Saint Peter's (Fig. 10-2). Bernini had to adjust his design to some preexisting structures on the site—an ancient obelisk the Romans brought from Egypt (which Pope Sixtus V had his architect, Domenico Fontana, relocate to the piazza in 1585 as part of the pope's vision of Christian triumph in Rome) and a fountain Maderno designed. He used these features to define the long axis of a vast oval embraced by colonnades joined to the Saint Peter's facade by two diverging wings. Four rows of huge Tuscan columns make up the two colonnades, which terminate in severely classical temple fronts. The dramatic gesture of embrace the colonnades make as worshipers enter the piazza symbolizes the welcome the Roman Catholic Church gave its members during the Counter-Reformation. Bernini himself referred to his design of the colonnade as appearing

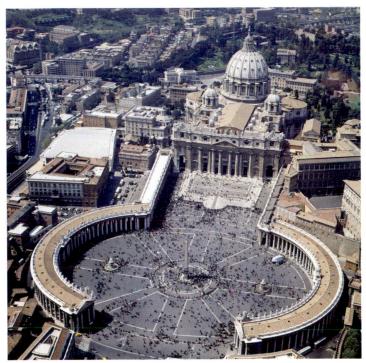

10-2 | Aerial view of Saint Peter's, Vatican City, Rome, Italy, 1506–1666.

The dramatic gesture of embrace the colonnades make as worshipers enter the piazza symbolizes the welcome the Roman Catholic Church gave its members during the Counter-Reformation.

like the welcoming arms of the church. Beyond their symbolic resonance, the colonnades served the functional purpose of providing pilgrims with easy access to the piazza.

The wings that connect the Saint Peter's facade with the oval piazza flank a trapezoidal space. Seen from the piazza, the diverging wings counteract the natural perspective and tend to bring the facade closer to the viewer. Emphasizing the facade's height in this manner, Bernini subtly and effectively compensated for its extensive width. Thus, a Baroque transformation expanded the compact central designs of Bramante and Michelangelo into a dynamic complex of axially ordered elements that reach out and enclose spaces of vast dimension. By its sheer scale and theatricality, the complete Saint Peter's fulfilled the desire of the Counter-Reformation Church to present an awe-inspiring and authoritative vision of itself.

A Soaring Bronze Canopy Long before the planning of the piazza, Bernini had been at work decorating the interior of Saint Peter's. His first commission, completed between 1624 and 1633, called for the design and erection of the gigantic bronze *baldacchino* (Fig. 10-3) under the great dome. The canopy-like structure (*baldacco* is Italian for "silk from Baghdad," such as for a cloth canopy) stands almost 100 feet high (the height of an average eight-story building). Given the enormous scale of the baldacchino, a considerable amount of bronze was required, which Pope Urban VIII (r. 1623–1644) acquired by dismantling the portico of the Pantheon. The

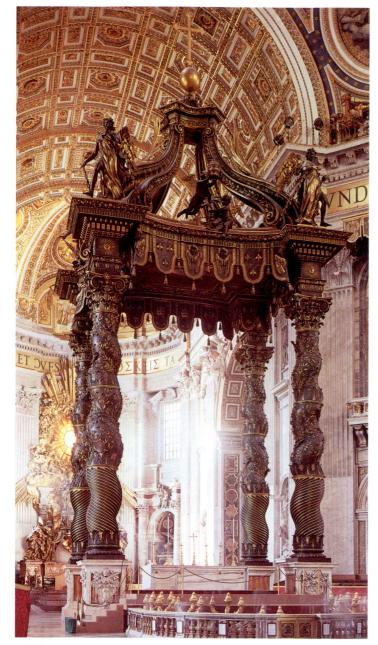

10-3 | GIANLORENZO BERNINI, baldacchino, Saint Peter's, Vatican City, Rome, Italy, 1624–1633. Gilded bronze, approx. 100' high.

Bernini's baldacchino serves both functional and symbolic purposes. It marks the tomb of Saint Peter and the high altar of the church, and it visually bridges human scale to the lofty vaults and dome above.

baldacchino (Fig. 10-3) serves both functional and symbolic purposes. It marks the tomb of Saint Peter and the high altar, and it visually bridges human scale to the lofty vaults and dome above. Further, for those entering the nave of the huge church, it provides a dramatic, compelling presence at the crossing. Its columns also create a visual frame for the elaborate sculpture representing the throne of Saint Peter (the Cathedra Petri) at the far end of Saint Peter's.

On a symbolic level, the structure's decorative elements speak to the power of the Catholic Church and of Pope Urban

VIII. Partially fluted and wreathed with vines, the baldacchino's four spiral columns recall those of the ancient baldacchino over the same spot in Old Saint Peter's (Fig. 4-3). thereby invoking the past to reinforce the primacy of the Roman Catholic Church. At the top of the columns, four colossal angels stand guard at the upper corners of the canopy. Forming the canopy's apex are four serpentine brackets that elevate the orb and the cross. Since the time of the emperor Constantine, builder of the original Saint Peter's basilica, the orb and the cross had served as symbols of the Church's triumph. The baldacchino also features numerous bees, symbols of the Barberini family. As the official patron of the work, Urban VIII (Maffeo Barberini) undoubtedly desired appropriate recognition. The structure effectively gives visual form to the triumph of Christianity and the papal claim to doctrinal supremacy.

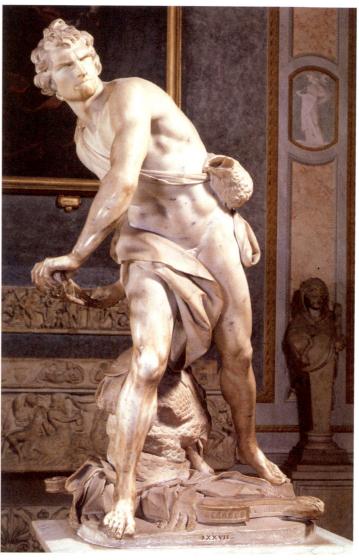

10-4 | GIANLORENZO BERNINI, *David*, 1623. Marble, approx. 5' 7" high. Galleria Borghese, Rome.

Bernini's sculptures are expansive and theatrical, and the element of time plays an important role in them. His emotion-packed *David* seems to be moving through both time and space.

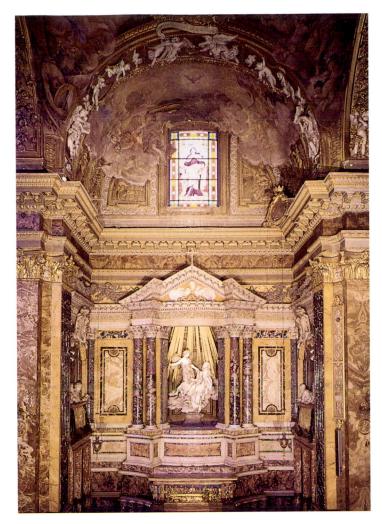

10-5 | GIANLORENZO BERNINI, interior of the Cornaro Chapel, Santa Maria della Vittoria, Rome, Italy, 1645–1652.

In the Cornaro Chapel, Bernini drew on his knowledge of the theater, utilizing the full capabilities of architecture, sculpture, and painting to charge the church's sacred space with palpable tension.

Bernini and Baroque Sculpture Although Bernini was a great and influential architect, his fame rests primarily on his sculpture, which, like his architecture, energetically expresses the Italian Baroque spirit. Bernini's sculpture is expansive and theatrical, and the element of time usually plays an important role in it. His David (Fig. 10-4), commissioned by Cardinal Scipione Borghese, aims at catching the figure's split-second action and differs markedly from the more restful figures of David portrayed by Donatello (Fig. 8-23) and Michelangelo (Fig. 9-7). Bernini's David, his muscular legs widely and firmly planted, is beginning the violent, pivoting motion that will launch the stone from his sling. Unlike Myron, the fifth-century BCE Greek sculptor whose Diskobolos (Fig. 2-30) is frozen in inaction, Bernini selected the most dramatic of an implied sequence of poses, so observers have to think simultaneously of the continuum and of this tiny fraction of it. The suggested continuum imparts a dynamic quality to the statue that conveys a bursting forth of energy. Bernini's statue seems to be moving through time and through space. This is not the kind of sculpture that can be

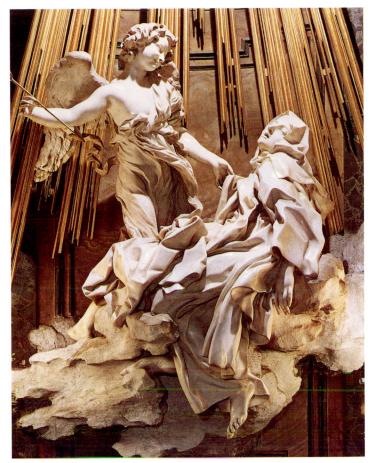

10-6 | GIANLORENZO BERNINI, Ecstasy of Saint Teresa, Cornaro Chapel, Santa Maria della Vittoria, Rome, Italy, 1645–1652. Marble, height of group 11' 6".

The passionate drama of Bernini's depiction of Saint Teresa correlated with the ideas of Ignatius Loyola, who argued that the re-creation of spiritual experience would do much to increase devotion and piety.

inscribed in a cylinder or confined in a niche. Its indicated action demands space around it. Nor is it self-sufficient in the Renaissance sense, as its pose and attitude direct the viewer's attention beyond it to its surroundings (in this case, toward an unseen Goliath). Bernini's sculpted figure moves out into and partakes of the physical space that surrounds it. The expression of intense concentration on David's face is a far cry from the placid visages of previous Davids and augments this sculpture's dramatic impact.

An Ecstatic and Radiant Vision Another Bernini sculpture that displays the expansive quality of Italian Baroque art and its refusal to limit itself to firmly defined spatial settings is *Ecstasy of Saint Teresa* in the Cornaro Chapel (Fig. 10-5) of the Roman Church of Santa Maria della Vittoria. For this chapel, Bernini utilized the full capabilities of architecture, sculpture, and painting to charge the entire area with palpable tension. He accomplished this by drawing on the considerable knowledge of the theater he derived from writing plays and producing stage designs. The marble sculpture (Fig. 10-6) that serves as the focus of this chapel depicts Saint Teresa,

who was a nun of the Carmelite order and one of the great mystical saints of the Spanish Counter-Reformation. Her conversion occurred after the death of her father, when she fell into a series of trances, saw visions, and heard voices. Feeling a persistent pain, she attributed it to the fire-tipped arrow of divine love that an angel had thrust repeatedly into her heart. In her writings, Saint Teresa described this experience as making her swoon in delightful anguish. The whole chapel became a theater for the production of this mystical drama. The niche in which it takes place appears as a shallow proscenium (the part of the stage in front of the curtain) crowned with a characteristically broken Baroque pediment and ornamented with polychrome marble. On either side of the chapel, sculpted relief portraits of Cardinal Federico Cornaro and his relatives behind draped praying desks attest to the piety of the patrons attending this heavenly drama. Bernini depicted the saint in ecstasy, unmistakably a mingling of spiritual and physical passion, swooning back on a cloud, while the smiling angel aims his arrow. The entire sculptural group is made of white marble, and Bernini's supreme technical virtuosity is evident in the visual differentiation in texture among the clouds, rough monk's cloth, gauzy material, smooth flesh, and feathery wings. Light from a hidden window of yellow glass pours down on bronze rays that suggest the radiance of Heaven, whose painted representation covers the vault. (Hidden lights have been installed near the top of the rays to ensure visitors to the chapel a consistent viewing experience.)

The passionate drama of Bernini's sculpture correlated with the ideas disseminated earlier by Ignatius Loyola, who founded the Jesuit order in 1534 and was canonized as Saint Ignatius in 1622. In his book *Spiritual Exercises*, Ignatius argued that the re-creation of spiritual experiences for worshipers would do much to increase devotion and piety. Thus, theatricality and sensory impact were useful vehicles for achieving Counter-Reformation goals. Bernini was a devout Catholic, which undoubtedly contributed to his understanding of those goals. His inventiveness, technical skill, sensitivity to his patrons' needs, and energy account for his position as the quintessential Italian Baroque artist.

A Church Facade in Motion? Francesco Borromini (1599–1667) took Italian Baroque architecture to even greater dramatic heights. A new dynamism appeared in the little Church of San Carlo alle Quattro Fontane (Saint Charles of the Four Fountains; Fig. 10-7), where Borromini went well beyond any of his predecessors or contemporaries in emphasizing a building's sculptural qualities. Maderno incorporated sculptural elements in his design for the facade of Saint Peter's (Fig. 10-1), but Borromini set his whole facade in undulating motion, forward and back, making a counterpoint of concave and convex elements on two levels (for example, the sway of the cornices). He emphasized the three-dimensional effect with deeply recessed niches. This facade is not the traditional flat frontispiece that defines a building's outer limits. It is a pulsating, engaging component inserted between interior and

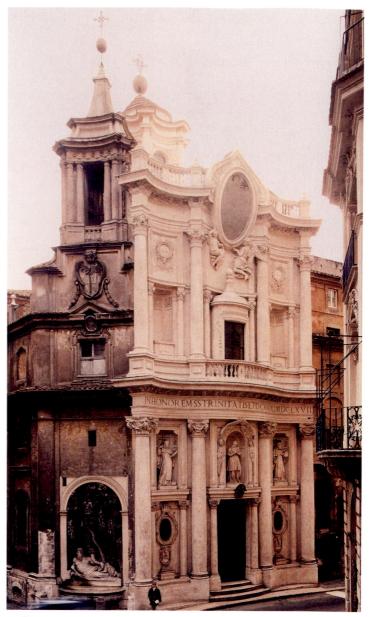

10-7 | FRANCESCO BORROMINI, facade of San Carlo alle Quattro Fontane, Rome, Italy, 1665–1676.

Borromini rejected the traditional notion of a facade as a flat frontispiece. He set San Carlo's facade in undulating motion, making a counterpoint of concave and convex elements.

exterior space, designed not to separate but to provide a fluid transition between the two. This functional interrelation of the building and its environment is underlined by the curious fact that it has not one but two facades. The second, a narrow bay crowned with its own small tower, turns away from the main facade and, following the curve of the street, faces an intersection. (The upper facade was completed seven years after Borromini's death, and historians cannot be sure to what degree the present design reflects his original intention.)

In plan (Fig. 10-8) San Carlo looks like a hybrid of a Greek cross and an oval, with a long axis between entrance and apse. The side walls move in an undulating flow that reverses

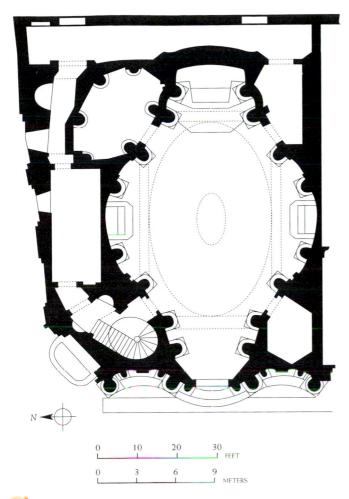

10-8 | FRANCESCO BORROMINI, plan of San Carlo alle Quattro Fontane, Rome, Italy, 1638–1641.

The plan of San Carlo is a hybrid of a Greek cross and an oval. The side walls pulsate in a way that reverses the facade's movement. The molded, dramatically lit space appears to flow from entrance to altar.

the facade's motion. Vigorously projecting columns define the space into which they protrude just as much as they accent the walls attached to them. This molded interior space is capped by a deeply coffered oval dome that seems to float on the light entering through windows hidden in its base. Rich variations on the basic theme of the oval, dynamic relative to the static circle, create an interior that appears to flow from entrance to altar, unimpeded by the segmentation so characteristic of Renaissance buildings.

Caravaggio Although sculpture and architecture provided the most obvious vehicles for manipulating space and creating theatrical effects, painting continued to be an important art form, as it was in previous centuries. Michelangelo Merisi, known as CARAVAGGIO (1573–1610) after the northern Italian town from which he came, developed a unique Baroque painting style that had tremendous influence throughout Europe. His outspoken disdain for the classical masters (probably more vocal than real) drew bitter criticism from many painters, one of whom denounced him as the "anti-Christ of

painting." Giovanni Pietro Bellori, the most influential critic of the age, felt that Caravaggio's refusal to emulate the models of his distinguished predecessors threatened the whole classical tradition of Italian painting that had reached its zenith in Raphael's work. Yet despite this criticism and the problems in Caravaggio's troubled life (reconstructed from documents such as police records), Caravaggio received many commissions, both public and private. Numerous artists paid him the supreme compliment of borrowing from his innovations. His impact on later artists, as much outside Italy as within, was immense. In his art, Caravaggio injected a naturalism into both religion and the classics, reducing them to human dramas played out in the harsh and dingy settings of his time and place by unidealized figures selected from the fields and the streets.

The Light of Divine Revelation Caravaggio painted *Conversion of Saint Paul* (Fig. 10-9) for the Cerasi Chapel in the Roman Church of Santa Maria del Popolo. It illustrates the conversion of the Pharisee Saul to Christianity, when he

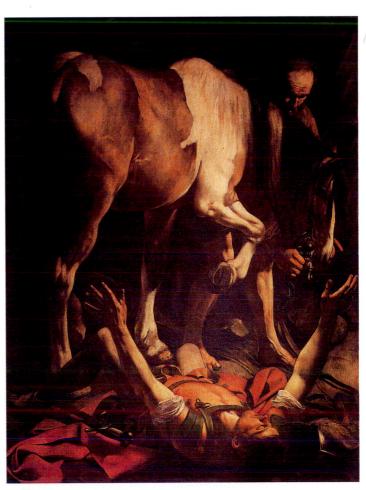

10-9 | CARAVAGGIO, Conversion of Saint Paul, Cerasi Chapel, Santa Maria del Popolo, Rome, Italy, ca. 1601. Oil on canvas, approx. 7' 6" × 5' 9".

Caravaggio used perspective, chiaroscuro, and dramatic lighting to bring viewers into the painting's space and action, almost as if they were participants in Saint Paul's conversion to Christianity.

became the disciple Paul. The saint-to-be appears amid his conversion, flat on his back with his arms thrown up. In the background, an old hostler seems preoccupied with caring for the horse. At first inspection, little here suggests the momentous significance of the spiritual event taking place. The subject seems to be a mere stable accident, not a man overcome by a great miracle. Caravaggio departed from the traditional representations of such religious scenes, but imbued the painting with eloquence and humanity.

Caravaggio also employed formal devices to compel interest and involvement in the event. In *Conversion of Saint Paul*, he used a perspective and a chiaroscuro intended to bring the viewer as close as possible to the scene's space and action, becoming almost a participant in the event. The sense of inclusion is augmented by the low horizon line. Caravaggio positioned *Conversion of Saint Paul* on the chapel wall at the line of sight of a person standing at the chapel entrance. In addition, the sharply lit figures are meant to be seen as emerging

from the dark of the background. The actual light from the chapel's windows functions as a kind of stage lighting for the production of a vision, analogous to the rays in Bernini's *Ecstasy of Saint Teresa* (FIG. 10-6).

The stark contrast of light and dark was a feature of Caravaggio's style that first shocked and then fascinated his contemporaries. His use of dark settings enveloping their occupants has been called *tenebrism*, from the Italian word *tenebroso*, or "shadowy" manner. In Caravaggio's work, tenebrism contributed mightily to the essential meaning of his pictures. In *Conversion of Saint Paul*, the dramatic spotlight shining down on the fallen Pharisee is the light of divine revelation converting Saul to Christianity.

From Tax Collector to Disciple A piercing ray of light illuminating a world of darkness and bearing a spiritual message is also a central feature of one of Caravaggio's early masterpieces, *Calling of Saint Matthew* (Fig. 10-10). It is one

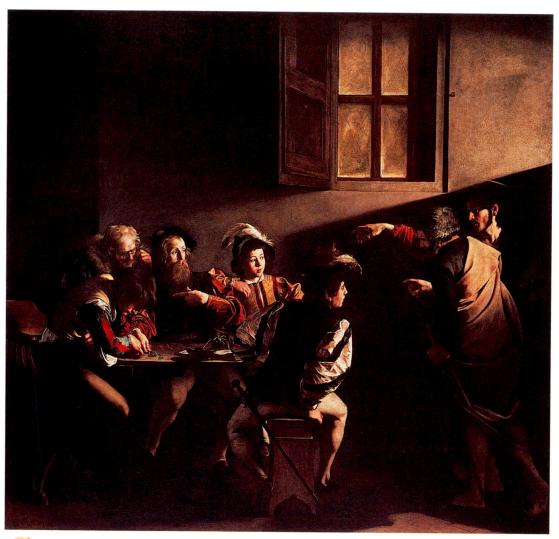

10-10 | CARAVAGGIO, Calling of Saint Matthew, Contarelli Chapel, San Luigi dei Francesi, Rome, Italy, ca. 1597–1601. Oil on canvas, 11' 1" × 11' 5".

The stark contrast of light and dark was a key feature of Caravaggio's style. Here, Christ, cloaked in mysterious shadow and almost unseen, summons Levi the tax collector (Saint Matthew) to a higher calling.

of two large canvases honoring Saint Matthew that the artist painted for the side walls of the Contarelli Chapel in San Luigi dei Francesi in Rome. The commonplace setting is typical of Caravaggio—a bland street scene with a plain building wall serving as a backdrop. Into this mundane environment, cloaked in mysterious shadow and almost unseen, Christ, identifiable initially only by his indistinct halo, enters from the right. With a commanding gesture that recalls that of the Lord in Michelangelo's Creation of Adam (Fig. 9-10), he summons Levi, the Roman tax collector, to a higher calling. The astonished tax collector, whose face is highlighted for the viewer by the beam of light emanating from an unspecified source above Christ's head and outside the picture, points to himself in disbelief. Although Christ's extended arm is reminiscent of the Lord in Creation of Adam, the position of Christ's hand and wrist is similar to that of Michelangelo's Adam. This reference is highly appropriate—theologically, Christ is the second Adam. Whereas Adam was responsible for the Fall of Man, Christ is responsible for human redemption. The conversion of Levi (who became Matthew) brought his salvation.

In Caravaggio's Footsteps Caravaggio's style became increasingly popular, and his combination of naturalism and drama appealed both to patrons and artists. A significant artist often discussed as a "Caravaggista" (a close follower of Caravaggio) is ARTEMISIA GENTILESCHI (ca. 1593–1653). Gentileschi was instructed by her artist father Orazio, who was himself strongly influenced by Caravaggio. Her successful career, pursued in Florence, Venice, Naples, and Rome, helped to disseminate Caravaggio's manner throughout Italy.

In Judith Slaving Holofernes (Fig. 10-11), Gentileschi used the tenebrism and what might be called the "dark" subject matter Caravaggio favored. Significantly, Gentileschi chose a narrative involving a heroic woman, a favorite theme of hers. The story, from the biblical Book of Judith, relates the delivery of Israel from its enemy, Holofernes. Having succumbed to Judith's charms, the Assyrian general Holofernes invited her to his tent for the night. When he fell asleep, Judith cut off his head. In this version of the scene (Gentileschi produced more than one image of Judith), Judith and her maidservant are beheading Holofernes. The drama of the event cannot be evaded-blood spurts everywhere, and the strength necessary to complete the task is evident as the two women struggle with the sword. The tension and strain are palpable. The controlled highlights on the action in the foreground recall Caravaggio's work and heighten the drama here as well.

The Bolognese Academy In contrast to Caravaggio, Annibale Carracci (1560–1609) not only studied but also emulated the Renaissance masters carefully. Carracci received much of his training at an academy of art in his native Bologna. Founded cooperatively by his family members, among them his cousin Ludovico Carracci (1555–1619) and brother Agostino Carracci (1557–1602), the Bolognese

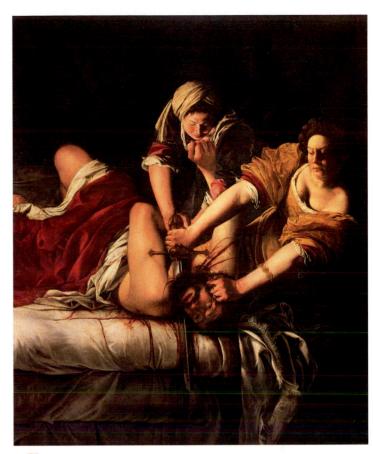

10-11 | ARTEMISIA GENTILESCHI, *Judith Slaying Holofernes*, ca. 1614–1620. Oil on canvas, 6' $6\frac{1}{3}$ " × 5' 4". Galleria degli Uffizi, Florence.

Narratives involving heroic women were a favorite theme of Gentileschi. In *Judith Slaying Holofernes*, the controlled highlights on the action in the foreground recall Caravaggio's paintings and heighten the drama.

academy was the first significant institution of its kind in the history of Western art. It was founded on the premises that art can be taught—the basis of any academic philosophy of art—and that its instruction must include the classical and Renaissance traditions in addition to the study of anatomy and life drawing. Thus, whereas Caravaggio championed a more naturalistic style, Carracci embraced a more classically ordered style.

A Ceiling Fit for the Gods Among Annibale Carracci's most notable works is his decoration of the Palazzo Farnese gallery (Fig. 10-12) in Rome. Cardinal Odoardo Farnese, a wealthy descendant of Pope Paul III, commissioned this ceiling fresco to celebrate the wedding of the cardinal's brother. Appropriately, its iconographic program is titled *Loves of the Gods*—interpretations of the varieties of earthly and divine love in classical mythology.

Carracci arranged the scenes in a format resembling framed easel paintings on a wall, but here he painted them on the surfaces of a shallow curved vault. The Sistine Chapel ceiling (Fig. 9-9), of course, comes to mind, although it is not an exact

10-12 | ANNIBALE CARRACCI, *Loves of the Gods*, ceiling frescoes in the gallery, Palazzo Farnese, Rome, Italy, 1597–1601.

On the shallow curved vault of this gallery in the Palazzo Farnese, Carracci arranged the mythological scenes in a format resembling easel paintings on a wall. This kind of design is called *quadro riportato*.

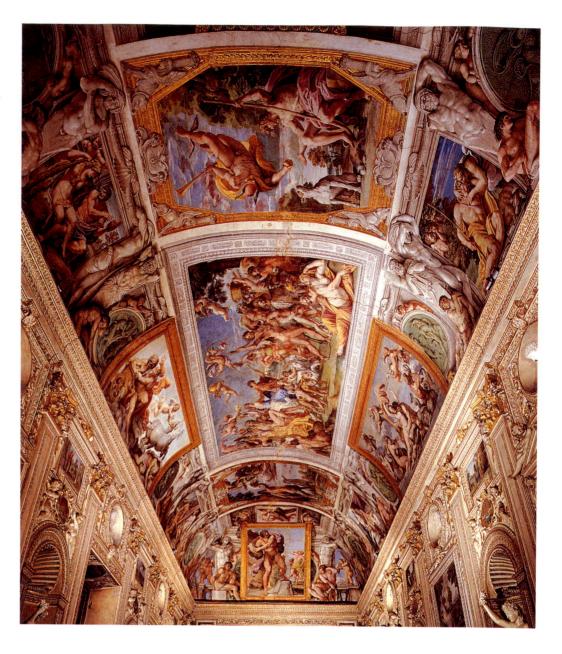

source. This type of simulation of easel painting for ceiling design is called quadro riportato (transferred framed painting). Carracci's great influence made it fashionable for more than a century. The framed pictures are flanked by polychrome seated nude youths, who turn their heads to gaze at the scenes around them, and by standing Atlas figures painted to resemble marble statues. Carracci derived these motifs from Michelangelo's Sistine Chapel ceiling. Notably, the chiaroscuro is not the same for both the pictures and the figures surrounding them. The painter modeled the figures inside each quadro in an even light. The outside figures seem to be lit from beneath, as if they were actual three-dimensional beings or statues illuminated by torches in the gallery below. This interest in illusion, already manifest in the Renaissance, continued in the grand ceiling compositions of the 17th century. In the crown of the vault, a long panel, Triumph of Bacchus, is a quite ingenious mixture of Raphael and Titian. It reflects Carracci's adroitness in adjusting their authoritative styles to make something of his own.

Honoring Saint Ignatius Another master of ceiling decoration was Fra Andrea Pozzo (1642-1709), a lay brother of the Jesuit order and a master of perspective, on which he wrote an influential treatise. Pozzo designed and executed the vast ceiling fresco Glorification of Saint Ignatius (Fig. 10-13) for the Church of Sant'Ignazio in Rome. The church was prominent in Counter-Reformation Rome because of its dedication to Saint Ignatius, the founder of the Jesuit order. In the ceiling fresco, Pozzo created the illusion that Heaven is opening up above the congregation. To accomplish this, the artist illusionistically continued the church's actual architecture into the vault so that the roof seems to be lifted off. As Heaven and Earth commingle, Saint Ignatius is carried to the waiting Christ in the presence of figures personifying the four corners of the world. A disk in the nave floor marks the ideal standpoint for the whole perspectival illusion. For visitors looking up from this spot, the vision is complete. They are truly in the presence of the heavenly and spiritual.

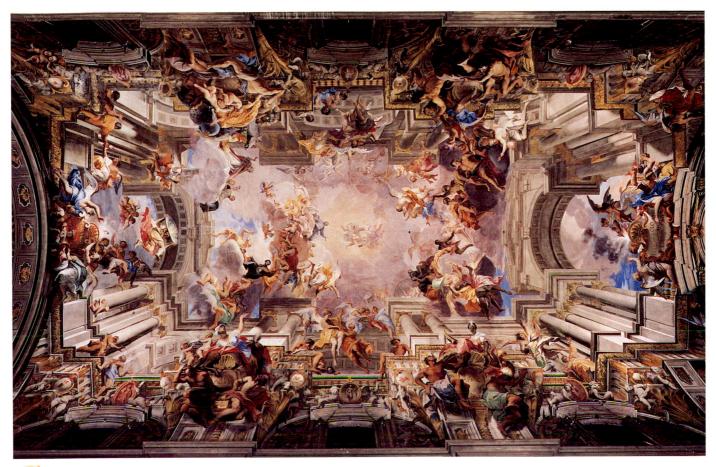

10-13 | FRA ANDREA POZZO, Glorification of Saint Ignatius, ceiling fresco in the nave of Sant'Ignazio, Rome, Italy, 1691–1694.

Pozzo created the illusion that Heaven is opening up above the viewer's head by continuing the church's actual architecture into the painted vault. The fresco makes it seem that the roof has been lifted off.

Baroque Imagery and Sound The effectiveness of Italian Baroque religious art depended on the drama and theatricality of individual images, as well as on the interaction and fusion of architecture, sculpture, and painting. Sound enhanced this experience. Churches were designed with acoustical effect in mind, and, in an Italian Baroque church filled with music, the power of both image and sound must have been immensely moving. Through simultaneous stimulation of both the visual and auditory senses, the faithful might well have been transported into a trancelike state that would, indeed, as England's contemporaneous poet John Milton eloquently stated in *Il Penseroso*, "bring all Heav'n before [their] eyes."

SPAIN

During the 16th century, Spain had established itself as an international power. The Habsburg kings had built a dynastic state that encompassed Portugal, part of Italy, the Netherlands, and extensive areas of the New World. However, the animosity such dominance provoked among other European countries increased the challenges to Spanish hegemony. By the beginning of the 17th century, the Habsburg empire was

struggling, and although Spain mounted a very aggressive effort during the Thirty Years' War, by 1660 the imperial age of the Spanish Habsburgs was over. In part, the demise of the Spanish empire was due to economic woes, which were exacerbated by the expensive military campaigns undertaken during the Thirty Years' War by Philip III (r. 1598–1621) and then by his son, Philip IV (r. 1621–1665). The increasing tax burden that was placed on Spanish subjects led to revolts and civil war in Catalonia and Portugal in the 1640s.

Thus, the dawn of the Baroque period in Spain found the country's leaders struggling to maintain control of their dwindling empire. Realizing as they did the value of visual imagery in communicating to a wide audience, both Philip III and Philip IV were avid art patrons.

Passionately committed to Catholic orthodoxy, Spain also encountered the same Counter-Reformation issues confronting Italy. As in Italy, Spanish Baroque artists sought ways to move the faithful and to encourage greater devotion and piety. Particularly appealing in this regard were scenes of death and martyrdom, which provided artists with opportunities both to depict extreme feelings and to instill those feelings in viewers. Spain prided itself on its saints (for example,

Saint Teresa of Avila, Fig. 10-6, and Saint Ignatius Loyola, Fig. 10-13, were both Spanish born), and martyrdom scenes surfaced frequently in Spanish Baroque art.

A Martyr at Peace Francisco de Zurbarán (1598– 1664) was a leading Spanish painter who produced forceful images of martyr saints, many of which were commissioned by monastic orders. For example, Zurbarán painted Saint Serapion (Fig. 10-14) as a devotional image for the funerary chapel of the Order of Mercy. The saint, who participated in the Third Crusade of 1196, was martyred while preaching the Gospel to Muslims. According to one account of his martyrdom, the monk was tied to a tree, tortured, and decapitated. The Order of Mercy was dedicated to self-sacrifice, and Saint Serapion's membership in this order amplifies the resonance of this work. In Saint Serapion the figure emerges from a dark background and fills the foreground. The bright light shining on the figure calls attention to Serapion's tragic death and increases the dramatic impact of the image. Two tree branches are barely visible in the background, and a small note next to the saint identifies him. The coarse features of the Spanish monk (who was born in England) label him as common, no doubt evoking empathy

10-14 | Francisco de Zurbarán, Saint Serapion, 1628. Oil on canvas, 3' $11\frac{1}{2}$ " × 3' $4\frac{3}{4}$ ". Wadsworth Atheneum Museum of Art, Hartford (The Ella Gallup Sumner and Mary Catlin Sumner Collection Fund).

The light shining on Serapion calls attention to his tragic death and increases the painting's dramatic impact. The Spanish monk's coarse features label him as common, evoking empathy from a wide audience.

from a wide audience. Zurbarán's paintings are often quiet and contemplative, appropriate for prayer and devotional needs.

Velázquez and Philip IV The artist often extolled as the greatest Spanish painter of the age is DIEGO VELÁZOUEZ (1599-1660). Velázquez, like many other Spanish artists. produced religious pictures, but he is justifiably renowned for the work he painted for his major patron, King Philip IV. Trained in Seville, Velázquez was quite young when he came to the attention of Philip IV. The king was struck by the artist's immense talent and named him to the position of court painter. With the exception of two extended trips to Italy and a few excursions, Velázquez remained in Madrid for the rest of his life. His close relationship with Philip IV and his high office as chamberlain of the palace gave him prestige and a rare opportunity to fulfill the promise of his genius with a variety of artistic assignments.

Velázquez's skill is evident in an early work, Water Carrier of Seville (Fig. 10-15), which he painted when he was only

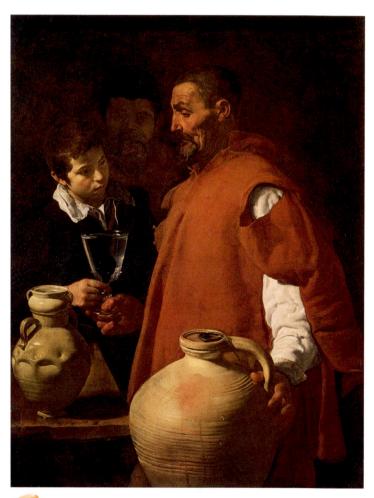

10-15 | Diego Velázquez, Water Carrier of Seville, ca. 1619. Oil on canvas, 3' $5\frac{1}{2}$ " \times 2' $7\frac{1}{2}$ ". Victoria & Albert Museum, London.

In this early work—a genre scene that seems to convey a deeper significance—the contrast of darks and lights, along with the plebeian nature of the figures, reveal Velázquez's indebtedness to Caravaggio.

about 20. The artist's command of his craft is impressive. He rendered the figures with clarity and dignity, and his careful depiction of the water jugs in the foreground, complete with droplets of water, adds to the credibility of the scene. As in Zurbarán's *Saint Serapion* (Fig. 10-14), the contrast of darks and lights, along with the plebeian nature of the figures, reveal the influence of Caravaggio, whose work Velázquez had studied. The artist presented this genre scene with such care and conviction that it seems to convey a deeper significance.

Of Art and Royal Life After an extended visit to Rome from 1648 to 1651, Velázquez returned to Spain and painted his greatest masterpiece, Las Meninas (The Maids of Honor; Fig. 10-16). In it, Velázquez showed his mastery of both form and content. The painter represented himself in his studio standing before a large canvas. The young Infanta (Princess) Margarita appears in the foreground with her two maidsin-waiting, her favorite dwarfs, and a large dog. In the middle ground are a woman in widow's attire and a male escort. In the background, a chamberlain is framed in a brightly lit open doorway. The personages present have been identified, including the two meninas and the dwarfs. The room represented in the painting was the artist's studio in the palace of the Alcázar in Madrid. After the death of Prince Baltasar Carlos in 1646, Phillip IV ordered part of the prince's chambers converted into a studio for Velázquez.

Las Meninas is noteworthy for its visual and narrative complexity. Indeed, art historians have yet to agree on any particular reading or interpretation. A central issue has been what, exactly, is taking place in Las Meninas. In the painting, what is Velázquez depicting on the huge canvas in front of him? He may be painting this very picture—an informal image of the infanta and her entourage. Alternately, Velázquez may be painting a portrait of King Philip IV and Queen Mariana, whose reflections appear in the mirror on the far wall. If so, that would suggest the presence of the king and queen in the viewer's space, outside the confines of the picture. Other scholars have proposed that the mirror image reflects not the physical appearance of the royal couple in Velázquez's studio but the image that he is in the process of painting on the canvas before him. This question has never been definitively resolved.

More generally, *Las Meninas* can be read as an attempt by Velázquez to elevate both himself and his profession. As first painter to the king and as chamberlain of the palace, Velázquez was conscious not only of the importance of his court office but also of the honor and dignity belonging to his profession as a painter. Throughout his career, Velázquez hoped to be ennobled by royal appointment to membership in the ancient and illustrious Order of Santiago. Because he lacked some of the required patents of nobility, he gained entrance only with difficulty at the very end of his life, and then only through the pope's dispensation. In the painting, he wears the order's red cross on his doublet, painted there, legend says, by the king himself. In all likelihood, the artist painted it. In Velázquez's mind, *Las Meninas* might have em-

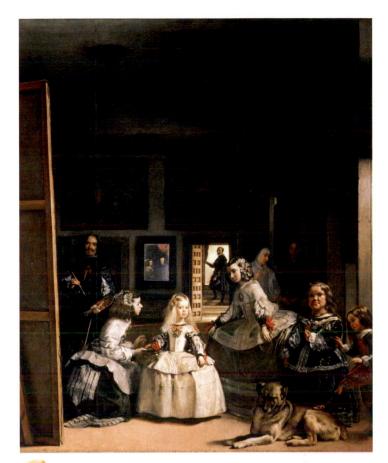

10-16 | DIEGO VELÁZQUEZ, *Las Meninas (The Maids of Honor)*, 1656. Oil on canvas, approx. 10′ 5″ × 9′. Museo del Prado, Madrid.

Velázquez seems to have intended this huge and complex work, with its cunning contrasts of actual spaces, mirrored spaces, and picture spaces, to elevate both himself and the profession of painting.

bodied the idea of the great king visiting his studio, as Alexander the Great visited the studio of the painter Apelles in ancient Greece. The figures in the painting all appear to acknowledge the royal presence. Placed among them in equal dignity is Velázquez, face-to-face with his sovereign.

The location of the completed painting reinforced this act of looking—of seeing and being seen. Las Meninas hung in the personal office of Philip IV in another part of the palace. Thus, although occasional visitors admitted to the king's private quarters may have seen this painting, it was viewed primarily by Philip IV. And each time he did so, standing before the large canvas, he again participated in the work as the subject of Velázquez's painting in Las Meninas and as the object of the figures' gazes. The art of painting, in the person of the painter, was elevated here to the highest status. This status was enhanced by the presence of the king—either in person as the viewer of Las Meninas or as a reflected image in the painting itself. This elevation of painting was further reinforced by the paintings that appear in Las Meninas. On the wall above the doorway and mirror, two faintly recognizable pictures have been identified as copies of paintings by Peter Paul Rubens that represent the immortal gods as the source of art. Ultimately, Velázquez sought ennoblement not for himself alone but for his art.

The painting is extraordinarily complex visually. Velázquez's optical report of the event, authentic in every detail, pictorially summarizes the various kinds of images in their different levels and degrees of reality. He portrayed the realities of image on canvas, of mirror image, of optical image, and of the two imaged paintings. This work—with its cunning contrasts of mirrored spaces, "real" spaces, picture spaces, and pictures within pictures—itself appears to have been taken from a large mirror reflecting the whole scene. This would mean that the artist did not paint the princess and her suite as the main subjects of *Las Meninas* but himself in the process of painting them. *Las Meninas* is a pictorial summary and a commentary on the essential mystery of the visual world, as well as on the ambiguity that results when different states or levels interact or are juxtaposed.

How did Velázquez achieve these results? The extension of the composition's pictorial depth in both directions is noteworthy. The open doorway and its ascending staircase lead the eye beyond the artist's studio, and the mirror device and the outward glances of several of the figures incorporate the viewer's space into the picture as well. (Compare how the mirror in Jan van Eyck's *Giovanni Arnolfini and His Bride*, Fig. 8-6, also incorporates the area in front of the canvas into the picture, although less obviously and without a comparable extension of space beyond the rear wall of the room.) Velázquez also masterfully observed and represented form and shadow. Instead of putting lights abruptly beside darks, as Caravaggio had done, Velázquez allowed a great number

of intermediate values of gray to come between the two extremes. His matching of tonal gradations approached effects that were later discovered in the photography age.

FLANDERS

In the 16th century, the Netherlands had come under the crown of Habsburg Spain when the emperor Charles V retired, leaving the Spanish kingdoms, their Italian and American possessions, and the Netherlandish provinces to his only legitimate son, Philip II. (Charles gave the imperial title and the German lands to his brother.) Philip's repressive measures against the Protestants led the northern provinces to break away from Spain and to set up the Dutch Republic. The southern provinces remained under Spanish control, and they retained Catholicism as their official religion. The political distinction between modern Holland and Belgium more or less reflects this original separation, which in the Baroque period signaled not only religious but also artistic differences. The Baroque art of Flanders (the Spanish Netherlands) retained close connections to the Baroque art of Catholic Europe, whereas the Dutch schools of painting developed their own subjects and styles.

Peter Paul Rubens The renowned Flemish master Peter Paul Rubens (1577–1640) drew together the main contributions of the masters of the Renaissance (Michelangelo and Titian) and of the Italian Baroque (Carracci and Caravaggio) to synthesize in his own style the first truly pan-European manner. Rubens's art, even though it is the consequence of his wide study of many masters, does not represent a weak eclecticism

PETER PAUL RUBENS, Elevation of the Cross, 1610. Oil on panels, center panel, $15' 1\frac{7}{8}'' \times 11' 1\frac{1}{2}''$; each wing, $15' 1\frac{7}{8}'' \times 4' 11''$. Antwerp Cathedral, Antwerp.

In this triptych, Rubens explored foreshortened anatomy and violent action. The whole composition seethes with a power that comes from heroic exertion. The tension is emotional as well as physical.

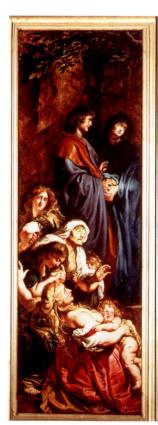

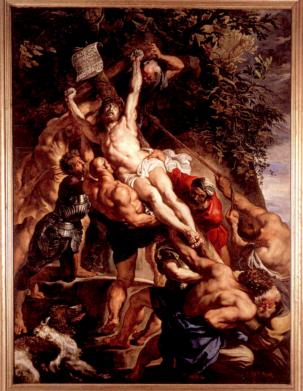

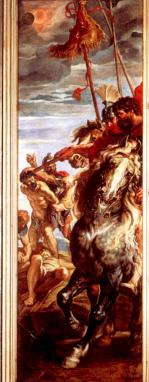

but an original and powerful synthesis. Ultimately, the influence of Rubens was international.

Among the most learned individuals of his time, Rubens possessed an aristocratic education, courtier's manner, diplomacy, and tact. All of this, along with his classical learning and facility with language, made him the associate of princes and scholars. He became court painter to the dukes of Mantua; friend of the king of Spain and his adviser on art collecting; painter to Charles I of England and Marie de' Medici, queen of France; and permanent court painter to the Spanish governors of Flanders. Rubens also won the confidence of his royal patrons in matters of state, and these patrons often entrusted him with diplomatic missions of the highest importance. In the practice of his art, scores of associates and apprentices assisted Rubens, turning out numerous paintings for an international clientele. In addition, he functioned as an art dealer, buying and selling contemporary artworks and classical antiquities. His many enterprises made him a rich man, with a magnificent town house and a château in the countryside. Wealth and honors, however, did not spoil his amiable, sober, and self-disciplined character.

Muscularity and Foreshortening Rubens became a master in 1598 and went to Italy two years later, where he remained until 1608. During these years, he formulated the foundations of his style. Shortly after his return from Italy, he painted the *Elevation of the Cross* (Fig. 10-17) for the Church of Saint Walburga. This triptych, later moved to Antwerp Cathedral, is the result of his long study of Italian art, especially the works of Michelangelo, Tintoretto, and Caravaggio, as well as ancient statuary. In his Latin treatise De imitatione statuarum (On the Imitation of Statues), Rubens stated: "I am convinced that in order to achieve the highest perfection one needs a full understanding of the [ancient] statues, nay a complete absorption in them."2 The scene brings together tremendous forces and counterforces as heavily muscled men strain to lift the cross. Here, as in his Lion Hunt (Fig. Intro-8), Rubens had the opportunity to show foreshortened anatomy and the contortions of violent action reminiscent of the twisted figures Michelangelo sculpted (Fig. INTRO-11) and painted. Rubens placed the body of Christ on the cross as a diagonal that cuts dynamically across the picture while inclining back into it. The whole composition seethes with a power that comes from genuine exertion, from elastic human sinew taut with effort. The tension is emotional as well as physical, as reflected not only in Christ's face but also in the features of his followers in the triptych's wings. Strong modeling in dark and light, which heightens the drama, marks Rubens's work at this stage of his career. It gradually gave way to a much subtler coloristic style.

An Extravagant Arrival Rubens's interaction with royalty and aristocrats provided him with an understanding of the ostentation and spectacle of Baroque (particularly Italian) art that were appealing to those of wealth and privilege. Rubens, the born courtier, reveled in the pomp and majesty of royalty. Likewise, those in power embraced the lavish spectacle that

served the Catholic Church so well in Italy. The magnificence and splendor of such Baroque imagery reinforced their authority and right to rule. Among Rubens's royal patrons was Marie de' Medici, a member of the famous Florentine house and widow of Henry IV, the first of the Bourbon kings of France. She commissioned Rubens to paint a series memorializing and glorifying her career. Between 1622 and 1626, Rubens, working with amazing creative energy, produced 21 huge historical-allegorical pictures designed to hang in the queen's new palace, the Luxembourg, in Paris.

Arrival of Marie de' Medici at Marseilles (FIG. 10-18) is from that series. Marie has just arrived in France after the sea voyage from Italy. As she disembarks, surrounded by her ladies-in-waiting, she is welcomed by an allegorical personification of France, draped in a cloak decorated with the royal fleur-de-lis (compare FIG. 10-31). The sea and sky rejoice at her safe arrival—Neptune and the Nereids (daughters of the sea god Nereus) salute her, and a winged, trumpeting Fame swoops overhead. Conspicuous in the galley's opulently carved stern-castle, under the Medici coat of arms, stands the

10-18 | Peter Paul Rubens, Arrival of Marie de' Medici at Marseilles, 1622–1625. Oil on canvas, approx. $5' 1'' \times 3' 9_2^{1''}$. Louvre, Paris.

Marie de' Medici commissioned Rubens to paint 21 large canvases glorifying her career. In this historical-allegorical picture of robust figures in an opulent setting, the sea and sky rejoice at the queen's arrival in France.

imperious commander of the vessel. In black and silver, his figure makes a sharp accent amid the swirling tonality of ivory, gold, and red. He wears the cross of a Knight of Malta, which may identify this as a ship belonging to that order (similar to Velázquez's Order of Santiago). The only immobile figure in the composition, he could be director of and witness to the lavish welcome. The artist enriched his surfaces here with a decorative splendor that pulls the whole composition together. The audacious vigor that customarily enlivens Rubens's figures, beginning with the monumental, twisting sea creatures, vibrates through the entire design.

Elegant Court Portraiture Most of Rubens's successors in Flanders were at one time his assistants. The most famous of these was Anthony Van Dyck (1599–1641). Early on, the younger man, unwilling to be overshadowed by the master's undisputed stature, left his native Antwerp for Genoa and then London, where he became court portraitist to Charles I (r. 1625–1649). Although Van Dyck created dramatic compositions of high quality, his specialty became the portrait. He developed a courtly manner of great elegance that was influential

10-19 | Anthony Van Dyck, *Charles I Dismounted*, ca. 1635. Oil on canvas, approx. 9' × 7'. Louvre, Paris.

Van Dyck specialized in court portraiture. In this painting, he depicted the absolutist monarch Charles I at a sharp angle so that the king, a short man in life, appears to look down on those viewing the picture. internationally. In one of his finest works, *Charles I Dismounted* (Fig. 10-19), the ill-fated Stuart king stands in a landscape with the river Thames in the background. An equerry and a page attend the king. Although Charles I impersonates a nobleman out for a casual ride in his park, no one can mistake the regal poise and the air of absolute authority his Parliament resented and was soon to rise against. Here, King Charles turns his back on his attendants as he surveys his domain. The king's placement is exceedingly artful. He stands off center but balances the picture with a single keen glance over his left shoulder. Because of the angle he chose, Van Dyck even managed to portray the short monarch in a position to look down on those viewing the picture. Van Dyck's elegant style resounded in English portrait painting well into the 19th century.

THE DUTCH REPUBLIC

The Dutch succeeded in securing their independence from the Spanish in the late 16th century. Not until 1648, however, after years of continual border skirmishes with the Spanish, were the northern Netherlands officially recognized as the United Provinces of the Netherlands (the Dutch Republic).

The ascendance of the Dutch Republic during the 17th century was largely due to its economic prosperity. Amsterdam had the highest per capita income in Europe, and emerged as the financial center of the continent, having founded the Bank of Amsterdam in 1609. The Dutch economy benefited enormously from the country's expertise on the open seas, which facilitated establishing far-flung colonies. By 1650, Dutch trade routes extended beyond Europe and included North America, South America, the west coast of Africa, China, Japan, Southeast Asia, and much of the Pacific.

Mercantilist Patrons The absence of an authoritative ruler and the Calvinist concern for the potential misuse of religious art affected the character of Dutch art. Commissions from royalty or from the Catholic Church, prominent in the art of other countries, were uncommon in the United Provinces. With the new prosperity, an expanding class of merchant patrons emerged, and this shift led to an emphasis on different pictorial content. Dutch Baroque art centered on genre scenes, landscapes, portraits, and still lifes, all of which appealed to the prosperous middle class (see "Dutch Patronage and Art Collecting," page 301). Art flourished in this mercantilist culture. The 17th century is considered the "Golden Age" of Dutch art.

Hals and Group Portraiture Frans Hals (ca. 1581–1666) was the leading painter in Haarlem and made portraits his specialty. Portrait artists traditionally had relied heavily on convention—for example, specific poses, settings, attire, and accoutrements—to convey a sense of the sitter. Because the subject was usually someone of status or note, such as a pope, king, or wealthy individual, the artist's goal was to produce an image appropriate to the subject's station in life. With the increasing numbers of Dutch middle-class patrons, the tasks for Dutch portraitists became more challenging. Not only were the

Dutch Patronage and Art Collecting

Art collecting often has been perceived as the purview of the wealthy, and, indeed, the money necessary to commission major artworks from esteemed artists can be considerable. During the 17th century in the Dutch Republic, however, the prosperity enjoyed by a large proportion of Dutch society significantly expanded the range of art patronage. As a result, one of the hallmarks of Dutch art during the Baroque period was how it catered to the tastes of a middle-class audience.

The term "middle class" is used broadly here. An aristocracy and an upper class of large-ship owners, rich businesspeople, high-ranking officers, and directors of large companies, still existed. These groups continued to be major patrons of the arts. With the expansion of the Dutch economy, traders, craftspeople, low-ranking officers, bureaucrats, and soldiers — the middle and lower-middle class — also became art patrons.

Although steeped in the morality and propriety central to the Calvinist ethic, members of the Dutch middle class sought ways to announce their success. House furnishings, paintings, tapestries, and porcelain were among the items collected and displayed in the home. The Dutch disdain for excessive ostentation, attributable to Calvinism, led these collectors to favor small, low-key works — portraits, still lifes, genre scenes, and landscapes. This contrasted with the Italian Baroque penchant for largescale, dazzling ceiling frescoes and opulent room decoration.

Although it is risky to generalize about the spending and collecting habits of the Dutch middle class, some information has been culled from probate records, contracts, and archived inventories. This documentation suggests that an individual earning between 1,500 and 3,000 guilders a year would be considered to be living comfortably. Such an individual might have spent 1,000 guilders for a house and another 1,000 guilders to furnish it. Those furnishings would have included a significant amount of art, particularly paintings. Although there was, of course, considerable variation in the prices of artworks, a great deal of art was very affordable. Prints were extremely cheap because of the quantity in which they were normally produced. Painted interior and genre scenes seem to have been relatively inexpensive, perhaps costing one or two quilders. Small landscapes ran between three and four quilders. Commissioned portraits were the most costly. Size of the work and quality of the frame were other factors in the determination of price.

This new middle-class clientele, in conjunction with the developing open market, influenced the direction of Dutch Baroque art. These patrons not only affected the type of art produced. They also were responsible for establishing the mechanisms and institutions for buying and selling art that constitute the foundation of today's art market.

traditional conventions inappropriate and thus unusable, but also the Calvinists shunned ostentation, instead wearing uniform, subdued, and dark clothing with little variation or decoration. Despite these difficulties, or perhaps because of them, Hals produced lively portraits that seem far more relaxed than the more formulaic traditional portraiture. He injected an engaging spontaneity into his images and conveyed the personalities of his sitters as well. His manner of execution intensified the casualness, immediacy, and intimacy in his paintings. The touch of Hals's brush was as light and fleeting as the moment when he captured the pose, so the figure, the highlights on clothing, and the facial expression all seem instantaneously created.

Hals also excelled at group portraits, which multiplied the challenges of depicting a single sitter. Archers of Saint Hadrian (Fig. 10-20) is one such painting. The Archers of Saint Hadrian were one of many Dutch civic militia groups who

10-20 FRANS HALS, Archers of Saint Hadrian, ca. 1633. Oil on canvas, approx.

6' 9" × 11'. Frans Halsmuseum, Haarlem.

In this brilliant composition, Hals succeeded in solving the problem of adequately representing each individual in a group portrait while retaining action and variety in the painting as a whole.

claimed credit for liberating the Dutch Republic from Spain. Like other companies, the Archers met on their saint's feast day in dress uniform for a grand banquet. The celebrations sometimes lasted several days. These events called for a group portrait, and such commissions gave Hals the opportunity to attack the problem of adequately representing each group member while retaining action and variety in the composition. Earlier group portraits in the Netherlands were rather ordered and regimented images. Hals sought to enliven the depictions, and the results can be seen in Archers. Here, each man is both a troop member and an individual with a distinct personality. Some engage the viewer directly, whereas others look away or at a companion. Where one is stern, another is animated. Each is equally visible and clearly recognizable. The uniformity of attire—black military dress, white ruffs, and sashes—does not seem to have deterred Hals from injecting a spontaneity into the work. Indeed, he used those elements to create a lively rhythm that extends throughout the composition and energizes the portrait. The impromptu effect—the preservation of every detail and fleeting facial expression—is, of course, due to careful planning. Yet Hals's vivacious brush appears to have moved instinctively, directed by a plan in his mind but not traceable in any preparatory scheme on the canvas.

Rembrandt's Night Watch REMBRANDT VAN RIJN (1606–1669), Hals's younger contemporary, was widely recognized as the leading Dutch painter of his time. Rembrandt's

move from his native Leiden to Amsterdam around 1631 provided him with a more extensive clientele, contributing to a flourishing career. In his portraits, for which he gained great renown, Rembrandt delved deeply into the psyche and personality of his sitters.

Rembrandt amplified the complexity and energy of the group portrait in his famous painting of 1642, *The Company of Captain Frans Banning Cocq* (Fig. 10-21), better known as *Night Watch*. This more commonly used title is, however, a misnomer—*Night Watch* is not a nocturnal scene. Rembrandt used light in a masterful way, and dramatic lighting certainly enhances the image. However, the painting's darkness (which prompted the shorter title) is due more to the varnish the artist used, which has darkened considerably over time, than to the subject depicted.

This painting was one of many civic-guard group portraits produced during this period. From the limited information available about the commission, it appears that Rembrandt was asked to paint the two officers, Captain Frans Banning Cocq and his lieutenant Willem van Ruytenburch, along with 16 members of this militia group (each contributing to Rembrandt's fee). This work was one of six paintings commissioned from different artists around 1640 for the assembly and banquet hall of the new Kloveniersdoelen (Musketeers' Hall) in Amsterdam. The large canvas was subsequently moved to the Amsterdam town hall in 1715, when it was unfortunately cropped on all sides.

RIJN, The Company of Captain Frans Banning Cocq (Night Watch), 1642. Oil on canvas (cropped from original size), 11′ 11″ × 14′ 4″. Rijksmuseum, Amsterdam.

Rembrandt's dramatic use of light contributes to the animation of this militia group portrait in which the artist showed the company scurrying about in the act of organizing themselves for a parade.

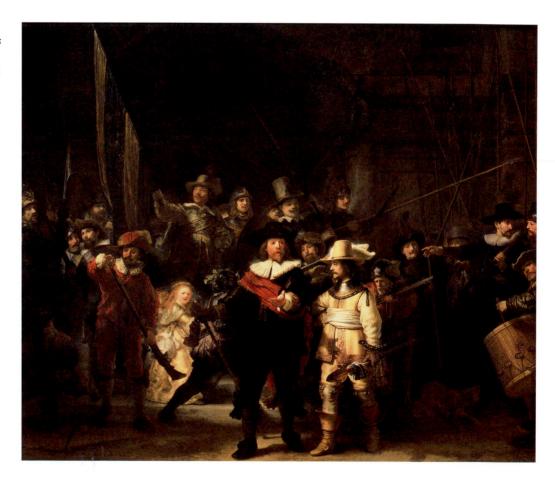

In *Night Watch*, Rembrandt captured the excitement and frenetic activity of the men preparing for the parade. Comparing his group portrait to Hals's *Archers of Saint Hadrian* (Fig. 10-20), also a militia portrait, reveals Rembrandt's inventiveness in enlivening what was, by then, becoming a conventional portrait format. Rather than present assembled men, the artist chose to portray the company scurrying about in the act of organizing themselves, thereby animating the image considerably.

Lighting the Way Rembrandt's use of light is among the hallmarks of his style. His pictorial method involved refining light and shade into finer and finer nuances until they blended with one another. Earlier painters' use of abrupt lights and darks gave way, in the work of artists such as Rembrandt and Velázquez, to gradation. Although these later artists may have sacrificed some of the dramatic effects of sharp chiaroscuro, a greater fidelity to actual appearances offset those sacrifices. This technique is closer to reality because the eyes perceive light and dark not as static but as always subtly changing.

Generally speaking, Renaissance artists represented forms and faces in a flat, neutral modeling light (even Leonardo's shading is of a standard kind). They represented the idea of light, rather than the actual look of it. Artists such as Rembrandt discovered degrees of light and dark, degrees of differences in pose, in the movements of facial features, and in psychic states. They arrived at these differences optically, not conceptually or in terms of some ideal. Rembrandt found that by manipulating the direction, intensity, distance, and surface texture of light and shadow, he could render the most subtle nuances of character and mood, both in persons and whole scenes. He discovered for the modern world that variation of light and shade, subtly modulated, could be read as emotional differences. In the visible world, light, dark, and the wide spectrum of values between the two are charged with meanings and feelings that sometimes are independent of the shapes and figures they modify. The theater and the photographic arts have used these discoveries to great dramatic effect.

An Illuminating Self-Portrait In his portraits, Rembrandt employed what could be called the "psychology of light." Light and dark are not in conflict. They are reconciled, merging softly and subtly to produce the visual equivalent of quietness. Their prevailing mood is that of tranquil meditation, of philosophical resignation, of musing recollection—indeed, a whole cluster of emotional tones heard only in silence.

In one of Rembrandt's late self-portraits (FIG. 10-22), the light that shines from the upper left of the painting bathes the artist's face in soft light, leaving the lower part of his body in shadow. Rembrandt depicted himself here as possessing dignity and strength, and the portrait can be seen as a summary of the many stylistic and professional concerns that occupied him throughout his career. Rembrandt's distinctive use of light is evident, as is the assertive brushwork that suggests confidence and self-assurance. He presented himself as a working artist

10-22 | REMBRANDT VAN RIJN, Self-Portrait, ca. 1659–1660. Oil on canvas, approx. 3' $8\frac{3}{4}$ " × 3' 1". The Iveagh Bequest, Kenwood House, London.

In this late self-portrait, Rembrandt's interest in revealing the human soul is evident in the careful attention given to his expressive face. The controlled use of light and the nonspecific setting contribute to this focus.

holding his brushes, palette, and maulstick. He is clothed in studio garb—a smock and painter's turban. The circles on the wall behind him (the subject of much scholarly debate) may allude to a legendary sign of artistic virtuosity—the ability to draw a perfect circle freehand. Ultimately, Rembrandt's abiding interest in revealing the human soul emerged here in his careful focus of the viewer's attention on his expressive visage. His controlled use of light and the nonspecific setting contribute to this focus. X rays of the painting have revealed that Rembrandt originally depicted himself in the act of painting. His final resolution, with the viewer's attention drawn to his face, produced a portrait not just of the artist but of the man as well.

Compassion Memorably Etched Many artists rapidly took up etching when it was perfected early in the 17th century, and Rembrandt was a master of the new medium. Baroque printmakers found etching to be far more manageable than engraving, and it allowed greater freedom in drawing the design. For etching, a copper plate is covered with a layer of wax or varnish. The artist incises the design into this surface with an etching needle or any pointed tool, exposing

10-23 | REMBRANDT VAN RIJN, Christ with the Sick around Him, Receiving the Children (Hundred Guilder Print), ca. 1649. Etching, approx. $11'' \times 1'' 3\frac{1}{4}''$. Pierpont Morgan Library, New York.

Rembrandt's mastery of the new printmaking medium of etching may be seen in his expert use of light and dark to draw attention to Christ as he preaches compassionately to the blind and lame.

the metal below but not cutting into its surface. The plate is then immersed in acid, which etches, or eats away, the exposed parts of the metal, as the burin does in engraving. The medium's softness gives etchers greater carving freedom than woodcutters and engravers have working directly in their more resistant media of wood and metal.

If Rembrandt had never painted, he still would be renowned, as he principally was in his lifetime, for his prints. Prints were a major source of income for him, and he often reworked the plates so that they could be used to produce a new issue or edition. This constant reworking was unusual within the context of 17th-century printmaking practices. *Christ with the Sick around Him, Receiving the Children* (Fig. 10-23) is one of Rembrandt's most celebrated etchings. Indeed, the title by which the print is best known, *Hundred Guilder Print*, refers to the high price this work brought during Rembrandt's lifetime. Rembrandt's expert use of light and dark draws attention to Christ, who appears in the center preaching compassionately to the blind, the lame, and the young. On the left, a group of Jews heatedly discuss issues among themselves.

Like his other religious works, *Christ with the Sick* is suffused with a deep and abiding piety. Rembrandt's images are not the opulent, overwhelming art of Baroque Italy. Rather, his art is that of a committed Calvinist who desired to interpret biblical narratives in human (as opposed to lofty theological) terms. The spiritual stillness of Rembrandt's religious art is that of inward-turning contemplation, far from the choirs and trumpets and the heavenly tumult of Bernini or Pozzo. Rembrandt gives the viewer not the celestial triumph of the Catholic Church but the humanity and humility of Jesus. His psychological insight and his profound sympathy for human affliction produced some of the most moving pictures in all religious art.

At Ease in Front of an Easel Another prominent Dutch painter who developed a thriving career as a portraitist was Judith Leyster (1609-1660). Leyster had studied with Frans Hals, and her Self-Portrait (Fig. 10-24) suggests the strong training she received. It is detailed, precise, and accurate, but also imbued with a spontaneity found in the works of Hals. In this painting, Leyster succeeded at communicating a great deal about herself. She depicted herself as an artist, seated in front of a painting on an easel. The palette in her left hand and brush in her right make it clear the painting is her creation. She thus allowed the viewer to evaluate her skill, which both the fiddler on the canvas and the image of herself demonstrate as considerable. Although she produced a wide range of paintings, including still lifes and floral pieces, her specialty was genre scenes such as the comic image seen on the easel. Her self-assurance is reflected in her quick smile and her relaxed pose as she stops her work to meet the viewer's gaze. Although presenting herself as an artist, Leyster did not depict herself wearing the traditional artist's smock, as Rembrandt did in his self-portrait (Fig. 10-22). Her elegant attire distinguishes her socially as a member of a well-to-do family, another important aspect of Leyster's identity.

Reclaiming Land from the Sea In addition to portraiture, the Dutch avidly collected landscapes, interior scenes, and still lifes. Each of these painting genres dealt directly with the daily lives of the urban mercantile public, accounting for their appeal. Landscape scenes abound in Dutch Baroque art. Due to topography and politics, the Dutch had a unique relationship to the terrain, one that differed from those of other European countries. After gaining independence from Spain, the Dutch undertook an extensive land reclamation project

10-24 | JUDITH LEYSTER, *Self-Portrait*, ca. 1630. Oil on canvas, 2' $5\frac{3}{8}'' \times 2'$ $1\frac{5}{8}''$. National Gallery of Art, Washington (gift of Mr. and Mrs. Robert Woods Bliss).

Although presenting herself as an artist specializing in genre scenes, Leyster wears elegant attire instead of a painter's smock, placing her socially as a member of a well-to-do family, an important aspect of her identity. that lasted almost a century. Dikes and drainage systems cropped up across the landscape. Because of the effort expended on these endeavors, the Dutch developed a very direct relationship to the land. Most Dutch families owned and worked their own farms.

Landscape Painting JACOB VAN RUISDAEL (ca. 1628-1682) achieved renown for his precise and sensitive depictions of the Dutch landscape. In View of Haarlem from the Dunes at Overveen (Fig. 10-25), van Ruisdael gives the viewer an overarching view of this major Dutch city. The specificity of the artist's image—the Saint Bavo church in the background. the numerous windmills that refer to the land reclamation efforts, and the figures in the foreground stretching linen to be bleached (a major industry in Haarlem)—endows the work with a sense of honesty and integrity. Yet this painting is, above all, a landscape. Although the scene is painted in an admirably clear and detailed manner, the inhabitants and dwellings are so miniscule that they blend into the land itself. Further, the horizon line is low, so the sky fills almost threequarters of the picture space. And the landscape is illuminated only in patches, where the sun has broken through the clouds above. In View of Haarlem, as in his other landscape paintings, van Ruisdael not only captured a specific and historical view of Haarlem but also succeeded in imbuing the work with a quiet serenity that seems almost spiritual.

View of Haarlem from the Dunes at Overveen, ca. 1670. Oil on canvas, approx. 1' $10'' \times 2'$ 1". Mauritshuis, The Hague.

In this painting, van Ruisdael succeeded in capturing a specific view of Haarlem, its windmills, and Saint Bavo church, but he also imbued the landscape with a quiet serenity that seems almost spiritual.

Jan Vermeer The sense of peace, familiarity, and comfort that Dutch landscape paintings like van Ruisdael's seem to exude also emerges in interior scenes. These paintings offer glimpses into the lives of prosperous, responsible, and cultured citizens. The best-known and most highly regarded of the Dutch interior scene painters is JAN VERMEER (1632–1675) of Delft. Vermeer derived most of his income from his work as an innkeeper and art dealer, and he painted no more than three dozen paintings that definitively can be attributed to him. Vermeer's pictures are small, luminous, and captivating. Earlier Flemish artists, such as Robert Campin (Fig. 8-5), had painted domestic interiors, but persons of sacred significance often occupied those scenes. In contrast, Vermeer and his contemporaries composed neat, quietly opulent interiors of Dutch middle-class dwellings with men, women, and children engaging in household tasks or some little recreation. These commonplace actions reflected the values of a comfortable domesticity that had a simple beauty.

Vermeer was a master of pictorial light and used it with immense virtuosity. He could render space so convincingly through his depiction of light that in his works, the picture surface functions as an invisible glass pane through which the viewer looks into the constructed illusion. Historians are confident that Vermeer used as tools both mirrors and the camera obscura (literally, "dark room"), an ancestor of the modern camera based on passing light through a tiny pinhole or lens to project an image on a screen or the wall of a room. (In later versions, the image was projected on a ground-glass wall of a box whose opposite wall contained the pinhole or lens.) This does not mean that Vermeer merely copied the image. Instead, these aids helped him obtain results he reworked compositionally, placing his figures and the furniture of a room in a beautiful stability of quadrilateral shapes. This gives his designs a matchless classical serenity. This quality is enhanced by colors so true to the optical facts and so subtly modulated that they suggest Vermeer was far ahead of his time in color science. Close examination of his paintings shows that Vermeer realized that shadows are not colorless and dark, that adjoining colors affect each other, and that light is composed of colors. Thus, he painted reflections off of surfaces in colors modified by others nearby. It has been suggested that Vermeer also perceived the phenomenon modern photographers call "circles of confusion," which appear on out-of-focus negatives. Vermeer could have seen them in images projected by the camera obscura's primitive lenses. He approximated these effects with light dabs that, in close view, give the impression of an image slightly "out of focus." When the observer draws back a step, however, as if adjusting the lens, the color spots cohere, giving an astonishingly accurate illusion of a third dimension.

Extolling the Art Profession Vermeer's stylistic precision and commitment to his profession surfaced in Allegory of the Art of Painting (Fig. 10-26). The artist himself appears in the painting, with his back to the viewer and dressed in "historical" clothing (reminiscent of Burgundian attire). He is

10-26 | JAN VERMEER, Allegory of the Art of Painting, 1670-1675. Oil on canvas, 4' 4" × 3' 8". Kunsthistorisches Museum, Vienna.

Vermeer used both mirrors and the camera obscura to depict opulent 17th-century Dutch domestic interiors so convincingly. He was also far ahead of his time in understanding the science of color.

hard at work on a painting of the model who stands before him wearing a laurel wreath and holding a trumpet and book, traditional attributes of Clio, the muse of history. The map of the provinces (an increasingly common wall adornment in Dutch homes) on the back wall serves as yet another reference to history. As in other Vermeer paintings, the viewer is outside the space of the action, and the drawn curtain provides visual access. Some art historians have suggested that the light radiating from an unseen window on the left that illuminates both the model and the canvas being painted alludes to the light of artistic inspiration. Accordingly, this painting has been interpreted (as reflected in the title) as an allegory—a reference to painting inspired by history. This allegorical reading was affirmed when Vermeer's widow, wishing to retain this painting after the artist's death, listed it in her written claim as "the piece . . . wherein the Art of Painting is portrayed."³

Of Beauty and Death The prosperous Dutch were justifiably proud of their accomplishments, and the popularity of still-life paintings—particularly images of accumulated material goods—reflected this pride. These still lifes, like Vermeer's

PIETER CLAESZ, *Vanitas Still Life*, 1630s. Oil on panel, 1' 2" × 1' $11\frac{1}{2}$ ". Germanisches National Museum, Nuremberg.

Vanitas still lifes reflect the pride Dutch citizens had in their material possessions, but that pride was tempered by Calvinist morality and humility. The inclusion of the skull and timepiece reminds the viewer of life's transience.

interior scenes, are beautifully crafted images that are both scientific in their optical accuracy and poetic in their beauty and lyricism. Paintings such as Vanitas Still Life (Fig. 10-27) by PIETER CLAESZ (1597–1660) reveal the pride Dutch citizens had in their material possessions, presented as if strewn across a tabletop or dresser. This pride is tempered, however, by the everpresent morality and humility central to the Calvinist faith. Thus, while appreciating and enjoying the beauty and value of the objects depicted, the viewer is reminded of life's transience by Claesz's inclusion of references to death—the skull, timepiece, tipped glass, and cracked walnut. Paintings with such features are called vanitas paintings. They suggest the passage of time or a presence that has disappeared. Something or someone was here, and now is gone. Claesz emphasized this element of time (and demonstrated his technical virtuosity) by including a portrait of himself, reflected in the glass ball on the left side of the table, in the act of painting this still life. In an apparent challenge to the message of inevitable mortality that his vanitas painting conveys, the portrait serves to immortalize the artist.

Ruysch and Floral Painting Like still-life paintings, flower paintings were prominent in Dutch Baroque art. As living objects that soon die, flowers, particularly cut blossoms, appeared frequently in vanitas paintings. However, floral painting as a unique genre also flourished. Among the leading practitioners of this art was RACHEL RUYSCH (1663–1750). Ruysch's father was a professor of botany and anatomy, which may account for her interest in and knowledge of plants and insects. She acquired an international reputation for lush paintings such as Flower Still Life (Fig. 10-28). In this image, the lavish floral arrangement is so full that many of the blossoms seem to be spilling out of the vase. Ruysch carefully constructed her paintings. Here, for example, she positioned

10-28 | RACHEL RUYSCH, Flower Still Life, after 1700. Oil on canvas, 2' 6" × 2'. The Toledo Museum of Art, Toledo (purchased with funds from the Libbey Endowment, gift of Edward Drummond Libbey).

Flower paintings were very popular in the Dutch Republic during the Baroque period. Ruysch achieved international renown for her lush paintings of floral arrangements, noted also for their careful compositions.

the flowers such that they create a diagonal that runs from the lower left of the painting to the upper right corner and that offsets the opposing diagonal of the table edge.

Dutch 17th-century art has a unique character that sets it apart from contemporaneous work elsewhere in Europe. The appeal of Dutch Baroque art lies in both its beauty and its sincerity, as well as in the insights it provides into the life and history of the Calvinist United Provinces of the Netherlands.

FRANCE

The history of France during the Baroque period is essentially the culmination of increasing monarchical authority that had been developing for centuries. This consolidation of power was embodied in King Louis XIV (r. 1661–1715), whose obsessive control determined the direction of French Baroque society and culture. Although its economy was not as expansive as that of the Dutch Republic, France was the largest and most powerful European country in the 17th century.

Invoking Classical Order In the early part of the 17th century, many French artists studied in Rome. Fascination with both ancient Roman and Italian Renaissance cultures

was largely responsible for the city's allure. NICOLAS POUSSIN (1594–1665), born in Normandy, spent most of his life in Rome. There, inspired by its monuments and countryside, he produced his grandly severe and regular canvases modeled on the work of Titian and Raphael. He also carefully worked out a theoretical explanation of his method, and was ultimately responsible for establishing classical painting as an important genre of French Baroque art.

Poussin's Et in Arcadia Ego (Even in Arcadia, I [am present]; Fig. 10-29) was informed by Raphael's rational order and stability and by antique statuary. Landscape, of which Poussin became increasingly fond, provides the setting for the picture. The foreground, however, is dominated by three shepherds, living in the idyllic land of Arcadia, who spell out an enigmatic inscription on a tomb as a statuesque female figure quietly places her hand on the shoulder of one of them. She may be the spirit of death, reminding these mortals, as does the inscription, that death is found even in Arcadia, supposedly a spot of Edenic bliss. The countless draped female statues surviving in Italy from Roman times supplied the models for this figure, and the youth with one foot resting on a boulder is modeled on Greco-Roman statues of Neptune, the sea god, leaning on his trident. The compact, balanced

10-29 | NICOLAS POUSSIN, *Et in Arcadia Ego*, ca. 1655. Oil on canvas, approx. 2' 10" × 4'. Louvre, Paris.

Poussin was the leading exponent of classicism in 17th-century Rome. His works incorporate the rational order and stability of Raphael's compositions and are peopled with figures inspired by ancient statuary.

grouping of these figures; the even light; and the thoughtful, reserved, mournful mood set the tone for Poussin's art.

In notes for an intended treatise on painting, Poussin outlined the "grand manner" of classicism, of which he became the leading exponent in Rome. Artists must first of all choose great subjects: "The first requirement, fundamental to all others, is that the subject and the narrative be grandiose, such as battles, heroic actions, and religious themes." Minute details should be avoided, as well as all "low" subjects, such as genre—"Those who choose base subjects find refuge in them because of the feebleness of their talents." Clearly, these directives rule out a good deal of decorative art, as well as the genre scenes that were popular in the Dutch Republic.

Poussin represents a theoretical tradition in Western art that goes back to the Early Renaissance. It asserts that all good art must be the result of good judgment. In this way, art can achieve correctness and propriety, two of the favorite categories of the classicizing artist or architect. Poussin praised the ancient Greeks, who "produced marvelous effects" with their musical "modes." He observed that "[t]he word 'mode' really means the system, or the measure and form which we use in making something. It constrains us not to pass the limits, it compels us to employ a certain evenness and moderation

in all things." Such evenness and moderation are the very essence of French classical doctrine. In the age of Louis XIV, scholars preached this doctrine as much for literature and music as for art and architecture.

A Landscapist Par Excellence Claude Gellée, called CLAUDE LORRAIN (1600–1682), modulated in a softer style the disciplined rational art of Poussin, with its sophisticated revelation of the geometry of landscape. Unlike the figures in Poussin's pictures, those in Claude's landscapes tell no dramatic story, point out no moral, and praise no hero. Indeed, they often appear added as mere excuses for the radiant landscape itself. For Claude, painting involved essentially one theme—the beauty of a broad sky suffused with the golden light of dawn or sunset glowing through a hazy atmosphere and reflecting brilliantly off the rippling water.

In Landscape with Cattle and Peasants (Fig. 10-30), the figures in the right foreground chat in animated fashion; in the left foreground, cattle relax contentedly; and in the middle ground, cattle amble slowly away. The well-defined foreground, distinct middle ground, and dim background recede in serene orderliness, until all form dissolves in a luminous mist. Atmospheric and linear perspective reinforce each other

10-30 | CLAUDE LORRAIN, *Landscape with Cattle and Peasants*, 1629. Oil on canvas, 3' $6'' \times 4'$ $10\frac{1}{2}''$. Philadelphia Museum of Art, Philadelphia (the George W. Elkins Collection).

Claude used atmospheric and linear perspective to transform the rustic Roman countryside filled with peasants and animals into an ideal classical landscape bathed in sunlight in infinite space.

to turn a vista into a typical Claudian vision, an ideal classical world bathed in sunlight in infinite space.

Claude's formalizing of nature with balanced groups of architectural masses, screens of trees, and sheets of water followed the great tradition of classical landscape. It began with the backgrounds of Venetian painting (Fig. 9-17) and continued in the art of Poussin (Fig. 10-29). Yet Claude, like the Dutch painters, studied the actual light and the atmospheric nuances of nature, making a unique contribution. He recorded carefully in hundreds of sketches the look of the Roman countryside, its gentle terrain accented by stone-pines, cypresses, and poplars and by ever-present ruins of ancient aqueducts, tombs, and towers. He made these the fundamental elements of his compositions.

The artist achieved his marvelous effects of light by painstakingly placing tiny value gradations, which imitated, though on a very small scale, the actual range of values of outdoor light and shade. Avoiding the problem of high-noon sunlight overhead, Claude preferred, and convincingly represented, the sun's rays as they gradually illuminated the morning sky or, with their dying glow, set the pensive mood of evening. Thus, he matched the moods of nature with those of human subjects. Claude's infusion of nature with human feeling and his recomposition of nature in a calm equilibrium greatly appealed to the landscape painters of the 18th and early 19th centuries.

Art and the Sun King The preeminent patron in Baroque France was King Louis XIV. Determined to consolidate and expand his power, Louis was a master of political strategy and propaganda. He ensured subservience by anchoring his rule in divine right (a belief in a king's absolute power as God's will). So convinced was he of his importance and centrality to the French kingdom that he eagerly adopted the nickname "the Sun King." Like the sun, Louis was the center of the universe. He also established a carefully crafted and nuanced relationship with the nobility. He allowed nobles sufficient benefits to keep them pacified but simultaneously maintained rigorous control to avoid insurrection or rebellion.

Louis's desire for control extended to all realms of French life, including art. The king and his principal adviser, Jean-Baptiste Colbert (1619–1683), were determined to organize art and architecture in the service of the state. They understood well the power of art as propaganda and the value of visual imagery for cultivating a public persona. No pains were spared to raise great symbols and monuments to the king's absolute power. The efforts of Louis XIV and Colbert to regularize taste were furthered by the foundation of the Royal Academy of Painting and Sculpture in 1648, which served to accelerate the establishment of the French classical style.

The portrait of Louis XIV (Fig. 10-31) by HYACINTHE RIGAUD (1659-1743) conveys the image of an absolute monarch in control. The king, 63 when this work was painted, looks out at the viewer with directness. The suggestion of haughtiness is perhaps due to the pose. Louis XIV

HYACINTHE RIGAUD, Louis XIV, 1701. Oil on canvas, approx. 9' 2" × 6' 3". Louvre, Paris.

In this portrait set against a stately backdrop, Rigaud portrayed the 5' 4" French monarch, the "Sun King," with his ermine-lined coronation robes thrown over his shoulder and wearing red high-heeled shoes.

stands with his left hand on his hip and with his elegant ermine-lined coronation robes thrown over his shoulder. The portrait's majesty is also derived from the composition. The king is the unmistakable focal point of the image, and the artist placed him so that he seems to look down on the viewer. Given that Louis XIV was very short in stature—only 5' 4", a fact that drove him to invent the high-heeled shoes he wears in the portrait—it seems the artist catered to his patron's wishes. The carefully detailed environment in which the king stands also contributes to the painting's stateliness and grandiosity.

From Hunting Lodge to Palace Louis XIV was also a builder on a grand scale. One of his projects was to convert a royal hunting lodge at Versailles, a few miles outside Paris, into a great palace. A veritable army of architects, decorators, sculptors, painters, and landscape architects was assembled

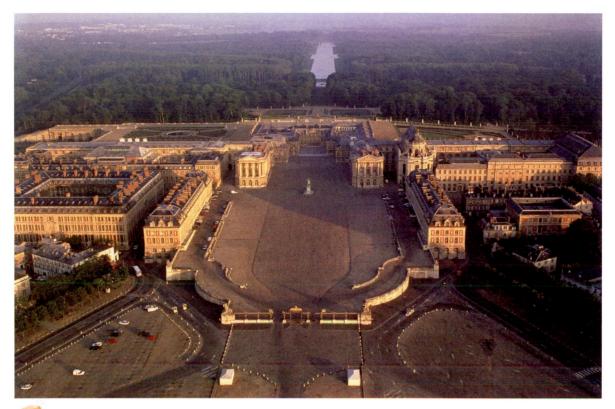

10-32 | Aerial view of palace at Versailles, France, begun 1669, and a portion of the gardens and surrounding area.

Louis XIV assembled a veritable army of architects, decorators, sculptors, painters, and landscape architects to convert a royal hunting lodge at Versailles into a great Baroque palace set in a vast park.

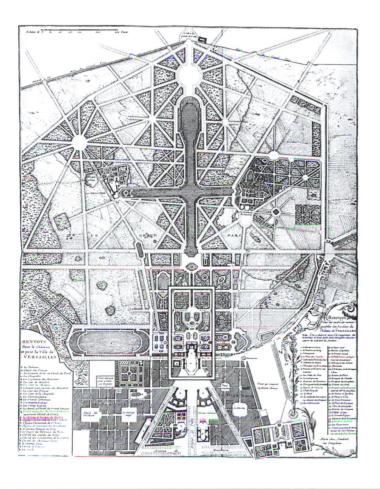

under the general management of CHARLES LE BRUN (1619–1690), a former student of Poussin. In their hands, the conversion of a simple lodge into the palace of Versailles (Figs. 10-32 and 10-33) became the greatest architectural commission of the age—a defining statement of French Baroque style and an undeniable symbol of Louis XIV's power and ambition.

Planned on a gigantic scale, the project called not only for a large palace flanking a vast park but also for the construction of a satellite city to house court and government officials, military and guard detachments, courtiers, and servants (undoubtedly to keep them all under the king's close supervision). This town was laid out to the east of the palace along three radial avenues that converge on the palace structure itself. Their axes, in a symbolic assertion of the ruler's absolute power over his domains, intersected in the king's bedroom, which

10-33 | Plan of the park, palace, and town of Versailles, France, (after a 17th-century engraving by François Blondel). The area outlined in the white rectangle (lower center) is shown in Fig. 10-32.

The Versailles project called not only for a gigantic palace and park but also for the construction of a satellite city, which was laid out along three radial avenues that intersected in the French king's bedroom.

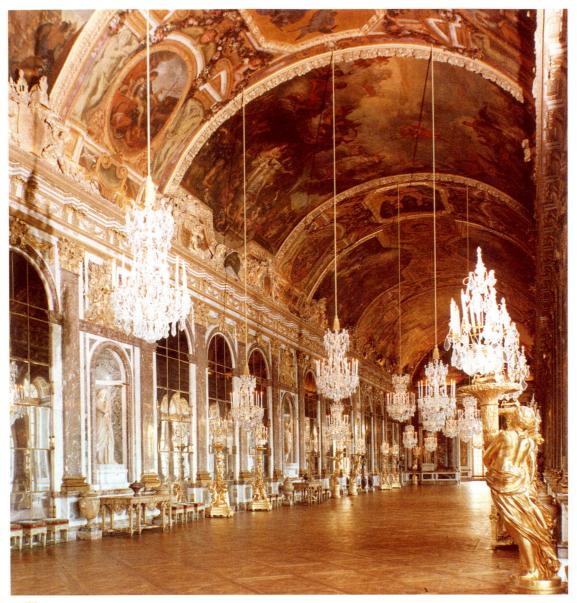

10-34 | Jules Hardouin-Mansart and Charles Le Brun, Galerie des Glaces (Hall of Mirrors), palace of Versailles, Versailles, France, ca. 1680.

This hall overlooks the Versailles park from the second floor of Louis XIV's palace. Hundreds of mirrors illusionistically extend the room's width and once reflected sumptuous gilded and jeweled furnishings.

also served as an audience room. The palace itself, more than a quarter of a mile long, was placed at right angles to the dominant east-west axis that runs through city and park.

Careful attention was paid to every detail of the extremely rich decoration of the palace's interior. The architects and decorators designed everything from wall paintings to door-knobs, to reinforce the splendor of Versailles and to exhibit the very finest sense of artisanship. Of the literally hundreds of rooms within the palace, the most famous is the Galerie des Glaces, or Hall of Mirrors (Fig. 10-34), designed by JULES HARDOUIN-MANSART (1646–1708) and Le Brun. This hall overlooks the park from the second floor and extends along most of the width of the central block. Although deprived of its original sumptuous furniture, which included gold and

silver chairs and bejeweled trees, the Galerie des Glaces retains much of its splendor today. Its tunnel-like quality is alleviated by hundreds of mirrors, set into the wall opposite the windows, that illusionistically extend the width of the room. The mirror, that ultimate source of illusion, was a favorite element of Baroque interior design. Here, it also enhanced the dazzling extravagance of the great festivals Louis XIV was so fond of hosting.

Controlling Nature The enormous palace might appear unbearably ostentatious were it not for its extraordinary setting in the vast park that makes it almost an adjunct. The Galerie des Glaces is dwarfed by the sweeping vista (seen from its windows) down the park's tree-lined central axis and

across terraces, lawns, pools, and lakes toward the horizon. The park of Versailles, designed by André Le Nôtre (1613–1700), must rank among the world's greatest artworks in both size and concept. Here, an entire forest was transformed into a park. Although the geometric plan (Fig. 10-33) may appear stiff and formal, the park in fact offers an almost unlimited variety of vistas, as Le Nôtre used not only the multiplicity of natural forms but also the terrain's slightly rolling contours with stunning effectiveness.

The formal gardens near the palace provide a rational transition from the frozen architectural forms to the natural living ones. Here, the elegant forms of trimmed shrubs and hedges define the tightly designed geometric units. Each unit is different from its neighbor and has a focal point in the form of a sculptured group, a pavilion, a reflecting pool, or perhaps a fountain. Farther away from the palace, the design loosens as trees, in shadowy masses, screen or frame views of open countryside. Le Nôtre carefully composed all vistas for maximum effect. Dark and light, formal and informal, dense growth and open meadows—all play against one another in unending combinations and variations. No photograph or series of photographs can reveal the design's full richness. The park unfolds itself only to people who actually walk through it.

ENGLAND

The authority of the absolute monarchy that prevailed in France was not found in England. Common law and the Parliament kept royal power in check. Thus, during the 17th and early 18th centuries, England experienced the development of both limited monarchy and constitutionalism. Although an important part of English life, religion was not the contentious issue it was on the continent. The religious affiliations of the English included Catholicism, Anglicanism, Protestantism, and Puritanism (the English version of Calvinism). In the economic realm, England was the one country (other than the Dutch Republic) to take advantage of the opportunities offered by overseas trade. England, like the Dutch Republic, possessed a large and powerful navy, as well as excellent maritime capabilities.

The most significant contributions England made to Baroque art were in the field of architecture, much of it incorporating classical elements.

Wren and Saint Paul's Until recently, the dominant feature of the London skyline was the majestic dome of Saint Paul's Cathedral (Fig. 10-35), the work of England's most renowned architect, Christopher Wren (1632–1723). A mathematical genius and skilled engineer whose work won Isaac Newton's praise, Wren was appointed professor of astronomy in London at age 25. Mathematics led to architecture, and Charles II (r. 1660–1685) asked Wren to prepare a plan for restoring the old Gothic Church of Saint Paul. Wren proposed to remodel the building based on Roman structures.

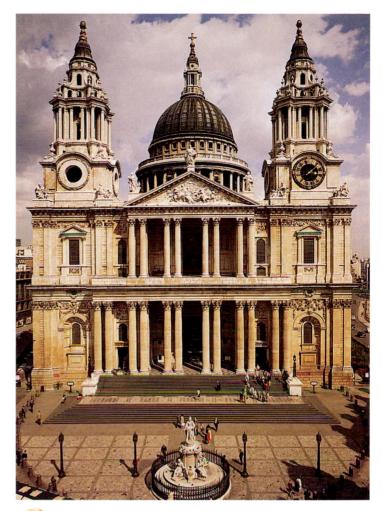

10-35 | SIR CHRISTOPHER WREN, new Saint Paul's Cathedral, London, England, 1675–1710.

Wren's new facade for this old Gothic church drew on French and Italian Renaissance and Baroque designs, including those of Palladio and Borromini. The great dome recalls that of Saint Peter's in Rome (FIGS. 10-1 AND 10-2).

Within a few months, the Great Fire of London, which destroyed the old structure and many churches in the city in 1666, gave Wren his opportunity. He built not only the new Saint Paul's but numerous other churches as well.

Wren had traveled in France, where he must have been much impressed by the splendid palaces and state buildings being created in and around Paris. He also must have closely studied prints illustrating Baroque architecture in Italy, for he harmonized Palladian, French, and Italian Baroque features in Saint Paul's.

In view of its size, the cathedral was built with remarkable speed—in a little more than 30 years—and Wren lived to see it completed. The building's form was constantly refined as it went up, and the final appearance of the towers was not determined until after 1700. In the splendid skyline composition, two foreground towers act effectively as foils to the great dome. This must have been suggested to Wren by similar schemes that Italian architects devised for Saint Peter's in

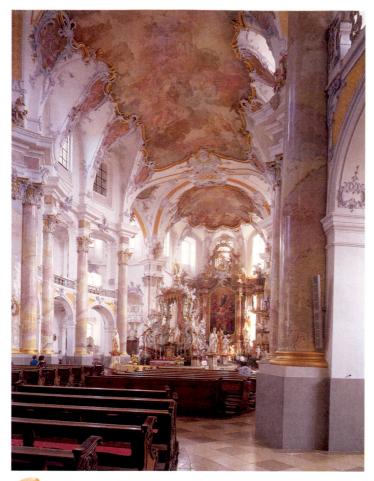

10-36 | Balthasar Neumann, interior of the pilgrimage chapel of Vierzehnheiligen, near Staffelstein, Germany, 1743–1772.

Neumann's design for this richly decorated pilgrimage church exhibits a vivacious play of architectural fantasy that retains the Italian Baroque's dynamic energy but shuns all its dramatic qualities.

Rome (Figs. 10-1 and 10-2) to solve the problem of the relationship between the facade and dome. The upper levels and lanterns of the towers are Borrominesque (Fig. 10-7), the lower levels are Palladian, and the superposed paired columnar porticos have parallels in contemporaneous French architecture. Wren's skillful eclecticism brought all these foreign features into a monumental unity.

GERMANY

As it did elsewhere in Europe, the work of Borromini and other Italian architects strongly influenced the ecclesiastical architecture of southern Germany and Austria in the late 17th and early 18th centuries.

Fourteen Saints One of the most splendid Baroque buildings in Germany is the pilgrimage church of Vierzehnheiligen (Fourteen Saints), designed by BALTHASAR NEUMANN (1687–1753) and built near Staffelstein. Born in the German part of Bohemia, Neumann traveled in Austria and northern Italy and studied in Paris before returning home to become one of the most active architects working in his native land. Numerous large windows in the richly decorated but continuous walls of Vierzehnheiligen flood the interior with an even, bright, and cheerful light. The pilgrimage church chapel (Fig. 10-36) exhibits a vivacious play of architectural fantasy that retains the Italian Baroque's dynamic energy but shuns all its dramatic qualities.

In his design for Vierzehnheiligen, Neumann seems to have deliberately banished the straight line. The church's plan is made up of tangent ovals and circles, achieving a quite different interior effect within the essential outlines of the traditional Gothic church (apse, transept, nave, and western towers). Undulating space is in continuous motion, creating unlimited vistas bewildering in their variety and surprise effects. The structure's features pulse, flow, and commingle as if they were ceaselessly in the process of being molded. The design's fluency of line, the floating and hovering surfaces, the interwoven spaces, and the dematerialized masses combine to suggest a "frozen" counterpart to the intricacy of voices in a Bach fugue. The church is a brilliant ensemble of architecture, painting, sculpture, and music, dissolving the boundaries of the arts in a visionary unity.

CONCLUSION

The art produced during the 17th and early 18th centuries was truly diverse, making any comprehensive summary of the "Baroque" period impossible. Each country encountered a different set of historical challenges, and even within national boundaries a wide variety of art forms emerged. For example, whereas drama and complexity were hallmarks of much of Italian Baroque art (especially that commissioned for the Catholic Church), Dutch Baroque art was characterized to a greater degree by restrained genre scenes, still lifes, and portraits produced for a growing class of merchant patrons.

Despite this period's lack of consistency in artistic development, its legacy was lasting. Many of the concerns of 17th-and early-18th-century artists, such as direct observation, emotional intensity, and manipulation of light and color, laid the foundation for two styles that emerged in the late 18th century, Neoclassicism and Romanticism. Further, the influence of such artists as Caravaggio, Bernini, Velázquez, Rubens, Rembrandt, and Vermeer, among many others, resonates in art to the present day.

1600

- Pope Paul V, r. 1605–1621
 - I Galileo Galilei refines telescope, 1609
 - Johannes Kepler's laws of planetary motion, 1609–1619
 - I Thirty Years' War, 1618-1648
 - Philip IV of Spain, r. 1621-1665
 - Pope Urban VIII, r. 1623–1644

1625

- Charles I of England, r. 1625-1649
- Pope Innocent X, r. 1644-1655
- I Treaty of Westphalia, 1648
- I United Provinces of the Netherlands founded, 1648
- I French Royal Academy of Painting and Sculpture founded, 1648

1650

2

- Pope Alexander VII, r. 1655-1667
- Charles II of England, r. 1660-1685
- Louis XIV of France, r. 1661-1715

1675

I Sir Isaac Newton's laws of motion, gravitation, 1687

1 Caravaggio, Conversion of Saint Paul, ca. 1601

Gianlorenzo Bernini, Cornaro Chapel, Santa Maria della Vittoria, Rome, 1645–1652

3 Jacob van Ruisdael, View of Haarlem from the Dunes at Overveen, ca. 1670

1725

1700

4

4 Hyacinthe Rigaud, Louis XIV, 1701

EUROPE AND AMERICA, 1750-1850

From 1750 to 1850, Europe (MAP 11-1, page 531) and America experienced profound change, both politically and culturally. Revolution overthrew the monarchy in France and gave birth to the United States. In art, this 100-year period saw Rococo give way to Neoclassicism and Romanticism. A new art form—photography—was also invented. In this chapter, we examine these diverse artistic currents.

We begin, however, with the death of Louis XIV in 1715, which had a major impact on French high society. The court of Versailles was at once abandoned for the pleasures of town life. Although French citizens still owed their allegiance to a monarch, the early 18th century saw a resurgence of aristocratic social, political, and economic power. The nobility reestablished their predominance as art patrons, and the elegant town houses of Paris soon became the centers of a new style called Rococo.

ROCOCO

Rococo appeared in France around 1700, primarily as a style of interior design. *Rococo* came from the French word *rocaille*, which literally means "pebble," but the term referred especially to the small stones and shells used to decorate grotto interiors. Such shells or shell forms were the principal motifs in Rococo ornament.

The Rococo salon was the center of Parisian society in the early 1700s, and Paris was the social capital of Europe. The medium of social intercourse was conversation spiced with wit, repartee as quick and deft as a fencing match. Artifice reigned supreme, and participants considered enthusiasm or sincerity in bad taste. Wealthy, ambitious, and clever society hostesses competed to attract the most famous and the most accomplished people to their salons. French Rococo salons were designed as lively total works of art with elegant furniture, enchanting small sculptures, ornamented mirror frames, delightful ceramics and silver, and decorative tapestry complementing the architecture, relief sculptures, and wall paintings.

French Rococo in Germany One of the finest examples of French Rococo interior design is, ironically, not in Paris but in Germany. The Amalienburg is a small lodge the French architect François de Cuvillés (1695–1768) built in the park of the Nymphenburg Palace in Munich. The lodge's spectacular circular Hall of Mirrors (Fig. 11-1) is a silver-and-blue ensemble of architecture, stucco relief, silvered bronze mirrors, and crystal. It dazzles the eye with myriad

Jacques-Louis David, The Death of Marat, 1793. Oil on canvas, approx. 5' 3" × 4' 1". Musées Royaux des Beaux-Arts de Belgique, Brussels.

11-1 | FRANÇOIS DE CUVILLIÉS, Hall of Mirrors, the Amalienburg, Nymphenburg Palace park, Munich, Germany, early 18th century.

Designed by a French architect, this circular hall in a German lodge displays the Rococo style at its zenith. It dazzles the eye with the organic interplay of silvered bronze mirrors, crystal, and stucco relief.

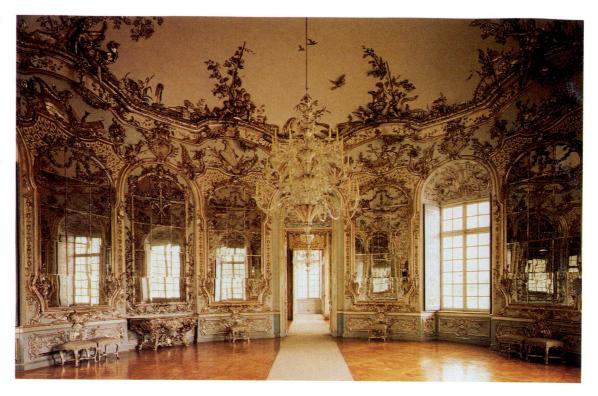

scintillating motifs, forms, and figurations, displaying the Rococo style at its zenith. Facets of silvery light, multiplied by windows and mirrors, sharply or softly delineate the endlessly proliferating shapes and contours that weave rhythmically around the upper walls and the ceiling coves. Everything seems organic, growing, and in motion, an ultimate refinement of illusion that the architect, artists, and artisans, all magically in command of their varied media, created with virtuoso flourishes. Rococo rooms like this one harmonized perfectly with the era's elaborate costumes of satin and brocade, and with the equally elegant etiquette and sparkling wit of the people who graced them.

Celebrating the Good Life Antoine Watteau (1684– 1721) is the painter most closely associated with French Rococo. He was largely responsible for creating a specific type of Rococo painting, called a fête galante painting, which depicted the outdoor amusements of upper-class society. Such a painting is Watteau's Return from Cythera (Fig. 11-2), completed between 1717 and 1719 as the artist's acceptance piece for admission to the French Royal Academy of Painting and Sculpture. At the turn of the century, the Royal Academy was divided rather sharply between two doctrines. One doctrine upheld the ideas of Le Brun (the major proponent of French Baroque under Louis XIV), who followed Nicolas Poussin in teaching that form was the most important element in painting, whereas "colors in painting are as allurements for persuading the eyes"1—additions for effect and not really essential. The other doctrine, with Rubens as its model, proclaimed the supremacy of color over form. Depending on which side they took, Academy members were called "Poussinistes" or "Rubénistes." Watteau was Flemish, and his work was deeply

influenced by Rubens's coloristic style. With Watteau in their ranks, the Rubénistes carried the day and established Rococo as the dominant painting style in France.

Return from Cythera represents a group of lovers preparing to depart from the island of eternal youth and love, sacred to Aphrodite. Young and luxuriously costumed, they move gracefully from the protective shade of a woodland park, filled with amorous cupids and voluptuous statuary, down a grassy slope to an awaiting golden barge. Watteau's figural poses, worked out in many preliminary drawings, combine elegance and sweetness. The drawings show that Watteau observed slow movement from difficult and unusual angles, intending to find the smoothest, most poised, and most refined attitudes. Watteau also strove for the most exquisite shades of color difference, defining in a single stroke the shimmer of silk at a bent knee or the iridescence that touches a glossy surface as it emerges from shadow. The haze of color, the subtly modeled shapes, the gliding motion, and the air of suave gentility were all to the taste of the Rococo artist's wealthy patronage.

An Intriguing Flirtation Watteau died when he was only 37 years old, but the Rococo painting manner he pioneered was carried on by others. Jean-Honoré Fragonard (1732–1806) was one of the leading Rococo painters of the mid-18th century. The Swing (Fig. 11-3) can stand as characteristic not only of Fragonard's work but also of the later Rococo in general. It is a typical Rococo "intrigue" picture. A young gentleman has managed an arrangement whereby an unsuspecting old bishop swings the young man's pretty sweetheart higher and higher, while her lover (and the work's patron), in the lower left-hand corner, stretches out to admire her ardently from a strategic position on the ground. The young

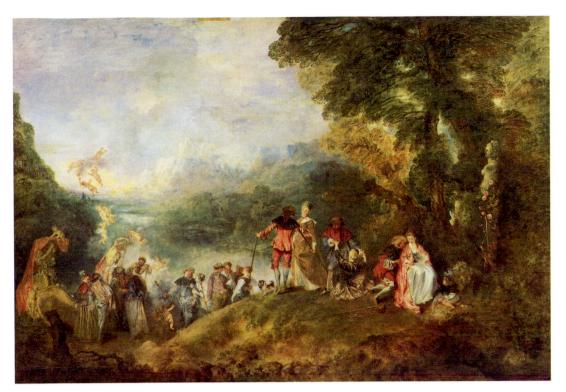

11-2 | ANTOINE WATTEAU, *Return from Cythera*, 1717–1719. Oil on canvas, approx. 4' 3" × 6' 4". Louvre, Paris.

Watteau's fête galante paintings depict the outdoor amusements of French upper-class society. The haze of color, subtly modeled shapes, gliding motion, and air of suave gentility match Rococo taste.

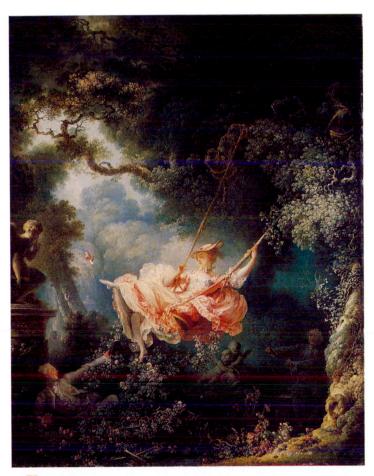

11-3 | JEAN-HONORÉ FRAGONARD, *The Swing*, 1766. Oil on canvas, approx. 2' 11" × 2' 8". The Wallace Collection, London.

The glowing pastel colors and soft light complement the sensuality of this Rococo "intrigue" picture in which a young lady flirtatiously kicks off her shoe at a statue of Cupid as her lover watches.

lady flirtatiously and boldly kicks off her shoe at the little statue of Cupid, who holds his finger to his lips. The land-scape setting is out of Watteau—a luxuriant perfumed bower in a park that very much resembles a stage scene for the comic opera. The glowing pastel colors and soft light convey, almost by themselves, the theme's sensuality.

THE ENLIGHTENMENT

By the end of the 18th century, revolutions had erupted in France and America. A major factor in the political, social, and economic changes that led to revolution was the Enlightenment. The Enlightenment was a new way of thinking critically about the world and about humankind, independently of religion, myth, or tradition. The new method was based on using reason to reflect on the results of physical experiments and was grounded in empirical evidence. Enlightenment thought promoted the scientific questioning of all assertions and rejected unfounded beliefs about the nature of humankind and of the world.

The Doctrine of Empiricism The Enlightenment had its roots in the 17th century, with the mathematical and scientific achievements of René Descartes, Blaise Pascal, Isaac Newton, and Gottfried Wilhelm von Leibnitz. England and France were the principal centers of the Enlightenment, though its dictums influenced the thinking of intellectuals throughout Europe and in the American colonies. Benjamin Franklin, Thomas Jefferson, and other American notables were educated in its principles. Of particular importance for Enlightenment thought was the work of Britons Isaac Newton (1642–1727) and John Locke (1632–1704).

In Newton's scientific studies, he insisted on empirical proof of his theories and encouraged others to avoid metaphysics and the supernatural—realms that extended beyond the natural physical world. This emphasis on both tangible data and concrete experience became a cornerstone of Enlightenment thought. John Locke, whose works acquired the status of Enlightenment gospel, developed these ideas further. What we know, wrote Locke, comes to us through sense perception of the material world and is imprinted on the mind as on a blank tablet. From these perceptions alone we form ideas. Our ideas are not innate or God given; it is only from experience that we can know. This belief is called the "doctrine of empiricism." Locke asserted that human beings are born good, not cursed by Original Sin. The laws of Nature grant them the natural rights of life, liberty, and property, as well as the right to freedom of conscience. Government is by contract, and its purpose is to protect these rights. If and when government abuses these rights, the citizenry has the further natural right of revolution.

The Doctrine of Progress The work of Newton and Locke also inspired French intellectuals. New philosophies that conceived of individuals and societies at large as parts of physical nature were advanced by thinkers in France, who are still known by their French designation *philosophes*. They shared the conviction that the ills of humanity could be remedied by applying reason and common sense to human problems. They criticized the powers of church and state as irrational limits placed on political and intellectual freedom. They believed that by the accumulation and propagation of knowledge, humanity could advance by degrees to a happier state than it had ever known. This conviction matured into the

characteristically modern "doctrine of progress" and its corollary doctrine of the perfectibility of humankind.

Animated by their belief in human progress and perfectibility, the philosophes took on the task of gathering knowledge and making it accessible to all who could read. Their program was, in effect, the democratization of knowledge. Denis Diderot (1713–1784) became editor of the pioneering 35-volume *Encyclopédie*, a compilation of articles and illustrations written by more than a hundred contributors, including all the leading philosophes. The *Encyclopédie* was truly comprehensive (its formal title was *Systematic Dictionary of the Sciences*, *Arts, and Crafts*; 1751–1780) and included all available knowledge—historical, scientific, and technical, as well as religious and moral—and political theory.

Voltaire and Revolution François Marie Arouet, better known as Voltaire (1694–1778) became, and still is, the most representative figure—almost the personification—of the Enlightenment's spirit and the revolutions it inspired. Voltaire was instrumental in introducing Newton and Locke to the French intelligentsia. He hated, and attacked through his writings, the arbitrary despotic rule of kings, the selfish privileges of the nobility and the church, religious intolerance, and, above all, the injustice of the *ancien regime* (the "old order"). Voltaire converted a whole generation to the conviction that fundamental changes were necessary. This conviction paved the way for the French Revolution as well as the American Revolution.

The Notion of Modernity Thus, the Age of Enlightenment ushered in a new way of thinking and affected historical developments worldwide. In the arts, the new thought patterns can be seen in the general label "modern" used to describe

of Derby, A Philosopher Giving a Lecture at the Orrery (in which a lamp is put in place of the sun), ca. 1763–1765. Oil on canvas, 4′ 10″ × 6′ 8″. Derby Museums and Art Gallery, Derby.

Wright's celebration of the inventions of the Industrial Revolution was in tune with the Enlightenment doctrine of progress. In this dramatically lit scene, everyone is caught up in the wonders of scientific knowledge.

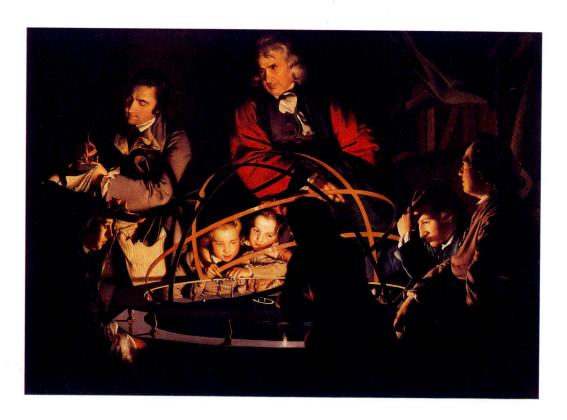

European and American art from the late 18th century on. Such a vague and generic term, covering centuries of art, renders any concrete definition of "modern art" virtually impossible. However, one defining characteristic traditionally ascribed to the modern era is an awareness that cultures perpetuate or reject previously established ideas or conventions. The concept of modernity—the state of being modern—involves being up-to-date, implying a distinction between the present and the past.

Science and Art Enlightenment scientific investigation and technological invention opened up new possibilities for human understanding of the world and for control of its material forces. Research into the phenomena of electricity and combustion, along with the discovery of oxygen and the power of steam, had enormous consequences. Steam power as an adjunct to, or replacement for, human labor began a new era in world history, beginning with the Industrial Revolution in England.

The fascination technological progress had for ordinary people as well as for the learned is the subject of A Philosopher Giving a Lecture at the Orrery (Fig. 11-4) by the English painter JOSEPH WRIGHT OF DERBY (1734-1797). Wright specialized in the drama of candlelit and moonlit scenes. He loved subjects such as the orrery demonstration, which could be illuminated by a single light from within the picture. In the painting, a scholar uses a special technological model (called an orrery) to demonstrate the theory that the universe operates like a gigantic clockwork mechanism. Light from the lamp, representing the sun, pours forth from in front of the boy silhouetted in the foreground to create dramatic light and shadows that heighten the drama of the scene. Awed children crowd close to the tiny metal orbs that represent the planets within the arcing bands that symbolize their orbits. An earnest listener makes notes, while the lone woman seated at the left and the two gentlemen at the right look on with rapt attention. Everyone in Wright's painting is caught up in the wonders of scientific knowledge. An ordinary lecture takes on the qualities of a historical event. Wright's elevation of the theories and inventions of the Industrial Revolution to the plane of history painting was in tune with the Enlightenment doctrine of progress.

THE TASTE FOR THE "NATURAL"

The name of Jean-Jacques Rousseau (1712–1778) is traditionally invoked along with that of Voltaire as representative of the French Enlightenment and as an individual instrumental in preparing the way ideologically for the French Revolution. Yet Voltaire, as has been noted, thought that the salvation of humanity was in the advancement of science and in the rational improvement of society. In contrast, Rousseau declared that the arts, sciences, society, and civilization in general had corrupted "natural man." According to Rousseau, "Man by nature is good . . . he is depraved and perverted by society."

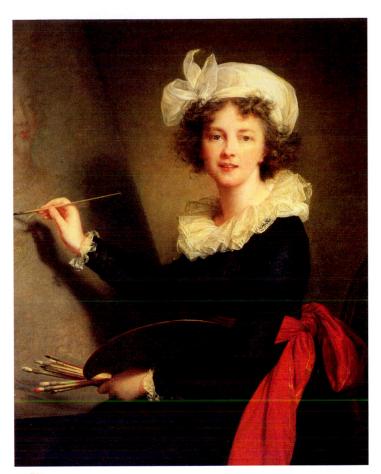

11-5 | ÉLISABETH LOUISE VIGÉE-LEBRUN, Self-Portrait, 1790. Oil on canvas, 8' 4" × 6' 9". Galleria degli Uffizi, Florence.

Vigée-Lebrun was one of the few women admitted to the Royal Academy of Painting and Sculpture. Here, the renowned portrait painter depicted herself confidently painting the likeness of Queen Marie Antoinette.

He rejected the idea of progress, insisting that "Our minds have been corrupted in proportion as the arts and sciences have improved." The society Rousseau attacked was Rococo France. Rousseau's views, widely read and popular, were largely responsible for the turning away from the Rococo sensibility and the formation of a taste for the "natural," as opposed to the artificial.

Natural Portraiture The "naturalistic" approach to art can be seen in the self-portrait (Fig. 11-5) ÉLISABETH LOUISE VIGÉE-LEBRUN (1755–1842) painted in 1790. The artist pauses in her work to turn and look directly at the viewer. Although her mood is lighthearted and her costume's details echo the serpentine curve beloved by Rococo artists and wealthy patrons, nothing about Vigée-Lebrun's pose or her mood speaks of Rococo frivolity. Hers is the self-confident stance of a woman whose art has won her an independent role in her society. Like many of her contemporaries, Vigée-Lebrun lived a life of extraordinary personal and economic independence, working for the nobility throughout Europe. She was famous

for the force and grace of her portraits, especially those of highborn ladies and royalty. She was successful during the age of the late monarchy in France and was one of the few women admitted to the Royal Academy of Painting and Sculpture. After the French Revolution, her membership in the Academy was rescinded, because women were no longer welcome in that organization. Vigée-Lebrun's continued success was indicative of her talent, her wit, and her ability to forge connections with those in power in the postrevolutionary period. For her self-portrait, Vigée-Lebrun painted herself in a close-up, intimate view at work on one of the portraits that won her renown, that of Queen Marie Antoinette. The naturalism and intimacy of her expression reflect the ideals of independence and self-reliance Vigée-Lebrun exhibited as a woman.

Grand Manner Portraiture A contrasting blend of "naturalistic" representation and Rococo setting is found in Mrs. Richard Brinsley Sheridan (Fig. 11-6) by the English painter THOMAS GAINSBOROUGH (1727–1788). This portrait shows the lovely woman, dressed informally, seated in a rustic landscape faintly reminiscent of Watteau (Fig. 11-2) in its soft-hued light and feathery brushwork. Gainsborough intended to match the natural, unspoiled beauty of the landscape with that of his subject. Her dark brown hair blows freely in the slight wind, and her clear "English" complexion and air of ingenuous sweetness contrast sharply with the pert sophistication of continental Rococo portraits. The artist originally had planned to give the picture a more pastoral air by adding several sheep, but he did not live long enough to paint them in. Even without this element, the painting clearly expresses Gainsborough's deep interest in the landscape setting. Although Gainsborough won greater fame in his time for his portraits, he had begun as a landscape painter and always preferred painting scenes of nature to the depiction of human likenesses.

Such a portrait is representative of what became known as Grand Manner portraiture, and Gainsborough was recognized as one of the leading practitioners of this genre. Although clearly depicting individualized people, Grand Manner portraiture also elevated the sitter by conveying refinement and elegance. Such grace and class were communicated through certain standardized conventions, such as the large scale of the figures relative to the canvas, the controlled poses, the landscape (often Arcadian) setting, and the low horizon line. Thus, despite the naturalism central to Gainsborough's portraits, he tempered it with a degree of artifice. This combination of aristocratic Rococo sophistication with rustic naturalism is an example of the hybrid nature of styles and reveals the dangers of the art historical penchant for categorizing artists and their works.

Hogarth and Satirical Painting Very different from Gainsborough's is the art of his elder contemporary, **WILLIAM** HOGARTH (1697–1764), who satirized contemporary life with comic zest. With Hogarth, a truly English style of painting emerged. Traditionally, the English imported painters

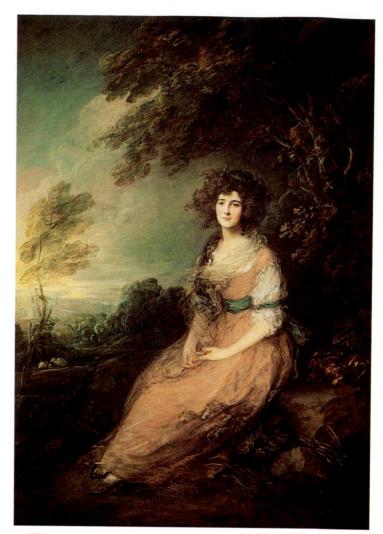

11-6 | THOMAS GAINSBOROUGH, Mrs. Richard Brinsley Sheridan, 1787. Oil on canvas, approx. $7' 2\frac{5}{8}'' \times 5' \frac{5}{8}''$. National Gallery of Art, Washington, D.C. (Andrew W. Mellon Collection).

In this Grand Manner portrait, Gainsborough intended to match the natural beauty of his subject with that of the landscape. The rustic setting, softhued light, and feathery brushwork recall Watteau ($F_{\rm IG}$. 11-2).

(such as Holbein, Rubens, and Van Dyck) from the continent. Hogarth waged a lively campaign throughout his career against the English feeling of dependence on, and inferiority to, continental artists. Although Hogarth would have been the last to admit it, his own painting owed much to the work of his contemporaries across the channel in France, the Rococo artists. Yet his subject matter, frequently moral in tone, was distinctively English. It was the great age of English satirical writing, and Hogarth saw himself as translating satire into the visual arts.

Hogarth's favorite device was to make a series of narrative paintings and prints, in a sequence like chapters in a book or scenes in a play, that followed a character or group of characters in their encounters with some social evil. He was at his best in pictures such as *Breakfast Scene* (Fig. 11-7) from *Marriage à la Mode*. This scene is one in a sequence of six paintings that satirize the immoralities practiced within marriage

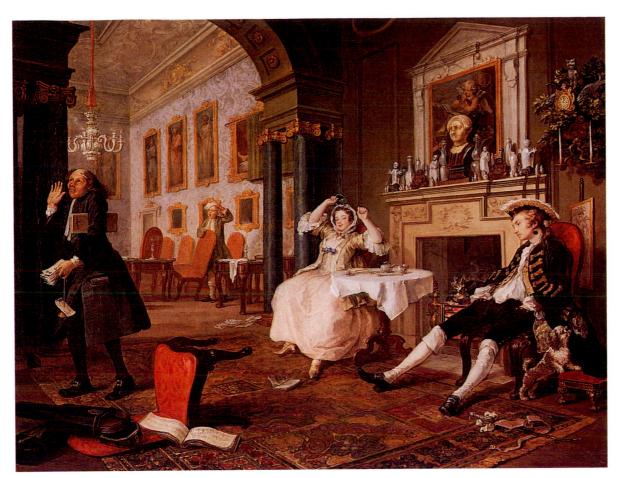

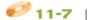

WILLIAM HOGARTH, Breakfast Scene, from Marriage à la Mode, ca. 1745. Oil on canvas, approx. 2' 4" × 3'. National Gallery, London.

Hogarth was famous for his paintings and prints satirizing contemporary English life with comic zest. This is one of a series of six paintings in which he chronicled the marital immoralities of the moneyed class.

by the moneyed classes in England. In it, a marriage is just beginning to founder. The husband and wife are tired after a long night spent in separate pursuits. While the wife stayed at home for an evening of cards and music-making, her young husband had been away from the house for a night of suspicious business. His hands are thrust deep into the empty money-pockets of his breeches, while his wife's small dog sniffs inquiringly at a woman's lacy cap protruding from his coat pocket. A steward, his hands full of unpaid bills, raises his eyes to Heaven in despair at the actions of his noble master and mistress. The house is palatial, but Hogarth filled it with witty clues to the dubious taste of its occupants. The piety demonstrated by the paintings of religious figures that hang on the upper wall of the distant room is countered by the curtained canvas at the end of the row that undoubtedly depicts an erotic subject. Appropriately, this painting is discretely hidden from the eyes of casual visitors and ladies, according to the custom of the day, but is available at the pull of a curtain cord for the gaze of the master and his male guests. In this composition, as in all his work, Hogarth proceeded as a novelist might, elaborating on his subject with carefully chosen detail, whose discovery heightens the comedy.

General Wolfe's Heroic Death Morality of a very different tone, yet in harmony with "naturalness," included the virtues of honor, valor, and love of country. Enlightenment philosophers believed that these virtues produced great people

and exemplary deeds. The concept of "nobility," especially as discussed by Rousseau, referred to character, not to aristocratic birth. As the century progressed and people felt the tremors of coming revolutions, these virtues of courage and resolution, patriotism, and self-sacrifice assumed greater importance. Having risen from humble origins, the modern military hero, not the decadent aristocrat, brought the excitements of war into the company of the "natural" emotions.

BENJAMIN WEST (1738–1820) was born in Pennsylvania, on what was then the American colonial frontier, but he was sent to Europe early in life to study art. West eventually settled in England and became a cofounder of the British Royal Academy of Arts and official painter to King George III (r. 1760–1820), retaining that position even during the strained period of the American Revolution. In The Death of General Wolfe (Fig. 11-8), West depicted the mortally wounded young English commander just after his defeat of the French in the decisive battle of Quebec in 1759, which gave Canada to Great Britain. West chose to portray a contemporary historical subject, and his characters wear contemporary costume. However, West blended this realism of detail with the grand tradition of history painting by arranging his figures in a complex and theatrically ordered composition. His modern hero dies among grieving officers on the field of victorious battle in a way that suggests the death of a great saint. West wanted to present this hero's death in the service of the state as a martyrdom charged with religious emotions. His innovative combination of the conventions of

WEST, The Death of General Wolfe, 1771. Oil on canvas, approx. 5' × 7'. National Gallery of Canada, Ottawa (gift of the Duke of Westminster, 1918).

West blended the realism of his contemporary subject and costumes with the grand tradition of history painting by arranging his figures in a complex and theatrically ordered composition.

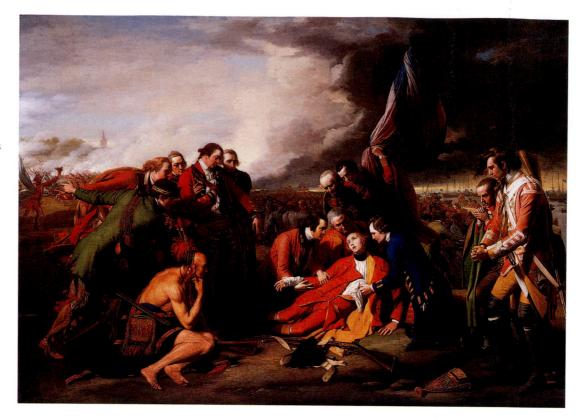

traditional heroic painting with a look of modern realism was so effective that it continued to influence history painting well into the 19th century.

Paul Revere, Silversmith JOHN SINGLETON COPLEY (1738-1815) matured as a painter in the Massachusetts Bay Colony. Like West, Copley later emigrated to England, where he absorbed the fashionable English portrait style. But unlike Grand Manner portraiture, Copley's Portrait of Paul Revere (Fig. 11-9), painted before Copley left Boston, conveys a sense of directness and faithfulness to visual fact that marked the taste for "downrightness" and plainness many visitors to America noticed during the 18th and 19th centuries. When the portrait was painted, Revere was not yet the familiar hero of the American Revolution. In the picture, he is working at his everyday profession of silversmithing. The setting is plain, the lighting clear and revealing. The subject sits in his shirtsleeves, bent over a teapot in progress. He pauses and turns his head to look the observer straight in the eye. The artist treated the reflections in the polished wood of the tabletop with as much care as Revere's figure, his tools, and the teapot resting on its leather graver's pillow. Copley gave special

11-9 | JOHN SINGLETON COPLEY, *Portrait of Paul Revere*, ca. 1768–1770. Oil on canvas, 2' $11\frac{1}{8}$ " × 2' 4". Museum of Fine Arts, Boston (gift of Joseph W., William B., and Edward H. R. Revere).

In contrast to Grand Manner portraiture, Copley's painting of Paul Revere emphasizes his subject's down-to-earth character, differentiating this American work from its British and continental counterparts.

prominence to his subject's eyes by reflecting intense reddish light onto the darkened side of the face and hands. The informality and the sense of the moment link this painting to contemporaneous English and European portraits. But the spare

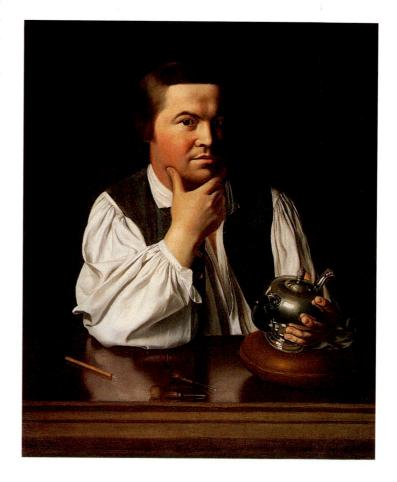

style and the emphasis on the sitter's down-to-earth character differentiate this American work from its British and continental counterparts.

NEOCLASSICISM

By the 18th century, a "Grand Tour" of Europe was considered part of every well-bred person's education. The Enlightenment had made knowledge of ancient Rome and Greece imperative, and a steady stream of Europeans and Americans traveled to Italy. Although Rome was established early on as the primary "pilgrimage site," tourists traveled as far north as Venice and as far south as Naples. Visits to the new excavations of the Roman cities of Herculaneum (begun in 1738) and Pompeii (1848) also became obligatory stops on the Grand Tour. The popularity of the Grand Tour was instrumental in fueling a renewed interest in classical antiquity. The most prominent manifestation of this interest was Neoclassicism, a movement in art that encompassed painting, sculpture, and architecture. The geometric harmony and rationality of classical art and architecture seemed to embody Enlightenment ideals. In addition, classical cultures represented the height of civilized society, and Greece and Rome served as models of enlightened political organization. These cultures, with their traditions of liberty, civic virtue, morality, and sacrifice, served as ideal models during a period of great political upheaval. Given such traditional associations, it is not coincidental that Neoclassicism was particularly appealing during the French and American Revolutions.

Winckelmann and Art History In the late 18th century, the ancient world also increasingly became the focus of scholarly attention. In 1755, Johann Joachim Winckelmann, the first modern art historian, published Thoughts on the Imitation of Greek Art in Painting and Sculpture, uncompromisingly designating Greek art as the most perfect to come from human hands. His later History of Ancient Art (1764) described each monument and positioned it within a huge inventory of works organized by subject matter, style, and period. Before Winckelmann, art historians had focused on biography, as reflected in Giorgio Vasari's Lives of the Most Eminent Italian Architects, Painters and Sculptors (first published in 1550). Winckelmann thus initiated one modern art historical method thoroughly in accord with Enlightenment ideas of ordering knowledgea system of description and classification that provided a pioneering model for the understanding of stylistic evolution.

A Roman Example of Virtue The Enlightenment fascination with classical antiquity and with classical art can be seen in the paintings of ANGELICA KAUFFMANN (1741–1807). Born in Switzerland and trained in Italy, Kauffmann spent many of her productive years in England. With West and others, she was a founding member of the British Royal Academy of Arts and enjoyed an enviable reputation. Her Cornelia Presenting Her Children as Her Treasures (Fig. 11-10) exemplifies early Neoclassical art. Its subject is an informative exemplum virtutis (example or model of virtue) drawn from Greek and Roman history and literature. The moralizing pictures of Hogarth (Fig. 11-7) already had marked a change in taste, but

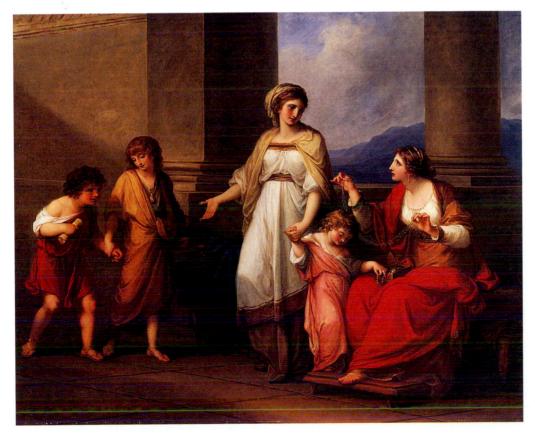

KAUFFMANN, Cornelia Presenting Her Children as Her Treasures, or Mother of the Gracchi, ca. 1785. Oil on canvas, 3' 4" × 4' 2". Virginia Museum of Fine Arts, Richmond (the Adolph D. and Wilkins C. Williams Fund).

The Enlightenment fascination with classical antiquity and with classical art can be seen in this painting celebrating Cornelia, the virtuous Roman mother who presented her children to a visitor as her jewels.

Kauffmann replaced the modern setting and characters of his works. She clothed her actors in ancient Roman garb and posed them in classicizing Roman attitudes within Roman interiors. The theme in this painting is the virtue of Cornelia, mother of the future political leaders Tiberius and Gaius Gracchus, who, in the second century BCE, attempted to reform the Roman Republic. Cornelia's character is revealed in this scene, which takes place after a lady visitor had shown off her fine jewelry and then haughtily requested that Cornelia show hers. Instead of rushing to get her own precious adornments, Cornelia brings her sons forward, presenting them as her jewels. The architectural setting is severely Roman, with no Rococo motif in evidence, and the composition and drawing have the simplicity and firmness of low-relief carving. The only Rococo elements still lingering are charm and grace—in the arrangement of the figures, in the soft lighting, and in Kauffmann's own tranquil manner.

David, Rome, and France The lingering echoes of Rococo disappeared in the work of JACQUES-LOUIS DAVID (1748–1825), the Neoclassical painter-ideologist of the French Revolution and the Napoleonic empire (MAP 11-1, page 531). David had studied in Rome as a young man and embraced the classical art tradition. He favored the academic teachings about using the art of the ancients and of the great Renaissance masters as models. He rebelled against the Rococo as an "artificial

taste" and exalted classical art as the imitation of nature in her most beautiful and perfect form.

David concurred with the Enlightenment belief that subject matter should have a moral and should be presented so that the "marks of heroism and civic virtue offered the eyes of the people [will] electrify its soul, and plant the seeds of glory and devotion to the fatherland." A milestone painting in David's career, Oath of the Horatii (Fig. 11-11), depicts a story from pre-Republican Rome, the heroic phase of Roman history. The topic was not an arcane one for David's audience. This story of conflict between love and patriotism, recounted by the ancient Roman historian Livy, had been retold in a play by Pierre Corneille performed in Paris several years earlier, making it familiar to David's viewing public. According to the story, the leaders of the warring cities of Rome and Alba decided to resolve their conflicts in a series of encounters waged by three representatives from each side. The Roman champions, the three Horatius brothers, were sent to face the three sons of the Curatius family from Alba. A sister of the Horatii, Camilla, was the bride-to-be of one of the Curatius sons, and the wife of the youngest Horatius was the sister of the Curatii.

David's painting shows the Horatii as they swear on their swords, held high by their father, to win or die for Rome, oblivious to the anguish and sorrow of their female relatives. In its form, Oath of the Horatii is a paragon of the Neoclassical style. The subject matter deals with a narrative of patriotism and

Jacques-Louis David, Oath of the Horatii, 1784. Oil on canvas, approx. 11' × 14'. Louvre, Paris.

David was the Neoclassical painter-ideologist of the French Revolution and the Napoleonic empire. This narrative of ancient Roman patriotism and sacrifice features statuesque figures and classical architecture.

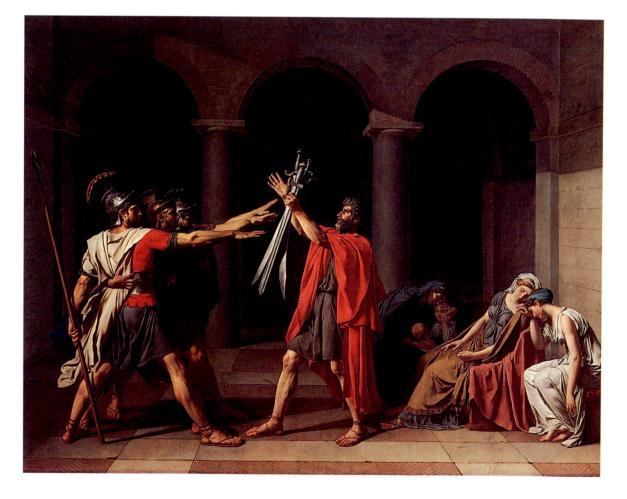

sacrifice excerpted from Roman history, and the image is presented with admirable force and clarity. David depicted the scene in a shallow space much like a stage setting, defined by a severely simple architectural framework. The statuesque and carefully modeled figures are deployed across the space, close to the foreground, in a manner reminiscent of ancient relief sculpture. The rigid, angular, and virile forms of the men on the left effectively contrast with the soft curvilinear shapes of the distraught women on the right. This visually pits virtues the Enlightenment leaders ascribed to men (such as courage, patriotism, and unwavering loyalty to a cause) against the emotions of love, sorrow, and despair that the women in the painting express. The French viewing audience perceived such emotionalism as characteristic of the female nature. The message was clear and of a type readily identifiable to the prerevolutionary French public. The picture created a sensation when it was exhibited in Paris in 1785, and although it had been painted under royal patronage and was not intended as a revolutionary statement, its Neoclassical style soon became the semiofficial voice of the revolution. David may have painted in the academic tradition, but he made something new of it. He created a program for arousing his audience to patriotic zeal.

In the Service of Revolution When the French Revolution broke out in 1789, David was thrust amid this momentous upheaval. He became increasingly involved with the revolution and threw in his lot with the Jacobins, the radical and militant faction. He accepted the role of de facto minister of propaganda, organizing political pageants and ceremonies that included floats, costumes, and sculptural props. He believed "the arts must . . . contribute forcefully to the education of the public," and he realized that the emphasis on patriotism and civic virtue perceived as integral to classicism would prove effective in dramatic, instructive paintings. However, rather than continuing to create artworks that focused on scenes from antiquity, David began to portray scenes from the French Revolution itself.

The Death of Marat (Fig. 11-12) is one such work and served not only to record an important event in the revolution but also to provide inspiration and encouragement to the revolutionary forces. Jean-Paul Marat, a revolutionary radical, a writer, and David's personal friend, was tragically assassinated in 1793. David depicted the martyred revolutionary after he was stabbed to death in his medicinal bath by Charlotte Corday, a member of a rival political faction. The inscription on the writing stand, the letter in the slain hero's left hand, and the medicinal bath all ensure immediate identification of Marat. The cold neutral space above Marat's figure slumped in the tub makes for a chilling oppressiveness. David vividly placed narrative details—the knife, the wound, the blood, the letter with which the young woman gained entrance—to sharpen the sense of pain and outrage and to confront viewers with the scene itself. The Death of Marat is convincingly real, yet it was masterfully composed to present Marat to the French people as a tragic martyr who died in the service of their state. In this way, the painting was meant to function as an "altarpiece" for the new civic

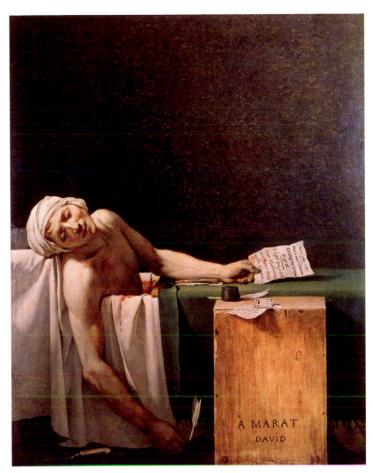

11-12 | JACQUES-LOUIS DAVID, *The Death of Marat*, 1793. Oil on canvas, approx. 5′ 3″ × 4′ 1″. Musées Royaux des Beaux-Arts de Belgique, Brussels.

David depicted Marat as a tragic martyr of the French Revolution, stabbed to death in his bath. Although the painting displays a severe Neoclassical spareness, its convincing realism conveys pain and outrage.

"religion." It was designed to inspire viewers with the saintly dedication of their fallen leader. Rather than the grandiosity of spectacle characteristic of West's *The Death of General Wolfe* (Fig. 11-8), a severe Neoclassical spareness pervades David's *Marat*, yet it retains its drama and ability to move spectators.

Napoleon's Ascendance At the fall of the French revolutionist Robespierre (1758–1794) and his party in 1794, David barely escaped with his life. He was tried and imprisoned, and after his release in 1795 he worked hard to resurrect his career. When Napoleon Bonaparte (1769–1821)—who had exploited the revolutionary disarray and ascended to power—approached David and offered him the position of First Painter of the Empire, David seized the opportunity. It was not just David's individual skill but Neoclassicism in general that appealed to the emperor. Napoleon embraced all links with the classical past as sources of symbolic authority for his short-lived imperial state. Such associations, particularly connections to the Roman Empire, served Napoleon well and were invoked in architecture and sculpture as well as painting.

11-13 | ANTONIO CANOVA, Pauline Borghese as Venus, 1808. Marble, life-size. Galleria Borghese, Rome.

Canova was Napoleon's favorite sculptor. Here, the artist depicted the emperor's sister—at her own request—as the Roman goddess of love in a marble statue inspired by classical models.

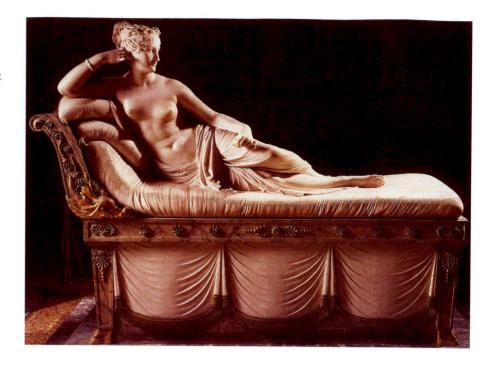

Canova and Neoclassical Sculpture Napoleon's favorite sculptor was Antonio Canova (1757-1822), who somewhat reluctantly left a successful career in Italy to settle in Paris and serve the emperor. Once in France, Canova became Napoleon's admirer and made numerous portraits, all in the Neoclassical style, of the emperor and his family. Perhaps the best known of these works is the marble portrait of Napoleon's sister, Pauline Borghese as Venus (Fig. 11-13). Initially, Canova had suggested depicting Borghese as Diana, goddess of the hunt. She, however, insisted on being shown as Venus, the goddess of love. Thus the emperor's sister appears reclining on a divan, gracefully holding the golden apple, a symbol of the goddess's triumph in the judgment of Paris. Although Canova clearly derived the figure from Greek art the sensuous pose and drapery recall Greek sculpture—the work is not as idealized as might be expected. The sculptor's sharply detailed rendering of the couch and drapery suggest a commitment to naturalism as well.

The public perception of Pauline Borghese influenced the sculpture's design and presentation. Napoleon Bonaparte had arranged the marriage of his sister to an heir of the noble Roman Borghese family. Once Pauline was in Rome, her behavior was less than dignified, and the public gossiped extensively about her affairs. Her insistence on portrayal as the goddess of love reflected her self-perception. Due to his wife's questionable reputation, Prince Camillo Borghese, the work's official patron, kept the sculpture sequestered in the Villa Borghese. Relatively few people were allowed to see it (and then only by torchlight).

Jeffersonian Idealism The versatility of Neoclassicism and the appeal of the qualities with which it was connected—morality, idealism, patriotism, and civic virtue—allowed the style to be associated with everything from revolutionary aspirations for democratic purity to imperial ambitions for unshakable authority. Thus, Napoleon invoked classical references to serve his imperial agenda. Meanwhile, in the new American

11-14

THOMAS JEFFERSON, Monticello, Charlottesville, Virginia, 1770–1806.

In the new American republic, Jefferson led the movement to adopt Neoclassicism as the national architectural style. His Virginia home is reminiscent of Palladio's Villa Rotonda (FIG. 9-15) but uses local materials.

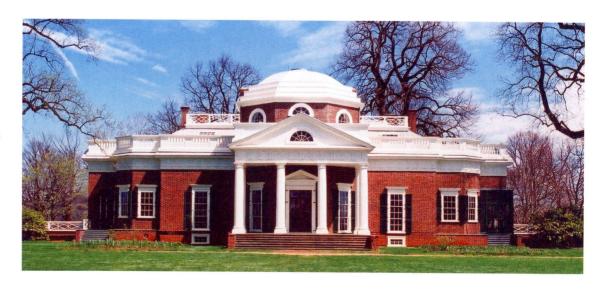

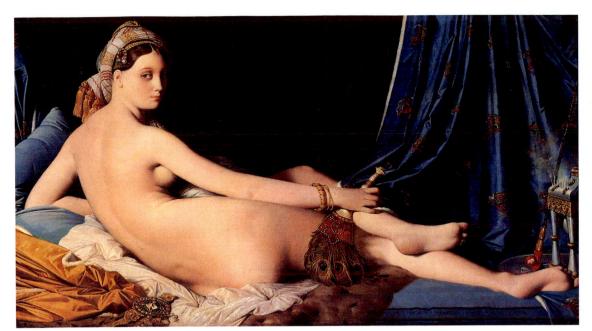

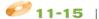

JEAN-AUGUSTE-DOMINIQUE INGRES, *Grande Odalisque*, 1814. Oil on canvas, approx. 2' 11" × 5' 4". Louvre, Paris.

The reclining female nude is a subject that goes back to classical antiquity, but Ingres converted his Neoclassical figure into an odalisque in a Turkish harem, consistent with the new Romantic taste for the exotic.

republic, Thomas Jefferson (1743 – 1826) spearheaded a movement to adopt Neoclassicism (a style he saw as representative of democratic qualities) as the national architecture.

Scholar, economist, educational theorist, statesman, and gifted amateur architect, Jefferson was by nature attracted to classical architecture. He worked out his ideas in his design for his own home, Monticello (Fig. 11-14), which was begun in 1770. Jefferson admired Palladio immensely and read carefully the Italian architect's *Four Books of Architecture*. After serving as minister to France, Jefferson returned home and completely remodeled Monticello, emulating Palladio's manner. The final version of Monticello is somewhat reminiscent of the Villa Rotonda (Fig. 9-15), but its materials are the local wood and brick used in Virginia.

Both Classical and Exotic JEAN-AUGUSTE-DOMINIQUE INGRES (1780-1867) arrived at David's studio in the late 1790s. His study there was to be short lived, however, as he soon broke with David on matters of style. This difference of opinion involved Ingres's adoption of what he believed to be a truer and purer Greek style than that employed by David. The younger artist adopted flat and linear forms approximating those found in Greek vase painting. In many of Ingres's works, the figure is placed in the foreground, much like a piece of lowrelief sculpture. In Grande Odalisque (Fig. 11-15), Ingres's subject, the reclining nude figure, is traditional enough and goes back to Giorgione, Titian (Fig. 9-19), and classical antiquity. Further, the work shows Ingres's admiration for Raphael in his borrowing of that master's type of female head. However, by converting the figure to an odalisque (a member of a Turkish harem), the artist made a strong concession to the contemporary Romantic taste for the exotic (discussed later).

This rather strange mixture of artistic allegiances—the combination of precise classical form and Romantic themes—prompted confusion, and when *Grande Odalisque* was first

shown in 1814, the painting drew acid criticism. Critics initially saw Ingres as a kind of rebel in terms of both the form and content of his works. They did not cease their attacks until the mid-1820s, when another enemy of the official style, Eugène Delacroix, appeared. Then they suddenly perceived that Ingres's art, despite its innovations and deviations, still contained many elements that adhered to the official Neoclassicism—the taste for the ideal. Ingres soon led the academic forces in their battle against the "barbarism" of Théodore Géricault, Delacroix, and their "movement." Gradually, Ingres warmed to the role his critics had cast for him, and he came to see himself as the conservator of good and true art, a protector of its principles against its would-be destroyers.

ROMANTICISM

Whereas Neoclassicism's rationality reinforced Enlightenment thought, particularly that promoted by Voltaire, Jean-Jacques Rousseau's ideas contributed to the rise of Romanticism. Rousseau's exclamation, "Man is born free, but is everywhere in chains!" summarizes a fundamental premise of Romanticism. This declaration appeared in the opening line of his Social Contract (1762), a book many of those involved in the late-18th-century revolutions carefully read and pondered. Romanticism emerged from a desire for freedomnot only political freedom but also freedom of thought, of feeling, of action, of worship, of speech, and of taste, as well as all the other freedoms. Romantics asserted that freedom is the right and property of one and all. In the opening paragraph of his Confessions (published posthumously 1781-1788), Rousseau made the following claim for each Romantic soul by making it for himself: "I am like no one in the whole world. I may be no better, at least I am different." Individual freedom was the first principle of Romanticism. Those who affiliated themselves with Romanticism believed that the path

to freedom was through imagination rather than reason. Romanticism as a phenomenon began around 1750 and ended about 1850. The term is also used more narrowly to denote an artistic movement that was in vogue from about 1800 to 1840, between Neoclassicism and Realism.

The Medieval and the Sublime The transition from Neoclassicism to Romanticism constituted a shift in emphasis from reason to feeling, from calculation to intuition, and from objective nature to subjective emotion. Among Romanticism's manifestations were the interests in the medieval period and in the sublime. For people living in the 18th century, the Middle Ages were the "dark ages," a time of barbarism, superstition, dark mystery, and miracle. The Romantic imagination stretched its perception of the Middle Ages into all the worlds of fantasy open to it, including the ghoulish, the infernal, the terrible, the nightmarish, the grotesque, the sadistic, and all the imagery that comes from the chamber of horrors when reason is asleep. Related to the imaginative sensibility was the period's notion of the sublime. Among the individuals most involved in studying the sublime was Edmund Burke (1729–1797), the British politician and philosopher. In A Philosophical Enquiry into the Origins of Our Ideas of the Sublime and Beautiful (1757), Burke articulated his definition of the sublime—feelings of awe mixed with terror. Burke observed that the most intense human emotions are evoked by pain or fear and that when these emotions are distanced, they can be thrilling. Thus, raging rivers and great storms at sea can be sublime to their viewer. Accompanying this taste for the sublime was the taste for the fantastic, the occult, and the macabre—for the adventures of the soul voyaging into the dangerous reaches of consciousness.

A Nightmarish Vision Henry Fuseli (1741–1825) specialized in night moods of horror and in dark fantasies—in the demonic, in the macabre, and often in the sadistic. Swiss by birth, Fuseli settled in England and eventually became a member of the Royal Academy. Largely self-taught, he contrived a distinctive manner to express the fantasies of his vivid imagination. In *The Nightmare* (Fig. 11-16), a beautiful young woman lies asleep, draped across the bed with her limp arm dangling over the side. An incubus, a demon believed in medieval times to prey, often sexually, on sleeping women, squats ominously on her body. In the background, a ghostly horse with flaming eyes bursts into the scene from beyond the curtain. As disturbing and perverse as Fuseli's art may be, he was among the first to attempt to depict the dark terrain of the human subconscious that became fertile ground for the Romantic artists to harvest.

Classical Anatomy, Romantic Dreams The visionary English poet, painter, and engraver William Blake (1757–1827) is frequently classified as a Romantic artist. His work, however, incorporates classical references. Blake greatly admired ancient Greek art because it exemplified the mathematical and thus the eternal. Yet Blake did not align himself with prominent Enlightenment figures. Blake, like many other Romantic artists, also was drawn to the art of the Middle Ages. He derived the inspiration for many of his paintings and poems from his dreams. The importance he attached to these nocturnal experiences led him to believe that the rationalist search for material explanations of the world stifled the spiritual side of human nature. He also believed that the stringent rules of behavior imposed by orthodox religions killed the individual creative impulse. Blake's vision of the Almighty in

11-16 | HENRY FUSELI, *The* Nightmare, 1781. Oil on canvas, 3' 4" × 4' 2". The Detroit Institute of Arts, Detroit (Founders Society Purchase with funds from Mr. and Mrs. Bert L. Smokler and Mr. and Mrs. Lawrence A. Fleishman).

The transition from Neoclassicism to Romanticism was manifested in a shift in emphasis from reason to feeling. Fuseli was among the first painters to depict the dark terrain of the human subconscious.

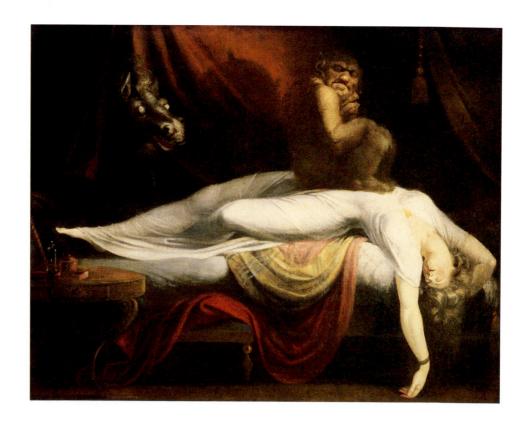

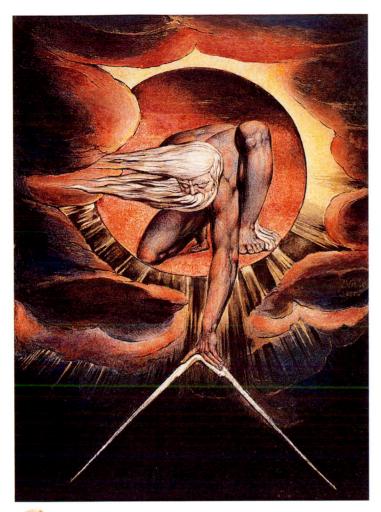

11-17 | WILLIAM BLAKE, *Ancient of Days*, frontispiece of *Europe: A Prophecy*, 1794. Metal relief etching, hand colored, approx. $9\frac{1}{2}$ " $\times 6\frac{3}{4}$ ". The Whitworth Art Gallery, University of Manchester, Manchester.

Although frequently classified as a Romantic artist, Blake incorporated classical references in his works. Here, ideal classical anatomy merges with the inner dark dreams of Romanticism.

Ancient of Days (Fig. 11-17) combines his ideas and interests in a highly individual way. Energy fills Blake's composition. The Ancient of Days leans forward from a fiery orb, peering toward earth and unleashing power through his outstretched left arm into twin rays of light. These emerge between his spread fingers like an architect's measuring instrument. A mighty wind surges through his thick hair and beard. Only the strength of his Michelangelesque physique keeps him firmly planted on his heavenly perch. Here, ideal classical anatomy merges with the inner dark dreams of Romanticism.

Francisco Goya In the early 19th century, Romantic artists increasingly incorporated dramatic action, all the while extending their exploration of the exotic, erotic, fictional, or fantastic. One artist whose works reveal these compelling dimensions is the Spaniard Francisco José DE GOYA Y LUCIENTES (1746–1828). Goya's skills as a painter were

recognized early on, and in 1786 he was appointed Pintor del Rey (Painter to the King). Charles IV (r. 1788–1808) promoted him to First Court Painter in 1799. Goya was David's contemporary, but one scarcely could find two artists living at the same time and in adjacent countries who were so completely unlike each other.

Goya did not arrive at his general dismissal of Neoclassicism without considerable thought about the Enlightenment and the Neoclassical penchant for rationality and order. This reflection emerges in such works as *The Sleep of Reason Produces Monsters* (Fig. 11-18), a print from a series titled *Los Caprichos (The Caprices)*. Goya depicted himself asleep, slumped onto a table or writing stand, while threatening creatures converge on him. Seemingly poised to attack the artist

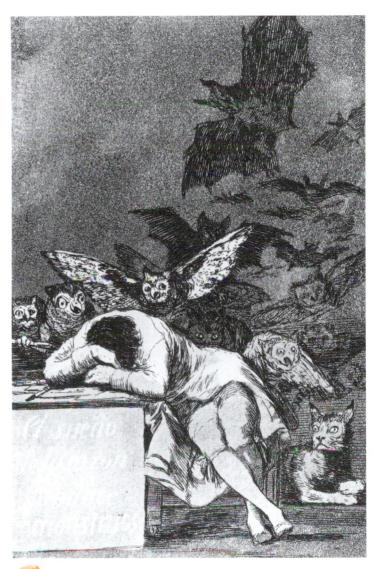

11-18 | Francisco Goya, *The Sleep of Reason Produces Monsters*, from *Los Caprichos*, ca. 1798. Etching and aquatint, $8\frac{7}{16}" \times 5\frac{7}{8}"$. Metropolitan Museum of Art, New York (gift of M. Knoedler & Co., 1918).

In this dramatic print, Goya depicted himself asleep while threatening creatures converge on him. The work reveals his commitment to the Romantic spirit—the unleashing of imagination, emotions, and nightmares.

are owls (symbols of folly) and bats (symbols of ignorance). This could be a portrayal of what emerges when reason is suppressed and, therefore, as advocating Enlightenment ideals. However, it also can be interpreted as Goya's commitment to the creative process and the Romantic spirit—the unleashing of imagination, emotions, and even nightmares.

Turmoil in Spain As dissatisfaction with the rule of Charles IV increased, the political situation grew more tenuous. The Spanish people eventually threw their support behind Ferdinand VII, son of Charles IV and Queen Maria Luisa, in the hope that he would initiate reform. To overthrow his father and mother, Ferdinand VII enlisted the aid of Napoleon Bonaparte, whose authority and military expertise in France at that time were uncontested. Napoleon had designs on the Spanish throne and thus willingly sent French troops to Spain. Not surprisingly, once Charles IV and Maria Luisa were ousted, Napoleon revealed his plan to rule Spain himself by installing his brother Joseph Bonaparte on the Spanish throne.

The Spanish people, finally recognizing the French as invaders, sought a way to expel the foreign troops. On May 2, 1808, in frustration, the Spanish attacked the Napoleonic soldiers in a chaotic and violent clash. In retaliation and as a show of force, the French responded the next day by executing numerous Spanish citizens. This tragic event is the subject of Goya's most famous painting, *The Third of May*, 1808 (Fig. 11-19).

In emotional fashion, Goya depicted the anonymous murderous wall of Napoleonic soldiers ruthlessly executing the unarmed and terrified Spanish peasants. The artist encouraged viewer empathy for the Spanish by portraying horrified expressions and anguish on their faces, endowing them with a humanity absent from the firing squad. Further, the peasant about to be shot throws his arms out in a cruciform gesture reminiscent of Christ's position on the cross.

Goya enhanced the drama of this event through his stark use of darks and lights. In addition, Goya's choice of imagery extended the time frame and thus heightened the emotion of the tragedy. Although the artist captured a specific moment when one man is about to be executed, others lie dead at his feet, their blood staining the soil, and many others have been herded together to be shot.

Death and Despair on a Raft In France, one of the two greatest Romantic painters was Théodore Géricault (1791–1824). Although Géricault retained an interest in the heroic and the epic and was well trained in classical drawing, he chafed at the rigidity of the Neoclassical style, eventually producing works that captivate the viewer with their drama, visual complexity, and emotional force.

Géricault's most ambitious project was *Raft of the Medusa* (Fig. 11-20). In this depiction of an actual historical event, the artist abandoned the idealism of Neoclassicism and instead invoked the theatricality of Romanticism. The painting's subject is an 1816 shipwreck off the African coast. The French frigate *Medusa* ran aground on a reef due to the incompetence of the captain, a political appointee. As a last-ditch effort to survive, 150 of those remaining built a makeshift raft from the

GOYA, *The Third of May*, 1808, 1814. Oil on canvas, approx. 8' 8" × 11' 3". Museo del Prado, Madrid.

Goya encouraged viewer empathy for the massacred Spanish peasants by portraying horrified expressions and anguish on their faces, endowing them with a humanity absent from the Napoleonic firing squad.

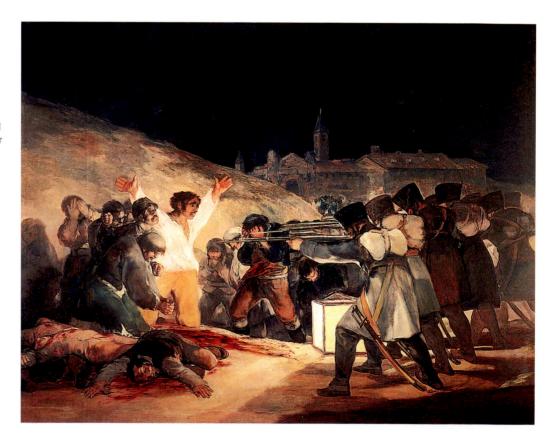

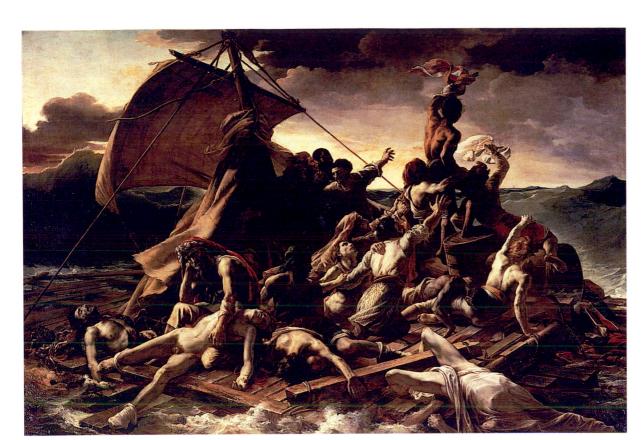

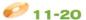

THÉODORE
GÉRICAULT, Raft
of the Medusa,
1818–1819.
Oil on canvas,
approx. 16' × 23'.
Louvre, Paris.

In this huge history painting, Géricault rejected Neoclassical compositional principles and, consistent with the Romantic spirit, presented a jumble of writhing bodies in every attitude of suffering, despair, and death.

disintegrating ship. The raft drifted for 12 days, and the number of survivors dwindled to 15. Finally, the raft was spotted, and the emaciated survivors were rescued. This horrendous event was political dynamite once it became public knowledge.

In Géricault's huge painting which took him eight months to complete, he sought to present the horror, chaos, and emotion of the tragedy while invoking the grandeur and impact of large-scale history painting. He depicted the few weak, despairing survivors as they summon what little strength they have left to flag down the passing ship far on the horizon. Géricault departed from the straightforward organization of Neoclassical compositions and instead presented a jumble of writhing bodies. The survivors and several corpses are piled onto one another in every attitude of suffering, despair, and death, and are arranged in a powerful X-shaped composition. One light-filled diagonal axis stretches from bodies at the lower left up to the black man raised on his comrades' shoulders and waving a piece of cloth toward the horizon. The cross axis descends from the storm clouds and the dark, billowing sail at the upper left to the shadowed upper torso of the body trailing in the open sea. Géricault's decision to place the raft at a diagonal so that a corner juts out toward the viewer further compels participation in this scene. Indeed, it seems as though some of the corpses are sliding off the raft into the viewing space. The subdued palette and prominent shadows lend an ominous pall to the scene.

Despite the theatricality and dramatic action that imbues this work with a Romantic spirit, Géricault did in fact go to great lengths to ensure a degree of accuracy. He visited hospitals and morgues to examine corpses, interviewed the survivors, and had a model of the raft constructed in his studio. Géricault also took this opportunity to insert a comment on the practice of slavery. The artist was a member of an abolitionist group that sought ways to end the slave trade in the colonies. Given Géricault's antipathy to slavery, it is appropriate that he placed Jean Charles, a black soldier and one of the few survivors, at the top of the pyramidal heap of bodies.

Line versus Color The history of 19th-century painting in its first 60 years often has been interpreted as a contest between two major artists—Ingres, the Neoclassical draftsman, and EUGÈNE DELACROIX (1798–1863), the Romantic colorist. Their dialogue reached back to the end of the 17th century in the quarrel between the Poussinistes, the conservative defenders of academism who held drawing as superior to color, and the Rubénistes, who proclaimed the importance of color over line.

No other painter of the time explored the domain of Romantic subject and mood as thoroughly and definitively as Delacroix. Delacroix's technique was impetuous, improvisational, and instinctive, rather than deliberate, studious, and cold. It epitomized Romantic colorist painting, catching the impression quickly and developing it in the execution process. His contemporaries commented on how furiously Delacroix worked once he had an idea, keeping the whole painting progressing at once. The fury of his attack matched the fury of his imagination and his subjects.

Orgiastic Destruction Delacroix's richly colored and emotionally charged Death of Sardanapalus (Fig. 11-21) was inspired by Lord Byron's poem Sardanapalus, but the painting does not illustrate that text (see "The Romantic Spirit in Music and Literature," page 335). Instead, Delacroix depicted the last hour of the Assyrian king (after he received news of his army's defeat and the enemy's entry into his city) in a much more tempestuous and crowded setting than Byron described. Here, orgiastic destruction replaces the sacrificial suicide found in the poem. In the painting, the king watches gloomily from his funeral pyre, soon to be set alight, as all of his most precious possessions-his women, slaves, horses, and treasure-are destroyed in his sight. Sardanapalus's favorite concubine throws herself on the bed, determined to go up in flames with her master. The king presides like a genius of evil over the panorama of destruction. Most conspicuous are the tortured and dying bodies of the harem women. In the foreground, a muscular slave plunges his knife into the neck of one woman. The spectacle of suffering and death is heightened by the most daringly difficult and tortuous poses and by the richest intensities of hue. With its exotic and erotic overtones, Death of Sardanapalus taps into the fantasies of the Romantic era.

Leading an Uprising Although *Death of Sardanapalus* reveals Delacroix's fertile imagination, like Géricault he also turned to current events, particularly tragic or sensational ones, for his subject matter. For example, he produced several images based on the Greek War for Independence (1821–1829).

Certainly, the French perception of the Greeks locked in a brutal struggle for freedom from the cruel and exotic Ottoman Turks generated great interest. Closer to home, Delacroix captured the passion and the energy of the Revolution of 1830 in his painting Liberty Leading the People (Fig. 11-22). Based on the Parisian uprising against the rule of Charles X (r. 1824-1830) at the end of July 1830, it depicts the allegorical personification of liberty, defiantly thrusting forth the Republic's tricolor banner as she urges the masses to fight on. The urgency of this struggle is reinforced by her scarlet Phrygian cap, the symbol of a freed slave in antiquity. Arrayed around Liberty are bold Parisian types—the street boy brandishing his pistols, the menacing worker with a cutlass, and the intellectual dandy in top hat with sawed-off musket. As in Géricault's Raft of the Medusa (Fig. 11-20), dead bodies are strewn about. In the background, the Gothic towers of Notre Dame (Fig. 7-6) rise through the smoke and haze. The painter's inclusion of this recognizable Parisian landmark specifies the locale and event. It also reveals Delacroix's attempt to balance contemporary historical fact with poetic allegory (Liberty).

The Transcendental Landscape Landscape painting came into its own in the 19th century as a fully independent and respected genre. Briefly eclipsed at the century's beginning by the taste for ideal form, which favored figural composition and history, landscape painting expressed the Romantic view, first extolled by Rousseau, of nature as a "being" that included the totality of existence in organic unity and harmony. In

EUGÈNE DELACROIX,

Death of Sardanapalus,
1826. Oil on canvas,
approx. 12' 1" × 16' 3".

Louvre, Paris.

Here, Delacroix painted the Romantic spectacle of an Assyrian king on his funeral pyre. His richly colored and emotionally charged canvas is filled with exotic and erotic figures in daring and tortuous poses.

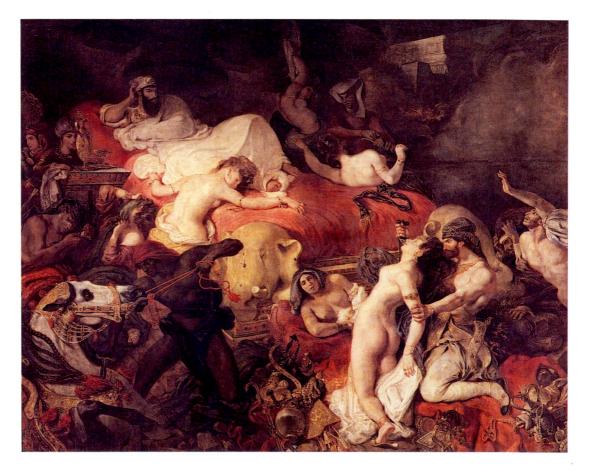

The Romantic Spirit in Music and Literature

The appeal of Romanticism, with its emphasis on freedom and feeling, extended well beyond the realm of the visual arts. In European music, literature, and poetry, the Romantic spirit was a dominant presence during the late 18th and early 19th centuries. These artistic endeavors rejected classicism's structured order in favor of the emotive and expressive. In music, the compositions of Franz Schubert (1797–1828), Franz Liszt (1811–1886), Frédéric Chopin (1810–1849), and Johannes Brahms (1833–1897) all emphasized the melodic or lyrical. These composers believed that music had the power to express the unspeakable and to communicate the subtlest and most powerful human emotions.

In literature, Romantic poets such as John Keats (1795–1821), William Wordsworth (1770–1850), and Samuel Taylor Coleridge (1772–1834) published volumes of poetry that manifested the Romantic interest in lyrical drama. *Ozymandias*, by Percy Bysshe Shelley (1792–1822), speaks of faraway, exotic locales. Lord Byron's poem of 1821, *Sardanapalus*, is set in the kingdom of Assyria in the seventh century BCE. It conjures images of eroticism and fury unleashed—images of the kind that

appear in Delacroix's painting *Death of Sardanapalus* (Fig. 11-21). One of the best examples of the Romantic spirit is the engrossing novel *Frankenstein*, written in 1818 by Shelley's wife, Mary Wollstonecraft Shelley (1797–1851). This fantastic tale of a monstrous creature run amok is filled with drama. As was true of many Romantic artworks, this novel not only embraced the emotional but also rejected the rationalism that underlay Enlightenment thought. Dr. Frankenstein's monster was a product of science, and this novel easily could have been interpreted as an indictment of the tenacious belief in science promoted by Enlightenment thinkers such as Voltaire. *Frankenstein* thus served as a cautionary tale of the havoc that could result from unrestrained scientific experimentation and from the arrogance of scientists like Dr. Frankenstein.

The imagination and vision that characterized Romantic paintings and sculptures were equally moving and riveting in musical or written form. The sustained energy of Romanticism is proof of the captivating nature of this movement and spirit.

nature—"the living garment of God," as the German poet and dramatist Johann Wolfgang von Goethe (1749–1832) called it—artists found an ideal subject to express the Romantic theme of the soul unified with the natural world. As all nature was mysteriously permeated by being, landscape artists had

the task of interpreting the signs, symbols, and emblems of universal spirit disguised within visible material things. Artists no longer merely beheld a landscape, but rather participated in its spirit. No longer were they painters of mere things but instead they were translators of nature's transcendent meanings.

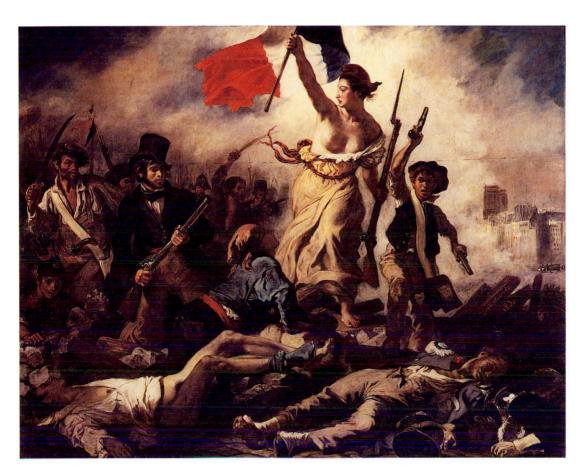

11-22 | EUGÈNE DELACROIX, *Liberty Leading the People*, 1830. Oil on canvas, approx. 8' 6" × 10' 8". Louvre, Paris.

Balancing contemporary historical fact with poetic allegory, Delacroix captured the passion and energy of the Revolution of 1830 in this painting of Liberty leading the Parisian uprising against Charles X. FRIEDRICH, Abbey in the Oak Forest, 1810. Oil on canvas, $7\frac{1}{2}$ " × 5' $7\frac{1}{4}$ ". Staatliche Museen zu Berlin-Preussischer Kulturbesitz, Nationalgalerie, Berlin.

Friedrich was a master of the Romantic transcendental landscape. The reverential mood of this winter scene with the ruins of a Gothic church and cemetery demands the silence appropriate to sacred places.

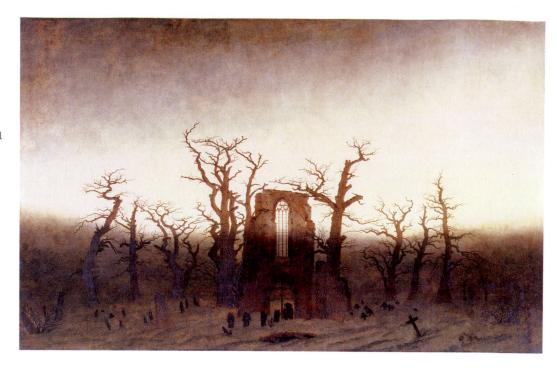

CASPAR DAVID FRIEDRICH (1774–1840) was among the first to depict the Romantic transcendental landscape. For Friedrich, landscapes were temples. His paintings themselves were altarpieces. The reverential mood of his works demands the silence appropriate to sacred places filled with a divine presence. Abbey in the Oak Forest (Fig. 11-23) is like a solemn requiem. Under a winter sky, through the leafless oaks of a snow-covered cemetery, a funeral procession bears a coffin into the ruins of a Gothic church. The emblems of death are everywhere—the season's desolation, the leaning crosses and tombstones, the black of mourning worn by the grieving, the skeletal trees, and the destruction time wrought on the church. The painting is a kind of meditation on human mortality, as Friedrich himself remarked: "Why . . . do I so frequently choose death, transience, and the grave as subjects for my paintings? One must submit oneself many times to death in order some day to attain life everlasting."5 The artist's sharp-focused rendering of details demonstrates his keen perception of everything in the physical environment relevant to his message. Friedrich's work balances inner and outer experience. "The artist," he wrote, "should not only paint what he sees before him, but also what he sees within him."6 Although Friedrich's works may not have the theatrical energy of the paintings of Géricault or Delacroix, they are pervaded by a resonant and deep emotion.

Nostalgia for Agrarian England One of the most momentous developments in Western history—the Industrial Revolution in England—impacted the evolution of Romantic landscape painting. Although discussion of the Industrial Revolution invariably focuses on technological advances, factory development, and growth of urban centers, its effect on the countryside and the land itself was no less severe. The detrimental economic impact industrialization had on the prices for agrarian products produced significant unrest in the English

countryside. In particular, increasing numbers of displaced farmers could no longer afford to farm their small land plots.

This situation is addressed in the landscape paintings of JOHN CONSTABLE (1776-1837). The Haywain (Fig. 11-24) is representative of Constable's art and reveals much about his outlook. In this placid, picturesque scene of the countryside, a small cottage appears on the left, and in the center foreground a man leads a horse and wagon across the stream. Billowy clouds float lazily across the sky, and the scene's tranquility is augmented by the muted greens and golds and by the delicacy of Constable's brush strokes. The artist portrayed the oneness with nature that the Romantic poets sought; the relaxed figures are not observers but participants in the landscape's being. Constable made countless studies from nature for each of his canvases. In his quest for the authentic landscape, Constable studied nature as a meteorologist (which he was by avocation). His special gift was for capturing the texture that the climate and the weather gave to landscape. He also could reveal that atmosphere as the key to representing the ceaseless process of nature, which changes constantly through the hours and through shifts of weather and season. Constable's use of tiny dabs of local color, stippled with white, created a sparkling shimmer of light and hue across the canvas surface—the vibration itself suggestive of movement and process.

The Haywain is also significant for precisely what it does not show—the civil unrest of the agrarian working class and the outbreaks of violence and arson that resulted. Indeed, this painting has a nostalgic, wistful air to it—a lament to a disappearing rural pastoralism. (Constable came from a rural landowning family of considerable wealth.) The people that populate Constable's landscapes blend into the scenes and are one with nature. Rarely does the viewer see workers engaged in tedious labor. This nostalgia, presented in such naturalistic terms, renders Constable's works Romantic in tone. That Constable felt a

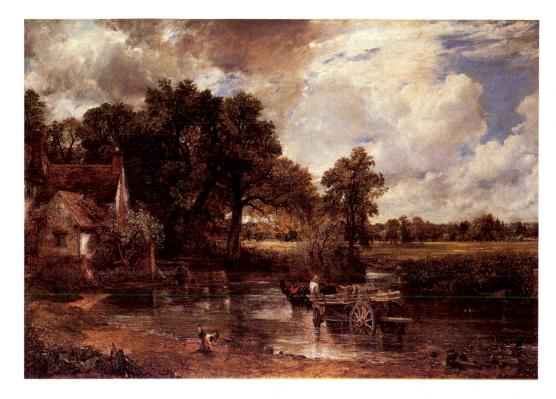

11-24 | JOHN CONSTABLE, *The Haywain*, 1821. Oil on canvas, 4' 3" × 6' 2". National Gallery, London.

The *Haywain* is a nostalgic view of the disappearing English countryside during the Industrial Revolution. Constable had a special gift for capturing the texture that climate and weather give to landscape.

kindred spirit with the Romantic artists is revealed by his comment, "painting is but another word for feeling."⁷

The Horrors of the Slave Trade JOSEPH MALLORD WILLIAM TURNER (1775–1851), Constable's contemporary in the English school of landscape painting, produced work that also responded to the encroaching industrialization. However, where Constable's paintings are serene and precisely painted,

Turner's are composed of turbulent swirls of frothy pigment. The passion and energy of Turner's works not only reveal the Romantic sensibility that provided the foundation for his art but also clearly illustrate Edmund Burke's concept of the sub-lime—awe mixed with terror.

Among Turner's most notable works is *The Slave Ship* (Fig. 11-25). Its subject is an incident that occurred in 1783 and was reported in a widely read book titled *The History of*

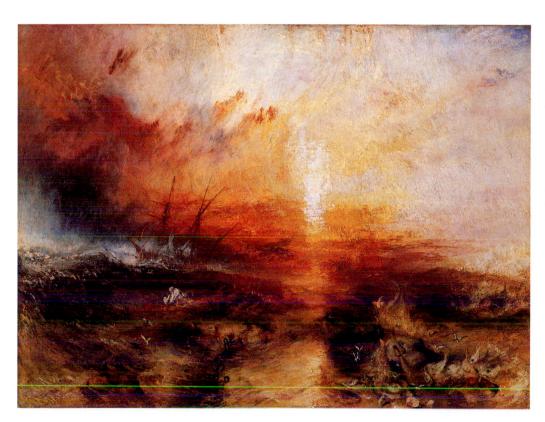

WILLIAM TURNER, The Slave Ship (Slavers Throwing Overboard the Dead and Dying, Typhoon Coming On), 1840. Oil on canvas, 2' $11\frac{11}{16}" \times 4'\frac{5}{16}"$. Museum of Fine Arts, Boston (Henry Lillie Pierce Fund).

Turner's style is deeply rooted in the emotive power of color. A great innovator, he released color from any defining outlines to express both the forces of nature and the painter's emotional response to them.

🥯 11-26 |

THOMAS COLE, *The*Oxbow (View from
Mount Holyoke,
Northampton,
Massachusetts, after a
Thunderstorm), 1836.
Oil on canvas, 4' $3\frac{1}{2}$ " × 6' 4". Metropolitan
Museum of Art,
New York (gift of
Mrs. Russell Sage,
1908).

Cole divided his canvas into dark, stormy wilderness on the left and more developed civilization on the right. The miniscule painter in the bottom center seems to be asking for advice about America's future course.

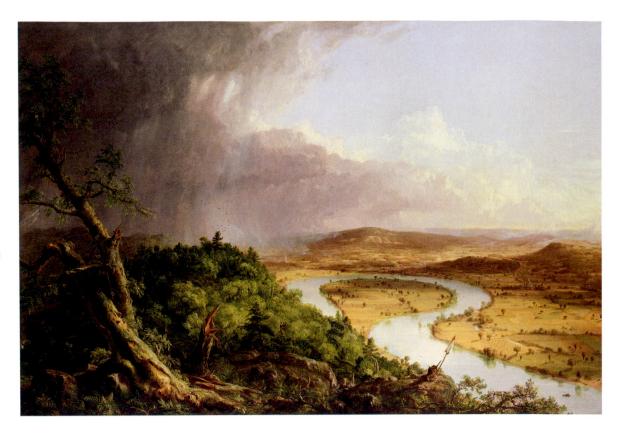

the Abolition of the Slave Trade, by Thomas Clarkson. Because the book had just been reprinted in 1839, Clarkson's account probably prompted Turner's choice of subject for this 1840 painting. The incident involved the captain of a slave ship who, on realizing that his insurance company would reimburse him only for slaves lost at sea but not for those who died en route, ordered the sick and dying slaves thrown overboard. Turner's frenzied emotional depiction of this act matches its barbaric nature. The sun is transformed into an incandescent comet amid flying scarlet clouds. The slave ship moves into the distance, leaving in its wake a turbulent sea choked with the bodies of slaves sinking to their deaths. The relative scale of the miniscule human forms compared to the vast sea and overarching sky reinforces the sense of the sublime, especially the immense power of nature over humans. The event's particulars are almost lost in the boiling colors, but on closer inspection, the cruelty is evident. Visible are the iron shackles and manacles around the wrists and ankles of the drowning slaves, denying them any chance of saving themselves.

Turner's style, often referred to as visionary, was deeply rooted in the emotive power of pure color. The haziness of his forms and the indistinctness of his compositions imbued color and energetic brush strokes with greater impact. Turner was a great innovator whose special invention in works such as *The Slave Ship* was to release color from any defining outlines so as to express both the forces of nature and the painter's emotional response to them. In works such as this, the reality of color is one with the reality of feeling. Turner's methods had an incalculable effect on the development of modern art. His discovery of the aesthetic and emotive power of pure color

and his pushing of the medium's fluidity to a point where the paint itself is almost the subject were important steps toward 20th-century abstract art, which dispensed with shape and form altogether.

America's Future Direction? In America, landscape painting was most prominently pursued by a group of artists known as the Hudson River School, so named because its members drew their subjects primarily from the uncultivated regions of the Hudson River valley. Many of these painters, however, depicted scenes from across the country and, thus, "Hudson River School" is actually too restrictive geographically. Like the early-19th-century landscape painters in Germany and England, the artists of the Hudson River School not only presented Romantic panoramic landscape views but also participated in the ongoing exploration of the individual's and the country's relationship to the land. Acknowledging the unique geography and historical circumstances in each country and region, American landscape painters frequently focused on identifying qualities that rendered America unique. One American painter of English birth, THOMAS COLE (1801-1848), often referred to as the leader of the Hudson River School, articulated this idea: "Whether he [an American] beholds the Hudson mingling waters with the Atlantic explores the central wilds of this vast continent, or stands on the margin of the distant Oregon, he is still in the midst of American scenery—it is his own land; its beauty, its magnificence, its sublimity—all are his; and how undeserving of such a birthright, if he can turn towards it an unobserving eye, an unaffected heart!"8

Another issue that surfaced frequently in Hudson River School paintings was the moral question of America's direction as a civilization. Cole presented the viewer with this question in *The Oxbow* (Fig. 11-26). A splendid scene opens before the viewer, dominated by the lazy oxbow turning of the Connecticut River near Mount Holyoke, Massachusetts. The composition is divided, with the dark, stormy wilderness on the left and the more developed civilization on the right. The miniscule artist in the bottom center of the painting (wearing a top hat), dwarfed by the landscape's scale, turns to the viewer as if to ask for input in deciding the country's future course. In their depiction of expansive wilderness, Cole's landscapes incorporated reflections and moods romantically appealing to the public.

MID-19TH-CENTURY ARCHITECTURE

In architecture, the 19th century saw the revival of many earlier styles, including the Gothic, the Classical, and the Baroque, but also the introduction of new building materials that would have an important future in design and construction.

Adapting Baroque Opulence For the Paris Opéra (Fig. 11-27), J. L. Charles Garnier (1825–1898) chose a festive and spectacularly theatrical Neo-Baroque facade with paired columns and rich sculptural ornamentation. The interior features intricate arrangements of corridors, vestibules, stairways, balconies, alcoves, entrances, and exits, which facilitate easy passage throughout the building and provide space for entertainment and socializing at intermissions. The Baroque grandeur of the layout and of the opera house's decorative appointments are characteristic of an architectural

style called Beaux-Arts, which flourished in the late 19th and early 20th centuries in France. Based on ideas taught at the dominant École des Beaux-Arts (School of Fine Arts) in Paris, the Beaux-Arts style incorporated classical principles (such as symmetry in design, including interior spaces that extended radially from a central core or axis) and included extensive exterior ornamentation. As an example of a Beaux-Arts building, Garnier's Opéra proclaims, through its majesty and lavishness, its function as a gathering place for glittering audiences in an age of conspicuous wealth.

A Crystal Palace Beginning around mid-century, architects gradually abandoned sentimental and Romantic designs from the historical past. They turned to honest expressions of a building's purpose. Since the 18th century, bridges had been built of cast iron, and most utilitarian architecture—factories, warehouses, dockyard structures, mills, and the like—long had been built simply and without historical ornament. Iron, along with other industrial materials, permitted engineering advancements in the construction of larger, stronger, and more fire-resistant structures than before. The tensile strength of iron (and especially of steel, available after 1860) permitted architects to create new designs involving vast enclosed spaces, as in the great train sheds of railroad stations and in exposition halls.

JOSEPH PAXTON (1801–1865) had built several conservatories (greenhouses) on the country estate of the duke of Devonshire. In the largest—300 feet long—he used an experimental system of glass-and-metal roof construction. Encouraged by the success of this system, Paxton submitted a winning glass-and-iron building design to the competition for the hall to house the Great Exhibition of 1851, organized to gather together "works of industry of all nations" in London.

11-27 | J. L. CHARLES GARNIER, the Opéra, Paris, France, 1861–1874.

The 19th century saw the revival of many architectural styles. For Paris's opera house, Garnier chose a festive and spectacularly theatrical Neo-Baroque facade with paired columns and rich sculptural ornamentation.

Palace, London, England, 1850–1851.
Photo from Victoria & Albert Museum,
London.

The tensile strength of iron permitted Paxton to experiment with a new system of glass-and-metal roof construction. Built with prefabricated parts, the vast Crystal Palace was erected in only six months.

Paxton's exhibition building, the Crystal Palace (Fig. 11-28), was built with prefabricated parts. This allowed the vast structure to be erected in the then-unheard-of time of six months and dismantled at the exhibition's closing to avoid permanent obstruction of the park. The plan borrowed much from ancient Roman and Christian basilicas, with a central flat-roofed "nave" and a barrel-vaulted crossing "transept." The design provided ample interior space to contain displays of huge machines as well as to accommodate such decorative touches as large working fountains and giant trees. The public admired the building so much that when it was dismantled, it was reerected at a new location on the outskirts of London, where it remained until fire destroyed it in 1936.

THE BEGINNINGS OF PHOTOGRAPHY

From the time Frenchman Louis-J.-M. Daguerre and Briton Henry Fox Talbot announced the first practical photographic processes in 1839, photography was celebrated as embodying a kind of revelation of visible things. The medium, itself a product of science, was an enormously useful tool for recording the century's discoveries. The relative ease of the process seemed a dream come true for scientists and artists, who for centuries had grappled with less satisfying methods for capturing accurate images of their subjects. Photography also was perfectly suited to an age that saw artistic patronage continue to shift away from the elite few toward a broader base of support. The growing and increasingly powerful middle class embraced both the comprehensible images of the new medium and its lower cost.

For the traditional artist, photography suggested new answers to the great debate about what is real and how to represent the real in art. It also challenged the place of traditional modes of pictorial representation originating in the Renaissance. Artists as diverse as Delacroix and Ingres, as well as the Realist Jean Désiré Gustave Courbet and the Impressionist Edgar Degas (see Chapter 12), welcomed photography as a

helpful auxiliary to painting. They increasingly were intrigued by how photography translated three-dimensional objects onto a two-dimensional surface. Other artists, however, saw photography as a mechanism capable of displacing the painstaking work of skilled painters dedicated to representing the optical truth of chosen subjects. Photography's challenge to painting, both historically and technologically, seemed to some an expropriation of the realistic image, until then the exclusive property of painting.

Developing the Daguerreotype Artists themselves were instrumental in the development of this new technology. As early as the 17th century, painters such as Vermeer (Fig. 10-26) had used the camera obscura to help them render the details of their subjects more accurately. These instruments were darkened chambers (some virtually portable closets) with optical lenses fitted into a hole in one wall through which light entered to project an inverted image of a subject onto the chamber's opposite wall. The artist could trace the main details from this image for later reworking and refinement. In 1807, the invention of the camera lucida (lighted room) replaced the enclosed chamber. Instead, a small prism lens, hung on a stand, was aimed downward at an object. The lens projected the image of the object onto a sheet of paper. Artists using either of these devices found this process long and arduous, no matter how accurate the resulting work. All yearned for a more direct way to capture a subject's image. Two very different scientific inventions that accomplished this were announced, almost simultaneously, in France and England in 1839.

The first new discovery was the *daguerreotype* process, named for LOUIS-JACQUES-MANDÉ DAGUERRE (1789–1851), one of its two inventors. Daguerre had trained as an architect before becoming a theatrical set painter and designer. This background led him to open (with a friend) a popular entertainment called the Diorama. Audiences witnessed performances of "living paintings" created by changing the lighting effects on

a "sandwich" composed of a painted backdrop and several layers of painted translucent front curtains. Daguerre used a camera obscura for the Diorama, but he wanted to find a more efficient and effective procedure. Through a mutual acquaintance, he was introduced to Joseph Nicéphore Nièpce, who in 1826 had successfully made a permanent picture of the cityscape outside his upper-story window by exposing, in a camera obscura, a metal plate covered with a light-sensitive coating. Although the eight-hour exposure time needed to record Nièpce's subject hampered the process, Daguerre's excitement over its possibilities led to a partnership between the two men to pursue its development. Nièpce died in 1833, but Daguerre continued to work on his own. He made two contributions to the process. He discovered latent development that is, bringing out the image through chemical solutions which considerably shortened the length of time needed for exposure. Daguerre also discovered a better way to "fix" the image (again, chemically) by stopping the action of light on the photographic plate, which otherwise would continue to darken until the image could no longer be discerned.

The French government presented the new daguerreotype process at the Academy of Science in Paris on January 7, 1839, with the understanding that its details would be made available to all interested parties without charge (although the inventor received a large annuity in appreciation). Soon, people worldwide were taking pictures with the daguerreotype "camera" in a process almost immediately christened *photography*, from the Greek *photos* (light) and *graphos* (writing).

Each daguerreotype is a unique work, possessing amazing detail and finely graduated tones from black to white. Both qualities are evident in *Still Life in Studio* (Fig. 11-29), one of the first successful plates Daguerre produced after perfecting his method. The process captured every detail—the subtle forms, the varied textures, the diverse tones of light and shadow—in Daguerre's carefully constructed tableau. The

three-dimensional forms of the sculptures, the basket, and the bits of cloth spring into high relief and are convincingly there within the image. Its composition was clearly inspired by 17th-century Dutch still lifes, such as those of Claesz (Fig. 10-27). Like Claesz, Daguerre arranged his objects to reveal their textures and shapes clearly. Unlike a painter, Daguerre could not alter anything within his arrangement to effect a stronger image. However, he could suggest a symbolic meaning through his choice of objects. Like the skull and timepiece in Claesz's painting, Daguerre's sculptural and architectural fragments and the framed print of an embrace suggest that even art is vanitas and will not endure forever.

"Beautiful" Photography The daguerreotype reigned supreme in photography until the 1850s, but the second major photographic invention was announced less than three weeks after Daguerre's method was unveiled in Paris, and eventually replaced it. It was the ancestor of the modern negative-print system. On January 31, 1839, William Henry Fox Talbot (1800–1877) presented a paper on his "photogenic drawings" to the Royal Institution in London. As early as 1835, Talbot made "negative" images by placing objects on sensitized paper and exposing the arrangement to light. This created a design of light-colored silhouettes recording the places where opaque or translucent objects had blocked light from darkening the paper's emulsion. In his experiments, Talbot next exposed sensitized papers inside simple cameras and, with a second sheet, created "positive" images. He further improved the process with more light-sensitive chemicals and a chemical development of the negative image. This technique allowed multiple prints. However, Talbot's process, which he named the calotype (a term he derived from the Greek word kalos, meaning "beautiful"), was limited by the fact that its images incorporated the paper's texture. This produced a slightly blurred, grainy effect very different from the crisp detail and wide tonal

11-29 | Louis-Jacques-Mandé Daguerre, Still Life in Studio, 1837. Daguerreotype, approx. $6\frac{1}{4}'' \times 8\frac{1}{4}''$. Collection Société Française de Photographie, Paris.

One of the first successful plates Daguerre produced after perfecting his new photographic process was this still life, in which he was able to capture amazing detail and finely graduated tones from black to white.

11-30 | TIMOTHY O'SULLIVAN. A Harvest of Death, Gettysburg, Pennsylvania, July 1863. Negative by Timothy O'Sullivan. Original print by Alexander Gardner, $6\frac{3}{4}$ " $\times 8\frac{3}{4}$ ". The New York Public Library (Astor. Lenox and Tilden Foundations, Rare Books and Manuscript Division), New York.

"Wet-plate" technology enabled photographers to record historical events on the spot - and to comment on the high price of war, as in this photograph of dead Union soldiers at Gettysburg in 1863.

range available with the daguerreotype. Aside from these drawbacks, widespread adoption of the calotype process was primarily prevented by the stiff licensing and equipment fees charged for many years after Talbot patented his new process in 1841. Due to both the look and the cost of the calotype, many photographers elected to stay with the daguerreotype until photographic technology could expand the calotype's capabilities.

Wet-Plate Photography In time, new photographic materials made possible a richer range of tones than the calotype could produce. Glass negatives and albumen printing paper (prepared with egg white) could record finer detail and a wider range of light and shadow. New "wet-plate" technology (so named because the plate was exposed, developed, and fixed while wet) almost at once replaced both the daguerreotype and the calotype and became the universal way of making negatives up to 1880. However, wet-plate photography had drawbacks. The plates had to be prepared and processed on the spot. To work outdoors meant taking along a portable darkroom of some sort—a wagon, tent, or box with lighttight sleeves for the photographer's arms. Yet, with the wet plate, artists could make remarkable images.

Documenting War The new technology meant that the photograph's documentary power could finally be realized. Thus began the story of the medium's influence on modern life and of the immense changes it brought to communication and information management. It was of unrivaled importance for the historical record. Great events could be recorded on the spot and the views preserved for the first time. The photographs taken of the Crimean War (1856) and of the American Civil War are still unsurpassed as incisive accounts of military life, unsparing in their truth to detail and poignant as expressions of human experience.

Of the Civil War photographs, the most moving are the records of combat deaths. Perhaps the most reproduced of these is A Harvest of Death, Gettysburg, July 1863 (Fig. 11-30) by TIMOTHY O'SULLIVAN (1840-1882). Although this image appears at first sight to be simple reportage, it also functions to impress on people the war's high price. Corpses litter the battlefield as far as the eye can see. O'Sullivan presented this "harvest" stretching far to the horizon. As the photograph modulates from the precise clarity of the bodies of Union soldiers in the foreground, boots stolen and pockets picked, to the almost illegible corpses in the distance, the suggestion of innumerable other dead soldiers is unavoidable. Though it was years before photolithography could reproduce photographs like this in newspapers, they were publicly exhibited and made an impression that newsprint engravings never could.

CONCLUSION

After the death of Louis XIV in 1715, French culture was dominated by the aristocracy and by a style known as Rococo. This soft, dainty style, characterized by elegance and sensuality, was soon challenged by the rise of the Enlightenment and the Neoclassical style. The revival of interest in classicism, as manifested by Neoclassicism, was widespread throughout both Europe and America. Because of Neoclassicism's associations with heroism, idealism, and rationality, it was invoked by leaders ranging from Napoleon to Thomas Jefferson. In contrast to Neoclassicism, with its emphasis on reason and logic, Romanticism, which also emerged in conjunction with Enlightenment thought, focused on the primacy of imagination and feeling. The invention of photography in the 1830s was a significant milestone, as it altered public perceptions of "reality." The issues of reality and realism were addressed specifically in the movement that followed on the heels of Romanticism—Realism, examined in Chapter 12.

- Voltaire, 1694–1778
- Jean-Jacques Rousseau, 1712–1778
- Johann Wolfgang von Goethe, 1749–1832

1750

- I Denis Diderot, Encyclopédie, 1751-1780
- George III of England, r. 1760–1820
- I J. J. Winckelmann, History of Ancient Art, 1764
- I England's Royal Academy of Arts founded, 1768
- Louis XVI of France, r. 1774-1792

Jean-Honoré Fragonard, The Swing, 1766

1775

- American Revolution, 1775-1783
- I Charles IV of Spain, r. 1788-1808
- French Revolution, 1789-1795

2

Thomas Jefferson, Monticello, Charlottesville, 1770–1806

1800

- I Napoleon Bonaparte crowned emperor, 1804
- Napoleon abdicates, 1814
 - I Greek War for Independence, 1821–1829
 - I Charles X of France, r. 1824-1830

Antonio Canova, Pauline Borghese as Venus, 1808

1825

Revolution of 1830 in France

4

1850

4 Louis-Jacques-Mandé Daguerre, Still Life in Studio, 1837

EUROPE AND AMERICA, 1850-1900

During the latter half of the 19th century, the Industrial Revolution in England spread throughout Europe (MAP 12-1, page 532) and to the United States. This dramatic expansion is often referred to as the second Industrial Revolution. Whereas the first Industrial Revolution centered on textiles, steam, and iron, the second was associated with steel, electricity, chemicals, and oil. The discoveries in these fields provided the foundation for developments in plastics, machinery, building construction, and automobile manufacturing and paved the way for the invention of the radio, electric light, telephone, and electric streetcar.

One of the most significant consequences of industrialization was urbanization. The number and size of Western cities grew dramatically during the latter part of the 19th century. Rural dwellers migrated to urban centers because of expanded agricultural enterprises that squeezed the smaller property owners from the land. The widely available work opportunities in factories, as well as improving urban health and living conditions, also contributed to the explosive growth of the cities.

Faith in Science An increasing emphasis on science was another characteristic of this period. Advances in industrial technology reinforced the Enlightenment's foundation of rationalism. The connection between science and progress seemed obvious to many, both in intellectual circles and among the general public, and, increasingly, people embraced empiricism (the search for knowledge based on observation and direct experience). Indicative of the widespread faith in science was the influence of positivism, a Western philosophical model that promoted science as the mind's highest achievement. Positivism was developed by the French philosopher Auguste Comte (1798–1857). Comte believed that scientific laws governed the environment and human activity and could be revealed through careful recording and analysis of observable data.

Survival of the Fittest The English naturalist Charles Darwin (1809–1882) and his theory of natural selection did much to increase interest in science. Darwin's concept of evolution based on a competitive system in which only the fittest survived, as presented in *On the Origin of Species by Means of Natural Selection* (1859), sharply contrasted with the biblical narrative of creation. By challenging traditional Christian beliefs, Darwinism contributed to a growing secular attitude. Others, most notably British philosopher Herbert Spencer (1820–1903), applied

Mary Cassatt, The Bath, ca. 1892. Oil on canvas, 3' $3'' \times 2'$ 2". The Art Institute of Chicago, Chicago (Robert A. Walker Fund).

Darwin's principles to the rapidly changing socioeconomic realm. As in the biological world, they asserted, intense competition led to the survival of the most economically fit companies, enterprises, and countries. Because of the pseudoscientific basis of this social Darwinism, those who espoused this theory perceived conflict and struggle as inevitable.

Class Struggle The concept of conflict was central to the ideas of the German political and social theorist Karl Marx (1818–1883), whose Communist Manifesto (1848), written with Friedrich Engels (1820–1895), called for the working class to overthrow the capitalist system. Like Darwin and other empiricists, Marx believed that scientific, rational laws governed nature and, indeed, all human history. For Marx, economic forces based on class struggle induced historical change. Throughout history, insisted Marx, those who controlled the means of production conflicted with those whose labor was exploited to benefit the wealthy and powerful. Marxism's ultimate goal was the seizure of power by the working class and the destruction of capitalism. Marxism was instrumental in the rise of trade unions.

Colonizing the World Industrialization and social Darwinism help to explain this period's extensive imperialism. Industrialization required a wide variety of natural resources, and social Darwinists easily translated their intrinsic concept of social hierarchy into racial and national hierarchies. These hierarchies provided Western leaders with justification for the colonization of peoples and cultures that they deemed "less advanced." By 1900, the major Western economic and political powers had divided up much of the world.

Modernity and Modernism The extensive technological changes and increased exposure to other cultures, coupled with the rapidity of these changes, led in the West to an acute sense of the world's lack of fixity or permanence. This, in turn, prompted a greater consciousness of and interest in modernity—the state of being modern. Avid exploration of the conditions of modernity and of people's position relative to a historical continuum permeated the Western art world as well, resulting in the development of modernism. Modernist art is differentiated from modern art by its critical function. Modern art, as noted in Chapter 11, is more or less a chronological designation, referring to art of the past few centuries. Modern artists were and are aware of the relationship between their art and that of previous eras. Modernism developed in the second half of the 19th century and is "modern" in that modernist artists, then and now, often seek to capture the images and sensibilities of their age. However, modernism goes beyond simply dealing with the present and involves the artist's critical examination of or reflection on the premises of art itself. Modernism thus implies certain concerns about art and aesthetics that are internal to art production, regardless of whether or not the artist is producing scenes from contemporary social life.

PAINTING

Clement Greenberg, an influential 20th-century American art critic, asserted that the "essence of Modernism lies . . . in the use of the characteristic methods of a discipline to criticize the discipline itself. . . . Realistic, illusionist art had dissembled [disguised] the medium, using art to conceal art. Modernism used art to call attention to art. The limitations that constitute the medium of painting—the flat surface, the shape of the support, the properties of pigment—were treated by the Old Masters as negative factors that could be acknowledged only implicitly or indirectly. Modernist painting has come to regard these same limitations as positive factors that are to be acknowledged openly."

This critical, modernist stance challenged the more conservative approach of the academies, where artists received traditional training. Eventually, toward the end of the 19th century, the aggressiveness of modernism led to the development of the *avant-garde* ("front guard," a military term for soldiers sent ahead of the army's main body). These trailblazing artists emphatically rejected the past and transgressed the boundaries of conventional artistic practice. The subversive dimension of the avant-garde was in sync with the anarchic, revolutionary sociopolitical tendencies in Europe at the time. The painters Vincent van Gogh, Paul Gauguin, Georges Seurat, and Paul Cézanne were among the first to receive this label.

Realism

Realism was a movement that developed in France around the middle of the 19th century. Gustave Courbet (1819–1877), long regarded as the leading figure of this movement, used the term "realism" when exhibiting his own works, even though he shunned labels. Like the empiricists and positivists, Realist artists argued that only the things of one's own time, what people can see for themselves, are "real." Accordingly, Realists focused their attention on the experiences and sights of everyday contemporary life and disapproved of historical and fictional subjects on the grounds that they were not real and visible and were not of the present world. Courbet declared in 1861: "The art of painting can consist only in the representation of objects visible and tangible to the painter. . . . An abstract object, invisible or nonexistent, does not belong to the domain of painting. . . . Show me an angel, and I'll paint one."²

This sincerity about scrutinizing the world around them led the Realists to portray objects and images that until then had been deemed unworthy of depiction—the mundane and trivial, working-class laborers and peasants, and so forth. Even further, the Realists depicted these scenes on a scale and with an earnestness and seriousness previously reserved for grand history painting.

The Lowest of the Low In *The Stone Breakers* (Fig. 12-1), Courbet captured on canvas in a straightforward manner a man and a boy in the act of breaking stones, traditionally the lot of the lowest in French society. Their menial labor is neither

12-1 | GUSTAVE COURBET, *The Stone Breakers*, 1849. Oil on canvas, 5′ 3″ × 8′ 6″. Formerly at Gemäldegalerie, Dresden (destroyed in 1945).

Courbet was the leading figure in the Realist movement. Using a palette of dirty browns and grays, he conveyed the dreary and dismal nature of menial labor in mid-19th-century France.

romanticized nor idealized but is shown with directness and accuracy. Courbet's palette of dirty browns and grays conveys the dreary and dismal nature of the task. The angular positioning of the older stone breaker's limbs suggests a mechanical monotony. The heroic, the sublime, and the dramatic are not found here. Theatricality was at the heart of Romanticism. Realism captured the ordinary rhythms of daily life.

Courbet's choice of the laboring poor as subject matter had special meaning for the mid-19th-century French audience. In 1848, workers rebelled against the bourgeois leaders of the newly formed Second Republic and against the rest of the nation, demanding better working conditions and a redistribution of property. The army quelled the revolution in three days, but not without long-lasting trauma and significant loss of life. The Revolution of 1848 thus raised the issue of labor as a national concern and placed workers on center stage, both literally and symbolically. Courbet's depiction of stone breakers in 1849 was both timely and populist.

Courbet's "Brutalities" Viewed as the first modernist movement by many scholars and critics, Realism also involved a reconsideration of the painter's primary goals, rejecting the established priority on illusionism. Accordingly, Realists called attention to painting as a pictorial construction by the way they applied pigment and manipulated composition.

Courbet's intentionally simple and direct methods of expression in composition and technique seemed unbearably crude to many of his more traditional contemporaries, and he was called a primitive. Although his bold, somber palette was essentially traditional, Courbet often used the palette knife to place and unify large daubs of paint quickly, producing a roughly wrought surface. His example inspired later Impressionists, such as Claude Monet and Auguste Renoir, but the public accused him of carelessness, and critics wrote of his "brutalities." The jury selecting work for the Paris International Exhibition in 1855 rejected two of his paintings on the grounds that his subjects and figures were too coarsely depicted (so much so as to be plainly "socialistic") and too large. In response, Courbet set up his own exhibition outside the grounds, calling it the Pavilion of Realism. Courbet's pavilion and his statements amounted to manifestos of the new movement.

The Barbizon School Like Courbet, JEAN-FRANÇOIS MILLET (1814–1878) found his subjects in the people and occupations of the everyday world. Millet was of peasant stock and identified with the hard lot of the country poor. He was one of a group of French painters of country life who, to be close to their rural subjects, settled near the village of Barbizon. This Barbizon school specialized in detailed pictures of

12-2 | JEAN-FRANÇOIS MILLET, *The Gleaners*, 1857. Oil on canvas, approx. 2' 9" × 3' 8". Louvre, Paris.

Millet and the Barbizon School painters specialized in depictions of French country life. In this Realist canvas, Millet portrayed three impoverished women picking up the remainders left in the field after a harvest.

forest and countryside. In *The Gleaners* (FIG. 12-2), Millet depicted three peasant women performing the back-breaking task of gleaning the last wheat scraps. These women were members of the lowest level of peasant society, and such impoverished people were permitted to glean—to pick up the remainders left in the field after the harvest. Millet characteristically placed his monumental figures in the foreground, against a broad sky. The field stretches back to a rim of haystacks, cottages, trees, and distant workers and a flat horizon, but the artist draws attention to the gleaners quietly doing their tedious and time-consuming work.

Although Millet's works have a sentimentality absent from those of Courbet, the French public reacted to paintings such as *The Gleaners* with disdain and suspicion. In the aftermath of the Revolution of 1848, Millet's investing the poor with solemn grandeur did not meet with the approval of the prosperous classes. Further, the middle class linked the poor with the dangerous, newly defined working class, which was finding outspoken champions in men such as Karl Marx, Friedrich Engels, and the novelists Émile Zola (1840–1902) and Charles Dickens (1812–1870). Socialism was a growing movement, and its views on property and its call for social justice, even economic equality, frightened the bourgeoisie. Millet's sympathetic depiction of the poor seemed to many like a political manifesto.

Daumier and Lithography Because people widely recognized the power of art to serve political means, the political and social agitation accompanying the violent revolutions in France and the rest of Europe in the later 18th and early 19th centuries prompted the French people to suspect artists of subversive intention. HONORÉ DAUMIER (1808–1879) was a defender of the urban working classes, and through his Realist art, he boldly

confronted authority with social criticism and political protest. In response, the authorities imprisoned Daumier. A painter, sculptor, and one of the world's great printmakers, Daumier produced *lithographs*—images printed from a flat stone—that allowed him to create an unprecedented number of prints, thereby reaching a broader audience. Daumier also contributed satirical lithographs to the widely read, liberal French Republican journal *Caricature*. In these prints, he mercilessly lampooned the foibles and misbehavior of politicians, lawyers, doctors, and the rich bourgeoisie in general.

Massacre in Lyons Daumier's 1834 lithograph, *Rue Transnonain* (Fig. 12-3), depicts an atrocity with the same shocking impact as Goya's *The Third of May, 1808* (Fig. 11-19). The title refers to a street in Lyons where an unknown sniper killed a civil guard, part of a government force trying to repress a worker demonstration. Because the fatal shot had come from a workers' housing block, the remaining guards immediately stormed the building and massacred all its inhabitants. With Goya's power, Daumier created a view of the atrocity from a sharp, realistic angle of vision. He depicted not the dramatic moment of execution but the terrible, quiet aftermath. The broken, scattered forms lie amid violent disorder. Daumier's pictorial manner is rough and spontaneous. How it carries expressive exaggeration is part of its remarkable force.

Promiscuity in a Park? Like Gustave Courbet, ÉDOUARD MANET (1832–1883) played a critical role in the articulation of Realist principles. His art was instrumental in affecting the course of modernist painting and the development of Impressionism in the 1870s. When attempting to explain the critique of the discipline central to modernism, art historians often have looked to Manet's paintings as prime examples.

12-3 | Honoré Daumier, Rue Transnonain, 1834. Lithograph, approx. $1' \times 1' 5\frac{1}{2}''$. Philadelphia Museum of Art, Philadelphia (bequest of Fiske and Marie Kimball).

Daumier used lithographs, which could be produced in great numbers, to reach a wide audience for his social criticism and political protest. This print records the horrific 1834 massacre in a workers' housing block.

Manet's Le Déjeuner sur l'Herbe, or Luncheon on the Grass (Fig. 12-4), depicts two nude women and two clothed men enjoying a picnic of sorts. The foreground figures were all based on living, identifiable people. The seated nude is Manet's favorite model at the time and the gentlemen are his brother (with cane) and the sculptor Ferdinand Leenhof. The two men wear fashionable Parisian attire of the 1860s. In contrast, the

foreground nude is a distressingly unidealized figure type. She also seems disturbingly unabashed and at ease, looking directly at the viewer without shame or flirtatiousness.

Manet's *Déjeuner* outraged the public. Rather than depicting a traditional pastoral scene, it seemed to represent promiscuous women in a Parisian park. Although Manet surely anticipated criticism of his painting, shocking the public was not his

ÉDOUARD MANET, Le
Déjeuner sur l'Herbe
(Luncheon on the Grass),
1863. Oil on canvas,
approx. 7' × 8' 10".
Musée d'Orsay, Paris.

Manet was widely criticized both for his shocking subject matter and his manner of painting. Moving away from illusionism, he used colors to flatten form and to draw attention to the painting surface. primary aim. His goal was more complex and involved a reassessment of the entire range of art. *Le Déjeuner* contains sophisticated references and allusions to many painting genres history, portraiture, landscape, nudes, and even religion. It is, in fact, a synthesis of the history of painting.

The negative response to Le Déjeuner by public and critics alike extended beyond Manet's subject matter to his manner of painting. He rendered in soft focus and broadly painted the landscape, including the pool in which the second woman bathes, compared with the clear forms of the harshly lit foreground trio and the pile of discarded female attire and picnic foods at the lower left. The lighting creates strong contrasts between darks and highlighted areas. In the main figures, many values are summed up in one or two lights or darks. The effect is both to flatten the forms and to give them a hard, snapping presence. Form, rather than being a matter of line, is only a function of paint and light. Manet himself declared that the chief actor in the painting is the light. In true modernist fashion, Manet was using art to call attention to art in other words, he was moving away from illusion and toward open acknowledgement of painting's properties, such as the flatness of the painting surface. The public, however, saw only a crude sketch without the customary "finish."

Scandalous Audacity Even more scandalous was Manet's *Olympia* (Fig. 12-5). This work depicts a young white prostitute (Olympia was at the time a common "professional" name for prostitutes) reclining on a bed. Entirely nude except for a thin black ribbon tied around her neck, a bracelet

on her arm, an orchid in her hair, and fashionable slippers on her feet, Olympia meets the viewer's gaze with a look of cool indifference. Behind her appears a black maid, who presents her a bouquet of flowers from a client.

Public and critics alike were horrified. Although images of prostitutes were not unheard of during this period, people were taken aback by the shamelessness of Olympia and her look that verges on defiance. The depiction of a black woman was also not new to painting, but the viewing public perceived Manet's inclusion of both a black maid and a nude prostitute as evoking moral depravity, inferiority, and animalistic sexuality. The contrast of the black servant with the fair-skinned courtesan also made reference to racial divisions. One critic described Olympia as "a courtesan with dirty hands and wrinkled feet . . . her body has the livid tint of a cadaver displayed in the morgue; her outlines are drawn in charcoal and her greenish, bloodshot eyes appear to be provoking the public, protected all the while by a hideous Negress." From this statement, it is clear that the critic was responding to Manet's artistic style as well as his subject matter. Manet's brush strokes are rougher and the shifts in tonality more abrupt than those found in traditional academic painting (see "The Academies: Defining the Range of Acceptable Art," page 351). This departure from accepted practice exacerbated the audacity of the subject matter.

Manet and the other French Realists challenged the whole iconographic stock of traditional art and called attention to what the French poet Charles Baudelaire (1821–1867) termed the "heroism of modern life." In so doing, they changed the course of Western art.

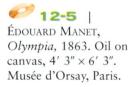

Manet scandalized the French public with this painting of a nude prostitute and her black maid carrying a floral bouquet from a client. He was also faulted for using rough brush strokes and abruptly shifting tonality.

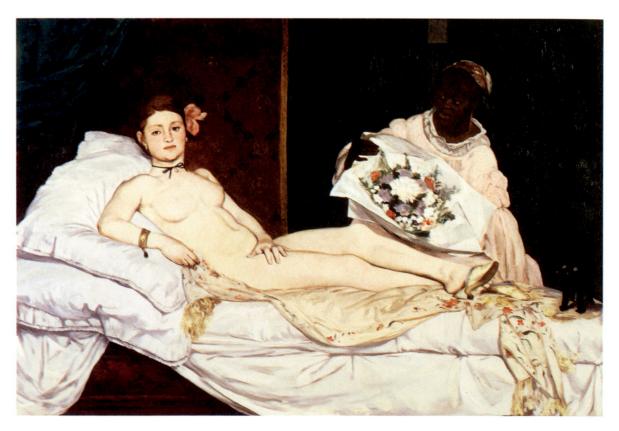

The Academies

Modernist art is often discussed in contrast to academic art. The latter term is used to refer to art sanctioned by the academies, established art schools such as the Royal Academy of Painting and Sculpture in France (founded in 1648) and the Royal Academy of Arts in Britain (founded in 1768). Both of these academies provided instruction for art students and sponsored exhibitions. During the long existence of these organizations, they exerted great control over the art scene. The annual exhibitions, called "Salons" in France, were highly competitive, as was membership in these academies. Subsidized by the government, the French Royal Academy thus supported a limited range of artistic expression, focusing on traditional subjects and highly polished technique. Because of the challenges modernist art presented to established artistic conventions, the Salons and other exhibitions often rejected the work of modernist artists. In 1863, for example, Emperor Napoleon III established the Salon des Refusés (Salon of the Rejected) to show all the works the Academy's jury had not accepted for exhibition in the regular Salon.

The Impressionists reinforced the perception of these academies as bastions of conservatism. After repeated rejections, these artists decided

Defining the Range of Acceptable Art

to form their own society in 1873 and began holding their own exhibitions in Paris. This decision allowed the Impressionists much freedom, for they did not have to contend with the academies' authoritative and confining viewpoint. The Impressionist exhibitions were held at one- or two-year intervals from 1874 until 1886. Another group of artists unhappy with the Salon's conservative nature adopted this same renegade idea. In 1884, these artists formed the Society of Independent Artists and held annual Salons des Indépendants. Georges Seurat's *La Grande Jatte* (Fig. 12-20) was included in the Society's 1886 Salon.

As the art market expanded, venues for the exhibition of art increased. Art circles and societies sponsored private shows in which both amateurs and professionals participated. Dealers became more aggressive in promoting the artists they represented by mounting exhibitions in a variety of spaces, some fairly small and intimate, others large and grandiose. All of these proliferating opportunities for exhibition gave artists alternatives to the traditional constraints of academy exhibitions and provided fertile breeding ground for the development of radical, avant-garde art.

An American Realist Although French artists took the lead in promoting Realism, this movement was not exclusively French. The determination to paint the realities of modern life is also seen in the work of American Winslow Homer (1836–1910). When the Civil War broke out in 1861, Homer joined the Union campaign as an artist-reporter for Harper's Weekly. At the end of the war, he painted The Veteran in a New Field (Fig. 12-6). Although it is fairly simple and direct, the painting provides significant commentary on the effects and aftermath of that catastrophic national conflict. The painting depicts a man with his back to the viewer, harvesting wheat. That he is a veteran is clear not only from the painting's

title but also from the uniform and canteen carelessly thrown on the ground. The veteran's involvement in meaningful and productive work implies a smooth transition from war to peace. This was seen as evidence of America's strength. "The peaceful and harmonious disbanding of the armies in the summer of 1865," poet Walt Whitman (1819–1892) wrote, was one of the "immortal proofs of democracy, unequall'd in all the history of the past."

The Veteran in a New Field also comments symbolically about death. By the 1860s, farmers used cradled scythes to harvest wheat. However, Homer chose not to insist on this historical reality and painted a single-bladed scythe. This transforms

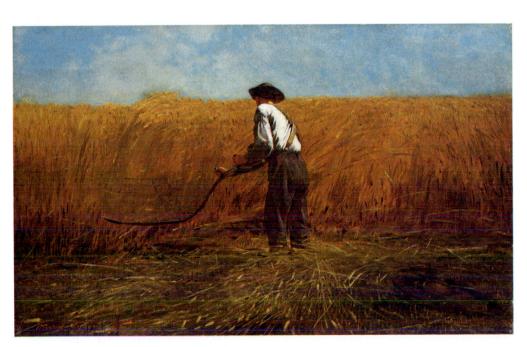

12-6 | WINSLOW HOMER, The Veteran in a New Field, 1865. Oil on canvas, $2' \frac{1}{8}'' \times 3' 2\frac{1}{8}''$. Metropolitan Museum of Art, New York (bequest of Miss Adelaide Milton de Groot, 1967).

This veteran's involvement in productive work implies a smooth transition to peace after the Civil War, but Homer placed a single-bladed scythe in his hands, a symbol of the deaths of soldiers and Abraham Lincoln.

12-7 | THOMAS EAKINS, *The Gross Clinic*, 1875. Oil on canvas, $8' \times 6'$ 6". Jefferson Medical College of Thomas Jefferson University, Philadelphia.

The too-brutal realism of Eakins's unsparing depiction of the Jefferson Medical College operating amphitheater caused this painting's rejection from the Philadelphia exhibition celebrating America's centennial.

the veteran into a symbol of Death—the Grim Reaper himself—and the painting into an elegy to the thousands of soldiers who died in the Civil War and into a lamentation on the death of the recently assassinated Abraham Lincoln.

Not for the Squeamish Thomas Eakins (1844–1916) was another renowned American Realist painter. His ambition was to paint things as he saw them rather than as the public might wish them portrayed. The too-brutal realism of Eakins's early masterpiece, The Gross Clinic (Fig. 12-7), prompted the art jury to reject it for the Philadelphia exhibition that celebrated the American independence centennial. The work presents the surgeon Dr. Samuel Gross in the operating amphitheater of the Jefferson Medical College in Philadelphia. Gross, with bloody fingers and scalpel, lectures about his surgery on a young man's leg. He is accompanied by colleagues, all of whom historians have identified, and by the patient's mother, who covers her face. The painting is an unsparing description of a contemporaneous event, with a good deal more reality than many viewers could endure. "It is a picture," one critic said, "that even strong men find difficult to look at long, if they can look at it at all."6

The Dignity of Ordinary Life The early work of HENRY OSSAWA TANNER (1859–1937) reveals another aspect of American Realist painting—the depiction of the lives of ordinary

people. Tanner studied art with Eakins before moving to Paris. There he combined Eakins's belief in careful study from nature with a desire to portray with dignity the people among whom he had been raised as the son of an African American minister in Pennsylvania. The mood in *The Thankful Poor* (Fig. 12-8) is one of quiet devotion. In Tanner's canvas, the grandfather, grandchild, and main objects in the room are painted with the greatest detail, whereas everything else dissolves into loose strokes of color and light. Expressive lighting reinforces the painting's reverent spirit, deep shadows intensifying the man's devout concentration. Golden light pours in the window to illuminate the quiet expression of thanksgiving on the younger face. In this painting, Tanner expressed his deep sense of the sanctity of everyday experience.

The Pre-Raphaelites Although Realism won wide acceptance in England, the *Pre-Raphaelite Brotherhood* refused to be limited to the contemporary scenes portrayed by strict Realists. These artists chose instead to represent fictional and historical subjects with a significant degree of convincing illusion. The Pre-Raphaelites wished to create fresh and sincere art, free from what they considered the tired and artificial manner the successors of Raphael propagated in the academies. Influenced by the well-known critic, artist, and writer John Ruskin (1819–1900), the Brotherhood, organized in 1848, agreed with his distaste for the materialism and ugliness of the contemporary industrializing

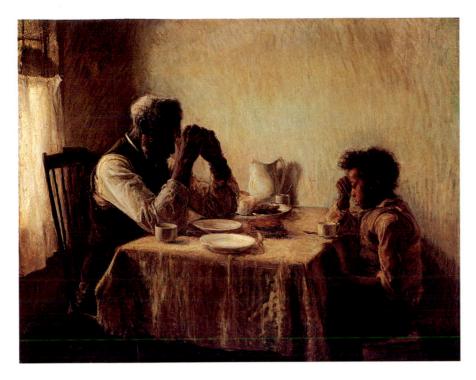

12-8 | Henry Ossawa Tanner, *The Thankful Poor*, 1894. Oil on canvas, 2' $11\frac{1}{2}$ " × 3' $8\frac{1}{4}$ ". Collection of William H. and Camille Cosby.

Tanner combined the Realists' belief in careful study from nature with a desire to portray with dignity the life of African American families. Expressive lighting reinforces the painting's reverent spirit.

world. The Pre-Raphaelites also appreciated the spirituality and idealism (as well as the art and artisanship) of past times, especially the Middle Ages and the Early Renaissance.

The Drowning of Ophelia One of the Pre-Raphaelite Brotherhood's founders was JOHN EVERETT MILLAIS (1829–1896). Millais's painstaking observation of nature is apparent in *Ophelia* (Fig. 12-9), which he exhibited in the Universal Exposition in Paris in 1855, where Courbet set up his Pavilion of Realism. The subject, from Shakespeare's *Hamlet*, is

the drowning of Ophelia. Attempting to make the pathos of the scene visible, Millais became a faithful and feeling witness of its every detail, reconstructing it with a lyricism worthy of the original poetry. Although the scene is fictitious, Millais worked diligently to present it with unswerving fidelity to visual fact. He painted the background at a spot along the Hogsmill River in Surrey. For the figure of Ophelia, Millais had a friend lie in a heated bathtub full of water for hours at a stretch. Because of the painting's meticulous detail, *Ophelia* was a huge success when it was exhibited.

12-9 | JOHN EVERETT MILLAIS, *Ophelia*, 1852. Oil on canvas, 2' 6" × 3' 8". Tate Gallery, London.

Millet was one of the founders of the Pre-Raphaelite Brotherhood, whose members refused to be limited to the contemporary scenes strict Realists portrayed. The drowning of Ophelia is a Shakespearean subject.

Impressionism

Impressionism, both in content and style, was an art of industrialized, urbanized Paris. As such, it furthered some of the Realists' concerns and was resolutely an art of its time. But whereas Realism focused on the present, Impressionism focused even more acutely on a single moment. Although Impressionism often is discussed as a coherent movement, it was actually a nebulous and shifting phenomenon. The Impressionists have been perceived as a group largely because they exhibited together in the 1870s and 1880s.

Impressionism and the Sketch A hostile critic applied the label "Impressionism" in response to the painting *Impression: Sunrise* (Fig. 12-10) by CLAUDE MONET (1840–1926). The artist exhibited this work in the first Impressionist show in 1874, and, although the critic intended the term to be derogatory, by the third Impressionist show in 1878, the artists themselves were using that label.

The term "impressionism" had been used in art before but in relation to sketches. Impressionist paintings incorporate the qualities of sketches—abbreviation, speed, and spontaneity. This is apparent in *Impression: Sunrise*. The brush strokes are clearly evident. Monet made no attempt to blend the pigment to create smooth tonal gradations and an optically accurate scene. Although this painting is not, technically speaking, a sketch, it has a sketchy quality. This concern with acknowledging the paint and the canvas surface continued the modernist exploration the Realists began. Beyond this connection to the sketch, Impressionism operates at the intersection of what the artists saw and what they felt. In other words, the "impressions" that these artists recorded in their paintings were neither purely objective descriptions of the exterior world nor solely subjective responses, but the interaction between the two. They were sensations—the artists' subjective and personal responses to nature.

Color, Light, and Shadow Scientific studies of light and the invention of chemically synthesized pigments increased 19th-century artists' sensitivity to the multiplicity of colors in nature and gave them new colors for their work. After scrutinizing the effects of light and color on forms, the Impressionists concluded that *local color*—an object's actual color in white light—is usually modified by the quality of the light in which it

12-10 | CLAUDE MONET, *Impression: Sunrise*, 1872. Oil on canvas, $1' 7\frac{1}{2}'' \times 2' 1\frac{1}{2}''$. Musée Marmottan, Paris.

A hostile critic applied the derogatory label "Impressionism" to this painting, and Monet and his circle embraced it. The term derives from the sketchy quality of the painting, in which the brush strokes are clearly evident.

12-11 | CLAUDE MONET, Saint-Lazare Train Station, 1877. Oil on canvas, $2' 5\frac{3}{4}'' \times 3' 5''$. Musée d'Orsay, Paris.

Impressionist canvas surfaces look unintelligible at close range, but the eye fuses the brush strokes at a distance. Monet's agitated application of paint contributes to the sense of energy and vitality in this urban scene.

is seen, by reflections from other objects, and by the effects produced by juxtaposed colors. Shadows do not appear gray or black, as many earlier painters thought, but seem to be composed of colors modified by reflections or other conditions. Using various colors and short, choppy brush strokes, Monet was able to catch accurately the vibrating quality of light. That Impressionist canvas surfaces look unintelligible at close range, their forms and objects appearing only when the eye fuses the strokes at a certain distance, accounts for much of the early adverse criticism leveled at Monet and his fellow Impressionists.

Capturing a Fleeting Moment The lack of pristine clarity characteristic of most Impressionist works is also historically grounded. The extensive industrialization and urbanization that occurred in France during the latter half of the 19th century can be described only as a brutal and chaotic transformation. The rapidity of these changes made the world seem unstable and insubstantial. As Baudelaire observed, "modernity is the transitory, the fugitive, the contingent." Accordingly, Impressionist works represent an attempt to capture a fleeting moment—not in the absolutely fixed, precise sense of a Realist painting but by conveying the elusiveness and impermanence of images and conditions.

The Railroads and Parisian Life That Impressionism was firmly anchored in the industrial development of the time and in the concurrent process of urbanization is also revealed by the artists' choice of subjects. Most of the Impressionists depicted scenes in and around Paris, where industrialization and urbanization had their greatest impact. Monet's Saint-Lazare Train Station (Fig. 12-11) depicts a dominant aspect of Parisian life. The expanding railway network had made travel more convenient, bringing throngs of people into Paris. Saint-Lazare Station was centrally located, adjacent to a bustling, fashionable commercial area. Monet captured the area's energy and vitality. The train, emerging from the steam and smoke it emits, comes into the station. The tall buildings that were becoming a major component of the Parisian landscape are just visible through the background haze. Monet's agitated paint application contributes to the sense of energy and conveys the atmosphere of urban life.

Leisure and Recreation Another facet of Paris that drew the Impressionists' attention was the leisure activities of its inhabitants. Scenes of dining, dancing, café-concerts, the opera, and the ballet were mainstays of Impressionism. Although seemingly unrelated to industrialization, these activities

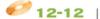

PIERRE-AUGUSTE RENOIR, *Le Moulin de la Galette*, 1876. Oil on canvas, approx. 4' 3" × 5' 8". Louvre, Paris.

Renoir's painting of this popular Parisian dance hall is dappled by sunlight and shade, artfully blurred into the figures to produce just the effect of floating and fleeting light that the Impressionists so cultivated.

were facilitated by it. With the advent of set working hours, people's schedules became more regimented, allowing them to plan their favorite pastimes.

Le Moulin de la Galette (FIG. 12-12) by PIERRE-AUGUSTE RENOIR (1841–1919) depicts a popular Parisian dance hall. Some people crowd the tables and chatter, while others dance energetically. So lively is the atmosphere that one can almost hear the sounds of music, laughter, and tinkling glasses. The whole scene is dappled by sunlight and shade, artfully blurred into the figures to produce just the effect of floating and fleeting light the Impressionists so cultivated. Renoir's casual, unposed placement of the figures and the suggested continuity of space, spreading in all directions and only accidentally limited by the frame, position the viewer as a participant, rather than as an outsider. Whereas classical art sought to express universal and timeless qualities, Impressionism attempted to depict just the opposite—the incidental and the momentary.

Degas and the Ballet The fascination EDGAR DEGAS (1834–1917) had with patterns of motion brought him to the Paris Opéra and its ballet school. There, his great observational power took in the formalized movements of classical ballet, one of his favorite subjects. In *Ballet Rehearsal* (Fig. 12-13), Degas used several devices to bring the observer into the pictorial space. The frame cuts off the spiral stair, the windows in the background, and the group of figures in the right foreground. The figures are not centered but rather arranged in a seemingly random manner. The prominent diagonals of

the wall bases and floorboards carry the viewer into and along the directional lines of the dancers. Finally, as is customary in Degas's ballet pictures, a large, off-center, empty space creates the illusion of a continuous floor that connects the observer with the pictured figures. By seeming to stand on the same surface with them, the viewer is drawn into their space.

The often arbitrarily cutoff figures, the patterns of light splotches, and the blurriness of the images in this and other Degas works indicate the artist's interest in reproducing single moments. Further, they reveal his fascination with photography. Degas not only studied the photography of others, but he also used the camera to make preliminary studies for his works, particularly photographing figures in interiors.

Japanese art also played an important role in the formation of Degas's style. The cunning spatial projections in his paintings probably derived in part from Japanese prints (see Figs. 17-13 and 17-14 and "Japanese Woodblock Prints," Chapter 17, page 485), which were more readily available in the West than any other Japanese art form. Japanese artists used diverging lines not only to organize the flat shapes of figures but also to direct attention into the picture space (Fig. 17-13). The Impressionists, acquainted with these prints as early as the 1860s, greatly admired their spatial organization, the familiar and intimate themes, and the flat unmodeled color areas.

An American Impressionist At the Salon of 1874, Degas admired a painting by a young Philadelphia artist, MARY CASSATT (1844–1926). Cassatt had moved to Europe to study

12-13 | EDGAR DEGAS, *Ballet Rehearsal*, 1874. Oil on canvas, 1' 11" × 2' 9". Glasgow Art Galleries and Museum, Glasgow (The Burrell Collection).

The arbitrarily cut-off figures, the patterns of light splotches, and the blurriness of the images in this work reveal Degas's interest in reproducing single moments, as well as his fascination with photography.

masterworks in France and Italy. Degas befriended and influenced her, and she exhibited regularly with the Impressionists. However, as a woman, she could not easily frequent the cafés with her male artist friends. She was also responsible for the care of her aging parents, who had joined her in Paris. Because of these restrictions, Cassatt's subjects were principally women and children, whom she presented with a combination of objectivity and genuine sentiment. Works such as *The Bath* (Fig. 12-14) show the tender relationship between a mother and child. The solidity of the mother and child contrasts with the flattened patterning of the wallpaper and rug. Cassatt's style in this work owed much to the compositional devices of Degas and of Japanese prints, but the painting's design has an originality and strength all its own.

Exploring Paris's Nightlife French artist HENRI DE TOULOUSE-LAUTREC (1864–1901) was interested in capturing the sensibility of modern life and deeply admired Degas. Because of this interest and admiration, his work intersects with that of the Impressionists, but it has an added satirical edge to it and often borders on caricature. Toulouse-Lautrec's art was, to a degree, the expression of his life. Self-exiled by his infirmities and diminuitive stature from the high society his ancient

12-14 | MARY CASSATT, *The Bath*, ca. 1892. Oil on canvas, 3' 3" × 2' 2". The Art Institute of Chicago, Chicago (Robert A. Walker Fund).

Cassatt's style owed much to the compositional devices of Degas and of Japanese prints, but her subjects differ from those of most Impressionists, in part because, as a woman, she could not frequent Parisian cafés.

TOULOUSE-LAUTREC, At the Moulin Rouge, 1892–1895. Oil on canvas, approx. 4' × 4' 7". The Art Institute of Chicago, Chicago (Helen Birch Bartlett Memorial Collection).

The influence of Degas, the Japanese print, and photography can be seen in this painting's oblique and asymmetrical composition, the spatial diagonals, the strong line patterns, and the dissonant colors.

aristocratic name entitled him to enter, he became a denizen of the night world of Paris, consorting with a tawdry population of entertainers, prostitutes, and other social outcasts. He reveled in the energy of cheap music halls, cafés, and bordellos. In At the Moulin Rouge (Fig. 12-15), the influences of Degas, of the Japanese print, and of photography can be seen in the oblique and asymmetrical composition, the spatial diagonals, and the strong line patterns with added dissonant colors. But Toulouse-Lautrec so emphasized or exaggerated each element that the tone is new. Compare, for example, this painting's mood with the relaxed and casual atmosphere of Renoir's Le Moulin de la Galette (Fig. 12-12). Toulouse-Lautrec's scene is nightlife, with its glaring artificial light, brassy music, and assortment of corrupt, cruel, and masklike faces. (He included himself in the background—the tiny man with the derby accompanying the very tall man, his cousin.) Such distortions by simplification of the figures and faces anticipated Expressionism (see Chapter 13), in which artists' use of formal elements-for example, brighter colors and bolder lines than ever before—increased their images' impact on observers.

Orchestrating Art James Abbott McNeill Whistler (1834–1903) was an American expatriate artist who worked on the European continent before settling finally in London. In Paris, he knew many of the Impressionists, and his art is an

interesting mixture of some of their concerns and his own. Whistler shared their interests in the subject of contemporary life and the sensations that color produces on the eye. To these influences he added his interest in creating harmonies paralleling those achieved in music. To underscore his artistic intentions, Whistler began calling his paintings "arrangements" or "nocturnes."

Nocturne in Black and Gold (Fig. 12-16), subtitled *The Falling Rocket*, is a daring painting with gold flecks and splatters that represent the exploded firework punctuating the darkness of the night sky. The artist was clearly more interested in conveying the atmospheric effects than he was in providing details of the actual scene. Whistler emphasized creating a harmonious arrangement of shapes and colors on the rectangle of his canvas, an approach that interested many 20th-century artists.

Such works angered many viewers. Ruskin responded to this painting by writing a scathing review accusing Whistler of "flinging a pot of paint in the public's face." In reply, Whistler sued Ruskin for libel. Although Whistler won the case, his victory had sadly ironic consequences for him. The judge, showing where his—and perhaps the public's—sympathies lay, awarded the artist only one farthing (less than a penny) in damages and required him to pay all of the court costs, which ruined Whistler financially.

12-16 | JAMES ABBOTT MCNEILL WHISTLER, Nocturne in Black and Gold (The Falling Rocket), ca. 1875. Oil on panel, 1' $11\frac{5''}{8} \times 1' 6\frac{1}{2}''$. The Detroit Institute of Arts, Detroit (gift of Dexter M. Ferry Jr.).

In this painting, Whistler reveals an Impressionist's interest in conveying the atmospheric effects of fireworks at night, but he also emphasized the abstract arrangement of shapes and colors, foreshadowing 20th-century art.

Post-Impressionism

By 1886, most critics and a large segment of the public accepted the Impressionists as serious artists. Just when their images of contemporary life no longer seemed crude and unfinished, however, a group of younger followers came to feel that the Impressionists were neglecting too many of the traditional elements of picture making in their attempts to capture momentary sensations of light and color on canvas. These artists were much more interested in examining the properties and expressive qualities of line, pattern, form, and color. Because their art diverged so markedly from Impressionism, art historians refer to this next generation of avant-garde artists as the Post-Impressionists.

Expressive Color VINCENT VAN GOGH (1853–1890) explored the capabilities of colors and distorted forms to express his emotions. Although the image of van Gogh as a madman persists in the public imagination, van Gogh is better described

as a tormented individual who suffered from epileptic seizures. Only after he turned to painting did he find a way to communicate his experiences. In one of the many revealing letters he wrote to his brother, Theo, van Gogh observed: "Instead of trying to reproduce exactly what I have before my eyes, I use color more arbitrarily so as to express myself forcibly." He explained that the color in one of his paintings was "not locally true from the point of view of the delusive realist, but color suggesting some emotion of an ardent temperament." ¹⁰

Van Gogh's insistence on the expressive values of color led him to develop a corresponding expressiveness in his paint application. The thickness, shape, and direction of his brush strokes created a tactile counterpart to his intense color schemes. He moved the brush vehemently back and forth or at right angles, giving a textilelike effect, or squeezed dots or streaks onto his canvas from his paint tube. This bold, almost slapdash attack enhanced the intensity of his colors.

12-17 | VINCENT VAN GOGH, The Night Café, 1888. Oil on canvas, approx. $2' 4\frac{1}{2}'' \times 3'$. Yale University Art Gallery, New Haven (bequest of Stephen Carlton Clark).

In this café scene, van Gogh explored the capabilities of colors and distorted forms to express his emotions. The thickness, shape, and direction of his brush strokes create a tactile counterpart to the intense colors.

The son of a Dutch Protestant pastor, van Gogh moved to Arles in southern France in 1888, where he painted The Night Café (Fig. 12-17). Although the subject is apparently benign, van Gogh invested it with a charged energy. The proprietor of the café rises like a specter from the edge of the billiard table, which van Gogh depicted in such a steeply tilted perspective that it threatens to slide out of the painting into the viewer's space. As van Gogh described it, the painting was meant to convey "a place where one can ruin oneself, go mad, or commit a crime." ¹¹ He communicated this by selecting vivid hues whose juxtaposition augmented their intensity: "I have tried to express the terrible passions of humanity by means of red and green. The room is blood red and dark yellow with a green billiard table in the middle; there are four citron-yellow lamps with a glow of orange and green. Everywhere there is a clash and contrast of the most disparate reds and greens."12

Stars at Saint-Rémy Just as illustrative of van Gogh's "expressionist" method is *Starry Night* (Fig. 12-18), which the artist painted in 1889, the year before he died of a self-inflicted gunshot wound. At this time, van Gogh was living in an asylum in Saint-Rémy, where he had committed himself. In *Starry Night*, the artist did not represent the sky as either a Realist or an Impressionist would have. Rather, he communicated the vastness of the universe, filled with whirling and exploding stars and galaxies of stars, the earth and humanity huddling beneath it. Given van Gogh's determination to use color to express himself forcibly, the dark, deep blue that pervades the entire painting cannot be overlooked. Together with the turbulent brush strokes, the color suggests a quiet but pervasive depression.

Abstract Shape and Color Like van Gogh, the French painter Paul Gauguin (1848–1903) rejected objective representation in favor of subjective expression. He also broke with the Impressionistic studies of minutely contrasted hues because he believed color above all must be expressive and that the artist's power to determine the colors in a painting was a seminal element of creativity. However, whereas van Gogh's heavy, thick brush strokes were an important component of his expressive style, Gauguin's color areas appear flatter, often visually dissolving into abstract patches or patterns. Gauguin admired Japanese prints, stained glass (Fig. 7-8), and cloisonné enamels (Fig. 6-1), and these contributed to his own daring experiment to transform traditional painting and Impressionism into abstract, expressive patterns of line, shape, and pure color.

Gauguin in Tahiti After a brief period of association with van Gogh in Arles in 1888, Gauguin settled in Tahiti in the South Pacific. Gauguin was attracted to Tahiti because he believed it would offer him a life far removed from materialistic Europe and an opportunity to reconnect with nature. Upon his arrival, he was disappointed to find that Tahiti, under French control since 1842, was extensively colonized. Gauguin tried to maintain his vision of an untamed paradise by moving to the Tahitian countryside, where he expressed his fascination with primitive life and brilliant color in a series of striking decorative canvases. Gauguin often based the design, although indirectly, on native motifs, and the color owed its peculiar harmonies of lilac, pink, and lemon to the tropical flora of the islands.

12-18 | VINCENT VAN GOGH, Starry Night, 1889. Oil on canvas, approx. 2' 5" × 3' $\frac{1}{4}$ ". Museum of Modern Art, New York (acquired through the Lillie P. Bliss Bequest).

In Starry Night, van Gogh painted the vast night sky filled with whirling and exploding stars, the earth and humanity huddling beneath it. His paintings are almost abstract, expressive patterns of line, shape, and color.

In 1897, worn down by failing health and the poor reception of his work, Gauguin tried unsuccessfully to take his own life, but not before painting *Where Do We Come From? What Are We? Where Are We Going?* (Fig. 12-19). This canvas can be read as a summary of Gauguin's art and his views on life. The scene is a tropical landscape, populated with native women and children. He described it in a letter to a friend: "Where are we going? Near to death an old woman. . . . What are we? Day to day existence. . . . Where do we come from? Source. Child.

Life begins.... Behind a tree two sinister figures, cloaked in garments of sombre colour, introduce, near the tree of knowledge, their note of anguish caused by that very knowledge in contrast to some simple beings in a virgin nature, which might be paradise as conceived by humanity, who give themselves up to the happiness of living."¹³

Gauguin's description of this work as "comparable to the Gospels" indicates the expansiveness of his vision, but Where Do We Come From? remains a sobering, pessimistic image of

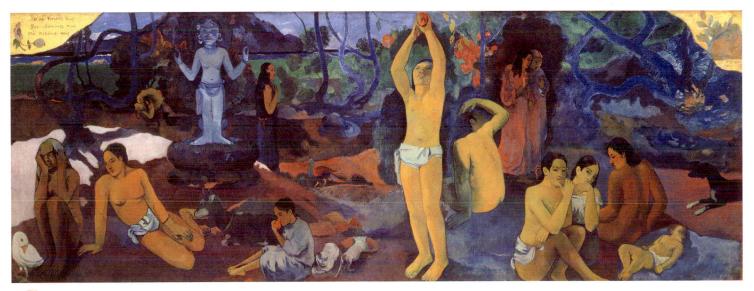

12-19 | PAUL GAUGUIN, Where Do We Come From? What Are We? Where Are We Going? 1897. Oil on canvas, $4' 6\frac{13''}{16} \times 12' 3''$. Museum of Fine Arts, Boston (Tompkins Collection).

Using Tahitian women as his subject, Gauguin here presented his own pessimistic view of the inevitability of the life cycle. As in his other paintings, Gauguin favored flat shapes of pure unmodulated color.

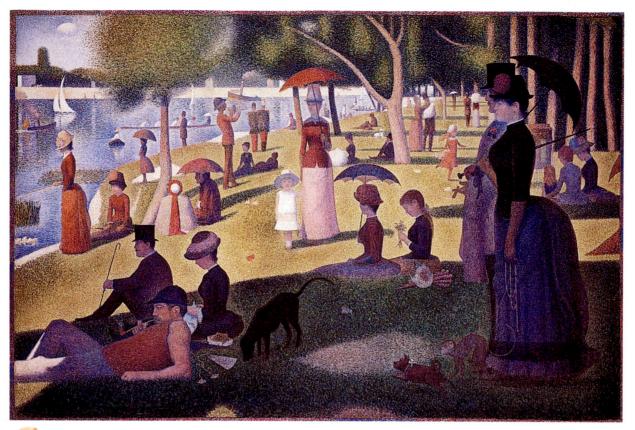

12-20 | GEORGES SEURAT, A Sunday on La Grande Jatte, 1884–1886. Oil on canvas, approx. 6' 9" × 10'. The Art Institute of Chicago, Chicago (Helen Birch Bartlett Memorial Collection, 1926).

Seurat's color system — pointillism — involved separating colors into their component parts and applying those colors to the canvas in tiny dots. The forms only become comprehensible from a distance.

the inevitability of the life cycle. In terms of style, this painting demonstrates Gauguin's commitment to the expressive ability of color. Although the venue is recognizable as a land-scape, most of the scene, other than the figures, is composed of flat areas of unmodulated color, which convey a lushness and intensity.

The Science of Color In contrast to the expressionistic nature of the work of van Gogh and Gauguin is the resolutely intellectual art of Frenchman Georges Seurat (1859-1891). Seurat devised a disciplined and painstaking system of painting that focused on color analysis. He was less concerned with the recording of immediate color sensations than he was with their careful and systematic organization into a new kind of pictorial order. Seurat disciplined the free and fluent play of color that characterized Impressionism into a calculated arrangement based on scientific color theory (see "19th-Century Color Theory," page 363). His system, known as pointillism or divisionism, involved carefully observing color and separating it into its component parts. The artist then applied these pure component colors to the canvas in tiny dots (points) or daubs. Thus, the shapes, figures, and spaces in the image become totally comprehensible only from a distance, when the viewer's eye blends the many pigment dots.

Pointillism was on view at the eighth and last Impressionist exhibition in 1886, when Seurat showed his A Sunday on La Grande Jatte (Fig. 12-20). The subject of the painting is reminiscent of the Impressionist interest in recreational themes, but this painting seems strangely rigid and remote. unlike the spontaneous representations of Impressionism. By using meticulously calculated values, Seurat carved out a deep rectangular space. He played on repeated motifs both to create flat patterns and to suggest spatial depth. Reiterating the profile of the female form, the parasol, and the cylindrical forms of the figures, Seurat placed each in space to set up a rhythmic movement in depth, as well as from side to side. The picture is filled with sunshine but not broken into transient patches of color. Light, air, people, and landscape are fixed in an abstract design whose line, color, value, and shape cohere in a precise and tightly controlled organization.

Making Impressionism "Durable" Like Seurat, the French artist PAUL CÉZANNE (1839–1906) turned from Impressionism to develop a more analytical style. Although at first he accepted the Impressionists' color theories and their faith in subjects chosen from everyday life, his own studies of Renaissance and Baroque paintings in the Louvre persuaded him that Impressionism lacked form and structure. Cézanne

MATERIALS + TECHNIQUES

19th-Century Color Theory

In the 19th century, advances in the sciences contributed to changing theories about color and how people perceive it. Many physicists and chemists immersed themselves in studying optical reception and the behavior of the human eye in response to light of differing wavelengths. They also investigated the psychological dimension of color. These new ideas about color and its perception provided a framework within which artists such as Georges Seurat worked. Although it is not known exactly which publications on color Seurat himself read, he no doubt relied on aspects of these evolving theories to develop *pointillism* (Fig. 12-20).

Discussions of color often focus on hue (for example, red, yellow, and blue), but it is important to consider the other facets of color—saturation (the hue's brightness or dullness) and value (the hue's lightness or darkness). Most artists during the 19th century understood the primary colors as red, yellow, and blue, and the complementary or secondary colors as those produced by mixing pairs of these primaries—green (blue plus yellow), violet (red plus blue), and orange (red plus yellow). Chemist Michel-Eugène Chevreul extended artists' understanding of color dynamics by formulating the law of simultaneous contrast of colors. Chevreul asserted that juxtaposed colors affect the eye's reception of each, making the two colors as dissimilar as possible, both in hue and value. For example, placing light green next to dark green has the effect of making the light green look even lighter and the dark green darker. Chevreul further provided an explanation of successive contrasts—the phenomenon of colored afterimages. When a person looks intently at a color (green,

for example) and then shifts to a white area, the fatigued eye momentarily perceives the complementary color (red).

Charles Blanc, who coined the term "optical mixture" to describe the visual effect of juxtaposed complementary colors, asserted that the smaller the areas of adjoining complementary colors, the greater the tendency for the eye to "mix" the colors, so that the viewer perceives a grayish or neutral tint. Seurat used this principle frequently in his paintings.

Also influential for Seurat was the work of physicist Ogden Rood, who published his ideas in *Modern Chromatics, with Applications to Art and Industry* in 1879. Rood expanded on the ideas of Chevreul and Blanc, and constructed an accurate and understandable diagram of contrasting colors. Further (and particularly significant to Seurat), Rood explored placing small dots or lines of color side by side to achieve gradation.

The color experiments of Seurat and other late-19th-century artists were also part of a larger discourse about human vision and how people see and understand the world. The theories of physicist Ernst Mach focused on the psychological experience of sensation. He believed that humans perceived their environments in isolated units of sensation that the brain then recomposed into a comprehensible world. Another scientist, Charles Henry, also pursued research into the psychological dimension of color—how colors affect people, and under what conditions. He went even further to explore the physiological effects of perception. Seurat's work, though characterized by a systematic and scientifically minded approach, also incorporated his concerns about the emotional tone of the images.

declared he wanted to "make of Impressionism something solid and durable like the art of the museums." ¹⁵

The basis of Cézanne's art was his unique way of studying nature, as seen in works such as Mont Sainte-Victoire

(Fig. 12-21). His aim was not truth in appearance, especially not photographic truth, nor was it the "truth" of Impressionism, but rather a lasting structure behind the formless and fleeting visual information the eye absorbs. Instead of employing

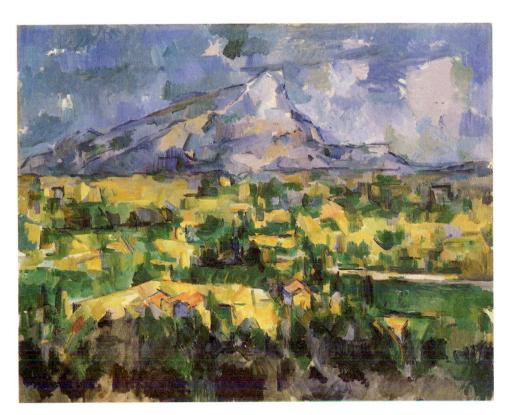

12-21 | PAUL CÉZANNE, Mont Sainte-Victoire, 1902–1904. Oil on canvas, $2' 3\frac{1}{2}'' \times 2' 11\frac{1}{4}''$. Philadelphia Museum of Art, Philadelphia (The George W. Elkins Collection).

In his landscapes, Cézanne replaced the transitory visual effects of changing atmospheric conditions that occupied the Impressionists with careful analysis of the lines, planes, and colors of nature.

the Impressionists' random approach when he was face-to-face with nature, Cézanne attempted to order his presentation of the lines, planes, and colors found in nature. He did so by constantly and painstakingly checking his painting against the part of the actual scene—he called it the "motif"—he was studying at the moment. When Cézanne wrote of his goal of "doing Poussin over entirely from nature," he apparently meant that Poussin's effects of distance, depth, structure, and solidity must be achieved not by traditional perspective and chiaroscuro but in terms of the color patterns an optical analysis of nature provides.

With special care, Cézanne explored the properties of line, plane, and color and their interrelationships. He studied the effect of every kind of linear direction, the capacity of planes to create the sensation of depth, the intrinsic qualities of color, and the power of colors to modify the direction and depth of lines and planes. To create the illusion of three-dimensional form and space, Cézanne focused on carefully selecting colors. He understood that the visual properties—hue, saturation, and value—of different colors vary. Cool colors tend to recede, warm ones to advance. By applying to the canvas small patches of juxtaposed colors, some advancing and some receding, Cézanne created volume and spatial depth in his works. On occasion, the artist depicted objects chiefly in one hue and achieved convincing solidity by modulating the intensity (or saturation). At other times, he juxtaposed contrasting colors of like saturation to compose specific objects, such as fruit or bowls.

Mont Sainte-Victoire is one of many views Cézanne painted of this mountain near his home in Aix-en-Provence. In it, he replaced the transitory visual effects of changing atmospheric conditions, effects that occupied Monet, with a more concentrated, lengthier analysis of the colors in large lighted spaces. The main space stretches out behind and beyond the canvas plane and includes numerous small elements, such as roads, fields, houses, and the viaduct at the far right, each seen from a slightly different viewpoint. Above this shifting, receding perspective rises the largest mass of all, the mountain, with an effect—achieved by equally stressing background and foreground contours—of being simultaneously near and far away. This portrayal approximates the actual experience a person observing such a view might have if apprehending the landscape forms piecemeal. The relative proportions of objects would vary, rather than being fixed by a strict one- or twopoint perspective, such as that normally found in a photograph. Cézanne immobilized the shifting colors of Impressionism into an array of clearly defined planes that compose the objects and spaces in his scene.

Revealing Underlying Structure The still life was another good vehicle for Cézanne's experiments, as he could arrange a limited number of selected objects to provide a well-ordered point of departure. In *The Basket of Apples* (Fig. 12-22), the objects have lost something of their individual character as bottles and fruit and approach the condition of

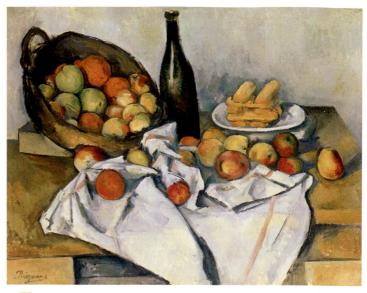

12-22 | PAUL CÉZANNE, *The Basket of Apples*, ca. 1895. Oil on canvas, $2'\frac{3}{8}'' \times 2'$ 7". The Art Institute of Chicago, Chicago (Helen Birch Bartlett Memorial Collection, 1926).

Cézanne's analytical approach to painting is evident in his still lifes. Here, he captured the solidity of bottles and fruit by juxtaposing color patches, but the resulting abstract shapes are not optically realistic.

cylinders and spheres. So analytical was Cézanne in preparing, observing, and painting these still lifes (in contrast to the Impressionist emphasis on the idea of the spontaneous) that he had to abandon using real fruit and flowers because they tended to rot. In The Basket of Apples, he captured the solidity of each object by juxtaposing color patches. Cézanne's interest in the study of volume and solidity is evident from the disjunctures in the painting—the table edges are discontinuous, and various objects seem to be depicted from different vantage points. In his zeal to understand threedimensionality and to convey the placement of forms relative to the space around them, Cézanne explored his still life arrangements from different viewpoints. This resulted in paintings that, although conceptually coherent, do not appear optically realistic. In keeping with the modernist concern with the integrity of the painting surface, Cézanne's methods never allow the viewer to disregard the actual two-dimensionality of the picture plane. In this manner, Cézanne achieved a remarkable feat—presenting the viewer with two-dimensional and three-dimensional images simultaneously.

Symbolism

Modernist artists, in particular the Impressionists and Post-Impressionists, concentrated on using their emotions and sensations to interpret nature. By the end of the 19th century, the representation of nature became completely subjectivized, to the point that artists did not imitate nature but created free interpretations of it. Artists rejected the optical world as

observed in favor of a fantasy world, of forms they conjured in their free imagination, with or without reference to things conventionally seen. Color, line, and shape, divorced from conformity to the optical image, were used as symbols of personal emotions in response to the world.

Many of the artists following this path adopted an approach to subject and form that associated them with a general European movement called *Symbolism*. The term had application to both art and literature, which, as critics in both fields noted, were in especially close relation at this time. Symbolists disdained the "mere fact" of Realism as trivial and asserted that fact must be transformed into a symbol of the inner experience of that fact. The task of Symbolist visual and verbal artists was not to see things but to see through them to a significance and reality far deeper than what superficial appearance gave.

Modern Psychic Life The Norwegian painter and graphic artist EDVARD MUNCH (1863–1944) felt deeply the pain of human life. His belief that humans were powerless

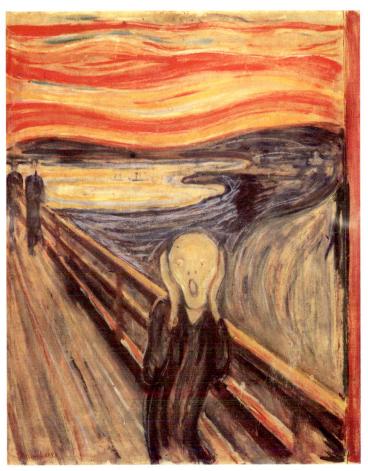

12-23 | EDVARD MUNCH, *The Cry*, 1893. Oil, pastel, and casein on cardboard, $2' 11\frac{3}{4}'' \times 2' 5''$. The Munch Museum, The Munch-Ellingsen Group, Oslo.

The Cry is grounded in the real world, but it departs significantly from visual reality. Instead, the painting evokes a visceral, emotional response from the viewer because of Munch's dramatic presentation.

before the great natural forces of death and love and the emotions associated with them—jealousy, loneliness, fear, desire, and despair—became the theme of most of his art. Because Munch's goal was to describe the conditions of "modern psychic life," as he put it, Realist and Impressionist techniques were inappropriate, focusing as they did on the tangible world. In the spirit of Symbolism, and influenced by Gauguin, Munch developed a style of putting color, line, and figural distortion to expressive ends.

Munch's The Cry (Fig. 12-23) is grounded in the real world—a man standing on a bridge or jetty in a landscape can be clearly discerned—but it departs significantly from a visual reality. Instead, the work evokes a visceral, emotional response from the viewer because of the artist's dramatic presentation. The man in the foreground, simplified to almost skeletal form, emits a primal scream. The landscape's sweeping curvilinear lines reiterate the curvilinear shape of the mouth and head, almost like an echo, as it reverberates through the setting. The fiery red and yellow stripes that give the sky an eerie glow also contribute to the painting's resonance. The emotional impulse that led Munch to produce *The* Cry is revealed in an epigraph Munch wrote to accompany the painting: "I stopped and leaned against the balustrade, almost dead with fatigue. Above the blue-black fjord hung the clouds, red as blood and tongues of fire. My friends had left me, and alone, trembling with anguish, I became aware of the vast, infinite cry of nature."17 Appropriately, this work originally was titled Despair.

Fin de Siècle

As the end of the 19th century neared, the momentous changes to which the Realists and Impressionists responded had become familiar and ordinary. The term fin de siècle, which literally means "end of the century," is used to describe this period. This designation is not merely chronological but also refers to a certain sensibility. The cultures to which this term applies experienced a significant degree of political upheaval. Moreover, prosperous middle classes dominated these societies—middle classes that aspired to the advantages the aristocracy already enjoyed. These people were determined to live "the good life," which evolved into a culture of decadence and indulgence. Characteristic of the fin de siècle period was an intense preoccupation with sexual drives, powers, and perversions. The femme fatale was a particularly resonant figure. People at the end of the century also immersed themselves in an exploration of the unconscious. This fin de siècle culture was unrestrained and freewheeling, but the determination to enjoy life masked an anxiety prompted by the fluctuating political situation and uncertain future. The country most closely associated with fin de siècle culture was Austria.

Opulence and Sensuality One Viennese artist whose works capture this period's flamboyance but temper it with unsettling undertones was Gustav Klimt (1863–1918). In

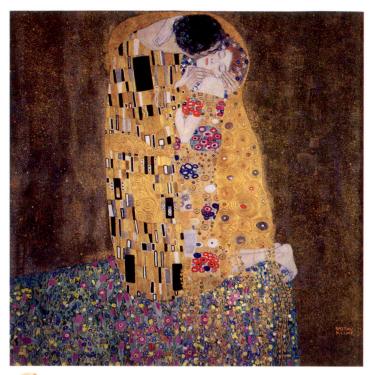

12-24 | GUSTAV KLIMT, *The Kiss*, 1907–1908. Oil on canvas, $5' 10\frac{3}{4}'' \times 5' 10\frac{3}{4}''$. Austrian Gallery, Vienna.

In this opulent fin de siècle painting, all that is visible of the two lovers is a segment of each person's head, hands, and feet. The rest of the painting dissolves into shimmering, extravagant flat patterning.

The Kiss (Fig. 12-24), Klimt depicted a couple locked in an embrace. All that is visible of the couple, however, is a segment of each person's head, hands, and feet. The rest of the painting dissolves into shimmering, extravagant flat patterning. Such a

12-25 | Auguste Rodin, Burghers of Calais, 1884–1889, cast ca. 1953–1959. Bronze, $6' 10\frac{1}{2}'' \times 7' 11'' \times 6' 6''$. Hirshhorn Museum and Sculpture Garden, Smithsonian Institution, Washington, D.C. (gift of Joseph H. Hirshhorn, 1966).

Rodin was able to capture the quality of the transitory through his highly textured surfaces, while also revealing larger themes, as in this moving group of six citizens who offered to sacrifice their lives for their city. depiction is reminiscent of the conflict between two- and three-dimensionality intrinsic to the work of Degas and other modernists. Paintings such as *The Kiss* were visual manifestations of fin de siècle spirit because they captured a decadence conveyed by opulent and sensuous images.

SCULPTURE

The three-dimensional art of sculpture was not readily adaptable to capturing the optical sensations favored by many late-19th-century painters. Sculpture's very nature—its tangibility and solidity—suggests permanence. Sculpture thus served predominantly as an expression of supposedly timeless ideals, rather than of the transitory. But that did not stop sculptors during this period from pursuing many of the ideas fundamental to movements such as Realism and Impressionism.

Of Surface and Substance The French artist Auguster Rodin (1840–1917) was one of those imbued with the Realist spirit, and he conceived and executed his sculptures with that sensibility. But he was also well aware of artistic developments such as Impressionism. Although color was not a significant factor in Rodin's work, Impressionist influence manifested itself in the artist's abiding concern for the effect of light on the three-dimensional surface. When focusing on the human form, he joined his profound knowledge of anatomy and movement with special attention to the body's exterior, saying, "The sculptor must learn to reproduce the surface, which means all that vibrates on the surface, soul, love, passion, life. . . . Sculpture is thus the art of hollows and mounds, not of smoothness, or even polished planes." Primarily a modeler of pliable material rather than a carver of hard wood or stone, Rodin worked his

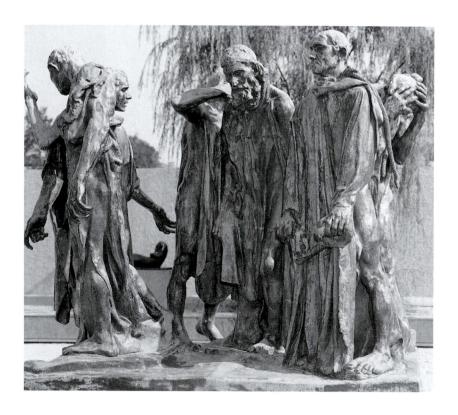

surfaces with fingers sensitive to the subtlest variations of surface, catching the fugitive play of constantly shifting light on the body. In his studio, he often would have a model move around in front of him while he made "sketches" with coils of clay.

Despair and Defiance In his sculptures, Rodin was able to capture the quality of the transitory through his highly textured surfaces while revealing larger themes and deeper, lasting sensibilities. Rodin's cast-bronze life-size group Burghers of Calais (Fig. 12-25) was commissioned to commemorate a heroic episode in the Hundred Years' War. During the English siege of Calais, France, in 1347, six of the city's leading citizens agreed to offer their lives in return for the English king's promise to lift the siege and spare the rest of the populace. Each of the bedraggled-looking figures is a convincing study of despair, resignation, or quiet defiance. Rodin enhanced the psychic effects through his choreographic placement of the group members. Rather than clustering in a tightly formal composition, the burghers (middle-class citizens) seem to wander aimlessly. The roughly textured surfaces add to the pathos of the figures and compel the viewer's continued interest. Rodin designed the monument without the traditional high base in the hope that the citizens of Calais would be inspired by the sculptural representation of their ancestors standing eye-level in the city center and preparing eternally to set off on their sacrificial journey. The government commissioners found Rodin's vision so offensive, however, that they banished the monument to a remote site and modified the work's impact by placing it high on an isolating pedestal.

ARCHITECTURE

In the later 19th century, new technology and the changing needs of urbanized, industrialized society, as well as the new modernist aesthetic, affected architecture throughout the Western world. The Realist impulse, for example, encouraged an architecture that honestly expressed a building's purpose, rather than elaborately disguised a building's function.

A Soaring Metal Skeleton The elegant skeletal structures of the French engineer-architect ALEXANDRE-GUSTAVE EIFFEL (1832-1923) can be seen as responses to this idea. Eiffel designed his best-known work, the Eiffel Tower (Fig. 12-26), for a great exhibition in Paris in 1889. Originally seen as a symbol of modern Paris, the metal tower thrusts its needle shaft 984 feet above the city, making it at the time of its construction the world's tallest structure. The tower rests on four giant supports connected by gracefully arching openframe skirts that provide a pleasing mask for the heavy horizontal girders needed to strengthen the legs. The transparency of the structure blurs the distinction between interior and exterior. Eiffel's metal skeleton structures jolted the architectural profession into a realization that newly available materials and processes could germinate a radically innovative approach to architectural design.

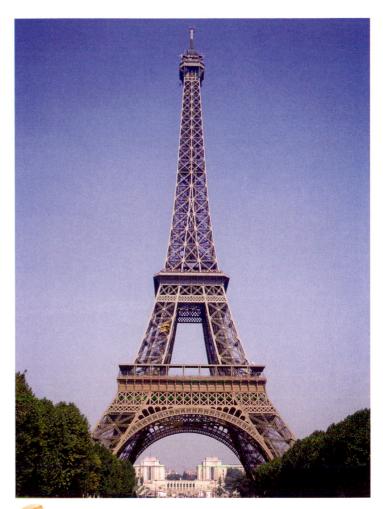

12-26 | ALEXANDRE-GUSTAVE EIFFEL, Eiffel Tower, Paris, France, 1889.

Eiffel's metal skeleton structures jolted the architectural profession into a realization that newly available materials and processes could germinate a radically new approach to architectural design.

The Skyscraper The desire for greater speed and economy in building, as well as for a reduction in fire hazards, prompted the use of cast and wrought iron for many building programs. Architects enthusiastically developed cast-iron architecture until a series of disastrous fires in the early 1870s demonstrated that cast iron by itself was far from impervious to fire. This discovery led to encasing the metal in masonry, combining the first material's strength with the second's fire resistance.

In cities, convenience required closely grouped buildings, and increased property values forced architects literally to raise the roof. Metal could support such tall structures, and the American skyscraper was born. As skyscrapers proliferated, architects refined the visual vocabulary of these buildings. LOUIS HENRY SULLIVAN (1856–1924), who has been called the first truly modern architect, arrived at a synthesis of industrial structure and ornamentation that perfectly expressed the spirit of late-19th-century commerce. To achieve this, he utilized the latest technological developments to create light-filled, well-ventilated office buildings and adorned both exteriors and interiors with ornate embellishments. These characteristics are evident in the Guaranty (Prudential)

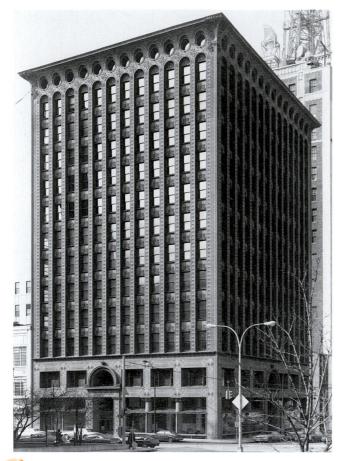

12-27 | LOUIS HENRY SULLIVAN, Guaranty (Prudential) Building, Buffalo, 1894–1896.

Sullivan utilized the latest technological developments to create lightfilled, well-ventilated office buildings and adorned them with ornate embellishments that imparted a sense of refinement and taste.

Building (Fig. 12-27) in Buffalo, New York, built between 1894 and 1896. The structure is steel, sheathed with terracotta. The imposing scale of the building and the regularity of the window placements served as an expression of the large-scale, refined, and orderly office work that took place within. Sullivan tempered the severity of the structure with lively ornamentation, both on the piers and cornice on the exterior of the building and on the stairway balustrades, elevator cages, and ceiling in the interior. The building's form, then, began to express its function, both actual and symbolic, and Sullivan's famous dictum that "form follows function" found its illustration here.

An Art Nouveau Staircase The international style of Art Nouveau took its name from a shop in Paris called L'Art Nouveau (New Art). Proponents of this movement tried to synthesize all the arts in a determined attempt to create art based on natural forms that could be mass-produced for a large audience. The Art Nouveau style emerged at the end of the 19th century and adapted the twining plant form to the needs of architecture, painting, sculpture, and all the decorative arts.

The mature Art Nouveau style was first seen in houses designed in Brussels in the 1890s by VICTOR HORTA

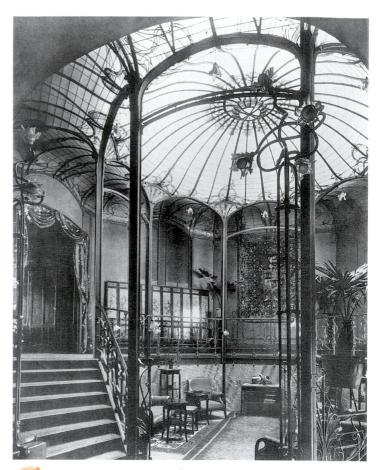

12-28 | VICTOR HORTA, staircase in the Van Eetvelde House, Brussels, Belgium, 1895.

The Art Nouveau movement was an attempt to create art and architecture based on natural forms. In this room, every detail is based on the theme of the twining plant and functions as part of a living whole.

(1861–1947)—for example, the staircase in the Van Eetvelde House (Fig. 12-28). Every detail functions as part of a living whole. Furniture, drapery folds, veining in the lavish stone panelings, and the patterning of the door moldings join with real plants to provide graceful counterpoints for the twining plant theme. Metallic tendrils curl around the railings and posts, delicate metal tracery fills the glass dome, and floral and leaf motifs spread across the fabric panels of the screen.

CONCLUSION

The later 19th century witnessed the rise of modernism, an artistic movement or sensibility that involved a reflection on the premises of art itself. Rather than create illusionistic views of the world, modernist artists called attention to the facts of art making—for example, in painting, the canvas surface and pigment. Realism, Impressionism, and Post-Impressionism alike reveal the persistence and power of the modernist mentality. The momentum established by these modernist challenges to artistic tradition by the end of the 19th century continued unabated during the 20th century, when such experiments took artists into the realm of complete abstraction.

- I Queen Victoria of England, r. 1837-1901
- I Karl Marx and Friedrich Engels, Communist Manifesto, 1848

1850

- Napoleon III of France, r. 1852-1870
- Matthew Perry opens trade with Japan, 1853
- I Pavilion of Realism, Paris, 1855
- I Charles Darwin, On the Origin of Species, 1859

Jean-François Millet, The Gleaners, 1857

1860

1

2

- American Civil War, 1861-1865
- Napoleon III establishes Salon des Refusés, 1863

Édouard Manet, Le Déjeuner sur l'Herbe, 1863

1870

- Third Republic founded in France, 1871
 - First Impressionist exhibition, Paris, 1874
 - I Ogden Rood, Modern Chromatics, 1879

1880

I Salon des Indépendants, Paris, 1886

Claude Monet, Impression: Sunrise, 1872

4

1890

Alexandre-Gustave Eiffel, Eiffel Tower, Paris, 1889

1900

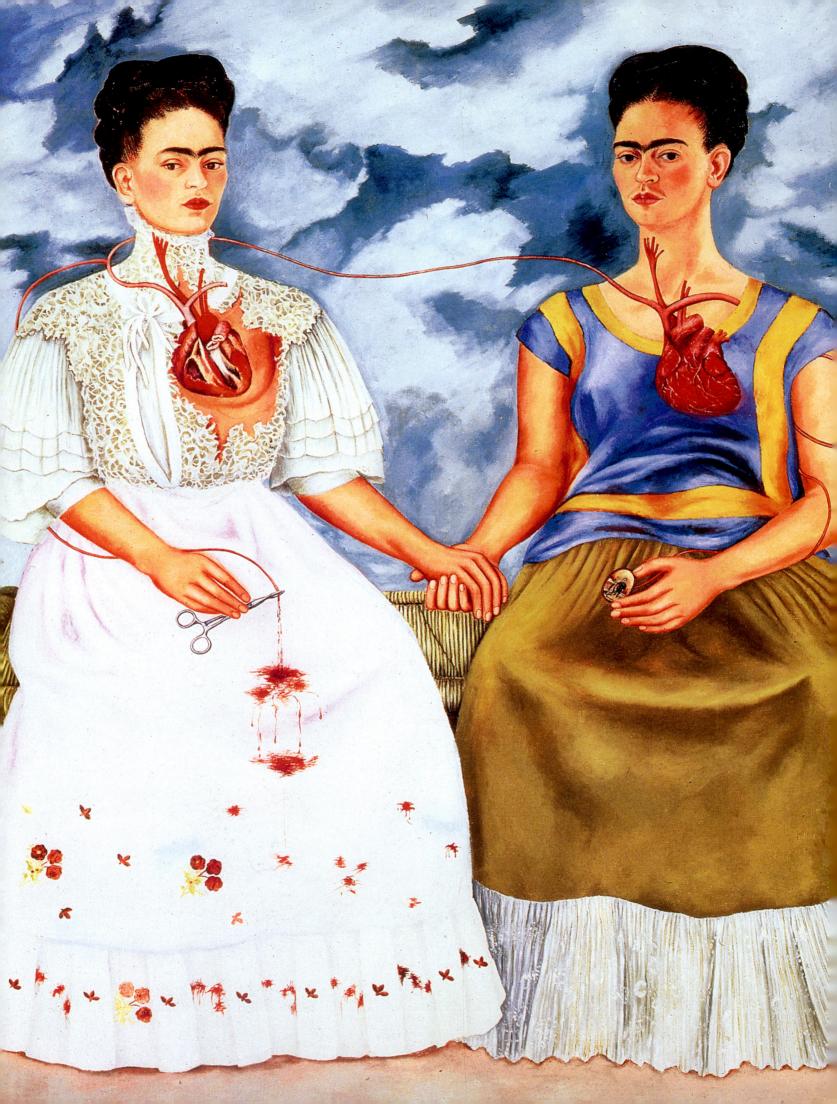

EUROPE AND AMERICA, 1900-1945

In the early 20th century, societies worldwide contended with discoveries and new ways of thinking in a wide variety of fields, including science, technology, economics, and politics. These new ideas forced people to revise radically how they understood their worlds. In particular, the values and ideals that were the legacy of the Enlightenment began to yield to innovative views. Intellectuals countered 18th- and 19th-century assumptions about progress and reason with ideas challenging traditional notions about the physical universe, the structure of society, and human nature.

Challenging Newtonian Physics One of the fundamental Enlightenment beliefs was faith in science. Because it was based on empirical, or observable, fact, science provided a mechanistic conception of the universe, which reassured a populace that was finding traditional religions less certain. As promoted in the classic physics of Isaac Newton, the universe was a huge machine consisting of time, space, and matter. In the early 20th century, Max Planck (1858-1947), Albert Einstein (1879-1955), Ernest Rutherford (1871-1937), and Niels Bohr (1885-1962) shattered the existing faith in the objective reality of matter. Planck's quantum theory (1900) raised questions about the emission of atomic energy. Einstein's 1905 paper, The Electrodynamics of Moving Bodies, outlined his theory of relativity. Einstein argued that space and time are not absolute, as postulated in Newtonian physics, but are relative to the observer and linked in what Einstein called a four-dimensional space-time continuum. He also concluded that matter is not a solid, tangible reality but actually another form of energy. Einstein's famous equation, $E = mc^2$, where E stands for energy, m for mass, and c for the speed of light, was a formula for understanding atomic energy. Rutherford's and Bohr's exploration of atomic structure between 1906 and 1913 contributed to this new perception of matter and energy. Together, all these scientific discoveries constituted a changed view of physical nature.

Advances in Technology Beyond the realm of physics, advances in chemistry, biology, biochemistry, microbiology, and medicine in the early 20th century yielded knowledge of polymers, plastics, fertilizers, enzymes, viruses, vitamins, hormones, and antibiotics. Technological advances in communication and transportation transformed daily life. People adapted to radios, radar, televisions, and talking cinema, as well as automobiles, airplanes, electrified railway and municipal transit systems, and electrification of street lighting and home appliances.

FRIDA KAHLO, *The Two Fridas*, 1939. Oil on canvas, 5' 7" × 5' 7". Museo de Arte Moderno, Mexico City.

Cybernetic theory and early computer models were in place by midcentury.

Mind over Matter In philosophy, psychology, and economic theory, significant challenges to the primacy of reason and objective reality emerged. Friedrich Nietzsche (1844-1900) argued that Western society was decadent and incapable of any real creativity precisely because of its excessive reliance on reason at the expense of emotion and passion. Sigmund Freud (1856–1939) developed the fundamental principles for what became known as psychoanalysis. In his book The Interpretation of Dreams (1900), Freud argued that inner drives and the unconscious control human behavior. Freud concluded that this control by the unconscious is due to repression—that is, individuals' mental suppression of uncomfortable experiences or memories. Carl Jung (1875-1961), building on Freud's theories, asserted that the unconscious is composed of two facets, a personal unconscious and a collective unconscious. The collective unconscious comprises memories and associations all humans share, such as archetypes (original models) and mental constructions. According to Jung, the collective unconscious accounts for the development of myths, religions, and philosophies.

Industrial Capitalism The industrialization so prominent during the 19th century matured quickly. By the early part of the 20th century, large corporations with enormous factories had become common. The "captains of industry"—the owners and managers of such industrial giants—wielded extraordinary economic and political power. Due to the widening gap between these captains of industry and the laborers, Marxism grew in popularity, and enrollment in trade unions and socialist parties increased.

The development of advanced industrial societies in Europe and America also led to frenzied imperialist expansion. Countries controlled far-flung empires and spread their spheres of influence worldwide (MAP 13-1, page 533). By the beginning of the 20th century, Britain, France, Germany, Belgium, Italy, Spain, and Portugal all had footholds in Africa. In Asia, Britain ruled India, the Dutch controlled Indonesia's vast archipelago, the French held power in Indochina, and the Russians ruled Central Asia and Siberia. Japan began rising as a new and formidable Pacific power that would stake its claims to empire in the 1930s. Such imperialism was capitalist and expansionist, establishing colonies as sources of raw materials, as manufacturing markets, and as territorial acquisitions.

The Great War Nationalism and imperialism produced international competition. The conflicts between the two major blocs—the Triple Alliance (Germany, Austria-Hungary, and Italy) and the Triple Entente (Russia, France, and Great Britain)—led to World War I. The "Great War" lasted from 1914 until 1918 and involved virtually all of Europe. Even the United States entered the fray in 1917. Nine million men killed in battle, and the introduction of poison gas in 1915,

added to the horror of humankind's inhumanity to itself. The devastation of World War I brought widespread misery, social disruption, and economic collapse.

The Tsar's Demise The Russian Revolution exacerbated the global chaos when it erupted in 1917. Dissatisfaction with the regime of Tsar Nicholas II had led workers to stage a general strike, causing the tsar to abdicate. In late 1917, the Bolsheviks wrested control of the country from the ruling Provisional Government. The Bolsheviks, led by Vladimir Lenin (1870–1924), promoted violent revolution and were eventually renamed the Communists. Once in power, Lenin nationalized the land and turned it over to the local rural soviets (councils of workers' and soldiers' deputies). After extensive civil war, the Communists succeeded in retaining control of Russia, officially renamed the Union of Soviet Socialist Republics in 1923.

Depression and More War The Great Depression of the 1930s dealt a serious blow to the stability of Western countries. By 1932, 25 percent of the British workforce was unemployed, and 40 percent of German workers were without jobs. Production in the United States plummeted by 50 percent. This economic disaster, along with the failure of postwar treaties and of the League of Nations to keep the peace, provided a fertile breeding ground for dangerous forces to emerge once again. In the 1920s and 1930s, totalitarian regimes came to the fore in several European countries. Benito Mussolini (1883-1945) headed the nationalistic Fascist regime in Italy. Joseph Stalin (1879-1953) gained control of the Communist Party in the Soviet Union in 1929. Concurrently, Adolf Hitler (1889–1945) consolidated his power in Germany by building the National Socialist German Workers' Party (the Nazi Party) into a mass political movement.

These ruthless seizures of power and the desire to develop "total states" led to the many conflicts that evolved into World War II. This catastrophic struggle erupted in 1939 when Germany invaded Poland, and Britain and France declared war on Germany. While Germany and Italy fought most of Europe and the Soviet Union, Japan invaded China and occupied Indochina. After the Japanese bombing of Pearl Harbor in Hawaii in 1941, the United States declared war on Japan. Germany, in loose alliance with Japan, declared war on the United States. Although most of the concerns of individual countries participating in World War II were territorial and nationalistic, other agendas surfaced as well. The Nazis, propelled by Hitler's staunch anti-Semitism, were determined to build a racially exclusive Aryan state. This resolve led to the horror of the Holocaust, the killing of nearly two of every three European Jews.

World War II drew to an end in 1945, when the Allied forces defeated Germany, and the United States dropped atomic bombs on Hiroshima and Nagasaki in Japan. The shock of the war's physical, economic, and psychological devastation immediately tempered the elation people felt at the conclusion of these global hostilities.

Avant-Garde and Expressionism Like other members of society, artists were deeply affected by the upheaval of the early 20th century. Working within the crucible of historical turmoil, avant-garde artists positioned themselves in the forefront by aggressively challenging traditional and often cherished notions about art and its relation to society. As the old social orders collapsed and new ones, from communism to corporate capitalism, took their places, avant-garde artists searched for new definitions of and uses for art in a radically changed world.

This reevaluation of the nature and role of art was marked by the emergence of *expressionism*. The term has been used over the years in connection with a wide range of art. Simply put, expressionism refers to art that is the result of the artist's unique inner or personal vision and that often has an emotional dimension. Expressionist art contrasts with art focused on visually describing the empirical world. The term first gained currency in the early 20th century and was popularized in *Der Sturm*, an avant-garde periodical initially published in Munich. Herwarth Walden, the editor of *Der Sturm*, proclaimed: "We call the art of this century Expressionism in order to distinguish it from what is not art. We are thoroughly aware that artists of previous centuries also sought expression. Only they did not know how to formulate it." 1

FAUVISM

In 1905, the first signs of a specifically 20th-century movement in painting, *Fauvism*, appeared in Paris. In that year, at the third Salon d'Automne (Autumn Salon), a group of young painters exhibited canvases so simplified in design and so shockingly bright in color that a startled critic described the artists as *fauves* (wild beasts). The Fauves were totally independent of the French Academy and the "official" Salon. The Fauve movement was driven by a desire to develop an art that had the directness of Impressionism but that also used intense color juxtapositions and their emotional capabilities, the legacy of such artists as van Gogh and Gauguin. The Fauves went even further in liberating color from its descriptive function and using it for both expressive and structural ends.

The Primacy of Color The Fauve use of color is particularly apparent in the work of HENRI MATISSE (1869–1954), who was the dominant figure of this group. Matisse realized that color could play a primary role in conveying meaning and focused his efforts on developing this notion. In Woman with the Hat (Fig. 13-1), Matisse depicted his wife, Amélie, in a rather conventional manner compositionally, but he employed seemingly arbitrary colors. The entire image—the woman's face, clothes, hat, and background—consists of patches and splotches of color juxtaposed in ways that sometimes produce jarring contrasts. Matisse explained his approach: "Color was not given to us in order that we should imitate Nature. It was given to us so that we can express our

13-1 | HENRI MATISSE, Woman with the Hat, 1905. Oil on canvas, $2' 7\frac{3}{4}'' \times 1' 11\frac{1}{2}''$. San Francisco Museum of Modern Art, San Francisco (bequest of Elise S. Haas).

Matisse portrayed his wife Amélie using patches and splotches of seemingly arbitrary colors. He and the other Fauve painters used color not to imitate nature but to express emotions.

own emotions."² For Matisse and the Fauves, color became the formal element most responsible for pictorial coherence and the primary conveyor of meaning.

From Green, to Blue, to Red The maturation of Matisse's exploration of the expressive power of color can be seen in *Red Room* (*Harmony in Red*; Fig. 13-2). Here, Matisse painted the interior of a comfortable, prosperous household with a maid placing fruit and wine on the table. The artist's color selection and juxtapositions generate much of the feeling of warmth and comfort. Matisse depicted objects in simplified and schematized fashion and flattened out the forms. For example, he eliminated the front edge of the table, making the table, with its identical patterning, as flat as the wall behind it. The colors, however, contrast richly and intensely. Matisse's process of overpainting reveals the importance of color to him. Initially, this work was predominantly

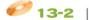

HENRI MATISSE, Red Room (Harmony in Red), 1908– 1909. Oil on canvas, approx. 5' 11" × 8' 1". State Hermitage Museum, Saint Petersburg.

Matisse depicted objects in simplified and schematized fashion and flattened out the forms. Here, the table and the wall seem to merge because they are the same intense color and have identical patterning.

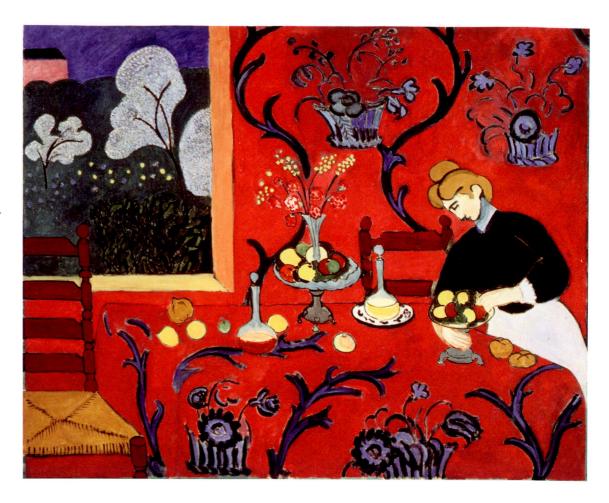

green, then he repainted it blue. Neither color seemed appropriate, and not until Matisse repainted this work red did he feel he had struck the proper chord. Like van Gogh and Gauguin, Matisse expected color to provoke an emotional resonance in the viewer.

GERMAN EXPRESSIONISM

The immediacy and boldness of the Fauve images appealed to many artists, including those of the *German Expressionism* movement. However, although color also plays a prominent role in the Expressionists' work, the expressiveness of their images is due as much to wrenching distortions of form, ragged outlines, and agitated brushstrokes. This resulted in savagely powerful, emotional canvases in the years leading to World War I.

Die Brücke

The first group of German artists to explore expressionist ideas gathered in Dresden in 1905 under the leadership of ERNST LUDWIG KIRCHNER (1880–1938). The group members thought of themselves as paving the way for a more perfect age by bridging the old age to the new, and called themselves Die Brücke (The Bridge). These artists protested the hypocrisy and materialistic decadence of those in power. Kirchner, in particular, focused much of his attention on the detrimental effects of industrialization, such as the alienation of individuals

in cities, which he felt fostered a mechanized and impersonal society.

Urban Street Life Kirchner's Street, *Dresden* (Fig. 13-3) provides a glimpse into the frenzied urban activity of a bustling German city before World War I. Rather than the distant, panoramic urban view of the Impressionists, this street scene is jarring and dissonant. The women in the foreground loom large, approaching the viewer somewhat menacingly. The steep perspective of the street, which threatens to push the women out of the canvas, increases their confrontational nature. Harshly rendered, the women's features make them appear zombielike and ghoulish, and the garish, clashing colors—juxtapositions of bright orange, emerald green, acrid chartreuse, and pink—add to the expressive impact of the image. Kirchner's perspectival distortions, disquieting figures, and color choices reflect the influence of the work of Edvard Munch, who made similar expressive use of formal elements in *The Cry* (see Fig. 12-23).

Der Blaue Reiter

A second major German Expressionist group, Der Blaue Reiter (The Blue Rider) formed in Munich in 1911. The two founding members, Vassily Kandinsky and Franz Marc, whimsically selected this name because of their mutual interest in the color blue and horses. Like Die Brücke and other expressionist artists, this group produced paintings that captured their

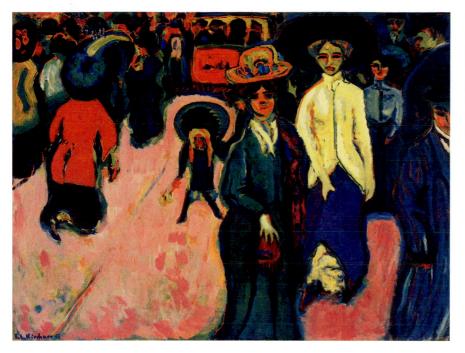

13-3 | ERNST LUDWIG KIRCHNER, Street, Dresden, 1908 (dated 1907). Oil on canvas, $4' 11\frac{1}{4}'' \times 6' 6\frac{7}{8}''$. Museum of Modern Art, New York.

Kirchner's perspectival distortions, disquieting figures, and color choices reflect the influence of the Fauves and of Edvard Munch (Fig. 12-23), who made similar expressive use of formal elements.

feelings in visual form while also eliciting an intense visceral response from the viewer.

Blueprints for Enlightenment Born in Russia, Vassily Kandinsky (1866–1944) moved to Munich in 1896 and soon developed a spontaneous and aggressively avant-garde expressive style. Indeed, Kandinsky was one of the first artists to explore complete abstraction, as in his *Improvisation 28* (Fig. 13-4). A true intellectual, widely read in philosophy, religion, history, and the other arts, especially music, Kandinsky was also one of the few early modernists to read with some comprehension the newest scientific theories. Rutherford's

exploration of atomic structure, for example, convinced Kandinsky that material objects had no real substance, thereby shattering his faith in a world of tangible things.

The painter articulated his ideas in an influential treatise, Concerning the Spiritual in Art, published in 1912. Artists, Kandinsky believed, must express the spirit and their innermost feelings by orchestrating color, form, line, and space. He produced numerous works like *Improvisation 28*, conveying feelings with color juxtapositions, intersecting linear elements, and implied spatial relationships. Ultimately, Kandinsky saw these abstractions as evolving blueprints for a more enlightened and liberated society emphasizing spirituality.

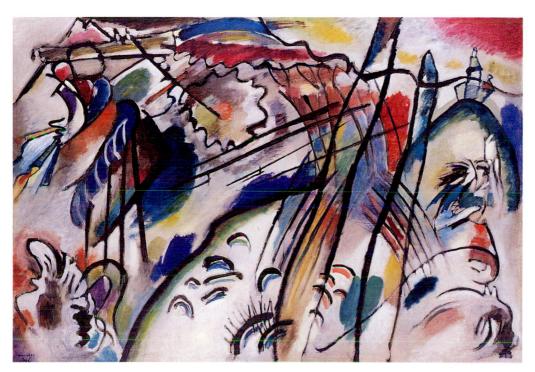

13-4 | VASSILY KANDINSKY, *Improvisation 28* (second version), 1912. Oil on canvas, $3' 7\frac{7}{8}'' \times 5' 3\frac{7}{8}''$. Solomon R. Guggenheim Museum, New York (gift of Solomon R. Guggenheim, 1937).

Kandinsky believed that artists must express their innermost feelings by orchestrating color, form, line, and space. He was one of the first painters to explore complete abstraction in his canvases.

13-5 | Franz Marc, Fate of the Animals, 1913. Oil on canvas, $6' \, 4\frac{3}{4}'' \times 8' \, 9\frac{1}{2}''$. Öffentliche Kunstsammlung Basel, Basel.

Marc focused on color and developed a system of correspondences between specific colors and feelings or ideas. In this apocalyptic scene of animals trapped in a forest, the colors of severity and brutality dominate.

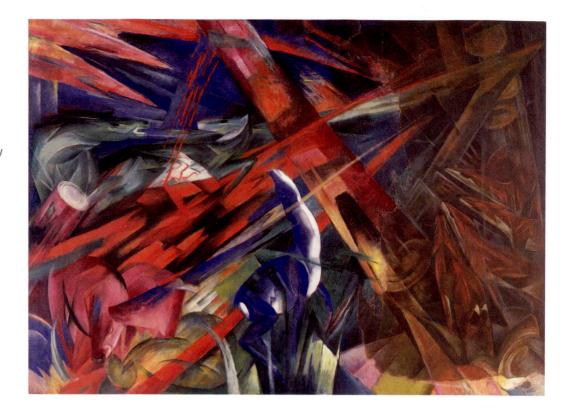

Expressing an "Inner Truth" Like many of the other German Expressionists, FRANZ MARC (1880-1916) grew increasingly pessimistic about the state of humanity, especially as World War I loomed on the horizon. His perception of human beings as deeply flawed led him to turn to the animal world for his subjects. Animals, he believed, were "more beautiful, more pure" than humanity and thus more appropriate as a vehicle to express an inner truth.³ In his quest to imbue his paintings with greater emotional intensity, Marc focused on color and developed a system of correspondences between specific colors and feelings or ideas. According to Marc, "Blue is the *male* principle, severe and spiritual. Yellow is the female principle, gentle, happy and sensual. Red is matter, brutal and heavy." 4 Marc's attempts to create, in a sense, an iconography (or representational system) of color links him to other avant-garde artists struggling to redefine the practice of art.

Fate of the Animals (FIG. 13-5) represents the culmination of Marc's color explorations. It was painted in 1913, when the tension of impending cataclysm had pervaded society and emerged in Marc's art. The animals appear trapped in a forest, some apocalyptic event destroying them. The entire scene is distorted—shattered into fragments. More significantly, the lighter and brighter colors—the passive, gentle, and cheerful ones—are absent, and the colors of severity and brutality dominate the work. Marc discovered just how well his painting portended war's anguish and tragedy when he ended up at the front the following year. His experiences in battle prompted him to write to his wife that Fate of the Animals "is like a premonition of this war—horrible and shattering. I can hardly conceive that I painted it." His contempt for people's

inhumanity and his attempt to express that through his art ended, with tragic irony, in his death in action in World War I in 1916.

CUBISM

The expressionist departure from any strict adherence to illusionism in art was a path other artists followed. Among those who most radically challenged prevailing artistic conventions and moved most aggressively into the realm of abstraction was PABLO PICASSO (1881–1973). A Spanish artist whose importance in the history of art is uncontested, he made staggering contributions to new ways of representing the surrounding world. Perhaps the most prolific artist in history, he explored virtually every artistic medium during his lengthy career.

A precocious student, Picasso mastered all aspects of late-19th-century Realist technique by the time he entered the Barcelona Academy of Fine Art in the late 1890s. His prodigious talent led him to experiment with a wide range of visual expression, first in Spain and then in Paris, where he settled in 1904. Throughout his career, Picasso remained a traditional artist in making careful preparatory studies for each major work. He exemplified the modern age, however, in his enduring quest for innovation, his lack of complacency, and his insistence on constantly challenging himself and those around him. Picasso revealed this modernity in his constant experimentation and in his sudden shifts from one style to another.

A Philosophical Bordello By 1906, Picasso was searching restlessly for new ways to depict form. He found clues in ancient Iberian sculpture and in the late paintings of Cézanne. He was also fascinated by African sculpture, of which he was

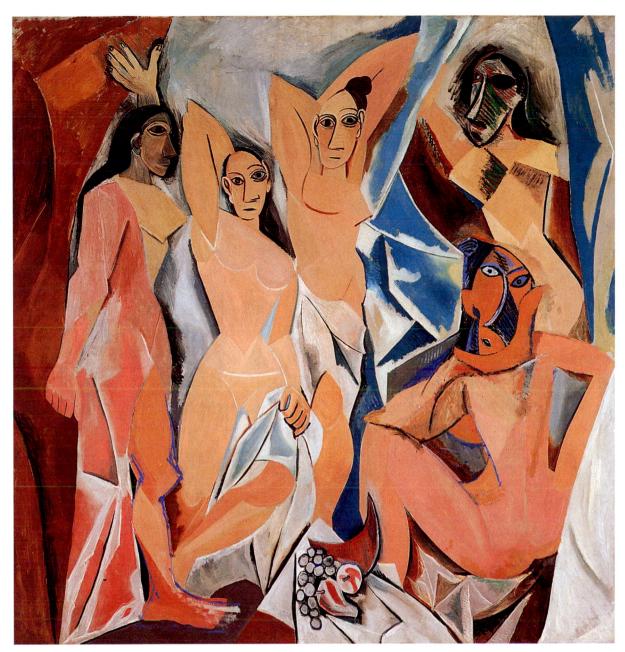

PABLO PICASSO, Les Demoiselles d'Avignon, June – July 1907. Oil on canvas, 8' × 7' 8". Museum of Modern Art, New York (acquired through the Lillie P. Bliss Bequest).

African and ancient Iberian sculpture and the late paintings of Cézanne lie behind this pivotal work, with which Picasso opened the door to a radically new method of representing forms in space.

an avid collector. Picasso believed these "primitive" objects were "magical things," "mediators" between humans and the forces of evil.⁶ Further, "primitive" art seemed to embody a directness, closeness to nature, and honesty that appealed to him and to other modernist artists determined to reject conventional models.

These diverse sources lie behind Les Demoiselles d'Avignon (The Young Ladies of Avignon; Fig. 13-6), which opened the door to a radically new method of representing form in space. Picasso began the work as a symbolic picture to be titled Philosophical Bordello, portraying male clients intermingling with women in the reception room of a brothel on Avignon Street in Barcelona. By the time the artist finished, he had eliminated the male figures and simplified the room's details to a suggestion of drapery and a schematic foreground still life. Picasso had become wholly absorbed in the problem of finding a new way to represent the five female figures in their interior

space. Instead of representing the figures as continuous volumes, he fractured their shapes and interwove them with the equally jagged planes that represent drapery and empty space. Indeed, the space, so entwined with the bodies, is virtually illegible. Here Picasso pushed Cézanne's treatment of form and space to a new tension. The tension between Picasso's representation of three-dimensional space and his statement of painting as a two-dimensional design is a tension between representation and abstraction.

The artist extended the radical nature of *Les Demoiselles d'Avignon* even further by depicting the figures inconsistently. The calm, ideal features of the three young women at the left were inspired by ancient Iberian sculptures, which Picasso saw during summer visits to Spain. The energetic, violently striated features of the two heads to the right emerged late in Picasso's production of the work and grew directly from his increasing fascination with the power of African sculpture

(see Chapter 19). Perhaps responding to the energy of these two new heads, Picasso also revised their bodies. He broke them into more ambiguous planes suggesting a combination of views, as if he were seeing the figures from more than one place in space at once. The woman seated at the lower right shows these multiple views most clearly, seeming to present the observer simultaneously with a three-quarter back view from the left, another from the right, and a front view of the head that suggests seeing the figure frontally as well. Gone is the traditional concept of an orderly, constructed, and unified pictorial space that mirrors the world. In its place are the rudimentary beginnings of a new representation of the world as a dynamic interplay of time and space. Clearly, Les Demoiselles d'Avignon represents a dramatic departure from the careful presentation of a visual reality. Explained Picasso: "I paint forms as I think them, not as I see them."7

The Birth of Cubism For many years, Picasso showed Les Demoiselles only to other painters. One of the first to see it was Georges Braque (1882-1963), a Fauve painter who was so agitated and challenged by it that he began to rethink his own painting style. Using the painting's revolutionary ideas as a point of departure, together Braque and Picasso formulated Cubism around 1908. Cubism represented a radical turning point in the history of art, nothing less than a dismissal of the pictorial illusionism that had dominated Western art for centuries. The Cubists rejected naturalistic depictions, preferring compositions of shapes and forms "abstracted" from the conventionally perceived world. These artists pursued the analysis of form central to Cézanne's artistic explorations, and they dissected life's continuous optical spread into its many constituent features, which they then recomposed, by a new logic of design, into a coherent aesthetic object. For the Cubists, the art of painting had to move far beyond the description of visual reality. This rejection of accepted artistic practice illustrates both the period's aggressive avant-garde critique of pictorial convention and the public's dwindling faith in a safe, concrete Newtonian world, fostered by the physics of Einstein and others. Although not immune to the effects of the societal turbulence of the early 20th century, the Cubists increasingly directed their energies into their critique of traditional aesthetics. The French writer and theorist Guillaume Apollinaire summarized well the central concepts of Cubism in 1913:

Authentic cubism [is] the art of depicting new wholes with formal elements borrowed not from the reality of vision, but from that of conception. This tendency leads to a poetic kind of painting which stands outside the world of observation; for, even in a simple cubism, the geometrical surfaces of an object must be opened out in order to give a complete representation of it. . . . Everyone must agree that a chair, from whichever side it is viewed, never ceases to have four legs, a seat and back, and that if it is robbed of one of these elements, it is robbed of an important part. 8

The new style received its name after Matisse described some of Braque's work to a critic, Louis Vauxcelles, as having been painted "avec des petits cubes" (with little cubes), and the critic went on in his review to speak of "cubic oddities."

Analytic Cubism

Historians often refer to the first phase of Cubism, developed jointly by Picasso and Braque, as *Analytic Cubism*. Because Cubists could not achieve the kind of total view Apollinaire described by the traditional method of drawing or painting models from one position, these artists began to dissect the forms of their subjects. They presented that dissection for the viewer to inspect across the canvas surface. In simplistic terms, Analytic Cubism involves analyzing form and investigating the visual vocabulary (that is, the pictorial elements) for conveying meaning.

Analyzing a Musician's Form Georges Braque's painting *The Portuguese* (Fig. 13-7) is a striking example of Analytic Cubism. The artist derived the subject from his memories of a Portuguese musician seen years earlier in a bar in Marseilles. In this painting, Braque concentrated his attention on

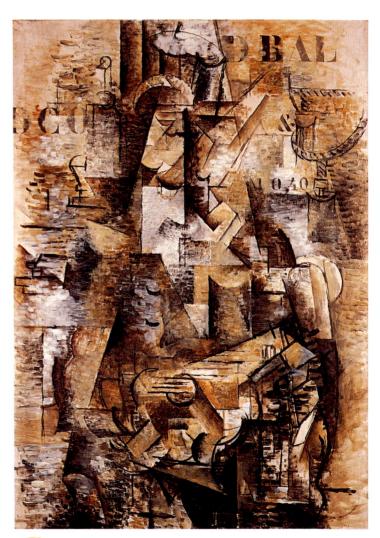

13-7 | GEORGES BRAQUE, *The Portuguese*, 1911. Oil on canvas, 3' $10\frac{1}{8}$ " \times 2' 8". Öffentliche Kunstsammlung Basel, Basel (gift of Raoul La Roche, 1952).

The Cubists rejected the pictorial illusionism that had dominated Western art for centuries. In this painting, Braque concentrated on dissecting form and placing it in dynamic interaction with space.

dissecting the form and placing it in dynamic interaction with the space around it. Unlike the high-keyed paintings of the Fauves and German Expressionists, the Cubists used subdued hues—here, only brown tones—to focus attention on form. In *The Portuguese*, the artist carried his analysis so far that the viewer must work diligently to discover clues to the subject. The construction of large intersecting planes suggests the forms of a man and a guitar. Smaller shapes interpenetrate and hover in the large planes. The way Braque treated light and shadow reveals his departure from conventional artistic practice. Light and dark passages suggest both chiaroscuro modeling and transparent planes that allow the viewer to see through one level to another. As the observer looks, solid forms emerge only to be canceled almost immediately by a different reading of the subject.

The stenciled letters and numbers add to the painting's complexity. Letters and numbers are flat shapes. On a book's pages, they exist outside three-dimensional space, but as shapes in a Cubist painting such as The Portuguese, they allow the painter to play with the viewer's perception of two- and three-dimensional space. The letters and numbers lie flat on the painted canvas surface, yet the image's shading and shapes seem to flow behind and underneath them, pushing the letters and numbers forward into the viewing space. Occasionally, they seem attached to the surface of some object within the painting. Picasso and Braque pioneered precisely this exploration of visual vocabulary and its role in generating meaning. Further, the inclusion of elements such as recognizable letters or numbers seems to anchor the painting in the world of representation, thereby exacerbating the tension between representation and abstraction. Ultimately, the constantly shifting imagery makes it impossible to arrive at any definitive or final reading of the image. Even today, examining such a painting is a disconcerting excursion into ambiguity and doubt.

Synthetic Cubism

In 1912, Cubism entered a new phase when the style no longer relied on a decipherable relation to the visible world. In this new phase, called *Synthetic Cubism*, artists constructed paintings and drawings from objects and shapes cut from paper or other materials to represent parts of a subject.

Illusion or Reality? The work marking the point of departure for this new style was Picasso's Still Life with Chair-Caning (Fig. 13-8), a painting that included a piece of oilcloth pasted on the canvas after it was imprinted with the photolithographed pattern of a cane chair seat. Framed with a piece of rope, this work challenges the viewer's understanding of reality. The photographically replicated chair caning seems so "real" that one expects the holes to break any brush strokes laid upon it. But the chair caning, although optically suggestive of the real, is actually only an illusion or representation of an object. In contrast, the painted abstract areas do not refer to tangible objects in the real world. Yet the fact that

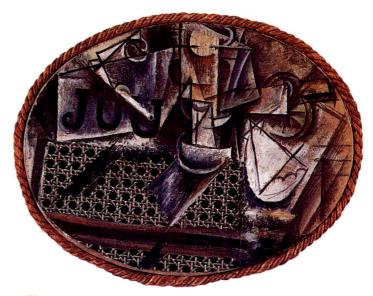

13-8 | PABLO PICASSO, *Still Life with Chair-Caning*, 1912. Oil and oilcloth on canvas, $10\frac{5}{8}" \times 1' 1\frac{3}{4}"$. Musée Picasso, Paris.

This painting includes a piece of oilcloth imprinted with the photolithographed pattern of a cane chair seat. Framed with a piece of rope, the still life challenges the viewer's understanding of reality.

they do not imitate anything makes them more "real" than the chair caning—no pretense exists. Picasso extended the visual play by making the letter U escape from the space of the accompanying J and O and partially covering it with a cylindrical shape that pushes across its left side. The letters JOU appear in many Cubist paintings. These letters formed part of the masthead of the daily French newspapers (journaux) often found among the objects represented. Picasso and Braque especially delighted in the punning references to jouer and jouir—the French words for "to play" and "to enjoy."

Subversive Art After Still Life with Chair-Caning, both Picasso and Braque continued to explore the medium of collage. From the French word meaning "to stick," a collage is a composition of bits of objects, such as newspaper or cloth, glued to a surface. The collage technique was modern in its medium—mass-produced materials never before found in "high" art—and modern in the way the artist embedded the art's "message" in the imagery and in the nature of these everyday materials. Although most discussions of Cubism and collage focus on the formal innovations they represented, it is important to note that the public also viewed the revolutionary and subversive nature of Cubism in sociopolitical terms. Cubism's attacks on artistic convention and tradition were easily expanded to encompass an attack on society's complacency and status quo. Many artists and writers of the period allied themselves with various anarchist groups whose social critiques and utopian visions appealed to progressive thinkers. Many critics in the French press consistently equated Cubism with anarchism, revolution, and disdain for tradition.

FUTURISM

A contemporaneous modernist art movement, Futurism, did indeed have a well-defined sociopolitical agenda. Inaugurated and given its name by the charismatic Italian poet and playwright Filippo Tommaso Marinetti in 1909, Futurism began as a literary movement but soon encompassed the visual arts, cinema, theater, music, and architecture. Indignant over the political and cultural decline of Italy, the Futurists published numerous manifestos in which they aggressively advocated revolution, both in society and in art. In their quest to launch Italian society toward a glorious future, the Futurists championed war as a means of washing away the stagnant past. The Futurists agitated for the destruction of museums, libraries, and similar repositories of accumulated culture, which they described as mausoleums. They also called for radical innovation in the arts. Of particular interest to the Futurists were the speed and dynamism of modern technology. Marinetti insisted that "a speeding automobile . . . is more beautiful than the Nike of Samothrace,"10 a Greek statue (Fig. 2-52) that had come to personify classical art. Appropriately, Futurist art often focuses on motion in time and space, incorporating Cubist discoveries derived from the analysis of form.

Simultaneity of Views The Futurists' interest in motion and in the Cubist dissection of form is evident in *Dynamism of a Dog on a Leash* (Fig. 13-9) by GIACOMO BALLA (1871–1958). Balla's subject is a passing dog and its owner, whose skirts the artist placed just within visual range. Balla achieved

13-9 | GIACOMO BALLA, *Dynamism of a Dog on a Leash*, 1912. Oil on canvas, $2' 11\frac{3}{8}'' \times 3' 7\frac{1}{4}''$. Albright-Knox Art Gallery, Buffalo (bequest of A. Conger Goodyear, gift of George F. Goodyear, 1964).

The Futurists' interest in motion and in the Cubist dissection of form is evident in Balla's painting of a passing dog and its owner. Simultaneity of views was central to the Futurist program.

the effect of motion by repeating shapes, as in the dog's legs and tail and in the swinging line of the leash. Simultaneity of views was central to the Futurist program.

The Sensation of Motion UMBERTO BOCCIONI (1882–1916) applied Balla's representational technique to sculpture. What we want, he claimed, is not fixed movement in space but the sensation of motion itself: "Owing to the persistence of images on the retina, objects in motion are multiplied and distorted, following one another like waves in space. Thus, a galloping horse has not four legs, it has twenty." Clearly, this description applies to *Dynamism of a Dog on a Leash*. Though Boccioni in this instance was talking about painting, his observation helps explain what is perhaps the definitive work of Futurist sculpture, his *Unique Forms of Continuity in Space* (Fig. 13-10).

This piece highlights the formal and spatial effects of motion rather than their source, the striding human figure. The "figure" is so expanded, interrupted, and broken in plane and contour that it disappears, as it were, behind the blur of its movement. Boccioni's search for sculptural means of expressing

13-10 | UMBERTO BOCCIONI, Unique Forms of Continuity in Space, 1913 (cast 1931). Bronze, $3' 7\frac{7}{8}'' \times 2' 10\frac{7}{8}'' \times 1' 3\frac{3}{4}''$. Museum of Modern Art, New York (acquired through the Lillie P. Bliss Bequest).

Boccioni applied Balla's representational technique to sculpture. This running figure is so expanded, interrupted, and broken in plane and contour that it disappears behind the blur of its movement.

dynamic movement reached a monumental expression here. In its power and sense of vital activity, this sculpture surpasses similar efforts in Futurist painting to create images symbolic of the dynamic quality of modern life. To be convinced by it, people need only reflect on how details of an adjacent land-scape appear in their peripheral vision when they are traveling at great speed on a highway or in a low-flying airplane. Although Boccioni's figure bears a curious resemblance to the *Nike of Samothrace* (Fig. 2-52), the modern work departs radically from the ancient one.

DADA

Although the Futurists celebrated the war and the changes they hoped it would effect, the mass destruction and chaos of World War I horrified other artists. Humanity had never before witnessed such wholesale slaughter on so grand a scale over such an extended period. The new technology of armaments, bred of the age of steel, changed the nature of combat. In the face of massed artillery hurling millions of tons of high explosives and gas shells and in the sheets of fire from thousands of machine guns, attack was suicidal, and battle movement congealed into the stalemate of trench warfare. The mud, filth, and blood of the trenches, the pounding and shattering of incessant shell fire, and the terrible deaths and mutilations were a devastating psychological, as well as physical, experience for a generation brought up with the doctrine of progress and a belief in the fundamental values of civilization.

Intuition and Absurdity With the war as a backdrop, many artists contributed to an artistic and literary movement that became known as Dada. This movement emerged, in large part, in reaction to what many of these artists saw as nothing more than an insane spectacle of collective homicide. The international scope of Dada proves this revulsion was widespread. Dada was more a mind-set or attitude than a single identifiable style. The Dadaists believed reason and logic had been responsible for the unmitigated disaster of world war, and they concluded that the only route to salvation was through political anarchy, the irrational, and the intuitive. Thus, an element of absurdity is a cornerstone of Dada, even reflected in the movement's name. According to an often repeated anecdote, the Dadaists chose dada at random from a French-German dictionary. The word is French for a child's hobby horse, and it satisfied the Dadaists' desire for something irrational and nonsensical.

Art historians often describe Dada as a nihilistic enterprise because of its goal of undermining cherished notions about art. However, by attacking convention and logic, the Dada artists unlocked new avenues for creative invention, thereby fostering a more serious examination of the basic premises of art than had prior movements. Dada was, in its subversiveness, extraordinarily avant-garde and tremendously liberating. In addition, although horror and disgust about the war initially prompted Dada, an undercurrent of humor and whimsy runs through much of the art. In its emphasis on the spontaneous

and intuitive, Dada paralleled the psychoanalytic views of Freud and Jung. Particularly interested in exploring the unconscious, the Dadaists believed art was a powerfully practical means of self-revelation. They were convinced that the images arising out of the subconscious mind had a truth of their own, independent of conventional vision.

The Anarchy of Chance The Zurich-based Dada artist Jean (Hans) Arp (1887–1966) pioneered the use of chance in composing his images. Tiring of the look of some Cubistrelated collages he was making, he took some sheets of paper, tore them into roughly shaped squares, haphazardly dropped them to a sheet of paper on the floor, and glued them into the resulting arrangement. The rectilinearity of the shapes guaranteed a somewhat regular design, but chance introduced an imbalance that seemed to Arp to restore to his work a special mysterious vitality he wanted to preserve. *Collage Arranged According to the Laws of Chance* (Fig. 13-11) is a work he

13-11 | JEAN ARP, Collage Arranged According to the Laws of Chance, 1916–1917. Torn and pasted paper, 1' $7\frac{1}{8}'' \times 1' 1\frac{5}{8}''$. Museum of Modern Art, New York.

In this collage, Arp dropped torn paper squares onto a sheet of paper and then glued them into the resulting arrangement. His reliance on chance in composing images reinforced the anarchy inherent in Dada. created by this method. As the Dada filmmaker Hans Richter stated, "For us chance was the 'unconscious mind' that Freud had discovered in 1900. . . . Adoption of chance had another purpose, a secret one. This was to restore to the work of art its primeval magic power and to find a way back to the immediacy it had lost through contact with . . . classicism." Further, in its renunciation of artistic control, Arp's reliance on chance when creating his compositions reinforced the anarchy and subversiveness inherent in Dada.

Freeing Art from Convention Perhaps the most influential of all the Dadaists was Frenchman MARCEL DUCHAMP (1887–1968), the central artist of New York Dada, also active in Paris. In 1913, he exhibited his first "ready-made" sculptures, which were mass-produced common objects the artist selected and sometimes "rectified" by modifying their substance or combining them with another object. Such works, he insisted, were created free from any consideration of either good or bad taste, qualities shaped by a society he and other Dada artists found aesthetically bankrupt. Perhaps his most outrageous ready-made was Fountain (Fig. 13-12), a porcelain urinal presented on its back, signed "R. Mutt," and dated. The "artist's signature" was, in fact, a witty pseudonym derived from the Mott plumbing company's name and that of the short half of the Mutt and Jeff comic-strip team.

13-12 | MARCEL DUCHAMP, *Fountain* (second version), 1950 (original version produced 1917). Ready-made glazed sanitary china with black paint, 1' high. Philadelphia Museum of Art, Philadelphia.

Duchamp's "ready-made" sculptures were mass-produced common objects that the Dada artist selected and modified. In Fountain, he conferred the status of art on a urinal and forced people to see the object in a new light.

Duchamp's choice of this object for exhibition had the effect of conferring the status of art on it and forced people to see the object in a new light.

Photomontage in Germany Dada spread throughout much of western Europe, arriving as early as 1917 in Berlin, where it soon took on an activist political edge, partially in response to the economic, social, and political chaos in that city. The Berlin Dadaists developed to a new intensity a technique used earlier in popular art postcards. Pasting parts from many pictures together into one image, the Berliners christened their version of the technique *photomontage*. Unlike Cubist collage, Dada collage was made up almost entirely of "found" details, such as pieces of magazine photographs, usually combined into deliberately antilogical compositions. Dadaists found collage to be an ideal medium for using chance when creating art and antiart.

One of the Berlin Dadaists who perfected this photomontage technique was HANNAH HÖCH (1889–1978). Höch's

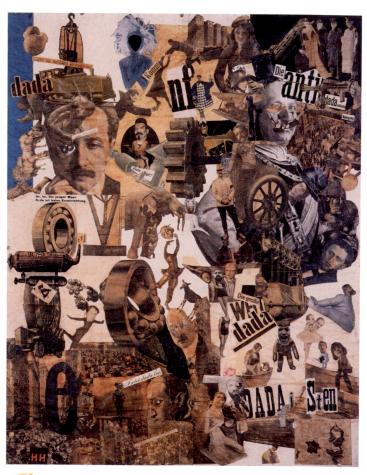

13-13 | Hannah Höch, Cut with the Kitchen Knife Dada through the Last Weimar Beer Belly Cultural Epoch of Germany, 1919–1920. Photomontage, $3' 9'' \times 2' 11\frac{1}{2}''$. Neue Nationalgalerie, Staatliche Museen, Berlin.

In this chaotic photomontage, Höch placed photographs of some of her fellow Dadaists among images of Marx, Lenin, and other political figures, thus aligning Dada with other revolutionary movements.

Art "Matronage" in America

Throughout history, the participation of women in the art world has been limited. Until the 20th century, the dearth of women artists was often due to professional institutions that restricted women's access to artistic training. For example, the proscription against women participating in life drawing classes, a staple of academic artistic training, in effect denied women the opportunity to become professional artists. By the early 20th century, many of these strictures were loosening. Women could gain entrance to established art schools, and today, women are a major presence in the art world. One of the developments in the early 20th century that laid the groundwork for this change was the prominent role that women played as art patrons. These "art matrons" provided financial, moral, and political support to cultivate the advancement of the arts in America.¹

Gertrude Vanderbilt Whitney (1875 – 1942) was a practicing sculptor and enthusiastic collector. To assist young American artists to exhibit their work, she opened the Whitney Studio in 1914. By 1929, dissatisfied with the recognition accorded young, progressive American artists, she offered her entire collection of 500 works to the Metropolitan Museum of Art. Her offer rejected, she founded her own museum, the Whitney Museum of American Art in New York City. She chose as the first director a visionary and energetic woman, Juliana Force (1876 – 1948), who inaugurated a pioneering series of monographs on living American artists and organized lecture series by influential art historians and critics. Through the efforts of these two women, the Whitney Museum was established as a major force in American art.

A trip to Paris in 1920 whetted the interest of Peggy Guggenheim (1898–1979) in avant-garde art. Like Whitney, she collected art and eventually opened a gallery in England. She continued her support for avant-garde art after her return to the United States. Her New York gallery, called Art of This Century, was instrumental in advancing the

careers of many artists. She eventually moved her art collection to a lavish Venetian palace, where these important artworks continue to be available for public viewing.

Lillie P. Bliss (1864–1931), Mary Quinn Sullivan (1877–1939), and Abby Aldrich Rockefeller (1874–1948) were philanthropists, art collectors, and educators who saw the need for a museum to collect and exhibit modernist art. Together these visionary women established the Museum of Modern Art in 1929, which became (and continues to be) the most influential museum of modern art in the world.

Isabella Stewart Gardner (1840–1924) and Jane Stanford (1828–1905) also undertook the ambitious project of founding museums. The Isabella Stewart Gardner Museum in Boston, established in 1903, contains an impressive collection of art that is comprehensive in scope. The Stanford Museum, the first American museum west of the Mississippi, got its start in 1905 on the grounds of Stanford University, which Leland Stanford Sr. and Jane Stanford founded after the tragic death of their son. The Stanford Museum houses a wide range of objects, including archaeological and ethnographic artifacts. These two driven women committed much of their time, energy, and financial resources to ensure the success of these museums. Both were intimately involved in the day-to-day operations of their institutions.

The museums these women established flourish today, attesting to the extraordinary vision of these "art matrons." These institutions and the art collections amassed by these women serve as tributes to the remarkable contributions women have made to the advancement of art in the United States.

¹ The term "art matronage" was coined by art historian Wanda Corn in the catalog *Cultural Leadership in America: Art Matronage and Patronage* (Boston: Isabella Stewart Gardner Museum, 1997).

photomontages not only advanced the absurd illogic of Dada by presenting the viewer with chaotic, contradictory, and satiric compositions but also provided scathing and insightful commentary on two of the most dramatic developments during the Weimar Republic (1918-1933) in Germany—the redefinition of women's social roles and the explosive growth of mass print media. She revealed these combined themes in her powerful photomontage Cut with the Kitchen Knife Dada through the Last Weimar Beer Belly Cultural Epoch of Germany (Fig. 13-13). The artist arranged an eclectic mixture of cutout photos and letters, including, at the lower right, "Die grosse Welt dada" ("The great Dada world"). Höch placed photographs of some of her fellow Dadaists among images of Marx, Lenin, and other political figures, thus aligning Dada with other revolutionary movements. Juxtaposing the heads of German military leaders with exotic dancers' bodies also provided the wickedly humorous critique central to much of Dada. Höch positioned herself in this topsy-turvy world as well. A photograph of her head appears in the lower right corner with a map of Europe showing the progress of women's enfranchisement. Aware of the power that both women and Dada had to destabilize society, Höch forcefully manifested that belief through her art.

THE ARMORY SHOW AND ITS LEGACY

Avant-garde artistic experiments were not limited to Europe. In the early 20th century, many American artists pursued modernist ideas—often with the support of visionary female patrons (see "Art 'Matronage' in America," above). One of the major vehicles for disseminating information about European artistic developments in the United States was the Armory Show, which occurred in early 1913. This large-scale and ambitious endeavor got its name from its location—the armory of the New York National Guard's 69th Regiment. The Armory Show contained more than 1,600 artworks by American and European artists. Among the European artists represented were Matisse, Kandinsky, Picasso, Braque, and Duchamp. In addition to exposing American artists and the

public to the latest in European artistic developments, this show also provided American artists with a prime showcase for their work.

A Nude in Motion The provocative exhibition, which traveled to Chicago and Boston after New York, served as a lightning rod for commentary, immediately attracting heated controversy. Critics demanded the exhibition be closed as a menace to public morality. The work the press most maligned was Marcel Duchamp's *Nude Descending a Staircase*, *No.* 2 (Fig. 13-14). The painting, a single figure in motion down a staircase in a time continuum, suggests the effect of a sequence

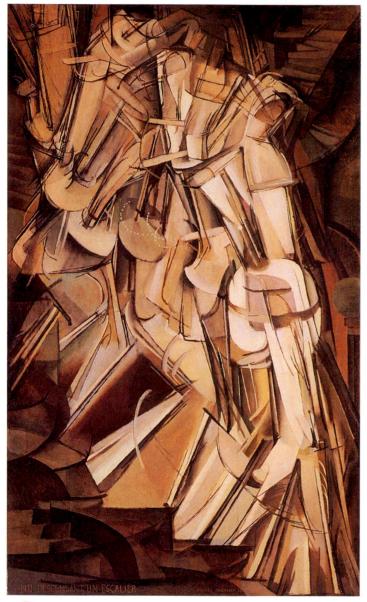

13-14 | MARCEL DUCHAMP, *Nude Descending a Staircase*, *No.* 2, 1912. Oil on canvas, approx. 4′ 10 "× 2′ 11". Philadelphia Museum of Art, Philadelphia (Louise and Walter Arensberg Collection).

The most notorious work in the Armory Show of 1913 was Duchamp's painting of a figure in motion down a staircase in a time continuum. The painting reveals the artist's indebtedness to Cubism and Futurism.

of overlaid film stills. Although Duchamp is primarily associated with the Dada movement, *Nude Descending a Staircase* has more in common with the work of the Cubists and the Futurists. The monochromatic palette is reminiscent of Analytic Cubism, as is Duchamp's faceted presentation of the human form. The artist's interest in depicting the figure in motion reveals an affinity to the Futurists' ideas. One critic described this work as "an explosion in a shingle factory," and newspaper cartoonists had a field day lampooning the painting.

Championing Photography Another catalyst in the period's artistic ferment was the artist Alfred Stieglitz (1864–1946). Committed to promoting the avant-garde in the United States, Stieglitz established an art gallery at 291 Fifth Avenue in New York, which eventually became known simply as "291." His gallery was renowned for exhibiting the latest in both European and American art and thus, like the Armory Show, played an important role in the history of modern art in America.

Stieglitz also channeled his artistic energies into producing photography. Taking his camera everywhere he went, he photographed whatever he saw around him, from the bustling streets of New York City to cloudscapes in upstate New York and the faces of friends and relatives. He believed in making only "straight, unmanipulated" photographs. ¹⁴ Thus, he exposed and printed them using basic photographic processes, without resorting to techniques such as double exposure or double printing that would add information not present in the subject when he released the shutter. Stieglitz said he wanted the photographs he made with this direct technique "to hold a moment, to record something so completely that those who see it would relive an equivalent of what has been expressed." ¹⁵

Stieglitz began a lifelong campaign to win a place for photography among the fine arts while a student of photochemistry in Germany. Returning to New York, he founded the Photo-Secession group, which mounted traveling exhibitions in the United States and sent loan collections abroad, and he also published an influential journal titled Camera Work. In his own works, Stieglitz specialized in photographs of his environment and saw these subjects in terms of form and of the "colors" of his black-and-white materials. He was attracted above all to arrangements of form that stirred his deepest emotions. His aesthetic approach crystallized in The Steerage (Fig. 13-15), which he made during a voyage to Europe with his first wife and daughter in 1907. Traveling first class, Stieglitz rapidly grew bored with the company of prosperous passengers. From the first-class level of the ship, he could see over the rail to the lower deck reserved for "steerage" passengers the government was returning to Europe after refusing them entrance into the United States. Stieglitz described what he saw:

The scene fascinated me: A round hat; the funnel leaning left, the stairway leaning right; the white drawbridge, its railing made of chain; white suspenders crossed on the back of a man below; circular iron machinery; a mast that cut into the sky, completing a triangle. I stood spellbound. I saw shapes related to one another—

13-15 | Alfred Stieglitz, *The Steerage*, 1907 (print 1915). Photogravure (on tissue), $1'\frac{3}{8}'' \times 10\frac{1}{8}''$. Amon Carter Museum, Fort Worth.

Stieglitz waged a lifelong campaign to win a place for photography among the fine arts. This 1907 image is a haunting mixture of found patterns of forms and human activity that stirs deep emotions.

a picture of shapes, and underlying it, a new vision that held me: simple people; the feeling of ship, ocean, sky; a sense of release that I was away from the mob called rich.... I had only one plate holder with one unexposed plate. Could I catch what I saw and felt? I released the shutter. If I had captured what I wanted, the photograph would go far beyond any of my previous prints. It would be a picture based on related shapes and deepest human feeling—a step in my own evolution, a spontaneous discovery. ¹⁶

The finished print fulfilled Stieglitz's vision so well that it shaped his future photographic work, and its haunting mixture of found patterns and human activity continues to stir viewers' emotions to this day.

Elegy to a Dead Officer The American painter MARSDEN HARTLEY (1877–1943) was introduced to European modernism at Stieglitz's 291 gallery. He traveled to Europe in 1912, visiting Paris, where he became acquainted with the work of the Cubists, and Munich, where he gravitated to the Blaue Reiter circle. Hartley was particularly taken with Kandinsky's work and developed a style that he called "Cosmic Cubism." He took these influences with him when he landed in Berlin in

1913. With the heightened militarism in Germany and the eventual outbreak of World War I, Hartley immersed himself in military imagery. Among his most famous paintings of this period is *Portrait of a German Officer* (Fig. 13-16). It depicts an array of common military-related images: German imperial flags, regimental insignia, badges, and emblems such as the Iron Cross. But the painting also includes references to Hartley's friend, Lieutenant Karl von Freyberg, with whom he had maintained an intimate relationship and who was killed in battle a few months before Hartley painted this work. Von Freyberg's initials appear in the lower left hand corner; his age when he died, 24, appears in the lower right hand corner; and von Freyberg's regiment number, 4, appears in the center of the painting. Also incorporated is the letter *E* for von Freyberg's

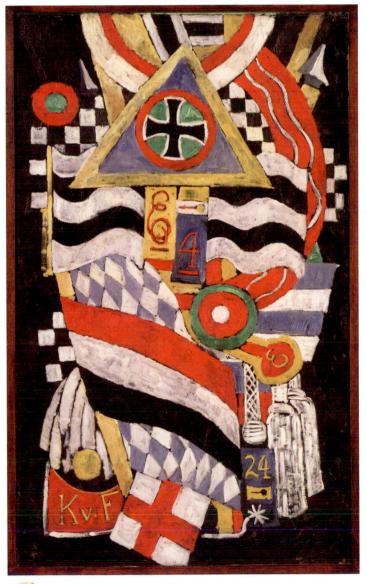

13-16 | MARSDEN HARTLEY, *Portrait of a German Officer*, 1914. Oil on canvas, $5' \ 8\frac{1}{4}'' \times 3' \ 5\frac{3}{8}''$. Metropolitan Museum of Art, New York (Alfred Stieglitz Collection).

In this elegy to a friend killed in battle, Hartley arranged military-related images against a somber black background. The influence of Synthetic Cubism is evident in the flattened, planar presentation.

regiment, the Bavarian Eisenbahn. The influence of Synthetic Cubism is evident in the flattened, planar presentation of the elements, which appear almost as abstract patterns. The somber black background against which the artist placed the colorful stripes, patches, and shapes casts an elegiac pall over the painting.

The Purity of Floral Form Georgia O'Keeffe (1887– 1986) moved from the tiny town of Canyon, Texas, to New York City in 1918. Alfred Stieglitz had seen and exhibited some of her earlier work, and she was drawn into the circle of painters and photographers surrounding Stieglitz and his gallery. Stieglitz became one of O'Keeffe's staunchest supporters and, eventually, her husband. O'Keeffe is best known for her paintings of cow skulls and of flowers. One such painting, Jack-in-the-Pulpit No. 4 (Fig. INTRO-3) reveals the artist's interest in stripping her subjects to their purest forms and colors to heighten their expressive power. In this work, O'Keeffe reduced the incredible details of the flower to a symphony of basic colors, shapes, textures, and vital rhythms, simplifying the flower's curved planes and contours almost to the point of complete abstraction. The fluid planes unfold like undulant petals from a subtly placed axis—the white jetlike streak—in a vision of the slow, controlled motion of growing life. O'Keeffe's painting, in its graceful, quiet poetry, reveals the organic reality of the object by strengthening its characteristic features.

BECKMANN, Night, 1918–1919. Oil on canvas, 4' $4\frac{3}{8}'' \times 5' \frac{1}{4}''$. Kunstsammlung Nordrhein-Westfalen, Düsseldorf.

Beckmann's treatment of forms and space in *Night* matches his view of the brutality and violence of early-20th-century society. Objects seem dislocated and contorted, and the space appears buckled and illogical.

NEUE SACHLICHKEIT

That American artists could focus on these modernist artistic endeavors with such commitment was due to the fact that World War I was fought entirely on European soil. Thus, its effects were not as devastating as they were both on Europe's geopolitical terrain and on individual and national psyches. Neue Sachlichkeit (New Objectivity) grew directly out of the war experiences of a group of German artists. All the artists associated with Neue Sachlichkeit served, at some point, in the German army and thus had firsthand involvement with the military. Their military experiences deeply influenced their worldviews and informed their art, the aim of which was to present a clear-eyed, direct, and honest image of the war and its effects.

Depicting World Violence Max Beckmann (1884–1950) enlisted in the German army and initially rationalized the war. He believed that the chaos would lead to a better society, but over time the mass destruction increasingly disillusioned him. Soon his work began to emphasize the horrors of war and of a society he saw descending into madness. His disturbing view of society is evident in *Night* (Fig. 13-17), which depicts a cramped room three intruders have forcefully invaded. A bound woman, apparently raped, is splayed across the foreground of the painting. At the left, one of the intruders hangs her husband, while another one twists his left arm out of its socket. An unidentified woman cowers in the

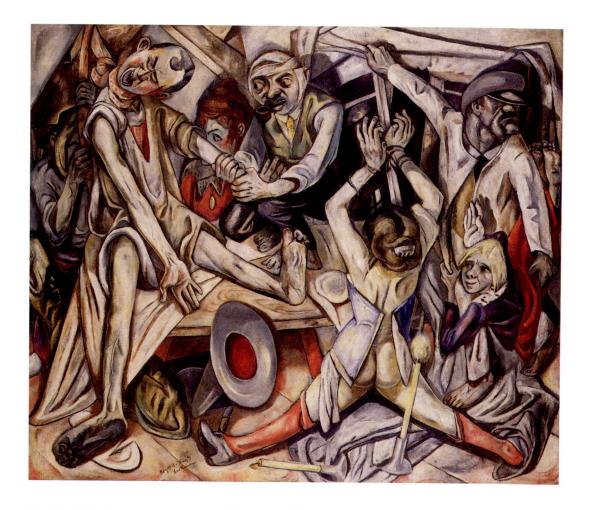

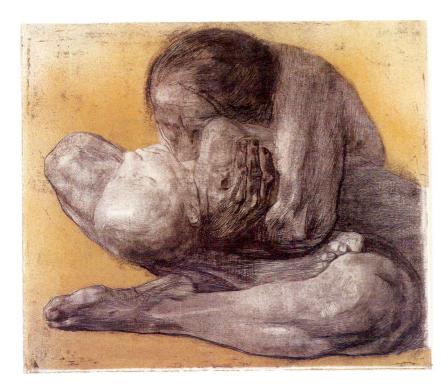

13-18 | KÄTHE KOLLWITZ, Woman with Dead Child, 1903. Etching and soft-ground etching, overprinted lithographically with a gold tone plate, $1' 4\frac{5}{8}" \times 1' 7\frac{1}{8}"$. British Museum, London.

Kollwitz derived the theme of the mother mourning over her dead child from images of the Pietà in Christian art, but transformed it into a powerful universal statement of maternal loss and grief.

background. On the far right, the third intruder prepares to flee with the child.

Although this image does not depict a war scene, the wrenching brutality and violence pervading the home is a searing and horrifying comment on society's condition. Beckmann also injected a personal reference by using himself, his wife, and his son as the models for the three family members. The stilted angularity of the figures and the roughness of the paint surface contribute to the image's savageness. In addition, the artist's treatment of forms and space reflects the world's violence. Objects seem dislocated and contorted, and the space appears buckled and illogical. For example, the woman's hands are bound to the window that opens from the room's back wall, but her body appears to hang vertically, rather than lying across the plane of the intervening table.

A Mother's Anguish The emotional range of postwar German Expressionism extends from passionate protest and satirical bitterness to sympathy for the poor in the work of KÄTHE KOLLWITZ (1867–1945). Kollwitz explored a range of issues from the overtly political to the deeply personal. One image that she treated in a number of print variations was that of a mother with her dead child. Although she initially derived the theme from Christian iconography, Kollwitz transformed it into a universal statement of maternal loss and grief. In Woman with Dead Child (Fig. 13-18), the reverence and grace that pervade the conventional Christian depictions of the grieving Mary holding the dead Christ have been replaced with an animalistic passion, as the mother ferociously grips the body of her dead child. The primal nature of the image is in keeping with the aims of the German Expressionists. The scratchy lines produced by the etching needle serve as evidence of Kollwitz's very personal touch. The impact of this image is undeniably powerful. That Kollwitz used her son Peter as the model for the dead child no doubt made the image all the more personal to her. The image stands as a poignant premonition. Peter was killed at the age of 21 in World War I.

SURREALISM

By 1924, with the publication in France of the First Surrealist Manifesto, most of the artists associated with Dada had joined the Surrealist movement. It is not surprising, therefore, that the Surrealists incorporated many of the Dadaists' improvisational techniques. The Surrealists believed these methods important for engaging the elements of fantasy and activating the unconscious forces that lie deep within every human being. They were determined to explore the inner world of the psyche, the realm of fantasy and the unconscious. Inspired in part by the ideas of Freud and Jung, the Surrealists were especially interested in the nature of dreams. In 1924, one of the leading Surrealist thinkers, André Breton, provided a definition of Surrealism: "Surrealism is based on the belief in the superior reality of certain forms of association heretofore neglected, in the omnipotence of dreams, in the undirected play of thought. . . . I believe in the future resolution of the states of dream and reality, in appearance so contradictory, in a sort of absolute reality, or surreality." ¹⁷

Thus, the Surrealists' dominant motivation was to bring the aspects of outer and inner "reality" together into a single position, in much the same way life's seemingly unrelated fragments combine in the vivid world of dreams. Surrealism developed along two lines. Naturalistic Surrealists presented recognizable scenes that seem to have metamorphosed into a dream or nightmare image. Biomorphic Surrealists produced largely abstract compositions, although they sometimes suggested organisms or natural forms.

13-19 | GIORGIO DE CHIRICO, *Melancholy and Mystery of a Street*, 1914. Oil on canvas, $2' 10\frac{1}{4}'' \times 2' 4\frac{1}{2}''$. Private collection.

De Chirico's Metaphysical Painting movement was a precursor of Surrealism. In this street scene in Turin, filled with mysterious forms and shadows, the painter was able to evoke a disquieting sense of foreboding.

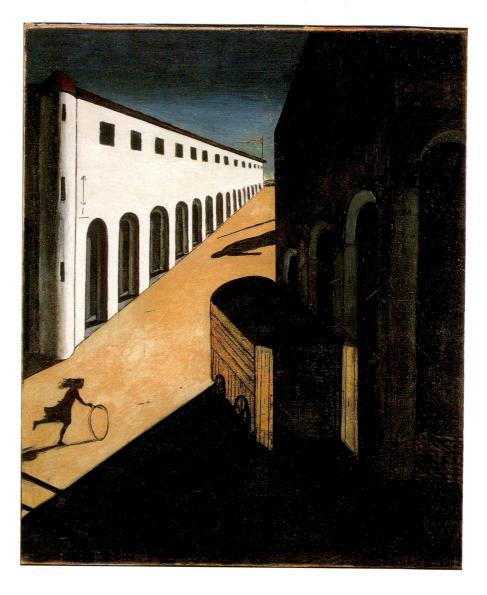

Metaphysical Painting The Italian painter GIORGIO DE CHIRICO (1888-1978) produced emphatically ambiguous works that position him as a precursor of Surrealism. De Chirico's paintings of cityscapes and shop windows were part of a movement called Pittura Metafisica, or Metaphysical Painting. Returning to Italy after study in Munich, de Chirico found hidden reality revealed through strange juxtapositions, such as those seen on late autumn afternoons in the city of Turin, when the long shadows of the setting sun transformed vast open squares and silent public monuments into "the most metaphysical of Italian towns." De Chirico translated this vision into paint in works such as Melancholy and Mystery of a Street (Fig. 13-19), where the squares and palaces of Italy evoke a disquieting sense of foreboding. The choice of the term "metaphysical" to describe de Chirico's paintings suggests that these images transcend their physical appearances. Melancholy and Mystery of a Street, for all its clarity and simplicity, takes on a rather sinister air. Only a few inexplicable and incongruous elements punctuate the scene's solitude—a small girl with her hoop in the foreground, the empty van, and the ominous shadow of a man emerging from behind the building. The sense of strangeness de Chirico could conjure up with familiar

objects and scenes recalls Nietzsche's "foreboding that underneath this reality in which we live and have our being, another and altogether different reality lies concealed." ¹⁸

A Disturbing Blue Dreamscape Spaniard SALVADOR DALÍ (1904-1989) is the most famous Naturalistic Surrealist painter. As he described it, in his painting he aimed "to materialize the images of concrete irrationality with the most imperialistic fury of precision ... in order that the world of imagination and of concrete irrationality may be as objectively evident . . . as that of the exterior world of phenomenal reality."19 All these aspects of Dalí's style can be seen in The Persistence of Memory (Fig. 13-20). Here, he created a haunting allegory of empty space where time has ended. An eerie never-setting sun illuminates the barren landscape. An amorphous creature draped with a limp pocket watch sleeps in the foreground. Another watch hangs from the branch of a dead tree that springs unexpectedly from a blocky architectural form. A third watch hangs half over the edge of the rectangular form, beside a small timepiece resting dial-down on the block's surface. Ants swarm mysteriously over the small watch, while a fly walks along the face of its large neighbor,

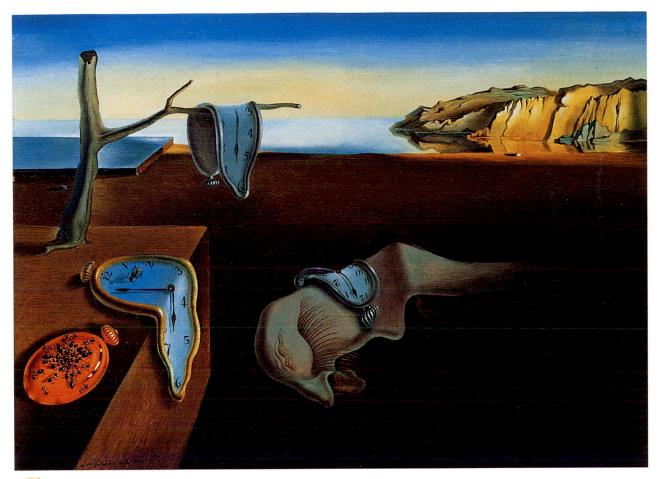

13-20 | SALVADOR DALÍ, *The Persistence of Memory*, 1931. Oil on canvas, $9\frac{1}{2}$ " \times 1' 1". Museum of Modern Art, New York.

Dalí aimed to paint "images of concrete irrationality." In this realistically rendered landscape including three "decaying" watches, he created a haunting allegory of empty space where time has ended.

13-21 | RENÉ MAGRITTE, *The Treachery (or Perfidy) of Images*, 1928–1929. Oil on canvas, 1' $11\frac{5}{8}$ " × 3' 1". Los Angeles County Museum of Art, Los Angeles (purchased with funds provided by the Mr. and Mrs. William Preston Harrison Collection).

The discrepancy between Magritte's meticulously painted briar pipe and his caption, "This is not a pipe," challenges the viewer's reliance on the conscious and the rational in the reading of visual art.

almost as if this assembly of watches were decaying organic life—soft and sticky. Dalí rendered every detail of this dream-scape with precise control, striving to make the world of his paintings as convincingly real as the most meticulously rendered landscape based on an actual scene from nature.

Words Contradicting Images The Belgian painter RENÉ MAGRITTE (1898-1967) also expressed in exemplary fashion the Surrealist idea and method—the dreamlike dissociation of image and meaning. His works administer disruptive shocks because they subvert viewers' expectations based on logic and common sense. The danger of relying on rationality when viewing a Surrealist work is apparent in Magritte's The Treachery (or Perfidy) of Images (Fig. 13-21). Magritte presented a meticulously rendered trompe l'oeil (fools the eye) depiction of a briar pipe. The caption beneath the image, however, contradicts what seems obvious: "Ceci n'est pas une pipe." ("This is not a pipe.") The discrepancy between image and caption clearly challenges the assumptions underlying the reading of visual art. Like the other Surrealists' work, this painting wreaks havoc on the viewer's reliance on the conscious and the rational.

13-22 | MERET OPPENHEIM, Object (Le Déjeuner en Fourrure), 1936. Fur-covered cup, $4\frac{3}{8}$ " in diameter; saucer, $9\frac{3}{8}$ " in diameter; spoon, 8" long. Museum of Modern Art, New York.

The Surrealists were enamored with sculpture, whose concrete tangibility made their art all the more disquieting. Oppenheim's functional fur-covered object captures the Surrealist flair for magical transformation.

Fuzzy Logic The Surrealists also were enamored with sculp-ture, whose concrete tangibility made their art all the more disquieting. Object (Le Déjeuner en Fourrure; Fig. 13-22), or "Luncheon in Fur," by Swiss artist MERET OPPENHEIM (1913–1985) captures the incongruity, humor, visual appeal, and, often, eroticism characterizing Surrealism. The artist presented a fur-lined teacup inspired by a conversation she had with Picasso. After admiring a bracelet Oppenheim had made from a piece of brass covered with fur, Picasso noted that anything might be covered with fur. When her tea grew cold, Oppenheim responded to Picasso's comment by ordering "un peu plus de fourrure" (a little more fur), and the sculpture had its genesis. Object takes on an anthropomorphic quality, animated by the quirky combination of the fur with a functional object. Further, the sculpture captures the Surrealist flair for alchemical, seemingly magical or mystical, transformation. It incorporates a sensuality and eroticism (seen here in the seductively soft, tactile fur lining the concave form) that are also components of much of Surrealist art.

A Twin Self-Portrait Born to a Mexican mother and German father, the painter FRIDA KAHLO (1907–1954) used the details of her life as powerful symbols for the psychological pain of human existence. Kahlo has often been discussed as a Surrealist due to the psychic and autobiographical issues she dealt with in her art. Indeed, Breton himself deemed her a Naturalistic Surrealist. Yet Kahlo consciously distanced herself from the Surrealist group, and it was left to others to impose Surrealist connections on her. Kahlo began painting seriously as a young student, during convalescence from an accident that tragically left her in constant pain. Her life became a heroic and tumultuous battle for survival against illness and stormy

personal relationships. *The Two Fridas* (Fig. 13-23), one of the few large-scale canvases Kahlo ever produced, is typical of her long series of unflinching self-portraits. The twin figures sit side by side on a low bench in a barren landscape under a stormy sky. The figures suggest different sides of the artist's personality, inextricably linked by the clasped hands and by the thin artery that stretches between them, joining their exposed hearts. The artery ends on one side in surgical forceps and on the other in a miniature portrait of Kahlo's husband, the artist Diego Rivera (Fig. 13-38), as a child. Her deeply personal paintings touch sensual and psychological memories in her audience.

Yet to read Kahlo's paintings solely as autobiographical overlooks the powerful political dimension of her art. Kahlo was deeply nationalistic and committed to her Mexican heritage. Politically active, she joined the Communist Party in 1920 and participated in public political protests. In The Two Fridas, Kahlo gave visual form to the struggle facing Mexicans in the early 20th century in defining their national cultural identity. The Frida on the right (representing indigenous culture) wears a Tehuana dress, the traditional costume of Zapotec women, whereas the Frida on the left (representing imperialist forces) is attired in a European-style, white lace dress. The heart, depicted here in such dramatic fashion, was an important symbol in the art of the Aztecs, whom Mexican nationalists idealized as Mexico's last independent rulers. Thus The Two Fridas represents both Kahlo's personal struggles and the struggles of her homeland.

13-23 | FRIDA KAHLO, *The Two Fridas*, 1939. Oil on canvas, 5' 7" × 5' 7". Museo de Arte Moderno, Mexico City.

Kahlo's deeply personal paintings touch sensual and psychological memories in her audience. Here, twin figures linked by clasped hands and a common artery suggest different sides of the artist's personality.

13-24 | JOAN MIRÓ, *Painting*, 1933. 5' 8" × 6' 5". Museum of Modern Art, New York (Loula D. Lasker Bequest by exchange).

Miró promoted automatism, the creation of art without conscious control. He began this painting with a scattered collage composition and then added silhouettes and outlines suggesting floating amoebic organisms.

Embracing the Intuitive Like the Dadaists, the Surrealists used many methods to free the creative process from reliance on the kind of conscious control that they believed society had shaped too much. The Spanish artist JOAN MIRÓ (1893-1983) used automatism—the creation of art without conscious control—and various types of planned "accidents" to provoke reactions closely related to subconscious experience. Although Miró resisted formal association with any movement or group, including the Surrealists, Breton identified him as "the most Surrealist of us all."20 From the beginning, his work contained an element of fantasy and hallucination. After Surrealist poets in Paris introduced him to using chance to create art, the young Spaniard devised a new painting method that allowed him to create works such as Painting (Fig. 13-24). Miró began this painting by making a scattered collage composition with assembled fragments cut from a catalog for machinery. The shapes in the collage became motifs the artist freely reshaped to create black silhouettes—solid or in outline, with dramatic accents of white and vermilion. They suggest, in the painting, a host of amoebic organisms or constellations in outer space floating in an immaterial background space filled with soft reds, blues, and greens.

Miró described his creative process as a switching back and forth between unconscious and conscious image making: "Rather than setting out to paint something, I begin painting and as I paint the picture begins to assert itself, or suggest

itself under my brush. The form becomes a sign for a woman or a bird as I work. . . . The first stage is free, unconscious. . . . The second stage is carefully calculated."²¹ Even the artist could not always explain the meanings of pictures such as *Painting*. They are, in the truest sense, spontaneous and intuitive expressions of the little-understood, submerged unconscious part of life.

SUPREMATISM AND DE STIJL

The pessimism and cynicism of movements such as Dada are thoroughly understandable in light of historical circumstances. However, not all artists gravitated toward alienation from society and its profound turmoil. Some avant-garde artists promoted utopian ideals, believing staunchly in art's ability to contribute to improving society. These efforts often surfaced in the face of significant political upheaval, illustrating the link established early on between revolution in politics and revolution in art. Among the art movements espousing utopian notions was Suprematism, which emerged in Russia during World War I.

The Supremacy of Pure Feeling The Russian painter KAZIMIR MALEVICH (1878–1935) developed an abstract style to convey his belief that the supreme reality in the world is pure feeling, which attaches to no object. Thus, this belief

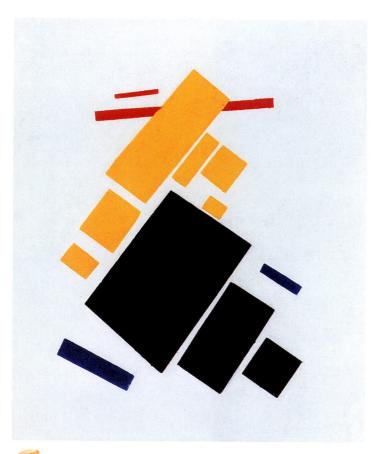

13-25 | KAZIMIR MALEVICH, Suprematist Composition: Airplane Flying, 1915 (dated 1914). Oil on canvas, 1' 10_8^{7} " × 1' 7". Museum of Modern Art, New York.

Malevich developed an abstract style he called Suprematism to convey his belief that the supreme reality in the world is pure feeling. In this work, the brightly colored rectilinear shapes float against white space.

called for new, nonobjective forms in art—shapes not related to objects in the visible world. Malevich had studied painting, sculpture, and architecture and had worked his way through most of the avant-garde styles of his youth before deciding none were suited to expressing the subject he found most important—"pure feeling." He christened his new artistic approach *Suprematism*, explaining: "Under Suprematism I understand the supremacy of pure feeling in creative art. To the Suprematist, the visual phenomena of the objective world are, in themselves, meaningless; the significant thing is feeling, as such, quite apart from the environment in which it is called forth. . . . The Suprematist does not observe and does not touch—he feels." ²²

The basic form of Malevich's new Suprematist nonobjective art was the square. Combined with its relatives, the straight line and the rectangle, the square soon filled his paintings, such as *Suprematist Composition: Airplane Flying* (Fig. 13-25). In this work, the brightly colored shapes float against and within a white space, and the artist placed them in dynamic relationship to one another. Malevich believed all peoples would easily understand his new art because of the universality of its symbols. It used the pure language of shape and color to which everyone could respond intuitively.

Neoplasticism The utopian spirit and ideals of the Suprematists were not limited to Russia. In Holland, a group of young artists formed a new movement in 1917 and began publishing a magazine, calling both movement and magazine *De Stijl* (The Style). One of the group's cofounders was the painter PIET MONDRIAN (1872–1944). In addition to promoting utopian ideals, group members believed in the birth of a new age in the wake of World War I. In their first manifesto of De Stijl, the artists declared: "There is an old and a new consciousness of the age. The old one is directed toward the individual. The new one is directed toward the universal."²³

The choice of the term "De Stijl" reflected Mondrian's confidence that this style—the style—revealed the underlying eternal structure of existence. Accordingly, De Stijl artists reduced their artistic vocabulary to simple geometric elements. Time spent in Paris, just before World War I, introduced Mondrian to modes of abstraction, such as Cubism. However, as his attraction to contemporary theological writings grew, Mondrian sought to purge his art of every overt reference to individual objects in the external world. Mondrian formulated a conception of nonobjective or pictorial design—"pure plastic art"—that he believed expressed universal reality. He articulated his credo in 1914: "Art is higher than reality and has no direct relation to reality. . . . To approach the spiritual in art, one will make as little use as possible of reality, because real-

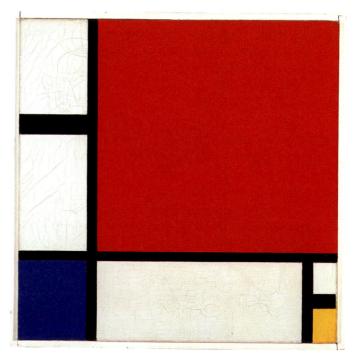

13-26 | PIET MONDRIAN, Composition with Red, Blue and Yellow, 1930. Oil on canvas, $18\frac{1}{8}" \times 18\frac{1}{8}"$. © 2007 Mondrian/ Holtzman Trust c/o HCR International, Warrenton, VA, USA.

Mondrian created numerous "pure plastic" paintings in which he locked primary colors into a grid of intersecting vertical and horizontal lines. By altering the grid patterns, he created a dynamic tension. ity is opposed to the spiritual.... [W]e find ourselves in the presence of an abstract art. Art should be above reality, otherwise it would have no value for man."²⁴

Mondrian soon moved beyond Cubism because he felt that "Cubism did not accept the logical consequences of its own discoveries; it was not developing towards its own goal, the expression of pure plastics."25 To achieve "pure plastic art," or Neoplasticism, as Mondrian called it, he eventually limited his formal vocabulary to the three primary colors (red, blue, and vellow), the three primary values (black, white, and gray), and the two primary directions (horizontal and vertical). He believed that primary colors and values were the purest colors and therefore the perfect tools to help an artist construct a harmonious composition. Mondrian created numerous paintings locking color planes into a grid of intersecting vertical and horizontal lines, as in Composition in Red, Blue, and Yellow (Fig. 13-26). In each of these paintings, he altered the grid patterns and the size and placement of the color planes to create an internal cohesion and harmony. This did not mean inertia. Rather, Mondrian worked to maintain a dynamic tension in his paintings through the size and position of lines, shapes, and colors.

ARCHITECTURE

The De Stijl group not only developed an appealing simplified geometric style but also promoted the notion that art should be thoroughly incorporated into living environments. As Mondrian had insisted, "Art and life are one; art and life are both expressions of truth." In Germany, a particular vision of "total architecture" was developed by the architect WALTER GROPIUS (1883–1969), who made this concept the foundation of his own work and that of generations of pupils under his influence.

The Bauhaus

In 1919, Gropius was appointed the director of the Weimar School of Arts and Crafts in Germany, founded in 1906. Under Gropius, the school was renamed Das Staatliche Bauhaus (State School of Building) and referred to as the *Bauhaus*. Gropius's goal was to train artists, architects, and designers to accept and anticipate 20th-century needs. He designed a comprehensive curriculum to meet that goal.

Bauhaus Principles The Bauhaus curriculum grew out of a few key principles. First, Gropius staunchly advocated the importance of strong basic design and craftsmanship as fundamental to good art and architecture. Second, he promoted the unity of art, architecture, and design. "Architects, painters, and sculptors," Gropius insisted, "must recognize anew the composite character of a building as an entity." To encourage the elimination of boundaries that traditionally separated art from architecture and art from craft, the Bauhaus offered courses in a wide range of artistic disciplines. These included weaving, pottery, bookbinding, carpentry, metalwork, stained glass, mural painting, stage design, and advertising and typology, in addition to painting, sculpture, and architecture. Third,

Gropius emphasized the need for thorough knowledge of machine-age technologies and materials. Ultimately, he hoped the Bauhaus approach would achieve a marriage between art and industry—a synthesis of design and production.

Like the De Stijl movement, the Bauhaus was founded on utopian principles. Gropius declared: "Together let us conceive and create the new building of the future, which will embrace architecture and sculpture and painting in one unity and which will rise one day toward heaven from the hands of a million workers like a crystal symbol of a new faith." The reference to a unity of workers also reveals the undercurrent of socialism in Germany at the time.

The Bauhaus in Dessau After encountering increasing hostility from a new government elected in 1924, the Bauhaus was forced to move north to Dessau in early 1925. By this time, the Bauhaus program had matured. In a statement, Walter Gropius listed the following goals for the Dessau school:

- A decidedly positive attitude to the living environment of vehicles and machines.
- The organic shaping of things in accordance with their own current laws, avoiding all romantic embellishment and whimsy.
- Restriction of basic forms and colours to what is typical and universally intelligible.
- Simplicity in complexity, economy in the use of space, materials, time, and money.²⁹

The building Gropius designed for the Bauhaus at Dessau visibly expressed these goals and can be seen as the Bauhaus's architectural manifesto. The building consisted of workshop and class areas, a dining room, a theater, a gymnasium, a wing with studio apartments, and an enclosed two-story bridge housing administrative offices. Of the major wings, the most dramatic was the Shop Block (Fig. 13-27). The Nazi government tore

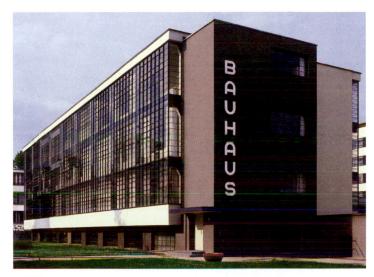

13-27 | Walter Gropius, Shop Block, the Bauhaus, Dessau, Germany, 1925–1926.

Gropius constructed this Bauhaus building by sheathing a reinforced concrete skeleton in glass. The design's simplicity followed his dictum that architecture should avoid "all romantic embellishment and whimsy."

down this building, but the Bauhaus's main buildings were later reconstructed. Three stories tall, the Shop Block housed a printing shop and dye works facility, in addition to other work areas. The builders constructed the skeleton of reinforced concrete but set these supports well back, sheathing the entire structure in glass, creating a streamlined and light effect. This design's simplicity followed Gropius's dictum that architecture should avoid "all romantic embellishment and whimsy." Further, he realized the "economy in the use of space" articulated in his list of principles in his interior layout of the Shop Block, which consisted of large areas of free-flowing undivided space. Gropius believed that such a spatial organization encouraged interaction and the sharing of ideas.

Less Is More In 1928, Gropius left the Bauhaus, and architect Ludwig Mies van der Rohe (1886–1969) eventually took over the directorship, moving the school to Berlin. Taking as his motto "less is more" and calling his architecture "skin and bones," he had already fully formed his aesthetic when he conceived the model for a glass skyscraper building

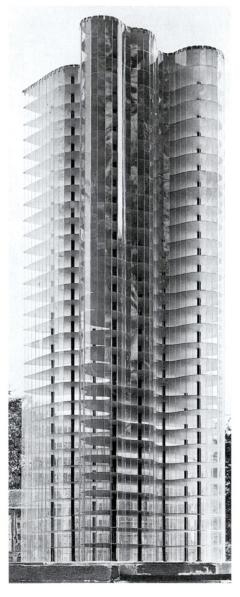

LUDWIG MIES VAN
DER ROHE, model for
a glass skyscraper,
Berlin, Germany,
1922 (no longer
extant).

In this technically and aesthetically adventurous design, the architect whose motto was "less is more" proposed a wholly transparent building that revealed its cantilevered floor planes and thin supporting elements.

in 1921 (Fig. 13-28). This model received extensive publicity when it was exhibited at the first Bauhaus exhibition in 1923. Working with glass provided Mies van der Rohe with new freedom and many expressive possibilities.

In the glass model, three irregularly shaped towers flow outward from a central court designed to hold a lobby, a porter's room, and a community center. Two cylindrical entrance shafts rise at the ends of the court, each containing elevators, stairways, and toilets. Wholly transparent, the perimeter walls reveal the regular horizontal patterning of the cantilevered floor planes and their thin vertical supporting elements. The bold use of glass sheathing and inset supports was, at the time, technically and aesthetically adventurous. A few years later, Gropius pursued it in his design for the Bauhaus building in Dessau (Fig. 13-27). The weblike delicacy of the lines of the glass model, its radiance, and the illusion of movement created by reflection and by light changes seen through it prefigured the design of many of the glass skyscrapers found in major cities throughout the world today.

The Demise of the Bauhaus In 1933, the Nazis finally occupied the Bauhaus and closed the school for good, one of Adolf Hitler's first acts after coming to power. During its 14-year existence, the beleaguered school graduated fewer than 500 students, yet it achieved legendary status. Its phenomenal impact extended beyond painting, sculpture, and architecture to interior design, graphic design, and advertising. Even further, the Bauhaus greatly influenced art education, and art schools everywhere structured their curricula in line with the Bauhaus's pioneering program. The Bauhaus philosophy and aesthetic were disseminated widely, in large part by the numerous instructors who fled Nazi Germany, many to the United States.

The International Style

The simple geometric aesthetic Gropius and Mies van der Rohe developed became known as the *International Style* because of its widespread popularity. The first and staunchest proponent of the International Style was the Swiss architect Charles-Edouard Jeanneret, called Le Corbusier (1887–1965). An influential theorist as well as practitioner, Le Corbusier sought to design a "functional" living space, which he described as a "machine for living."³⁰

A "Purist" House Le Corbusier's Villa Savoye (Fig. 13-29) at Poissy-sur-Seine near Paris illustrates one of the major principles associated with the "purism" of the International Style—the elimination of the weight-bearing wall. New structural systems using materials such as steel and ferroconcrete (reinforced concrete) made such designs possible. A cube of lightly enclosed and deeply penetrated space, the Villa Savoye has only a partially confined ground floor (containing a three-car garage, bedrooms, a bathroom, and utility rooms). Much of the house's interior is open space, with the thin steel columns supporting the concrete main living floor

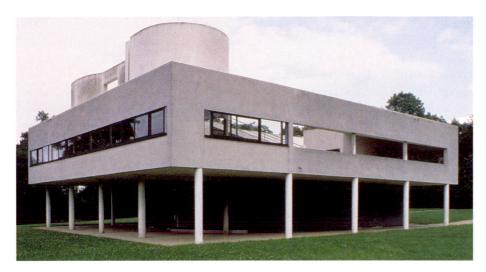

13-29 | Le Corbusier, Villa Savoye, Poissy-sur-Seine, France, 1929.

Steel and ferroconcrete made it possible for Le Corbusier to invert the traditional practice of placing light architectural elements above heavy ones and to eliminate weight-bearing walls on the ground story.

and roof garden area. Le Corbusier inverted the traditional design practice of placing light elements above and heavy ones below by refusing to enclose the ground story of the Villa Savoye with masonry walls. This openness makes the "load" of the Villa Savoye's upper stories appear to hover lightly on the slender column supports.

The major living rooms in the Villa Savoye are on the second floor, wrapping around an open central court and lighted by strip windows that run along the membranelike exterior walls. From the second floor court, a ramp leads up to a flat roof-terrace and garden protected by a curving windbreak along one side. The ostensible approach to Villa Savoye does not define an entrance. The building has no traditional facade. People must walk around and through the house to comprehend its layout. Spaces and masses interpenetrate so fluently that inside and outside space intermingle. Le Corbusier used several colors on the building's exterior—originally, a dark-green base, cream walls, and a rose-and-blue windscreen on top. The machine-planed smoothness of the surfaces, entirely without adornment; the slender ribbons of continuous windows; and the buoyant

lightness of the whole fabric—all combine to reverse the effect of traditional country houses (compare Andrea Palladio's Villa Rotonda, Fig. 9-15).

"Natural" Architecture

One of the most striking personalities in the development of early-20th-century architecture was FRANK LLOYD WRIGHT (1867–1959). Born in Wisconsin, Wright moved to Chicago, where he eventually joined the firm headed by Louis Sullivan (FIG. 12-27). Wright believed in "natural" or "organic" architecture. He saw architecture as serving free individuals who have the right to move within a "free" space, which he envisioned as a nonsymmetrical design interacting spatially with its natural surroundings. He sought to develop an organic unity of planning, structure, materials, and site.

A House with Waterfall Wright's "naturalism" is clearly displayed in the house nicknamed "Fallingwater" (Fig. 13-30), which he designed as a weekend retreat at Bear Run,

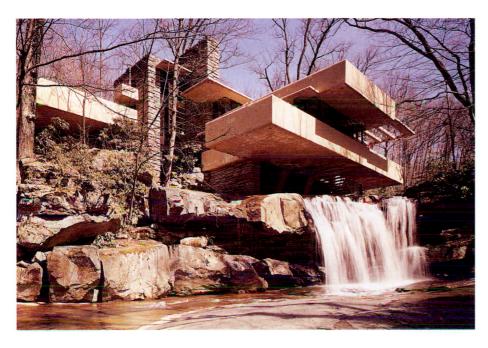

13-30 | FRANK LLOYD WRIGHT, Kaufmann House (Fallingwater), Bear Run, Pennsylvania, 1936–1939.

Perched on a rocky hillside over a waterfall, Wright's Fallingwater has long sweeping lines, unconfined by abrupt wall limits, reaching out and capturing the expansiveness of the natural environment.

Pennsylvania, for the Pittsburgh department store magnate Edgar Kaufmann Sr. Perched on a rocky hillside over a small waterfall, the Kaufmann house has long sweeping lines, unconfined by abrupt wall limits, reaching out toward and capturing the expansiveness of the natural environment. Abandoning all symmetry, Wright eliminated a facade, extended the roofs far beyond the walls, and all but concealed the entrance. The contrasting textures of concrete, painted metal, and natural stones in its walls enliven its shapes, as does Wright's use of full-length strip windows to create a stunning interweaving of interior and exterior space. In designing Fallingwater, Wright sought to find a way to incorporate the structure fully into its site. Rather than build the house overlooking or next to the waterfall, Wright decided to build it over the waterfall, because he believed that the inhabitants would become desensitized to the waterfall's presence and power if they merely overlooked it. To take advantage of the location, he designed a series of terraces as independent cantilevers, or self-supporting shelves, that extend on three levels from a central core structure. As soon as the Kaufmann house was completed, it became an icon of modernist architectural design.

SCULPTURE

During the second quarter of the 20th century, many sculptors also tried to emphasize the natural or organic in their work. The sculptures of Romanian artist Constantin Brancusi (1876–1957) are often composed of softly curving surfaces and ovoid forms, referring, directly or indirectly, to the cycle of life. Brancusi sought to move beyond surface appearances to capture the essence or spirit of the object depicted. He claimed: "What is real is not the external form but the essence of things. Starting from this truth it is impossible for anyone to express anything essentially real by imitating its exterior surface." ³¹

The Essence of Flight Brancusi's ability to design rhythmic, elegant sculptures conveying the essence of his subjects is evident in *Bird in Space* (Fig. 13-31). Clearly not a literal depiction of a bird, the work is the final result of a long process. Brancusi started with the image of a bird at rest with its wings folded at its sides and ended with an abstract columnar form sharply tapered at each end. Despite the abstraction, the sculpture retains the suggestion of a bird about to soar in free flight through the heavens. The highly reflective surface of the polished bronze does not allow the eye to linger on the sculpture itself. Instead, the viewer's eye follows the gleaming reflection along the delicate curves right off the tip of the work, thereby inducing a feeling of flight.

Kinetic Sculpture American sculptor ALEXANDER CALDER (1898–1976) used his thorough knowledge of engineering techniques to combine nonobjective organic forms and motion

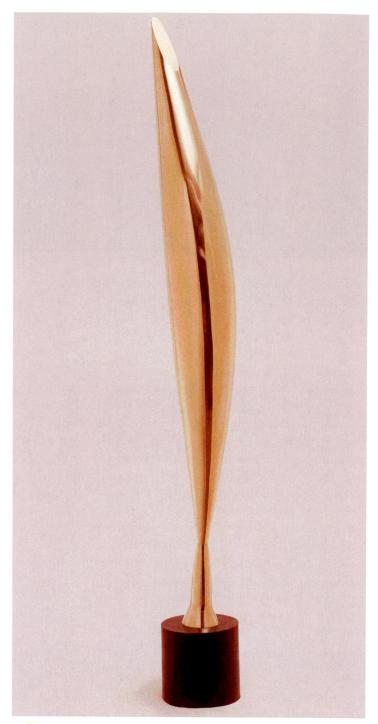

13-31 | Constantin Brancusi, *Bird in Space*, 1928. Bronze (unique cast), $4' 6'' \times 8'' \times 6''$. Museum of Modern Art, New York (given anonymously).

Although not a literal depiction of a bird, Brancusi's softly curving light-reflecting abstract sculpture in polished bronze suggests a bird about to soar in free flight through the heavens.

to create a new kind of sculpture that expressed reality's innate dynamism. Both the artist's father and grandfather were sculptors, but Calder initially studied mechanical engineering. Fascinated all his life by motion, he explored that phenomenon and its relationship to three-dimensional form in much of his sculpture.

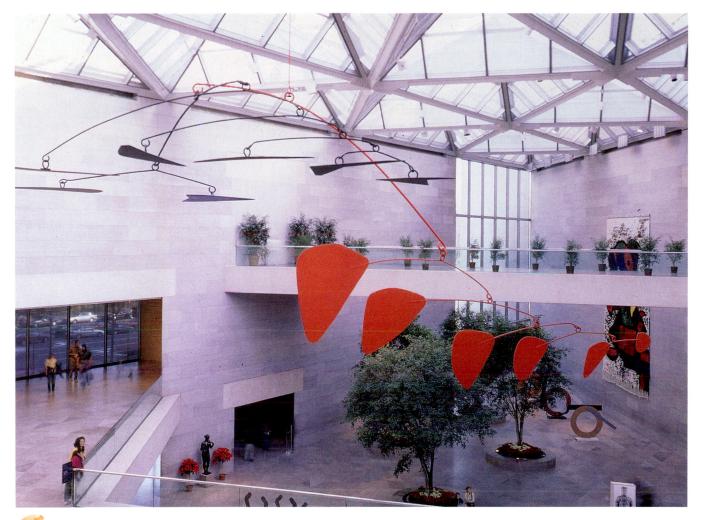

13-32 | ALEXANDER CALDER, untitled, 1976. Aluminum honeycomb, tubing, and paint, 29′ $10\frac{1}{2}$ ″ × 76′. National Gallery of Art, Washington, D.C. (Gift of the Collectors Committee).

Using his thorough knowledge of engineering to combine nonobjective organic forms and motion, Calder created a new kind of sculpture, the mobile, that expressed reality's innate dynamism.

As a young artist in Paris in the late 1920s, Calder invented a circus full of wire-based miniature performers that he activated into realistic analogues of the motion of their counterparts in life. After a visit to Mondrian's studio in the early 1930s, Calder was filled with a desire to set into motion the brightly colored rectangular shapes in the Dutch painter's compositions. (Marcel Duchamp, intrigued by Calder's early motorized and hand-cranked examples of moving abstract pieces, named them mobiles.) Calder's engineering skills soon helped him to fashion a series of balanced structures hanging from rods, wires, and colored, organically shaped plates, such as the untitled work we illustrate (Fig. 13-32). The sculptor carefully planned each nonmechanized mobile so that any air current would set the parts moving to create a constantly shifting dance in space. When air currents activate the sculpture, its patterns suggest clouds, leaves, or waves blown by the wind.

Mondrian's work may have provided the initial inspiration for Calder's mobiles, but their organic shapes resemble those in Joan Miró's Surrealist paintings (Fig. 13-24). Indeed, Calder's forms can be read either as geometric or organic. Geometrically, the lines suggest circuitry and rigging, and the shapes are derived from circles and ovoid forms. Organically, the lines suggest nerve axons, and the shapes are reminiscent of cells, leaves, fins, wings, and other bioforms.

POLITICAL AND SOCIAL COMMENTARY

Throughout history, art has regularly served political ends and addressed political themes and issues. The phenomenal upheaval the Western world experienced during the first half of the 20th century compelled numerous artists to speak out and use their art to make a political statement.

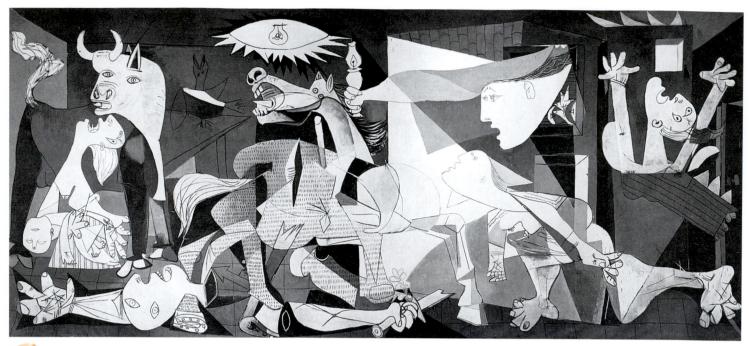

13-33 | PABLO PICASSO, *Guernica*, 1937. Oil on canvas, $11' 5\frac{1}{2}'' \times 25' 5\frac{3}{4}''$. Museo Nacional Centro de Arte Reina Sofia, Madrid.

Picasso used Cubist techniques, especially the fragmentation of objects and dislocation of anatomical features, to expressive effect in this monumental painting condemning the Nazi bombing of the Basque capital.

Picasso's Outcry of Grief Although previous discussion of Pablo Picasso focused on his immersion in aesthetic issues, he also engaged in political commentary. He declared: "Painting is not made to decorate apartments. It is an instrument for offensive and defensive war against the enemy."32 This belief was reinforced as Picasso watched his homeland descend into civil war in the late 1930s. In January 1937, the Spanish Republican government in exile in Paris asked Picasso to produce a monumental work for the Spanish pavilion at the Paris International Exposition that summer. Like other artists interested in disseminating political and social messages, Picasso realized the importance of placing his work in public arenas. He was well aware of the immense visibility and large international audience this opportunity afforded him. Picasso accepted this invitation but was not inspired to work on the project until he received word that Guernica, capital of the Basque region in southern France and northern Spain, had been almost totally destroyed in an air raid on April 26 by Nazi pilots acting on behalf of the rebel general Francisco Franco. The Germans not only bombed the city itself but, because they attacked at the busiest hour of a market day, also killed or wounded many of the 7,000 citizens. The event jolted Picasso into action. By the end of June, he completed the mural-sized canvas of Guernica (Fig. 13-33).

Picasso produced this monumental painting condemning the senseless bombing without specific reference to the event—depicting neither bombs nor German planes. Rather, the individual images in *Guernica* combine to create a visceral outcry of human grief. In the center, along the lower edge of the paint-

ing, lies a slain warrior clutching a broken and useless sword. A gored horse tramples him and rears back in fright as it dies. On the left, a shrieking, anguished woman cradles her dead child. On the far right, a woman on fire runs screaming from a burning building, while another woman flees mindlessly. In the upper right corner, a woman, represented only by a head, emerges from the burning building, thrusting forth a light to illuminate the horror. Overlooking the destruction is a bull, which, according to the artist, represents "brutality and darkness." 33

Picasso used aspects of his Cubist discoveries to expressive effect in *Guernica*, particularly the fragmentation of objects and the dislocation of anatomical features. The dissections and contortions of the human form in *Guernica* parallel what happened to the figures in real life. To emphasize the scene's severity and starkness, Picasso reduced his palette to black, white, and shades of gray.

Aware of the power of art to make political statements, Picasso refused to allow exhibition of *Guernica* in Spain while Franco was in power. At the artist's request, *Guernica* hung in the Museum of Modern Art in New York City after the International Exhibition concluded. Not until after Franco's death in 1975 did Picasso allow the mural to be patriated to his homeland. It was moved in 1981 and hangs today in the Centro de Arte Reina Sofia in Madrid as a testament to a tragic chapter in Spanish history.

The Great Depression The catastrophic U.S. stock market crash of October 1929 marked the onset of the Great Depression, which dramatically changed the nation. Artists were

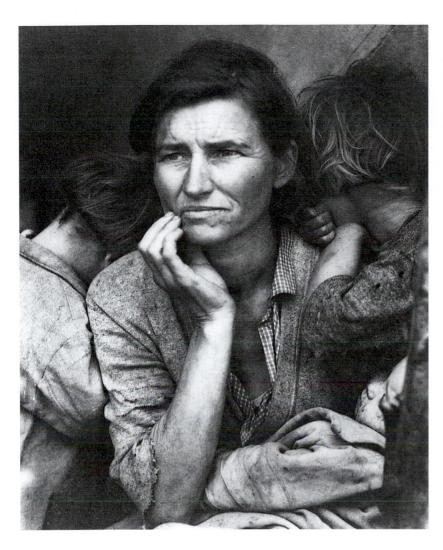

13-34 | DOROTHEA LANGE, *Migrant Mother*, *Nipomo Valley*, 1935. Gelatin silver print. Copyright © the Dorothea Lange Collection, The Oakland Museum of California, Oakland (gift of Paul S. Taylor).

While documenting the lives of migratory farm workers during the Depression, Lange made this unforgettable photograph of a mother and her children in which the artist captured the woman's strength and worry.

particularly affected. The already limited art market virtually disappeared, and museums curtailed both their purchases and exhibition schedules. Many artists sought financial support from the federal government, which established numerous programs to provide relief, aid recovery, and promote reform. Among the programs supporting artists were the Treasury Relief Art Project, founded in 1934 to commission art for federal buildings, and the Works Progress Administration (WPA), founded in 1935 to relieve widespread unemployment. Under the WPA, the Federal Art Project paid artists, writers, and theater people a regular wage in exchange for work in their professions. Another important program was the Resettlement Administration (RA), later known as the Farm Securities Administration (FSA). The FSA oversaw emergency aid programs for farm families caught in the Depression and provided information to the public about both the government programs and the plight of the people such programs served.

Starving Migrant Workers The RA hired American photographer DOROTHEA LANGE (1895–1965) in 1936, sending her to photograph the dire situation of the rural poor displaced by the Great Depression. At the end of an assignment to document the lives of migratory pea pickers in California, Lange stopped at a camp in Nipomo and found the migrant workers

there starving because the crops had frozen in the fields. Among the pictures she made on this occasion was *Migrant Mother, Nipomo Valley* (Fig. 13-34). Generations of viewers have been moved by the mixture of strength and worry in the raised hand and careworn face of a mother holding a baby on her lap. Two older children cling to her trustfully while turning their faces away from the camera. Like *Guernica*, Lange's photograph reveals the power of art. Within days after this image was printed in a San Francisco newspaper, people rushed food to Nipomo to feed the hungry workers.

Urban Loneliness EDWARD HOPPER (1882–1967) produced paintings evoking the national mind-set during the Depression. However, rather than depict historically specific scenes, he took as his subject the more generalized theme of the overwhelming loneliness and echoing isolation of modern life in the United States. Trained as a commercial artist, Hopper studied painting and printmaking in New York and Paris before returning to the United States. He then concentrated on scenes of contemporary American city and country life, painting buildings, streets, and landscapes that are curiously muted, still, and filled with empty spaces. Motion is stopped and time suspended, as if the artist recorded the major details of a poignant personal memory. From the darkened streets outside

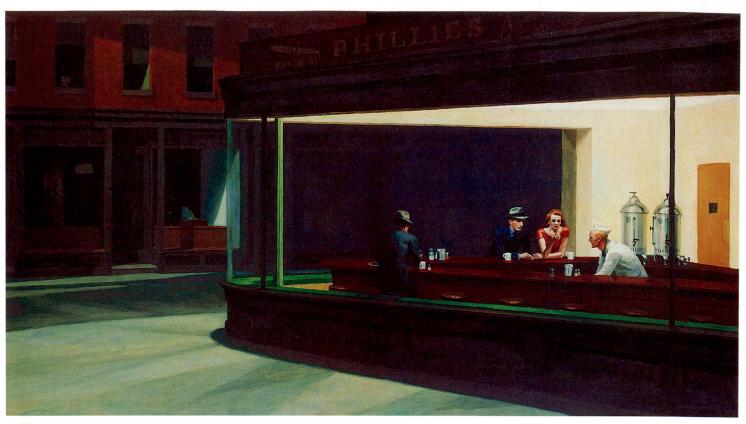

13-35 | EDWARD HOPPER, *Nighthawks*, 1942. Oil on canvas, $2' 6'' \times 4' 8\frac{11}{16}''$. The Art Institute of Chicago, Chicago (Friends of American Art Collection).

The seeming indifference of Hopper's characters to one another, and the echoing spaces that surround them, evoke the overwhelming loneliness and isolation of Depression-era life in the United States.

a restaurant in *Nighthawks* (FIG. 13-35), the viewer glimpses the lighted interior through huge plate-glass windows, which lend the inner space the paradoxical sense of being both a safe refuge and a vulnerable place for the three customers and the counterman. The seeming indifference of Hopper's characters to one another, and the echoing spaces that surround them, evoke the pervasive loneliness of modern humans. Although Hopper invested works such as *Nighthawks* with the straightforward mode of representation, creating a kind of Realist vision recalling that of 19th-century artists such as Thomas Eakins (FIG. 12-7) and Henry Ossawa Tanner (FIG. 12-8), he simplified the shapes in the painting, moving toward abstraction, in order to heighten the mood of the scene.

African American Migration American artist JACOB LAWRENCE (1917–2000) moved to Harlem, New York, in 1927 at about age 10. There, he came under the spell of the African art and the African-American history he found in lectures and exhibitions and in the special programs sponsored by the 135th Street New York Public Library. Inspired by the politically oriented art of Goya (Fig. 11-19), Daumier (Fig. 12-3), and others, Lawrence found his subjects in the everyday life of Harlem and his people's history. He defined his own vision of the continuing African American struggle against discrimination.

In 1941, Lawrence began a 60-painting series titled The Migration of the Negro. Unlike his earlier historical paintings depicting important figures in American history, such as Frederick Douglass, Toussaint L'Ouverture, and Harriet Tubman, this series called attention to a contemporaneous event—the ongoing exodus of black laborers from the southern United States. Disillusioned with their lives, hundreds of thousands of African Americans left the South in the years following World War I, seeking improved economic opportunities and more hospitable political and social conditions in the North. The "documentation" of the period, such as the FSA program, ignored African Americans, and thus this major demographic shift remained largely invisible to most Americans. Lawrence and his family were part of that migration, and he knew that the conditions African Americans encountered in the North were often as difficult and discriminatory as those they had left behind in the South.

Lawrence's series provides numerous vignettes capturing the experiences of these migrating people. Often, a sense of bleakness and of the degradation of African American life dominates the images. *No.* 49 in the series (Fig. 13-36) bears the caption "They also found discrimination in the North although it was much different from that which they had known in the South." The artist depicted a blatantly segregated dining room with a barrier running down the room's center separating the whites on

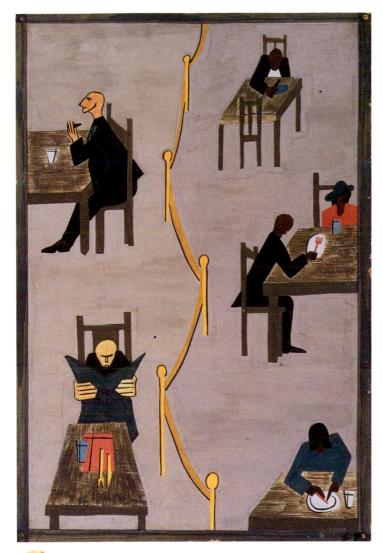

13-36 | JACOB LAWRENCE, No. 49 from *The Migration of the Negro*, 1940–1941. Tempera on Masonite, 1' $6'' \times 1'$. The Phillips Collection, Washington, D.C.

This is the 49th in a series of 60 paintings documenting African American life in the North. The depiction of a segregated dining room underscored that the migrants had not left discrimination behind.

the left from the African Americans on the right. To ensure a continuity and visual integrity among all 60 paintings, Lawrence interpreted his themes systematically in rhythmic arrangements of bold, flat, and strongly colored shapes. His style drew equally from his interest in the push-pull effects of Cubist space and his memories of the patterns made by the colored scatter rugs brightening the floors of his childhood homes. Further, he unified the narrative with a consistent palette of bluish green, orange, yellow, and grayish brown throughout the entire series. Lawrence believed that this story, like every subject painted during his long career, had important lessons to teach.

Regionalism At a conference in 1931, GRANT WOOD (1891–1942) announced a new movement developing in the Midwest known as *Regionalism*, which he described as focused on American subjects and as standing in reaction to "the abstraction of the modernists" in Europe and New York.³⁴

The Regionalists, sometimes referred to as the American Scene Painters, turned their attention to rural life as America's cultural backbone.

Grant Wood's paintings focus on rural scenes from Iowa, where he was born and raised. The work that catapulted Wood to national prominence was *American Gothic* (Fig. 13-37), which became an American icon. The artist depicted a farmer and his spinster daughter standing in front of a neat house with a small lancet window, typically found on Gothic cathedrals. The man and woman wear traditional attire—he appears in worn overalls and she in an apron trimmed with rickrack. The dour expression on both of their faces gives the painting a severe quality, which Wood enhanced with his meticulous brushwork. When *American Gothic* was exhibited, many people saw the couple as embodying "strength, dignity, fortitude, resoluteness, integrity," and were convinced Wood had captured the true spirit of America.³⁵

Wood's Regionalist vision involved more than his subjects, extending to a rejection of avant-garde styles in favor of a clearly readable, realist style. Surely this approach appealed to many people alienated by the increasing presence of abstraction in art. But, despite the accolades this painting received, it also

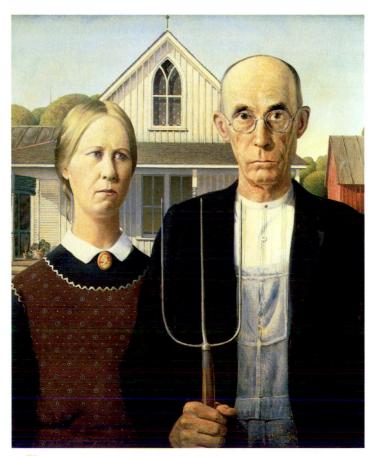

Oil on beaverboard, 2' $5\frac{7}{8}$ " \times 2' $\frac{7}{8}$ ". Art Institute of Chicago, Chicago (Friends of American Art Collection).

In reaction to the modernist abstraction of Europe and New York, the Regionalism movement in the Midwest focused on American subjects. Wood's painting of an Iowa farmer and his daughter became an American icon. 13-38 |

DIEGO RIVERA, Ancient Mexico, from History of Mexico, National Palace, Mexico City, 1929–1935. Fresco.

A staunch Marxist, Rivera painted vast mural cycles in public buildings to dramatize the history of his native land. This fresco depicts the conflicts between the indigenous people of Mexico and the Spanish colonizers.

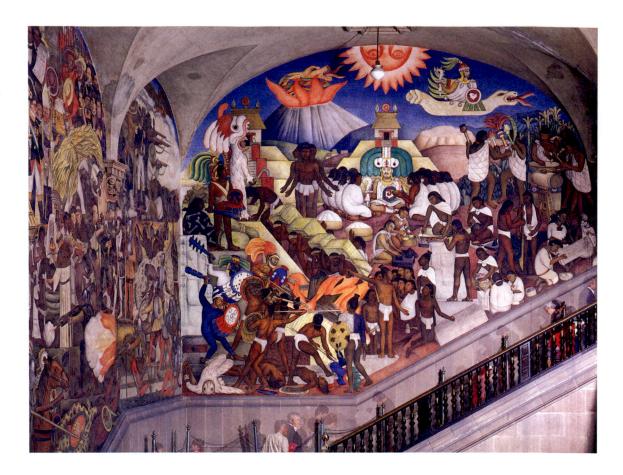

was criticized. Not everyone saw the painting as a sympathetic portrayal of midwestern life. Indeed, some in Iowa felt insulted by the depiction. In addition, despite the seemingly reportorial nature of *American Gothic*, some viewed it as a political statement—one of staunch nationalism. In light of the problematic nationalism in Germany at the time, this perceived nationalistic attitude was all the more disturbing. Ultimately, Regionalism had both stylistic and political implications.

Validating Mexican History DIEGO RIVERA (1886–1957) was one of a group of Mexican artists determined to base their art on the indigenous history and culture of Mexico. The movement these artists formed was part of the idealistic rethinking of society that occurred in conjunction with the Mexican Revolution (1910–1920) and the lingering political turmoil of the 1920s. Among the projects these politically motivated artists undertook were vast mural cycles placed in public buildings to dramatize and validate the history of Mexico's native peoples. A staunch Marxist, Rivera was committed to developing an art that served his people's needs. He sought to create a national Mexican style focusing on Mexico's history and also incorporating a popular, generally accessible aesthetic in keeping with the Socialist spirit of the Mexican Revolution.

Among Rivera's murals is a series lining the staircase of the National Palace in Mexico City. In these images, painted between 1929 and 1935, he depicted scenes representing the conflicts between the indigenous people of Mexico and the Spanish

colonizers. In *Ancient Mexico* (Fig. 13-38), Rivera included portraits of important historical figures in the struggle for Mexican independence. Although complex, the decorative, animated mural retains the legibility of folklore. The figures consist of simple monumental shapes and areas of bold color.

CONCLUSION

The upheaval during the early 20th century—World War I, the Russian Revolution, the Spanish Civil War, and the Great Depression—was a catalyst for significant change in art. Artists explored in depth various elements of artistic expression, such as color (the Fauves) and form (the Cubists). They also challenged the processes by which art was created. The Surrealists, for example, delved into the subconscious realm to produce works prompted by intuition.

The early 20th century was also characterized by increased dialogue between American and European artists. The Armory Show in 1913 was an important vehicle for disseminating information about developments in European art. The havoc Hitler and the Nazis wreaked in the early 1930s forced artists to flee to the United States, where many of them accepted teaching positions. Both the Armory exhibition and the expatriate European artists in the United States were crucial for the development of American art and contributed to the burgeoning interest in the avant-garde in the United States, propelling the country into the prominent position in the art world it enjoyed following World War II.

1900

- I Sigmund Freud, The Interpretation of Dreams, 1900
- Max Planck, quantum theory, 1900
- Wright brothers' first flight, 1903
- Albert Einstein, The Electrodynamics of Moving Bodies, 1905
- Futurist manifesto, 1909

Pablo Picasso, Les Demoiselles d'Avignon, 1907

1910

- I Niels Bohr, atomic theory, 1913
- Armory Show opens in New York, 1913
- World War I, 1914–1918
- Russian Revolution, 1917-1921
- | Bauhaus founded, 1919

1920

- Mexican Revolution ends, 1920
- League of Nations, 1921-1939
- I U.S.S.R. officially established, 1923
- I Surrealist manifesto, 1924
- I Museum of Modern Art established, 1929
- I U.S. stock market crashes, 1929

3

- 1930

 Great Depression, 1930s
 - I Rise of Nazism in Germany, 1930s
 - Roosevelt's "New Deal" in the United States, 1933-1939
 - Spanish Civil War, 1936-1939
 - World War II, 1939-1945

2 Umberto Boccioni, Unique Forms of Continuity in Space, 1913

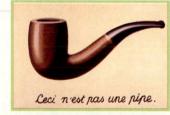

Rene Magritte, The Treachery (or Perfidy) of Images, 1928–1929

1940

Frank Lloyd Wright, Kaufmann House (Fallingwater), Bear Run, 1936–1939

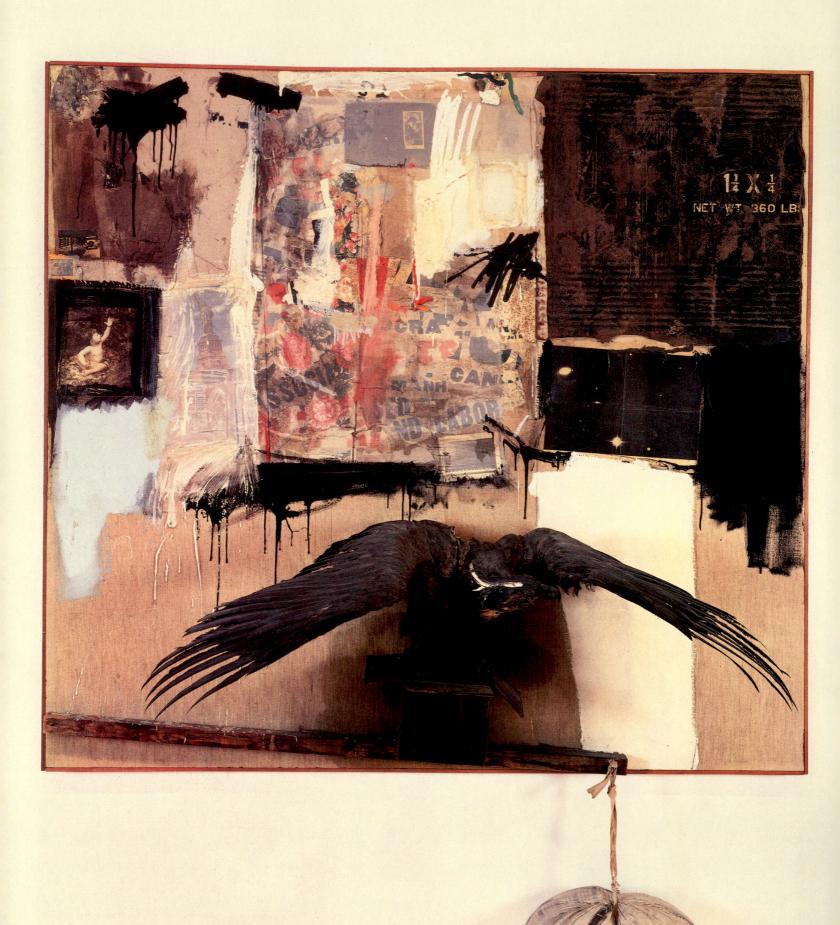

EUROPE AND AMERICA AFTER WORLD WAR II

World War II, with the global devastation it unleashed on all dimensions of life—psychological, political, physical, and economic—set the stage for the second half of the 20th century. The history of the past half century has been one of upheaval, change, and conflict (MAPS 14-1 and 14-2, page 534).

Disruption Abroad In 1947, the British left India, which erupted in a murderous Hindu-Muslim war that divided the subcontinent into the new, still hostile nations of India and Pakistan. After a catastrophic war, Communists came to power in China in 1949. North Korea challenged the authority of the fledgling United Nations (UN), founded after the war, by invading South Korea in 1950 and fighting a grim war with the United States and its UN allies that ended in 1953. The Soviets suppressed uprisings in their subject nations—East Germany, Poland, Hungary, and Czechoslovakia. The United States intervened in disputes in Central and South America. Hardly had the previously colonized nations of Africa-Kenya, Uganda, Nigeria, Angola, Mozambique, the Sudan, Rwanda, and the Congo—won their independence than civil wars devastated them. In Indonesia, civil war left more than 100,000 dead. Algeria expelled France in 1962 after the French waged a prolonged and vicious war with Algeria's Muslims. Following 15 years of bitter war in Southeast Asia, the United States withdrew from Vietnam. In 1979, the Soviets invaded Afghanistan but were driven out. Arab nations, economically flourishing from oil wealth, fought wars with Israel in 1967, 1978, and the early 1980s. A revitalized Islam rose in the Arab world, inspired a fundamentalist religious revolution in Iran, and encouraged "holy war" with the West, using a new weapon—international terrorism. Unrest continues to plague many countries worldwide. The instability in the Middle East (especially the war in Iraq) and the divisive ethnic clashes in many African nations emphasize that international hostilities and political uncertainty still characterize the world situation.

Rebellion at Home In part because the United States emerged relatively unscathed from World War II (compared to Europe, Japan, and the Soviet Union), it could pursue its economic, political, and cultural agendas more aggressively and establish a global presence. But although North American culture

ROBERT RAUSCHENBERG, Canyon, 1959. Oil, pencil, paper, fabric, metal, cardboard box, printed paper, printed reproductions, photograph, wood, paint tube, and mirror on canvas, with oil on eagle, string, and pillow, 6' $9\frac{3}{4}'' \times 5'$ $10'' \times 2'$. Sonnabend Collection.

seemed to take center stage during the latter part of the 20th century, the United States was not immune from upheaval either. In the postwar years, Americans increasingly questioned the status quo. The struggle for civil rights for African Americans, for free speech on university campuses, and against the Vietnam War led to a rebellion of young Americans. They took to the streets in often raucous demonstrations, with violent repercussions, during the 1960s and 1970s. The prolonged ferment produced a new system of values, a "youth culture," expressed in radical rejection not only of national policies but often also of the society generating them. The young derided their elders' lifestyles and adopted unconventional dress, manners, habits, and morals deliberately subversive of conventional social standards. The youth era witnessed the sexual revolution, the widespread use and abuse of drugs, and the development of rock music, then an exclusively youthful art form. Young people "dropped out" of regulated society, embraced alternative belief systems, and rejected university curricula as irrelevant.

This counterculture had considerable societal impact and widespread influence beyond its political phase. The civil rights movement of the 1960s and later the women's liberation movement of the 1970s reflected the spirit of rebellion, coupled with the rejection of racism and sexism. In keeping with the growing resistance to established authority, women systematically began to challenge the male-dominated culture, which they perceived as having limited their political power and economic opportunities for centuries. Feminists charged that the institutions of Western society, particularly the nuclear family headed by the patriarch, perpetuated male power and subordination of women. They further observed that monuments of Western culture—its arts and sciences, as well as its political, social, and economic institutions—masked the realities of male power.

The Dynamics of Power The central issue that fueled these rebellions and changes—from international political conflicts to the rise of feminism—was power. Increasingly, individuals and groups sought not just to uncover the dynamics of power but to combat actively the inappropriate exercise of power or change the balance of power. For example, following patterns developed first in the civil rights movement and later in feminism, various ethnic groups and gays and lesbians all have mounted challenges to discriminatory policies and attitudes. Such groups have fought for recognition, respect, and legal protection and have battled discrimination with political action. In addition, the growing scrutiny in numerous academic fields—cultural studies, literary theory, and colonial and postcolonial studies—of the dynamics and exercise of power has also contributed to the dialogue on these issues. As a result, identity (both individual and group) has emerged as a potent arena for discussion and action. Explorations into the politics of identity aim to increase understanding of how self-identifications, along with imposed or inherited identities, affect lives.

POSTWAR EXPRESSIONISM IN EUROPE

The end of World War II in 1945 left devastated cities, ruptured economies, and governments in chaos throughout Europe. These factors, coupled with the massive loss of life and the indelible horror of the Holocaust and the dropping of atomic bombs on Hiroshima and Nagasaki, resulted in a pervasive sense of despair, disillusionment, and skepticism. Although many (for example, the Futurists in Italy) had tried to find redemptive value in World War I, it was virtually impossible to do the same with World War II, coming as it did so closely on the heels of the war that was supposed to "end all wars." Further, World War I was largely a European conflict that left roughly 10 million people dead, whereas World War II was a truly global catastrophe, leaving 35 million dead in its wake.

Existentialism The cynicism emerging across Europe was reflected in the popularity of existentialism, a philosophy asserting the absurdity of human existence and the impossibility of achieving certitude. Many existentialists also promoted atheism. The writings of the French author Jean-Paul Sartre (1905–1980) most clearly captured the existentialist spirit of the postwar period. According to Sartre, people must consider seriously the implications of atheism. If God does not exist, then individuals must constantly struggle in isolation with the anguish of making decisions in a world without absolutes or traditional values. This spirit of pessimism and despair emerged frequently in the European art of the immediate postwar period. A brutality or roughness appropriately expressing both the artist's state of mind and the larger cultural sensibility characterized much of this art.

An Indictment of Humanity Painting (Fig. 14-1) by British artist Francis Bacon (1910–1992) is a compelling and revolting image of a powerful figure who presides over a scene of slaughter. Painted in the year after World War II ended, this work can be read as an indictment of humanity and a reflection of war's butchery. The central figure is a stocky man with a gaping mouth and a vivid red stain on his upper lip, as if he were a carnivore devouring the raw meat sitting on the railing surrounding him. Bacon may have based his depiction of this central figure on news photos of Nazi leaders Joseph Goebbels and Heinrich Himmler, Benito Mussolini, or Franklin Roosevelt, which were an important part of media coverage during World War II and very familiar to the artist. The umbrella recalls wartime images of Neville Chamberlain, the British prime minister who so disastrously misjudged Hitler and was frequently photographed with an umbrella. Bacon suspended the flayed carcass hanging behind the central figure like a crucified human form, adding to the painting's visceral impact. Although the specific sources for the imagery in Painting may not be entirely clear, it is not difficult to see the work as "an attempt to remake the violence of reality itself" (as Francis Bacon often described his art), and the artist surely based it on what he referred to as "the brutality of fact."1

14-1 | Francis Bacon, *Painting*, 1946. Oil and pastel on linen, $6' 5_{8}^{7} \times 4' 4''$. Museum of Modern Art, New York.

Painted in the aftermath of World War II, this intentionally revolting image of a powerful figure presiding over a scene of slaughter is Bacon's indictment of humanity and a reflection of war's butchery.

Lost in the World's Immensity The spirit of existentialism is perhaps best expressed in the sculpture of Swiss artist ALBERTO GIACOMETTI (1901–1966). Although Giacometti never claimed that he pursued existentialist ideas in his art, his works capture the spirit of that philosophy. Indeed, Sartre, Giacometti's friend, saw the artist's figurative sculptures as the epitome of existentialist humanity-alienated, solitary, and lost in the world's immensity. Giacometti's sculptures of the 1940s, such as Man Pointing (Fig. 14-2), are thin, virtually featureless figures with rough, agitated surfaces. Rather than convey the solidity and mass of conventional bronze figurative sculpture, these severely attenuated figures seem swallowed up by the space surrounding them, imparting a sense of isolation and fragility. Like much of European postwar art, Giacometti's sculptures are evocative and moving, speaking to the pervasive despair in the aftermath of world war.

14-2 | Alberto Giacometri, Man Pointing, 1947. Bronze no. 5 of 6, 5' $10'' \times 3'$ $1' \times 1'$ $5\frac{5}{8}''$. Nathan Emory Coffin Collection of the Des Moines Art Center, Des Moines (purchased with funds from the Coffin Fine Arts Trust).

The writer Jean-Paul Sartre, Giacometti's friend, saw the artist's thin and virtually featureless sculpted figures as the epitome of existentialist humanity—alienated, solitary, and lost in the world's immensity.

ABSTRACT EXPRESSIONISM

In the 1940s, the center of the Western art world shifted from Paris to New York. This was due in large part to the devastation World War II had inflicted across Europe, coupled with the influx of émigré artists to the United States. American artists picked up the European avant-garde's energy, which movements such as Cubism and Dada had fostered.

Greenbergian Formalism Postwar modernism increasingly became identified with a strict *formalism*—an emphasis on an artwork's visual elements rather than its subject. This shift was due largely to the prominence of the American art critic Clement Greenberg (1909–1994), who wielded considerable influence from the 1940s through the 1970s. So dominant was Greenberg that scholars often refer to the general modernist tenets during this period as Greenbergian formalism. Greenberg promoted the idea of purity in art. He believed that artists should strive for a more explicit focus on the properties exclusive to each medium—for example, two-dimensionality in painting and three-dimensionality in sculpture. To achieve this, artists had to eliminate illusion and embrace abstraction.

Greenberg argued that "a modernist work of art must try, in principle, to avoid communication with any order of experience

14-3 | JACKSON POLLOCK, Number 1, 1950 (Lavender Mist), 1950. Oil, enamel, and aluminum paint on canvas, 7' 3" × 9' 10". National Gallery of Art, Washington (Ailsa Mellon Bruce Fund).

Pollock's paintings emphasize the creative process. His mural-size canvases are composed of rhythmic drips, splatters, and dribbles of paint that envelop viewers, drawing them into a lacy spiderweb.

not inherent in the most literally and essentially construed nature of its medium. Among other things, this means renouncing illusion and explicit subject matter. The arts are to achieve concreteness, 'purity,' by dealing solely with their respective selves—that is, by becoming 'abstract' or nonfigurative."²

The New York School Abstract Expressionism, the first major American avant-garde movement, emerged in New York (and hence is often referred to as the New York School) in the 1940s. As the name suggests, the artists associated with Abstract Expressionism produced paintings that are, for the most part, abstract but express the artist's state of mind. These artists also intended to strike emotional chords in the viewer. To do so, many Abstract Expressionists adopted Surrealist improvisation methods, and used their creative minds as open channels for unconscious forces to make themselves visible. These artists turned inward to create, and the resulting works convey a rough spontaneity and palpable energy.

The artist Mark Rothko eloquently wrote: "We assert man's absolute emotions. We don't need props or legends. We create images whose realities are self evident. Free ourselves from memory, association, nostalgia, legend, myth. Instead of making cathedrals out of Christ, man or life, we make it out of ourselves, out of our own feelings. The image we produce is understood by anyone who looks at it without nostalgic glasses of history."³

The Abstract Expressionist movement developed along two lines—gestural abstraction and chromatic abstraction. The gestural abstractionists relied on the expressiveness of energetically applied pigment. In contrast, the chromatic abstractionists focused on color's emotional resonance.

The Primacy of Process The artist whose work best exemplifies gestural abstraction is JACKSON POLLOCK (1912-1956). Pollock developed his unique signature style in the mid-1940s. By 1950, he had refined his technique and was producing large-scale abstract paintings such as Number 1, 1950 (Lavender Mist; Fig. 14-3). These paintings are composed of rhythmic drips, splatters, and dribbles of paint, and the muralsized fields of energetic skeins of pigment envelop viewers, drawing them into a lacy spiderweb. The label "gestural abstraction" nicely describes Pollock's working technique. Using sticks or brushes, he flung, poured, and dripped paint (not only traditional oil paints but aluminum paints and household enamels as well) onto a section of unsized canvas he simply unrolled across his studio floor (Fig. 14-4). Responding to the image as it developed, Pollock created art that was both spontaneous and choreographed. His working method highlights a particularly avant-garde aspect of gestural abstraction—its emphasis on the creative process. Pollock explained, "I feel nearer, more a part of the painting, since this way I can walk around it, work from the four sides, and literally be in the painting."4 The idea that he improvised his works and drew from his subconscious has been linked by scholars to the artist's interest in Jungian psychology and the concept of the collective unconscious. He was also influenced by the Surrealists, who relied heavily on the subconscious. The improvisational nature of Pollock's work also parallels the work of Kandinsky (Fig. 13-4), who, appropriately enough, was described as an abstract expressionist as early as 1919.

In addition to Pollock's unique working methods, the lack of a well-defined compositional focus in his paintings significantly departed from conventional painting. He enhanced this

14-4 | Photo of Jackson Pollock painting. Center for Creative Photography.

"Gestural abstraction" nicely describes Pollock's working technique. Using sticks or brushes, he flung, poured, and dripped paint onto a section of canvas he simply unrolled across his studio floor.

rejection of tradition with the expansive scale of his canvases, a resolute move away from easel painting. These avant-garde dimensions of his work earned Pollock the public's derision and the nickname "Jack the Dripper."

A Ferocious Woman Despite the public's skepticism about abstract art, other artists enthusiastically pursued similar avenues of expression. Dutch-born WILLEM DE KOONING (1904–1997) also developed a gestural abstractionist style. Even images such as Woman I (Fig. 14-5), although rooted in figuration, display the sweeping gestural brushstrokes and energetic application of pigment typical of gestural abstraction. Out of the jumbled array of slashing lines and agitated patches of color appears a ferocious-looking woman with staring eyes and ponderous breasts. Her toothy smile, inspired by an ad for Camel cigarettes, seems to turn into a grimace. Female models on advertising billboards partly inspired Woman I, one of a series of female images, but de Kooning's female forms also suggest fertility figures and a satiric inversion of the traditional image of Venus, goddess of love.

Process was important to de Kooning, as it was for Pollock. Continually working on *Woman I* for almost two years,

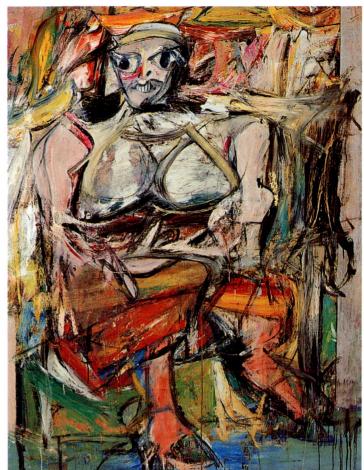

14-5 | WILLEM DE KOONING, Woman I, 1950–1952. Oil on canvas, 6' $3\frac{7}{8}$ " × 4' 10". Museum of Modern Art, New York.

Although rooted in figuration, including pictures of female models on advertising billboards, de Kooning's $Woman\ I$ displays the energetic application of pigment typical of gestural abstraction.

de Kooning painted an image and then scraped it away the next day and began anew. His wife Elaine, also a painter, estimated that he painted approximately 200 scraped-away images of women on this canvas before settling on the final one.

In addition to this *Woman* series, de Kooning created non-representational works dominated by huge swaths and splashes of pigment. His images suggest a rawness and intensity. His dealer, Sidney Janis, confirmed this impression, recalling that de Kooning occasionally brought him paintings with ragged holes in them, the result of overly vigorous painting. Like Pollock, de Kooning was very much "in" his paintings.

Action Painting Gestural abstraction is often also called action painting, a term the critic Harold Rosenberg applied first to the work of the New York School. In his influential article of 1952, "The American Action Painters," Rosenberg described the working method of these artists: "At a certain moment the canvas began to appear to one American painter after another as an arena in which to act—rather than as a space in which to reproduce, redesign, analyze or 'express' an object, actual or imagined. What was to go on the canvas was not a picture but an event. The painter no longer approached his easel with an

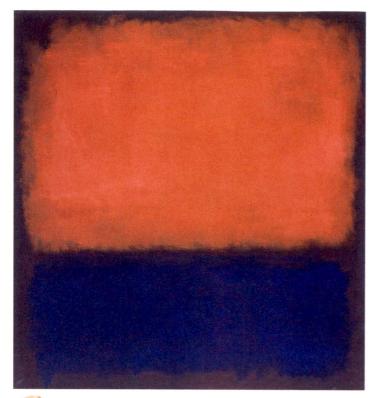

14-6 | MARK ROTHKO, *No. 14*, 1960. Oil on canvas, 9' 6" × 8' 9". San Francisco Museum of Modern Art, San Francisco (Helen Crocker Russell Fund Purchase).

Rothko was a chromatic abstractionist. His paintings—typically consisting of hazy rectangles of pure color hovering in front of a colored background—are compositionally simple but compelling visual experiences.

image in his mind; he went up to it with material in his hand to do something to that other piece of material in front of him. The image would be the result of this encounter."⁵

Shimmering Veils of Color In contrast to the aggressively energetic images of the gestural abstractionists, the work of the chromatic abstractionists exudes a quieter aesthetic, exemplified by the work of MARK ROTHKO (1903–1970). The emotional resonance of his works derives from his eloquent use of color. Born in Russia, Rothko moved with his family to the United States when he was 10. His early paintings were figurative in orientation, but he soon arrived at the belief that references to anything specific in the physical world conflicted with the sublime idea of the universal, supernatural "spirit of myth," which he saw as the core of meaning in art.

Rothko's paintings became compositionally simple, and he increasingly focused on color as the primary conveyor of meaning. In works such as *No. 14* (Fig. 14-6), Rothko created compelling visual experiences consisting of two or three large rectangles of pure color with hazy, brushy edges that seem to float on the canvas surface, hovering in front of a colored background. When properly lit, these paintings appear as shimmering veils of intensely luminous colors suspended in front of the canvases. Although the color juxtapositions are visually captivating, Rothko intended them as more than decorative. He saw

color as a doorway to another reality, and he was convinced that color could express "basic human emotions—tragedy, ecstasy, doom." He explained, "The people who weep before my pictures are having the same religious experience I had when I painted them. And if you, as you say, are moved only by their color relationships, then you miss the point." Like the other Abstract Expressionists, Rothko produced highly evocative, moving paintings that relied on formal elements rather than specific representational content to raise emotions in the viewer.

Welded Steel Sculptures Although American sculptor David Smith (1906–1965) was not associated with the Abstract Expressionists, his metal sculptures have affinities to the tenets of that movement. Smith learned to weld in an automobile plant in 1925, and later applied to his art the technical expertise in handling metals he gained from that experience. After experimenting with a variety of sculptural styles and materials, Smith created his *Cubi* series in the early 1960s. We illustrate *Cubi XVIII* (Fig. 14-7). It, like all the works in this series, consists of simple geometric forms—cubes, cylinders, and rectangular bars. Made of stainless steel, piled on top of one another, and then welded together, these forms create an imposing large-scale sculpture. Despite the basic geometric vocabulary, Smith composed all his *Cubi* in a way that suggests human characteristics. Smith added gestural elements reminiscent of Abstract

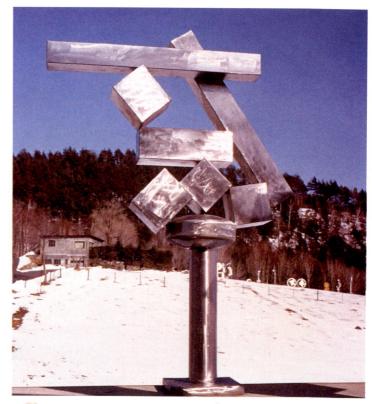

14-7 | DAVID SMITH, *Cubi XVIII*, 1963–1964. Polished stainless steel, 9' $7\frac{3}{4}$ " high. Museum of Fine Arts, Boston (gift of Susan W. and Stephen D. Paine).

David Smith's metal sculptures have affinities to the Abstract Expressionism movement. They consist of simple geometric forms—cubes, cylinders, and rectangular bars—piled up and then welded together.

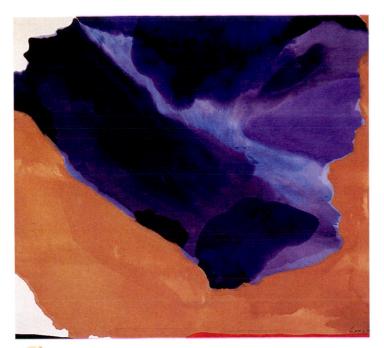

14-8 | HELEN FRANKENTHALER, Bay Side, 1967. Acrylic on canvas, 6' 2" × 6' 9". Private collection, New York.

Color field painters like Frankenthaler distilled painting down to its essential elements, producing spare, elemental images that force the viewer to acknowledge that a painting is simply pigment on a flat surface.

Expressionism by burnishing the metal with steel wool, producing swirling random-looking patterns that draw attention to the two-dimensionality of the sculptural surface. This treatment, which captures the light hitting the sculpture, activates the surface and imparts a texture to the metal.

POST-PAINTERLY ABSTRACTION

Post-Painterly Abstraction, another American art movement, developed out of Abstract Expressionism. Yet Post-Painterly Abstraction manifests a sensibility radically different from Abstract Expressionism. Whereas Abstract Expressionism conveys a feeling of passion and visceral intensity, Post-Painterly Abstraction exhibits a cool, detached rationality emphasizing tighter pictorial control. Clement Greenberg coined the term "Post-Painterly Abstraction." He saw this art as contrasting with "painterly" art, characterized by loose, visible pigment application. Evidence of the artist's hand, so prominent in gestural abstraction, is conspicuously absent in Post-Painterly Abstraction. Greenberg championed this art form because it seemed to embody his idea of purity in art.

Color Field Painting Attempting to arrive at pure painting, the Post-Painterly Abstractionists distilled painting down to its essential elements, producing spare, elemental images containing no suggestion of the illusion of depth. These painters insisted that the viewer acknowledge that a painting is simply pigment on a flat surface.

Post-Painterly Abstraction took different forms. In color field painting, the artist pours diluted paint onto unprimed

canvas, allowing these pigments to soak into the fabric. It is hard to conceive of another painting method that results in such literal flatness. The images created, such as *Bay Side* (Fig. 14-8) by Helen Frankenthaler (b. 1928), appear spontaneous and almost accidental. These works differ from Rothko's in that the emotional component, so integral to his work, is here subordinated to resolving formal problems.

MINIMALISM

Minimal art, or *Minimalism*, was a predominantly sculptural movement that emerged in the 1960s. The movement's name reveals its reductive nature. Difficult to describe other than as three-dimensional objects, Minimal artworks often lack identifiable subjects, colors, surface textures, and narrative elements. By rejecting illusionism and reducing sculpture to basic geometric forms, Minimalists emphasized their art's "objecthood" and concrete tangibility. In so doing, they reduced experience to its most fundamental level.

Sculpture's Objecthood Donald Judd (1928–1994) sought clarity and truth in his art, which led to a spare, universal aesthetic. Judd's determination to arrive at a visual vocabulary that avoided deception or ambiguity propelled him away from representation and toward precise and simple Minimalist sculpture. For Judd, a work's power derived from its character as a whole and from the specificity of its materials. *Untitled* (Fig. 14-9) presents basic geometric boxes

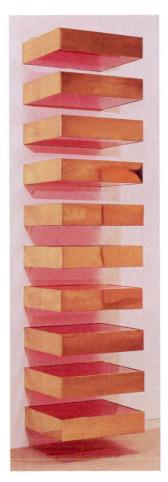

14-9 | DONALD JUDD, Untitled, 1969. Brass and colored fluorescent Plexiglass on steel brackets, 10 units, $6\frac{1}{8}$ " × 2' × 2' 3" each, with 6" intervals. Hirshhorn Museum and Sculpture Garden, Smithsonian Institution, Washington, D.C. (gift of Joseph H. Hirshhorn, 1972).

By rejecting illusionism and symbolism and reducing sculpture to basic geometric forms, Donald Judd and other Minimalist artists emphasized their works' "objecthood" and concrete tangibility. constructed of brass and red Plexiglass, undisguised by paint or other materials. The artist did not intend the work to be metaphorical or symbolic but a straightforward declaration of sculpture's objecthood. In works such as this, Judd used Plexiglass because its translucency allows the viewer access to the interior, thereby rendering the sculpture both open and enclosed. This aspect of the design was consistent with his desire to banish ambiguity or falseness.

Healing Psychic Wounds Maya Ying Lin (b. 1960) designed the Vietnam Veterans Memorial (Fig. 14-10) at age 21. The austere, simple memorial, a V-shaped wall constructed of polished black granite panels, begins at ground level at each end and gradually ascends to a height of 10 feet at the center of the V. Lin set the wall into the landscape, enhancing an awareness of descent as one walks along the wall toward the center. The names of the Vietnam War's 57,939 casualties (and those missing in action) incised on the wall, in the order of their deaths, contribute to the work's dramatic effect.

When Lin designed this pristinely simple monument, she gave a great deal of thought to the purpose of war memorials. She concluded that a memorial "should be honest about the reality of war and be for the people who gave their lives." She decided that she "didn't want a static object that people would just look at, but something they could relate to as on a journey, or passage, that would bring each to his own conclusions. . . . I wanted to work with the land and not dominate it. I had an impulse to cut open the earth . . . an initial violence that in time would heal. The grass would grow back, but the cut would remain . . ." In light of the tragedy of the war, this unpretentious

14-10 | MAYA YING LIN, Vietnam Veterans Memorial, Washington, D.C., 1981–1983. Black granite, each wing 246' long.

Like Minimalist sculpture, Lin's memorial to the veterans of Vietnam is a geometric form. The monument, with its serene simplicity, actively engages the viewer in a psychological dialogue about the war.

memorial's allusion to a wound and long-lasting scar contributes to its communicative ability (see "The Power of Minimalism: Maya Lin's Vietnam Veterans Memorial," page 413).

Biomorphic Sensuality Although Minimalism was a dominant sculptural trend in the 1960s, many sculptors pursued other styles. A sensuous organic quality recalling the evocative biomorphic Surrealist forms of Joan Miró (Fig. 13-24) pervades the work of French-American artist LOUISE BOURGEOIS (b. 1911). *Cumul I* (Fig. 14-11) is a collection of roundheaded units huddled, with their heads protruding, within a collective cloak dotted with holes. The units differ in size, and their position within the group lends a distinctive personality to each. Although the shapes remain abstract, they refer strongly to human figures. Bourgeois uses a wide variety of materials in her works, including wood, plaster, latex, and plastics, in addition to alabaster, marble, and bronze. She exploits each material's qualities to suit the expressiveness of the piece.

In *Cumul I*, the marble's high gloss next to its matte finish increases the sensuous distinction between the group of swelling forms and the soft folds swaddling them. Bourgeois connects her sculpture with the body's multiple relationships to

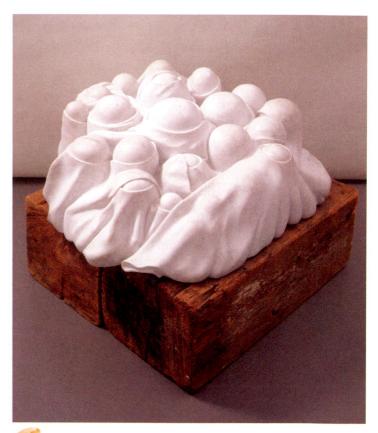

14-11 | LOUISE BOURGEOIS, Cumul I, 1969. Marble, $1' 10_8^{3''} \times 4' 2'' \times 4'$. Musée National d'Art Moderne, Centre Georges Pompidou, Paris. Copyright © Louise Bourgeois/Licensed by VAGA, New York.

Bourgeois's sculptures are made up of sensuous organic forms that recall the evocative biomorphic Surrealist forms of Miró (Fig. 13-24). Although the shapes remain abstract, they refer strongly to human figures.

ART + SOCIETY

The Power of Minimalism

Although Minimal art first seemed to many to operate only in the realm of the formal, the immediacy and physical presence of Minimalist artworks often endow the works with an enduring resonance. Maya Lin's design for the Vietnam Veterans Memorial (Fig. 14-10) is, like other Minimalist sculptures, a simple geometric form. Yet the controversy that erupted when her design was first publicized and the emotional public response to the completed memorial demonstrate how some Minimalist artworks can move beyond concrete objecthood. The monument, with its serene simplicity, actively engages viewers in a psychological dialogue, rather than standing mute. This dialogue gives people the opportunity to explore their feelings about the Vietnam War and perhaps arrive at some sense of closure.

The history of the Vietnam Veterans Memorial provides dramatic testimony to this monument's power. In 1981, a jury of architects, sculptors, and landscape architects selected Lin's design in a blind competition for a memorial to be placed in Constitution Gardens in Washington, D.C. Conceivably, the jury not only found her design compelling but also thought its unabashed simplicity would be the least likely to provoke controversy. When the selection was made public, however, heated debate ensued. Because of the stark contrast between the bracketing gigantic white memorials (the Washington Monument and the Lincoln Memorial) and Lin's wall, some people saw the design as criticizing the Vietnam War and, by extension, the efforts of those who fought in the war. Some of these critics perceived the wall's insertion into the earth as an admission of guilt about U.S. participation in the war. The wall's color came under attack as well. One veteran charged that black is "the universal color of shame, sorrow and degradation in all races, all societies worldwide."

landscape: "[My pieces] are anthropomorphic and they are landscape also, since our body could be considered from a topographical point of view, as a land with mounds and valleys and caves and holes." Bourgeois's sculptures are also often openly sexual. *Cumul I* represents perfectly the allusions Bourgeois seeks: "There has always been sexual suggestiveness in my work. Sometimes I am totally concerned with female shapes—characters of breasts like clouds—but often I merge the activity—phallic breasts, male and female, active and passive."

PERFORMANCE ART

In the interest of challenging artistic convention, some avantgarde artists in the 1960s developed the fourth dimension of time as an integral element of their artwork. Their brief, temporary works eventually were categorized under the broad term *Performance art*. In such work, movements, gestures, and sounds of persons communicating with an audience, whose members may or may not participate in the event, replace physical objects. Generally, the only evidence remaining after these events is the documentary photographs taken at the time of their occurrence. These actions, events, or *Happenings*, as they were frequently called, in large measure

Maya Lin's Vietnam Veterans Memorial

Due to the vocal opposition, a compromise was necessary to ensure the memorial's completion. The Commission of Fine Arts, the federal group overseeing such projects, commissioned an additional memorial from artist Frederick Hart in 1983. This larger-than-life-size realistic bronze sculpture of three soldiers, armed and in uniform, was eventually installed approximately 120 feet from the wall. More recently, a group of nurses, organized as the Vietnam Women's Memorial Project, got approval for a sculpture honoring women's service in the Vietnam War. The seven-foottall bronze statue by Glenna Goodacre depicts three female figures, one cradling a wounded soldier in her arms. Unveiled in 1993, the work was placed about 300 feet south of the wall.

Despite this controversy and compromise, the wall generates dramatic responses. Commonly, visitors react very emotionally, even those who know none of the soldiers named on the monument. Many visitors leave mementos at the foot of the wall in memory of loved ones they lost in the Vietnam War or make rubbings from the incised names. It can be argued that much of this memorial's power derives from its Minimalist simplicity. Like all Minimalist sculpture, it does not dictate response and therefore encourages personal exploration. The polished granite surface also prompts such individual soul-searching — viewers see themselves reflected among the names.

Given the contentiousness and divided sentiments about the Vietnam War, any memorial to that conflict surely would encounter opposition. Maya Lin's wall, however, has illustrated the ability of art to elicit emotions in a diverse population and to help heal a nation.

¹ Elizabeth Hess, "A Tale of Two Memorials," *Art in America* 71, no. 4 (April 1983): 122.

derived from the spirit characterizing Dada and Surrealist work and anticipated the rebellion and youthful exuberance of the 1960s. The informal and spontaneous nature of much of such work using the human body as primary material pushed art outside the confines of museums and galleries. Extreme examples of Performance art involved artists who created various performance pieces centered on risk-taking activities such as being shot with a gun or crawling over broken glass. Such work dramatically challenged accepted definitions of art. In the later 1960s, however, museums commissioned performances with increasing frequency, thereby neutralizing much of this art form's subversive edge.

Performance as Ritual German artist Joseph Beuys (1921–1986) created actions aimed at illuminating the condition of modern humanity. He wanted to make a new kind of sculptural object that would stimulate thought about art and life. This goal was partially due to his experiences during World War II. While serving as a pilot, he was shot down over the Crimea, and claimed that nomadic Tatars nursed him back to health by swaddling his body in fat and felt to warm him. Fat and felt thus symbolized healing and regeneration to Beuys, and he incorporated these materials into many of his sculptures and actions, such as *How to Explain Pictures to a*

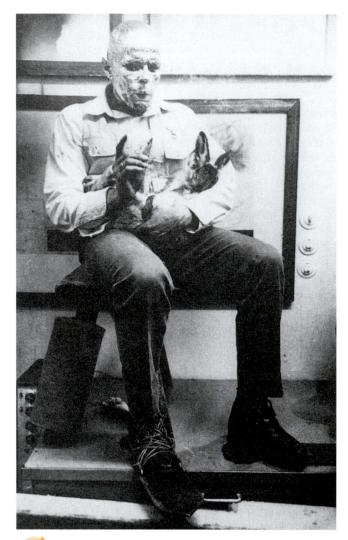

14-12 | JOSEPH BEUYS, How to Explain Pictures to a Dead Hare, 1965. Photograph of performance art. Schmela Gallery, Düsseldorf.

Performance art challenges artistic convention and introduces the dimension of time into an artwork. In this one-person event, Beuys used stylized actions to evoke a sense of mystery and sacred ritual.

Dead Hare (Fig. 14-12). This one-person event consisted of stylized actions evoking a sense of mystery and sacred ritual. Beuys appeared in a room hung with his drawings, cradling a dead hare he spoke to softly. Beuys coated his head with honey covered with gold leaf, creating a shimmering mask. In this manner, he took on the role of the shaman, an individual with special spiritual powers. As a shaman, Beuys believed he was acting to help revolutionize human thought so that each human being could become a truly free and creative person.

CONCEPTUAL ART

The relentless challenges to artistic convention fundamental to the historical avant-garde reached a logical conclusion with *Conceptual art* in the late 1960s. Conceptual artists asserted that the "artfulness" of art lay in the artist's idea, rather than in its final expression. Indeed, some Conceptual artists eliminated the object altogether. In addition, Conceptual artists

rethought aesthetic issues, which long have formed the foundation of art. These artists regarded the idea, or concept, as the defining component of the artwork.

The Idea of an Artwork American artist JOSEPH KOSUTH (b. 1945) was a major proponent of Conceptual art. His work operates at the intersection of language and vision, dealing with the relationship between the abstract and the concrete. In a broader sense, his art explores the ways in which aesthetic meaning is generated. For example, One and Three Chairs (Fig. 14-13) consists of an actual chair flanked by a full-scale photograph of the chair and an enlarged photocopy of a dictionary definition of the word chair. Kosuth asks the viewer to ponder the notion of what constitutes "chairness." He explained, "It meant you could have an art work which was that idea of an art work, and its formal components weren't important. I felt I had found a way to make art without formal components being confused for an expressionist composition. The expression was in the idea, not the form the forms were only a device in the service of the idea."9

Other Conceptual artists pursued this idea that "the idea itself, even if not made visual, is as much a work of art as a product" by creating works involving such invisible materials as inert gases, radioactive isotopes, or radio waves. In each case, viewers must base their understanding of the artwork on what they know about the properties of these materials, rather than on any visible empirical data, and depend on the artist's linguistic description of the work. In Conceptual artists' intellectual and aesthetic investigation of art's structure, they challenged the very premises of art, pushing art's boundaries to a point where no concrete definition of "art" is possible.

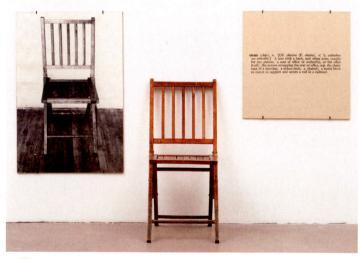

14-13 | JOSEPH KOSUTH, *One and Three Chairs*, 1965. Wooden folding chair, photographic copy of a chair, and photographic enlargement of a dictionary definition of *chair*; chair, $2' \ 8_8^{3''} \times 1' \ 2_8^{7''} \times 1' \ 8_8^{7''}$; photo panel, $3' \times 2' \ \frac{1}{8}''$; text panel, $2' \times 2' \ \frac{1}{8}''$. Museum of Modern Art, New York (Larry Aldrich Foundation Fund).

Conceptual artists like Kosuth work at the intersection of language and vision. Here, he juxtaposed an actual chair, a full-scale photograph of the chair, and an enlarged dictionary definition of the word *chair*.

POP ART

In the decades following World War II, the public became alienated by the prevalence of abstraction and the formal experimentation in much avant-garde art. Pop art reintroduced all the artistic devices—signs, symbols, metaphors, allusions, illusions, and figurative imagery—traditionally used to convey meaning in art that many postwar artists, in search of purity, had purged from their abstract and often reductive works. Pop artists not only embraced representation but also produced an art resolutely grounded in consumer culture, the mass media, and popular culture, thereby making it much more accessible and understandable to the average person. Indeed, the name "Pop art" (credited to the British art critic Lawrence Alloway, although he is unsure of the term's initial usage) is short for popular art and referred to the popular mass culture and familiar imagery of the contemporary urban environment. This was an art form firmly entrenched in the sensibilities and visual language of a late-20th-century mass audience.

British Pop The roots of Pop art can be traced to a group of young British artists, architects, and writers who formed the Independent Group at the Institute of Contemporary Art in London in the early 1950s. The members of this group sought to initiate fresh thinking in art, in part by sharing their fascination with the aesthetics and content of such facets of popular culture as advertising, comic books, and movies.

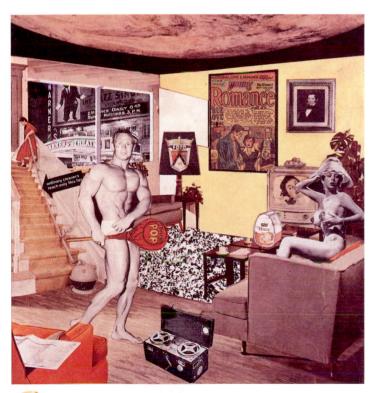

14-14 | RICHARD HAMILTON, Just What Is It That Makes Today's Homes So Different, So Appealing? 1956. Collage, $10\frac{1}{4}" \times 9\frac{3}{4}"$. Kunsthalle Tübingen, Tübingen.

The fantasy interior in Hamilton's collage reflects the values of modern consumer culture through figures and objects cut from glossy magazines. This kind of toying with mass-media imagery typifies British Pop art.

Discussions at the Independent Group in London probed the role and meaning of symbols from mass culture and the advertising media. In 1956, a group member, RICHARD HAMILTON (b. 1922), made a small collage, Just What Is It That Makes Today's Homes So Different, So Appealing? (Fig. 14-14), that characterized many of the attitudes of British Pop art. Trained as an engineering draftsman, exhibition designer, and painter, Hamilton was very interested in the way advertising shapes public attitudes. Long intrigued by Duchamp's ideas, Hamilton consistently combined elements of popular art and fine art, seeing both as belonging to the whole world of visual communication. The Pop artist created Just What Is It for the poster and catalog of one section of an exhibition titled This Is Tomorrow, which was filled with images from Hollywood cinema, science fiction, the mass media, and one reproduction of a van Gogh painting (to represent popular fine artworks).

The fantasy interior in Hamilton's collage reflects the values of modern consumer culture through figures and objects cut from glossy magazines. *Just What Is It* includes references to the mass media (the television, theater marquee outside the window, and newspaper), to advertising (for Hoover vacuums, Ford cars, Armour hams, and Tootsie Pops), and to popular culture (the girlie magazine, Charles Atlas, and romance comic books). Scholars have written much about the possible deep meaning of this piece, and few would deny the work's sardonic effect, whether or not the artist intended to make a pointed comment. Such artworks stimulated wide-ranging speculation about society's values, and this kind of intellectual toying with mass-media meaning and imagery typified British and European Pop art.

American Pop Although Pop originated in England, the movement found its greatest articulation and success in the United States, in large part because America's more fully matured consumer culture provided a fertile environment for the movement. Indeed, Independent Group members claimed that their inspiration came from Hollywood, Detroit, and Madison Avenue, New York, paying homage to U.S. predominance in the realms of mass media, mass production, and advertising. Two artists pivotal to the early development of American Pop were Jasper Johns and Robert Rauschenberg. Both artists introduced elements from popular culture into their art.

Seen but Not Looked At In his early work, JASPER JOHNS (b. 1930) was particularly interested in drawing attention to common objects in the world—what he called things "seen but not looked at." To this end, he did several series of paintings of targets, flags, numbers, and alphabets. For example, *Flag* (Fig. 14-15) depicts an object people view frequently but rarely scrutinize. The surface of the work is highly textured due to Johns's use of encaustic, an ancient method of painting with liquid wax and dissolved pigment. First, the artist embedded a collage of newspaper scraps or photographs in wax. He then painted over them with the encaustic. Because the wax hardened quickly, Johns could work

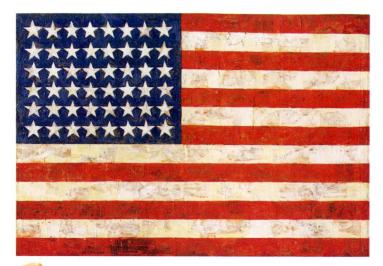

14-15 | JASPER JOHNS, *Flag*, 1954–1955, dated on reverse 1954. Encaustic, oil, and collage on fabric mounted on plywood, 3' $6\frac{1}{4}$ " × 5' $\frac{5}{8}$ ". Museum of Modern Art, New York (gift of Philip Johnson in honor of Alfred H. Barr Jr.).

American Pop artist Jasper Johns wanted to draw attention to common objects that people view frequently but rarely scrutinize. He made several series of paintings of targets, flags, numbers, and alphabets.

rapidly, and the translucency of the wax allows the viewer to see the layered painting process.

Pop "Combines" Johns's friend ROBERT RAUSCHENBERG (b. 1925) began using mass-media images in his work in the 1950s. Rauschenberg set out to create works that would be open and indeterminate, and he began by making "combines," which intersperse painted passages with sculptural elements. Combines are, in a sense, Rauschenberg's personal variation on assemblages, which are artworks constructed from already existing objects. Some combines seem to be sculptures with painting incorporated into certain sections. Others seem to be paintings with three-dimensional objects attached to the surface. In the 1950s, such works contained an array of art reproductions, magazine and newspaper clippings, and passages painted in an Abstract Expressionist style. In the early 1960s, Rauschenberg adopted the commercial medium of silk-screen printing, first in black and white and then in color, and began filling entire canvases with appropriated news images and anonymous photographs of city scenes.

Canyon (Fig. 14-16) is typical of his combines. Pieces of printed paper and photographs are attached to the canvas. Much of the unevenly painted surface consists of pigment roughly applied in a manner reminiscent of de Kooning's work (Fig. 14-5). A stuffed eagle attached to the lower part of the combine spreads its wings as if lifting off in flight. Completing the combine, a pillow dangles from a string attached to a wood stick below the eagle. The artist presented the work's components in a jumbled fashion. He tilted or turned some of the images sideways, and each overlays or is invaded by part of another image. The compositional confusion may

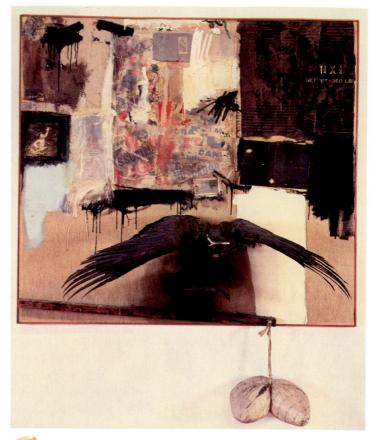

14-16 | ROBERT RAUSCHENBERG, Canyon, 1959. Oil, pencil, paper, fabric, metal, cardboard box, printed paper, printed reproductions, photograph, wood, paint tube, and mirror on canvas, with oil on eagle, string, and pillow, $6' \ 9\frac{3\pi}{4} \times 5' \ 10'' \times 2'$. Sonnabend Collection.

Rauschenberg's "combines" intersperse painted passages with sculptural elements. *Canyon* incorporates pieces of printed paper, photographs, a pillow, and a stuffed eagle with pigment on canvas.

resemble that in a Dada collage, but the parts of Rauschenberg's combine paintings maintain their individuality. The various recognizable images and objects appear to be a sequence of visual non sequiturs, and it is virtually impossible to arrive at a consistent reading of a Rauschenberg combine. The eye scans a Rauschenberg canvas much as it might survey the environment on a walk through the city.

Comic Art As the Pop movement matured, the images became more concrete and tightly controlled. ROY LICHTENSTEIN (1923–1997) turned his attention to the comic book as a mainstay of American popular culture. In paintings such as *Hopeless* (Fig. 14-17), Lichtenstein excerpted an image from a comic book, a form of entertainment meant to be read and discarded, and immortalized the image at monumental scale. Aside from that modification, Lichtenstein was remarkably faithful to the original comic strip image. First, he selected a melodramatic scene common to the romance comic books that were exceedingly popular at the time. Second, he used the

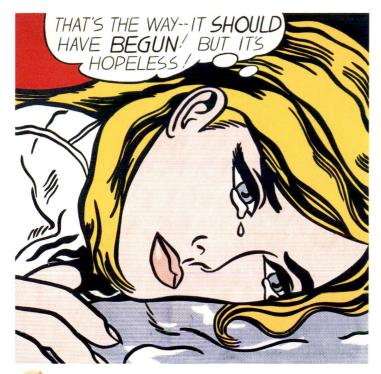

14-17 | ROY LICHTENSTEIN, *Hopeless*, 1963. Oil on canvas, 3' 8" × 3' 8". Öffentliche Kunstsammlung Basel, Basel.

Comic books appealed to Lichtenstein because they were a mainstay of American popular culture, meant to be read and discarded. The Pop artist, however, immortalized their images at monumental scale.

visual vocabulary of the comic strip, with its dark black outlines and unmodulated color areas, and retained the familiar square dimensions. Third, Lichtenstein's printing technique, benday dots, called attention to the mass-produced derivation of the image. Named after its inventor, the newspaper printer

Benjamin Day, the benday dot system involves the modulation of colors through the placement and size of colored dots.

The Art of Commodities The quintessential American Pop artist was ANDY WARHOL (1928–1987). An early successful career as a commercial artist and illustrator grounded Warhol in the sensibility and visual rhetoric of advertising and the mass media, knowledge that proved useful for his Pop art. So immersed was Warhol in a culture of mass production that he not only produced numerous canvases of the same image but also named his studio "the Factory."

Warhol often produced images of Hollywood celebrities, such as Marilyn Monroe. Like his other paintings, these works emphasize the commodity status of the subjects depicted. Warhol created Marilyn Diptych (Fig. 14-18) in the weeks following the tragic suicide of the movie star in August 1962, capitalizing on the media frenzy prompted by her death. Warhol selected a publicity photo of Monroe, one that provides no insight into the real Norma Jean Baker. Rather, all the viewer sees is a mask—a persona generated by the Hollywood myth machine. The garish colors and the flat application of paint contribute to the image's masklike quality. The repetition of Monroe's face reinforces her status as a consumer product, her glamorous, haunting visage seemingly confronting the viewer endlessly, as it did the American public in the aftermath of her death. The right half of this work, with its poor registration of pigment, suggests a sequence of film stills, referencing the realm in which Monroe achieved her fame.

Warhol's own ascendance to the realm of celebrity underscored his remarkable and astute understanding of the dynamics and visual language of mass culture. He predicted that the age of mass media would enable everyone to become famous for 15 minutes. His own celebrity has lasted much longer.

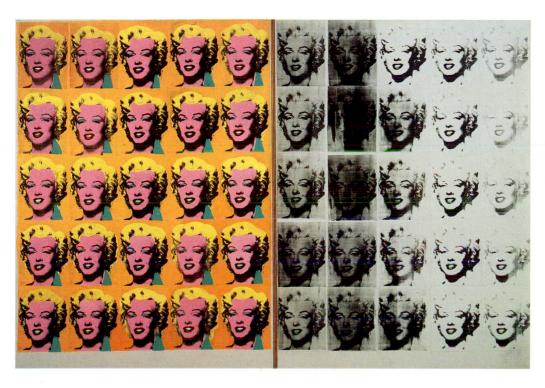

14-18 | ANDY WARHOL, *Marilyn Diptych*, 1962. Oil, acrylic, and silk-screen enamel on canvas, each panel 6' 8" × 4' 9". Tate Gallery, London.

Warhol's repetition of Monroe's face reinforced her status as a consumer product, her glamorous, haunting visage confronting the viewer endlessly, as it did the American public in the aftermath of her death.

SUPERREALISM

Like the Pop artists, the artists associated with *Superrealism* were interested in finding a form of artistic communication that was more accessible to the public than the remote, unfamiliar visual language of the Abstract Expressionists or the Post-Painterly Abstractionists. The Superrealists expanded Pop's iconography in both painting and sculpture by making images in the late 1960s and 1970s involving scrupulous photographic fidelity to optical fact. Because many Superrealists used photographs as sources for their imagery, Superrealist painters are often also called *Photorealists*.

Photorealist Portraits American artist CHUCK CLOSE (b. 1940) is best known for his large-scale Photorealist portraits. For Close, however, realism, rather than an end in itself, was the result of an intellectually rigorous, systematic approach to painting. He based his paintings of the late 1960s and early 1970s, such as his *Big Self-Portrait* (Fig. 14-19), on photographs, and his main goal was to translate photographic information into painted information. Because he aimed simply to record visual information about his subject's appear-

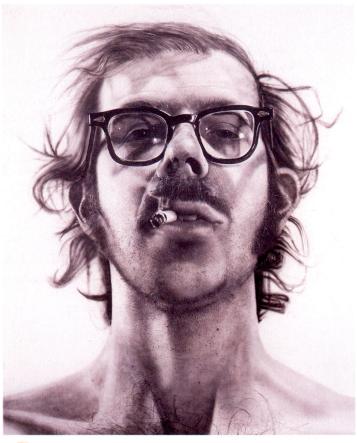

14-19 | CHUCK CLOSE, *Big Self-Portrait*, 1967–1968. Acrylic on canvas, 8' 11" × 6' 11" × 2". Walker Art Center, Minneapolis (Art Center Acquisition Fund, 1969).

Close's main goal was to translate photographic information into painted information. In his portraits, he deliberately avoided creative compositions, flattering lighting effects, and revealing facial expressions.

ance, he deliberately avoided creative compositions, flattering lighting effects, and revealing facial expressions. Close, not interested in providing insight into the personalities of those portrayed, painted anonymous and generic people, mostly friends. By reducing the variables in his paintings (even their canvas size is a constant 9×7 feet), Close could focus on employing his methodical presentations of faces, thereby encouraging the viewer to deal with the formal aspects of his works. Indeed, because of the large scale of the artist's paintings, close scrutiny causes the images to dissolve into abstract patterns.

ENVIRONMENTAL ART

Environmental art, sometimes called Earth art or earthworks, emerged in the 1960s and included a wide range of artworks. most of them site specific and existing outdoors. Many artists associated with these sculptural projects also used natural or organic materials, including the land itself. This art form developed during a period of increased concern for the American environment. The ecology movement of the 1960s and 1970s aimed to publicize and combat escalating pollution, depletion of natural resources, and the dangers of toxic waste. The problems of public aesthetics (for example, litter, urban sprawl, and compromised scenic areas) were also at issue. Widespread concern about the environment led to the passage of the National Environmental Policy Act in 1969 and the creation of the federal Environmental Protection Agency. Environmental artists used their art to call attention to the landscape and, in so doing, were part of this national dialogue.

As an innovative art form that challenged traditional assumptions about art making and artistic models, Environmental art clearly had an avant-garde, progressive dimension. It is discussed here with the more populist art movements such as Pop and Superrealism, however, because these artists insisted on moving art out of the rarefied atmosphere of museums and galleries and into the public sphere. Most Environmental artists encouraged spectator interaction with the works. Thus these artists, like the Pop artists and Superrealists, intended their works to connect with a larger public. Ironically, the remote locations of many earthworks have limited public access.

The Enduring Power of Nature A leading American Environmental artist was ROBERT SMITHSON (1938–1973), who used industrial construction equipment to manipulate vast quantities of earth and rock on isolated sites. One of Smithson's best-known pieces is *Spiral Jetty* (Fig. 14-20), a mammoth coil of black basalt, limestone rocks, and earth that extends out into Great Salt Lake in Utah. Driving by the lake one day, Smithson came across some abandoned mining equipment, left there by a company that had tried and failed to extract oil from the site. Smithson saw this as a testament to the enduring power of nature and to humankind's inability to conquer nature. He decided to create an artwork in the lake that ultimately became a monumental spiral curving out from the shoreline and running 1,500 linear feet into the water.

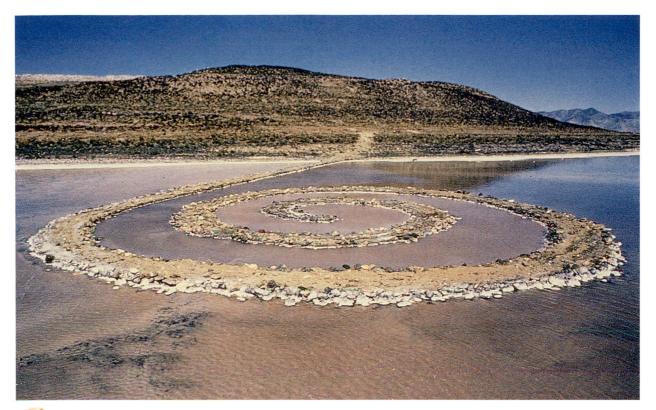

14-20 | ROBERT SMITHSON, *Spiral Jetty*, 1970. Black rock, salt crystals, earth, and red water (algae) at Great Salt Lake, Utah. $1,500' \times 15' \times 3\frac{1}{2}'$.

Smithson used industrial equipment to create Environmental artworks by manipulating earth and rock on isolated sites. *Spiral Jetty* is a mammoth coil of black basalt, limestone, and earth extending into the Great Salt Lake.

Smithson insisted on designing his work in response to the location itself. He wanted to avoid the arrogance of an artist merely imposing an unrelated concept on the site. The spiral idea grew from Smithson's first impression of the location: "As I looked at the site, it reverberated out to the horizons only to suggest an immobile cyclone while flickering light made the entire landscape appear to quake. A dormant earthquake spread into the fluttering stillness, into a spinning sensation without movement. The site was a rotary that enclosed itself in an immense roundness. From that gyrating space emerged the possibility of the Spiral Jetty." 12

The appropriateness of the spiral forms was reinforced when, while researching Great Salt Lake, Smithson discovered that the molecular structure of the salt crystals that coat the rocks at the water's edge is spiral in form. Smithson not only recorded *Spiral Jetty* in photographs but also filmed its construction in a movie that describes the forms and life of the whole site. The photographs and film have become increasingly important, because fluctuations in the Great Salt Lake's water level often place *Spiral Jetty* under water.

The Art of Wrapping Christo and Jeanne-Claude (both b. 1935), intensify the viewer's awareness of the space and features of rural and urban sites. However, rather than physically alter the land itself, as Smithson often did, Christo and Jeanne-Claude prompt this awareness by temporarily

modifying the landscape with cloth. Their pieces also incorporate the relationships among human sociopolitical action, art, and the environment. Christo studied art in his native Bulgaria and in Vienna. After a move to Paris, he began to encase objects in clumsy wrappings, thereby appropriating bits of the real world into the mysterious world of the unopened package whose contents can be dimly seen in silhouette under the wrap. Starting in 1961, Christo and Jeanne-Claude, husband and wife, began to collaborate on large-scale projects.

These projects normally deal with the environment itself. For example, in 1969 Christo and Jeanne-Claude wrapped more than a million square feet of Australian coast and in 1972 hung a vast curtain across a valley at Rifle Gap, Colorado. The land pieces required years of preparation, research, and scores of meetings with local authorities and interested groups of local citizens. The artists always consider the planning, the process of obtaining the numerous permits, and the visual documentation of each piece part of the artwork. These temporary works are usually on view for a few weeks.

Created for two weeks in May 1985, Surrounded Islands 1980–83, Biscayne Bay, Greater Miami, Florida (Fig. 14-21), typifies Christo and Jeanne-Claude's work. For this project, they surrounded 11 small human-made islands in the bay (from a dredging project) with specially fabricated pink polypropylene floating fabric. The project required three years of preparation to obtain the required permissions, to assemble

14-21 | CHRISTO and JEANNE-CLAUDE, Surrounded Islands 1980–83, Biscayne Bay, Greater Miami, Florida, 1980–1983. Pink woven polypropylene fabric, $6\frac{1}{2}$ million sq. ft.

Unlike Smithson (Fig. 14-20), Christo and Jeanne-Claude do not alter the land itself but modify it with cloth. In Biscayne Bay, they surrounded 11 small islands with pink polypropylene floating "skirts."

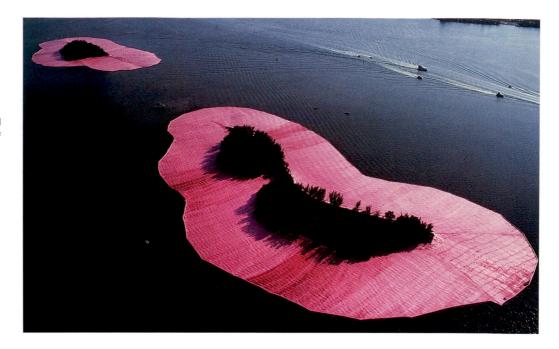

the necessary labor force of unskilled and professional workers, and to raise the \$3.2 million cost (accomplished by selling preparatory drawings, collages, models, and works of the 1950s and 1960s). Huge crowds watched as crews removed accumulated trash from the 11 islands (to assure maximum contrast between their dark colors, the pink of the cloth, and the blue of the bay) and then unfurled the fabric "cocoons" to form magical floating "skirts" around each tiny bit of land.

MODERNIST ARCHITECTURE

During the 20th century, not only painters and sculptors but also architects became increasingly concerned with a formalism that stressed simplicity. Modernist architects articulated this in

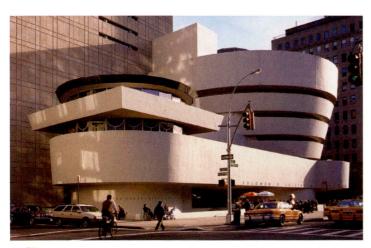

14-22 | FRANK LLOYD WRIGHT, Solomon R. Guggenheim Museum (exterior view from the north), New York, 1943–1959.

Using reinforced concrete almost as a sculptor might use resilient clay, Wright designed a snail shell-shaped museum with a winding interior ramp for the display of artworks along its gently inclined path.

buildings that retained intriguing organic sculptural qualities, as well as in buildings that adhered to a more rigid geometry.

Wright's Concrete Spiral Frank Lloyd Wright (see Chapter 13) ended his long, productive career with his design for the Solomon R. Guggenheim Museum (Fig. 14-22), built in New York City between 1943 and 1959. Using reinforced concrete almost as a sculptor might use resilient clay, Wright designed a structure inspired by the spiral of a snail's shell. The shape of the shell expands toward the top, and a winding interior ramp spirals to connect the gallery bays, which are illuminated by a skylight strip embedded in the museum's outer wall. Visitors can stroll up the ramp or take an elevator to the top of the building and proceed down the gently inclined walkway, viewing the artworks displayed along the path. Thick walls and the solid organic shape give the building, outside and inside, the sense of turning in on itself. Moreover, the long interior viewing area opening onto a 90-foot central well of space seems a sheltered environment, secure from the bustling city outside.

Sculptural Architecture The startling organic forms of Le Corbusier's Notre Dame du Haut (Fig. 14-23), completed in 1955 at Ronchamp, France, present a fusion of architecture and sculpture in a single expression. The architect designed this small chapel on a pilgrimage site in the Vosges Mountains to replace a building destroyed in World War II. The monumental impression of Notre Dame du Haut seen from afar is somewhat deceptive. Although one massive exterior wall contains a pulpit facing a spacious outdoor area for large-scale open-air services on holy days, the interior holds at most 200 people. The intimate scale, stark and heavy walls, and mysterious illumination (jewel tones cast from the deeply recessed stained-glass windows) give this space an aura reminiscent of a sacred cave or a medieval monastery.

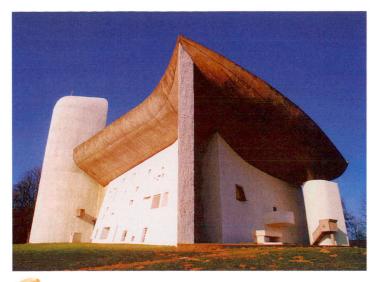

14-23 | Le Corbusier, Notre Dame du Haut, Ronchamp, France, 1950–1955.

The organic forms of Le Corbusier's chapel on a mountainous pilgrimage site at Ronchamp present a fusion of architecture and sculpture. The intimate and mysteriously lit interior has the aura of a sacred cave.

Notre Dame du Haut's structure may look free-form to the untrained eye, but Le Corbusier actually based it, like the medieval cathedral, on an underlying mathematical system. The fabric was formed from a frame of steel and metal mesh, which was sprayed with concrete and painted white, except for two interior private chapel niches with colored walls and the roof, left unpainted to darken naturally with the passage of time. The roof appears to float freely above the sanctuary, intensifying the quality of mystery in the interior space. In reality, the roof is elevated above the walls on a series of nearly invisible blocks. Le Corbusier's preliminary sketches for the building indicate that he linked the design with the shape of praying hands, with the wings of a dove (representing both peace and the Holy Spirit), and with the prow of a ship (a reminder that the Latin word used for the main gathering place in Christian churches is *nave*, meaning "ship"). The artist envisioned that in these powerful sculptural solids and voids, human beings could find new values—new interpretations of their sacred beliefs and of their natural environments.

Glass Towers From the mid-1950s through the 1970s, other architects created massive, sleek, and geometrically rigid buildings, which present pristine, authoritative faces to the public. The architects designed most of these structures following Mies van der Rohe's contention that "less is more" (see Chapter 13). Appropriately, such buildings, and the powerful presence they exude, symbolize the monolithic corporations often inhabiting them.

The "purest" example of these corporate skyscrapers is the rectilinear glass and bronze Seagram Building (Fig. 14-24) in Manhattan designed by Mies van der Rohe and American architect Philip Johnson (b. 1906). By the time this structure was built (1956–1958), concrete, steel, and glass towers,

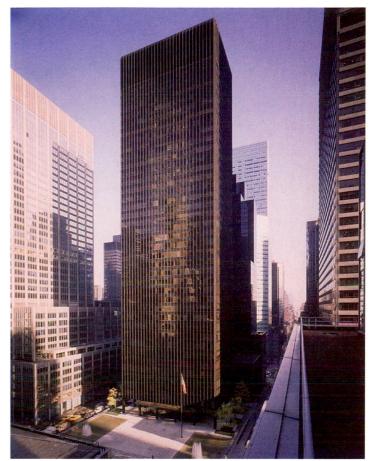

14-24 | Ludwig Mies van der Rohe and Philip Johnson, Seagram Building, New York, 1956–1958.

The concrete, steel, and glass skyscraper is a familiar sight in modern cities all over the world. These towering, heroic structures symbolize the powerful monolithic corporations often inhabiting them.

pioneered in the works of Louis Sullivan (Fig. 12-27) and in Mies van der Rohe's own model for glass skyscrapers (Fig. 13-28), had become a familiar sight in cities all over the world. Appealing in its structural logic and clarity, the style was easily imitated and quickly became the norm for postwar commercial high-rise buildings. The architects deliberately designed the Seagram building as a thin shaft, leaving the front quarter of its midtown site as an open pedestrian plaza. The tower appears to rise from the pavement on stilts. Glass walls even surround the recessed lobby. The building's recessed structural elements make it appear to have a glass skin, interrupted only by the thin strips of bronze anchoring the windows. The bronze strips and the amber glass windows give the tower a richness found in few of its neighbors.

POSTMODERN ARCHITECTURE

The impersonality and sterility of many modernist corporate towers led to a rejection of modernism's authority in architecture, ushering in what has come to be called *postmodernism*. Postmodernism is not a unified style. In contrast to the simplicity of modernist architecture, postmodern architecture is

complex, pluralistic, and eclectic. Where the modernist program was reductive, the postmodern vocabulary of the 1970s and 1980s was expansive and inclusive.

Among the first to explore this new direction in architecture were Jane Jacobs (b. 1916) and Robert Venturi. In their influential books *The Death and Life of Great American Cities* (Jacobs, 1961) and *Complexity and Contradiction in Architecture* (Venturi, 1966), both argued that the uniformity and anonymity of modernist architecture (in particular, the corporate skyscrapers dominating many urban skylines) are unsuited to human social interaction and that diversity is the great advantage of urban life. Postmodern architecture accepted, indeed embraced, the messy and chaotic nature of urban life.

Further, when designing these varied buildings, many postmodern architects consciously selected past architectural elements or references and juxtaposed them with contemporary elements or fashioned them of high-tech materials, thereby creating a dialogue between past and present. Postmodern architecture incorporated not only traditional architectural references but references to mass culture and popular imagery as well.

An "Enlarged Jukebox"? The Portland Building (Fig. 14-25), designed by American architect MICHAEL GRAVES

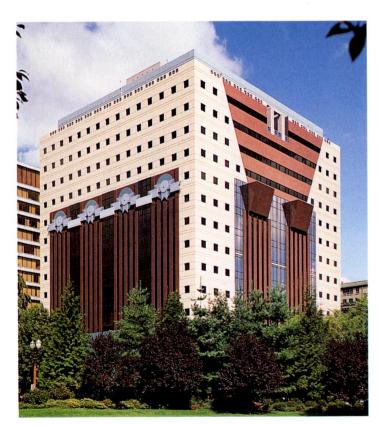

14-25 | MICHAEL GRAVES, Portland Building, Portland, Oregon, 1980.

In this early example of postmodern architecture, Graves reasserted the horizontality and solidity of the wall. He drew attention to the mural surfaces through polychromy and ornamental motifs.

(b. 1934), reasserts the wall's horizontality against the verticality of the tall, fenestrated shaft of modernist skyscrapers. Graves favored the square's solidity and stability, making it the main body of his composition (echoed in the windows), resting on a wider base and carrying a set-back penthouse crown. Narrow vertical windows tying together seven stories open two paired facades. These support capital-like large hoods on one pair of opposite facades and a frieze of stylized Baroque roundels tied by bands on the other pair. A huge painted keystone motif joins five upper levels on one facade pair, and painted surfaces further define the building's base, body, and penthouse levels.

The assertion of the wall, the miniature square windows, and the painted polychromy define the surfaces as predominantly mural and carry a rather complex symbolic program. The modernist purist surely would not welcome either ornamental wall, color painting, or symbolic reference. These features, taken together, raised a storm of criticism. Various critics denounced Graves's Portland Building as "an enlarged jukebox," an "oversized Christmas package," a "marzipan monstrosity," a "histrionic masquerade," and a kind of "pop surrealism." Yet others approvingly noted its classical references as constituting a "symbolic temple" and praised the building as a courageous architectural adventure. All agreed that the Portland Building was an early marker of postmodernist innovation.

Making "Metabolism" Visible In Paris, the short-lived partnership of British architect RICHARD ROGERS (b. 1933) and Italian architect RENZO PIANO (b. 1937) involved using motifs and techniques from ordinary industrial buildings in their design for the Georges Pompidou National Center of Art and Culture (Fig. 14-26), known popularly as the Beaubourg, in Paris. The anatomy of this six-level building is fully exposed, rather like an updated version of the Crystal Palace (Fig. 11-28). However, the architects also made visible the Pompidou Center's "metabolism." They color-coded pipes, ducts, tubes, and corridors according to function (red for the movement of people, green for water, blue for airconditioning, and yellow for electricity), much as in a sophisticated factory.

Critics who deplore the Beaubourg's vernacular qualities disparagingly refer to the complex as a "cultural supermarket" and point out that its exposed entrails require excessive maintenance to protect them from the elements. Nevertheless, the building has been popular with visitors since it opened in 1977. The flexible interior spaces and the colorful structural body provide a festive environment for the crowds flowing through the building enjoying its art galleries, industrial design center, library, science and music centers, conference rooms, research and archival facilities, movie theaters, rest areas, and restaurant (which looks down and through the building to the terraces outside). The sloping plaza in front of the main entrance has become part of the local scene. Peddlers, street performers, Parisians, and tourists fill this "square" at

14-26 | RICHARD ROGERS and RENZO PIANO, Georges Pompidou National Center of Art and Culture (the "Beaubourg"), Paris, France, 1977.

The anatomy of this six-level building is fully exposed, as in the centuryearlier Crystal Palace (Fig. 11-28). Inside, the parts are color-coded according to function, much as in a sophisticated factory.

almost all hours of the day and night. The kind of secular activity that once occurred in the open spaces in front of cathedral portals interestingly now takes place next to a center for culture and popular entertainment—perhaps today's most commonly shared experiences.

DECONSTRUCTIVIST ARCHITECTURE

In the later decades of the 20th century, art critics assumed a commanding role. Indeed, their categorization of movements and their interpretation and evaluation of monuments became a kind of monitoring, gatekeeping activity that determined, as well as described, what was going on in the art world. The voluminous and influential writing produced by these critics (along with artists and art historians) prompted scholars to examine the basic premises of criticism. This examination has generated a field of study known as critical theory. Critical theorists view art and architecture, as well as literature and the other humanities, as a culture's intellectual products or "constructs." These constructs unconsciously suppress or conceal the actual premises that inform the culture, primarily the values of those politically in control. Thus, cultural products function in an ideological capacity, obscuring, for example, racist or sexist attitudes. When revealed by analysis, the facts behind these constructs, according to critical theorists, contribute to a more substantial understanding of artworks, buildings, books, and the overall culture.

Deconstruction Many critical theorists use an analytical strategy called *deconstruction*, after a method developed by

French intellectuals, notably Michel Foucault and Jacques Derrida, in the 1960s and 1970s. For those employing deconstruction, all cultural constructs are "texts." Acknowledging the lack of fixed or uniform meanings in such texts, critical theorists accept a variety of interpretations as valid. Further, as cultural products, how texts signify and what they signify are entirely conventional. They can refer to nothing outside of themselves, only to other texts. Thus, no extratextual reality exists that people can reference. The enterprise of deconstruction is to reveal the contradictions and instabilities of these texts, or cultural language (written or visual).

With primarily political and social aims, deconstructive analysis has the ultimate goal of effecting political and social change. Accordingly, critical theorists who employ this approach seek to uncover, to deconstruct, the facts of power, privilege, and prejudice underlying the practices and institutions of any given culture. In so doing, deconstruction reveals the precariousness of structures and systems, such as language and cultural practices, along with the assumptions underlying them. Yet because of the lack of fixed meaning in texts, many politically committed thinkers assert that deconstruction does not provide a sufficiently stable basis for dissent.

Critical theorists are not unified about any philosophy or analytical method, because in principle they oppose firm definitions. They do share a healthy suspicion of all traditional truth claims and value standards, all hierarchical authority and institutions. For them, deconstruction means destabilizing established meanings, definitions, and interpretations while encouraging subjectivity and individual differences.

Destabilization and Disorientation In architecture, deconstruction as an analytical strategy emerged in the 1970s. Some scholars refer to this development as Deconstructivist architecture. It proposes, above all, to disorient the observer. To this end, Deconstructivist architects attempt to disrupt the conventional categories of architecture and to rupture the viewer's expectations based on them. Destabilization plays a major role in Deconstructivist architecture. Disorder, dissonance, imbalance, asymmetry, unconformity, and irregularity replace their opposites—order, consistency, balance, symmetry, regularity, and clarity, as well as harmony, continuity, and completeness. The haphazard presentation of volumes, masses, planes, borders, lighting, locations, directions, spatial relations, and disguised structural facts challenge assumptions about architectural form as it relates to function. According to Deconstructivist principles, the very absence of the stability of traditional categories of architecture in a structure announces a "deconstructed" building.

Disorder in Bilbao The architect with whom scholars perhaps have most identified Deconstructivist architecture is the Canadian-born FRANK GEHRY (b. 1929). Trained in sculpture, Gehry works up his designs by constructing models and then cutting them up and arranging them until he has a

14-27 | Frank Gehry, Guggenheim Bilbao Museo, Bilbao, Spain, 1997.

Gehry is the leading practitioner of Deconstructivist architecture. His limestone-and-titanium Bilbao museum is an immensely dramatic building that appears as a random mass of asymmetrical and imbalanced forms.

satisfying composition. His Guggenheim Museum (Fig. 14-27) in Bilbao, Spain, is an immensely dramatic building that appears as a mass of asymmetrical and imbalanced forms. The irregularity of the main masses—whose profiles change dramatically with every shift of a visitor's position—seems like a collapsed or collapsing aggregate of units. The scaled limestone- and titanium-clad exterior lends a space-age character to the building and highlights further the unique cluster effect of the many forms. A group of organic forms that Gehry refers to as a "metallic flower" tops the museum. Gehry was inspired to create the offbeat design by what he called the "surprising hardness" of the heavily industrialized city of Bilbao. His fascination with Fritz Lang's 1926 film Metropolis also contributed to this industrial severity. The film, now considered a classic by film historians, reveals a futuristic urban vision of a cold, mechanical industrial world in 2026. In the museum's center, an enormous glass-walled atrium soars to 165 feet in height, serving as the focal point for the three levels of galleries radiating from it. The seemingly weightless screens, vaults, and volumes of the interior float and flow into one another, guided only by light and dark cues. Overall, the Guggenheim at Bilbao is a profoundly compelling structure. Its disorder, its seeming randomness of design, and the disequilibrium it prompts in the visitor fit nicely into postmodern and deconstructivist agendas.

POSTMODERN PAINTING, SCULPTURE, AND PHOTOGRAPHY

Arriving at a concrete definition of postmodernism in other media is as difficult as it is in architecture. Historically, by the 1970s, the range of art—from abstraction to performance to figuration—was so broad that the inclusiveness central to postmodern architecture characterizes postmodern art as well. Just as postmodern architects incorporate traditional elements or historical references, many postmodern artists reveal a self-consciousness about their place in the art historical continuum. They resurrect artistic traditions to comment on and reinterpret those styles or idioms. Many people view postmodernism as a critique of modernism. For example, numerous postmodern artists have undertaken the task of challenging modernist principles, such as the avant-garde's claim to originality. In the avant-garde's zeal to undermine traditional notions about art and to produce ever more innovative art forms, they placed a premium on originality and creativity. Postmodern artists challenge this claim by addressing issues of the copy or reproduction (already explored by Pop artists) and the appropriation of images or ideas from others.

Some scholars, such as Frederic Jameson, assert that a major characteristic of postmodernism is the erosion of the boundaries between high culture and popular culture—a separation Clement Greenberg and the modernists had staunchly defended. With the appearance of Pop art, that separation became more difficult to maintain. Jameson argues that the intersection of high and mass culture is, in fact, a defining feature of the new postmodernism.

The intellectual inquiries of critical theorists serving as the basis for Deconstructivist architecture also impacted the other media. For many recent artists, postmodernism involves examining the process by which meaning is generated and the negotiation or dialogue that transpires between viewers and

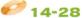

Anselm Kiefer, *Nigredo*, 1984. Oil paint on photosensitized fabric, acrylic emulsion, straw, shellac, and relief paint on paper pulled from painted wood, 11' × 18'. Philadelphia Museum of Art, Philadelphia (gift of Friends of the Philadelphia Museum of Art).

Kiefer's paintings have thickly encrusted surfaces, made more complex by the addition of materials such as straw. Here, the German artist used perspective to pull the viewer into an incinerated landscape alluding to the Holocaust.

artworks. Like the theorists using deconstructive methods to analyze "texts," or cultural products, many postmodern artists reject the notion that each artwork contains a single fixed meaning. Their work, in part, explores how viewers derive meaning from visual material.

Neo-Expressionism One of the first coherent movements to emerge during the postmodern era was *Neo-Expressionism*. This international movement's name reflects postmodern artists' interest in reexamining earlier art production and connects this art to the powerful, intense works of the German Expressionists and the Abstract Expressionists.

German artist Anselm Kiefer (b. 1945) has produced some of the most lyrical and engaging works of the contemporary period. His paintings, such as *Nigredo* (Fig. 14-28), are monumental in scale, but also draw attention to details of the textured surface. Kiefer's paintings have thickly encrusted surfaces, made more complex by the addition of materials such as straw and lead. It is not just the impressive physicality of Kiefer's paintings that accounts for the impact of his work. His images function on a mythological or metaphorical level, as well as on a historically specific one. Kiefer's works of the 1970s and 1980s often involve a reexamination of German history, particularly the painful Nazi era of 1920–1945, and evoke a feeling of despair. Kiefer believes that Germany's participation in World War II and the Holocaust left permanent scars on the souls of the German people and on the souls of all humanity.

Nigredo (a term used in alchemy, meaning "blackening") pulls the viewer into an expansive landscape depicted using Renaissance perspectival principles. This landscape, however, is far from pastoral or carefully cultivated. Rather, it appears bleak and charred. Although it does not make specific reference to the Holocaust, this incinerated landscape does indirectly allude to

the horrors of that historical event. More generally, the blackness of the landscape may refer to the notion of alchemical change or transformation, a concept of great interest to Kiefer. Black is one of the four symbolic colors of the alchemist—a color that refers both to death and to the molten, chaotic state of substances broken down by fire. The alchemist, however, focuses on the transformation of substances, and thus the emphasis on blackness is not absolute, but can also be perceived as part of a process of renewal and redemption. Kiefer thus imbued his work with a deep symbolic meaning that, when combined with the intriguing visual quality of his parched, congealed surfaces, results in paintings of enduring impact.

Art as Political Weapon With the renewed interest in representation ushered in by the Pop artists and Superrealists in the 1960s and 1970s, artists once again began to embrace the persuasive powers of art to communicate with a wide audience. In recent decades, artists have investigated more insistently the dynamics of power and privilege, especially in relation to issues of race, ethnicity, gender, and class. Some of the art produced in the 1980s and 1990s has unleashed strong passions and even prompted indignant demands for cancellations of exhibitions (see "Contesting Culture: Controversies in Art," page 426).

A Feminist Dinner Party In the 1970s, the feminist movement focused public attention on the history of women and their place in society. JUDY CHICAGO (born Judy Cohen in 1939) cofounded the Feminist Art Program and sought to educate the public about women's role in history and the fine arts. She aimed to establish a respect for women and their art, to forge a new kind of art expressing women's experiences, and to find a way to make that art accessible to a large

Contesting Culture

Controversies in Art

Although there is much in art that inspires and moves us, beauty and uplift are not art's only raison d'être. Throughout its history, art has also challenged and offended. In recent years, a number of heated controversies about art have surfaced in the United States. That attempts were made in each of these controversies to remove the offending works from public view brought charges of censorship. Ultimately, the question has been raised time and again: Are there limits to what art can appropriately be exhibited, and do authorities (for example, the federal government) have the right to monitor and pass judgment on creative endeavors? Further, should the acceptability of art be a criterion in determining the federal funding of art?

Two exhibits in 1989 placed the National Endowment for the Arts (NEA), a federal agency charged with supporting the arts (particularly through the distribution of federal funds) squarely on the hot seat. One of the exhibitions, which was devoted to recipients of the Awards for the Visual Arts (AVA), was held at the Southeastern Center for Contemporary Art in North Carolina. Among the award winners was Andres Serrano, whose Piss Christ, a photograph of a crucifix submerged in urine, sparked an uproar. Responding to this artwork, Reverend Donald Wildmon, an evangelical minister from Mississippi and head of the American Family Association, was outraged both that such a work was being exhibited and that the exhibition was funded by the NEA and the Equitable Life Assurance Society (a sponsor of the AVA). He demanded that the work be removed and launched a letter-writing campaign that led Equitable Life to cancel its sponsorship of the awards. To Wildmon and other staunch conservatives, this exhibition, along with the Robert Mapplethorpe: The Perfect Moment show, served as evidence of cultural depravity and immorality, which they insisted should not be funded by government agencies, such as the NEA. Mapplethorpe was a photographer well known for his elegant, spare photographs of flowers and vegetables as well as his erotic, homosexually oriented images. As a result of media furor over The Perfect Moment, the director of the Corcoran Museum of Art decided to cancel the

scheduled exhibition of this traveling show. The real showdown, however, came in Cincinnati, where the director of the Contemporary Arts Center decided to mount the show and was indicted on charges of obscenity. (He and the Center were acquitted six months later.)

These controversies intensified public criticism of the NEA and its funding practices. The following year, in 1990, the head of the NEA, John Frohnmayer, vetoed grants for four lesbian, gay, and feminist performance artists — Karen Finley, John Fleck, Holly Hughes, and Tim Miller — who became known as the "NEA Four." Infuriated by what they perceived as overt censorship, the artists filed suit, eventually settling the case and winning reinstatement of their grants. As a result of these incidents, however, the funding and future of the NEA have become more precarious. Its budget has been dramatically reduced by Congress, and it no longer awards grants or fellowships to individual artists.

In more recent years, controversies have continued to surface. In 1999, a furor erupted over the exhibition *Sensation: Young British Artists from the Saatchi Collection*. Led by Rudolph Giuliani, the mayor of New York at that time, a number of individuals and groups expressed their outrage over some of the included artworks, especially Chris Ofili's *The Holy Virgin Mary*, a collage of Mary incorporating cutouts from pornographic magazines and shellacked clumps of elephant dung. Denouncing the show as "sick stuff," the mayor threatened to cut off all city subsidies to the Brooklyn Museum, where *Sensation* was on view. Such oratory polarized the community and no doubt fueled interest in the show (and Ofili's work in particular).

Art that seeks to unsettle and challenge is critical to the cultural, political, and psychological life of a nation. The regularity with which such art raises controversy reflects the competition between those who defend free speech and free artistic expression and those who are reluctant to impose images on an audience that finds them repugnant or offensive. What these controversies do demonstrate, beyond doubt, is the impact and power of art.

audience. Chicago developed a personal painting style that consciously included abstract organic vaginal images. In the early 1970s, she began planning an ambitious piece, The Dinner Party (Fig. 14-29), using craft techniques (such as china painting and stitchery) traditionally practiced by women, to celebrate the achievements and contributions women made throughout history. She originally conceived the work as a feminist Last Supper attended by 13 women (the "honored guests"). The number 13 also refers to the number of women in a witches' coven. This acknowledges a religion (witchcraft) founded to encourage the worship of a female—the Mother Goddess. In the course of her research, Chicago uncovered so many worthy women that she expanded the number of guests threefold to 39 and placed them around a triangular table 48 feet long on each side. The triangular form refers to the ancient symbol for both woman and the Goddess. The notion of a dinner party also alludes to women's traditional role as homemakers. A team of nearly 400 workers under Chicago's supervision assisted in the creation and assembly of the artwork to her design specifications.

The Dinner Party rests on a white tile floor inscribed with the names of 999 additional women of achievement to signify that the accomplishments of the 39 honored guests rest on a foundation other women laid. Among the "invited" women at the table are Georgia O'Keeffe (Fig. Intro-3), the Egyptian pharaoh Hatshepsut (Fig. 1-29), the British writer Virginia Woolf, the Native American guide Sacajawea, and the American suffragist Susan B. Anthony. Chicago acknowledged each guest with a place setting of identical eating utensils and a goblet. Each also has a unique oversized porcelain plate and a long place mat or table runner filled with imagery that reflects significant facts about her life and culture. The plates range from simple concave shapes with china-painted imagery to dishes whose sculptured three-dimensional designs almost seem to struggle to free themselves. The unique designs on each plate incorporate both butterfly and vulval motifs—the butterfly as the ancient symbol of liberation and the vulva as the symbol of female sexuality. Each table runner combines traditional needlework techniques, including needlepoint, embroidery, crochet, beading, patchwork, and appliqué.

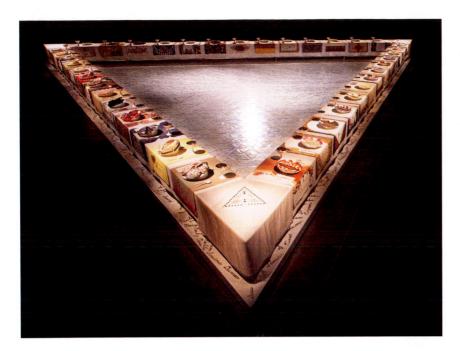

14-29 | JUDY CHICAGO, *The Dinner Party*, 1979. Multimedia, including ceramics and stitchery, 48' along each side of triangular installation.

Chicago's *Dinner Party* honors 39 women from antiquity to 20th-century America. The triangular form and the materials she chose—painted china and fabric—are traditionally associated with women.

Challenging the "Male Gaze" Early attempts at dealing with feminist issues in art tended toward essentialism, emphasizing universal differences—either biological or experiential-between women and men. More recent discussions have gravitated toward the notion of gender as a socially constructed concept, and an extremely unstable one at that. Identity is multifaceted and changeable, making the discussion of feminist issues more challenging. Consideration of the many variables, however, results in a more complex understanding of gender roles. In her work, American artist CINDY SHERMAN (b. 1954) addresses the way that much of Western art has been constructed to present female beauty for the enjoyment of the "male gaze," a primary focus of contemporary feminist theory. She produced a series of more than 80 black-andwhite photographs titled Untitled Film Stills, which she began in 1977. Sherman considered how representation constructs reality, and this led her to rethink how her own image was conveyed. She got the idea for the Untitled Film Stills series when she was shown some soft-core pornography magazines and was struck by the stereotypical ways they depicted women. Sherman decided to produce her own series of photographs, designing, acting in, directing, and photographing the works. In so doing, she took control of her own image and constructed her own identity. In works from the series, such as Untitled: Film Still #35 (Fig. 14-30), Sherman appears, often in costume and wig, in a photograph that seems to be a film still. Most of the images in this series recall popular film genres but are sufficiently generic so that the viewer cannot relate them to specific movies. Sherman often reveals the constructed nature of these images with the shutter release cable she holds in her hand to take the pictures. (The cord runs across the floor in our example.) Although she is still the object of the viewer's gaze in these images, the identity is one she has chosen to assume.

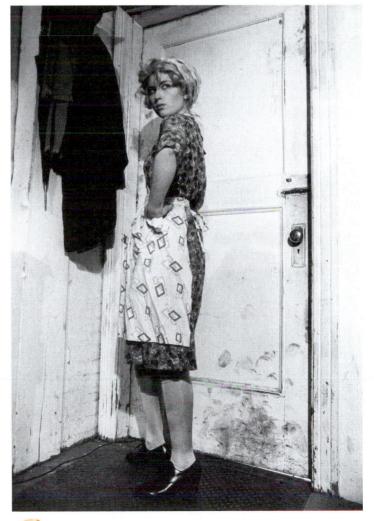

14-30 | CINDY SHERMAN, Untitled Film Still #35, 1979. Gelatin silverprint, 10" × 8".

Sherman here assumes a role and poses for one of a series of 80 photographs resembling film stills in which she addresses the way women have been presented in Western art for the enjoyment of the "male gaze."

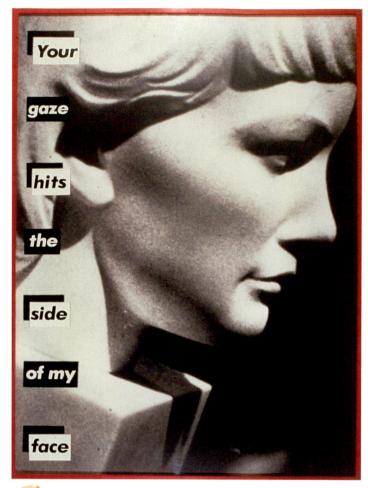

14-31 | BARBARA KRUGER, *Untitled (Your Gaze Hits the Side of My Face)*, 1981. Photograph and red painted frame, 4' 7" × 3' 5". Courtesy Mary Boone Gallery, New York.

Kruger, like Sherman, has explored the male gaze in her art. Using the layout techniques of mass media, she constructed this huge word-and-photograph collage to challenge culturally constructed notions of gender.

Text and Image Another artist who has also explored the male gaze and the culturally constructed notion of gender in her art is BARBARA KRUGER (b. 1945), whose best-known subject has been her exploration of the strategies and techniques of contemporary mass media. Kruger created pieces that drew on her early training and work as a graphic designer for the magazine Mademoiselle. Mature works such as Untitled (Your Gaze Hits the Side of My Face; Fig. 14-31) incorporate layout techniques the mass media use to sell consumer goods. Although Kruger favored the reassuringly familiar format and look of advertising, her goal was to subvert the typical use of such imagery. Rather, she aimed to expose the deceptiveness of the media messages the viewer complacently absorbs. Kruger wanted to undermine the myths—particularly those about women—the media constantly reinforce. Her huge word-andphotograph collages (often 4 × 6 feet in size) challenge the cultural attitudes embedded in commercial advertising.

In our example, Kruger overlaid a ready-made photograph of the head of a classically beautiful female sculpture with a vertical row of text composed of eight words selected by the artist. They cannot be taken in with a single glance. Reading them is a staccato exercise, with an overlaid cumulative quality that delays understanding and intensifies the meaning (rather like reading a series of roadside billboards from a speeding car). Kruger's use of text in her work is significant. Many cultural theorists have asserted that language is one of the most powerful vehicles for internalizing stereotypes and conditioned roles.

Guerrilla Art The New York-based GUERRILLA GIRLS, formed in 1984, bill themselves as the "conscience of the art world." This group sees it as its duty to call attention to injustice in the art world, especially what it perceives as the sexist and racist orientation of the major institutions. The women who are members of the Guerrilla Girls remain anonymous at all times and protect their identities by wearing gorilla masks in public. They employ guerrilla tactics (hence their name) by demonstrating in public, putting on performances, and placing posters and fliers in public locations. This distribution network expands the impact of their messages. One poster that reflects the Guerrilla Girls' agenda facetiously lists "the advantages of being a woman artist" (Fig. 14-32). Actually, the list itemizes for readers the numerous obstacles women artists face in the contemporary art world. The Guerrilla Girls hope their publicizing of these obstacles will inspire improvements in the situation for women artists.

Both Personal and Political FAITH RINGGOLD (b. 1930) uses her art to explore issues associated with being an African American woman in contemporary America. Inspired by the civil rights movement, Ringgold produced numerous works in the 1960s that provided pointed and incisive commentary on the realities of racial prejudice. She increasingly incorporated references to gender as well and, in the 1970s, turned to fabric

THE ADVANTAGES OF BEING A WOMAN ARTIST:

Working without the pressure of success.

Not having to be in shows with men.

Having an escape from the art world in your 4 free-lance jobs.

Knowing your career might pick up after you're eighty.

Being reassured that whatever kind of art you make it will be labeled feminine.

Not being stuck in a tenured teaching position.

Seeing your ideas live on in the work of others.

Having the opportunity to choose between career and motherhood.

Not having to choke on those big cigars or paint in Italian suits.

Having more time to work when your mate dumps you for someone younger.

Being included in revised versions of art history.

Not having to undergo the embarrassment of being called a genius.

Getting your picture in the art magazines wearing a gorilla suit.

14-32 | GUERRILLA GIRLS, *The Advantages of Being a Woman Artist*, 1988. Poster. Courtesy Guerrilla Girls.

The anonymous Guerrilla Girls wear gorilla masks in public performances and produce posters like this one in which they call attention to injustice in the art world, especially what they perceive as sexism and racism.

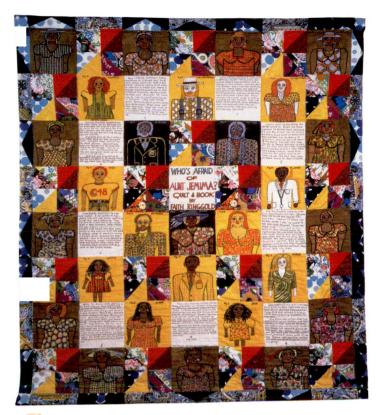

14-33 | FAITH RINGGOLD, Who's Afraid of Aunt Jemima? 1983. Acrylic on canvas with fabric borders, quilted, 7' 6" × 6' 8". Private collection.

In this quilt, a medium traditionally associated with women, Ringgold presented a tribute to her mother that also speaks to the larger issues of African American culture and the struggles of women to overcome oppression.

as the predominant material in her art. Using fabric allowed her to make more specific reference to the domestic sphere, traditionally associated with women, and to collaborate with her mother, Willi Posey, a fashion designer. After her mother's death in 1981, Ringgold created *Who's Afraid of Aunt Jemima?* (Fig. 14-33), a quilt composed of dyed, painted, and pieced fabric. A moving tribute to her mother, this work combines the personal and the political. The quilt includes a narrative—the witty story of the family of Aunt Jemima, most familiar as the stereotypical black "mammy" but here a successful African American businesswoman. Ringgold conveyed this narrative through both a text, written in black dialect, and embroidered portraits, all interspersed with traditional patterned squares. This work, while resonating with personal, autobiographical references, also speaks to the larger issues of the history of African American culture and the struggles of women to overcome oppression.

Trading with the White Man Exploring the politics of identity has been an important activity for people from many different walks of life. JAUNE QUICK-TO-SEE SMITH (b. 1940) is a Native American artist descended from the Shoshone, the Salish, and the Cree tribes and raised on the Flatrock Reservation in Montana. Quick-to-See Smith's native heritage has always informed her art, and her concern for the invisibility of Native American artists has led her to organize exhibitions of their art. Yet she has acknowledged a wide range of influences in her work, including "pictogram forms from Europe, the Amur [the river between Russia and China], the Americas; color from beadwork, parfleches [hide cases], the landscape; paint application from Cobra art, New York expressionism, primitive art; composition from Kandinsky, Klee or Byzantine art." 13

Despite the myriad references and visual material in Quick-to-See Smith's art, her work retains a coherence and power, and, like many other artists who have explored issues associated with identity, she challenges stereotypes and unacknowledged assumptions. *Trade* (*Gifts for Trading Land with White People*; Fig. 14-34) is a large-scale painting with collage elements and

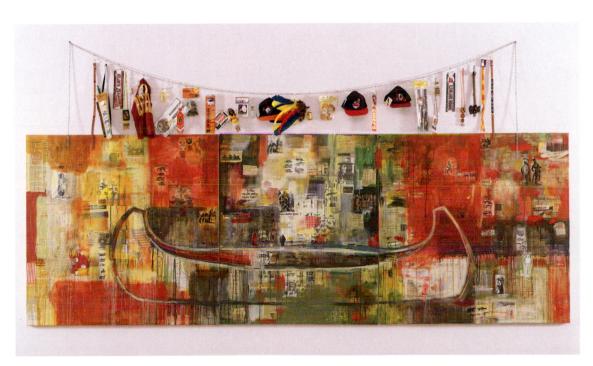

QUICK-TO-SEE SMITH, *Trade* (Gifts for Trading Land with White People), 1992. Oil and mixed media on canvas, 5' × 14' 2". Chrysler Museum of Art, Norfolk.

Quick-to-See Smith's mixed media canvases are full of references to her Native American identity. Some of the elements in this work refer to the controversy surrounding sports teams with American Indian names. attached objects, reminiscent of a Rauschenberg combine (Fig. 14-16). The painting's central image, a canoe, appears in an expansive field painted in loose Abstract Expressionist fashion and covered with clippings from Native American newspapers. Above the painting, as if hung from a clothesline, is an array of objects. These include Native American artifacts, such as beaded belts and feather headdresses, and contemporary sports memorabilia from teams with American Indian–derived names—the Cleveland Indians, Atlanta Braves, and Washington Redskins. The inclusion of these contemporary objects immediately recalls the vocal opposition to such names and to acts such as the Braves' "tomahawk chop." Quick-to-See Smith uses the past—cultural heritage and historical references—to comment on the present.

Fabric and the Soul The stoic, everyday toughness of the human spirit has been the subject of figurative works by the Polish fiber artist MAGDALENA ABAKANOWICZ (b. 1930). A leader in the recent exploration in sculpture of the expressive powers of weaving techniques, Abakanowicz gained fame with experimental freestanding pieces in both abstract and figurative

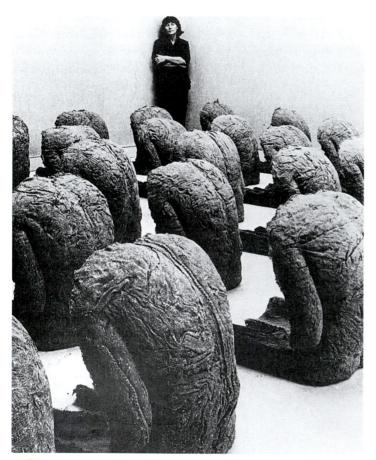

14-35 | MAGDALENA ABAKANOWICZ, artist with *Backs*, at the Musée d'Art Moderne de la Ville de Paris, Paris, 1982.

Polish fiber artist Abakanowicz explored the stoic, everyday toughness of the human spirit in this group of nearly identical sculptures that serve as symbols of distinctive individuals lost in the crowd.

modes. For Abakanowicz, fiber materials are deeply symbolic: "I see fiber as the basic element constructing the organic world on our planet, as the greatest mystery of our environment. It is from fiber that all living organisms are built—the tissues of plants and ourselves. . . . Fabric is our covering and our attire. Made with our hands, it is a record of our souls." ¹⁴

To all of her work, Abakanowicz brought the experiences of her early life as a member of an aristocratic family disturbed by the dislocations of World War II and its aftermath. She is best known for her works based on human forms, in which each work is multiplied for exhibition in groups as symbols for the individual in society, lost in the crowd yet retaining some distinctiveness. This impression is especially powerful in Backs (Fig. 14-35). Abakanowicz made each piece by pressing layers of natural organic fibers into a plaster mold. Every sculpture depicts the slumping shoulders, back, and arms of a figure of indeterminate sex and rests legless directly on the floor. The repeated pose of the figures in Backs suggests meditation, submission, and anticipation. Although made from a single mold, the figures achieve a touching sense of individuality because each assumed a slightly different posture as the material dried and because the artist imprinted a different pattern of fiber texture on each.

Commodity Culture In keeping with Fredric Jameson's evaluation of postmodern culture as inextricably linked to consumer society and mass culture, several postmodern artists have delved into the issues associated with commodity culture. American JEFF KOONS (b. 1955) first became prominent in the art world for a series of works in the early 1980s that involved exhibiting common purchased objects such as vacuum cleaners. Clearly following in the footsteps of artists such as Marcel Duchamp and Andy Warhol, Koons made no attempt to manipulate or alter the objects. More recently, Koons has produced porcelain sculptures, such as Pink Panther (Fig. 14-36). Here, Koons continued his immersion into contemporary mass culture by intertwining a magazine centerfold nude with a well-known cartoon character. He reinforced the trite and kitschy nature of this imagery by titling the exhibition of which this work was a part The Banality Show. Some art critics have argued that Koons and his work instruct viewers because both artist and work serve as the most visible symbols of everything wrong with contemporary American society. Whether or not this is true, people must acknowledge that, at the very least, Koons's prominence in the art world indicates that he, like Warhol before him, developed an acute understanding of the dynamics of consumer culture.

NEW MEDIA

Initially, video was available only in commercial television studios and generally not accessible to artists. In the 1960s, with the development of relatively inexpensive portable video recording equipment and of electronic devices allowing manipulation of the recorded video material, artists began to explore in

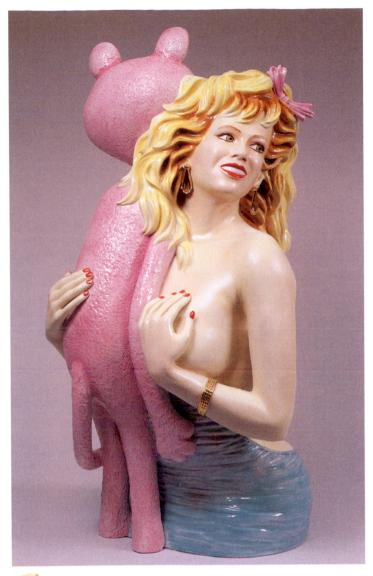

14-36 | JEFF KOONS, *Pink Panther*, 1988. Porcelain, $3' 5'' \times 1' 8_{\overline{2}}'' \times 1' 7''$. Museum of Contemporary Art, Chicago (Gerald S. Elliot Collection).

Koons is one of several postmodern artists who have addressed American consumer culture. In this porcelain sculpture, exhibited in *The Banality Show*, he intertwined a magazine centerfold and a cartoon character.

earnest the expressive possibilities of this new medium. In its basic form, video technology involves a special motion-picture camera that captures visible images and translates them into electronic data that can be displayed on a video monitor or television screen. Video pictures resemble photographs in the amount of detail they contain, but, like computer graphics, a video image is displayed as a series of points of light on a grid, giving the impression of soft focus. Viewers looking at television or video art are not aware of the monitor's surface. Instead, fulfilling the Renaissance ideal, they concentrate on the image and look through the glass surface, as through a window, into the "space" beyond. Video images combine the optical realism of photography with the sense that the subjects move in real time in a deep space "inside" the monitor.

Physical Music When video introduced the possibility of manipulating subjects in real time, artists such as the Koreanborn, New York-based videographer NAM JUNE PAIK (b. 1932) were eager to work with the medium. After studying music performance, art history, and Eastern philosophy in Korea and Japan, Paik worked with electronic music in Germany in the late 1950s. He then turned to performances using modified television sets. In 1965, after relocating to New York City, Paik acquired the first inexpensive video recorder sold in Manhattan (the Sony Porta-Pak) and immediately recorded everything he saw out the window of his taxi on the return trip to his studio downtown. Experience acquired as artist-in-residence at television stations WGBH in Boston and WNET in New York allowed him to experiment with the most advanced broadcast video technology.

A grant permitted Paik to collaborate with the gifted Japanese engineer-inventor Shuya Abe in developing a video synthesizer. This instrument allows artists to manipulate and change the electronic video information in various ways, causing images or parts of images to stretch, shrink, change color, or break up. With the synthesizer, artists also can layer images, inset one image into another, or merge images from various cameras with those from video recorders to make a single visual kaleidoscopic "time-collage." This kind of compositional freedom permitted Paik to combine his interests in music, painting, Eastern philosophy, global politics for survival, humanized technology, and cybernetics. Paik called his video works "physical music" and said that his musical background enabled him to understand time better than video artists trained in painting or sculpture.

Paik's best-known video work, Global Groove (Fig. 14-37), combines in quick succession fragmented sequences of female

14-37 | NAM JUNE PAIK, video still from *Global Groove*, 1973. $\frac{3\pi}{4}$ videotape, color, sound, 30 minutes. Collection of the artist.

Korean-born video artist Paik's best-known work is a cascade of fragmented sequences of performances and commercials intended as a sample of the rich worldwide television menu of the future.

tap dancers, poet Allen Ginsberg reading his work, a performance of cellist Charlotte Moorman using a man's back as her instrument, Pepsi commercials from Japanese television, Korean drummers, and a shot of the Living Theatre group performing a controversial piece called *Paradise Now*. Commissioned originally for broadcast over the United Nations satellite, the cascade of imagery in *Global Groove* was intended to give viewers a glimpse of the rich worldwide television menu Paik had predicted would be available in the future.

Digital Sensory Experience BILL VIOLA (b. 1951) has spent much of his artistic career exploring the capabilities of digitized imagery, producing many video *installations* (artworks creating an artistic environment in a room or gallery). Often focusing on sensory perception, the pieces not only heighten viewer awareness of the senses but also suggest an exploration into the spiritual realm. Viola, an American, spent years seriously studying Buddhist, Christian, Sufi, and Zen mysticism. Because he fervently believes in art's transformative power and in a spiritual view of human nature, Viola designs works encouraging spectator introspection. His recent video projects involve such techniques as extreme slow motion, contrasts in scale, shifts in focus, mirrored reflections, staccato editing, and multiple or layered screens to achieve dramatic effects.

The power of Viola's work is evident in The Crossing (Fig. 14-38), an installation piece involving two color video channels projected on 16-foot-high screens. The artist either shows the two projections on the front and back of the same screen or on two separate screens in the same installation. In these two companion videos, shown simultaneously on the two screens, a man surrounded in darkness appears, moving closer until he fills the screen. On one screen, drops of water fall from above onto the man's head; on the other screen, a small fire breaks out at the man's feet. Over the next few minutes, the water and fire increase in intensity until the man disappears in a torrent of water on one screen, and flames consume the man on the other screen. The deafening roar of a raging fire and a torrential downpour accompanies these visual images. Eventually, everything subsides and fades into darkness. This installation's elemental nature and its presentation in a dark space immerse viewers in a pure sensory experience very much rooted in tangible reality.

CONCLUSION

In the years following World War II, modernist artists, especially the Abstract Expressionists and Minimalists, focused on visual elements rather than subject matter in their works. In the later 20th century, the domination of modernist formalism in art gave way to an eclectic postmodernism. The emergence of postmodern thought not only encouraged a wider range of styles and approaches but also prompted commentary (often ironic) about the nature of art production and

14-38 | BILL VIOLA, *The Crossing*, 1996. Video/ sound installation with two channels of color video projection onto screens 16'-high.

Viola's video projects use extreme slow motion, contrasts in scale, shifts in focus, mirrored reflections, and staccato editing to create dramatic sensory experiences rooted in tangible reality.

dissemination. In recent decades, many artists have produced works prompted by sociopolitical concerns, dealing with aspects of race, gender, class, and other facets of identity.

What will the 21st century bring? Will a similarly fertile period in art and culture arise as the new century progresses? It is, of course, impossible to predict anything with any certainty. But the universally expanding presence of computers, digital technology, and the Internet will surely have an effect on the art world. Indeed, as we move into the new millennium, it seems that one of the major trends is a relaxation of the traditional boundaries between artistic media. New technologies may well erode remaining conceptual and geographical boundaries and make art and information about art available to virtually everyone, thereby creating a truly global artistic community.

1945

- United Nations organized, 1945
- I Atomic bombs devastate Hiroshima and Nagasaki, 1945
- Independence of India and Pakistan, 1947
- I State of Israel created, 1948
- People's Republic of China established, 1949

1950

- Korean conflict, 1950-1953
 - I Sputnik I launched, 1957
 - Computer chip invented, 1959

Jackson Pollock, Number 1, 1950 (Lavender Mist), 1950

1960

- I First manned space flight, 1961
- John F. Kennedy assassinated, 1963
 - Martin Luther King and Robert Kennedy assassinated, 1968
 - Moon landing, 1969

Roy Lichtenstein, Hopeless, 1963

1970

- War in Vietnam ends, 1975
- Personal computers introduced, 1978
- I Islamic Revolution in Iran, 1978-1979

3

1980

- I Opening of Berlin Wall and collapse of Soviet Union, 1989
- I Tiananmen Square massacre, 1989

3 Judy Chicago, The Dinner Party, 1979

1990

■ Breakup of Yugoslavia, 1990s

Frank Gehry, Guggenheim Bilbao Museo,

2000

4

I Terrorist attacks on New York City and Washington, D.C., 2001

HOW TO USE THE MAPS IN

GARDNER'S ART THROUGH THE AGES: A CONCISE HISTORY OF WESTERN ART

All the sites discussed in the text appear in the following maps.

These maps will enable you easily to locate where artworks were created and to visualize the relationships of cities, countries, and regions discussed in the text. The maps vary widely in both geographical and chronological scope. Some focus on a small region, while others encompass a vast territory and occasionally bridge two or more continents. Several plot the art-producing sites of a given area over hundreds, even thousands, of years. In every instance, our aim is to provide maps that will allow you to locate quickly the places where works of art originated or were found and where buildings were erected. To this end we have regularly placed the names of modern nations on maps of the territories of past civilizations.

These maps can also be found on the ArtStudy 2.1 CD-ROM. Use the interactive maps with dragand-drop exercises and commentary to test your knowledge.

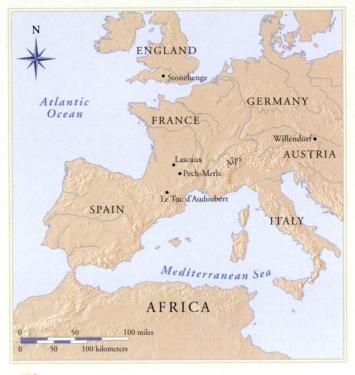

MAP 1-1 | Prehistoric Europe

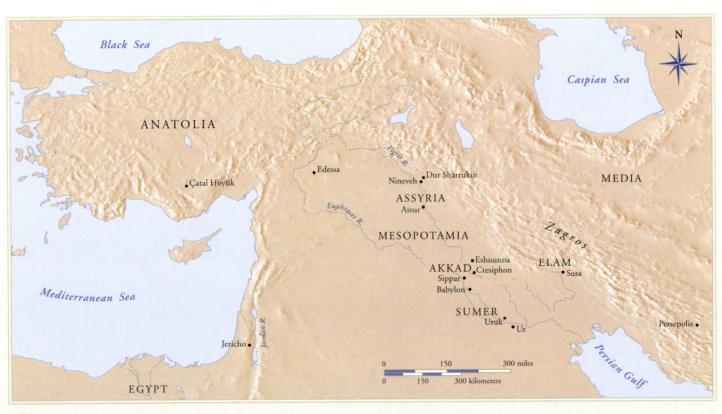

MAP 1-2 | The Ancient Near East

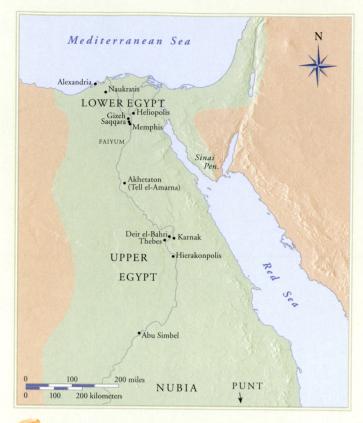

MAP 1-3 | Egypt during the New Kingdom

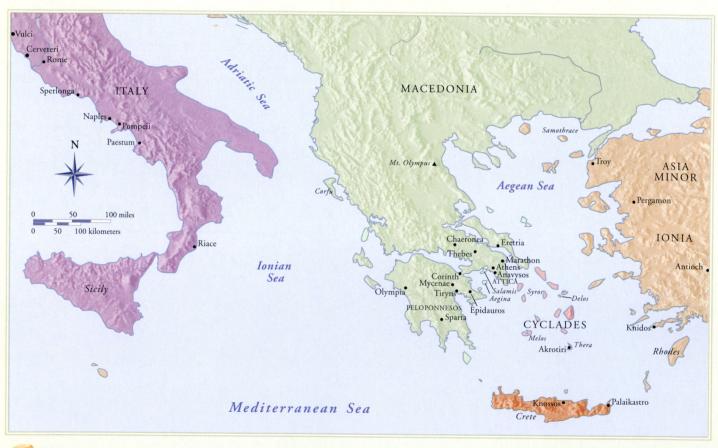

MAP 2-1 | The Greek World

MAP 3-1 | The Roman Empire

MAP 4-1 | Europe and the Byzantine Empire ca. 1000

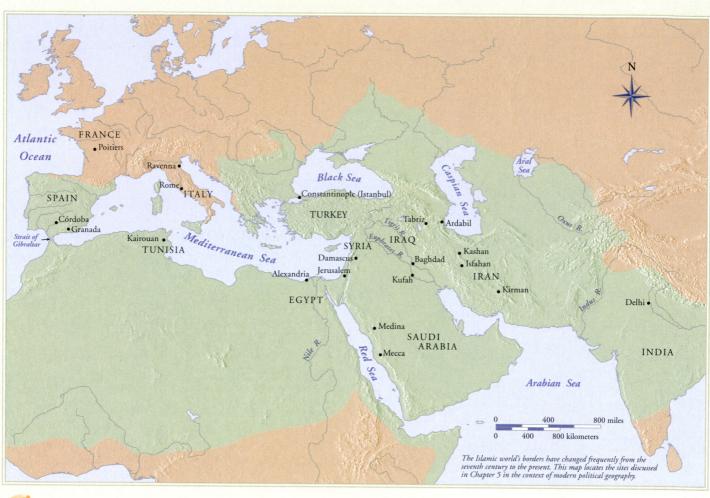

MAP 5-1 | The Islamic World

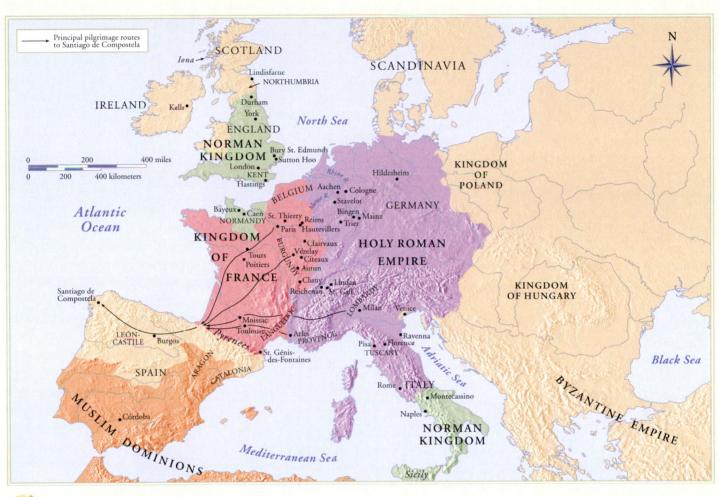

MAP 6-1 | Europe about 1100

MAP 7-1 | Europe about 1200

MAP 8-1 | 15th-Century Northern Europe

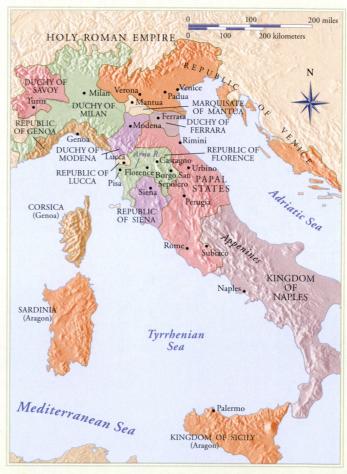

MAP 8-2 | Italy around 1400

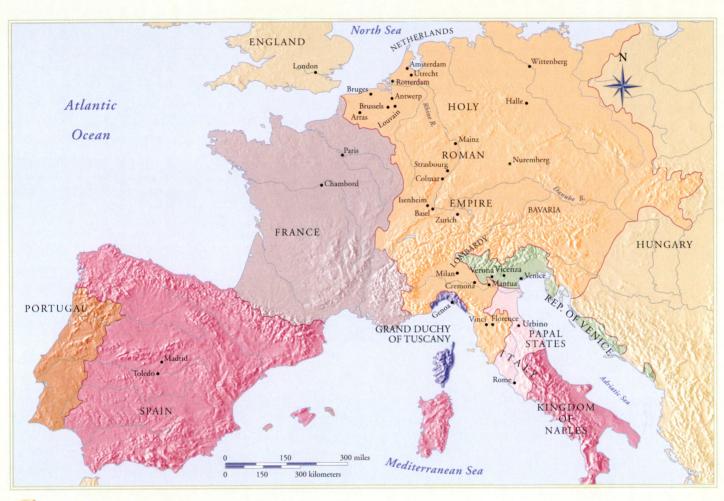

MAP 9-1 | Western Europe in the 16th Century

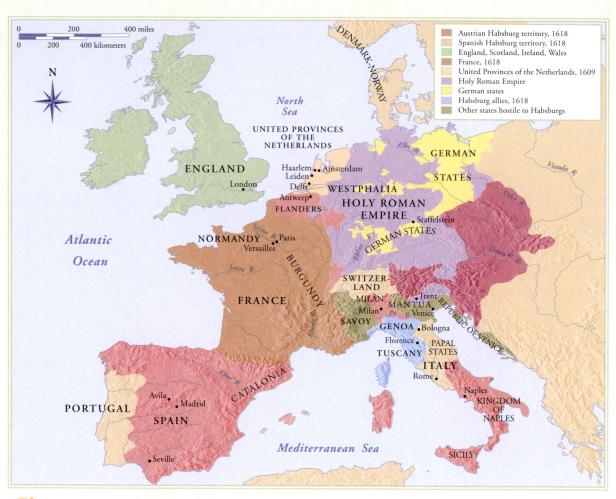

MAP 10-1 | Early 17th-Century Europe

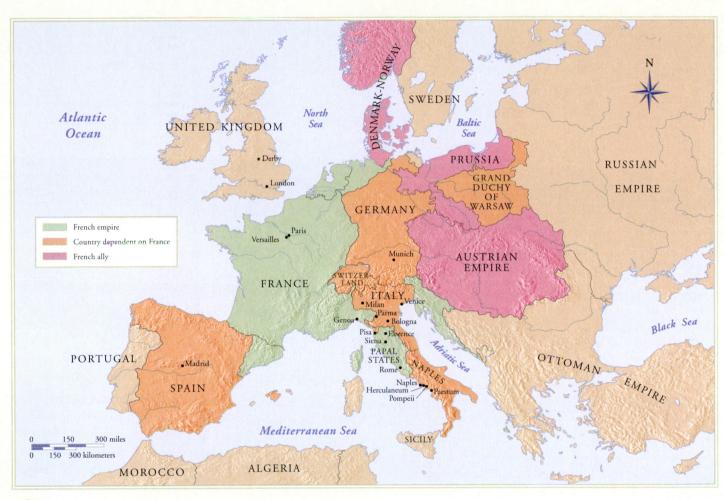

MAP 11-1 | Napoleonic Europe, 1800–1815

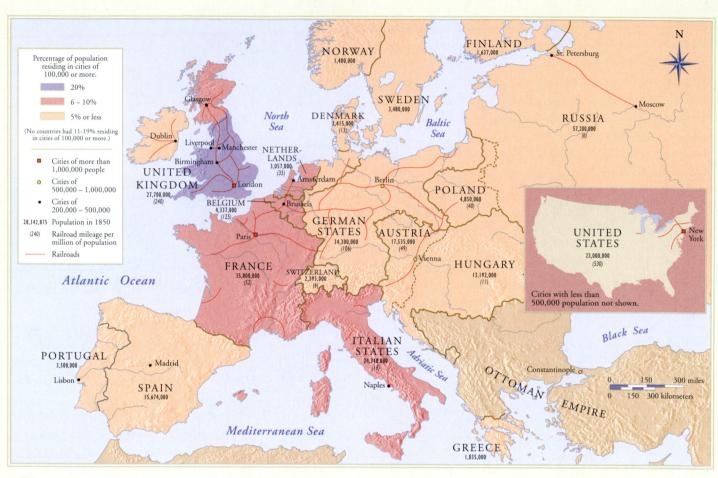

MAP 12-1 | Industrialization of Europe and the United States about 1850

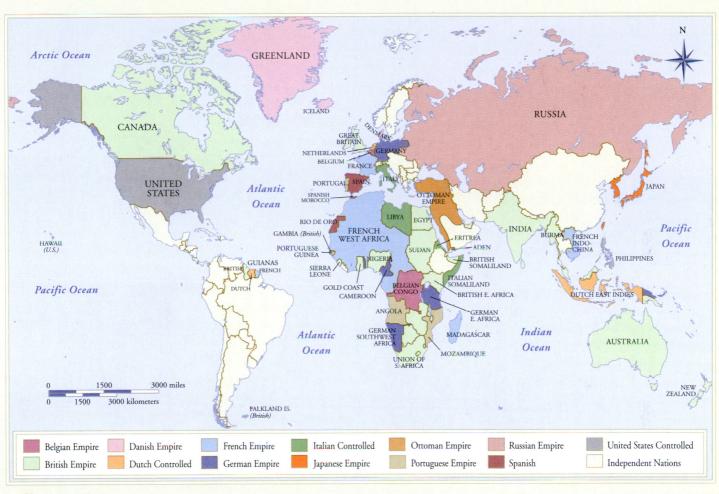

MAP 13-1 | Colonial Empires about 1900

0

MAP 14-1 | Europe, Asia, and Africa in 1945

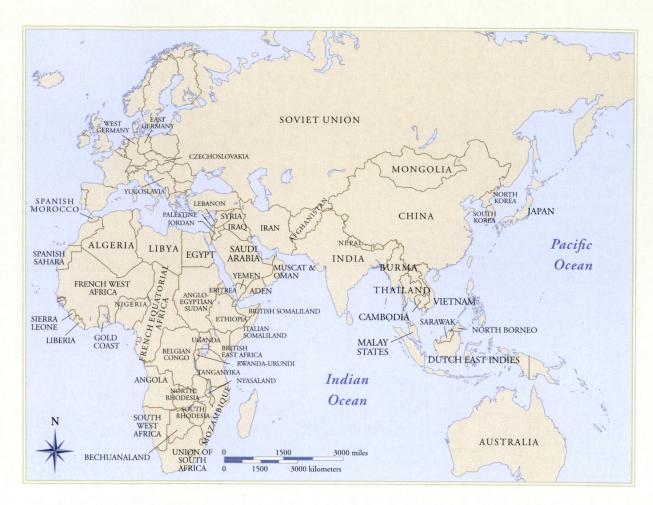

MAP 14-2 | Europe, Asia, and Africa in 2000

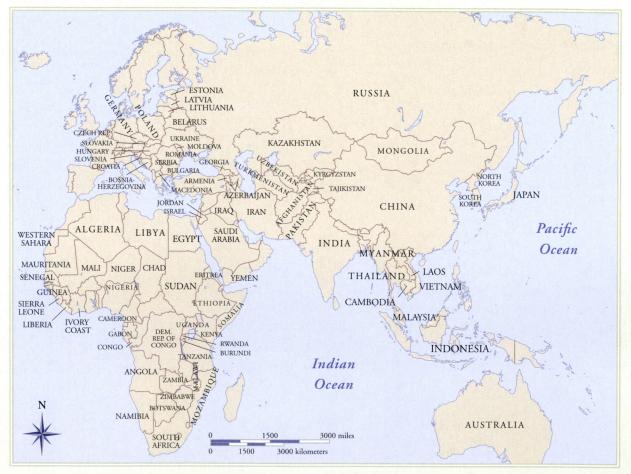

CHAPTER 1

- 1. Herodotus, Histories, 2.35.
- 2. Manetho, an Egyptian high priest in the third century BCE, is the main source for the sequence of pharaohs. He divided the Egyptian kings into the still-useful groups called dynasties, but his chronology was inaccurate, and the absolute dates of the rulers and dynasties are still debated. The chronologies scholars have proposed for the earliest Egyptian dynasties can vary by as much as two centuries. Exact years cannot be assigned to the reigns of individual pharaohs until 664 BCE (Dynasty XXVI). We follow the chronology proposed by John Baines and Jaromir Malék in Atlas of Ancient Egypt (Oxford: Oxford University Press, 1980), 36–37, and the division of kingdoms favored by, among others, Mark Lehner, The Complete Pyramids (New York: Thames & Hudson, 1997), 8–9, and David P. Silverman, ed., Ancient Egypt (New York: Oxford University Press, 1997), 20–39.

CHAPTER 2

- Galen, De placitis Hippocratis et Platonis, 5. Translated by J. J. Pollitt, The Art of Ancient Greece: Sources and Documents (New York: Cambridge University Press, 1990), 76.
- 2. Pliny the Elder, Natural History, 34.55. Translated by Pollitt, 75.
- 3. Pliny the Elder, Natural History, 36.20.
- 4. Lucian, Amores, 13-14; Imagines, 6.
- 5. Pliny the Elder, Natural History, 35.110.

CHAPTER 3

- 1. Livy, *History of Rome*, 25.40.1-3.
- 2. Pliny the Elder, Natural History, 35.133.

CHAPTER 4

- 1. Augustine, City of God, 16.26.
- 2. Translated by Cyril Mango, *The Art of the Byzantine Empire*, 312–1453: Sources and Documents (Englewood Cliffs, N.J.: Prentice Hall, 1972), 74.
- 3. Ibid., 83, 86.
- 4. Ibid., 75.

CHAPTER 6

- 1. Beowulf, translated by Kevin Crossley-Holland (New York: Farrar, Straus & Giroux, 1968), 119.
- Apologia, 12.28–29. Translated by Conrad Rudolph, The "Things of Greater Importance": Bernard of Clairvaux's Apologia and the Medieval Attitude toward Art (Philadelphia: University of Pennsylvania Press, 1990), 279, 283.
- 3. Translated by Calvin B. Kendall, *The Allegory of the Church:* Romanesque Portals and Their Verse Inscriptions (Toronto: University of Toronto Press, 1998), 207.
- Quoted in Elizabeth Gilmore Holt, A Documentary History of Art, 2nd ed. (Princeton, N.J.: Princeton University Press, 1981), 1: 18.

CHAPTER 7

Giorgio Vasari, Introduzione alle tre arti del disegno (1550), ch. 3.
 Paul Frankl, The Gothic: Literary Sources and Interpretations through Eight Centuries (Princeton, N.J.: Princeton University Press, 1960), 290-91, 859-60.

- Translated by Erwin Panofsky, Abbot Suger on the Abbey Church of Saint-Denis and Its Art Treasures, 2nd ed. (Princeton, N.J.: Princeton University Press, 1979), 101.
- 3. Ibid., 65.
- 4. Dante, Divine Comedy, Purgatory, 11.81.
- Translated by Roland Behrendt, Johannes Trithemius, In Praise of Scribes: De laude scriptorum (Lawrence, Kans.: Coronado Press, 1974), 71.
- 6. Frankl, 55.

CHAPTER 8

- 1. Giorgio Vasari, *Lives of the Painters, Sculptors and Architects*, translated by Gaston du C. de Vere (New York: Knopf, 1996), 1: 304.
- 2. Vasari, 1: 318.
- 3. Quoted in H. W. Janson, *The Sculpture of Donatello* (Princeton, N.J.: Princeton University Press, 1965), 154.

CHAPTER 9

- 1. Da Vinci to Ludovico Sforza, ca. 1480–81, in Elizabeth Gilmore Holt, ed., *Literary Sources of Art History* (Princeton: Princeton University Press, 1947), 170.
- 2. Quoted in Anthony Blunt, Artistic Theory in Italy, 1450–1600 (London: Oxford University Press, 1964), 34.
- 3. Quoted in Robert Klein and Henri Zerner, *Italian Art* 1500–1600: *Sources and Documents* (Evanston, Ill.: Northwestern University Press, 1966), 7–8.
- 4. Giorgio Vasari (1511-1574) established himself as both a painter and architect during the 16th century, but he is best known for his landmark biographies, first published in 1550. Scholars long have considered Vasari's *Lives* a major source of information about Italian art and artists, although many of the details have proven inaccurate.
- Quoted in James M. Saslow, The Poetry of Michelangelo: An Annotated Translation (New Haven: Yale University Press, 1991), 407
- 6. Giorgio Vasari, *Lives of the Painters, Sculptors and Architects*, translated by Gaston du C. de Vere (New York: Knopf, 1996), 2: 736.
- 7. Quoted in A. Richard Turner, Renaissance Florence: The Invention of a New Art (New York: Abrams, 1997), 163.
- 8. Quoted in Bruce Boucher, Andrea Palladio: The Architect in His Time (New York: Abbeville Press, 1998), 229.
- 9. Quoted in Robert J. Clements, *Michelangelo's Theory of Art* (New York: New York University Press, 1961), 320.
- 10. Quoted in Francesco Valcanover, "An Introduction to Titian," in *Titian: Prince of Painters* (Venice: Marsilio, 1990), 23–24.

CHAPTER 10

- 1. John Milton, Il Penseroso (1631, published 1645), 166.
- 2. Quoted in Wolfgang Stechow, Rubens and the Classical Tradition (Cambridge, Mass.: Harvard University Press, 1968), 26.
- 3. Quoted in Bob Haak, The Golden Age: Dutch Painters of the Seventeenth Century (New York: Abrams, 1984), 450.
- 4. Quoted in Robert Goldwater and Marco Treves, eds., *Artists on Art*, 3rd ed. (New York: Pantheon Books, 1958), 155.
- 5. Ibid., 155.
- 6. Ibid., 151-53.

CHAPTER 11

- 1. Robert Goldwater and Marco Treves, eds., Artists on Art, 3rd ed. (New York: Pantheon Books, 1958), 157.
- The Indispensable Rousseau, compiled and presented by John Hope Mason (London: Quartet Books, 1979), 39.
- 3. Quoted in Goldwater and Treves, eds., Artists on Art, 205.
- 4. Ibid., 205.
- 5. Quoted in Helmut Borsch-Supan, Caspar David Friedrich (New York: Braziller, 1974), 7.
- Quoted in Charles Harrison and Paul Wood, eds., with Jason Gaiger, Art in Theory 1815–1900: An Anthology of Changing Ideas (Oxford: Blackwell, 1998), 54.
- 7. Quoted in Brian Lukacher, "Nature Historicized: Constable, Turner, and Romantic Landscape Painting," in Stephen F. Eisenman, ed., *Nineteenth Century Art: A Critical History* (New York: Thames & Hudson, 1994), 121.
- Quoted in John W. McCoubrey, American Art 1700–1960: Sources and Documents (Englewood Cliffs, N.J.: Prentice Hall, 1965), 98.

CHAPTER 12

- 1. Clement Greenberg, "Modernist Painting," *Art and Literature*, no. 4 (Spring 1965): 193–94.
- 2. Quoted in Robert Goldwater and Marco Treves, eds., Artists on Art, 3rd ed. (New York: Pantheon Books, 1958), 295–97.
- 3. Stephen F. Eisenman, *Nineteenth Century Art: A Critical History* (New York: Thames & Hudson, 1994), 242.
- 4. "On the Heroism of Modern Life" (the closing section of Baudelaire's *Salon of 1846*, published as a brochure in Paris in 1846).
- Quoted in Nikolai Cikovsky Jr. and Franklin Kelly, Winslow Homer (Washington, D.C.: National Gallery of Art, 1995), 26.
- Lloyd Goodrich, Thomas Eakins, His Life and Work (New York: Whitney Museum of American Art, 1933), 51–52.
- Quoted in Linda Nochlin, Realism (Harmondsworth: Penguin Books, 1971), 28.
- Quoted in John McCoubrey, American Art 1700–1960: Sources and Documents (Englewood Cliffs, N.J.: Prentice Hall, 1965), 184.
- Van Gogh to Theo van Gogh, 11 August 1888, Van Gogh: A Self-Portrait; Letters Revealing His Life as a Painter, selected by W. H. Auden (New York: Dutton, 1963), 313.
- 10. Ibid., 321.
- Van Gogh to Theo van Gogh, September 1888, in J. van Gogh-Bonger and V. W. van Gogh, eds., *The Complete Letters of Vincent* van Gogh (Greenwich, Conn.: New York Graphic Society, 1979), 3: 534.
- 12. Van Gogh to Theo van Gogh, 8 September 1888, Van Gogh: A Self-Portrait, 320.
- 13. Quoted in Belinda Thompson, ed., *Gauguin by Himself* (Boston: Little, Brown, 1993), 270–71.
- 14. Quoted in Herschel B. Chipp, *Theories of Modern Art* (Berkeley: University of California Press, 1968), 72.
- 15. Quoted in Richard W. Murphy, *The World of Cézanne* 1839–1906 (New York: Time-Life Books, 1968), 70.
- 16. Quoted in Goldwater and Treves, eds., Artists on Art, 363.
- 17. Quoted in George Heard Hamilton, *Painting and Sculpture in Europe*, 1880–1940, 6th ed. (New Haven: Yale University Press, 1993), 124.
- 18. Quoted in Victor Frisch and Joseph T. Shipley, *Auguste Rodin* (New York: Stokes, 1939), 203.

CHAPTER 13

- 1. Herwarth Walden, "Kunst und Leben," Der Sturm 10 (1919): 2.
- 2. Quoted in John Russell and the editors of Time-Life Books, *The World of Matisse* 1869–1954 (New York: Time-Life Books, 1969), 98.
- 3. Quoted in Herschel B. Chipp, *Theories of Modern Art* (Berkeley: University of California Press, 1968), 182.
- Quoted in Frederick S. Levine, The Apocalyptic Vision: The Art of Franz Marc as German Expressionism (New York: Harper & Row, 1979), 57.
- 5. Quoted in Sam Hunter and John Jacobus, *Modern Art*, 3rd ed. (New York: Abrams, 1992), 121.
- 6. Jean-Louis Paudrat, "From Africa," in William S. Rubin, ed., "Primitivism" in 20th Century Art: Affinity of the Tribal and the Modern (New York: Museum of Modern Art, 1984), 1:141.
- 7. Quoted in George Heard Hamilton, *Painting and Sculpture in Europe 1880–1940*, 6th ed. (New Haven: Yale University Press, 1993), 246.
- 8. Quoted in Edward Fry, ed., *Cubism* (London: Thames & Hudson, 1966), 112–13.
- 9. Hamilton, Painting and Sculpture, 238.
- From the *Initial Manifesto of Futurism*, first published 20 February 1909.
- 11. Umberto Boccioni, Carlo Carrà, Luigi Russolo, Giacomo Balla, and Gino Severini, "Futurist Painting: Technical Manifesto," *Poesia*, 10 April 1910.
- 12. Hans Richter, *Dada: Art and Anti-Art* (London: Thames & Hudson, 1961), 57.
- Charles C. Eldredge, "The Arrival of European Modernism," Art in America 61 (July-August 1973): 35.
- Dorothy Norman, Alfred Stieglitz: An American Seer (Millerton, N.Y.: Aperture, 1973).
- 15. Ibid., 161.
- 16. Ibid., 9–10, 161.
- 17. Quoted in William S. Rubin, *Dada, Surrealism, and Their Heritage* (New York: Museum of Modern Art, 1968), 64.
- 18. Quoted in Hamilton, Painting and Sculpture, 392.
- 19. Quoted in Rubin, Dada, Surrealism, and Their Heritage, 111.
- 20. Quoted in Hunter and Jacobus, Modern Art, 179.
- 21. Quoted in William S. Rubin, Miró in the Collection of the Museum of Modern Art (New York: Museum of Modern Art, 1973), 32.
- 22. Quoted in Chipp, Theories of Modern Art, 341, 345.
- 23. Kenneth Frampton, Modern Architecture: A Critical History (London: Thames & Hudson, 1985), 142.
- 24. Quoted in Michel Seuphor, *Piet Mondrian: Life and Work* (New York: Abrams, 1956), 177.
- 25. Quoted in Hamilton, Painting and Sculpture, 319.
- Piet Mondrian, "Dialogue on the New Plastic," in Charles Harrison and Paul Wood, eds., Art in Theory 1900–1990: An Anthology of Changing Ideas (Oxford: Blackwell, 1992), 285.
- 27. Walter Gropius, from The Manifesto of the Bauhaus, April 1919.
- 28. Ibid.
- Quoted in John Willett, Art and Politics in the Weimar Period: The New Sobriety, 1917–1933 (New York: Da Capo Press, 1978), 119.
- 30. Quoted in Wayne Craven, American Art: History and Culture (Madison, Wis.: Brown & Benchmark, 1994), 403.
- 31. Quoted in Hamilton, Painting and Sculpture, 462.
- 32. Pablo Picasso, "Statement to Simone Téry," in Harrison and Wood, eds., *Art in Theory* 1900–1990, 640.
- 33. Quoted in Roland Penrose, *Picasso: His Life and Work*, Rev. ed. (New York: Harper & Row, 1973), 311n.

- 34. Quoted in James M. Dennis, Grant Wood: A Study in American Art and Culture (Columbia: University of Missouri Press, 1986), 143.
- 35. Wanda M. Corn, *Grant Wood: The Regionalist Vision* (New Haven: Yale University Press, 1983), 131.

CHAPTER 14

- 1. Dawn Ades and Andrew Forge, Francis Bacon (London: Thames & Hudson, 1985), 8; and David Sylvester, The Brutality of Fact: Interviews with Francis Bacon, 3rd ed. (London: Thames & Hudson, 1987), 182.
- 2. Clement Greenberg, "Sculpture in Our Time," Arts Magazine 32, no. 9 (June 1956): 22.
- 3. Marcus Rothko and Adolph Gottlieb, quoted in Edward Alden Jewell, "The Realm of Art: A New Platform and Other Matters: 'Globalism' Pops into View," *New York Times*, 13 June 1943, 9.
- 4. Jackson Pollock, "My Painting," Possibilities 1 (Winter 1947): 79.
- 5. In Harold Rosenberg, *The Tradition of the New* (New York: Horizon Press, 1959), 25.

- 6. Quoted in Selden Rodman, Conversations with Artists (New York: Devin-Adair, 1957), 93–94.
- 7. Quoted in "Vietnam Memorial: America Remembers," *National Geographic* 167, no. 5 (May 1985): 557.
- 8. Quoted in Deborah Wye, *Louise Bourgeois* (New York: Museum of Modern Art, 1982), 22, 25, 27.
- 9. Quoted in "Joseph Kosuth: Art as Idea as Idea," in Jeanne Siegel, ed., *Artwords: Discourse on the 60s and 70s* (Ann Arbor, Mich.: UMI Research Press, 1985), 225.
- 10. Sol Le Witt, quoted in Daniel Wheeler, Art since Mid-Century: 1945 to the Present (Englewood Cliffs, N.J.: Prentice Hall, 1991), 247.
- 11. Quoted in Richard Francis, *Jasper Johns* (New York: Abbeville, 1984), 21.
- 12. Quoted in Nancy Holt, ed., *The Writings of Robert Smithson* (New York: New York University Press, 1975), 111.
- Jaune Quick-to-See Smith and Harmony Hammond, Women of Sweetgrass: Cedar and Sage (New York: American Indian Center, 1984), 97.
- 14. Quoted in Mary Jane Jacob, *Magdalena Abakanowicz* (New York: Abbeville, 1982), 94.

PRONUNCIATION KEY \Bar{u} abut, kitten a cot, cart \Bar{a} bake \Bar{u} back au out ch chin e less \Bar{e} easy g gift \Bar{u} trip \Bar{u} life j joke \Bar{k} kick \Bar{u} French vin ng sing o flaw \Bar{o} boat \Bar{o} bi(r)d oi coin u foot \Bar{u} loot \Bar{u} few y yoyo zh vision Note: The stress mark (') is before the stressed syllable (be-'for).

A

abacus (ă-ba-'kŭs) The uppermost portion of the capital of a column.

abbess The chief nun who presides over an abbey.

abbey A monastic community under the rule of an abbot or abbess.

abbot The chief monk who presides over an abbey.

abrasion The rubbing or grinding of stone or another material to produce a smooth surface.

Abstract Expressionism Also known as the New York School. The first major American avant-garde movement, Abstract Expressionism emerged in New York City in the 1940s. The artists produced abstract paintings that expressed their state of mind and were intended to strike emotional chords in the viewer. The movement developed along two lines: gestural abstraction and chromatic abstraction.

acropolis (a-'kra-pŭ-lŭs) Greek, "high city." In ancient Greece, usually the site of the city's most important temple(s).

action painting Also called *gestural abstraction*. The kind of *Abstract Expressionism* practiced by Jackson Pollock, in which the emphasis was on the creation process, the artist's gesture in making art. Pollock poured liquid paint in linear webs on his canvases, which were laid out on the floor, thereby physically surrounding himself in the painting during its creation.

additive light The sum of all the wavelengths composing the visible spectrum; natural light, or sunlight.

additive sculpture A kind of sculpture technique in which materials (for example, clay) are built up or "added" to create *form*.

aerial perspective See perspective.

aisle The portion of a *basilica* flanking the *nave* and separated from it by a row of *columns* or *piers*.

altarpiece A panel, painted or sculpted, situated above and behind an altar. See also *retable*.

alternate-support system In church architecture, the use of alternating wall supports in the *nave*, usually *piers* and *columns* or *compound piers* of alternating form.

Amazonomachy (ă-mŭ-zon-'a-mŭ-kē) In Greek mythology, the legendary battle between the Greeks and Amazons.

ambulatory ('ăm-byŭ-lŭ-to-rē) A covered walkway, outdoors (as in a church *cloister*) or indoors, especially the passageway around the *apse* and the *choir* of a church.

amphiprostyle (ăm-fi-'pro-stīl) The style of Greek building in which the *colonnade* was placed across both the front and back, but not along the sides.

amphitheater Greek, "double theater." A Roman building type resembling two Greek theaters put together. The Roman amphitheater featured a continuous elliptical *cavea* around a central *arena*.

amphora ('ăm-fŭ-ra) A two-handled jar used for general storage purposes, usually to hold wine or oil.

amulet ('ăm-yŭ-lŭt) An object worn to ward off evil or to aid the wearer.

Analytic Cubism The first phase of *Cubism*, developed jointly by Pablo Picasso and Georges Braque, in which the artists analyzed *form* from

every possible vantage point to combine the various views into one pictorial whole.

anamorphic image (ăn-ŭ-'mor-fik *image*) A distorted image that must be viewed by some special means, such as with a mirror or at an angle, to be recognized.

antae ('ăn-tī) The molded projecting ends of the walls forming the *pronaos* or *opisthodomos* of an ancient Greek temple.

apadana (ă-pa-'da-na) The great audience hall in ancient Persian palaces.

apse (ặps) A recess, usually semicircular, in the wall of a Roman *basilica* or at the east end of a church.

apsidal Rounded; apse shaped.

arcade A series of arches supported by piers or columns.

Arcadian (adj.) In Renaissance and later art, depictions of an idyllic place of rural peace and simplicity. Derived from Arcadia, an ancient district of the central Peloponnesos in southern Greece.

arch A curved structural member that spans an opening and is generally composed of wedge-shaped blocks (voussoirs) that transmit the downward pressure laterally. See also thrust.

Archaic smile In Archaic Greek sculpture, the smile sculptors represented on faces as a way of indicating that the person portrayed is alive.

architrave ('ar-kŭ-trāv) The *lintel* or lowest division of the *entablature*; also called the epistyle.

archivolt The continuous molding framing an arch. In Romanesque or Gothic architecture, one of the series of concentric bands framing the tympanum.

arcuated Arch shaped.

arena In a Roman *amphitheater*, the central area where bloody gladiatorial combats and other boisterous events took place.

armature ('ar-mŭ-chŭr) The crossed, or diagonal, *arches* that form the skeletal framework of a *Gothic rib vault*. In sculpture, the framework for a clay form.

arriccio The first, rough layer of lime plaster in fresco painting.

Art Nouveau (ar nū-'vō) A late-19th- and early-20th-century art movement whose proponents tried to synthesize all the arts in an effort to create art based on natural forms that could be mass produced by technologies of the industrial age.

ashlar masonry Carefully cut and regularly shaped blocks of stone used in construction, fitted together without mortar.

assemblage (a-sem-'blazh) An artwork constructed from already existing objects.

atmospheric perspective See perspective.

atrium ('ā-trē-ŭm) The court of a Roman house that is partly open to the sky. Also the open, colonnaded court in front of and attached to a Christian basilica.

attic The uppermost story of a building.

attribute A unique characteristic that identifies a figure.

attribution Assignment of a work to a maker or makers.

automatism In painting, the process of yielding oneself to instinctive motions of the hands after establishing a set of conditions (such as size of paper or *medium*) within which a work is to be carried out.

avant-garde ('ă-van gard) French, "advance guard" (in a platoon). Late-19th- and 20th-century artists who emphasized innovation and challenged established convention in their work. Also used as an adjective.

axis A straight line around which a geometric figure or three-dimensional object is symmetrical.

baldacchino (bal-da-'kē-nō) A canopy on *columns*, frequently built over an altar.

balustrade ('băl-us-trād) A railing held up by small posts, as on a staircase.

baptistery ('băp-tus-trē) In Christian architecture, the building used for baptism, usually situated next to a church.

Baroque A blanket designation for the art of the period 1600 to 1750.

barrel vault See vault.

bar tracery See tracery.

base In ancient Greek architecture, the lowest part of *Ionic* and *Corinthian columns*.

basilica (bu-'sil-ŭ-kŭ) In Roman architecture, a civic building for legal and other civic proceedings, rectangular in plan with an entrance usually on a long side. In Christian architecture, a church somewhat resembling the Roman basilica, usually entered from one end and with an *apse* at the other.

bas-relief ('ba rŭ-'lef) See relief.

Bauhaus ('bau-haus) A school of architecture in Germany in the 1920s under the leadership of Walter Gropius, who emphasized the unity of art, architecture, and design. The Bauhaus trained students in a wide range of both arts and crafts, and was eventually closed by the Nazis in 1933.

bay The area between the *columns* or *piers* in the *nave* or *aisles* of a

ben-ben ('ben-ben) A pyramidal stone; a fetish of the Egyptian god Re.

benday dots A printing technique that involves the modulation of color through the placement of individual colored dots. Named after its inventor, Benjamin Day.

bestiary A collection of illustrations of real and imaginary animals.

bilateral symmetry A composition or plan in which the parts are the same on either side of an axis.

black-figure painting In Greek pottery, the silhouetting of dark figures against a light background of natural, reddish clay, with linear details *incised* through the silhouettes.

blind arcade An *arcade* having no actual openings, applied as decoration to a wall surface.

buon fresco (bwan 'fres-kō) See fresco.

burin ('byū-rin) A pointed tool used for engraving or incising.

buttress ('but-trus') An exterior masonry structure that opposes the lateral *thrust* of an *arch* or a *vault*. A pier buttress is a solid mass of masonry; a flying buttress consists typically of an inclined member carried on an arch or a series of arches and a solid buttress to which it transmits lateral thrust.

C

caduceus (ka-'d(y)ū-sē-ŭs) In ancient Greek mythology, a magical rod entwined with serpents carried by Hermes (Roman, Mercury), the messenger of the gods.

caldarium (kal-'dă-rē-ŭm) The hot-bath section of a Roman bathing establishment.

caliph(s) ('kā-lef or 'kal-ŭf) Muslim rulers, regarded as successors of Muhammad.

calligraphy Greek, "beautiful writing." Handwriting or penmanship, especially elegant writing as a decorative art.

calotype ('kă-lŭ-tip) A photographic process in which a positive image is made by shining light through a negative image onto a sheet of sensitized paper.

camera lucida ('kă-mŭ-rŭ lū-'sē-dŭ) Latin, "lighted room." A device in which a small lens projects the image of an object downward onto a sheet of paper.

camera obscura ('kā-mŭ-rŭ ŭb-'skyū-rŭ) Latin, "dark room." An ancestor of the modern camera in which a tiny pinhole, acting as a lens, projects an image on a screen, the wall of a room, or the ground-glass wall of a box; used by artists in the 17th, 18th, and early 19th centuries as an aid in drawing from nature.

cames (kāms) The lead strips in *stained-glass* windows that join separate pieces of colored glass.

campanile (kam-pa-'nē-lā) A bell tower of a church, usually, but not always, freestanding.

canon A rule, for example, of proportion. The ancient Greeks considered beauty to be a matter of "correct" proportion and sought a canon of proportion, for the human figure and for buildings.

capital The uppermost member of a *column*, serving as a transition from the *shaft* to the *lintel*. In classical architecture, the form of the capital varies with the *order*.

Capitolium (kă-pi-'tō-lē-ŭm) An ancient Roman temple dedicated to the gods Jupiter, Juno, and Minerva.

Carolingian (adj.) (kă-rō-'lin-jŭn) Pertaining to the empire of Charlemagne (Latin, Carolus Magnus) and his successors.

carpet pages In early medieval manuscripts, decorative pages resembling textiles.

cartoon In painting, a full-size preliminary drawing from which a painting is made.

caryatid ('kă-rē-ăt-id) A female figure that functions as a supporting column. See also atlantid.

casting Pouring a fluid substance such as bronze into a mold.

catacombs ('kăt-ŭ-kōmz) Subterranean networks of rock-cut galleries and chambers designed as cemeteries for the burial of the dead.

cathedral A bishop's church.

cavea (kă-vē-ŭ) Latin, "hollow place or cavity." The seating area in ancient Greek and Roman theaters and *amphitheaters*.

cella ('se-lŭ) The chamber at the center of an ancient temple; in a classical temple, the room (Greek, *naos*) in which the cult statue usually stood.

centaur ('sen-tor) In ancient Greek mythology, a fantastical creature, with the front or top half of a human and the back or bottom half of a horse.

centauromachy (sen-to-'ra-mŭ-kē) In ancient Greek mythology, the battle between the Greeks and *centaurs*.

central plan See plan.

chaplets Metal pins driven through the *investment* to connect it to the clay core in the *lost-wax process* of *casting*.

chiaroscuro (kē-ă-rō-'skū-rō) In drawing or painting, the treatment and use of light and dark, especially the gradations of light that produce the effect of modeling.

chiton ('kī-tan) A Greek tunic, the essential (and often only) garment of both men and women, the other being the *himation*, or mantle.

choir The space reserved for the clergy and singers in the church, usually east of the *transept* but, in some instances, extending into the *nave*.

Christogram ('kris-tō-grăm) The three initial letters (chi-rho-iota) of Christ's name in Greek (XPI), which came to serve as a monogram for Christ.

chromatic abstraction A kind of Abstract Expressionism that focused on the emotional resonance of color, as exemplified by the work of Mark Rothko.

chryselephantine (kris-el-ŭ-'făn-tīn) Fashioned of gold and ivory.

cire perdue (sēr per-'dū) See lost-wax process.

city-state An independent, self-governing city.

clerestory ('klēr-sto-rē) The fenestrated part of a building that rises above the roofs of the other parts. In Roman basilicas and medieval churches, the windows that form the uppermost level of the nave below the timber ceiling or the vaults.

cloison ('kloi-zŭn) A cell made of metal wire or a narrow metal strip soldered edge-up to a metal base to hold *enamel* or other decorative materials.

cloisonné ('kloi-zŭ-nā) A process of enameling employing *cloisons*. Also, decorative brickwork in later Byzantine architecture.

cloister A monastery courtyard, usually with covered walks or ambulatories along its sides.

cluster pier See compound pier.

codex (pl. codices) ('kō-deks/'kō-dŭ-sēz) Separate pages of *vellum* or *parchment* bound together at one side; the predecessor of the modern book. The codex superseded the *rotulus*.

coffer A sunken panel, often ornamental, in a vault or a ceiling.

collage (kō-'lazh) A *composition* made by combining on a flat surface various materials, such as newspaper, wallpaper, printed text and illustrations, photographs, and cloth. See also *photomontage*.

colonnade A series or row of columns, usually spanned by lintels.

colonnette A thin column.

colophon ('ka-lŭ-fan) An inscription, usually on the last page, giving information about a book's manufacture. In Chinese painting, written texts on attached pieces of paper or silk.

color field painting A variant of *Post-Painterly Abstraction* whose artists sought to reduce painting to its physical essence by pouring diluted paint onto unprimed canvas, allowing these pigments to soak into the fabric.

colorito (ko-lo-'rē-tō) Italian, "colored" or "painted." A term used to describe the application of paint. Characteristic of the work of 16th-century Venetian artists who emphasized the application of paint as an important element of the creative process. Central Italian artists, in contrast, largely emphasized *disegno*—the careful design preparation based on preliminary drawing.

column A vertical, weight-carrying architectural member, circular in cross-section and consisting of a base (sometimes omitted), a shaft, and a capital.

complementary colors Those pairs of colors, such as red and green, that together embrace the entire spectrum. The complement of one of the three *primary colors* is a mixture of the other two.

composite view See twisted perspective.

composition The way in which an artist organizes *forms* in an artwork, either by placing shapes on a flat surface or by arranging forms in space.

compound pier A pier with a group, or cluster, of attached shafts, or responds, especially characteristic of Gothic architecture.

Conceptual art An American *avant-garde* art movement of the 1960s that asserted that the "artfulness" of art lay in the artist's idea rather than its final expression.

conch (kank) Half-dome.

concrete A building material invented by the Romans and consisting of various proportions of lime mortar, volcanic sand, water, and small stones.

condottiere (kon-da-'tyer-ē) A professional military leader employed by the Italian city-states in the early Renaissance.

congregational mosque A large *mosque* designed to accommodate a community's entire population for the Friday noonday prayer. Also called the *Friday mosque* or the great mosque.

connoisseur An expert in assigning artworks to one artist rather than another.

contour line In art, a continuous line defining the outer shape of an object.

contrapposto (kon-trŭ-'pas-tō) The disposition of the human figure in which one part is turned in opposition to another part (usually hips and legs one way, shoulders and chest another), creating a counterpositioning of the body about its central *axis*. Sometimes called "weight shift" because the weight of the body tends to be thrown to one foot, creating tension on one side and relaxation on the other.

corbel ('kor-bul) A projecting wall member used as a support for some element in the superstructure. Also, *courses* of stone or brick in which each course projects beyond the one beneath it. Two such walls, meeting at the topmost course, create a corbeled arch or corbeled *vault*.

corbeled arch See corbel.

Corinthian capital A more ornate form of capital than *Doric* or *Ionic*. It consists of a double row of acanthus leaves from which tendrils and flowers grow, wrapped around a bell-shaped *echinus*. Although this *capital* form is often cited as the distinguishing feature of the Corinthian *order*, there is, strictly speaking, no Corinthian order, but only this type of capital used in the Ionic order.

cornice The projecting, crowning member of the *entablature* framing the *pediment*; also, any crowning projection.

course In masonry construction, a horizontal row of stone blocks.

cromlech ('krom-lek) A circle of monoliths. Also called henge.

crossing The space in a *cruciform* church formed by the intersection of the *nave* and the *transept*.

crossing square The area in a church formed by the intersection (crossing) of a nave and a transept of equal width, often used as a standard module of interior proportion.

crossing tower The tower over the *crossing* of a church.

cross vault See vault.

cruciform ('kru-sŭ-form) Cross shaped.

Crusades In medieval Europe, armed pilgrimages aimed at recapturing the Holy Land from the *Muslims*.

cubiculum (pl. cubicula) (kū-'bik-yū-lŭm/kū-'bik-yū-lŭ) A small cubicle or bedroom that opened onto the *atrium* of a Roman house. Also, a chamber in an Early Christian *catacomb* that served as a mortuary chapel.

Cubism An early-20th-century art movement that rejected naturalistic depictions, preferring *compositions* of shapes and *forms* abstracted from the conventionally perceived world. See also *Analytic Cubism* and *Synthetic Cubism*.

cult statue The statue (usually over lifesize) placed in the *cella*, representing the deity to whom the temple is dedicated.

cuneiform (kyū-'nā-ŭ-form) Latin, "wedge-shaped." A system of writing used in ancient Mesopotamia, in which wedge-shaped characters were produced by pressing a *stylus* into a soft clay tablet, which was then baked or otherwise allowed to harden.

cutaway An architectural drawing that combines an exterior view with an interior view of part of a building.

Cyclopean masonry (sī-klō-'pē-ŭn masonry) A method of stone construction, named after the mythical one-eyed giant Cyclops, using massive, irregular blocks without mortar, characteristic of the Bronze Age fortifications of Tiryns and other Mycenaean sites.

Dada ('da-da) An art movement prompted by a revulsion against the horror of World War I. Dada embraced political anarchy, the irrational, and the intuitive, and the art produced by the Dadaists was characterized by a disdain for convention, often enlivened by humor or whimsy.

Daedalic ('de-dŭl-ĭk) Refers to the early Archaic Greek style of the seventh century BCE named after the legendary Daedalus.

daguerreotype (da-'ger-ō-tip) A photograph made by an early method on a plate of chemically treated metal; developed by Louis J. M. Daguerre.

damnatio memoriae (dam-'na-tē-ō mŭ-'mor-ĭ-ī) Latin, "damnation of memory." The Roman decree condemning those who ran afoul of the Senate. Those who suffered damnatio memoriae had their memorials demolished and their names erased from public inscriptions.

deconstruction An analytical strategy developed in the late 20th century according to which all cultural "constructs" (art, architecture, literature) are "texts." People can read these texts in a variety of ways, but they cannot arrive at fixed or uniform meanings. Any interpretation can be valid, and readings differ from time to time, place to place, and person to person. For those employing this approach, deconstruction means destabilizing established meanings and interpretations while encouraging subjectivity and individual differences.

Deconstructivist architecture Using *deconstruction* as an analytical strategy, Deconstructivist architects attempt to disorient the observer by disrupting the conventional categories of architecture. The haphazard presentation of volumes, masses, *planes*, lighting, and so forth challenges the viewer's assumptions about *form* as it relates to function.

demos ('dē-mas) The Greek word meaning "the people," from which the word democracy is derived.

De Stijl (du stēl) Dutch, "the style." An early-20th-century art movement (and magazine) founded by Piet Mondrian and Theo van Doesburg, whose members promoted utopian ideals and developed a simplified geometric style.

diagonal rib See rib.

diptych ('dip-tik) A two-paneled painting or altarpiece.

disegno (dē-'zā-nyō) Italian, "drawing" and "design." Renaissance artists considered drawing to be the external physical manifestation (disegno esterno) of an internal intellectual idea of design (disegno interno).

dome A hemispheric *vault*; theoretically, an *arch* rotated on its vertical *axis*.

domus ('dō-mŭs) A Roman private house.

donor portrait A portrait of the individual who commissioned (donated) a religious work—for example, an *altarpiece*—as evidence of devotion.

Doric ('dor-ik) One of the two systems (or *orders*) evolved for articulating the three units of the *elevation* of an ancient Greek temple—the platform, the *colonnade*, and the superstructure (*entablature*). The Doric order is characterized by, among other features, *capitals* with funnel-shaped *echinuses*, *columns* without *bases*, and a *frieze* of *triglyphs* and *metopes*. See also *Ionic*.

drum One of the stacked cylindrical stones that form the *shaft* of a *column*; the cylindrical wall that supports a *dome*.

dressed masonry Stone blocks shaped to the exact dimensions required, with smooth faces for a perfect fit.

dry fresco See fresco.

drypoint An engraving in which the design, instead of being cut into the plate with a *burin*, is scratched into the surface with a hard steel "pencil." See also *engraving*, *etching*, *intaglio*.

eaves The lower part of a roof that overhangs the wall.

echinus (ŭ-'kīn-ŭs) In architecture, the convex element of a *capital* directly below the *abacus*.

écorché (ā-'ko-zhā) A figure painted or sculpted to show the muscles of the body as if without skin.

edition A set of impressions taken from a single print surface.

effigy mounds Ceremonial mounds built in the shape of animals or birds by native North American peoples.

elevation In architecture, a head-on view of an external or internal wall, showing its features and often other elements that would be visible beyond or before the wall.

embroidery The technique of sewing threads onto a finished ground to form contrasting designs.

enamel A decorative coating, usually colored, fused onto the surface of metal, glass, or ceramics.

encaustic (en-'kos-tik) A painting technique in which pigment is mixed with hot wax and applied to the surface.

engaged column A half-round column attached to a wall. See also pilaster.

engraving The process of *incising* a design in hard material, often a metal plate (usually copper); also, the print or impression made from such a plate.

entablature (in-'tăb-lǔ-chǔr) The part of a building above the *columns* and below the roof. The entablature of a classical temple has three parts: *architrave* or epistyle, *frieze*, and *pediment*.

entasis ('en-tŭ-sŭs) The convex profile (an apparent swelling) in the *shaft* of a *column*.

Environmental art An American art form that emerged in the 1960s. Often using the land itself as their material, Environmental artists construct monuments of great scale and minimal *form*. Permanent or impermanent, these works transform some section of the environment, calling attention both to the land itself and to the hand of the artist. Sometimes referred to as Earth art or earthworks.

epistyle ('ep-ŭ-stil) See architrave.

etching A kind of *engraving* in which the design is *incised* in a layer of wax or varnish on a metal plate. The parts of the plate left exposed are then etched (slightly eaten away) by the acid in which the plate is immersed after incising. See also *drypoint*, *engraving*, *intaglio*.

Eucharist ('yū-ku-rist) In Christianity, the partaking of the bread and wine, which believers hold to be either Christ himself or symbolic of him.

exedra (pl. exedrae) (ek-'sē-drŭ/ek-'sē-drī) Recessed area, usually semicircular.

expressionism Twentieth-century *modernist* art that is the result of the artist's unique inner or personal vision and that often has an emotional dimension. Expressionism contrasts with art focused on visually describing the empirical world.

F

facade (fŭ-'sad) Usually, the front of a building; also, the other sides when they are emphasized architecturally.

fan vault See vault.

fasciae ('făsh-ē-ī) In the *Ionic order*, the three horizontal bands that make up the *architrave*.

fauces ('fo-sēz) Latin, "throat." In a Roman house, the narrow foyer leading to the *atrium*.

Fauvism ('fō-viz-ŭm) From the French word *fauve*, "wild beast." An early-20th-century art movement led by Henri Matisse, for whom color became the formal element most responsible for pictorial coherence and the primary conveyor of meaning.

fenestrated ('fen-ŭ-strā-tŭd) Having windows.

fenestration The arrangement of the windows of a building.

fête galante (fet ga-'lan') A type of *Rococo* painting depicting the outdoor amusements of upper-class society.

fin de siècle (fă n-dŭ-sē-'ek-lŭ) French, "end of the century." A period in Western cultural history from the end of the 19th century until just before World War I, when decadence and indulgence masked anxiety about an uncertain future.

finial A crowning ornament.

First Style The earliest style of Roman *mural* painting. Also called the Masonry Style, because the aim of the artist was to imitate, using painted stucco *relief*, the appearance of costly marble panels.

flashing In making *stained-glass* windows, fusing one layer of colored glass to another to produce a greater range of colors.

flute or fluting Vertical channeling, roughly semicircular in crosssection and used principally on columns and pilasters.

flying buttress See buttress.

folio ('fō-lĭ-ō) A page of a manuscript or book.

foreshortening The use of *perspective* to represent in art the apparent visual contraction of an object that extends back in space at an angle to the perpendicular *plane* of sight.

form In art, an object's shape and structure, either in two dimensions (for example, a figure painted on a surface) or in three dimensions (such as a statue).

formal analysis The visual analysis of artistic form.

formalism Strict adherence to, or dependence on, stylized shapes and methods of *composition*. An emphasis on an artwork's visual elements rather than its subject.

forum The public square of an ancient Roman city.

Fourth Style In Roman *mural* painting, the Fourth Style marked a return to architectural illusionism, but the architectural vistas of the Fourth Style are irrational fantasies.

freestanding sculpture See sculpture in the round.

fresco ('fres-kō) Painting on lime plaster, either dry (dry fresco or fresco secco) or wet (true or buon fresco). In the latter method, the pigments are mixed with water and become chemically bound to the freshly laid lime plaster. Also, a painting executed in either method.

fresco secco ('fres-kō 'sek-ō) See fresco.

fret An ornament, usually in bands but also covering broad surfaces, consisting of interlocking geometric motifs. An ornamental pattern of contiguous straight lines joined usually at right angles.

Friday mosque See congregational mosque.

frieze (frēz) The part of the *entablature* between the *architrave* and the *cornice*; also, any sculptured or painted band in a building. See *register*.

frigidarium (fri-jŭ-'dă-rē-ŭm) The cold-bath section of a Roman bathing establishment.

Futurism An early-20th-century movement involving a militant group of Italian poets, painters, and sculptors. These artists published numerous manifestos declaring revolution in art against all traditional tastes, values, and styles and championing the modern age of steel and speed and the cleansing virtues of violence and war.

(

genre ('zhaⁿ-rŭ) A style or category of art; also, a kind of painting that realistically depicts scenes from everyday life.

German Expressionism An early-20th-century art movement. German Expressionist works are characterized by bold, vigorous brushwork, emphatic line, and bright color. Two important groups of German Expressionists were Die Brücke, in Dresden, and Der Blaue Reiter, in Munich.

gestural abstraction Also known as *action painting*. A kind of abstract painting in which the gesture, or act of painting, is seen as the subject of art. Its most renowned proponent was Jackson Pollock. See also *Abstract Expressionism*.

gigantomachy (jī-gŭn-'ta-mŭ-kē) In ancient Greek mythology, the battle between gods and giants.

giornata (pl. giornate) Italian, "day." The section of plaster that a fresco painter expects to complete in one session.

glaze A vitreous coating applied to pottery to seal and decorate the surface; it may be colored, transparent, or opaque, and glossy or matte. In oil painting, a thin, transparent, or semitransparent layer put over a color to alter it slightly.

glazed brick Bricks painted and then kiln fired to fuse the color with the baked clay.

glazier A glassworker.

gorgon In ancient Greek mythology, a hideous female demon with snake hair. Medusa, the most famous gorgon, was capable of turning anyone who gazed at her into stone.

Gospels The four New Testament books that relate the life and teachings of Jesus.

Gothic A term, originally derogatory, named after the Goths, used to describe the history, culture, and art of western Europe in the 12th to 14th centuries.

graver An incising tool used by engravers and sculptors.

Greek cross A cross with four arms of equal length and at right angles. grisaille (grŭ-'zīy) A monochrome painting done mainly in neutral grays to simulate sculpture.

groin The edge formed by the intersection of two vaults.

groin vault See vault.

ground line In paintings and *reliefs*, a painted or carved baseline on which figures appear to stand.

Н

Happenings A term coined by American artist Allan Kaprow in the 1960s to describe loosely structured performances, whose creators were trying to suggest the aesthetic and dynamic qualities of everyday life. As actions, rather than objects, Happenings incorporate the fourth dimension (time).

hatching A technique used in drawing and in printmaking methods such as *engraving* and *woodcut*, in which fine lines are cut or drawn close together to achieve an effect of shading.

Hellenes (adj., Hellenic) The name the ancient Greeks called themselves as the people of Hellas.

Hellenistic The term given to the culture that developed after the death of Alexander the Great in 323 BCE and that lasted almost three centuries, until the Roman conquest of Egypt in 31 BCE.

henge See cromlech.

heraldic composition A composition that is symmetrical on either side of a central figure.

Hiberno-Saxon ('hi-ber-no 'sak-sŭn) An art style that flourished in the monasteries of the British Isles in the early Middle Ages. Also called Insular.

hierarchy of scale An artistic convention in which greater size indicates greater importance.

hieratic (hī-ŭ-'ră-tik) A fixed, stylized method of representation, often determined by religious principles and ideas.

hieroglyphic (hī-rō-'glif-ik) A system of writing using symbols or pictures. high relief See *relief*.

Hijra ('hĭj-rŭ) The flight of Muhammad from Mecca to Medina in 622, the year from which Islam dates its beginnings.

himation (hī-'mā-shǔn) An ancient Greek mantle worn by men and women over the *chiton* and draped in various ways.

historiated Ornamented with representations, such as plants, animals, or human figures, that have a narrative—as distinct from a purely decorative—function.

hue The name of a color. See *primary colors*, *secondary colors*, and *complementary colors*.

humanism In the Renaissance, an emphasis on education and on expanding knowledge (especially of classical antiquity), the exploration of individual potential and a desire to excel, and a commitment to civic responsibility and moral duty.

 $\mbox{{\bf hydria}} \quad ('\mbox{{\bf h}\bar{\imath}}\mbox{{\bf d}r\bar{e}}\mbox{-}\bar{u}) \mbox{ An ancient Greek three-handled water pitcher.}$

hypostyle hall ('hī-pŭ-stīl hall) A hall with a roof supported by columns.

icon A portrait or image; especially in Byzantine art, a panel with a painting of sacred personages that are objects of veneration. In the visual arts, a painting, a piece of sculpture, or even a building regarded as an object of veneration.

iconoclasm (ī-'kan-'ŭ-klăz(-ŭ)m) The destruction of images. In Byzantium, the period from 726 to 843 when there was an imperial ban on images. The destroyers of images were known as iconoclasts. Those who opposed such a ban were known as iconophiles or iconodules.

iconography (ī-kŭn-'a-grŭ-fē) Greek, the "writing of images." The term refers both to the content, or subject, of an artwork and to the study of content in art. It also includes the study of the symbolic, often religious, meaning of objects, persons, or events depicted in works of art.

illuminated manuscript A luxurious handmade book with painted illustrations and decorations.

illumination Decoration (usually in gold, silver, and bright colors), especially of medieval manuscript pages.

illusionistic The depiction of the three-dimensional spatial world on a two-dimensional surface.

imagines (i-'ma-gi-nes) In ancient Rome, wax portraits of ancestors.

imam (i-'mam or i-'mam) In Islam, the leader of collective worship.

imperator (im-pŭ-'ra-tŭr) Latin, "commander in chief," from which the word *emperor* is derived.

impluvium (im-'plū-vē-um) In a Roman house, the basin, located in the *atrium*, that collected rainwater.

Impressionism A late-19th-century art movement that sought to capture a fleeting moment, thereby conveying the illusiveness and impermanence of images and conditions.

in antis (in 'ăn-tis) In classical architecture, between the antae.

incise (in-'sīz) To cut into a surface with a sharp instrument; also, a method of decoration, especially on metal and pottery.

incrustation Wall decoration consisting of bright panels of different colors.

inscriptions Texts written on the same surface as the picture (as in Chinese paintings) or *incised* in stone (as in ancient art). See also *colophon*.

installation An artwork that creates an artistic environment in a room or gallery.

intaglio (in-'ta-lē-ō) A graphic technique in which the design is *incised*, or scratched, on a metal plate, either manually (*engraving*, *drypoint*) or chemically (*etching*). The incised lines of the design take the ink, making this the reverse of the *woodcut* technique.

International Style A style of 14th- and 15th-century painting begun by Simone Martini, who adapted the French *Gothic* manner to Sienese art fused with influences from the North. This style appealed to the aristocracy because of its brilliant color, lavish costume, intricate ornament, and themes involving splendid processions of knights and ladies. Also a style of 20th-century architecture associated with Le Corbusier, whose elegance of design came to influence the look of modern office buildings and skyscrapers.

intonaco The final, smooth layer of plaster in fresco painting.

investment The final clay mold used in the lost-wax process of casting.

Ionic (ī-'an-ik) One of the two systems (or *orders*) evolved for articulating the three units of the *elevation* of a Greek temple: the platform, the *colonnade*, and the superstructure (*entablature*). The Ionic order

is characterized by, among other features, volute capitals, columns with bases, and an uninterrupted frieze.

iwan ('ē-wan) In Islamic architecture, a vaulted rectangular recess opening onto a courtyard.

J

jambs ('jăms) In architecture, the side posts of a doorway.

K

ka (ka) In ancient Egypt, the immortal human life force.

Kaaba ('ka-ba) Arabic, "cube." A small cubical building in Mecca, the *Muslim* world's symbolic center.

key or meander See fret.

Koran (ko-'ran) Islam's sacred book.

kore (pl. korai) ('kor-ā/'kor-ī) Greek, "young woman." An Archaic Greek statuary type depicting a young woman.

kouros (pl. kouroi) ('kūr-os/'kūr-oi) Greek, "young man." An Archaic Greek statuary type depicting a young man.

krater An ancient Greek wide-mouthed bowl for mixing wine and water.

Kufic ('kū-fŭk) An early form of Arabic script, characterized by angularity, with the uprights forming almost right angles with the baseline.

lamassu (la-'ma-sū) Assyrian guardian in the form of a man-headed winged bull.

lancet ('lăn-sŭt) In *Gothic* architecture, a tall narrow window ending in a *pointed arch*.

landscape A picture showing natural scenery, without narrative content. lateral section See *section*.

leading In the manufacture of *stained-glass* windows, the joining of colored glass pieces using lead *cames*.

lekythos (pl. lekythoi) ('lek-ē-thos/'lek-ē-thoi) A flask containing perfumed oil; lekythoi were often placed in Greek graves as offerings to the deceased.

letterpress The technique of printing with movable type invented in Germany in the 15th century.

linear perspective See perspective.

lintel ('lin-tŭl) A beam used to span an opening.

lithograph A printmaking technique in which images are printed from a flat stone.

local color An object's actual color in white light.

loggia ('lo-jŭ) A gallery with an open *arcade* or a *colonnade* on one or both sides.

longitudinal section See section.

lost-wax process (cire perduc) A bronze-casting method in which a figure is modeled in wax and covered with clay; the whole is fired, melting away the wax and hardening the clay, which then becomes a mold for molten metal.

low relief See relief.

lunette (lū-'net) A semicircular area (with the flat side down) in a wall over a door, niche, or window; also, a painting or *relief* with a semicircular frame.

M

magi ('mă-jī) The three wise men from the East who presented gifts to the infant Jesus.

maniera greca Italian, "Greek style." The Italo-Byzantine style of painting of the 13th century.

Mannerism A style of later Renaissance art that emphasized "artifice," often involving contrived imagery not derived directly from nature. Such artworks showed a self-conscious stylization involving

complexity, caprice, fantasy, and polish. Mannerist architecture tended to flout the classical rules of order, stability, and symmetry, sometimes to the point of parody.

maqsura (mak-'sū-ra) In some *mosques*, a screened area in front of the *mihrab* reserved for a ruler.

Mass The Catholic and Orthodox ritual in which believers understand that Christ's redeeming sacrifice on the cross is repeated when the priest consecrates the bread and wine in the *Eucharist*.

mastaba (ma-'sta-ba) Arabic, "bench." An ancient Egyptian rectangular brick or stone structure with sloping sides erected over a subterranean tomb chamber connected with the outside by a shaft.

maulstick A stick used to steady the hand while painting.

mausoleum (mo-sō-'lō-ŭm) A monumental tomb. The name derives from the mid-fourth century BCE tomb of Mausolos at Halikarnassos, one of the Seven Wonders of the ancient world.

meander or key See fret.

medium The material (for example, marble, bronze, clay, *fresco*) in which an artist works; also, in painting, the vehicle (usually liquid) that carries the pigment.

megalith (adj., megalithic) ('me-gŭ-lith/me-gŭ-'lith-ik) Greek, "great stone." A large, roughly hewn stone used in the construction of monumental prehistoric structures. See also *cromlech*.

Mesolithic (mez-ō-'lith-ik) The "middle" Stone Age, between the *Paleolithic* and the *Neolithic* ages.

Messiah (mŭ-'sī-ŭ) The savior of the Jews prophesized in the Old Testament. Christians believe that Jesus of Nazareth was the Messiah.

metope ('met-ŭ-pē) The panel between the *triglyphs* in a *Doric frieze*, often sculpted in *relief*.

mihrab (mi-'rab) A semicircular niche set into the qibla wall of a mosque.

minaret ('min-ŭ-ret) A distinctive feature of *mosque* architecture, a tower from which the faithful are called to worship.

minbar ('min-bar) In a mosque, the pulpit on which the imam stands.

Minimalism (Minimal art) A predominantly sculptural American trend of the 1960s whose works consist of a severe reduction of *form*, oftentimes to single, homogeneous units.

modeling The shaping or fashioning of three-dimensional *forms* in a soft material, such as clay; also, the gradations of light and shade reflected from the surfaces of matter in space, or the illusion of such gradations produced by alterations of value in a drawing, painting, or print.

modernism A movement in Western art that developed in the second half of the 19th century and sought to capture the images and sensibilities of the age. Modernist art goes beyond simply dealing with the present and involves the artist's critical examination of the premises of art itself.

module A basic unit of which the dimensions of the major parts of a work are multiples. The principle is used in sculpture and other art forms, but it is most often employed in architecture, where the module may be the dimensions of an important part of a building, such as the diameter of a *column*.

mold A hollow form for shaping a fluid substance.

molding In architecture, a continuous, narrow surface (projecting or recessed, plain or ornamented) designed to break up a surface, to accent, or to decorate.

monolith A *column shaft* that is all in one piece (not composed of *drums*); a large, single block or piece of stone used in *megalithic* structures.

moralized Bible A heavily illustrated Bible, each page pairing paintings of Old and New Testament episodes with explanations of their moral significance.

mosaic (mō-'zā-ŭk) Patterns or pictures made by embedding small pieces (tesserae) of stone or glass in cement on surfaces such as walls and floors; also, the technique of making such works.

mosaic tilework An Islamic decorative technique in which large ceramic panels are fired, cut into smaller pieces, and set in plaster.

mosque (mask) The Islamic building for collective worship. From the Arabic word *masjid*, meaning a "place for bowing down."

Muhaqqaq (mū-ha-'kak) A cursive style of Islamic calligraphy.

mullion ('mŭl-yŭn) A vertical member that divides a window or that separates one window from another.

mummification A technique used by ancient Egyptians to preserve human bodies so that they may serve as the eternal home of the immortal *ka*.

muqarnas (mū-'kar-nas) Stucco decorations of Islamic buildings in which stalactite-like forms break a structure's solidity.

mural Pertaining to a wall; a wall painting.

Muslim A believer in Islam.

N

naos ('nā-os) See cella.

narthex ('nar-theks) A porch or vestibule of a church, generally colon-naded or arcaded and preceding the nave.

naturalism The close observation of the natural world and the depiction in art of a perceptual reality.

nave The central area of an ancient Roman basilica or of a church, demarcated from aisles by piers or columns.

nave arcade In *basilica* architecture, the series of *arches* supported by *piers* or *columns* separating the *nave* from the *aisles*.

necropolis (nŭ-'krop-ŭ-lŭs) Greek, "city of the dead." A large burial area or cemetery.

nemes ('ne-mes) In ancient Egypt, the linen headdress worn by the pharaoh, with the uraeus cobra of kingship on the front.

Neoclassicism A style of art and architecture that emerged in the later 18th century. Part of a general revival of interest in classical cultures, Neoclassicism was characterized by the utilization of themes and styles from ancient Greece and Rome.

Neo-Expressionism An art movement that emerged in the 1970s and that reflects the artists' interest in the expressive capability of art, seen earlier in *German Expressionism* and *Abstract Expressionism*.

Neolithic (Nē-ō-'lith-ik) The "new" Stone Age.

Neoplasticism A theory of art developed by Piet Mondrian to create a pure plastic art composed of the simplest, least subjective, elements, *primary colors*, primary values, and primary directions (horizontal and vertical).

Neue Sachlichkeit (New Objectivity) ('noi-ŭ 'sa<u>k</u>-li<u>k</u>-kīt) An art movement that grew directly out of the World War I experiences of a group of German artists who sought to show the horrors of the war and its effects.

nimbus A halo or aureole appearing around the head of a holy figure to signify divinity.

nymphs In classical mythology, female divinities of springs, caves, and woods.

C

oculus (pl. oculi) (a-kyū-lus/a-kyū-lē) Latin, "eye." The round central opening of a dome. Also, a small round window in a *Gothic cathedral*.

ogive (adj., ogival) (ō-'jīv/ō-'jī-vŭl) The diagonal *rib* of a *Gothic vault*; a pointed, or Gothic, *arch*.

oil paint Pigment mixed with oil. Oil paint dries more slowly than *tem-pera*, allowing the painter to lay down the color in translucent layers. See *glaze*.

opisthodomos (o-pis-'thad-ŭ-mŭs) In Greek architecture, a porch at the rear of a temple, set against the blank back wall of the cella.

orant ('or-ănt) In Early Christian art, a figure with both arms raised in the ancient gesture of prayer.

oratory The church of a Christian monastery.

orchestra Greek, "dancing place." In ancient Greek theaters, the circular piece of earth with a hard and level surface on which the performance took place.

order In classical architecture, a style represented by a characteristic design of the *columns* and *entablature*. See also *superimposed orders*.

orthogonal (or-'thag-ŭn-ŭl) A line imagined to be behind and perpendicular to the picture plane; the orthogonals in a painting appear to recede toward a vanishing point on the horizon.

Ottonian (adj.) Pertaining to the empire of Otto I and his successors.

P

Paleolithic (pā-lē-ō-'lith-ik) The "old" Stone Age, during which humankind produced the first sculptures and paintings.

palette In ancient Egypt, a slate slab used for preparing makeup. A thin board with a thumb hole at one end on which an artist lays and mixes colors; any surface so used. Also, the colors or kinds of colors characteristically used by an artist.

Pantocrator (pan-'tak-rŭ-tŭr) Christ as ruler and judge of heaven and earth.

papyrus (pŭ-'pī-rŭs) A plant native to Egypt and adjacent lands used to make paperlike writing material; also, the material or any writing on it.

parapet A low, protective wall along the edge of a balcony or roof.

parchment Lambskin prepared as a surface for painting or writing.

paten A large bowl to hold the bread used in the Eucharist.

patricians Roman freeborn landowners.

pebble mosaic Mosaic made of irregularly shaped stones of various colors.

pediment In classical architecture, the triangular space (gable) at the end of a building, formed by the ends of the sloping roof above the *colonnade*; also, an ornamental feature having this shape.

pendant The large hanging terminal element of a Gothic fan vault.

pendentive A concave, triangular section of a hemisphere, four of which provide the transition from a square area to the circular base of a covering *dome*. Although pendentives appear to be hanging (pendant) from the dome, they in fact support it.

peplos ('pep-los) A simple long woolen belted garment worn by ancient Greek women.

Performance art An American *avant-garde* art trend of the 1960s that made time an integral element of art. It produced works in which movements, gestures, and sounds of persons communicating with an audience replace physical objects. Documentary photographs are generally the only evidence remaining after these events. See also *Happenings*.

peripteral (pŭ-'rip-tŭr-ŭl) See peristyle.

peristyle ('per-rŭ-stīl) In classical architecture, a colonnade all around the cella and its porch(es). A peripteral colonnade consists of a single row of columns on all sides; a dipteral colonnade has a double row all around.

personification An abstract idea represented in bodily form.

perspective A method of presenting an illusion of the three-dimensional world on a two-dimensional surface. In linear perspective, the most common type, all parallel lines or surface edges converge on one, two, or three vanishing points located with reference to the eye level of the viewer (the horizon line of the picture), and associated objects are rendered smaller the farther from the viewer they are intended to seem. Atmospheric, or aerial, perspective creates the illusion of distance by the greater diminution of color intensity, the shift in color toward an almost neutral blue, and the blurring of contours as the intended distance between eye and object increases.

photomontage (fō-tō-mon-'taj) A composition made by pasting together pictures or parts of pictures, especially photographs. See also collage.

Photorealists See Superrealism.

piazza Italian, "plaza" or "square." An open-air public space.

pier A vertical, freestanding masonry support.

Pietà (pē-a-'ta) A painted or sculpted representation of the Virgin Mary mourning over the body of the dead Christ.

pilaster A flat, rectangular, vertical member projecting from a wall of which it forms a part. It usually has a *base* and a *capital* and is often *fluted*.

pillar Usually a weight-carrying member, such as a *pier* or a *column*; sometimes an isolated, freestanding structure used for commemorative purposes.

pinnacle In *Gothic* churches, a sharply pointed ornament capping the *piers* or flying *buttresses*; also used on church *facades*.

Pittura Metafisica (pēt-'tū-ra me-ta-'fē-sē-ka) Italian, "metaphysical painting." An early-20th-century Italian art movement led by Giorgio de Chirico, whose work conveys an eerie mood and visionary quality.

plan The horizontal arrangement of the parts of a building or of the buildings and streets of a city or town, or a drawing or diagram showing such an arrangement. In an axial plan, the parts of a building are organized longitudinally, or along a given *axis*; in a central plan, the parts of the structure are of equal or almost equal dimensions around the center.

plane A flat or two-dimensional surface.

plate tracery See tracery.

poesia (pō-e-zē-ŭ) A term describing "poetic" art, notably Venetian Renaissance painting, which emphasizes the lyrical and sensual.

pointed arch A narrow *arch* of pointed profile, in contrast to a semi-circular arch.

pointillism ('poin-tŭ-liz-ŭm) A system of painting devised by the 19th-century French painter Georges Seurat. The artist separates color into its component parts and then applies the component colors to the canvas in tiny dots (points). The image becomes comprehensible only from a distance, when the viewer's eyes optically blend the pigment dots. Sometimes referred to as divisionism.

polyptych ('pa-lŭp-tĭk) An *altarpiece* made up of more than three sections.

pontifex maximus Latin, "chief priest." The high priest of the Roman state religion, often the emperor himself.

Pop art A term coined by British art critic Lawrence Alloway to refer to art, first appearing in the 1950s, that incorporated elements from consumer culture, the mass media, and popular culture, such as images from motion pictures and advertising.

portico ('por-tŭ-kō) A roofed colonnade; also an entrance porch.

post-and-lintel system A system of construction in which two posts support a *lintel*.

postmodernism A reaction against modernist *formalism*, seen as elitist. Far more encompassing and accepting than the more rigid confines of modernist practice, postmodernism offers something for everyone by accommodating a wide range of styles, subjects, and formats, from traditional easel painting to *installation* and from abstraction to illusionistic scenes. Postmodern art often includes irony or reveals a self-conscious awareness on the part of the artist of the processes of art making or the workings of the art world.

Post-Painterly Abstraction An American art movement that emerged in the 1960s and was characterized by a cool, detached rationality emphasizing tighter pictorial control. See also *color field painting*.

predella (prŭ-'del-lŭ) The narrow ledge on which an *altarpiece* rests on an altar.

prefiguration In Early Christian art, the depiction of Old Testament persons and events as prophetic forerunners of Christ and New Testament events.

Pre-Raphaelite Brotherhood A group of 19th-century artists who refused to be limited to contemporary scenes and chose instead to represent fictional, historical, and fanciful subjects in a style influenced by Italian artists before Raphael.

primary colors Red, yellow, and blue—the colors from which all other colors may be derived. print An artwork on paper, usually produced in multiple impressions.

pronaos ('pro-nā-os) The space, or porch, in front of the *cella*, or *naos*, of an ancient Greek temple.

proscenium The part of a theatrical stage in front of the curtain.

prostyle ('prō-stīl) A style of ancient Greek temple in which the columns are only in front of the cella and not on the sides or back.

provenance ('prō-vŭ-nans) Origin or source; findspot.

psalter ('sol-tŭr) A book containing the Psalms.

pseudoperipteral (sū-dō-pŭ-'rip-tŭr-ŭl) In Roman architecture, a pseudoperipteral temple has a series of *engaged columns* all around the sides and back of the *cella* to give the appearance of a *peripteral colonnade*.

putto (pl. putti) ('pū-tō/'pū-ti) A cherubic young boy.

pylon ('pī-lan) A simple and massive gateway with sloping walls.

pylon temple The type of Egyptian temple, characteristic of the New Kingdom, entered through a monumental *pylon*.

C

qibla ('kē-blŭ) The direction (toward Mecca) that *Muslims* face when praying.

quadrant arch An *arch* whose curve extends for one quarter of a circle's circumference.

quadro riportato ('kwa-drō re-por-'ta-tō) A ceiling design in which painted scenes are arranged in panels that resemble framed pictures transferred to the surface of a shallow, curved *vault*.

quatrefoil ('ka-trŭ-foil) A shape or plan in which the parts assume the form of a cloverleaf.

R

radiating chapels In medieval churches, chapels for the display of *relics* that opened directly onto the *ambulatory* and the *transept*.

raking cornice The cornice on the sloping sides of a pediment.

Rayonnant (rā-yō-'nan) The "radiant" style of *Gothic* architecture, dominant in the second half of the 13th century and associated with the French royal court of Louis IX at Paris.

Realism A movement that emerged in mid-19th-century France. Realist artists represented the subject matter of everyday life (especially that which up until then had been considered inappropriate for depiction) in a relatively naturalistic mode.

red-figure painting In Greek pottery, the silhouetting of red figures against a black background, with painted linear details; the reverse of *black-figure painting*.

refectory (rŭ-'fek-tŭ-rē) The dining hall of a Christian monastery.

Regionalism A 20th-century American movement that portrayed American rural life in a clearly readable, Realist style. Major Regionalists include Grant Wood and Thomas Hart Benton.

register One of a series of superimposed bands or *friezes* in a pictorial narrative, or the particular levels on which motifs are placed.

relics The body parts, clothing, or objects associated with a holy figure, such as the Buddha or Christ or a Christian saint.

relief In sculpture, figures projecting from a background of which they are part. The degree of relief is designated high, low (bas), or sunken. In the last, the artist cuts the design into the surface so that the highest projecting parts of the image are no higher than the surface itself. See also repoussé.

relieving triangle In Mycenaean architecture, the triangular opening above the *lintel* that serves to lighten the weight to be carried by the lintel itself.

reliquary ('rel-ŭ-kwe-rē) A container for keeping relics.

repoussé (rǔ-pū-'sā) Formed in *relief* by beating a metal plate from the back, leaving the impression on the face. The metal is hammered into a hollow mold of wood or some other pliable material and finished with a *graver*. See also *relief*.

respond An *engaged column*, *pilaster*, or similar element that either projects from a *compound pier* or some other supporting device or is bonded to a wall and carries one end of an *arch*.

retable (rē-'tā-bŭl) An architectural screen or wall above and behind an altar, usually containing painting, sculpture, carving, or other decorations. See also *altarpiece*.

revetment (ru-'vet-munt) In architecture, a wall covering or facing.

rib A relatively slender, molded masonry arch that projects from a surface. In Gothic architecture, the ribs form the framework of the vaulting. A diagonal rib is one of the ribs that form the X of a groin vault. A transverse rib crosses the nave or aisle at a 90-degree angle.

rib vault A *vault* in which the diagonal and transverse *ribs* compose a structural skeleton that partially supports the masonry *web* between them.

Rococo (rō-kō-'kō) A style, primarily of interior design, that appeared in France around 1700. Rococo interiors were extensively decorated and included elegant furniture, small sculpture, ornamental mirrors, easel paintings, *tapestries*, *reliefs*, and *mural* painting.

Romanesque (rō-mŭ-'nesk) "Romanlike." A term used to describe the history, culture, and art of medieval western Europe from ca. 1050 to ca. 1200.

Romanticism A Western cultural phenomenon, beginning around 1750 and ending about 1850, that gave precedence to feeling and imagination over reason and thought. More narrowly, the art movement that flourished from about 1800 to 1840.

rose window A circular stained-glass window.

rotulus ('rat-yū-lūs) The manuscript scroll used by Egyptians, Greeks, Etruscans, and Romans; predecessor of the *codex*.

rotunda (rō-'tŭnd-ŭ) The circular area under a *dome*; also a domed round building.

roundel A circular painting or relief sculpture, also called a tondo.

rusticate To give a rustic appearance by roughening the surfaces and beveling the edges of stone blocks to emphasize the joints between them. Rustication is a technique employed in ancient Roman architecture, and popular during the Renaissance, especially for stone courses at the ground-floor level.

rustication Rough, unfinished masonry; see rusticate.

S

sarcophagus (pl. sarcophagi) (sar-'kof-ŭ-gŭs/sar-'kof-ŭ-gī) Latin, "consumer of flesh." A coffin, usually of stone.

saturation The brightness or dullness of a hue.

satyr ('sāt-ŭr) A part-human, part-goat male follower of the ancient Greek god Dionysos.

school A chronological and stylistic classification of works of art with a stipulation of place.

scriptorium (pl. scriptoria) (skrip-'tor-ē-um/skrip-'tor-ē-ŭ) The writing studio of a monastery.

sculpture in the round Freestanding figures, carved or modeled in three dimensions.

secondary colors Orange, green, and purple, obtained by mixing pairs of *primary colors* (red, yellow, blue).

Second Style The style of Roman *mural* painting in which the aim was to dissolve the confining walls of a room and replace them with the illusion of a three-dimensional world constructed in the artist's imagination.

section In architecture, a diagram or representation of a part of a structure or building along an imaginary *plane* that passes through it vertically. Drawings showing a theoretical slice, or cross-section, across a structure's width are lateral sections. Those cutting through a building's length are longitudinal sections. See also *elevation* and *cutaway*.

senate Latin, "council of elders." The legislative body in Roman constitutional government.

serdab (sŭ(r)-'dab) A small concealed chamber in an Egyptian mastaba for the statue of the deceased. sexpartite vault (seks-'par-tīt vault) See vault.

sfumato (sfū-'ma-tō) A smokelike haziness that subtly softens outlines in painting; particularly applied to the painting of Leonardo and Correggio.

shaft The tall, cylindrical part of a *column* between the *capital* and the *base*

silverpoint A *stylus* made of silver, used in drawing in the 14th and 15th centuries because of the fine line it produced and the sharp point it maintained.

sinopia The burnt-orange pigment used in drawing on the *arriccio* in *fresco* painting.

skene The scene building of a Greek theater.

skenographia (skā-no-gra-'fē-ŭ) Greek, "scene painting." The Greek term for *perspective* painting.

slip A mixture of fine clay and water used in ceramic decoration.

spandrel ('spăn-drul) The roughly triangular space enclosed by the curves of adjacent arches and a horizontal member connecting their vertexes; also, the space enclosed by the curve of an arch and an enclosing right angle. The area between the arch proper and the framing columns and entablature.

spectrum The full range of visible wavelengths of light.

sphinx (sfengks) A mythical Egyptian beast with the body of a lion and the head of a human.

springing The lowest stone of an *arch*. In *Gothic* vaulting, the lowest stone of a diagonal or transverse *rib*.

squinch (skwinch) An architectural device used as a transition from a square to a polygonal or circular base for a *dome*. It may be composed of *lintels*, *corbels*, or *arches*.

stained glass In *Gothic* architecture, the colored glass used for windows. stanza (pl. stanze) ('stan-zā/'stan-zē) Italian, "room."

stele (pl. stelae) ('stē-lē/'stē-lē) A carved stone slab used to mark graves or to commemorate historical events.

still life A picture depicting an arrangement of objects.

stringcourse A raised horizontal molding, or band in masonry, ornamental but usually reflecting interior structure.

stylobate ('stī-lŭ-bāt) The uppermost *course* of the platform of a Greek temple, which supports the *columns*.

stylus ('stī-lŭs) A needlelike tool used in *engraving* and *incising*; also, an ancient writing instrument used to inscribe clay or wax tablets.

subtractive light The light reflected from painting pigments and objects.

subtractive sculpture A kind of sculpture technique in which materials are taken away from the original mass; carving.

sultan A Muslim ruler.

Sunnah ('su-nŭ) Collection of the Prophet Muhammad's moral sayings and descriptions of his deeds.

superimposed orders Orders of architecture that are placed one above another in an arcaded or colonnaded building, usually in the following sequence: Doric (the first story), Ionic, and Corinthian. Superimposed orders are found in later Greek architecture and were used widely by Roman and Renaissance builders.

Superrealism A school of painting and sculpture of the 1960s and 1970s that emphasized producing artworks based on scrupulous fidelity to optical fact. The Superrealist painters were also called Photorealists because many used photographs as sources for their imagery.

Suprematism A type of art formulated by Kazimir Malevich to convey his belief that the supreme reality in the world is pure feeling, which attaches to no object and thus calls for new, nonobjective *forms* in art—shapes not related to objects in the visible world.

Surrealism A successor to *Dada*, Surrealism incorporated the improvisational nature of its predecessor into its exploration of the ways to express in art the world of dreams and the unconscious. Biomorphic Surrealists, such as Joan Miró, produced largely abstract *compositions*. Naturalistic Surrealists, notably Salvador Dalí, presented recognizable scenes transformed into a dream or nightmare image.

symbol In art, an image that stands for another image or encapsulates an idea.

Symbolism A late-19th-century movement based on the idea that the artist was not an imitator of nature but a creator who transformed the facts of nature into a symbol of the inner experience of that fact.

symmetria (sim-ŭ-'trē-ŭ) Greek, "commensurability of parts." Polykleitos's treatise on his *canon* of proportions incorporated the principle of symmetria.

Synthetic Cubism A later phase of *Cubism*, in which paintings and drawings were constructed from objects and shapes cut from paper or other materials to represent parts of a subject, in order to engage the viewer with pictorial issues, such as figuration, realism, and abstraction.

taberna (ta-'ber-na) In Roman architecture, a single-room shop usually covered by a barrel *vault*.

tablinum ('ta-bli-num) The study or office in a Roman house.

tapestry A weaving technique in which the weft threads are packed densely over the warp threads so that the designs are woven directly into the fabric.

technique The processes that artists employ to create *form*, as well as the distinctive, personal ways in which they handle their materials and tools.

tempera ('tem-pŭ-rŭ) A technique of painting using pigment mixed with egg yolk, glue, or casein; also the *medium* itself.

templon ('tem-plan) The columnar screen separating the sanctuary from the main body of a Byzantine church.

tenebrism ('ten-ŭ-briz(-ŭ)m) Painting in the "dark manner," using violent contrasts of light and dark, as in the work of Caravaggio.

tepidarium (tep-ŭ-'dă-rē-ŭm) The warm-bath section of a Roman bathing establishment.

terracotta (te-rŭ-'ko-tŭ) Hard-baked clay, used for sculpture and as a building material. It may be *glazed* or painted.

tesserae ('tes-ŭ-rē) Greek, "cubes." Tiny stones or pieces of glass cut to the desired shape and size to form a *mosaic*.

tetrarchy (te-'trar-kē) Greek, "rule by four." A type of Roman government established in the late third century CE by Diocletian in an attempt to establish order by sharing power with potential rivals.

texture The quality of a surface (rough, smooth, hard, soft, shiny, dull) as revealed by light. In represented texture, a painter depicts an object as having a certain texture even though the paint is the actual texture.

theatron (thē-'ăt-ron) Greek, "place for seeing." In ancient Greek theaters, the slope overlooking the *orchestra* on which the spectators sat.

Theotokos (thē-'ō-tō-kos) Greek, "bearer of God." The Virgin Mary, the mother of Jesus.

Third Style In Roman *mural* painting, the style in which delicate linear fantasies were sketched on predominantly monochromatic backgrounds.

tholos (pl. tholoi) ('thō-los/'thō-loi) In classical architecture, a temple with a circular plan. In Mycenaean architecture, a beehive-shaped burial chamber.

thrust The outward force exerted by an *arch* or a *vault* that must be counterbalanced by a *buttress*.

tondo See roundel.

torque (tork) The neck band worn by Gauls.

tracery Ornamental stonework for holding *stained glass* in place, characteristic of *Gothic cathedrals*. In plate tracery the glass fills only the "punched holes" in the heavy ornamental stonework. In bar tracery the stained-glass windows fill almost the entire opening, and the stonework is unobtrusive.

transept ('trăn-sept) The part of a church with an *axis* that crosses the *nave* at a right angle.

transverse arch An arch separating one vaulted bay from the next.

transverse rib See rib.

tribune In church architecture, a gallery over the inner *aisle* flanking the *nave*.

triclinium (tri-'klin-ē-um) The dining room of a Roman house.

trident The three-pronged pitchfork associated with the ancient Greek sea god Poseidon (Roman, Neptune).

triforium (tri-'for-ē-ŭm) In a *Gothic cathedral*, the *blind arcaded* gallery below the *clerestory*; occasionally the arcades are filled with *stained glass*.

triglyph ('tri-glif) A triple projecting, grooved member of a *Doric frieze* that alternates with *metopes*.

trilithons ('tri-lith-onz) A pair of *monoliths* topped with a *lintel*; found in *megalithic* structures.

triptych ('trip-tik) A three-paneled painting or altarpiece.

triumphal arch In Roman architecture, a freestanding *arch* commemorating an important event, such as a military victory or the opening of a new road. In Christian architecture, the arch framing the *apse* at the end of a church *nave*.

trompe l'oeil (tronp 'loi) French, "fools the eye." A form of illusionistic painting that aims to deceive viewers into believing that they are seeing real objects rather than a representation of those objects.

true fresco See fresco.

trumeau (trū-'mō) In church architecture, the *pillar* or center post supporting the *lintel* in the middle of the doorway.

tumulus (pl. tumuli) ('tū-myū-lus/'tū-myū-li) Burial mound; in Etruscan architecture, tumuli cover one or more subterranean multichambered tombs cut out of the local tufa (limestone).

tunnel vault See vault.

Tuscan column The standard type of Etruscan column. It resembled ancient Greek *Doric* columns, but was made of wood, was unfluted, and had a *base*.

twisted perspective A convention of representation in which part of a figure is shown in profile and another part of the same figure is shown frontally; a composite view.

tympanum (pl. tympana) ('tim-pŭ-nŭm/'tim-pŭ-nŭ) The space enclosed by a *lintel* and an *arch* over a doorway.

uraeus The rearing cobra, part of the royal headdress of Egyptian pharaohs.

ushabti (ū-'shăb-te) In ancient Egypt, a figurine placed in a tomb to act as a servant to the deceased in the afterlife.

V

value The lightness or darkness of a hue.

vanishing point The point on which all *orthogonal* lines converge in a composition employing one-point *perspective*.

vanitas ('va-nē-tas) A term describing paintings (particularly 17th-century Dutch still lifes) that include references to death.

vault A masonry roof or ceiling constructed on the *arch* principle. A barrel or tunnel vault, semicylindrical in cross-*section*, is in effect a deep arch or an uninterrupted series of arches, one behind the other, over an oblong space. A quadrant vault is a half-barrel vault. A groin or cross vault is formed at the point at which two barrel vaults intersect at right angles. In a ribbed vault, there is a framework of *ribs* or arches under the intersections of the vaulting sections. A sexpartite vault is a vault whose ribs divide the vault into six compartments. A fan vault is a vault characteristic of English Perpendicular *Gothic*, in which radiating ribs form a fanlike pattern.

vaulting web See web.

vellum Calfskin prepared as a surface for writing or painting.

veristic (ver-'is-tik) True to natural appearance; superrealistic.

volute (vŭ-'lūt) A spiral, scroll-like form characteristic of the ancient Greek *Ionic* capital.

votive offering A gift of gratitude to a deity.

voussoir (vū-'swar) A wedge-shaped block used in the construction of a true arch. The central voussoir, which sets the arch, is the keystone.

 \bigvee

web In *Gothic* architecture, the masonry blocks that fill the area between the *ribs* of a groin *vault*.

westwork The *facade* and towers at the western end of a medieval church, principally in Germany.

wet fresco See fresco.

white-ground painting An ancient Greek vase painting technique in which the pot was first covered with a *slip* of very fine white clay, over which black *glaze* was used to outline figures, and diluted brown, purple, red, and white were used to color them.

woodcut A wooden block on the surface of which those parts not intended to print are cut away to a slight depth, leaving the design raised; also, the printed impression made with such a block.

This list of books is intended to be comprehensive enough to satisfy the reading interests of the beginning art history student and general reader, as well as those of more advanced readers who wish to become acquainted with fields other than their own. The resources listed range from works that are valuable primarily for their reproductions to those that are scholarly surveys of schools and periods. No entries for periodical articles are included.

GENERAL STUDIES

- Baxandall, Michael. Patterns of Intention: On the Historical Explanation of Pictures. New Haven: Yale University Press, 1985.
- Broude, Norma, and Mary D. Garrard, eds. *The Expanding Discourse: Feminism and Art History.* New York: HarperCollins, 1992.
- Bryson, Norman, Michael Ann Holly, and Keith Moxey. *Visual Theory: Painting and Interpretation.* New York: Cambridge University Press, 1991.
- Chadwick, Whitney. Women, Art, and Society. New York: Thames & Hudson, 1990.
- Cheetham, Mark A., Michael Ann Holly, and Keith Moxey, eds. *The Subjects of Art History: Historical Objects in Contemporary Perspective*. New York: Cambridge University Press, 1998.
- Chilvers, Ian, and Harold Osborne, eds. *The Oxford Dictionary of Art*. Rev. ed. New York: Oxford University Press, 1997.
- Cummings, P. Dictionary of Contemporary American Artists. 6th ed. New York: St. Martin's Press, 1994.
- Deepwell, K., ed. *New Feminist Art*. Manchester: Manchester University Press, 1994.
- Encyclopedia of World Art. 15 vols. New York: Publisher's Guild, 1959–1968. Supplementary vols. 16, 1983; 17, 1987.
- Fleming, John, Hugh Honour, and Nikolaus Pevsner. *Penguin Dictionary of Architecture*. 4th ed. New York: Penguin, 1991.
- Frazier, Nancy. The Penguin Concise Dictionary of Art History. New York: Penguin, 2000.
- Freedberg, David. The Power of Images: Studies in the History and Theory of Response. Chicago: University of Chicago Press, 1989.
- Haggar, Reginald G. A Dictionary of Art Terms: Architecture, Sculpture, Painting, and the Graphic Arts. Poole: New Orchard Editions, 1984.
- Hall, James. *Dictionary of Subjects and Symbols in Art.* 2nd rev. ed. London: J. Murray, 1979.
- Hauser, Arnold. *The Sociology of Art*. Chicago: University of Chicago Press, 1982.
- Holt, Elizabeth Gilmore, ed. *A Documentary History of Art.* 2nd ed. 2 vols. Princeton, N.J.: Princeton University Press, 1981.
- Hults, Linda C. The Print in the Western World: An Introductory History. Madison: University of Wisconsin Press, 1996.
- Kostof, Spiro. A History of Architecture: Settings and Rituals. 2nd ed. New York: Oxford University Press, 1995.
- Kultermann, Udo. *The History of Art History*. New York: Abaris, 1993. Murray, Peter, and Linda Murray. *A Dictionary of Art and Artists*. 5th ed. New York: Penguin, 1988.
- Nelson, Robert S., and Richard Shiff, eds. *Critical Terms for Art History*. Chicago: University of Chicago Press, 1996.
- Penny, Nicholas. *The Materials of Sculpture*. New Haven: Yale University Press, 1993.
- Pevsner, Nikolaus. A History of Building Types. London: Thames & Hudson, 1987. Reprint of 1979 ed.
- Pierce, James Smith. From Abacus to Zeus: A Handbook of Art History. 7th ed. Upper Saddle River, N.J.: Pearson Prentice Hall, 2004. Placzek, Adolf K., ed. Macmillan Encyclopedia of Architects. 4 vols.
- New York: Macmillan, 1982. Podro, Michael. *The Critical Historians of Art.* New Haven: Yale Uni-
- Podro, Michael. *The Critical Historians of Art.* New Haven: Yale University Press, 1982.
- Pollock, Griselda. Vision and Difference: Femininity, Feminism and Histories of Art. London: Routledge, 1988.

- Preziosi, Donald, ed. *The Art of Art History: A Critical Anthology.* New York: Oxford University Press, 1998.
- Reid, Jane D. The Oxford Guide to Classical Mythology in the Arts 1300-1990s. 2 vols. New York: Oxford University Press, 1993.
- Roth, Leland M. Understanding Architecture: Its Elements, History, and Meaning. New York: Harper & Row, 1993.
- Slatkin, Wendy. Women Artists in History: From Antiquity to the 20th Century. 2nd ed. Upper Saddle River, N.J.: Prentice Hall, 1985.
- Stangos, Nikos. The Thames & Hudson Dictionary of Art and Artists. Rev. ed. New York: Thames & Hudson, 1994.
- Steer, John, and Antony White. Atlas of Western Art History: Artists, Sites and Monuments from Ancient Greece to the Modern Age. New York: Facts on File, 1994.
- Stratton, Arthur. The Orders of Architecture: Greek, Roman and Renaissance. London: Studio, 1986.
- Sutton, Ian. Western Architecture: From Ancient Greece to the Present. New York: Thames & Hudson, 1999.
- Trachtenberg, Marvin, and Isabelle Hyman. Architecture, from Prehistory to Post-Modernism. 2nd ed. New York: Abrams, 2002.
- Turner, Jane, ed. *The Dictionary of Art.* 34 vols. New York: Grove Dictionaries, 1996.
- Van Pelt, R., and C. Westfall. Architectural Principles in the Age of Historicism. New Haven: Yale University Press, 1991.
- Wittkower, Rudolf. Sculpture Processes and Principles. New York: Harper & Row, 1977.

CHAPTER 1 Prehistory and the First Civilizations

Prehistory

- Bahn, Paul G. *The Cambridge Illustrated History of Prehistoric Art*. New York: Cambridge University Press, 1998.
- Bahn, Paul G., and Jean Vertut. *Journey through the Ice Age*. Berkeley: University of California Press, 1997.
- Chippindale, Christopher. Stonehenge Complete. New York: Thames & Hudson, 1994.
- Cunliffe, Barry, ed. The Oxford Illustrated Prehistory of Europe. New York: Oxford University Press, 1994.
- Mellaart, James. The Neolithic of the Near East. New York: Scribner, 1975.
- Ruspoli, Mario. The Cave of Lascaux: The Final Photographs. New York: Abrams, 1987.
- Scarre, Chris. Exploring Prehistoric Europe. New York: Oxford University Press, 1998.

Ancient Near East

- Amiet, Pierre. Art of the Ancient Near East. New York: Abrams, 1980. Bienkowski, Piotr, and Alan Millard, eds. Dictionary of the Ancient Near East. Philadelphia: University of Pennsylvania Press, 2000.
- Collon, Dominique. Ancient Near Eastern Art. Berkeley: University of California Press, 1995.
- Crawford, Harriet. Sumer and the Sumerians. New York: Cambridge University Press, 1991.
- Curtis, John E. Ancient Persia. Cambridge, Mass.: Harvard University Press, 1990.
- Frankfort, Henri. The Art and Architecture of the Ancient Orient. 5th ed. New Haven: Yale University Press, 1996.

Meyers, Eric M., ed. The Oxford Encyclopedia of Archaeology in the Near East. New York: Oxford University Press, 1997.

Parrot, André. The Arts of Assyria. New York: Golden Press, 1961.

——. Sumer: The Dawn of Art. New York: Golden Press, 1961.
Reade, Julian E. Assyrian Sculpture. Cambridge, Mass.: Harvard University Press, 1999.

. Mesopotamia. Cambridge, Mass.: Harvard University Press,

Roaf, Michael. Cultural Atlas of Mesopotamia and the Ancient Near East. New York: Facts on File, 1990.

Sasson, Jack M., ed. Civilizations of the Ancient Near East. New York: Scribner, 1995.

Snell, Daniel C. Life in the Ancient Near East: 3100–332 B.C. New Haven: Yale University Press, 1997.

Strommenger, Eva, and Max Hirmer. 5000 Years of the Art of Mesopotamia. New York: Abrams, 1964.

Egypt

Arnold, Dorothea, ed. Egyptian Art in the Age of the Pyramids. New York: Abrams, 1999.

Baines, John, and Jaromír Málek. Atlas of Ancient Egypt. New York: Facts on File, 1980.

Bard, Kathryn A., ed. Encyclopedia of the Archaeology of Ancient Egypt. London: Routledge, 1999.

Davis, Whitney. *The Canonical Tradition in Ancient Egyptian Art.* New York: Cambridge University Press, 1989.

Lehner, Mark. The Complete Pyramids: Solving the Ancient Mysteries. New York: Thames & Hudson, 1997.

Málek, Jaromír. Egyptian Art. London: Phaidon, 1999.

Redford, Donald B., ed. *The Oxford Encyclopedia of Ancient Egypt*. New York: Oxford University Press, 2001.

Robins, Gay. The Art of Ancient Egypt. Cambridge, Mass.: Harvard University Press, 1997.

Schulz, Regina, and Matthias Seidel, eds. Egypt: The World of the Pharaohs. Cologne: Könemann, 1999.

Shafer, Byron E., ed. *Temples of Ancient Egypt*. Ithaca, N.Y.: Cornell University Press, 1997.

Shaw, Ian, and Paul Nicholson. *The Dictionary of Ancient Egypt*. London: British Museum, 1995.

Silverman, David P., ed. *Ancient Egypt*. New York: Oxford University Press, 1997.

Smith, William Stevenson, and William Kelly Simpson. *The Art and Architecture of Ancient Egypt*. Rev. ed. New Haven: Yale University Press, 1998.

Wildung, Dietrich. Egypt: From Prehistory to the Romans. Cologne: Taschen, 1997.

CHAPTER 2 Greece

Prehistoric Aegean

Cadogan, Gerald. Palaces of Minoan Crete. London: Methuen, 1980.

Cullen, Tracey, ed. Aegean Prehistory: A Review. Boston: Archaeological Institute of America, 2001.

Dickinson, Oliver P.T.K. *The Aegean Bronze Age*. New York: Cambridge University Press, 1994.

Doumas, Christos. *The Wall-Paintings of Thera*. Athens: Thera Foundation, 1992.

Fitton, J. Lesley. Cycladic Art. Cambridge, Mass.: Harvard University Press, 1989.

-----. The Discovery of the Greek Bronze Age. London: British Museum, 1995.

Forsyth, Phyllis Young. Thera in the Bronze Age. New York: Peter Lang, 1997

Getz-Preziosi, Patricia. Sculptors of the Cyclades: Individual and Tradition in the Third Millennium B.C. Ann Arbor: University of Michigan Press, 1987.

Immerwahr, Sarah A. Aegean Painting in the Bronze Age. University Park: Pennsylvania State University Press, 1990.

Preziosi, Donald, and Louise A. Hitchcock. Aegean Art and Architecture. New York: Oxford University Press, 1999.

Taylour, Lord William. The Mycenaeans. London: Thames & Hudson, 1990.

Warren, Peter. The Aegean Civilisations from Ancient Crete to Mycenae. 2nd ed. Oxford: Elsevier-Phaidon, 1989.

Greece

Biers, William. *The Archaeology of Greece: An Introduction*. 2nd ed. Ithaca, NY.: Cornell University Press, 1996.

Boardman, John. Athenian Black Figure Vases. Rev. ed. New York: Thames & Hudson, 1985.

— . Athenian Red Figure Vases: The Archaic Period. New York: Thames & Hudson, 1988.

——. Greek Sculpture: The Archaic Period. Rev. ed. New York: Thames & Hudson, 1985.

— . Greek Sculpture: The Late Classical Period and Sculpture in Colonies and Overseas. New York: Thames & Hudson, 1995.

Fullerton, Mark D. *Greek Art.* New York: Cambridge University Press, 2000.

Hurwit, Jeffrey M. The Art and Culture of Early Greece, 1100-480 B.C. Ithaca, NY.: Cornell University Press, 1985.

— The Athenian Acropolis: History, Mythology, and Archaeology from the Neolithic Era to the Present. New York: Cambridge University Press, 1999.

Lawrence, Arnold W., and R. A. Tomlinson. *Greek Architecture*. Rev. ed. New Haven: Yale University Press, 1996.

Martin, Roland. Greek Architecture: Architecture of Crete, Greece, and the Greek World. New York: Electa/Rizzoli, 1988.

Mattusch, Carol C. Classical Bronzes: The Art and Craft of Greek and Roman Statuary. Ithaca, N.Y.: Cornell University Press, 1996.

Morris, Sarah P. Daidalos and the Origins of Greek Art. Princeton, N.J.: Princeton University Press, 1992.

Osborne, Robin. Archaic and Classical Greek Art. New York: Oxford University Press, 1998.

Pedley, John Griffiths. *Greek Art and Archaeology*. 3rd ed. Upper Saddle River: Prentice Hall, 2003.

Pollitt, Jerome J. Art in the Hellenistic Age. New York: Cambridge University Press, 1986.

Rhodes, Robin F. Architecture and Meaning on the Athenian Acropolis. New York: Cambridge University Press, 1995.

Ridgway, Brunilde S. *The Archaic Style in Greek Sculpture*. 2nd ed. Chicago: Ares, 1993.

— Fourth-Century Styles in Greek Sculpture. Madison: University of Wisconsin Press, 1997.

——. Hellenistic Sculpture I: The Styles of ca. 331–200 B.C. Madison: University of Wisconsin Press, 1990.

------. Hellenistic Sculpture II: The Styles of ca. 200–100 B.C. Madison: University of Wisconsin Press, 2000.

Robertson, Martin. A History of Greek Art. Rev. ed. 2 vols. New York: Cambridge University Press, 1986.

Smith, R.R.R. Hellenistic Sculpture. New York: Thames & Hudson, 1991.

Spivey, Nigel. Greek Art. London: Phaidon, 1997.

Stewart, Andrew. *Greek Sculpture: An Exploration*. 2 vols. New Haven: Yale University Press, 1990.

CHAPTER 3 The Roman Empire

Etruria

Bonfante, Larissa, ed. Etruscan Life and Afterlife: A Handbook of Etruscan Studies. Detroit: Wayne State University Press, 1986.

Brendel, Otto J. Etruscan Art. 2nd ed. New Haven: Yale University Press, 1995. Haynes, Sybille. *Etruscan Civilization: A Cultural History*. Los Angeles: J. Paul Getty Museum, 2000.

Spivey, Nigel. Etruscan Art. New York: Thames & Hudson, 1997.

Sprenger, Maja, Gilda Bartoloni, and Max Hirmer. *The Etruscans: Their History, Art, and Architecture.* New York: Abrams, 1983.

Torelli, Mario, ed. The Etruscans. New York: Rizzoli, 2001.

Rome

Andreae, Bernard. The Art of Rome. New York: Abrams, 1977.

Claridge, Amanda. Rome: An Oxford Archaeological Guide. New York: Oxford University Press, 1998.

Clarke, John R. *The Houses of Roman Italy, 100 B.C.-A.D. 250.* Berkeley: University of California Press, 1991.

D'Ambra, Eve. *Roman Art*. New York: Cambridge University Press, 1998. Elsner, Jaś. *Imperial Rome and Christian Triumph*. New York: Oxford University Press, 1998.

Hannestad, Niels. Roman Art and Imperial Policy. Aarhus: Aarhus University Press, 1986.

Kleiner, Diana E.E. Roman Sculpture. New Haven: Yale University Press, 1992.

Kraus, Theodor. Pompeii and Herculaneum: The Living Cities of the Dead. New York: Abrams, 1975.

Ling, Roger. Roman Painting. New York: Cambridge University Press, 1991.

MacDonald, William L. The Architecture of the Roman Empire I: An Introductory Study. Rev. ed. New Haven: Yale University Press, 1982.

Pollitt, Jerome J. *The Art of Rome*, 753 B.C.-A.D. 337: Sources and Documents. Rev. ed. New York: Cambridge University Press, 1983.

Ramage, Nancy H., and Andrew Ramage. Roman Art: Romulus to Constantine. 4th ed.\Upper Saddle River, N.J.: Prentice Hall, 2004.

Richardson, Lawrence, jr. A New Topographical Dictionary of Ancient Rome. Baltimore: Johns Hopkins University Press, 1992.

——. *Pompeii: An Architectural History.* Baltimore: Johns Hopkins University Press, 1988.

Wallace-Hadrill, Andrew. Houses and Society in Pompeii and Herculaneum. Princeton, N.J.: Princeton University Press, 1994.

Ward-Perkins, John B. Roman Imperial Architecture. 2nd ed. New Haven: Yale University Press, 1981.

Wilson-Jones, Mark. *Principles of Roman Architecture*. New Haven: Yale University Press, 2000.

Zanker, Paul. The Power of Images in the Age of Augustus. Ann Arbor: University of Michigan Press, 1988.

CHAPTER 4 Early Christianity and Byzantium

Bowersock, G. W., Peter Brown, and Oleg Grabar, eds. *Late Antiquity: A Guide to the Postclassical World*. Cambridge, Mass.: Harvard University Press, 1998.

Cormack, Robin. Byzantine Art. New York: Oxford University Press, 2000.

Elsner, Jaś. *Imperial Rome and Christian Triumph*. New York: Oxford University Press, 1998.

Evans, Helen C., and William D. Wixom, eds. *The Glory of Byzantium:* Art and Culture of the Middle Byzantine Era A.D. 843–1261. New York: Metropolitan Museum of Art, 1997.

Grabar, André. The Beginnings of Christian Art, 200-395. London: Thames & Hudson, 1967.

——. Christian Iconography. Princeton, N.J.: Princeton University Press, 1980.

——. The Golden Age of Justinian: From the Death of Theodosius to the Rise of Islam. New York: Odyssey Press, 1967.

Jensen, Robin Margaret. *Understanding Early Christian Art.* New York: Routledge, 2000.

Koch, Guntram. Early Christian Art and Architecture. London: SCM Press, 1996.

Krautheimer, Richard, and Slobodan Curcić. Early Christian and Byzantine Architecture. 4th rev. ed. New Haven: Yale University Press, 1986.

Lowden, John. Early Christian and Byzantine Art. London: Phaidon, 1997.

Mango, Cyril. Art of the Byzantine Empire, 312-1453: Sources and Documents. Toronto: University of Toronto Press, 1986. Reprint of 1972 ed.

Mathews, Thomas F. Byzantium: From Antiquity to the Renaissance. New York: Abrams, 1998.

Milburn, Robert. Early Christian Art and Architecture. Berkeley: University of California Press, 1988.

Ousterhout, Robert. Master Builders of Byzantium. Princeton, N.J.: Princeton University Press, 2000.

Pelikan, Jaroslav. *Imago Dei: The Byzantine Apologia for Icons*. Princeton, N.J.: Princeton University Press, 1990.

Rodley, Lyn. Byzantine Art and Architecture: An Introduction. New York: Cambridge University Press, 1994.

Webster, Leslie, and Michelle Brown, eds. *The Transformation of the Roman World*, A.D. 400–900. Berkeley: University of California Press, 1997.

CHAPTER 5 The Islamic World

Blair, Sheila S., and Jonathan Bloom. *The Art and Architecture of Islam* 1250–1800. New Haven: Yale University Press, 1994.

Bloom, Jonathan, and Sheila S. Blair. *Islamic Arts*. London: Phaidon, 1997.

Brend, Barbara. *Islamic Art*. Cambridge, Mass.: Harvard University Press. 1991.

Ettinghausen, Richard, Oleg Grabar, and Marilyn Jenkins-Madina. *The Art and Architecture of Islam, 650–1250*. Rev. ed. New Haven: Yale University Press, 2001.

Frishman, Martin, and Hasan-Uddin Khan. The Mosque: History, Architectural Development and Regional Diversity. New York: Thames & Hudson, 1994.

Hattstein, Markus, and Peter Delius, eds. *Islam: Art and Architecture*. Cologne: Könemann, 2000.

Hillenbrand, Robert. *Islamic Architecture: Form, Function, Meaning*. Edinburgh: Edinburgh University Press, 1994.

—. Islamic Art and Architecture. New York: Thames & Hudson, 1999.

Irwin, Robert. Islamic Art in Context: Art, Architecture, and the Literary World. New York: Abrams, 1997.

CHAPTER 6 Early Medieval and Romanesque Europe

Alexander, Jonathan J. G. Medieval Illuminators and Their Methods of Work. New Haven: Yale University Press, 1992.

Andrews, Francis B. *The Mediaeval Builders and Their Methods*. New York: Barnes & Noble, 1993.

Benton, Janetta Rebold. Art of the Middle Ages. New York: Thames & Hudson, 2002.

Cahn, Walter. Romanesque Manuscripts: The Twelfth Century. 2 vols.

London: Miller, 1998. Calkins, Robert G. Medieval Architecture in Western Europe: From A.D.

300 to 1500. New York: Oxford University Press, 1998. Collins, Roger. Early Medieval Europe, 300–1000. New York: St. Martin's Press, 1991.

Conant, Kenneth J. Carolingian and Romanesque Architecture, 800–1200. 4th ed. New Haven: Yale University Press, 1992.

Cross, Frank L., and Elizabeth A. Livingstone, eds. *The Oxford Dictionary of the Christian Church*. 3rd ed. New York: Oxford University Press, 1997.

Davis-Weyer, Caecilia. Early Medieval Art, 300-1150: Sources and Documents. Toronto: University of Toronto Press, 1986. Reprint of 1971 ed.

Diebold, William J. Word and Image: An Introduction to Early Medieval Art. Boulder, Colo.: Westview Press, 2000.

Dodwell, Charles R. *The Pictorial Arts of the West*, 800–1200. New Haven: Yale University Press, 1993.

Harbison, Peter. The Golden Age of Irish Art: The Medieval Achievement 600-1200. New York: Thames & Hudson, 1999.

Hearn, Millard F. Romanesque Sculpture: The Revival of Monumental Stone Sculpture in the Eleventh and Twelfth Centuries. Ithaca, N.Y.: Cornell University Press, 1981.

- Lasko, Peter. Ars Sacra, 800–1200. 2nd ed. New Haven: Yale University Press, 1994.
- Minne-Sève, Viviane, and Hervé Kergall. Romanesque and Gothic France: Architecture and Sculpture. New York: Abrams, 2000.
- Murray, Peter, and Linda Murray. The Oxford Companion to Christian Art and Architecture. New York: Oxford University Press, 1996.
- Nees, Lawrence J. Early Medieval Art. New York: Oxford University Press, 2002.
- Petzold, Andreas. Romanesque Art. New York: Abrams, 1995.
- Ross, Leslie. Medieval Art: A Topical Dictionary. Westport, Conn.: Greenwood, 1996.
- Sekules, Veronica. Medieval Art. New York: Oxford University Press, 2001.
- Snyder, James. Medieval Art: Painting, Sculpture, Architecture, 4th–14th Century. New York: Abrams, 1989.
- Stalley, Roger. Early Medieval Architecture. New York: Oxford University Press, 1999.
- Toman, Rolf, ed. Romanesque: Architecture, Sculpture, Painting. Cologne: Könemann, 1997.

CHAPTER 7 Gothic Europe

- Bomford, David. Art in the Making: Italian Painting before 1400. London: National Gallery, 1989.
- Bony, Jean. French Gothic Architecture of the Twelfth and Thirteenth Centuries. Berkeley: University of California Press, 1983.
- Borsook, Eve, and Fiorelli Superbi Gioffredi. *Italian Altarpieces* 1250–1550: Function and Design. Oxford: Clarendon Press, 1994.
- Branner, Robert. Manuscript Painting in Paris during the Reign of St. Louis. Berkeley: University of California Press, 1977.
- St. Louis and the Court Style in Gothic Architecture. London: Zwemmer, 1965.
- Camille, Michael. *Gothic Art: Glorious Visions*. New York: Abrams, 1996. Cole, Bruce. *Sienese Painting: From Its Origins to the Fifteenth Century*. New York: HarperCollins, 1987.
- Courtenay, Lynn T., ed. The Engineering of Medieval Cathedrals. Aldershot: Scolar, 1997.
- Erlande-Brandenburg, Alain. *The Cathedral: The Social and Architectural Dynamics of Construction*. New York: Cambridge University Press, 1994.
- Frankl, Paul, and Paul Crossley. *Gothic Architecture*. New Haven: Yale University Press, 2000.
- Grodecki, Louis, and Catherine Brisac. Gothic Stained Glass, 1200–1300. Ithaca, N.Y.: Cornell University Press, 1985.
- Maginnis, Hayden B. J. *Painting in the Age of Giotto: A Historical Reevaluation.* University Park: Pennsylvania State University Press, 1997.
- . The World of the Early Sienese Painter. University Park: Pennsylvania State University Press, 2001.
- Minne-Sève, Viviane, and Hervé Kergall. Romanesque and Gothic France: Architecture and Sculpture. New York: Abrams, 2000.
- Moskowitz, Anita Fiderer. *Italian Gothic Sculpture: c. 1250–c. 1400.* New York: Cambridge University Press, 2001.
- Norman, Diana, ed. Siena, Florence, and Padua: Art, Society, and Religion 1280–1400. New Haven: Yale University Press, 1995.
- Radding, Charles M., and William W. Clark. Medieval Architecture, Medieval Learning. New Haven: Yale University Press, 1992.
- Rudolph, Conrad. Artistic Change at St-Denis: Abbot Suger's Program and the Early Twelfth-Century Controversy over Art. Princeton, N.J.: Princeton University Press, 1990.
- Toman, Rolf, ed. The Art of Gothic: Architecture, Sculpture, Painting. Cologne: Könemann, 1999.
- White, John. *Art and Architecture in Italy 1250–1400*. 3rd ed. New Haven: Yale University Press, 1993.
- Williamson, Paul. *Gothic Sculpture*, 1140–1300. New Haven: Yale University Press, 1995.
- Wilson, Christopher. The Gothic Cathedral: The Architecture of the Great Church, 1130–1530. London: Thames & Hudson, 1990.

CHAPTER 8 15th-Century Europe

Alberti, Leon Battista. *Ten Books on Architecture*. Edited by J. Rykwert; translated by J. Leoni. London: Tiranti, 1955. (Written ca. 1450; originally published 1486)

- Baxandall, Michael. Painting and Experience in Fifteenth Century Italy: A Primer in the Social History of Pictorial Style. 2nd ed. New York: Oxford University Press, 1988.
- Campbell, Lorne. The Fifteenth Century Netherlandish Schools. London: National Gallery Publications, 1998.
- Christiansen, Keith, Laurence B. Kanter, and Carl B. Strehle, eds. *Painting in Renaissance Siena*, 1420–1500. New York: Metropolitan Museum of Art, 1988.
- Cole, Alison. Virtue and Magnificence: Art of the Italian Renaissance Courts. New York: Abrams, 1995.
- Cole, Bruce. Masaccio and the Art of Early Renaissance Florence. Bloomington: Indiana University Press, 1980.
- Cuttler, Charles P. Northern Painting from Pucelle to Bruegel. New York: Holt, Rinehart & Winston, 1968.
- De Hamel, Christopher. A History of Illuminated Manuscripts. Oxford: Phaidon, 1986.
- Dempsey, Charles. The Portrayal of Love: Botticelli's Primavera and Humanist Culture at the Time of Lorenzo the Magnificent. Princeton, N.J.: Princeton University Press, 1992.
- Edgerton, Samuel Y., Jr. The Heritage of Giotto's Geometry: Art and Science on the Eve of the Scientific Revolution. Ithaca, N.Y.: Cornell University Press, 1991.
- Gilbert, Creighton, ed. *Italian Art* 1400–1500: Sources and Documents. Evanston, Ill.: Northwestern University Press, 1992.
- Gombrich, E. H. Norm and Form: Studies in the Art of the Renaissance. 4th ed. Oxford: Phaidon, 1985.
- Hall, Marcia B. Color and Meaning: Practice and Theory in Renaissance Painting. New York: Cambridge University Press, 1992.
- Harbison, Craig. The Mirror of the Artist: Northern Renaissance Art in Its Historical Context. New York: Abrams, 1995.
- Hartt, Frederick. History of Italian Renaissance Art: Painting, Sculpture, Architecture. 4th ed. Revised by David G. Wilkins. Upper Saddle River, N.J.: Prentice Hall, 1994.
- Hollingsworth, Mary. Patronage in Renaissance Italy: From 1400 to the Early Sixteenth Century. Baltimore: Johns Hopkins University Press, 1994.
- Jacobs, Lynn F. Early Netherlandish Carved Altarpieces, 1380–1550: Medieval Tastes and Mass Marketing. New York: Cambridge University Press, 1998.
- Kemp, Martin. Behind the Picture: Art and Evidence in the Italian Renaissance. New Haven: Yale University Press, 1997.
- Kempers, Bram. Painting, Power, and Patronage: The Rise of the Professional Artist in the Italian Renaissance. London: Penguin, 1992.
- Kent, F. W., and Patricia Simons, eds. *Patronage, Art, and Society in Renaissance Italy.* Canberra: Humanities Research Centre and Clarendon Press, 1987.
- Lane, Barbara G. The Altar and the Altarpiece: Sacramental Themes in Early Netherlandish Painting. New York: Harper & Row, 1984.
- Müller, Theodor. Sculpture in the Netherlands, Germany, France and Spain, 1400–1500. New Haven: Yale University Press, 1986.
- Murray, Peter. *The Architecture of the Italian Renaissance*. Rev. ed. New York: Schocken, 1986.
- Murray, Peter, and Linda Murray. *The Art of the Renaissance*. London: Thames & Hudson, 1985.
- Olson, Roberta J. M. *Italian Renaissance Sculpture*. London: Thames & Hudson, 1992.
- Snyder, James. Northern Renaissance Art: Painting, Sculpture, the Graphic Arts from 1350 to 1575. New York: Abrams, 1985.
- Thomson, David. Renaissance Architecture: Critics, Patrons, and Luxury. Manchester: Manchester University Press, 1993.
- Turner, A. Richard. Renaissance Florence: The Invention of a New Art. New York: Abrams, 1997.
- Vasari, Giorgio. *Lives of the Painters, Sculptors and Architects*. Translated by Gaston du C. de Vere. New York: Knopf, 1996. (Originally published 1550)
- Welch, Evelyn. Art and Society in Italy 1350–1500. New York: Oxford University Press, 1997.
- White, John. *The Birth and Rebirth of Pictorial Space*. 3rd ed. Boston: Faber & Faber, 1987.
- Wolfthal, Diane. The Beginnings of Netherlandish Canvas Painting, 1400–1530. New York: Cambridge University Press, 1989.

CHAPTER 9 16th-Century Europe

Blunt, Anthony. Art and Architecture in France, 1500–1700. 4th ed. New Haven: Yale University Press, 1982.

Brown, Patricia Fortini. Art and Life in Renaissance Venice. New York: Abrams, 1997.

Farago, Claire, ed. Reframing the Renaissance: Visual Culture in Europe and Latin America, 1450–1650. New Haven: Yale University Press, 1995.

Freedberg, Sydney J. *Painting in Italy:* 1500–1600. 3rd ed. New Haven: Yale University Press, 1993.

Gibson, W. S. "Mirror of the Earth": The World Landscape in Sixteenth Century Flemish Painting. Princeton, N.J.: Princeton University Press, 1989

Hall, Marcia B. After Raphael: Painting in Central Italy in the Sixteenth Century. New York: Cambridge University Press, 1999.

Harbison, Craig. The Mirror of the Artist: Northern Renaissance Art in Its Historical Context. New York: Abrams, 1995.

Holt, Elizabeth Gilmore, ed. A Documentary History of Art. Vol. 2, Michelangelo and the Mannerists. Rev. ed. Princeton, N.J.: Princeton University Press, 1982.

Humfry, Peter. Painting in Renaissance Venice. New Haven: Yale University Press, 1995.

Huse, Norbert, and Wolfgang Wolters. *The Art of Renaissance Venice: Architecture, Sculpture, and Painting.* Chicago: University of Chicago Press, 1990.

Landau, David, and Peter Parshall. *The Renaissance Print:* 1470–1550. New Haven: Yale University Press, 1994.

Partridge, Loren. The Art of Renaissance Rome. New York: Abrams, 1996. Pietrangeli, Carlo, André Chastel, John Shearman, John O'Malley, S. J., Pierluigi de Vecchi, Michael Hirst, Fabrizio Mancinelli, Gianluigi Colalucci, and Franco Bernbei. The Sistine Chapel: The Art, the History, and the Restoration. New York: Harmony Books, 1986.

Shearman, John K. G. Mannerism. Baltimore: Penguin, 1978.

——. Only Connect . . . Art and the Spectator in the Italian Renaissance. Princeton, N.J.: Princeton University Press, 1990.

Smith, Jeffrey C. German Sculpture of the Later Renaissance, c. 1520–1580: Art in the Age of Uncertainty. Princeton, N.J.: Princeton University Press, 1993.

Stechow, Wolfgang. Northern Renaissance Art, 1400–1600: Sources and Documents. Englewood Cliffs, N.J.: Prentice Hall, 1966.

Summers, David. Michelangelo and the Language of Art. Princeton, N.J.: Princeton University Press, 1981.

CHAPTER 10 Baroque Europe

The Age of Caravaggio. New York: Metropolitan Museum of Art, 1985. Alpers, Svetlana. The Art of Describing: Dutch Art in the Seventeenth Century. Chicago: University of Chicago Press, 1984.

Brown, Christopher. Scenes of Everyday Life: Dutch Genre Painting of the Seventeenth Century. London: Faber & Faber, 1984.

Brown, Jonathan. *The Golden Age of Painting in Spain*. New Haven: Yale University Press, 1991.

——. Kings and Connoisseurs: Collecting Art in Seventeenth-Century Europe. Princeton, N.J.: Princeton University Press, 1994.

Bryson, Norman. Word and Image: French Painting of the Ancien Régime. New York: Cambridge University Press, 1981.

Chastel, André. French Art: The Ancien Regime, 1620–1775. New York: Flammarion, 1996.

Enggass, Robert, and Jonathan Brown. *Italy and Spain*, 1600–1750: Sources and Documents. Englewood Cliffs, N.J.: Prentice Hall, 1970.

Franits, Wayne. Looking at Seventeenth-Century Dutch Art: Realism Reconsidered. New York: Cambridge University Press, 1997.

Haak, Bob. The Golden Age: Dutch Painters of the Seventeenth Century. New York: Abrams, 1984.

Haskell, Francis. Patrons and Painters: A Study in the Relations between Italian Art and Society in the Age of the Baroque. Rev. ed. New Haven: Yale University Press, 1980.

Held, Julius, and Donald Posner. 17th and 18th Century Art: Baroque Painting, Sculpture, Architecture. New York: Abrams, 1971.

Hempel, Eberhard. Baroque Art and Architecture in Central Europe. New York: Viking Penguin, 1977. Martin, John R. Baroque. New York: Harper & Row, 1977.

Mérot, Alain. French Painting in the Seventeenth Century. New Haven: Yale University Press, 1995.

Montagu, Jennifer. Roman Baroque Sculpture: The Industry of Art. New Haven: Yale University Press, 1989.

North, Michael. Art and Commerce in the Dutch Golden Age. New Haven: Yale University Press, 1997.

Rosenberg, Jakob, Seymour Slive, and E. H. ter Kuile. *Dutch Art and Architecture*, 1600–1800. New Haven: Yale University Press, 1979.

Schama, Simon. The Embarrassment of Riches: An Interpretation of Dutch Culture in the Golden Age. Berkeley: University of California Press. 1988.

Summerson, Sir John. Architecture in Britain: 1530–1830. 9th ed. New Haven: Yale University Press, 1989.

Varriano, John. *Italian Baroque and Rococo Architecture*. New York: Oxford University Press, 1986.

CHAPTER 11 Europe and America, 1750-1850

Bermingham, Ann. Landscape and Ideology: The English Rustic Tradition, 1740–1850. Berkeley: University of California Press, 1986.

Boime, A. Art in the Age of Bonapartism, 1800–1815. Chicago: University of Chicago Press, 1990.

Art in the Age of Revolution, 1750–1800. Chicago: University of Chicago Press, 1987.

Bryson, Norman. Tradition and Desire: From David to Delacroix. New York: Cambridge University Press, 1984.

Cooper, Wendy A. Classical Taste in America, 1800–1840. Baltimore: Baltimore Museum of Art, 1993.

Crow, Thomas E. *Painters and Public Life in Eighteenth-Century Paris*. New Haven: Yale University Press, 1985.

Eitner, Lorenz. Neoclassicism and Romanticism, 1750-1850: An Anthology of Sources and Documents. New York: Harper & Row, 1989.

Holt, Elizabeth Gilmore, ed. From the Classicists to the Impressionists: A Documentary History of Art and Architecture in the Nineteenth Century. Garden City, N.J.: Anchor Books/Doubleday, 1966.

Honour, Hugh. Romanticism. New York: Harper & Row, 1979. Kroeber, Karl. British Romantic Art. Berkeley: University of California

Press, 1986.
Mendelowitz, Daniel M. A History of American Art. 2nd ed. New York:

Holt, Rinehart & Winston, 1970.

Middleton, Robin, and David Watkin. Neoclassical and 19th Century

Architecture. 2 vols. New York: Electa/Rizzoli, 1987.

Novotny, Fritz. Painting and Sculpture in Europe, 1780-1880. 3rd ed. Harmondsworth: Penguin, 1988.

Pierson, William. American Buildings and Their Architects. Vol. 1, The Colonial and Neo-Classical Style. Garden City, N.J.: Doubleday, 1970.

Stillman, Damie. English Neo-Classical Architecture. 2 vols. London: Zwemmer, 1988.

Vaughn, William. German Romantic Painting. New Haven: Yale University Press, 1980.

Wolf, Bryan Jay. Romantic Revision: Culture and Consciousness in Nineteenth-Century American Painting and Literature. Chicago: University of Chicago Press, 1986.

CHAPTER 12 Europe and America, 1850-1900

Adams, Steven. The Barbizon School and the Origins of Impressionism. London: Phaidon, 1994.

Benjamin, Roger. Orientalist Aesthetics: Art, Colonialism, and French North Africa, 1880–1930. Berkeley: University of California Press, 2003.

Boime, Albert. The Academy and French Painting in the 19th Century. London: Phaidon, 1971.

Broude, Norma. Impressionism: A Feminist Reading. New York: Rizzoli, 1991.

Chu, Petra ten-Doesschate. Nineteenth-Century European Art. New York: Abrams, 2003.

Clark, T. J. The Painting of Modern Life: Paris in the Art of Manet and His Followers. Princeton, N.J.: Princeton University Press, 1984.

Duncan, Alastair. Art Nouveau. New York: Thames & Hudson, 1994.

- Eisenmann, Stephen F. 19th-Century Art: A Critical History. 2nd ed. New York: Thames & Hudson, 2002.
- Fried, Michael. Manet's Modernism, or, The Face of Painting in the 1860s. Chicago: University of Chicago Press, 1996.
- Garb, Tamar. Bodies of Modernity: Figure and Flesh in Fin-de-Siècle France. New York: Thames & Hudson, 1998.
- Hamilton, George Heard. Painting and Sculpture in Europe, 1880– 1940. 6th ed. New Haven: Yale University Press, 1993.
- Herbert, Robert L. Impressionism: Art, Leisure, and Parisian Society. New Haven: Yale University Press, 1988.
- Holt, Elizabeth Gilmore, ed. *The Expanding World of Art*, 1874–1902. New Haven: Yale University Press, 1988.
- Mainardi, Patricia. The End of the Salon: Art and the State in the Early Third Republic. New York: Cambridge University Press, 1993.
- Middleton, Robin, ed. *The Beaux-Arts and Nineteenth-Century French Architecture*. Cambridge, Mass.: MIT Press, 1982.
- Nochlin, Linda. Impressionism and Post-Impressionism, 1874–1904:
 Sources and Documents. Englewood Cliffs, N.J.: Prentice Hall, 1966.

 Realism and Tradition in Art, 1848–1900: Sources and Docu-
- ments. Englewood Cliffs, N.J.: Prentice Hall, 1966. Novak, Barbara. American Painting of the Nineteenth Century: Realism and the American Experience. New York: Harper & Row, 1979.
- Pollock, Griselda. Vision and Difference: Femininity, Feminism, and Histories of Art. New York: Routledge, 1988.
- Rosenblum, Robert, and Horst W. Janson. 19th Century Art. New York: Abrams, 1984.
- Schapiro, Meyer. Modern Art: 19th and 20th Centuries. New York: Braziller, 1978.
- Shiff, Richard. Cézanne and the End of Impressionism: A Study of the Theory, Technique, and Critical Evaluation of Modern Art. Chicago: University of Chicago Press, 1984.
- Silverman, Debora L. Art Nouveau in Fin-de-Siècle France: Politics, Psychology, and Style. Berkeley: University of California Press, 1989.
- Smith, Paul. Impressionism: Beneath the Surface. New York: Abrams, 1995.
- Taylor, Joshua, ed. *Nineteenth-Century Theories of Art.* Berkeley: University of California Press, 1987.
- Wood, Christopher. The Pre-Raphaelites. New York: Viking Press, 1981.

CHAPTER 13 Europe and America, 1900-1945

- Antliff, Mark. Cultural Politics and the Parisian Avant-Garde. Princeton, N.J.: Princeton University Press, 1993.
- Barr, Alfred H., Jr. Cubism and Abstract Art: Painting, Sculpture, Constructions, Photography, Architecture, Industrial Arts, Theatre, Films, Posters, Typography. Cambridge, Mass.: Belknap, 1986.
- Barron, Stephanie, ed. Degenerate Art: The Fate of the Avant-Garde in Nazi Germany. Los Angeles: Los Angeles County Museum of Art, 1991.
- Bayer, Herbert, Walter Gropius, and Ise Gropius. *Bauhaus*, 1919–1928. New York: Museum of Modern Art, 1975.
- Bearden, Romare, and Harry Henderson. A History of African-American Artists from 1792 to the Present. New York: Pantheon Books, 1993.
- Breton, André. Surrealism and Painting. New York: Harper & Row, 1972. Campbell, Mary Schmidt, David C. Driskell, David Lewis Levering, and Deborah Willis Ryan. Harlem Renaissance: Art of Black America. New York: Studio Museum in Harlem; Abrams, 1987.
- Curtis, William J. R. Modern Architecture Since 1900. Englewood Cliffs, N.J.: Prentice Hall, 1996.
- Davidson, Abraham A. Early American Modernist Painting, 1910–1935. New York: Harper & Row, 1981.
- Eberle, Matthias. World War I and the Weimar Artists: Dix, Grosz, Beckmann, Schlemmer. New Haven: Yale University Press, 1985.
- Elderfield, John. The "Wild Beasts": Fauvism and Its Affinities. New York: Museum of Modern Art, 1976.
- Elsen, Albert. Origins of Modern Sculpture. New York: Braziller, 1974.
 Fer, Briony, David Batchelor, and Paul Wood. Realism, Rationalism, Surrealism: Art between the Wars. New Haven: Yale University Press, 1993.
- Frampton, Kenneth. A Critical History of Modern Architecture. London: Thames & Hudson, 1985.

- Golding, John. Cubism: A History and an Analysis, 1907-1914. Cambridge, Mass.: Belknap, 1988.
- Gordon, Donald E. Expressionism: Art and Idea. New Haven: Yale University Press, 1987.
- Hamilton, George Heard. *Painting and Sculpture in Europe*, 1880–1940. 6th ed. New Haven: Yale University Press, 1993.
- Harrison, Charles, Francis Frascina, and Gill Perry. Primitivism, Cubism, Abstraction: The Early Twentieth Century. New Haven: Yale University Press, 1993.
- Herbert, James D. Fauve Painting: The Making of Cultural Politics. New Haven: Yale University Press, 1992.
- Hurlburt, Laurance P. *The Mexican Muralists in the United States*. Albuquerque: University of New Mexico Press, 1989.
- Jaffé, Hans L. C. De Stijl, 1917-1931: The Dutch Contribution to Modern Art. Cambridge, Mass.: Belknap, 1986.
- Kandinsky, Wassily. Concerning the Spiritual in Art. Translated by M.T.H. Sadler. New York: Dover, 1977.
- Krauss, Rosalind. The Originality of the Avant-Garde and Other Modernist Myths. Cambridge, Mass.: MIT Press, 1986.
- Le Corbusier. *The City of Tomorrow*. Cambridge, Mass.: MIT Press, 1971.

 ———. *Towards a New Architecture*. Translated from the 13th French edition and with an introduction by Frederick Etchells. Oxford: Architectural Press, 1997.
- Lloyd, Jill. German Expressionism: Primitivism and Modernity. New Haven: Yale University Press, 1991.
- Margolin, Victor. The Struggle for Utopia: Rodchenko, Lissitzky, Moholy-Nagy, 1917-1946. Chicago: University of Chicago Press, 1997.
- Motherwell, Robert, ed. *The Dada Painters and Poets: An Anthology.* 2nd ed. Boston: Hall, 1981.
- Richter, Hans. Dada: Art and Anti-Art. London: Thames & Hudson, 1961.
- Rubin, William S. *Dada and Surrealist Art.* New York: Abrams, 1968. Selz, Peter. *German Expressionist Painting*. Reprint. Berkeley: University of California Press, 1974. (Originally published 1957)
- Stott, William. Documentary Expression and Thirties America. New York: Oxford University Press, 1973.
- Tisdall, Caroline, and Angelo Bozzolla. *Futurism*. New York: Oxford University Press, 1978.
- Trachtenberg, Alan. Reading American Photographs: Images as History—Mathew Brady to Walker Evans. New York: Hill and Wang, 1989.
- Vogt, Paul. Expressionism: German Painting, 1905-1920. New York: Abrams, 1980.
- Wright, Frank Lloyd. American Architecture. Edited by Edgar Kaufmann. New York: Horizon, 1955.

CHAPTER 14 Europe and America after World War II

- Anfam, David. Abstract Expressionism. New York: Thames & Hudson, 1990.
- Battcock, Gregory, ed. Minimal Art: A Critical Anthology. New York: Studio Vista, 1969.
- Battcock, Gregory, and Robert Nickas, eds. *The Art of Performance: A Critical Anthology.* New York: Dutton, 1984.
- Beardsley, Richard. Earthworks and Beyond: Contemporary Art in the Landscape. New York: Abbeville Press, 1984.
- Beardsley, John, and Jane Livingston. *Hispanic Art in the United States: Thirty Contemporary Painters and Sculptors.* Houston: Museum of Fine Arts; New York: Abbeville Press, 1987.
- Broude, Norma, and Mary D. Garrard. The Power of Feminist Art: The American Movement of the 1970s, History and Impact. New York: Abrams, 1994.
- Cockcroft, Eva, John Weber, and James Cockcroft. *Toward a People's Art.* New York: Dutton, 1977.
- Goldberg, Rose Lee. *Performance Art: From Futurism to the Present.* Rev. ed. New York: Abrams, 1988.
- Goodman, Cynthia. Digital Visions: Computers and Art. New York: Abrams, 1987.
- Green, Jonathan. American Photography: A Critical History, 1945 to the Present. New York: Abrams, 1984.

- Greenberg, Clement. Collected Essays and Criticism. Edited by John O'Brian. 4 vols. Chicago: University of Chicago Press, 1986–93.
- Grundberg, Andy. *Photography and Art: Interactions since* 1945. New York: Abbeville Press, 1987.
- Hays, K. Michael, and Carol Burns, eds. *Thinking the Present: Recent American Architecture*. New York: Princeton Architectural, 1990.
- Herbert, Robert L. Modern Artists on Art. Englewood Cliffs, N.J.: Prentice Hall, 1971.
- Hertz, Richard, ed. *Theories of Contemporary Art.* 2nd ed. Englewood Cliffs, N.J.: Prentice Hall, 1993.
- Hunter, Sam. An American Renaissance: Painting and Sculpture since 1940. New York: Abbeville Press, 1986.
- Jacobus, John. Twentieth-Century Architecture: The Middle Years, 1940–1964. New York: Praeger, 1966.
- Jencks, Charles. The Language of Post-Modern Architecture. 6th ed. New York: Rizzoli, 1991.
- Jones, Amelia, ed. Sexual Politics: Judy Chicago's Dinner Party in Feminist Art History. Berkeley: University of California Press, 1996.
- Kaprow, Allan. Assemblage, Environments, and Happenings. New York: Abrams, 1966.
- Kirby, Michael. Happenings. New York: Dutton, 1966.
- Leja, Michael. Reframing Abstract Expressionism: Subjectivity and Painting in the 1940s. New Haven: Yale University Press, 1993.
- Lewis, Samella S. *African American Art and Artists*. Rev. ed. Berkeley: University of California Press, 1994.
- Lippard, Lucy R. Mixed Blessings: New Art in a Multicultural America. New York: Pantheon Books, 1990.
- _____. Pop Art. New York: Praeger, 1966.
- Lovejoy, Margot. Postmodern Currents: Art and Artists in the Age of the Electronic Media. Ann Arbor, Mich.: UMI Research Press, 1989.

- Lucie-Smith, Edward. *Movements in Art since 1945*. Rev. ed. New York: Thames & Hudson, 1984.
- Norris, Christopher, and Andrew Benjamin. What Is Deconstruction? New York: St. Martin's Press, 1988.
- Risatti, Howard, ed. *Postmodern Perspectives: Issues in Contemporary Art.* Englewood Cliffs, N.J.: Prentice Hall, 1990.
- Rosen, Randy, and Catherine C. Brawer, eds. Making Their Mark: Women Artists Move into the Mainstream, 1970–1985. New York: Abbeville Press, 1989.
- Sandford, Mariellen R., ed. *Happenings and Other Acts*. New York: Routledge, 1995.
- Sandler, Irving. Art of the Postmodern Era. New York: HarperCollins,
- Sayre, Henry M. The Object of Performance: The American Avant-Garde since 1970. Chicago: University of Chicago Press, 1989.
- Schneider, Ira, and Beryl Korot. Video Art: An Anthology. New York: Harcourt Brace Jovanovich, 1976.
- Shapiro, David, and Cecile Shapiro. Abstract Expressionism: A Critical Record. New York: Cambridge University Press, 1990.
- Sonfist, Alan, ed. Art in the Landscape: A Critical Anthology of Environmental Art. New York: Dutton, 1983.
- Stiles, Kristine, and Peter Selz, eds. *Theories and Documents of Contemporary Art: A Sourcebook of Artists' Writings*. Berkeley: University of California Press, 1996.
- Venturi, Robert, Denise Scott-Brown, and Steven Isehour. Learning from Las Vegas. Cambridge, Mass.: MIT Press, 1972.
- Waldman, Diane. Collage, Assemblage, and the Found Object. New York: Abrams, 1992.
- Wheeler, Daniel. Art since Mid-Century: 1945 to the Present. Englewood Cliffs, N.J.: Prentice Hall, 1991.
- Wood, Paul. Modernism in Dispute: Art since the Forties. New Haven: Yale University Press, 1993.

Key to Abbreviations

AL Alinari/Art Resource, NY BPK

Bildarchiv Preussischer Kulturbesitz/

Art Resource, NY

Canali Canali Photobank, Italy Gir Giraudon/Art Resource, NY Hir Hirmer Fotoarchiv, Munich Lessing Erich Lessing/Art Resource, NY The Metropolitan Museum of Art MMA **RMN** Réunion des Musées Nationaux/Art

Resource, NY

Saskia Saskia Ltd Cultural Documentation

Scala/Art Resource, NY Scala

Note: All references in the following credits are to figure numbers unless otherwise indicated.

Introduction - Aerofilms Limited: 1; akg-images/ Rabatti-Domingie: 2; ©2005 The Georgia O'Keefe Foundation/Artist Rights Society (ARS), New York: 3; © Estate of Ben Shahn/Licensed by VAGA, New York, NY: 4; MMA, gift of Junius S. Morgan, 1919 (19.73.209) Photograph © MMA: 5; © National Gallery, London: CO, 6; MOA Art Museum, Japan: 7; Joachim Blauel/Arthothek: 8; Jürgen Liepe, Berlin: 9; Photograph © 1983 MMA: 10; Nimatallah/Art Resource, NY: 11

Chapter 1—Lessing: 1, 12; Jean Vertut: 2, 3, 5, 28; Hans Hinz: 4; © Gianni Dagli Orti/Corbis: 6; By P. Dorrell and S. Laidlaw, with permission of the "Ain Ghazal Archaeological Project": 7; Pubbli Aer Foto: 8; Reconstruction painting by Martin E. Weaver after Heinrich. From "The Dawn of Civilization," ed. Stuart Piggott, Thames & Hudson, London and New York: 9; Erwin Böhm: 10, 11; © Copyright the Trustees of the British Museum: 13, 18; Joseph Scherschel/National Geographic Society: 14; RMN: 15, 16; Saskia: 17; BPK: 19, 34; The Art Archive/Dagli Orti: 20; Jurgen Liepe: 21; Carolyn Brown/PRI: 23; Simon Harrus/Robert Harding Picture Library: 24; Robert Harding Picture Library: 25; Araldo de Luca: 26, 33; Courtesy, Museum of Fine Arts, Boston. Reproduced with permission. © 2000 Museum of Fine Arts, Boston. All Rights Reserved: 27; Getty Research Library, Wim Swaan Photograph Collection, 96.P.21: 29; John P. Stevens/Ancient Art & Architecture: 30; From Sir Banister Fletcher, A History of Architecture on the Comparative Method, 17th ed., rev. by R. A. Cordingly, 1961. Athlone Press of the University of London and the British Architectural Library, Royal Institute of British Architects: 31; MMA, Purchase, 1890, Levi Hale Willard Bequest (90.35.1): 32; Boltin Picture Library: 35; Rainbird/Robert Harding Picture Library: CO, 36

Chapter 2—The Art Archive/National Archaeological Museum, Athens/Dagli Orti: 1; Getty Research Library, Wim Swaan Photograph Collection, 96.P.21: 3; Studio Kontos: 4, 6; photo Henri Stierlin: 5; © Archivo Iconografico, S.A./Corbis: 7, 45; Photo by Raymond V. Schoder, © 1987 by Bolchazy-Carducci Publishers, Inc.: 8; Lessing: 9; © Vanni Archive/Corbis: 10, 11; Hir: 12; MMA, Rogers Fund, 1914. (14.130.14) Photograph © 1996 MMA: 13; RMN: 14; MMA, Fletcher Fund, 1932. (32.11.1). Photograph © 1993 MMA: 15; © Gianni Dagli Orti/Corbis: 16, 32; Studio Kontos: 17, 28, 33; Summerfield: 18; Vanni/Art Resource, NY: 20; Photo Vatican Museums: 21: RMN: 22; Colorphoto Hans Hinz: CO, 23; From H. Berve and G. Gruben, Greek Temples, Theaters, and Shrines, Harry N. Abrams, Inc., Fig. 41: 24; Ancient Art & Architecture Collection Ltd.: 25; Saskia: 26, 27, 40, 42; Scala: 29, 31, 38, 39, 43, 44; Araldo de Luca: 30; Hilda Westervelt: 35; © Copyright the Trustees of the British Museum: 36; Ancient Art & Architecture Collection Ltd.: 37, 38; Nimatallah/Art Resource, NY: 41; Canali: 46, 47; Photo by Raymond V. Schoder, © 1987 by Bolchazy-Carducci Publishers, Inc.: 48; BPK: 49, 50; Summerfield: 51; RMN: 52, 53; MMA: 54; © 1988 T. Okamura/Photo Vatican Museums: 55

Chapter 3—David Lees: 1; Canali: 2, 19, 20, 31, 42; © Mike Andrews/Ancient Art & Architecture Collection Ltd.: 3; Archivio I.G.D.A., Milano: 4; Ancient Art & Architecture Collection Ltd.: 5; © Araldo de Luca/Corbis: 6, 26, 41; Archivo Iconografico, S.A./Corbis: 7; K. Koskimies: 8; photo Henri Stierlin: CO, 9, 13, 35; German Archaeological Institute, Rome: 10; The Whittlesey Foundation/ Aristide D. Caratzas, Publisher: 11: White Star: 12; Photo Archives Skira, Geneva, Switzerland: 14; Scala: 15, 17, 29, 32, 43; MMA, Rogers Fund, 1903. (03.14.13) Photograph by Schecter Lee. Photograph © 1986 MMA: 16; MMA: 18; © M. Sarri/Photo Vatican Museums: 21; Saskia: 22, 23, 27; Oliver Benn/Tony Stone Images: 24; The Image Bank/Guido Rossi: 25a; Roy Rainford/Robert Harding Picture Library: 25b; Werner Forman/Art Resource, NY: 28; Courtesy James E. Packer and John Burge: 30; Pubbli Aer Foto: 33; De Masi/Canali: 36; Peter Muscato: 37; Fototeca: 38; MMA, Samuel D. Lee Fund, 1940. (40.11.1a) Photograph by Schecter Lee. Photograph © 1986 MMA: 39; Araldo de Luca: 40; Index/Artphoto: 45; Istituto Centrale per il Catalogo e la Documentazione, (ICCD): 46

Chapter 4—Madeline Grimoldi: 1; Foto Archivio Fabbrica di San Pietro in Vaticano: 2; Scala: 4, 5, 7, 8; Hir: 6, 14; Österreichische Nationalbibliothek, Vienna: 9; © Yann Arthus-Bertrand/Corbis: 10; photo Henri Stierlin: 11; Archivio e Studio Folco Quilici, Roma: 13; Canali: 15, 16, 17; Ronald Sheridan/Ancient Art & Architecture: 18; The Art Archive/Dagli Orti: 19; Studio Kontos: 20; Ricciarini/Visconti: 21; Josephine Powell: 22; Bibliothèque Nationale, Paris: 23; Sovfoto/Eastfoto: CO, 24; Archaeological Receipts Fund: 25

Chapter 5 — Yoram Lehmann, Jerusalem: 1; Lessing: 2; © Yann Arthus-Bertrand/Corbis: 3; www. bednorz-photo.de: 4; Adam Woolfitt/Robert Harding Picture Library: CO, 5; C. Rennie/Robert Harding Picture Library: 6; photo Henri Stierlin: 7; MMA: 8; Reproduced by kind permission of the Trustees of the Chester Beatty Library, Dublin: 9; Photographer: Daniel McGrath: 10

Chapter 6—© Copyright The British Museum: 1; The British Library: 2; The Board of Trinity Col-

lege, Dublin, Ireland/Bridgeman Art Library: 3; Kunsthistorischen Museums, Wien: 4; Saint Matthieu, fol. 18. v. MS1. Médiathèque d'Épernay: 5; © The Pierpont Morgan Library/Art Resource, NY: 6; www.bednorz-photo.de: CO, 8, 10, 23, 24; Photo: Dom-Museum, Hildesheim (Frank Tomio): 12; Rheimisches Bildarchiv: 13; Jean Dieuzaide: 14; Conant, Kenneth J., A Brief Commentary On Early Medieval Church Architecture, with Especial Reference to Lost Monuments; Letures given November 7, 8, 9, 14, 15, 16, 1939 at the JHU. © 1942. The Johns Hopkins University Press: 15: akg-images/Stefan Drechsel: 16; Canali: 17; Marvin Trachtenberg: 18; © Florian Monheim: 19; Anthony Kersting: 20; Scala: 21, 25; photo Paul M.R. Maeyaert: 22; Scala: 25; Photograph Speldoorn O Musées royaux d'Art et d'Histoire-Brussels: 26; Lessing: 27; The Master and Fellows of Corpus Christi College, Cambridge: 28; Trinity MS R.17.1.f.283, Eadwine the Scribe: 29; Abtei St. Hildegard: 30; by special permission of the City of Bayeux: 31

Chapter 7—www.bednorz-photo.de: 1, 11, 14, 21, 22, 23; Pubbli Aer Foto: 3; Anthony Scibilia: 4, 9; www.bednorz-photo.de: 5; Hir: 6, 10; photo Paul M.R. Maeyaert: 7; © Angelo Hornak Library: CO, 8; © photo Jean Mazenod, L'art gothique, éditions Citadelles & Mazenod, Paris: 12; Roger-Viollet: 13; Österreichische Nationalbibliothek, Vienna: 15; © The Pierpont Morgan Library/Art Resource, NY: 16; RMN: 17; Aerofilms Limited: 18; © Florian Monheim: 19, 20; Lessing: 24; © Alinari Archives/Corbis: 25, 34; Scala: 26, 28, 29, 30, 32; Summerfield Press: 27; Canali: 31

Chapter 8—Scala: CO, 2, 8, 14, 15, 20, 21, 28, 30; Lessing: 1, 10, 34; Artothek: 3; Copyright © Museo del Prado: 4, 7; Photo Copyright © 1981 Metropolitan Museum of Art. All rights reserved: 5, 11, 24; Copyright © National Gallery, London: 6; BPK: 9a; © Arte & Immagini srl/Corbis: 12, 13; © The Art Archive/Sta Maria del Carmine Florence/Dagli Orti (a): 16; Canali: 17, 27, 29; AL: 19, 32; Ralph Lieberman: 22, 23; © Summerfield Press Ltd.: 25; Saskia: 26; © 1987 M. Sarri/Photo Vatican Museums: 31; G. Giovetti: 33

Chapter 9—Photo Vatican Museums: CO, 9; Scala: 1, 18, 25, 28, 31, 36; © Edimedia/Corbis: 2: RMN: 3; The Royal Collection © 2003 Her Majesty Queen Elizabeth II: 4; Lessing: 5; © 1983 M. Sarri/Photo Vatican Museums: 6; © Michael S. Yamashita/Corbis: 7; © Nippon Television Network Corporation, Tokyo: 9, 11; @ Bracchietti-Zigrosi/Photo Vatican Museums: 10: Canali: 12, 20; Leonard von Matt/Photo Researchers: 14; © Sandro Vannini/Corbis: 15; RMN: 17, 32; AL: 19, 23; Summerfield Press, Ltd.: 21; © Cameraphoto/Art Resource, NY: 24; © Gir: 26; © 1999 Museum of Fine Arts Boston. All rights reserved: 29; National Gallery, London: 30; Uppsala University Art Collection: 33; Photo: Martin Buhler: 34; Kunsthistorisches Museum, Vienna: 35

Chapter 10—Lessing: CO, 16, 18, 26; © Ruggero Vanni/Corbis: 1; Pubbli Aer Foto: 2; © Saskia: 3; Scala: 4, 6, 10, 11; Gabinetto Fotographico Nazionale, ICCD, Rome: 5; Canali: 7, 9, 12; Summerfield Press, Ltd.: 13; © Victoria & Albert Museum, London/Art Resource, NY: 15; Lessing: 16, 18, 26; Royal Institute for the Study and Conservation of Belgium's Artistic Heritage: 17; RMN: 19, 31, 32; Photo Tom Haartsen: 20; © Rijksmuseum, Amsterdam: 21; © English Heritage Photographic Library: 22; © Pierpont Morgan Library/Art Resource, NY: 23; © 2004 Board of Trustees, National Gallery of Art Washington, D.C.: 24; © Mauritshuis, The Hague: 25; Ancient Art and Architecture Collection: 34; A.F. Kersting: 35, 36

Chapter 11—Gir: CO, 12; Scala: 1, 2; Reproduced by permission of the Trustees of The Wallace Collection: 3; Derby Museums and Art Gallery, Derby, Derbyshire: 4; Summerfield Press, Ltd.: 5; © 1999 Board of Trustees, National Gallery of Art, Washington, D.C.: 6; National Gallery, London: 7, 24; National Gallery of Canada: 8; Courtesy, Museum of Fine Arts, Boston. All rights reserved: 9, 25; © Virginia Museum of Fine Arts: 10; RMN: 11, 15, 20, 21, 22; Gir: 12; © The Art Archive/ Galleria Gorghese Rome/Dagli Orti: 13; Monticello/Thomas Jefferson Foundation, Inc: 14; Photo © The Detroit Institute of Arts: 16; Whitworth Art Gallery: 17; © Victoria and Albert Museum, London/Art Resource, NY: 18, 28; @ Museo del Prado: 19; © BPK, Bildarchiv Preussischer/Art Resource, NY: 23; photo © 1995 Metropolitan Museum of Art. All rights reserved: 26; Lessing: 27; © Société Française de Photographie. Tous droits réservés: 29; © Art Resource, NY: 30

Chapter 12—Photography © The Art Institute of Chicago: CO, 14, 15, 20, 22; Bridgeman Art Library: 1; Scala: 2, 25; Philadelphia Museum of Art, Philadelphia: 3; RMN: 4, 5, 12; Photo © MMA. All rights reserved: 6; Jefferson Medical College of Thomas Jefferson University, Philadelphia: 7; Art Resource Technical Services, Hyattsville, MD: 8; © Tate Gallery/Art Resource, NY: 9; © Gir: 10; Lessing: 11, 24; RMN: 12; Glasgow Art Galleries and Museum: 13; Photo © The Detroit Institute of Arts: 16; Yale University Art Gallery, New Haven, Connecticut: 17; © 2004 The Museum of Modern Art, New York/Art Resource, NY: 18; Photograph © Museum of Fine Arts, Boston: 19; Philadelphia Museum of Art, Philadelphia: 21; © 2001 The

Munch Museum/The Munch-EllingsenGroup/Scala/ Art Resource, NY: 23; Scala: 25; © Corbis: 26; Ralph Lieberman: 27

Chapter 13-BPK: CO, 13; © 2006 Succession H. Matisse, Paris/Artists Rights Society (ARS), New York: 1; Scala @ 2006 Succession H. Matisse, Paris/Artists Rights Society (ARS), New York: 2; © MOMA/Art Resource, NY: 3, 6, 10, 13, 11, 12, 20, 22, 24, 25; Photo David Heald @ The Solomon R. Guggenheim Foundation, New: 4; Offentliche Kunstsammlung Basel, Martin Buhler: 5; © 2006 Estate of Pablo Picasso/Artists Rights Society (ARS), New York: 6, 8, 33; © 2006 Artists Rights Society (ARS), New York/ADAGP, Paris: 4, 7, 29; RMN: 8; Bridgeman Art Library © 2006 Artists Rights Society (ARS), New York/SIAE, Rome: 9, 19; © Photo Graydon Wood, 1992 © 2006 Artists Rights Society (ARS), New York/ADAGP, Paris/ Succession Marcel Duchamp: 12, 14; © 2006 Artists Rights Society (ARS), New York/VG Bild-Kunst, Bonn: 11, 17, 18; © 2006 The Georgia O'Keefe Foundation/Artists Rights Society (ARS), New York: 15; Photo by Walter Klein, Dusseldorf: 17; © 2006 Salvador Dali, Gala-Salvador Dali Foundation/Artists Rights Society (ARS), New York: 20; © 1993 Museum Associates, Los Angeles County Museum of Art. All rights reserved. © 2006 C. Herscovici, Brussels/Artists Rights Society (ARS), New York: 21; © 2006 Artists Rights Society (ARS), New York/DACS, London: 22; © Schalkwijk/Art Resource, NY: 23; © 2006 Succession Miro/Artists Rights Society (ARS), New York/ADAGP, Paris: 24; © 2007 Mondrian/ Holtzman Trust c/o HCR International, Warrenton, VA, USA: 26; @ Vanni/Art Resource, NY: 27; Photo courtesy The Mies van der Rohe Archive, The Museum of Modern Art, New York/Art Resource, NY © 2006 Artists Rights Society (ARS), New York/VG Bild-Kunst, Bonn: 28; Photo by Ralph Lieberman © 2006 Artists Rights Society (ARS), New York/ADAGP, Paris/FLC: 29; Ezra Stoller © Esto, All rights reserved © 2006 Frank Lloyd Wright Foundation, Scottsdale, AZ: 30; © Philadelphia Museum of Art/Corbis: 31; Image © 2003 Board of Trustees, National Gallery of Art, Washington, D.C.: 32; Institut Amatller d'Art Hispanic © Museo del Prado: 33; Courtesy The Dorothea Lange Collection, The Oakland Museum of California: 34; Photography © The Art Institute of Chicago: 35; The Phillips Collection,

Washington, D.C.: 36; Photography © The Art Institute of Chicago. © T. H. Benton and R. P. Benton Testamentary Trusts/Licensed by VAGA, New York, NY: 37; Photo © 1986 The Detroit Institute of the Arts/Dirk Bakker © INBA Mexico: 38

Chapter 14—© Robert Rauschenberg/Licensed by VAGA, New York, NY: CO, 16; @ The Museum of Modern Art/Licensed by Scala/Art Resource, NY: 1, 5, 13, 14; Center for Creative Photography: 4; © Kate Rothko Prizel & Christopher Rothko/ARS, NY: 6; © VAGA, NY/Art Resource, NY. Art © Estate of David Smith/Licensed by VAGA, New York, NY: 7; © 2003 Helen Frankenthaler: 8; Art © Donald Judd Foundation/Licensed by VAGA, New York, NY: 9; © Frank Fournier/Contact Press Images/PictureQuest: 10; © CNAC/MNAM/Dist. RMN, NY Art © Estate of Louise Bourgeois/ Licensed by VAGA, New York, NY: 11; © 2006 Artists Rights Society (ARS), New York/VG Bild-Kunst, Bonn: 12, 24; © 2006 Joseph Kosuth/ Artists Rights Society (ARS), New York: 13; Bridgeman Art Library © 2006 Artists Rights Society (ARS), New York/DACS, London: 14; © Jasper Johns/Licensed by VAGA, New York, NY: 15; Offentliche Kunstsammlung Basel/Photo Martin Buhler. © Estate of Roy Lichtenstein: 17; © Tate Gallery, London/Art Resources, NY © 2006 Andy Warhol Foundation for the Visual Arts/ARS, NY: 18; © Estate of Robert Smithson/ Licensed by VAGA, New York, NY: 20; © 1983 Christo photo Wolfgang Volz. Christo & Jeanne-Claude: 21; © Angelo Hornak/Corbis © 2006 Frank Lloyd Wright Foundation, Scottsdale, AZ: 22; © Archivo Iconografico, S.A./Corbis © 2006 Artists Rights Society (ARS), New York/ADAGP, Paris/FLC: 23; © Ezra Stoller/ESTO/Arcaid: 24; Peter Aaron © Esto: 25; Richard Bryant © Esto/ Arcaid: 26; © FMGB Guggenheim Bilbao Museoa © 1997 Erica Barahona Ede, photographer. All rights reserved. Partial or total reproduction prohibited: 27; Courtesy Sperone Westwater: 28; © Judy Chicago/ARS, NY, photo © Donald Woodman © 2006 Judy Chicago/Artists Rights Society (ARS), New York: 29; Courtesy of the artist and Metro Pictures: 30; Courtesy: Mary Boone Gallery, New York: 31; Courtesy Guerrilla Girls: 32; © 1983 Faith Ringgold: 33; Jaune Quick-to-See Smith: 34: Photo Michael Tropea, Chicago: 36; photo © Benny Chan/Fotoworks. Courtesy of the Artist: 38

Boldface names refer to artists.

Pages in italics refer to illustrations. Abakanowicz, Magdalena, Backs, 430, Abbey in the Oak Forest (Friedrich), 336, Abduction of the Sabine Women (Giovanni), 270, 271 Abraham, 228–229, 228 Abrasion, 37 Abstract art: Abstract Expressionism, 407–411, 408, 409, 410; gestural vs. chromatic, 408; Post-Painterly Abstraction, 411, 411 Abstract Expressionism, 407-411, 408, 409, 410 Academies of art, 351 Achaemenid Persian art, 30-31, 30 Achilles and Ajax playing a dice game (Exekias), 62, 62 Achilles Painter, Warrior taking leave of his wife, 76, 76 Acoustics, 295 Acropolis, Athens, 69–75, 69, 70, 71, 72, 73, 74, 75; model of, 69 Action painting, 409-410, 410 Actual space, 7 Actual texture, 7 Adam and Eve: in Early Christian art, 125, 125; in Flemish art, 217–219, 218, 222–223, 223; in Holy Roman Empire art, 275, 275; in Italian, 16thcentury art, 260, 260; in Ottonian art, 166, 166 Adam and Eve (Dürer), 275, 275 Additive light, 7 Additive sculpture, 12 The Advantages of Being a Woman Artist (Guerrilla Girls), 428, 428 Aegean art: Cycladic, 48, 49; Minoan, 49–52, 49, 50, 51, 52; Mycenaean, 52–55, 53, 54, 55. See also Greek art Aeneid (Vergil), 105 Aerial perspective, 101, 101, 230, 230 Aertsen, Pieter, Meat Still-Life, 278–279, African-American artists, 400-401, 401, 428-429, 429 African art and culture: Benin, 10-11, 11; influence on Western painting, 376-378, 37 Age of artworks, 2-3 Ain Ghazal, Jordan, 21, 21 Aisles, 128, 128 Akhenaton, 41–42, 42 Akkadian art, 26–27, 26, 27 Alberti, Leon Battista: On the Art of Building, 236; Church of Sant'Andrea, Mantua, 244-245, 245; On Painting, 230–231; Santa Maria Novella, 235–237, 236 Alexander, Saint, 178, 178 Alexander Mosaic (Philoxenos of Eretria), 79–80, 79 Alexander the Great, 30-31, 77, 79-80, 79; Alexander Mosaic, 79 Alexandros of Antioch-on-the-Meander, Venus de Milo, 83, 84 Alhambra palace, Granada, Spain, 151–152, 151 Allegory of the Art of Painting (Vermeer), 306, 306 306, 306 Altar of Zeus, Pergamon, 81–82, 81 Altarpieces: Flemish, 217–221, 218, 220, 221; German, 225–226, 226; Holy Roman Empire, 272–273, 273; Italian, 16th-century, 251–252, 251, 267, 267; Italian Gothic, 204–205, 205, 207–209, 208, 209; Maesta, Siena Cathedral, 208 Altars: Altar of Zeus, Pergamon, 81-82, 81; Ara Pacis Augustae, Rome, 105–106, 105; Roman, 105

Alternate-support systems, 165, 165, 170-171, 170, 171 Amalienburg lodge (Cuvilliés), 317-318, Amazonomachy, 71 Ambulatory, 129, 129, 186, 186 Amen-Re, temple of, Egypt, 40–41, 40 American art: Abstract Expressionist, 407–411, 408, 409, 410; Armory Show (1913), 383–386, 384, 385; Comic, 416–417, 417; Conceptual, 414, 414; controversies in, 426; Cosmic Cubist, 385–386, 385; Dadaist, 382, 382; early 20th-century sculpture, 396–397, 397; Environmental, 418–420, 419, 420; Great Depression and, 398-400, 399 400; Impressionist, 344, 356–358, 357, 358, 359; later 20th-century history, 405–406; matronage and, 383; Minimalist, 411-413, 411, 412 Modernist architecture, 420–421, 420, 421; Natural architecture, 395–396, 395; Naturalistic, 323–325, 324; Neoclassical, 328–329, 328; Neoclassical, 328–329, 326; Performance art, 414; photography, 342, 342, 384–385, 385, 399, 399; po-litical commentary, 342, 342, 399–401, 399, 400, 401, 425–430, 428, 429, 430; Pop, 404, 415–417, 415, 416, 417; Postmodern architecture, 421–422, 422; Postmodern multimedia, 428-430, 428, 429, 430; Postmodern photography, 427–428, 427, 428; Postmodern sculpture, 425–427, 427, 430, 430, 431; Post-Painterly Abstraction, 411, 411; Realist, 351–353, 351, 352, 353; Romantic, 330, 330, 338–339, 338; skyscrapers, 367-368, 368, 394, 394, 421, 421; Superrealist, 418, 418; timelines, 343, 433; video media, 430–431, American Civil War, 342, 342, 351 American Gothic (Wood), 401–402, 401 Amiens Cathedral (Luzarches, Cormont, and Cormont), 194, 194 Amphitheater, Flavian, 106-107, 107 Amphitheater, Pompeii, 98, 98 Amphoras, 62–63, 62, 63 Amulets, 33 Analytic Cubism, 378–379, 378, 384 Anamorphic image, 276, 276 Anatolia, Neolithic, 20, 20 Anatomical drawing, 254-255, 254 Ancien regime, 320 Ancient Mexico (Rivera), 402, 402 Ancient of Days (Blake), 330-331, 331 Anguissola, Sofonisba, Portrait of the Artist's Sisters and Brother, 269-270, Animals: Assyrian, 28-29, 28, 29; Early Animals: Assyrian, 28–29, 28, 29; Early Christian, 130, 131; Egyptian, 32, 32, 36, 36; Etruscan, 92–93, 92, 93; German Expressionist, 376, 376; Greek Archaic, 61, 61; Greek High Classical, 71, 71; Hiberno-Saxon, 158–159, 158, 159; Holy Roman Empire, 275, 275; Minoan, 50–51, 50, 51; Mycenaean, 53, 53; Neolithic, 20, 20; Paleolithic, 15–19, 16, 17, 18, 19; Romanesque, 174, 176–177, 176, 181, 182 Annunciation (Campin), 221, 221 Annunciation (Fra Angelico), 240-241, Annunciation (Martini and Lippo), 208-209, 209 The Annunciation and the Nativity (Nicola Pisano), 203-204, 204

Antae, 59, 59

Apadana, 31

Anthemius of Tralles, Hagia Sophia, Constantinople, 133–135, *133*, *134* Anthony, Saint, 227, 227, 273, 274

64–65, 64, 65 Aphrodite of Knidos (Praxiteles), 77-78, Apollodorus of Damascus, Forum of Trajan, 110–111, 110, 111 Apostles, 177–178, 177, 274–275, 275 Apoxyomenos (Scraper), Lysippos, 78, 79 Apses, 110, 128, 128 Apsidal sanctuaries, 135 Apulu (Apollo), Veii, 90, 90 Aquaducts, Roman, 106, 106 Ara Pacis Augustae, Rome, 105–106, 105 Arcades, 135 Archaic (Greek) art, 56-65; architecture, 58–61, 59, 60, 64, 64; pottery, 46, 61–64, 61, 62, 63; sculpture, 56–58, 56, 57, 58, 61, 61, 64–65, 65 Archaic smile, 57, 58, 58 Archers of Saint Hadrian (Hals), 300-302, 301 Arches: corbeled, 52; pointed, 186-187, 186; quadrant, 172; transverse, 169, 169; triumphal, 108–109, 108, 109 Architectural drawings, 12, 13 Architecture: Achaemenid Persian, rchitecture: Achaemenid Persian, 30–31, 30, Art Nouveau, 368, 368; Baroque, German, 314, 314; Baroque, Italian, 286–291, 287, 288, 289, 290, 291; Baroque British, 313–314, 313; Baroque French, 310–313, 311, 312; Bauhaus, 393–394, 393, 394; Beaux-Arts, 339, 339; Byzantine, Early, 133–136, 133, 134, 135, 136; Byzantine, Middle 140–142, 142. Byzantine, Middle, 140–142, 142; Carolingian, 162–164, 162, 163; Christian, Early, 126–129, 128, 129; Christian, Early, 126–129, 128, 129; Deconstructivist, 423–424, 424; Etruscan, 89–90, 90; Europe, mid-19th century, 339–340, 339, 340; France, 16th-century, 277, 277; glass-andmetal, 340; Gothic, English, 199-200, 199, 200; Gothic, French, 186–197; Gothic, German, 201, 201; Gothic, Gothic, German, 201, 201; Gothic, Italian, 210–212, 211, 212; Greek Archaic, 58–61, 59, 60, 61, 64, 64; Greek High Classical, 69–75, 69, 70, 71, 72, 73, 74; Hellenistic, 81–82, 81; 71, 72, 73, 74; Hellenistic, 81–82, 81; International Style, 20th-century, 394–395, 395; Islamic, 147–153, 147, 148, 149, 150, 151, 152; Italian, 15th-century, 233–237, 234, 235, 236, 244–245, 245; Italian, 16th-century, 261–265, 262, 263, 264, 265; Minoan, 49–50, 49, 50; Modernist, 420–421, 420, 421; Natural, 395-396, 395; 720, 421; Natural, 373–376, 373; Neo-Baroque, 339, 339; Neoclassical, 328–329, 328; Ottonian, 165–166, 165, 166; Pompeiian, 96–99, 96, 97, 98, 99; Postmodern, 421–423, 422, 423; Realist, 367–368, 367, 368; Rococo, 317–318, 318; Roman Early Empire, 106–108, 107, 108; Roman High Empire, 88, 110-113, 110, 111, 112; Roman Late Empire, 114-115, 114, 118–119, 118, 119; Roman Republic, 94, 95; Romanesque, 167–173, 168, 169, 170, 171, 172 173; skyscrapers, 367-368, 368, 394, 394, 421, 421 Architrave, 59, 59 Arch of Constantine, Rome, 119-120, Arch of Titus, Rome, 108, 108 Arcuated openings, 108 Arena Chapel, Padua, Italy, 205–207, 206, 207 Armatures, 12, 187 Armory Show (1913), 383–386, 384, 385

Arnolfo di Cambio, Florence Cathedral,

Arp, Jean (Hans), Collage Arranged

According to the Laws of Chance, 381–382, 381

211-212, 211

Arriccio, 206

Aphaia, Temple of, Aegina, Greece,

(Rubens), 299-300, 299 Art appreciation, 1 Artemis, Temple of, Corfu, 61, 61 Art history, study of, 1–6, 13 Art Nouveau, 368, 368 Ascension of Christ, 127, 140–141, 141, 177–178, 177, 187–189, 188 Ashlar masonry, 35, 170, 172 Ashurbanipal hunting lions, Nineveh, 29, Assemblages, 416, 416 The Assumption of the Virgin (Riemenschneider), 225-226, 226 Assumption of the Virgin (Titian), 266-267, 267 Assyrian art, 28-29, 28, 29 Athanadoros, Laocoön and his sons, 85-86, 85 Athena: Greek Archaic art, 65, 65; Greek Classical art, 69–71, 69, 74–75, 75; Hellenistic art, 81–82, 81 Athena battling Alkyoneos, Pergamon, 81-82, 82 Athena Nike, Temple of (Kallikrates), 69, 74–75, 74, 75 Atmospheric perspective, 101, 101, 230, Atria (singular, atrium), 98-99, 128, 128 At the Moulin Rouge (Toulouse-Lautrec), 357–358, 358 Attics, 108 Attributes, 5 Attributions, 5–6 Augustus as general, Primaporta, 104, Aule Metele (Arringatore), 93, 93 Austria, 132, 132 Automatism, 390–391, 391 Avant-garde, 346, 373 Awards for the Visual Arts (AVA), 426 Axis, 6 Babylon, ziggurat at, 22–23 Babylonian art, 22–23, 27–30, 27, 30 Backs (Abakanowicz), 430, 430 Bacon, Francis, Painting, 406, 407 Baldacchino, Saint Peter's (Bernini), 287–288, 288 267-268, 288 Baldacchinos, 128, 287-288, 288 Balkans, 142-143, 142, 143 Balla, Giacomo, Dynamism of a Dog on a Leash, 380, 380 Ballet Rehearsal (Degas), 356, 356 Balustrades, 74 The Banality Show (Koons), 430 Banking systems, 286 Barking systems, 266
Baptisteries, 128, 173, 173
Barbizon school, 347–348, 348
Baroque Europe, 284–315; British architecture, 313–314, 313; Dutch painting, 300–308, 301, 302, 303, 304, 305, 306, 307; Flemish painting, 298–300, 298, 299, 300; French art, 308–313, 308, 309, 310, 311, 312; German architecture, 314, 314; Italian architecture, 286–291, 287, 288, 289, 290, ture, 286–271, 287, 288, 289, 290, 291; Italian painting, 284, 291–295, 291, 292, 293, 294, 295; Italian sculpture, 288, 289–290, 289; Spanish painting, 295–298, 296, 297; timeline, Barrel vaults, 97, 97, 106-107, 107, 169-170, 170 Bar tracery, 192 Basilica Nova, Rome, 118-119, 118 Basilicas: Carolingian, 164; domed, 134–135, 134; Early Christian, 127–129, 128, 129; Late Roman Empire, 118–119, 118; Ottonian, 165, 165; Pompeiian, 96, 97; Romanesque, The Basket of Apples (Cézanne), 364,

Arrival of Marie de'Medici at Marseilles

Bas-relief sculpture, 12. See also Relief sculptures The Bath (Cassatt), 344, 356-357, 357 Baths of Caracalla, Rome, 114–115, 114 Battle of Hastings (1066), 181, 182 Battle of Issus (Philoxenos of Eretria), 79–80, 79 Battle of the Ten Nudes (Pollaiuolo), 238, 238 Bauhaus architecture, 393-394, 393, 394 Bayeux Tapestry, 181, 182 Bay Side (Frankenthaler), 411, 411 "Beaubourg," Paris (Rogers and Piano) Beauvais Cathedral (France), 2, 3-4, 12, Beaux-Arts style, 339, 339 Beckmann, Max, *Night*, 386–387, 386 Belgian art, 178, 178, 389, 389 Belvedere, 264 Ben-ben, 34, 35 Benday dots, 417, 417 Benedictine monasteries, 162–164, 163 Benin kingdom, 10-11, 11 Beowulf, 157 Bernard of Clairvaux, 174, 178, 180 Bernini, Gianlorenzo: baldacchino, 287–288, 288; David, 288, 289; Ecstasy of Saint Teresa, 289–290, 289; piazza design, 287, 287; Saint Peter's, Rome, 287–288, 287, 288 Bernward (bishop of Hildesheim), 165–166, 165, 166 Bestiaries, 174 Bestaries, 1/4
Beuys, Joseph, How to Explain Pictures to a Dead Hare, 413–414, 414
Bibles, illustrated, 132, 132; gospels, 158–161, 159, 160, 161; moralized, 197–198, 197, 198; Romanesque, 179–180, 179. See also Illustrated manuscripts Big Self-Portrait (Close), 418, 418 Bilateral symmetry, 36, 37 Bird in Space (Brancusi), 396, 396 Birth of Venus (Botticelli), 238–239, 239 Black Death, 215 Black-figure painting, 61–62, 62 Blake, William, Ancient of Days, 330-331, 331 Blanc, Charles, 363 Blanche of Castile, Louis IX, and two monks, moralized Bible, 197–198, 198 Der Blaue Reiter (The Blue Rider), 374–376, 375, 376 Bliss, Lillie P., 383 Blondel, Francois, engraving of Versailles, Boccaccio, Giovanni, 216 Boccioni, Umberto, Unique Forms of Continuity in Space, 380-381, 380 Bohr, Niels, 371 Book of Hours (Limbourg Brothers), 223–224, 224 Book of Kells, 159-160, 159 Books: Carolingian, 160, 161; Hiberno-Saxon, 159. See also Illustrated manuscripts Borghese, Pauline, 328, 328 Borromini, Francesco, San Carlo alle Quattro Fontaine, Rome, 290–291, Bosch, Hieronymus, Garden of Earthly Delights, 222–223, 223 Botticelli, Sandro, Birth of Venus, 238-239, 239 Bourgeois, Louise, Cumul I, 412–413, 412 Bramante, Donato d'Angelo: Saint Peter's, Rome, 262–263; Tempietto, San Pietro, Rome, 261-262, 262 Brancusi, Constantin, Bird in Space, 396, 396 Braque, Georges, The Portuguese, 378, Breakfast Scene (Hogarth), 322–323, 323 Breton, André, 387 Bridges, 106, 106 British art: Baroque architecture, 313–314, 313; Crystal Palace, 339–340, 340; Enlightenment, 319–321, 320; Gothic, 199–200, 199, 319–321, 320; Gothic, 199–200, 199, 200; Grand Manner portraiture, 322, 322; Hiberno-Saxon, 158–160, 158, 159; Pop, 415, 415; Romanesque, 172, 172, 179–181, 179, 180, 181; Romantic, 330–331, 330, 331, 336–338, 337

Bronze doors, Florence Cathedral (Ghiberti), 214, 228-229, 228, 229 Bronze doors, Saint Michael's, Hildesheim, Germany, 165–166, 166 Findesiteith, Germany, 193–190, 100 Fronze statues: Etruscan, 93, 93; Greek Early Classical, 66, 67; hollow-casting technique, 26, 67, 67; Italian, 15th-century, 237, 237, 239–240, 239 Brucelleschi, Filippo: dome of Florence Cathedral, 234, 234; Sacrifice of Isaac, 228–229, 228; Santa Spirito, 234–235, 234 Die Brucke (The Bridge), 374, 375 Bruegel the Elder, Pieter, Hunters in the Snow, 280, 280 Bulls: Assyrian, 28, 28; Egyptian, 32, 32; Minoan, 50–51, 50; Paleolithic, 18–19, Buon fresco, 206 Burghers of Calais (Rodin), 366-367, 366 The Burial of Count Orgaz (El Greco), 281–282, 281 281–282, 281 Burials: Aegean, 49; Early Christian, 123–125, 124, 125; Early Medieval, 157–158, 158; Egyptian, 32–34, 33, 42–44, 43, 44; Etruscan, 90–92, 91, 92; Greek, 55–56, 55, 75–76, 75, 76; Islamic, 154, 154; mummification, 33; Neolithic, 20; Roman, 95, 116, 116 Burins, 226 Burke, Edmund, A Philosophical Enquiry..., 330 Bury Bible (Master Hugo), 179–180, 179 Buttresses: flying, 190–191, 190, 191; Roman, 97; Romanesque, 171–172 Byron, Lord, Sardanapalus, 334-335, Byzantine art: Early, 122, 132-139 Iconoclasm, 139-140, 250; Middle, 140–144, 140, 141, 142, 143; timeline, 155. See also Early Byzantine art Byzantium, 132. See also Constantinople Caldarium, 114, 114 Calder, Alexander, untitled, 396-397, Caliphs, 148 Calligraphy: Islamic, 152-154, 153. See also Writing Calling of Saint Matthew (Caravaggio), 292–293, 292 Calotype process, 341–342 Calvinism, 250 Camera degli Sposi, Mantua (Mantegna), 245–246, 246 Camera lucida, 340 Camera obscura, 306, 340–341 Cames, 192 Campanile, 173, 173 Campin, Robert, Mérode Altarpiece, 221, Canons, 10, 38 Canova, Antonio, Pauline Borghese as Venus, 328, 328 Canyon (Rauschenberg), 404, 416, 416 Capitalism, industrial, 372 Capitals: Corinthian, 105, 105; Doric, 59, 59, 61; Egyptian, 41, 41; Gothic, 203; Ionic, 59, 59; Romanesque, 174, 174. See also Columns Capitoline Wolf, Rome, 93, 93 Capitolum, Pompeii, 96, 96 Cappella Scrovegni (Arena Chapel), Padua, Italy, 205–207, 206, 207 Caracalla, Baths of, Rome, 114-115, 114 Caracalla, portrait of, 115, 115 Caravaggio: Calling of Saint Matthew, 292–293, 292; Conversion of Saint Paul, 291, 291 Carolingian art, 160-164, 160, 161, 162, 163 Carpet pages, 158-159, 159 Carpets, Islamic, 154, 154 Carracci, Annibale, Loves of the Gods, 293–294, 294 Carthusian order, 217 Cartoons, 206 Carving, 12 Caryatids, 60, 74 Cassatt, Mary, *The Bath*, 344, 356–357,

Castagno, Andrea del, Last Supper, 241,

Casting, 12

Catacomb of Saints Peter and Marcellinus, Rome, 124, 124 Catacombs, 123–124, 124 Çatal Höyük, 20, 20 Cathedral of Notre-Dame, Chartres, France, 187–189, 188, 189 Cathedrals, 172. See also under names of individual cathedrals Cats, Egyptian, 32, 32 Causeways, 36 Cave paintings, Paleolithic, 16-19, 17, Cella, 22, 59, 59, 90 Cennini, Cennino, Il libro dell'arte, 219 Censorship, 426 Centauromachy, 71, 71 Ceramics. See Pottery Cerveteri sarcophagus, 90, 91 Cézanne, Paul: The Basket of Apples, 364, 364; Mont Sainte-Victoire, 362–364, 363 Chaplets, 67 Charlemagne, 160, 162. See also Carolingian art Charles I Dismounted (Van Dyck), 300, Chartres Cathedral, France: High Gothic, 190–194, 192, 193; original, 187–189, 188, 189 Chartreuse de Champmol, Dijon, France, Chartreuse de Chambrid, Dijoli, France, 216–217, 217
Château de Chambord, France, 277, 277
Chevalier, Étienne, 225, 225
Chevreul, Michel-Eugène, 363 Chiaroscuro: in Analytic Cubist painting, 378, 379; in Italian painting, 207, 232, 232, 252–253, 292 Chiastic balance, 69 Chicago, Judy, The Dinner Party, 425-426, 427 Children: in Baroque art, 284, 297–298, 297; in Gothic art, 196, 197; in Impressionist art, 356–357, 357; in Italian, 15th-century art, 242, 242; in Italian, 16th-century art, 251–252, Tanan, 16th-century art, 231–232, 251, 255, 255; in Mannerist art, 269–270, 270; in Roman art, 105, 106 China paper, 226 Chiton, 75, 75 Choirs, 136 Christ: Ascension of, 127, 140–141, 141, 177–178, 177, 187–189, 188; Crucifixion of, 273, 298; delivering the keys to Saint Peter, 243–244, 244; Deposition, 127, 220, 220; descent from the Cross, 268, 269; entering Jerusalem, 125, 125, 127; as Good Shepherd, 124, 124, 130–131, 130; healing the sick, 303–304, 304; as Lamb, 218, 219; Lamentation, 127, 123, 143, 143, 143, 163, 207, 207, 246, 246. 142, 142, 206–207, 207, 246, 246; Last Judgment, 176–177, 176, 261, 261; Last Supper, 241, 241, 252–253, 252, 271–272, 271, 272; miracles of, 126, 131, 131; overview of life in art, 126-127; as Pantokrator, 140, 140; in Pietà, 202-203, 203; Redemption, 205-207, 206; Second Coming of, 127, 175–176, 175, 187–189, 188; tribute money, 231–233, 232. See also Crucifixion of Christ Christ Delivering the Keys of the Kingdom to Saint Peter (Perugino), 243-244, 244 Christian art: during the Counter-Reformation, 250–251, 271–272; Hiberno-Saxon, 158, 159; Middle Byzantine, 140, 141, 142, 143 Christian art, early. See Early Christian Counter-Reformation, 250-251

Christianity: under Constantine, 117; 271–272, 295; Great Schism, 215; Inquisition, 272; Protestantism, 249–250, 272, 278; Scholasticism, 186; Vatican, 15th-century, 243-244, 244 Christ in the House of Levi (Veronese),

Christo, Surrounded Islands, 419-420, 420

Christogram, 137, 137 Christ with the Sick around Him, Receiving the Children (Rembrandt), 303-304, 304

Chromatic abstraction, 408, 410 Chronological overview. See Timelines Chronology, 2 Chronology, 2
Chryselephantine statues, 71
Church design: acoustics, 295; Baroque, 286–287, 287, 290–291, 291, 295; basilicas, 127–129, 128, 129, 134–135, 172–173, 173; Carolingian, 162–164, 162; central plan, 128–129, 129, 135–136, 135, 136, 261–262; components, 191, 191; cruciform, 141–142, 141; Early Byzantine, 134–136, 134, 135, 136; French Gothic, 191; Gothic, 186–196, 191, 199–200, 210–212; Italian, 15th-century, 233–236, 234, 236, 244–245, 245; Italian, 15th-century, 261–264, 245; Italian, 16th-century, 261–264, 262, 263; Middle Byzantine, 140–141, 141; Modernist, 420-421, 421; Ottonian, 165, 165; Romanesque, 168–173, 168, 169, 170, 171, 172, Church of Holy Wisdom, Constantinople (Anthemius of Tralles and Isidorus of Miletus), 133–135, 133, 134 Church of Saint Agnes, Rome, 129 Church of Saint Pantaleimon, Nerezi, Macedonia, 142, 142 Church of Saint Peter at Wimpfen-im-Tal, Germany, 199 Church of the Dormition, Daphni, Greece, 140–141, 140, 141 Cimabue, Madonna Enthroned with Angels and Prophets, 204, 205 'Circles of confusion," 306 Cire perdue method, 67 Cistercians, 164, 174, 178 Citadels: Assyrian, 28, 28; Mycenaean, 52–55, 53, 54, 55; Persian, 30–31, 30 Cities: Çatal Höyük, 20, 20; Mycenaean, 52-55, 53; Neolithic, 20; Rome, 95; Sumerian, 22 Civil War, American, 342, 342, 351 Claesz, Pieter, Vanitas Still Life, 306-307, Clarkson, Thomas, The History of the Abolition of the Slave Trade, 337–338 Class struggle, 346 Claude Lorrain: Embarkation of the

Queen of Sheba, 7-8, 7; Landscape with Cattle and Peasants, 309-310,

Clerestory, 41, 128, 171-172, 171, 191,

Cloisonné, 158, 158 Cloister of Saint-Pierre, Moissac, France, 173–174, 174 Cloisters, 163, 173–174, 174 Close, Chuck, Big Self-Portrait, 418, 418 Cluniac order, 174

Cluster piers, 191, 191 Codex, 131 Coffers, 112

Cole, Thomas, The Oxbow, 338-339, Collage Arranged According to the Laws

of Chance (Arp), 381–382, 381 Collages, 7; Dadaist, 381–382, 381; Pop, 415–416, 415, 416; Synthetic Cubist, 379; video, 431

Cologne Cathedral (Gerhard of Cologne), 166, 167, 201, 201 Colonnades, Egyptian, 39, 39 Colonnettes, 102, 102

Color: in Abstract Expressionism, 410, 410; in Fauvist painting, 373–374, 373, 374; in German Expressionism, 374, 375-376, 376; in Impressionist painting, 354–355, 354; in Italian, 16th-century painting, 266–268, 267; 19th-century color theory, 363; in pointillism, 362–363, 362; in Post-Impressionist painting, 359–364, 360, 361, 362, 363, 364; in Rococo painting, 318; in Romantic painting, 333-335

Color field painting, 411, 411 Colorito, 265
Colosseum (Flavian Amphitheater),
Rome, 106–107, 107
Column of Trajan (Apollodorus of

Damascus), 110, 111, 111
Columns: Corinthian, 105, 105; Doric, 59–61, 59, 64, 64; Early Christian, 129, 129; Egyptian, 41, 41; Etruscan,

Columns: (continued) Cuneiform, 22, 27 Donor portraits: Flemish, 217-219, 218, Enlightenment art and culture, 319–321. 90, 90; Gothic, 187–189, 188, 189, 203; Ionic, 59, 59; Minoan, 50, 50; 221, 221; Gothic, 202, 202; Italian, 15th-century, 233, 233
Doric temples: Greek Archaic, 58–61, 59, Cutaway drawings, 12 Cut with the Kitchen Knife Dada Entablature, 59, 59 Persian, 30, 31; Roman, 94, 95; Romanesque, 169, 169, 171, 173–174, through the Last Weimar Beer Belly 60, 64, 64; Greek High Classical, 70–73, 70, 71

Dormition, Church of the, Daphni, Greece, 140–141, 140, 141 Cultural Epoch of Germany (Höch), 174; superimposed orders, 107, 107 Combines, 416, 416 Comic art, 416–417, 417 382-383, 382 Cuvilliés, Francois de, Hall of Mirrors, the Amalienburg, 317–318, 318 Cycladic art, 48, 49 The Company of Captain Frans Banning
Cocq (Rembrandt), 302–303, 302
Complementary colors, 7, 363
Complexity and Contradiction in Doryphoros (Spear Bearer), Polykleitos, 68–69, 68 Dragons, 178–179, *17*9 Cyclopean masonry, 52 Drama, Greek, 80 Architecture (Venturi), 422 Composite view, 20 Dada, 381-383, 381, 382 Drawing, Italian, 16th-century, 254, 254 Drypoint, 226 Daedalic art, 56 Composition, 6 Daguerre, Louis-Jacques-Mandé, Still Duccio di Buoninsegna, Virgin and Child Composition in Red, Blue, and Yellow (Mondrian), 392–393, 392 Life in Studio, 340–341, 341 Daguerreotype process, 340–341, 341 Dali, Salvador, The Persistence of Enthroned with Saints, 207–208, 208 Duchamp, Marcel, 396; Fountain (second Compound piers, 169, 171, 191, 191 version), 382, 382; Nude Descending a Staircase, No. 2, 384, 384

Dürer, Albrecht, 274–275; The Fall of
Man (Adam and Eve), 275, 275; Four
Apostles, 274–275, 275; The Four
Horsemen of the Apocalypse, 5–6, 5

Durham Cathedral, England, 172, 172 Comte, Auguste, 345 Conceptual art, 414, 414 Memory, 388–389, 388 Damnatio memoriae, 108 Conceptual pictures, 28 Dante Alighieri, Divine Comedy, 197, Concerning the Spiritual in Art (Kandinsky), 375 216 Darwin, Charles, 345 Conches, 135 Daumier, Honore, Rue Transnonain, 348, 63-64, 64 Dutch Republic, Baroque painting, 300–308 Concrete construction, Roman, 97, 97 349 Condottieri, 227 David (Bernini), 288, 289 David (Bernini), 288, 289
David (Donatello), 237–238, 237
David (Michelangelo), 257–258, 258
David, Jacques-Louis: The Death of
Marat, 317, 327, 327; French
Revolution and, 327; Oath of the
Horatii, 326–327, 326
David the psalmist, 142–143, 143, 237, 258, 288, 289; in Baroque art, 288, 289; in Byrannie art, 142–143, 143. Confessions (Rousseau), 329 Dying Gaul (Epigonos), 82-83, 82 Congregational mosques, 150 Dying warrior, Temple of Aphaia, 65, 65 Connoisseurs, 6 Dynamism of a Dog on a Leash (Balla), Constable, John, The Haywain, 336-337, 380, 380 Constantine, 117–120, 118, 119, 126 Constantine, portrait of, 118, 118 Constantinople (Istanbul): Arab invasions Eadwine Psalter (Eadwine), 180, 180 Eadwine the Scribe, Eadwine Psalter, 289; in Byzantine art, 142–143, 143; in 15th-century art, 237–238, 237; in 16th-century art, 257–258, 258 of, 139-140; during the Crusades, 144; Early Byzantine art in, 133–135, 133, 134; founding of, 117 Eakins, Thomas, The Gross Clinic, 352, Dead Christ (Mantega), 246, 246 Contour lines, 6 Early Byzantine art, 133-139; architec-247 Contrapposto: in 15th-century sculpture, 231, 231, 237, 237; in Gothic sculpture, 195, 195; in Greek sculpture, The Death and Life of Great American ture, 133-136, 133, 134, 135, 136; icons, 122, 139, 139; mosaics, 137–138, 137, 138 Cities (Jacobs), 422 Death masks, 14 The Death of General Wolfe (West), Early Christian art, 123–132; architecture, 127–129, *128*, *129*; funerary, 123–125, *124*, *125*; manuscript illumination, 131–132, *132*; mosaics, 66-68, 66, 67, 68 Conversion of Saint Paul (Caravaggio), 291, 291 323-324, 324 The Death of Marat (David), 317, 327, Copley, John Singleton, Portrait of Paul Revere, 324-325, 324 Death of Sardanapalus (Delacroix), 334, 130–131, 130, 131; timeline, 155 Copperworking, 26, 26 334 Early Classical (Greek) art, 65, 66-68, 66, Death of the Virgin, Strasbourg Cathedral, 201–202, 201 Corbeled arches, 52 67, 68; sculpture, 65, 66, 66, 67, 68, 69 Early Empire (Roman) art, 104–109, 104, 105, 106, 107, 108, 109 Corbels, 200 Corinthian columns, 105, 105 De Chirico, Giorgio, Melancholy and Cormont, Renaud de, Amiens Cathedral, 194, 194 Mystery of a Street, 388, 388 Early Medieval art and culture, 157-166; Deconstruction, 423 Carolingian, 160–164, 160, 161, 162, 163; Hiberno-Saxon, 158–160, 158, Cormont, Thomas de, Amiens Cathedral, Deconstructivist architecture, 423-424, 194, 194 159; Ottonian, 165-166, 165, 166, Degas, Edgar, Ballet Rehearsal, 356, 356 Deities: Babylonian, 27-28, 27, 30; Egyptian, 32, 36, 41; Etruscan, 90, 90; Greek, 47-48; Minoan, 51-52, 52; Roman, 116; Sumerian, 22, 24 Le Déjeuner en Fourrure (Oppenheim), Cornaro Chapel, Rome (Bernini), 289, 289 Cornelia Presenting Her Children as Her 167; timeline, 183; warrior lords, 157–158, 158 Treasures (Kauffmann), 325-326, 325 Ebbo Gospels, Hautvillers, France, Cornices, 59, 59 Coronation Gospels, Germany, 160, 160 Cosmic Cubism, 385–386, 385 160-161, 161 Écorché, 238 Ecstasy of Saint Teresa (Bernini), 289–290, 289 Council of Trent, 250-251, 286 389, 389 Le Déjeuner sur l'Herbe (Manet), 348–350, 349 de Kooning, Willem, Woman I, 409, 409 Counterculture, 406 Editions, 226 Counter-Reformation, 250-251. Effects of Good Government in the City 271-272, 286, 295 and in the Country (Lorenzetti), Courbet, Gustave, The Stone Breakers, Delacroix, Eugène, 333–335; Death of Sardanapalus, 334, 334; Liberty Leading the People, 334, 335 209-210, 210 Egyptian art: Early Byzantine, 138–139, 139; New Kingdom, 38–43, 38, 39, 40, 41, 42, 43, 44; Old Kingdom, 34–38, 35, 36, 37, 38; Predynastic and 346-347, 347 Creation of Adam (Michelangelo), 260, Les Demoiselles d'Avignon (Picasso), Creglingen Altarpiece (Riemenschneider), 225–226, 226 Crete, 49–52, 49, 50, 51, 52 Cromlechs, 21, 21 376-378, 377 Early Dynastic periods, 10, 10, 31–34, 32, 33, 34; Roman, 113–114, 114 Deposition (Rogier), 220, 220 Der Sturm, 373 Eiffel, Alexandre-Gustave, Eiffel Tower, Descent from the Cross (Pontormo), 268, Paris, 367, 367 Eiffel Tower, Paris (Eiffel), 367, 367 Einstein, Albert, 371 The Crossing (Viola), 432, 432 Descriptive approach, 19 De Stijl, 392 Crossing squares, 164, 169 Crossing towers, 169 Cross vaults. See Groin vaults Diagonal ribs, 191, 191 Ekkehard and Uta, Naumburg Cathedral, Crucifixion of Christ, 127; in Baroque art, 298, 299; in Carolingian art, 161, Diderot, Denis, Encyclopédie, 320 The Dinner Party (Chicago), 425–426, Germany, 202, 202 Elevation of the Cross (Rubens), 298, 299 161; in Holy Roman Empire art, 272–274, 273; in Italian, 15th-century art, 233, 233; in Middle Byzantine art, 166 Elevations, 12 El Greco, The Burial of Count Orgaz, Dionysiac mystery frieze, Pompeii, 100, 281–282, 281 Embalming, 33, 113 Embarkation of the Queen of Sheba (Claude), 7–8, 7 100 Diorama, 340–341 Diptychs, 224–225, 225, 417, 417 Disegno, 254, 254, 265 Diskobolos (Myron), 68, 68 140-141, 141; in Ottonian art, 166, Crusades, 144, 177–178 The Cry (Munch), 365, 365 Crystal Palace, London (Paxton), (Claude), 7–8, 7 Embroidery, 181, 182 Empiricism, 319–320, 345 Encaustic, 58, 113–114, 114, 139, 139 Encyclopédie (Diderot), 320 Engaged columns, 94, 95 England, 5ca Patrick, art Disproportion, 10 Divine Comedy (Dante), 197, 216 Djoser, Stepped Pyramid of, 33–34, 34 Dome of the Rock, Jerusalem, 147–149, 339–340, 340 *Cubicula*, 124, 124 Cubism: Analytic, 378–379, 378; Cosmic, 385–386, 385; origin of, 376–378, 377, 397–398, 398; Synthetic, 379, 379 Dome-shaped vaults, 54, 54 Domes on pendentives, 134–135, 134 Donatello: *David*, 237–238, 237; England. See British art Engravings, 226–227, 227, 238, 238, 275, 275; German, 15th-century, 227; Facades: Baroque, 286–287, 287, 290–291, 290, 313–314, 313; Gothic, 188, 194–195, 195, 199; Greek, 60; Cubi XVIII (Smith), 410-411, 410 Gattamelata, 239-240, 239; Saint Mark, 231, 231 Cult statues, 58 Cumul I (Bourgeois), 412–413, 412 Holy Roman Empire, 275; Italian, 15th-century, 238

Environmental art, 418–420, 419, 420 Epidauros theatre (Polykleitos the Younger), 80-81, 80 Epigonos, Dying Gaul, 82–83, 82 Epistyle, 59, 59 Equestrian statues: Italian, 15th-century, 239-240, 239; Roman, 113, 113 Erechtheion, 69, 73-74, 74 Ergotism, 274 Eroticism: Hellenistic, 83-84, 84 Eshnunna statuettes (Iraq), 24, 24 Etchings, 226; Baroque, 303–304, 304; Romantic, 330–332, 331; 20th-century, 387, 387 Étienne Chevalier and Saint Stephen (Fouquet), 224–225, 225 Et in Arcadia Ego (Poussin), 308–309, 308 Etruscan art and culture, 89-93, 90, 91, Euphronios, Herakles wrestling Antaios, Europe, Gothic. See Gothic art and culture Europe, 15th-century, 215–247; Flemish art, 216–223, 217, 218, 220, 221, 222, 223; French art, 223–225, 224, 225; German art, 225–227, 226, 227; humanism in, 216; Hundred Years' War, 215; Italian architecture, 233–237, 215; Italian architecture, 233–237, 234, 235, 236; Italian painting, 231–233, 232, 233, 238–243, 239, 240, 241, 242, 243; Italian princely courts, 243–246, 244, 245, 246; Italian sculpture, 214, 227–231, 228, 229, 231, 237, 237, 239–240, 239; timeline, 477 Europe, 16th-century, 248-283; French urope, 16th-century, 248–283; French art, 277, 277; Giorgione, 265–266, 266; Holy Roman Empire, 272–277, 273, 275, 276; Italian architecture, 261–265, 262, 263, 264, 265; Italian painting, 251–257, 251, 252, 253, 254, 255, 256, 265–268, 266, 267; Leonardo da Vinci, 250–255, 251, 252, 253, 254; Mannerism, 268–272, 269, 270, 271, 272, 281–282, 281; Michelangelo Buonarroti, 249 Michelangelo Buonarroti, 249, 257–261, 258, 259, 260, 261, 263–264, 263; Netherlands, 278–280, 278, 279, 280; Raphael, 255–257, 255, 256; Spanish art, 280–282, 281; timeline, 283; Titian, 266–268, 267 timeline, 283; Ittian, 266–268, 267 Europe, Baroque. See Baroque Europe Europe, early 20th-century: Analytic Cubism, 378–379, 378; Bauhaus architecture, 393–394, 393, 394; Cubism, 376–378, 377, 397–398, 398; Dada, 381–383, 381, 382; expressionism in, 373; Fauvism, 373–374, 373, 374; Futurism, 380-381, 380; German Expressionism, 374–376, 375, 376; history of, 371–372; International Style architecture, 394–395, 395; Neoplasticism, 392-393, 392; Neue Recopisations, 372–373, 372; Nede Sachlichkeit, 386–387, 386, 387; sculpture, 396, 396; Suprematism, 391–392, 392; Surrealism, 387–391, 388, 389, 390, 391; Synthetic Cubism, 379, 379; timeline, 403 Europe, postwar 20th-century: Deconstructivist architecture, 423-424, 424; Modernist architecture, 420-421, 421; performance art, 413–414, 414; Pop art, 415, 415; Postmodernism, 422–425, 423, 425; Postmodern painting, 425; Postwar Expressionism, 406–407, 407; timeline, 433 Euthymides, Three revelers, 46, 63–64, Exedras, 111
Exekias, Achilles and Ajax playing a dice game, 62, 62 Existentialism, 406, 407 Expressionism, 373; Abstract, 407–411, 408, 409, 410; German, 374–376, 375, 376; Neo-Expressionism, 425, 425; Postwar, 406–407, 407 Fabric arts, 428-429, 429

Italian, 15th-century, 236-237, 236, 244-245, 245; Neo-Baroque, 339, 339 Faience, 52 Fallingwater (Wright), 395–396, 395 The Fall of Man (Dürer), 275, 275 Fan vaults, 200, 200 Fasciae, 59, 59 Fate of the Animals (Marc), 376, 376 Fauces, 98–99, 99
Fauvism, 373–374, 373, 374
Female artists. See Women artists Female figures: Abstract Expressionist, 409, 409; Baroque, 289–290, 289; Cubist, 376–378, 377; Cycladic, 48, Tourist, 407, 408, 1810, 182, 183, 184, 49; Early Byzantine, 138, 138; Egyptian, 37–39, 37, 42, 43; Flemish, 221–222, 221, 222, 225, 225; Gothic, 195–199, 195, 197, 199, 202–204, 202, 203, 204; Greek Archaic, 56, 56, 58, 58; Greek High Classical, 72, 72, 73, 74–76, 75, 76; Greek Late Classical, 77–78, 77; Hellenistic, 81–85, 82, 83, 84; Holy Roman Empire, 275, 275; Impressionist, 356–357, 357; Italian, 16th-century, 251, 252–255, 253, 255, 265–267, 266, 267; Mannerist, 268–269, 269; Minoan, 51–52, 52; Neoclassical, 326, 327–329, 328, 329; Paleolithic, 15, 16; Pointillist, 362, 362; Pompeii, 100, 100; Post-Impressionist, 361, 361; Pointilist, 362, 362; Poinpell, 100, 100; Post-Impressionist, 361, 361; Realist, 348–350, 349, 350; Roman, 108, 108; Romantic, 330, 330, 334, 334; Sumerian, 23, 24 334; Sumerian, 23, 24 Female nudes: Cubist, 376–378, 377, 384, 384; Cycladic, 48, 49; Greek Late Classical, 77–78, 77; Hellenistic, 83–84, 84; Holy Roman Empire, 275, 275; Italian, 15th-century, 238-239, 239; Italian, 16th-century, 266, 267–268, 267; Mannerist, 270, 271; Neoclassical, 328–329, 328, 329; Paleolithic, 15, 16; Realist, 348-350, 349, 350; Romantic, 334, 334 Feminist art, 425–428, 427, 428 Fenestrated sequence of groin vaults, 97, Fite galante painting, 318, 319
The Fetus and Lining of the Uterus
(Leonardo), 254–255, 254
Fiber arts, 428–430, 429, 430
Fin de siècle, 365–366, 366 Finding of the True Cross and Proving of the True Cross (Piero), 242-243, 243 Finials, 154 First Style (Pompeii), 98-99, 99 Flag (Johns), 415–416, 416 Flanders. See Flemish art Flashing, 192 Flavian Amphitheater, Rome, 106–107, Flavian woman, portrait of, 108, 108 Flemish art, 215; Baroque, 298–300, 298, 299, 300; 15th-century, 216–223, 217, 218, 220, 221, 222, 223 Fleurs-de-lis, 193 Florence: architecture, 211-212, 211, 233-237, 234, 235, 236; engraving, 238, 238; painting, 204–205, 205, 207–209, 209, 231–233, 232, 233, 238–243, 239, 240, 241, 242, 243; Savonarola in, 243; sculpture, 227–231, 228, 229, 231, 237–240, 237, 239 Florence Cathedral (Arnolfo di Cambio), 211–212, 211; baptistery doors (Ghiberti), 214, 228–230, 228, 229; dome (Brunelleschi), 234, 234; tower (Giotto), 211-212, 211 Flower Still Life (Ruysch), 307–308, 307 Flying buttresses, 190–191, 190, 191 Folios, 131 Force, Juliana, 383 Foreshortening, 8–10; in Babylonian art, 27, 28; in Baroque art, 298, 299; in Greek art, 63–64, 63, 76; in Italian, 15th-century painting, 246, 246 Form, 6 Formal analysis, 6–12 Formalism, 407 "Fortuna Virilis," Temple of, Rome, 94, Forum, Pompeii, 96, 96 Forum of Trajan (Apollodorus of Damascus), 110, *110*

Galerie des Glaces (Hardouin-Mansart and Le Brun), 312, 312 Garden of Earthly Delights (Bosch), 222-223, 223 Gardens, 313, 313 Gardner, Isabella Stewart, 383 Garnier, J. L. Charles, the Opéra, Paris, 339, 339 Gate of All Lands, Iran, 31 Gates: Lion Gate, Mycenae, 53 "Gates of Paradise," Florence Cathedral (Ghiberti), 214, 229, 229 Gattamelata (Donatello), 239–240, 239

Gehry, Frank, Guggenheim Bilbao Museo, Spain, 423–424, 424 Genre subjects, 224 Fountain (second version), Duchamp, 382 382 Fouquet, Jean, Melun Diptych, 224-225, Gentileschi, Artemisia, Judith Slaying Holofernes, 293, 293 Geometric (Greek) art, 55–56, 55 Four Apostles (Dürer), 274-275, 275 The Four Horsemen of the Apocalypse (Dürer), 5-6, 5 Georges Pompidou National Center of Four tetrarchs, portraits of, Constantinople, 116–117, 117 Fourth Style (Pompeii), 102–103, 102, Art and Culture, Paris (Rogers and Piano), 422–423, 423 Fra Angelico, Annunciation, 240-241, Fra Filippo Lippi, Madonna and Child with Angels, 241–242, 242 Fragonard, Jean-Honoré, The Swing, 318–319, 319 France. See French art Frankenstein (Shelley), 335 Frankenthaler, Helen, Bay Side, 411, 411 Freestanding sculptures, 12 The French Ambassadors (Holbein), 276–277, 276 French art: Baroque, 308-313, 308, 309, rench art: Baroque, 308–313, 308, 309, 310, 311, 312; Beaux-Arts architecture, 339, 339; Carolingian, 160–161, 161; Cubist, 378–379, 378, 384, 384; Dadaist, 381–382, 381, 382; Fauvist, 373–374, 373, 374; 15th-century, 223–225, 224, 225; Gothic architecture, 186–197, 191; Gothic book illumination, 197–198, 197, 198; Gothic luxury arts, 198–199, 199; Impressionist, 354–358, 354, 355, 356, 357, 358; Modernist architecture. Romantic, 334-336, 336. See also Holy Roman Empire 376 218 Ghiberti, Lorenzo, Florence Cathedral 357, 358; Modernist architecture, 420–421, 421; Naturalist, 321–322, 229 321; Neo-Baroque architecture, 339 339; Neoclassical painting, 326–327, 326, 327, 329, 329; Paleolithic, 16–19, 16, 17, 18, 19; Postmodern architec-Giacomo Della Porta, Saint Peter's, Rome, 263, 264 Gifts for Trading Land with White ture, 422–423, 423; Realist painting, 346–351, 347, 348, 349, 350; Rococo, 317–319, 318, 319; Roman aqueducts, Gigantomachy, 61, 61, 71, 81, 81 Giorgione da Castelfranco, Pastoral 106, 106; Romanesque architecture, 168–172, 168, 169, 171; Romanesque manuscripts, 178–179, 179; Symphony, 265-266, 266 Romanesque sculpture, 173–178, 174, 175, 176, 177; Romantic, 332–334, 333, 334, 335; 16th-century, 277, 277; Surrealist, 387 French Revolution, 327, 327, 347 Fresco painting: Italian, 15th-century, 231–233, 232, 233, 240–246, 240, 241, 243, 244, 245; Italian, 16th-century, 249, 252–253, 252, 256–261, Sabine Women, 270, 271 Giovanni Pisano, 204 256, 259, 260, 261; Italian Baroque, 293–295, 294, 295; Italian Gothic, 205–207, 206, 207, 209–210, 210; Mexican, 402, 402; Minoan, 50–51, Gladiators, 98 50, 51; Pompeiian, 98–103, 99, 100, 101, 102, 103; technique, 50, 206. See Glazed bricks, 29-30, 30 also Murals Fresco secco, 50, 206, 252 Glazes: Greek, 62-63, 76 Freud, Sigmund, 372 Glaziers, 192 Freidrich, Caspar David, Abbey in the Oak Forest, 336, 336
Friezes: Doric, 59, 59; Greek High Classical, 71–73, 72, 73; Hellenistic, 81–82, 81; Ionic, 59, 59; Roman, The Gleaners (Millet), 347-348, 348 Global Groove (Paik), 431-432, 431 294, 295 105-106, 105, 110, 111, 119-120, Bible, 197, 197 Bible, 197, 197
Gold: Baroque, 311–312, 312; Byzantine, 141–142, 141; Carolingian, 161, 161; Egyptian, 14, 42–44, 43, 44; Egyptian New Kingdom, 43–44, 43, 44; Gothic, 197–198, 197, 198, 206–209, 206, 207, 209; Italy, 15th-century, 214, 229, 232; Margargen, 54, 55, 55 119; Sumerian, 23, 23 Frigidarium, 114, 114 Funerary art, Early Christian, 123-125, Fuseli, Henry, The Nightmare, 330, 330 Futurism, 380-381, 380 229; Mycenaean, 54-55, 55 Gonzaga, Marquis Ludovico, 244-246 Gainsborough, Thomas, Mrs. Richard Brinsley Sheridan, 322, 322 Goodacre, Glenna, 413 The Good Shepherd, Catacomb of Saints

Gerhard of Cologne, Cologne Cathedral, Germany, 166, 167, 201, 201
Géricault, Théodore, Raft of the Medusa, 332–333, 333 German art: Baroque, 314, 314; Bauhaus architecture, 393–394, 393, 394; Carolingian, 160, 160, 162, 162; Ottonian, 165–166, 165, 166, 167; Performance, 413–414, 414; Rococo, 317–318, 318; Romanesque, 180, 181; German Expressionism, 374-376, 375, Gestural abstraction, 408-409, 408, 409 Ghent Altarpiece (van Eyck), 217-219, baptistery doors, 214, 228-231, 228, Giacometti, Alberto, Man Pointing, 407, People (Quick-to-See Smith), 429-430, Giornate, 206
Giotto di Bondone, 204; Arena Chapel,
Padua, 205–207, 206, 207; Florence
Cathedral tower, 211–212, 211;
Lamentation, 206–207, 207; Madonna
Enthroned, 204–205, 205 Giovanni Arnolfini and His Bride (van Eyck), 222, 222 Giovanni da Bologna, Abduction of the Gislebertus, Last Judgment, Saint-Lazare, Autun, France, 176–177, 176 Glass skyscraper (Mies van der Rohe), 394, 394 Glorification of Saint Ignatius (Pozzo), God as architect of the world, moralized

Gorgons, 61, 61 Gospel Book of Archbishop Ebbo of

Gospels, 158–161, 159, 160, 161;

160, 160

Gaugin, Paul, Where Do We Come From?..., 360-362, 361

Gospel Book of Charlemagne, Germany,

Hiberno-Saxon, 159 Gothic art and culture, 184–213; British

architecture, 199–200, 199, 200; French architecture, 186–197, 191; French book illumination, 197–198,

197, 198; French luxury arts, 198–199, 199; German art, 201–203, 201, 202,

203; Italian architecture, 210-212, 201; Italian architecture, 210–212, 211, 212; Italian painting, 204–210, 205, 206, 207, 208, 209, 210; Italian sculpture, 203–204, 204; timeline, 213 Goya y Lucientes, Francisco José de: The Sleep of Reason Produces Monsters, 331–332, 331; The Third of May, 1808, 332, 332 Grande Odalisque (Ingres), 329, 329 Grand Manner portraiture, 322, 322 Grand Tour, 325 Grave Circle A, Mycenae, 54–55, 55 Grave goods: Sumerian, 25 Gravers, 62 Graves, Michael, Portland Building, Oregon, 422, 422 Grave stele of Hegeso, Dipylon cemetery, 75–76, 75 Great Depression of 1930s, 372, 398–400, 399, 400 Great Mosque, Córdoba, Spain, 146, 150-151, 150, 151 Great Mosque, Isfahan, Iran, 152, 152 Great Mosque, Kairouan, Tunisia, 149–150, 149 Great Pyramids at Gizeh, 34-36, 35, 36 Great Schism, 215 Great Sphinx, Gizeh, 35–36, 36 reat War, 372 El Greco, The Burial of Count Orgaz, 281–282, 281 Greek art and culture, 55-87; Archaic, Feek at and culture, 33–37, Architack, 56–65; Early Classical, 65, 66–68, 66, 67, 68; Geometric period, 55–56, 55; High Classical, 68–76, 68, 69, 70, 71, 72, 73, 74, 75, 76; High Classical sculpture, 68, 70–75, 71, 72, 73, 75; influence of parties civilizations on 47. influence of earlier civilizations on, 47; Late Classical, 76–81, 77, 78, 79, 80; Middle Byzantine, 140-141, 141; in the Roman Empire, 85, 94; timeline, 87. See also Aegean art; Archaic (Greek) art Greenberg, Clement, 346, 407-408, 411, Greenbergian formalism, 407-408 Grisaille, 206 Groin vaults (cross vaults): Roman, 97, 97; Romanesque, 169–172, 170, 171, 172 Gropius, Walter, Shop Block, Bauhaus, 393, 393 The Gross Clinic (Eakins), 352, 352 Ground line, 18 Grünewald, Matthias, Isenheim Altarpiece, 272–274, 273 Guaranty (Prudential) Building, Buffalo (Sullivan), 367–368, 368 Guernica (Picasso), 397–398, 398 Guerrilla Girls, The Advantages of Being a Woman Artist, 428, 428 Guggenheim, Peggy, 383 Guggenheim Bilbao Museo, Spain (Gehry), 423–424, 424 Guggenheim Museum (Wright), 420, 420 Gutenberg, Johann, 216 Hagenauer, Nikolaus, Isenheim Altarpiece, 272–274, 273 Hagesandros, Laocoön and his sons, 85–86, 85 Hagia Sophia, Anthemius of Tralles and Isidorus of Miletus, Constantinople, 133–135, 133, 134 Hall of Mirrors, the Amalienburg (Cuvilliés), 317–318, 318 Hall of the Bulls, Lascaux (France), 18–19, 18 Granada, Spain, 151–152, 151 Hals, Frans, Archers of Saint Hadrian, 300–302, 301 Peter and Marcellinus, Rome, 124, 124 Hamilton, Richard, Just What Is It ..., Reims, Hautvillers, France, 160-161,

Hall of the Two Sisters, Alhambra palace, 415, 415 Hammurabi, 27–28, 27 Happenings, 413 Hardouin-Mansart, Jules, Galerie des Glaces, 312, 312 Hart, Frederick, 413 Hartley, Marsden, Portrait of a German Officer, 385–386, 385 A Harvest of Death, Gettysburg, Pennsylvania, July 1863 (O'Sullivan), 342, 342

Hatching, 227, 238 Hatshepsut, mortuary temple of, 39, 39 The Haywain (Constable), 336–337, 337 Head of an Akkadian ruler, Nineveh, 26, Head of a Roman patrician, 96, 96 Hegeso grave stele, Dipylon cemetery, 75–76, 75 Helena, Saint, 242, 243 Heliopolis, 34 Helios and his horses, and Dionysos, Parthenon, 72, 72 Hellenes, 47 Hellenistic art, 81–86, 81, 82, 83, 84, 85 Hemispherical domes, 97, 97, 112, 112 Henges, 21–22, 21 Henry, Charles, 363 Hera, Temple of, Olympia, 78 Hera, Temple of, Paestum, Italy, 60–61, Herakles wrestling Antaios (Euphronios), 63-64, 64 Heraldic trio, 158 Hermes and the infant Dionysos (Praxiteles), 78–79, 78 Hesire, from tomb at Saqqara, 10, 10, 38 Hiberno-Saxon art, 158–160, 158, 159 Hierakonpolis, Egypt, 31–32, 32 Hierarchy of scale, 10 Hieratic style, 139 Hieroglyphs, 32 High Classical (Greek) art, 68–76, 68, 69, 70, 71, 72, 73, 74, 75, 76
High Empire (Roman) art, 110–114, 110, 111, 112, 113, 114 High relief sculpture, 12. See also Relief sculptures High Renaissance. See Europe, 16thcentury Hijra, 148 Hildegard of Bingen, Scivias, 180, 181 Himation, 83 Historiated capitals, 174, 174 The History of the Abolition of the Slave Trade (Clarkson), 337–338 Hitler, Adolph, 394 Höch, Hannah, Cut with the Kitchen Knife Dada..., 382-383, 382 Hogarth, William, Breakfast Scene, 322-323, 323 Holbein the Younger, Hans, The French Ambassadors, 276–277, 276 Hollow-casting, 26, 26, 67, 67 Holy Roman Empire, 16th-century, 272–277, 273, 275, 276. See also German art Holy Trinity (Masaccio), 233, 233 The Holy Virgin Mary (Ofili), 426 Holy Wisdom, Church of, Constantinople (Anthemius of Tralles and Isidorus of Miletus), 133–135, 133, 134 Homer, Winslow, The Veteran in a New Field, 351–352, 351 Hopeless (Lichtenstein), 416–417, 417 Hopper, Edward, Nighthawks, 399-400, Horses, 17-18, 17, 181, 182. See also Equestrian statues Horta, Victor, Van Eetvelde House, Brussels, 368, 368 House of the Vettii, Pompeii, 98, 98, 102, 103 Houses: Art Nouveau, 368, 368; French châteaux, 277, 277; Natural, 395–396, 395; Roman, 98–99, 98, 99 How to Explain Pictures to a Dead Hare (Beuys), 413–414, 414 Hudson River School, 338-339, 338 Hue, 363 Hugo, Master, Bury Bible, 179-180, 179 Human figures: Akkadian, 26, 26; Babylonian, 27–28, 27; Baroque, 288, 289–290, 289, 298, 299, 301–302, 289–290, 289, 298, 299, 301–302, 301; Carolingian, 160–161, 160, 161; Cubist, 376–378, 377, 384, 384, 397–398, 398; Early Byzantine, 137, 137; Early Christian, 131, 131; Egyptian, 32, 32, 36–38, 37, 41–42, 42; Etruscan, 90, 90, 91, 93, 93; Flemish, 217, 217, 220–222, 220, 221, 222, 224, 224; Gothic French, 189, 189, 193–198, 193, 195, 196, 199 222, 224, 224; Souther Friedly, 197, 189, 193–198, 193, 195, 196, 199, 202–203, 202, 203; Gothic Italian, 203–205, 203, 204, 205, 207, 207; Greek Archaic, 56–58, 57, 58, 62–63, 62, 63, 65, 65; Greek Classical, 65, 66;

Greek Early Classical, 65, 66-68, 66, Greek Early Classical, 63, 66–68, 66 67, 68; Greek Geometric, 55, 56; Greek Late Classical, 77–79, 77, 78; Hellenistic, 82–86, 82, 83, 84, 85; Holy Roman Empire, 275, 275; Impressionist, 356–358, 357, 358, 50; Neoclassical, 326, 327–329, 328, 329; Neolithic, 20, 20; Ottonian, 166, 167; Paleolithic, 15, 16; Pointillist, 167; Paleolithic, 15, 16; Pointillist, 362, 362; Realist, 366–367, 366, 367; Roman, 117, 117; Romanesque, 175–180, 175, 177, 178, 179; Sumerian, 23, 24, 24; Symbolist, 365, 365. See also Female figures Humanism, 216, 227, 237, 240, 243 Hundred Guilder Print (Rembrandt), 303–304, 304 Hundred Years' War, 215, 367 Hunters in the Snow (Bruegel the Elder), 280, 280 Hunting, 20, 20, 29, 29, 38, 38 Hypostyle halls, 41, 41 Hypostyle mosques, 149-150, 149, 150 Iconoclasm, 139-140, 250 Iconography, 5 Icons: Early Byzantine, 122, 139, 139; Middle Byzantine, 143–144, 143; opposition to, 139–140, 143; or position to, 139–140 Ignatius, Saint, 290, 294–295, 295 Iktinos, Parthenon, 69–73, 69, 70, 71, 72, 73 Illusionistic space, 7 Illustrated manuscripts: Carolingian, 160–161, 160, 161; Early Christian, 131–132, 132; 15th-century, 223–224, 224; Gothic, 197–198, 197, 198; Hiberno-Saxon, 158–160, 159; Koran, 153–154, 153; Middle Byzantine, 142–143, 143; monasteries and, 164; Romanesque, 178–180, 179, 180, 181 Imagines, 95 Imams, 150 Imhotep, Stepped Pyramid, 33–34, 34 Imperialism, 346, 372 Impluvium, 98–99, 98, 99 Impression: Sunrise (Monet), 354, 354 Impressionism: painting, 354–358, 354, 355, 356, 357, 358, 359; sculpture, 366–367, 366, 367 Improvisation 28 (Kandinsky), 374-375, Inanna, 23–24, 23 Incrustation, 173, 173 Independent Group, 415 Indulgences, 249, 255 Industrial Revolution, 336, 345 Ingres, Jean-Auguste-Dominique, *Grande* Odalisque, 329, 329 In Praise of Scribes (Trithemius), 198 Inquisition, 272 Intaglio, 226-227 International Style, 14th-century, 209, International Style, 20th-century, 394-395, 395 Intonaco, 206 Investment, 67 Ionic temples, 58–60, 59, 70 Iranian art: Achaemenid Persian, 30–31, Tanian art: Achaemenid Persian, 30–31, 30; Akkadian, 26–27, 26, 27; Assyrian, 28–29, 28, 29; Babylonian, 27–28, 27; Islamic, 152–154, 152, 153, 154; Sumerian, 22–25, 22, 23, 24, 25 Iraqi art: Akkadian, 26–27, 26, 27; Assyrian, 28–29, 28, 29; Babylonian, 27–28, 27; Sumerian, 22–25, 22, 23, 24, 25 24, 25 Isaac, 228–229, 228 Isenheim Altarpiece (Grünewald), Iseniem Attarpiece (Grunewaid), 272–274, 273 Ishtar Gate, Babylon, Iraq, 30, 30 Isidorus of Miletus, Hagia Sophia, Constantinople, 133–135, 133, 134 Islamic art and culture, 146–155; architecture, 147–153, 147, 148, 149, 150,

151, 152; ceramic calligraphy, 152–153, 153; luxury arts, 153–154,

153, 154; Muhammad, 148; textiles, 154, 154; timeline, 155 Istanbul. See Constantinople Istanbul. See Constantinople
Italian art: Baroque architecture,
286–291, 287, 288, 289, 290, 291;
Baroque painting, 284, 291–295, 291,
292, 293, 294, 295; Early Byzantine,
135–138, 135, 136, 137, 138; Early
Christian, 124–131, 124, 125, 128,
129, 130, 131; Etruscan, 89–93, 90,
21, 22, 31, 518, capture schirtere. 129, 130, 131; Etruscan, 89–93, 90, 91, 92, 93; 15th-century architecture, 233–237, 234, 235, 236; 15th-century painting, 231–233, 232, 233, 238–243, 239, 240, 241, 242, 243; 15th-century sculpture, 214, 227–231, 228, 229, 231, 237, 237, 239–240, 239; Futurist, 380–381, 380; Gothic architecture, 210–212, 211, 212; Ceptile spining 210–212, 211, 212; Gothic painting, 204–210, 205, 206, 207, 208, 209, 210; Gothic sculpture, 203-204, 204; Greek temples, 60–61, 60; Middle Byzantine, 141–142, 141; Neoclassical, 328, 328; princely courts, 15th-century, 243–246, 244, 245, 246; Romanesque architecture, 170, 170, 172–173, 173; 16th-century architecture, 261-265, 262, 263, 264, 265; 16th-century painting, 251–257, 251, 252, 253, 254, 255, 256, 265–268, 266, 267; Surrealist, 388, 388 *Iwans*, 150, 152, *152*Ixion Room, House of the Vettii, Pompeii, 102, *103* Jack-in-the-Pulpit No. 4 (O'Keeffe), 4-5, 4, 386 Jacobs, Jane, 422 Jambs, 175, 175, 195, 195 Japanese art and culture: influence on Western art, 356–358, 360 Japan paper, 226 Jeanne-Claude, Surrounded Islands, 419-420, 420 Jefferson, Thomas, Monticello, Virginia, 328–329, 328 Jerusalem, Dome of the Rock, 147–149, 148, 149 Jerusalem, Temple of, 108-109, 109 Jesuit order, 290 Jesus. *See* Christ Johns, Jasper, Flag, 415-416, 416 Johnson, Philip, Seagram Building, New York, 421 Jonah, Catacomb of Saints Peter and Marcellinus, Rome, 124, 124 Judd, Donald, Untitled, 411–412, 411 Judith Slaying Holofernes (Gentileschi), Julius II (pope), 255, 258–259, 262 Jung, Carl, 372 Junius Bassus, sarcophagus of, Rome, Justinian, Bishop Maximianus, and attendants, San Vitale, Ravenna, 137, 137 Just What Is It That Makes Today's Homes So Different, So Appealing? (Hamilton), 415, 415 Kaaba, 148 Kahlo, Frida, The Two Fridas, 370, 389–390, 390 Kallikrates: Parthenon, 69-73, 69, 70, 71, 72, 73; Temple of Athena Nike, 74–75, 74, 75 Kandinsky, Vassily, Improvisation 28, 374–375, 375 Karnak, temple of Amen-Re at, 40-41, 40 Kauffmann, Angelica, Cornelia Presenting Her Children as Her Treasures, 325–326, 325 Kaufmann House (Wright), 395-396, 395 Khafre, pyramid of, 35-36, 35 Khafre, seated statue of, 36–37, 37 Khufu, tomb of, 34–35, 35 Kiefer, Anselm, Nigredo, 425, 425 Kinetic sculpture, 396–397, 397 King on horseback with attendants, Benin, Nigeria, 10-11, 11 Kirchner, Ernst Ludwig, Street, Dresden, 374, 375 The Kiss (Klimt), 365-366, 366 Klimt, Gustav, The Kiss, 365-366, 366

Knight fighting a dragon, Moralia in Job, Cîteaux, France, 178–179, 179

Child, 387, 387 Koons, Jeff, Pink Panther, 430, 431 Koran, 148, 153–154, 153 Kores, 56, 56 Korin, Ogata: White and Red Plum Blossoms, 8, 8, 9; White Plum Blossoms, xvi Kosuth, Joseph, One and Three Chairs, 414, 414 Kouros, 56–57, 57 Kraters, 55–56, 55 Kritios Boy (Kritios), 66, 66 Kroisos, Anavysos, Greece, 57–58, 57 Kruger, Barbara, Untitled (Your Gaze Hits the Side of My Face), 428, 428 Kufic script, 152–154, 153 Lady of Auxerre, Crete, 56, 56 Laity, 163 La Madeleine, Vézelay, France, 177-178, Lamassu, from citadel of Sargon II, Iraq, 28, 28 Lamentation (Giotto), 206-207, 207 Lancets, 191, 191, 193, 193 Landscapes, 5; Dutch Baroque, 304–305, 305; French Baroque, 309–310, 309; Japanese, Edo, 8, 8, 9, xvi; Minoan, Japanese, Edo, 8, 8, 9, 891, Milmoan, 51, 51; Neo-Expressionist, 425, 425; Netherlands, 16th-century, 280, 280; Pompeiian, 101, 101; Post-Impressionist, 360, 361, 362–364, 363; Romantic, 334-339, 336, 337, 338. See also Gardens Landscape with Cattle and Peasants (Claude), 309-310, 309 Landscape with swallows, Santorini, 51, Lang, Fritz, Metropolis, 424 Lange, Dorothea, Migrant Mother, Nipomo Valley, 399, 399 Laocoön and his sons (Athanadoros, Hagesandros, and Polydoros of Rhodes), 85-86, 85 Lapith versus centaur, Parthenon, 71, 71 Lascaux cave paintings, France, 18–19, 18 Last Judgment (Gislebertus), 176–177, Last Judgment (Michelangelo), 261, 261 Last Supper (Castagno), 241, 241 Last Supper (Leonardo), 252–253, 252 Last Supper (Tintoretto), 271, 27 Late Classical (Greek) art, 76–81, 77, 78, Late Empire (Roman) art, 114-120, 114, 115, 116, 117, 118, 119 Lateral sections, 12, 13 Lavender Mist (Pollock), 408-409, 408 Law code of Hammurabi, Susa, 27-28, Lawrence, Jacob, The Migration of the Negro, 400-401, 401 Leaning Tower of Pisa, Italy, 173, 173 Le Brun, Charles: Galerie des Glaces, 312, 312; palace at Versailles, 310–313, 311 Le Corbusier: Notre Dame du Haut, 420–421, 421; Villa Savoye, Poissy-sur-Seine, 394–395, 395 Legal codes: Hammurabi, 27, 27 Lekythos, 76, 76 Lenin, Vladimir I., 372 Le Nôtre, André, park of Versailles, 313 Leonardo da Vinci, 250–251; *The Fetus* and Lining of the Uterus, 254–255, 254; Last Supper, 252–253, 252; Mona Lisa, 253–254, 253; Treatise on Painting, 252; Virgin of the Rocks, 251–252, 251 Letterpress, 226 Le Tuc d'Audoubert cave (France), 16, 17 Leyster, Judith, Self-Portrait, 304, 305 Lichtenstein, Roy, Hopeless, 416–417, Light, 6-7; Caravaggio and, 291-292, 291; Claude and, 309–310, 309; Fragonard and, 318–319, 319; Manet and, 350; Rembrandt and, 303; Vermeer and, 306 Limbourg Brothers, Les Très Riches Heures du Duc de Berry, 223–224, 224 Lin, Maya Ying, Vietnam Veterans Memorial, 412–413, 412

Knossos, palace at, Crete, 49-50, 49, 50

Kollwitz, Käthe, Woman with Dead

Lindau Gospels, 161, 161 Lindisfarne Gospels, 158–159, 159 Linear perspective, 100, 101, 229–231, 230 Lines 6 Lintels, 21, 175, 175 Lion Gate, Mycenae, 52–53, 53 Lion Hunt (Rubens), 8–10, 9 Lions: Assyrian, 29, 29; Flemish, 8–10, 9; Mycenaean, 52–53, 53; Romanesque, 175, 176 Lippo Memmi, Annunciation, 208–209, Lithography, 348, 349 Local color, 354 Locke, John, 319-320 Loggia, 240 Longitudinal sections, 12 Lorenzetti, Ambrogio, Effects of Good Government in the City and in the Country, 209–210, 210 Country, 207–10, 21 Lost-wax process, 67 Louis XIV, 310–313, 310, 311, 312 Louis XIV (Rigaud), 310, 310 Loves of the Gods (Carracci), 293-294, Low relief sculpture, 12. See also Relief sculptures Luncheon on the Grass (Manet), 348–350, 349 Lunettes, 124, 124, 175, 175 Luther, Martin, *Ninety-Five Theses*, 240-241 Lutheranism, 274–275 Lux nova, 187, 192 Luxury arts: cloisonné, 158, 158; Gothic, 198-199, 199; Islamic, 153-154, 153, 154 Luzarches, Robert de, Amiens Cathedral, 194, 194 Lysippos, Apoxyomenos (Scraper), 78, 79 M Macedonian Renaissance, 142-143, 143 Mach, Ernst, 363 La Madeleine, Vézelay, France, 177-178, Maderno, Carlo, Saint Peter's, Rome, 286-287, 287 Madonna and Child with Angels (Fra Filippo), 241–242, 242 Madonna Enthroned (Giotto), 204-205, 205 Madonna Enthroned with Angels and Prophets (Cimabue), 204, 205 Madonna in the Meadow (Raphael), 255, Madonna with the Long Neck (Parmigianino), 268–269, 269 Madrasa Imami, Isfahan, Iran, 152-153, 153 Maesta altarpiece, Siena Cathedral, Italy, 207-208, 208 Magritte, René, The Treachery (or Perfidy) of Images, 389, 389 Maitani, Lorenzo, Orvieto Cathedral, Italy, 210–211, 211 'Male gaze," 427–428, 427, 428 Malevich, Kazimir, Suprematist Composition: Airplane Flying, 391-392, 392 Malouel, Jean, 217 Mandorla, 176, 176 Manet, Édouard: Le Déjeuner sur l'Herbe, 348-350, 349; Olympia, 350, 350 Manetti, Gianozzo, 237 Maniera greca, 204 Mannerism, 268–272, 269, 270, 271, 272, 281–282, 281 Man Pointing (Giacometti), 407, 407 Mantegna, Andrea: Camera degli Sposi, Mantua, 245–246, 246; Dead Christ, Mantua, 244-245, 245 Manuscript illumination. See Illustrated manuscripts Mapplethorpe, Robert, The Perfect Moment, 426 Maqsud of Kushan, Ardabil, Iran, 154, Maqsura, 150, 152 Marc, Franz, 374; Fate of the Animals, Marcus Aurelius, equestrian statue of,

113, 113

Marilyn Diptych (Warhol), 417, 417 Miró, Joan, Painting, 390-391, 391 Marinetti, Filippo Tommaso, 380 Mark, Saint, 231, 231
Markets of Trajan (Apollodorus of Damascus), 110–111, 111
Marriage à la Mode (Hogarth), 322–323, Marriage portraits, 222, 222 Martini, Simone, Annunciation, 208–209, 209 Marx, Karl, 346 Mary, mother of God. See Virgin Mary Masaccio: Holy Trinity, 233, 233; Tribute Money, 231–233, 232 Masks: Egyptian, 14, 44, 44; Mycenaean, 54–55, 5.5 Massys, Quinten, Money-Changer and His Wife, 278, 278 Mastabas, 33–34, 33 Matisse, Henri: Red Room, 373–374, 374; Woman with the Hat, 373, 373 Matthew, Saint, 160–161, 160, 161 Maulstick, 279 Mausoleum of Galla Placidia, Ravenna, 130–131, 130 Mausoleums, 126, 130–131 Mazzola, Girlamo Grancesco Maria (Parmigianino), 269 Meanders, 56 Meat Still-Life (Aertsen), 278–279, 279 Medici, Cosimo, 235, 237 Medici, Lorenzo, 237 Medici, Marie de', 299–300, 299 Medici family, 227, 235, 237, 241, 243, Medieval art and culture. See Early Medieval art and culture Meditations (Marcus Aurelius), 113 Medium (plural, media), 6 Medusa, 61, 61
Meeting of Saints Anthony and Paul
(Grünewald), 273, 274
Megaliths, 21–22, 21 Melancholy and Mystery of a Street (de Chirico), 388, 388 Melun Diptych (Fouquet), 224–225, 225 Las Meninas (Velázquez), 284, 297-298, Menkaure, Pyramid of, 35 Menkaure and Khamerernebty, Gizeh, 37-38, 37 Mercantilism, 286, 300 Mérode Altarpiece (Campin), 221, 221 Mesopotamian art: Akkadian, 26-27, 26, 27; Assyrian, 28–29, 28, 29; Babylonian, 27–28, 27; Islamic, 147; Neo-Babylonian, 29–30, 30; Sumerian, 22–25, 22, 23, 24, 25 Metaphysical Painting, 388, 388 Metopes, 59, 59 Metropolis (Lang), 424 Mexican art, 370, 389–390, 390, 402, 402 Michelangelo Buonarroti, 257–261; Creation of Adam, 260, 260; David, 257–258, 258; Last Judgment, 261, 261; Saint Peter's, Rome, 263–264, 263; on sculpture, 257; Sistine Chapel, 249, 258–261, 259, 260, 261; unfinished captive, 12, 12, 257 Michelozzo di Bartolommeo, Palazzo Medici-Riccardi, Florence, 235–236, 235, 236 Middle Byzantine art, 140-144, 140, 141, 142, 143 Mies van der Rohe, Ludwig: glass skyscraper drawing, 394, 394; Seagram Building, New York, 421, 421 Migrant Mother, Nipomo Valley (Lange), 399, 399 The Migration of the Negro (Lawrence), 400–401, 401 Mihrab, 150–151, 151 Mihrab from Madrasa Imami, Isfahan, Iran, 152–153, 153
Milan Cathedral, Italy, 212, 212
Millais, John Everett, Ophelia, 353, 353
Millet, Jean-François, The Gleaners, 347–348, 348 Minarets, 150 Minbar, 150

Minimalism, 411–413, 411, 412 Minoan art, 49–52, 49, 50, 51, 52 Minotaur's labyrinth, 49–50, 49

Sant'Apollinare Nuovo, Ravenna, 131,

Miracle of the loaves and fishes,

Mobiles, 396-397, 397 Modeling, 207 Modernism, concept of, 346 Modernist architecture, 420–421, 420, 421 Modules, 10 Moissac cloister, France, 173–174, 174 Moldings, 60 Mona Lisa (Leonardo da Vinci), 253-254, 253 Monastery at Saint Gall, Switzerland, 162–163, 163 Monastery of Saint Catherine, Mount Sinai, Egypt, 138-139, 139 Monastic movement: Benedictine order, 162–164, 163; Carthusian order, 217; Cistercian order, 164, 174, 178; Cluniac order, 174; Early Byzantine, 138; Jesuit order, 290; origins of, 138 Mondrian, Piet, Composition in Red, Blue, and Yellow, 392–393, 392 Monet, Claude: Impression: Sunrise, 354, 354; Saint-Lazare Train Station, 355, 355 Money-Changer and His Wife (Massys), 278, 278 Monoliths, 21 Monroe, Marilyn, 417, 417 Monticello, Virginia (Jefferson), 328–329, 328 Mont Sainte-Victoire (Cézanne), 362-364, 363 Monuments: Babylonian, 30; Egyptian pyramids, 34, 35, 36; Islamic, 148, 149; Minimalist, 412; Mycenaean, 53, Moralia in Job, Cîteaux, France, 178–179, 179 Moralized Bible, Paris, 197-198, 197, 198 Mortuary temples: Egyptian Old Kingdom, 39 Mortuary temples, Egyptian, 39-40, 39, Mosaics: Early Byzantine, 137-138, 137, 138; Early Christian, 130–131, 130, 131; Islamic, 149, 149; Late Classical Greek, 79–80, 79; materials and techniques, 130; Middle Byzantine, 140–142, 140, 141 Mosaic tilework, 152–153, 153 Moses expounding the Law (Master Hugo), 179–180, 179 Mosques, 150; Dome of the Rock, Jerusalem, 148, 149; funerary, 154, 154; Great Mosque, Córdoba, 146, 150–151, 150, 151; Great Mosque, Isfahan, 152, 152; Great Mosque, Kairouan, 149–150, 149 Le Moulin de la Galette (Renoir), 356, Mount Sinai monastery, Egypt, 138-139, Mrs. Richard Brinsley Sheridan (Gainsborough), 322, 322 Muhammad, 148 Muhaqqaq, 152 Mullions, 196, 196 Mummification, 33, 113 Mummy portrait of a man, Faiyum, Egypt, 113–114, 114 Munch, Edvard, The Cry, 365, 365 Munch, Edvard, The Cry, 365, 365
Magarnas, 151, 152
Murals: Early Christian, 124, 124;
Etruscan, 92, 92; Italian Baroque, 293–295, 294, 295; Italian, 15th-century, 231–233, 232, 233, 240–246, 240, 241, 243, 244, 245; Italian Gothic, 205–207, 206, 207, 209–210, 210; Italian, 16th-century, 249, 252–253, 252, 256–261, 256, 259, 260, 261; Mexican, 402, 402; Middle Byzantine, 142, 142; Minoan, 50–51, 50, 51; Neolithic, 20, 20; Paleolithic, 17–18, 17; Pompeiian, 98–103, 99, 100, 101, 102, 103 100, 101, 102, 103 Music, Romantic, 335 Muslims, 148. See also Islamic art and Mycenaean art, 52-55, 53, 54, 55 Myron, Diskobolos, 68, 68 Naos (cella), 22, 59, 59, 90 Napoleon Bonaparte, 327, 332

Narmer's palette, Hierakonpolis, 31-32, Narrative art, 19 Narrative reliefs: Akkadian, 26, 27; Assyrian, 29, 29; Egyptian, 31–32, 32; Sumerian, 23–25, 23, 25 Narthex, 128, 128, 136 National Endowment for the Arts (NEA), Native American artists: modern, 429–430, 429 Natural architecture, 395–396, 395 Naturalistic art, 321–325, 321, 322, 323, Naumburg Cathedral, Germany, 202, 202 Nave arcades, 191, 191
Nave bays, 169, 170
Naves, 97, 128
Near East. See Mesopotamian art
Nebuchadnezzar II (king of Babylon), 29-30 Necropolis, Etruscan, 91–92, 91 Nefertiti (Thutmose), 42, 43 Nemes headdress, 36, 37 Neo-Babylonian art, 29–30, 30 Neoclassicism, 325–329, 325, 326, 327, 328, 329 Neo-Expressionism, 425, 425 Neolithic art, 19–22, 20, 21 Neoplasticism, 392–393, 392 Netherlands, 298; Abstract Expressionism, 409, 409; Neoplasticism, 392–393, 392; 16th-century art, 278–280, 278, 279, 280 Neue Sachlichkeit, 386–387, 386, 387 Neumann, Balthasar, chapel of Vierzehnheiligen, Germany, 314, 314 New Kingdom (Egypt), 38–43, 38, 39, 40, 41, 42, 43, 44 New media, 430–432, 431, 432 Newton, Isaac, 319–320, 371 Nicola Pisano, The Annunciation and the Nativity, 203–204, 204 Nièpce, Joseph Nicéphore, 341 Nietzsche, Friedrich, 88, 372 Nigeria: Benin art, 10–11, 11 Night (Beckmann), 386–387, 386 Neumann, Balthasar, chapel of Night (Beckmann), 386-387, 386 The Night Café (van Gogh), 359-360, Nighthawks (Hopper), 399-400, 400 The Nightmare (Fuseli), 330, 330 Night Watch (Rembrandt), 302–303, 302 Nigredo (Kiefer), 425, 425 Nike adjusting her sandal, Acropolis, Nike alighting on a warship (Nike of Samothrace), 83, 83 Nile River, 31 Nimbus (halo), 131 No. 14 (Rothko), 410, 410 Nocturne in Black and Gold (Whistler), 358, 359 Normans, 171, 181, 182 Notre-Dame, Paris, France, 190, 190 Notre Dame du Haut, Ronchamp (Le Corbusier), 420–421, 421 Nude Descending a Staircase, No. 2 (Duchamp), 384, 384

Nudes: Cubist, 376–378, 377, 384, 384; Cycladic, 48, 49; Flemish, 222–223, 223; Greek Archaic, 56–57, 57, 62–63, 62, 63, 65, 65; Greek Early Classical, 65, 66–68, 66, 67, 68; Greek High Classical, 68–69, 68, 72, 72; Greek Late Classical, 77–79, 77, 79; Hellenistic, 81–86, 82, 84, 85; Holy Roman Empire, 275, 275; Italian, 15th-century, 237–238, 237, 238; Italian, 16th-century, 257–261, 258, 260, 265–266, 266; Mannerist, 270, 271; Neoclassical, 328–329, 328, 329; Paleolithic, 15, 16; Realist, 348–350, 349, 350. See also Female nudes (Duchamp), 384, 384 349, 350. See also Female nudes Number 1, 1950 (Pollock), 408–409, Oath of the Horatii (David), 326-327, 326

Object (Le Déjeuner en Fourrure) (Oppenheim), 389, 389 October (Limbourg Brothers), 223–224, 224 Octopus jar, Crete, 51, 51 Oculus, 97, 97, 112, 112, 190–191, 190,

Odalisque, 329, 329 Ofili, Chris, The Holy Virgin Mary, 426 Ogata Korin: White and Red Plum Blossoms, 8, 8, 9; White Plum Blossoms, xvi Ogival section, 234 Oil paints, 219-220 O'Keeffe, Georgia, Jack-in-the-Pulpit No. 4, 4-5, 4, 386 Old Kingdom (Egypt), 34-38, 35, 36, 37, Old market woman, 84–85, 84 Old Saint Peter's, Rome, 127–128, 128 Old Saint Peter's, Rome, 127–128, 128
Old Testament themes: in Baroque art, 293, 293; in Early Christian art, 124–125, 124, 125; in Flemish art, 217–219, 217, 218; in Gothic art, 187–189, 188, 189, 193; in Islamic art, 148; in Italian art, 228–229, 228, 257–260, 258, 259, 260; in Ottonian art, 166, 166; in Permangement art, 166, 166; in Romanesque art, 179–180, 179, 180 Olympia (Manet), 350, 350 Olympic Games, 132 One and Three Chairs (Kosuth), 414, One-point linear perspective, 230–231 On Painting (Alberti), 230–231 Opéra, Paris (Garnier), 339, 339 Opere francigeno, 199 Ophelia (Millais), 353, 353 Opisthodomos, 59 Oppenheim, Meret, Object (Le Déjeuner en Fourrure), 389, 389 Optical approach, 18–19 Orants, 124, 124 Oratories, 138 Orchestra, 80 Order of architecture, 59 Orthogonals, 230, 230 Orvieto Cathedral (Maitani), 210-211, 211 Oscans, 96 O'Sullivan, Timothy, A Harvest of Death, Gettysburg, Pennsylvania, July 1863, 342, 342 Ottonian art, 165–166, 165, 166, 167 The Oxbow (Cole), 338–339, 338 Ozymandias (Shelley), 335 Paik, Nam June, Global Groove, 431–432, 431 Painting: Abstract Expressionist, 407–411, 408, 409, 410; Analytic Cubist, 378–379, 378; color field, 411,

411; Cosmic Cubist, 385–386, 385; Cubist, 376–378, 377, 397–398, 398; Dadaist, 382–383, 382; Depressionera, 399–400, 400; Dutch Baroque, 300–308, 301, 302, 303, 304, 305, 306, 307; Fauvist, 373–374, 373, 374; fin de siècle, 365–366, 366; Flemish, 15th-century, 217–223, 218, 219, 220, 221, 222, 223; Flemish Baroque, 221, 222, 223; Fremish Baroque, 298–300, 298, 300; French, 15th-century, 223–225, 224, 225; French Baroque, 308–310, 308, 309, 310; Futurist, 380, 380; German Expressionist, 374–376, 375, 376; Holy Roman Empire, 272–277, 273 275, 276; Impressionist, 354-358, 354, 355, 356, 357, 358, 359; Italian Baroque, 284, 291–295, 291, 292, 293, 294, 295; Italian, 15th-century, 231–233, 232, 238–244, 239, 240, 243, 244; Italian Gothic, 204–210, 245, 244; Italian Gotnic, 204–210, 205, 206, 207, 208, 209, 210; Italian, 16th-century, 251–261, 251, 252, 253, 254, 255, 256, 259, 260, 261, 265–268, 266, 267; Japanese, Edo, 8, 263–268, 269, 267, Japanese, Edo, 8, 8, 9, xvi; Mannerist, 268–272, 269, 270, 271, 272, 281–282, 281; Naturalistic, 321–325, 321, 322, 323, 324; Neoclassical, 325–327, 325, 326, 327, 329, 329; Neolithic, 20, 20; Neoplasticist, 392–393, 392; Netherlands, 16th-century, 278–280, 278, 279, 280; Neue Sachlichkeit, 386–387, 386, 387; Paleolithic cave, 16–19, 17, 18, 19; Photorealism, 418, 418; Pop, 404, 416, 416; Post-Impressionist, 359–364, 360, 361, 362, 363, 364; Postmodernist, 425, 425; Post-Painterly Abstraction, 411, 411; Postwar Expressionist, 406–407, 406,

407; Pre-Raphaelite, 352-353, 353; Realist, 346–353, 347, 348, 349, 350, 351, 352; Regionalist, 401–402, 401; Rococo, 318–319, 319; Romanesque, Rococo, 318–319, 319; Romanesque, 178–182, 179, 180, 181, 182; Romantic, 330–339, 330, 332, 333, 334, 335, 336, 337; Spanish Baroque, 295–298, 296, 297; Spanish, 16th-century, 280–282, 281; Superrealist, 418, 418; Suprematist, 391–392, 392; Surrealist, 370, 387–391, 388, 389, 290, 391, Smalls, 246, 365, 365 312; Italian, 15th-century, 235–236, 235, 236; Minoan, 49–50, 49, 50; Spanish, 151–152, 151 Palatine Chapel of Charlemagne, Aachen, Germany, 162, 162 Palazzo Ducale, Mantua, 245–246, 246 Palazzo Farnese gallery, Rome, 293-294, 294 Palazzo Medici-Riccardi, Florence (Michelozzo), 235–236, 235, 236 Paleolithic art, 15–19, 16, 17, 18, 19 Palette of King Narmer, Hierakonpolis, 31-32, 32 Pallatio, Andrea, Villa Rotonda, Vicenza, 264–265, 264, 265 Panathenaic Festival procession frieze, Parthenon, 72–73, 73 Pantheon, Rome, 88, 111–113, 111, 112 Pantokrator, Christ as, 140, 140 Papermaking, 226 Papyrus, 131
Paradise Now (Living Theatre group), Parapets, 74 Parchment, 131, 254 Paris Psalter, 142–143, 143 Parks. See Gardens Parmigianino, Madonna with the Long Neck, 268-269, 269 Parthenon (Iktinos and Kallikrates), 69-73, 69, 70, 71, 72, 73 The Passion of Sacco and Vanzetti (Shahn), 4–5, 4 Pastoral Symphony (Giorgione), 265–266, 266 *Paten*, 137, 137 Patriarchs, Greek Orthodox, 135 Patrician class, 94-96, 96 Patrons, 6, 300, 383. See also Donor portraits Paul, Saint, 291–292, 291 Pauline Borghese as Venus (Canova), 328, 328 Pax Romana, 104 Paxton, Joseph, Crystal Palace, London, 339–340, 340 Peaceful City (Lorenzetti), 209-210, 210 Pebble mosaics, 130 Pech-Merle cave (France), 17–18, 17 Pediments, Greek Archaic, 59, 59, 61, 61, 64–65, 65 Pendentive construction, 133–135, 133, Peplos Kore, 58, 58 The Perfect Moment (Mapplethorpe), 426 Performance art, 413-414, 414 Pergamon, Altar of Zeus at, 81-82, 81 Pericles, 69 Period style, 3 Peripteral colonnades, 60, 60 Peristyle, 59, 59, 60, 99
Perpendicular Style, England, 200, 200
Persepolis, Iran, 30–31, 30
Persian art, 30–31, 30 The Persistence of Memory (Dalí), 388–389, 388

Personal style, 4-5

Personifications, 5, 5 Perspective, 7–8, 229; atmospheric, 101, 101, 230, 230; foreshortening, 8–10,

28, 63–64, 76, 246, 299; linear, 100, 101, 229–231, 230; twisted, 18
Perugino, Christ Delivering the Keys of

Peter, Saint, 127, 243-244, 244, 288

Petrarch, Francesco, 216

the Kingdom to Saint Peter, 243-244,

Phidias, Athena Parthenos, 70 A Philosopher Giving a Lecture at the Orrery (Wright), 320, 321 Philosophes, 320 Philosophy: early 20th-century, 372; Empiricism, 319–320, 345; Enlightenment, 320; French philosophes, 320; Positivism, 345; Scholasticism, 186 Philoxenos of Eretria, *Battle of Issus*, 79–80, 79 Photography: calotype process, 341-342; daguerreotype process, 340–341, 341; development of, 340–341; feminist, 427–428, 427, 428; on the Great Depression, 399, 399; photorealism, 418; Stieglitz, 384–385, 385; 19thcentury, 340–342, 341, 342; wet-plate process, 342, 342
Photomontage, Dadaist, 382–383, 382 Photorealism, 418, 418 Piano, Renzo, Georges Pompidou National Center of Art and Culture, Paris, 422-423, 423 Piazza (Bernini), 287, 287 Picasso, Pablo: Guernica, 397–398, 398; Les Demoiselles d'Avignon, 376–378, 377; life of, 376; Still Life with Chair-Caning, 379, 379 Piero della Francesca, Finding of the True Cross and Proving of the True Cross, 242–243, 243 Pilasters, 105, 105, 245 Pilgrimages, 168, 174 Pillars: Egyptian, 40. See also Columns Pink Panther (Koons), 430, 431 Pinnacles, 191, 191 Pisa Cathedral, Italy, 172–173, 173, 203-204, 204 Piss Christ (Serrano), 426 Pittura Metafisica, 388, 388 Planck, Max, 371 Planes, 6 Plans, 12, 13 Plate tracery, 192 Poesia, 265–266, 266 Pointed arches, 186-187, 186 Pointillism, 362–363, 362 Pollaiuolo, Antonio, Battle of the Ten Nudes, 238, 238 Pollock, Jackson: Number 1, 1950 (Lavender Mist), 408-409, 408; photo of, 409 Polydoros of Rhodes, Laocoön and his sons, 85–86, 85 Polykleitos, Doryphoros (Spear Bearer), -69, 68 Polykleitos the Younger, Theater, Epidauros, 80–81, 80 Polyptychs, 217–219, 218 Pompeii, 96–103; architecture, 96–99, 96, 97, 98, 99; city of, 96; First Style, 98–99, 99; Fourth Style, 102–103, 102, 103; fresco painting, 98–103, 99, 100, 101, 102, 103; Second Style, 99-101, 100, 101; Third Style, 102, 102 Pompidou National Center of Art and Culture, Paris (Rogers and Piano), 422-423, 423 Pont-du-Gard, Nîmes, 106, 106 Pontormo, Jacopo da, Descent from the Pontormo, Jacopo da, Descent John Cross, 268, 269
Pop art, 404, 415–417, 415, 416, 417
Porch of the Martyrs, Chartres
Cathedral, France, 193–194, 193
Portals: Gothic, 187–189, 188;
Pagagagaiga 175–176, 175 Romanesque, 175-176, 175 Porticos, 96 Portland Building, Oregon (Graves), 422, Portrait of a German Officer (Hartley), 385-386, 385 Portrait of Paul Revere (Copley), 324–325, 324 Portrait of the Artist's Sisters and Brother (Anguissola), 269-270, 270 Portraits, painted: American, 324–325, 324; Baroque, 300–304, 300, 301, 302, 303, 305, 310, 310; Flemish, 222, 302, 303, 303, 310, 310; Frelinish, 22c, 222; Grand Manner, 322, 322; group, 300–303, 301, 302; Holy Roman Empire, 276–277, 276; Italian, 16th-century, 253–254, 253; Mannerist, 269–270, 270; Natural, 321–322, 321; Reims Cathedral, France, 194–196, 195 Relics, 128, 168 Reliefs, print, 226 Relief sculptures, 12; Achaemenid Persian, 31; Akkadian, 26, 27; Netherlands, 16th-century, 279, 279;

Roman, 113–114, 114; Surrealist, 370, 389–390, 390. See also Donor portraits; Self-portraits Portraitus: Egyptian, 36–38, 37, 41–42, 42, 43; Etruscan, 93, 93; Flemish, 222, 222; Gothic, 202, 202; Italian, 15thcentury, 239–240, 239; Photorealist, 418, 418; Roman, 95, 96, 104, 104, 108, 108, 113–118, 113, 114, 115, 117, 118. See also Portraits, painted The Portuguese (Braque), 378, 378 Portunus, Temple of, Rome, 94, 95 Posey, Willi, 429 Positivism, 345 Post-inpressionism, 359–364, 360, 361, 362, 363, 364 Postmodernism: architecture, 421–423, 422, 423; description of, 424-425; Neo-Expressionism, 425, 425 Post-Painterly Abstraction, 411, 411 Post-Painterly Abstraction, 411, 411
Postwar Expressionism, 406–407, 407
Pottery: glazes, 62–63, 76; Greek
Archaic, 46, 61–64, 61, 62, 63; Greek
Geometric, 55–56, 55; Greek High
Classical, 76, 76; Minoan, 51, 51 Poussin, Nicolas, Et in Arcadia Ego, 308–309, 308 Pozzo, Fra Andrea, Glorification of Saint Ignatius, 294, 295 Praxiteles: Aphrodite of Knidos, 77–78, 77; Hermes and the infant Dionysos, 78–79, 78
Predella, 274 Prefiguration, 124, 124 Pre-Raphaelite Brotherhood, 352-353, 353 Primary colors, 7 Printmaking, 226–227. *See also* Etchings Proportion, 10 Propylaia, 69 Proscenium, 290 Protestantism, 249–250, 272, 278 Provenance, 3 Pseudoperipteral temples, 94 Purse cover, Sutton Hoo ship burial, Suffolk, 157–158, 158 Putti, 259 Pylons, 41 Pylon temples, 40-41, 40 Pyramids: building, 35; Early Dynastic Egyptian, 33–34, 34; Great Pyramids at Gizeh, 34–36, 35, 36 Pythagoras of Samos, 69 Qibla, 150 Quadrant arches, 172 Quadro riportato, 294, 294 Quatrefoil, 228 Quatrejon, 228 Quick-to-See Smith, Jaune, Trade (Gifts for Trading Land with White People), 429–430, 429 Quilts, 428–429, 429 Radiating chapels, 169, 186, 186 Raft of the Medusa (Géricault), 332-333, Ramses II, Temple of, 39-40, 40 Raphael, 255–257; Madonna in the Meadow, 255, 255; School of Athens, 256–257, 256 Rauschenberg, Robert, Canyon, 404, 416, 416 Rayonnant style, 196, 196 "Ready-made" sculptures, 382, 382 De re aedificatoria (Alberti), 236 Be te acaincatoria (Alberti), 256
Realism: architecture, 367–368, 367, 368; painting, 346–353, 347, 348, 349, 350, 351, 352; sculpture, 366–367, 366, 367
Rebecca and Eliezer at the well, Vienna Genesis, 132, 132 Red-figure painting, 46, 62–64, 63 Red Room (Matisse), 373–374, 374 Refectories, 138 Reformation, 249–250, 272 Regionalism, 401–402, 401 Regional style, 3 Registers, 23, 23

Assyrian, 29, 29; Babylonian, 27-28, 27; Early Christian, 125, 125; Egyptian New Kingdom, 39; Egyptian Predynastic, 10, 10, 31–32, 32; Gothic, 201–204, 201, 204; Greek Archaic, 61, 61; Greek High Classical, 70–75, 71, 72, 73, 75; Hellenistic, 81–82, 82; Italian, 15th-century, 214, 228–229, 228, 229; Ottonian, 165–166, 166; 228, 229; Ottonian, 165–166, 166; Paleolithic, 16, 16; Roman Early Empire, 105–106, 105, 108–109, 109; Romanesque, 173–178, 174, 175, 176, 177; Roman High Empire, 110, 111; Roman Late Empire, 116, 116, 119–120, 119; Sumerian, 24–25, 25 Relieving triangles, 52–54, 54 Relievo, 227 Religion: Calvinism, 250; Egyptian, 33, 41; Greek, ancient, 48; Greek Orthodox, 134–135; Islam, 147–148, 150; Sumerian, 22. See also Christianity; Deities Reliquaries: Romanesque, 178, 178 Rembrandt van Rijn: Christ with the Sick around Him, Receiving the Children (Hundred Guilder Print), 303–304, 304; The Company of Captain Frans Banning Cocq (Night Watch), 302–303, 302; Self-Portrait, 303, 303 Renaissance. See Europe, 15th-century; Europe, 16th-century Renoir, Pierre-Auguste, Le Moulin de la Galette, 356, 356 Repoussé, 54, 55, 178, 178 Represented texture, 7 Respons, 191, 191 Retables, 225–226, 226. See also Altarpieces Return from Cythera (Watteau), 318, 319 Revere, Paul, 324–325, 324 Rhinoceros, Lascaux, 19, 19 Riace warrior, 66–67, 67 Ribbed groin vaults, 172, 172 Rib vaulting, 170, 186-187, 186, 187 Richter, Hans, 382 Ridgepoles, 60 Riemenschneider, Tilman, Creglingen Altarpiece, 225–226, 226 Rigaud, Hyacinthe, Louis XIV, 310, 310 Ringgold, Faith, Who's Afraid of Aunt Jemima?, 428-429, 429 Rivera, Diego, Ancient Mexico, 402, 402 Robert Mapplethorpe: The Perfect Moment, 426 Rockefeller, Abby Aldrich, 383 Rococo art, 317–319, 318, 319 Rodin, Auguste, Burghers of Calais, 366–367, 366 Rogers, Richard, Georges Pompidou National Center of Art and Culture, Paris, 422–423, 423 Rogier van der Weyden, Deposition, 220, Roman art and culture, 93-120; Early Empire, 104–109, 104, 105, 106, 107, 108, 109; High Empire, 110–114, 110, 111, 112, 113, 114; houses, 98–99, 98, 99; interest in Greek art, 94, 104; Late Empire, 114-120, 114, 115, 116, 117, 118, 119; outline of history, 94; Pompeii, 96–103; Roman Republic, 94-96, 95, 96; timeline, 121 Roman Catholic Church: art and, 250–251, 255, 286; Great Schism, 215; Inquisition, 272; Vatican, 15th-century, 243–244, 244 Romanesque art and culture, 167-182; architecture, 167–173, 168, 169, 170, 171, 172, 173; painting, 178–180,

179, 180, 181; sculpture, 173–178, 174, 175, 176, 177, 178; tapestry, 181, 182; timeline, 183

330–332, 331; music and literature, 335; painting, 330–339, 330, 332, 333, 334, 335, 336, 337; Rousseau on,

architecture, 106–112, 107, 108, 110, 111, 112, 114–115, 114, 118–119, 118; Roman Republic architecture, 95;

16th-century art, 261–264, 262, 263. See also Roman art and culture

Rome: city model, 95; Roman Empire

Romanian art, 396, 396 Roman Republic art, 94–96, 95, 96. See

also Pompeii Romanticism, 329–339; etching,

329-330

Roundel, 193 Rousseau, Jean-Jacques, 321; Confessions, 329; Social Contract, 329 Royal Academy of Arts in Britain, 351 Royal Academy of Painting and Sculpture, France, 351 Royal Cemetery at Ur, 24–25, 25 Royal Portal, Chartres Cathedral, France, 187-189, 188 Rubens, Peter Paul, 298-299; Arrival of Marie de'Medici at Marseilles, 299-300, 299; Elevation of the Cross, 298, 299; Lion Hunt, 8-10, 9 Rue Transnonain (Daumier), 348, 349 Ruskin, John, 352 Russian art: Expressionist, 375, 375; Middle Byzantine, 143–144, 143; Suprematist, 391–392, 392 Russian Revolution, 372 Rustication, 235, 235 Rutherford, Ernest, 371 Ruysch, Rachel, Flower Still Life, 307-308, 307 Sacrifice of Isaac (Brunelleschi), 228-229, Sacrifice of Isaac (Ghiberti), 228-229, Saint Agnes, Church of, Rome, 129 Saint Alexander, Stavelot Abbey, Belgium, 178, 178 Saint Anthony Tormented by Demons (Schongauer), 227, 227 Saint-Denis, France, 186–187, 186 Sainte-Chapelle, Paris, 196, 196 Saint-Étienne, Caen, France, 171–172, 171 Saint Gall monastery, Switzerland, 162-163, 163 Saint-Lazare, Autun, France, 176-177, Saint-Lazare Train Station (Monet), 355, Saint Mark (Donatello), 231, 231 Saint Mark's, Venice, 141–142, 141 Saint Michael's, Hildesheim, Germany, Saint Pantaleimon, Church of, Nerezi, Macedonia, 142, 142 Saint Paul's Cathedral, London (Wren), 313-314, 313 Saint Peter at Wimpfen-im-Tal, Church of, Germany, 199 Saint Peter's, Rome: Baroque completion of, 286–288, 287, 288; new Saint Peter's, 262–264, 263; Old Saint Peter's, 127–128, 128 Saint-Pierre, Moissac, France, 156, 175–176, 175 Saint Serapion (Zurbarán), 296, 296 Saint-Sernin, Toulouse, France, 168-170, 168, 169 Saint Theodore, Chartres Cathedral, France, 193–194, 193 Salisbury Cathedral, England, 199–200, 199, 200 Salon d'Automne, 373 Salon des Refusés, 351 Salons des Indépendants, 351 Samnite House, Herculaneum, 98-99, 99 Samnites, 96 San Carlo alle Quattro Fontaine, Rome (Borromini), 290–291, 290 Santa Costanza, Rome, 128–129, 129 Santa Croce, Florence, 3–4, 3 Santa Maria Novella, Florence (Alberti), 235–237, 236 Sant'Ambrogio, Milan, Italy, 170, 170 Sant'Andrea, Mantua (Alberti), 244-245, Sant'Apollinare Nuovo, Ravenna, 128, 129, 131, 131 Sant'Apollonia, Florence, 241, 241 Santiago de Compostela, 176 Sant'Ignazio, Rome, 294–295, 295 Santorini, 51, 51 Santo Spirito, Florence (Brunelleschi), 234-235, 234

Romulus and Remus, 93, 93

Rotulus, 131

Rotundas, 149

Rood, Ogden, 363 Rose window, Chartres Cathedral,

France, 184, 192–193, 193 Rothko, Mark, 408; No. 14, 410, 410 Röttgen Pietà, Germany, 202–203, 203 San Vitale, Ravenna, 135-138, 135, 136, 137, 138 Sarcophagi (singular, sarcophagus), 90; Early Christian, 125, 125; Etruscan, 90, 91; Roman, 116, 116 Sarcophagus with battle of Romans and Sarteophagus Will Jatte of Konfalis a barbarians, Rome, 116, 116 Sardanapalus (Byron), 334–335, 334 Sartre, Jean-Paul, 406–407, 407 Sasanian Persia, 31 Satirical painting, 322–323, 323 Saturation, 363 Savonarola, Girolamo, 243 Scholasticism, 186 Schongauer, Martin, Saint Anthony Tormented by Demons, 227, 227 Schoolmen of Paris, 186 School of Athens (Raphael), 256-257, 256 Science, 345; early 20th-century, 371; 16th-century, 250 Scientific drawings, 254–255, 254 Scivias (Hildegard of Bingen), 180, 181 Scotland. See British art Scriptoria, 158 Scriptoria, 158
Sculptural technique, 12, 257–258, 258
Sculpture: Abstract Expressionist,
410–411, 410; Akkadian, 26, 26;
Assyrian, 28–29, 28, 29; Baroque, 288,
289–290, 289; Cycladic, 48, 49;
Dadaist, 382, 382; Egyptian, 36–43,
37, 40, 42, 43; Etruscan, 90, 90, 91,
93, 93; Existentialist, 407, 407;
Flemish, 217, 217; Euturist, 380–381. 201–203, 201, 202, 203; Gothic Italian, 203–204, 204; Greek Archaic, 56–58, 56, 57, 58, 61, 61, 64–65, 65; Greek Classical, 65; Greek Early Classical, 65, 66–68, 66, 67, 68; Greek High Classical, 68–69, 68, 71–76, 71, 72, 73, 75; Greek Late Classical, 77–79, 77, 78; Hellenistic, 82–86, 82, 83, 84, 85; Impressionist, 366–367, 366, 367; Italian, 15th-century, 214, 227–231, 228, 229, 231, 237, 237, 239–240, 239; Italian, 16th-century, 257–258, 258; Mannerist, 270, 271; Minimalist, 411–413, 411, 412; Minoan, 51–52, 52; Neoclassical, 328, 328; Neolithic, 21, 21; Ottonian, 165–166, 166, 167; Paleolithic, 15, 16; Postmodernist, 425–427, 427, 430, 430; Realist, 366–367, 366, 367; Roman Early Empire, 104–106, 104, 105, 108–109, 108, 109; Romanesque, 173–178, 174, 175, 176, 177, 178; Roman High Empire, 113, 113; Roman Late Empire, 115–120, 115, 116, 117, 118, 119; Roman Republic, 96, 96; Sumerian, 24, 24; 20th-century, early, 380–382, 380, 382, 396–397, 396, 397; 20th-century, postwar, 430, 430 Seagram Building, New York (Mies van der Rohe and Johnson), 421, 421 Secondary colors, 7, 363 Second Style (Pompeii), 99–101, 100, Sections, 12 Self-Portrait (Leyster), 304, 305 Self-Portrait (Rembrandt), 303, 303 Self-Portrait (van Hemessen), 279, 279 Self-Portrait (Vigée-Lebrun), 321-322, 321 Self-portraits: Close, 418, 418; Eadwine the Scribe, 180, 180; Kahlo, 370, 389–390, 390; Leyster, 304, 305; Rembrandt, 303, 303; van Hemessen. 279, 279; Vigée-Lebrun, 321-322, 321 Sensation: Young British Artists from the Saatchi Collection, 426 Serapion, Saint, 296, 296 Serdab, 33 Serrano, Andres, Piss Christ, 426 Seurat, Georges, 363; A Sunday on La Grande Jatte, 362, 362 Seven Wonders of the ancient world, 29, 34–36, 35, 36 Sexpartite vaults, 172 Sfumato, 219, 254 Shahn, Ben, The Passion of Sacco and

Shelley, Mary Wollstonecraft, Frankenstein, 335 Shelley, Percy Bysshe, Oxymandias, 335 Sheridan, Mrs. Richard Brinsley, 322, 322 Sherman, Cindy, Untitled Film Still #35, 427, 427 Shop Block, Bauhaus (Gropius), 393, 393 Siena Cathedral, Italy, 207–208, 208 Silk, in Gothic art, 208 Silverpoint, 254 Simultaneity of views, 380–381, 380 Sinopia, 206 Sistine Chapel, Vatican: ceiling (Michelangelo), 248, 258–261, 259, 260, 261; Christ Delivering the Keys of the Kingdom to Saint Peter (Perugino), 243-244, 244 Skenographia, 100 Skyscrapers, 367–368, 368, 394, 394, Skysctapers, 387–368, 366, 354, 354, 421, 421 Slavery, 337–338, 337 The Slave Ship (Turner), 337–338, 337 The Sleep of Reason Produces Monsters (Goya), 331–332, 331 Slip, 76, 76 Sluter, Claus, Well of Moses, 217, 217 Smith, David, Cubi XVIII, 410–411, 410 Smithson, Robert, Spiral Jetty, 418-419, Snake Goddess, Crete, 52, 52 Social Contract (Rousseau), 329 Solomon R. Guggenheim Museum (Wright), 420, 420 Sound installations, 432, 432 Spandrels, 108 Spanish art: Baroque, 295–298, 296, 297; Cubist, 376–379, 377, 379, 397–398, 398; Deconstructivist archi-531–332, 331, 332; 16th-century, 280–282, 281; Surrealist, 388–391, 388, 391 Spanish Civil War, 399-398 Spectrum, 7 Spencer, Herbert, 345–346 Sphinx, at Gizeh, 36, 36 Spiral Jetty (Smithson), 418–419, 419 Spoils of Jerusalem, Arch of Titus, Rome, 108-109, 109 Spring Fresco, Santorini, 51, 51 Springing, 191, 191 Squinches, 151 Stained glass windows, 187, 192; Chartres Cathedral, France, 184, 192–193, 193; Sainte-Chapelle, Paris, 196, 196 Standard of Ur, 24–25, 25 Stanford, Jane, 383 Stanza della Segnatura, Vatican Palace, 256–257, 256 Starry Night (van Gogh), 360, 361 Statue columns: Gothic, 189, 189, 195–196, 195 195–196, 195
Statues: Cycladic, 48, 49; Egyptian, 36–42, 37, 40, 42; Etruscan, 90, 90, 91, 93, 93; Gothic, 187–189, 188, 193–194, 193, 196–197, 196, 202–203, 202, 203; Greek Archaic, 56–58, 56, 57, 58, 64–65, 65; Greek Classical, 65; Greek Early Classical, 65, 66–68, 66, 67, 68; Greek High Classical, 68–69, 68, 71–72, 72; Greek Late Classical, 77–79, 77, 78; Hellenistic, 82–86, 82, 83, 84, 85; Italian, 15th-century, 231, 231, 237, 237, 239–240, 239; Italian, 16th-century, 257–258, 258; Mannerist, century, 257–258, 258; Mannerist, 270, 271; Minoan, 51–52, 52; Neolithic, 21, 21; Paleolithic, 15, 16; Roman Early Empire, 104, 104; Roman High Empire, 113, 113; Roman Late Empire, 116–118, 117, 118; Sumerian, 24, 24 The Steerage (Stieglitz), 384–385, 395 Stelae: grave stele of Hegeso, 75–76, 75; stele with law code of Hammurabi, 27–28, 27; Victory stele of Naram-Sin, 26, 27 Steles, 27 Stele with law code of Hammurabi, Susa, 27-28, 27 Stepped Pyramid, Saqqara, Egypt (Imhotep), 33–34, 34

Stieglitz, Alfred, The Steerage, 384-385, Temptation of Saint Anthony Tunnel vaults, 97, 97, 106-107, 107, Vietnam Veterans Memorial (Lin), (Grünewald), 273, 274 Tenebrism, 292–293 169-170, 170 412-413, 412 Still Life in Studio (Daguerre), 340-341, Turner, Joseph Mallord William, The Slave Ship, 337–338, 337 Tuscan columns, 90, 90 View of Haarlem from the Dunes at Tepidarium, 114, 114 Overveen (van Ruisdael), 305, 305 Still lifes, 5; Dutch, 306–308, 306, 307; Fauvist, 374; Netherlands, 278–279, Teresa, Saint, 289-290, 289 Vigée-Lebrun, Élisabeth Louise, Self-Terracotta sculpture: Etruscan, 90, 90 Tutankhamen death mask, 14, 44, 44 Tutankhamen innermost coffin, 43, 43 Portrait, 321–322, 321
Villa of Agrippa Postumus, Boscotrecase, 279; photographic, 340–341, 341; Post-Impressionist, 364, 364; Roman, 103, 103; Synthetic Cubist, 379, 379 Tesserae, 130 Tetrarchy, 116
Textiles: Assyrian, 29; Islamic, 154, 154; Twisted perspective, 18 102, 102 Villa of Livia, Primaporta, 101, 101 Villa of Publius Fannius Synistor, The Two Fridas (Kahlo), 370, 389-390, Still Life with Chair-Caning (Picasso), silk, 208 Two-point linear perspective, 230 Tympanum, 175–178, 175, 176, 177, 201–202, 201 Boscoreale, 100, 101
Villa of the Mysteries, Pompeii, 100, 100
Villa Rotonda, Vicenza (Palladio),
264–265, 264, 265 Texture, 7 Still life with peaches, Herculaneum, 103, The Thankful Poor (Tanner), 352, 353 Theaters, Greek, 80–81, 80 Theatron, 80 The Stone Breakers (Courbet), 346-347, Theodora and attendants, San Vitale, Villa Savoye (Le Corbusier), 394-395, Stonehenge, 21-22, 21 Unfinished captive (Michelangelo), 12, 12, 257 Ravenna, 138, *138* Theodore, Saint, 193–194, *193* Stone sculpture: Akkadian, 27; Assyrian, 28, 29; Babylonian, 27; Egyptian, 36–38, 37, 38, 42; Paleolithic, 16 Viola, Bill, The Crossing, 432, 432 Virgin and Child (Fouquet), 224–225, Theotokópoulos, Doménikos (El Greco), 281–282, 281 Unique Forms of Continuity in Space (Boccioni), 380–381, 380 United States. See American art Strasbourg Cathedral, France, 201-202, The Third of May, 1808 (Goya), 332, Virgin (Theotokos) and Child, icon 332 Untitled (Calder), 396–397, 397 Untitled (Judd), 411–412, 411 Untitled (Your Gaze Hits the Side of My (Vladimir Virgin), 143-144, 143 Third Style (Pompeii), 102, 102
Thirty Years' War, 285, 295
Tholos tombs, 54, 54
Thoughts on the Imitation of Greek Art Street, Dresden (Kirchner), 374, 375 Virgin (Theotokos) and Child between String-courses, 235, 235 Der Sturm, 373 Saints Theodore and George, Mount Face) (Kruger), 428, 428 Untitled Film Still #35 (Sherman), 427, Sinai, 122, 139, 139 Virgin and Child Enthroned with Saints (Duccio), 207–208, 208 Style, artistic, 3–5 Stylobates, 59, 59, 70 Stylus, 226 in Painting and Sculpture (Winckelmann), 325 Three goddesses, Parthenon, 72, 72 427 Ur, Iraq, 22–25, 23, 25, 27; Royal Cemetery at, 25; ziggurat at, 22–23, 23 Virgin Mary: Annunciation, 203–204, 204, 208–209, 209, 221, 221, Subject of art, 5 204, 208–209, 209, 221, 221, 240–241, 240; Assumption of, 225–226, 226, 266–267, 267; with Child, 122, 139, 139, 193, 193, 196–199, 196, 199, 224–225, 225, 241–242, 242, 268–269, 269; with Child, in nature, 251–252, 251, 255, Subtractive light, 7 Subtractive sculpture, 12, 37 Three revelers (Euthymides), 46, 63-64, Urban planning. See Cities Uruk temple, Iraq, 22–23, 22 Ushabtis, 33 Successive contrasts, 363 Suger, Abbot, 186–187 Sullivan, Louis Henry, Guaranty Thutmose, Nefertiti, 42, 43 Tilework, Islamic, 148, 149, 152-153, 153 (Prudential) Building, Buffalo, Timelines: Early Christianity and Valley temples (Egypt), 36, 36 367-368 368 Byzantium, 155; early civilizations, 45; Europe, Baroque, 315; Europe, Early Medieval and Romanesque, 183; Value, 363 255; at the Crucifixion, 140-141, 141; Sullivan, Mary Quinn, 383 Van Dyck, Anthony, Charles I Dismounted, 300, 300 death of, 201–202, 201; at the death of Christ, 202–203, 203, 268, 269; on Sultans, 152 Sultans, 132 Sumerian art, 22–25, 22, 23, 24, 25 A Sunday on La Grande Jatte (Seurat), Europe, Gothic, 213; Europe, 15th-century, 247; Europe, 16th-century, 283; Europe and America, 1750-1850, Van Eetvelde House, Brussels (Horta), icons, 143–144, 143; intercession by, 188, 189; Lamentation, 142, 142; as Madonna, 204–205, 205, 241–242, 242, 255, 255, 268–269, 269; official recognition of, 138; as Queen of Heaven, 196–197, 196, 204–205, 205, 207–208, 208, 218, 219; as Theotokos, 122, 139, 139, 143–144, 143; Visitation, 195–196, 195
Virgin of Jeanne d'Eureux, Saint-Denis, France, 198–199, 199
Virgin of Paris, Notre-Dame, Paris, 196–197, 196
Virgin of the Rocks (Leonardo), 251–252, 251
Virgin with the Dead Christ (Röttgen icons, 143–144, 143; intercession by, 368, 368 362, 362 van Eyck, Jan: Ghent Altarpiece, Sunnah, 148 343; Europe and America, 1850-1900, 369; Europe and America, 1900-1945, 403; Europe and America, after World 217–219, 218; Giovanni Arnolfini and His Bride, 222, 222 van Gogh, Vincent: The Night Café, Superimposed orders, 107, 107 Superrealism, 418, 418
Suprematism, 391–392, 392
Suprematist Composition: Airplane War II, 433; Greek and Hellenistic, 87; Islamic, 155; Roman Empire, 121 Tintoretto, Last Supper, 271, 271 359–360, 360; Starry Night, 360, 361 van Hemessen, Caterina, Self-Portrait, Flying (Malevich), 391–392, 392 Surrealism, 370, 387–391, 388, 389, 390, 391 Vanishing points, 230, 230, 233, 233 Vanitas Still Life (Claesz), 306–307, 307 van Ruisdael, Jacob, View of Haarlem from the Dunes at Overveen, 305, 305 Titian: Assumption of the Virgin, 266–267, 267; Venus of Urbino, 267–268, 267 Surrounded Islands (Christo and Jeanne-Claude), 419–420, 420 Sutton Hoo ship burial, Suffolk, England, Ti watching a hippopotamus hunt, Saqqara, Egypt, 38, 38 Tombs: Early Dynastic Egyptian, 32–34, Vase painting: Greek Archaic, 61–64, 62, 63; Greek Geometric, 55–56, 55; Greek High Classical, 76, 76; Minoan, 157–158, 158 The Swing (Fragonard), 318–319, 319
Swiss art: Carolingian, 161–164, 161, 163; Dadaist, 381–382, 381;
Existentialist, 407, 407; International Style architecture, 394–395, 395; 33, 34; Etruscan, 90–92, 91, 92; Mycenaean, 53–54, 54; Old Kingdom Egyptian, 34–36, 35, 36, 38, 38; Sumerian, 24–25, 25. See also Burials; Mortuary temples; Sarcophagi Virgin with the Dead Christ (Röttgen Pietà), Germany, 202–203, 203 Visitation, Reims Cathedral, France, 51. 51 Vatican: 15th-century art, 243-244, 244; 195–196, 195 Vitruvius, 70, 89, 235, 264 Vladimir Virgin, 143–144, 143 Old Saint Peter's, 127-128, 128; Saint Peter's, 262-264, 263; School of Athens (Raphael), 256-257, 256; Surrealist, 389, 389 Symbolism, 364–365, 365 Symmetry, 36, 37, 70 Synthetic Cubism, 379, 379 Tomb of the Leopards, Tarquinia, 92, 92 Attens (Rapnael), 256–257, 256; Sistine Chapel, 243–244, 244, 248, 258–261, 259, 260, 261 Vaulting webs, 191, 191 Vaults: barrel, 97, 97, 106–107, 107, 169–170, 170; dome-shaped, 54, 54; fan, 200, 200; Gothic rib, 186–187, Tomb of the Reliefs, Cerveteri, 91–92, 91 Toulouse-Lautrec, Henri de, At the Moulin Rouge, 357–358, 358 Voltaire, 320, 321 Votive offerings, 24, 24 Voussoirs, 175, 175 Tower of Babel, Babylon, 22-23 Trade (Quick-to-See Smith), 429-430, 429 Taberna, 111
Talbot, Henry Fox, 340–341 Trajan Decius, portrait bust of, 115-116, War, art and: Cubism, 397-398, 398; war, art and: Cubism, 397–398, 398; Dada, 381; Futurism, 380–381; Neue Sachlichkeit, 386–387, 386, 387; paintings, 351–352, 351; photography, 342, 342; postwar expressionism, 406–407, 406, 407 Warhol, Andy, Marilyn Diptych, 417, 186, 187; groin, 97, 97, 169–172, 170, 171, 172; rib, 170, 186–187, 186, 187; ribbed groin, 172, 172; sexpartite, 172 Tanner, Henry Ossawa, The Thankful Transcendental landscapes, 334-336, 336 Poor, 352, 353 Transepts, 128, 128, 164 Transverse arches, 169, 169
Transverse ribs, 191, 191
The Treachery (or Perfidy) of Images (Magritte), 389, 389
Treasury of Atreus, Mycenae, 53–54, 54
Les Très Riches Heures du Duc de Berry Velázquez, Diego: Las Meninas, 284, 297–298, 297; Water Carrier of Seville, 296–297, 296 Tapestries, 181, 182 Technique, 6 Technology, advances in, 371–372 Tempera, 219 Vellum, 131, 254 Tempietto, San Pietro, Rome (Bramante), 261–262, 262 Warka Vase, Uruk, 23–24, 23 Warrior, Riace, Italy, 66–67, 67 Venice: Mannerism, 270–272, 271, 272; Middle Byzantine art, 141–142, 141; 261–262, 262 Temples: Egyptian, 36, 36, 39–41, 39, 40, 41; Etruscan, 89–90, 90; Greek Archaic, 58–61, 59, 60, 61, 64, 64; Greek High Classical, 69–75, 69, 70, 71, 74; Hellenistic, 81–82, 81; Pompeiian, 96, 96; Roman, 94, 95, 111–113, 111, 112; Sumerian, 22–23, (Limbourg Brothers), 223–224, 224 Tribune galleries, 169–170, 169, 170 Tribute Money (Masaccio), 231–233, 16th-century art, 264–268, 266, 267 Venturi, Robert, 422 Venus, 238–239, 239, 267–268, 267 Warrior taking leave of his wife (Achilles Painter), 76, 76 Water Carrier of Seville (Velázquez), Venus de Milo (Alexandros of Antiochon-the-Meander), 83, 84 Venus of Urbino (Titian), 267–268, 267 296-297, 296 Triclinum, 99, 99 Watteau, Antoine, Return from Cythera, 318, 319 Triforium, 190, 192, 191
Triglyphs, 59, 59
Trilithons, 21–22, 21
Triptychs: Flemish, 220–223, 220, 221, Venus of Willendorf, 15, 16 Vergil, 86, 105 Well of Moses (Sluter), 217, 217 West, Benjamin, The Death of General Temple of Aphaia, Aegina, Greece, 64–65, 64, 65 Vermeer, Jan, Allegory of the Art of Painting, 306, 306 Veronese, Paolo, Christ in the House of Levi, 272, 272 Wolfe, 323–324, 324 Westwork, 164 Wet-plate photography, 342, 342 223, 298, 299; Holy Roman Empire, Temple of Artemis, Corfu, 61, 61 Temple of Athena Nike (Kallikrates), 69, 74–75, 74, 75 272-274, 273 Trithemius, Johannes, In Praise of Scribes, 198 Versailles palace (Le Brun), 310-313, Where Do We Come From?... (Gaugin), 360-362, 361 Temple of "Fortuna Virilis," Rome, 94, Triumphal arches, 108-109, 108, 109, 311, 312 Ti19–120, 119
Triumph of Bacchus (Carracci), 294, 294
Triumph of Titus, Arch of Titus, Rome, Vesuvius. See Pompeii Whistler, James Abbott McNeill, Temple of Hera, Olympia, 78 The Veteran in a New Field (Homer), 351-352, 351 Nocturne in Black and Gold, 358, 359 White and Red Plum Blossoms (Ogata Temple of Hera, Paestum, Italy, 60-61, Victory stele of Naram-Sin, Iran, 26, 27 Video images, 430–432, 431, 432 Vienna Genesis, 132, 132 109, 109 Korin), 8, 8 Temple of Jerusalem, 108–109, 109 Temple of Portunus, Rome, 94, 95 White-ground painting, 76, 76
White Plum Blossoms (Ogata Korin), xvi
White Temple, Uruk, 22–23, 22
Whitney, Gertrude Vanderbilt, 383 Trompe l'oeil, 389, 389 Trumeau, 175, 175 Tumuli, 91 Temple of Ramses II, 39-40, 40

Tunisian art, 149-150, 149

Vierzehnheiligen Chapel, Germany (Neumann), 314, 314

Templon, 143

Who's Afraid of Aunt Jemima? (Ringgold), 428–429, 429 Wibald, abbot of Stavelot, 178 Winckelmann, Johann Joachim, Thoughts on the Imitation of Greek Art in Painting and Sculpture, 325 Woman I (de Kooning), 409, 409 Woman with Dead Child (Kollwitz), 387,

Woman with the Hat (Matisse), 373, 373 Women: Egyptian, 39; feminist art, 425–428, 427, 428; Greek, 47; as "matrons" of art, 383. See also Female figures; Female nudes; Women

Women artists: African-American, 428–429, 429; Baroque, 293, 293; Dutch, 307–308, 307; feminist art, 425–428, 427, 428; Mannerist, 269–270, 270; Minimalist, 412–413, 412; Native American, 429–430, 429; Naturalistic, 293, 293; Neoclassical, 325–326, 325; Netherlands, 16th-century, 279, 279; Postmodernist, 425–430, 427, 428, 429, 430; Post-Painterly Abstraction, 411, 411

Wood, Grant, American Gothic, 401–402, 401

Woodblock printing, 226–227

Wood carvings: German, 225–226, 226; Gothic, 202–203, 203; Holy Roman Empire, 272–274, 273; Sumerian, 24–25, 25 24–25, 25
Woodcuts, 226–227
World War I, 372, 406
World War II, 372, 406
Wren, Christopher, Saint Paul's
Cathedral, London, 313–314, 313
Wright, Frank Lloyd: Kaufmann House
(Fallingwater), 395–396, 395; Solomon
R. Guggenheim Museum, 420, 420
Wright of Derby, Joseph, A Philosopher
Giving a Lecture at the Orrery, 320, 321

Writing: cuneiform, 22, 27; hieroglyphs, 32; Islamic, 152–154, 153. See also Calligraphy Your Gaze Hits the Side of My Face (Kruger), 428, 428

Z Ziggurats, 22–23, 22, 23, 27 Zurbarán, Francisco de, Saint Serapion, 296, 296